ENCYCLOPEDIA OF PHOTOGRAPHY

ENCYCLOPEDIA OF PHOTOGRAPHY

Edited By
BERNARD E. JONES

Introduction By
PETER C. BUNNELL
Princeton University

ROBERT SOBIESZEK
*International Museum of Photography
at George Eastman House*

WITH A NEW PICTURE PORTFOLIO

ARNO PRESS
A New York Times Company
New York • 1974

Reprint Edition 1974 by Arno Press Inc.

Introduction Copyright © 1974
 by Peter C. Bunnell and
 Robert A. Sobieszek

Manufactured in the United States of America

Library of Congress Cataloging in Publication Data

Jones, Bernard Edward, 1879- ed.
 Encyclopaedia of photography.

 Reprint of the 1911 ed. published by Cassell, London,
New York under title: Cassell's cyclopaedia of photography.
 1. Photography—Dictionaries. I. Title.

TR9.J6 1974 770' .3 74-19443
ISBN 0-405-04922-6

INTRODUCTION

Contemporary photography, like the photography of any period, has as its base an extra-ordinary technology. This facet of the medium is what is sometimes referred to as craft, and expertise in the craft of photography has always reflected ability beyond the simple selection of a lens, a shutter speed, or an aperture. However, one might observe that for today's serious amateur little technical skill is required to take an accomplished picture with cameras, lenses, and exposure meters being what they are. But as we all know, though we rarely admit it, accomplishment in photography comes down to a successful combination of the technique or craft and the expressive sensibility of the photographer. Such sensibility is integral to the breadth of one's knowledge and the facility of one's curiosity.

The encyclopedic dictionary of photography is as old as photography itself, but the delightful thing about those which have been published is their close resemblance to a kind of recipe book. The earliest volumes on photography dealt with a bit of history, a bit of approach, and a good deal of home recipe and chemistry. Indeed, it might be said that the first manuals and books on photography told you everything *except* what to use photography for. By the early twentieth century, when this encyclopedia was published, this deficiency had been recognized and, as the author of this book states, "the object has been to include *every* accepted photographic term and to survey the *whole* field of photographic knowledge, whilst giving particular attention to the require-ments of the working photographer, both amateur and professional." And indeed he did in nearly six hundred pages, from Abat-jour to Zoopraxiscope.

In so doing the editor covered such formulae and their background as that for the Arabian gum-bichromate process, the glycine developer, the kallitype, pyro, and a charming process much in vogue in the nineteenth century, the honey process. Today many of these processes are experiencing a revival of interest as photographers seek a more direct sense in the making of the photographic object as well as the picture. Then there was the question of what to photograph and so there are such subjects discussed — in addition to what you would expect — as figures in landscape, photography of locomotives, natural history, Rembrandt effects, and psychic photography. Finally there are the famous names of those whose contributions to the medium remain singular, D. O. Hill, Julia Margaret Cameron, Daguerre, Rejlander, Herschel, and some whose stars have fallen from glory, Hardwick, Dallmeyer, Sayce, and Burton.

In addition to the fascination which today's photographer should find in this book, one should also be prepared for some curious phenomena. For instance, many early processes probably worked simply because the impurities in the chemical compounds produced side effects which in turn produced the ultimate result. Using the same for-mulae today, one might find that the exact purity of present day commercial chemicals prohibits such bizarre side effects and a new challenge exists to literally 'invent' again the described process and produce its effect. Likewise consider our interest today in archival processing and the desire to assure complete washing of the print and negative. The photographer working in the field in the nineteenth century probably thought his

methods primitive, but consider the fine papers readily available for coating and the resultant assurance of having done the coating himself. Can we even remember the purity of our streams and lakes in which the prints and negatives were once washed? So it is that photography is a living medium which presents both a challenge and a delight to the seriously interested. This book, written in the spirit of completeness, may be seen to be as valuable today and as fascinating as when it was first published.

Here the camera collector will find descriptions of all the apparatus in use during the last century. This information is also of great value to the collector of photographic prints interested in knowing how the pictures were made; under what conditions and limitations were the photographers working. Surprisingly one may discover how effects sometimes seen today as pictorial were actually the result of the physical properties of the cameras and lenses, or of the processes themselves. One of the favorite terms used in such books was "practical hints on . . ." and while this may be thought to be somewhat quaint, such a phase reflected accurately how photography was viewed and how, in the nature of its scientific base, it was conceived. Practicality in photography has always been its basis, and in so far as the art is concerned, that came afterward.

There is something here for everyone. For all who since this famous slogan was first announced, "You push the button and we do the rest" have felt that what was being referred to was *not* the photography for them.

Peter C. Bunnell
Robert Sobieszek

New York, 1974

PREFACE

MANY years ago, while assisting in the production of a small photographic manual, the difficulty experienced in finding room for everything that ought to have been included brought to my mind a suggestion for an encyclopædic work covering all the phases of photography. It was not until this suggestion had been discussed, seven years later, with Mr. Percy R. Salmon that it became crystallised into something concrete and workable. To Mr. Salmon, more than anyone else, is due the credit for the particular form which this work has assumed. Together we planned it, and together decided the majority of the multitudinous questions of detail that arose.

Of photographic dictionaries and cyclopædias printed in the English language there have been as many as could be counted on the fingers of one's hands ; but the present volume is essentially different from any of them, and is undoubtedly the most ambitious work of its kind yet projected. With possible exceptions, its predecessors were written or compiled from cover to cover by one hand ; whereas this work is the result of the co-operation of many men, each having special knowledge of his own particular branch. Modern photography has so many ramifications, each calling for the application of special knowledge, that I felt that the only proper course, in attempting to produce a photographic cyclopædia at once authoritative and complete, was to enlist the services of as many specialists as possible. About a score of the best-known and most authoritative expert photographic writers extended their co-operation, and their contributions constitute the bulk of this work.

While it must be confessed that complete accuracy is almost too much to hope for in the first edition of a work of reference, I have taken care to do all that could be done to check and verify the statements made. My especial thanks in this connection are due to Messrs. Percy R. Salmon, E. J. Wall, Arthur Lockett and William Gamble, for the trouble they have taken in reading the proofs. I shall appreciate and acknowledge any minor corrections that readers may send me, and shall hope to be able to incorporate them in later editions, in the happy event of such being called for.

The scope of the work demands some words of explanation. The object has been to include every accepted photographic term and to survey the whole field of photographic knowledge, whilst giving particular attention to the requirements of the working photographer, both amateur and professional. This cyclopædia is intended essentially as a simple guide to photographic practice, whatever else it may be. In all cases where the process described is commonly used, or is likely to be worked nowadays, working directions and definite formulæ are given.

This work is intended not only for the practical photographer, but also for the scientific student, who will find in all those articles that have been written especially for him valuable, because authoritative, summaries of what has already been attained in the many branches of photographic science. The manufacturer, too, especially the manufacturer of materials, will find in this volume a mass of information relating to what others have done before him, and by profiting by it he will be prevented from wasting time and money in useless trials in some directions and possibly be given ideas as to commercially remunerative lines of experiment in others.

There are two matters, in particular, upon which I think it desirable to address a word to the critical reader. It will be noticed that a few biographies are given, and the question as to why such and such men are included and others omitted is sure to arise. The biography of no living photographer will be found in these pages ; and with regard to the dead worthies, I have done my best to include only those who, when viewed historically, have real claims to distinction. And in such a matter much must be left to personal opinion. The other matter is the omission, with a few exceptions, of trade names. Their inclusion, a highly debatable point, would have meant the addition of more than thirteen hundred headings, the information given under which might rapidly have gone out of date. The exceptions, as in the case of a certain camera which it would be superfluous to mention, have now become part of the language, and are associated in the public mind quite as much with broad types of apparatus or certain classes of materials as with any particular brands of manufacture.

The illustrations call for a word of explanation. The monochrome plates have been selected as representing separate phases of photographic art, and are offered as being good examples of their kind. On the other hand, three of the coloured plates are intended to represent merely the capabilities of the screen plates with which the original pictures were made; while, of the remaining two, one plate shows the steps in the production of a four-colour print and the other the composition of six of the best-known screen plates. The line drawings throughout the book (almost all of which have been drawn by E. S. W. Cunnington from the contributors' sketches) have the sole object of elucidating the text; much thought was given to the advisability or otherwise of using photographic illustrations in the text, but it was decided that drawings would be far more instructive. In many cases the drawings have been based upon illustrations appearing in trade catalogues, and in this connection my thanks are due to a large number of firms, including the following: Adams & Co.; A. H. Baird; Bausch and Lomb Optical Co.; R. and J. Beck, Ltd.; W. Butcher and Sons, Ltd.; J. J. Griffin and Sons, Ltd.; J. Fallowfield; J. Halden and Co.; Houghtons, Ltd.; Infallible Exposure Meter Co.; Kodak, Ltd.; J. Lancaster and Son, Ltd.; Marion and Co., Ltd.; G. Mason and Son; Newman and Guardia, Ltd.; A. W. Penrose and Co., Ltd.; Ross Ltd.; Sanger Shepherd and Co., Ltd.; O. Sichel and Co.; Thornton-Pickard Mfg. Co., Ltd.; W. Tyler; A. G. Voigtländer and Sohn; Watkins Meter Co.; W. Watson and Sons, Ltd.; Westminster Engineering Co., Ltd.; Westminster Photographic Exchange, Ltd.; and C. Zimmermann and Co.

For the principal information given in the article " Ceramic Process " I am indebted to Mr. W. Ethelbert Henry's standard work, " Photo-Ceramics."

With regard to the formulæ, in practically all cases the parts are given in both British and Metric measures; by whichever system a solution is made up, the relative proportions of the ingredients will be almost exactly the same, although the actual quantities nearly always differ.

B. E. J.

LIST OF CHIEF CONTRIBUTORS

T. THORNE BAKER, F.C.S. . . Isochromatic Photography, Photo-telegraphy

HENRY W. BENNETT, F.R.P.S. Architectural Photography, Carbon Process, Lantern Slides, etc.

A. H. BLAKE, M.A. . . . Night Photography

GEORGE E. BROWN, F.I.C. . Copyright

THEODORE BROWN . . . Stereoscopic Photography, Kine-matography

J. C. BURROW, F.R.P.S. . . Mine Photography

CHARLES P. BUTLER, A.R.C.Sc. (Lond.), F.R.P.S., F.R.A.S. Astronomical Photography

DRINKWATER BUTT, F.R.P.S. . Studio Design and Construction

EDGAR CLIFTON, F.R.P.S. . . Lenses

F. MARTIN DUNCAN, F.R.P.S. Natural History Photography

WILLIAM GAMBLE . . . Photo-mechanical Processes

ARTHUR D. GODBOLD . . . Studio Work

WALTER KILBEY, F.R.P.S.. . Focal-plane Shutter Work

ARTHUR LOCKETT, *Honours Silver Medallist in Photography, City and Guilds.* Cameras, Apparatus, Special Processes, etc.

THOMAS MANLY, F.R.P.S. . . Ozobrome, Ozotype

J. I. PIGG, F.R.M.S., F.R.P.S.. Photomicrography, X-ray Photography

PERCY R. SALMON, F.R.P.S. . Historic and General Processes, Developers and Miscellaneous

E. J. WALL, F.R.P.S. . . . Chemistry, Colour Photography, Special Processes

W. L. F. WASTELL, F.R.P.S. . Pictorial Photography and Special Processes

ABOUT THE PORTFOLIO

This portfolio of rare early photographs has been added to this edition in order to more fully illustrate the references found in the book. Each picture is identified by photographer and captioned in italics with the specific entry which it illustrates. The photographs are of international origin and they were all made prior to 1911.

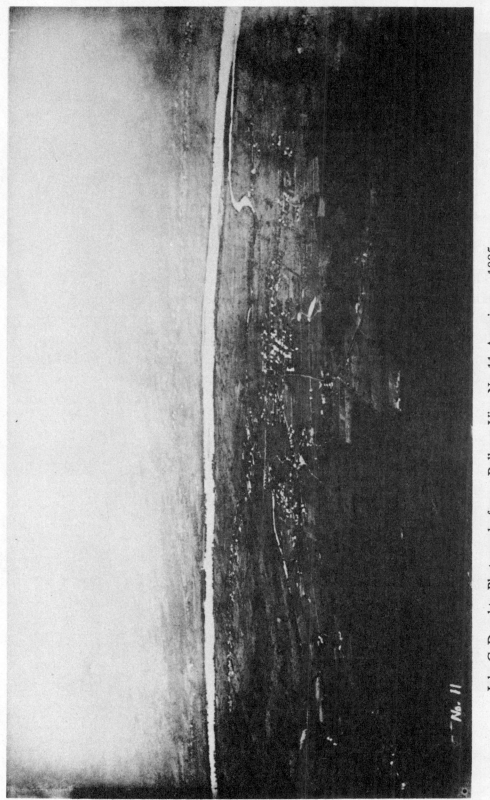

No. 11

John G. Doughty. Photography from a Balloon, View No. 11. American, c. 1885.
International Museum of Photography at George Eastman House. *Aerial Photography*

Saul M. Davis. Unidentified man in front of Niagara Falls. Ambrotype. Canadian, c. 1860. International Museum of Photography at George Eastman House. *Ambrotypes.*

A.A.E. Disderi et al. Two pages from a carte-de-visite album. French, c. 1860-18

Unidentified Photographer. Portrait of Frederick Scott Archer. British, c. 1851-1857.
International Museum of Photography at George Eastman House.
Frederick Scott Archer.

On facing page:
Hoeger Studio. Anonymous Portrait. American, c. 1883.
The Library of Congress. *Background.*

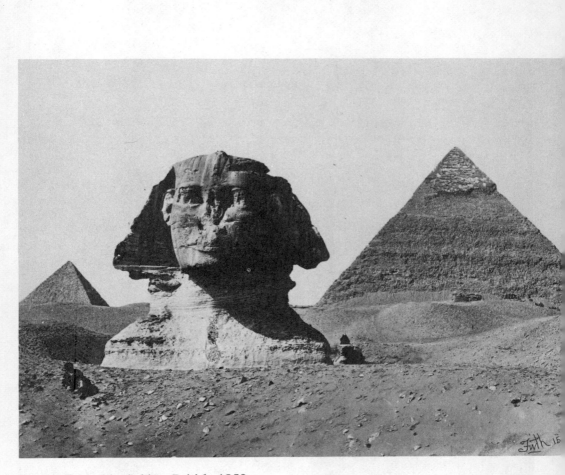

Francis Frith. The Sphinx. British, 1858.
Princeton University.
Architectural Photography.

Rothengatter and Dillon. Astarte. American, 1889.
The Library of Congress.
Photography by Artificial Light.

C.S.S. Dickins. Landscape. Calotype negative. British, c. 1850-1855.
International Museum of Photography at George Eastman House.
Calotype, or Talbotype, Process.

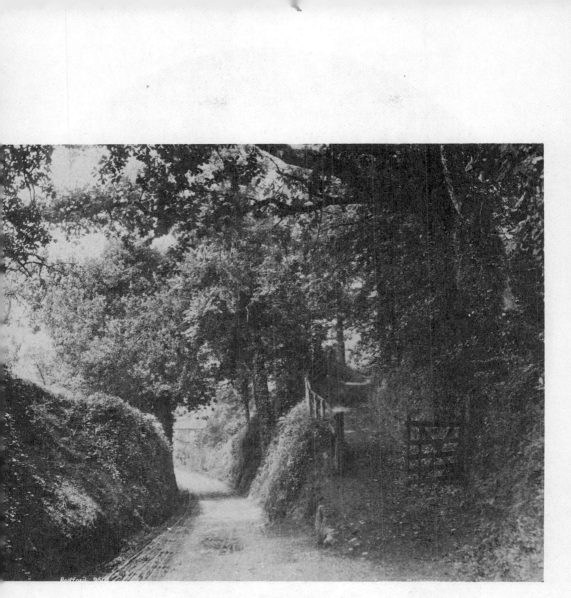

Francis Bedford. Torquay, Cockington Lane. British, c. 1880's.
International Museum of Photography at George Eastman House.
Francis Bedford.

Unidentified Photographer. Print from glass plate negatives used in a vest concealed "detective" camera. American, c. 1886–1890. International Museum of Photography at George Eastman House. *Buttonhole, or Vest, Camera.*

On facing page:
N. Sarony. Sarah Bernhardt. Cabinet photograph. American, 1880. International Museum of Photography at George Eastman House. *"Cabinet" Size.*

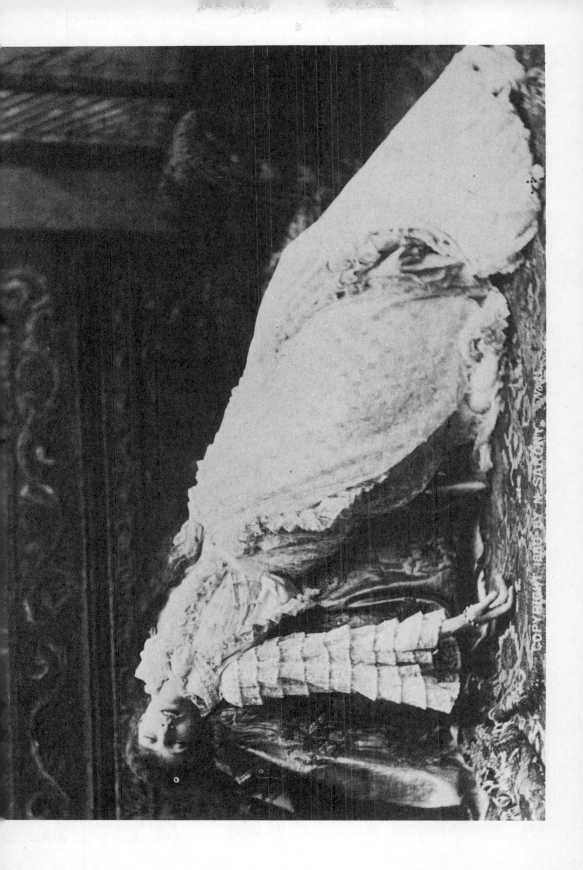

Peter Henry Emerson. The Clay Mill (Norfolk). Aquatint photogravure. British, 1888.
International Museum of Photography at George Eastman House.
Aquatint (Photogravure).

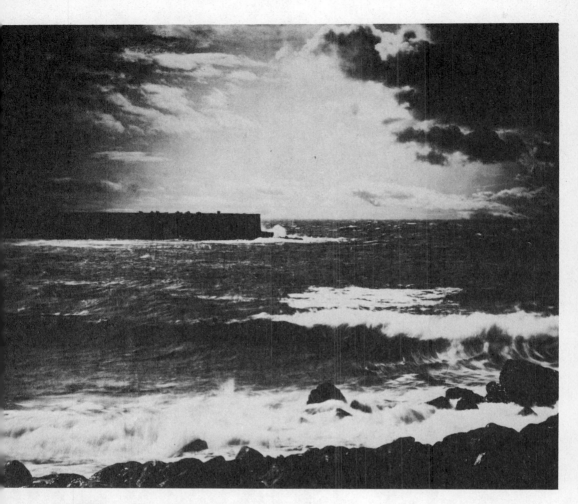

Gustave LeGray. Seascape. French, c. 1858.
International Museum of Photography at George Eastman House.
Clouds, Printing In.

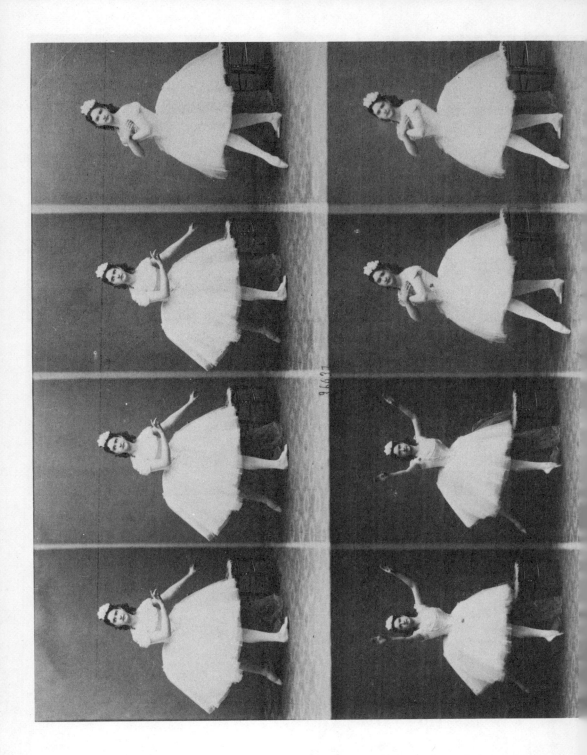

On facing page:

A.A.E. Disderi. Dancer. Uncut sheet of carte-de-visite photographs. French, c. 1862.
International Museum of Photography at George Eastman House. *Carte-de-visite.*

Eadweard Muybridge. Wrestlers. American, born England, 1886.
Princeton University. *Chrono-photography.*

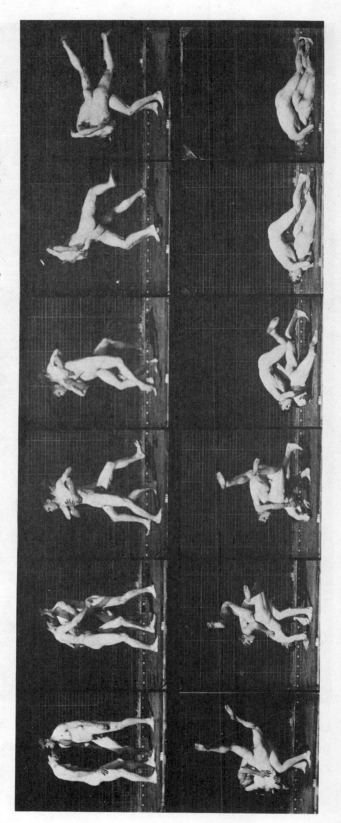

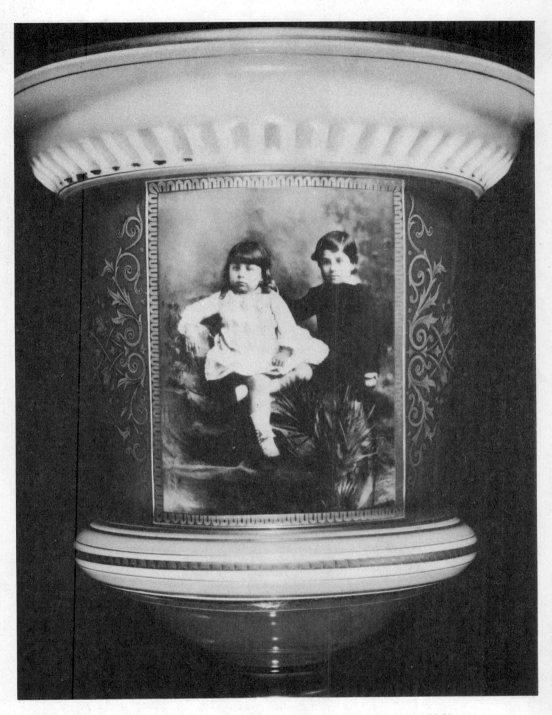

Unidentified photographer. Photograph on ceramic vase. American, c. 1890's.
International Museum of Photography at George Eastman House.
Ceramic Process and Photographs on China.

A.F.J. Claudet. Self-portrait (?). British, c. 1860.
International Museum of Photography at George Eastman House.
Antoine Jean Francois Claudet.

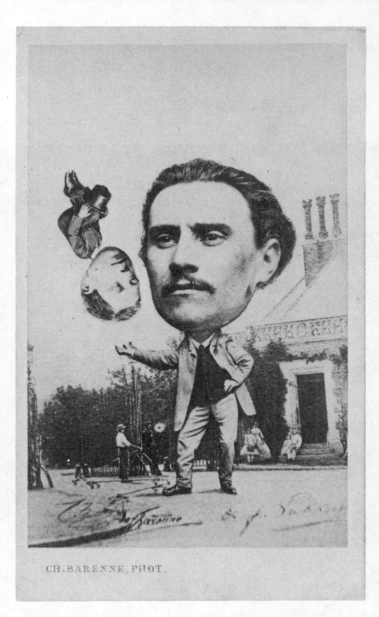

CH.BARENNE, PHOT.

Charles Barenne. Self-portrait caricature. Carte-de-visite
photo-montage. French, c. 1860's.
International Museum of Photography
at George Eastman House. *Caricature*.

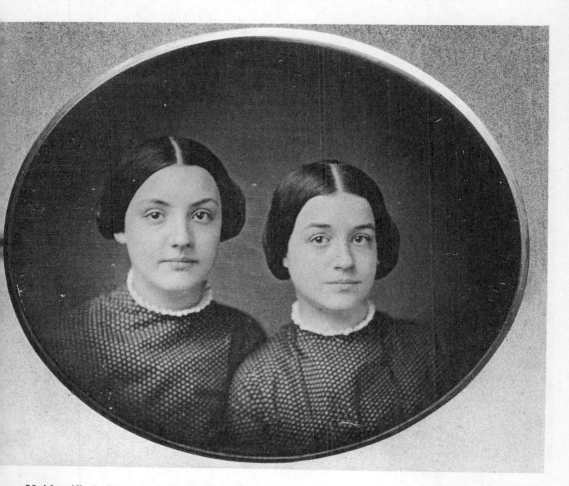

Unidentified photographer. Quaker Sisters. Daguerreotype. American, 1853.
International Museum of Photography at George Eastman House.
Daguerreotype Process.

Josef Berres. Heliogravure from an etched daguerreotype plate. Austrian, 1840.
International Museum of Photography at George Eastman House.
Daguerreotype, Etching.

John W. Draper. Portrait of Dorothy Catherine Draper. American, 1840.
University of Kansas Museum of Art. *John W. Draper*.

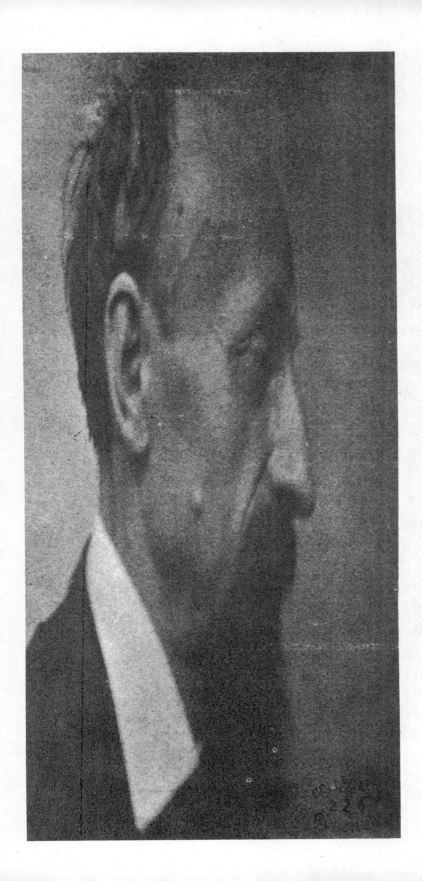

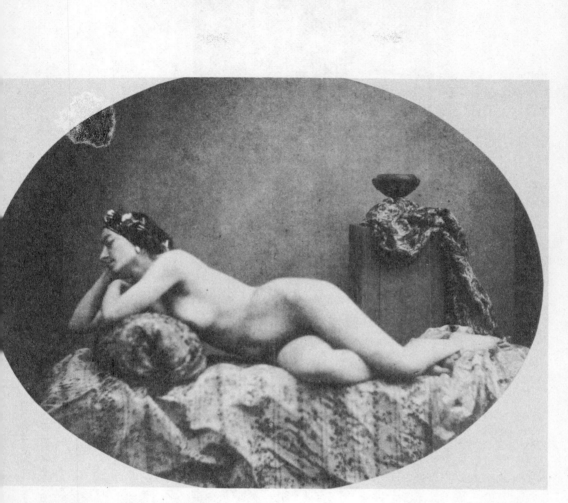

Eugène Durieu. Odalesque, French, c. 1854.
International Museum of Photography at George Eastman House.
Figure Studies and Photography of the Nude.

On facing page:
Louis Ducos du Hauron. Self-portrait with distorting camera. French, 1884-1890.
International Museum of Photography at George Eastman House. *Ducos du Hauron.*

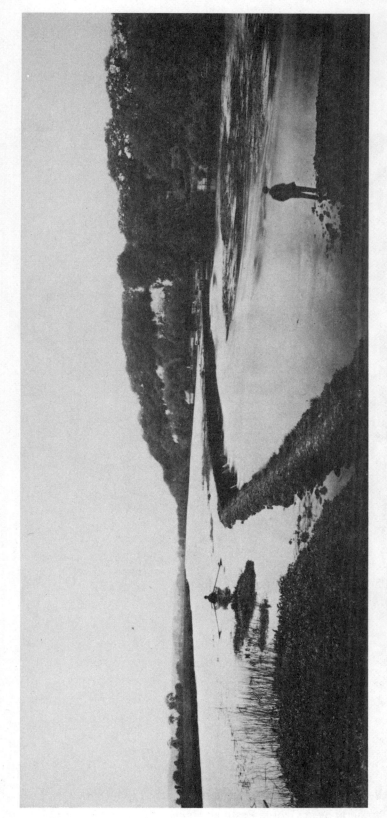

Roger Fenton (?). New Loch, Hurley. British, c. 1862.
International Museum of Photography at George Eastman House. *Figures in Landscapes.*

On facing page:
Felice Beato. Winnowing Rice. British/Japanese, c. 1860-1865.
International Museum of Photography at George Eastman House. *Genre Work.*

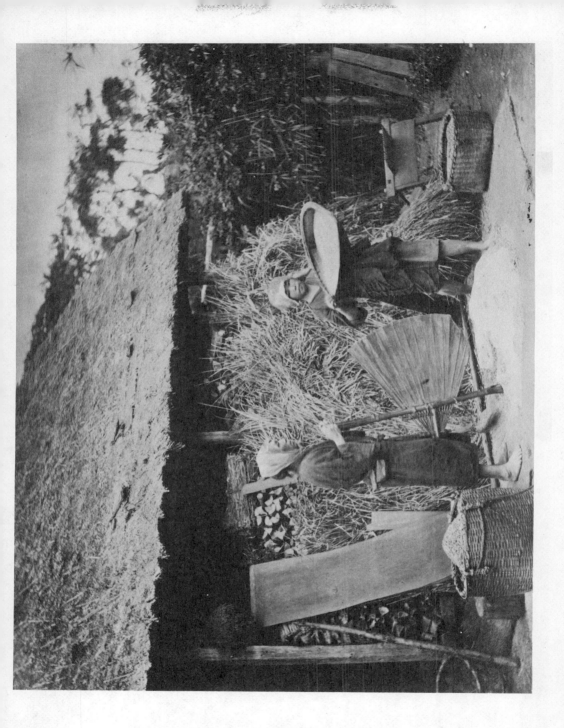

Heinrich Kuhn. Landscape. Gum-bichromate print. Austrian, c. 1900.
International Museum of Photography at George Eastman House. *Gum-bichromate Process.*

Unidentified Photographer. Oriental Scene. Algerian (?), c. 1870's.
International Museum of Photography at George Eastman House. *Halation.*

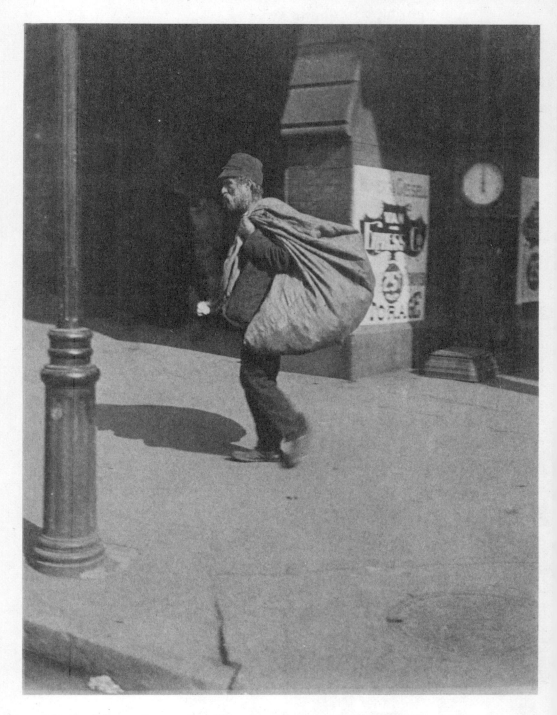

Dallett Fuguet. Street scene. Cyanotype. American, c. 1900-1910.
International Museum of Photography at George Eastman House.
Hand Camera Work.

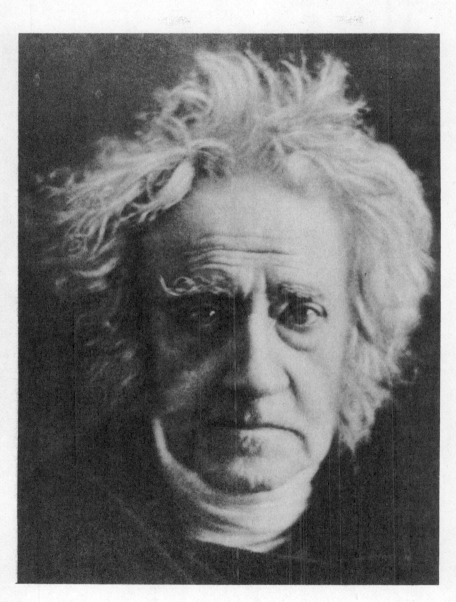

Julia Margaret Cameron. Sir John Hershel. British, 1867.
Princeton University. *J.F.W. Hershel* and *Julia Margaret Cameron.*

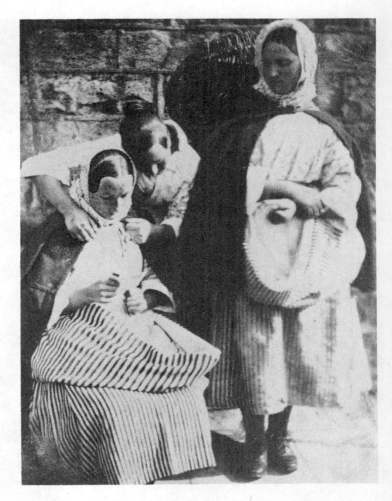

David Octavius Hill and Robert Adamson. Fisherwomen,
Newhaven. British, 1845.
Princeton University. *David Octavius Hill*.

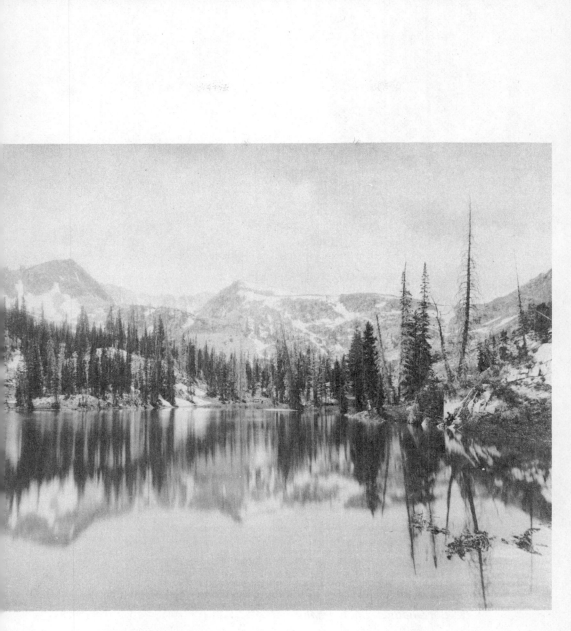

William Henry Jackson. Twin Lake, Utah. American, 1875.
Princeton University. *Landscape Photography*.

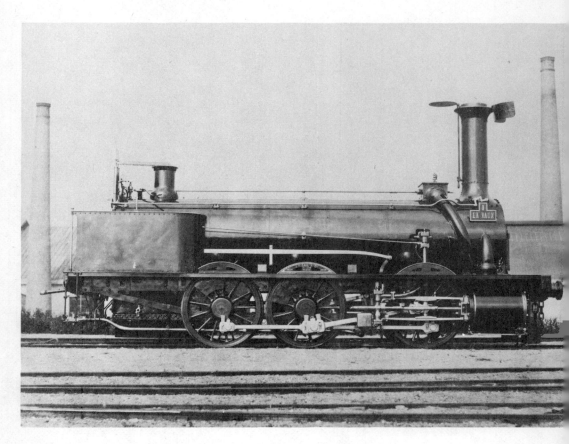

Bisson Frères. "La Vaux." French, c. 1855.
International Museum of Photography at George Eastman House.
Locomotives, Photography of.

Unidentified Photographer. Illustration from *Spinal Disease and Spinal Curvature,* London, 1877.
International Museum of Photography at George Eastman House.
Medical Photography.

Francois Willeme. Photosculpture bust, intermediate stage. French, c. 1860's.
International Museum of Photography at George Eastman House. *Photo-sculpture.*

On facing page:
B. J. Falk. Lillian Russell as "Dorothy." American, 1887.
The Library of Congress. *Portraiture.*

Blanc d'Aubigny. Post-mortem daguerreotype. French, c. 1845.
International Museum of Photography
at George Eastman House.
Post-mortem Photography.

On facing page:
W. Bacon and J. W. Taylor. The Flood in Rochester. Photograph
and its derived engraving. American, 1865.
International Museum of Photography at George Eastman House.
Press Photography.

Unidentified Photographer. Carte-de-visite spirit photograph.
American, c. 1860's.
International Museum of Photography at George Eastman House.
Psychic Photography.

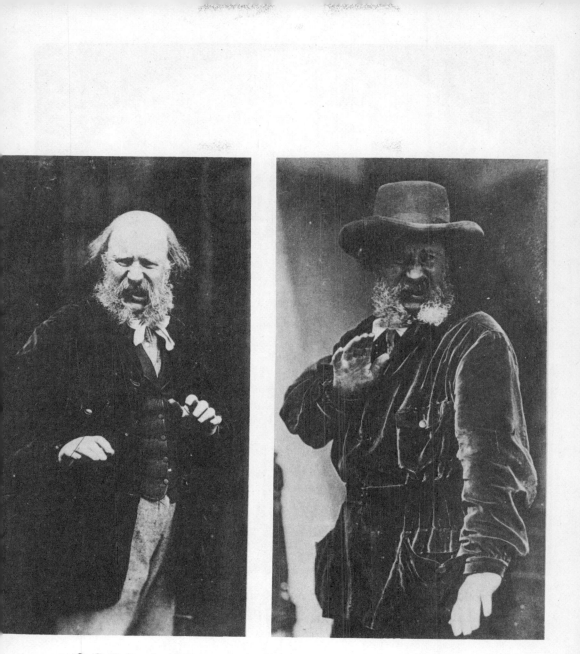

O. G. Rejlander. Self-portrait. British, c. 1872.
International Museum of Photography at George Eastman House.
Oscar G. Rejlander.

Unidentified Photographer. Photograph from a Kodak No. 2 camera. American, c. 1890. International Museum of Photography at George Eastman House. *Snapshot*.

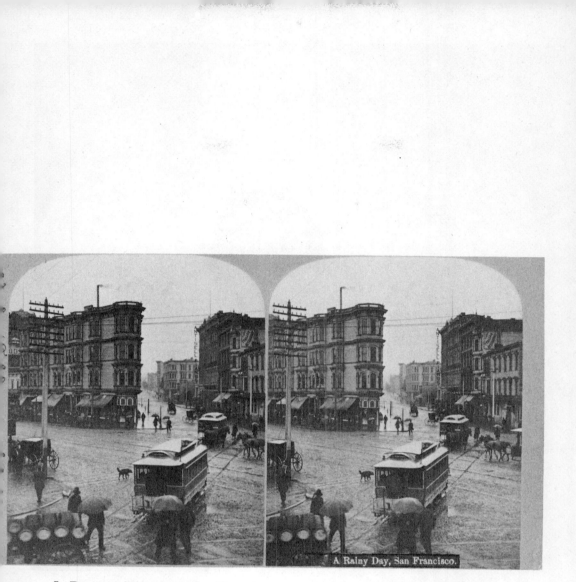

L. Dowe. A Rainy Day, San Francisco. Stereograph. American, c. 1880's.
International Museum of Photography at George Eastman House.
Stereoscopic Photography.

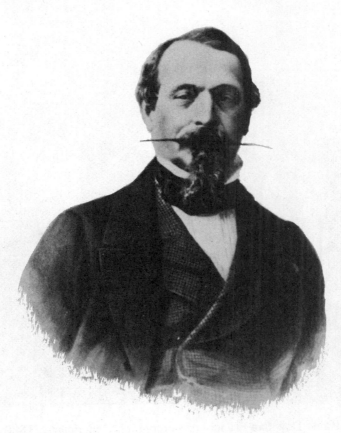

Unidentified Photographer. Louis Napoleon.
Vignetted carte-de-visite photograph. French, c. 1860's.
International Museum of Photography at George Eastman House.
Vignetters and Vignetting.

On facing page:
Alfred Stieglitz. Portrait (*Camera Notes*). American, 1900.
International Museum of Photography at George Eastman House.
Sketch Effects.

ENCYCLOPEDIA OF PHOTOGRAPHY

ABAT - JOUR (Fr.) (Ger., *Schräge Fenster, Oberlicht*)

A skylight or aperture for admitting light to a studio, or an arrangement for securing the same end by reflection. In the days when studios for portraiture were generally found at the tops of buildings not originally erected for that purpose, and perhaps in narrow thoroughfares or with a high obstruction adjacent, it became necessary to obtain all the available top light. This alone, however, is not well suited for artistic lighting, a side light being usually preferable. The abat-jour, therefore, was so designed as to give what was practically a side light, although coming principally from above. A style much used formerly, and still occasionally met with, is

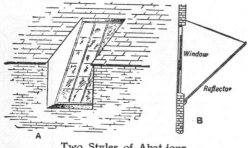

Two Styles of Abat-jour

shown at A. Into a bevelled opening cut in the wall, the roof, or both, is let a slanting glazed frame. Another form (B) is an inclined box-like structure open at the top and furnished with a mirror, or painted white inside, to reflect light downward through the window or glazing. The reflector used in daylight enlarging is really an application of the latter kind of abat-jour, by which the light, falling vertically from the sky, is reflected in a horizontal direction on the negative in the enlarging camera.

ABAXIAL

Away from the axis. A term applied to the oblique or marginal rays passing through a lens.

ABBE CONDENSER

One of the most popular types of substage condensers for the microscope and used in photo-micrographic work. It is made in two forms. The first consists of two lenses, and is of low numerical aperture. The second, used for high-power objectives, has three lenses, and is of higher numerical aperture (N.A.).

ABBE, ERNST

Professor Abbe died at Jena on January 14, 1905, aged 65 years. He was associated with the optical firm of Carl Zeiss, and paid particular attention to microscope objectives, with which his name is now generally connected. In 1881 he took an interest in the smelting of new optical glasses which was being made by Dr. Schott, and this was the beginning of the Jena glass factory of Schott and Genossen, the products of which have been used by lens makers as the raw materials of the large-apertured lenses known as anastigmats. Professor Abbe was the first to apply these glasses in a practical way to photographic lenses. On the death of Carl Zeiss in 1888 Professor Abbe became sole proprietor, and in 1896 he introduced an arrangement by which the employees became practically the owners of the business.

ABERRATION (Fr., *Aberration*; Ger., *Abirrung*)

A term used in photographic optics to express a fault in a lens. (*See* "Chromatic Aberration," "Spherical Aberration," "Curvilinear Distortion," "Astigmatism," etc.)

ABRADING POWDER

Rubbed on the smooth surface of dried negatives and bromide enlargements in order to give a "tooth" for subsequent pencilling. Such abrasives as pumice, cuttle-fish bone, etc., are generally used, and these must be very finely ground and be free from grit. On negatives the powder is rubbed on lightly with the finger-tip, but on bromide prints it is applied with a leather stump. An excellent abrading powder for negatives consists of 1 part of powdered resin and 2 parts of cuttle-fish bone, the whole being sifted through silk. Cigar or tobacco ash also serves the purpose. Negatives may be reduced by means of a moist abrading mixture as described under the heading "Baskett's Reducer." Various grades of emery powder and carborundum are used in lens and screen grinding, etc.

In process work, pumice and emery powders are used with water for cleaning or polishing zinc or copper. Fine emery powder is employed for graining the thick glass plates used for collotype printing. Pumice powder is used for removing gloss from prints that have to be retouched.

ABRASION MARKS

Black or pencil-like markings upon bromide and gaslight papers, chiefly occurring on glossy surfaces. They are seen only upon the finished print, and are due to pressure upon the gelatine film, and particularly to scratching against the printing frame or edges or corners of the packet when withdrawing the sheets. Handling the paper carefully will prevent them, and the use of a special developer, such as the following, will generally be of assistance :—

Metol			34 grs.	3.4 g.
Hydroquinone	.		60 ,,	6 ,,
Sodium sulphite	.		240 ,,	24 ,,
Sodium carbonate	.		400 ,,	40 ,,
Potass. iodide	.		20 ,,	2 ,,
Potass. bromide (10 %)			36 drops	4 drops.
Water to	.		20 oz.	1,000 ccs.

Any other metol-hydroquinone developer may be used if 1 grain of potassium iodide is added to each ounce of developer used. The addition of potassium cyanide is also resorted to, the proportion being 3 or 4 drops of a 10 per cent. solution to 1 oz. of developer. But the use of a special developer does not answer for all papers. Abrasion marks may often be removed from the finished print by rubbing lightly with a pad of cotton wool soaked in water, weak ammonia (5 drops per ounce of water), or methylated spirit. An effective—although rather troublesome—plan is to immerse the finished print for one minute in the following solution :—

Potass. iodide	.		20 grs.	2 g.
Iodine	.	.	2 ,,	0.2 ,,
Water	.	.	20 oz.	1,000 ccs.

When the white parts of the print turn blue, transfer to a fresh "hypo" fixing bath for five minutes, and then wash thoroughly. If the iodide bath is allowed to act too long, it acts as a reducer.

ABSORPTION (Fr., *Absorption*; Ger., *Absorption*)

This term is used both in a chemical and an optical sense. In the former sense it is used to designate the taking up of one substance by another, just as a sponge absorbs or sucks up water. As a rule, this is not accompanied by any chemical, but merely a physical change.

Optically, absorption is applied to the suppression of light, and to it are due all colour effects (*see* "Colour"). It is of great importance from a photographic point of view, as on Draper's law, according to which only those rays which are absorbed by a substance act chemically on it, is based the whole of the photochemical action of light. Light, when absorbed, is not lost but is converted into some other form of energy, either heat or chemical action. The absorption spectra of dyes are of great interest, as by their aid it is possible to prepare colour filters of any given tint. Many substances and dyes have simple absorption spectra—that is to say, more or less well defined continuous portions of the spectrum are absorbed ; other substances, on the other hand, such as chlorophyll, have complicated absorption spectra, which change in character according to the concentration of the solution, or the depth of the solution, which is practically the same thing.

The position and shape of the absorption bands of a substance are in many cases so characteristic that they serve as a means of identification. Obviously, the most opaque substances are the metals, but even these are translucent in thin films ; silver, for instance, appears blue, whilst gold in thin films is green. Even such transparent and colourless substances as water, alcohol, glycerine, etc., possess characteristic absorption spectra, and therefore appear coloured when in sufficiently thick films. In studying the absorption spectra of coloured solutions, either the visual or the photographic method may be used, and the latter will be found not only more reliable, but considerably quicker. The visual method can obviously be applied only to the visible portion of the spectrum, whilst by the aid of photography the ultra-violet and infrared regions can also be mapped out.

Dr. Kenneth Mees and S. H. Wratten, who have made a special study of dye absorption spectra by photographic means, give the following outline of the methods which may be adopted : " (1) One may take a series of photographs with increasing dilution of the dye ; (2) one may take a series of photographs with a constant concentration of the dye, but an increasing thickness of the cell; (3) one may take a series of photographs with a constant concentration and constant cell thickness, but with a varying exposure. These three methods will all produce results differing slightly, though (1) and (2) are nearly equivalent to one another. (1) is a very slow method, and it would be probably quicker to use a spectro-photometer. (2) and (3), though quicker, are still slow if carried out as described. But if in method (2) instead of varying thicknesses of cell there is used a cell of which the thickness varies throughout the length—that is to say, a wedge-shaped cell placed in front of the slit so that the thickness of the layer of dye solution in front of the slit varies from end to end of the slit—the method resolves itself into taking one or possibly two photographs of each dye. Method (3) is inferior to the two other methods, as it involves the interpretation of the photograph of the plate curve. It is, however, a convenient way of examining the absorptions of coloured films and filters." This method is most conveniently carried out by placing directly in front of the slit a small wedge of black glass so that the intensity of the light varies from end to end of the slit. This black wedge consists of a narrow prism of neutral tinted glass cemented to a similar prism of white glass, which of course destroys the prismatic effect by forming a parallel plate. With this the intensity of the light varies from 1 to 10,000.

For visual measurement of absorption spectra a spectro-photometer is used. This consists of a spectroscope and some means of comparing the brightness of two spectra of one light source. This can be effected in several ways, as, for

instance, by two slits, which can be independently opened or closed, or by polarising prisms. The disadvantage of the variable slit system is that the two spectra are of unequal purity, and therefore accurate readings are impossible. In the polarising spectro-photometers the slit is usually divided across the middle by a small bar of metal, and the two light beams are polarised and dispersed, or dispersed and polarised, equality being obtained by rotation of a Nicol prism. The two spectra are brought into juxtaposition at the eyepiece, and equality of illumination obtained throughout its length. As one spectrum is continuous and the other darkened by the absorption band, the former is reduced in brightness till the two are equal and the necessary readings obtained from the varied width of the slit or the angle through which the Nicols are turned. The transmitted light, divided by the incident light, which is always taken as unity, equals the extinction coefficient.

ACCELERATOR (Fr., *Accélérateur*; Ger., *Beschleuniger*)

A substance added to developing solutions to shorten the duration of development and bring out the image more quickly. Usually it is an alkali which hastens the development owing to its power of absorbing the bromine set free from the silver salt during development, thus forming an alkaline bromide which acts as a restrainer, and as this increases with continued or repeated use of a developer, due allowance should be made.

Common accelerators are sodium carbonate, washing soda, ammonia, potassium carbonate, sodium hydrate (caustic soda), and potassium hydrate (caustic potash). "Hypo" (sodium hyposulphite) has been recommended when developing with a mixture of ferrous-oxalate, but not infrequently it causes a partial reversal of the image; merely adding a few drops of a weak solution of "hypo" to the normal developer has a wonderful accelerating effect in some cases. Attempts have been made to introduce substitutes for alkaline accelerators in the form of acetone with sodium sulphite, tribasic sodium phosphate, and other chemicals, but only the two named have met with any success. Some "one solution" developers—such as rodinal, azol, etc.—include an accelerator; but in "two solution" developers, the developer proper is generally included in bottle "A" or "No. 1," and the accelerator in bottle "B" or "No. 2." It was long thought that an increase of the accelerator in cases of under-exposure brought out more detail, but photographers are now growing out of the idea. It is never advisable to add much alkali, because this invariably tends to produce fog. Accelerators cannot be used as the fancy dictates, some being more suitable for certain developers than others. Ammonia and sodium carbonate, for example, are found to give their best results in conjunction with pyro. Some of the newer developers—amidol, for example—do not require an alkali accelerator, and they will work with sodium sulphite, which is a preservative rather than an accelerator. In regard to the comparative strengths of the numerous alkalis used for accelerating development, a table will be found under the heading "Alkalis, Chemical Equivalence of."

ACCOMMODATION OF THE EYE (*See* "Axial Accommodation.")

ACCUMULATOR (Fr. *Accumulateur*; Ger., *Akkumulator*)

Accumulators or storage batteries are used in X-ray work when the electric current cannot be obtained from mains. An accumulator consists of a series of lead grids filled in with lead oxide and immersed in dilute sulphuric acid. The potential of an accumulator when fully charged is 2 volts, and recharging is necessary when it falls to 1·8. Current is always leaking from accumulators even when not in use, and they should therefore be recharged at least once a month, or the plates will be ruined. The positive terminal of a cell is painted red, the negative black. In coupling up two or more cells the positive terminals are connected up with the negative terminals, the free terminals being then connected with the induction coil. A coil giving a 10-in. spark requires from six to eight accumulators, supplying a current of 5 to 10 amperes.

ACETALDEHYDE (*See* "Aldehyde.")

ACETATES

Salts formed by acting upon metals or their oxides with acetic acid. Examples are lead acetate, sodium acetate, etc., etc., which are described under their own headings.

ACETIC ACID (Fr., *Acide acetique*; Ger., *Essigsäure*)

Also known as purified pyroligneous acid. $HC_2H_3O_2$. Molecular weight, 60. There are three kinds of acetic acid :—(1) glacial, containing about 99 per cent. of acid and 1 per cent. of water (sp.g., 1·065); glacial acetic acid is the most widely used for photographic purposes, and receives its name from the fact that it solidifies and freezes into long ice-like crystals at comparatively low temperatures; (2) commercial "strong," about one-third the strength of the glacial variety, and containing about 33 per cent. of acid, sometimes known as Beaufoy's acetic acid (sp.g., 1·44); (3) dilute acetic acid, made by mixing 1 part of the "strong" acid with 7 parts of water (4⅛ per cent.), and sold as "distilled white vinegar" (sp.g., 1·006). Acetic is the oldest of acids, and is given in old dictionaries as "acetous acid." Its impurities may be hydrochloric, sulphuric and sulphurous acids, but most samples sold by chemists are quite pure enough for photographic purposes. Acetic acid readily dissolves in water, alcohol, and ether; it is a strong escharotic, causing painful blisters if allowed to remain on the skin, but the application of a solution of soda or any other alkali will at once neutralise it. It is extremely volatile, and should be kept in a glass-stoppered bottle and in a cool place. It has many uses in photography, and in the early days, when it cost as much as 8d. per ounce, was largely used as a constituent of the developer for wet plates. Nowadays, it is used for clearing the iron out of bromide prints after development with ferrous oxalate, to assist uranium toning, and, on rare occasions, as a restrainer when developing with hydroquinone. Acetic acid is a solvent for celluloid, gelatine, and pyroxyline.

In process work, acetic acid is used in the iron developer for wet plates. The amount required increases as the working temperature increases; at 60° F. ½ oz. of glacial acetic acid to 20 oz. of developer is a suitable proportion. The acid retards the action of the ferrous sulphate. A mixture of acetic acid and salt is used for cleaning up the copper plates during half-tone etching to enable the etcher to see the image better when proceeding to re-etch. It is also used for removing the magnesia that is rubbed into the etched plate to make the image visible.

ACETIC ETHER (Fr., *Éther acétique, Acétate d'éthyle ;* Ger., *Essigaether*)

Synonym, ethyl acetate. $CH_3 CO O(C_2H_5)$. Molecular weight, 89. Solubilities, 1 in 17 water, miscible in all proportions with alcohol and ether. It should be kept in well-stoppered bottles away from fire, as the vapour is very inflammable. A light, volatile, colourless liquid, with pleasant acetous smell, obtained by distillation from alcohol, acetic acid, or sodium acetate with strong sulphuric acid. Sometimes used in making collodion.

ACETOL (Fr., *Acétol ;* Ger., *Acetol*)

A gelatine with an acetic acid substratum, used for collodion emulsion. It is said by its advocates to give a beautiful surface and spotless negatives.

ACETOMETER (Fr., *Acétomètre ;* Ger., *Acetometer*)

A hydrometer specially graduated to show the strength of acetic acid.

ACETONE (Fr., *Acétone ;* Ger., *Aceton*)

A colourless volatile liquid of peculiar and characteristic odour, having the formula $C_3 H_6 O$ or $CH_3 CO CH_3$. It is met with commercially in various qualities. It is miscible in all proportions with water, alcohol, and ether. As the vapour is highly inflammable, the liquid should be kept in a bottle with a close-fitting cork or glass stopper. Acetone has two separate and distinct uses in photography, as an addition to developers and in varnish making. It acts as a solvent for resins, camphor, celluloid, etc., and should therefore never be used for films or in a celluloid dish.

As a constituent of a developer acetone works best perhaps with pyro in the following one-solution form :—

Pyro . . .	180 grs.	18 g.
Sodium sulphite (crystals)	1,120 ,,	112 ,,
Acetone . . .	24 mins.	2·4 ccs.
Water to . .	20 oz.	1,000 ,,

It may, however, be used with other developers. When mixed with sulphite it forms acetone sulphite, and the soda of the sulphite combines with the developing agent to form a phenolate, so that it may be used in place of an alkali when sulphite is present. It gives a very clean-working developer, moderately free from stain, and hardens the gelatine, or at any rate does not soften it as alkalies do. As a developer for paper prints it is best when combined with metol-hydroquinone in the following form :—

Metol . . .	27 grs.	2·7 g.
Sodium sulphite .	5½ oz.	275 ,,
Hydroquinone .	88 grs.	8·8 ,,
Potass. bromide (10 %)	22 mins.	2·2 ,,
Acetone . .	40 drms.	25 ccs.
Water to . .	20 oz.	1,000 ,,

This is a one-solution developer which, as above compounded, is ready for use for both plates and papers.

ACETONE SULPHITE (Fr., *Acétone sulfite ;* Ger., *Acetonsulphit*)

A compound of acetone with acid sodium sulphite, introduced as a substitute for sodium sulphite and the metabisulphites for development. It has the form of a white powder, and its formula is $NaHSO_3 CO(CH_3)_2 H_2O$. It is soluble in water (up to 50 per cent.), but less so in alcohol, and it is used for making concentrated forms of developers, also for fixing baths and to blacken negatives after being bleached with mercury. Unlike acetone itself, it does not make the developer active, and consequently an alkali or a carbonate must be used. Ten parts of acetone sulphite are equivalent to 7 parts of potassium metabisulphite or 20 parts of anhydrous sulphite of soda (40 of soda sulphite crystals) in a developer. As a preservative for pyro, ½ oz. of acetone sulphite should be added for each ounce of dry pyro used.

ACETOUS ACID

The old, and now obsolete, name for acetic acid (*which see*).

ACETYLENE (Fr., *Acétylène ;* Ger., *Acetylen*)

A hydrocarbon gas (C_2H_2) having, when pure, a sweet odour, the well known unpleasant smell associated with this gas being due to the presence of impurities. It burns in air with a very bright flame, and is largely used by photographers for studio lighting, copying, etc., and as an illuminant in enlarging and projection lanterns. It is produced by the action of water upon calcium carbide (*which see*), 1 lb. of which will yield about 5 ft. of gas. It was first described and demonstrated in the year 1836 at a meeting of the Royal Dublin Society under the auspices of Edmund Davy, a professor of chemistry, and was brought into commercial use about half a century later by the discovery of the modern method of manufacturing calcium carbide in the electric furnace. Acetylene forms, like other combustible gases, an explosive mixture with ordinary air, the presence of as little as 4 per cent. of the gas being sufficient to constitute a dangerous combination. It was in the early part of 1895 that photographers began to turn their attention to the photographic value of acetylene, and photometric tests prove that acetylene has eight times the actinic power of the average incandescent gas mantle. As an illuminant in optical lanterns, acetylene is better than the incandescent gas mantle, but not so good as limelight. (*See* " Optical Lantern Illuminants.")

ACETYLENE GENERATOR (Fr., *Générateur d'acétylène ;* Ger., *Acetylengasentwickler*)

An apparatus for generating acetylene by the action of water on calcium carbide. Of the two

types of generators, that is probably the better in which the carbide is immersed in or dropped into the water, as when water is permitted to fall on the carbide great heat is created, tending to the production of inferior gas, and the evolution of oily products which are liable to accumulate in the pipes. However, many generators in which the water drips very slowly on the

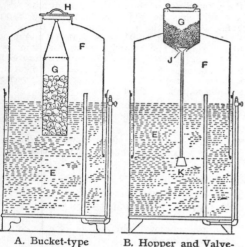

A. Bucket-type Acetylene Generator B. Hopper and Valve-type Acetylene Generator

carbide, as in the majority of acetylene lamps for cycle use, have a high reputation. Carbide to water generators are illustrated herewith. In the apparatus shown at A the water is contained in the tank E, in which slides the gas bell or reservoir F. The receptacle G, filled with lump carbide, is suspended from the top of the reservoir, which falls by its own weight, acetylene beginning to generate directly the carbide comes in contact with the water. The gas, filling the reservoir, causes it to rise and lifts the carbide receptacle, thus stopping further generation until by the consumption of the gas the reservoir again falls. The carbide receptacle is introduced or removed by extracting the tightly-fitting plug H. In the generator shown at B granulated carbide is contained in the hopper G, in which is a small opening or valve closed by the conical plug J. The plug is attached to a rod having a weight K as its lower end. The reservoir falls when empty, until the weight strikes the bottom of the water tank, this causing the rod to push up the plug J, allowing a small quantity of carbide to fall through the opening. The ascent of the reservoir as gas is generated raises the weight, which pulls down the plug and again closes the aperture. B is better in principle than A, as the carbide is acted upon in smaller quantities at a time.

In all the earlier generators the carbide receptacle was attached to the reservoir, causing an unnecessary pressure, and one also that varied as the carbide was consumed. Another disadvantage was the fact that the waterseal was furnished from the same water as that used for generation. In the devices shown at C and D these objections are obviated. In the former of these the plug J is weighted to keep it normally

closed, and its rod is connected at its upper end to a T-piece, this being in turn pivoted at each side to angle irons, which carry wheels at their outer ends. The reservoir F, in falling, depresses the angle irons, and these raise the plug rod by means of the T-piece, thus liberating a small charge of carbide. The plug is re-closed by the weight as the gas-laden reservoir rises. In the device shown at D the hopper G containing the carbide has an upward-closing plug J fixed to a rod. The reservoir F in falling presses on the top of the rod and opens the plug, while the spring L serves to return the rod and close the opening when the reservoir rises.

Except when the carbide is dropped in small quantities into a sufficient excess of water, a washing apparatus of some kind is called for. If any quantity of acetylene is made, it is better also to remove the remaining impurities by passing the gas through calcium chloride with which is mixed a little unslaked lime, the mixture being contained in muslin bags arranged on perforated shelves, one over the other, in the purifier. A similar mixture is sold ready-prepared, and with this no bags or shelves are required, the lumps being merely packed in the receptacle.

The pressure should not rise above two or three inches of water in the generator, and the pipes should not be less than ⅜ in. diameter. All taps must be well ground in, and should be lubricated with vaseline to prevent the corrosive action exerted by acetylene on brasswork. Since the gas leaks more easily than ordinary house gas, greater care must be taken with all joints. Tar and paint are quickly affected,

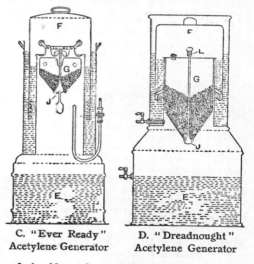

C. "Ever Ready" Acetylene Generator D. "Dreadnought" Acetylene Generator

and should not be used for this purpose; red-lead or white-lead, applied sparingly, is best. To detect a leak, a solution of soap and water may be applied, noticing if bubbles appear. In starting, the first gas coming off should be allowed to escape, as it contains an admixture of air. The generator should be kept at least 8 ft. or 10 ft. distant from any light, and no light should be at hand when emptying it after use. Copper should not be employed in acetylene

generators, as under certain conditions a detonating explosive compound is formed. The best material for the body is tinned or galvanised sheet-iron, brass being used only for taps.

Special burners are required for acetylene. The best are of steatite, on the air-injector principle. For photographic use, Bray's 00000 (acetylene) burners are perhaps most suitable. Fifteen of these, mounted in a white reflector, can be employed for studio portraiture, but a slightly larger number is better. Two-, three-, and four-burner jets are made for optical lantern and enlarging purposes. The soot that soon collects on the burners may be removed with a toothbrush or anything similar, while the holes may be cleared with a fine needle or wire.

ACETYLIDE EMULSION

Wratten and Mees prepared a silver acetylide emulsion by passing acetylene into ammoniacal solution of silver nitrate and emulsifying the precipitate, which is very explosive, in gelatine. They found that it blackened in daylight about ten times faster than silver chloride paper, but could obtain no evidence of the formation of a latent image with short exposures.

ACHROMATIC (Fr., *Achromatique;* Ger., *Achromatisch*)

A photographic lens is said to be achromatic when the visual image as focused upon the ground glass falls upon the same plane as the actinic image which forms the impression upon the sensitive surface. In telescopes and microscopes, achromatism means that the visual images are free from colour fringes, but it is quite possible for a photographic lens to show these fringes upon the focusing screen and yet to be capable of giving a sharply defined image upon the plate. "Actinic" is a better term to use in connection with photographic instruments than achromatic. (*See also* "Chromatic Aberration.")

ACHROMATISM

The condition of being achromatic.

ACID BLAST

The name given to an etching machine for process work, invented by Louis E. Levy, of Philadelphia. The working principle is that the acid is blown up to the plate, by means of air under compression, from a series of atomisers or sprays projecting upwards; a partial vacuum is maintained in the etching chamber above them, and the plate is held face downwards, and slowly moved to and fro horizontally to equalise the etching.

ACID CHROMATE OF POTASH (See "Potassium Chromate.")

ACID DEVELOPERS

A term usually applied to ferrous sulphate and other wet-plate developers in an acid condition.

ACID FIXING BATH

The "hypo" (hyposulphite of soda) fixing bath made acid. Ordinary "hypo" fixing baths are neutral, not acid; but acid fixing baths may be used for negatives and bromide and gas-light prints, although not for prints on print-out papers. Their advantages are that they immediately stop the action of the developer, prevent stains, and keep quite clear in use. It does not do simply to add any acid—say sulphuric or hydrochloric—to an ordinary "hypo" bath, inasmuch as this causes a yellow precipitation with the accompanying evolution of sulphuretted hydrogen, which militates against the permanency of the prints. Sulphurous acid, however, may be added to an ordinary hypo fixing bath in the proportion of 2 drms. to 1 pint. The best acid fixer is made by adding a little potassium metabisulphite to the ordinary solution of "hypo"; the exact proportions are of no importance, $\frac{1}{2}$ oz. to 1 pint being, however, a good average. The following is a precise formula suitable for prints :—

Sodium hyposulphite .	3 oz.	150 g.
Potass. metabisulphite.	$\frac{1}{2}$,,	25 ,,
Water . . .	20 ,,	1,000 ccs.

This is suitable for negatives if the "hypo" is increased to 4 oz. A cheaper form of acid fixer is the following :—

"Hypo" solution (1 in 5) 25 oz. 1,000 ccs.

To which add a mixture of :—

Tartaric acid solution (1 in 2) . .	$\frac{3}{4}$ oz.	30 ccs.
Sodium sulphite solution (1 in 4) . .	$1\frac{3}{4}$,,	70 ,,

There is a danger of overworking acid baths and consequently of not fixing properly, as the clearness of the solution is apt to lead to the belief that it is still in a good working condition, although really it may be partly exhausted.

ACID OXALATE OF POTASH (See "Potassium Oxalate.")

ACID RESIST

A term applied in process work to all substances used to form the image or protecting coating which prevents portions of the metal from being attacked. Practically all resinous bodies—bitumen, pitch, waxes, lacs, indiarubber, guttapercha—and fatty bodies form acid resists. Talc, graphite, silica, sulphur, carbon, and other inert bodies also form acid resists when dusted on to an image of a tacky nature. Non-corrosive metals form another class of resists, as the image may be formed by a metal that is not attacked by the acid, which, however, attacks the base plate. Colloid bodies—such as gelatine, glue, gums, and albumen—also form acid resists, as in the so-called "enamel process" (*which see*). Acid resists are applied as varnishes for protecting the back and margins of the plate, as etching grounds, for scratching or engraving through with needle points and gravers, as etching inks, paints, dusting powders, light-sensitive films, electrolytic deposits, fused metals. They are used for relief and intaglio etching, for lithography on stone, zinc, and aluminium, for protecting vessels and other articles used for etching, and for electrolytic etching or deposition.

ACID RESIST VARNISH

Shellac is probably the best and most used of the gum resins as a resist varnish. Cover

the shellac with wood alcohol, and leave for a few hours to dissolve. For 4 oz. of shellac about 8 oz. of methylated spirit will be required, and, for colouring, about 2 drms. of methyl violet dye. To prevent the varnish setting too hard, add to every pint about ½ oz. of linseed oil.

Shellac varnish is said to contain impurities which, when exposed to light, become insoluble, so that the varnish is difficult to remove ; the remedy is to add 60 drops of oil of lavender to each pint of varnish, and use the varnish a little thinner.

ACID STAIN REMOVERS

Acid solutions used for clearing away stains caused by developers. Their use is open to objection, as fully explained under the heading " Stain Removers."

ACID SULPHITE (*See* " Sodium Bisulphite.")

ACIDS (Fr., *Acides ;* Ger., *Säuren*)

Hydrogen compounds, which have a sharp taste and redden blue litmus paper. Acids may be solid, liquid, or gaseous, and are divided into strong and weak, organic and inorganic. Organic acids are usually such as contain carbon, whilst inorganic are those containing a metal. A further subdivision is made as to hydrogen or oxy-hydrogen acids ; of the former, hydrochloric acid HCl is an example, and of the latter, sulphuric acid H_2SO^4, as this contains oxygen as well as hydrogen. Acids are further differentiated into mono-, di-, tri-, etc., basic acids, and this refers to the number of molecules of hydrogen which are replaceable by a metal. For instance, nitric acid HNO_3 is monobasic, and forms salts of the typical formula XNO_3 (X here being a metal). Dibasic acids can be exemplified by oxalic acid, $H_2C_2O_4$, which would form a salt having the composition of $X_2C_2O_4$.—*e.g.* $K_2C_2O_4$, oxalate of potash. An example of a tribasic acid is boric acid H_3BO_3, which forms borates X_3BO_3.

In process work, acids play an important part. Nitric acid is almost exclusively the mordant used for etching zinc. Acetic, chromic, citric, fluoric, formic, gallic, hydrochloric, nitrous, phosphoric, picric, and tannic acids are all used in photo-mechanical processes.

ACIDS, TESTS FOR

Whilst strictly belonging to the domain of chemistry, it may be useful to give the usual tests for the acidity or otherwise of a solution. Blue litmus paper is reddened by acids. Phenolphthalein solution (30 grs. in 10 oz. alcohol), a colourless solution, is reddened by alkalis, and the colour discharged by acids. Methyl orange (4 grs. in 10 oz. of water), an orange solution, turns pink with acids.

ACLASTIC (Fr., *Aclastique ;* Ger., *Aclastisch*)

Not capable of refracting, or bending, light.

ACRIDINE YELLOW AND ACRIDINE ORANGE NO (Fr., *Jaune d'acridine, Orangé d'acridine NO ;* Ger., *Akridingelb, Akridinorange NO*)

Two complex basic aniline dyes which have been suggested as sensitisers for emulsion work.

They are two of the most powerful sensitisers for green, but have found no practical application, as they stain gelatine very deeply, alcohol alone removing the stain.

ACROGRAPH (Fr., *Acrographe ;* Ger., *Akrograph*)

An engraving machine invented by N. S. Amstutz, an American engineer. Its essential features are a revolving cylinder and an engraving tool—a V-shaped graver—carried along parallel to its axis ; a phonograph, or a screw-cutting lathe, gives the idea. A photographic gelatine relief, such as a carbon transfer on celluloid with the image in perceptible relief, is wrapped round the cylinder, and over this relief is stretched a sheet of thin celluloid. As the cylinder revolves, a spiral thread is cut on the celluloid, this having the effect of making cuts in straight lines across the picture, but as the tool passes over the relief it cuts more or less deeply, according to the light and shade of the picture. Thus it reproduces the photograph as a kind of half-tone. The celluloid cutting can be printed from direct, or it can be made to serve as a matrix for electrotyping and stereotyping. By filling in the lines with transfer ink it can be used as a lithographic transfer, or by filling them with any opaque substance it can be used as a negative for printing an image on to metal. The elaborations from the simple principle outlined above are in the form of micrometer adjustments for the tool, a microscope and electric lamp for watching the progress of the cutting and for setting the tool, and dividing wheels for varying the pitch of the lines.

ACROMETER (Fr., *Oléomètre ;* Ger., *Oelwage*)

A kind of hydrometer specially graduated for testing the specific gravity of oils ; known also as an oleometer or oil tester. An instrument of this description is sometimes useful for verifying the purity of the oils used in certain photographic and photo-mechanical processes.

ACTINIC (Fr., *Actinique ;* Ger., *Aktinisch*)

A term applied to light that is rich in actinism, this being the property of light that causes chemicals to combine and decompose. In the early days of photography it was assumed that only the ultra-violet, violet, and blue rays were chemically active or actinic, hence these regions of the spectrum were so termed. Later researches have proved that it is practically merely a question of length of exposure which determines the photo-chemical action of light ; in other words, that all the rays of the spectrum or all colours will act on sensitive emulsions if sufficient exposure be given. The expression most usual now is the " more refrangible " or " less refrangible " rays.

In process work, where the electric arc light is almost entirely used, the actinic value of the light is of great importance. It is found that the enclosed arc is very rich in actinic rays, and these are increased by operating the lamps with a comparatively high voltage, resulting in a long flowing arc emitting a violet light. This is photographically very active, and exposures are greatly reduced compared with those necessary with the open arc.

ACTINIC DOUBLET (*See* "Lens.")

ACTINIC FOCUS

A term generally used to express the focus for the blue end of the spectrum, to which the sensitiveness of the earlier photographic plates was almost entirely limited. The focus of the yellow or strongly luminous region of the spectrum did not always coincide with that of the blue and violet rays, so that an image sharply focused, as far as visual observation went, gave a blurred image on the sensitive plate. A lens giving such a result was said to have the visual and "chemical" or actinic foci non-coincident. This is very rare in modern lenses, even of the cheaper class. (*See also* "Lens.")

ACTINOGRAPH

An instrument for estimating the exposure necessary for a photographic plate, invented by Hurter and Driffield. It embraces no new principle, but is simply a kind of slide-rule for arriving at a result without calculation in a manner precisely similar to that which was adopted in the exposure tables that were published by W. K. Burton and other pioneers of modern photography. It consists of two parts, a light scale and a scale of subjects, plate speeds, and lens apertures. The light scale is based on the fact published by Dr. Scott about 1880 that in clear weather the actinic value of the light varies in direct proportion to the height of the sun above the horizon. For example, the altitude of the sun is nearly four times as great in mid-summer as in mid-winter, and little more than one-fourth of the exposure is necessary in the middle of June when compared with that of December. In practice its use is less satisfactory to the ordinary worker than the exposure meter.

ACTINOMETER

An instrument for gauging the depth of printing in those processes in which little or no visible image is produced by exposure to light; known

A. Actinometer with Paper Scale

also as a print meter. There are two types of actinometers, differing both in character and in method of using. The essential feature in each, however, is that a piece of silver printing-out paper is exposed to light until a certain effect is produced, and by this the correct printing of the invisible image can be estimated. The older

and simpler pattern consists of a small box with an opaque cap or lid, in which is a small opening. At one side of this opening is a small square painted in a medium dark colour to resemble as closely as possible the colour that silver paper assumes *and passes* during printing. It is essen

B. Johnson's Actinometer

tial that this tint should be a medium tint in silver printing, and that the paper should pass the colour by continuing the exposure; otherwise it would be difficult to determine when the correct matching of the colour, or the correct time of printing, had been reached. A square or a strip of silver printing-out paper is placed under the lid and kept in fair contact by a pad. The actinometer is put out to print with the frames containing the carbon prints, and the small portion of the silver paper visible through the opening gradually darkens until it matches the printed tint at the side of the opening. The time necessary for this is called "one tint." As soon as one tint is printed the silver paper is moved forward and a second tint printed, and so on until the prints are completed. Experience alone can determine how many tints will correspond with the correct exposure for any print; as negatives and actinometers vary considerably. With this form of actinometer each succeeding tint need not always be exposed immediately the preceding one is printed if the light is uniform. The time of matching the tint may be noted, and three or four succeeding tints timed from that.

The second form of actinometer is more simple in use, and more suitable for the amateur worker. It consists of a series of squares of varying density —practically a test negative—and is used exactly as an ordinary negative. These squares range from one very thin up to a density equal to that of the sky in a very strong negative, and they are numbered consecutively to facilitate reference in printing. If a piece of silver paper is exposed to light under this test plate, a short exposure will show a faint image of the first two or three squares, and with a longer exposure more of the squares will be visible on the silver paper. The squares are surrounded by an opaque margin to render the image more plainly visible. The actinometer is put out to print at the same time as the frames containing the carbon prints, and each is brought in when the number considered correct for that negative is reached on the actinometer. The actinometer is examined occasionally, and the "number" that is considered printed is the square bearing the highest number that can be seen. Of course, a very faint image of that square is all that will be visible, the lower numbers, that have been fully printed for some

time, being seen as darker squares. These darker squares assist in determining the highest number visible—the faintest square that can be seen. One actinometer will serve for several frames, provided that all are put out at the same time.

In process work, various forms of actinometers are used for timing the printing of the image on the plate when exposed to daylight. The simplest form is that shown at A, consisting of a series of thicknesses of tracing paper bearing a number corresponding to the layers underneath. Another form has a glass scale bearing a Woodbury film, the pigmented gelatine graduating in thickness from transparency to opacity. Burton's actinometer consists of a series of six tiny negatives made by the carbon process. The negative to be printed can be compared with these, and a corresponding exposure given. This form of actinometer is very useful for collotype and photogravure work. Johnson's actinometer B is chiefly used for carbon printing. It only registers one tint, which is compared with a suitably coloured mask. If more than one tint is required to complete an exposure, the sensitive paper is shifted to a fresh position. The Sanger-Shepherd fraction tint actinometer consists of a scale of densities on a quarter-plate glass which is put into a printing frame and a piece of sensitised paper exposed behind it. It is very useful for timing the bichromated films in colour transparency work and for carbon printing, but it can be applied to any other process in which the exposure has to be accurately timed.

ACTINOMETRIC (Fr., *Actinométrique ;* Ger. *Aktinometrisch*)

Pertaining to actinometers, or to the measurement of the chemical, or actinic, power of light. Actinometry is the branch of science that deals with the numerous methods of testing the chemical activity of light, and which makes a study of the variations in its intensity in different quarters of the globe, or at different seasons and hours.

ACTINO-POLYCHROME (Fr., *Actino-Polychrome ;* Ger., *Farbenphotograph*)

An early name for a photograph in natural colours.

ACTION

More often than not, action is rendered in an unsatisfactory manner by photography, although this does not apply to cinematograph renderings. A person's mental impression of a man walking, a horse running, and so on, is the result of a blending of all the different positions assumed during the action. A single photograph naturally records but one position, and inadequately suggests the idea of action (*see* " Chromo-photography ").

What is known as an " instantaneous " picture of a railway train or other object in rapid motion will not convey the impression of speed if it shows, for example, the spokes of the wheels sharply defined ; rather would it suggest suspended motion. O. G. Rejlander once well exemplified this in a couple of photographs of a lady at a spinning wheel. In one, the foot and

spokes were of microscopic sharpness ; in the other, the foot and wheel were slightly blurred by intentional movement. Yet it was the second that gave the better impression of an " instantaneous " picture and the more complete suggestion of action.

ADAMANTEAN

An old form of ferrotype plate, largely used for the wet collodion process.

ADAMANTINE PROCESS

A secret process of half-tone etching on copper invented by A. C. Austin in the United States. It produced an extremely hard black enamel resist image for etching. Probably it was a modification of the fish-glue process, but no details have been published.

ADAPTERS (*See* " Plate Adapters " and " Lens Adapters.")

ADHESIVE TISSUES

Thin sheets of paper prepared, generally by the use of shellac, for use in the dry-mounting process.

ADIACTINIC (Fr., *Inactinique ;* Ger., *Unactinisch*)

Non-actinic ; a term sometimes applied to the red or orange glass and fabric used to screen the light in a dark-room. No light, however, is absolutely non-actinic, since any light, whatever its colour may be, will affect a photographic plate if sufficient time is allowed. Photographs have, in fact, been taken by the light obtained from a ruby lamp, although the exposure was, necessarily, very prolonged. For this reason, the plate should not be unduly exposed to the light of the lamp when developing, however " safe " it is believed to be. The " safety " of any so-called non-actinic glass or fabric is merely relative, and much depends on the nature of the plate or paper and its particular colour-sensitiveness. Thus, a yellow fabric or material that is quite safe for developing bromide papers will instantly fog a rapid dry plate ; while even a deep ruby light will have a marked effect on a panchromatic plate.

ADIAPHOROUS (Fr., *Adiaphore ;* Ger., *Adiaphor*)

Neutral ; a chemical term, sometimes applied to substances that are neither acid nor alkaline.

ADON

A low-power telephoto lens, especially suitable for hand-camera use. The positive lens is placed in front of the ordinary lens of a camera, in this way producing an enlarged image without abnormal extension of the camera or substantial reduction of the working aperture of the lens.

ADUROL (Fr. and Ger., *Adurol*)

A developer intermediate in character between the short factor developers, such as pyro and hydroquinone, and the longer factor developers such as metol, rodinal, amidol, etc. ; introduced in 1899. It is a mono-chlor (or mono-brom) hydroquinone. Adurol-Hauff has the formula $C_6H_3Cl(OH)_2$, and Adurol-Schering $C_6H_3Br(OH)_2$

—their actions being similar. The developer as purchased is in the form of a white or greyish-white crystalline powder, readily soluble in water and alkalis. In its action and results it resembles hydroquinone, but it is more soluble, keeps better, and the negatives are slightly softer. The addition of potassium bromide as a restrainer has not much effect, and the developing action is not much slower when the solution is cold. Since its introduction many formulæ have been published for one-solution, two-solution, and three-solution developers. The following are those in most general use :—

Sodium sulphite	.	8 oz.	400 g.
Potass. carbonate	.	6 ,,	300 ,,
Water	. .	20 ,,	1,000 ccs.

Shake till dissolved, then add—

Adurol	. .	1 oz.	100 g.

For negatives and gaslight paper dilute with 3 to 5 parts of water; and for bromide prints with from 7 to 10 parts of water.
The above is a one-solution developer, and may be used over and over again. The formula for the two-solution developer is :—

No. 1. Adurol	. 85 grs.	17 g.	
Sodium sulphite	. 1¾ oz.	175 ,,	
Water to	. 10 ,,	500 ccs.	
No. 2. Potass. carbonate	1¼ ,,	125 g.	
Water to	. 10 ,,	500 ccs.	

For use with plates and gaslight paper mix 3 parts of No. 1 with 2 parts of No. 2; for bromide prints add an equal quantity of water.
A three-solution adurol developer is as follows :—

No. 1. Sodium sulphite	. 650 grs.	130 g.	
Adurol	. 80 ,,	16 ,,	
Water to	. 10 oz.	500 ccs.	
No. 2. Sodium carbonate	100 grs.	20 g.	
Water to	. 1 oz.	50 ccs.	
No. 3. Potass. bromide	. 48 grs.	10 g.	
Water to	. 1 oz.	50 ccs.	

For soft negatives mix 1 oz. of No. 1, 310 minims of No. 2, and 20 minims of No. 3. For more brilliant negatives use 10 drms. of No. 1, ½ oz. of No. 2, and ½ drm. of No. 3. The three-solution formula is best for time-exposed plates, and when over-exposure is suspected.
Adurol combines well with metol and gives a developer which acts like metol-hydroquinone. One formula is :—

Metol	. .	130 grs.	13 g.
Adurol	. .	1 oz.	50 ,,
Water to	. .	20 ,,	1,000 ccs.

Dissolve and add gradually—

Sodium sulphite	.	7 oz.	350 g.
Potass. carbonate	.	4½ ,,	225 ,,

For negatives and gaslight papers, dilute with 10 times the quantity of water; for bromide prints, with 15 times the quantity of water, or take of the stock adurol-metol developer as above 1 drm. and sufficient water to make 2 oz., and add a little bromide.
Adurol is the best developer for obtaining warm tones on bromide paper by direct development. The concentrated one-solution developer

as given above (let it be called A) is used with three others—namely, 10 per cent. solutions of potassium bromide, B; ammonium bromide, C; and ammonium carbonate, D. The colours are obtained by altering the exposures and varying the proportions of the four solutions.

ADVERTISING, PHOTOGRAPHY IN

Photographs are extensively resorted to in the production of effective pictorial advertisements reproduced by the half-tone process. They are only occasionally used in the form of straight prints, but are nearly always " worked up " by skilled artists into what are actually monochrome wash drawings. Frequently the advertiser wants ideas rather than technically good prints, and he has at his command the services of men who can work up the poorest print until the desired effect is arrived at. So much work, in fact, is generally done by the artist that the photographer may easily fail to recognise the finished picture. A plan frequently adopted by the artist is to cut away the background, paste as much of the print as required on white cardboard, and then " work up " by means of the air-brush, etc., introducing suitable wording, etc. Often only the head is used from a photograph of a model, there being always a fairly brisk demand for studies of pretty ladies and children; but in submitting pictures to advertisers care should be taken about copyright matters (see " Copyright "), as any error on the part of the photographer may possibly put the advertiser to much trouble and expense. It is courteous, and often necessary, to obtain the model's permission to use his or her photograph in the proposed manner. Rough prints of suitable subjects should be submitted to advertisers with the intimation that, if desired, enlargements will be supplied upon bromide paper for working up. More often than not it is a waste of time on the photographer's part to work up a photograph according to his own ideas, and it is better to submit an untouched print and to leave the rest to the advertiser's artist.

AERIAL FOG (See " Fog.")

AERIAL IMAGE (Fr., Image aërienne; Ger., Aetherisch Bild)

A properly corrected lens produces, as it were, an aerial model at its focus of the scene at which it is directed. Each portion of this model is at the same relative distance from other portions as are the corresponding parts in the scene itself. Different parts of this aerial model are brought into focus on the ground-glass screen as the lens is racked in or out, so that the picture shown on the screen and recorded by the plate may be regarded as a section, vertical to the axis of the lens, through the many light rays which constitute, or proceed from, the aerial model. Owing to the coarse grain of the ground-glass screens at first supplied with photographic apparatus, it used to be thought that critical focusing could only be accomplished when the aerial image is directly inspected, which could be done by means of a telescope attached to the camera and arranged to focus simultaneously with it, or by having a transparent spot on the

focusing screen, made by cementing a microscopic cover glass on the latter with Canada balsam. This idea is theoretically correct for obtaining the greatest possible sharpness; but general satisfaction is now given by the definition obtainable by the ordinary method of focusing, especially if finely-ground glass is used. Ground glass of quite superior fineness is now procurable which, in conjunction with a really good lens, should remove most of the difficulties met with by earlier workers. An advantage of the telescope attachment was that it enabled moving objects to be followed, with the plate in position ready for exposure, a result now achieved more conveniently by the use of a reflex camera.

AERIAL PERSPECTIVE

A gradual softening down as objects recede into the distance, whereby they lose strength both in colour and in light and shade. Very distant objects are often seen as a mass of light grey without detail. A print which successfully renders this is said to possess "atmosphere," and the suggestion of space and air is of very great value in pictorial work. The use of orthochromatic plates in conjunction with deep colour screens frequently destroys aerial perspective to a greater or less extent.

AERIAL PHOTOGRAPHY

The art of taking photographs from aeroplanes, airships, balloons, kites, etc. Very quick exposures are necessary because of the movement and of the great flood of light. Photographs were first taken from a balloon by Nadar, of Paris, in 1858, since when photography from balloons has been practised in war time very considerably, particularly during the American and South African wars. In balloons, airships, etc., the operator holds the camera, but in kite work the shutter is released by means of a cord held by the operator on the ground as explained under the heading "Kite Photography," where details of working will be found. The best photographs from balloons are, according to the late Rev. J. M. Bacon, those taken at an elevation of between 250 ft. and 4,000 ft. At a greater height than 4,000 ft. it ceases to be worth while to use the camera, since the particles of water and dust suspended in the atmosphere spoil the definition and sharpness of the pictures. M. Antonin Boulade, the eminent French authority on the subject, has advocated orthochromatic plates, and those sensitive to rays chiefly between the G and F lines. The choice of a screen is also of the utmost importance, and the best results in his opinion were those obtained with a two or three "times" screen. From great altitudes, where the action of the blue of the sky is very intense, yellow screens needing about six times the normal exposure produce the best negatives.

AERIAL SCREEN (Fr., _Écran d'air_; Ger., _Windschirm_)

A form of screen for giving relief and other effects for optical lantern pictures, its special object being to arrest the light coming from a lantern and to reflect it back to the point at which the projected image is to be observed. The "Bruce" aerial screen consists of a white

lath, turning on a vertical axis in a plane parallel with the lantern lens. The mechanism and the rotating lath occupy a position in front of a black velvet screen or background, which absorbs all rays of light not falling on the lath and thus prevents them from reaching the eye of the observer. An ordinary optical lantern projects the subjects, which are preferably pictures of statuary in which fine photographic quality is present, giving as much rotundity as possible, and having a black background. The revolving lath, which takes the place of the ordinary lantern sheet, is caused to rotate at a moderate speed, calculated to make one revolution within the time needed to satisfy the laws of persistence of vision. Viewing it in broad daylight as it is rotated at the specified speed, it would present the appearance of a transparent cylinder. When the apartment is darkened and the picture is projected upon the rotating lath, the subject presents a somewhat solid aspect, and the audience will not be conscious of a revolving device, the illusion being caused by light from all parts of the image impinging upon the lath as it arrives at each and all of its positions. In virtue of the law of persistence of vision, there-

Producing Illusion with Invisible Screen

fore, a complete image will be made up. The chief object of this form of aerial screen is to bring about relief, but naturally a full stereoscopic effect is not obtained in this way. Another form of aerial screen consists of a column of vapour rising from the ground and acting as a reflector of the projected rays of light, just as a cloud in the sky may reflect the rays of the sun, but as the medium cannot be controlled as regards its reflecting surface it is only useful for producing weird effects in which absolute definition is not a necessity.

Yet another and much more recent form of aerial screen is that in which the laws of partial reflection are made use of; it is termed "the invisible screen," because the medium upon which the image is actually received is hidden from the observer's view by the front of the proscenium. A method of reflection somewhat similar to that used in the old illusion known as "Pepper's Ghost" is adopted, but there are variations in the arrangement of the apparatus which make the results far more perfect and realistic. An observer situated in the auditorium at A (_see_ the illustration) looks towards the proscenium B, and sees in a clear plate glass C the aerial image D E, and at the same time observes at F any actors (real persons) who may be performing. The light rays constituting the

spectre D E are arrested before reaching the glass C by a semi-transparent screen G. In the basement under the stage an ordinary optical lantern, or a kinematograph projector H, is set up. A mirror J, placed at an angle of 45 deg. in relation to the optical axis of the lantern objective, diverts the light from its horizontal course into a vertical direction, so that the defined picture or image is received upon the semi-transparent screen G. In virtue of the angle of reflection being equal to the angle of incidence, whatever may be projected on C will be seen by the observer at A, and will appear to be situated in mid-air in the vicinity of F. Hence, the so-called " invisible screen " may be regarded as the aerial screen, although the aeriograph is seen in quite a different place. The chief object of the invisible screen in this case is to afford means for producing aerial images or spectra in combination with real actors; whilst by the use at H of a kinematographic apparatus instead of an ordinary lantern many startling effects, otherwise impossible, are produced.

AEROGRAPH, OR AIR BRUSH (Fr., *Aérographe*; Ger., *Aerograph*)

A mechanical sprayer working by means of compressed air, and used for finishing and working up both prints and negatives; invented by Charles L. Burdick, of Chicago, in 1892, and introduced into England a year later. It is capable of great technical possibilities, and pro-

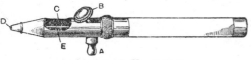

Aerograph Handpiece

duces effects varying from peculiarly soft and beautiful graduations to strong and vigorous work. At will, and in successive instants of time, the operator can draw lines or wide bands of colour, and shadows, either soft and delicate, or hard and coarse. The complete outfit includes the handpiece, or fountain air brush, an air pump with compressed air reservoir, an air pressure-gauge, rubber tubing, liquid colour, etc.; inasmuch as a high and uniform air pressure is essential to the best results, a motor-driven air pump is superior to the foot-operated one, and both kinds are manufactured. Cylinders of compressed carbon dioxide (" carbonic acid gas ") may be used in place of the pump with equal convenience. When using the foot pump the pressure obtained is about 15 lb. per square inch, and when using the motor pump from 30 lb. to 40 lb. per square inch, this producing a much finer grain.

The illustration shows the appearance of the aerograph. Air is pumped into a chamber connecting with the handpiece by means of a rubber tube at A. Finger pressure on a button B opens a valve and admits the air, which sucks the liquid colour from the reservoir C and throws it from D in the form of a fine spray, over which the operator has complete control. The spray is regulated and stopped by a needle-like rod E worked by B.

In the management of the aerograph, scrupulous cleanliness is always necessary. Keep the pencil in the case when not in use, and before fitting it up for service, pump air into the cylinder, squeeze the tube for a moment or so, and then release so as to allow the dust inside the tube to blow out. Use the colour thinly, and go over the work several times to get a fine, even grain. Use fresh colour for every occasion, and change the water frequently to avoid dust, which otherwise will cause the colour to splutter. Before and after using the instrument, pass two or three lots of clean water through it, and clear away any accumulation of paint with a wet brush. To adjust the needle, just fit it easily to the platinum point where the valve lever is as far forward as it will go. Do not jam it hard and push far in, otherwise too much colour will be ejected on pressing down the valve. Also see that the rubber tubes are free from kinks or bands. Having mixed the colour in a clean saucer, transfer to the reservoir by means of a brush. Spray a little in the air before treating the original, to make sure that all the cleaning water is expelled and the brush is working properly. Hold the aerograph about 6 in. distant from the original, press the lever down and slightly backwards, move it horizontally with a gliding sweep from left to right, beginning at the top left-hand corner, and releasing the valve at the end of each journey until it has travelled in this way downwards over the whole space to be covered. The air brush unaided does not produce sharply defined lines and edges; paper masks must therefore be used to obtain these, or if the background has merely to be painted out, then the parts that are to be protected can be covered over with a special preparation, " Masklene," supplied by the makers of the aerograph; the colour is sprayed on, and the protected parts are then cleaned with a pledget of cotton wool soaked in benzine.

In process work, the aerograph is extensively employed for working up originals for reproduction, especially photographs of objects for catalogue illustration. Backgrounds are in most cases put in with the aerograph and vignetted off. Sometimes the main object is cut out of the photographic print with scissors or a sharp knife, then mounted on cardboard, and a background and other detail put in. Another method largely adopted is to stop out portions on which the aerograph spray is not to be applied, the stopping-out medium being of such a nature that it can afterwards be removed without injuring the rest of the drawing. The medium used may be either of a greasy nature, such as vaseline, which may be afterwards cleared away with benzol, or it may be a celluloid varnish, which may be removed with amyl acetate or other solvent of celluloid. India-rubber solution and yolk of egg are other substances used for the same purpose. The former can be peeled off by rubbing with the ball of the finger, whilst the latter will flake off. In either case the colour applied by the aerograph comes away with the medium, and leaves quite clean the portions which have been covered. Larger surfaces may be stopped out by cutting out masks of tracing paper and attaching these

temporarily to the print with rubber solution. The colours used should be mixed to match as nearly as possible the tints of the original to be worked up. Chinese white should be avoided, as it photographs darker than the white papers on which it is applied. Albanine, Ullmanine, and Blanc d'Argent are good whites to use for this work. Lampblack and "process black" are the blacks commonly employed. For large lithographic work, such as posters, a larger handpiece is employed, which will give a coarser spray and will not clog with the transfer ink necessitated by the lithographic process.

AEROMETER

A hydrometer for measuring the density of acids.

ÆSCULIN (Fr., *Æsculine ;* Ger., *Æskulin, Schillerstoff*)

Synonyms, esculine, esculin, esculinic acid, polychrome, bicolorin, enallachrom. An extract obtained from the bark of the horse-chestnut (*Æsculus Hippocastanum*). $C_{15}H_{16}O_9$. Molecular weight, 340. A white powder, a solution of which, of a strength of about 1 part in 500 parts of water, is used as a filter to absorb ultra violet rays.

In process work, where the white (particularly Chinese white) reproduces as if it were yellow, an æsculin filter should be used. This may be a solution contained in a glass cell having parallel sides, or it may be in the form of a dry filter.

AGAR-AGAR, OR AGAL-AGAL (Malayan) (Fr. and Ger., *Agar-agar*)

A gelatinous vegetable material obtained from certain white seaweeds (*Gracilaria lichenoides* and *Eucheuma spinosum*), found principally on the shores of the Red Sea. It is used to a small extent as a substitute for gelatine in plate and paper making, but it is more difficult to melt than gelatine, and is not generally so satisfactory for emulsion work. It has also been recommended as a substitute for arrowroot in the preparation of silver paper, the latter, if very porous, being first sized with a 1½ per cent. solution of gelatine. Five parts of agar-agar are allowed to soak for an hour or two in 500 parts of water, heated till dissolved, boiled for five minutes, and then mixed with twenty parts of common salt and strained through a cloth. It is carefully brushed on the paper, and this, when dry, is floated in the dark upon a 14 per cent. solution of silver nitrate containing 10 per cent. of citric acid. In the case of thick and coarse paper, the silver solution is first brushed on, and then, when dry, the paper is floated on the agar-agar solution and again dried in the dark. After being sensitised the paper keeps well. It is printed and toned as other plain silver papers, but if platinum is used as a toner the picture must be deeply printed.

In process work, agar-agar has been suggested as a substitute for fish glue in the enamel process of preparing the resist for etching, but it has not come into commercial use.

AGATE BURNISHER

A burnisher consisting of a polished piece of agate fitted to a handle ; it was used in the original method of burnishing albumen prints. The unmounted print was laid on plate glass or marble and polished with the burnisher. The operation was thought to cure "measles" on prints, and give depth to the shadows. The process was rendered obsolete by the introduction of the burnishing machine.

AIR-BELLS (*See* "Bubbles.")

AIR BRUSH (*See* "Aerograph.")

AIROSTYLE

A form of air brush, introduced in 1907.

AKTINAL (Fr., *Actinal*)

A preparation sold in Germany as a desensitiser for exposed plates, after treatment with which they may safely be developed in daylight, using a metol-hydroquinone developer, with caustic potash as the accelerator, and fully restrained with potassium bromide. It is said to be a 4 per cent. solution of potassium iodide.

ALABASTER, OR ALABASTRINE, PROCESS

A very old process for improving the quality of positives made on glass by the wet collodion process. The picture was bleached in a solution of mercuric chloride in order to increase the brilliancy of the white image, was then varnished, and finally, when dry, was bound at the back. The process is even now occasionally used in obtaining a good result from a thin gelatine negative, which must be free from fog. The faulty negative is bleached in a solution of mercuric chloride, washed, dried, backed with black material, and copied in the camera. Ready-made mercury solutions for the process have been sold under the name of "alabaster" solutions. The original formula is : Water, 2 oz. ; nitric acid, 60 minims ; hydrochloric acid, 60 minims ; to which must be added sufficient mercuric chloride to saturate the solution, the excess remaining in crystals ; finally, 60 minims of alcohol must be added. A more modern mixture—and one equally suitable for dry (gelatine) plates—is : Water, 2 oz. ; bichloride of mercury, 40 grs. ; hydrochloric acid, 1 drm. ; sodium chloride (common salt), 20 grs. ; and sulphate of iron, 20 grs. Wet collodion pictures bleached with this are permanent if varnished, and so protected from the atmosphere, but dry plate negatives thus bleached will not remain white for long if kept in a strong light.

ALBANINE

A very pure white water-colour pigment used by process retouchers for working up originals either by brush or with the aerograph. It photographs as white, and should be employed pure for brilliant touches in the highest lights of a drawing or print. It can be mixed with "process black" for obtaining graduations of shadow. No other white should be mixed with it.

ALBERINI'S PROCESS (*See* "Asphaltum.")

ALBERT PAPER (*See* "Photo-Lithography.")

ALBERT'S COLOUR PROCESS (*See* "Cito-chrome.")

ALBERT'S RELIEF OR GALVANO PROCESS (Fr., *Méthode à rehausser d'Albert*; Ger., *Albert's Unterlage*)

A method of imparting a varying relief to the surface of printing blocks, so as to avoid the necessity for overlaying to bring up the darker portions in typographic printing; invented by Dr. E. Albert, of Munich. A heavily inked proof is taken from the plate, and transferred to a thin zinc plate. The ink image is strengthened by dusting with resin or bitumen powder and heated to fuse the powder and ink. Then the plate is etched strongly until the highest lights are etched away, and the half-tones partially, the shadows remaining solid and, consequently, in the highest relief. This plate is covered with a sheet of thin gutta-percha, and the back of the original plate placed on it in exact register, the whole being then put into a heated press, with a soft packing over the face of the plate. On strong pressure being applied the underlay plate is attached to the original plate, and the undulations of surface on the former communicate relief to the latter plate. The combined plate is mounted on wood or metal to type height, and is then ready for printing, no "making-ready" by the printer being necessary.

ALBERTYPE, ALBERT-TYPE, OR ALBERTOTYPE (Fr. and Ger., *Albertypie*)

The first workable collotype process made known; invented by Josef Albert, of Munich. It differs somewhat from the present-day collotype process. A piece of glass ⅜ in. thick is coated, in a dark-room, with the following solution:—

Water	300 parts.	
Albumen	150	,,
Gelatine	15	,,
Potassium bichromate	8	,,

When the film is dry it is exposed to light for two hours *through the glass*, backed by a piece of dark cloth, so that the film may harden from the bottom (next the glass) to the surface. The exposed plate is now coated with the following:—

Gelatine	300 parts.	
Potassium bichromate	100	,,
Water	1,800	,,

When again sufficiently dry the plate is exposed from the coated side under a negative, and is then washed for fifteen minutes, and dried. The film is next damped, and inked in the usual way. Printing is done in a lithographic press, or in a proper collotype press. The process is said to give prints with fine half-tones, but it requires considerable care and experience in manipulation, much depending on the printing.

ALBUM (Fr. and Ger., *Album*)

Blank-leaved books for storing and displaying photographic prints. They may be roughly divided into two classes—slip-in and pastedown. As the names suggest, the former has a double page with cut-out openings on the upper leaf so that the prints (generally glazed) may be slipped in between the two sheets; the latter has plain pages on to which the prints are pasted. The colour of the leaves is important; white is generally unsuitable, and bright tints should be avoided. It is also important when prints are to be pasted down to make sure that both paper and adhesive are free from acid or anything that will be deleterious to the photographs. Prints do not show to the best advantage when many are crowded together on one page. A print that is worth mounting at all deserves to be presented alone on a separate page, of a tint that is harmonious and unobtrusive. Special albums are made for the storage of film negatives, thus affording an easy means of indexing and reference.

ALBUMEN (Fr., *Albumine*; Ger., *Albumen*)

A very complex organic compound containing carbon, hydrogen, oxygen, and sulphur, which occurs both in the animal and vegetable kingdom. Animal albumen exists as the serum or white fluid of blood, but photographically the white of eggs is the only animal albumen used. To prepare it for photographic purposes the whites of eggs should be separated from the yolks and the germ, and thoroughly beaten to a froth, allowed to settle for twelve or twenty-four hours, and then filtered. Actually, the albumen is contained in minute cells, and the beating has the purpose of breaking the cell walls, which subsequently form the flocks or scum.

Albumen is coagulated by heat (150° F. or 65·5° C.), by alcohol, and most metallic and inorganic salts, the resultant precipitate with the latter being albumenates. It is an almost colourless, gummy liquid, which dries to a pale yellow solid. Seventy grains of the dried egg albumen dissolved in one fluid ounce of distilled water forms a solution equal to the fresh white of egg. The solution is extremely liable to decomposition, and should be either freshly prepared or preserved with an antiseptic. It is used for albumenised paper, the albumen negative, beer, and positive processes.

Invert albumen is obtained from ordinary albumen by first treating with acid and then with alkali, by which treatment it is so altered in character that it becomes soluble in alcohol. The following process has been suggested by Sanger Shepherd:—

White of eggs	20 oz.	1,000 ccs.	
Glacial acetic acid	148 mins.	16·5	,,

Beat up thoroughly, and allow to stand for one hour, then add a 20 per cent. solution of sodium hydrate drop by drop with constant stirring till the mixture thickens; next allow to stand for one hour, break up into small pieces, and wash (*see* "Emulsion"), drain well, and dissolve in boiling alcohol. Invert albumen gives an extremely tough, structureless film, and was suggested for making colour filters.

In process work, albumen is used as a substratum, or for edging the glass plates in making wet plate negatives. Also, it is almost universally employed with potassium bichromate for sensitising the zinc plate for photo-etching. Albumen is also often mixed with fish-glue in making up the enamel solution for printing on zinc or copper from half-tone negatives. Dried albumen is frequently employed in preference to the liquid white of eggs. Varying opinions are expressed as to the quantity of dried albumen

required to equal the albumen of one egg, but 70 grs. to 1 oz. of water may be taken as a safe standard.

ALBUMEN PROCESS

NEGATIVES.—An old process invented by Niepce de St. Victor, in 1848. Glass was coated with albumen containing potassium iodide, and the film was sensitised by dipping in a nitrate of silver bath. Many modifications followed, but probably the process most widely used was the one published on May 21, 1855, by Mayall; this comprised six distinct operations, as follow :—

(1) The albumen (white) of a fresh egg is beaten to a snow-like mass with a bunch of quills, afterwards dropping into it 10 drops of a saturated solution of potassium iodide and allowing to stand six hours at a temperature of 60° F. (2) A piece of plate glass having smooth edges is cleaned by rubbing over it nitric acid with cotton wool, and polished with Tripoli powder moistened with a few drops of a concentrated solution of potassium carbonate. To the centre of the back of the glass is attached a pneumatic holder to serve as a handle. (3) The prepared albumen is strained through linen, and is then used to coat the polished side of the glass, this being placed on a level slab in a warm and dustless place to dry. The glass is now known as the "iodo-albumenised" glass, and it will keep in a good condition for any length of time. It may be prepared in daylight. (4) The sensitising mixture, or "exciting solution," is made by dissolving 50 grs. of silver nitrate in a mixture of 1 oz. of distilled water and 120 minims of strong acetic acid, which operation and the following one must be done in a weak yellow light. Pour the sensitising mixture into a clean porcelain dish a little larger than the plate to be coated; place one end of the albumenised glass in the solution; with a quill, support the upper end of the glass and let it fall suddenly into the solution, lifting it up and down for ten seconds; take it out, and place it face upwards in another dish half filled with distilled water; allow the water to pass over the surface twice, take out and set aside in the dark to drain and dry. The plate at this stage is ready for exposure in the camera, and will keep good for ten days if kept from the light, in a moderately warm place, and free from moisture. The surplus sensitising solution may be filtered back into a black bottle for use again and again, adding occasionally a few drops of acetic acid and keeping in the dark. Exposure varies from four to ten minutes, according to light and stop. On a very bright day, and using the $f/16$ stop, Mayall recommended an exposure of five minutes. (5) For development, the glass is placed film side upwards on a levelling stand, and a concentrated solution of gallic acid is poured over it; the image takes from thirty minutes to two hours to develop. A temperature of 10° higher than that of the room is advised, and if the image is feeble the plate is rinsed and covered with a solution of equal quantities of aceto-nitrate of silver and gallic acid diluted with water to half strength. This causes the image to appear more quickly and stronger. The plate is next washed in three waters, and is

then ready for fixing. (6) The fixing solution is made by dissolving 3 drms. of hyposulphite of soda in 1 oz. of water. The plate is allowed to remain until all the yellow iodide has disappeared, and is next well washed and dried. "Success," said Mayall, when publishing this process in the *Athenæum* [No. 1,220], "is sure to attend anyone practising this method, provided the eggs are fresh and the glass quite clean; if the glass is not clean and the eggs stale, the albumen will split off the plate during the fixing." Among the modifications which followed for the purpose of quickening the plates were the addition of grape sugar, honey, and potassium fluoride, the latter proving to be the best of all. Malone's and other processes in use in the 'fifties of the nineteenth century differed in detail from the above, but in essentials were the same.

POSITIVES.—At one time the albumen process was widely used for the production of positives or lantern slides, and even at the present time, owing to the exquisite results obtainable with it, the albumen process is used by some of the largest lantern and stereoscopic transparency firms in the world. It is hardly a process for the beginner, because of the somewhat complicated formulæ and manipulations. The famous "Ferrier et Soulier" slides were produced by the albumen process, but the exact formula used was kept secret. Other formulæ have, however, been published and worked successfully, the best being that in which the plate is coated first with collodion and then with iodised albumen; the details are as follow : Pieces of good clear glass should be thoroughly cleaned by washing in a solution of 8 oz. of soda in 1 gal. of hot water, and rubbing well with rags tied to a wooden stick. Next, the plates are rinsed in plain water and placed in dilute hydrochloric acid (1 in 20). A substratum is next required, and this is made by mixing the white of one egg with 50 oz. of water; the mixture being shaken up three or four times during the day and allowed to stand all one night, it is then filtered through fine muslin. The plates are taken from the acid bath, rinsed, drained slightly, and coated on one side with the albumen substratum mixture; next they are laid flat and dried. Great care is necessary to avoid dust and to get an even coating. When dry, collodionising and sensitising may take place. Some ready-made iodised collodion is obtained (the longer it has been iodised the better), and the following solution is prepared :—

Distilled water	. 20 oz.	1,000 ccs.
Silver nitrate	. 2 ,,	100 g.
Potass. iodide	. 2 grs.	.2 ,,

Shake well, stand in sunlight for a day, and filter into a glass dipping bath, when it is ready for use. The following albumen solution must also be prepared and kept ready at hand for use after collodionising :—

Albumen (fresh white of egg)	. 8 oz.	800 ccs.
Liquor ammoniæ	. 2 drms.	25 ,,
Potass. bromide	. 10 grs.	.4 g.
Potass. iodide	. 50 ,,	2·0 ,,
Distilled water	. 3 oz.	300 ccs.

The albumen must be well beaten up with a silver fork, the bromide and iodide mixed with it, the water and the liquor ammoniæ being then added. The mixture should stand twenty-four hours before use, and then be filtered through muslin. Take one of the plates prepared with the substratum, coat with the iodised collodion, drain, and move to and fro in the air so that the ether may evaporate, place at once upon the dipper and immerse in the silver nitrate bath. A deep ruby light is not necessary, an orange or a deep yellow light being quite safe enough. The plate must be moved up and down in the silver bath a few times, allowed to stand for two minutes, taken out, the silver drained off, and then washed for a few minutes and drained, but not dried. While the surface is still damp the plate is covered with the albumen solution, drained, and again coated with the albumen. When dry, the plate must be treated in order to make the bromo-iodised albumen more sensitive to light, for which purpose the following bath is used :—

Silver nitrate (recrystallised) . . . 600 grs.	60 g.	
Distilled water to . 20 oz.	1,000 ccs.	
Glacial acetic acid . 110 drms.	1 cc.	

The plates are allowed to remain in this bath for two or three minutes, washed well, and flowed over with a nearly saturated solution of gallic acid, and finally dried in a warm dark place. The plates are then ready for exposing. The time of exposure will be about fifteen times as long as an ordinary modern gelatine lantern plate. Over- is better than under-exposure. The following pyro developer should be used :—

A. Pyrogallic acid . 96 grs.	100 g.	
Alcohol to . . 1 oz.	500 ccs.	
B. Potass. bromide . 12 grs.	125 g.	
Water to . . 1 oz.	500 ccs.	
C. Ammonium carbonate . . . 80 grs.	84 g.	
Water to . . 1 oz.	500 ccs.	

To prepare the developer for use, 12 drops of A are mixed with 1 dram of B and 6 drams of C. The image soon appears, but will be thin and usually requires to be strengthened by redevelopment, which is done by applying a small quantity of the following developer, after washing off the first developer :—

Pyrogallic acid . . 6 grs.	4 g.	
Distilled water to . 3 oz.	85 ccs.	
Citric acid . . . 1½ grs.	1 g.	

Before using this, add a few drops of a solution of 30 grs. of silver nitrate in 1 oz. of water. As soon as dense enough, the plate is fixed in a solution of sodium hyposulphite (4 oz. to 20 oz. of water), washed for about five minutes, and dried.

Many other formulæ have been advocated, some much more simple than the above and without the use of collodion, but the process described probably gives the most satisfactory results and offers fewer opportunities for failure.

ALBUMEN PROCESS (BEER)

A dry collodion process for solar photography, introduced by Sir William Abney in 1874, also of use for landscape work. Abney's formula is :—

Alcohol (·825) . 4½–3 drms.	270–180 ccs.	
Ether . . 3½–5 ,,	210–300 ,,	
Pyroxyline . 7 grs.	7 g.	
Ammonium iodide 2 ,,	2 ,,	
Cadmium bromide 5 ,,	5 ,,	

The relative proportions of alcohol and ether are adjusted according to temperature. The plate is then sensitised in a silver bath of from 40 to 60 grs. per oz., and is next washed, and the first preservative applied :—

Albumen . . . 1 oz.	100 ccs.	
Water . . . 1 ,,	100 ,,	
Liquor ammoniæ . 1 drm.	12·5 ,,	

This is beaten to a froth and allowed to settle. The clear part is mixed with an equal quantity of flat beer or stout immediately before use, and is then applied to the plate ; fresh bottled beer or stout must not be used. The excess is then drained off, the film washed for two minutes, and finally covered with a solution made by adding to every ounce of plain beer 2 grs. of pyrogallic acid. The plate is then dried in the usual way. Great latitude in exposure is permissible, even up to twenty times the correct amount, and, if desired, the plates need not be developed for a month, but they need to be washed just previous to development. For developing, four solutions are necessary :—

A. Pyrogallic acid . 12 grs.	12 g.	
Water . . . 1 oz.	500 ccs.	
B. Liquor ammoniæ (·880) . . 1 drm.	62 ccs.	
Water . . . ½ oz.	250 ,,	
C. Citric acid . . 60 grs.	60 g.	
Acetic acid . . 30 mins.	2 ccs.	
Water . . . 1 oz.	500 ,,	
D. Silver nitrate . 20 grs.	20 g.	
Water, distilled . 1 oz.	500 ccs.	

Three drops of B are mixed with each half-ounce of A, and flowed over the plate. The image will then gradually appear. Two more drops of B per half-ounce are added, the solution again flowed over the plate and returned to the measure. Six drops of C are placed in a measure, and the partially used developer poured on to it, afterwards adding a few drops of D. The application of this solution intensifies the image. Abney states that it is not advisable to bring out too much detail with the pyro-ammonia solution, but to allow some of it to be brought up at the finish with the intensifier. When the image is sufficiently dense, the plate is fixed either by a solution of potassium cyanide or with "hypo," then washed and dried. The process is not an easy one, and many failures are likely to be met with, but the resultant negatives, when all goes well, are of a remarkably high quality.

ALBUMEN PROCESS (PHOTO-MECHANICAL) (See "Zinc Etching.")

ALBUMENISED PAPER

A prepared paper for obtaining prints from negatives. It is similar to plain salted paper, except that albumen is used with the first or salting solution in order to give the paper a gloss

PORTRAIT OF A. HADDON BY FURLEY LEWIS, F.R.P.S.

STUDIO PORTRAITURE

PROSPECT STREET, RYE By T. K. Grant, F.R.P.S.

and to keep the silver sensitising solution on the surface. The introduction of albumenised paper has been credited to Talbot, but definite instructions for making it emanated from other experimenters—notably Le Gray, Hunt, and Pollock—during the years 1851, 1852, and 1853. For about forty years albumen paper remained the most popular of all printing processes, and reigned supreme until the introduction of gelatino-chloride (P.O.P.) and similar papers. It, however, is still used by some professional workers and for some special processes, as crystoleum work, for example. Ordinary white papers were used at first, but in 1863 methods of slightly tinting the papers mauve, pink, etc., by means of dyes, were introduced.

ALCOHOL (Fr., *Alcool ;* Ger., *Alkohol*)

Chemically, alcohols are neutral compounds formed by the replacement of hydroxyl OH for one atom of hydrogen in a saturated carbon compound ; for instance, C_2H_6 ethylene gives C_2H_5 OH ethyl hydrate, or ordinary alcohol. They unite with acids with elimination of water to form ethers. Alcohols are hydrates of organic radicles and may be considered as equivalent in organic chemistry to the metallic hydrates in inorganic. For example, KOH potassium hydrate ; C_2H_5 OH ethyl hydrate. They are divided into monatomic, diatomic, triatomic, etc., according to the number of OH groups attached to the organic radicle.

Alcohol, Ethyl (Fr., *Alcool ordinaire, Alcool éthylique ;* Ger., *Aethylalkohol*)

Synonyms, ethylic alcohol, ethyl hydrate. C_2H_5 HO. Molecular weight, 46. Solubilities, miscible with water and ether in all proportions. A colourless, volatile, inflammable liquid of pleasant odour ; it is obtained from grain, starch, or sugar by fermentation and subsequent distillation. It is principally used for preparing collodion (*which see*).

Absolute Alcohol contains from 98 to 99 per cent. of pure alcohol, and is used for making collodion.

Rectified spirit or spirits of wine contains 10 per cent. of water, and is known as 58 over-proof. The term "proof spirit" refers to an old test with gunpowder, which was moistened with the spirit and then a light applied ; if the gunpowder fired the spirit was termed proof.

Alcohol, Methyl or Methylic (Fr., *Alcool méthylique ;* Ger., *Methylalkohol, Holzgeist*)

Synonyms, wood alcohol, wood spirit, wood naphtha, methyl hydrate or hydroxide. CH_3 OH. Molecular weight, 32. Solubilities, miscible with water, alcohol, and ether in all proportions. A colourless, mobile liquid, prepared by the destructive distillation of wood. It is an excellent solvent for resins and pyroxyline, with which it gives a very tenacious film.

Alcohol, Methylated (Fr., *Alcool dénaturé ;* Ger., *Brennspiritus*)

Synonyms, methylated spirit, denatured alcohol or spirit. Solubilities, miscible with water and ether in all proportions. It usually contains about 90 per cent. of aqueous ethyl alcohol with about 10 per cent. of methyl alcohol and $\frac{1}{8}$ of 1 per cent. of mineral naphtha to render

2

it unpotable. Industrial methylated spirit does not contain naphtha, and can only be obtained by special permit of the Inland Revenue under a heavy bond ; it may be used for nearly all photographic purposes instead of pure alcohol, except for printing-out collodion emulsions. The admixture of methylated spirit with water turns it milky in consequence of the separation of the naphtha.

In process work, alcohol plays an important part. For making up collodion for the wet plate process, absolute alcohol of ·805 sp. g. is usually employed. Spirit of wine is used in the wet plate developer to overcome the repellent actions of the silver solution on the plate when the bath has become charged with alcohol through the frequent sensitising of plates. As the bath gets older the proportion of alcohol is increased. Methylated spirit is not generally employed on account of the presence in it of mineral naphtha, which is apt to give fog, scum, and other troubles, but industrial alcohol (wood spirit) may replace the pure spirit on the score of economy. In making up collodion emulsion only pure alcohol should be employed. Alcoholic solutions of dyes are largely used in colour sensitising, and in this case only pure alcohol should be used. Methylated spirit is used for drying off the fish-glue print after development. It is also employed for developing resinous images, for making up acid resist varnish, for diluting stopping-out varnish, and for cleaning off varnish coatings. In the aquatint process alcohol is used with resin to give the granular ground which is formed on the plate for etching. Similarly, alcohol is used in certain bitumen processes, such as the Frey process, where the alcohol with the asphalt causes the film to reticulate—that is, to form a network. An alcoholic solution of bichromate is used for sensitising carbon tissue, the object being to promote quicker drying.

ALCOHOLOMETER (Fr., *Alcoolmètre ;* Ger., *Alkoholometer*)

A hydrometer graduated so that the percentage of alcohol can be read off directly on the scale.

ALDEHYDE (Fr., *Aldéhyde ordinaire ;* Ger., *Aldehyd*)

Synonyms, acetaldehyde, ethaldehyde, acetic aldehyde. CH_3 CHO. Molecular weight, 58. Solubilities, miscible in all proportions with water, alcohol, and ether. A colourless, light, inflammable liquid, with pungent smell, obtained by oxidising ethyl alcohol with chromic acid. It was suggested by Lumière and Seyewetz as a substitute for the alkaline caustics and carbonates in developers, but it is rarely used. It forms, as does acetone (*which see*), compounds with the bisulphites, and its action in developers may be represented by the same equation.

In process work, aldehyde as an impurity in alcohol is often the cause of foggy negatives in wet collodion and collodion emulsion. The aldehyde may be detected by adding a small quantity of a strong solution of silver nitrate to the alcohol and exposing the whole to light for some hours, when the liquid will gradually blacken if aldehyde is present.

ALETHOSCOPE (Fr., *Aléthoscope* ; Ger., *Alethoskop*)

An optical device invented by Signor Ponti, of Venice, and intended for the inspection of transparencies or ordinary photographic prints. It consisted of a large single lens, suitably mounted, somewhat after the manner of the modern lanternoscope or pantoscope used for viewing lantern slides. It was claimed that the alethoscope showed single photographs with stereoscopic relief, but that is a theoretical impossibility, although it is possible to obtain a deceptive approximation to relief when looking with both eyes through a large convex lens at a single photograph, provided the lighting, modelling, and perspective of the picture are good and natural ; but this effect is more due to imagination and suggestion than anything else. If a coloured picture is used the illusion is heightened. According to Sir Howard Grubb, who investigated this effect as seen in the graphoscope, this is due to the lens being non-achromatic, so that it fringes everything with red on one side and with blue on the other. Thus the outline of, say, a red flower is a little extended on one side to the right eye and on the other side to the left eye, which causes the two pictures seen by the respective eyes to be really dissimilar, in such a manner as to give the appearance of relief when combined, although not properly stereoscopic.

ALGRAPHY

A process of lithographic printing from aluminium plates, as a substitute for lithographic stone, patented by Joseph Scholz, of Mainz, Germany. Aluminium had previously been used for lithographic printing, but Scholz was the first to make it a commercial process. His method chiefly relates to the preparation of the surface, phosphoric acid playing an important part in the process.

ALIZARINE, ARTIFICIAL (Fr., *Alizarine artificielle* ; Ger., *Alizarin künstlich*)

Synonym, dioxyanthraquinone α—β. A group of organic dye-stuffs obtained from anthracene. The only one of importance is alizarin S, the sodium-bisulphite compound, which has been occasionally used for sensitising plates for red. Its action is somewhat uncertain, and it has been entirely replaced by the isocyanines (*which see*).

ALIZARINE, NATURAL (Fr., *Alizarine naturelle* ; Ger., *Alizarin natürlich*)

Synonyms, madder, rubia. The root of *rubia tinctorum*, obtained from South Europe and the Orient, yields by extraction the colouring matter alizarine, which is used for making carbon tissue and in dyeing.

ALKALI (Fr., *Alcali* ; Ger., *Alkali*)

The direct opposite to an acid. A term by which the accelerator used in development is often known. An alkaline solution is one that will turn red litmus paper blue, or change the yellow colour of turmeric paper to brown. Most of the modern developers for dry plates are known as alkaline developers because of an alkali—ammonia, soda, etc.—being used as the accelerator. In 1862 a Mr. Leahy, of Dublin, found that liquor ammoniæ assisted the pyro developer, but Major Russell, the inventor of the tannin process, had for some time been experimenting in the same direction, and in 1862 published the first complete account of a workable system of alkaline development. Since then alkalis other than ammonia—namely, sodium and potassium carbonates—have come into wide use. Previous to 1862 ammonia was largely used in America, but not in the developer itself ; the plates were merely exposed to the fumes of ammonia before the pyro was applied.

ALKALIS, CAUSTIC

Potassium hydrate, sodium hydrate, and lithium hydrate are examples of the caustic alkalis, being often referred to, respectively, as caustic potash, caustic soda, and caustic lithia. Their caustic nature is easily demonstrated by the rapidity with which they will disintegrate the human skin. The carbonates are sometimes referred to as the " mild " alkalis to distinguish them from the hydrates or " caustic " alkalis. Caustic soda is, as a rule, purer than caustic potash, but both have an action upon glass, and render grease soluble in water. (*See also* " Caustic.")

ALKALIS, CHEMICAL EQUIVALENCE OF

All alkalis are not alike in their action as accelerators in developers, and one cannot be used in the place of another indiscriminately. The table below, compiled by George E. Brown, is the most widely used for finding the equivalent values of the alkalis :—

Caustic Soda	Caustic Potash	Ammonia ·880 Solution	Soda Carbonate (anhydrous)	Soda Carbonate (crystals)	Potass. Carbonate (anhydrous)	Potass. Carbonate (crystals)
80	112	97·14	106	286	138	174
1	1·400	·867	1·325	3·575	1·725	2·174
·714	1	1·211	·946	2·553	1·232	1·554
·834	1·153	1	1·091	2·944	1·421	1·791
·755	1·033	·916	1	2·698	1·302	1·641
·280	·392	·340	·371	1	·483	·608
·580	·812	·704	·768	2·072	1	1·260
·460	·644	·558	·609	1·644	·793	1

The ammonia solution (·880) should be weighed, not measured. To find weights of other alkalis equivalent to any particular compound, run the finger down the proper column until the figure 1 is reached. The figures in the same horizontal line are the equivalent weights of the other alkalis as denoted at the head of each column. Thus, 1 gr. of carbonate of soda (crystals) equals ·280 grs. caustic soda or ·608 grs. potassium carbonate crystals. A rough and ready method, said to work well in practice when changing from one accelerator to another, is to consider that one drop of liquor ammoniæ is equivalent in its action to 8 gr. of sodium carbonate or 5 grs. of potassium carbonate crystals. Dr. Mason gives the following comparative table :—

Potassium hydrate.	.	.	112 grs.
Sodium hydrate	.	.	80 „
Potassium carbonate	.	.	165 „
Sodium carbonate (anhydrous)	106 „		
Sodium carbonate (crystals)	.	286 „	
Sodium bicarbonate	.	.	168 „

(*See also* " Accelerator.")

ALKALIMETER (Fr. *Alcalimètre ;* Ger., *Alkalimeter*)

An instrument for testing the amount of alkali present in a commercial sample which may have an admixture of impurities. It was invented by F. A. H. Descroizilles, of Dieppe, though some have claimed the discovery for Dr. Andrew Ure, of Glasgow. It consists of a graduated glass tube divided into 100 degrees

A. Faraday
Alkalimeter

B. Burette Pattern
Alkalimeter

and furnished at one end with a dropping nozzle. The form recommended by Dr. Faraday is shown at A, but many now prefer to use the more convenient burette pattern B, having a glass tap or pinchcock at its lower end. The tube of the alkalimeter is filled with dilute sulphuric acid, containing as much of the strong acid as would suffice to neutralise a given weight, say 100 grs., of potassium carbonate or sodium carbonate. One hundred grains of the alkali to be tested is then dissolved in water, the solution being placed in a glass beaker or flask, and the acid solution is allowed to drop gradually into it until the mixture is neutralised. The purer the substance the more of the acid will be required. If the tube is emptied to, say, 80 deg., the alkali is known to contain 20 per cent. of impurities. The point at which neutralisation occurs used to be determined by means of litmus or turmeric, but more sensitive and easily recognisable indicators are now employed,

the principal of these being methyl-orange and phenol-phthalein. A mixture of these two reagents in alcoholic solution gives a pale yellow colour to a perfectly neutral liquid, which is instantly changed to pink by the least trace of acid, or to a deep red by a trace of alkali. Commercial potassium carbonates and sodium carbonates frequently contain a certain proportion of the sulphate or chloride, silicates, etc., and since the value of the sample depends on the proportion of carbonate present it is obviously requisite to ascertain this. Impure commercial alkalis are, of course, scarcely suitable for photographic purposes, but the above method of testing is often useful. By using an alkaline solution of known strength instead of the acid solution, the strength of acids may be tested ; or the strength of a solution of silver may be ascertained by charging the instrument with a standard solution of sodium chloride.

ALKALINE FIXING BATH

A " hypo " (hyposulphite of soda) fixing bath that is not in an acid condition. Fixing baths for printing-out papers should always be distinctly alkaline, and as ordinary mixtures of hyposulphite of soda and water are sometimes slightly acid, various methods of destroying the acidity have been recommended. A normal fixing bath may be rendered alkaline by adding sufficient liquor ammoniæ until after stirring it smells faintly, or by adding sodium carbonate or bicarbonate. A standard formula for an alkaline bath is :—

Hyposulphite of soda	2 oz.	124 g.	
Washing soda .	¼ „	16 „	
Common salt .	.	¼ „	16 „
Water .	.	18 „	1,000 ccs.

At least one authority considers this too weak, and reduces the water to 12 oz. or 14 oz. Some advocate the use of ½ oz. of sodium sulphite in place of the ¼ oz. of washing soda. It is not advisable to use this bath with any paper having a substratum tinted pink or mauve, as these colours, which are aniline dyes, would in almost every case be destroyed.

ALLONGÉ PAPER

A rough-grained hand-made drawing paper, used by artists in crayon drawing for process reproduction. It has a very pleasing surface grain, and may be used on the right or wrong side with different results, the right side being the rougher and perhaps the better. This paper may be sensitised for printing a photographic image on to it as a guide to the artist. (*See* " Sensitising.")

ALLYL-SULPHOUREA, ALLYL-THIO-CARBAMIDE, AND ALLYL-THIO-UREA (*See* " Thiosinamine.")

ALPHA PAPERS AND PLATES

A particular make of chloro-bromide printing paper and transparency plate introduced in 1890 and 1891 respectively by Ilford, Ltd. The plate or paper is printed by artificial light, and afterwards developed ; the image may then, if desired, be toned in a toning bath, which gives a large variety of colours.

ALTOGRAVURE

A process for the production of half-tone intaglio plates for power-press printing after the style of Rembrandt photogravure.

ALTO-RELIEVO (Fr., *Haut relief;* Ger., *Hochrelief*)

Derived from the Italian term *alto rilievo*, meaning high relief; applied to sculptured, carved, or modelled ornaments and figures which stand out from their background by more than half their proportionate thickness. The term is sometimes employed in processes in which relief is obtained by methods depending on the action of light, the results so produced being known as photo-reliefs. As a rule, however, these processes are not capable of yielding a great amount of relief. A low degree of relief is known as a basso-relievo, or bas-relief (*which see*); while a medium amount is known as a mezzo-relievo.

ALUM (Fr., *Alun;* Ger., *Alaun*)

This term comprises a large class of salts characterised by the formula M'_2SO_4 M'''_2 $(SO_4)_3$ $24H_2O$, in which M' and M''' are monatomic and triatomic metals. All the alums crystallise in octahedra, but all do not contain alumina. The following are the principal alums used in photography:—

Ammonia Alum (Fr., *Alun d'ammoniaque;* Ger., *Ammoniakalaun*)

$(NH_4)_2SO_4$ $Al_2(SO_4)_3$ $24H_2O$. Molecular weight, 906. Solubilities, 1 in 8·5 water, insoluble in alcohol and ether.

Potash Alum (Fr., *Alun de potasse;* Ger., *Kalialaun*)

Synonym, aluminium and potassium sulphate. K_2SO_4 $Al_2(SO_4)_3$ $24H_2O$. Molecular weight, 948. Solubilities, 1 in 7·5 water, insoluble in alcohol and ether. This is the most generally used "alum," and is met with in large octahedral clear crystals or a white powder of peculiar astringent taste. It is used for a hardening and clearing bath and for making the "hypo" and alum bromide toning bath.

In process work, potash alum is used with dilute nitric acid for graining or matting the surface of zinc plates previous to coating them with the albumen-bichromate sensitising solution. The graining makes the coating hold better, and after the image has been inked and developed, the grained surface holds the damping solution, which prevents the ink from spreading and soiling the whites when rolling up.

Soda Alum (Fr., *Alun de soude;* Ger., *Natriumalaun*)

Synonyms, sodium alum, sodium and aluminium sulphate. Solubilities, 1 in 2·2 water; insoluble in alcohol and ether. This is occasionally used in place of the ammonia or potash alum.

Chrome Alum (Fr., *Alun de chrome;* Ger., *Chromalaun*)

Synonym, chromium and potassium sulphate. K_2SO_4 $Cr_2(SO_4)_3$ $24H_2O$. Molecular weight, 916. Solubilities, 1 in 6·25 water, insoluble in alcohol and ether. This is in the form of rich violet coloured crystals, giving a dichroic solution that is reddish violet by transmitted, and green by reflected light, obtained as by-products in the manufacture of alizarine, aniline violet, etc. Stolze suggested the addition of sufficient ammonia to chrome alum solution to give a permanent precipitate after well stirring and then filtering. Namias suggested the admixture of equal quantities of a 10 per cent. solution of ordinary and chrome alums, rendering the mixture alkaline with ammonia, boiling and filtering. Lumière and Seyewetz have also confirmed the statement that alkaline chrome alum exerts a greater hardening effect. The maximum hardening effect is produced by 2 per cent. of the total dry gelatine employed.

Chrome alum is used as an addition to emulsions, and for this purpose it is general to render the solution distinctly alkaline with ammonia, filter, and then render neutral by the addition of glacial acetic or hydrobromic acid. It is also used in the fixing bath (*which see*) and combined bath (*which see*).

Lumière and Seyewetz have pointed out that 100 parts of gelatine are most hardened by 0·64 parts of alumina, and the following table gives the quantities of the aluminium compounds which contain this quantity of alumina:—

Potash alum . . .	6 parts
Ammonia alum . . .	5·6 ,,
Aluminium sulphate . .	4·2 ,,
Aluminium chloride, anhydrous	1·6 ,,
Aluminium nitrate. . .	4·5 ,,

Below these quantities the full hardening effect is not produced, whilst increase produces no greater hardness. They have also pointed out that "alum" has the least hardening effect, and is extremely liable to fungoid growths, so that it is far better to use chrome alum in its place.

In process work, chrome alum is used as a hardening agent for gelatine. It is added sometimes to fish-glue when the image has a tendency to wash away too freely. Also it has been added to the nitric acid bath when etching enamel images on zinc, with the object of preventing the images from being softened.

Iron Alum (Fr., *Alun de fer;* Ger., *Ammoniakeisenalaun*)

Synonyms, ammonia-iron-alum, ammonioferric-sulphate, ferric ammonium sulphate. $(NH_4)_2SO_4$ $Fe_2(SO_4)_3$ $24H_2O$. Molecular weight, 962. Solubilities, 1 in 2 water, insoluble in alcohol and ether. This is in the form of large pale violet or amethyst octahedral crystals, which give a brown solution when dissolved in tap water, due to the formation of basic iron salts. Used for making ferric oxalate (*which see*).

ALUM BATHS

These are used in both negative and print making. In negative work an alum bath was originally used for the purpose of hardening the film, but with most modern plates and modern improvements in working such treatment is rarely necessary. It serves another purpose, however. If the bath is rendered acid, alum removes all development stain and improves the colour of the negative. A good formula is:—

Common alum .	.	1 oz.	58 g.
Hydrochloric acid	.	1 drm.	50 ccs.
Water . .	.	20 oz.	1,000 ,,

After a short rinsing from the developer, the plate should be immersed in this bath for two or three minutes, then well washed for ten or fifteen minutes, and fixed as usual. The use of a good acid fixing bath renders the employment of an acidified alum bath unnecessary, as it clears and hardens the film while fixing is progressing.

In the carbon and allied processes, in which a bichromate is used for sensitising, an alum bath is employed after the print is developed. Its object is twofold. It hardens those parts of the film that may remain partially soluble, and also removes any yellow bichromate stain that may be left after development. The following is an excellent formula :—

Alum	.	.	. 1 oz.	55 g.
Water	.	.	. 20 ,,	1,000 ccs.

Hot water should be used for dissolving the alum, but the bath must not be used until it is quite cold.

ALUM TROUGH

A glass-sided trough containing alum solution, and sometimes used in the optical lantern between the light and the condenser in order to absorb the heat rays before they reach the slide or other object to be projected. Alum troughs are widely used for cinematograph films, and slides by the screen-plate (colour) processes, as these are easily damaged by heat. Glycerine and other solutions have been advocated in place of a saturated solution of alum, while even plain water, circulating through pipes and a tank on the thermo-syphon principle, is sometimes employed.

ALUM-HYPO TONING

A method of toning black-and-white prints on bromide and gaslight papers to a sepia colour, sometimes referred to as the " boiling process " and as " sulphur toning "; actually it is a sulphur toning process, but not the only one. The formula for the bath is :—

Sodium hyposulphite	2½ oz.	125 g.
Powdered alum	. ½ ,,	25 ,,
Granulated sugar	. ½ ,,	25 ,,
Boiling water to	. 20 ,,	1,000 ccs.

Dissolve the " hypo " in the water first, add the alum slowly, and next the sugar, although this may be omitted if desired. When all is dissolved the solution should be milk white and a sediment should form at the bottom of the bottle, but it should not be filtered. The bath should be heated two or three times to about 120° F. (nearly 49° C.), allowing to cool in between; this " ripening " is necessary because were it omitted the newly-made bath would not work well, and would bleach the prints. The older and more used the bath is (it may be used over and over again) the more evenly it works, and the richer the tones. When possible, one part of an old bath should be added to four parts of the new bath. Another method of ripening the bath is to tear up some old prints and place in the solution previous to heating; still another is to add 5 grs. of silver nitrate to each ounce of the bath, this tending to give a purplish-brown tone. The fixed black-and-white prints to be toned should be placed in the bath when this is cold, and the whole then warmed, keeping the prints on the move. The time of toning will vary according to the kind of paper and developer, age of print, and temperature of solution. The quickest results are obtained by raising the temperature as high as the picture will stand, generally about 100° F. (nearly 38° C.), but the best tones are those obtained at about 85° F. (between 29° and 30° C.), the average time being fifteen minutes. The bath may be used cold, in which case toning may take as long as two or three days. Prints developed with amidol appear to tone the quickest, and those toned with hydroquinone the slowest. When the prints reach the desired tone they are allowed to remain in the solution until it is tepid, or cold, and then well washed.

Another method of toning with this bath is to harden the prints first of all in a solution of alum (alum 1 oz.; water 30 oz.), or a portion of the cold toning bath, and then place in the alum-hypo bath made hot, and, after toning, in the alum-and-water solution again, finally washing. The object of the alum baths is to prevent blisters, which would in all probability occur if the prints were put direct into the hot toning bath, and thence into cold water for washing. The use of the extra alum baths is obviated by warming the toner containing the prints. Rich and good tones depend upon the print having been properly developed, and upon the ripeness of the bath. If the toned prints are washed for about one hour they may be considered quite permanent, the image consisting of silver sulphide.

The alum-hypo bath may also be used for toning P.O.P. prints. The prints must first be washed, fixed in an ordinary " hypo " bath, next placed in a cold alum-hypo bath, where they tone to a good purple-brown colour, and then washed well. P.O.P. prints to undergo this treatment should be over-printed, since they reduce considerably in toning.

ALUMINIUM, OR ALUMINUM (Fr. and Ger., *Aluminium*)

Al. Atomic weight, 27. A very light, silvery-white metal, obtained by electrolysis from aluminium chloride. It is principally used for the construction of light cameras and for lens fittings, but difficulties in working it and its softness led to the introduction of a harder alloy of aluminium and magnesium, called magnalium. Aluminium is used in some flashlight powders, and in algraphy (*which see*). " Aluminum " is now the accepted American spelling.

Aluminium plates are now largely used for lithography as a substitute for lithographic stone. (*See* " Algraphy.")

In process work, aluminium has been used for relief etching, but is not commercially in vogue. Nitric acid has little action on it, but hydrochloric acid attacks it more readily. Phosphoric and fluo-silicic acids are active mordants, but not convenient to use. Perchloride of iron has a strong action upon it ; a solution of common salt will also attack it freely. Aluminium is largely used for the screen and plate holders of process cameras, as it is not readily acted on by the silver nitrate solution.

ALUMINIUM CHLORIDE (Fr., *Chlorure d'alumine ;* Ger., *Chloraluminium*)

Al_2Cl_6 12 H_2O. Atomic weight, 483. Soluble in water, alcohol, and ether. It is a yellowish-white granular crystalline powder which (very rarely) is used in the gold and platinum toning baths. It is extremely deliquescent, and must be kept in well-stoppered bottles.

ALUMINIUM FLASHLIGHT

Aluminium bronze powder, also known as "silver bronze," may be used in place of, or in conjunction with, magnesium for flashlight work. It is cheaper than magnesium, burns under certain conditions with less smoke, but it is not quite so actinic. The first experiments with this metal appear to have been carried out by Dr. Piffard, of New York, in 1888. Dr. Miethe has found that fine aluminium bronze powder (5 to 10 per cent. of aluminium and 90 to 95 per cent. of copper) burns almost completely in the flame of a Bunsen burner. Aluminium, however, is better, even if more dangerous, when mixed with potassium chlorate, in which form it becomes an explosive mixture, and must be treated as such ; that is to say, the mixture must have a light applied to it, and not be blown through a flame. The potassium chlorate intended for mixing with the aluminium bronze powder should be quite free from the deliquescent potassium chloride, because if this is present the chlorate will tend to be moist. The chlorate should be well dried, and powdered sufficiently finely as to pass through a sieve of eighty meshes to the inch. The aluminium and the chlorate must not be mixed together in a mortar, but with a feather or a flat blade on a sheet of paper. A suitable formula is :—

Aluminium	.	. 1 part.
Potassium chlorate	.	. $2\frac{1}{4}$ parts.

For more rapid flashes, antimony sulphide should be added, the formula being :—

Antimony sulphide	.	. 3 parts.
Aluminium	.	. 5 ,,
Potassium chlorate	.	. 15 ,,

Another formula is :—

Aluminium	.	. 20 parts.
Lycopodium	.	. 5 ,,
Ammonia nitrate	.	. 1 part.

All these mixtures are explosive and dangerous, and proper precautions should be observed, as directed under the heading "Flashlight Mixtures," where a formula for aluminium in conjunction with magnesium will be found.

A flashlight mixture, patented in 1904 by Dr. G. Krebs, gives very little smoke and consists of aluminium 2 parts, magnesium 2 parts, and chrome alum 10 parts. A "time" powder, also due to Dr. Krebs, contains aluminium 20 parts, magnesium 80 parts, chrome alum or copper sulphate 100 parts, lime oxide, carbonate, or glass 20 parts. Aluminium cartridges, to contain a flash mixture and burn with it, have lately been made, the metal case being of from ·1 to ·3 mm. thickness.

Aluminium leaf burned in oxygen gives a very powerful light. The method is to place a few leaves of aluminium in a dry bottle containing oxygen gas, and on applying a lighted taper to the top leaf the contents of the bottle burn with a flash which, for actinic power and general brightness, is said to exceed anything obtainable with an equal amount of magnesium.

ALUMINIUM POTASSIUM SULPHATE (*See* "Alum.")

ALUMINIUM SULPHATE (Fr., *Sulfate d'alumine ;* Ger., *Aluminiumsulfat*)

$Al_2(SO_4)_3$ 18 H_2O. Molecular weight, 166. Solubility, 1 in 2 water. White crystals with sweet, astringent taste, obtained by dissolving aluminum hydrate in sulphuric acid. It has been suggested as a hardening agent, but has found very little use.

ALUMINIUM SULPHOCYANIDE (Fr., *Sulfocyanure d'alumine ;* Ger., *Aluminiumrhodanid*)

Synonym, aluminium sulphocyanate or rhodanide. $Al_2(CNS)_6$. Molecular weight, 402. A yellowish powder occasionally used as a preliminary bath for self-toning papers. It is extremely deliquescent, and must be kept in well-stoppered bottles.

ALUMINOGRAPHY (*See* "Algraphy.")

AMACRATIC

A term relating to photographic lenses and implying that the chemical rays of light are united into one focus. "Amasthenic" is a term with the same meaning.

AMASTHENIC (*See* "Amacratic.")

AMATEUR PHOTOGRAPHER

One who practises photography as a pastime, and not as a profession. In photography the question of who is and who is not an amateur is a difficult one to decide. So-called amateurs do not hesitate to accept a little payment for their prints "just to cover the cost of materials," while others win prizes in cash competitions, or sell prints to periodicals. It is maintained in many quarters that the acceptance of money by an amateur for his work places him in the professional category. The consensus of opinion, however, is that a photographer who does not advertise, invite custom, or rely upon the art as a livelihood, is an amateur. The old controversy and jealousy between amateurs and professionals has, at any rate in Great Britain, faded away to extinction, and the two classes of photographers understand more clearly that their interests are parallel and do not clash, and that photographic progress has need of them both.

AMBER (Fr., *Ambre jaune ;* Ger., *Bernstein*)

A fossil, yellow and translucent resin used occasionally in varnishes, for which purposes it must first be fused.

Fused amber	. . 3 oz.	150 g.
Chloroform to	. . 20 ,,	1,000 ccs.

When dissolved, filter and use cold.

Another formula is that known as Brannt's, namely :—

Fused amber	.	4 oz.	400 g.
Sandarac	.	6 „	600 „
Elemi	.	1 „	100 „
Methylated spirit (90 %)	12 „	1,000 ccs.	

When dissolved add—

Camphor	.	$\frac{1}{8}$ oz.	$12\frac{1}{2}$ g.

AMBROTYPES

The American name for wet collodion positives upon glass or " tin " (thin plates of enamelled iron or steel). Those upon glass are sometimes said to be by the " alabastrine process " (*which see*); those upon " tin " are called " tintypes " or " ferrotypes." Ambrotypes are produced by the " finished while you wait " process formerly so extensively practised by itinerant photographers, but now practically superseded. Full particulars will be found under the heading " Ferrotype Process."

AMIDINE (Fr., *Amidon ;* Ger., *Amidin*)

Synonyms, amadine, amylum. An amylaceous substance identical in chemical composition with cellulose, and found in many cereals and vegetables. It is practically equivalent to starch. It forms the translucent jelly or paste obtained when boiling water is poured on ordinary starch, so extensively used as a photographic mountant.

AMIDO-ACETIC ACID (Fr., *Glycocoll ;* Ger., *Amidoessigsäure, Glykokoll*)

Synonyms, glycocoll, amido-glycollic acid, amino-acetic acid, glycocine, sugar of gelatine. $NH_2 CH_2 COOH$. Molecular weight, 75. Soluble in water. White crystals, formed by replacing one of the hydrogen atoms of ammonia by the acetic acid. It possesses both acid and basic properties, and the sodium salt $NH_2 CH_2 COONa$ was introduced (1902) under the name of *Pinakolsalz N* by Meister, Lucius and Brüning as a substitute for the alkalis in developers, but on account of its high price did not replace them in practice.

Amido-acetic acid is called sugar of gelatine on account of its sweet taste, and from its being a product of the decomposition of gelatine by acids or alkalis. It is sometimes termed glycin, but must not be confused with the developer of that name (*which see*), this being a phenol derivative of it, having the formula $C_6H_4OH\ NH\ (CH_2COOH)$.

AMIDO-BENZINE (*See* " Aniline.")

AMIDO-CARBOXYLIC ACIDS (*See* " Carboxylic Acids.")

AMIDO-GLYCOLLIC ACID (*See* " Amido-acetic Acid.")

AMIDO-PHENOL (*See* " Amidol.")

AMIDOL, OR DIAMIDOPHENOL (Fr. and Ger., *Amidol*)

A developer having the formula $C_6H_3 OH(NH_2)_2$, and introduced in the year 1892. It is sold in the form of a white or greyish crystal-line powder, which keeps well in a dry state but in solution rapidly loses its developing powers. The dry amidol is therefore best added to the solution immediately before use. It forms a developer when mixed with a solution of sodium sulphite, no alkali being needed, and it works very rapidly, the detail appearing almost immediately the developer is applied to the plate. This sudden appearance is apt to deceive those unacquainted with it, but the negative must not be taken from the developer until it has attained the required density. It has been stated that amidol will develop when in an acid condition, and appropriate formulæ have been published, but it is better to regard amidol as an alkaline developer, because. even if it does work when slightly acid, it works better when slightly alkaline. The addition of acetone sulphite in quantity equal to that of the amidol preserves the developer for a considerable time, but acts as a restrainer ; other preservatives have been advocated, but it is better to add the dry amidol when required for use. A normal developer consists of :—

Sodium sulphite	.	600 grs.	60 g.
Amidol	.	40–60 „	4–6 „
Water to	.	20 oz.	1,000 ccs.

The mixed developer will keep well for four or five days. It should be made up with a new solution of fresh and pure sulphite. It is usual to make up a stock solution of sodium sulphite and to add 2 to 3 grs. of dry amidol to each ounce of solution.

Potassium bromide has but little restraining effect in an amidol developer, except when used in large quantities, but when added in small quantities it has a clearing effect. In cases of over-exposure, about 15 drops of a 10 per cent. solution of potassium bromide may be added for every ounce of developing solution. Acetic, citric, and tartaric acids have been recommended as restrainers and sodium hyposulphite (" hypo ") as an accelerator, but with the latter the image loses density beyond a certain point. Two- and three-solution amidol developers are rarely resorted to, as they have but little advantage over the one-solution, which is in wide use, particularly for bromide paper, for which most paper-makers give a special formula. The two-solution form is not given here because it is of doubtful value.

Amidol has the property of staining the finger-nails. Sometimes it stains bromide prints a rosy pink colour, which may be removed by the use of eau-de-javelle followed by citric acid.

Another formula with bromide, and specially recommended by Abney for the development of " instantaneously " exposed plates, is :—

Amidol	.	5 grs.	5 g.
Sodium sulphite	.	40 „	40 „
Potass. bromide	.	1 „	1 „
Water to	.	2 oz.	1,000 ccs.

This solution will keep for a few days, but is most energetic when fresh.

Another form of a one-solution amidol developer is that known as Balagny's acid-amidol, which has found great favour upon the Continent, both for negatives and bromide paper.

One of its advantages is its slowness. The original formula is :—

Water	.	.	10½ oz.	300 ccs.
Amidol	.	.	30 grs.	2 g.
Sodium sulphite crystals	.	120 „	8 „	
Potassium bromide solution (10 %)	.	170 mins.	10 ccs.	
Sodium bisulphite solution ·	.	.	340 „	20 „

The bisulphite solution is a commercial article. A substitute can be made by preparing a saturated solution of the commercial bisulphite and then adding 1 drm. of strong sulphuric acid to each ½ pint. Many similar acid-amidol mixtures have been advocated.

It has been frequently stated that amidol-developed negatives and prints should not be fixed in an acid fixing bath, because of its causing fogging or further development during fixation, but T. H. Greenhall says that there is nothing to be feared in this respect when using bromide paper. An old acid fixing bath heavily charged with amidol and sulphite gave stronger prints than plain " hypo," due to the fact that plain " hypo " had a slight reducing action, and not to any defect in the acid fixer, which was absolutely necessary for some papers.

Some photographers find that amidol has an effect upon the skin resembling that of metol, but not so intense.

AMMONIA (Fr., *Ammoniaque ;* Ger., *Ammoniak, Ammoniakwasser, Salmiakgeist*)

A volatile, pungent gas, which for photographic and many other purposes is used in the form of a watery solution (NH_3OH) ; formerly known as " spirit of hartshorn." The strongest solution, and that mostly used, is of ·880 sp. g., contains 35 per cent. of the gas NH_3, and is commonly known as " ammonia ·880 " or " liq. ammon. fort." " Liquid ammonia " is the incorrect, popular form of the term " liquor ammoniæ." A weaker liquor, kept by most chemists, one-third the strength of the ·880 solution, is rarely used in photography. Ammonia has many uses in photography, the principal being as an accelerator in the pyro developer, for blackening the mercury-bleached image in intensification, in emulsion-making, and as an addition to the bichromate bath for sensitising carbon tissue. Liquor ammoniæ should be kept in a glass-stoppered bottle, as it loses its strength rapidly if exposed to the air, and cork stoppers very soon deteriorate. The fumes of ammonia are extremely irritating to the eyes, throat, and nose, and particular care should be taken when opening bottles of it in hot weather, or when the bottles have been left on a warm shelf, as the liquid may spurt out and cause serious damage. Bottles containing liquor ammoniæ should be kept in a cool place, as heat develops great pressure, which may blow out the stopper or burst the bottle.

A. Haddon states that experiments show that ammonia expands on dilution with water about 18 per cent., and points out how very unreliable and varying is a solution of ammonia in hot weather, freshly bought samples of the ·880 solution varying in specific gravity from that to ·904, or from 35·8 to 26·9 NH_3 per cent. volume. It is this variation that makes it unreliable as an accelerator in development ; hence the necessity of using it fresh or keeping it in a gas-tight bottle and in the cool.

In process work, ammonia is not largely used. It is added to the albumen bichromate solution and also to the fish-glue solution to neutralise acidity, and increase the keeping qualities. A few drops added to the developing water makes the albumen bichromate image develop more quickly. A dilute solution of ammonia with whiting is used for cleaning copper, to free the surface from grease. Perchloride of iron solution for etching, especially for photogravure, is often neutralised by the addition of ammonia. Added to copper sulphate until a bright blue solution is formed, ammonia makes a bath for coating zinc with a film of copper without the use of an electric battery.

AMMONIA FUMING

Years ago, when most photographers, both professional and amateur, prepared their own plain salted and albumenised papers, it was customary to expose these to the fumes of ammonia in a box. The ammonia, uniting with the free silver nitrate in the paper, gave greater sensitiveness and richer prints. It has now fallen into almost entire disuse, but it formerly found favour owing to the brilliance imparted to the prints so treated.

AMMONIA METER

A small glass bulb, devised by Haddon and Grundy, which floated at exact balance in a 2·9 per cent. solution of ammonia of a certain temperature, thus enabling the strength to be determined without analysis. It has also been known as a " specific gravity ball."

AMMONIA-IRON-ALUM (*See* " Alum.")

AMMONIA, ROCK (*See* " Ammonium Carbonate.")

AMMONIO-CITRATE OF IRON (*See* " Ferric Ammonio-citrate.")

AMMONIO-NITRATE PROCESS (*See* " Emulsion.")

AMMONIO-OXALATE OF IRON (*See* " Ferric Ammonio-oxalate.")

AMMONIUM (*See* " Ammonia.")

AMMONIUM ALUMINIUM SULPHATE (*See* " Alum.")

AMMONIUM BICHROMATE (Fr., *Bichromate d'ammoniaque ;* Ger., *Ammonium-dichromat; Saures chromsaures ammon*)

(NH_4)$_2Cr_2O_7$. Molecular weight, 252. Solubilities, 1 in 4 water, soluble in alcohol ; known also as ammonium dichromate. Orange crystals, obtained by neutralising chromic acid with ammonia. It is sometimes used for sensitising carbon tissue, gum bichromate, and in some photo-mechanical processes, as it has a stronger

sensitising power, and is more soluble than the potassium salt, and in carbon printing gives richer pictures.

In process work, ammonium bichromate is largely used as a sensitiser with fish-glue for printing half-tone images on zinc and copper. It is believed to be a better sensitiser than potassium bichromate in this respect, the latter being chiefly used with albumen for the line process. It gives a more sensitive solution with fish-glue, the solution keeps better, and develops more freely. Ammonium bichromate is said to be more than twice as sensitive to light as potassium bichromate.

AMMONIUM BROMIDE (Fr., *Bromure d'ammon um ;* Ger., *Bromammonium*)

NH_4Br. Molecular weight, 98. Solubilities, 1 in 1·4 water, 1 in 31 absolute alcohol. A white, crystalline, slightly hygroscopic powder, with pungent saline taste, obtained by neutralising hydrobromic acid with ammonia, evaporating the solution and crystallising. It is sometimes used as a restrainer in place of the potassium salt, but must not be used with the caustic alkalis or carbonates, as ammonia is set free, which may give rise to fog. Its principal use is in emulsion making. If the salt has become damp by absorption of aqueous vapour, it may be dried in an oven without injury.

AMMONIUM CARBONATE (Fr., *Carbonate d'ammoniaque;* Ger., *Kohlensaures ammon, Ammoniumkarbonat*)

Synonyms, hartshorn, rock ammonia. $(NH_4)HCO_3$ $(NH_4)NH_2CO_2$. Molecular weight, 157. Solubility, 1 in 4 water. Keep in well-stoppered bottle, and before use scrape off any adherent white powder. White, hard, translucent, striated masses, obtained by heating ammonia salts and chalk. It is used in place of liquor ammoniæ in some developers. Hot water must not be used to dissolve it.

AMMONIUM CHLORIDE (Fr., *Chlorure d'ammoniaque ;* Ger., *Chlorammonium*)

Synonyms, sal-ammoniac, muriate or hydrochlorate of ammonia. NH_4Cl. Molecular weight, 53·5. Solubilities, 1 in 3 water, 1 in 8 alcohol. A white, crystalline powder, or tough, transparent, fibrous masses, the latter usually known as sal-ammoniac. The pure powdered salt is apt to attract aqueous vapour from the air, whilst sal-ammoniac remains dry. It is chiefly used for salting albumenised paper and also in preparing chloride emulsions.

AMMONIUM CITRATE (Fr., *Citrate d'ammoniaque;* Ger., *Ammoniumcitrat*)

$(NH_4)_3C_6H_5O_7$. Molecular weight, 243. Solubility, 1 in 0·5 water, soluble in alcohol. This salt is so deliquescent and so easy to make that the user should prepare it himself :—

Citric acid	.	1 oz.	100 g.
Distilled water	.	2 ,,	200 ccs.

When dissolved add—

Liq. ammoniæ ·880, (about) 250 mins. 50 ccs.

The ammonia should be cautiously added, and the solution tested for neutrality with litmus paper. When neutral, make the total bulk up to 10 oz. or 1,000 ccs. with distilled water, which practically gives a 10 per cent. solution. It is used as a restrainer with the pyro developer in the proportion 5 to 10 grs. per ounce.

AMMONIUM FLUORIDE (Fr., *Fluorure d'ammonium;* Ger., *Fluorammon*)

NH_4F. Molecular weight, 36. Soluble in water and alcohol. This is in the form of small, deliquescent, colourless, flat crystals, and it is used for etching glass and stripping negatives. As it attacks glass, it must be kept in indiarubber or wax-lined bottles.

AMMONIUM HYDRATE

A very seldom used synonym for liquor ammoniæ, NH_3HO.

AMMONIUM HYDROSULPHIDE (*See* "Ammonium Sulphydrate.")

AMMONIUM HYPOSULPHITE (Fr., *Hyposulphite d'ammoniaque;* Ger., *Ammonthiosulfat*)

Synonym, ammonium thiosulphate. $(NH_4)_2S_2O_3$. Molecular weight, 148. Very soluble in water. It occurs in colourless crystals, or can be readily made in solution, as follows :—

Sodium hyposulphite	.	5 oz.	248 g.
Ammonium chloride	.	2¼ ,,	106 ,,
Distilled water	to .	20 ,,	1,000 ccs.

It was suggested first in 1888 by John Spiller as a substitute for the sodium salt, on account of its greater solubility, and therefore of the greater ease with which it can be washed out of prints and negatives. It has recently been patented as a fixing salt. Lumière and Seyewetz point out that fixation is only quicker when the proportion of thiosulphate is less than 40 per cent., and if the proportion of chloride is only sufficient to convert one-fourth of the sodium salt, and further that the use of this salt must be regarded with suspicion on account of the rapid decomposition of the silver salts formed if the subsequent washing is not very rapid.

AMMONIUM IODIDE (Fr., *Iodure d'ammonium ;* Ger., *Iodammon*)

NH_4I. Molecular weight, 145. Solubilities, 1 in 0·6 water, 1 in 9 alcohol, slightly soluble in ether. It is a white to yellowish-white hygroscopic crystalline powder, which is very unstable, readily giving off iodine, which may be dissolved out by ether. It is occasionally used in making iodised collodion and negative gelatine emulsions.

In process work, ammonium iodide is a constituent in most iodising formulæ.

AMMONIUM MOLYBDATE (Fr., *Molybdate d'ammoniaque;* Ger., *Molybdänsaures ammonium*)

$(NH_4)_6Mo_7O_{24}4H_2O$. Molecular weight, 1,236. Soluble in water. It is in the form of large colourless or slightly greenish crystals, readily decomposed by heat. It has been suggested as an ingredient in printing out emulsions in order to obtain greater contrast.

AMMONIUM NITRATE (Fr., *Azotate d'ammonium;* Ger., *Salpetersaures ammon*)

NH_4NO_3. Molecular weight, 80. Solubilities, 1 in 0·5 water, 1 in 2·25 alcohol. These colourless, long, rhombic crystals are obtained by neutralising ammonia or ammonium carbonate with nitric acid. It has been suggested as a substitute for the potassium salt in flashlight mixtures (*which see*), though its hygroscopic nature is somewhat against it. It is also formed in emulsion making by double decomposition between ammonium bromide and silver nitrate, and is removed in washing. It is deliquescent, and should be kept in well-stoppered bottles.

AMMONIUM OXALATE (Fr., *Oxalate d'ammoniaque;* Ger., *Ammonoxalat*)

$(NH_4)_2C_2O_4H_2O$. Molecular weight, 142. Solubilities, 1 in 25 water. It is in the form of colourless crystals, obtained by neutralising oxalic acid with ammonia, and it is used to prepare ferric ammonio-oxalate.

AMMONIUM PERSULPHATE (Fr., *Persulfate d'ammoniaque;* Ger., *Ueberschwefelsaures ammonium*)

$(NH_4)_2S_2O_8$. Molecular weight, 228. Solubility, 1 in 2·5 water. It takes the form of colourless crystals, which are obtained by electrolysis. It is principally used as a reducer, and is especially valuable in that it reduces the high lights more than the shadows. The following formula may be used :—

Ammonium persulphate 480 grs. 50 g.
Distilled water to 20 oz. 1,000 ccs.

The negative should be immersed in this until the reduction is nearly complete, and then rapidly washed. A stop bath of sodium sulphite (5 per cent. solution) is sometimes recommended, but it occasionally gives rise to stains, and it is better to use water only. The chemical action which takes place is supposed to be—

$$Ag + (NH_4)_2S_2O_8 = (NH_4)_2SO_4 + Ag_2SO_4$$
Silver Persulphate Ammonium Silver
 sulphate sulphate

The silver sulphate dissolves in water. Namias states that a solution of persulphate acidified with nitric acid acts like the ordinary " hypo " and ferricyanide reducer.

The addition of 0·5 to 1 per cent. to the normal platinotype developer shortens the scale of gradation, and is thus useful for over-exposed prints.

H. W. Bennett has made a special study of ammonium persulphate as a reducer, and his special formula will be found under the heading, " Bennett's Reducer." The addition of ammonium sulphocyanide has been recommended, this causing the persulphate reducer to act in the opposite way—namely, to clear the shadows first after the manner of the ferricyanide and " hypo " reducer, which makes it particularly suitable for negatives of line subjects. The formula for the persulphate reducer often referred to as " Puddy's reducer " is: water 1 oz., ammonium persulphate 25 grs., and ammonium sulphocyanide (10 per cent. solution) 120 minims. Namias advocates a 5 per cent. solution of persulphate made acid with 1 per cent. of sulphuric acid for developing over-exposed carbon

prints. Ammonium persulphate has also been suggested as a " hypo " eliminator, stain remover, and as an addition to the oxalate developer for platinotypes ; $\frac{1}{2}$ to 1 per cent. added to the normal oxalate developer shortens the scale of gradation and saves over-exposed prints.

AMMONIUM PHOSPHATE (Fr., *Phosphate d'ammonium;* Ger., *Ammonphosphat, Phosphorsäures ammoniak*)

Synonyms, hydrogen diammonium phosphate, diammonium orthophosphate, dibasic phosphate of ammonia. $(NH_4)_2HPO_4$. Molecular weight, 132. Solubility, 1 in 4 water. Sometimes used in emulsion making and in toning, but infrequently ; its chief use is in fireproofing fabrics. It is obtained on drying the normal, or neutral ammonium phosphate $(NH_4)_3PO_4$. The latter is made by mixing phosphoric acid and ammonia in concentrated solution ; on cooling, the normal salt crystallises out in short prismatic needles.

AMMONIUM AND POTASSIUM CHROMATE (Fr., *Chromate d'ammonium et potasse;* Ger., *Kaliammoniumchromat*)

$NH_4KCrO_4H_2O$. Molecular weight, 191. Soluble in water. The pure salt occurs in bright, yellow crystals, but is rarely used except in the form of a solution which is made by adding ammonia to potassium bichromate solution. It has been suggested as an improved sensitiser for carbon printing, etc., but it frequently makes the tissue horny and reticulated.

In process work, when making up this bichromate sensitising solution for carbon printing, collotype, photo-lithography, and zinc printing, it is usual to add liquor ammoniæ drop by drop until the solution turns a light lemon yellow, and distinctly smells of ammonia. This forms the double chromate of potassium and ammonium.

AMMONIUM SULPHIDE (Fr., *Sulfure d'ammonium;* Ger., *Schwefel-ammonium*)

A yellowish solution, formula $(NH_4)_2S$, having a most objectionable smell ; known also as sulphuret of ammonia. It is widely used for toning bromides to a brown colour after bleaching, also for toning P.O.P. Its evil odour and bad-keeping qualities are reasons why some prefer to make it as required, according to the following method : A. Sodium sulphide, $\frac{1}{2}$ oz. ; water, $2\frac{1}{2}$ oz. B. Ammonium sulphide, 24 grs. ; water, $2\frac{3}{4}$ oz. Mix A and B, and use at once or any time within ten or twelve weeks ; in this form its odour is not so bad. Ammonium sulphide should not be kept in the same room as sensitive plates and papers, as the vapour acts injuriously upon them.

In process work, ammonium sulphide has been extensively used for blackening wet plate negatives after lead or copper intensification, but is now being largely superseded by sodium sulphide.

AMMONIUM SULPHOCYANIDE (Fr., *Sulfocyanure d'ammonium;* Ger., *Rhodanammonium*)

Synonyms, sulphocyanate, thiocyanate, or rhodanide of ammonia. NH_4CNS. Molecular weight, 76. Solubilities, 1 in 0·6 water, very soluble in alcohol. It is very hygroscopic, and should be kept well stoppered. It takes the

form of colourless crystals, obtained from carbon disulphide, strong alcohol, and liquor ammoniæ. It is used in toning printing-out papers. (See "Potassium Sulphocyanide.")

A 5 per cent. solution of the sulphocyanide will dissolve gelatine in the cold, and it has therefore been used to develop over-exposed carbon prints.

Owing to the highly deliquescent properties of this salt, it is a common practice to make it up into a nominal 10 per cent. solution as soon as possible after buying. 1 oz. of the salt should be dissolved in 2 oz. or 3 oz. of water, and then made up to a total bulk of 9 oz. Ten drops of this stock solution will then contain 1 gr, so that any toning formula may be made up from it with less trouble than by weighing the damp solid. Two drms. (120 drops) contain 12 grs., which is a good average quantity to mix with 1 gr. of gold chloride and 8 oz. of water.

AMMONIUM SULPHYDRATE (Fr., *Sulphydrate d'ammoniaque*; Ger., *Schwefelammon*)

Synonyms, ammonium hydrosulphide, ammonium sulphide. NH_4HS. Molecular weight, 50. Soluble in water. The pure salt occurs in colourless, crystalline masses, which rapidly turn yellow on exposure to the air. The commercial ammonium sulphide, which is generally used, is prepared by passing sulphuretted hydrogen H_2S into liquor ammoniæ NH_4OH, and forms $(NH_4)_2 S = 68$, a colourless or slightly yellow solution with disagreeable odour. It is used for blackening wet collodion negatives after intensification with silver iodide, copper bromide, or lead nitrate.

AMMONIUM THIOCYANATE (See "Ammonium Sulphocyanide.")

AMMONIUM THIOMOLYBDATE (Fr., *Sulfomolybdate d'ammonium*; Ger., *Ammoniak thiomolybdanat*)

$(NH_4)_2MoS_4$. Molecular weight, 260. Solubilities, soluble in water, insoluble in alcohol. It takes the form of red scales obtained by boiling molybdenum trisulphide in ammonium sulphide. Its use has been patented for sulphiding bromide prints in place of sodium sulphide.

AMMONIUM VANADATE (Fr., *Vanadate d'ammoniaque*; Ger., *Vanadinsaures ammoniak*)

Synonym, ammonium metavanadate. $NH_4 VO_3$. Molecular weight, 116. Slightly soluble in water. These colourless crystals have been recommended as an addition to printing-out emulsions to increase contrast.

AMPHITYPE

One of the many curious and interesting printing processes invented by Sir John Herschel, but of no practical value. It depends upon the light-sensitiveness of ferric, mercuric, and lead salts, and it gives a rich, vigorous print which can be viewed from both sides of the paper, or as a transparency. A sheet of paper is prepared with a solution, either of ferro-tartrate or ferro-citrate of protoxide, or peroxide of mercury, and then with a saturated solution of ammonia-citrate of iron. Exposed in a camera

for a time varying from half an hour to five or six hours, according to the intensity of the light, a negative is produced on the paper which gradually fades in the dark, but may be restored as a black positive by immersion in a solution of nitrate of mercury, and ironing with a very hot flat-iron.

Amphitype is also the name of a photo-lithographic transfer process invented by W. H. Shawcross, of Liverpool. The paper is sensitised with an iron salt, and keeps indefinitely. It is printed under a negative, then inked all over with a special ink, and developed with a solution of yellow prussiate of potash. The lines of the print are thus covered with transfer ink whilst the ground is a deep blue, which, however, can be bleached away in a solution of common soda. The transfers are applied to zinc or stone in the usual way.

AMPLIFIER

A supplementary lens placed between a positive or image-producing lens and the focusing screen for the purpose of producing an enlarged image. Amplifiers may be positive or negative in their form; if positive, they must be placed outside the principal focus of the primary lens, as in the Dallmeyer photo-heliograph or as in photo-micrography, where the eyepiece (usually of special design) forms the amplifier. When negative amplifiers are used, they may be placed at any point between the back surface of the primary lens and the principal focus; the size of image and the necessary camera extension become greater as the negative lens approaches the positive one. The earliest practical form of negative amplifier was the Barlow lens, designed for shortening the tube length of telescopes. The principle is extensively employed in the construction of the telephoto lens, in which the amplifier is usually termed the "negative element." (See "Telephoto Lens" and "Photoheliograph.")

AMSTUTZ PROCESS (See "Acrograph.")

AMYL ACETATE (Fr., *Acétate d'amyle*; Ger., *Amylacetat, Birnenöl*)

Synonyms, essence of jargonelle pears, amylacetic ester, isoamylacetate. $C_5H_{11}C_2H_3O_2$. Molecular weight, 130. Solubilities, insoluble in water, miscible in all proportions with alcohol and ether. It is a colourless ethereal liquid with characteristic odour, and is obtained by distillation from amyl alcohol, sulphuric and acetic acids. It is used for making celluloid cold varnish or zaponlack, a formula for which is—

Celluloid .	.	150 grs.	15 g.
Amyl acetate to .		20 oz.	1,000 ccs.

This gives a hard, resistant film which can be applied cold to negatives. The addition of acetone gives a milky film. It is also used in the amyl acetate lamp (*which see*).

In process work, amyl acetate is used as a solvent for celluloid, and the resulting varnish is used for stripping instead of collodion. The varnish is used in aerograph retouching for stopping out, and the amyl acetate for removing the varnish after the colour has been applied by the aerograph.

AMYL ACETATE LAMP (Fr., *Lampe à amylacetate ;* Ger., *Hefner Lamp*)

A lamp devised by Hefner-Alteneck and adopted by the International Congress of Photography in 1889 as the standard light for sensitometry. The wick should consist of loose cotton threads, and be held in a tube of 8 mm. (about ·32 in.) internal and 8·3 external diameter, and of 25 mm. (1 in.) length. The height of the flame should be 40 mm. (1·6 in.), and this must be gauged by a sight hole and cross wire. Outside the flame, at a distance of 1 cm. (·4 in.) from its axis, is a metal chimney pierced with a hole 4 mm. (·16 in.) broad and 30 mm. (1·2 in.) long, which can be shifted so as to bring it opposite the brightest part of the flame. The amyl acetate should be free from acetic acid and water, and have a constant boiling point of 138° C. (280·4° F.). The standard English candle = 1·14 H.K. or Hefner-Kerze.

The great objections to the amyl acetate lamp as a standard photographic light are its spectral composition, which is very poor in violet and blue rays, and its variability under varying heights of the flame (1 mm. or ·04 in. variation in height produces an alteration of about 3 per cent.), the influence of aqueous vapour and carbonic acid in the air, and also the state of the barometer on the uniformity of the light. (*See also* " Sensitometry.")

AMYL ALCOHOL (*See* " Alcohol.")

AMYLOTYPE (Fr., *Amylotypie ;* Ger., *Amylotypie*)

A photograph or print obtained by the action of light upon vegetable matter or extracts. (*See* " Anthotype.")

ANACHROMATIC

A name given to certain lenses, mostly of French manufacture, which are uncorrected for chromatic aberration.

ANACLASTIC (Fr., *Anaclastique ;* Ger., *Anaclastisch*)

Capable of refracting, or bending, rays of light. Dioptrics, that branch of optical science dealing with the phenomena of refraction, was formerly called anaclastics.

ANAGLYPH (Fr., *Anaglyphe ;* Ger., *Anaglyph*)

The name given to Du Hauron's stereoscopic pictures. A pair of stereoscopic photographs is taken and half-tone process illustrations prepared from them. The picture belonging to the left eye is printed in one colour — say blue ; and the picture belonging to the right eye is printed in another colour, usually red. The two impressions are superposed, but owing to their stereoscopic dissimilarity they do not exactly register, with the result that a confused effect is produced. To observe the pictures stereoscopically, eyeglasses (*see* " Anaglyphoscope ") are provided. If the left eye phase has been printed in blue and the right-eye phase in red, the eyepiece for the left eye will be red, and that for the right eye will be blue. The eye looking through the red glass will observe only the phase that has been printed in the blue colour, and vice versa. The result is that only one picture or stereoscopic phase reaches each eye and the one rightly belonging to it. Further, as both images appear at the same place, unison takes place in virtue of the laws governing binocular perception, and stereoscopic relief is observed. The fundamental principle of Du Hauron's invention has also been applied to lantern stereoscopic pictures.

ANAGLYPHOSCOPE

An appliance or arrangement for the inspection of anaglyphs, usually made in the form of eyeglasses or spectacles with a red and a green glass, or red and blue. Tinted gelatine and other transparent materials are also used. Perhaps the simplest form consists of a card with two circular openings, at a distance apart equal to that between the average pair of eyes, over which are glued pieces of gelatine of the requisite tints. This is simply held up to the eyes in viewing the anaglyph, which is then seen in stereoscopic relief.

ANALYSER (Fr., *Analyseur ;* Ger., *Analysator, Zerstreuungsprisma*)

A prism of Iceland spar, divided diagonally down its long axis, which receives the extraordinary ray from the Nicol prism (*which see*). The analyser enables the observer to study the phenomena of polarised light. It is usually mounted in a brass cell above the objective, but may be placed above or in the eyepiece. (*See also* " Polariscope " and " Polariser.")

ANALYTICAL PORTRAITURE

The taking of several properly adjusted portraits of different persons upon one plate, or the printing of several different portrait negatives upon one piece of paper ; the result is supposed to give the type of the whole. Better known as " Composite Portraiture " (*which see*).

ANAMORPHOSCOPE (Fr., *Anamorphoscope ;* Ger., *Anamorphoskop*)

A cylindrical convex mirror for reflecting the image of a distorted drawing and restoring it to its proper proportions. Concave or convex mirrors distort images in a singular manner, and produce very interesting effects. Anamorphoses constitute particular objects belonging especially to the class of experiments relating to cylindrical mirrors. They are images made according to determined rules, but so distorted that, regarding them fixedly, only confused strokes can be distinguished. When they are seen reflected in the curved mirrors, they present, on the contrary, a perfectly regular appearance. In other words, an anamorphose is a distorted diagram, the corrected image of which can be seen in the mirror of the convex anamorphoscope. It may be said that distorted copies of photographs suitable for inspection in an anamorphoscope may be prepared in the following manner : Procure an optically worked cylindrical concave mirror large enough to reflect a half-plate photograph. Place the photograph in a horizontal position upon a table, and place the mirror at right angles thereto, keeping it vertical. On looking into the mirror from a given position, a distorted image of the photograph will be seen. This image may now be photographed by placing a camera lens

at the point previously occupied by the eye, a position to be discovered by experiment, and which will, of course, depend upon the curvature of the mirror in use and the focal length of the camera lens. The resultant photograph will bear no apparent resemblance to the original; but if viewed in a convex cylindrical mirror whose curvature corresponds to the curvature of the concave mirror, a true copy of the original photograph, in miniature, will be seen. The order of things may be reversed with equally true results. In taking photographs of this character it is important so to arrange the lighting that the original photograph receives full illumination, while the mirror is well shaded.

A curious effect may be produced by taking a photograph with a plate placed very obliquely to the axis of a lens or pinhole, the latter being preferable. The image is of course terribly distorted, but upon being viewed from a position similar to that occupied by the lens it will appear correct. A portrait painted in this style may be seen in the National Portrait Gallery, London.

ANAPLANATIC

Not aplanatic. The term has been applied (incorrectly) to ordinary rectilinear lenses.

ANASCOPE (Fr., *Anascope*; Ger., *Anaskop*)

A focusing glass or optical arrangement by the aid of which the image on the camera screen is seen right way up instead of being inverted.

ANASTATIC PROCESS (Fr., *La Photographie Anastatique*; Ger., *Anastatisch Druck*)

A method of copying line drawings by placing a sensitive material with its film side in contact with the drawings, and exposing to light through the back of the sensitive paper or plate. This process, originally invented by J. H. Player, has been rediscovered and elaborated by E. E. Fournier d'Albe, who has given it the above name. As in Playertype, it depends on the fact that the light passing through the plate or sensitive paper is reflected back to the film from the white surface of the plan or drawing, whereas the dark lines of the latter reflect hardly any light. If plates are used, the photo-mechanical kind is best. The exposure is about the same as would be required to make a positive transparency from an ordinary negative on the same kind of plate. A quick-acting developer giving contrast is to be preferred, as, for example, hydroquinone with caustic potash, or a 1 in 15 solution of rodinal. The slight fog that occurs in the lines may be removed by a brief immersion in a ferricyanide and "hypo" reducer after fixing and washing, following this by at least half an hour's further washing.

A positive instead of a negative may be produced by soaking an unexposed dry-plate for five minutes in a 10 per cent. solution of potassium bichromate and allowing it to dry, of course in non-actinic light. This is exposed to daylight through the glass side, in contact with the drawing to be copied, and is developed with a dilute rodinal solution. The parts which have received reflected light from the drawing are rendered more insoluble than those parts in contact with

the darker portions, and the latter in consequence alone absorb the developer. It follows that the lines of the original are developed out, while the background remains white or nearly so. The positive is fixed in "hypo" as usual. Copies can also be produced by this process on bromide paper, and there are many other ways in which the process may be applied. It is immaterial if the drawing has printing or other matter on the back. Distinctive points of this process are that no camera or lens is employed, and that the copy is exactly the same size as the original.

Anastatic photography must not be confused with the anastatic lithography process described below.

ANASTATIC PROCESS OF LITHOGRAPHY

A process of lithography by which prints, particularly old ones, may be treated so as to yield a transfer, which may be inked up and printed from. The essential features of the process are that the ink of the print is softened and made transferable by damping the back of the paper with dilute acid; or the print is so treated that the ink can be reinforced by rolling it up with an ink roller without soiling the paper. The usual method, when the print is not too old, is to wet the print with a weak solution of nitric acid in water. It is then placed face downwards on a sheet of polished zinc and passed through the press. Sometimes the plate is flooded with turpentine, and, after allowing it to stand, the surplus is squeegeed off. Then the print is laid down before the turpentine has had time to evaporate. Another procedure is to float the print face upwards on a solution of 1 part of sulphuric acid in 20 parts of water. When damped through, superfluous moisture is removed between blotting-paper, and the print is then left in contact with the plate for some time.

The following is said to be a process employed by a Paris firm, who make a speciality of lithographic facsimiles of old and rare prints. Prepare a bath as follows:—

Sulphuric acid .	. .	3 to 5 parts.
Alcohol .	. .	3 to 5 ,,
Water .	. .	100 ,,

The proportions are varied according to antiquity of the print, thickness of paper, etc. In this solution soak the print from five to fifteen minutes, remove, spread face downwards on glass, and wash thoroughly in a gentle stream of running water. If the paper is heavy, reverse the sides, and let the water flow over the print as well; remove carefully, and place on a heavy sheet of blotting-paper, cover with a similar piece, and press out every drop of water possible. A wringing machine with rubber rollers is most convenient for the purpose. The print, still moist, is laid face upward on a heavy glass plate, or lithographic stone, and smoothed out. With a very soft sponge go over the surface with a thin gum-arabic solution. The print is now ready for inking, which is done with a lithographic roller and lithographic ink thinned with turpentine. The print is then applied to a zinc plate or a lithographic stone, and as many copies as desired "pulled"—that is, printed by the usual lithographic method.

ANASTIGMAT

A lens free from the defect known as astigmatism (see "Astigmatism" and "Lens"). Anastigmatic is the adjective formed from this term.

ANGLE OF FIELD OR OF VIEW

The angle subtended by two lines drawn from the node of emergence of any lens to the corners of the plate in use. As a general rule, when the angle of field of a lens is referred to, the extreme angle which the lens is capable of covering is meant, and it should be clearly stated in all cases whether this angle is measured along the longest side of the plate or diagonally from opposite corners. It will readily be seen that a much wider angle can be included in a circular picture than in a rectangular one if the full diameter of the image circle is taken as the base instead of taking the longest side of the plate. For example, when using a 6-in. lens which will illuminate a 12-in. circle, the extreme angle is 90°, but the largest rectangular picture (say, 9½ in. by 7½ in.) which could be placed within this circle would include an angle of less than 77°. To cover a plate having a base line of 12 in. (12 in. by 10 in.) to the corners, an image circle of 15·6 in. is required, giving an angle of 90° along the longest side of the plate. (See also "View-angles, Table of.")

ANGLOL

An English trade name for eikonogen (which see).

ANGULAR APERTURE

A synonym for focal aperture (which see). It has no relation to the angle embraced by the lens, being a measure of rapidity only. The statement that a lens has a large angular aperture means in simple language that it is very rapid in its action.

ANHYDROUS (Fr., Anhydre; Ger., Wasserfrei)

A term applied to chemicals when deprived of water; literally, not containing water. Anhydrous sodium sulphite is the most widely used anhydrous salt in photography. It is said to keep better in an anhydrous state than when crystallised. The anhydrous salt is double the strength of the crystallised salt, so that 1 part of the former may at any time be replaced in a formula by 2 parts of the latter, or vice versa. Anhydrous chemicals are not so popular in England as in many other countries.

ANILINE (Fr., Aniline; Ger., Anilin)

Synonyms, aniline oil, phenylamine, amidobenzene, amido-benzol. $C_6H_5NH_2$. Molecular weight, 93. Solubilities, insoluble in water, miscible in all proportions with alcohol and ether. It is poisonous, the antidotes being the use of the stomach pump and emetics. Its sole use is in the now obsolete aniline process (which see), and as the starting-point for the manufacture of numerous artificial colouring matters. It should not be confused with aniline, or coal-tar, colours (which see).

ANILINE, OR COAL-TAR, COLOURS

Under this generic name are included all the artificial colouring matters or dyes, some of which are of great interest photographically, either from their sensitising properties or their uses as colour screens or filters. Others, again, are used for tinting prints, transparencies, etc. It would be impossible to give information with regard to all the dyes, but the principal ones are briefly dealt with under their respective names. (See also "Orthochromatism," "Filters," "Colour Sensitisers," etc.)

In process work, aniline dyes are extensively used, especially in three-colour reproduction. They are either applied to the plate by bathing, or by adding to the emulsion as in the collodion emulsion process. For the latter they are also sometimes flowed over the plate before exposure. Attempts have also been made to bathe wet collodion plates, but the process has not come into commercial use. Methyl violet is an aniline dye that is largely used for dyeing the fish-glue image in order to make it visible during development. The dyes are also much used for making colour filters, either by staining gelatine and collodion films and allowing them to dry (dry filters), or as aqueous or alcoholic solutions, which are contained in glass cells and placed in front of or behind the lens.

ANILINE PROCESS

A process patented on November 11, 1864, by W. Willis, of Birmingham, for reproducing, without a negative, drawings made on tracing or other transparent paper. It is cheap, and the results are fairly permanent, but it has never come into general use. Paper is prepared with a solution of potassium (or ammonium) bichromate, 30 grs.; dilute phosphoric acid, 60 minims; water, 1 oz.—the paper being brushed over with the mixture. When dry, a print is obtained by exposure to daylight under the drawing on transparent paper. It is then developed by exposure to the fumes of 1 part of aniline dissolved in 16 parts of benzole, sprinkled upon blotting-paper, and placed in a shallow box, the exposed paper being pinned to the inner side of the lid. When fully developed the picture is washed and placed in water acidulated with 1 per cent. of sulphuric acid and again washed. The finished print is of a bluish-black colour. This process is suitable for copying plans, etc., other methods being the "Blue Print Process," "Ferrigallic Process," etc. etc.

ANIMALCULÆ TANK (Fr., Cuvette des animalcules; Ger., Microskopischer Tierchenbehälter)

A shallow glass-sided tank for use as a slide with the projection microscope and optical lantern, in order to show animalculæ and small water insects on the screen. A good temporary substitute is made by clamping together two strips of glass, with a semicircle or ring of india-rubber between them to form a cell.

ANIMALS, PHOTOGRAPHY OF

This branch of photographic work is one that has received increasing attention as improvements have been made in lenses, plates, apparatus, and special devices. The reflex camera and the telephoto lens, especially, have been effective helps to the natural history photographer. Animal photography may be roughly divided into three

sections : (a) that of domestic animals—the horse, cow, sheep, dog, cat, etc. ; (b) that of wild animals in their natural habitat ; (c) that of wild animals in captivity.

In the case of wild animals in their native haunts, a very limited amount of work may be done with the ordinary apparatus ; still more may be accomplished by the use of telephoto lenses ; while a good deal has been done by special arrangements by means of which animals have been made to photograph themselves, so to speak, by flashlight.

The methods of dealing with domestic animals, and with wild animals in captivity, are practically identical. The work is greatly facilitated by the use of a reflex camera ; a lens of fairly long focus in relation to the plate, and of large aperture ; a rapid plate ; and a shutter working as quietly as possible with high efficiency and capable of good speed. It is advisable to know something of the animal to be dealt with, especially its characteristic poses and movements. The reflex camera enables the worker to keep the animal accurately in focus and in position on the plate, and to make the exposure at the most suitable moment. The use of a large stop makes full exposure possible even at high-shutter speeds, and also bestows the important advantage of being able to keep the background diffused while the animal itself is sharply defined.

Selective focusing and a suitable lighting of the animal itself are important factors in obtaining an impressive result. It must be remembered, however, that even when the background is diffused its character and suitability must be carefully considered. If, for example, it contains many points of bright light, these may be exaggerated into " blobs " that are unsightly and irritating. Another thing to avoid is the use of a short focus lens at close quarters, especially when taking an animal " head on," the result being an exaggeration of the head and a dwarfing of the body. It is generally advisable, particularly in the case of small animals, to hold the camera low down. An effort should be made in the case of wild animals in captivity to keep out of the picture any railings, network, or other evidence of their not being in their natural haunts.

When the camera used focuses to scale, and a reflex camera is not available, failure is minimised by not attempting work at very close quarters, but rendering the animal on a smaller scale and afterwards enlarging the result. The most noticeable drawback to this procedure is that the surroundings and background are rendered too sharply, and so compete in importance with the animal itself. (See also " Birds, Photography of," and " Zoological Photography.")

ANIMATED PHOTOGRAPHY (See " Kinematography.")

ANIMATOGRAPH (See " Kinematograph.")

ANIME (See " Gums and Resins.")

ANOMALOUS DISPERSION (Fr., Dispersion irregulière ; Ger., Abweichende Zerstreuung)

As a rule, light rays of short wave-length are refracted more than those of long wave-length

when passing from one transparent medium to another of different density. With some refracting media, however, this law is departed from to a certain extent. When this occurs it is known as anomalous dispersion.

ANTHION

A trade name for potassium persulphate (which see).

ANTHOTYPE

An obsolete " nature printing " process invented by Sir John Herschel and founded upon the sensitiveness of juices of plants. Chevreul and Hunt also experimented in the same direction. The expressed juices, and alcoholic or watery infusions of certain flowers, more particularly papaver rhœas and corchorus japonica, were spread on paper and printed upon under a negative. Herschel found that the most sensitive colour was the yellow tint of the japonica, and that the blue tincture of the double purple groundsel completely bleached in the sunshine. According to his original instructions, published in 1842, the petals of fresh and well selected flowers are bruised to a pulp in a marble mortar, either alone or with a small quantity of alcohol, and then are squeezed through fine linen. The paper to be treated is moistened at the back with water, by sponging and blotting off, and pinned to a board, moist side downwards. The alcoholic tincture (mixed with a very little water if necessary) is then applied with a brush, in strokes from left to right. Then with a sweeping movement carry the strokes up and down so as to cover the paper completely and leave no spaces. The paper is dried quickly, over a stove or otherwise. Papers so prepared generally require an exposure under a negative of about three or four weeks, and the pictures are not permanent. Herschel found that similar effects could be produced by light on the gums, resins, and residues of essential oils, when thin films were spread on metal plates ; also that a paper coated with an alcoholic solution of guaiacum, and placed in an aqueous solution of chlorine, acquired a beautiful blue colour, and could be used for copying engravings. All images by these processes quickly fade, and are of no value except as curiosities while they last. (See also " Nature Printing.")

ANTHRAKOTYPE (Fr. and Ger., Anthrakotypie)

A dusting-on process, suitable for copying tracings or line drawings, first described by Dr. Sobacchi, and elaborated by Captain G. Pizzighelli. Paper is coated with, say, a 10 per cent. solution of gelatine, and when dry is sensitised in a solution of potassium bichromate of about 5 per cent. strength. After again drying, the paper is exposed under a tracing or other suitable positive until the ground assumes a light brown colour, on which the lines are faintly visible in pale yellow. The print is then soaked in slightly warm water for about two minutes, blotted off, and dusted over with a pigment. The latter may be any finely powdered colour, lampblack being suitable. The pigment adheres to the unexposed parts (that is, the lines of the drawing), which are swelled by the water ; while the portions on which light has acted are ren-

dered insoluble, and take only slight traces of the colour. When dry, any of the pigment adhering to the exposed parts is removed carefully with a damp sponge.

ANTHRAPHOTOSCOPE

An incorrect form of the word " anthrophotoscope " (explained below).

ANTHROPHOTOSCOPE (Fr., *Anthrophotoscope*; Ger., *Anthrophotoskop*)

A kind of photographic peep-show, patented in 1867 by Dr. Isaac Rowell and Francis E. Mills, of San Francisco. Portrait photographs are carefully cut out from their backgrounds and placed in front of substituted backgrounds attached to an inclined plane, diverging upward from the plane of the portrait and intersecting the latter at the feet. By this arrangement the foreground is slightly nearer to the observer than the middle distance, while the distance is still further off, so that when viewed with both eyes through a large magnifying lens of long focus, the illusion of perspective and at least an imitation of stereoscopic relief are obtained. By means of a small toothed wheel the pictures may be arranged into groups at pleasure, and the scenery in the background may also be varied as desired.

ANTI-CURLING FILMS

Rollable or flat films which do not curl during developing and drying. The makers prevent curling by coating the back of the film with gelatine, or other substance, to counteract the curling properties of the gelatine on the sensitive side of the film. Previous to the introduction of the above films, it was customary to soak ordinary films, after developing, fixing, and washing, for a few minutes in a solution of 1 part of glycerine to 40 parts of water, and afterwards to dry. This solution checks curling, but keeps the film slightly moist, and at times leads to stains and fading.

ANTIDOTES (*See* "Poisons and Their Antidotes.")

ANTI-HALATION PLATES

Dry plates coated on the back (plain glass side), or otherwise prepared, to prevent light being reflected to the film when in the camera. Such reflection causes the defect known as halation (*which see*). Dry plates made of green glass instead of white glass are said to prevent halation perfectly (no backing being necessary), but they are not articles of commerce.

The earliest forms of anti-halation plates were made by staining the film. W. E. Debenham, in 1891, used saffron and logwood, but these increased the exposure. Weir Brown advocated dipping plates in ammoniacal erythrosine. A. Haddon suggested a thin coloured substratum, and T. Bolas the coating of ruby glass with emulsion and then stripping the film, also the addition of some neutral salt to the emulsion. Anti-halation plates with a coloured substratum were for a time articles of commerce, but the term now generally refers to plates backed in the ordinary way. (*See also* "Backings, Plate.")

ANTILUMIN

A special paper impregnated with a ruby or orange dye and rendered semi-transparent. It is used for covering dark-room windows and lanterns, to make the light " safe."

ANTIMONY PROCESS (Fr., *Photographie à l'antimoine*; Ger., *Spiessglas-Druck*)

A printing process discovered by Francis Jones, of the Manchester Grammar School, in 1876. When the gas stibine, or antimonietted hydrogen (SbH_3), is passed through a glass tube containing sulphur, in the presence of sunlight, a decomposition takes place, resulting in the formation of the orange antimony sulphide :—

$$2SbH_3 + 6S = Sb_2S_3 + 3H_2S.$$

Stibine / Sulphur / Antimony Sulphide / Sulphuretted Hydrogen

Since no change occurs in the dark, it was found possible to utilise the reaction for photographic purposes. Ordinary writing paper may be treated with a solution of sulphur in carbon disulphide and the solvent allowed to evaporate, the loose grains of sulphur being then gently brushed off the surface with a tuft of cotton-wool. A special printing frame is used, having a tube led into the back, so that the gas may be conveyed into the felt with which this is lined in order to impregnate the paper. A fern, a piece of lace, or other suitable object having been placed in the frame and the paper laid over it, the frame is exposed to sunlight, and connection is made with the gas. A print of an orange red colour is quickly produced, the image consisting of permanent metallic sulphide imbedded in free sulphur. No fixing is required, the gas being simply disconnected when printing is sufficiently advanced. The operation should be carried out in the open air, care being taken not to inhale the fumes, which are poisonous. To obtain the gas, a small quantity of a solution of antimony trichloride (butter of antimony) is added to any hydrogen generating apparatus, as, for example, a Woulff's bottle furnished with a thistle funnel and a delivery tube, and containing dilute sulphuric acid and granulated zinc. The emerging gas then consists of a mixture of antimonietted hydrogen and hydrogen. It is advisable to dry the gas by passing it through a calcium chloride tube before leading it into the printing frame. Although of considerable interest, this process appears to have certain disadvantages, which have hitherto prevented its use by the practical worker, not the least of these being that the silver image of a negative begins to be affected by the sulphur after several impressions have been taken.

In process work, there is an antimony process which consists in blackening a zinc plate with a solution of antimony chloride in order that an image transferred to the plate may show up after the plate has been slightly etched. This allows of an artist working on the plate by stopping-out for re-etching.

ANTIMONY SULPHIDE (Fr., *Sulfure d'antimoine*; Ger., *Schwefelantimon*)

Synonyms, antimonous sulphide, black antimony. Sb_2S_3. Molecular weight, 336. Solubilities, insoluble in water, soluble in hydro-

chloric acid. It is poisonous, the antidotes being the use of the stomach pump and emetics. It takes the form of a greyish black powder or steel-grey metallic masses, occurring native. It is occasionally advised as an admixture with magnesium powder for flashlight work, but its use is not to be recommended as the products of its combustion are poisonous.

ANTIPHOTOGENIC (Fr., *Antiphotogénique ;* Ger., *Antiphotogenisch*)

Opposed to photographic or photo-chemical action ; non-actinic.

ANTIPLANAT, OR ANTIPLANATIC LENS

A lens introduced by Steinheil, of Munich, in 1881, and made in two intensities, $f/3$ for portraits A and $f/6$ for general work B. They differed

A. Steinheil Antiplanat B. Steinheil Antiplanat
F/3 F/6

from most contemporary lenses inasmuch as they were composed of a positive front and a negative back lens. In the more rapid form the antiplanat may be regarded as a triple combination lens, while in the slower one it is a doublex.

ANTIPYR

An American trade name for formaline.

ANTISEPTICS (Fr., *Antiseptiques ;* Ger., *Fäulnisswidrig Mittel*)

Agents used to prevent putrefaction. They find but very limited use in photography. Thymol or phenol is used for gelatine emulsions, and salicylic acid in one or two aqueous solutions which have a tendency to form fungoid growths.

ANTISPECTROSCOPIC (Fr., *Antipectroscopique ;* Ger., *Antispectroskopisch*)

An optical term applied to a lens to signify that it does not split up white light into its constituents. Achromatic (*which see*) has the same meaning.

APERTOMETER (Fr., *Ouverture mètre ;* Ger., *Oeffnungmesser*)

An instrument for measuring the numerical aperture of a lens or objective. Of those forms used in photomicrography, the best was devised by Abbe, consisting of a semicircular glass plate with the various apertures figured on the outer edge. The straight edge of the glass is bevelled to an angle of $45°$, and in the centre of the bevel is a metal disc pierced with a small hole. The lamp must be placed opposite and in line with this hole. The objective to be tested is focused on the metal edge of the hole, the draw-tube is removed, and a low-power objective, which forms part of the apparatus, is screwed into the lower end. The draw-tube with this second

objective is replaced, and the auxiliary lens is focused by means of the draw-tube upon the back of the objective which is being tested, by sliding the draw-tube up and down till the images of two metal pointers on the outer edge of the apertometer are sharply defined. A band of light should be seen across the field, and the pointers are moved till they just reach the edge of the luminous band, where it disappears from the field of view. The readings given by the outer edges of the metal pointers are added together, and the half of the sum gives the numerical aperture.

Cheshire's is an inexpensive and fairly accurate apertometer, consisting of a glass disc with concentric rings on the under surface. The objective is focused on a mark in the centre of the plate, and the eyepiece is then removed. The observer looks down the tube and notes the number of rings which are visible on the back lens of the objective. The value of each ring is c·1 numerical aperture (N.A.), and the total gives the N.A. of the objective.

APERTURE

The diameter of the beam of light admitted by a lens, which may or may not coincide with the diameter of the " stop " or " diaphragm " (*which see*). A lens which can be used with a comparatively large stop, or no stop at all, without showing want of definition or other defects, is said to be " rapid," and to have a " large working aperture." When there is no stop in the lens at all, it is |said to work at " open aperture " or " full aperture."

APHENGESCOPE (Fr., *Mégascope, Aphengescope ;* Ger., *Aphengeskop, Wunderkamera für Undurchsichtige*)

In the aphengescope or opaque lantern, also sometimes called the megascope, the images are projected upon the screen by reflection instead of by transmitting the light through transparencies. The first magic lantern of this nature appears to have been invented by Euler, the mathematician, and was described in his " Letters to a German Princess." In his letter to her of

A. Euler's Aphengescope

January 8, 1762, he gives diagram A, and says that he had the honour of presenting her with one of the lanterns six years previously.

The object to be optically projected was placed in the back of the lantern at B, and opposite it in a sliding tube in the front of the lantern was the projection lens A. It contained two side wings, with lamps and mirrors to illuminate the object. In the " Encyclopædia Metropolitane "

is a plan of this or another lantern by Euler for the projection of opaque objects. Prior to Euler's invention it seems that the rays of the sun were used to illuminate an object the image of which was then thrown upon a screen. Really practical instruments, however, were not constructed until about the year 1839, when Mr. Longbottom used the oxyhydrogen light in

B. Diagram of Single Lantern Aphengescope

conjunction with opaque lanterns, with which he gave exhibitions at the old Polytechnic Institute, London. Twenty years later Mr. Chadburn, of Liverpool, obtained a patent for a lantern of the opaque class, in which he also used oxyhydrogen illumination.

In all aphengescopes great illuminating power is necessary if a large picture upon the screen is desired. Fair results may be secured by using an ordinary optical lantern for the purpose, arranged as shown in B, in which A is the objective lens, L the lantern containing the source of illumination, and B the space in which to place the picture or object to be projected. When very large pictures are needed two lanterns may be

D. Foote's "Polyopticon" Aphengescope

used, as indicated in illustration C. The double source of illumination makes the picture or object B very bright, and the lens A transmits a brilliant image to the screen.

A most ingenious form of aphengescope was invented some years ago by an American, Dr. Foote, of New York, who termed his instrument the "Polyopticon Wonder Camera." Great illumination is secured by the use of a concave mirror M, in illustration D, gathering up all the rays from a lamp at D, and reflecting on to the picture at B; the objective lens is shown at A.

The reflector is pierced for the lamp-chimney, and also for the object glass. The apparatus may be compared to a huge egg, having one end sliced off obliquely, against which opening the picture to be projected is placed. There is no condenser needed, and although the size of the projected picture is necessarily of limited dimen-

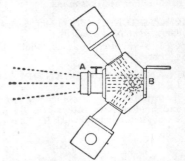

C. Diagram of Double Lantern Aphengescope

sions, it is very popular in the United States for projecting enlarged views of cartes, coloured lithographs, etc., of small size. Illustration E represents a more recent form of aphengescopic attachment. The objective lens is at A, the object or picture to be projected at B, and a mirror at M, the latter serving to divert the rays coming from the illuminant D from a horizontal into a more or less vertical direction. A biunial form of this apparatus is shown in illustration F. Two lanterns are used, and two mirrors M concentrate the light to a common point B, where the picture or object to be projected is situated. Naturally, a much brighter picture is the result, and accordingly a much larger image upon the screen is permissible. The aphengescope suggested by Mon. Trouvé, and introduced by Mon. Molteni, of Paris, was termed "l'Auxanoscope," and the

E. Recent Type of Aphengescope with Adjustable Diverting Mirror

simplest form of this apparatus is provided with a lamp on each side of the objective. The incandescent electric lights are fixed in tubes, the ends of which are provided with reflectors, with a hole in each to allow of the insertion of the conducting wires. In the pattern having three illuminants, two are used as just described; while a third, at the back, is utilised for transmitting light direct when inserting an ordinary transparency in the groove provided.

Devices on the same principle have lately been used for projecting the image of the dial of a watch upon the ceiling so that a person lying in bed may switch on the lamp and see the time.

A practicable form of aphengescope for attachment to optical lanterns is hexagonal in plan, and is made of either wood or metal. At the back are two doors permitting of one object being shown while another is being prepared. At the front are three holes, the central one having a flange to receive a lantern objective of long focus and large diameter, and the side holes being bushed with brass tubing to receive the draw-tubes of two lanterns. The object to be shown is placed in the aphengescope behind the objective.

Modern lighting facilities are responsible for the recent revival in opaque lanterns. Incandescent gas, incandescent electric lamps, and the more powerful electric arc, supply all that is necessary with regard to illumination in order

F. Biunial Form of Aphengescope

to procure brilliancy of image upon the screen. But with improved lighting facilities comes the possible evil of overheating the subject, and consequently damaging the originals. One precaution against this evil suggests itself in the form of an alum tank, interposed between illuminant and subject, which performs the function of absorbing heat rays without unduly interfering with the course of the illuminant rays. Such a device has often been used in conjunction with lanterns when projecting transparencies, especially when the slide is required to remain stationary for any length of time. Moving panoramic pictures for the aphengescope have been suggested, and in this case it may not be necessary to introduce an alum tank or heat absorber; but for lecture purposes, when the picture is fixed for a considerable period, an absorber is a useful adjunct. "Mirroscope" is the name given to a recent form of aphengescope, and it is designed separately for electric, acetylene, and incandescent gas light.

APLANAT

A lens sufficiently well corrected for chromatic and spherical aberrations to define well at a large aperture. The name is now usually applied to lenses of the rapid rectilinear type, although a special lens called a "rapid aplanat" ($f/6.5$) was introduced by Steinheil in 1893. This somewhat resembled the antiplanat of the same maker in having a positive front and negative back lens, but consisted of five glasses.

APLANATIC

Capable of working at full aperture, a term first applied to photographic lenses by Thomas Grubb, of Dublin, who introduced an "aplanatic landscape lens."

APLANATISM

The quality of being aplanatic.

APOCHROMATIC (Fr., *Apochromatique*; Ger., *Apochromatisch*)

A term applied to lenses in which light of more than two colours is brought to a focus. In the ordinary achromatic construction, the green and yellow rays near the D line in the spectrum and the violet-blue rays near G are combined; but in the apochromatic lenses the red rays also come to a focus on the same plane. This quality is invaluable for three-colour work, as images taken through blue, green, and red screens are of equal size.

In process work, apochromatic lenses are specially suitable for use in three-colour reproduction. The term is one specially used by Carl Zeiss to describe lenses for colour reproduction; for example, the "Apochromatic Planar" and "Apochromatic Tessar."

AQUA FORTIS (Latin)

Weak nitric acid. The term was once universally used by chemists for nitric acid, whether dilute or not.

AQUA REGIA (Latin)

So called because it dissolves the noble metals; a mixture of 3 parts of nitric acid and 1 part of hydrochloric acid. It is used for dissolving gold and platinum, as, for example, when making gold chloride, the metals being insoluble in the separate acids. Its solvent action depends upon the fact that it contains free chlorine, liberated by the oxidizing action of nitric acid upon the hydrogen of the hydrochloric acid.

AQUA VITÆ (Latin)

An old name for alcohol (*which see*).

AQUARELL PROCESS

A combination of half-tone and chromolithography for colour printing, practised in Germany. Also known as aquarell facsimile reproduction, aquarell imitation, and aquarell gravure. The last-mentioned is really a combination of colour plates with collotype.

AQUATINT (*See* "Gum-bichromate Process.")

AQUATINT ETCHING PROCESS (Fr., *Aquatinte*; Ger., *Aquatint Manier*)

An old method of forming a ground, or tint, for etching on copper. Resin is dissolved in alcohol, the proportion of the latter determining the firmness or coarseness of the grain, and this solution is poured on the polished copper plate. As the alcohol evaporates the resin reticulates into a granular structure. The plate is slightly etched, and then certain parts are stopped out corresponding to the tones of the picture. Further etchings and stoppings out follow until the complete picture is formed in graduated tones. Usually the plates are printed from by the intaglio method, but the method has also been applied in connection with photo-processes for typographic colour work.

AQUATINT, PHOTO (*See* "Photogravure.")

ARABIC, GUM (*See* "Gums and Resins.")

ARABIN (Fr., *Acide gummic*)

The pure, soluble principle of gum arabic, and existing in different proportions in different samples. In good Soudanese gum the proportion of arabin is between 78 and 80 per cent.; in Turkey gum about 40 per cent. It is used in the arabin gum-bichromate process, under which heading a method of preparing arabin is given.

ARABIN GUM-BICHROMATE PROCESS

A gum-bichromate printing process, worked out by Nelson K. Cherril, and published in June, 1909. To prepare the arabin, a quantity of best Soudan gum arabic is sifted through a 40-mesh sieve. Place in a quart earthenware jar 150 ccs. of water, 7½ ccs. of pure hydrochloric acid, and then sift into the mixture, stirring the while, 100 g. of the powdered gum. Keep the whole at about 120° F. (about 49° C.), and stir frequently until solution is complete. Cool and add 600 ccs. of the best methylated alcohol, free from petroleum, and stir for half an hour or so, or until the arabin is thrown down as a white precipitate and has lost all stickiness or gumminess. Filter through two thicknesses of cheese-cloth, gather the arabin in the cloth into a ball, and squeeze it well, place it in a small jar, cover with new spirit, stirring it and breaking it up well, and leave for several hours until the spirit has absorbed all the water. Squeeze again in cheese cloth, then put the arabin in a towel and squeeze it in a press, with as heavy pressure as possible. Break up the cake formed, to allow the remaining alcohol to evaporate, with gentle heat; then break the remaining lumps in a mortar and dry until all is a dry, gritty powder. The formula in the English system would be roughly as follows :—

Water	5¼ oz.
Hydrochloric acid . .	127 mins.
Powdered gum . .	1540 grs.
Methylated alcohol ▪ .	21 oz.

To prepare synthetic gum, take 20 g. of arabin, 20 g. of heavy magnesium carbonate, and from 40 ccs. to 75 ccs. of water, according to the thickness of the solution preferred for coating. This formula in English is —

Arabin	308 grs.
Magnesium carbonate .	308 „
Water . . .	1½ to 2¼ oz.

When mixed, stir occasionally until the froth subsides, then filter through muslin.

To prepare the pigment, lampblack is used; wash it with repeated doses of mixed ether and acetone until all fatty, gummy matters are removed; or, preferably, burn small pieces of camphor slowly under a piece of porcelain—say the bottom of a porcelain developing dish. Scrape off the soot with a palette knife into a test-tube and wash with mixed ether and acetone until these solvents come away with only slight discoloration. Pour off as much as possible without losing the black, and dry by stirring the test-tube in hot water, keeping the water from the pigment. When dry, the tube is inverted, and the black will fall out freely. A special lampblack, known as No. 4, has been prepared for this particular process. To mix the gum and pigment for coating upon paper, it is necessary to experiment with the particular paper to be used, taking a normal temperature —say 95° F.—for the developing water and a normal time—say forty-five minutes—for development. The mixture must be such as will just soak clean from the paper in the development time. With too little gum the pigment soaks into the paper; with too much, it washes away before development is complete. In practice it is best to make up an under-gummed and an over-gummed ink, and experiment with these will show the proportions for any paper. For instance, Cherril recommends the making of one ink containing gum in the proportion of 20 arabin to 75 water, and the other in the proportion of 20 to 45 of water. If both these are pigmented in the same proportion as to quantity—that is to say, about 400 to 500 mm. of lampblack to each 10 ccs., the one will be found to give too much penetration to Joynson's or Rive's paper, and the other too little; a mixture of the two will be found to give a good result. The mixture is sensitised just before use by an addition of an equal volume of bichromate solution made by adding 15 g. (230 grs.) of ammonium bichromate to 100 ccs. (3½ oz.) of water; dissolve by heat, and neutralise by stirring in a little chalk, decanting when effervescence ceases and the solution settles. The paper to be used is brushed over thinly with the freshly-mixed gum and bichromate, the brush marks being obliterated by crossing and recrossing the strokes. After drying, the paper is ready to be exposed. Exposure should be by actinometer after the manner of carbon, and the paper is much more sensitive than the average gum-bichromate paper prepared by other processes. If the development of a print from an ordinary negative is complete in about forty-five minutes in water at a temperature of 95° F. (35° C.), the result will be perfect. Development may be performed in a vertical tank by floating face downwards on the water, only "controlling" in the usual manner. (For particulars of gum work in general, see "Gumbichromate Process.")

ARAGO, DOMINIQUE FRANÇOIS

An eminent French astronomer and physicist (b. 1786, d. 1853), to whom Daguerre showed and explained his earliest results. Daguerre's discovery was communicated to the Paris Academy of Science by Arago on December 7, 1839, and it was on the latter's recommendation that the French government awarded Daguerre a life pension of 6,000 francs, on condition that he published the process.

ARC LAMPS (Fr., *Lampes à arc*; Ger., *Bogenlampen*)

Lamps in which a powerful light is obtained by passing an electric current through a pair of slightly separated carbon pencils. Where the current is interrupted by the gap an intensely brilliant arc is created. Arc lamps are of two principal kinds : (a) open, in which the carbons are exposed to the air, and (b) enclosed, in which the carbons are almost hermetically sealed in a glass-covered case, and burn in a mixture of carbon monoxide and nitrogen formed by their own combustion. The enclosed type is coming

to be preferred, on account of its increased actinic power, due to its larger arc, the greater proportion of violet rays, and the fact that the life of the carbons is much longer, owing to the practical absence of air, and consequently slower combustion. Some excellent open-type arc lamps are, however, obtainable, in which several pairs of carbons are used ; these obviously yield a more powerful light than the single carbon pattern.

The arc light is employed in studio portraiture, printing, copying, enlarging, and photomicrography, also in the optical lantern and cinematograph.

In studio work the lamp should be supported on an adjustable tripod or bracket, so that it may be raised as high as 8 ft. or 9 ft. or lowered at will. The direct light of the arc is liable to produce hard lighting and heavy shadows ; and it is therefore advisable either to cut this off by a small opaque disc placed in front of the carbons

A. Open Type Arc Lamp, with B. Enclosed
Diffusing Screen, etc. Arc Lamp

and to use only the light obtained from an umbrella reflector or screen at the back of the lamp, or, as an alternative, to use a translucent diffusing screen of muslin or tracing cloth in front of the lamp. Sometimes these two plans are combined. A illustrates the use of a diffusing screen C with the Boardman multi-carbon arc lamp (open type). The metal shield D screening the direct light of the arcs will be noticed, and also the large umbrella reflector E. B shows an extensively-used pattern of enclosed arc (the "Westminster ") designed for general photographic use. For low studios, a reversed model is made, having the arc chamber on top instead of beneath. Whatever kind of lamp is employed, the lens must be shielded from the direct rays by means of a projecting hood.

For printing, the lamp should not be too near the frames, a good average distance being 2 ft. or 3 ft. Various stands are obtainable to support a number of frames in circular tiers, the lamp being suspended in the centre.

In lantern and cinematograph work the open arc at present holds the field, though the enclosed arc is coming into use. Lantern arc lamps are so designed as to economise space, and are fitted to a sliding tray. A model having the carbons at a right angle is claimed to give a better and more direct light, and to take up less room than those types in which the carbons form a very obtuse angle with each other.

In process work, arc lamps play an important part, practically all work being done by electric light, because of its uniformity and the certainty of the exposures as compared with daylight. The "open" arc has been almost entirely superseded by the "enclosed " arc. For copying, a pair of lamps is usually employed taking about 10 amperes, though for large work four lamps may be necessary. The lamps are enclosed with semi-cylindrical reflectors, which are whitewashed inside. For colour work 15 ampere lamps are frequently adopted, and coloured flame carbons utilised to aid the exposure through the colour filters. Red flame carbons, for instance, are found beneficial with the red filter for the blue printing plate. Search lights of high amperage are also employed in some studios for securing very powerful illumination. For printing on the metal, lamps of from 15 to 20 amperes are employed. Arc lamps for process work are usually run in "parallel " ; and a high voltage—200 volts or more—is preferable with enclosed lamps so as to obtain about 140 volts across the arc, by which means a long flaring arc of great actinic power is obtained.

ARCHER, FREDERIC SCOTT

Born at Bishops Stortford, 1813, died in London, May, 1857. He invented the wet collodion process in 1848, and published working details in *The Chemist*, dated March, 1851, his own "Manual of the Collodion Photographic Process " following in 1852. His process practically displaced both the Daguerreotype and Talbotype (calotype) processes, and enjoyed popularity from 1855 to 1880. Many historians have coupled other names with Archer's, either as assistants or co-inventors, but close study of all the facts leads inevitably to the conclusion that Archer deserves the whole of the credit. He introduced pyrogallic acid (then sold at 6s. 8d. per dram) as a developer ; a camera within which plates could be exposed, developed, and fixed ; a triple lens to shorten the focus of a double combination lens ; and a method of whitening collodion positives upon glass (*see* "Alabaster Process "). Archer lived and died a poor man ; and at his death a subscription list was opened and a sum of £747 raised for his widow and children. Mrs. Archer died shortly afterwards (March, 1858) and the amount was settled upon his children, together with a Government pension of £50 per annum. *Punch*, referring to the testimonial, said (June 13, 1857): " To the Sons of the Sun.—The inventor of collodion has died leaving his invention unpatented, to enrich thousands, and his family unportioned to the battle of life. Now, one expects a photographer to be almost as sensitive as the collodion to which Mr. Scott Archer helped him. A deposit of silver is wanted (gold will do), and certain faces

now in the dark chamber will light up wonderfully, with an effect never before equalled in photography. . . . Now, answers must not be negatives."

ARCHEROTYPE, AND ARCHOTYPE

The early names (after Archer, the inventor) of the collodion process.

ARCHITECTURAL PHOTOGRAPHY

In photographing architectural subjects, whether for pictorial or record purposes, regard must be paid to the fact that technical correctness is absolutely essential. Many technical points that can be ignored without any serious disadvantage in landscapes become important in architecture, and disregarding them would involve serious loss of quality. The camera back must be kept upright so as to secure vertical lines in the photograph ; it should be tested with a level or a plumb indicator. The one exception to this rule is that in many old buildings the walls lean outwards, the heavy pressure of the roof, acting for centuries, having forced them into that position. In that case, the camera may be tilted slightly, the back leaning backwards, so as to bring the walls or columns vertical in the photograph. Wide-angle lenses, or those that include a large expanse of view, become a necessity in most architectural work. In exteriors as well as interiors, the space is frequently too limited to allow a distant point of view to be taken, and a lens that will include sufficient of the subject from a very short distance becomes necessary. Although this is by some regarded as a disadvantage, it cannot in every respect be so considered. Photographing a subject from a near point of view possesses one distinct advantage. It conveys the impression of looking upwards in a manner that cannot be attained by any other means ; and this frequently adds impressiveness to the picture. Small portions or details can be effectively taken with a lens that would be suitable for general landscape work, but larger subjects require the shorter focus instrument. The most useful wide-angle lens will have its focus about four-fifths of the longer side of the plate ; and if the worker has a second lens, its focus should be about the same as the longer side of the plate. And the ordinary landscape lens—one and one-third the length of the plate—will be useful for those subjects that provide sufficient space. The lens, whatever may be its focus, should be capable of covering a much larger area than the plate in use. In many subjects the lens has to be raised considerably above the centre of the plate, and, unless the lens will cover when it is so raised, dark empty corners will appear on the negative. Tilting the camera to accommodate a lens of limited covering capacity is very undesirable ; the front and back not being parallel necessitates the use of a very small stop to secure sharp definition.

The camera should be simple and rigid, so that long exposures may be given without any risk of vibration. The rising front should allow the lens to be raised well above the centre ; almost as far as the top edge of the plate is occasionally required. Within reasonable limits, the greater the rise obtainable, and the greater the covering power of the lens, the more useful

and adaptable will be the apparatus for architectural subjects. An anastigmat possesses so many advantages that no other type of lens should be employed.

In all subjects an oblique position rather than a full front view should be chosen. The latter destroys the effect of relief, whereas the former shows it effectively. It is very rare that a full front view of any subject is effective ; the result is almost always flat and lacking in interest, as the projection of one part of a subject beyond another is lost in the picture. A wide-angle lens is frequently valuable in enabling the photographer to select a more oblique position than would otherwise be obtainable.

A liberal proportion of foreground should always be included in front of the nearest important vertical object ; it assists in conveying the impression of space. The normal height of vision—5 ft. from the ground—is the best for all large or high subjects ; it conveys the most natural impression of size. Photographing from a height dwarfs the effect of the building, and should be adopted only for special purposes. At times the camera may be much lower than 5 ft., especially for small subjects taken with a wide-angle lens. (*See* " Interiors, Photographing.")

Symmetry in the arrangement of the subject on the plate should be studiously avoided ; and, equally, an arch, a column, or a doorway that may form an important part of the subject should never be shown almost but not quite completed, broken by the boundary line of the picture. It conveys the sense of incompleteness and absence of support. Sunlight is very effective in some exterior work, especially in comprehensive views of large buildings. In smaller subjects, too, it is frequently a valuable aid to picturesque quality. At times, the sun shining almost along the principal face of the building photographed will produce exceptionally good effect by throwing very long shadows of all projecting details. In many small details, direct sunshine is best avoided in order to show the form and surface of the details free from cast shadows. When photographing in sunshine a full exposure is absolutely necessary in order to secure transparency and full detail in the shadows. (*See also* " Interiors, Photographing " and " Exteriors, Photographing.")

AREA SYSTEM OF STOPS

An obsolete system of marking lenses and stops suggested in 1886 by George Smith. Every stop and every lens had its own number, and the relation of the stop number to the lens number was supposed to indicate the correct exposure.

ARGENTIC SALTS, OPALS, ETC.

Argentic salts are salts of silver ; argentic opals are opals sensitised with silver. *Argentum* is the Latin name, and *Argent* the French name for silver. Sensitised materials of one particular make are called argentic opals, paper, etc., but bromide opals, paper, etc., are more popular names.

ARGENTOMETER (Fr., *Argentomètre, Pèse Nitrate* ; Ger., *Argentometer, Silbermesser*)

This instrument is used by wet collodion

workers for testing the strength of the silver bath. It consists of a hydrometer which is floated in a tall glass jar. The hydrometer is graduated either to show grains per ounce of water, parts in a certain volume of water, or percentages. The first-mentioned is most

Argentometer

commonly employed by English workers, and the second or third by Continental workers. The reading is only accurate in case of a new bath, as by use the bath becomes charged with iodising salts and alcohol from the collodionised plates, but for all practical purposes it forms a sufficient test.

ARGENTOTYPE

A name for bromide paper, and widely used in the early days of the bromide process.

ARISTOGEN

A concentrated one-solution hydroquinone developer, introduced by Liesegang, consisting of hydroquinone, sodium acetate, sodium sulphite, and citric acid, for developing faintly printed-out gelatino-chloride and collodio-chloride papers. According to Schnauss a similar and suitable formula is:—

Hydroquinone (7 % alcoholic
 solution) 4 parts
Sodium acetate (15 % solution) 8 ,,
Water 70 ,,

ARISTOSTIGMAT (*See* "Lens.")

ARISTOTYPE

A gelatino-chloride P.O.P. The original aristotype paper was simply a paper prepared with a substratum of barium, and coated with a collodio-chloride of silver emulsion, and the term was first used early in the 'eighties, Obernetter, of Munich, being the first to introduce it. The name is still used by some makers of P.O.P., both gelatino- and collodio-chloride, especially in America.

AROMATIC CARBON COMPOUNDS

A very large class of chemical compounds which are derivatives of benzene or contain what is known as a closed chain or nucleus similar to benzene. Generally, they contain a larger percentage of carbon than the fatty or aliphatic compounds, and are more frequently crystalline at ordinary temperatures, and more easily converted into substitution products, especially by the action of nitric and sulphuric acids, which produce nitro and sulphonic derivatives. Most of the newer developers belong to this class.

ARROWROOT (Fr., *Arrowroot;* Ger., *Pfeilwurzelmehl*)

A prepared pure starch obtained from various plants, the finest being the West Indian, of which the source is the rhizomes of *Maranta arundinacea*. English arrowroot is the starch obtained from potatoes. Arrowroot is used for sizing papers before sensitising and also as a mountant.

ARTIFICIAL IVORYTYPES

Photographs made in 1857, by Mayall, on a paper substitute prepared by mixing barium sulphate with albumen, and rolling the paste into sheets. These, when dry, were printed upon and used as paper.

ARTIFICIAL LIGHT

Thanks in no small measure to the introduction of rapid plates, and of lenses working at very large apertures, artificial light has become of inestimable service in photography. It is used for lighting the subject, for illuminating the darkroom, and for printing. The actinic power is obviously important, and the following table gives the approximate comparative powers of the illuminants in common use, a standard candle being taken as 1 :—

ACTINIC POWERS OF ARTIFICIAL LIGHTS

Standard candle . . .	1
Colza lamp, ½-in. wick . .	2
Paraffin lamp, ½-in. wick . .	4
,, ,, 1-in. wick . .	10
Paraffin duplex lamp . .	30
2-ft. gas burner . . .	12
5-ft. ,, ,, . . .	35
16-c.p. electric incandescent lamp	35
32-c.p. ,, ,, ,,	70
Welsbach incandescent gas .	80

Sir William Abney gives the following table, showing the photographic value of some artificial lights in terms of the photographic value of a standard candle, the photographic value being taken as the effect on bromide of silver:—

Light of the Optical Value of one Standard Candle	Photographic Value in Terms of Standard Candle
Standard candle . . .	1
Ordinary paraffin candle .	1·3
Oxyhydrogen light, blow-through jet	2
Electric arc light . .	10
Magnesium burnt at the rate of 1 gr. per minute. .	15
Bright sun at noon in summer	21·6

Referring to the above, Sir William Abney says: "It will be noticed how the optical and photographic values differ. It might be thought that, although these differences do exist, yet, by increasing the smaller number, the same effect

might be obtained. It must be recollected, however, that the electric light radiates from 1,000 to 10,000 candles from a very small area, and that, to make the same photographic illumination, the number of candles would have to be the same, but multiplied by 10. Thus, if an electric arc light radiated 1,000 candles, the number of standard candles that would have to be employed would be 10,000, a number which would never be concentrated in any reasonable area. Sunlight may be taken as equal, optically, to 5,600 candles placed at one foot from the object illuminated."

The electric arc and the mercury vapour lamps are the most powerful for photographic purposes, and largely used by professional workers because of their richness in those rays to which dry plates are the most sensitive. The light from incandescent electric lamps is usually of a yellowish tint, serviceable enough for printing, dark-room illumination, etc., but hardly strong enough for portrait work unless used in large numbers. Acetylene gives a very serviceable and intensely actinic light for most photographic purposes. The artificial light that is most generally used for printing, however, is the incandescent gas mantle, which, when of an average quality and full size, gives a light of between 60 and 70 candle power. Magnesium, in the form of either powder or ribbon, is extensively used for portrait work outside the studio at night, its use dating from 1863. Ribbon and powder, weight for weight, give approximately the same illumination ; and one inch of ribbon in contact printing is equal to four minutes' exposure to an ordinary flat flame gas burner at the same distance (*see also* " Flashlight Photography "). In 1882 a lamp was devised for burning magnesium ribbon in oxygen ; a number of improvements followed, and the lamp is now an article of commerce. Ordinary gas burners, oil lamps, and candles give lights that are of poor actinic value. As regards the cost of some illuminants, Leon Gaster, A.M.I.E.E., has given the following table :—

	Cost per 1,000 hours per candle power.
Petroleum	9·08d.
Alcohol incandescent . .	10·03d.
Auer burner, incandescent gas .	3·17d.
Pressure gaslight, incandescent .	2·12d.
Carbon filament lamp . .	14·11d.
Nernst lamp	8·82d.
Arc lamp.	5·18d.
Flame arc lamp . . .	1·06d.

(*See also* " Acetylene," " Flashlight Photography," " Candle Power," " Limelight," " Artificial Light, Portraiture by," etc.)

ARTIFICIAL LIGHT, PHOTOGRAPHY BY

Photography by artificial light presents no serious difficulty if proper precautions are taken, and a correct exposure given. It is imperative that the source of light should be in such a position that no direct rays reach the lens. When it is unavoidable that the source of light is in front of the camera, the lens may have fitted to it a sky-shade or a large temporary hood, so

as to protect it from the light. Whenever possible, the source of light should be behind the camera, not directly at the back, but at one side or the other. Where the arrangement of the light is under the photographer's control, and the light is of such a nature that it can be divided, the larger part should be placed at one side and behind the camera, and the smaller part at the other side. Even where the light is fixed, but divided, as with two or more electric arc lamps, a similar result may be obtained by placing the camera so that one light is almost directly behind it, slightly to one side, and the other one considerably towards the other side. When practicable, the light should be diffused by a screen of tissue paper. This softens the light, and destroys the harshness of the cast shadows, which would otherwise be very strongly marked.

When photographing an interior, or a small object in a building, by electric arc lamps, the strength or actinic value of the light may be tested by means of an actinometer while the camera and subject are being arranged. For a room about 40 ft. by 25 ft. or 30 ft., with the camera and a single arc light of about 2,000 candle power at one end, the exposure should be ten minutes, using a lens aperture of $f/16$ and a plate of a speed of 200 or 250 H. & D. For a small object photographed at a distance of 6 ft. or 7 ft., illuminated by a single arc light of 2,000 candle power at a distance of 10 ft. or 12 ft., the exposure should be five or six minutes for a light-coloured object, up to twelve or fifteen minutes for one of dark colour.

Where arc lamps are not available, magnesium ribbon or powder, or a mixture of magnesium and aluminium, may be employed. The powder is frequently burned in the form of a flash, and though this may be desirable when groups of persons have to be included, the methods in which the powder is burned more slowly are preferable. Magnesium alone produces considerable smoke in burning, and though this smoke is only in evidence after the exposure is completed, it is a serious objection in many cases, and quite prohibits making a second exposure. (*See* " Flashlight Powders.")

A convenient form of artificial light easily obtainable is that sold under the name of " Flash Candle." These candles consist of a celluloid tube filled with a perfectly safe mixture which burns for a few seconds and produces a light of great intensity. They are obtainable in various sizes, called two-second, four-second, and seven-second candles respectively. Two, three, or four of these may be placed in suitable positions for lighting an interior, and they may be lighted in rapid succession by applying a lighted taper to the touch-paper with which each candle is provided. Focusing and arranging must be done before lighting the candles. A room or space about 25 ft. by 16 ft. would be sufficiently illuminated if the camera and lights were at one end and two four-second candles were burned, using a lens aperture of $f/16$ and a plate having a speed of 200 or 250 H. & D. As in the exposures given for electric light, it is assumed that there is a wall near the lights, or an equally well-lighted space beyond. If these candles or an electric light were used to illuminate a small space which formed part of a large room

or open space, in such a manner that there was a large open dark space beyond the light, at least half the illumination would be lost by diffusion.

Still life and flower photography may be carried out very successfully by artificial light, using either magnesium ribbon or the flash candles. One four-second candle at a distance of 3 ft. should be sufficient, using the lens at $f/16$ and a 200 H. & D. plate; a screen of ground glass or tissue paper for diffusing the light is imperative, and a white reflector behind it.

Copying may be done in a similar manner, or by means of the ordinary gas or electric house lighting. Two lights should be used if possible, one placed at each side of the camera, so as to light the work to be copied as evenly as possible; or half the exposure may be made with a single light at one side, and then the light placed at the other side for the remainder of the time. When copying a print with a glossy surface, care must be taken to avoid the sheen that may be produced by an improperly placed light. For copying a photographic print, the same size as the original, using a 50 candle-power gas or electric light placed about 2 ft. from the print, the exposure required for $f/16$ and a plate 200 H. & D. would be about five minutes. For copying a black print on plain white paper—a line engraving, for example—two minutes would be sufficient.

For rapid work by artificial light, *see* under the headings " Flashlight Photography " and " Flashlight Powders." For the application of artificial light in the production of prints, *see* under the headings " Bromide Paper " and " Gaslight Papers and Lantern Slides."

ARTIFICIAL NEGATIVES

Hand-made, and not photographic negatives; known also as factitious negatives. An opaque ground or varnish is spread on glass, and, when dry, is scratched through with a needle point, making a drawing after the style of an etching. The process is also used for making lantern slides (positives) of diagrams, writing, etc. Asphalt varnish to which wax is added until a pliable ground is obtained makes a suitable coating. If the ground is sticky or is not dense enough it may be dusted over and polished with fine blacklead, such as is used by electrotypers. White grounds may also be formed by dusting with *blanc d'argent*. A wet plate may be fogged, developed, and intensified to form a ground; and there are numerous other methods of preparing such plates.

ARTIGUE PROCESS

A modification of the carbon process, named after its inventor, Mons. Artigue. No safe-edge is necessary on the negative, there is no transfer, and consequently the print is not reversed. The paper for this process is supplied coated with a mixture of a colloid substance and a very fine black pigment. It is supplied insensitive, and requires to be sensitised by floating on a 2 per cent. solution of potassium bichromate. A thin negative is most suitable for this process, and the exposure of the print is timed by means of an actinometer as in ordinary carbon printing. An essential

feature of the process is the method of development. A very fine sawdust is supplied by the makers of the paper; this has to be mixed with water to about the consistency of a thick soup. The print is soaked in tepid water for a few minutes, and then laid face upwards on a sheet of glass. The sawdust and water mixture, preferably tepid, is poured over the print from a jug. The print is rinsed from time to time so that the progress of development may be judged, and the pouring of the sawdust mixture is continued until the print is sufficiently light, exactly as the pouring of water in an ordinary carbon print. As soon as development is completed, the print is well rinsed to remove any of the sawdust that may adhere, then placed in a 5 per cent. solution of alum for five minutes, rinsed in two or three changes of water, and dried. The surface of the prints is exceedingly delicate, and very great care has to be exercised throughout to prevent injury. The prints produced by this process are characterised by very great delicacy and rich quality. They have a delicate velvety matt surface, the deepest shadows are a rich black with full detail, and the scale of gradation is good.

The Artigue process has never been extensively worked in England. Suggested reasons are the extreme tenderness and delicacy of the coating, which necessitates great care at all stages, and the difficulty experienced in obtaining the materials. The introduction of the gum-bichromate process has lessened the demand for a paper of the Artigue character, and several attempts to introduce a paper somewhat similar have met with very slight success. It must be conceded, however, that none of the substitutes has equalled Mons. Artigue's production in delicacy of surface, in richness of quality, or in gradation.

ARTISTIC PHOTOGRAPHY

A frequently used but somewhat vague term. The idea underlying it is that the producer of a given picture has aimed at something more than a merely realistic rendering of the subject, and has attempted to convey a personal impression. Thus, a landscape may be rendered solely as a topographical view or as the material for conveying the idea of, for example, solitude; an interior may be intended to show architectural detail or to suggest, for example, grandeur The results are consequently either realistic or artistic. The artistic element becomes more pronounced the more the merely mechanical and thoughtless is subordinated to the deliberate and intentional control of the producer.

ARTOGRAPH

An automatic machine, known also as the electric artograph and telautograph, for sending sketches or line drawings along a telegraph wire, invented about 1891 by N. S. Amstutz, of Cleveland, Ohio. According to a description published at the time, the picture was photographed on a " stripping film " of gelatine and potassium bichromate, which, after washing with luke-warm water to remove the portions not hardened by the action of the light, gave a picture in relief, more or less high, according to the tones of the original. The next step was to vary the strength

of current in the telegraph wire according to the variations of light and shade in the picture—that is to say, according to the heights and depths of the etched film. This was done by an arrangement similar to the stylus which moves over the indentations on the wax surface of the phonograph. The point of the stylus passed over every part of the film, and tripped up and down according to the degree of relief. By a multiplying lever its movements up and down were caused to depress a series of keys which completed the electric circuit. If the relief was very low only one key was depressed, and more keys were closed in proportion to the depth of the relief. The current was thus varied in strength according to the degree of relief on the film. At the receiving end the current passed through an electromagnet, which bore with more or less force on a travelling graver, according to the strength of the current, and the design was cut in a surface of wax, from which an electrotype could be obtained for printing purposes. The results published at the time of the introduction of the system were crude.

ARTOTYPE

A name give to an early collotype process in which the plate was given two separate coatings of bichromated gelatine instead of, as at present, one.

ASKAU PIGMENT PRINTING PROCESS (Fr., *Procédé Askau* ; Ger., *Askau-Druck*)

A dusting-on process introduced in Germany by Joseph Rieder, in 1909, in which pure india-rubber (caoutchouc), with a small proportion of asphalt added, is used as the sensitising material. Paper coated with the mixture will keep for a month. It is exposed under a positive transparency, as in other dusting-on processes, and is "developed" with a mixture of sea-sand and a suitable powdered pigment, the latter adhering to the light-affected parts according to the exposure each portion has received. A lac varnish is then sprayed over the print by means of an air brush to fix the pigment.

ASPHALT

The chief of the many synonyms for asphaltum (*which see*).

ASPHALT PROCESS

A process of using asphaltum for photo-etching. (*See* "Asphaltum.")

ASPHALTO-PHOTO-LITHOGRAPHIC PROCESS (Fr., *La Photolithographie au Bitume* ; Ger., *Asphalt-Photolithographie*)

An adaptation of the bitumen process of Joseph Nicéphore Niepce. A lithographic stone is coated with a solution of bitumen in ether, or other suitable solvent, and is exposed to light under a negative. The light-affected parts are rendered insoluble, and the unexposed portions may then be dissolved away by the application of ether. After rinsing and allowing to dry, the stone is wetted with gum water, which is applied with a sponge. When dry, the surface gum is washed off with a slightly-damp cloth and the stone is lightly etched with a very weak solution of nitric acid. It is then rinsed to remove the

acid, again gummed, and, when dry, wiped with the damp cloth, after which it is ready for printing from in the ordinary lithographic manner, wetting the stone at each impression. The same process can be employed with zinc or aluminium plates. (*See also* "Photo-lithography.")

ASPHALTOTYPE

A name given to one of the processes for using light sensitive asphalt for making typographic printing blocks. (*See also* "Asphaltum.")

ASPHALTUM (Fr., *Asphalte, Bitume de Judée* ; Ger., *Asphalt, Judenpech*)

Synonyms, asphalt, bitumen, bitumen of Judea, mineral pitch, and Jew's pitch. A natural product of the decomposition of vegetable substances.

The term asphaltum comes from the Greek word for fossil pitch, ἡ ἄσφαλτος (and σφαλλομαι) and signifies an unchangeable body. The Latin word bitumen is derived from *pix tumens*. Geologically, asphalt is, as stated above, a natural product of the decomposition of vegetable substances ; and it is found in all parts of the world, most frequently in volcanic neighbourhoods. The principal sources are on the shores of the Dead Sea in Syria (whence comes the name Syrian asphaltum), and in the Great Pitch Lake of the Island of Trinidad ; but it is also found in the Lake of Maracaibo (in Venezuela), at Coxitambo (in Peru), at Barbadoes, and in the island of Cuba ; whilst in Europe there are deposits at Seyssel and at Bechelbronn (in Alsace). Small deposits have been found in Cornwall, Derbyshire, and Shropshire. For photographic processes, however, only the Syrian and the Trinidad asphalt are considered, these having the characteristic properties of asphaltum—namely, brownish-black colour, high melting point, and conchoidal fracture. Bitumen has usually been considered to be formed by the oxidation of petroleum, and according to the generally accepted analysis is composed of carbon, hydrogen and oxygen, with a small quantity of nitrogen, together with sulphur and mineral substances (iron, manganese and calcium). Syrian asphalt comes into the market in large pieces, which frequently contain small lumps of earthy substances consisting of carbonate of lime, gypsum, clay, and sand. Trinidad asphalt also comes into commerce in large pieces, which, however, do not contain the earthy particles found in the Syrian. The commercial asphalt can be purified by boiling in water, when the pure asphalt melts and floats upon the surface while the impurities subside. The Syrian asphalt begins to melt at 275° F. (135° C.), and the Trinidad at 266° F. (130° C.). The specific gravity of the former is 1·103, and of the latter 1·96 ; both kinds behave the same in relation to solvents. They are partly soluble in alcohol and ether, more so in benzole, completely and easily soluble in chloroform, bisulphide of carbon, tetrachloride of carbon, turpentine and the various mineral oils. They are insoluble in solutions of caustic potash or soda, weak or strong, hot or cold. With concentrated sulphuric acid the Syrian asphaltum is decomposed, but only by the heat, with evolution of sulphurous acid, and it dissolves into a dirty

brown fluid. Concentrated nitric acid has but very little action on it, even with heat.

The results of analysis show that the Syrian and Trinidad varieties are similar in composition. Each is found to contain 10 per cent. of sulphur, and this constitutes an important factor in regard to photographic sensitiveness. By successive treatment with boiling alcohol, boiling ether and chloroform, it is found that both kinds may be separated into three components, differing in their chemical composition and photographic properties. The portion (*a*) insoluble in ether shows the highest sensitiveness, (*b*) the substance soluble in ether is less sensitive, and (*c*) an oily substance extracted by alcohol is quite insensitive. The part that is insoluble in ether is, as a rule, easily soluble in chloroform and turpentine, and less so in benzole and petroleum. Syrian asphaltum contains 52 per cent. of the sensitive component, while Trinidad contains only 38 per cent.

Spectroscopically examined, solutions of Syrian asphaltum of the most sensitive kinds show weak absorption bands, whilst the less sensitive kinds show the bands more strongly.

As obtained from dealers, asphaltum is generally fit to be used at once ; but, if necessary, it may be purified by powdering it and digesting it with dilute hydrochloric acid, which dissolves the earthy particles. Some authorities recommend a treatment with boiling water, by which soluble and earthy particles may be separated out. In order to obtain the most rapid results, it is desirable to extract the least sensitive constituent of the asphaltum with ether, and use the residue in making the sensitive solution. The simplest way of doing this is to digest the powdered asphaltum in a bottle with an excess of ether, shaking it up from time to time, and, if necessary, stirring it with a glass or wooden rod. The ether is changed at intervals of a few hours, till all or nearly all the soluble constituents are removed. The last ether is then poured off, and the residue thoroughly dried. Husnik's asphaltum, which is believed to be prepared in some such way, is obtainable as an article of commerce in the dry powder form. The solvent used for making up the sensitive solution is generally benzole, which should be quite free from water. Sometimes chloroform is added, and generally some essential oil, such as lavender or lemon, which prevents the too rapid drying of the coating, and so keeps it uniform ; the addition of oil is said to increase sensitiveness.

The following is a practical formula for preparing a sensitive solution of asphaltum for coating zinc plates for etching : Dissolve 150 grs. of finest powdered Syrian asphaltum in 2 oz. of chloroform and 3 oz. of anhydrous benzole. Add 30 grs. of Venice turpentine and 10 drops of oil of lemon or oil of lavender. The film should be of a transparent golden yellow tint. The coating should be done by means of a whirler (*which see*). The exposure is best made under stripped films, which may be treated with a bath of glycerine to make them adhere when squeegeed down to the plates. It is not necessary to use a printing frame. The exposure may vary from half an hour in the sun to two or three hours in the shade. In bad weather the exposure may extend to days. Development is usually done with turpentine, which dissolves the soluble parts of the image. The scum is rinsed away, and the greasiness removed from the surface with soap and water or a weak solution of soda.

Prof. Valenta has published a process for augmenting the sensitiveness of bitumen by incorporating sulphur with it. By this process, 100 g. (3½ oz. 11 grs.) of raw Syrian asphalt are boiled in a retort with an equal quantity of raw pseudo-cumene—which has the formula $C_3H_3(CH_3)_3$, and a boiling point of about 170° C.—and 12 g. (186 grs.) of flowers of sulphur which should have been previously dissolved in the pseudo-cumene. When after about three or four hours' boiling, the evolution of sulphuretted hydrogen has ceased, the pseudo-cumene is distilled off and the black pitchy residue dissolved in benzole in the proportion of 4 to 100, which solution is used for the sensitive coating of the plate or stone. The sulphurised asphalt prepared in this way is almost insoluble in ether, but dissolves fairly readily in benzole, toluene, xylene, cumene, and turpentine, and is very sensitive to light. Recently Prof. Valenta has simplified his method by dissolving the asphaltum in carbon disulphide and adding sulphur chloride.

A number of processes mostly used for photolithography take advantage of the fact that when bitumen is dissolved in both alcohol and ether in suitable proportions it will split up into a grain on drying. The film can then be printed under an ordinary continuous tone negative and yield a picture in half-tones. The Frey process is a successful method worked on this basis.

Bitumen processes are not much employed nowadays, owing to the slowness and uncertainty of the exposures. Bitumen powder is, however, largely used for dusting on plates to strengthen the resist for etching, and the solution is used as a resist varnish for the backs and margins of plates, and for stopping out.

Alberini's reversed bitumen process consists in removing the exposed bitumen from the metal plate instead of the unexposed bitumen as in the ordinary process. This makes it possible to expose the bitumenised zinc plate under an engraving, print, or inked drawing on thin paper, dispensing with the use of a negative. The preparation of the plate and exposure follow on the lines of the ordinary process, but development is effected by immersing the plate in a dish of 40 per cent. alcohol. The principle of the process is that the alcohol dissolves the part which has been acted on by light, and not the unexposed part, which is usually developed with turpentine.

ASPIRATOR

An instrument used to promote the flow of gas or liquid from one vessel to another by suction. In its simplest form it is a cylindrical glass or other vessel having a pipe to admit air at the top and a stop-cock at the lower end. A shows a simple form of aspirator bottle. As a container for solutions which must be kept in bulk free from air, it is shown at B. The large bottle C contains, say, a hydroquinone-metol developer and has two glass tubes, one of which F reaches to the bottom ; F passes through a rubber stopper and is continued down below the shelf, having a piece of rubber tubing with a

clip and a piece of drawn-out tube at the end. The other tube E just pierces the rubber stopper, and is connected with a small bottle D containing about 50 grs. of pyro dissolved in 2 oz. of a 10 per cent. solution of caustic soda. The tube from the large bottle just pierces the rubber stopper in the smaller one, while a third tube G goes to the bottom, its other end being open to the air. This tube should be high enough to prevent the pyro-soda mixture being forced out of the bottle. To use the arrangement, unclip the rubber at the end of the tube F and blow through G. This forces the developer up and down the tube F and so creates a siphon, it being then only necessary to unclip the tube to obtain developer from the large bottle down the tube. The solution in the small bottle filters the air from both carbonic acid and oxygen, and the developer keeps good indefinitely. If

ASTIGMATION

An old and practically obsolete synonym of astigmatism.

ASTIGMATISM

A serious defect in many lenses by which they are prevented from rendering vertical and horizontal lines with equal degrees of sharpness. It is more noticeable towards the edges of the field, the centre being quite free from it. The defect is best explained by a diagram. If, using a lens defective in this way, a clearly defined cross is focused in the centre of the field, it will go evenly out of focus on moving the screen to and fro, the edges being uniformly blurred as at A. Upon focussing the same cross near the margin of the plate, the vertical or horizontal line only will be blurred, the other becoming sharper as the screen moves to one side or the other of the

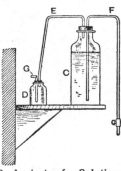

A. Aspirator Bottle

B. Aspirator for Solutions to be kept from Contact with Air

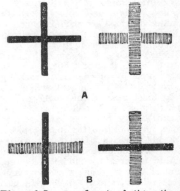

Blurred Images due to Astigmatism

the depth of the liquid in the small bottle exceeds 3 inches, the tube F should be at least 6 inches below the shelf.

ASPRAY-FISHER ANIMATED STEREO-GRAMS (Fr., *Méthode Aspray-Fisher de la Stéréoscopie Animée*; Ger., *Aspray-Fisher Lebendige-Stereographie*)

An invention patented in 1859 by C. Aspray and R. Fisher. The two halves of a pair or series of stereoscopic pictures are so taken as to be views of the same person or object in slightly different positions. By rapidly opening and closing each eyepiece in turn with a revolving disc, so that either eye is alternately eclipsed, the illusion of motion combined with stereoscopic relief is obtained. This is the earliest recorded attempt to combine apparent movement with the effect of natural relief and modelling.

ASTIGMATIC CORRECTOR

A negative attachment for removing the astigmatism of portrait lenses. It was invented by T. R. Dallmeyer in 1897. Although highly successful in producing a perfectly flat and non-astigmatic field, the corrector was never placed upon the market, as it was found necessary to grind special glasses for each individual lens. The focal length of the portrait lens was increased by from 30 to 40 per cent. with, of course, a corresponding decrease in rapidity.

focal plane of the image, as at B. In like manner, a circle is drawn out into an ellipse either horizontally or vertically, as the case may be. Astigmatism may be minimised by the employment of a small aperture, but cannot be entirely removed. It is usually found in portrait and rectilinear lenses, and may be partly cured by shortening the tube; this, however, has the disadvantage of increasing the curvature of field.

ASTRO - PHOTOGRAPHY. (See " Stars, Photographing," " Celestial Photography," " Comets, Photographing," etc.)

ASTROPHOTOMETRY

The use of the photographic plate for astrophotometry is not unattended with disadvantages, for whilst the correction of the instruments may be good it is impossible to bring all the rays to an accurate focus, and they are grouped in rings around the actual image of the star. As the brightness of the star increases, or the exposure is prolonged, the image not only becomes denser, but also widens; therefore it has been suggested to estimate the magnitude of the star both by the density and the increase in diameter, or either. Unfortunately, the law breaks down that increase of the exposure is equivalent to the increasing of actinic luminosity, but it has been found to apply to stars down to the eleventh

magnitude. When the diameter of the star image is used, an allowance has to be made for the duration of exposure, and this has to be determined for every plate and instrument, but may then be taken as constant. When the density of the image alone is used, Pickering and Schwarzschild independently suggested that the out-of-focus images should be photographed when they no longer appreciably differ in size but do in density. One of the chief difficulties to which attention has only been recently directed is the effect of the different colours of the stars, for obviously a blue star and a red star photographed on an ordinary plate and then on a panchromatic or red-sensitive plate would present totally different images, not only as regards size, but density.

ATMOGRAPHY

The name given to the curious effects on sensitive plates and papers caused by emanations and vapours from sugar, eggs, smoke, and other substances, sometimes referred to as effluviography and vapography.

ATMOMETER (Fr., *Atmomètre ;* Ger., *Dunstmesser*)

An instrument for measuring the quantity of water passing into the air by evaporation in a given time.

ATMOSPHERE, RENDERING

In the pictorial sense the word atmosphere is generally used to indicate a certain amount of visible vapour or mist in the air. The presence of mist is frequently a valuable aid to picture making, often imparting a suggestion of delicacy and mystery to subjects that are less satisfactory when the air is clear and the light bright. The rendering of subjects under these conditions is not always easy. The exposure must be carefully timed, and development must be so adjusted as to secure a negative of soft and delicate gradation. The use of a colour screen, or light filter, is generally a disadvantage, as it has a tendency in certain conditions to make the veiled distance clearer and brighter than it appears. The best result is obtained with a full exposure on an ordinary plate, followed by development carried only far enough to secure detail and gradation without blocking up the lighter tones. A delicate grey print in bromide or platinum is frequently the best presentment of the effect.

ATMOSPHERIC ACTION

The atmosphere is a mixture of oxygen and nitrogen containing always more or less carbonic acid and aqueous vapour. In the neighbourhood of cities there is also more or less smoke and traces of sulphur compounds, and occasionally ammonia. All developing agents when exposed, either in the solid state or in solution, to the air greedily absorb oxygen, and they discolour and become less active, the oxidation products not being developers. Silver in a finely divided state, as it occurs both in negatives and prints, is extremely liable to be attacked by any sulphur compounds, particularly when gelatine is the vehicle, as this readily absorbs aqueous vapour and thus brings the deleterious sulphur compounds into more intimate contact with the silver of the image.

ATOMIC WEIGHTS (Fr., *Poids atomiques ;* Ger., *Atomgewichte*)

A term relating to the number of atoms forming a molecule of any element, according to the atomic theory. On the atomic weights are based the molecular or equivalent weights, and a list of these is given in a table to be found under the heading " Solubilities."

ATZPINSEL (Ger.)

A round, mop-shaped brush (*see* illustration) of soft hair, generally marten fur, bound to a wooden handle by means of waxed string varnished with shellac. It is used for brushing

Atzpinsel

the surface of the metal plate in etching, to free the image from scum. It is also occasionally employed in etching on copper with iron perchloride when the plate etches slowly and there appears to be a deposit in the hollows.

AURAMINE (Fr., *Auramine ;* Ger., *Auramin*)

Synonyms, auramine yellow, amidotetramethyl diamido-diphenylmethane hydrochloride. Solubilities, soluble in water, alcohol, and ether. A sulphur-yellow-coloured aniline dye which is sometimes used for making light filters or yellow screens. It is unsatisfactory in this respect, as it passes the bright blue, the extreme end of the violet, and ultra-violet, absorbing only the deep blue.

AURANTIA (Fr., *Aurantia ;* Ger., *Aurantia, Kaisergelb*)

Solubilities, slightly soluble in water, very soluble in alcohol. An orange-coloured aniline dye used for making light filters. Much superior filters can be made with other yellow dyes— that is, filters that do not absorb so much red and orange as those made with aurantia.

AUREOLINE (*See* " Primuline Yellow.")

AURIC CHLORIDE (*See* " Gold Chloride.")

AURIN (Fr. and Ger., *Aurin*)

Solubilities, insoluble in water, soluble in alcohol. A mixture of aurin, methyl-aurin, and corallin aniline dyes occurring in yellowish brown lumps with greenish fracture. It is occasionally used for making coloured spirituous backing.

AURORA YELLOW

A fine yellow pigment used both as a water colour and as an oil colour. It is cadmium sulphide CdS, prepared by passing sulphuretted hydrogen SH through a solution of cadmium chloride CdCl$_2$, the precipitate being washed with hot water and dried. A final treatment

with carbon disulphide CS_2 is desirable, as this removes free sulphur.

AUROTYPE (Fr. and Ger., *Aurotypie*)

A printing process made known in 1844 by Robert Hunt, in which gold chloride was used in conjunction with potassium ferricyanide and ferrocyanide. Hunt published other printing processes in which salts of gold were employed.

AUROUS CHLORIDE (*See* "Gold Chloride.")

AUTOCHROM, OR AUTOCHROM PRINTING

A combination of typographic and lithographic printing used for cheap colour work, such as coloured postcards. The keyplate is a half-tone typographic block, and the colours are filled in with tint plates printed lithographically.

AUTOCHROME PROCESS

A process of screen-plate colour photography invented by MM. Lumière [Eng. Pat. 22,077, 1904; 25,718, 1904; 9100, 1906], based on the use of starch grains, as far as possible of a uniform size, dyed to the necessary colours, red, green and blue violet, mixed and sifted on to glass coated with a tacky surface. The grains are then rolled and any white interspaces filled with a black pigment. The screen-plate thus formed is coated with a panchromatic emulsion. (*See* "Screen-plate Processes.")

The plate is placed in the dark-slide so that the glass side faces the lens, and a black, smooth card should be placed in contact with the sensitive emulsion to prevent any damage to the latter. A yellow screen must be used to cut down the excessive action of the blue violet and blue, and the makers provide special screens for this purpose, though the following, suggested by Von Hübl, has proved satisfactory in practice :—

A. Tartrazine . . 15½ grs. 1 g.
 Distilled water . 17½ oz. 500 ccs.
B. Phenosaffranine . 1·5 grs. 0·1 g.
 Distilled water . 24½ oz. 900 ccs.
C. Gelatine . . 93 grs. 6 g.
 Distilled water . 3 oz. 85 ccs.

640 minims or 38 ccs. of C should be mixed with 168 minims or 10 ccs. each of A and B. Immediately before use, 6·2 grs. or 0·4 g. of æsculine dissolved in 338 minims or 20 ccs. of water with 3 or 4 drops of ammonia should be added to the dyed gelatine ; it is important to make the æsculine solution only just before use, as it rapidly discolours. Of this dyed gelatine, 140 minims or 7 ccs. should be coated on every 16 sq. in. or every 100 qcm. The exposure must be determined by meter, or the speed of the plate may be taken as approximately 2 H. & D. or 3 Watkins, but, unfortunately, the speed varies practically both in sunlight and shade, and in winter and summer, this variation being dependent on the spectral composition of the light.

After exposure the plate should be developed, and the developer first recommended was pyroammonia, but a later recommendation is the following :—

Quinomet (metoquinone) 62 grs. 4 g.
Sodium sulphite (anhydrous) 278 ,, 18 ,,
Liquor ammoniæ (·880) 4 mins. 0·2 ccs.
Potassium bromide . 15½ grs. 1 g.
Distilled water to . 35 oz. 1,000 ccs.

The duration of development should be 2½ minutes at a temperature of 60° F. (15·5° C.). Many other developers may be used, such as a normal metol-quinol developer or rodinal 1 in 12 for six minutes, amidol, rytol, etc.

As the emulsion is very sensitive to red, the plates must be worked in total darkness or in a deep green light such as is obtained through the following filter, and even then the plate should be exposed to this light as little as possible :—

New Bordeau R 3 %
 solution . . 2½ oz. 125 ccs.
Tartrazine 4 % solu-
 tion . . . 3 ,, 150 ,,
Light green S 5 %
 solution . . 3½ ,, 175 ,,
Glycerine . . 1 ,, 50 ,,
Gelatine 10 % solu-
 tion to . . 20 ,, 1,000 ,,

2 oz. or 56 ccs. should be coated on every 100 sq. in. or 645 qcm. Or, in place of the above, fixed-out dry plates may be dyed in tartrazine and methyl violet to form a red screen, which should be placed in contact with one stained with malachite green, and if a brilliant light is used a sheet of tissue paper, stained with tartrazine or malachite green, should be placed between them.

At the conclusion of development the plate should be rinsed for fifteen to twenty seconds, and then immersed in the following reversing bath :—

Potassium permanganate 31 grs. 2 g.
Sulphuric acid . . 170 mins. 10 ccs.
Distilled water to . 35 oz. 1,000 ,,

The plate should remain in this for two or three minutes and then be examined by a weak white light, and if all the metallic silver has disappeared it should be washed for about a minute. It is advisable to keep the above reversing solution in two separate solutions and mix as required.

After dissolving out the primary image of silver and washing, the plate should be exposed, emulsion side up, to white light and then redeveloped, which may be done by the following amidol developer :—

Sodium sulphite (anhydrous) 135 grs. 15 g.
Amidol . . . 45 ,, 5 ,,
Distilled water to . 20 oz. 1,000 ccs.

The original developer, metol-quinol, rodinal etc., may also be used. When the second development has completely reduced the silver bromide, and the picture now shows up in colour, the plate is washed for three or four minutes and, without fixing, set to dry. If the plate is seen to lack brilliancy (due to over exposure) it may be intensified with the following, first immersing for not more than ten seconds in 192 minims of the permanganate solution given above, diluted with 20 oz. of water :—

A. Pyro	.	.	26 grs.	3 g.
Citric acid	.	.	26 ,,	3 ,,
Distilled water to			20 oz.	1,000 ccs.
B. Silver nitrate	.		39 grs.	2·5 g.
Distilled water	.		3½ oz.	100 ccs.

For use mix 50 minims or 11 ccs. of B with 1 fluid oz. or 100 ccs. of A, and immediately apply to the plate and allow to act for three or four minutes, then rinse for a minute or two and clear in the following :—

| Potassium permanganate 8½ grs. | 1 g. |
| Distilled water . 20 oz. | 1,000 ccs. |

for about one minute, and wash. The plate can then be fixed in—

" Hypo "	.	.	3 oz.	150 g.
Sodium bisulphite lye	1	,,	50 ccs.	
Water to	.	.	20 ,,	1,000 ,,

for two minutes and washed and dried by a gentle heat. When dry it should be varnished with—

Gum dammar	.	.	31 grs.	20 g.
Copal	.	.	77 ,,	50 ,,
Carbon tetrachloride to	3½ oz.	1,000 ccs.		

or

| Gum dammar | . | . | 1 oz. | 20 g. |
| Benzole | . | . | 5 ,, | 100 ccs. |

When properly treated, and with correct selection of the subject, particularly if glaring contrasts of colours are avoided, very exquisite results can be obtained.

Autochromes have been successfully reproduced by the three-colour and four-colour block processes by illuminating the transparency with reflected light and copying through colour filters, the same as in copying from a painting or other coloured original. The frontispiece to this volume is an example of four-colour reproduction.

AUTOCHROMEDIASCOPE

A reservoir viewing instrument for autochrome and other screen-plate pictures. The transparency is viewed, not directly, but reflected

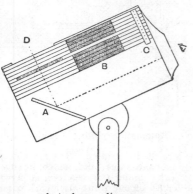

Autochromediascope

in a mirror as at A. The plates are held in grooves B, and any given one may be brought from the grooves (by means of levers C) to the open position D, and so receive illumination from the sky. A ground-glass screen is placed over the opening at the top, in order to diffuse the light. The viewing box is mounted on a rotating head, by which it can be tilted to any convenient angle.

AUTOCOPYIST

A simplified process of collotype, in which the glass plates for bearing the printing image are replaced by parchment paper, which is coated with gelatine, immersed in bichromate solution, dried, and exposed under a negative, after which it is washed, stretched over a bed-plate, inked up and printed from in the usual collotype way. The printing is done by means of an ordinary letter-copying press, or similar means.

AUTOGLYPHIC PROCESS

A method invented by Duncan C. Dallas, by which a drawing was made on a metal plate by means of a heated pen and a wax composition. The plate could be printed from without etching.

AUTOGRAPHY

A process of lithographic printing simplified for the reproduction of writing in facsimile. The writing is done on a hard, smooth-surfaced writing-paper with transfer ink, and then transferred to stone or zinc in a press. In some processes the paper was damped on the back with water ; in others with acid, and in one process blotting paper soaked in turpentine was applied to the back of the sheet. The process has also been applied to type-written sheets, and to crayon drawings on grained paper.

AUTOGRAVURE

A photo-mechanical process modified from the well-known photogravure process, the resist image being formed by a special carbon tissue manufactured by the company that works the system.

Autogravure is also the name of a process worked by a firm in Vienna for reproducing paintings. Negatives are made for yellow, red, blue, and grey printings. Positives are made from the first three, and from these half-tone negatives are made. These are printed on to stone, zinc, or aluminium for lithographic printing. Further printings are added if necessary from the same negatives in other shades of ink. From the fourth negative an embossing plate is made to give relief to the picture.

AUTOMATIC PHOTOGRAPHY (Fr., *La Photographie Automatique* ; Ger., *Automatische Photographie*)

A term frequently applied loosely, and referring strictly only to apparatus that carries out the entire operation of making a finished photograph. To this class belongs the automatic machine exhibited by M. Enjalbert at the Paris Exhibition of 1889. Full directions to the sitter were shown in turn at the proper times on the face of the machine, which was started by dropping a specified number of coins into a cash-box. The duration of the exposure was indicated by the ringing and cessation of a bell, and a finished ferrotype portrait was delivered in about five minutes. Apart from the liability to get out of order, the great drawback to apparatus of this

description is that it cannot make allowance for the sitter's possible inattention to instructions, or for variations in light or temperature. Partly automatic machines, with an attendant or operator, have in consequence enjoyed greater popularity. The illustration shows a typical so-called automatic camera of the kind used by itinerant photographers and at exhibitions

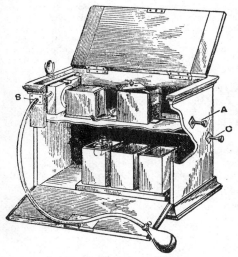

Automatic Ferrotype Camera

The box in the centre of the upper shelf is filled with forty ferrotype plates in sheaths, which may be inserted in daylight, a heavy lid being then placed on top to keep them flat. On drawing out and returning the rod A, which is attached to a plunger, the bottom plate is pushed into a horizontal holder. By turning a milled head at the side, the plate is raised into position for exposure at the back of the small fixed-focus camera shown to the left. Having ascertained that the sitter is correctly placed by inspecting the image in the finder—the small concave lens seen at the top—the exposure is made by pressing the bulb, this being connected to a rubber tube passing to the shutter through B. Any exposure may be given according to the length of time the pressure is continued on the bulb. By means of another small rod in the side the exposed plate is allowed to drop into a wire cradle, controlled by the knob C. The cradle is raised or lowered by turning the knob, while on the attached rod are marked distances to indicate how far it must be drawn out to bring the cradle over each trough in turn. Having allowed the plate to remain in the developer a stated time, the knob is turned to raise the cradle and the rod is pulled out to the distance marked for the fixing bath, in which the cradle is left till the plate is fixed. The knob is then again turned and the cradle transferred in a similar manner to the third or washing tank; after which the panel in the front can be let down to examine and remove the plate. With a little practice the apparatus is very easily manipulated, a finished positive being obtained in about one minute.

Another branch of automatic photography—or, rather, automatic exposure—is that in which a photograph is obtained by the action, although without the concurrence, of the subject, as when securing pictures of wild beasts in the jungle, or in taking a flashlight portrait of a burglar. The latter undertaking is quite feasible, and various arrangements have been patented for the purpose, in which, for example, the unwelcome visitor is supposed to make an electric connection by stepping on a mat or opening a window, thus rendering a platinum wire red-hot and firing a charge of magnesium flash-powder, while at the same time actuating the exposure shutter of a camera. The one thing against the idea is the fact that the modern burglar would undoubtedly prevent the survival of the record by smashing the camera to pieces. The automatic photography of animals, birds, and reptiles in their natural surroundings is, however, an accomplished fact, and some admirable results have been obtained. The exposure—or, at night, the simultaneous exposure and ignition of flash-powder—is usually arranged by causing the animal or other subject to disturb an electrically connected cord, or to make a contact by treading on a prepared stone, branch, or twig.

AUTOMATIC PRINTING (Fr., *Impression automatique*; Ger., *Automatisch Druck*)

As early as 1860, Fontayne, of Cincinnati, employed an automatic printing apparatus, by which 200 exposures per minute were possible upon a band of sensitive paper, a large condensing lens being used to concentrate sunlight on the negative. Of later date is a very ingenious clockwork printing machine, patented in 1885 by J. Urie, of Glasgow; its internal arrangement

Automatic Printing Machine

is shown in the illustration. The bromide paper is used in a continuous band, which, having once been adjusted under the negative, is moved on by the length of one print after each exposure. The light is furnished by a gas burner, and is automatically lowered when the paper travels; while a flat dish containing water is interposed between the burner and the negative, to prevent the overheating of the latter. The correct exposure having first been ascertained, the

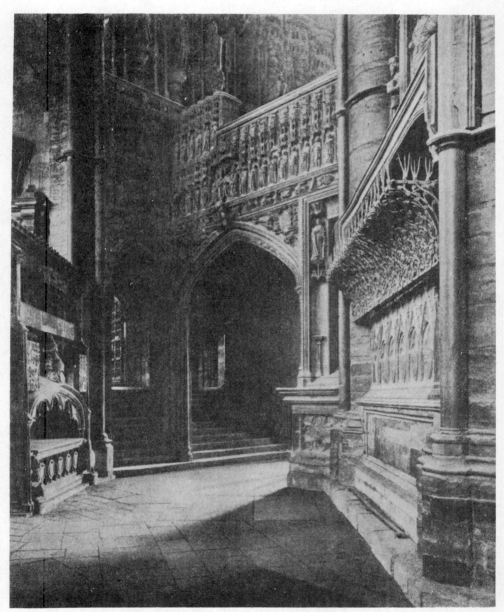

IN WESTMINSTER ABBEY BY HENRY W. BENNETT, F.R.P.S.

ARCHITECTURAL PHOTOGRAPHY (INTERIOR)

2

machine may be regulated to repeat it indefinitely as long as it will run, and may be left to itself. Large automatic printing machines, power-driven and electrically illuminated, have of recent years been adopted for the production in quantities of bromide prints, pictorial postcards, etc. Automatic printing machines of a special description are also employed in making the positive film from the negative one for the kinematograph.

AUTOTYPE (*See* "Carbon Process.")

AUTOTYPOGRAPHY (Fr., *Autotypographie ;* Ger., *Autotypiegraphie*)

A term sometimes used for relief printing blocks. It has been particularly applied to a process for the making of prints from the leaves of plants and flowers.

A process called by this name was invented by George Wallis, in 1859 and 1860, by which drawings made upon gelatine could be transferred to metal plates, and afterwards used for printing from in the same way as an ordinary copper plate.

AUX DEUX CRAYONS

A style of stained print once popular in America. The print is immersed in a solution of alcohol 3 oz., powdered aloes ¼ oz., until stained, or toned, a lemon colour, is then well washed, and placed in 3 oz. of water to which have been added 4 drops of liquor ammoniæ. It remains there until of a warm orange colour, and is then washed, dried, and mounted. The high lights are touched up with Chinese white and the blacks with Indian ink, and the whole is finally coated with a solution of plain collodion 1½ oz., castor oil 4 drops. The process is now obsolete, but for a time was a craze in the United States, where carefully made and artistic examples commanded good prices.

AUXILIARY EXPOSURE

A method used in the early days of photography in connection with slow plates to assist exposure. Before or after the proper exposure was made, extra exposures were given on coloured papers or through coloured glasses, as it was thought that by so doing more detail was obtained. In process work even to-day a piece of white paper is often placed for a few seconds in front of a photograph while it is being copied ; while in France it is the custom with some expert operators with modern dry plates to expose for a second or so upon a piece of white paper before photographing dark interiors. It is doubtful if such auxiliary exposures are of any real use in these days of extra rapid plates, and there is always the risk of fogging. Auxiliary ex posures have also been advocated for papers, particularly when harsh negatives are used, for the purpose of getting flatter, actually fogged, prints. When photographing gloomy interiors, the daylight is utilised as far as possible, and sometimes an auxiliary exposure with magnesium is given for the shadows.

AUXOMETER (Fr., *Auxomètre ;* Ger., *Auxometer*)

An instrument for ascertaining the magnifying power of a lens or optical system.

AXIAL ACCOMMODATION OF THE EYE

In binocular vision, the converging or diverging of the axes of the eyes as required so that they meet where the object of attention is situated. The axis here referred to is the imaginary line drawn through the centre of the eye from the pupillary centre to the retina. In ordinary vision, the axes meet at the point where the object of immediate attention happens to be situated, and as the attention is turned from one object to another, the two eyes move by muscular control, simultaneously, so that whatever may be the position and distance of objects looked at, the axes converge or diverge as the case may require, bringing the attention of both eyes to a common point. When the object looked at is remotely placed, the eyes look almost parallel with each other ; but if the object is only a few feet distant from the observer, a conspicuous convergence of the axes is noticeable. The constant change in the direction of the eyes' axes is known as axial accommodation, and without this double images would be seen and confusion of perception result. The term is sometimes applied to the adjustment of optical centres in binocular instruments, such, for instance, as the adjustment of twin lenses in a stereoscopic camera, binocular microscope, and so on. (*See* "Stereoscopic Photography.")

AZALINE (Fr. and Ger., *Azalin*)

A mixture of chinoline red and cyanine, introduced as a red sensitiser by H. W. Vogel, the use of which has been superseded by the newer isocyanines.

AZOL (Fr. and Ger., *Azol*)

A trade name for a concentrated one-solution developer whose action resembles that of rodinal. For plates and films 20 minims of azol are added to 1 oz. of water. For over-exposure 10 drops more of azol per 1 oz. of water are added, but for under-exposure the original quantity required is only 15 drops per 1 oz. For bromide papers the proportion is 15 drops of azol per 1 oz. of water, adding a few drops of a 10 per cent. solution of potassium bromide if the whites are not pure. Gaslight papers need 40 drops of azol per 1 oz. of water and potassium bromide as required ; while for lantern slides the developer should be : Azol, 25 drops ; bromide (10 per cent.), 5 drops ; water to 1 oz.

AZOTATE

A term derived from the French and meaning nitrate.

AZOTE

A French term for nitrogen.

AZOTIC ACID

An Anglicised form of the French term for nitric acid.

B

BACK FOCUS

A term used to denote the distance between the back surface of a lens and the sensitive plate. It bears no fixed relation to the true focal length of the lens, and the old opticians inserted it in their catalogues only as a guide to the camera extension necessary. Many of the early cameras were sliding boxes, and would not close up enough to accommodate all lenses.

BACKGROUND (Fr., *Fond*; Ger., *Hintergrund*)

A term commonly applied to the painted sheets or screens used in studio portraiture; but actually the scenery, or anything else, whether

these. It is a common fact that many portraits are spoilt by ugly and unsuitable backgrounds, but it is possible to take out these and print-in more suitable ones.

The printing-in of backgrounds is easier with print-out papers than with development papers, such as bromide and carbon, where the progress of printing cannot be seen. The simplest method is first to block out the background on the original negative with an opaque mixture, going carefully round the outline of the figure with a finely-pointed camel-hair pencil charged with the pigment, which may be red water-colour. The broad expanse of background may be gone over with the pigment on the film side of the negative;

A. Roller Background hung on Brackets

C. Background Cords passed through Staple

B. Background with Roller at Bottom

natural or artificial, behind the sitter or object. Studio backgrounds are of many kinds, to suit different purposes and tastes; as, for example, vignette, full-length, interior, exterior, plain, graduated, and cloud backgrounds. They are usually painted in oil or distemper on canvas or stout paper, and are either attached to rollers or stretched tightly on a wooden frame having supporting feet. Backgrounds on rollers may be hung on brackets like blinds, as shown at A, with or without a spring roller, a pulley and cord being provided for raising and lowering. In another system B the background is fastened at the top to a horizontal lath, and is made to roll up or down from the bottom by cords passing through staples C, or over pulleys, on the same principle as theatre curtains are made to work.

BACKGROUNDS, PRINTING-IN

The art of using two or more negatives to form one print has been widely practised for many years. It is sometimes referred to as double printing and as combination printing, but the former term is generally understood to mean the printing-in of clouds (*which see*), and the latter term (fully described under a separate heading) the art of combining in one picture pieces taken from a number of others. The printing-in of backgrounds differs from both of

or Brunswick black, or red or black paper, may be used on the glass side. It matters not how it is done so long as the background is covered up. In the illustrations, A represents a sitter against a brick wall which, being quite unsuitable, it is desired to take out. The blocked-out negative is printed in the usual way, and will give the result indicated at B—that is, the figure will have no background whatever. The print must not be toned or fixed yet. The selected background must next be printed in. To do this, carefully paint over the entire figure in print B, by gas or lamp-light, with red water-colour paint C, well covering the image and carefully following the outline. When quite dry place the print in contact with a suitable background negative and print in the usual way. The image will be printed upon the hitherto blank paper only, and the figure will be unaffected owing to the protection given by the red pigment (*see* D). Washing the print in water removes the paint and gives the result shown at F; this should be toned and fixed. Other prints may, of course, be made in the same way, but if a number is required it will save time to copy F in the camera and so obtain a new negative. If a good water-colour is used, the portrait image will not be injured in any way. If the work has been carefully done, no joins will be apparent. Any slight

overlapping may be touched out on the finished print.

Another method of printing-in backgrounds is first to block out the background, as in the previous case, so as to obtain result B. Print two of these. From one the figure is carefully cut out with scissors and laid face downwards on the background negative. (A print from it would

which cause halation. Plates may be obtained ready backed, many of the commercial backings being secret preparations and of excellent quality. Backings are of many kinds, more or less difficult to prepare, apply to, and remove from, the plate.

Liquid Backings.—Any red or black mixture will serve for ordinary plates, the latter being the

A. Print with Undesirable Background

B. Print with Background Blocked Out

C. Figure Painted Over with Water-colour

resemble E, but this is not the result required.) The second print B is now laid on the prepared background negative in such a way that the printed figure is covered by the cut-out figure. The background is then printed in to give the result shown at F. A variation of the process is to print in the reverse way—that is, to make a print from the background negative (with the cut-out figure attached), so as to obtain a print like E, and to use this over the original negative with the background blocked out, so as to print in the figure B. Either method gives result F.

Both of the chief methods here described

more suitable for isochromatic or colour-sensitive plates. Such homely mixtures as red and black currant jam and shoe blacking have been advocated at various times, but there is no need to use such uncertain materials. Brunswick black is good for the purpose, but somewhat slow in drying. A quick-drying backing is a thin solution of bitumen in benzene, and this may be left upon the plate until after the negative is developed, fixed and dried, being then removed by the aid of benzene. As a general rule, backings should be removed before developing, because otherwise it is difficult to judge the

D. New Background printed-in ; Figure Painted Over

E. Print from Background Negative, with Figure Blocked Out

F. Final Result. The Old Figure with the New Background

demand great care, and the first has the disadvantage that some little difficulty is experienced in getting the two separate printings to the same depth. By any of these methods, it is difficult to avoid false lighting of the figure.

BACKINGS, PLATE

A backing is a coating upon the plain (glass) side of a dry plate in order to prevent reflections

progress of development and the density of the image. One of the commercial backings dissolves in the developer without affecting the working. Perhaps the best of the home-made backings is :—

Crystal caramel powder	. .	1 oz.
Water	1 ,,
Methylated spirit .	. .	$\frac{1}{2}$,,

The ingredients need to be mixed well together. Another formula is :—

Caramel	1	oz.
Powdered burnt sienna .		.	.	1		,,
Office gum	1	,,

For isochromatic plates lampblack should be used instead of the sienna. J. S. Teape recommends the following :—

Caramel	1½	oz.
Saturated solution of gum traga-						
canth	1	oz.
Powdered burnt sienna .		.	.	2		,,
Methylated spirit	.	.	.	2		,,

The spirit is added after the ingredients have been well mixed. The above are liquid backings, which are in optical contact with the glass.

Instead of caramel, it is possible to use various dyes and pigments, such as sienna, lampblack, etc. The following are typical formulæ :—

1. Powdered burnt sienna.		.	½	oz.
Powdered gum arabic .		.	½	,,
Glycerine	.	.	1	,,
Water .	.	.	5	,,

2. Essence of cloves	.	.	6	parts
Turpentine .	.	.	7	,,
Lampblack .	.	.	q.s.	

to form a paste that may easily be distributed on the back of the dry plate.

3. Methylated spirit .	.	.	10	oz.	
Soap	200 grs.	
Erythrosin .	.	.	1	drm.	
Aurin	1	,,

Scrape the soap, and allow it to digest in the spirit for a week, shaking at intervals ; filter, and add the dyes. This gives a good yellow backing solution, which dries at once.

Paper Backings.—Backing sheets or papers are not so effective as liquid backings. Red or black paper is cut to size, one side smeared with glycerine, and pressed into close contact with the glass side of the plate. Special backing pads, which

A. Plates Clipped Together for Backing

are preferable to the above, may be made by coating strong paper with the following mixture :—

Gelatine	1	oz.
Water	2	,,
Glycerine	1	,,
Indian ink, sufficient to colour.						

Dissolve by heating, and apply when warm to pieces of stout paper or calico, which require to be squeegeed on to the backs of the plates, and may be used over and over again if smeared occasionally with glycerine.

B. Plate-holder for Use in Backing

Comparisons.—The following table shows the effectiveness of the various backings, the test subject being severe :—

		Halation.
Unbacked plate	. . .	Very bad.
Plate backed with—		
Caramel and water	. .	Very slight.
Bitumen .	. .	Very slight.
Sienna and water	. .	Very slight.
Black paper and water	.	Bad.
Black paper and glycerine	.	Not so bad.
Shoe blacking	. .	Slight.
Red and black currant jam	.	Slight.
Canada balsam and lampblack	.	Nil.
Caramel and sienna	.	Nil.

Films and lantern-slide plates are sometimes backed, but they do not show halation so badly as dry plates, and therefore the simplest backing will serve, if needed at all. (*See also* " Halation.")

Applying Backings.—The work of backing plates must be done in the dark-room, and varies somewhat with the nature of the material used. It is not absolutely necessary to wait until the backing is dry, although it is desirable to do so ; but if a plate is used with the backing still wet it should be covered with paper, preferably the oiled kind in which sensitive paper is sometimes wrapped. The backing must be applied evenly

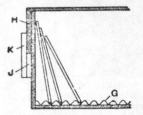

C. Light-tight Drying Box

and not in streaks, and should cover every part of the plain glass side of the plate. The simplest method for small plates is carefully to put two plates film to film, and to clip them together at both ends as at A. The backing may then be applied by means of cotton wool or soft flannel (brushing causes streaks), and the plates then

hung up or laid aside to dry. In this way, and with ordinary care, the backing mixture is kept from the films.

For very messy backings the worker may prefer to use a holder as at B. In the centre of a piece of flat wood D, stout enough to prevent warping, is glued a piece of black velvet or other soft-surfaced material of the size of the dry plate. A piece of millboard or of thin wood E, of the same thickness as the dry plate and the same size as D, to which it is hinged, has at its centre a space F of the size of the plate, so that when the flap E is placed over the base D the velvet is seen through the hole. The plate is placed film side downwards upon the velvet, and E is brought into position over D, the back of the plate coming through F. The backing is spread over the plate, any superfluity going on to the card. The flap is then lifted up, and the plate removed.

When using slow-drying backings, a dark box is convenient, and this can be made with a strong cardboard box 1 in. deeper than the longest side of the plates to be coated; the corners and joints should be covered inside with black paper so as to make the box light-tight. Place corrugated paper G or strips of cardboard along the bottom, as in illustration C, to prevent the plates from slipping. The first plate leans against the end of the box and supports the next one, a piece of red or black paper being interposed. The lid is made light-tight in the following manner: Under the edge of the lid H glue a strip J, and on J glue another strip K, covering over the edge of the lid of the box by an inch or more. When the lid is put on, the box will be quite light-tight, because of the light trap formed by J and K.

In process work, it is found that backing the plate gives greater freedom from grain between the lines or dots, and is quite worth the extra trouble. A good backing for this purpose is Lichtenstein's caramel with a little water and lampblack added.

BAG (*See* "Camera Bag," "Changing Bag," etc.)

BAIN-MARIE (Fr.)

A hot-water bath which in its simplest form is that of a jar in a saucepan of water, the gelatine, etc., to be dissolved or melted, being

Simple Type of Bain-marie or Water Bath

placed in the jar. The ordinary gluepot is an example of a bain-marie. The French cook has a utensil of the same style and name. A water bath of this kind (*see* illustration) is used by photo-lithographers for coating transfer paper.

BALAGNY'S DEVELOPER

An early form of pyro-ammonium carbonate developer for dry plates. The formula is :—

A. Ammon. carbonate	.	1¾ oz.	64·5 g.
Water	. . .	35 ,,	1,000 ccs.
B. Pyrogallic acid .	. 1 ,,		28·4 ,,
Ammon. bromide 90 to 180 grs.			5·8 to 11·6 g.
Alcohol	. . .	18 oz.	500 ccs.

For use, mix 6 oz. of A with 1 to 2 drms. of B. Under-exposed plates are soaked first in A alone, and then in the mixture of the two.

More recently, Balagny has advocated an acid mixture of amidol. (*See* "Amidol.")

BALANCE IN COMPOSITION (*See* "Composition, Pictorial.")

BALANCES (Fr., *Balances*; Ger., *Wagen*)

Weighing instruments. A high degree of

A. Scales

sensitiveness is not required in the photographer's balances; neither need the instruments be expensive. A pair of scales A, or a spring balance with pan to weigh up to about 4 oz. or ½ lb.,

B. Pharmacist's Balance

and a smaller balance B, of the kind used by pharmacists, will suffice for most photographic purposes. Glass pans, preferably removable, are best, as it is easier to keep them clean. A good balance should possess stability and

sensibility—that is, it should not oscillate long when the two pans are equalised, while a very trifling addition on either side should at once disturb the equilibrium.

BALLOON PHOTOGRAPHY (See " Aerial Photography.")

BALSAM (See " Canada Balsam.")

BALSAMO'S PROCESS (Fr., Procédé Balsamo; Ger., Balsamo's Prozess)

A printing process discovered by Prof. J. G. Balsamo, of Lucca, in 1861. Phosphorus is digested for a considerable time in hydrochloric acid at the ordinary temperature, or, to hasten matters, at a temperature of about 120° to 140° F. (about 49° to 60° C.). The solution improves by keeping. When saturated with phosphorus, the acid is diluted with copper acetate until the liquid assumes an olive green colour. Paper is immersed in this solution in a flat dish for three or four minutes, taking care that it is thoroughly impregnated, and is then thoroughly dried. The paper, which is very hygroscopic, is now exposed behind a negative, with a piece of blotting-paper at the back to absorb any moisture that may be disengaged, until the parts acted upon by the light become of a greyish colour, due to the production of copper binoxide. After removal from the frame, the print is exposed for about five minutes to the vapour of sulphuretted hydrogen, which converts the copper binoxide into copper sulphide. The print is next washed to remove the superfluous copper salts, and is then toned in a dilute solution of bismuth nitrate acidified with a little nitric acid, by which means bismuth is substituted for copper, thus rendering the print permanent.

BARIUM BROMIDE (Fr., Bromure de baryum; Ger., Baryumbromid)

$BaBr_2\ 2H_2O$. Molecular weight, 333. Solubilities $1\frac{1}{3}$ in 1 water, soluble in benzole. All barium salts are poisonous, and the antidotes are sodium or magnesium sulphates followed by emetics and the use of the stomach pump. Barium bromide is in the form of colourless crystals, which are prepared by dissolving barium carbonate in hydrobromic acid, evaporating and crystallising the solution. It is occasionally used in collodion.

BARIUM CHLORIDE (Fr., Chlorure de baryum; Ger., Baryumchlorid)

$BaCl_2\ 2H_2O$. Molecular weight, 244. Solubilities, 1 in 2·5 water, insoluble in alcohol. Poisonous (see " Barium Bromide "). It takes the form of colourless flat-sided crystals, which are prepared from barium carbonate and hydrochloric acid. It is occasionally used in emulsion making, but chiefly in the preparation of barium sulphate.

BARIUM IODIDE (Fr., Iodure de baryum; Ger., Iodbaryum)

$BaI_2\ 2H_2O$. Molecular weight, 427. Solubilities, 1 in 0·5 water, 1 in 20 alcohol. It is poisonous; for the antidote, see under heading " Barium Bromide." It is in the form of colourless crystals, obtained by decomposing

ferric iodide with barium hydroxide. It is readily decomposed on exposure to the air, giving off free iodine. Occasionally it is used in making collodion emulsion.

BARIUM MONOXIDE, OR BARYTA (Fr., Monoxyde de baryum; Ger., Baryum-monoxyd)

BaO. Molecular weight, 153. A grey, porous mass, fusing at a high temperature. It is prepared by decomposing barium nitrate by heat, and is (or was) used in Brin's process for the manufacture of oxygen—the method employed in extracting the oxygen for compression into cylinders as used by lanternists.

BARIUM NITRATE (Fr., Azotate de baryum; Ger., Baryumnitrat)

$Ba(NO_3)_2$. Molecular weight, 261. Solubilities, 1 in 12 water, insoluble in alcohol. It is poisonous; for the antidotes, see under heading " Barium Bromide." It is occasionally used as an admixture in magnesium flashlight powder and for making barium monoxide.

BARIUM PEROXIDE (Fr., Bioxyde de baryum; Ger., Baryumperoxyd)

Synonyms, barium dioxide or superoxide. BaO_2. Molecular weight, 169. Solubilities, insoluble in water, soluble in dilute acids with decomposition. A heavy, greyish-white powder, obtained by heating barium nitrate. It has been suggested for dissolving the silver image so as to obtain reversal, its action being due to the formation of nascent oxygen. It also occurs in a hydrated form, $Ba(OH)_2\ 8H_2O$, having the molecular weight, 315, and being slightly soluble in water.

BARIUM SACCHARATE (Fr., Sucrate de baryum; Ger., Zuckerbaryt)

Soluble in water. It is poisonous; for the antidotes, see under heading " Barium Bromide." It occurs in white crystals, but a solution was suggested by Mathet as a substitute for the alkalis in developers. Excess of barium hydrate is shaken for several days with a 10 per cent. solution of sugar and then filtered; but it has found no practical use.

BARIUM SULPHATE (Fr., Sulfate de baryum; Ger., Schwefelsaures baryt, Schwerspat)

Synonyms, barytes, synthetic barytes, blanc fixé, permanent white, baryta white, mountain snow. $BaSO_4$. Molecular weight, 233. Solubilities, insoluble in water and alcohol. It is a heavy, white, impalpable powder, occurring naturally or prepared by adding sulphuric acid or a soluble sulphate to a soluble barium salt. It is used to prepare baryta paper (which see), the very commonly used paper for silver printing processes.

BAROMETER, PHOTOGRAPHIC

Photographic prints that act as weather indicators; known also as weather-glass prints. Certain coloured photographs will alter with the varying atmospheric conditions, owing to the fact that cobalt chloride ($CoCl_2$) has been used in preparing them, this salt being blue when anhydrous (perfectly dry) and pink when

damp. Cobalt solutions may be used as sympathetic inks, the writing being almost invisible until warmed before a fire and all moisture driven out, when it becomes blue. A finished but unmounted bromide print is soaked for ten minutes in a 5 per cent. solution of formaline, and then is washed and dried. The cobalt solution is made as follows :—

Gelatine	.	.	$\frac{1}{4}$ oz.	68 g.
Glycerine	.	.	I ,,	250 ccs.
Cobalt chloride	.	. 40 grs.	23 g.	
Water	.	.	. 4 oz.	1,000 ccs.

The gelatine (ordinary cooking gelatine will serve) is soaked in the water until swollen, and is then melted by gentle heat ; then the glycerine is added and next the cobalt chloride. The warm solution is brushed over the bromide print that has been previously treated with the formaline. The print is drained, dried, and hung up unframed or in an unglazed frame. The print is of a pinkish colour in wet weather, blue in dry and fine weather, and of a lilac or lavender colour in changeable weather.

BARYTA (*See* " Barium Monoxide.")

BARYTA PAPER (Fr., *Papier baryté;* Ger. *Barytpapier, Kreidepapier*)

Good raw paper stock coated with an insoluble emulsion of baryta in gelatine and used principally for coating paper intended to take a gelatino-chloride emulsion. A good baryta paper must be coated with three films, the first two serving to prevent the emulsion from coming into contact with the paper and the third giving the particular surface and tint desired. Both glazed and matt surfaces, tinted red, blue or violet, or white, can be obtained. It is also used in surfacing paper for collotype and Woodburytype.

Its preparation requires costly machinery. The baryta is either precipitated by the paper coater, or bought in the form of powder and mixed in a kneading machine with one-third its weight of water till a perfectly uniform cream is obtained, which is carefully sifted, divided into two equal parts, and thoroughly mixed with gelatine solution. To one part of the baryta emulsion is slowly added, with constant stirring, a solution of chrome alum, which causes the emulsion to become ropy, and at the moment of this appearance the other half of the baryta emulsion is added. The mixture is again passed through sieves, some glycerine added, and then coated on the paper. The first coating is so adjusted that there is about 12 to 15 g. of dry baryta to every square meter (17 to 21 grs. per square foot). The emulsion is picked up by the paper, which is coated in long rolls, by passing through a trough, or it is wiped on by a roller, and it then passes over a rubber-coated cylinder ; evenness of coating is obtained by seven brushes with reciprocating motion, the first being hard and the others gradually increasing in softness until the seventh is of the very finest and softest badger hair, about 2 in. long. The paper is then hung in festoons to dry, rolled up, and given the second coating in precisely the same way. Sometimes it is then calendered, but usually again coated by the same machine with another baryta emulsion containing glycerine and chrome alum, and more or less gelatine, according to the surface desired. To this emulsion is also added the colouring matter—Paris blue, ammoniacal carmine solution, etc., being used. After drying, the paper is passed through calendering machines, which are provided with heavy steel rollers, which may, or may not, be heated, and exert a pressure of about 10,000 lb. The paper is sprayed with water before passing through the calender rolls, and the surfaces of the latter are highly polished, roughened, or grained respectively, so as to impart a special surface to the baryta film.

The commercial baryta paper is usually obtainable in rolls of about 600 metres in length, and is graded according to surface—matt, glossy, rough or grained—and according to the weight in grammes per square meter.

BASEBOARD (Fr., *Base ;* Ger., *Bodenbrett*)

The board serving as the foundation of any apparatus, particularly of a camera. Except in studio and process cameras, it is generally hinged to the body, in order to fold up ; and it is provided with a bush to take the screw attaching the camera to the tripod stand, or with a circular turntable, which can be fitted on the legs of the latter. The stability of the baseboard is a vital consideration for serious work, especially that of a scientific or technical nature, and for such the studio pattern of camera is preferable, where it may be used.

BASKETT'S REDUCER

A mechanical abrading reducer for negatives and lantern slides, introduced by Robert Baskett in 1901 ; known also as the Globe polish reducer. The formula is :—

Terebene 2 oz.
Salad oil 2 ,,
Globe metal polish	.	. One 2d. tin.		

The terebene is sold at oil and colour shops as a paint drier at about eightpence per pint ; the refined spirit, costing about one shilling per ounce, is not required. The ingredients are well mixed together and strained once or twice through fine muslin into a bottle. When required for use, shake up the mixture, put a few drops on a piece of cotton wool or chamois leather, and rub gently and evenly over the parts of the negative (which must be perfectly dry) to be reduced. Rub with a circular motion and not too hard, as it is easy to rub a hole in the film. When the surface reduction has proceeded far enough and the surplus grease has been wiped off with a piece of clean cotton wool, a final rubbing with a pad slightly moistened with benzene will give a polished and nearly waterproof surface that is with difficulty distinguished from the glass side of the negative. Alcohol will also clean off the superfluous reducer. The reducer is particularly suitable for local reduction when only a part of a negative and not the whole is to be reduced. Some kinds of liquid metal polishes, which are put up in convenient metal bottles, can be used as reducers exactly as bought.

Alcohol used in the same way as this reducer acts similarly, but takes very much longer.

BAS-RELIEFS

Plaster or wax casts in low relief produced from photographs; formerly they were popular for brooches, cameos, etc. Generally, the relief obtained is very small. The process depends primarily upon the hardening action of light upon gelatine impregnated with potassium bichromate. A negative should be specially taken for the purpose of the first experiments, a suitable subject being a modelled bust or a sculptured bas-relief. Landscapes are practically impossible subjects; while portraits should not be attempted unless the sitter's face and hair have been powdered to imitate a bust, great care has been taken with the lighting, and the photograph has been taken in the brightest possible light against a perfectly black background. Any heads attempted should not exceed 3 in. in height, as the relief obtained is not sufficiently strong for larger sizes. Success depends upon the contrasts in the negative, and if not sufficient these should be increased by local intensification or by working on the back of the negative.

Having obtained a suitable negative, a sheet of No. 4 gelatine is soaked in a solution of 1 drm. of potassium bichromate in 6 oz. of water. The swollen gelatine is next squeegeed on to a well-waxed glass plate and dried slowly in the dark, it being then stripped from the glass and its polished side printed upon from the negative.

An alternative method of preparing the bichromated gelatine is to soak 5 oz. of gelatine (Nelson's No. 1) and 2 oz. of powdered gum arabic for four hours in a mixture of $6\frac{1}{2}$ oz. of acetic acid and $18\frac{1}{2}$ oz. of water; at the end of the four hours dissolve by gentle heat, strain through clean linen, and coat some polished glass plates with it, avoiding air-bubbles and dust. Dry the plates in a well-ventilated darkroom as rapidly as possible, maintaining the temperature at from 50° to 75° F. (10° to 24° C.).

Either gelatine sheet or plate is printed by daylight in contact with the special black and white negative. Exposure depends upon the strength of light and density of the negative, the average duration being thirty minutes. The gelatine shows a faint image, which is a slight guide.

The gelatine sheet, after printing, is cemented firmly, face upwards, to a piece of glass, by means of liquid glue or similar adhesive, and the whole is then soaked in cold water for several hours, at the end of which time the parts acted upon by light are found to have lost their power of absorbing water, while the other parts swell considerably. If the relief is not sufficiently pronounced, it may be increased by soaking in a solution of 1 oz. of citric acid in 4 oz. of water and transferring to water. When swelled as much as possible the superfluous water is drained and removed with blotting-paper, some oil poured on and drained off, and it is then ready for casting from.

In the case of a glass plate instead of the gelatine sheet, after printing it is soaked in a solution of 2 oz. of powdered alum and 30 drops of glacial acetic acid in 40 oz. of water. At the end of two hours a fairly good relief should be secured. If the relief is not enough the negative may have been unsuitable, the exposure under the negative not long enough, or the plate dried too slowly after sensitising. The superfluous moisture is blotted off and the relief oiled.

Whichever method has been employed, the result so far is an oiled gelatine mould, from which a cast is now to be made in plaster-of-paris or wax. The mould is placed in an old printing frame or a tray; or, instead, wooden sides are built up round it to form a receptacle for the plaster. All surfaces which the plaster will touch, except the relief itself, should now be smeared with vaseline. Mix up some perfectly fresh plaster-of-paris to about the consistency of cream, immediately strain through muslin, and without losing time pour on to the oiled relief to a depth of $\frac{1}{2}$ in. When the plaster has set it may be separated from the relief and the latter used again after soaking in water and oiling.

In addition to plaster, stearine, spermaceti, and even heavy brown wax, make excellent casts. Coloured waxes may be made according to the following formulæ (given by H. E. Blackburn): *Red.*—Wax 500 grs., India red 64 grs., carmine lake 90 grs. *Sepia.*—Wax 500 grs., sepia 50 grs., lampblack 10 grs. *Green.*—Wax 500 grs., cobalt blue 10 grs., Indian ink 50 grs. *Blue.*—Wax 500 grs., Frankfort blue 100 grs., alizarin blue 15 grs., Indian ink 50 grs. *Warm black.*—Wax 500 grs., lampblack 50 grs., burnt umber 60 grs., indigo 32 grs. If desired a thin layer of wax of one colour may be brushed on the mould, allowed to set, and the mould then filled up with wax of another colour. The plaster gives more permanent results.

BAS-RELIEF PRINTS

Photographic prints embossed in low relief. Platinotype prints are the best for this purpose, but others may be used if hardened in a 10 per cent. solution of formaline. A folding wooden frame A is required large enough to take an unmounted print. The opening in the frames

B. Bas-relief Print in Folding Frame

A. Folding Frame used in making Bas-relief Prints

must be as large as the actual portrait, but smaller than the complete print. Profile portraits give the best results. On a piece of cardboard the same size as the print, is traced the outline of the head and bust; to do this, trace the head on a piece of tracing paper and transfer to the cardboard by means of carbon (manifolding) paper. Cut out the space inside the outline,

and the card will then form a mask, which should exactly correspond with the outline of the portrait. The print is now mounted on thick blotting-paper with starch or other slow-drying adhesive, and is placed under heavy pressure for ten or fifteen minutes, after which time it should feel damp and pliant. Some workers wet the blotting-paper to ensure this. The cut-out mask is next placed over the face of the print in register, and the whole put into the frame and clamped. The arrangement is shown by B, the bust being seen through the hole in the card. By means of a bone or ivory paper-knife, or the handle of a tooth-brush, carefully apply pressure from the blotting-paper side and raise or emboss those parts desired, holding the frame in the left hand and working with the right, the face of the print being nearest the operator. First of all work the tool all over the back of the portrait with a circling motion, and then apply more pressure to the nose, cheeks, dress, etc., which need to be given in prominence. The work must be done very gently, as the blotting-paper is damp, and the tool may go through the picture and spoil it. Leave in the frame until dry and mount on stiff card by the edges only. (For imitation bas-reliefs, *see* " Plastic Photographs.")

BATHS (Fr., *Bains ;* Ger., *Bäder*)

A name given both to the trays, dishes, or troughs holding photographic solutions, and to the solutions themselves. Thus, the dish used in fixing is known as the " fixing bath," a term also applied to the " hypo " solution which it contains. Baths may be either upright (as, for example, the silver bath in the wet collodion process), or horizontal (as, for example, the dishes or trays for developing, toning, and fixing). Dishes and trays are made in many different materials, such as porcelain, stoneware, " granitine," glass, enamelled iron and steel, papier mâché, vulcanite, celluloid, zinc, lead, etc. Glass dishes and dishes coated with vitreous enamel have the advantage that they are unaffected by chemicals, readily cleaned, and show distinctly any lack of cleanliness. But porcelain dishes are commonly preferred for most purposes, although they will not resist all chemicals. For developing, ebonite or celluloid dishes are probably most convenient ; for toning and fixing, porcelain or glass ; while enamelled iron or steel is used for hot-bath platinotype. Lead or stoneware troughs and trays are employed to resist acids.

BAUDRAN'S COLOUR PROJECTION METHOD

A method of projecting ordinary uncoloured photographic prints on to a surface whereon they are said to appear more or less coloured. It was invented by Baudran, of Versailles, in 1891. It is well known that some daguerreotype pictures show a trace of natural colour when viewed at a certain angle, and Baudran thought that by properly lighting ordinary pictures on silver paper he could obtain colours in the same way. An opening is made in the shutter of a dark-room, and on a shelf outside is placed a photograph, preferably an enamelled print on albumen paper, facing the opening and cutting

off much of the light that would otherwise be admitted. A mirror is so placed as to reflect light upon the photograph, the object being to light the image in the same way as the original subject was lighted. In the opening in the shutter is placed a camera which projects an enlarged image on a screen inside the dark-room. The image is said to be coloured. All colours do not appear equally well, but that of the flesh is said to be visible mostly always, although not very bright.

BEACH'S DEVELOPER

A pyro-potash developer popular at one time, particularly in the United States, where it was originally introduced by F. C. Beach. It gives a clear negative and a fine black image, which was considered preferable to the yellowish, slow-printing negatives produced by the pyroammonia developer. The inventor appears to have modified his developer a number of times, but the chief ingredients were always pyrogallic acid, sodium sulphite, acid and potash. The best way to make up the two stock solutions is described below, the actual formula being :—

No. 1 (pyro solution)—

Water	.	5 oz.	142 ccs.
Sodium sulphite	.	4 „	124 g.
Sulphurous acid	.	4 „	124 „
Pyrogallic acid	.	1 „	28·4 ccs.

No. 2 (potash solution)—

Potassium carbonate		3 oz.	93 g.
Sodium sulphite	.	2 „	62 „
Hot water to	.	10 „	284 ccs.

For the pyro solution the water is boiled and the sodium sulphite dissolved therein. When cold the sulphurous acid (dilute, as sold by chemists) needs to be added, and finally the pyro. Beach's original method of making the potash solution was to dissolve the carbonate in 4½ oz. of hot water, the sulphite in 4 oz. of hot water, and to mix the two. The above are stock solutions, which will keep good for a long time. To make a working developer, take 1 oz. of water, add to it 1 drm. (60 minims) of the potash (No. 2) solution, and from 20 to 30 drops of the pyro (No. 1) solution. Add bromide in cases of over-exposure.

BEAUMÉ DEGREES (*See* " Hydrometer.")

BECQUEREL RAYS

Very shortly after the discovery of the Röntgen rays, H. Becquerel discovered that the metal uranium, its earths and compounds, emitted rays which penetrated wood, glass, and even some metals, and exerted an action on a dry plate similar to that of light. He proved that the richer an earth or compound was in uranium the stronger were the rays emitted, and this led to an examination of pitchblende by M. and Mme. Curie, who finally isolated radium from the uranium pitchblende and proved that to this were due the Becquerel rays.

BEDFORD, FRANCIS

Francis Bedford (*b.* 1816, *d.* 1894) was associated with photography since its first practical inception, and had such skill as a landscape worker that he was invited to form one of the

party selected to accompany the late King Edward (then Prince of Wales) when he visited the East in 1863. His son William (b. 1847, d. 1893) was President of the Bath Convention, 1891.

BEECHEY'S DRY PLATE (EMULSION) PROCESS

A method of preparing collodion dry plates, published by the Rev. Canon Beechey in October, 1875, further details appearing in 1879. The plates were coated with a collodion made according to the following directions : First prepare a solution of cadmium bromide 32 grs., alcohol 1 oz. Decant after standing for some time, and add hydrochloric acid 8 minims. Next take above solution ½ oz., absolute ether 1½ oz., pyroxyline 12 grs. The plates having been coated with this are next sensitised in an alcoholic silver nitrate bath (40 grs. to the ounce), the plates being previously given a substratum of gelatine or indiarubber. They are then soaked in a solution of 20 grs. of pyrogallic acid in 20 oz. of flat bitter beer, which acts as a preservative. Great latitude is allowable in the exposure, from thirty seconds to five minutes being common. The following developer was specially recommended :—

Potassium bromide (12 grs. per 1 oz. solution) . . .	15 drops
Pyrogallic acid (96 grs. solution)	30 ,,
Ammonium carbonate (60 grs. solution)	3 drms.

The plates were an article of commerce for many years, and were very popular for transparency work.

BEER DRY PLATES

Dry collodion plates at one time used chiefly for positive (lantern-slide) work. The plates were sensitised in the usual way, washed, coated with beer, and dried. Further information will be found under the following headings : "Albumen Process," "Beechey's Dry Plate (Emulsion) Process," and "Coffee Process." The beer, coffee, etc., acted as preservatives.

BEESWAX (Fr., *Cire ;* Ger., *Bienenwachs*)

A wax obtained from the honeycomb of the bee. Melts at 62° to 65° F. It is insoluble in water and alcohol, but, if pure, entirely soluble in hot oil of turpentine. The wax when pure is a yellowish mass of a pleasing smell, and breaks with a granular structure. It is used in some processes of carbon printing. White wax should be ordinary beeswax bleached by exposure to sunlight and air.

In process work, beeswax forms an important ingredient in the composition of etching inks. A dusting-on powder, known as waxed asphaltum, for photo-lithographic half-tone transfers, consists of beeswax and asphaltum melted together and powdered. Beeswax (preferably the best Gambia) is largely used in electrotyping, for making the moulds from blocks or type.

BELITSKI'S REDUCER

A one-solution reducer for negatives, known also as the " green " reducer. The formula is :—

Potassium ferric oxalate	.	150 grs.
Sodium sulphite	. . .	125 ,,
Water	7 oz.

Shake until dissolved, and add oxalic acid 40 to 45 grs. Shake again until the solution turns green, pour off the solution from any undissolved crystals, and add hypo 1¾ oz. Instead of the potassium ferric oxalate, which is at times difficult to obtain, 100 grs. of ferric chloride crystals and 190 grs. of potassium oxalate may be used. The reducer is usable over and over again, does not stain, and keeps well in the dark.

BELLOWS (Fr., *Soufflet ;* Ger., *Balg*)

The light-tight, collapsible, or expanding connection between the back and front of the camera, usually made of leather or American cloth lined with black fabric. There are various shapes, as, for example, square A, oblong, conical (or, more correctly, pyramidal) C, stereoscopic B, truncated-cornered D, and others. The square bellows is generally preferred for studio, process, and scientific apparatus. The lighter and handsomer pyramidal bellows, now

A. Square, Parallel Bellows B. Stereoscopic Bellows with Division

C. Conical or Pyramidal Bellows D. Bellows with Truncated Corners

almost universally seen on field and hand cameras, may sometimes cut off a part of the view when using the rising front, unless care is taken. The oblong bellows is practically out of date, except for stereoscopic cameras, owing to the introduction of the reversing back. The stereoscopic bellows, which may be either oblong or pyramidal, is provided with a central partition folding in unison with the bellows. A bellows with truncated corners has the advantages that it closes in smaller space, is more elastic, and the folds are less liable to cling together.

BENNETT'S CARBON SENSITISER

A solution for sensitising the carbon tissue supplied in an insensitive condition ; introduced by H. W. Bennett. The formula is :—

Potassium bichromate .	4 drms.	22 g
Citric acid . . .	1 drm.	5·5 ,,
Strong ammonia (about)	3 drms.	16·5 ,,
Water . . .	25 oz.	1,000 ccs.

The proportion of water may be altered, any quantity from 10 oz. to 25 oz. being used ; the smaller quantity of water makes the tissue more

rapid, but it gives less contrast in the print, and the full quantity is better for ordinary work. The quantity of ammonia is only approximate ; it must be determined by the amount necessary to change the colour of the solution from the deep orange of the bichromate to a distinct lemon yellow. To sensitise, the piece of tissue should be immersed in the solution for two minutes, withdrawn, laid on a piece of glass or ferrotype, squeegeed to remove as much of the solution as possible, and then lifted from the glass and pinned by two corners, or suspended from a cord by clips, so as to hang freely exposed to the air to dry. Drying should be accomplished in from four to six hours. Sensitising may be done in full daylight, but drying must take place in the dark.

Tissue sensitised in this solution will render gradation much more perfectly, especially in the lighter tones. A little gaslight in the drying-room will have no effect on the quality or solubility of the tissue ; even a considerable amount of gaslight will be practically negligible. Details of working are given under the heading " Carbon Process."

BENNETT'S REDUCER

A well-known reducer, introduced by H. W. Bennett, made by adding sodium sulphite to a solution of ammonium persulphate, and acidifying by means of sulphuric acid. Reducing by means of this reagent is reliable and uniform in its results ; the operation is free from the risk of staining and other irregularities which previously made the ammonium persulphate reducer uncertain. The formula is :—

Ammonium persulphate	1	oz.	118	g.
Sodium sulphite	.	85 grs.	21	,,
Sulphuric acid	.	45 mins.	10	ccs.
Water to make	.	9¼ oz.	1,000	,,

(For working details, see " Reducing Negatives by Chemical Means.")

BENNETT'S TONING BATH FOR P.O.P.

A combined toning and fixing bath that gives rich purple tones on most brands of P.O.P., introduced in 1908 by H. W. Bennett. It contains a sufficiently large proportion of " hypo " to ensure perfect fixation of the prints, and the bath is rendered slightly alkaline with ammonia. Prints toned and fixed in this bath are as permanent as any silver prints ; they preserve their original richness and freshness unimpaired for many years. A feature of the bath is the fact that separate solutions are kept of each ingredient, and they are so adjusted that equal quantities of each are taken, excepting the " hypo " solution, and 1 oz. of that is required for each dram of the others. No calculation is needed, whatever quantity of solution may be required. Five solutions are necessary :—

A. Sodium hyposulphite . . 1 lb.
 Water, sufficient to make . 32 oz.

The " hypo " should be dissolved in boiling water.

B. Ammonium sulphocyanide . 2 oz.
 Water to make . . . 8¼ ,,
C. Lead acetate . . . 1 ,,
 Boiling water to make . 8¼ ,,

A dense precipitate will settle. The bottle must be well shaken each time any solution is required.

D. Gold chloride . . . 15 grs.
 Water . . . 2 oz. 7 drms.
E. Strong ammonia . . 120 mins.
 Water to 10 oz.

Each solution will keep indefinitely. To prepare the bath, mix together in the order given : 1 oz. of A, 1 drm. of B, 1 drm. of C, 2 oz. water, 1 drm. of D, and 1 drm. of E. The measure must be thoroughly rinsed after measuring C and D. The solution is ready for use in five minutes. This quantity is sufficient for ten quarter-plate prints ; a suitable quantity for any other number may be prepared by allowing ¼ oz. of A for every five quarter-plate prints, and remembering that whatever number of ounces of A solution are taken, the same number of drams of each of the others will be required. The prints are immersed in the bath without previous washing, and they should be put in the solution one at a time, and each one thoroughly wetted before the next is added. All the prints that are to be toned in one dish should, however, be put into the solution as quickly as possible consistently with covering each with the solution evenly.

As soon as the last print is placed in the dish the first should be taken from the bottom, brought to the top, and quickly examined. Should any air-bells have formed on the surface they will show as dark marks ; but if they are broken at once with the finger they will not show on the finished print. The second print that was placed in the bath will now be the lowest ; this should be brought to the top, and so on with each print in turn, until all have been changed in position. Throughout the operation the same method of procedure must be followed—the lowest print brought to the top ; but after the first changing the work should proceed more leisurely, leaving each print a longer time at the top of the solution. The minimum time of immersion in the bath is twelve minutes in hot weather if the temperature of the solution is 70° F. (21° C.) or more, and fifteen minutes in cool weather, though the toning should not be done in a room at a lower temperature than about 60° F. (15·5° C.). This minimum time is very important ; if less time in the solution is given, imperfect fixing will result. Longer time may be allowed if cooler tones are desired ; twenty minutes will not be too long. If warmer tones are required, the composition of the bath must be varied, so that the desired tones are not reached before the prints are fixed. The amount of water used for making the B and C solutions may be increased to 11 oz., and for the D solution 3¾ oz., and the bath still prepared by taking 1 drm. of each for 1 oz. of A. As soon as the minimum time has elapsed, or the desired tone reached if longer than the minimum time, the prints are taken from the bath and at once well washed. If washed in water that is frequently changed, from one to two hours should be allowed, according to the frequency of the changes and the quantity of prints in one dish. Prints for this toning bath require to be very deep.

BENNETTO'S COLOUR PHOTO-GRAPHY

A process of three-colour photography in which the three negatives were obtained at one exposure in a camera, the positives being made on red, yellow, and blue carbon tissues and superimposed. It has not been commercially introduced.

BENZENE (Fr., *Benzol, Benzine crystallisable;* Ger., *Benzol, Steinkohlenbenzin*)

Synonyms, benzol or benzole, coal tar naphtha, phenyl hydride. C_6H_6. Molecular weight, 78. Solubilities, insoluble in water, soluble in alcohol, ether, chloroform, acetone, and glacial acetic acid. The vapour is extremely inflammable. It is a colourless, mobile, volatile liquid, which can be obtained from benzoic acid, but is usually procured by distillation from coal-tar. It is used in varnishes and for developing in the bitumen process.

This substance must not be confounded with benzine or benzoline (*which see*). A crystal of iodine dropped into benzene turns carmine-coloured, whilst with benzine a violet colour is obtained. A drop or two of absolute alcohol will not mix with benzine, but mixes at once with benzene.

In process work, benzole is used for dissolving indiarubber to make the solution used in edging wet collodion negatives, and for coating the latter as a preliminary to applying collodion for stripping. It is the best solvent for asphaltum.

BENZINE (Fr., *Benzine,* Ger., *Benzin Petroleumbenzin*)

Synonyms, benzoline, petroleum ether, naphtha, petroleum naphtha; practically identical with petrol and gasolene. It is a colourless liquid obtained from petroleum by distillation. It is rarely used in photography, and must not be confounded with benzene (*which see*).

BENZOATE TONER

One of the many toners recommended in bygone days for plain salted paper. The following is a typical formula, and gives black-violet tones :—

Ammonium benzoate	.	30 grs.	4·2 g.
Gold chloride	. .	6 ,,	·8 ,,
Water	16 oz.	1,000 ccs.

BENZOIC ACID (Fr., *Acide benzoïque;* Ger., *Benzoesäure*)

Synonym, phenylformic acid. C_6H_5COOH. Molecular weight, 122. Solubilities, 1 in 15 boiling water, 1 in 1·8 alcohol; soluble also in ether, chloroform, glycerine, benzole, fixed and volatile oils. Borax or sodium phosphate increases the solubility in water. It occurs as white or faintly yellowish pearly plates or needles with agreeable aromatic odour and taste, and is obtained by sublimation from gum benzoin, or from toluene by oxidation with nitric acid, or from the urine of herbivorous animals by distillation.

BENZOLE (*See* "Benzene.")

BENZOLINE (*See* "Benzine.")

BENZOQUINONE, OR QUINONE

$C_6H_4O_2$. Molecular weight, 108. Slightly soluble in water, more so in alcohol and ether. It forms volatile yellow prisms, plates, or needles, having a pungent smell. It is procured commercially by acting on aniline with a bichromate and sulphuric acid. It is used in the preparation of the developer hydroquinone (benzoquinol, or quinol, $C_6H_4(OH)_2$), a substance which is obtained by the reduction of quinone with sulphurous acid.

BERGHEIM LENS

This lens was constructed in 1896 by T. R. Dallmeyer at the suggestion of J. S. Bergheim, a painter, who wished for a lens which would give him correct drawing and soft definition without sacrificing the natural structure of the original. To obtain this end the inventor introduced a large amount of both spherical and chromatic aberration, so that to obtain the maximum sharpness possible with this lens an allowance has to be made after focusing. Although primarily intended for portraiture, the Bergheim lens is constructed on the telephoto principle, the front element B being a single uncorrected positive lens, while the back is an uncorrected negative lens C of similar focal length—that is to say, when the two lenses are brought into contact they neutralise each other, various focal lengths being obtained by separating them.

Bergheim Lens

The greater the separation the shorter is the resulting focal length. The diaphragm A is fixed in the hood of the lens, and is marked for apertures requiring certain fixed relative exposures, no matter what the temporary focal length may be. The characteristic feature of the definition given by this lens when skilfully used is a pleasing semi-sharpness through a very deep field, no actual sharpness or offensive fuzziness being visible.

BERKELEY'S SULPHO-PYROGALLOL

The first of the developing substances to be preserved in solution by means of an acidified sulphite; it was introduced by H. B. Berkeley, in 1882.

Berkeley's solution consists of 4 oz. of sodium sulphite with sufficient citric acid (about ¼ oz.) to render the solution distinctly acid; 1 oz. of pyro is dissolved in 9 oz. 55 minims of the solution, so that every 10 minims contain 1 gr. of pyro. The sulphite must be thoroughly dissolved in the water, and the solution acidified before the pyro is added. The introduction of sulphite as a preservative of pyro in solution has been of great service to photographers. The sulphite not only preserves the developing substance in solution, but prevents the rapid oxidation of the developer in use, thus keeping

the plate clean and free from stain. Without sulphite the use of pyro with the alkaline carbonates would be impracticable, on account of the very rapid discoloration of the developer and the excessive staining of the plate.

The use of an acidified solution of sodium sulphite as a preservative has been largely superseded in the case of pyro by the introduction of potassium metabisulphite, a strongly acid sulphite, though the sodium sulphite is still added to the developer to ensure clean working and freedom from staining. It is also used as a preservative for most of the more recently introduced developing reagents.

BICHROMATE

The bichromates commonly referred to in photographic literature are "Potassium Bichromate" and "Ammonium Bichromate" (*which see*).

BICHROMATE DISEASE

A skin disease that affects some workers who use potassium bichromate extensively. It occurs only when the skin is particularly sensitive and the hands are brought much into contact with the bichromate (dry or dissolved), and it takes the form of small ulcers or an irritating "rash." A preventive is to wear rubber gloves or fingerstalls. The hands should always be well washed in warm water after using bichromate, and wiped thoroughly dry. The use of a carbolic soap will often give relief from the itching, the hands being afterwards rubbed with a cooling ointment or the following mixture: Glycerine 4 drms., carbolic acid 1 drm., alcohol 5 oz. For very severe cases the following treatment has been advised: Rub into the skin a little nitrate of mercury ointment (obtainable from most chemists, and called by the Pharmacopœia "Unguentum hydrargyri nitratis"). (*See also* "Skin, Effects of Chemicals Upon.")

BICHROMATE LAMP

A lamp for dark-room use in which a solution of potassium bichromate serves as the light filter. Howard Farmer found that the various kinds of ruby and orange fabrics and glass in common use transmit only 2 per cent. or less of the light, whereas a 6 per cent. solution of potassium bichromate gives quite as much safety and gives more than 80 times the amount of illumination possible with orange glass. With other solutions the differences are still greater, but the potassium bichromate solution appears to be the best for general use. Most bichromate lamps are based on the pattern designed by Farmer, whose original lamp is shown at A. It consists of two concentric glass cylinders, about 4 in. and 5 in. in diameter respectively, placed one inside the other, mounted on a suitable solid base and furnished with a wooden cap, in which is mounted an incandescent electric bulb. This is excellent as a central light. A glass tank, for use with oil or gas lamps, is shown at B and C, such tanks being filled with a suitable solution and used in place of the usual red glass. As either type of lamp may be filled with any light-filtering solution, an opportunity is afforded of adapting the actinic quality of the light to particular requirements. A 6 per cent. solution of potassium bichromate is safe for bromide papers, but not for dry plates, especially isochromatic plates, a safe solution for which is made as follows: Dissolve 1 oz. of the bichromate in about 9 oz. of water. Take about 4 oz. of the solution, and add 1 drm. of

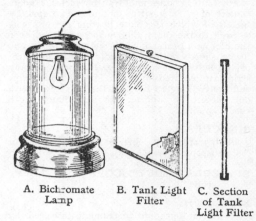

A. Bichromate Lamp B. Tank Light Filter C. Section of Tank Light Filter

eosine, which is a strong red dye, and gently heat until the colour is a deep red; mix the two solutions and pour into the lamp cell. Should the solution have a muddy appearance, pass it through filter paper.

BICHROMATE REDUCER

An acid solution of potassium bichromate may be used as a reducer for dense negatives in the same way as the more popular acid solution of potassium permanganate. A suitable formula is :—

Potassium bichromate	200 grs.		20 g.	
Sulphuric acid	.	.	$\frac{1}{4}$ oz.	1·2 ccs.
Water to	.	.	. 20 ,,	1,000 ,,

Dissolve the bichromate in water, and add the acid. The solution keeps well, but is liable to be irregular in action.

BICHROMATED GELATINE

A term fully explained under the heading "Carbon Process." It refers to gelatine that has been sensitised with potassium bichromate.

BICONCAVE LENS

A lens, either simple or compound, of which both outer surfaces are concave. (*See also* "Lens.")

Biconcave Lens Biconvex Lens

BICONVEX LENS

A lens, either simple or compound, of which both outer surfaces are convex. (*See also* "Lens.")

BICYCLE (*See* "Cycle.")

BI-GUM PROCESS

A familiar designation for the " Gum-bichromate Process " (*which see*).

BINDERS

For lantern slides and transparencies, binders consist of narrow strips of gummed paper by means of which the plate bearing the image is secured to the plain glass which is placed over the film as a protection. They are made in two forms, short lengths sufficiently long for one edge of the lantern slide only, so that four binding strips are required for each slide, and long strips sufficiently long to bind all the four edges with one piece. The former are very much more easily applied.

BINOCULAR

Photographically, this is another name for " stereoscopic " (*which see*).

BINOCULAR MICROSCOPE (See " Microscope.")

BIOGRAPH

A kinematographic instrument invented by Herman Casler, of Canastota, New York, U.S.A. In the early stages of kinematograph science the size of the film pictures was (as now) only 1 in. by ¾ in., and owing to optical and chemical limitations early results were unsatisfactory. Casler considered that improvements could be made if the film pictures were taken on a larger scale ; and he proceeded to devise the biograph, in which he arranged to take pictures measuring 2⅝ in. by 2 1/16 in. and to utilise the whole surface of the film, dispensing with side perforations, by the introduction of an arrangement of rollers, instead of sprocket wheels. Hence he presented his invention to the public in America during the autumn of 1896. The biograph projected pictures at the rate of thirty to forty per second, and flickering was thus largely overcome. Further, Casler, claimed that inasmuch as the film was carried forward by friction rollers instead of by sprocket teeth, there was greater steadiness of the images upon the screen. Against the advantages indicated must, however, be set the increased cost of production and the inconvenience of cumbersomeness in both the taking apparatus and the projecting machines. The biograph enjoyed a season of popularity in the United States and also in London ; but it failed to become universal, whilst time has shown that small-size pictures and simpler apparatus could be improved to meet all requirements.

BIOSCOPE

A well-known type of kinematograph projector. The name is derived from two words signifying respectively *life* and *to see*, and was in use long before the introduction of the kinematograph, to which it was first applied by Charles Urban, at that time associated with the Warwick Company. The courts did not sustain the use of the word as a trade-mark.

BIRDS, PHOTOGRAPHY OF

Most of the methods used in the photography of animals (*see* " Animals, Photography of," " Zoological Photography," etc.) apply also in the case of birds. There are other points, however, to be taken into account. Many birds are not only small in size, but are difficult to approach because of their natural timidity and wildness, this being especially the case with birds in a free state. The telephoto lens becomes of increased value, even high magnifications having often to be employed. Even more than in the case of animals, it is necessary to possess considerable knowledge of the haunts and habits of birds, and frequently there must be added an unbounded store of patience and perseverance. It is frequently necessary to use all sorts of elaborate and ingenious appliances to bring the camera into workable proximity to the bird without alarming it and arousing its suspicions. In fact, no work of much value can be done in the direction of bird photography without making a special study of it and acquiring the necessary knowledge and apparatus to make good results possible. Particular attention should be paid to effective and characteristic pose, and natural surroundings, and the use of orthochromatic plates and suitable screens is often imperative to secure a true rendering of the colour values of the plumage.

BIS-TELAR

A telephoto lens of fixed magnification, introduced by Busch. It has a focal length of about 1¾ times the camera extension required, and the two kinds obtainable work at $f/9$ and $f/7$ respectively. It is well adapted for hand-camera work, and is largely used by press photographers when photographing distant objects.

BISULPHITE LYE (See " Sodium Bisulphite.")

BITUMEN (See " Asphaltum.")

BITUMEN OF JUDEA (See " Asphaltum.")

BLACK CLOTH (See " Focusing Cloth.")

BLACK, DEAD

Recipes for dead blacks are given under the heading " Blackening Apparatus."

BLACK LINE PROCESS

A name given to the original ferro-gallic, or Colas process, described under the heading " Ferro-gallic Process."

Another process known as " black line " is a printing process worked out in 1894 by R. Nakahara, of Tokyo. The sensitising solution is :—

Gum arabic .	. 3 oz.	93	g.
Water . .	. 22 ,,	625	ccs.
Tartaric acid	. 192 grs.	12.5	g.
Common salt	. 864 ,,	60	,,
Ferric sulphate	. 2 oz.	62	,,
Ferric perchloride .	3 ,,	93	,,

The gum is dissolved by heat in the water, and the other chemicals added to the warm solution. The solution is spread over well-sized paper with a sponge, and, after allowing it a little time to penetrate, all superfluous moisture is removed with the sponge well wrung out, and the paper dried as rapidly as possible. The exposure to daylight under a negative or plan is rather long. The colour of the prepared paper is yellow, but

during printing all but the lines turn to white. The print is developed in a plain aqueous solution of gallic acid, the strength of which is not important ; the print must not be left too long in the developer or stains will result. The developed print is rapidly washed and dried. Success depends chiefly upon the sponging off of the superfluous sensitising solution and rapid drying.

BLACK MIRROR

A mirror formed of black glass and used for photographing clouds by reflection

BLACK OXIDE OF MANGANESE (*See* "Manganese.")

BLACK, PROCESS

A black water-colour pigment largely used in retouching photographic prints with the aerograph and otherwise for process reproduction. It is claimed that it has no blue in its composition. It may be diluted with water for pure greys, or mixed with Albanine for the lighter shadows. It dries a dull black and reproduces well.

BLACK SPOTS

Black specks on negatives and prints, but more particularly upon ordinary P.O.P. Those upon the P.O.P. are caused (*a*) by metallic particles in the first washing water, these coming from a pump, tap, pipes, cistern, etc. ; or (*b*) by trimming the untoned prints upon a metal plate. The spots cannot be removed, but they are easily prevented by immersing the prints before toning in a 10 per cent. solution of common salt, so as to convert all the soluble salts of silver into chloride, then washing again before toning. The addition of a little washing soda to the salt solution has also been recommended, the actual formula being 2 oz. of common salt and 1 oz. of washing soda to 1 pint of water. The prints are left in this for from five to ten minutes, then washed in running water for five minutes, and toned as usual. The above method serves to prevent spots, but when platinum is used as a toner instead of gold, the washing soda should not be used, only the plain salt and water.

Black specks upon negatives and developed prints (bromide and gaslight papers) are caused by undissolved particles of the developer proper, hydroquinone, amidol, etc., settling upon the film. These particles may be present undissolved in a freshly made developer, or may be flying about the room and settling upon the sensitive surface in the form of dust.

BLACK TONES

Black tones are obtainable upon carbon and other pigment papers, which already have a base of black pigment, platinotype, bromide, and gaslight papers with ease, and on print-out papers with difficulty. The richness and quality of the blacks on platinotype are characteristic of the process and depend upon the state of the paper, exposure, etc. The quality of the blacks upon bromide and gaslight papers depends upon the exactness of exposure and upon the state of the developer, because if too much potassium bromide is used in the latter the blacks are

greenish in tone, and if too little is used neither the blacks nor the whites are of the best.

All tones upon P.O.P. largely depend upon the quality of the negative ; and for black tones the negative should preferably be rather hard—that is, should have dense high lights and clear shadows. Such a negative should be printed under green glass and toned in any gold or platinum bath, or in the following combined toning and fixing bath :— A. "Hypo" 4 oz. ; water 10 oz. B. Lead nitrate 1 oz. ; distilled water 10 oz. ; glacial acetic acid 48 drops. Add B to A gradually, and with shaking, until a distinct cloudiness appears ; then filter. Take 10 oz. of the above mixture and add 1 grain of gold chloride, and this forms the toning bath. If black tones do not result, the negative was not suitable, or the printing has not been suitably carried out. Some workers obtain a rich black tone on P.O.P. by using gold first and platinum afterwards, but, as in all cases, much depends upon the suitability of the negative.

BLACK VARNISH (*See* "Varnish.")

BLACK VIGNETTES

A style of portrait known also as "Magic," "Egyptian," and "Russian" vignettes, invented in 1868 by a Russian photographer named Bergamaso. The sitter's head is made to stand out against a perfectly black background, the edges of the picture all round being black instead of white as in an ordinary vignetted

A. Black Vignetting with Serrated Card in front of Lens

B. Black Vignetting with Card inside the Camera

portrait. The sitter is placed against a perfectly black background, and the light is prevented from acting on the edges of the plate, more particularly on the lower part (upper part as it is seen on the focusing screen). The light is cut off from the plate either by means of a serrated piece of blackened card or tinplate on an adjustable rod outside the camera, and before the lens, as A, or by the insertion of a black card with an opening in the centre, in the bellows of the camera, as B. Either system, when properly used, cuts off the light at the top or bottom and gives a negative with plain glass borders which print black, the well-lighted head appearing in the centre.

BLACKENING APPARATUS

Only a dead black is suitable for the interior of a camera, as a glossy black would give rise to reflections.

Blackings should be tested upon pieces of metal, wood, leather, etc., before applying to the apparatus. Recipes are as follow:

Brasswork.—To blacken camera brasswork, clean with fine emery, rinse, and immerse in a saturated solution of copper nitrate for about two minutes. Then take out, heat over a Bunsen burner or ordinary spirit flame, and repeat the process several times. To make the copper nitrate, dissolve 1 oz. of copper filings in 2 oz. of nitric acid; do this in the open air, and stir with a glass rod to assist dissolving.

Zincwork.—Clean and rinse as before, and immerse in a solution of copper chloride 45 grs., zinc nitrate 30 grs., and water 4 oz., to which is added ½ oz. of hydrochloric acid. Finally, rinse and dry.

Tin.—Use carbon black mixed with the least possible amount of French polish. Excess of polish makes it glossy. A dye can be used instead of a pigment; for example, boil together 1 oz. of water, 15 grs. of borax, 30 grs. of shellac, and 15 minims of glycerine. Maintain the boiling till dissolved, and then add 60 grs. of nigrosin.

Bellows Interiors.—Use a solution of shellac in methylated spirit coloured with lampblack.

Camera Interior (Woodwork).—Dissolve ½ oz. of shellac and ¼ oz. of borax in 10 oz. of hot water, and add about ½ drm. of glycerine and sufficient aniline black (soluble in water) to form a good solid black. Two coats should produce a rich velvety dead black. Another recipe is: Aniline black 50 grs., gum shellac 100 grs., methylated spirit 2½ oz. Negative varnish mixed with powdered lampblack may also be used.

Lampblack mixed with gold size and turpentine makes a good dead black for general use.

BLACKLEAD (Fr., *Plombagine;* Ger., *Graphit*)

Synonyms, graphite, plumbago. Used for lubricating apparatus and in retouching.

In process work, finely powdered blacklead is sometimes rubbed on to wet plate half-tone negatives in order to intensify the dots in certain parts where additional density is required. It is also used in the "Powder Process" or "Dusting-on Process" for the duplication of negatives. As an inert powder it forms an acid resist, and is dusted-on to an ink image for that purpose. In electrotyping it is used to give the wax mould an electro-conductive surface.

BLAKE-SMITH PROCESS

The modern method of toning bromide prints by first bleaching the image or converting it into such a form that treating with a sulphide solution will convert it into sulphide of silver; largely due to the experimental work of R. E. Blake-Smith. Various methods of bleaching the image have been used, but the most simple as well as the most satisfactory is to convert the image into a bromide or chloride by means of a solution containing potassium ferricyanide and either potassium chloride or potassium bromide. (For details of this method, *see* "Toning Bromide Prints," etc.)

BLANC D'ARGENT

A pure white pigment water-colour of French manufacture, largely used by process retouchers, and preferred for aerograph work. Drawings or retouching done with it should be reproduced without delay, as it discolours.

BLANC FIXÉ (*See* "Barium Sulphate.")

BLANCHARD, VALENTINE

Born at Wisbech, 1831; died at Herne Common, November 14, 1901. A famous portrait photographer in the 'sixties and the inventor of apparatus and processes. He was the first to recommend making large transparencies from small negatives, and the art of printing-in clouds from separate negatives, the latter being published on September 4, 1863. He was always opposed to microscopic sharpness in definition, and the slight diffusion which he gained by the use of a single lens caused much attention to be paid his work. He was an advocate of long exposures and large plates, giving about forty-five seconds' exposure and using 15-in. by 12-in. plates for his portraits. His method of obtaining carbon prints without transfer consists in immersing the tissue for a minute in petroleum, the paper support being thus rendered translucent. The tissue, after the removal of the surplus oil, was placed in a printing frame with the support next the negative, printed in the usual manner, and developed from the front. He also invented a brush, known as the Blanchard brush (*see* "Brushes"), which is widely used for sensitising.

BLEACHING NEGATIVES (*See* "Intensification.")

BLEACHING POWDER (*See* "Calcium Hypochlorite.")

BLEACHING PRINTS (*See* "Drawings Made from Photographs.")

BLIND SHUTTER (*See* "Shutters.")

BLINDS, STUDIO (*See* "Studio.")

BLISTERS

Blisters appear at times upon all makes of plates, films, and papers in the manufacture of which albumen or gelatine is employed, but the papers most subject to the trouble are albumen and bromide. The principal cause of blisters is the use of a too strong "hypo" bath, rapid washing, excess of alkali in the developer, and the difference in temperature between the developing, toning, or fixing solutions and the washing water. The blisters usually appear when the plates or papers are being washed after fixing. It is a curious fact that fewer blisters appear where ordinary tap water is used than where soft water is employed. It is, however, the fixing bath that usually needs attention when bromide and gaslight papers are prone to blister. The fixing bath, as freshly made with cold water and "hypo," should not be used immediately, the temperature of such a solution dropping almost to freezing point, and of course many degrees lower than the temperature of the washing water used before and after; hence the expansion of the wet gelatine, which is very susceptible to temperature, in the form of blisters. If a fixing bath is needed quickly it should be made with hot water and used when the temperature has fallen to the level of the washing water; or, if cold water is used, the bath should be mixed some considerable time before use in order that

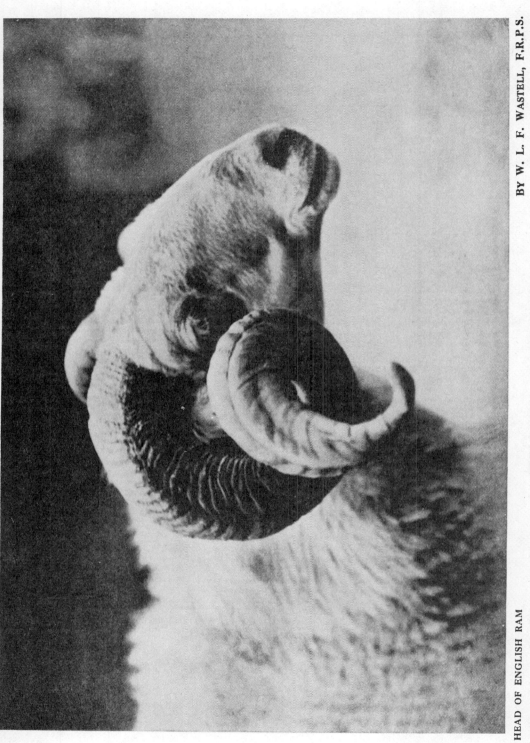

HEAD OF ENGLISH RAM

ZOOLOGICAL PHOTOGRAPHY

BY W. L. F. WASTELL, F.R.P.S.

it may have time to rise in temperature. When care is not taken about the temperature of the bath, blisters may be prevented by allowing the washing water to run gradually into the fixing bath while the fixed prints remain therein. The water gradually replaces the " hypo," the difference in temperature (if any) is gradually made up, and the expansion of the gelatine is too slow to do any harm ; this method, too, largely prevents blisters due to the use of a strong fixing bath.

The use of an acid fixing bath is widely advocated for the prevention of blisters on bromide papers and negatives. Any formula will serve, but that containing " hypo " and metabisulphite will be found best. Another plan is to soak the prints previous to, or immediately after, fixing in a 20 per cent. solution of formaline and then to wash well. There is really no satisfactory cure for blisters when once they have appeared ; pricking the paper at the back with a pin for the purpose of allowing the air to escape from the bubble has been advised, but the loosened film never becomes properly attached to the paper, and frequently peels off when dry. Another plan is to squeegee the blistered print upon cleaned ground glass and strip when dry, but, as in the previous remedy, the blisters invariably scale off later.

Information given above on preventing blisters applies equally well to negatives and bromide and gaslight papers. Blisters but rarely appear on negatives, but when they do the negatives should be soaked in methylated spirit and dried ; a more general trouble with plates is " frilling " (which see).

Albumen paper, as a rule, blisters very badly if carelessly manipulated, the cause being the unequal temperatures of the solutions employed. Rives paper, which is now almost universal, is thought to blister more than the Saxe paper, which is tougher, but not now so widely used. Preventive measures are (a) to use solutions of as even temperatures as possible ; (b) to soak the prints in hot water or methylated spirit, afterwards washing well, previous to toning ; (c) to remove the prints from the ordinary alkaline fixing bath (acid baths must not be used for albumen paper) to water to which has been added one-tenth its weight of common salt, allowing them to remain for ten minutes and finally washing well.

Carbon prints show minute blisters when the water used is too hot. Blisters may be also due to free air in the water, greater trouble in this direction being experienced when water comes direct from the main than when it comes through a cistern. It is advisable to boil sufficient water for the bath in which the tissue is to be soaked before squeegeeing to the temporary or final support. Fifteen minutes' boiling should be sufficient to expel all the air, and it is then cooled in a jug in order that only a small surface may be exposed to the air, of which water can absorb a large quantity.

Gelatine (P.O.P.) *prints* rarely blister, but when they do the cause is a too strong " hypo " fixing bath, or the unequal temperatures of solutions and water. An acid fixing bath must not be used for P.O.P. ; if hardening is thought necessary, formaline should be used.

BLITZ-PULVER

The German name for flashlight powder. It is occasionally used in English and American literature. In the United States, a powder having this name contains the mixed nitrates of barium and strontium 5 oz., metallic magnesium 2 oz., and amorphous phosphorus 120 to 180 grs.

BLOCK (Fr., *Cliché, Planche ;* Ger., *Block, Auto-typie-druckform, Autotypieklischee, Galvano*)

A block of wood or metal, or metal plate backed by either wood or metal, and having a typographic printing surface. It may be a process block (produced photographically), a woodcut, in the production of which photography may or may not play a part, an electrotype, or stereotype. " Block Processes " include all those processes in which, by the aid of photography, a relief surface is produced, capable of being printed from in an ordinary printing press together with letterpress.

BLOCKING OUT, OR STOPPING OUT

A method of painting out undesirable details upon a negative, the painted portions appearing white upon the finished print ; parts of lantern slides may also be blocked out, in which case the blocking out appears black upon the screen. Blocking out is extensively used on photographs of machinery, furniture, etc., for reproduction in catalogues, etc. It is generally desired that the article photographed should stand by itself upon a white ground, in which case opaque pigment is used as the medium for stopping out the rest of the picture ; but when a perfectly black background is required the best thing to do is to make a transparency and block this out, and from this to make a second negative, on which the blocked-out portions will be clear glass, which will, of course, print black. Whichever method is adopted, the actual work of blocking out is precisely the same. In order to do the work properly, the following materials are necessary : a retouching desk, one or two sable or crow-quill brushes with fine points, a mapping pen, Indian ink, ruler, a bottle of black varnish, and red water-colour or other opaque medium. The negative is placed film side uppermost on the retouching desk and the film worked on with the opaque. A rough print to serve as a guide should be taken from the negative before the work of blocking out is begun. It is advisable also to begin from the centre of the negative and work outwards. A retoucher with a steady hand may be able to do all the necessary work with a brush, but many will need the rule, pen and ink. The pen, if used, is charged with Indian ink and held perfectly vertical to the surface of the plate ; it should have a smooth and well-rounded point, as otherwise it is apt to cut the film. Any errors made with the pen and ink may be removed by washing away the line by means of a camel-hair brush charged with water ; but when this is done care must be taken to wait until the gelatine film is perfectly dry before going over it again with a pen, otherwise the film will be torn. Having ruled all the necessary lines, the rest of the blocking out may be done with the black varnish diluted with turpentine, or with any other opaque pigment. Those pigments used with water are perhaps

5

the easiest to use because, should any error be made in the work, they may easily be washed off, or wiped off with a damp sponge, whereas black varnish is difficult to remove even with turpentine; the varnish, however, is the more durable, and will stand any amount of wear and tear.

All the fine work, if desired, may be done on the film side with a pen and Indian ink, or with a brush charged with opaque or red water-colour, and the bulk of the stopping out on the glass side with black varnish or Brunswick black, taking care that the working on one side overlaps the other.

Another method is to take a rough print from the unblocked negative, cut out the part required, and use the cut print as a mask, which may be pasted on the glass side of the negative. This serves as opaque, and but little fine work may be required on the film side, care, however, being taken to let the working on the film side overlap the paper mask. The latter may, if desired, be wetted and placed on the film side, but it is removed more easily from the glass side of the negative. (*See also* "Camphor.")

Any of the above methods may also be employed for transparency work, but in the case of lantern slides it will be necessary to use a stopping-out mixture which will not crack when subjected to the heat of the lantern illuminant concentrated by the condenser.

The present-day commercial practice is for the photographer to make as good a photograph of the subject as he can, supply a good print, and leave the blocking out to the process worker's artist, the work being done on the print and not on the negative. The photographer can often assist matters by seeing that the background is of such a nature that the work of blocking out is facilitated, as the merging of the picture of a machine, for instance, into the background makes it difficult to see where one ends and the other begins. Frequently it is sufficient to run a line of white pigment between the subject and the background, and the process worker then understands that the latter is not to be included. The aerograph is largely used for blocking out on prints, etc.

BLOOD ALBUMEN (*See* "Albumen.")

BLOTTING-PAPER

Used for blotting off water from negatives, and for drying those papers not having a gelatine or sticky surface. Inked and coloured blotting-paper is not suitable. The paper should be as fluffless as possible; special blotting-papers for photographic purposes are obtainable. Ordinary blotting-paper may be freed from all impurities likely to damage prints by pouring boiling water and a hot weak solution of sodium carbonate over it alternatively two or three times, ending with the boiling water. This treatment removes the acids and sulphites, which might otherwise affect the permanency of the silver prints.

BLOW-THROUGH JET (*See* "Limelight.")

BLUE GLASS, PHOTOGRAPHIC USES OF

Blue glass of good quality has several uses in photography. By looking through a piece of it at the view to be taken, or by fixing a sheet of it over the focusing screen, the photographer is enabled to see the subject with its colour contrasts toned down, and will be the better able to judge what the effect will be in a photographic monochrome print. Some years ago blue glass was advocated for glazing studios, but exposures under blue glass need to be longer than under white glass, and the only gain to the photographer is that he is working in a light that is less trying to his eyes. Blue glass is of service if placed over a harsh negative when printing on P.O.P., it having the effect of giving a softer print, inasmuch as certain organic salts are not acted upon as they would be were the blue glass absent. Blue glass is also of service when copying a faded or yellowish photograph; a piece of pale blue glass is held before the lens during the exposure, and the resultant negative gives increased contrasts, and in general is of better all-round quality.

BLUE TONES

These are obtained most easily on blue-print (ferro-prussiate) paper or by using blue carbon tissue, in both cases a blue print being produced. Good blues are difficult to obtain on P.O.P., a blue-black (*which see*) being the nearest. Bromide prints may be partially or wholly changed to a prussian blue. Ferric ferricyanide is usually employed, it being made as required by mixing together solutions of potassium ferricyanide and ferric ammonium citrate, adding a little nitric acid. The formula for the toner is :—

Potassium ferricyanide	45 grs.	10 g.
Nitric acid (pure) . .	24 mins.	5 ccs.
Ferric ammonium citrate	22 grs.	5 g.
Water	10 oz.	1,000 ccs.

If this works too quickly, add more water. Place the prints, after developing, fixing, and washing, in the above, until of the desired colour, and wash in running water for twenty minutes, or until the whites are clear.

BLUE VITRIOL (*See* "Copper Sulphate.")

BLUE-BLACK TONES

In silver printing these can be obtained only by using a toning bath rich in gold, say 1 gr. to 5 oz. or 6 oz., and also a liberal allowance for the prints being toned, 2 grs. or more to each full-size sheet of paper, or fifteen half-plate prints. In addition, a rich print from a strong negative is absolutely essential, the tone of the shadows being very largely determined by their depth. Some toning baths will give blue-black tones much more readily than others; with some, these tones cannot be obtained. In separate toning and fixing the sulphocyanide bath, if strong, will give blue-black tones readily. In combined toning and fixing Bennett's toning bath will give a similar result by increasing the quantities of the B, C, and D solutions. One and a half drams of each should be used to each ounce of the A solution, in place of 1 drm., as given under the heading "Bennett's Toning Bath for P.O.P."

BLUE-PRINT PROCESS

Known also as "Cyanotype" (negative) and "Ferro-prussiate" process, and largely used by

engineers, architects, etc., for reproducing technical drawings. It is one of the oldest photographic printing processes, having been invented by Sir John Herschel in 1840. Paper is coated with a mixture of ammonio-citrate of iron and potassium ferricyanide dissolved in water, then dried in the dark, and printed by daylight in contact with a negative or drawing on tracing paper, when an image in insoluble Prussian blue (Turnbull's blue) is produced. The print is washed to remove the soluble coating unacted upon by light, leaving a finished print, blue on a white ground.

Another blue-print process is the positive cyanotype, or Pellet's process (*which see*, under the latter heading), which gives blue lines on a white ground, the opposite process to the above, it being one in which blue is formed where the light does not act. The negative cyanotype or blue-print process proper is the one particularly suitable for negatives, and is that to which attention is here directed.

Blue-print paper, ready sensitised for immediate use, may be purchased, but as it does not keep well, and is so easy to prepare, it is better to make it as required. A large number of sensitising formulæ have been published from time to time, considerable latitude being permissible in the quantities of chemicals used as well as in the methods of working. They all, however, resemble one another, and yield prints which are all very much alike. Almost any kind of paper can be coated with the sensitive mixture ; fairly stout cream-laid notepaper, or a real photographic paper such as Rives, is as good as any ; it should be free from wood-pulp or other impurities usually found in cheap white papers, its surface should be fairly hard and not too absorbent, and it should be tough enough to withstand thorough washing. Common rough papers are better if sized before sensitising, because the size prevents the image from sinking into the paper. For the size use the following arrowroot mixture :—Take ½ oz. of arrowroot and mix to a smooth stiff paste with a small quantity of cold water. Add warm water to make 22 oz. in all, and boil gently until clear. Thin papers may be immersed bodily in the warm mixture for a minute or two, and then drained and dried. Thick papers should be pinned by the corners to a flat board and the warm size applied first up and down and then across, by means of a soft sponge or a Blanchard brush (*see* the heading " Brushes "). Then with a clean soft sponge go over the paper again in order to efface all streaks and make the surface smooth ; hang up, and when quite dry it is ready to sensitise. The two sensitising solutions are made according to the following formulæ :—

A. Ferric ammonium
 citrate (brown) . 80 grs. 160 g.
 Water . . . 1 oz. 1,000 ccs.
B. Potassium ferri-
 cyanide . . 60 grs. 120 g.
 Water . . . 1 oz. 1,000 ccs.

Unless quite fresh and clear the ferricyanide crystals should be washed before weighing, and dried between blotting-paper, to free the crystals from powder or crust. Mix the solutions, and keep in a stone bottle or in a dark place. The

solution is usable at once, but works better when a week or ten days old, but it must be filtered just before using, and if older than this, should be preserved by adding to every 2 oz. of it 1 gr. of potassium bichromate. The sized common paper or the plain good paper, with blotting-paper underneath it, should be pinned to a flat board, placed (as illustrated) at an angle of about 20° to the horizontal in preference to being either flat or upright. Sufficient of the sensitive solution should be poured into a saucer and then applied to the paper with a sponge, Buckle brush, or large soft camel-hair mop. The coating must be done in artificial light or very weak daylight, and the solution should be spread upon the paper by strokes across the sheet, beginning at the top and joining the second stroke to the first. The strokes should then be made vertically in order that the paper may receive a perfectly even coat, without any of the sensitive mixture running in rivulets down the sheet. When evenly coated the paper must be dried as quickly as possible, and in the dark—a warm cupboard is a good place—but no very great heat should be applied to the wet paper to hasten the drying. The coated paper

Paper Ready for Coating in Blue-print Process

will not keep good for many days ; a heavily-coated poor paper will not keep so long as an unsized or lightly sized good one. The colour of the sensitised paper may be a dirty greenish yellow tinge, but will vary according to the sensitising formula. The paper is placed in contact with a negative or drawing on tracing paper, and printed by daylight, preferably in strong sunlight. On exposure to light the colour of the paper gradually changes through bluish-green and bluish-grey to a kind of dirty olive-green, the image having a choked-up appearance when fully printed. The print is washed for about fifteen minutes in water, which should remove the soluble salts and leave a brilliant blue print. The water serves both as a developer and fixer, the print needing no further treatment. Prolonged washing weakens the image, as will also water containing carbonate of lime. Brighter prints are obtained by adding about 20 grs. of citric acid to the pint of water. A solution of 5 parts of alcohol in 95 parts of water has been advocated for improving the whites, and a 2½ per cent. alum solution has been recommended for brightening the blue colour ; but neither of these aids is necessary if the water is free from lime, the negative or tracing a suitable one, and the paper properly prepared.

An alternative method is to use single solutions, one for sensitising and the other for developing the faint image, obtained by printing in the usual way, to the desired blue colour. The sensitising mixture is as follows :—

Ferric ammon. citrate (green) 110 grs. 220 g.
Uranic nitrate . . . 35 ,, 70 ,,
Water 1 oz. 1,000 ccs.

Paper is coated with this mixture and printed in the manner already described. The faint image is developed to its full strength by placing in—

Potassium ferricyanide 22 grs. 44 g.
Water 1 oz. 1,000 ccs.

The print is completed by washing in water. This process is more rapid than the one first described.

The blue-print processes are used for printing upon fabrics and for the making of blue transparencies for window decoration. For the latter it is necessary to use a plate coated with gelatine to serve as a vehicle for the sensitiser.

Toning Blue-prints.—Blue-prints may be toned to several other colours, but the various formulæ published are uncertain in their action on home-made papers, two samples of which are seldom alike ; they answer better with commercial blue-print papers. Before toning, wash the prints thoroughly. *Green.*—Make a saturated solution of ferric protosulphate, acidify with sulphuric acid, and dilute with an equal quantity of water. Immerse the blue-print until the required tint is obtained, wash well, and dry. A weak solution of sulphuric acid (acid 4 drops, water 1 oz.) will also give the print a greenish tinge. *Lilac.*—For lilac-violet, immerse in a hot solution of lead acetate, or a cold solution of borax. A 2 per cent. solution of potassium sulphocyanide (10 grains in 1 oz. of water) gives a pink-lilac tone, after obtaining which blot off superfluous solution, expose to strong sunlight, wash, and dry. *Greenish Black.*—Dissolve 30 grs. of borax in 1 oz. of water and add sulphuric acid drop by drop till the solution just reddens litmus paper ; next add a weak solution of ammonia till the red colour begins to change, and finally add 4 grs. of catechu, shake well and filter ; tone, wash, and dry. *Brownish Black.*—Add 6 drops of liquor ammoniæ to 1 oz. of water, immerse the blue-print, and allow to remain until the colour has vanished ; then wash and place in water 1 oz., tannic acid 9 grs., in which the bleached print gradually assumes a brown or brownish black colour ; wash and dry. *Purple Brown.*—Add 30 grs. of tannic acid and 1 gr. of pyrogallic acid (or even less) to 1 oz. of hot water, immerse the blue-print until toned to a lilac, rinse, and place quickly into a weak solution of caustic potash (potash 8 grs., water 1 oz.) ; wash and dry. *Black.*—A good black is difficult to obtain ; success depends upon the quality of the negative and upon the depth of the blue-print. The deep shadows tone to a rich black, but there is a falling-off in the half-tones. Of the many formulæ, Lagrange's is the best, but one of the most troublesome. Rinse the print in distilled water and, in a yellow light, bleach in a silver nitrate solution (9 grs. in 1 oz. of distilled water). Wash well in distilled water,

expose to the fumes of ammonia, and afterwards develop with an ordinary ferrous oxalate developer ; the print may then be washed and dried. *Grey to Red.*—Print darker than usual, wash for ten minutes, and immerse in a solution of copper nitrate (24 grs. to 1 oz. of water) to which a little liquor ammoniæ has been added cautiously, a few drops at a time, until the precipitate first formed is just redissolved, leaving the liquid a deep blue. This bath turns the blue-print mauve, then grey, and after a time red. Prints dry more blue than they appear when wet. The bath does not act well on prints showing great contrasts, since by the time the dark parts have turned grey the half-tones and lighter tones will become red. Most of the tones obtained by the above methods are unsatisfactory. (*See also* " Window Transparencies " and " Fabrics, Printing on.")

Bleaching Blue-prints.—Instructions are given under " Drawings Made from Photographs."

BLURRING

In a photographic image, the absence of sharp or crisp definition, a point of light becoming a nebulous circle, and a fine line a hazy broad band. Blurring may result from several independent causes. A large working aperture of the lens may be necessitated by the nature of the subject demanding a rapid exposure, and the difference in the various planes of the subject may result in some being out of focus, and consequently blurred. Or occasionally, the entire image may be out of focus, either by accident or design. Many lenses, when used at full aperture, will not give sharp definition over the entire plate, and while the central part is crisp and well defined, the corners are blurred. Or the camera may move during the exposure, with the result that the whole image is blurred. Or, again, in photographing moving objects, the exposure may not be sufficiently short to prevent the object showing movement on the plate. A lens that has been tampered with and put together incorrectly, may give a blurred effect.

BOLOMETER (Fr., *Bolomètre* ; Ger., *Bolometer*)

Practically an extremely sensitive thermometer formed of one, two, or four metallic grids or gratings so connected as to form a Wheatstone bridge, and carrying a very sensitive galvanometer mirror. It is used to measure extremely small differences in temperature (0·0000001° C.). S. P. Langley utilised this instrument in conjunction with a series of rocksalt lenses and prisms, and received the deflected light from the galvanometer mirror on a strip of bromide paper. Thus he was able to measure further into the infra-red and map out the absorption lines with remarkable accuracy.

BOLTING CLOTH (Fr., *Etamine* ; Ger., *Beuteltuch*)

A material of fine regular texture, originally made for bolting or sifting flour ; known also as bolting silk and silk bolting cloth. It is used for obtaining softness of definition in a print. For use when enlarging upon bromide paper, a piece of the cloth, slightly larger than the enlargement to be made, is stretched free from creases on a light wooden frame. This is interposed

between the enlarging lantern and the sensitive paper. It may be tacked over and in actual contact with the paper, but in this case the grain of the fabric shows as a canvas effect in the enlargement; it is more often used away from the paper, the greater the distance the greater being the diffusion obtained and the less marked being the grain. Different effects are obtainable by moving the bolting cloth during exposure, also by giving part of the exposure with the cloth and the remainder without. The interposition of the cloth increases the exposure by about one-third, but this largely depends upon the effect desired.

In contact printing, the bolting cloth is placed in between the negative and the printing paper.

The cloth may be obtained in various degrees of texture and in sheets up to 39 in. by 36 in. It must be carefully handled, as it is easily damaged, and any tear shows upon the finished print. In the hands of an artistic worker bolting cloth is a useful device for obtaining soft pictures.

BOLTON, W. B.

Born 1848; died 1899. Editor of the *British Journal of Photography* from 1879 to 1885. An authority on photographic emulsions; published in September, 1864 (with B. J. Sayce), a formula for collodio-bromide emulsion, and in January, 1874, particulars of a washed collodion emulsion process, this amounting to an almost revolutionary improvement on the unwashed collodion process.

BONE BLACK (Fr., *Noir animal;* Ger., *Knochenfohle*)

The product formed in the retort by heating bones in the absence of air; animal charcoal. It contains about 10 per cent. of carbon and about 80 per cent. of calcium phosphate, the remainder being calcium carbonate and other substances. Used in photography as a pigment in carbon and like processes, also in plate backings and black varnish. Ivory black prepared from ivory chips is a similar but superior pigment.

BOOK CAMERA (Fr., *Chambre à livre;* Ger., *Buchkamera*)

An early form of detective camera, made to

Book Camera

resemble either a book, as shown, or several books strapped together.

BOOKS OF KINEMATOGRAPH PICTURES

(*See* " Kinematograph Pictures in Book Form.")

BORACIC ACID

Another name for boric acid (*which see*).

BORAX (Fr. and Ger., *Borax*)

The common name for sodium borate (*which see*). Also known as sodium biborate or pyroborate.

BORAX TONING

A certain and reliable method of toning sensitised albumenised paper and some forms of plain salted paper prepared and sensitised by the worker. It is not very satisfactory as a toning bath for gelatino-chloride of silver emulsion papers that is, for the modern printing-out paper. A good formula is :—

Borax	. . .	80 grs.	23 g.
Gold chloride .	. .	1 gr.	·28 ,,
Water	. . .	8 oz.	1,000 ccs.

The borax should be dissolved in boiling water, and when the solution is cool the gold should be added. The prints must be washed well before toning, and when the desired tone is obtained they should be rinsed in two or three changes of water and then fixed in the usual manner.

BORDER PRINTING

This is an alternative to mounting a print. A sheet of paper and a printing frame, both larger than the actual picture, are used, and by masking the negative the print appears in its first stage with a plain margin. Masks are next used to cover the picture itself, and also the plain margin with the exception of an edge all round the print. A second exposure then gives a narrow border to the picture. This method may be elaborated almost indefinitely, and special printing frames are made to minimise the difficulty of securing accurate registration. Used with discretion and taste, good effects may be secured by surrounding borders of varying width and tint, the great advantage being that the tone and quality of the tints are the same as in the picture itself. The great pitfall is over-elaboration, resulting in distracting attention from the picture itself. (*See* " Borders, Fancy.")

BORDERS, FANCY

These are generally made by means of special negatives (films, as a rule), which may be bought commercially in considerable variety. The subject is first printed while the margin is masked and then the border printed while the picture is masked (*see* " Border Printing "). Some of the more tasteful of these borders are effective in making picture postcards, cards with Christmas greetings, and so on. When a small subject is used, on a postcard, for example, a well printed border of good design and tone is preferable to a bare expanse of white. At the same time, however, a picture of real value will practically never gain in effectiveness by such an addition, and the suitability or otherwise of a fancy border for the purpose in hand needs careful consideration.

BORIC ACID (Fr., *Acide borique ;* Ger., *Borsäure*)

Synonym, boracic acid. H_3BO_3. Molecular weight, 62. Occurs in shining scales or amorphous powder. It is used in pyro developers as a restrainer and to prevent stains, and also in the fixing bath as a stain preventer. A solution of 30 grs. of the acid in 1 oz. of water has been recommended for stopping development instantly. In cases of very great over-exposure it works well as a restrainer, the proportions being 3 drops of a saturated solution added to each working ounce of developer. A formula for a pyro-hydroquinone developer containing boric acid is given under the heading " Developers, Mixed." As a preservative, 10 grs. may be added to each pint of developer, and it will then also act as a restrainer. In a fixing bath it may be added in the proportion of 70 grs. to each ounce of dry " hypo " used, but should not be used after an acid developer. It was at one time recommended as an addition to the combined toning and fixing bath, but it is next to useless employed in that way, and may possibly harm the prints. However, Eder recommends its addition to the " hypo " bath when used before toning. (*See* " Toning after Fixing.")

BOTTLES (Fr., *Bouteilles, Flacons ;* Ger., *Flaschen*)

Narrow-mouthed bottles A are best for liquids, and wide-mouthed ones, B and C, for solids. Those with flat-topped stoppers are preferable, it being then less easy for dust to collect in the space between the neck and the stopper. A useful and neat type of bottle has a space for a label ground on its side, on which the name of the substance may be written in pencil, or with waterproof Indian ink. Corrosive and volatile substances and solutions, and deliquescent or moisture-absorbing chemicals require to be kept in bottles provided with well-ground stoppers. The stoppers of acid bottles should be rubbed round with vaseline, which renders them perfectly air-tight and prevents them from sticking ; the same may be done to the stoppers of bottles containing caustic alkalis or carbonates, which have a slightly corrosive action on glass. Hydrofluoric acid, which attacks glass, must be kept in a guttapercha or lead bottle. Dark or orange-

A. Narrow-mouth Bottle　　　B and C. Wide-mouth Bottles

coloured bottles are used for substances that are deteriorated by light. Corked bottles are not recommended for photographic purposes, except for chemicals that will keep well and are not in frequent use. They may be rendered air-tight by melting wax over the cork and round the

neck. A convenient way of doing this is to hold a lighted candle above the cork, allowing the melted wax to run all over and around it. (For special bottles of various kinds, as collodion bottles, dropping bottles, etc., *see* under separate headings.)

BOX, LANTERN-SLIDE (Fr., *Boîte aux épreuves pour projections ;* Ger., *Laternbilderkasten, Diapositivkasten*)

A long wooden or metal box with a hinged lid, grooved for the storage of lantern slides. The ordinary pattern resembles a grooved negative box, but some workers prefer plain boxes without grooves, and for storage purposes only these are sometimes of greater convenience, since a number of slides can more readily be

Lantern-slide Box

inserted or removed at once ; however, for reference or indexing requirements the grooved type is preferable. Travelling lantern - slide boxes are designed with a view to the prevention of breakage ; the example shown is fitted with a rubber buffer at top and bottom to stop any movement of the slides, and has strong brass end fasteners and leather straps. The lid is furnished with pegs fitting closely into holes in the top edges of the box.

BOX, NEGATIVE (Fr., *Boîte aux clichés ;* Ger., *Negativenkasten*)

A box, usually either of wood or metal, for the storage of negatives. The ordinary grooved wooden type is shown at A, but there are several other patterns. In one B there is a grooved drawer sliding in an outer case, and this offers the advantage that any given negative can be examined without disturbing other boxes above,

A. Grooved Box for Negatives

and possibly without even needing to remove the drawer. Either single drawers, which can be added to as desired, or drawer cabinets may be obtained. Another type of negative box has an outer shell made like a book with a label to indicate the contents, and having an inner grooved case that slips into it from the back.

Grooved metal boxes are also made, with slip-on lids. One pattern is an adaptation of the card index and vertical filing system, the negatives being kept in numbered envelopes, on which

B. Negative Box with Grooved Drawer

full particulars can be written, and an index card is also provided. Guide cards may be used to divide or subdivide the negatives, and as there are no grooves a good deal of space is saved.

BOX, PLATE (Fr., *Boîte aux plaques* ; Ger., *Plattenkasten*)

A light-tight wooden or metal box, usually grooved, for the safe custody of unexposed or undeveloped plates. Such boxes are made in various patterns. Some resemble grooved negative boxes, but are more carefully constructed, with a deeper lid and rebate. Others A have an outer sliding lid, together with an inner lid furnished with a spring, which keeps it pressed

A. Wooden Plate Box with Double Lid

B. Metal Plate Box with Slip-on Lid

tightly down over the plates when the outer lid is in position. Metal boxes with slip-on lids and spring clips fastening over the latter B are also obtainable.

BOX-FORM CAMERA (Fr., *Détective* ; Ger., *Kasten-Kamera*)

A non-folding hand camera in the shape of a box. It is generally of fixed focus, though sometimes there is a focusing adjustment. The majority of box-form hand cameras have a magazine to hold a number of plates in sheaths ; or provision is made for carrying roll films, or a pack of flat films. (*See* " Hand Camera.")

BOUDOIR

A commercial size and style of mount largely used by professional photographers. The average size of a boudoir print is 8 in. by 5 in.—that is, a trimmed whole plate, and the mount may measure anything from 8½ in. by 5½ in. upwards. Boudoir midget mounts measure about 3¾ in. by 2 in.

B.P.

The initial letters of the words " British Pharmacopœia," which is an official catalogue, published from time to time by the General Medical Council, giving the standards of purity of drugs, etc. The Pharmacopœias of different countries vary slightly. The initials, when found in a formula, mean simply that the chemical named should be of the standard strength and purity.

BRASS, BLACKENING

Recipes for dead blacks for application to brass are given under the heading " Blackening Apparatus."

BRASS ETCHING

Brass is etched in intaglio or relief by means of ferric chloride, the same as in copper etching. The resist image is generally applied by the enamel process.

BRASSES, PHOTOGRAPHING

Memorial brasses are frequently difficult to photograph owing to their position, but unfixed brasses may be arranged so that a suitable light (preferably a side light) falls upon them. When the light or reflections are troublesome, it is a good plan to dab the brass with a rag dipped in whitening. If the camera is pointed upwards or downwards to the brass, take care to have the focusing screen—and, of course, the plate—vertical. The stop should be small and the plate should be a slow or medium one of the isochromatic variety. As a rule, rubbings from old brasses make better photographs than the brasses themselves.

BREATH PRINTING (Fr., *Impression à l'haleine* ; Ger., *Atemkopieren*)

A curious process, due to Sir John Herschel, by which invisible, or latent, photographs may be produced, capable of development by the breath or by a moist atmosphere. A solution of silver nitrate (sp. g. 1·200) is added to ferro-tartaric acid (sp. g. 1·023), a precipitate falling which is nearly redissolved by a gentle heat. A yellow liquid is thus obtained in which the further addition of silver nitrate causes no turbidity. The total bulk of the silver nitrate solution used should amount to half that of the ferro-tartaric acid. Paper sensitised with this liquid, thoroughly dried in the dark, and exposed under a negative or engraving in sunshine for from thirty seconds to one minute, does not yield any visible impression unless over-exposed. To develop the latent image it is only requisite to breathe upon the paper, when a vigorous picture appears as if by magic. Or the print may be laid in a blotting-book, some of the outer leaves of which have been damped by holding them over warm water.

BRENZCATECHIN

One of the names of the developer popularly known as " Pyrocatechin " (*which see*). Known also as ortho-dihydroxybenzene, catechol, and oxyphenic acid.

BREWSTER, SIR DAVID

Born at Jedburgh, 1781 ; died at Allerly, 1868. Knighted, 1832. He made many discoveries in optics, investigated polarisation of light, invented the kaleidoscope, and in 1844 designed the Brewster stereoscope. In 1836 he visited Fox Talbot and became interested in the latter's method of producing paper negatives ; he also corresponded with Claudet, Ross, Hill, and other fathers of photography. He wrote many articles and books (about 400), several of which dealt with photography.

BRILLIANCY

A term implying that a print is bright and clear in quality. It generally accompanies a long range of tones with strong shadows and bright high lights.

BRISTOL BOARD

A fine kind of pasteboard made by pasting down successive layers of thin paper and having a smooth or glazed surface. Its thickness is indicated by the terms 6-sheet, 8-sheet, etc.

BRITISH GUM (See " Dextrine.")

BROKEN NEGATIVES

These must not be confused with cracked negatives (*which see*), as they are not treated in the same way. Broken negatives are generally understood to be those in which the film is broken as well as the glass. If the glass only is broken the film can be transferred to another piece of glass, but this method is not suitable when the film as well as the glass is broken, because of the danger of distorting or losing the pieces during the process of stripping. In many ways a mended broken negative is more satisfactory than a film that has been stripped and put on a new glass backing, and some photographers advocate the breaking of the film purposely when the glass is cracked in order that it may be treated as a broken negative. To mend a negative which has been broken into two or more pieces, take each piece and clean the edges free from dust and dirt. The largest portion is then laid upon a clean and perfectly level glass plate, and Canada balsam diluted with xylol applied to the edges very thinly with a small camel-hair brush. Xylol (or xylene) is a coal-tar product, and if it is not obtainable benzene can be used in its place. The remaining pieces of the negative are also touched all round the edges with the cement, and are then carefully joined so as to fit exactly. The addition of xylol enables one to use the balsam without heating, and as it has about the same index of refraction as glass, the internal surfaces of the glass, if correctly placed together, will no longer reflect light, and the breaks will hardly be perceptible. The surface of the film is afterwards cleaned with a piece of cotton-wool dipped in benzene. Negatives carefully mended in this way show no sign of breakage if printed slowly in the shade.

BROMEOSINE (See " Eosine.")

BROMHYDRIC ACID (See " Hydrobromic Acid.")

BROMIDES

Salts formed by the action of bromine on a metal, with the characteristic formula M_2Br.

BROMIDE EMULSION (See " Emulsion.")

BROMIDE ENLARGING (See " Enlarging.")

BROMIDE PAPER (Fr., *Papier au bromure*; Ger., *Bromsilber papier*)

Paper coated with an emulsion of silver bromide in gelatine, for contact printing and direct enlarging by natural or artificial light. It is prepared with a variety of surfaces. Made and introduced commercially about 1874, but not on a large scale until 1880. Working details are given under the heading " Bromide Process."

BROMIDE PAPER NEGATIVES

Bromide paper may be used in place of dry plates for negative making. The process is described under the heading " Paper Negatives."

BROMIDE PENCILS (Fr., *Crayons au bromure*; Ger., *Bromidpinsel*)

Black crayons used in working-up bromide enlargments and prints, platinotypes, etc. They are obtainable either in cedar pencils or as points for adjustable holders, and are sharpened by rubbing on a piece of No. 0 glasspaper. White crayons are also procurable. For a blue-black enlargement it is important not to employ a brown-black pencil, or the work will show too much ; and it should be remembered that ordinary black chalk drawing pencils have frequently a tendency to brownness.

BROMIDE PROCESS

The essential feature of the bromide process is its suitability for obtaining either contact prints or direct enlargements by artificial light, and the consequent facilities that it gives for securing any desired result with absolute certainty. If a print is produced which is not exactly in accordance with the result desired, a second exposure may be made while all the conditions remain absolutely constant, and the time of exposure may be so modified that the second print will give exactly the effect desired. In adopting the bromide process, the following conditions are desirable. A light that can be kept as uniform as possible, a means of fixing the relative positions of light and printing frame so that the distance between them is always the same, and the exclusive use of one brand of bromide paper. The distance between the light and frame should be so adjusted that exposures will vary from ten seconds for a moderately thin negative up to forty or fifty for a strong or dense plate. It is impossible to work accurately if exposures are as short as two or three seconds ; such exposures cannot be timed with certainty, whereas longer exposures can be timed with an inappreciable percentage of error. Correctness of exposure is absolutely essential in bromide

printing if good results are desired; there is no more fruitful source of imperfect prints than incorrect exposure, and the consequent attempts to compensate by incomplete or forced development. A perfect bromide print is one that has been so exposed that full development with a normal solution will give the contrast and depth required. In order to expose a print in this manner, it will be found desirable to make a preliminary trial exposure on a small slip of paper, selecting a portion of the plate that has part of the densest tones. An ordinary piece of paper may be cut into six or eight trial slips, and several may be exposed on different negatives and developed together. The development of these trial slips should be full, in order that the correctness of the exposure may be judged from the final appearance when in the fixing bath.

Another prolific source of loss of quality in bromide work is the system of using one portion of developer for several prints in succession. The prints last developed are inferior in colour and general quality, and if toning is afterwards performed, the colour is very poor and weak. For prints of moderate size, sufficient developer should be taken for one print, the solution used once and then thrown away. For small prints this is also the preferable plan, but as the quantity of solution necessary is much larger relative to the size of the print, it may be permissible to use the same solution for two prints in succession, or, better, to develop two prints together. But this should be the limit.

Where practicable, as in the case of an incandescent electric light or an inverted incandescent gas burner, the frame should be placed horizontally below the light for making the exposure. It will facilitate shielding parts of the negative during the exposure, and also the making of the exposure by uncovering and recovering the frame, using a sheet of card.

Diamidophenol and amidol are good developers for bromide prints, but they cannot be kept in solution satisfactorily for more than three days. The seriousness of this objection is realised when only two or three small prints are required, and then no more wanted for perhaps a week. Amidol is, however, a favourite with many workers, on account of the fine blue-black colour of the prints produced with it. Ortol is also a good developer for bromide paper, and it keeps for a long time in solution. Metol and hydroquinone form a developer that is a favourite with many workers, as it keeps well in solution. Excellent formulæ are as follow :—

Diamidophenol Developer for Bromide Paper

Diamidophenol (or amidol)	16 grs.	4·4 g.
Sodium sulphite .	160 ,,	44 ,,
Potassium bromide	4 ,,	1·1 ,,
Water . . .	8 oz.	1,000 ccs.

The sodium sulphite must be dissolved in the water first. This solution is used without dilution.

Ortol Developer for Bromide Paper

A. Ortol . .	4 drms.	54 g.	
Potass metabisulphite	2 ,,	27 ,,	
Potassium bromide	1 ,,	13·5 ,,	
Water . .	10 oz.	1,000 ccs.	

The potassium metabisulphite must be dissolved in the water first.

B. Sodium carbonate .	2 oz.	218 g.	
Sodium sulphite .	2 ,,	218 ,,	
Water . .	10 ,,	1,000 ccs.	

To develop, take 40 minims of A, 80 minims of B, and add sufficient water to make 1 oz.

Metol-Hydroquinone for Bromide Paper

A. Metol . . .	10 grs.	2·3 g.	
Sodium sulphite .	120 ,,	27 ,,	
Hydroquinone .	30 ,,	7 ,,	
Potassium bromide	10 ,,	2·3 ,,	
Water . .	10 oz.	1,000 ccs.	

Dissolve the constituents in the order given in the formula.

B. Sodium carbonate .	$\frac{1}{2}$ oz.	55 g.	
Sodium sulphite .	$\frac{1}{4}$,,	27·5 ,,	
Water . .	10 ,,	1,000 ccs.	

Mix equal parts of A and B to form the working developer.

All these formulæ produce rich prints of a good, pure colour, which will tone quite satisfactorily. Full development will take about three minutes with the diamidophenol and metol-hydroquinone formulæ, and four minutes with the ortol. The print should be soaked in water for about half a minute, the water then drained off, and the developer flowed evenly over the surface, the dish being rocked until development is completed. Then the print should be rinsed and immersed in the fixing bath, taking care that the prints do not cling together and that the solution has free access to their surfaces. An acid fixing bath is preferable, containing 1 oz. of potassium metabisulphite to 1 lb. of " hypo," the solution being so mixed that 1 pint should contain 3 oz. of " hypo." The prints should remain in the fixing bath for fifteen minutes, and should afterwards be thoroughly washed. From one to two hours, in water frequently changed, according to the frequency of the changes, and the number of prints in the dish, should be sufficient.

Daylight can also be used for bromide work if desired, and many prefer it for enlarging purposes, though it is not suitable for contact printing. (*See also* " Enlarging.")

BROMIDE OF URANIUM PLATES

Plates coated with a silver bromide collodion emulsion containing a small quantity of uranium nitrate to keep it free from fog; these plates are now obsolete.

BROMINE (Fr., *Brome* ; Ger., *Brom*)

Br. Molecular weight, 80. Solubilities, 1 in 28 water, very soluble in alcohol, ether, and solutions of alkaline bromides. A deep reddish brown liquid giving off at normal temperatures an extremely irritating orange vapour. It is rarely used in photography except in its salts, though bromine water has been suggested for bleaching bromide prints prior to sepia toning.

BROMINE WATER (Fr., *Eau bromée* ; Ger., *Bromwasser*)

An orange-yellow solution, formed by shaking bromine with water and decanting from the excess which settles at the bottom of the bottle.

BROMISED COLLODION, OR BROMO-IODISED COLLODION (See "Collodion.")

BROMISER

A solution of alkaline or metallic bromides usually kept in a separate solution and added to collodion just before coating the plate therewith. (See "Collodion, Wet.")

BROMO-ARGENTOTYPE

An obsolete name for bromide paper.

BROMOIL PROCESS

A process of obtaining pictures by bleaching and pigmenting bromide prints; suggested by E. J. Wall in 1907. Working details were first published by C. Welborne Piper in August of the same year, and the modified process, as now worked, was introduced in the following month.

Prints for the ordinary oil-pigment process (*which see*) are made by contact, and as the pigment process is generally more suitable for prints of fairly large size it follows that users of small plates must make an enlarged negative before they can produce an ordinary oil print. It was to obviate this that the bromoil process was devised. Essentially, it is a means by which a bromide print (which, of course, may be an enlargement from a small negative) can be prepared for pigmenting. Special bromide papers for this purpose are obtainable, although many of the ordinary brands are equally suitable. The print should not be too old, and it should possess certain qualities. A flat print, or one whose development has been curtailed, will seldom give a satisfactory result. The exposure should be so adjusted that when the developing action has been carried to its fullest extent the result is a clean, strong print, rather more vigorous than would be desirable if it were intended to remain unaltered. Amidol is a good developer for the purpose, a suitable form being 50 grs. of dry amidol added to 20 oz. of water in which 1 oz. of sodium sulphite has been dissolved. The print is fixed in plain "hypo" solution, and very thoroughly washed. At this stage the prints may preferably be dried. Subsequently they are re-soaked for a few minutes to facilitate the even action of a bleaching solution. A suggested formula is:—

Citric acid	.	. 120 grs.	12·5 g.
Potassium bromide	. 120 „	12·5 „	
Potassium ferricyanide	120 „	12·5 „	
Potassium bichromate	240 „	25 „	
Alum	.	. 480 „	50 „
Water to	.	. 20 oz.	1,000 ccs.

Dissolve in the order given. It is well to crush the crystals, dissolve in hot water, and use when cold. This is applied to each print separately until the black image is entirely changed to a yellowish brown colour. The prints are then washed until the bichromate stain is removed, and they are then placed for about five minutes in a bath containing 1 oz. pure sulphuric acid to 20 oz. of water. This is prepared by adding the acid slowly to the water, and as considerable heat is generated it should be made some time before use, or blistering of the print will result.

After a short washing, the prints require five minutes' immersion in a solution of 2 oz. of "hypo" crystals and ½ oz. of sodium sulphite in 20 oz. of water. A further washing to eliminate most of the "hypo" brings the prints to the stage where pigmenting may be proceeded with.

There are many variations of the routine of preparing the print. For example, many workers prefer to dry the prints again, and re-soak them for pigmenting. Others omit the acid bath from the preliminary stage, and use it immediately before this second soaking instead. When the prints are only soaked in water before pigmenting it is generally advisable to see that the temperature of the water is at least 65° F. (about 18° C.) in order to secure the necessary swelling and relief in the gelatine. (For an outline of the method of finishing the prepared print by pigmenting, see the heading "Pigmenting.")

A modification of the bromoil process has been made for the preparation of lithographic transfers, especially in large sizes for poster work. The bromide paper used should be the so-called "carbon" or velvet surface, and should be of a good substance. An enlargement of a half-tone negative is made on to the paper, which is then developed with amidol, though some workers prefer pyro-ammonia. The print is fixed and washed as usual. It is next bleached in the usual bromoil bleaching solution at a temperature of 75° F. (about 24° C.) for two minutes; soaked in a 5 per cent. solution of sulphuric acid for six minutes; washed in several changes of water for five minutes; fixed in "hypo" or toned with sodium sulphide for one minute; washed in water for five minutes; and dried thoroughly. It is inked all over with a composition roller charged with lithographic printing ink thinned with turpentine, until a thin even coating is laid upon the surface; five minutes or so is allowed for the turpentine to evaporate completely, and the print is then immersed in water at about 70° F. (about 21° C.), and after soaking for about half an hour the transfer may be developed in exactly the same way as an ordinary bichromated gelatine transfer.

BROMO-IODIDE OF SILVER (See "Silver Bromide.")

BRONZED PRINTS

Prints on certain makes of papers which have a metallic appearance when held at a suitable angle. The effect occurs chiefly upon self-toning papers and sometimes upon platinum prints, more particularly when the print has been over-exposed or made from a negative having very clear shadows. The more sensitive the paper the more likely are the deep shadows to be bronzed. Bronzed shadows may be eliminated usually by applying a print varnish, or rubbing with wax or encaustic paste.

BROWN TONES (See "Sulphide Toning," etc.)

BRUSH DEVELOPMENT

The development of negatives, bromide prints and platinum prints by applying a suitable developer by means of a brush instead of immersing in the developer. For negatives the slower-

working developers, such as pyro, are more suitable than the rapid kinds, such as rodinal, metol, etc. It is usual to soak the plate in a very weak developer until the image just begins to show, and then to rinse in water and apply the weak developer, or even a normal developer, by means of a camel-hair mop, giving the partially developed negative repeated rinses in water in order that there may be no distinct line of demarcation. Where a sharp line is wanted, glycerine may be mixed with the developer. The brush method enables parts of the negative to be subdued or accentuated in a wonderful manner. The process is perhaps of the greatest service in portrait work where white dresses are likely to give undesired effects. It is more widely used in the United States than in England, and R. W. Phillips, an American, recommends the following method of brush development for portrait work; a three-solution pyro-soda formula is used: A. Water 20 oz., sodium sulphite ½ oz.; when dissolved add enough pure acetic acid to turn blue litmus paper red, then add 1 oz. of pyro. B. Water 16 oz., sodium sulphite 4 oz. C. Water 16 oz., sodium carbonate 4 oz. To make a normal developer add 1 oz. of each of the three solutions to 8 oz. of water. For brush development two working solutions are made up, one the normal developer given above, the other being the same, except that the carbonate is omitted. Then use a separate solution of one-half carbonate and one-half water, or two-thirds carbonate and one-third water, whichever is found to suit the strength of the negative desired. In the case of a plate exposed on a sitter in white drapery, develop until the image shows faintly, then pour off this regular developer and wash the plate. Next pour on the pyro and sulphite solution previously made up, hold the negative horizontally up to the light in the hand, and with a camel-hair mop saturated with the carbonate solution rub over that portion of the negative which is to appear the most prominently. This must be done the first time very quickly, putting the negative back into the solution immediately. The operation is then repeated, the carbonate being well blended over the plate so as not to show streaks and defined lines.

The principle involved is this: the negative is developed only to a slight extent in the first immersion, and as soon as the pyro and sulphite solution is poured on development practically ceases. Then the high lights are controlled absolutely with the carbonate solution. Some little practice is necessary in order to get a perfect result. Over-exposed negatives are unsuitable for brush development, the control being so difficult.

It is found rather difficult to carry out delicate work of this character in the dark-room, and there is a very serious risk of exposing the plate too freely to the light, and so producing fog and loss of quality.

In bromide printing, brush development is very frequently adopted for large prints. A smaller quantity of developing solution can be employed than most workers could use satisfactorily in a dish, though the results produced by the brush method are almost always inferior in richness and quality to those obtained in the ordinary manner. The print is thoroughly wetted, so that it will lie perfectly flat on a sheet of glass, and the developing solution brushed rapidly over its entire surface in the manner described under the heading " Brush Toning "

Platinotype prints may be developed with a brush if glycerine is mixed with the developer. (*See* " Platinotype Process.")

BRUSH TONING

A method of toning in which the solution is applied by means of a brush. This method is occasionally adopted for large prints. A concentrated solution is employed and the print, after washing, is laid on a sheet of glass and the solution rapidly brushed over its entire surface. It is desirable to cover the print with the toning solution as quickly as possible, and each stroke of the brush must slightly overlap the part wetted by the preceding stroke ; also, no part of the print must be left uncovered in the first application, or uneven toning will result. The brush strokes are first made along the print, then across, and then diagonally, continuing the work until the toning is completed.

Prints, particularly those on bromide paper, can be brush-toned to two or more colours. The method is widely used for the rapid toning of ordinary gelatine or collodion P.O.P., and almost every formula can be adapted, but the following is considered to be the most suitable. Four stock solutions are necessary :—

No. 1. Ammonium sulphocyanide 1 oz., water to 9 oz.
No. 2. Sodium phosphate 1 oz., water to 9 oz.
No. 3. Saturated solution of borax.
No. 4. Gold chloride solution 1 gr. to 1 drm.

To make up a working mixture take 14 minims of No. 1 and make up to 1 drm. with water ; then add 12 drops of No. 4 very slowly, shaking the mixture after each drop is added. Then add 6 minims of No. 2, and finally 16 minims of No. 3. Each ounce of the working solution referred to above contains practically 7 grs. of sulphocyanide, 1 gr. of gold chloride, 5 grs. of phosphate, and 7 grs. of borax, and the bath, if desired, may be made up by adding these quantities to each ounce of water used. By this method, the print exactly as it comes from the printing frame, is placed on a sheet of glass or pinned to a board, and the working solution brushed quickly and evenly over it with a camel-hair mop. Toning should be complete in about two minutes, after which it is washed and fixed as usual.

Great care should be taken not to expose the print to a strong light during the process of toning as otherwise there will be a risk of discolouring the whites.

BRUSHES (Fr., *Brosses;* Ger., *Pinsel*)

The most suitable brushes for mounting, colouring, and other photographic operations will be found described under their respective headings. The two brushes (always home-made) most widely used in the dark-room are the Blanchard and the Buckle brushes. The Blanchard brush A is made by taking a strip of glass about 6 in. long and 2 in. wide, and attaching to one end one or two thicknesses of swan's-down

calico, wrapping it round the end and fastening by means of an elastic band or thread. The Buckle brush B is made by drawing some cotton-wool, by means of a loop of silver wire or strong thread, partially through a glass tube, so that a tuft protrudes. Both these brushes are con-

A. Blanchard Brush

B. Buckle Brush

venient instruments for all kinds of photographic uses, as either the cotton-wool or the swan's-down may easily be renewed. The Blanchard brush is mostly used for applying sensitising solutions.

The Atzpinsel (*which see*) is a special brush used by process workers.

BUBBLES IN LENSES

Small bubbles (or air-bells) are occasionally seen in even the best of photographic lenses, but generally they are no detriment. Their presence, even under the most unfavourable conditions, does not occasion a loss of light exceeding $\frac{1}{50}$ per cent., and their influence upon the optical efficiency of a lens system is therefore of no moment whatsoever. The efforts of opticians during recent years to improve lenses in their higher optical characteristics have led to more extended use of glasses that differ widely in their optical properties and chemical composition from the crown and flint glass hitherto employed, and still used for commoner lenses. Their manufacture is attended by greater technical difficulties, and it is no easy matter to secure perfect freedom from air bubbles.

BUBBLES ON PLATES AND PAPERS

Bubbles or air-bells frequently form on plates and papers during development, and they have the effect of preventing the developer acting on the spots covered by them. The result is clear glass spots upon the negative or white spots upon developed prints. Bubbles invariably arise from stale or frequently used developer, particularly pyro, or they are caused by a careless and uneven flowing of the solution over the surface to be developed. Soaking the sensitive material in water previous to development also causes bubbles to form on the film. A huge crop of tiny clear spots—the result of bubbles—of an irregular form and appearing mostly at or near the edges of the negative, is generally due to an old or oxidised developer, or to one that has been allowed to stand even for a short time after mixing. Larger, round spots are caused by bubbles which attach themselves firmly to the sensitive surface during a preliminary soaking in

water, or when the developer is poured on rashly and unevenly. Spots with small black centres are also caused by bubbles; these form during development and cause the gelatine under them to be harder than the developed portions, and therefore slower in fixing, the result being the small specks of unfixed silver bromide in the centres of the spots. The methods of preventing bubbles are obvious. The plate or paper should not be soaked in water before the developer is applied; the developer should be freshly mixed, and poured on to the sensitive surface in an even sweep, first along one edge, and the dish then tilted so as to cover the surface as quickly as possible; the dish should be rocked slowly and regularly, and not violently and in sudden jerks. Many workers pass a clean broad camel-hair brush, a pad of cotton-wool, or a Buckle brush over the film as soon as the developer is poured on, so as to break up and remove any possible bubbles; the brush must, however, be quite clean and soft, or the remedy will be worse than the disease.

BULLETS IN FLIGHT, PHOTOGRAPHING

The first attempt to photograph a projectile in flight is said to have been made at Woolwich Arsenal in 1860. Owing to the slow wet-plate process used, the results were unsatisfactory. In 1884 some experiments were made at Prague by Mach and Wentzel which were far more successful; these were on the lines described below. In 1887 an improvement on the Prague results was made by Drs. Salcher and Riegler, of Fiume.

Probably the most important experiments in the photography of flying bullets were those published in 1892 by Prof. C. V. Boys, a full account of which will be found in the *Journal* of the Royal Photographic Society (April 30, 1892). His procedure was partly suggested by Lord Rayleigh's methods of obtaining photographs of drops, breaking soap bubbles, etc., which were taken by the light of an electric spark. The following description of the two chief methods employed by Prof. Boys are due to the above-mentioned publication.

The first is shown diagrammatically at A. J is a fulminating pane or condenser of small capacity, which may be charged on its two sides respectively, positively + and negatively —, by means of any kind of frictional or induction machine. This pane is allowed to discharge through a very short circuit in which are two gaps $s\,s^1$. The spark at s is allowed to shine on the photographic plate P without the intervention of lenses of any kind. The spark at s^1 is hidden. A second condenser, the jar j (of very small capacity compared with the pane J), is connected to J, one coating by means of wire, as shown by the full lines, and the other by means of a string wetted with a solution of calcium chloride, as indicated by the dotted line. Its coatings, therefore, till the time of discharge arrives, are kept at the same potentials as those of the pane J. The discharge circuit of j includes the gaps s^1 and n. The potential is so chosen that neither condenser is able to discharge across the two gaps $s\,s^1$ or $n\,s^1$ as the case may be, but that either would go off if either of its gaps were

made conducting. This is effected by the passage of the bullet across n, which immediately causes a feeble spark at s^1, due to the discharge there of j. The air here, being now conducting, no longer prevents the pane J from discharging across the gap s, and therefore a spark is produced which casts upon the photographic plate a shadow of the bullet, and in effect an image of any atmospheric phenomena accompanying the bullet. The difficulty in photographing bullets is to obtain a spark which, while it is bright enough to act on the plate, is yet of such short duration that the bullet has not time to move more than a hundredth of an inch or less while it is yet in existence. If glass lenses are used a large proportion of the actinic rays are absorbed (in the case of a spark between magnesium terminals, four-fifths of the whole); but in the case of a true image any spark formed by the bullet at

where difficulty might arise in closing the gap n. In the first arrangement the gap n must be more perfectly closed than is the small space s, in order to make the action of what may be called the " spark relay " certain. By the introduction of a second pane or jar (see B) J^2 in series with J^1, the potential of the little jar j may be made $n + I$ times that of J^1 if the capacity of J^2 is $\frac{I}{n}$ that of J^1. In the discharge, only J^1 is affected, so it will be necessary to discharge J^2 also before beginning a new experiment.

The above sufficiently indicates the principle of the electrical arrangements. With regard to the practical details, the apparatus mostly used consisted of a box lined with black cloth, in which the photographic plate was placed. The large condenser was a plate of glass about a foot square, and the small condenser was a jar or bottle to act as a starter for the spark. The bullet enters and leaves the box by two holes covered with paper to exclude the light, and in passing in front of the plate it touches the terminals of two thin lead wires, thus completing the circuit and causing two flashes—a small one which does not affect the photographic plate, and a larger one which does affect the plate, and has a duration of less than one-millionth of a second.

BULL'S-EYE CONDENSER

A plano-convex (almost hemispherical) lens, mounted upon a stand and fitted with a universal joint. It is used in microscopy to focus the light upon the object, or upon the substage mirror,

Bull's-eye Condenser

A. Arrangement for Photographing Bullet in Flight

B. Modification of of Method A for Photographing Bullet

n is properly focused by the camera lens, and does not much interfere with the result. If lenses are not used the whole of the rays (except such as may be absorbed by the air) are effective, but any spark at n, being near the plate, would fog it so completely as to make the more distant spark at s almost, if not quite, inoperative. This difficulty is completely avoided by the use of the jar j, of very small capacity, which is unable to produce a spark of any appreciable photographic effect. Moreover, the spark at s is brighter, and should last less time when a very short discharge circuit is employed than the corresponding spark produced in the discharge through a greater length of wire, such, for instance, as would be necessary if the main discharge were taken to the bullet and back.

The second method is a modification of the first, and was arranged to meet those cases

and is almost indispensable when examining or photographing opaque objects. Also it is useful for improving the illumination of transparent specimens.

BURETTE

An apparatus used in volumetric analysis to deliver accurately measured quantities of liquids. It consists of a glass tube of uniform bore, graduated, and usually fitted with a stop-cock at the bottom from which any desired quantity of a liquid can be allowed to flow from the tube. A modified form working after the manner of a fountain-pen filler is used for measuring small quantities of photographic solutions.

BURGUNDY PITCH (Fr., *Poix blanche de Bourgogne*; Ger., *Burgunderpech*)

The resin of *Abies* or *Pinus excelsa*, the spruce fir, purified by melting in hot water and

straining. True Burgundy pitch is not easy to obtain, and a fictitious article is often sold for it. The true resin is translucent and has a dull yellowish brown colour, and the fracture is shining and conchoidal ; some examples contain much water, and are opaque and of a dull grey colour ; they require straining to free them from impurities. The odour is peculiarly aromatic and characteristic. It is not wholly soluble in alcohol of ·838, a little flocculent white matter being left ; much the same happens if placed in contact in a vial with twice its weight of glacial acetic acid. It is very soluble in acetone. The false Burgundy pitch is usually brighter in colour than the true, with a weak, scarcely aromatic odour ; it is less soluble in alcohol, and in glacial acetic acid it forms a turbid mixture separating into two layers, a thick, oily liquid above and a bright solution below. Burgundy pitch is used in process work in the preparation of photo transfer inks. In solution with spirit of wine it forms an excellent aquatint etching ground.

BURNETT'S PRINTING PROCESS

One of the many printing processes employing uranium ; invented by Burnett in 1857.

BURNISHER (Fr., *Presse à satiner à chaud ;* Ger., *Heisssatinirmaschine*)

A machine for imparting a glossy surface to prints by pressure and friction against a heated and polished bar or roller. The bar burnisher A —the older type—has a polished steel or nickelled

A. Bar Burnisher

bar and merely a single roller ; while the roller burnisher—or, as it is sometimes called, " enameller " B—has two rollers, one or both being of polished nickel. The bar burnisher is said to give the better gloss, but has the disadvantage that the prints need lubricating, and they occasionally get scratched. Both kinds are heated by spirit or gas, or with hollow rollers steam is sometimes employed. Rolling presses, properly so-called, have a large flat steel plate and a single polished roller, and are used either with or without heat.

Burnishers of agate or other stone have had in the past a few photographic uses. (*See* " Agate Burnisher.")

BURNISHING (Fr., *Satinage ;* Ger., *Satiniren*)

The method of obtaining a glossy surface on P.O.P. and albumenised prints by drawing them through a heated burnisher. For P.O.P the bar or roller of the burnisher should be just too hot to be touched with the finger, and for albumenised prints a trifle hotter, but excessive heat

must be avoided. The prints should not be quite bone dry, and if kept too long they do not burnish so well. On the other hand, they must not be damp, or they may blister and stick to the bar or roller.

When a bar burnisher is used, the prints will require, before burnishing, to be lubricated by rubbing with a mixture consisting of 4 grs. of castile soap dissolved in 1 oz. of alcohol, applied with a tuft of cotton-wool. To dissolve the soap, the bottle containing the mixture is placed in hot water. The print is passed through the burnisher face downward, pulling it upward in a slightly curved direction from the back as it goes through. This is done three or four times. When the print is passed through flat, without pulling it, whether in a burnisher or a rolling press, hot or cold, the operation is known as " rolling " ; but this term is frequently applied indiscriminately to burnishing also.

With a roller burnisher, a lubricant is not required. Solid rollers take some time to get hot and require to be rubbed lengthwise with a soft cloth until heated, meanwhile revolving the roller backwards ; this is to prevent the deposition of condensed moisture from the air, due to the lower part of the machine getting warm first, while the roller is still cold ; this moisture, if allowed to settle and dry on, would make the roller dull and streaky, and might cause rust.

The more modern burnishers have a hollow roller with the gas burners inside it ; this gets hot in a much shorter time, and the heat is also

B. Enameller or Roller Burnisher

more even. A screw adjustment is usually provided for regulating the distance between the rollers, bar burnishers having instead nuts under the plate, or some similar arrangement. Should the steel bar of a bar burnisher become scratched it should be rubbed carefully with a slip of fine oilstone having a little sweet oil on it, until uniformly smooth and bright. The oilstone should be held flat on the bar and drawn from end to end only, not across. Nickelled rollers are difficult to repolish satisfactorily when worn, and generally require sending to be replated.

BURNT-IN PHOTOGRAPHS (*See* " Ceramic Photography.")

BURTON, W. K.

Born in Scotland, 1853 ; died at Tokio, Japan, 1899. Author and experimentalist ; first became prominent in the early 'eighties as an authority on the theory and practice of emulsion making. Burton was an engineer by profession, and early in 1887 left for Tokio, where, at the Imperial

College, he was appointed to a professorship. He compiled an exposure table and published an "A B C of Photography."

BUTTONHOLE, OR VEST, CAMERA (Fr., *Chambre à boutonnière* ; Ger., *Knopfloch-Kamera*)

A small detective camera of circular form, somewhat like a large watch, and worn under

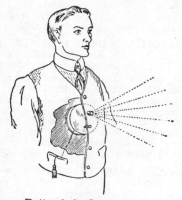

Button-hole Camera

the vest, as shown in the illustration. The lens protruded through a buttonhole. Six round pictures about the size of a penny were taken in succession on a circular plate. The device was invented by Stirn.

BUTTONS, PHOTOGRAPHIC

Celluloid buttons containing photographs. Ordinary prints are first prepared, these being albumen, P.O.P., or bromide, and after fixing, washing, and drying, they are mounted face down with starch or gelatine on sheets of celluloid sold for the purpose. If necessary, the photographs may be mounted before they are dried. When dry the photographs are cut out with a punch or die, placed in a machine with the metal discs, and stamped into buttons. The bent pin, strut, or frame is then attached.

Gas-heated Roller and Metal Plate

Professional workers use a gas-heated roller and metal plate, as shown. The dry print is immersed in alcohol till both sides are moistened. A sheet of blotting-paper is placed on the plate, then the celluloid, next the print, face down, and finally a piece of tissue paper. The roller, sufficiently hot to sizzle when touched with water, is now passed over all, uniting the print and celluloid.

C

"C. DE V."

The abbreviated form of "carte-de-visite" (*which see*).

"CABINET" SIZE

A popular size of professional portrait, having a mount measuring $6\frac{5}{8}$ in. by $4\frac{1}{4}$ in. The actual print may be $5\frac{1}{2}$ in. by 4 in., $5\frac{3}{4}$ in. by 4 in., or 6 in. by $4\frac{1}{4}$ in., these being known in the trade as "No. 1," "No. 2," and "Special" cabinet sizes respectively. Cabinets were introduced in 1867 by F. R. Window, of Baker Street, London, who, as a professional photographer, found the then popular carte-de-visite too small for groups and for ladies' dresses, possibly crinolines, which were fashionable between 1856 and 1867.

CACHET, ROUGE ET VERT

Names once given to some French isochromatic plates, "rouge" being of medium rapidity and "vert" special rapid. A French chemist (Tailfer) was the first to make a successful isochromatic dry plate (1882). The British rights to the patent were secured in 1886 by B. J. Edwards & Co.

CADMIUM BROMIDE (Fr., *Bromure de cadmium*; Ger., *Bromcadmium*)

$CdBr_2$, or $CdBr_2 4H_2O$. Molecular weights, 272 and 344. Solubilities, 1 in 0·94 water, 1 in 3 alcohol, 1 in 250 ether, 1 in 16 alcohol and ether. A yellowish crystalline powder, obtained by heating cadmium to redness in bromine vapour. It is used to bromise collodion.

CADMIUM CHLORIDE (Fr., *Chlorure de cadmium*; Ger., *Chlorcadmium*)

$CdCl_2$, or $CdCl_2 2H_2O$. Molecular weights, 183 and 201. Solubilities, 1 in 0·71 water, 1 in 8 alcohol. It occurs as small white crystals, which are occasionally used in collodion emulsions.

CADMIUM IODIDE (Fr., *Iodure de cadmium*; Ger., *Iodcadmium*)

CdI_2. Molecular weight, 366. Solubilities, 1 in 1·08 water, 1 in 1 alcohol, 1 in 3·6 ether. It takes the form of colourless flaky crystals.

This salt is preferred for iodising collodion for process negatives, generally in conjunction with ammonium iodide.

CADMIUM-AMMONIUM BROMIDE (Fr., *Bromure double de cadmium et d'ammonium*; Ger., *Zweifach-ammonium-cadmiumbromid*)

$2CdBr_2 2NH_4Br H_2O$. Molecular weight, 758. Solubilities, 1 in 0·73 water, 1 in 5·3 alcohol, 1 in 24 of equal parts alcohol and ether. A double salt suggested by Eder on account of its greater stability for collodion processes. It can be prepared by dissolving 344 parts of crystallised cadmium bromide and 98 parts of ammonium bromide in water and then crystallising.

CADMIUM-AMMONIUM IODIDE (Fr., *Iodure double de cadmium et d'ammonium*; Ger., *Zweifach-ammonium-cadmiumiodid*)

$CdI_2 2NH_4I 2H_2O$. Molecular weight, 692. Solubilities, 1 in 0·58 water, 1 in 0·70 alcohol, 1 in 1·8 equal parts alcohol and ether. A double salt suggested by Eder, as it gives greater sensitiveness to collodion than the single salts. It can be prepared by dissolving 145 parts of ammonium iodide and 183 parts of cadmium iodide in water and then crystallising.

CALCIUM BROMIDE (Fr., *Bromure de calcium*; Ger., *Bromcalcium*)

$CaBr_2$. Molecular weight, 200. Solubilities, 1 in 0·7 water, very soluble in alcohol. Very deliquescent. Should be kept well stoppered. A white, granular powder, obtained by neutralising hydrobomic acid with chalk. It is used in making collodion emulsion.

CALCIUM CARBIDE (Fr., *Carbure de calcium*; Ger., *Calciumkarbid*)

CaC_2. Molecular weight, 64. It is decomposed by water, and extreme care must therefore be exercised in storing free from moisture. It occurs in greyish-black, irregular lumps, or sometimes in coarse granules, and is obtained by direct union of lime and carbon in the electric furnace. On being added to water acetylene gas (*which see*) is evolved, slaked lime being left as a residue: $Ca C_2 + H_2O = C_2 H_2 + CaO$.

CALCIUM CARBONATE, OR CHALK (Fr., *Carbonate de chaux*; Ger., *Kreide, Kohlensaures Kalk*)

$CaCO_3$. Molecular weight, 100. Solubilities, insoluble in water, alcohol, or ether. Prepared, or drop, chalk occurs as a white amorphous powder or small cones, and is obtained by washing native chalk. Precipitated chalk is obtained by precipitation from a soluble calcium salt by a carbonate, and should alone be used in photography, as it is freer from impurities; it is an impalpable white powder, and is used to neutralise toning baths.

CALCIUM CHLORIDE (Fr., *Chlorure de calcium*; Ger., *Chlorcalcium*)

$CaCl_2$ (anhydrous), $CaCl_2 6H_2O$ (crystal). Molecular weights, anhydrous 111, crystal 219. Solubilities, 1 in 1·4 water (anhydrous), 1 in 0·25 water (crystal), soluble in alcohol. It is extremely deliquescent, and must therefore be kept well stoppered. The pure anhydrous salt occurs as a white, granular powder, in sticks or lumps; the hydrated salt as white crystals; both are used occasionally in emulsion making.

The commercial granulated dry chloride ($CaCl_2$ $2H_2O$) occurs in greyish-white porous masses about the size of a pea, and is used as a desiccating agent for platinotype and other papers. When from absorption of moisture it becomes a pasty mass, it can be easily dried in an ordinary oven.

In process work, calcium chloride is used in iodisers for collodion. The dry commercial variety of calcium chloride in hard lumps is used for placing in drying boxes for carbon tissue, gelatine films, etc. Also it is used in calcium tubes for storing sensitised paper.

CALCIUM CHROMATE (Fr., *Chromate de calcium*; Ger., *Calciumchromat*)

$CaCrO_4$ $2H_2O$. Molecular weight, 192. Solubilities, soluble in water and alcohol. It is a yellowish powder, prepared by neutralising chromic acid with chalk. It was suggested by Valenta as an addition to printing out emulsions to obtain greater contrast, and he gives the following method of making a 10 per cent. solution :—

Chromic acid (pure) .	386 grs.	25 g.
Distilled water to .	3½ oz.	100 ccs.

Dissolve, and add sufficient precipitated chalk to make the solution permanently milky after well stirring. Filter, and wash the filter with sufficient distilled water to make 8¾ oz., or 250 ccs., in all.

CALCIUM HYDRATE, OR HYDROXIDE

Ca (OH)$_2$. Molecular weight, 74. A synonym for slaked lime, a substance which has been suggested as an addition to the gold toning bath, but is very rarely used.

CALCIUM HYPOCHLORITE (Fr., *Chlorure de chaux, Chlore à blanchir*; Ger., *Chlorkalk*)

Synonyms, bleaching powder, chloride of lime. Solubilities, 1 in 400 water, 1 in 7·5 alcohol. It is poisonous, the antidotes being ammonia vapour, steam, ether vapour, and dilute sulphuretted hydrogen. It occurs as a white or greyish-white powder with powerful chlorine smell, and is obtained by passing chlorine gas over slaked lime. Its composition is doubtful, but may be considered to be approximately Ca(OCl)Cl. It is used for preparing Labarraque's solution and Eau de Javelle (*which see*).

CALCIUM SULPHATE (Fr., *Sulfate de calcium*; Ger., *Calciumsulfat*)

Synonyms, sulphate of lime, gypsum. $CaSO_4$ $2H_2O$. Molecular weight, 172. Solubility, 1 in 380 water. It occurs naturally as the mineral anhydrite $CaSO_4$, and, in combination with $2H_2O$, as alabaster, gypsum, satin-spar and selenite. Gypsum when heated moderately loses its water, becoming what is known as plaster-of-paris, which, when mixed to a paste with water, again takes up $2H_2O$ and sets to a hard solid with expansion. Plaster-of-paris is used for making casts and moulds in some photo-mechanical processes, and for photographic bas-reliefs. It is sometimes useful for stopping leaks and repairing broken articles. It should be kept in air-tight stoppered jars, and only the

finest quality should be used for photographic purposes. Calcium sulphate is a common impurity in spring water, causing what is known as permanent hardness, which is not removed by boiling.

CALCIUM TUBE

A tube or box, usually of " tin " (tin-plate), divided into two parts, the larger for storing paper and the smaller for containing calcium chloride. The illustration shows a good home-made pattern. The larger tin holds the sensitive paper, which rests upon a smaller tin having a perforated top and containing the chloride. Such tins may be used for all kinds of paper likely to be affected by damp, and, indeed, are necessary for keeping platinotype paper dry and in a good printing condition. The calcium chloride absorbs the moisture. Platinotype paper is sold in air-tight tins, each of which contains a twist of paper or cotton-wool holding a small piece of asbestos, which has been saturated with calcium chloride; this may be used over and over again by heating on a red-hot shovel to drive out the moisture. Should a

Calcium Tube

new piece be required it may be prepared by taking a saturated solution of calcium chloride, adding to it coarse commercial asbestos, and kneading the whole into small cubes, afterwards drying them in an oven. Calcium chloride may be purchased in the anhydrous form and used in place of the asbestos; it should be tied up in fine muslin or placed in a small perforated tin, care being taken to prevent any particles of it getting on to the sensitive paper.

CALMEL'S POWDER

A mixture of resin, pitch, and asphaltum melted and ground to fine powder for use as an acid resist in photo-etching.

CALOMEL (*See* " Mercurous Chloride.")

CALOSCOPIC LENS (Fr., *Objectif caloscopique*; Ger., *Caloskopische Linse*)

A landscape lens made in the late fifties and early sixties of the nineteenth century. It was designed on the same principles as Petzval's orthoscopic lens.

CALOTYPE, OR TALBOTYPE, PROCESS

A negative process upon paper, invented by Fox Talbot and patented by him on September

20, 1841. It was the third British patent for photography, the two previous ones being for the Daguerreotype process. The patent was afterwards disputed by the Rev. J. B. Reade, but Talbot's claim was upheld in the law courts, mainly for the reason that Reade's previous discovery was not properly published or made known. Fox Talbot's process was afterwards considerably improved by C. Cundall. The original process is briefly as follows: Paper of close texture was washed over with a solution of 100 grs. of silver nitrate in 6 oz. of water. When dry, the paper was immersed in a solution of potassium iodide, 25 grs. to each ounce of water, for two or three minutes, then rinsed in water and dried. Paper in this condition was called "iodised paper," and could be stored in a portfolio for use as required. Sometimes the double operation referred to above was performed at one time by brushing a solution of iodide of silver and potassium over the paper with a Buckle brush. In order to prepare the paper for exposure in the camera two solutions were necessary: A. 100 grs. of silver nitrate dissolved in 2 oz. of water, to which is added one-sixth of its volume of strong acetic acid. B. A saturated solution of crystallised gallic acid. Equal parts of A and B were mixed together, the mixture being called gallo-nitrate of silver. The iodised paper was brushed over with this solution, or the paper floated upon it for half a minute, then rinsed in water or blotted off, the operations being carried out in the dark-room. The paper was then placed, either wet or dry, in the dark slide and exposed in the camera, the exposure necessary being, under good conditions, about six minutes. The paper was developed by washing over with gallo-nitrate of silver (as above), and was fixed, after washing in water, by a minute's immersion in a solution of 100 grs. of potassium bromide in 8 oz. of water. Finally it was washed, dried, and printed from.

Modifications of the process consisted in slight alterations in the sensitising bath, the use of ferric protosulphate as a developer, and of sodium hyposulphite as a fixer, and the making of the paper negatives more easily printable by waxing or by immersion in almond oil. The calotype process was popular between 1841 and 1851, but was superseded by the collodion process

CAMARSAC'S PROCESS (Fr., *Procédé Camarsac* ; Ger., *Camarsac's Prozess*)

Lafon de Camarsac was the first, in 1855, to discover the method of making burnt-in photographic enamels, now known as ceramic photographs, or photo-ceramics, and the process was in the beginning named after its originator. (*See* "Ceramic Photography.")

CAMBOGE (*See* "Gamboge.")

CAMEO (Fr., *Camée* ; Ger., *Kamee*)

Photographically, a bas-relief portrait finished in plaster-of-paris or coloured waxes. (For working details, *see* "Bas-reliefs.")

CAMEO PRINTS

An old type of professional carte-de-visite portrait, popular between the 'sixties and 'eighties. It was the invention of Messrs.

Window & Grove, and in its earliest form, called "diamond cameos," consisted of four positions on one card, as A, and raised as medallions. Later, one position took the place of four, and it became even more popular. After mounting

A. Cameo Print, B. Convexity C. Cameo
Medallion Style of Cameo Print backed
 Print with Cotton-
 wool

the print in the ordinary way upon a flat card, it was put in a press and made convex, as B. Another and a more expensive plan was to make only the print convex, and to fill the concave part with cotton-wool before pasting it upon a flat card, as C.

CAMERA (Fr., *Chambre, Chambre noire* ; Ger., *Kamera*)

The photographic camera is essentially a light-tight box, having a lens at one end and provided at the other with a suitable arrangement for the insertion and withdrawal of the sensitive plate or film. To ensure that the required amount of subject is included, a ground-glass focusing screen, or some kind of finder or sight, is employed. The prototype of the photographic camera is the camera obscura (*which see*). The first camera used for photography was that of Nicéphore Niepce, who, writing in 1816, describes it as a box about 6 in. square, furnished with a sliding tube carrying a lens. In Daguerre's first camera A the only means of focal adjustment

A. Daguerre's First Camera

was a rack and pinion on the objective. Charles Chevalier, of Paris, introduced some improvements, among them the method of making the body in two portions, one sliding within the other and clamped by a screw working in a slot on the baseboard, as seen in Daguerre's later apparatus B ; this arrangement is still met with in

some ferrotype cameras. The mirror E at the back, to erect the image in focusing, will be noticed. The next step forward was the invention of the bellows, which was probably suggested by that of the accordion, and seems to

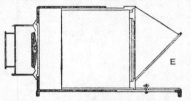

B. Daguerre's Sliding-body Camera

have been known as early as 1839, though it was not in general use till the 'fifties. It was originally square or oblong, and the only way of reversing the plate was to turn the entire apparatus on its side. The pyramidal, or so-called " conical," bellows was first made in 1861, and at about the same period were introduced the swing front, swing back, and side-shifting movement. Since then progress in camera construction has been rapid. The reversing back, rising and falling front, turn-table, and many other conveniences, have been added, until the elaborate and beautifully-finished outfits of to-day bear scarcely any resemblance to the heavy and clumsy apparatus of earlier years. Yet, to give a curious instance of how ideas tend to repeat themselves, the

an inclined mirror and using it both for focusing and as a shutter. D will serve to explain the various fittings and movements of a modern triple-extension field camera, each part being named and indicated by an arrow. The different

C. Box-form Camera Obscura : Early Anticipation of Reflex Principle

kinds of cameras are described in this work under their separate headings as " Studio Camera," " Field Camera," " Hand Camera," " Reflex Camera," " Enlarging Camera," etc., and any not so found should be looked for under

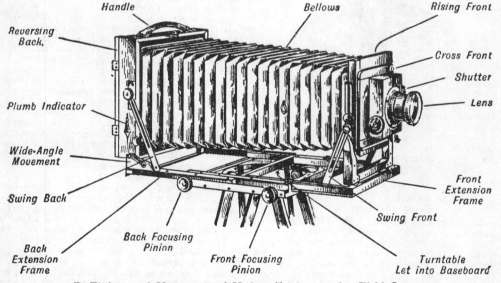

D. Fittings and Movements of Modern Triple-extension Field Camera

latest refinement of mechanical skill, the reflex or reflector camera, is strikingly similar in design to an early pattern of box-form camera obscura C described by the Abbé Nollet in his " Leçons de Physique," published at Paris in 1755. Thomas Sutton, in 1861, was the first to adopt the reflector principle in exposure by hingeing

the particular branch of work for which it is used.

CAMERA BAG, OR CASE (Fr., *Sac à chambre ;* Ger., *Schnappsack, Sack*)

A receptacle for the carriage and protection of the camera, lens, and slides, commonly of

canvas or leather, and generally provided with a strap to sling over the shoulders. The better-class bags are lined with baize, felt, or velvet, and have suitable partitions. A lock and key is a useful precaution against the dark-slides being tampered with when travelling.

CAMERA CARRIER (Fr., *Porte-chambre* ; Ger., *Kameraträger*)

An attachment for carrying the camera, etc., on a bicycle or tricycle. Various patterns are made, with screw clamps to fit on the front, back stays, or handle-bar of the cycle, and furnished with straps or spring clips to secure the apparatus. There is a general opinion, however, that the camera is best carried when slung on the rider's back. (*See also* "Cycle.")

CAMERA LEVEL (Fr., *Niveau* ; Ger., *Nivelle*)

A device to enable the back of the camera to be kept truly vertical or the base horizontal, as the case may be. For the first purpose, a plumb

A. Circular Spirit B. Long Spirit Level
Level

C. Quadrant or Two-way Level

indicator hung at the side is ordinarily employed, though a circular spirit level A let into the top is sometimes preferred. For the baseboard, either a long spirit level B or a circular one is used. There are many patterns of levels, some working with spirit, others having a small ball enclosed. A quadrant or "two-way" level is illustrated at C.

CAMERA LUCIDA (Fr., *Chambre claire* ; Ger., *Die Helle Kammer*)

An instrument used for delineating views from nature and copying drawings. It was a camera lucida that Fox Talbot was using when, in October, 1833, he began to think out a plan for fixing the images seen by its aid, but he at a later date put it aside in favour of the camera obscura. The camera lucida proper was invented by Dr. Wollaston, who died in 1828, but the name was originally given to an instrument, invented by Dr. Hooke, analogous to the microscope.

The best form of the camera lucida consists of a four-sided prism having the vertical cross section A B C D as shown in the diagram. The side A B is at an angle of 22½ deg. with the horizontal, while the side B C makes the same angle with the vertical. A horizontal ray of light from

an object E is twice totally reflected at F and G, and emerges vertically from H to J. The eye at J refers the ray to a point vertically beneath at K, and at the same time is able to look over the edge C of the prism at a sheet of white paper

Optical Principle of Camera Lucida

placed below, on which the image of the object is seen, and on which it may be traced with a pencil. The prism is mounted in a brass case, and is fixed by a movable joint to an upright rod about 1 ft. high, provided with a clamp at its outer end to attach it to a drawing board.

CAMERA OBSCURA (Fr., *Chambre obscure* ; Ger., *Die Dunkelkammer*)

Literally, "dark chamber"; an optical instrument invented by Baptista Porta in 1569, although there is evidence of an even earlier knowledge of its principle and properties. This simple instrument depends in principle on the fact that if a tiny hole is made in the shutter of a room from which light is otherwise excluded, a small reversed image of the view outside will, under favourable circumstances, be thrown on the opposite wall. This experiment appears to have been known to philosophers from time immemorial, but only comparatively recently was discovered the improvement effected by using a convex lens in place of the hole. Baptista Porta's box-form of camera obscura appears to have been used as an entertaining toy, or as a ready means of tracing landscapes and views, for nearly three centuries prior to the discovery of photography. A quaint form of camera obscura, designed by A. M. Guyot, for outdoor work in tracing land-scapes, is shown in section at A. It resembles an ordinary table, the camera being situated between the legs and the top being formed by a sheet of plain glass M, on which is laid a piece of tracing paper. The image formed by the convex lens K is thrown upwards on the screen M by being reflected from an inclined mirror L. A modification of this device is shown at B, the projected image being viewed under cover of a dark chamber, at the top of which the optical system is arranged. A double convex lens is placed in a sliding mount at K, and over it is a mirror L, set at an angle of 45° relative to the horizon. As the lens is uncorrected for spherical aberration, the image would suffer in definition at the margin if received upon a perfectly plane surface. Therefore the surface M is made con-cave, and part of a sphere whose radius is the focal distance of the convex lens K.

The best form of camera obscura is that in which internal instead of specular reflection is employed, to prevent the loss of light attendant

on the latter. The optical system then consists of a rectangular prism C, having one of its faces convex and another concave, such a combination doing away with the necessity of a mirror to change the direction of the rays from

A. Guyot's Camera Obscura

a horizontal to a vertical course. The rays from a distant object or landscape will be made to converge after impinging on the convex surface, and being reflected in the interior of the prism, will pass into the dark chamber to the surface upon which the picture is to be received. The picture thus obtained will be extremely vivid. With an optical system of this character, the surface on which the picture is formed may be plane and not concave. As these meniscus prisms are difficult to procure, they may be replaced by a triangular prism N (*see* illustration D), having a plano-convex lens O and a plano-concave lens P, both of proper focal length, cemented by Canada balsam on two of its faces. Spherical aberration is sometimes guarded against by using a plano-concave lens E in place

B. Camera Obscura, with Concave Surface to receive Image

of the more complex combination, in which case the lens is placed at the top of the dark chamber with its concave surface uppermost. With this latter arrangement a plane surface suffices to receive the picture, but the mirror L in illustration B will still be needed to turn the rays from the horizontal to the vertical direction.

The box-form camera obscura is shown at F, and it will be seen that the principle here employed is practically the same as that of Guyot's table-form apparatus, with the addition of a shade Q. This device is sometimes used by

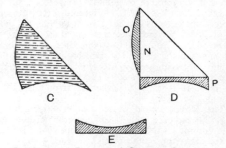

Prisms and Lenses of Camera Obscura employing Internal Reflection

artists in sketching or, rather, tracing outline pictures of landscapes. K is the lens, L the mirror, and M the sheet of tracing paper, or ground glass with the matt surface uppermost. The modern photographic camera obscura—which will be readily recognised as the reflex or reflector camera—is arranged in the same way as F, but the lens used at K is of the compound type, in which spherical aberration, achromatism, and all the other defects of a simple lens are corrected ; so that when the mirror L is mechanically moved out of the path of the rays a perfect negative image is received upon the sensitive plate, suitably placed at the back of the camera.

A stereoscopic camera obscura devised by Theodore Brown is a half-plate instrument fitted with a mirror for reflecting the rays on to a horizontal screen where the stereoscopic images are seen. Unlike an ordinary stereoscopic camera, in which a pair of lenses side by side are used, only one lens is used, but it is supplemented with a double reflecting device (the "Stereophotoduplicon," *which see*), to be used on the hood of the single lens. The effect is very

F. Diagram of Box-form Camera Obscura

charming, especially when the face of the observer is properly enclosed within the hood or shade placed above the screen on which the dissimilar images are projected. By turning the camera on its axis during inspection of the images a panoramic, as well as a stereoscopic, natural colour effect is produced.

CAMERA SCREW (Fr., *Vis du pied;* Ger., *Stativschraube*)

The screw attaching the baseboard of the camera to the head, or top, of the tripod, in those cases when a turntable is not fitted. The loose screw is very liable to get lost, and is difficult to insert without several ineffectual attempts, in which the bottom of the camera frequently gets scratched. Several special forms of tripod screws have been introduced to avoid these objections, among which may be mentioned Renbold's, which is permanently attached to the camera and folds into a recess in the bottom when not in use. It is tightened on the tripod head by means of a nut.

The Royal Photographic Society recommend that all screws fitted to cameras either for attachment to the stand, for fixing rising fronts, or for other movable parts, be either $\frac{3}{16}$ in., $\frac{1}{4}$ in., $\frac{5}{16}$ in., or $\frac{3}{8}$ in. in external diameter, and in pitch of thread and other details in accordance with the generally recognised Whitworth standards for these sizes.

CAMERA STAND (Fr., *Pied;* Ger., *Stativ*)

A raised support for the camera, to keep it steady during focusing and exposure. There are several varieties, differing in construction according to their purpose. In the older but still very common form of studio camera stand B the top is raised or lowered by rack and pinion, or by a counterpoise and weight, while the table has a tilting movement. The better class of studio stand is, however, much more ornate and elaborate (*see* "Studio Camera"). The Hana studio stand C is novel in construction, having a counter-

ease and smoothness of movement, the camera may be raised as high at 7 ft. or lowered to only 2 ft. from the ground. The tripod stand A for

B. An Ordinary Form of Studio Stand

C. Studio Stand with Counterbalanced Platform

A. Tripod Stand for Field Camera

balanced platform travelling on two upright pillars, to which it may instantly be clamped by pulling a lever. Besides the advantages of

field cameras is usually made to fold up, the three legs being then strapped together for carrying.

The bottom joint should have a sliding movement to allow of adjustment on uneven ground. The top, or head, is detachable; it is covered

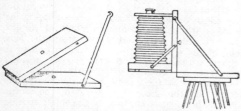

D. Telescopic Stand

with felt to avoid scratching the camera, and it has a hole for the screw by which the latter is secured. Many tripod legs, however, are made to fit a turntable at the bottom of the camera. The tripod head must be sufficiently large for the apparatus which it is to support, or vibration will occur. Steadiness and rigidity should be the distinguishing characteristics of a tripod stand, and should be considered before lightness, though the two qualities are not necessarily antagonistic. Telescopic stands D of brass, steel, or aluminium, are very portable, but are suitable only for light cameras.

CAMERA, VERTICAL

Cameras are used vertically for the purpose of photographing ceilings, floors, or articles laid upon a horizontal surface. Vertical fittings are

A and B. Hinged and Strutted Table for
Vertical Camera

obtainable commercially, but most are home-made. A and B show a very simple arrangement, the exact size of which will depend upon the camera used. The accessory takes the form of a narrow hinged table, which is screwed to the

ordinary tripod top, the camera being screwed to the hinged portion, which, in use, is supported vertically by a strut, as shown. The camera can be pointed upwards or downwards in a perfectly vertical position, or, if the strut contains various holes to pass over the screw, at any angle. The late T. C. Hepworth's method (described first in 1894) allows of the camera being pointed downwards but not upwards, and it is largely used for photographing precious stones, medals, illustrations from books, etc. One advantage of such an arrangement (*see* figure C) is that it may be used in an ordinary room against a window, and the subjects will probably be as well lighted as in a studio. This arrangement has been used for photographing a baby lying in a cradle. The camera is fixed at the top end of a skeleton stand; upon the glass platform E can be placed a coloured card, paper, or other medium to serve as a background on which the opaque objects, flowers, etc., may be laid and photographed from above. By employing a glass platform shadows are obviated, and this in some cases is of great advantage, while at the same time it is possible to use at any distance below the glass a background of any colour, which, by screening the light, can be lightened or darkened as may be required. A useful addition is a blind F to shut off all light from the upper surface of the platform; another is a mirror G to reflect the light upwards. By placing a negative upon the glass platform a reduced or enlarged transparency can be obtained more easily than by any other plan. Should the negative be a film it can be kept flat by placing a piece of glass over it.

C. Vertical Camera

In process work, stands holding cameras vertically are frequently used when copying small objects supported on a horizontal surface and these stands are also of advantage when copying from open books.

CAMERON, JULIA MARGARET

Born in Calcutta, 1815 ; died in Ceylon, 1879. Came to London in 1848, started photography in 1865, and became famous for her admirable portraits of celebrated persons.

CAMPHOR (Fr., *Camphre ;* Ger., *Kampfer*)

Common camphor is known also as Japan camphor. A colourless, translucent, crystalline solid with characteristic smell ; melts at 175° F. (nearly 80° C.), is soluble 1 in 700 of water, and is readily soluble in alcohol, oils, etc. It is used in the manufacture of celluloid, varnishes, and retouching mediums. Skies may be blocked out of a negative by holding the latter glass-side downwards over a piece of lighted camphor, and wiping away the soot from the parts of the negative it is desired to print.

CANADA BALSAM (Fr., *Baume du Canada ;* Ger., *Canadabalsam*)

Known also as Canada turpentine. A resinous fluid, transparent, and of a greenish yellow tint, very viscous, and hardening into a clear transparent solid, whose refractive index is about equal to that of glass. It is obtained from the Balsam Fir of North America, *Abies balsamea* (Coniferæ). In its commercial state it has the consistency of honey ; it may be hardened by exposing to the air or rendered more liquid by heating or by the addition of turpentine, ether, or chloroform, but is insoluble in water. It has several uses in photography—for the cementing of lenses together, making varnishes, and rendering paper negatives and prints for the crystoleum process translucent.

In process work, Canada balsam is used for sealing together the two halves of the ruled screens and for sealing colour filters. A further use is for sealing a thin microscope cover glass to the centre of the ground-glass focusing screen, so that a transparent spot is provided for focusing by means of a magnifying eye-piece.

CANARY AND ORANGE MEDIUM

A yellow or orange non-actinic fabric used for screening the light in dark-rooms ; yellow paper and glass may also be used in place of the usual red light for some photographic purposes. It is less tiring to the eyes than red and gives more illumination. A yellow light, however, is not safe for modern rapid dry plates and isochromatic plates, but it is admirable for bromide papers and lantern plates. It is more suitable for use with artificial light than with daylight, and when the latter is used two thicknesses of canary medium may be necessary. Orange medium or paper cuts off more green and blue light than canary medium, and allows more orange and red to pass, and it may therefore be used for the slower brands of plates providing the light is not particularly strong. According to Sir William Abney, the total illuminating value of the orange is nearly twice that of the canary.

CANDLE BALANCE (Fr., *Balance à chandelle ;* Ger., *Kerzenwage*)

An instrument employed in photometry to ascertain the loss of weight undergone by a candle after burning a given time.

CANDLE-LIGHT EFFECTS

Lighting effects in a photograph, apparently due to the use of a candle as the illuminant. Actually the candle pictured plays no part whatever in the real illumination of the subject. This branch of work was made popular by Newson Gibson, who, during the years 1901 to 1904, produced many remarkable candle-light effects which were puzzling at the time, as it was well known that a candle did not give a sufficiently actinic light for ordinary photography. The secret consists in using a piece of lighted magnesium wire hidden from the lens, but placed as near as possible to the candle flame, so that the light from the magnesium appears to come from the candle, the back-

A. Magnesium Wire Holder Over Candle

ground immediately above and behind the candle being quite black. A blackened holder supports the magnesium wire above the candle, and is invisible against the black background. Proper arrangements must be made for carrying off the smoke. In the illustration above, A B C D represents the amount of the subject taken in by the lens, the candle being placed as shown and the remainder of the picture being filled with suitable objects. The blackened shield or tube, with the wire behind it, is shown at E, and is lowered until the wire ignites, the smoke escaping up the tube and not showing in the picture.

Another arrangement B is also recommended by N. Gibson. A strip of wood G 30 in. long and 1¾ in. wide is faced on the side that goes nearest the camera with black velvet ; to the top is loosely fastened a long rod H as a handle for the operator, so that the light shield itself hangs vertically, whilst its weight prevents any motion. On the reverse side of the wooden strip is fastened a triangular chimney J made of tinplate, its bottom being about 1½ in. from the lower end of the wooden strip. At the bottom of the chimney the magnesium K is placed, in such a way that the wire may be easily lighted when lowered on to the candle, and the smoke may escape up the chimney and out of the picture. When the magnesium ignites, the shield is raised to expose the flame of the candle and the exposure is made. The long chimney is necessary when the candle is low down in the picture, but when near the top and the smoke has not far to travel a shorter chimney may be used. Another worker uses a platinotype tin, as shown at E, one half at the bottom being cut away and the magnesium wire F suspended from a wire

running across the centre, the whole arrangement being suspended on wire and let down on the candle. It matters little what method is adopted as long as the magnesium is hidden and burned as near as possible in the position of the flame. The flame of the candle must also be kept steady during the exposure. A little daylight may at times be used to light up the dark corners of the room, but it must not be too strong, as the light must appear to come from the candle itself. The necessary exposure can only be found by trial ; as a basis for experiment, expose for the whole of the time during which 1 in. of magnesium wire is burning and after it has burnt out allow another second for

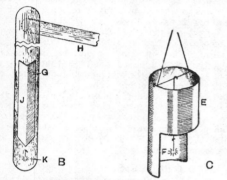

B and C. Arrangements for Burning Magnesium for Candlelight Effects

the candle flame, the stop being $f/11$ and the plate extra rapid. The "lamps" described have an effective radius of only 2 ft. or 3 ft., so that subjects must be arranged accordingly.

CANDLE-POWER

The unit for photometric work in England. The light emitted by a standard candle. (*See* "Unit of Light.")

CANDLES, FLASHLIGHT

Magnesium made up in the form of candles with a wick of "touch" material. The commercial candles are of various sizes, burning for and giving exposures up to about half a minute, the most popular being the 2, 4, 7, 12, and 20 seconds sizes. The candles should be kept in a dry place, as otherwise they will burn and splutter badly when fired, and they should be burnt on a metal tray or iron shovel. Serviceable flash candles of a kind may be made at home according to the following formula :—

Magnesium powder .	. 20 parts
Barium nitrate. .	30 ,,
Flowers of sulphur .	8 ,,
Beef tallow (or suet) .	7 ,,

Melt the suet or tallow, carefully knead in the other ingredients, place in small metal boxes, mould the top to a point like that of a candle, and fire by means of a torch. They should be burnt on an iron shovel. This preparation gives a good light, and may be used out of doors in large quantities for street work at night, and in small quantities in a room. (*See also* "Flashlight Mixtures.")

CANVAS EFFECTS

Photographs having the appearance of being printed upon canvas. Negatives may be printed upon canvas-grained paper, which is obtainable commercially, or a piece of thin canvas or bolting cloth (*which see*) may be interposed between the negative and the sensitive paper. Negatives for producing canvas effects direct upon the paper may be obtained by exposing in the camera in the ordinary way, and then making a second exposure, this time with the lens focused on canvas, so adjusting the exposures that the grain of the canvas does not predominate over the original exposure. Another method is to make a separate negative of the canvas, and to print from this before or after using the same piece of paper for printing from another negative ; this is probably the easiest and most economical method, as the one negative of the canvas may be used for any number of pictures, and the canvas effect printed light or dark over the original print as desired. A good strong sidelight should be used when making a negative from the canvas in order to emphasise the grain. Any suitable fabric may be substituted for the canvas.

In process work, a canvas grain is often imparted to the highly glazed "art" papers used for three-colour printing, so as to give a more artistic effect imitating the painter's canvas. This graining is done by running the paper between a pair of embossing rollers, one of which is steel, bearing the pattern, and the other of paper, to take the impression.

CANVAS, ENLARGEMENTS UPON

Enlargements are made direct upon canvas for the use of artists, either for finishing direct or as a basis for oil-colours. The canvas must first be cleaned with a mixture of 1 oz. of liquor ammoniæ (·880), and 4 oz. of methylated spirit, this being rubbed on with a clean rag or sponge until all greasiness is removed. Three solutions will then be required for sizing, sensitising, and developing.

Sizing

Distilled water .	.	10 oz.	1,000 ccs.
Ammonium bromide .		35 grs.	7 g.
Ammonium chloride .		10 ,,	2 ,,
Potassium iodide .		80 ,,	16 ,,
Gelatine .	.	60 ,,	12 ,,
Dry albumen .	.	1 oz.	100 ,,

Mix and warm the mixture until the gelatine is dissolved, but avoid overheating or the albumen will be coagulated.

Sensitising

Distilled water .	.	6 oz.	500 ccs.
Glacial acetic acid .	.	$\frac{1}{4}$,,	40 g.
Silver nitrate .	.	$\frac{1}{2}$,,	80 ,,

Mix and filter.

Developer

Distilled water .	.	5 oz.	500 ccs.
Lead acetate .	.	5 grs.	1 g.
Gallic acid .	.	30 ,,	6 ,,

The cleaned canvas is sponged over with the sizing mixture as evenly as possible. When dry it is ready for sensitising. Take the canvas into a dark-room, pour over it some of the silver sensitising mixture, and spread evenly with a

pad of cotton wool. Wet or dry it is ready for exposing in the same way as bromide paper, but it is slower than most bromide papers. The developer is applied with the sponge previously used for sensitising, the residue of silver assisting development. The canvas is fixed in a bath of "hypo" 1 oz., water 5 oz., and washed well. During all these processes the canvas may remain on its stretcher.

CANVAS, MOUNTING PRINTS ON

The canvas needs to be strained on a frame. The print or enlargement is placed on a table face downwards, and coated with any good mountant, starch paste being as good as anything. The paste should be rubbed in well with the brush or sponge until the print is limp. Then the stretched canvas is lowered upon it, picked up with the adhering print, and laid right way up on the table. The print needs to be rubbed into close contact, special attention being given to the edges, which may need treatment with a paper-knife.

CANVAS, PRINTING ON (See "Fabrics, Printing on.")

CAOUTCHOUC (See "Indiarubber.")

CAP, LENS (Fr., *Bouchon*; Ger., *Objectiv-Deckel, Linse Kappe*)

A circular, closely-fitting covering for the lens, lined with black velvet. At one time all exposures were made by taking off and replacing the cap, but for this purpose a shutter is now commonly used. The cap is still, however, often resorted to for time exposures; and caps are generally provided on stand cameras for the protection of the lens, even when a shutter is fitted behind the lens.

CARAMEL (Fr., *Caramel*; Ger., *Karamel*)

A deep reddish-brown, sticky liquid, made by heating loaf sugar. It may be obtained in liquid form from chemists, who call it *saccharum ustum*. It is used in photography as a backing for plates to prevent halation. A rough and ready method of making a small quantity at home is to place loaf-sugar in a dry iron sauce-pan over a slow fire and stir with an iron spoon. At about 400° F. (204° C.) caramel will be formed, but it requires a considerable amount of care to make it properly, as over- or under-heating will spoil it. The superiority of caramel over other backings is due to its non-actinic colour and to the fact that its refractive index is nearly the same as that of glass. (*See also* "Backings, Plate.")

CARBOLIC ACID (Fr., *Acide phénique*; Ger., *Karbolsäure*)

Synonyms, phenylic alcohol, phenol, phenic acid, and hydrate of phenyl. C_6H_5OH. Molecular weight, 94. It is soluble in water, alcohol, ether, benzine, chloroform, etc.; it is volatile and extremely poisonous, and causes burns on the skin. It is colourless when fresh and pure, but gradually turns pink on exposure to light. It is used to preserve mountants, emulsions, and many other mixtures. It is the starting-point of many photographic chemicals.

CARBON BISULPHIDE (*See* "Carbon Disulphide.")

CARBON DISULPHIDE (Fr., *Sulfure de carbone*; Ger., *Schwefelkohlenstoff*)

Synonym, carbon bisulphide. CS_2. Molecular weight, 76. Solubilities, insoluble in water, soluble in alcohol and ether. Its vapour is inflammable. It is a colourless, highly refractive liquid with characteristic odour, which in impure samples is extremely unpleasant. It is used as a solvent for unvulcanised indiarubber in making rubber solution.

CARBON ENLARGEMENT

An enlargement made by the carbon process. As this process of printing is much too slow for making direct enlargements in the camera, an enlarged negative has to be made, and prints taken from that by daylight in the ordinary manner. For printing in carbon, an enlarged negative should be reversed, so that the print can be made by the single transfer method and still be non-reversed. The most simple and satisfactory manner of obtaining a reversed negative when reproducing or enlarging is to reverse the transparency in the carrier, putting the glass side towards the lens instead of the film. (*See also* "Enlarged Negatives" and "Carbon Process.")

CARBON PROCESS

The idea of the carbon process as it is known to-day is credited to A. L. Poitevin, who, in a patent dated December 13, 1855, describes the action of light upon a chromated gelatine mixed with a pigment. J. Pouncy is supposed to have been the first actually to produce carbon prints, his patent being dated April 10, 1858. In these early processes the half-tones were mostly unsatisfactory, and modifications were made by J. C. Burnett (1858) and Fargier (1860); but it was not until J. W. Swan's improvement in 1864, when he patented carbon tissue, that the process became of any practical use to photographers. J. R. Johnson made further improvements in 1869, and in 1874 the flexible support used in the process was patented by J. R. Sawyer.

The carbon process differs essentially from all other methods of photographic printing. It depends for its working on the fact that gelatine, to which has been added a suitable proportion of an alkaline bichromate, becomes insoluble when exposed to light, but retains its solubility if kept in the dark. A sheet of paper is coated with a mixture of gelatine, colouring matter, and potassium bichromate, and then exposed to daylight under a negative. The portions of the gelatine film that were protected by the high lights or dense parts of the negative retain their solubility, while those that receive the full force of the light through the shadow portions become insoluble. Parts exposed under the intermediate tones become partially soluble. By treating the film with hot water the soluble portions are dissolved away, while the insoluble parts remain, and form the picture. Any colouring matter may be employed, and consequently a picture may be produced in any desired colour.

Carbon tissue is a dark-surfaced paper, the

colour corresponding to the deepest tone that can be obtained in the picture. No visible image is produced by exposure to light, and consequently, the exposure in the printing frame must either be timed or gauged by an actinometer. Carbon tissue sensitised in H. W. Bennett's sensitising bath requires about half the exposure necessary for printing-out silver paper to the full depth necessary for toning, or rather less than the printing-out paper requires to give a visible image resembling a finished result. The prints should be developed as soon as possible after taking from the frame (*see* "Continuing Action"). A piece of single-transfer paper, slightly larger than the exposed print, is also required. The exposed film must be developed from the back, for the reason that the whole of the face has been rendered insoluble, excepting the extreme high-lights, while all the surface in contact with the paper has remained soluble. The film is so thick that the strongest shadow does not penetrate right through. In the deep shadows the insolubility penetrates deeply; in the medium tones there is a moderate thickness of insoluble gelatine, while in the very light parts there is simply a slight superficial insolubility. This layer of soluble gelatine of varying thickness underlying the insoluble image necessitates transferring the film so that the soluble portion becomes the surface. Any attempt to develop the film on its original paper would result in its floating right off as soon as the soluble gelatine commenced to dissolve.

Transferring and developing the exposed print are simple matters. The piece of transfer paper is soaked in cold water until limp. The exposed print is then immersed in cold water for a few seconds, until it begins to become flat, and its face is then brought into contact with the prepared surface of the transfer paper, preferably under water, the two papers brought out together, squeegeed firmly into contact, and then partially dried between blotting-paper under moderate pressure for ten or twelve minutes. The print is now ready for development. It is placed in water that has been warmed to 105° to 110° F. (40·5° to 43·3° C.), and kept below the surface. In about twenty or thirty seconds some of the colour will be seen oozing from the edges. This is the object of the safe edge, to preserve a margin of soluble gelatine; without it the next operation would be impracticable. As soon as the colour is seen to be oozing out, the corner of the paper bearing the film is lifted, and if it comes away easily it is pulled steadily away, leaving the film on the transfer paper. This film is allowed to soak for a few minutes in the hot water, and from time to time the water is gently splashed over it, and it is taken from the water and partially drained. This treatment is continued until the print is sufficiently light, when it is drained thoroughly and then rinsed in cold water to wash off any loose gelatine and colour that may adhere. It is next immersed for about five minutes in an alum bath (1 oz. to 20 oz. water), washed in about three changes of water, and dried. With the exception of the developing bath, all the solutions should be cold. Care must be taken to avoid touching the surface of the film during the working.

An objection to this method of working—the single transfer method—is that the picture is reversed, the left side becoming the right. When it is desirable to avoid this a second transfer is necessary, and the method is known as "double transfer." Instead of using the single transfer paper, a temporary support is substituted (*see* "Flexible Support"). The method of working is exactly the same as described for single transfer, excepting for the preliminary waxing of the support. After development, treatment in the alum bath, and drying the print on the temporary support, it is ready for the second transfer. The drying on the temporary support must not be rapid, and the transfer should take place as soon as possible after drying, or else the print should be kept in a cool place, moist rather than too dry. A piece of final support or double transfer paper is soaked in cold water for at least half an hour, and then the temporary support bearing the print is similarly soaked until quite limp. Both are then immersed in warm water, about 90° F. (32° C.), for about fifteen or twenty seconds, face to face. Then they are withdrawn clinging together and squeegeed into good contact. When thoroughly dry the two papers may be pulled apart, and the image will be firmly and permanently attached to the double transfer paper. The necessity for the second transfer is frequently obviated by the employment of a reversed negative. (*See also* "Carbon Tissue," "Carbon Transfer Papers," "Flexible Support," "Bennett's Carbon Sensitiser," etc.)

CARBON TETRACHLORIDE

Synonym, tetrachloromethane. CCl_4. Molecular weight, 156. A colourless, oily substance, resembling chloroform, volatilising completely without odour, having a boiling point of 170·6° F. (77° C.), and a specific gravity of 1·593 at 68° F. (20° C.). It is obtained by acting upon chloroform with chlorine, and in other ways. It has no action on metals, fabrics or colours, and it is an excellent solvent of shellac, asphalt, fats, etc.

CARBON TISSUE

The paper prepared for printing by the carbon process. It consists of a stout paper thickly coated with a mixture of soft, soluble gelatine and finely ground colour. As gelatine is colourless, any suitable and permanent colouring matter may be employed, and this determines the colour of the print. In preparing carbon tissue, it is necessary that the film should be appreciably thicker than the depth of the strongest shadow of the finished print in order that a thin layer of soluble gelatine should remain between the insoluble shadow and the paper support. Carbon tissue is prepared in two forms, sensitive and insensitive. In the former, a certain proportion of potassium bichromate is mixed with the gelatine and colour when preparing the film; in the latter, the bichromate is omitted, and the tissue requires sensitising by immersion in a bath of potassium bichromate before it can be used.

In process work, carbon tissue is used to a considerable extent, the photogravure process being, for example, solely worked with a carbon resist developed on the copper plate. The special autogravure tissue is generally employed, but some workers prefer the ordinary standard

brown. It is also used as the resist in engraving copper rollers for the rotary intaglio process of printing. It may also be used as a resist for relief grain blocks (an inverted photogravure). In the Government Survey Offices an electrotyping process for the reproduction of maps is worked by developing a carbon print on a silvered copper plate, and then depositing copper on it so as to form a duplicate plate.

CARBON TRANSFER PAPERS

Transfer papers for receiving the film or image in the carbon printing process. Two kinds of such paper are used, called respectively "single transfer paper" and "double transfer paper." The former are those employed when the film or image is transferred from its original paper to one on which it is to remain permanently; the latter are used when the film is transferred to a temporary support for development, and re-transferred to a final support as its permanent basis. Single transfer paper is prepared by coating any suitable paper with gelatine that has been so hardened as to be practically insoluble and impermeable. Double transfer paper bears a thicker coating of soluble gelatine. Both kinds of paper are easy to prepare; any carbon worker can therefore obtain his favourite paper by preparing it himself.

The easiest method of working for the single transfer process is to coat the paper first and harden the gelatine coating afterwards. A solution of gelatine should be prepared, 1 oz. being soaked until soft and then dissolved by heat and made up to about 25 oz. The gelatine solution should be applied to the paper as evenly as possible, by means of a flat brush or a sponge. The brush should be taken first along the sheet of paper, then across, and then diagonally, so as to avoid ridges and to render the coating even. Many workers prefer to give two thin coatings rather than one of medium thickness, the second being applied after the first is quite dry. When the gelatine coating is thoroughly dry it should be hardened by immersing the prepared paper in a solution of chrome alum, 12 grs. to each 1 oz. of water. Three or four minutes should be allowed for immersion, and the paper should then be rinsed in two or three changes of water and dried.

For double transfer a thicker coating of gelatine is required, this being obtained by two or three coatings of the solution given for single transfer; and no hardening solution is employed. Both kinds of paper will keep indefinitely if stored in a dry place. The methods of using are given under the heading "Carbon Process."

The double transfer paper is often used by photo-lithographers as a photo-transfer paper, and is found to be very suitable for this purpose when sensitised with bichromate.

CARBONATE

A salt derived from the hypothetical dibasic acid H_2CO_3, or carbonic acid; for instance, Na_2CO_3 carbonate of soda. Carbonates are of three kinds, normal, acid, and basic; all are decomposed by dilute sulphuric or hydrochloric acid, with the production of carbon dioxide.

CARBOXYLIC ACIDS

Acids derived from the aromatic hydrocarbons by the substitution of one or more carboxyl groups (COOH) for a corresponding number of hydrogen atoms; they are named mono-, di-carboxylic acids, etc., accordingly. Examples are formic and acetic acid.

Hydroxycarboxylic acids are carboxylic acids containing also a hydroxyl group (OH). An example is lactic acid.

Amido-carboxylic acids contain the amido or amino group (NH_2) as well as COOH.

CARCEL LAMP (Fr., *Lampe carcel*; Ger., *Carcel-lampe*)

A lamp adopted at the Paris Electrical Congress of 1881 as the French unit of illumination in photometry. It burns 42 g. of colza oil per hour, has a flame 40 mm. in height, and gives a light equal to about $9\frac{1}{2}$ standard candles.

CARICATURE (Fr., *Caricature*; Ger., *Zerrbild*, *Karikatur*)

A freak portrait obtained by using special backgrounds and foregrounds, distorting the film, copying, etc. Some of the methods of producing caricatures are described below, and others will be found under such definite headings as "Doubles" and "Trick Photography." *Large heads on small bodies.*—These may be produced in many ways, one of which is to draw the necessary figure, without a head, upon a sheet of

A and B. Caricature Cards

white cardboard, the collar, or neck, being at the extreme top, as at A, or a circle may be cut out for the insertion of the head, as at B. If the former is used, the model sits upon a chair and holds the design under the chin. The background should be of the same colour as the caricature card, and the junction between the two is spotted out so as not to show upon the finished print. An objection to the above plan is that only the head of the sitter is photographed and the following method may be preferable: Two negatives, one of the head of the size required and one a smaller picture of the body, are made; the larger head is cut from the print and pasted over the smaller head in the other picture, the whole being then copied in the camera. *Distorted heads and bodies.*—Distorted images may be obtained by warming a partially dried negative before a fire or over a gas flame, the heat causing the gelatine to melt; the picture can be made to "run," and can be distorted, therefore, to any extent. When dry, the negative can be printed from in the usual way; but,

of course, it cannot be restored to its original state. Another plan is to strip the film from the negative, and to attach it to another glass, stretching it during the process, and allowing it to dry in its stretched position upon the new

C. Obtaining Thin-face Caricature

support. *Broad and long faces.*—Excessively long or broad faces may be produced by the use of convex or concave mirrors. The sitter is posed in front of the mirror, and the distorted image in the glass photographed; but great care is necessary to avoid reflections. Another, and a much easier, plan is to copy an existing and proper photograph; for example, the portrait print is placed in front of the camera, with one edge nearer to it than the other, as in C. The result will be that the width of the face is partly lost, the effect being a lengthening of the face. If an excessively broad face is desired, the print is copied while lying at an angle to the horizontal plane (the less the angle the shorter will be the resulting figure); D shows the idea, the bottom edge of the picture being nearer to the

D. Obtaining Broad-face Caricature

camera than the top edge. Many firms sell specially painted comic backgrounds for making caricatures, also negatives of comic scenes into which the head from any existing negative can be printed.

CARMINE AND CRIMSON TONES

If a negative is of good contrasts P.O.P. prints from it may be toned to a good carmine, as follows : Print and wash as usual, and tone in—

Ammonium sulpho—cyanide	. .	20 grs.	45 g.
Potassium iodide	.	4 ,,	9 ,,
Gold chloride	.	1 gr.	2.25 ,,
Water	. .	1 oz.	1,000 ccs.

Toning takes from twenty to thirty minutes, and the tone as well as the time may be altered by varying the amount of iodide. The bath has a slight intensifying action. Any discoloration on the back of the paper and in the high lights will disappear in the fixing bath. Wash and fix in "hypo" as usual.

CARRAGEEN (*See* "Iceland Moss.")

CARRIER (*See* "Camera Carrier," "Plate Carrier," etc.)

CARTE-DE-VISITE (Fr.)

A popular size of professional studio portrait. Size of mount, $4\frac{1}{4}$ in. by $2\frac{1}{2}$ in. ; size of print, $3\frac{1}{2}$ in. by $2\frac{1}{4}$ in. or $3\frac{3}{4}$ in. by $2\frac{3}{8}$ in., the latter being "No. 1 C. de V.," and the former "No. 2 C. de V." The carte-de-visite was at the height of its popularity in England in the sixties of the nineteenth century. Its origin was due to a fancy of the Duke of Parma, who, in 1857, had his portrait gummed on his visiting-cards in the place of his name. Ferrier, a professional photographer of Nice, is supposed to have produced the first of this popular size ; but it was Disderi, of Paris, the Court photographer to Napoleon III., who made it popular.

CARTON DURA

Hard waterproofed cardboard, formerly used for making photographic dishes. It was made by coating Bristol board with linseed oil, varnish and asphalt, but has now been superseded by papier mâché.

CARTRIDGE FILM (Fr., *Pellicule enroulée* ; Ger., *Patronfilm*)

A daylight-loading roll-film, consisting of an emulsion on paper or celluloid, wound on a wooden spool, together with a length of opaque black paper. Cartridge films are used in roll-holders—a kind of dark-slide—and in various forms of hand cameras made to take the films direct. A winding key is employed to pass the film, as exposed, on to another spool. The first roll-film on a paper support was introduced, in 1875, by L. Warnerke, and the first celluloid roll-film in 1889, by the Eastman Company. The non-curling film—that is, a celluloid film with a thin layer of plain gelatine on the back—was placed on the market by the latter firm, now known as Kodak, Ltd., in 1903.

CASEIN, OR CASEINE (Fr., *Caséine* ; Ger. *Kasein*)

Solubilities, insoluble in water, soluble in alkalis and organic acids. It is obtained from milk by acidification, and is commonly known as curds. It has been introduced as a vehicle for the silver salts in printing-out paper, as it gives a film which does not become sticky, does not curl up, and is not easily scratched.

In process work, caseine has been advocated for some years past by Prof. Namias and others as a substitute for albumen and fish-glue enamel to form a resist for etching zinc or copper. It has not, however, come into general use. The casein solution is made up as follows :—

Liquor ammoniæ	. .	.	$3\frac{1}{2}$ oz.
Potassium carbonate	.	.	15 ,,
Caseine	$\frac{1}{2}$,,

Allow the whole to stand some hours to dissolve, and sensitise the solution with a saturated solution of ammonium bichromate. The whole is mixed and filtered into a clean bottle, which has to be kept closed. The plate is coated in the usual way, and after exposure under a

negative is inked and then immersed in water. Afterwards it is rinsed without rubbing with cotton-wool. The caseine image is highly resistant to the mordants usually employed, without the necessity of burning-in.

CASEINE PIGMENT PRINTING (Fr., *Tirage en caséine et pigment ;* Ger., *Kasein Pigmentdruck*)

A process patented by the Neue Photographische Gesellschaft, in 1908, for obtaining prints in caseine and pigment from bromide or other silver prints. The caseine is employed either in the form of " curd," or in an acid or alkaline solution. In a typical formula, 2,200 grs. of pressed-out curds and 440 to 520 grs. of water-colour are ground together, the mixture being brushed over the bromide print and allowed to dry. The print is then immersed for ten to fifteen minutes in :—

Potassium bichromate	. 88 grs.	9 g.	
Potassium ferricyanide	. 88 ,,	9 ,,	
Potassium bromide	. 88 ,,	9 ,,	
Water to . .	. 20 ,,	1,000 ccs.	

This has the effect of rendering the pigment-incorporated caseine insoluble at those parts where the silver image is present, the action varying in degree according to the depth or gradation of the latter. The picture may therefore be developed in water at from 105° to 125° F. (41° to 51° C.), after the fashion of a carbon print, a little potassium oxalate or sodium bicarbonate being added to ensure clearness of the lights. The original black silver image fades to a faint brown during treatment, and is practically invisible under the final pigmented picture.

CASKET LENSES

In their original form casket lenses were put upon the market by Darlot, of Paris. His set consisted of a portrait lens (covering 7 in. by 6 in., or with a smaller stop and adjustment of the tube $8\frac{1}{2}$ in. by $6\frac{1}{2}$ in.) and six single achromatic lenses fitting into the same tube, which could be used alone or in pairs, giving fifteen double lenses varying in focal length from $2\frac{1}{2}$ in. to 9 in., each covering a plate whose length is considerably greater than the focal length of the lens. Other makers have since produced similar sets, amongst them being caskets of simple uncorrected "spectacle" lenses for artistic photography. The highest development of the casket idea is found in the Zeiss Satz-anastigmats. These consist of three or four perfectly corrected anastigmatic lenses working at $f/12\cdot5$. The D set gives, in the single combinations, focal lengths of $11\frac{1}{2}$ in. to 19 in., and as doublets four combinations working at $f/6\cdot3$, the focal lengths varying from 7 in. to 10 in. The casket system was very popular some years ago.

CASSETTE (Ger., *Kassette*)

A French term occasionally used in early British photographic works, and meaning the plate-holder or dark-slide.

CASTILE SOAP

A pure soap made from olive oil and soda, and obtainable in two varieties, one a pure white

or yellowish white, and the other marbled or veined with bluish-green ; the former is the better for photographic purposes. It is used for making encaustic pastes or for waxing glasses to be used for stripping, also, when mixed with methylated spirit, as a lubricator for prints to be passed through a bar burnisher.

CASTOR OIL (Fr., *Huile de ricin ;* Ger., *Rizinusöl*)

Solubilities, insoluble in water, soluble in alcohol, ether, and glacial acetic acid. It is a pale yellow, non-drying oil, obtained by expression from the seeds of *Ricinus communis*. It is used in some varnishes and enamel collodion, and to render paper translucent. Also, it is used for temporarily cementing lenses, and as a lubricant.

In process work, castor oil is used in two very useful ways. It is added to collodion to make it more flexible for the stripping process, and it is used for treating the surface of an albumen or fish-glue coating on zinc or copper, so as to cause a negative film to adhere temporarily whilst printing is in progress.

CATALYSOTYPE (Fr. and Ger., *Catalysotypie*)

A variation of the calotype process, invented in 1844 by Dr. Woods, in which the paper is coated with a syrupy mixture containing ferrous iodide instead of with potassium iodide. The coated paper, having been sensitised by brushing over with a silver nitrate solution, is exposed in the camera, and the image either develops itself, or is caused to appear by merely keeping the paper moist. Its name was given under the erroneous impression that the development was due to a catalytic action—that is, a chemical change brought about by an agent which remains itself apparently unaffected. It is now known, however, that this is not the case, since ferrous nitrate, an energetic developer, is produced when the paper is treated with the silver nitrate solution, by the same decomposition that forms the sensitive silver iodide. The process is not very satisfactory, the silver solution being soon blackened by the iron, and the ferrous iodide mixture itself being inconstant in composition.

CATATYPE (Fr. and Ger., *Catatypie*)

A process depending on catalytic action, which is defined in the preceding article. In the original catatype process patented by Messrs. Ostwald & Gros in 1901, a negative image consisting either of silver or platinum is immersed in a solution of hydrogen peroxide in ether, being then withdrawn and the ether permitted to evaporate. The peroxide is decomposed wherever it comes in contact with the metal, but in various degrees according to the different gradations of the picture. The negative so treated is now pressed into contact with a gelatine film for a few seconds, an invisible hydrogen peroxide image being thereby taken up by the latter. If the gelatine film is then immersed in an alkaline solution of a manganous salt, brown manganese peroxide is formed wherever hydrogen peroxide is present, a brown positive image being thus obtained. Or, if an alkaline silver

solution is used instead of a manganous salt, a black image in metallic silver results.

Another method is to place an ordinary negative in contact with hydrogen peroxide, as before, and to bring it for about thirty seconds into contact with a gelatine paper in which a pigment is incorporated, the paper being then immersed in a solution of a ferrous salt. The invisible hydrogen peroxide image taken up by the gelatine will oxidise the ferrous salt to the ferric state, in which it is able to render the gelatine insoluble, the insolubilisation exactly corresponding to the various degrees in which the peroxide is present. The print can then be developed with warm water, as in the carbon process. There are many other variations of the catatype process, mostly patented.

CATECHOL

Another name for the pyrocatechin developer.

CATECHU OR CUTCH (Fr., *Catechou ;* Ger., *Katechu*)

Solubilities, soluble in water and alcohol. It occurs in irregular, brittle masses of dark brown colour, slightly porous and glossy when freshly broken ; it is an extract obtained from the wood of a species of acacia.

There are several varieties of catechu known in commerce, the principal being ordinary or brown catechu, yellow lump catechu, and cubical or yellow catechu, but all are of practically the same composition. Bengal or Bombay catechu, of the ordinary or brown variety, is the best for photographic purposes, it being rich in tannin. It is of a dark reddish-brown colour with a brilliant fracture, and is almost entirely soluble in water, giving a highly coloured brown solution. It is used for toning platinum prints, the process being known as " Packham's," also for toning blue (ferro-prussiate) prints to a greenish-black colour, the latter being known as Roy's process. (*See* " Blue-print Process.")

CATECHU TONING

A method of toning prints on platinum paper to various shades of brown by means of a solution of catechu was introduced by J. Packham in 1895. The stock toning solution is made up as follows : Place 120 grs. of catechu in 5 oz. of water and boil for five minutes ; allow to cool, and then add 1 oz. of alcohol. To make up a working solution add 30 to 40 drops of the stock solution to one pint of water, and heat to a temperature between 130° and 150° F. (54° to 66° C.). The washed black and white platinum pictures are immersed therein, and toning wil be complete in about fifteen minutes, the colour being a rich mellow brown. Within one minute of immersion the prints will probably begin to change, and thereafter pass through various shades of brown in succession ; immediately the desired brown is reached, the print is put into cold water which at once stops the toning action. A few minutes' washing completes the operation. When the water with which the toning bath is made contains a considerable amount of lime, the solution becomes pink and slightly stains the whites of the picture. This may be counteracted by adding 2 grs. of potassium oxalate to each pint of the toning bath, the

addition tending to give tones of a warmer colour. J. Packham also states that after toning with catechu and washing, the permanency and brightness of the image are aided by immersing the print for about five minutes in a solution of very weak potassium bichromate of a light straw colour. The prints must not be allowed to remain too long in the catechu toning bath, or the whites will be degraded, as the process is really that of staining. If desired, the bath may be used cold, in which case toning is very slow indeed. As the catechu-tannic acid in the catechu combines to form an inky compound with iron, it is important that the latter be entirely removed from the prints before toning.

Chapman Jones has stated that catechu toning is due to the action of the extract upon the iron compound left in the print, which it is difficult, if not impossible, to remove completely, and that other substances which give colours with iron salts would give similar results, though perhaps not such desirable colours. The fact that the image is toned appears to be due to the fact that platinum holds the minute residue of iron more tenaciously than the paper alone, and that the residual iron compound is therefore roughly proportional to the thickness of the platinum deposit. (*See also* " Platinotype Process.")

CATHODAL RAYS (*See* " X-ray Photography.")

CATHODOGRAPHY AND CATHOGRAPHY

Names at one time given to radiography, or, as it is more commonly called, " X-ray " photography.

CATOPTER (Fr., *Catoptron ;* Ger., *Katopter*)

An optical instrument in which reflection is made use of ; a mirror. A concave mirror was employed by some of the early Daguerreotypists instead of a lens.

CAUSTIC (Fr., *Caustique ;* Ger., *Ätz*)

Synonyms, hydroxide or hydrate. Caustic compounds are those in which it may be considered that a metal has replaced one of the hydrogen atoms in water, thus H_2O = water, KHO = potassium hydrate, or caustic potash, NaHO = sodium hydrate, or caustic soda, CaHO = calcium hydrate, LiHO = caustic lithia. They are all powerful alkalis. Caustic potash and soda are used in some developers as accelerators, especially with hydroquinone, but must be employed sparingly as they tend to cause frilling.

CAUSTIC LITHIA (*See* " Lithium Hydrate.")

CAUSTIC POTASH (*See* " Potassium Hydrate.")

CAUSTIC SODA (*See* " Sodium Hydrate.")

C.C.

Cubic centimetre, a measure used in the metric system. The English equivalent is 17 minims (nearly), or ·035 fluid ounce.

C.C. is also used to indicate collodio-chloride paper.

CEDAR OIL (Fr., *Huile essentielle de cèdre ;* Ger., *Zedernholzöl*)

Synonym, oil of red cedar wood. A yellowish, volatile liquid with pleasant odour, obtained from *Juniperus virginia*, and other species of cedar. It is used in microscopy as a clearing agent and with oil immersion lenses.

CELESTIAL PHOTOGRAPHY (Fr., *La photographie astronomique ;* Ger., *Astronomische photographie*)

This is described fully under the heading " Cosmical Photography."

CELLOIDIN (Fr. and Ger., *Celloidin*)

Solubilities, insoluble in water, soluble in a mixture of alcohol and ether. A specially pure form of pyroxyline (*which see*), made by Schering. Usually it occurs in the form of thin, yellowish, transparent shavings.

In process work, celloidin is largely used by those who make up their own collodion. The substance comes on the market either in large dry flakes or in small dry chips, or in chips moistened with alcohol. It is used in the proportion of from 1 to 2 per cent.

CELLS, LENS (*See* " Lenses, Brasswork of.")

CELLS FOR MICROSCOPICAL SPECIMENS

Cells for mounting preserved specimens or sections in glycerine, etc., are made by tracing a circle of Brunswick black on a glass slide and attaching a cover glass.

In the photo-micrography of living objects one of the most convenient materials for cell making is plasticine ; a small piece of this is rolled out between the hands, bent into a circle, placed on the glass slide, and flattened out by pressure with another glass slide, until the cell is of the required depth. The cell is filled with water and the object placed inside ; then a cover slip pressed down keeps the liquid in the cell. Another common form of cell for living objects is an indiarubber ring cemented by Canada balsam or rubber solution to the glass slide, a cover glass being placed on top when the object is in position.

CELLULOID (Fr. *Celluloïde ;* Ger., *Celluloid*)

Solubilities, insoluble in water, soluble in acetone, alcohol, and ether. It is obtained by casting on metal cylinders a viscous solution of pyroxyline (*which see*) in naphtha, amyl acetate, fusel oil, and camphor in varying proportions. This gives the thin sheets used in roll-film cameras, and the thicker strips used in kinematography. Thick sheet celluloid is usually obtained by casting the celluloid in blocks and shaving off to the required thickness. Its principal use is for the support of films of all kinds and for making celluloid varnish or zaponlack.

A great objection to celluloid is its inflammability. A non-inflammable variety (*see* "Cellulose Acetate ") has been placed on the market.

A formula for a celluloid varnish is :—

Celluloid or pyroxyline	90 grs.	6 g.
Acetone . . .	10 drms.	35 ccs.
Amyl acetate . .	20 ,,	70 ,,
Benzole . . .	20 ,,	70 ,,

Old and spoilt films with the gelatine cleaned off will provide the celluloid ; more or less is used to regulate the consistency of the varnish.

In process work, a celluloid varnish made by dissolving celluloid in acetone is sometimes used as a substitute for stripping collodion. The celluloid solution is flowed over the negative, after the application of rubber solution.

CELLULOID, CEMENTS FOR

The best cement for celluloid is a solution of celluloid in amyl acetate or acetone. In joining a kinematograph film, for example, the two ends are scraped thin, lightly coated with cement, and placed between glass plates to dry ; grease on the glass will prevent the pressed-out cement adhering to the glass. Many other cements are available for mending broken celluloid goods. A solution of 1 part of shellac in a mixture of 1 part spirit of camphor and 3 to 4 parts of alcohol (90 per cent.) will answer ; as will also a marine glue consisting of pure indiarubber, shellac, and naphtha. Canada balsam may also be used in the form of a solution in benzine.

CELLULOSE (Fr., *Cellulose ;* Ger., *Zellulose*)

$(C_6H_{10}O_5)_n$. Molecular weight, $(162)_n$. Obtained from the cell walls of plants and usually in the form of cotton-wool, which is the material from which cellulose acetates and nitrates are made.

CELLULOSE ACETATE (Fr., *Cellulose acétate ;* Ger., *Celluloseacetat*)

$(C_8H_{10}O_5)_n$ $3COOH$. This is obtained by the action of acetic anhydride on cellulose, usually in the form of cotton or cotton-wool, in the presence of glacial acetic acid and some condensing agent such as sulphuric or phosphoric acids or acetyl and zinc chlorides. The cotton may be mercerised or not, or previously converted into hydrocellulose, or the hydrolising may be effected in the acetylising bath. It occurs as a granular powder of white or faintly yellowish colour, or in the form of the original cellulose itself. It is of special interest, as it forms the basis of the non-inflammable celluloids that have been placed on the market. Films prepared with it fuse and char, but will not burn. It is insoluble in alcohol and ether, and nearly all the solvents of pyroxyline, but soluble in phenol, tetrachlorethane and alcohol, acetone and alcohol, etc.

CELLULOSE NITRATES (*See* " Pyroxyline.")

CELLULOTYPE

Etching on celluloid with the needle point for intaglio printing.

CELLUTYPE

Printing blocks cut in celluloid with the object of superseding woodcuts.

CELSIUS THERMOMETER (*See* " Thermometer.")

CEMENTS (*See* " Mountants " and various substances, " Ebonite," " Glass," etc.)

CEMENTING LENSES (*See* "Lenses, Cementing.")

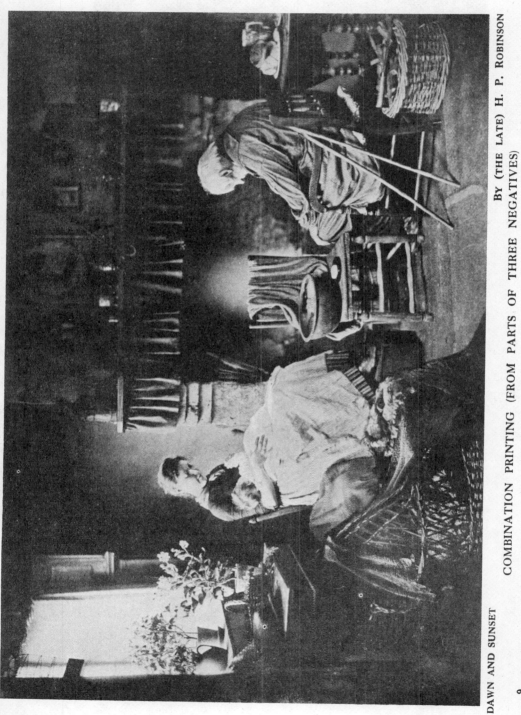

DAWN AND SUNSET

9

BY (THE LATE) H. P. ROBINSON

COMBINATION PRINTING (FROM PARTS OF THREE NEGATIVES)

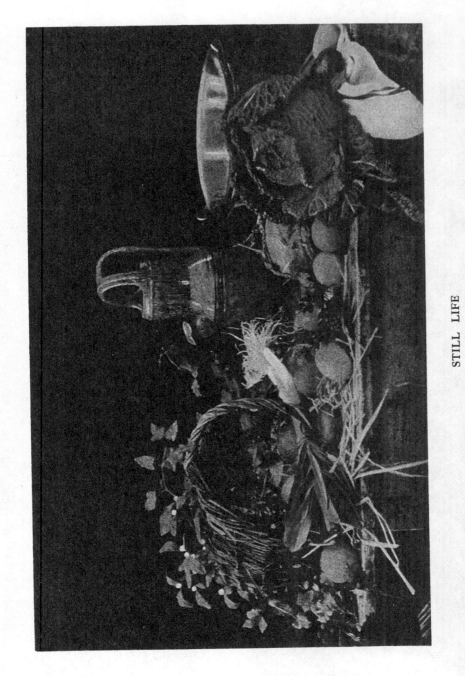

STILL LIFE

A photograph in natural colours, taken on the Dufay Dioptichrome plate, and reproduced by the four-colour process

CENTIGRADE THERMOMETER (*See* "Thermometer.")

CENTIGRAM, CENTIMETRE, CENTI-LITRE, ETC. (*See* "Weights and Measures.")

CENTRAL SPOT (*See* "Flare.")

CENTRE OF ADMISSION (*See* "Nodal Points.")

CENTRIFUGAL SEPARATION (Fr., *Séparation centrifuge;* Ger., *Separiren mittels einer Zentrifugalmaschine*)

A method introduced by Plener in 1881 for separating the sensitive silver salts from the gelatine used during the manufacture of emulsions. The fluid emulsion is poured into a gunmetal receptacle, which is rotated at a speed of from 4,000 to 6,000 revolutions a minute, the silver salts being thrown on to the walls of the container, whilst the gelatine and water escape by an orifice at the bottom. It is claimed for this method that the emulsion is very rapidly freed from the nitrates, formed as by-products, and the decomposed gelatine. The method has fallen into almost complete desuetude.

CENTRING OF LENSES

When a lens is correctly centred the axes of all its surfaces are in a straight line; otherwise, good definition cannot be obtained. Faulty centring gives a distortion to the image similar to that of astigmatism or coma, and is easily detected by fixing the lens upon a camera or optical bench and focusing a brightly illuminated object, such as a small lamp flame or mercury bulb. The position of the image is carefully noted, and the lens gently rotated in its flange, when, if the centring be perfect, the image will remain quite stationary, but if not it will move in more or less of a circular direction upon the screen. The fault may be in the flange, or rather the body ring of the lens tube, or it may be in the thread upon the lens cells, in the cementing of the separate components, or the surfaces of one or more of the single glasses of the combination may not be correctly adjusted. In any case, it is a matter for an experienced optical workman to put right.

The centring of the actual components of the lens is a simple process, but one requiring considerable skill. When a lens leaves the polisher's hands it has a more or less rough edge, and is a little larger than the cell it is destined to fit. It then goes into the hands of a workman for "edging" and "centring," which operations are performed simultaneously. The lens is stuck with pitch upon a revolving chuck, and a gas flame is so adjusted that two images of it are seen by reflection from the inner and outer surfaces of the lens. These will be found to "wobble" as the lathe head rotates, and the workman slides the lens upon the soft pitch until they are quite steady. The pitch is then allowed to set and the edge of the lens is ground to correct size upon the lathe by the application of a copper plate fed with wet emery powder. A similar process is gone through after cementing two or more glasses together while the balsam is suffi-ciently soft to allow the surfaces to be moved upon each other.

CERAMIC PAPER

A paper at one time used for the production of ceramics; invented by Guerot in 1891. It was sensitised with a solution the constituents of which were kept a trade secret. The paper was printed upon, washed, squeegeed in contact with the vitrifiable plaque, and stripped. The image was then treated with a solution of potassium permanganate, washed, dried, and finally fired.

CERAMIC PROCESS

The art of obtaining a burnt-in impression of a photograph on earthenware, china, or porcelain. Such pictures are permanent because the image, formed by a vitrifiable powder, is protected by an imperishable glaze. The material of which the picture is composed must obviously be of a special nature. The process is based on the dusting-on or powder process, in which a bichromated film loses its tackiness in different degrees by exposure to light under a negative, so that on brushing it over with a suitable powder an image is obtained; but in ceramic photography the powder used is a vitrifiable colour which stands firing without injury.

The transparency used must be bright, vigorous, and of the highest quality. The image for firing is not produced at first on its final support. A polished glass plate forms a temporary support, the print obtained on it being afterwards coated with collodion, stripped and transferred. The glass plate is cleaned and coated with a mixture of the following two solutions :—

Organifier

Le Page's fish-glue	.		2 oz.	62 g.
Glucose	.	.	8 „	248 „
Glycerine	.	.	20 mins.	1·2 ccs.
Water	.	.	21 oz.	600 „

Sensitiser

Ammonium bichromate			900 grs.	58 g.
Water	.	.	21 oz.	600 ccs.

If a smaller quantity is desired, keep to the same proportions. Mix together in equal parts and filter as required. Such solutions may be purchased ready prepared. The coated plate is dried by gentle heat, not greater than that which can be borne comfortably by the back of the hand. A whirler is useful for rapid drying. A thin, even coating should be aimed at, and the film ought to be quite glossy when dry. The exposure under the transparency varies with the quality of the latter and the light, and it is better to use an actinometer; it may range from forty seconds to three minutes in the sun, or to as much as fifteen minutes in diffused light. With a correct exposure the image will be faintly visible on the film. Development is performed as in the dusting-on process (*which see*), but the plate is held in an inclined position resting on a sheet of white paper, sensitive side towards the light, so that progress may be viewed by both transmitted and reflected light; and vitrifiable powders must be employed. These consist of metallic oxides and other fusible substances, and they are obtainable in a number of

different tints. Sift the powder through silk, but it may be necessary, before doing this, to re-grind it with water, using a muller on a glass slab. The powder must be thoroughly dried before sifting. Firing alters the colours of the powders to an extent that only experience will show. When the image possesses about the same vigour and transparency as a good lantern slide, the surplus powder is dusted off, and the picture coated with collodion (either plain or a special preparation), which is flowed over the plate like a varnish. When the collodion has set, a sharp penknife is pressed downward through the edges of the film on three sides of the plate, cutting through to the glass ; the plate is then immersed in several changes of water, preferably filtered, to remove the bichromate salt. The film will separate from the plate, except on one side. When the bichromate seems nearly all removed, the film is placed in a solution of fused borax for about ten minutes, finally washing in a fresh bath of filtered water for an equal period. To prepare the fused borax solution, place 2 oz. of the fused borax in an enamelled saucepan with water, boil rapidly for five minutes, decant, add fresh water, and repeat until all the borax is dissolved. For use, take three parts of the saturated solution (cold) and add one part of water. For transferring, fill a large basin or dish with the borax solution. The plate, after its final washing, is stood in a rack for a few minutes to drain off the surplus moisture. The penknife is then very carefully passed along the fourth edge of the film, which must not be cut through by drawing the blade along, as that would pucker or tear the film. The plate is now placed in the basin, and the film will float off the glass, which can then be withdrawn. With a camel-hair brush turn over the film in the solution so that the collodion side is downward ; if the fingers were used there would be a risk of damaging the loose film or of abrading the powdered side. The plaque or other support is next introduced under the floating film, which is guided into its correct final position. The support is then slowly, and by degrees, lifted out of the water with the film adhering, powder side uppermost, and placed on blotting-paper to dry, after which loose pieces of film may be removed with a damp sponge, and the image should be very carefully examined for any black spots or imperfections, the former being removed with a fine needle-point set in a wooden handle. The delicate powder is next protected by flowing over it—

Fatty oil of turpen-
 tine . . . 10 mins. 20 ccs.
Oil of turpentine . 1 oz. 1,000 ,,

Oil of turpentine oxidises by exposing for some time to light and air. The mixture should be filtered and kept from the dust. When dry, the plaque coated with this medium should appear uniformly dull. Any white spots on the picture may now be filled in with a little of the powder colour mixed with the medium above mentioned. If the plaque is given a light firing, just sufficient to attach the powder to the surface, it can be spotted or worked upon with facility.

Firing is the next process. The work will be fired at any pottery for a moderate charge ; but by the aid of a gas muffle the worker can easily do his own. For tiles and plaques the heat must be applied very carefully, gradually increasing the consumption of gas. When the furnace is fully heated the gas is immediately turned out, the chimney covered up, and the whole left to cool, or, instead, the work can be transferred to an annealing chamber. Enamel plaques or medallions on a metal base need not be cooled with such extreme care.

Dust is especially to be avoided in ceramic work ; it is advisable to sprinkle the floor of the room with water, which will probably suffice to lay the floating dust, and on no account should any sweeping or dusting be done immediately preceding any of the manipulations. Charging the air with moisture by means of a spray diffuser or vaporiser prevents the dust nuisance, but makes the room too moist for developing.

It may be said that the image may be printed direct on perfectly flat surfaces, instead of using a temporary support.

There are many possible modifications of the above process. (1) Instead of using the dusting-on process, a film prepared with ferric chloride may be employed. The film is exposed under a negative to obtain a plate of various degrees of tackiness, which is then brushed over with powdered enamel colour as before. No transparency is required. The picture so obtained is coated with collodion, stripped, and treated as before described. (2) Prints obtained by the carbon process, simply substituting enamel colours in the preparation of the film, may be developed upon porcelain as a final support, forming excellent pictures for firing. (3) A method that is useful where numbers are required is to obtain a photo-mechanical impression in the usual manner on a special transfer paper prepared with a collodion substratum. A suitably tacky ink is used for printing, and the ceramic powder is dusted over this. The paper is then moistened and removed, while the film and picture, collodion side downwards, are transferred to the porcelain support or plaque, which is first treated with an adhesive medium. (4) The following procedure may be taken as representative of the substitution process. A collodion positive is obtained in the camera by the wet process, fixed, washed, bleached in a 5 per cent. solution of mercuric chloride, again washed and placed in the substitution bath, which is to replace the original image, unsuitable for firing, with one of platinum or iridium. A gold and platinum bath, as follows, gives a purple-brown colour :—

Potassium chloro-		
platinite . .	8 grs.	1.5 g.
Gold chloride (1 in 60)	4½ drms.	43 ccs.
Water (distilled) .	4½ oz.	345 ,,
Lactic acid . .	5 mins.	·9 ,,

An iridium and gold bath gives a warm black tone :—

Iridium chloride .	8 grs.	1.5 g.
Gold chloride (1 in 60)	4½ drms.	43 ccs.
Water (distilled) .	4½ oz.	345 ,,
Lactic acid . .	6 mins.	1 ,,

After the deepest shadows of the picture have been toned through, wash for a few minutes to

remove the free toning solution. Cut round the margins of the film, immerse the plate in a 1 per cent. solution of sulphuric acid, wash the film after it strips off, transfer to the final support of porcelain, collodion side up, and dry. Then remove the collodion film by gently rubbing with a sponge moistened with ether and alcohol, again dry, and dust the image with flux, when it is ready for firing. (5) It is possible to obtain a burnt-in picture in natural colours by the exact superposition of a blue, a red, and a yellow picture printed from three negatives obtained through suitable screens. The yellow film is first transferred and fired, allowed to cool, and the blue image very carefully superposed on this in exact register and burnt in. After again cooling, the red film is transferred and fired.

CERATE PASTE

A paste or waxy mixture for surface application to finished prints. Better known as encaustic paste, under which heading formulæ will be found.

CERIC SULPHATE (Fr., *Sulfate de cérium, Sulfate cérique;* Ger., *Cerisulfat*)

Synonym, sulphate of cerium. Solubilities, slightly soluble in water, more soluble in dilute sulphuric acid. $Ce(SO_4)_2$ $4H_2O$. Molecular weight, 404. It occurs as reddish yellow crystals, and was suggested by Lumière as a reducer, the formula being:—

Ceric sulphate	.	2 oz.	100 g.
Sulphuric acid	.	384 mins.	40 ccs.
Distilled water to	.	20 oz.	1,000 ,,

This acts very energetically, and can be diluted for prints and lantern slides. A 5 per cent. solution acts more strongly on the high lights of a negative than the shadows.

CERIO PRINTING

A term commercially applied to the kallitype process (*which see*).

CERIUM SALTS, PRINTING WITH

There are two series of cerium salts, a cerous and a ceric, the former being stable, but the latter extremely unstable; this fact induced Lumière and Seyewetz to examine their photographic properties, and they found that ceric sulphate and nitrate, when used for sensitising gelatinised paper with exposure under a positive, were reduced to the cerous state, and became pale coloured. The print, being then treated with certain organic substances, gave coloured images, due to the formation of dyes through the oxidation of the developers by the unreduced ceric salts, and the dye images thus formed were insoluble in water. In an acid solution phenol gives grey images; aniline salts give greens; naphthylamine gives blue; amidobenzoic acid, brown; parasulphanilic acid, red; and ortho-toluidine salts, brown images. With ammoniacal solutions other colours are obtained; for instance, aniline gives violet and naphthylamine reddish violet images. Paper sensitised with these cerium salts is far more sensitive than with iron or manganese salts and the range of colours is far greater, but no commercial application of this process has yet been made.

CEROGRAPHY

The art and process of engraving on wax. (*See* "Wax Engraving.")

CEROLINE (Fr., *Céroline;* Ger., *Ceroline*)

A solution of white wax in benzole, used in the early days to render paper translucent.

CERTINAL

A highly concentrated liquid developer in one-solution form, introduced by Ilford Ltd., March, 1909. The best proportion for developing plates and films which have received normal exposure is certinal 24 drops, water 1 oz. At a temperature of 60° F. (nearly 16° C.) the image appears in a few seconds, and development will be complete in from 4 to 8 minutes, according to the plate and the class of negative desired. The rapid appearance on dry plates must not be mistaken for signs of over-exposure, and the image will need to be developed for density. As a rule, the image on a properly exposed plate appears in 15 seconds, and development is complete in 6 minutes. With under-exposure the best results are obtained by using the developer weaker (16 drops of certinal to each ounce of water) and developing longer. Over-exposed plates need a stronger developer and the addition of potassium bromide (certinal 48 drops, water 1 oz., 10 per cent. solution of bromide 48 drops); development will then take about one-fourth less time than would be required when exposure and developer are normal. For tank or stand development ¼ oz. (120 drops) of certinal should be added to 25 oz. of water; development will be complete in from 30 to 60 minutes, according to temperature, plate, subject, and type of negative desired. For lantern plates and bromide paper the best strength is 16 drops to each ounce of water, but gaslight papers and plates need double that strength. More contrast may be obtained on papers and lantern plates by using a stronger developer, and still more by adding potassium bromide, while softer results are obtained by diluting the developer. Additional bromide gives warmer blacks, especially on gaslight papers and plates.

CHALK (Fr., *Craie;* Ger., *Kreide*)

Precipitated chalk, a fine white substance, is a pure form of carbonate of lime. It is often used for neutralising gold toning baths, for which purpose common whiting (prepared from chalk by grinding and levigating) is sometimes used; chalk is also used for clearing varnishes.

In process work, precipitated chalk or washed whiting is largely used for cleaning glass, for giving a final polish to copper and zinc plates, so as to remove grease (the chalk being made into a paste with ammonia), and for rubbing in an engraved plate, so that the image may show up and enable the engraver or fine etcher to do any retouching that may be required. Magnesia is, however, more generally used now for the latter purpose, the chalk often tending to grittiness.

Lithographic chalk is somewhat a misnomer, this substance being the black, greasy, crayon used for drawing on grained lithographic stone, zinc, or aluminium, and for drawing on grained transfer papers. The term no doubt originated

from the similarity of the crayons to ordinary black and white chalks used for drawing on paper.

Chalk ink is a stiff black lithographic ink used for inking-up lithographic drawings in chalk on grained surfaces.

Chalk transfer paper is a grained paper for drawing upon with lithographic chalks.

CHALK, FRENCH (Fr., *Talc, Savon à marquer ;* Ger., *Talk, Französische Kreide*)

Synonyms, talc and steatite. French chalk is a hydrous silicate of magnesia, a typical analysis being : silica 62, magnesia 33·1, and water 4·9 per cent. ; 1 or 2 per cent. of iron often occurs as well. It has the appearance of a fine white or greyish white powder, and is used chiefly for polishing glass, to which prints are squeegeed for the purpose of glazing.

In process work, it is used for polishing glass for stripping purposes, and also as a resist for etching, for which latter purpose it is dusted upon an ink image. It is especially useful in this way in lithographic work on stone, and it is sometimes employed in admixture with black-lead.

CHALK PLATE

An iron plate thickly coated with a chalky substance, through which a drawing is scratched with a pointed stylus. The plate is then used as a matrix for stereotyping.

CHALKINESS (NEGATIVES AND PRINTS)

" Hardness " or excessive contrast ; chalky negatives and prints show a very great difference between the high lights and deep shadows. The fault is due to under-exposure and over-development, and a partial remedy is the ammonium persulphate reducer. Softer prints may be obtained from such negatives by bleaching with, say, a mercuric bichloride solution as used for intensifying, and printing from the negative in its bleached or whitened condition. There is no complete remedy for chalky or hard prints.

CHALKINESS (WATER)

Water, particularly hard water, is sometimes chalky, and although it rarely does any harm to solutions it is better to boil it before use (*see* " Water "). Dr. Hauberisser has described a chalkiness which comes over the negative in a kind of fog, and is due to impurities in the water, these giving rise to an insoluble calcium compound. When water containing not only sodium chloride, but a calcium salt as well, is used, there is the risk of calcium oxalate being formed should a ferrous oxalate developer be employed. Similarly, with water containing organic agents, the use of potassium carbonate may cause calcium carbonate to be precipitated as a sediment in the gelatine, thus producing a calcic fog. A simple remedy for such a deposit consists in the application of a weak solution of hydrochloric acid to the negative, this converting the calcium carbonate to soluble calcium chloride, which, of course, washes out. There may, however, be a risk of the liberated carbon dioxide causing blisters.

CHANGING BAGS AND BOXES

A changing bag is a device to allow of reloading dark-slides or sheaths without the necessity for a dark-room. It is generally a bag of several thicknesses of black and red material, provided with sleeves which tighten round the arms by means of elastic, so that the hands are inside the bag. In some forms the changing has to be effected by the sense of touch alone ; in others there is an eye-piece to fit on the face so that the interior of the bag can be seen, light being admitted through a panel of red fabric or celluloid in one side of the bag. The utility of such a bag as a makeshift dark-room is obvious.

A changing box is a magazine holding plates in sheaths, and is generally detachable from the camera. An exposed plate can be moved from the front to the back, or an unexposed plate taken from the back and placed in front of the one last exposed. The usual method of accomplishing this is to raise the plate into a bag of flexible leather and place it in position by hand, but in some cases the transfer is made mechanically. The front of the changing box is fitted with a draw shutter, which is opened for exposure and closed when the box is to be removed from the camera. The back of the box can be opened for the removal of exposed plates and for reloading the sheaths. Hence there is some advantage in those types in which the exposed plates find their way to the back of the box, as they may be removed without disturbing unused plates. Many boxes are constructed to take cut films instead of plates, their capacity thus being doubled. Obviously the number of plates or films available may be increased by the use of additional changing boxes. (*See also* " Daylight Changing.")

CHARBON VELOURS (Fr.)

The name originally given to the paper introduced by V. Artigue, of Bordeaux, in 1892 (*see* " Artigue Process "). A recipe for making a similar paper is given under the above denomination by H. Schneeberger. The pigment may be any ordinary water-colour ; or moist colours may be used, provided they do not contain a tanning ingredient. The colour is rubbed up in a stiff paste of starch and applied to the paper in a thin uniform coating. Too thin a coating, or one containing insufficient pigment, does not give the desired velvety appearance ; while, if too thick, the half-tones and other parts where the light has not penetrated to the support are apt to wash away in developing. The coated paper will keep indefinitely. It is sensitised, for flat negatives, in a 2 per cent. bath of potassium bichromate, or, for hard negatives, in a 5 per cent. bath. Development is with a warm sawdust mixture, as in the Artigue process, a temperature of about 80° F. (about 27° C.) being recommended.

CHARCOAL, ANIMAL

Known generally as bone black (*which see*).

CHARCOAL, WOOD (Fr., *Charbon de bois ;* Ger., *Holzkohle*)

Wood charcoal is the residue from the destructive distillation of wood. Wood having been heated to a high temperature out of contact with

the air, the volatile portions are driven off, and the yield is very nearly pure carbon. Sticks of charcoal made from vine or willow wood are used as crayons for working up enlargements.

In process work, blocks of charcoal are used for polishing the metal plates. Formerly, selected sticks of willow charcoal were used, but of late years this has been superseded by charcoal made of trimmed blocks of soft pine. Such charcoal comes from the United States, and is known as "American charcoal." It is beautifully soft and even in texture, and can be had in "hard" and "soft" qualities.

CHARDON'S PROCESS (Fr., *Procédé Chardon;* Ger., *Chardon's Prozess*)

A collodion emulsion process due to Alfred Chardon, who won with it the prize of 1,000 francs offered jointly, in 1876, by the Photographic Society of France and A. Liebert, of Paris, for the best and most reliable dry process for outdoor use. It was, as its author stated, more a well-judged selection and combination of the best points of other processes than an original or new method, although possessing some novel features: as the use of two different kinds of precipitated pyroxyline; washing the emulsion by pouring it into the water, instead of the reverse, as was formerly done; the employment of glucose in the developer to obtain density, etc.

CHEMICAL FOCUS (Fr., *Foyer chimique;* Ger., *Chemischer Brennpunkt*)

The plane on which the actinic rays are brought to a focus. In simple periscopic or non-achromatic lenses, the focal plane for the actinic rays lies nearer the lens than that of the visual rays; it follows, therefore, that the sharp image obtained by focusing, which is affected by the visual rays, is not reproduced by the sensitive film on which the actinic rays act most. This defect, which is rarely met with now, can be remedied either by reducing the distance between the lens and plate, after focusing and before exposure, by from $\frac{1}{30}$ to $\frac{1}{50}$ of the extension of the camera, or by the temporary insertion, only whilst focusing, of a weak supplementary lens which reduces the focal length.

CHEMICAL FOG (*See* "Fog.")

CHEMICAL RAYS (*See* "Actinic.")

CHEMICAL RETOUCHING (*See* "Retouching, Chemical.")

CHEMICALS

A list of the chemicals used in photography, with their formulæ and solubilities, appears under the heading "Solubilities."

CHEMICALS, STORING

Chemicals need careful storing if they are to be kept good and in a proper working condition. Those given below are the chemicals mostly used in photography, and the remarks apply generally to the chemicals themselves, as bought, and not to made-up solutions, as developers, intensifiers, etc., for information as to which *see* under the heading "Solutions." Photographic chemicals may be divided into four classes—namely :—

(1) Chemicals that keep well and need no special precautions, other than being stored in a dry place :—

Alum (ordinary and chrome)	Potassium bichromate
	Potassium bromide
Borax	Potassium ferricyanide
Boric acid	Potassium oxalate
Caramel	Sodium acetate
Citric acid	Sodium carbonate
Mercuric chloride	Sodium hyposulphite

(2) Chemicals that must be kept in bottles with tight-fitting corks (not glass stoppers) because of their deliquescent nature or oxidising properties :—

Adurol	Magnesium powder
Amidol	Potassium carbonate
Ammonium carbonat	Potassium cyanide
Ammonium sulpho-cyanide	Potassium hydrate
	Potassium iodide
Eikonogen	Potassium metabisulphite
Ferric chloride	
Ferrous sulphate	Pyrogallic acid
Formosulphite	Sodium hydrate
Glycin	Sodium sulphate
Hydroquinone	Sodium sulphite
Metol	Uranium nitrate

and all other dry developers not mentioned above, as metoquinone, pyro-catechin, etc.

(3) Corrosive and volatile substances, which should be kept in bottles having accurately ground glass stoppers, not corks :—

Acetic acid	Collodion
Acetone	Ether
Alcohol	Formaline
Ammonia (liquor)	Hydrochloric acid
Ammonium persulphate	Iodine
	Nitric acid
Amyl acetate	Sulphuric acid

(4) Materials that should be kept in a dark cupboard, or in black bottles when not in use :—

All kinds of liquid aniline dyes.
Gold chloride in solution.
Potassium chloroplatinite in solution
Silver nitrate, dry and in solution.

Chemicals that are poisonous, or otherwise dangerous, should be stored in a cupboard or some out-of-the-way place where they cannot be got at by persons unacquainted with their dangerous properties. Such chemicals include :—

Acetic acid	Sodium oxalate
Hydrofluoric acid	Chromic acid
Nitric acid	Hydrochloric acid
Chrome alum	Sulphuric acid
Ammonium bichromate	Ammonia
	Ammonium oxalate
All soluble barium salts	Bromine
	Formaline
Soluble copper salts	Lead acetate
Lead nitrate	Potassium oxalate
Potassium bichromate	Caustic soda
Caustic potash	Sodium bichromate
Silver nitrate	All developers

These are in addition to the scheduled poisons, all of which must be kept in a safe place.

CHEMIGLYPHY

Another name for "Glyphography" (*which see*).

CHEMIGRAPHY

A general name, not often used now, for zinc etching. (*See also* " Chemitype.")

CHEMITYPE

Before the application of photography to zinc etching, lithographic transfers or drawings direct on zinc were etched into relief for letterpress printing. This process was generally called " Chemitype " or " Chemigraphy."

CHIAROSCURO (It.)

A word adapted from the Italian *chiaro*, clear, and *oscuro*, dark, and indicating the light and shade in a picture. The suitable placing of the highest light and the deepest shadow is of great importance. Scattered high lights and disjointed shadow masses are fatal to harmonious effect. The portraits of Rembrandt are good and familiar examples of effective knowledge of the value of proper chiaroscuro.

Chiaroscuro is the name of a class of colour prints in which the varying effects of light and shade are represented, not by lines or cross-hatching, as in ordinary engraving on wood or metal, but by tones in the shape of broad masses of colour, produced by surface printing from wood-blocks. These were usually employed for the purpose of colouring an outline woodcut.

CHILDREN, PHOTOGRAPHY OF

The success or failure in photographing a child is nearly always dependent on the ability of the operator to gain the confidence of his juvenile sitter. In the case of amateur work, the child is often personally acquainted with the photographer, but in professional work the child is probably a complete stranger to the operator. It is useless to treat a child in the same manner as an adult, and simply request it to assume the desired position. Particular art is necessary in getting the child to adopt the pose required. Too many friends of the child should not be allowed into the studio, one being quite enough ; otherwise difficulties are likely to ensue, especially in the case of very young children whose attention is very easily diverted. Children differ so much in their disposition that it is possible to make friends easily with some, whilst others are shy and require quite diplomatic handling. In some cases it is better to ignore the child at first, and to engage in conversation with whoever is in attendance on the child, and then, by opening a picture-book, operating a mechanical toy, introducing a dog or cat, the child becomes interested and gradually its confidence is won. Some of the most successful child photographers have cultivated an ability to bring themselves down to the children by playing games and in other ways giving them the impression " that they are one of themselves." By this means they engage a child's attention, until both the desired position in the studio and the happy expression are attained, at which juncture an assistant makes the exposure.

The introduction of modern high-speed plates has given new possibilities to child photography. Some few years ago it was necessary to draw up all the studio blinds so as to admit as much light as possible, but although this allowed a quicker exposure to be made, the picture was devoid of all light and shade gradations. The plates at present available allow of a more subdued light being used ; and proper attention should be given to the arrangement of blinds for controlling the lighting.

The studio reflex camera is at present but very little used, but for child photography it possesses very great advantages, as it frequently happens that when the child has been correctly focused and the dark-slide inserted for exposure, the child moves to some other position, necessitating re-focusing. With a reflex camera this trouble is avoided, as it is possible to focus the sitter right up to the moment of exposure.

The dress of the child often makes or mars a picture, and some photographs owe their charm almost entirely to dainty garments. On the other hand, quite young children usually make more pleasing pictures when photographed either nude or with only a single garment on.

Amateur work takes place under varied conditions, some workers possessing lofty rooms with abundant light in which it is possible to obtain pictures equal to those produced in a studio ; but for those not so fortunate special arrangements must be made so as to obtain sufficient light for the quick exposures necessitated. In an ordinary room with a bow window it is often an advantage to take away all existing blinds and hangings, as these, when drawn up or to the side, frequently cut off much light. The window-panes may be covered with tissue paper, as this gives a more equal diffusion of light ; on the shadow side a screen should be used with a sheet thrown over it for use as a reflector, but care must be exercised not to move this reflector too close to the child, otherwise too flat a lighting is obtained, and there is great risk of producing false lights in the eyes. As children are usually taken so as to show the entire figure, it is necessary to see that the lighting reaches well down to the ground ; to accomplish this it is sometimes useful to build up a platform some 12 in. or 18 in. from the floor. Care must be taken to prevent the light coming too much from the side, and so to arrange the light that the strongest portion of it falls from a point higher than the child's head. This can be attained by covering the lower panes of the glass with three or four thicknesses of tissue paper. In photographing children out of doors, good lighting is possible if care is taken to choose a position where the light is screened from one side ; this is easily done by utilising the side of a house and arranging the sitter near to it, so that the main direction of light falls from the side and front. If a head screen is available it should be used to cut off the immediate top light. An entrance doorway or portico is very often suitable for such portrait work. (*See also* " Home Portraiture," " Studio Portraiture," etc.)

CHINA CLAY (*See* " Kaolin.")

CHINA, PHOTOGRAPHS ON

There are several methods of printing photographs upon china, crockery, opal, etc. For objects where the picture is to be viewed by reflected and not transmitted light, the carbon process (*which see*) is perhaps the best ; tissue of

any colour may of course be used, and the picture, after being printed upon the tissue, is transferred and developed upon the china support, after the latter has been properly prepared with a suitable substratum. By this process it is an easy matter to transfer photographs upon curved surfaces. The ceramic process (*which see*) is more difficult, but the results are absolutely permanent and will permit of any amount of washing.

The blue-print (ferroprussiate) process is simple, and is often employed for producing pictures upon china and glass. It will be necessary to give the article a coating of gelatine to serve as a vehicle for holding the sensitive solutions, the blue-print being a direct printing and not a transferring process, as carbon. A suitable gelatine substratum may be made by soaking 22 grs. of Nelson's No. 1 gelatine in 1 oz of water and melting by the aid of heat, afterwards filtering while hot. The solution, when warm (130° F. or 54° C.), is coated as evenly as possible upon the part of the article to be printed upon, and then set aside to cool. The prepared part is then sensitised as if it were paper, and when dry it is ready for printing upon.

Printing on Vase

Collodion has also been recommended as a vehicle for the blue sensitising solution, and the results are perhaps more permanent. The formula is: pyroxyline (high temperature) 120 grs., methylated alcohol (·820) 6 oz., and methylated ether 5 oz. Mix a day or two before using, allow to settle, coat the article with the mixture, and when set sensitise with the "blue-print" mixture. Substratums of collodion have been known to peel off, and to prevent this the places where the edge of the collodion is to come should be treated before coating with a solution of indiarubber in benzole.

Ordinary glass negatives can only be employed for printing when the surface is flat: on curved surfaces film negatives may be kept in contact by means of elastic bands, as shown in the illustration, or by means of gummed paper at the corners. As it is not desirable to remove the negative from the vase for the purpose of examining the progress of printing, there must be something left to chance, or an actinometer must be used. It is advisable to varnish such pictures when dry. Blue pictures may be toned to a different colour by any of the methods advocated under the heading "Blue-print Process," sub-heading "Toning Blue-prints."

CHINA, PHOTOGRAPHY OF

The principal difficulties in photographing china arise from the highly glazed surface and the consequent reflections. These may be minimised, if not altogether destroyed, by attention to two points. The lighting should never be from the front, but well towards one side—almost a side lighting. An inspection of the pieces being photographed from the position of the lens will show when the lighting produces no direct reflections. In addition, a plain, dark-coloured cloth should be hung immediately behind the camera, so that no light or bright objects may produce reflections. A colour-sensitive plate and a yellow screen should also be employed. In addition to giving a better and a truer rendering of the ornamentation, this also assists in reducing the effects of reflections.

CHINA SILK

A soft material, recommended for cleaning lenses, prisms, screens, and other optically-worked glass surfaces. In using china silk for cleaning ruled screens, merely breathe on the surface before rubbing.

CHINESE WHITE

This white water-colour pigment, which consists of zinc oxide, though formerly much used for retouching photographs for reproduction, has been largely superseded by Albanine, Blanc d'Argent, and Ullmanine. The objection to Chinese white is that it photographs darker than paper; it may, however, be used for mixing with other pigments to form a body colour. R. W. Wood has shown that Chinese white photographs black in ultra-violet light.

CHINOLINE BLUE (*See* "Cyanine.")

CHINOLINE RED (Fr., *Quinoléine rouge*; Ger., *Isochinolinerot*)

Synonym, isochincline red. A complex, organic dye, obtained by heating benzole trichloride with chinaldine and isochinoline. It is extremely sensitive to light, and this induced Vogel to test it as a sensitiser (*see* "Azaline"). It has now been almost entirely replaced by the isocyanines, but Dr. Miethe has stated that a small addition to an isocyanine bath keeps the plates free from fog; and the following is a typical formula:—

Isocyanine dye sol. (1 : 1,000
 water + alcohol) . . . 10 parts
Chinoline red (1 : 1,000 w. + alc.) 50 ,,
Water to . . . 500 ,,

The chinoline red also helps to fill up the usual gap in the green.

CHLORAL HYDRATE (Fr., *Chloral hydrate*; Ger., *Chloral hydrat*)

Synonym, trichloraldehyde. $CCl_3CH(OH)_2$. Molecular weight, 165·5. Solubilities, very soluble in water, alcohol, and ether. It is poisonous, the antidotes being ether, cocaine, and camphor. It occurs as transparent, colourless crystals or flat crystalline masses, obtained by the action of chlorine on aldehyde, with peculiar pungent odour and taste. It has been recommended as

a solvent of gelatine for making a mountant, and has been suggested for making a non-inflammable film.

CHLORATES (Fr., *Chlorates* ; Ger., *Chlor-saures*)

Salts formed by the action of chloric acid, $HClO_3$, such as potassium chlorate, $KClO_3$.

CHLORHYDRIC ACID (*See* " Hydrochloric Acid.")

CHLORIDE OF LIME TONING BATH

A toning bath, suitable for albumenised paper. Fifteen grains of chloride of gold should be dissolved in 1 oz. of water, a few grains of prepared chalk added, the solution well shaken, allowed to settle, and then filtered, the clear solution being used for making up the bath. The formula is :—

Sodium acetate	.	30 grs.	2·3 g.
Chloride of lime	.	1½ ,,	·11 ,,
Gold chloride (1 oz. of			
solution as described)		15 mins.	1·2 ccs.
Water .	.	30 oz.	1,000 ,,

This forms a stock solution which improves by keeping. For use, take 2 oz. and add 8 oz. or 10 oz. of water, this being sufficient for eight whole-plate prints.

CHLORIDE PLATES AND PAPERS

Plates or paper coated with a slow gelatino-chloride emulsion intended for development. (*See* " Emulsion.")

CHLORIDES (Fr., *Chlorures* ; Ger., *Chloride*)

A salt formed by the action of hydrochloric acid, HCl, on metal, such as sodium chloride, Na Cl. (*See* respective names of metals.)

CHLORINATED LIME OR CHLORINATE OF LIME (*See* "Lime.")

CHLORINE (Fr., *Chlore* ; Ger., *Chlor*)

Cl. Atomic weight, 35·5. A yellowish green, gaseous element, obtained commercially by heating manganese dioxide with hydrochloric acid. A solution of chlorine has been employed as a " hypo " eliminator.

CHLOROBROMIDE EMULSION

An emulsion containing both chloride and bromide of silver, the former being in excess. (*See* " Emulsion.")

CHLOROCYANINE

Eder stated that ordinary (iodo-) cyanine acted better as a sensitiser and that it gave plates freer from fog if it was treated with hydrochloric acid ; but König has pointed out that this process only purifies the cyanine, and does not form chlorocyanine.

CHLOROFORM (Fr. *Chloroforme* ; Ger., *Chloro-form*)

Synonyms, trichloromethane, (improperly) formyl trichloride. $CHCl_3$. Molecular weight, 119·5. Solubilities, 1 in 200 water, miscible with alcohol, ether, and benzole. It is poisonous, the antidotes being emetics, the use of the stomach pump, fresh air, cold douche, strychnine hypo-

dermically. It must be kept in the dark. It is a heavy, colourless liquid, with characteristic sweet smell and taste, and is obtained by the action of bleaching powder on alcohol or acetone. As a solvent of amber, etc., and indiarubber, it is useful for varnishes.

CHLORO-IODO-BROMIDE EMULSION

An emulsion containing chloride, bromide, and iodide of silver.

CHLOROPHYLL (Fr., *Chlorophylle* ; Ger., *Chlorophyll*)

Solubilities, slightly soluble in water, soluble in alcohol and ether. The green colouring matter from plants, which was used as a red sensitiser for gelatine plates.

CHLOROPLATINITE OF POTASSIUM (*See* " Potassium Chloroplatinite.")

CHLOROPLATINOUS ACID (*See* " Platinum Perchloride.")

CHONDRIN (Fr., *Chondrine* ; Ger., *Chondrin*)

One of the constituents of gelatine (*which see*).

CHOREUTOSCOPE

A fitting for the optical lantern, designed by Beale, of Greenwich, to illustrate persistence of vision. It consisted of a circular glass plate with images drawn upon it, which rotated in the lantern, zoëtrope fashion. In a later and more simple form the images were drawn on a strip of glass, which was used in a special carrier.

CHRIPOTYPE

One of the many printing processes invented by Sir John Herschel, who named it " Chryso-type " (*which see*).

CHROMATED GELATINE (*See* "Bi-chromated Gelatine.")

CHROMATES (Fr., *Chromates* ; Ger., *Chrom-sauresalz*)

Salts formed by the action of chromic acid, H_2CrO_4, on a metal, and having the formula $M''CrO_4$. These salts are most of them highly coloured and sensitive to light in the presence of organic matter.

CHROMATIC ABERRATION (Fr., *Aberration chromatique* ; Ger., *Chromatische Abweichung*)

To arrive at a proper understanding of the cause of chromatic aberration, it is necessary to remember that a lens is practically a prism with the power of refracting or altering the direction of rays of light and, in an uncorrected form, of refracting rays of different colours to a different extent. Diagram A indicates the effect of passing a ray of white light through a prism ; the bending of the rays will be noticed. The most active in their chemical action are the blue and violet, and these are diverted from their original path more than on the others ; B shows two prisms placed base to base so that in the case of each colour the rays are directed to a common point. The effect of this arrangement more nearly approximates to that of a simple

lens as in C, where only three colours are included for the sake of simplicity. Such a lens is in fact a circular prism with the power of bending the rays of one colour so that after passing through it they meet at one point. This point is called the focus, and it will be seen that the focus for the blue-violet rays to which ordinary photographic plates are most sensitive is much nearer to the lens than the luminous rays, green-yellow, which are those that form the visual image upon the focusing screen. This is chromatic aberration in its simplest form. If the image produced by such a lens upon the

A. Ray of White Light Passed through Prism

ground-glass screen be examined with a magnifier, it will be found that the outline of any bright object, such as that of a white china knob, is surrounded with a fringe of colour, either blue or orange. If a photographic plate be substituted for the focusing screen there will be obtained a blurred outline, the image being "out of focus." On moving the plate nearer the lens by one-thirtieth to one-fortieth of the total distance between the lens and the visual focus, there will be obtained on a plate an image which is practically sharp. When using ordinary spectacle lenses, a course that is possible where extreme definition is not required, the precaution above mentioned must be observed.

The avoidance of chromatic aberration in a photographic lens is effected by the use of at

double concave flint one (*see* D). In ordinary photographic lenses the optician combines the most visually powerful region of the spectrum, namely the green and yellow near the D line, and the most chemically active, namely the blue and violet near G. It will be seen that the red rays are neglected, but in ordinary photography this is of little moment. In three-colour work, in which one of the images is made through a red screen, a higher degree of correction is necessary, and by the use of a third variety of glass it is possible to bring the red rays to a focus in the same plane as the green and blue,

C. Rays Passing through Lens or Circular Prism

so that images taken through screens of these colours are identical in sharpness and size. A lens of this description is called apochromatic (*which see*). Recent advances in glass manufacture have rendered the old terms "crown" and "flint" somewhat meaningless, as the dispersive elements are now frequently made of special forms of crown glass.

CHROMATISM

A lens that possesses the defect of chromatic aberration, described in the previous article, is said to suffer from chromatism.

CHROMATYPE (*See* "Chromotype.")

CHROME ALUM (*See* "Alum.")

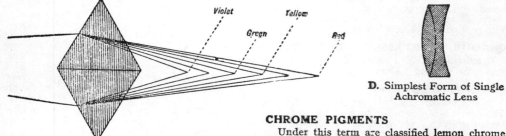

B. Rays Passing through Prisms Placed Base to Base

least two kinds of glass possessing different degrees of refraction (or bending power) and dispersion (or power of spreading out the various colours). These glasses, in the case of ordinary landscape and portrait lenses, were usually (1) crown glass, which, if made to suitable curves, could be caused to give any desired degree of refraction with the minimum of dispersion; and (2) flint glass, which had a higher degree of refraction, but relatively a much greater dispersion. The simplest form of single achromatic lens is composed of a double convex crown element and a

D. Simplest Form of Single Achromatic Lens

CHROME PIGMENTS

Under this term are classified lemon chrome, which is chromate and sulphate of lead; chrome green, a mixture of chrome yellow and prussian blue; chrome yellow, a normal lead chromate; and chrome orange and chrome red, which are basic lead chromates. They are occasionally used in colouring prints, but possess little photographic interest.

CHROMIC ACID (*See* "Chromic Anhydride.")

CHROMIC ANHYDRIDE (Fr., *Acide chromique*; Ger., *Chromsaure Anhydrid*)

Synonyms, chromic acid, chromium trioxide. CrO_3. Molecular weight, 100. Solubilities, 1 in 0·6 water, decomposed by alcohol. It is poisonous, the antidote being emetics, then

milk, white of egg, and calcium saccharate. It must be kept dry. It violently explodes when it comes in contact with organic substances. It is in the form of deep, reddish brown acicular crystals, and is obtained by the action of sulphuric acid on potassium dichromate. It has been suggested for bleaching prints, but the potassium salt is more generally used.

In process work, chromic acid is used as an addition to the fish-glue enamel solution. It increases sensitiveness and hardens the film, making it hold better on the metal. The acid should be pure, in fine, needle-like, purple crystals, not the red efflorescent variety used for electric batteries. Chromic acid is also used with sulphuric acid for " clearing " the fish-glue image before etching, by which means it removes any scum from between the half-tone dots.

CHROMIUM INTENSIFIER

For this intensifier two stock solutions should be prepared ; each will keep indefinitely.

A. Potassium bichromate. $\frac{1}{2}$ oz. 55 g.
 Water . . . 10 ,, 1,000 ccs.

B. Hydrochloric acid . $\frac{1}{2}$ oz. 55 g.
 Water to . . . 10 ,, 1,000 ccs.

The working solution is prepared by taking 1 part A, 1 part B, and 2 parts water. The mixed solution will not keep. The plate, after being well soaked in water, is immersed in this solution until thoroughly bleached, and is next well washed until the yellow colour of the bichromate quite disappears, exposed to daylight for a few minutes, and then redeveloped. Any alkaline developer may be employed, but pyro is not so suitable as those that are used for making bromide prints. Both amidol and metol-hydroquinone are good. A moderate degree of intensification is secured, the printing value being multiplied by $1\frac{1}{2}$; but if this should be insufficient, the operation may be repeated, and increased intensity will be obtained each time. The result is quite permanent.

CHROMIUM POTASSIUM SULPHATE

Commonly called chrome alum (*which see,* under the heading " Alum ").

CHROMO-COLLOTYPE

A process of collotype printing in colours. The term is also applied to a method of combining collotype with chromo-lithography for colour printing.

CHROMO-CRYSTAL

A type of coloured photograph similar to crystoleum and popular in the early days of albumen prints. The print was pasted face downwards on a piece of thick plate glass, coloured at the back, and backed up with another piece of thick glass, the coloured picture having the appearance of being embedded in crystal. The method is now employed, with or without the back glass, for producing ornamental paperweights and other fancy articles.

CHROMOGRAM

The name given by Ives to the three constituent pictures for his Kromskop.

CHROMO-PHOTOGRAPHS

An early name given to photographs coloured from the back, now known as crystoleums (*which see*).

CHROMOSCOPE

The earlier name of the Ives Kromskop (*which see*).

CHROMOTYPE

A process of reproduction in colours by means of half-tone blocks, either by three-colour or four-colour printings.

CHRONOMETRIC SHUTTER (Fr., *Obturateur chronométrique ;* Ger., *Chronometrischer Verschluss*)

A shutter mechanically geared to give a precisely timed exposure, or successive exposures at accurately recurring intervals.

CHRONO-PHOTOGRAPHY

The art of making photographic records of the motion of an object in chronological order. In the year 1870, Prof. E. J. Marey, of France, commenced his researches on the analysis of motion, and the advance in sensibility of photo-surfaces has lent continual aid from that time onward. The object of chrono-photography is to discover the successive attitudes which collectively make up a given motion, and to embrace phases of a swiftly-moving object otherwise escaping the notice of the unaided human eye. From a physiological point of view, this branch of the photographic art has proved of inestimable value, and it has served to dispel from the minds of artists certain erroneous ideas hitherto held regarding the various poses assumed by animals, birds, and the like, during the evolution of their movements.

In the year 1865, Messrs. Onimus and Martin exposed the bared heart of a living animal before an open lens for the purpose of photographing it while in motion. With the low degree of sensibility then obtaining among photo-surfaces, the exposure necessarily extended over one or more pulsations of the heart, but as a pause takes place at each extreme of the heart's beat the outline of these positions was better defined than the space between, and a record was therefore obtained of the maximum and minimum limits of a pulsation. Clearly it is only necessary to secure outlines of several intermediate positions in order that the experiment should attain this character of chrono-photography, properly so-called. A photograph of a man lifting his arm would (if the exposure lasted during the whole movement) result in a blur, but if a number of separate exposures was made in the same time a series of overlapping images, equal in number to the exposures, would occupy the place of one-exposure blur, and the outlines of these images would in addition form a perfect record of the successive positions of the arm. An ocular demonstration of these phenomena may be readily produced by means of any ordinary photographic camera, supplemented with a disc perforated with a number of holes, and so attached to the lens that by rotating the disc each of the apertures comes opposite the lens in succession. By pointing the apparatus to cover a man walking

along the footpath, and observing the inverted image on the ground-glass screen of the camera, meanwhile rotating the aperture disc, successive and clearly defined images of the man will be seen. Marey's chrono-photographs were obtained somewhat in this way, and diagram A shows his

of a seagull. One of them is remarkable for showing the wings in a downward position. It is a curious fact that European artists seldom or never represent this downward stroke of the wing, but that the Japanese frequently do. Two years after Marey started his researches in

A. Marey's Device for Obtaining Chrono-photographs

D and E. Pictures Obtained with Marey's Photographic Gun

B. Subject in Special Suit for Chrono-photography

precise apparatus. A sensitive plate was placed in a slide at P. A disc with apertures revolved between the lens and the plate. On turning the handle at the side, which communicated the necessary motion to the disc, a rapid succession of images was secured. Marey found that the images, which were almost superposed, made it difficult to distinguish individual phases. To overcome this defect the subject, as shown at B, was attired in a black velvet suit, with dots and white lines marked thereon. During the act of photographing, the subject ran, jumped, or walked against a black background, in a direction at right angles to the axis of the lens. The result was a (negative) image, as represented at C, in which each separate attitude of the head, left arm, and leg can be easily distinguished. Such pictures provide valuable data in physiological research. In order to secure complete and detached pictures of birds in flight, Marey contrived a photographic gun (see " Gun and

France, Muybridge, of California, began to investigate the progressive movements of animals, his operations being carried out in the open air,

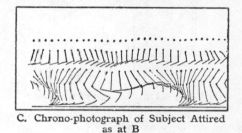

C. Chrono-photograph of Subject Attired as at B

as shown at F. In 1877 he erected a long shed containing a battery of cameras, and stretched in front of it, at right angles, a series of threads, which became broken as the subject (a man on

F. Muybridge's Arrangement for Obtaining Chrono-photographs

Revolver Cameras "), which was of real value for analysing motion in such a way that the record could be subsequently re-compounded by means of the zoëtrope (which see). D and E are enlargements from two of a series of pictures obtained with this gun, representing the flight

horseback) proceeded along the course. The breaking of each thread communicated electrically with the corresponding camera in the shed, and effected the necessary exposure just at that moment when the horseman was opposite the lens. A slanting fence-reflector formed

a suitable background for the subject, which was silhouetted against it, and the ground was covered with indiarubber to prevent dusty clouds flying from the horse's hoofs. Muybridge's chrono-photographs of animals in motion, especially of the horse, gave rise to much controversy. The first thought on looking at some of the attitudes portrayed is that they are unnatural and impossible; but the matter is explained when it is remembered that the eye has a certain peculiarity not shared by optical instruments, namely, persistence of vision. An impression of everything looked at remains upon the retina for about one-eighth part of a second; and it is obvious that movements occurring in less time than the period named cannot be appreciated by the eye. In looking at a galloping horse the general effect of the movements is observed, and they are involuntarily commuted into three or four positions. Such positions have been adopted by artists from time immemorial, and we have thus come to regard them as being correct.

The Muybridge system of chrono-photography

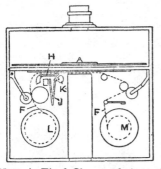

G. Marey's Final Chrono-photographic Device

was modified by Anschütz, of Lissa, in Prussia, who added many new features to the apparatus and secured results superior to those of the earlier investigator. Prof. Marey, already alluded to, later devised a camera in which a roll of sensitised paper could be used, and finally substituted transparent celluloid film. His final apparatus is shown at G. A clamp H is supported by a spring frame J. A cam K effects the feed motion of the film F, which is wound upon rollers or spools L and M. By means of this instrument Marey was able to secure a much longer series of pictures than was possible with his earlier machines. (*See also* under the heading "Kinematography.")

CHRYSOIDINE, OR DIAMIDO-AZOBEN-ZENE (Fr., *Chrysoïdine*; Ger., *Chrysoidin*)

An orange aniline dye used as a light filter in orthochromatic and three-colour photography. Its formula is $C_6H_5N_2\ C_6H_3(NH_2)_2$. The hydrochloride of the base crystallises in brown octahedrons. According to Frederick Ives, it is possible to employ a chrysoidine filter for orthochromatic work without colour-sensitising the plates, but extremely long exposures are then necessary.

CHRYSOSULPHITE (Fr., *Chrysosulfite*; Ger., *Chrysosulfit*)

A preparation of magnesium picrate introduced by Lumière as an addition to developers, so that plates could be used in daylight. Chrysosulphite No. 1 contains 100 parts of anhydrous sodium sulphite and 50 parts of magnesium picrate. No. 2 contains 100 parts anhydrous sodium sulphite and 15 parts magnesium picrate. This preparation has found but little general use. The normal strength in developers varies from 8 to 12 per cent.

CHRYSOTYPE

An obsolete process analogous to the blueprint process, invented by Sir John Herschel in 1842; known also as "chripotype." It can be best described in the inventor's own words:

"Paper is washed with a moderately strong solution of ammonia-citrate of iron, and dried. The strength of the solution should be such as to dry into a good yellow colour and not at all brown. In this state it is ready to receive a photographic image, which may be impressed on it either from nature in the camera or from an engraving (or positive) in a printing frame in sunlight. The image so impressed, however, is very faint and sometimes hardly perceptible. The moment it is removed from the frame or the camera, it must be washed over with a neutral solution of gold of such strength as to have about the colour of sherry wine. Instantly the picture appears, not, indeed, at once of its full intensity, but darkening with great rapidity up to a certain point, depending upon exposure and strength of solutions. At this point nothing can surpass the sharpness and perfection of detail of the resulting picture. To arrest this process and to fix the picture (so far at least as the further agency of light is concerned) it is to be thrown into water very slightly acidified with sulphuric acid, and well soaked, dried, washed with hydrobromate of potash, rinsed, and dried again."

Herschel later recommended developing with a solution of nitrate of silver instead of gold, and fixing in sodium hyposulphite; and other workers advocated the use of a solution of potassium iodide after developing with gold. The finished chrysotype pictures were of a purplish colour.

CHRYSTOLOTYPE

An early and secret process of making paper negatives, invented by a Mr. Whipple. He afterwards published an albumen process in which glass was used, giving similar, if not identical results, this leading to the supposition that the negatives were on a kind of albumen paper.

CINEMATOGRAPH (*See* "Kinematograph.")

CIRCLE OF ABERRATION

The spreading of the image of a point of light into a disc of appreciable size. This may be due to spherical aberration or to diffraction.

CIRCLE OF ILLUMINATION

A term used to express the diameter of the largest circular picture produced by a lens working

at its "infinity focus," irrespective of definition or equality of illumination. A lens having a relatively large circle of illumination as compared with its focal length is known as a wide-angle lens. The extreme range in lenses commercially obtainable is from a circle having a diameter five times the focal length of the lens, as in the Goerz "Hypergon," to a circle barely equal to the focal length, as in the Petzval portrait lens.

CIRCLE OF LEAST CONFUSION

The theoretically perfect lens is capable of sharply reproducing a point or a line, no matter how small or fine. In telescope and microscope objectives, where only rays near the axis of the lens are used, this condition is nearly fulfilled, but in photographic lenses, where approximate sharpness over an extended field is desired, this critical definition at the centre of the field is sacrificed in order to obtain other qualities. The size of the disc to which the image of a theoretical point is spread out by any lens is called the circle of least confusion, and is a measure of the defining or "resolving" power of the lens; in British practice, $\frac{1}{100}$ of an inch is the maximum diameter of such a disc of which a "sharp" picture can be composed, but latterly on the European Continent $\frac{1}{200}$ of an inch is often taken as the standard of sharpness. To realise what this means assume that an engraving is composed of lines and dots $\frac{1}{100}$ of an inch in width; with a lens having a disc of confusion of $\frac{1}{100}$ of an inch a full sized copy would have the lines and dots broadened out to more than $\frac{1}{100}$ in., but at 10 in. distance from the eyes the whole picture would appear to be sufficiently sharp. By stopping down the lens the sharpness can be increased until almost any desired degree is attained. The circles of confusion at the true focus are due to spherical aberration (*which see*), but they are also found in portions of the image which are "out of focus" and are easily recognised in the backgrounds of portraits. In this case they are due to the plate cutting the cone of rays at some distance from the point of sharp focus.

CITOCHROME (Ger., *Citochromie*)

A process of four-colour printing from half-tone blocks, invented by Dr. Albert, of Munich. The black or g ey plate is printed first, and then the yellow, red, and blue, but the solid parts of these colours, which would in the ordinary process print over each other and imperfectly produce black, are cut out during the process of making the plates, so that the black first printed shows through the three-colour impressions and prints as pure black. The inventor claims that by this means more rapid colour printing can be done, as there is no waiting for the solid colours to dry before each successive colour is superimposed. In carrying out the process continuous tone negatives of the colour separations are made, and also an orthochromatic negative of the black. A positive is prepared from the latter. The continuous tone negatives for the colour separations are put in a special printing frame, together with the positive of the black plate and a ruled screen, the whole being in contact with a sensitised zinc plate. Either the frame or the arc light is made to describe a circular path in a vertical plane so as to spread the light passing through the ruled screen. The positive of the black plate has the effect of stopping out the dark parts of each negative. The negative of the black plate is, of course, made without the positive plate being superposed.

CITRATES IN DEVELOPMENT

Alkaline citrates have been recommended as restrainers in dry-plate development in place of potassium bromide. The consensus of opinion is that bromide is better than any citrate if added to the developer before it is applied to the plate, but that citrates (particularly ammonium citrate) act better as restrainers when once development has begun. If added in sufficient quantities, citrates correct over-development better than bromide, and have the advantage that, after they have been added to the developer, density can be obtained without further fogging, though the development or detail has stopped. If ammonium citrate itself is used—or, in fact, the citrates of either potash or soda—the usual quantity required to be effective is from 6 to 12 grs. per ounce of developer; but obviously more or less can be used. The ammonium citrate is the most widely used and appears to work well with all developers, but when potash or soda is used as the alkali in a developer the citrates of potash and soda are to be preferred.

CITRIC ACID (Fr., *Acide citrique*; Ger., *Citronensäure*)

Occurs in colourless and odourless crystals, or amorphous powder, and has a strong acid lemon-like flavour. $C_6H_8O_7H_2O$. Molecular weight, 210. Easily soluble in water, either cold or hot, slightly soluble in ether, and still less so in alcohol. It is hygroscopic, and should be kept in a well-corked bottle. Aqueous solutions of citric acid, and all other alkaline citrates, develop in course of time a fungoid growth, due to *Saccharomyces mycoderma*, with decomposition into carbonic acid and water. Citric acid is used in some developers as a preservative and in others as a restrainer, for making acid fixing and clearing baths, and as a preservative in emulsions.

CITRO-CHLORIDE PAPERS

Another name for gelatino-chloride printing-out papers (*which see*).

CLAMP (Fr., *Crampon, Agrafe*; Ger., *Klampe*)

There are several kinds of clamps used in photography. The lantern-slide clamp is intended for holding the slide and cover glass firmly

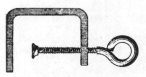

Clamp for General Use

together while binding. The etcher's clamp is used when etching copper plates face downwards in the ferric perchloride bath; it is made of oak thickly varnished. Various kinds of clamps are

employed in chemical operations, for supporting burettes, test-tubes, retorts, etc. Fretwork clamps (*see* illustration) are cheap and are often useful to secure photographic apparatus in unusual situations, to support backgrounds, or to improvise temporary accessories. Clips (*which see*) are occasionally wrongly referred to as clamps.

CLARIFYING

A term applied usually to the mechanical clearing of a solution by allowing a precipitate to settle or by causing more rapid precipitation by the addition of some inert substance to carry down a precipitate which does not easily subside. It is occasionally used to obtain clear solutions of varnishes, when an inert powder like pumice or chalk is added.

In process work, the fish-glue that is used must undergo a process of clarifying, and " clarified fish-glue " is obtainable as a commercial product. Formerly, process workers had to clarify the glue themselves, and some still prefer to do so. It is done by adding an equal quantity of albumen and heating the glue to boiling-point, stirring well the whole time, and boiling for one minute. The albumen coagulates and holds the suspended matter, which can then be filtered out.

CLAUDE LORRAINE GLASS

A convex mirror of black glass, commonly known as a " Lorraine mirror," or " Claude glass." It was used by Claude Lorraine, the famous French painter, nearly three centuries ago as a means of reducing the view and at the same time modifying the colours. Used in photography, it is of service in showing how a view will look when reduced and, to a certain extent, when reproduced in monochrome. Used in cloud photography, it facilitates the obtaining of the necessary contrast between the clouds and the blue sky, owing to the fact that the black glass does not reflect the whole of the ultra-violet light. A convex glass, silvered but not blackened, is used on the reading desk by lecturers to reflect the lantern pictures shown on the screen, and to reproduce them in miniature for personal reference while speaking.

CLAUDET, ANTOINE JEAN FRANCOIS

Born in France, 1796 ; died in London, 1867. One of the earliest workers and improvers of the Daguerreotype process in England, and one of the last to use it professionally. In 1840 there were only two photographic establishments in London, those of Beard and Claudet. Claudet was also a partner in the firm of Claudet and Houghton (1834). In addition to improving the Daguerreotype process by the employment of chlorine vapour to increase the sensitiveness, he, in 1844, took out a patent for the use of red light in the dark-room. One month before his death his studio in Regent Street was burned down, and all his valuable daguerreotypes, pictures, and papers destroyed.

CLAYBOARD

A cardboard thickly coated with a chalky enamel and used by artists for drawing upon. The chalk surface permits of high lights to be scraped out and white lines to be cut through the blocks. This board may be sensitised with silver nitrate for printing under a negative so as to form a basis for drawing on. The surface is first prepared with arrowroot and ammonium chloride in the usual way adopted for sensitising plain papers.

CLEANING BOTTLES

The methods employed for cleaning bottles will depend upon what the bottles have contained. The simple and old-fashioned method of half-filling the bottle with water and adding sand, cinders, or shot may serve in some cases, as may the use of a little vinegar and broken-up egg-shell. Generally, however, the best bottle-cleaning solution is one made in the proportion of from 2 oz. to 4 oz. of hydrochloric acid to one pint of water. This mixture is allowed to remain for a time in the bottle, shaken frequently, poured into another one, and the bottle rinsed well with clean water. Bottles that have contained oil should be rinsed first with a strong solution of household washing soda, caustic soda or potash, or liquor ammoniæ, and finally with weak hydrochloric acid. Commercial benzole may also be used for greasy bottles, followed by a strong solution of washing soda, finally rinsing with plenty of water.

Bottles which have been used for varnish may be cleaned by rinsing with liquor ammoniæ 1 part, methylated spirit 10 parts, and finally with weak ammonia and water. It is better to use liquid than mechanical cleaners (sand, shot, etc.), which are apt to roughen the insides of the bottles, such roughness causing them to become dirty and unsightly very quickly. Bottles used for gold toning solutions quickly become dirty owing to the gold depositing itself upon the inside of the bottle ; if the deposit is not removed the gold in fresh solutions will be attracted by it, to the detriment of the solutions. Weak hydrochloric acid should be used as a cleaner for such bottles, and if this fails *aqua regia* should be used.

CLEANING DAGUERREOTYPES (*See* " Daguerreotypes, Cleaning and Restoring.")

CLEANING DISHES

Dishes used for " hypo " should not be put to other photographic purposes, even after cleaning, as any print treated therein is liable to be stained. Dishes used for developing and toning soon become dirty, particularly when the developer oxidises quickly, as pyro, for example. All dishes require to be cleaned at intervals, but those made of porcelain appear to require the most cleaning. There are two kinds of stains, those which appear on the surface of the glaze, and those which find their way under the glaze into the very substance of the dish, from which it is almost impossible to remove them. A solution of hydrochloric acid will remove most surface stains without damaging the dish, the method being to pour water into the dish and add hydrochloric acid until the solution is strong enough ; commercial spirit of salt will do equally well and is cheaper. An old tooth-brush, or a rag tied to a stick, may be used for the corners, it not being advisable to use the fingers. Fresh

stains will not require to be rubbed. For obstinate stains, mix together 8 oz. of pearl-ash, 4 oz. of quicklime, and 1 pint of water, stir up and place in the stained dishes ; allow to remain for one hour, pour out, rinse with very dilute hydrochloric acid in order to destroy the last traces of the pearl-ash and lime, and finally wash well. However, spirit of salt is more generally used, and it makes dishes chemically clean enough, even if it does not entirely eliminate the stains.

To remove slight stains from fragile dishes, rub damp salt on them with a piece of flannel, or rinse with very dilute hydrochloric acid and then rub with salt.

CLEANING LENSES

It is easy to damage a lens by improper cleaning, optical glass being generally much softer than other kinds. Apart from actual scratches the surface is liable to become dulled, a condition that affects the "rapidity." The necessity for frequent cleaning is obviated by fitting all lenses with caps to both front and back combinations, or by keeping them in airtight cases. When a lens requires cleaning it should first be dusted with a camel-hair brush or tuft of cotton-wool, and then carefully wiped with a very soft silk or linen handkerchief, or with a soft wash-leather. If the surface still appears cloudy, a single drop of pure alcohol should be put on each of the surfaces, which should be carefully wiped until quite dry. The spirit must not be allowed to run between the lens and its brass cell, and care must be taken not to remove the dead black coating from the lens cell. The edges of the lens in contact with the cell are best cleaned with the pointed end of a bit of soft wood over which the rag is stretched. Dr. Miethe recommends the use of pith, such as that of the rush or elder, for this purpose. A lens that has become scratched or dulled should be sent to the maker to be repolished. The greatest mistake an amateur can make is to attempt to repolish a lens with rouge, putty-powder, etc. ; even the maker cannot repolish a badly scratched lens so that it will work quite as well as when it was new, therefore the result of unskilled work can easily be anticipated. A lens should not be wetted if it can be avoided, and in the case of condensation of steam or dew upon the surfaces, the moisture should be removed as quickly as possible.

CLEANING NEGATIVES

The films of negatives are best cleaned when wet. Usually they are merely wiped over with a piece of wet cotton-wool ; but to remove a dirty or messy appearance from a dry negative use cotton-wool soaked in methylated spirit, rubbing very lightly to avoid reducing the density. The metal-polish reducer (see " Baskett's Reducer ") may also be used for cleaning the dried film, but must be used very gently.

It is generally the glass side, not the film side, of a negative that requires cleaning. In the process of manufacture some stray emulsion may get on the glass side, which, if allowed to remain, would show in the print. Emulsion streaks are best removed when wet by rubbing with damp table salt ; but the same method answers when the negatives are dry.

To clean off the films from "waster" negatives that have been varnished, soak them in a hot solution of soda or potash, and then rub with a stiff scrubbing-brush, finally rinsing ; if potash is used, do not let it touch the fingers. Soaking in water containing a little nitric acid answers for unvarnished negatives, scrubbing or scraping afterwards if necessary. The following solution is also recommended for removing unvarnished films : Citric acid 1 oz., hydrochloric acid 2¼ oz., water 20 oz. Soak in this for an hour or two, scrub, and finally rinse.

An excellent cleaning and polishing mixture for glass consists of the following :—

Rain or soft water .	.	1 oz.
Powdered pumice-stone .	.	1 ,,
Whiting or prepared chalk	.	1½ ,,
Liquor ammoniæ .	.	½ ,,

Apply with a piece of chamois leather or flannel, and polish with a clean rag or soft paper.

CLEARING SOLUTIONS

Used for removing development stains from negatives or prints. When the staining is due to insufficient sodium sulphite in the developer the following formula is recommended :—

Alum	.	1 oz.	55 g.
Hydrochloric acid	.	¼ ,,	12 ccs.
Water	.	20 ,,	1,000 ,,

The plate should be well rinsed from the developer, immersed in this clearing solution for two or three minutes, and then washed for fifteen minutes and fixed as usual. The use of an acid fixing bath renders a clearing solution unnecessary. For clearing development fog, or chemical fog, or staining caused by the plates or paper being stale, a solution of thiocarbamide is the best to employ. (See under the heading of " Fogged Negatives, Treatment of." Lantern slides are treated as described under their own heading.)

In process work, clearing solutions are used to remove any deposit of silver from between the dots of half-tone negatives, and also to sharpen up the dots. This process is called " cutting.' For dry plates, ferricyanide and " hypo " (Farmer's reducer, *which see*) is used, and for wet plates, iodine and cyanide.

CLERK-MAXWELL, JAMES

Born at Edinburgh, 1831 ; died at Cambridge, 1879. First Professor of Experimental Physics at Cambridge (elected 1871). He made researches into the composition and vision of colour, the kinetic theory of gases, electricity, etc., and was associated with the early experiments in colour photography, with regard to which he made, about 1861, many suggestions.

CLICHÉ

The French term, now anglicised, applied to electrotypes, stereotypes, and process blocks. Also used sometimes to indicate negatives and positives. (*See also* " Block.")

CLIPS (Fr., *Pinces ;* Ger., *Klammern*)

Spring clips of various kinds are used for hanging up wet prints or films. The American wood clip A is useful for many purposes ; clothes

" pegs " of practically identical shape are obtainable at a very cheap rate. Metal clips B are obtainable in variety. Such clips are especially useful for suspending sensitised carbon tissue or photo-lithographic paper for drying. Split

A. Wooden Clip B. Metal Clip

corks with rubber bands make good clips for some purposes (see an illustration referred to under the heading "Film Manipulation"). Negative clips, or plate-holders, are used for holding and lifting negatives during development, washing, etc., to avoid touching them with the fingers. Film-developing clips are intended for holding the ends of roll-films when developed in the length.

CLIP COPYBOARD

A board used in process work for holding the original for copying; it is provided with spring clips instead of with pins. In one type the clips slide in grooves, whilst in another they are inserted in holes, and large clips to hold books and small clips to hold paper or cardboard are provided.

CLOCK, DARK-ROOM (Fr., *Horloge de laboratoire ;* Ger., *Dunkelzimmer Uhr*)

A clock specially made to facilitate the timing of photographic operations. The Watkins darkroom clock, a former pattern of which was known as the eikronometer, is primarily designed for factorial development. It has two hands, one completing a revolution in one minute, while the other takes ten minutes. A stop motion permits both hands to be started from zero as the developer is poured on the plate, and an outside indicator marks the completed time. The Welborne Piper stop clock is for factorial development, and for timing numerous other manipulations, in addition to which it has various novel and useful movements.

CLOTH, BOLTING (See " Bolting Cloth.")

CLOTH, FOCUSING (See " Focusing Cloth.")

CLOUD NEGATIVES

Clouds that are to be added to landscapes must be taken under similar conditions to those of the landscapes for which they are required. A large common or open space should be selected for photographing, so that a low horizon line may be included on the plate. And this low horizon line should be as unbroken as possible. The formation of clouds near the horizon is different from that at higher altitudes, and it is therefore necessary that clouds near the horizon should be included on the plate so that they may appear correct if the formation of the landscape picture necessitates showing sky near the horizon. Clouds taken right opposite the sun, or directly towards it, are quite useless for adding to the large majority of landscape pictures, as most landscapes are taken with an oblique front lighting. Clouds should therefore be photographed with a similar lighting. If the sun should be in the south at the time of photographing clouds, those about the north-west and north-east will be the most useful. As opportunities offer, cloud negatives should be taken with different lighting, and of varied character; brilliant piled-up masses, rain clouds, broken-up skies, quiet, calm, summer effects, etc., so that a suitable negative can be be selected when it becomes necessary to add clouds to a cloudless landscape. It is necessary to study the arrangement or grouping of the clouds on the plate so as to get the principal point of light, or the principal feature in the grouping, towards one side of the plate. The grouping must be such that it can be utilised in assisting the formation or composition of a picture whenever practicable. The principal cloud masses should form an angular line across the plate. The exposure for cloud negatives must be very short, ranging from one-sixtieth of a second for very light clouds, up to one-fortieth for heavy masses, using a rapid plate (200 H. and D.), and lens aperture $f/16$ at mid-day in late spring or early summer. Development may be normal. With such short exposures the negative will be thin, and suitable in every way for printing into landscapes.

CLOUD SHUTTER (See "Foreground Shutter.")

CLOUDS, PRINTING IN

The landscape or marine picture should be printed first and the clouds added subsequently. No attempt should ever be made to block out the sky on the landscape negative, even if it should print to a pale grey tone. Painting out a sky leaves the outlines of the distance hard and crude, instead of delicate and soft, as they invariably appear in a landscape print, even if sharply defined throughout. It is no disadvantage to print a sky over a pale tone of grey ; the clouds are softened in their contrasts, and frequently harmonise better with the tone of the landscape. At times, the grey tone of a sky may be a disadvantage when it is desired to add a sky that should be as brilliant as possible for a special effect. In that case the sky may be kept white by shielding. A card is roughly cut to the shape of the outline of the landscape, and supported over the sky part of the picture during printing, the edge of the card being directly over the outline of the landscape. This plan allows the landscape to print fully, but the sky will be vignetted off from its full printing, where it joins the landscape, to a pure white for the greater part of its area. The suddenness or the gradual nature of this vignetting will be determined by

With Ordinary Plate

With Isochromatic Plate and Medium (" Three Times ")
Screen

With Isochromatic Plate, but Without Screen

With Isochromatic Plate and " Six Times " Screen;
over-corrected

VARIOUS RENDERINGS OF DAFFODILS IN BLUE VASE

the distance of the card from the surface of the negative. When the landscape print is obtained, a mask is also required, to be used to shield it from the action of the light while the clouds are printed. The most satisfactory method of obtaining this mask is to take a rough silver

A and B. Landscape Negative and Mask

print of the landscape, and cut it carefully to the outline of the subject. Any small dark objects, such as a church spire, the branches and twigs of a leafless tree, may be disregarded in cutting this mask, as the clouds may be printed over them. But the mask must be cut so as to shield any light object, excepting in special cases which must be determined on their merits. The landscape and mask are shown at A and B. The landscape print must be placed in position behind the cloud negative, care being taken that the horizon of one is near the horizon of the other, so as to ensure that the cloud forms are in correct relation to the landscape. The clouds must be printed in a frame one or two sizes larger than the landscape, the frame being provided with a sheet of plain glass so that the smaller negative can be printed without difficulty. The large frame allows space for arranging the landscape print in the correct position on the cloud negative irrespective of the extent to which it may project in any direction.

If a large number of prints are required from one negative, the most satisfactory manner of using the mask is to attach it permanently to a piece of glass the same size as the print. If only a few are wanted, the mask may be wetted sufficiently to render it quite limp; it will cling to the glass thoroughly satisfactorily, without risk of movement, while the sky is printed. In either case, the mask is adjusted in position on the outside of the plain glass in the printing frame when everything is ready for printing the clouds. The frame should be in a horizontal position.

The mask should be carefully adjusted so that it overlaps the landscape very slightly, about one-sixteenth of an inch, or less in small work

C and D. Diagrams Showing How Carbon and Bromide Prints are Marked for Masking

The fact that there are two thicknesses of glass between the mask and the print—the plain glass of the frame and the sky negative—will cause the mask to print with a soft or vignetted outline, and this slight overlapping is to compensate for the manner in which the light diffuses under the

mask, and it prevents the print from showing any hard junction. In addition, a card should be supported over the landscape portion, as shown at E, while the clouds are being printed; this card should project over the sky to a small extent to soften off the depth of printing near the horizon. The extent and nature of this softening will be determined by the extent to which the card projects beyond the landscape and its height above the surface of the negative. The edge of the card may be either straight or cut approximately to the outline of the landscape, according to the subject. This vignetting off towards the horizon becomes absolutely necessary when a grey sky has been vignetted into a plain white, as described earlier.

All preliminary work in cloud printing should be on silver printing-out paper. Working by daylight in a process that gives a very strong image enables the work to be followed easily. The mask can be adjusted to the correct position without any difficulty, and any error in adjustment or in arranging the card shield can be seen at almost the beginning of printing, and rectified immediately. The experience gained by printing clouds in silver will enable any photographer to place the masks and shields correctly without difficulty when adding clouds to platinotype

E. Shielding Part of Negative when Printing

carbon, or bromide prints, though in these processes there is no strong image to act as a guide.

The method of working in platinotype and carbon, inasmuch as they are daylight processes, will be similar to that described for silver printing, but there is no image that can be seen sufficiently well through the cloud negative to assist in correctly placing the mask. In platinotype, the image is an assistance, but it cannot be utilised in the same manner as in silver. When the landscape print is taken from the frame, a small pencil mark is made at each end of the print, at the exact point to which the mask has been cut; and about an eighth of an inch above each mark, a second one is made to serve as a guide in placing the mask. These pencil marks are shown at E E. When the landscape is being arranged under the cloud negative, these pencil marks are of great assistance in securing the correct position. But their great value consists in the manner in which they enable the correct placing of the mask to be determined. They are plainly visible through the cloud negative, and the mask can be fitted to them as easily as to the strong image of a silver print. It is self-evident that if the mask is in the correct position at the two margins it must be in the correct position throughout its length. The exposure should be timed by means of an actinometer.

In carbon prints there is no image whatever

to serve as a guide for marginal marks, and their position must be determined differently. A little water-colour is required—white or light yellow—and a fine brush. When the print is in the frame, either before or after the exposure, one-half of the back of the frame is opened, and a fine mark is made on the margin of the negative at the spot corresponding with the mask. That half of the back of the frame is at once closed again so as to press the tissue on to the negative, and the moist colour will set off on to the margin of the print. While this half remains closed, the other half is opened and a similar mark made on the margin of the negative at the correct position for the mask. The precaution should be taken of opening each half separately a second time to ascertain that the colour has been transferred to the face of the tissue ; and, before removing the print, a mark should be made on the back to indicate which is the top. The exposed tissue should then be removed from the frame, the marks strengthened, and a second mark made just above each to correspond with the pencil marks in platinotype. With these marks the correct placing of the mask is easy, and this and the printing will be the same as described for platinotype. The appearance of the carbon print is shown at C, the white brush marks F F corresponding to E E in diagram A.

In bromide printing, the method of working is the same as in carbon, but a dark colour must be used for the brush marks, black or dark-brown. Diagram D illustrates a bromide print to be used with the mask B, the brush marks being indicated at G G. In bromide printing, the card shield must be kept moving during the exposure, to prevent a sharp line from appearing.

In enlarging by means of a lantern, pencil marks can be made on the enlargement, the image thrown by the lens forming the guide. The card shield may be held in any convenient position between the lens and the enlarging easel so as to shield the landscape, and it must be kept in motion throughout the exposure of the cloud negative.

COAL-TAR COLOURS (*See* "Aniline, or Coal-tar, Colours.")

COATING

It will be found somewhat easy with a little practice to coat plates if the operation is practised first in daylight or gaslight, and for this purpose it is advisable to start with whole plates, assuming that one wishes subsequently to obtain quarter plates. A pneumatic holder (*which see*) should be obtained, and the sheets of glass thoroughly cleaned and stacked, with the surfaces to be coated away from the operator. The emulsion should be at a temperature of 95° F. (35° C.) in summer and 98° F. (36·6° C.) in winter ; and if the room is cold the glass itself should be warmed. The pneumatic holder is taken in the left hand, the bulb well squeezed, and the lip of the holder just wetted and then pressed on to the back of a sheet of glass in the centre and the pressure relaxed. The suction —really the pressure of the atmosphere on the surface of the glass—holds it firmly against the holder, wherein there is a partial vacuum. The glass should then be held horizontally, and

the emulsion poured on to the middle, preferably from an earthenware teapot which has a spout that starts from near the base, as this avoids the air bubbles which rise to the top of the emulsion. Failing a teapot, the ordinary invalid's feeding cup would be a good substitute.

The pool of emulsion should be poured on to the centre of the plate, and, as soon as it covers about half the area, the plate should be tilted so as to cause the emulsion to run to the top right-hand corner, then to the top left-hand corner, then to the bottom left-hand corner, and finally to the bottom right-hand corner, and the excess drained off here. This must be done slowly, otherwise the emulsion will run over the edges ; and it is advisable to practise over a good-sized dish so as to catch any spillings. As soon as coated, the plate should be slid on to a sheet of plate glass accurately levelled, and allowed to set.

The coating of paper is not so easy, but it may be done by pouring the emulsion into a dish, tilting this, and drawing the paper over the top of the emulsion. At least a yard of paper can be coated in this way, and with care but few bubbles will arise. But by far the simplest plan is to use one of the film developing dishes provided with a roller. Having the paper cut in long lengths, pass one end round

Tilted Dish of Emulsion for Coating Paper

the roller, and, keeping it tightly strained against the latter, pour in enough emulsion to cover a little less than half the diameter of the roller. Then the paper can be drawn through the emulsion and straight up, and enough will cling to it to give good results. Naturally, the emulsion must be kept hot.

Commercially, of course, special machinery is used both for plates and papers, and in the former case the cleaned glasses are fed on to the bed of the machine and coated with emulsion by various devices. Thence the glasses pass through an ice tunnel, which thoroughly sets the emulsion, and at the other end of the machine, which may be 30 ft to 40 ft. from the coating end, they are stacked in racks by hand and thence conveyed to the drying-room.

The commercial paper-coating machinery is usually arranged so that the paper, which is in long reels, passes round a roller through the emulsion. The coating is chilled either by a cold roller or by cold air ; the paper then passes on, is formed into loops or festoons, and traverses the drying-room, being again reeled at the other end.

In process work, coating is an important operation. For collotype, the gelatine coating is applied by levelling the glass plate and pouring on a measured quantity of solution, guiding it to the edges by means of a catgut bow or a

glass rod. For coating zinc or copper a whirler (*which see*) is invariably used, the coating being evenly spread by centrifugal force, while the surplus is thrown off. In the case of very volatile mediums, such as bitumen, it is sometimes the practice to coat by pouring on the solution with a sweep of the bottle along the top edge of the plate, taking care to incline the plate so as to allow the solution to run down and the surplus to run off.

CO-AXIAL

Having a common axis. Thus the positive and negative elements of a telephoto lens or the eyepiece and object glasses of a telescope or microscope are said to be co-axial.

COBALT BLUE (Fr., *Bleu de cobalt ;* Ger., *Kobaltblau*)

A compound of alumina and oxide of cobalt used in painting ; of slight photographic interest.

COBALT CHLORIDE (Fr., *Chlorure de cobalt ;* Ger., *Kobaltchlorid*)

Synonym, cobaltous chloride. $CoCl_2\ 6H_2O$. Molecular weight, 238. Solubilities, soluble in water and alcohol. Ruby red crystals, obtained by dissolving cobalt carbonate in hydrochloric acid and evaporating. The addition of small quantities of cobalt chloride to printing-out emulsions produces greater contrast.

COBALT SALTS, PRINTING WITH

Cobalt belongs to the same group of metals as iron and manganese, and, like these, many of its salts are sensitive to light. Although no practical process has so far been founded on this fact, it is as well to record briefly the researches of A. and L. Lumière on the subject. The most promising salt is obtained by dissolving cobaltic oxide, Co_2O_3, to saturation in oxalic acid solution, or by precipitating cobaltic oxyhydrate from a cobaltous salt solution by means of sodium peroxide and dissolving the precipitate, after careful washing, to saturation in oxalic acid solution, the cobaltic salt being kept all the time in excess. This operation must be performed in the cold, and takes some hours. A green solution is obtained which can be used to sensitise gelatinised paper, and, after drying, on exposure to light under an ordinary negative, a pale rose-coloured image of a cobaltous salt is obtained. The action is extremely rapid, taking but a fraction of the time necessary to print under similar conditions with a silver salt. The print, when ready, should next be immersed in a 5 per cent. solution of potassium ferricyanide and washed. The image thus obtained is a pale rose colour and not very intense, consisting of cobalt ferrocyanide. This may be toned with an alkaline sulphide, which produces dark brown cobalt sulphide. By treatment with an iron salt, a blue image is obtained ; a nickel salt gives a red image. Attempts to develop the cobaltous image with organic compounds (*see* "Manganese, Printing with") were not satisfactory, in all cases it being found much more difficult, and the only substances proved to be of any value were hæmatoxyline, which gave a violet blue image that was changed to reddish by hydrochloric acid, and benzidine, toluidine, and their hydrochlorate salts. These produced on the places not affected by light, so that they would give a negative print from a negative, an intense blue image, which was turned brown by ammonia and pale yellow by hydrochloric acid.

Further researches with the citrate, stannate, nitrite, tartrate, gallate, and sulphocyanide of cobalt have been made, but the results were still less promising.

COBALT-LEAD TONING

A process for toning bromide and gaslight prints to a green colour, introduced by MM. Lumière and Seyewetz in 1905. Two solutions are required :—

A.	Potassium ferri-cyanide	144 grs.	65 g.
	Lead nitrate	96 ,,	44 ,,
	Water	5 oz.	1,000 ccs.
B.	Cobalt chloride	$\frac{1}{2}$,,	110 g.
	Hydrochloric acid	$1\frac{1}{2}$,,	330 ,,
	Water	5 ,,	1,000 ccs.

For vigorous greens fully developed prints must be used. The print is placed in A until bleached, is next washed very thoroughly, and then immersed in bath B. The image on the finished print is made up of lead, silver, iron, and cobalt in the form of a ferrocyanide and of the chlorides of silver and lead. If the toning action is prolonged, the cobalt will completely replace the silver and lead.

COCKLING OF PRINTS

Photographs mounted in a wet state upon thin cardboard, or upon the leaves of an album, invariably cockle or curl when dry, whereas prints mounted surface-dry do not cockle so badly. The defect is due to uneven expansion caused by the wet mountant, and can be made worse by unskilful manipulation. Careful selection of the mountant minimises the trouble, and the following formula is as good as any in this respect :—

White dextrine		360 grs.	82 g.
Powdered alum		16 ,,	3·6 ,,
Sugar		60 ,,	13·6 ,,
Hot water		1 oz.	100 ccs.

This, when thoroughly mixed, should form a thick cream, which should be allowed to stand a day before use. Take the trimmed dry print and lay it face downwards on a sheet of glass, and with a fairly stiff brush apply the smallest possible quantity of mountant to the back of the print, distributing evenly and quickly ; before the mountant has had time to soak through, place the print upon the mount and squeegee or rub down. Place two or three thicknesses of fluffless blotting-paper over the picture and mount, and put into a copying press and screw down hard, or put under heavy pressure for several hours. When dry, there should be little or no cockling.

Another plan is to brush the back of the dry print over with a strong solution of gelatine or soft glue, and to damp slightly the mount before placing the print in position, drying under pressure.

The theory of the subject is to prevent

expansion of the print before pressing it in contact with the mount; or, if this expansion is unavoidable, to expand the mount, as in the preceding paragraph, and let mount and print contract together. Another point is to use a thoroughly even mountant, because should one part of the print get wetter than another, cockling is almost sure to occur.

Photographers may learn something from the draughtsman's method of stretching drawing paper, and even if it is dangerous to mount prints in this way, they can adopt it when pasting brown paper on the backs of photograph frames. The draughtsman slightly damps the back of the paper, thus evenly expanding it all over, touches the margin all round with paste, and "lays" the paper on the board, thoroughly pressing the margin into contact. The paper contracts in drying and becomes as tight as a drum-head.

CODDINGTON LENS

A biconvex spherical lens with a deep groove filled with an opaque substance running round the centre. The groove acts as a diaphragm. This lens is used as a hand magnifier, and gives a large, bright field, but its working distance is short.

CŒRULINE S (Fr. and Ger., *Cœruleïn S*)

Synonyms, cœruleïn, cœrulean. A compound of alizarine blue and sodium bisulphite, which has been occasionally used for colour-sensitising plates.

COFFEE PROCESS

A mixture of coffee, advocated by Colonel Baratti, used as a preservative in the early days of the dry collodion plate. About 1855 there were numerous announcements of new preservatives wherewith the sensitive surface of collodion plates could be covered, so as to enable them to be dried and kept ready for use. Among the many substances recommended and widely used were beer, tea, treacle, gum arabic, brown sugar, white sugar, raspberry vinegar, wort, malt, and tobacco.

COINS AND MEDALS, PHOTOGRAPHING

The difficulty presented by subjects of this character is solely due to the low relief of the image and the consequent absence of contrast in light and shade. This difficulty may be entirely overcome by suitable lighting. The coin or medal should be placed so that it receives a strong light from one side, the direction of the light being parallel with the face of the coin and striking the edge strongly. There may be a little diffused light in front, but as large a proportion as possible should be across the face, just skimming the surface. However slight the relief, it will be shown by strongly marked lights and shadows if this method of lighting is adopted, and the production of a successful negative will present no difficulty. The exposure must be short.

COINS AS WEIGHTS

English silver coinage is minted exactly by weight in proportion to its value—namely, $436\frac{1}{11}$ grs. for every five shillings; thus a new

threepenny-piece weighs 21·8 grs., a sixpence 43·6 grs., and so on, the sixpence and threepenny piece being almost exactly one-tenth and one-twentieth respectively of the avoirdupois ounce. The list gives the approximate avoirdupois weights obtainable by the use of coins just slightly worn :—

20 grs.	=	one threepenny-piece.
40 ,,	=	one sixpence.
43 ,,	=	one farthing.
61 ,,	=	half-sovereign.
88 ,,	=	one halfpenny.
123 ,,	=	one sovereign.
145 ,,	=	one penny.
175 ,,	=	one florin.
218 ,,	=	half-crown.
$\frac{1}{4}$ oz.	=	one halfpenny and one threepenny piece.
$\frac{1}{2}$,,	=	florin and sixpence.
1 ,,	=	three pennies, or five halfpennies.
1 lb.	=	forty-eight pennies.

The United States five cent nickel coin is exactly 5 g. (77 grs.) in weight and 2 centimetres in diameter. The English halfpenny-piece is exactly 1 in. in diameter and weighs, when new, exactly one-fifth of an ounce; the penny is of less convenient weight—one third of an ounce. No halfpenny-piece is issued that is more than ·2 per cent. wrong in weight, one-fifth of 1 per cent. being what is known as the legal "remedy" in weight, and this does not amount to 1 gr. per ounce.

French coins are particularly suitable as metric weights, namely :—

25 g.	=	5 francs (silver)		
10 ,,	=	2 ,,	,,	
5 ,,	=	1 ,,	,,	
2½ ,,	=	½ ,,	,,	
10 ,,	=	10 centimes (bronze)		
5 ,,	=	5 ,,	,,	
2 ,,	=	2 ,,	,,	
1 ,,	=	1 ,,	,,	

COLAS'S PROCESS

A ferro-gallic printing process perfected by Colas, a German. It is described under the heading "Ferro-gallic Process."

COLD BATH PROCESS (*See* "Platinotype.")

COLD, EFFECT OF

The action of photographic chemicals is seriously retarded by cold, as explained under the heading "Temperatures."

COLD EMULSION (*See* "Emulsion.")

COLLIMATING LENS (Fr., *Collimateur*; Ger., *Kollimatorlinse, Kollimator*)

An achromatic biconvex lens placed in a tube at its principal focal distance from a narrow slit or small aperture. A collimator is used in lens-testing apparatus to produce a parallel beam of light, and in conjunction with the spectroscope. Another form of collimator is a small fixed telescope having cross-wires at its focus; this is employed for adjusting the optical axis, or line of sight, in astronomical instruments.

COLLINEAR LENS

An anastigmat lens introduced in 1894 by Voigtländer, and made in intensities varying

Collinear Lens

from $f/4.5$ to $f/12.5$. The illustration shows the construction of the original type.

COLLOCHROME

Coloured collotype printing.

COLLODIO-ALBUMEN PROCESS

An obsolete process, which gave most beautiful transparencies. A plate is first coated with bromo-iodide collodion, then sensitised in a silver bath and washed to remove excess of silver nitrate. Next it is coated with a mixture of albumen, bromide, and iodide of potassium, which destroys the sensitiveness of the plate so that it can be dried in daylight. When required for use, the plate is resensitised with silver nitrate and thoroughly washed and dried. A gallic acid and silver nitrate developer is generally used. (For working details *see* "Albumen Process," sub-heading "Positives.")

COLLODIO - BROMIDE (*See* "Collodion Emulsion.")

COLLODIO - BROMO - CHLORIDE EMULSION (*See* "Collodion Emulsion.")

COLLODIO-CHLORIDE

An emulsion of silver chloride suspended in collodion. Generally used for printing- out papers. (*See also* "Collodion Emulsion.")

COLLODIO-GELATINE (Fr. and Ger., *Collodio-gelatine*)

H. W. Vogel suggested that dry gelatino-bromide emulsion should be dissolved in glacial acetic acid and alcohol, and mixed with a solution of pyroxyline in similar solvents, with the object of combining the advantages of the two processes. The process has found no practical use, as the sensitiveness is very low. Husnik gave the following formula :—

Dry gelatino-bromide			
emulsion .	. 1 oz.	30 g.	
Glacial acetic acid	. 1 ,,	30 ccs.	
Alcohol . .	. 1 ,,	30 ,,	

Dissolve, and add—

Pyroxyline . .	. 2 oz.	60 g.	

dissolved in—

Glacial acetic acid	. 1 oz.	30 ccs	
Alcohol . .	. 800 mins.	50 ,,	

COLLODION (Fr., *Collodion;* Ger., *Kollodium*)

A solution of pyroxyline in a mixture of equal quantities of alcohol and ether; it should be kept in a well-stoppered bottle. It is a colourless, syrupy liquid, being more or less fluid according to the quantity and nature of the pyroxline used. It will keep indefinitely if made with a good pyroxyline ; the pyroxyline should be first well saturated with the ether and then the alcohol added, and, on shaking, the cotton should completely dissolve. The solution should now be set aside in the dark and allowed to stand two or three days to allow any mechanical impurities to settle, this being preferable to filtration, as in this process some of the solvents are lost. The ether used may be the so-called methylated ether, and should have a specific gravity of ·720 ; the alcohol may be the industrial methylated spirit, but it is preferable to use the pure alcohol ; aqueous alcohol should be used when aqueous solutions of salts are to be added to the collodion, as is often the case in making collodio-chloride printing-out emulsion.

Collodion is used for enamelling prints (*see* "Collodion, Enamel") and as the vehicle for the silver salts in the wet-plate process, dry collodion plates, collodion emulsion, and collodio-chloride paper.

It is important that collodion should always have that degree of viscosity which has been found the most satisfactory for the particular purpose. Viscosity may be defined as the thickness or syrupy nature of the collodion. A very thin collodion—that is, one with less viscosity—is apt to allow the silver salts to deposit at the bottom of the bottle ; on the other hand, for some purposes—such as enamelling—a less viscosity is advisable. The simplest method of testing the viscosity is by means of Von Hübl's viscosimeter, a glass tube 6 in. (15 cm.) long, 1·2 in. (3 cm.) internal diameter, with one end drawn into a fine aperture of about $\frac{1}{25}$ in. (1 mm.). About $\frac{1}{3}$ in. (8 cm.) from the wide end, and on the outside of the tube, should be scratched a line. This tube should be filled up to the mark with distilled water, the small aperture being covered with the finger, and by means of a stop-watch the time taken for the water to flow out should be noted. The mean of six tests should be taken. Then the same process should be gone through with the collodion to be tested ; the time taken by the collodion divided by that taken by the water gives the viscosity of the collodion. For instance, assume the mean for six tests for distilled water at a certain temperature to be 84 seconds, and the time for a specially thick 4 per cent. collodion to be 187 seconds ; then $187 \div 84 = 2.226$, the viscosity of the collodion.

The proportion of alcohol and ether is not a fixed quantity. In summer more alcohol should be used, and thus the loss from evaporation slightly checked. For coating large plates a collodion rich in ether is difficult to work, as the solvents evaporate before the plate is covered ; on the other hand, a film produced by a collodion rich in ether is tougher. In the wet collodion process excess of alcohol produces greater sensitiveness, whilst in the dry collodion process the ratio of the solvents is of less importance, and certainly in those emulsions washed by precipitation an excess of alcohol is an advantage. The solubility of the silver nitrate and the salts has also considerable bearing on this point, and it may be considered as a general axiom that all

salts are more soluble in alcohol than in ether. More particular details will be found under the special headings.

In process work, collodion is an important factor on account of the facility and cheapness with which, by its help, negatives suitable for the various reproductive processes can be made. The comparative slowness of wet-plate exposures is no drawback where exposures are invariably made by electric light; and the development, fixing, intensification, clearing, and drying are all executed much more quickly than on gelatine plates. The silver deposit being on the surface, the image is more susceptible to intensification and reduction than an emulsion film. Finally, on the ground of cheapness, wet collodion holds the field. It has been calculated that the average cost of making negatives in half-plate size is: Wet collodion, 1d.; collodion emulsion, 1¼d.; dry plate, 2¼d. Collodion is also largely used in process work for stripping. (*See also* conclusion to article "Collodion Process (Wet).")

COLLODION BOTTLE (Fr., *Flacon à collodion*; Ger., *Kollodiumgiessflasche*)

A long, narrow bottle for holding and pouring collodion in the wet-plate process. The earlier patterns had merely an ordinary stopper, but in the modern "cometless" collodion bottle A, so called because its peculiar construction

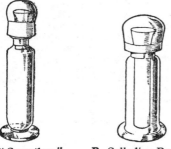

A. "Cometless" **B. Collodion Pouring**
Collodion Bottle **Bottle and Filter**

ensures practical freedom from the comet-shaped spots and other markings incidental to wet-plate work, a closely-ground cap is substituted. A combined pouring bottle and filter is shown at B. A piece of muslin or cotton is tied over the lower end of the inner tube, through which the contents must pass before being poured out. The surplus is returned to the bottle through a notch at the side of the tube. For a third type of bottle, see under the heading "Collodion Filter."

COLLODION EMULSION

A suspension of various silver salts in collodion, and used for printing-out papers, transparencies by development, and negative work. The simplest of all collodion emulsions to make is that for printing-out paper, or, as it is sometimes called, collodio-chloride paper. There are numerous formulæ, but those given in the next column and in the first column of p. 119 have been found of great practical use.

Valenta's Formula

Lithium chloride	. . .	0·9 g.
Strontium chloride	. .	1·8 ,,
Absolute alcohol	. . .	10 ccs.
Glycerine	. . .	10 ,,

Dissolve by the aid of a gentle heat, and add to—

Celloidin collodion (3 %)	.	950 ccs.

Then add—

Citric acid	5 g.
Warm alcohol	. . .	q.s.

Enough alcohol should be used just to dissolve the acid. Shake thoroughly, and add:—

Silver nitrate	. . .	16 g.
Hot water	. . .	20 ccs.

This should be added in small quantities at a time, shaking thoroughly between each addition. Allow the emulsion to stand for twenty-four hours, then filter and use.

Hanneke's Formula

A. Celloidin collodion (4 %)	.	620 ccs.
Ether	. .	100 ,,
Absolute alcohol	. .	30 ,,

To this add—

B. Silver nitrate	. .	25 g.
Distilled water	. .	25 ccs.
Absolute alcohol	.	120 ,,

Then add in small quantities, shaking well after each addition and observing the order given :—

C. Calcium chloride (crystal)	.	4 g.
Distilled water	. .	4 ccs.
Absolute alcohol	. .	30 ,,
D. Citric acid .	. .	5 g.
Distilled water	. .	5 ccs.
Absolute alcohol	. .	30 ,,
E. Castor oil .	. .	7·5 ,,
Glycerine	. . .	7·5 ,,
Absolute alcohol	. .	15 ,,

For solutions B, C, and D, the salts or acid should be dissolved in the water by the aid of heat and then the alcohol added; if this throws down any crystals the solution should be gently warmed, and as soon as clear added to the collodion. In all cases the solutions should be added in small quantities at a time with constant shaking in between, so as to obtain as fine-grained an emulsion as possible.

Silver Bromide Printing-out Emulsion

This was suggested in 1906 by Valenta, and gives an excellent printing-out paper.

A. Celloidin collodion (3 %)	.	1,000 ccs.
B. Citric acid .	. .	20 g.
Absolute alcohol	. .	90 ccs.
Strontium bromide	.	3·2 g.
Glycerine .	. .	4 ccs.
C. Silver nitrate	. .	20 g.
Hot distilled water	.	10 ccs.
Absolute alcohol	. .	80 ,,
D. Ether.	. . .	160 ,,

Mix A and B in daylight and add C in the dark-room in small quantities with thorough agitation; add D, allow the emulsion to stand fifteen minutes, and then filter through wool and use for coating. This gives an extremely rapid

printing paper with a long scale of gradation, and therefore requires rather brilliant negatives. An emulsion which is much more suitable for the average negative can be prepared by adding to the B solution :—

Calcium chloride (anhydrous) . 0·5 g.

Greater contrasts still can be obtained by using uranyl chloride or adding calcium chromate.

Collodio-chloride Emulsion for Development
This gives very slow plates, but the grain is exceptionally fine and very warm tones are obtainable.

Magnesium chloride (crystal) . 4 g.
Absolute alcohol . . . 20 ccs.

Rub up in a mortar, and add—

Collodion (2 %) . . . 50 ccs.

As soon as the mixture becomes slimy, add—

Ether 30 ccs.

And finally add—

Nitro-hydrochloric acid . . 0·6 ccs.

The silver collodion is prepared as follows :—

Silver nitrate . . . 4 g.
Hot distilled water . . 3 ccs.

When dissolved, add—

Hot alcohol 20 ccs.

And then—

Raw collodion (2 %) . . 50 ccs.

The chloride collodion should be added to the silver collodion in small quantities, well shaken, and allowed to stand for twenty-four hours with occasional agitation ; then it should be poured in a fine stream into about sixteen times its volume of warm water (100° F., or nearly 38° C.) with constant stirring. The emulsion is precipitated in fine flocks, which should be collected on a clean linen filter, gently squeezed, and then well stirred up with warm water two or three times and finally well drained, rinsing once or twice with alcohol. Five parts of the dried emulsion should be dissolved in 100 parts of a mixture of equal volumes of alcohol and ether, shaken till dissolved, and then filtered.

Pure bromide and chloro-bromide collodion emulsions were much used for transparency making, but of recent years the gelatine lantern plates have completely ousted them from practical use. They are, however, now employed for negative work, and the most satisfactory formulæ are those given by Von Hübl.

Collodio-bromide Emulsion
Silver nitrate . . . 50 g.
Distilled water . . . 50 ccs.

Dissolve, and add liq. ammoniæ (·880) in sufficient quantity to form a perfectly clear solution ; allow to cool, and add the silver solution to—

Collodion (4 %) . . . 600 ccs.

This should be in a large bottle, preferably one that will contain about three times the total volume, and if any of the cotton or silver settles

out no notice need be taken of it. To this silver collodion add the following, whilst still warm :—

Ammonium bromide . . 32 g.
Hot distilled water . . 35 ccs.
Alcohol 50 ,,

Shake the emulsion for about five minutes, and then add in small quantities with vigorous agitation about one-fourth of its volume of distilled water. This causes the emulsion to precipitate. It should then be poured into about ten times its bulk of water and well stirred, the water drained off, and the washing repeated three or four times. The shreds of emulsion are finally collected on a linen filter, and gently pressed ; then shaken up with alcohol, and again pressed out. The emulsion shreds should now be shaken up with 8¾ oz. or 250 ccs. of absolute alcohol, and allowed to stand for twenty-four hours ; at the end of this time 5¼ oz. or 150 ccs. of the liquid should be poured off and replaced by 5¼ oz or 150 ccs. of absolute alcohol in which 7½ grs. or 0·5 g. of narcotine have been dissolved, and 8¾ oz. or 250 ccs. of ether added, well shaken, and allowed to stand three days and then—

Absolute alcohol . . . 250 ccs.
Ether 250 ,,

added and the emulsion filtered.

Chloro-bromide Emulsion
This can be made in precisely the same way as described above by reducing the ammonium bromide to 416 grs. or 27 g. and adding 23 grs. or 1·5 g. of pure anhydrous lithium chloride. Both these emulsions are very suitable for positive work and also for sensitising with eosine and other dyes for colour negatives.

Von Hübl recommends a glycin developer, but hydroquinone is the general favourite. Collodion positives and negatives can be intensified, reduced, or toned like any other silver images.

In process work, collodion emulsion has been revived of late years because of its suitability for colour work, owing to the emulsion being susceptible to colour sensitising with aniline dyes. A chloro-bromide emulsion is used for this purpose, and it is always exposed in the moist state. The sensitising dyes are sometimes added to the emulsion, and in other cases flowed over. Excellent emulsions are on the market.

COLLODION, ENAMEL

A mixture used for giving to prints the highest possible gloss, the process being called enamelling, an expression sometimes incorrectly applied to burnishing and rubbing with encaustic paste. Enamel collodion may be purchased ready for use, or may be made according to the following formula :—

Pyroxyline . . . 4 grs.
Methylated alcohol . . ½ oz.
Methylated ether . . ½ ,,
Castor oil . . . 4 drops

(For methods of using, *see* " Enamelling Prints.")

COLLODION FILTER (Fr., *Filtre à collodion* ; Ger., *Kollodiumfiltrierflasche*)

An arrangement for filtering the collodion used in the wet-plate process. As here shown,

a tuft of cotton is adjusted loosely in the lower part of the bulb-shaped receptacle at the top, the collodion being poured into this and filtering into the bottle beneath. A glass tube runs

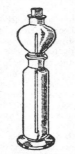

Collodion Filter

from top to bottom to allow of the escape of air as the filtered collodion ascends; this tube should be kept above the surface of the solution as the filtering proceeds. (*See also* "Collodion Bottle.")

COLLODION PELLICLE

A preparation, advertised and described by W. B. Bolton in 1876, for making sensitive plates which could be used in a dry or wet state.

COLLODION POSITIVE

A collodion negative image taken on thin, black-surfaced metal or on glass backed with velvet or black varnish. By reflected light the image appears as a positive. Collodion positives are usually made by the wet-plate process (*see* "Collodion Process (Wet)"). A thin image being necessary, the collodion should be diluted and development stopped directly the details are out. An iron developer gives the whitest deposit, and allows a shorter exposure to be given. Except when taken with a reversing mirror or prism in front of the lens, the ferrotype image is laterally reversed—that is, the left hand of the sitter appears as the right hand in the picture. The following developer gives an exceptionally white deposit suitable for ferrotypes, etc. :—

Potassium nitrate	. 200 grs.	22·8 g.	
Ferric protosulphate	. 300 ,,	34·2 ,,	
Acetic acid (glacial)	. 1½ oz.	75 ccs.	
Nitric acid (pure)	. 30 mins.	3 ,,	
Water . .	. 20 oz.	1,000 ,,	

Collodion positives must be varnished or glazed, as otherwise the film is abraded by handling.

COLLODION PROCESS (DRY)

In this process plates and papers coated with a collodion emulsion (*which see*) are employed, thus obviating the great disadvantage of the older wet process in which the plates had to be exposed immediately they came from the sensitiser. Full information on preparing the emulsion is given under the heading to which allusion is made above. Generally, collodion plates are of about the same speed as lantern plates, and they can be developed with any standard solutions used for gelatine dry plates. Glycine is particularly recommended owing to its freedom from fog.

COLLODION PROCESS (WET), OR WET-PLATE PROCESS (Fr., *Procédé à la collodion humide, Collodion mouillé*; Ger., *Kollodiumverfahren, Nasses kollodionverfahren*)

Collodion was introduced into England in 1847; immediately afterwards R. J. Bingham (one of Faraday's assistants) suggested its use for photography. Gustave Le Gray, a noted French worker, also suggested that collodion might prove useful. The actual invention of the first workable process is due, however, to F. Scott Archer, who made the first collodion negatives in the autumn of 1848, and who published his perfected process in the *Chemist* for March, 1851. So popular did Archer's process become that it practically displaced daguerreotype and calotype, and it was almost exclusively used between 1855 to 1881. It is largely used to-day by process workers and by itinerant photographers; while for certain other branches of photography—lantern slides, for example—it is considered by many to be unsurpassed. Its chief advantages are a structureless film, an extremely fine grain, and clear whites. The fixing agent is easily washed out of the film, and the negative can be dried by heat. Wet-plate negatives can also be easily reduced and intensified.

Wet plates are of low sensitiveness, their speed being about the same as that of lantern plates.

The photographer must prepare his own plates. A deep porcelain dish for the silver bath, a size larger than the plate to be sensitised, is required; it must be scrupulously clean, and if it has previously contained other chemicals it must be very thoroughly washed. Place 480 grs. of silver nitrate in a clean pint bottle, and add 15 oz. of distilled water (rain or tap water will not do). Shake until dissolved, and add 3 drops of pure nitric acid. Keep a day or two before using.

Each ounce of the silver bath contains 32 grs. of silver nitrate, and the strength should be kept as near this as possible, using, if necessary, an argentometer for testing the density. The silver bath is filtered, poured into the porcelain dish, covered with a piece of cardboard, and placed in the corner of the dark-room that is farthest from the developing sink. Adjust the dark-room lamp so that a good light is thrown on the dish. Wet plates will stand far more red or yellow light than dry plates.

For coating the glass the following are necessary :—(a) A 4-oz. bottle of Mawson's collodion, with iodiser in a separate bottle. Before use the iodiser is poured into the collodion, and this iodised collodion will keep in good condition for several months, becoming deep red in colour, the plates then requiring a much longer exposure. Iodised collodion can be purchased ready for use, but the plan here described is preferable. (b) Rubber solution for edging the plate.

For developing, fixing, etc., obtain :—

Pyrogallic acid	.	. 1 oz.
Glacial acetic acid	.	. 4 ,,
Ferric protosulphate	.	. 1 lb.
Mercuric bichloride	.	. 1 oz.
Liquor ammoniæ .	.	. 1 ,,
Lead nitrate	.	. 1 ,,
Potassium ferricyanide	.	. 1 ,,
Sodium hyposulphite or potassium cyanide	.	. 1 lb.

Before coating with collodion, the plate is " edged " to prevent the film from leaving the glass. A drop of rubber solution is taken up on a piece of cotton-wool and run round the edge of the glass, and the plate is then ready for coating.

Take the glass at one corner between the finger and thumb, and pour a small pool of collodion upon it. Carefully tilt the glass so that the collodion flows to the corner farthest from the fingers, tilt again into the other top corner, next bring the collodion to the corner nearest the thumb, and then pour the surplus back into the bottle via the remaining corner. While the collodion is being poured into the bottle the plate must be kept moving to and fro laterally, or the collodion will set in ribs. This movement of the plate must be continued for several seconds, till the collodion is set. Replace the stopper in the collodion bottle, close the door of the dark-room, and immerse the plate in the sensitising solution.

When placing the plate in the silver bath, the dish should be tilted, so that the solution flows to one end. Place the plate in the other end of the dish, and immediately lower the dish to let the bath flow in an even wave over the plate. If the flow is checked, a streak across the image will result on development. The cover of the dish is now replaced, and the door of the dark-room can be opened for a minute or so.

Sensitising begins directly the plate is inserted in the bath, and is complete in about two and a half minutes. The plate is ready to be removed from the bath when the film presents a creamy appearance ; but, as a rule, leaving the plate in the bath for two or three minutes will suffice. Of course, if it is desired to look at the plate while in the bath the door of the dark-room must be closed.

If ordinary dry-plate slides are to be used the rebates for the glass must first be covered with strips of blotting-paper. If the wet plate touches the woodwork of the slide, scum will form over the plate and the picture will be spoilt. If the strips of blotting-paper are damped before use they can easily be fixed in the rebate. Wet-plate slides are provided with silver wires with the object of supporting the plate, but even these slides require blotting-paper at the bottom and top of the plate. After remaining in the bath for two or three minutes the plate is removed by being raised with the handle of a silver spoon, or with a lifter made of horn or vulcanite. The fingers must not be dipped into the silver bath, and neither wood nor metal, other than silver, must be used. The collodion of the sensitised plate has a creamy, opalescent appearance, owing to the formation of silver iodide in the film.

The plate is allowed to drain for a few seconds over the bath, and the moisture is then removed from the back with a piece of blotting-paper, the plate meanwhile resting on its edge upon a sheet of clean paper.

Next, the plate is inserted in the dark-slide, care being taken that the collodion film is not in contact with either wood or metal. The exposure for wet plates is from ten to twenty times longer than is required for an ordinary dry plate ; fresh collodion requires less exposure than stale,

and in cold weather the sensitiveness of the film is considerably diminished. In a weak light or in a slightly yellow one a wet collodion plate is far less effective than a gelatine film.

An acid, instead of an alkaline, developer is necessary for wet collodion plates. The following is a formula for a pyro developer stock solution :—

Pyrogallic acid	.	.	. 24 grs.
Glacial acetic acid	.	.	2 oz.

This solution keeps well. For use, add 6 parts of water to 1 part of the stock solution.

The above is quite reliable, but some workers prefer ferric sulphate, as in the following :—

Ferric protosulphate	.	.	1 oz.
Glacial acetic acid	.	.	1 ,,
Water	.	.	. 15 ,,

Methylated spirit should be added to the developer after the bath has been in use some time, to ensure even flowing of the solution over the plate. A shorter exposure is required for iron development. Developing and fixing dishes are not required. The plate is removed from the dark-slide and the developer is poured quickly and evenly over the film. The plate is kept moving during development, in order to keep the film covered with solution. Fresh developer must be used for each plate. The image develops steadily, and usually begins to appear in about ten seconds ; but in cold weather the time may be considerably longer. Development is stopped when all the details are visible. The plate is washed for a few seconds under the tap and is then fixed with potassium cyanide, which should be kept in a saturated solution, and for use diluted with double its volume of water.

" Hypo " can be used instead of cyanide ; but it does not work so quickly, and takes longer to wash out of the film. After fixing with potassium cyanide, the plate is washed for a minute or so under the tap ; if " hypo " is the fixing agent, five minutes' washing is necessary. If the picture is satisfactory, the plate can be dried in front of the fire. The collodion image, when fixed, should be bright and clear, without a trace of fog or stain. The best reducer, should one be found necessary, is cyanide and iodine, made by dissolving a few crystals of iodine in methylated spirit and adding a saturated solution of potassium cyanide until the red colour of the iodine has disappeared.

If intensification is required, a solution of mercuric bichloride, followed by ammonia, can be used as in dry plate operations. If the image is very flat, or when black-and-white work is required, intensification with lead nitrate can be adopted, using :—

Lead nitrate	.	.	. 1 drm.
Potassium ferricyanide	.	.	1½ ,,
Water	.	.	. 10 oz.

The plate is immersed in the above solution till sufficient density is reached, then washed under the tap till all yellowness has disappeared. The picture, in most cases, need not be blackened when intensified by lead, as sufficient density is obtained without the use of an alkali. When absolute opacity is required, ammonium hydrosulphuret can be used, after all the yellow stain

has been washed from the film. It must be noted that the lead intensifier has a drastic action and must be used only for flat pictures or for the reproduction of black-and-white drawings.

Another method of intensification, known as re-development, is perhaps the best for beginners. When the image, after fixing, seems to be lacking in contrast, the plate is rinsed and fresh developer, mixed with a few drops of a 10 per cent. solution of silver nitrate, is flowed over the film. The addition of the silver to the developer gives vigour to the image. After fixing the plate, mercuric intensification will give further contrast, if necessary. When dry, the plate should be varnished, as the collodion film is easily torn.

For ferrotype plates, a thinner film is necessary, and the iodised collodion should be further diluted with sulphuric ether. A developer giving a white deposit (see " Collodion Positive ") should be used. The general procedure of sensitising, developing, and fixing ferrotypes is the same as for wet-plate negatives.

In process work, a very clean working collodion is required, and at the same time one that gives great density. Further, the film must be tough to withstand intensification and reduction. Celloidin collodion of not more than 2 per cent. strength is usually employed. Pure solvents have to be used in order to avoid fog and scum. Ammonium and cadmium iodide and cadmium bromide with cadmium chloride are the general ingredients of the iodiser. A typical formula for collodion suitable for process work is—

Celloidin	.	.	.	1 oz.	31 g.
Alcohol (·805)	.	.	40 ,,	1,136 ccs.	
Ether (·720)	.	.	60 ,,	1,704 ,,	

The following is the iodiser :—

Alcohol (·820)	.	.	10 oz.	284 ccs.
Cadmium iodide	.	½ ,,	15.5 g.	
Ammonium iodide	.	180 grs.	11·6 ,,	
Cadmium bromide	.	15 ,,	1 ,,	
Cadmium chloride	.	30 ,,	2 ,,	
Iodine	.	.	10 ,,	·6 ,,

Take one part iodiser to nine parts collodion, and allow to stand for ten to fourteen days. The silver bath is usually 35 to 40 grs. per oz. Development is with the iron developer ; fixing with potassium cyanide ; intensification with either lead nitrate (for line negatives), or with copper bromide (for half-tone), followed with ammonium or sodium sulphide. " Cutting " or reducing to sharpen up the dots or lines is generally resorted to, the solutions employed being iodine and cyanide. For stripping, the negatives are coated with rubber solution and then with collodion to which a small proportion of castor oil has been added to make it flexible. The glass plates are, as a rule, edged with rubber solution before coating with collodion, to make the latter hold.

COLLODION TRANSFERS

Collodion positives transferred from the original glass to other supports, usually paper. Special collodions and papers for transfer work are now commercial articles, and the process is quite easy nowadays, compared with what it was in 1857, when it was first practised no special

collodions for the purpose being then obtainable. A suitable transfer paper is made by evenly coating smooth-surfaced cream-wove foolscap with a solution of gelatine made by dissolving ½ oz. of gelatine in from 20 to 30 oz. of water, and then drying. After the collodion picture is fixed and washed in the usual way, the transfer paper is soaked and carefully squeegeed into contact with the picture, film to film, and allowed to dry. When dry, one corner of the paper may be lifted with a penknife, when it will strip from the glass and bring the picture with it. If the pictures to be transferred are large, the glass should be coated with a substratum of wax before the usual collodion is applied. Five grains of pure sun-bleached white wax in 1 oz. of ether forms the waxing solution ; this is spread evenly and rapidly over the glass, and, when dry, polished until no trace of the wax apparently remains, although enough will be left to assist the picture to leave the glass easily. In some cases, negative films, too much under-exposed to print from, were bleached by means of mercury and transferred to black paper, on which they appeared to be positive and finished pictures.

COLLODIONISED PAPER

A term somewhat loosely applied to collodio-chloride paper.

COLLODIOTYPE

An early name for any kind of photograph produced by the collodion process.

COLLOGRAPHIC PROCESSES

A general term applied to collotype methods, all based on the principle of the action of light on a bichromated colloid, the latter being usually gelatine.

COLLOGRAPHY

A process said to have been invented by Pumphrey, of Birmingham, in 1880, and similar to that formerly well known under such terms as " Autocopyist," etc., in which a film of gelatine on glass or on some flexible support, such as parchment, was bichromatised and dried. Writing or drawing is done on a suitable paper with solutions of iron salts, nutgalls, or similar substances having a tanning action on the gelatine surface, to which the design is next transferred. By keeping the gelatine pad moist and applying an ink roller, the lines will take the greasy ink, but the white parts will repel it. Paper is then brought into contact with the pad, and an impression taken by rubbing or squeegeeing.

COLLOGRAVURE

A kind of collotype invented by Balagny, of Paris, in 1893-4, in which gelatino-bromide of silver films were converted into collotype printing surfaces, the prints being made with fatty ink.

COLLOIDS

A name derived from Greek *kolla* (glue) and *eidos* (appearance), and given by Graham to those non-crystalline substances which do not diffuse through porous membranes. The chief organic colloids are cellulose, starch, dextrine, tannin, gelatine, caramel, and albumen. The

inorganic colloids are hydrated oxides of iron, hydrated silica, alumina, etc.

Graham, in 1861, discovered that many substances, particularly those which readily crystallise, diffuse through animal membranes, whilst other substances, such as gelatine, which do not crystallise, do not so diffuse. (Modern researches have shown that Graham's conclusions must be modified somewhat.) The latter class of bodies he called "colloids." The diffusion of the crystalline salts through a membrane he termed "dialysis," and the vessel in which the solution was placed a "dialyser." There are a great many natural or organic substances, such as starch, dextrine, gums, albumen, caramel, rubber, resin, etc., which are colloids and behave precisely in the same way as the first-mentioned gelatine ; but there are also many inorganic chemicals, such as ferric hydrate, silicic acid, etc., which act similarly. Apparently these dissolve in water, but when submitted to the test of dialysis prove themselves to be true colloids. The apparent solutions of such substances are called "pseudo-solutions," to differentiate them from the so-called true solutions.

Graham also discovered that water was not unique in forming colloidal solutions, but that alcohol, benzole, glycerine, and sulphuric acid, as well as other solvents, were capable of acting in the same way ; and the term "sol" is used to designate these. Thus, hydrosol indicates a water sol, alkosol an alcoholic sol, and glycerosol a glycerine colloidal sol. Generally, when the solution is of an organic nature, it is termed an "organosol."

The scientific student may here be told that, practically, a sol or colloidal solution consists of two ingredients, a liquid and a solid, the latter being in an extremely finely divided state, distributed or suspended in the liquid. The sharply separated parts of the sol are said to be its phases, and in colloidal solutions there are several multiple-phase or heterogeneous formations, and the one phase, being in an extremely finely divided state, naturally presents to the second phase a very large surface, and with normal examination the sol appear perfectly homogeneous. This is called "microheterogeneity." Many substances, particularly those which form jellies or "gels," do not, however, show this particular form of heterogeneity, particularly when coagulation is effected, and then it is termed "macroheterogeneity." In continental literature, the term "disperse-heterogene" is used for the former, and a generic term of "dispersoids" is used for all microheterogeneous systems. Other colloid solutions take another form, and this has been likened to a sponge, that is, they practically form a network distributed throughout the dispersion medium.

The density of colloidal solutions cannot be calculated from the densities of the disperse phase and the dispersion medium, or the substance and solvent; for instance, a solution of a given quantity of gelatine in a given quantity of water is not the sum of their respective volumes, but less, a small but marked contraction taking place. Their osmotic pressure is very low, and in many cases not to be detected, and their boiling and freezing points vary but very slightly from those of the liquid, water, alcohol, etc.

It has been already stated that colloids would not diffuse through an animal membrane, but recent researches have shown that this is only partially true, and that some colloids will diffuse as well as crystalloids, but at a much slower rate, so that the fundamental difference is in their rate of diffusion.

Provided that the size of the particles of the disperse phase are sufficiently small, they exhibit under a powerful microscope peculiar vibratory motions, which were first discovered by Brown in 1827, and are therefore called "Brownian movements." This motion is approximately a zig-zag or to-and-fro motion, and has been ascribed to the contrary pull of gravity and the viscosity or thickness of the liquid. Particles which are larger than 3 to 5 μ (1 μ = ·001 millimetre = $\frac{1}{25000}$ in.) do not show this movement. Many hydrosols appear perfectly clear and homogeneous, but others exhibit the phenomena of fluorescence or opalescence when illuminated by suitable light, and Tyndall's phenomenon is often apparent with light of very small wave length, that is to say, the particles are sufficiently large to reflect violet or ultra-violet light of extremely short wave length, and polarise it. This is the foundation of ultramicroscopy.

The disperse phase carries a positive or negative electric charge, which is dependent to some extent on the dispersion medium—that is, the water or other liquid—and sometimes on its alkalinity or acidity. Colloidal solutions can exhibit a change of condition under mechanical action, or the application of heat, and the dissolved substance may separate in an insoluble form or be converted into jellies by the addition or certain substances, such as electrolytes. When the substance separates out in an insoluble form it is known as a "gel," and if formed from an aqueous solution it is known as a "hydrogel," an "alkogel" from alcohol, and a "sulfogel" from sulphuric acid, etc. The process of the formation of the gel is called pectinisation or coagulation. When the residue left after coagulation is soluble in water, the process is said to be reversible ; if insoluble, it is irreversible. Frequently an insoluble and otherwise irreversible colloid is precipitated in the presence of a reversible colloid; it also becomes reversible; and the colloid that produces this state is known as a protective colloid, or, to use the German word, a "schutz-kolloide." Lottermoser has also pointed out that by certain precipitating agents a colloid may be precipitated from the hydrosol in such a condition that it will again form a hydrosol, and therefore suggests the terms "solid" and "liquid" hydrosol, and confines the term hydrogel to the insoluble amorphous substance. The law is that sols with opposite electric charge precipitate one another, but those of like charge do not.

Gels or jellies may be considered as colloid solutions in which the disperse phase is in a higher concentration, and molecular and colloidal solutions can diffuse through a gel more or less rapidly, according to the concentration of the disperse phase of the gel.

Colloidal solutions differ from true solutions in that the latter are perfectly homogeneous under the most critical visual examination that can be applied, whilst the former show the

particles under sufficiently high power as already pointed out. They differ also from suspension liquids or mixtures in that in the latter the particles or disperse phase are sufficiently large to be seen with the naked eye or a weak power. There is, however, some evidence to prove that these divisions are but arbitrary, and that so-called true solutions may be of a colloid nature.

P. Weimarn and Wolfgang Ostwald ("Grundriss der Kolloidchemie") considering that, as suspensions, colloidal and true solutions are merely varying degrees of dispersion, have proposed the name of "dispersoids," and the latter divides them into (1) coarse dispersions, such as suspensions and emulsions; (2) colloidal solutions; (3) molecular dispersoids; and (4) iondispersoids, assuming that free ions exist. The crystalloid solutions belong to classes (3) and (4). The above classes merge one into the other, and colloidal solutions are divided into suspension colloids and emulsion colloids, which are also termed suspensoids and emulsoids. The occurrence of colloidal silver and gold is assumed in many photographic processes, and many reactions can only be satisfactorily explained on this assumption. There is, however, an increasing tendency to drag the phenomena of colloids into every obscure photographic process, and there is the grave danger that it may be used merely to cloak our ignorance of the true state of affairs.

COLLOTYPE (Fr., *Phototypie*; Ger., *Lichtdruck*)

A process known also as "phototype," and, in slight variations, as "Albertype," "Artotype," etc. It is based on the principle that if a film of bichromated gelatine is exposed to light under a negative, and the unaltered bichromate is washed out, the film will have a similar property to that possessed by a lithographic stone of attracting ink in some parts and absorbing water in others, the water repelling the ink. It differs essentially, however, from lithographic work in the fact that the attraction for ink and water in the different parts is proportionate to the action of the light, so that the strength of the ink image varies in proportion to the light and shade of the picture. The discovery of this property was made by Fox Talbot in 1853, and his researches were followed up by A. Poitevin, of Paris, from 1856 onward. The first practical collotype process was introduced by Tessié du Motay and Ch. R. Maréchal, of Metz, in 1865; and the perfection of the present-day process of collotype is due to the labours of Josef Albert, Husnik, and Obernetter. Although the process is still largely worked, its commercial success has been much retarded of late years by the progress of halftone, photogravure, and other etching methods, and it has to a considerable extent fallen into disfavour, especially in England and America.

The general method of working the process is as follows :—A thick glass plate is ground on one side with fine emery powder, and is then placed on a levelling stand or levelling screws, and having first been coated with a suitable substratum and dried, is flowed over with a measured quantity of bichromated gelatine. When the film is set the plate is placed in a dry-

ing oven, which is brought up to a temperature not higher than 130° F. (54° C.), at which the drying takes about two hours. When cool, the plate is placed with the negative in a special printing frame, pressure being applied by wedges. The plate is next washed to remove the unaltered bichromate, and allowed to dry. To prepare the image for printing, the surface is flooded with a mixture of glycerine, water, and sometimes other ingredients, allowing it to stand for thirty minutes. Then the excess is removed and the plate is rolled up with a lithographic roller charged with a special collotype ink, which is similar to lithographic ink, but stiffer. When completely inked, paper is laid on the plate and pressure applied in a press. An ink image reproducing the tones of the original is thus obtained. Success depends on the proper formation of a grain caused by reticulation of the gelatine during the drying, and the grain is modified by exposure according to the action of the light passing through different parts of the negative.

Many modifications of detail have been made by different workers, but the above general outline applies to all the methods, except that in some cases attempts have been made to form the image on aluminium, copper, lead, and other plates instead of glass.

Collotype in colours has been worked with success for some years in Germany, and to some extent in England. The number of negatives made varies with the number of different colours required. A collotype plate is made from each negative, and all its parts are blocked out except those required for that particular colour. The printing is then done as in chromo-lithography, the impressions of each colour being superimposed in exact register.

COLOPHONY (Fr., *Colophane*; Ger., *Colophonium*)

Another name for resin, more used on the Continent than in England. Properly it is applied to a black resin, the solid residuum of the distillation of turpentine after the oil has been worked off. (Particulars of resins are given under the heading "Gums and Resins.")

COLORIMETER (Fr., *Colorimètre*; Ger., *Farbenmesser*)

An instrument for ascertaining the strength or purity of a substance by comparing its colour with a given standard. There are several forms, as, for example, Mill's, in which the colour is varied by altering the depth of a tinted solution until a match is obtained; Lovibond's, in which a number of coloured glasses are adjusted; and so on. A colorimeter is occasionally useful in photography, as, for instance, in the volumetric estimation of silver nitrate solution with potassium chromate, in which it is often difficult to recognise the red reaction that ensues owing to the original yellow colour of the test solution itself. A properly adjusted colorimeter renders the change of tint at once manifest.

COLOUR (Fr., *Couleur*; Ger., *Farbe*)

A person sitting in a perfectly dark room can see neither the form nor colour of the objects around him; but the moment light is admitted

TABLE OF SUBTRACTIVE COLOUR MIXTURES OR SUBTRACTIVE ANALYSIS (STOLZE)

Orange	Yellow	Yellow green	Green	Blue green	Cyan. blue	Indigo blue	Violet	
							Bluish violet	Indigo blue
						Blue	Blue violet	Cyan. blue
					Greenish blue	Greenish blue	Bluish grey	Blue green
					Blue green	Blue green	Grey	Green
			Yellowish green	Bluish green	Bluish green	Green	Violet grey	Yellow green
		Greenish yellow	Yellow-green	Yellow green	Green	Yellowish olive	Dirty red brown	Yellow
	Gold yellow	Olive	Yellowish grey	Yellowish grey	Olive	Olive	Red-brown	Orange
Deep red	Yellowish red	Greyish yellow	Yellowish grey	Grey	Grey violet	Greyish brown	Dirty red violet	Deep red
Deep red	Scarlet	Yellowish grey	Grey	Bluish grey	Bluish violet	Violet	Red violet	Purple

he at once sees the shape of objects and also their colours. It is obvious then that to have colour there must be light. Colour is due to the suppression or absorption of some of the constituent rays of white light (see "Spectrum"). A sheet of red glass looks red because it has suppressed or absorbed that particular region of the spectrum or those colours to which red is complementary (see "Colour, Complementary"), and it is the residuary colours that give the observer the impression of red. Precisely the same thing happens with any substance which is not transparent, as, for instance, a sheet of red paper or a green leaf; the light incident on its surface penetrates to a slight depth into the substance of the paper or leaf, and there meets with a material or surface which reflects the light back to the eye, but in its passage into and out of the paper or leaf the light undergoes selective absorption, and the residuum of the incident light now appears either red or green.

White, grey, and black are not colours; the first is the sum of all the spectral rays; grey is all the rays reduced in intensity; whilst black is the suppression of all light, and therefore of all colour. This can be strikingly illustrated by projecting a spectrum or a series of coloured glasses or filters on to a white, a grey, and a black surface. In the first case, all the colours are seen in their original purity and strength, whereas in the case of the grey surface, the colours are still there, but they are reduced in luminosity, that is, they appear less brilliant. With a black surface, such as good black velvet, the colours are absorbed entirely.

Colour may also be formed by the interference of the light rays with one another, but this is also a suppression of some of the spectral rays. (See "Interference of Light.")

It is usual, therefore, to designate colours as "body colours" and "surface or interference colours." To the former class belong all coloured pigments, and to the latter those colours seen on a diffraction grating, a thin soap bubble or a peacock's tail feathers.

It is important to differentiate between the action of mixed pigments and mixed lights, as the results are not comparable. In the former case, mixing increases in each case the suppression or absorption of light with each pigment used, whereas the mixing of coloured lights adds light to light. To illustrate the first point, take three printing inks, red, yellow, and blue, such as are used in trichromatic printing, and examine the absorption spectrum of each. The letters at the top of the diagram refer to the Fraunhofer lines, the colours being placed underneath; the black portions show the assumed absorptions of the inks, whilst the white portions show the

TABLE OF ADDITIVE COLOUR MIXTURES OR OPTICAL SYNTHESIS (HELMHOLTZ)

	Violet	Indigo blue	Cyan. blue	Blue green	Green	Greenish yellow	Yellow
Red	Purple	Dark crimson	Whitish crimson	White	Whitish yellow	Golden yellow	Orange
Orange	Dark crimson	Whitish crimson	White	Whitish yellow	Yellow	Yellow	
Yellow	Whitish crimson	White	Whitish green	Whitish green	Greenish yellow		
Greenish yellow	White	Whitish green	Whitish green	Green			
Green	Whitish blue	Water blue	Blue green				
Blue green	Water blue	Water blue					
Cyan. blue	Indigo blue						

light reflected, the sum of which is severally red, yellow, and blue. Now, it is obvious that by superimposing these three spectra there is no part which is transmitted by all three, and the result is total absorption of light, or black. Taking the case of three-coloured lights, by mixing them on a screen by means of a triple lantern, just the reverse of the above effect is obtained; for convenience, let there be taken red, yellow, and blue glasses, matching approximately the inks referred to above. Then, considering not the absorptions or black portions, but the white or transmitted portions in the figure, it will be understood that the whole spectrum is transmitted and the result is white light.

The former is called subtractive colour mixing or analysis, whilst the latter is termed additive colour synthesis. It must not be overlooked that whilst pigmentary colours have been dealt with, in the case of subtractive colour analysis, the argument applies also to superimposed transparent colour filters.

The tables on the preceding page show the difference between the two systems.

Diagram Indicating Absorption Spectra of Red, Yellow and Blue Printing Inks

In these tables the colour resulting from a mixture of any two colours is found where the vertical and horizontal colours meet. Also, the term " whitish " means that the colour appears pale—that is, mixed with white light. It is usual to designate the main or predominant colour and precede it by the colour with which it is mixed; for instance, there may be a full or pure green; when mixed with blue, this becomes bluish-green; with still more blue, a pure blue-green; with increasing quantity of blue, it becomes greenish-blue.

COLOUR ABSORPTION

Whilst colour itself is an absorption of light (see " Colour "), it is extremely important in some cases to know the colours absorbed by certain materials, such as aniline dyes for filter making. The only method of determining this satisfactorily is by means of a spectroscope, or, for accurate work, a spectro-photometer. It is laborious work, as the absorption of a dye solution will alter with increased concentration or depth of solution, and it is necessary, therefore, to make very careful spectro-photometric observations at various dilutions. This, however, can be performed much more readily by photography, as has been done by Uhler and Wood, of the Carnegie University, of Washington, U.S.A., and more completely by Wratten and Wainwright in their " Atlas of Absorption Spectra," which contains the absorption spectra of 170 dyes. For this work was used a small box spectrograph fitted with a prism grating, and the dye solution was contained in a wedge cell of rectangular form of 1 cm. (·4 in.) internal length and 5 mm. internal width, with a diagonal partition which divided it into two wedge-shaped cells, the one being filled with the dye solution and the other with the solvent, so as to obviate the prismatic effect of the cell. The thickness of the dye solution thus varied considerably, the actual thickness from end to end of the slit being about 1 to 15. The spectrograph was provided with a wave length scale and an ultra-violet filter. Precisely the same results can be obtained by using a parallel-sided cell of fixed width and varying the strength of the solution, or keeping the dye strength constant and varying the cell width, but these plans are laborious and do not give the required information in such compact form.

COLOUR, COMPLEMENTARY (Fr., *Couleur complémentaire*; Ger., *Komplementärfarben*)

For every saturated and unsaturated colour there exists another colour which, when suitably mixed with it, forms white; such pairs are called complementary colours. It is important to know—roughly, at any rate—the complementary colours, because one can at once determine the colour of the filter required to absorb one or the other. For instance, supposing one had to photograph a photomicrographic object which was stained green and blue in parts, and it was desired clearly to differentiate the green; then all one would require to know would be the complementary colour to green, and a filter of that colour would absorb the green and show it as black. On the other hand, if one wanted to show the green and suppress the blue-stained portions, then one would only require to know the complementary colour to the blue to absorb this and render the green clear.

The following table, compiled by Prof. Grünberg, of Vienna, contains the sum of the observations of the leading physicists of the day :—

Colour	Wave length in μμ	Complementary colour	Wave length in μμ
Red	656	Greenish blue	492
Orange	608	Blue	489
Gold yellow	{585 {576	Blue Blue	483 472
Yellow	{571 {566	Indigo blue Indigo blue	462 447
Greenish yellow	564	Violet	433

He also gives the following very simple formula for finding approximately the complementary colour :—

$$L' = 498 - \frac{424}{L - 559}$$

in which L' = the complementary colour and

L, the given wave length. Ex.—What is the complementary to wave length 589 ?

$$L' = 498 - \frac{424}{589 - 559}$$
$$= 498 - \frac{424}{30} = 498 - 14 \cdot 13 = 483 \cdot 87$$

There is no true spectral colour complementary to the pure green spectrum region ; this is found in the purples or crimsons made by a mixture of violet and red. (*See also* "Zander's Complementary Colour Process.")

COLOUR, EFFECT OF

The effect of the various colours on the photographic emulsion is dependent chiefly on whether the emulsion is colour-sensitised or not, on the use of colour filters, and the length of the exposure. The ordinary (non-colour-sensitised) plate is sensitive to the ultra-violet, violet and blue rays, the commercial iso- or orthochromatic plate has an added sensitiveness to yellowish-green and yellow, whilst the panchromatic plate has red sensitiveness as well.

There is one effect of colour which is particularly marked when using screenplates, and that is the effect of reflections from surrounding coloured objects on a sitter or object. When dealing with ordinary monochrome photography this is entirely overlooked, but with colour reproductions these coloured reflections obtrude themselves sometimes in the most unexpected manner.

COLOUR FILTER (*See* "Colour Screen or Filter.")

COLOUR FOG (*See* "Fog, Colour.")

COLOUR, FUNDAMENTAL (*See* "Colour Sensations.")

COLOUR PHOTOGRAPHY (*See* "Autochrome Process," "Ives' Process," "Lippman's Process," "Screenplate Colour Photography," etc.)

COLOUR, POSITIVES IN (*See* "Positives in Colours.")

COLOUR SCREEN OR FILTER

A sheet of coloured glass, or glass coated with dyed gelatine or collodion, or a cell containing a coloured liquid, used to modify the action of some particular region of the spectrum on the sensitive plate. It is usual to divide colour screens into two classes, (*a*) continuing and (*b*) contrast screens, though the division is purely arbitrary and the two insensibly merge one into the other. The most used form of screen or filter is the yellow screen, which is employed with iso- or orthochromatic plates to reduce the excessive action of the ultra-violet, the violet and blue rays, which it does by partially or wholly absorbing them, and thus, by prolonging the exposure, gives the green and yellow rays more time to act so that the colours may be reproduced more nearly in the order of their respective visual luminosities (*see* "Colour Sensations" and "Luminosity, Visual"). The exact depth of the yellow screen is dependent on the relative sensitiveness of the emulsion to the yellow and blue, and also on the effect desired. For instance, in photographing extremely faint

white cirrus clouds against a blue sky the difference in photo-chemical action of the sky and clouds is so slight that a contrast or deep-coloured screen is used abnormally to suppress the action of the sky. On the other hand, when it comes to a pictorial representation of a field of wheat intermingled with poppies, the visual luminosities of which may be approximately equal, the operator's æsthetic feeling or education must teach him to choose either to disregard the truth and to accentuate the golden hue of the wheat at the expense of the scarlet poppy, or else to obtain a compromise between the two. In such a case another factor, of the permissible exposure, comes into play.

Numerous dyes have been used or suggested for making the yellow screen, which has now largely replaced the old form of pot glass orange-colour screen, which contained also a considerable proportion of black that merely increased the exposure by cutting down the available light. Aurantia, auramine, naphthol yellow, methyl orange, tartrazine, and filter yellow K, have all been used. Of these, the last is by far the most effective, as it completely suppresses the ultra-violet rays, which are invisible to us, and has a gradual absorption for the violet and blue. It is a very soluble dye, and is stable to light in the ordinary way.

The following instructions are modifications of those issued by the Hoechst Dyeworks, the makers of this dye, for the manufacture of yellow screens, and they may be considered typical for making all filters, the quantities and dyes merely varying according to the particular requirements.

Stock Dye Solution

Filter yellow K	. 31 grs.	2 g.
Distilled water .	14 oz. 38 mins.	400 ccs.

Stock Gelatine Solution

Gelatine (hard emulsion) .	. 420 grs.	60 g.
Distilled water to	. 16 oz.	1,000 ccs.

Wash the gelatine by stirring two or three times in distilled water, then drain and add to about three-quarters of the total quantity of water, dissolve in a water bath at 120° F., and if it is to be kept, add a grain of thymol or a few drops of carbolic acid, filter, and make the total bulk up to 16 oz. or 1,000 ccs.

No. 1 Yellow Filter

Stock gelatine solution	2 oz.	120 ccs.
Stock dye solution	. 24 mins.	3 "
Distilled water .	. 168 "	21 "

No. 2 Yellow Filter

Stock gelatine solution	2 oz.	120 ccs.
Stock dye solution .	48 mins.	6 "
Distilled water .	. 144 "	18 "

No. 3 Yellow Filter

Stock gelatine solution	2 oz.	120 ccs.
Stock dye solution	. 96 mins.	12 "
Distilled water .	. 96 "	12 "

No. 4 Yellow Filter

Stock gelatine solution	2 oz.	120 ccs.
Stock dye solution .	192 mins.	24 "

For every 16 sq. in. or 100 sq. cm. of glass allow 122 minims or 7 ccs. of the dyed gelatine, and two of each of the screens must be bound

together. The increase in the exposure with the above filters for pinachrome or erythrosine bathed plates is No. 1 1·3, No. 2 1·7, No. 3 2·0, and No. 4 3·0 times. For commercial iso- or ortho-chromatic plates—that is, those sensitised in the emulsion before coating—the exposure is about half as much again.

The glass of which the screens are made should be selected patent plate, about $\frac{1}{16}$ in. thick, and it should be as parallel as possible ; for the best-quality screens optically worked glass should alone be used. In order to test the glass for parallelism of its sides, it should be placed on a sheet of black velvet and held at an angle of about 45° some distance from the cross-bars of a window, so that the reflection of these can be seen in the glass. On turning the glass round on the velvet, the image of the cross-bars will be seen to be double—that is, the reflection from both the front and back of the glass will be seen. These double images should, as far as possible, be constant in position one to the other, and not shift up and down or from side to side. The glass must be thoroughly cleaned and placed on a thick sheet of plate glass which has been accurately levelled, and the necessary quantity of dyed gelatine poured on to it, coaxed out to the edges with a glass rod, and allowed to set, when it can be put away to dry.

It may be pointed out here that the position of the filter has some effect on the focal length of the lens and also on the definition of the image. When placed behind the lens it slightly lengthens the focus, but its effect on definition is a matter of actual test with every filter, though the nearer the filter is to the plate the less the effect ; therefore, obviously, if placed in contact with the sensitive surface, the question of the quality of the glass is not of so much moment, and in this case even fixed-out and washed dry plates may be used.

The cementing of colour screens is a messy process, and requires considerable practice to perform successfully. A fairly thick solution of Canada balsam in xylol, such as is used by microscopists, should be used, and the screens well warmed for at least half an hour, so as to ensure that they are thoroughly dry ; the balsam should also be gently warmed. A pool of balsam, about half the size of the plate, should be poured on to one screen somewhat near one edge, and the other screen lowered first on to this edge and slowly allowed to fall down, when it will squeeze the pool of balsam out so as to cover the whole surface. Then a stout bulldog clip should be fastened on each side, and the screens put away in a warm place for the balsam to dry out ; this will probably take four or five days. At first it is better to use excess of balsam, as this will be squeezed out and can be easily cut off when dry ; but with experience the quantity of balsam may be reduced.

The filters for three-colour work are innumerable, the following being satisfactory :—

Hoechst Dyeworks' subtractive filters for three-colour printing of all kinds.

Blue-violet Stock Solution

Crystal violet .	. 61·7 grs.	4 g.	
Warm distilled water	12 oz. 155 mins.	350 ccs.	
Glacial acetic acid	. 5–6 mins.	5–6 drops	

Filter

Dye solution	338 mins.	20 ccs.
Gelatine solution (6 %)	3½ oz.	100 „

or—

Stock Solution

Rapid filter blue .	15½ grs.	1 g.
Hot distilled water 6 oz.	160 mins.	180 ccs.
Liquor ammoniæ .	8 mins.	8–10 drops

Filter

Dye solution	. 338 mins.	20 ccs.
Gelatine solution	. 3½ oz.	100 „

This is faster to light than crystal violet.

Green Stock Solution

Rapid filter green I .	62 grs.	4 g.
Distilled water .	3½ oz.	100 ccs.

Filter

Dye solution .	. 338 mins.	20 ccs.
Gelatine solution (6 %)	3½ oz.	100 „

This transmits a narrow band in the extreme red ; the following does not, and should always be used with panchromatic plates :—

Stock Solution

Filter blue green .	15½ grs.	1 g.
Rapid filter yellow .	15½ „	1 „
Distilled water .	3½ oz.	100 ccs.

Filter

Dye solution .	. 338 mins.	20 ccs.
Gelatine solution (6 %)	3½ oz.	100 „

Red Stock Solution

Rapid filter red I .	77 grs.	5 g.
Distilled water .	7 oz.	200 ccs.

Filter

Dye solution .	. 338 mins.	20 ccs.
Gelatine solution (6 %)	3½ oz.	100 „

Allow 118 minims to every 16 sq. in., or 7 ccs. to every 100 qcm., and cement two glasses of each colour together. The ratio of exposures for pinachrome or pinacyanol bathed plates is, for the blue screen (yellow printing) negative, 4 ; for the green screen (red printing) negative, 8–12 ; for the red (blue printing) negative, 8–12.

For liquid filters the following, suggested by Newton and Bull, for use with panchromatic plates, with cells of 1 cm. internal thickness :—

Blue Filter

Victoria Blue B		
(Bayer) (1% sol.) . 448 mins.	47 ccs.	
Naphthol green (1% sol.) 174 „	18 „	
Distilled water to . 20 oz.	1,000 „	

This will not keep well when mixed.

Green Filter

Rapid filter green (1% sol.) . . .	87 mins.	9 ccs.
Naphthol green (1% sol.) 87 „	9 „	
Rapid filter yellow K (1% sol.) . . 87 „	9 „	
Distilled water to . 20 oz.	1,000 „	

Red Filter

Rose Bengal (1% sol.) 442 mins.	84 ccs.	
Rapid filter yellow K (1% sol.) . . 442 „	84 „	
Distilled water to . 20 oz.	1,000 „	

The above are to be used for the subtractive

process or three-colour printing, whether on paper or in the shape of superimposed stained transparencies for projection. For the projection of transparencies by means of coloured lights or the additive process, the following should be used for obtaining the negatives :—

Violet-blue Stock Solution

Crystal violet .	. 62 grs.	3 g.
Methylene blue	. 15½ ,,	1 ,,
Distilled water	8 oz. 384 mins.	250 ccs.
Glacial acetic acid	. 5–6 mins.	5–6 drops

Filter

Dye solution .	. 338 mins.	20 ccs.
Gelatine solution (6 %)	3½ oz.	100 ,,

Green Stock Solution

Rapid filter green 2 .	62 grs.	4 g.
Distilled water	4 oz. 107 mins.	120 ccs.

Filter

Dye solution .	. 338 mins.	20 ccs.
Gelatine solution	. 3½ oz.	100 ,,

This transmits a narrow band in the red, but the following does not :—

Stock Solution

Filter blue green	. 18½ grs.	1·2 g.
Rapid filter yellow	. 38¾ ,,	2·5 ,,
Distilled water	. 7 oz.	200 ccs.

Filter

Dye solution .	. 338 mins.	20 ccs.
Gelatine solution .	3½ oz.	100 ,,

Stock Red Solution

Rapid filter red 2 .	77 grs.	5 g.
Distilled water	. 7 oz.	200 ccs.

Filter

Dye solution .	. 338 mins.	20 ccs.
Gelatine solution (6 %)	3½ oz.	100 ,,

The quantity of dyed gelatine per area is the same as for the subtractive filters, and two filters of like colour must be cemented together. The ratio of exposures with pinachrome or pinacyanol bathed plates is blue 4, green 12, red 12.

COLOUR SENSATIONS

Although there are considered to be but six or seven spectrum colours—red, orange, yellow, green, blue, indigo, and violet—they melt so insensibly one into the other that there are an

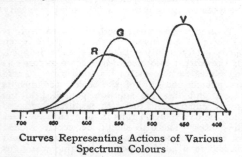

Curves Representing Actions of Various Spectrum Colours

infinite number of distinct colours; again, in natural objects there are innumerable colours. It has been proved, however, that there are only three fundamental colours, that give rise to all the other colours by the excitation of three sets

of nerve fibrils in the retina. This theory was enunciated first by Thos. Young ("Lectures on Natural Philosophy," 1807), and further elaborated by Clerk-Maxwell (*Edinburgh Transactions*, 21,275, 1855), Von Helmholtz, Abney, König, and others. The curves representing the respective actions of the various spectrum colours, according to König and Dieterici, are shown in the accompanying diagram, and represent the sensations excited in the retinal nerves by the three fundamental colours. There is some difference in opinion between physicists as to the exact wave lengths of the fundamental colours, but there is not much error in the assumption that they are :—

Red—extreme end of the visible spectrum about λ 665.
Green—λ 507.
Blue—λ 475.

The red sensation curve begins about λ 680, reaches its maximum at λ 575, drops strongly at λ 490, with a slight rise again toward λ 450, and ends at λ 390. The green sensation curve begins at λ 680, rises to a maximum at λ 550, and ends at λ 440. The blue sensation curve rises from λ 580, rises sharply at λ 480 with a maximum at λ 450, and ends at λ 390.

The above may be considered as the now generally accepted theory of the colour sensations, but Hering suggested six fundamental colours—red, green, yellow, blue, white, and black. This theory has not been accepted, but is interesting, as on it has been based a four-colour printing method (Zander).

COLOUR SENSITISING

It was very early recognised that certain colours acted more strongly on the photographic plate than others, and that the former were nearly all those that reflected the violet and blue spectral rays, which therefore were called the "chemically active" or "actinic," whilst green, yellow, orange, and red hardly produced any action at all. This view prevailed for many years, though Herschel pointed out in 1842 that it did not apply generally, as violet petals faded most quickly in green light and the other blue flowers faded most in yellow light. Draper enunciated the law that only those rays acted chemically on a substance which were absorbed by it.

In 1873 H. W. Vogel was examining various silver salts in the spectrograph and found that some English collodion plates, which had been stained with a yellow dye to prevent halation, were distinctly sensitive to green. Led by this fact, Vogel examined the absorptions of various dyes and then added them to collodion emulsion, and found that these also sensitised for the colours they absorbed. This principle was confirmed by others, and soon after was successfully applied to commercial gelatine plates by Attout Tailfer, of Paris.

The action of a very large number of dyes has been examined by various authorities, Eder, Valenta, Von Hübl, Eberhard, Hinterberger, Ruh, etc., and the first-named, who has paid special attention to this subject, has formulated the following important conclusions : (1) The absorption spectrum of neither an alcoholic nor

of an aqueous solution of the dye coincides with the position of maximum light action on the dyed gelatino-bromide of silver. (2) The maximum of sensitiveness of the dyed silver bromide lies nearer the red than does the absorption maximum of any solution. (3) The position of the maximum of absorption of the dye in gelatine and that of the maximum of sensitiveness of the dyed silver bromide differ generally by about thirty wave lengths; that is to say, those rays of light that are most active photographically on the dyed silver bromide possess a mean greater wave length of about thirty wave lengths than those that are absorbed by the dyed gelatine (without the silver bromide). (4) The absorption maximum of silver bromide dyed with eosine coincides exactly with the maximum of light sensitiveness on silver bromide dyed with eosine; that is to say, those light rays which are absorbed by eosine-dyed silver bromide have the same wave length as those for which the dyed silver bromide shows the increased sensitiveness. (5) The dyes must stain the silver bromide grain; the dyes that act vigorously are all "substantive" dyes. (6) They must show in the dry state—on dyed gelatine, or more correctly, on dyed silver bromide—even in considerable dilution, an intense absorption band if they are to produce an intense action on the silver bromide. A narrow absorption band gives a narrow sensitising band.

Although it has been established that a colour sensitiser must dye the silver bromide grain, yet all dyes that stain the silver bromide are not sensitisers. Neither fluorescence nor fugitiveness to light plays any important part, as pure erythrosine is not fluorescent and yet is a powerful sensitiser, and is fairly stable to light, whilst cyanine is very unstable and is a good sensitiser. Apparently, there is no connection between the chemical constitution of a dye and its sensitising powers, though Lumière and Seyewetz have concluded that the sensitising action is connected in some way with the chromophoric group of elements. Joly has pointed out that all the sensitisers are photo-electric, and assumes that electrons are set free from the dye which act on the silver halides.

Colour sensitive plates may be divided into practically two main classes, the commercial isochromatic or orthochromatic plate and the panchromatic plate. The former are usually prepared by adding erythrosine to the emulsion, either at the time of mixing or just before coating, and are sensitive mainly to yellow-green and yellow, there being a characteristic gap or lack of sensitiveness in the blue-green. The panchromatic plates are nearly all made by bathing the finished and dried plates in a solution of the erythrosine.

The method of introducing the dye into the emulsion has considerable influence on the resulting colour sensitiveness. Those dyed in the emulsion—that is, before coating—have usually a lower χ than plates bathed in a dye solution; that is, they are less colour sensitive, though the reason for this is not apparent.

Although excellent commercial colour-sensitive plates can be obtained, the following information may be useful. To sensitise for blue-green and green, up to about λ 5,500, the best dye is acridine orange NO, of the Leonhardt Farbwerke, Mühlheim.

Stock Solution

Acridine orange NO .	9·6 grs.		1 g.
Alcohol . . .	20 oz.		1,000 ccs.

Industrial alcohol may be used instead of the pure. The actual sensitising bath is :—

Stock dye solution .	4 oz.	200 ccs.	
Distilled water to .	20 ;;	1,000 ,,	

For greenish-yellow and yellow up to λ 5,900, erythrosine should be used, and the most suitable dyes are bluish erythrosine of the Badische Anilin and Soda Fabrik, that made by Schuchardt, of Görlitz, or the pure dye of Meister, Lucius and Brüning, of Hoechst. A stock solution is made of 1 : 1000 of alcohol, as with acridine; the sensitising bath is :—

Stock dye solution .	4 oz.	200 ccs.	
Liq. ammoniæ (·880) .	96 mins.	10 ,,	
Distilled water to .	20 oz.	1,000 ,,	

Erythrosine is an excellent sensitiser for the above region, but it leaves a minimum or gap in the bluish green, which, however, fills up with a generous exposure, so that it can be used instead of acridine orange for all but spectrum work in the blue-green, and has the advantage of being more readily washed out of the gelatine, alcohol alone being able to remove the last traces of acridine.

To sensitise for green, yellow, and red up to about λ 6,200—λ 6,400, one of the following should be used: orthochrome T, pinaverdol, pinachrome, or homocol, the action as red sensitisers being greater in the last two than the first two. A 1 : 1000 alcoholic stock solution should be made, which should be kept in the dark; the actual sensitiser is—

Stock dye solution .	20 mins.	2 ccs.	
Distilled water .	20 oz.	1,000 ,,	

For the extreme visible red pinacyanol should be used in the same way.

For the infra-red, about wave length λ 7,180, "little a," as it is usually called, dicyanine should be used as above, only the stock solution must be added to the water at the very last moment, when everything is quite ready, and the plate immediately flowed with the dye, as the weak solution loses its sensitising power very quickly.

The most convenient method of sensitising is by means of a grooved trough, into which, when filled with dye solution, the plates can be dropped. Or the worker may use a dish twice as large as the plates to be sensitised at one time. These are put at one end of the dish; the dish is tilted, and the dye solution poured into the empty end; then the dish is tilted back, so that the dye solution runs in an even wave over the plates. The dish should be gently rocked for three minutes, then the plates removed and washed in a good stream of running water for three minutes, and set up to dry in a proper drying cupboard, or in an air-tight box containing a saucerful of calcium chloride.

An alternative method of sensitising which considerably hastens the drying, is to replace two-fifths of the water in the above baths by

acetone or methyl alcohol ; the plates then dry in about half an hour in a warm place.

The best panchromatic sensitiser is that suggested by R. J. Wallace.

Pinacyanol (1 : 1,000 sol.)	134 mins.	14	ccs.
Pinaverdol (1 : 1,000 sol.)	106 ,,	11	,,
Homocol (1 : 1,000 sol.)	106 ,,	11	,,
Liquor ammoniæ .	. 318 ,,	33	,,
Alcohol . .	8 oz.	400	,,
Distilled water to	. 20 ,,	1,000	,,

The plate to be sensitised should be clean working and with a fine grain, and therefore not too rapid. Care must be exercised as to the darkroom illumination and no light should be used for red sensitising. E. J. W.

COLOUR SENSITIVENESS

Silver bromide precipitated in the form of an emulsion possesses great sensitiveness for the ultra-violet, the violet, and blue spectral regions. With an admixture of iodide of silver, precipitated at the same time, the sensitiveness extends beyond the bright blue slightly into the bluish green, but there is no practical sensitiveness to green, yellow, orange, or red. Sensitiveness to these regions is conferred on the silver halides by the addition of certain dyes to the emulsion in the making, or preferably by bathing the dry plates in aqueous solutions of dyes. It will be noted that the expression " no practical sensitiveness " is used, and this is employed for the specific reason that if the exposure is sufficiently prolonged, all the spectral colours will affect the silver halides, but the more actinic rays must be screened off by suitable filters ; it is not practical to give such prolonged exposures in the process.

COLOUR SENSITOMETER

A series of coloured glasses or dyed gelatines having special spectral transmissions, used for testing the colour sensitiveness of plates. Vidal constructed one of the first of these instruments, and the Chapman-Jones plate tester can also be used for the same purpose. Abney has suggested a somewhat similar instrument. They have not found extended practical application. (*See* " Colour Sensitometry.")

COLOUR SENSITOMETRY

Soon after the introduction of the colour sensitive plate some method was found needful for expressing the added colour sensitiveness, and this was effected by exposing a plate in the spectrograph and estimating the densities by visual examination or merely drawing a graphic curve, a test of great unreliability, still further complicated by the fact that prismatic spectrographs were used. Later, plates were exposed to isolated patches of monochromatic light, a curve being obtained from the resulting negatives. This method was still further improved by using a spectrum and varying intensities of white light and obtaining an interpolation curve.

The great disadvantage of the spectrographic method is that it is not capable of brief and commonly understood expression, and therefore many attempts have been made to obtain sensitometric tests by means of charts of coloured pigments, which are open to the most serious objection that the pigmentary colours reflect an enormous amount of white light, and whilst there is no object in nature that does not reflect white light, what the worker really desires to measure is the true increase in sensitiveness to a pure colour. Abney's colour sensitometer and the Chapman-Jones plate tester consist of coloured glasses or gelatines of equal luminosity, transmitting either small or broad isolated patches of the spectrum, and the densities obtainable can then be read and charted. Later, Eder and others divided the spectrum into three broad regions, the one including the blue and violet up to about λ 5,000, which is practically the sensitiveness of the ordinary emulsion ; a second region extending from the blue through the green to the yellow up to λ 5,900 ; and a third, used only for panchromatic plates, extending through the red. Eder utilised the Scheiner sensitometer, and thus expressed numerically the actual ratio of speeds of the non-colour-sensitised emulsion and the added colour sensitiveness.

This method has been still further extended by Mees and Sheppard to the Hurter and Driffield system, and is the most practical. The following are briefly the main features of it: the H. & D. sector wheel and the screened acetylene light (*see* " Plate Testing ") are used, and between the light source and the sector wheel are inserted absorbent solutions which limit the active light to particular regions of the spectrum. For testing commercial iso- or orthochromatic plates, a yellow and a blue filter (Eder) are used ; the yellow filter consists of a 4 per cent. solution of potassium chromate (not bichromate) in a thickness of 1 cm. The blue filter is a 2 per cent. solution of ammonio-sulphate of copper, also in 1 cm. thickness. The plate to be tested is exposed behind these two filters, and after development the inertias are found in the usual way, and the result or ratio termed χ (*chrōma*, a colour), and is—

$$\frac{\text{yellow inertia}}{\text{blue inertia}} = \frac{\text{blue sensitiveness}}{\text{yellow sensitiveness}}.$$

For instance, a commercial iso plate was found to have an inertia of 0·34 behind the blue screen and an inertia of 4·8 behind the yellow screen ; then—

$$\frac{\text{yellow inertia } 4\cdot8}{\text{blue inertia } 0\cdot34} = \frac{\text{blue sensitiveness } 100}{\text{yellow sensitiveness } 7\cdot1} = \chi\ 14.$$

For panchromatic plates, it is essential to know also the increased sensitiveness to red ; and Mees and Sheppard use three screens as follows : the blue screen is Eder's given above, which passes the violet and blue up to λ 5,000 ; the green screen, which passes from λ 5,900 to λ 5,000, consists of Eder's chromate screen given above plus a screen of 1 cm. thickness of a saturated solution of copper acetate ; the red screen is made with rose Bengal and tartrazine :—

Rose Bengal .	. 48 grs.	5	g.
Tartrazine .	. 96 ,,	10	,,
Distilled water to	. 20 oz.	1,000	ccs.
Gelatine .	. 728 grs.	73	g.

Allow 20 minims, or 1·25 ccs., to every square inch of glass.

In all cases the screened acetylene light has been used, and whilst this does not give the absolute inertias of the plate, the ratios of colour sensitiveness are preserved. For three-colour work the actual filters to be employed may be used in the same way, and if an exposure be made without a filter the necessary increase of exposure for the blue-violet filter over the unscreened plate can readily be found. Considerable influence is exercised naturally upon the results obtained by the nature of the light employed, and one can easily understand that the standard light should be, if possible, daylight of constant spectral composition, or a secondary standard with as near as possible the same spectral composition; for if the light be yellow, with a decided paucity in violet and blue rays, and corresponding richness in yellow and orange, the colour sensitive plate would show a much higher colour sensitiveness, which would be totally misleading. E. J. W.

COLOUR TEST FOR PLATES (*See* "Plate Testing.")

COLOURING PHOTOGRAPHS, ETC.

The three popular processes for colouring prints and slides are by means of aniline dyes, water colours, and oil colours. Colouring by the crystoleum process (*which see*) is also widely practised. Aniline dyes, although not so permanent as water colours, have largely superseded the latter, the dyes being so cheap and easy to use; they are also transparent, and allow the details in the pictures to show through them, whereas some water and oil colours are body colours which hide all detail.

Photographs to be coloured with dyes or transparent pigments should not be deeply printed or given too warm a tone; but these points are of no importance when body colours are used. A desk of some kind, or an easel, will be required for large prints, but small ones may be laid flat upon a table or held in the hand. Lantern slides and other transparencies are best held in the hand over white paper, or placed upon a retouching desk in such a way that the light comes through the slide, using preferably artificial light, as slides coloured in daylight are sometimes disappointing when viewed on the screen; transmitted light allows the density of the colours to be better judged. Sable brushes of the sizes known as No. 0 (very small) to Nos. 5 or 6 will be found the most serviceable for average work, but others, as experience dictates, may be found useful.

Aniline Dyes.—These are the simplest of all colours in use, and may be used for slides and all kinds of prints, although they appear to best advantage on ordinary P.O.P. (gelatine) prints. Suitable dye solutions all ready for use may be purchased, the colours being put up in cheap sets and in very convenient form. Penny packets of dyes, obtainable at oil shops, are good enough for experimental work; to prepare them for use dissolve first in $\frac{1}{4}$ oz. of acetic acid or vinegar and make up to 2 oz. with water. The raw dyes may be dissolved and prepared in the same way, but very little of the actual dye need be used, as they are very strong, and a few grains will make a large quantity of coloured solution. The

number of colours will depend upon the character of the work; clever colourists, it should be said, can get all the colours they want by using only three—blue, yellow, and red—as by mixing there in suitable proportions any colour likely to be needed can be produced; blue and yellow make green; red and yellow, orange; blue and red, violet, etc. etc., the exact tints depending upon the proportions of the two colours. The average worker will prefer ready-made dye solutions, and the following will be found the most serviceable: Blue, yellow, brown, olive green, scarlet, purple, orange, and pink. These dyes may be combined if desired, green and orange, for example, making citrine; orange and purple, russet; etc. The secret of success in using aniline dyes is to have them weak, building up the colours required by repeated washes of the dye rather than attempting to obtain in one application a colour of full strength. So important is this that the beginner is advised to begin colouring with dyes near to a water tap, so that as the colours are put on they may be largely washed off under the tap, the operations being repeated until the desired strength is obtained. The process is really that of staining or dyeing the print rather than painting, as the last-mentioned term is generally understood. If the print is mounted and cannot be satisfactorily rinsed in water, the colours should be applied to the print very dilute, and immediately blotted with clean white blotting-paper. This prevents the dyes acting too quickly, and obliges the worker to proceed slowly and build up the colour. Blotting-paper is not suitable for use on slides, and the slides should be repeatedly rinsed instead, unless the dyes are applied sufficiently weak in the first instance. Prints do not usually require any preparation for colouring, but if much blotting or rinsing is to be done or the brush is at all stiff, it is advisable to harden gelatine films—P.O.P., bromide and gaslight papers and lantern slides—with a solution of 1 oz. of formaline in 10 oz. of water; the fixed and washed slide or print is immersed in this for about ten minutes and then washed well. Alum should not be used for hardening previous to colouring with dyes, as it is apt to react chemically with some of the colours.

Water Colours.—Water colours may be employed for all kinds of prints and slides. They differ essentially from dyes in that they do not sink into and stain the film, and therefore the surfaces need to be specially prepared so that they do not repel the colours; also, a medium is necessary for the colours in order that they may not dry dull and dead. A suitable application for prints is the following oxgall mixture:—

Purified oxgall	.	. 15 grs.	6 g.
Methylated spirit	.	. 1 oz.	250 ccs.
Distilled water	.	. 4 „	750 „

This should be well mixed and applied to the surface with a broad, soft brush, and the print when dry will be in a proper state to take both water colours and even oil colours. This preparation is essential for albumen prints and others with a greasy surface, but may be omitted in the case of freshly-made P.O.P. or other gelatine prints.

A suitable medium to use in place of water

for the water colours is made by dissolving a small quantity of the best gum arabic in sufficient water to cover it, and adding two or three drops of glycerine. This is not necessary for matt surface prints. An albumen solution must be used as a medium when colouring albumen prints, and some workers use it for all kinds of glossy prints; it takes the place of the gum mixture, and is quite as good. The albumen mixture consists of the following :—

White of egg	.	.	1 oz.	30 ccs.
Glycerine	.	.	15 drops	15 drops
Liquor ammoniæ	.	15 ,,		15 ,,
Ammonium carbonate	20 grs.			13 g.
Water	.	.	2 drms.	7 ccs.

Whip the white of egg to a froth, allow to stand until clear, add the other chemicals previously dissolved in the water, and filter through muslin.

The choice of water colours is an important item ; there is a feeling in favour of colours in pans and not in tubes, but there is probably not much in the preference. Some are transparent, others semi-transparent, and others, again, are opaque or body colours. An experienced worker may use any or all for print colouring, but for lantern slides transparent colours must be used. They are easily recognised by painting a few dabs upon glass and examining by transmitted light. Transparent colours are Prussian blue, crimson, alizarine yellow, Italian pink (which is really a yellow), olive green, sap green, purple madder and lake, and burnt carmine. The opaque colours are light red, yellow ochre, scarlet lake, ultramarine, Naples yellow, burnt umber, and Vandyke brown. The semi-transparent colours are sepia, madder brown, raw and burnt sienna, cobalt, and bistre. The above list is not by any means complete, but contains enough for average work. When white is required, Chinese white and no other should be used. For faces of portraits the colouring is usually put on very weak in the form of cross hatching, but for all other work colours are brushed on in the usual way, using plenty of the medium so as to weaken the colours.

Lantern slides can be coloured with transparent water colours, but they need no special preparation, although many consider it advisable to harden them with formaline. Colours are applied in broad, even sweeps, and but little difficulty will be experienced except in skies, which more often than not are plain glass. When the Prussian blue—really the only pigment available for the purpose—is put on the plain film, brush marks are likely to show, but this defect is remedied by dabbing the blue while wet very gently with the finger-tip, or with a piece of kid glove stretched over the finger. The sky may be stained an even blue with dyes, and then given character with water colours. The slides also may be chemically toned to various tints and then completed with water colours. Considerable practice is necessary for lantern-slide work, and no small artistic skill, if it is wished to avoid the banal effects frequently seen in commercial slides.

Oil Colours.—Painting in oils, particularly upon enlargements, is chiefly a professional practice, and the method of doing the work depends to some extent upon the materials used. Trans-parent oil colours may be handled in a different manner from that adopted when body (opaque) pigments are used. The latter cover up the image, whereas the former, which give a rather weak effect, permit the shades and details of the picture to show through. For strength and high colouring the opaque colours are necessary, and for their use a knowledge of drawing and painting in general is requisite, as the photographic image is simply used as a base. The colours which will be found of the greatest service are emerald green, Vandyke brown, indigo, Indian red, burnt umber, pink madder, light red, raw sienna, Naples yellow, yellow ochre, burnt sienna, crimson lake, raw umber, ultramarine, flake white, and ivory black.

Any kind of print may be coloured in oils—bromide paper being the most widely used—but owing to the oily nature of the colours it is necessary to size the print first in order to prevent the colours sinking into the paper. To make a suitable size, dissolve one pennyworth of clear patent size (obtainable at an oil-shop) in one pint of hot water, and when nearly cool give the picture a coat, and set aside to dry in a warm place. The coat of size must not be too thick, or it may peel off at a later stage and bring the colours with it. The brushes should be varied both in kind and size, according to the work. There should be provided stout hog-hair brushes, some thin badger brushes, and a few small sables ; a badger softener is also useful. Megilp is used for thinning the colours, and a plentiful supply of turpentine should be provided for washing the brushes.

The methods of applying the actual colours vary considerably. It is usual to apply a suitable tint to the deepest shadows, and to work from this to the highest lights, using a more solid colour as the work proceeds, the reverse of water-colour painting. Drapery and costumes in portrait work may first be covered with transparent colour, working into it the various tints for the shadows, half-tones, and high lights. After the first tints have been put in, it is usual to let the canvas dry and to rub over with poppy oil, removing the excess with chamois leather ; the more delicate colouring is then worked in. It is difficult to give precise instructions for colouring, and the worker must to a large extent be guided by his own tastes. When the painting is completed it should stand on one side for a month before varnishing with copal or mastic, and in no case must the varnish be applied until the painting is dry. Copal is a hard and durable varnish, but mastic is widely used because it dries quicker and, if necessary, may be removed easily.

For lantern slides transparent oil colours must be used. They are sometimes put on with a brush in the same way as water colours, but it is more general to dab on the colouring with the finger-tip. The best way of obliterating the grain of the finger-tip is to work upon the slide placed at different angles so as to cross the markings and break them up very lightly into a series of small dots. The finer details are best coloured by means of a fine sable brush, but too much colour must not be put on, as it is better to under-paint than over-paint, it being easier to add the colour than it is to take

it away. A useful dodge is to put the oil colours at first on the plain glass side, from which they may easily be removed if any error is made, or the colouring may be put on the cover glass of the slide. Parts of the slide may be coloured with dyes and parts with oil and water colours with good effect, but, no matter what process of colouring is adopted, some practice is necessary, particularly with oils, which are the most difficult for a beginner to use satisfactorily. A slide for colouring in oil or water colours must be lighter and brighter than those for ordinary use, and it is important that they be dried in a room free from dust, as any specks or hairs upon the slide will show up very prominently when magnified upon the screen. P. R. S.

COMA (Fr., *Aberration zonale;* Ger., *Zonen abirrung, Nebeliger saum*)

Synonyms: oblique spherical aberration, zonal aberration. A defect resulting from the unequal magnification of the different zones of a lens, these zones being defined as imaginary circles dividing the surface of the lens into concentric rings. As a result of coma the image of a bright point of light towards the margin of the field of view, produced by oblique rays, will be rendered as a comma- or pear-shaped blur—whence the name " Coma." Coma may occur in a lens otherwise well corrected for chromatic and spherical aberration, and is approximately removed by careful design of the curves of the objective and precise selection of the different kinds of glass.

COMBINATION PRINTING

The art of making a print by the use of two or more negatives. The simplest form of combination printing is the printing of a cloud into a landscape, but combination printing proper is the art of adding trees, figures, or other objects to a picture, as practised by Rejlander, Robinson, and other past masters of the art. Combination printing had its origin in 1855, when Berwick and Annan, of Glasgow, exhibited a

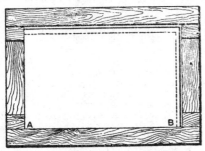

Arrangement for Combination Printing

picture printed from two different negatives—a figure in a landscape. In 1858 Sarony patented an improved process which consisted of taking up the different portions of the collodion film from the glass of one or more negatives and laying them down upon another glass in their proper relative positions and printing from it. Rejlander, however, was the first to draw attention to the possibilities of combination printing, and in 1857 he used thirty negatives

to produce a single picture (" The Two Ways of Life "), which he exhibited at the Manchester Exhibition of that year; all except the part required was blocked out on each negative, all the negatives were then laid in turn upon sensitive paper and printed, the remainder of the paper being covered with black velvet. In the following year (1858) Robinson produced the first of his famous series of combination prints, " Fading Away," for which five negatives were used, and in 1863 " Bringing Home the May " (nine negatives); this type of combination printing then became the craze.

The methods fully described under " Clouds, Printing in," may be adopted in some forms of combination printing; but in others, such as the addition of a figure to a landscape, or the substitution of a suitable background for an unsuitable in a figure subject, a different method will be more fitting (*see*, for example, " Backgrounds, Printing in "). In many cases, however, the pencil and brush marks described under the heading first given above will be found useful in securing registration.

For combining portions of two or more negatives to form one print, whether the object is to print a new background to a figure or to combine in one picture selected parts of two or three landscapes, etc., the method described under the heading, " Backgrounds, Printing in," or some modification of it, can be adopted. In some respects the method about to be described has points of advantage compared with that given at the reference last mentioned. A silver print is taken from the figure negative, and the figure cut out very carefully with a sharp knife. Both parts of the print must be kept to form masks. First, the portion from which the figure was cut should be attached to the glass side of the figure negative, and then the two negatives should be held together vertically with their edges resting on the table and the corners accurately coinciding, or preferably placed on a retouching desk with their corners together. The figure negative must be underneath and the glass side of each negative towards the worker. The figure that was cut from the rough print must now be attached to the glass side of the background negative in such a manner that it corresponds in position accurately with the opening in the mask on the figure negative, this opening being easily seen for obtaining a correct adjustment by this method of holding the two plates.

In printing, it is immaterial which negative is used first. Either negative is placed in the printing frame with one edge in close contact with the woodwork of the frame—preferably the edge that was resting on the table when the masks were adjusted on the negatives. In the diagram the edge A B is shown pressed closely against the frame, the corner being pressed right into that of the frame. The printing paper need not be cut accurately to fit the negative, but it must touch the same side and the same corner of the frame as the negative. The paper is indicated by dotted lines. When this part of the printing is finished, the print and the negative are removed from the frame, and the second negative is placed in the frame with its corresponding side and corner pressed closely against the side and corner A B. The print is again

placed in position as before with the same side and corner touching the same parts of the frame, and the second part of the printing completed.

If the masks have both been accurately fitted to their respective negatives, the two parts of the print should join perfectly. Each print will show a soft outline due to the fact that the blocking out is on the glass side of the negative, and these two outlines will slightly overlap and soften into each other in such a manner that, with reasonable care in fitting the masks and in printing, the junction will not show. When the blocking out is on the film of the negative it is almost impossible to prevent the junction from showing as a hard and crude line, white in some places, dark in others. Masking on the glass side possesses the great advantage that it does not spoil the negative for other purposes. At any time the masking may be removed, leaving the negative uninjured.

COMBINED DEVELOPMENT AND FIXING
(*See* "Development and Fixing Combined.")

COMBINED LENSES

When two lenses, such as the Zeiss single anastigmats, are combined to form a doublet, there is a simple formula for finding the focal length of the combination. It is to divide the product of the focal lengths of the two components by their sum minus the distance by which their optical centres or nodes of emission are separated. Thus, in the case of two lenses with focal lengths of 7 in. and 11 in. respectively, with a separation of 2 in., the focal length is arrived at as follows :

$$\frac{7 \times 11}{7 + 11 - 2} = \frac{77}{16} = 4\frac{13}{16} \text{ in.}$$

If a positive and negative lens are combined, the focus of the negative lens is taken as a minus quantity, the calculation being otherwise the same.

It is often necessary to find the focal length of a lens which when added to another of known focus shall produce a given focal length. Thus, a single lens having a focal length of 18 in. is to be used with another so that the focal length is reduced to 12 in. The rule is to multiply the focus of the lens of known focus by the focus desired, and to divide the product by the known focus less the desired focus. Taking the above example, the working is :—

$$\frac{18 \times 12}{18 - 12} = \frac{216}{6} = 36 \text{ in.}$$

No account of the separation has here been taken, but if absolute accuracy is desired with, say, a separation of 2 in., the formula is :—

$$\frac{(18 \times 12) - 2}{18 - 12} = \frac{214}{6} = 35\frac{2}{3} \text{ in}$$

(*See also* "Magnifier.")

COMBINED REDUCERS (*See* "Reducers, Combined")

COMBINED TONING AND FIXING (*See* "Toning and Fixing, Combined.")

COMETS, PHOTOGRAPHING

The first attempt to portray the form of a comet was in the case of Donati's comet of 1858, but the results were very imperfect, owing to the photographic processes being then in their infancy. The first useful photographic cometary records are of Tebbutt's comet of 1881. The gelatine dry plate had been introduced, and with its increased rapidity, compared with the old collodion plates, the problem was much less formidable. Further improvements were made by the employment of large-aperture telescopes, chiefly of the reflector class. Inasmuch as the comet is generally moving very rapidly in a special orbit of its own, irrespective of the earth's direction of rotation, the usual equatorial telescope is of little use unless special arrangements are made. To obviate the difficulty various schemes have been devised The most successful, and the only one we need mention in a practical treatise, is that employed by Prof. E. E. Barnard, of the Yerkes Observatory, near Chicago. He first makes a preliminary observation to determine the rate of motion of the cometary nucleus, and its direction as projected on the sky. Then, attached to the eyepiece of his telescope, with which he follows the comet nucleus during exposure of the plate, he provides a fine spider thread fixed on a movable frame actuated by a delicate micrometer screw. If, now, he knows how far the comet will move on the ground glass of his camera in, say, a second, he has only to move this adjustable cross-wire, set in the direction of the comet's motion, by the same amount, and then by keeping the comet nucleus continually bisected by the cross-wires, its image will of necessity be kept exactly on the same portion of the photographic plate. It is a similar problem, but somewhat more delicate, to that of taking a series of photographs of a moving object with a kinematograph camera : the whole apparatus is usually traversed by means of a screw-and-worm gear.

For recording the whole phenomena attending the passage of a comet, probably the most useful instrument is a wide-angle camera attached to a perfectly rigid form of equatorial mounting. Needless to say, the better the lens that is available the better will be the resulting photographs. The modern wide-angle anastigmat is the ideal instrument, and as in these cases it is an object of definite area that has to be portrayed, the greater the ratio of aperture to focal length the shorter will be the time of exposure necessary to obtain a satisfactory image, and in consequence the risks of failure due to vibration or bad weather will be minimised in proportion.

The plates used should certainly be backed and panchromatic, as a considerable proportion of the cometary light is green and yellowish-green, and this is all ineffective if ordinary plates, sensitive only to the blue and violet, are employed.

Development should be very carefully performed, as in general the range of gradation will be very great, varying from the intensely brilliant nucleus to the filmy streamers constituting the delicate tail. The developer may be pyro soda, rodinal, metol, or metol-hydroquinone, but the developers giving excessive density without the full scale of detail should be avoided.

COMPASS, PHOTOGRAPHER'S (Fr., *Boussole horaire;* Ger., *Photographischer Kompass*)

A magnetic compass the dial of which is arranged to indicate the time of day when the subject, in any given direction, will be most favourably lighted for photography.

COMPENSATING EYEPIECE (*See* "Eyepieces.")

COMPENSATION FILTER

A screen (generally yellow) for cutting off excess of ultra-violet, blue, and violet rays (*see also* "Colour Screen or Filter "). In process work it is used largely in colour work, especially with collodion emulsion, it obviating excessive staining of the emulsion in cases where the latter is stained by the addition of a dye.

"COMPENSATOR" NEGATIVES

A system advocated by Newton Gibson and published in April, 1905, for preventing halation without backing and controlling contrasts when taking difficult subjects, particularly interiors. The method is to place a dry plate, glass side towards the lens, in the camera and to give a very short exposure in order to secure the high-lights and not the shadows; the plate is then developed, fixed, and dried. When quite dry the under-exposed negative is placed in the dark-slide in contact (film to film) with another dry plate, and the same view taken again through the compensator negative, taking care to give a full exposure for the shadows. If the first negative is of the right density, the second will develop in good gradation, the windows and other high-lights not being over-exposed and too dense, because of their being covered by the compensator through which the light has to pass to act on the second plate. Obviously the camera must not be moved in the slightest degree between the two exposures, or the picture will not be in register; and the system is therefore out of the question where the camera cannot be left untouched for some time. Success depends mainly upon the accuracy of register, and the relative amount of exposure and development necessary for the compensator negative and for the final negative. It is possible to over-correct the highest lights by making them so dense on the first negative that light will not go through them.

The process can be adapted to existing faulty negatives. A thin positive is made by contact on celluloid film, and when developed and dry it is bound or cemented to the negative in the position occupied when printing. The thickness of the celluloid film between the negative image and the sensitive paper when printing will cause no trouble if a fairly concentrated light, entirely from the front and not from the sides of the frame, is used for printing.

COMPOSITE, ANALYTICAL, OR "AVERAGE" PORTRAITS

A style of picture made by taking several portraits of the same size upon one plate, or by printing from several portrait negatives upon one piece of paper, the result being supposed to give a type of the whole. Such pictures are claimed by some to be of scientific value to students of anthropology, but they are more generally looked upon as curiosities. About the year 1887 they were popular in the United States. Their origin is said to be due to a conversation between Herbert Spencer and Francis Galton about the year 1876, and Darwin also had some correspondence on the subject in 1877. The original idea was to have heads of two different people, one upon each half of a stereoscopic picture, and to combine the two in a stereoscope, which method serves admirably; but not more than two different heads can be combined in this way, whereas by taking negatives specially for the work any number of faint images of several portraits in succession can be obtained on one plate, finally developing the whole as one portrait. If reasonable care is taken in the making of such a composite negative there is seldom anything about the composite picture to indicate that it is not a mere portrait of an individual, whereas, of course, it is a combination of the portraits of several. Full or three-quarter faces make the best composites, and before beginning the work the focusing screen should be marked where the eyes, nose, and mouth are to be upon the screen, the markings being made when the first sitter is posed and focused. The images of the sitters which follow must be adjusted to those lines; and as there is a variation in the distances between eyes, nose, and mouth, the camera has to be adjusted after each partial exposure. The total time of exposure must be divided up between the number of sitters. If, for example, the time required for an ordinary portrait is three seconds, and it is required to make a composite portrait of three sitters, the exposure in each case will be one second. When the number of sitters is relatively great, the lens must be stopped down to allow of increased exposure being given. For example, in making a composite portrait of six sitters, it would be better to use such a small stop that the exposure would be increased to, say, twelve seconds, when each sitter would be given two seconds. The lighting should be the same throughout, and it is also advisable to have a dark covering over the shoulders and round the neck, instead of white collars, fancy ties, blouses, etc., so as to obtain a uniform effect.

An inferior method is to copy a series of portrait prints upon one plate so as to get one negative of the whole; and another is to make transparencies from several portrait negatives (if they match properly) and make one negative from them by contact or through the camera, printing or copying each in turn so as to get a negative of the whole, by a series of partial exposures.

Probably the most famous of all composite portraits was that produced by Oliver Lippincott of New York; it included portraits of fifty-one bank managers, and took from December 10, 1908, to July 27, 1909, to complete. All were taken full face, and all eyes and pupils were registered, irrespective of the size of the head. Positives were made from the original negatives—all of which were taken separately—by means of prismatic reflectors and a twelve-power magnifying glass, and registered accurately

upon the screen. Every fourth positive was again converted into a negative, and every fourth negative again into a positive, the process being repeated until the final negative was arrived at, and the whole of the fifty-one individuals converted into one portrait. Lippincott states that it took 783 negatives and positives to accomplish the work, and, deducting failures, it took 553 positives and negatives to complete the one picture, which was widely published under the title of " The King of Finance."

Composite prints of a sort may be made from existing portrait negatives if they happen to match in posing, lighting, and size. P.O.P. is used and the first negative partly printed, the remaining negatives being then printed in turn upon the one piece of paper, and the print finished in the usual way.

There is a kind of composite photography (not portraiture) frequently employed in the production of picture postcards. Figures are cut out from different prints, stuck upon the same base, and copied, in this way obtaining many curious but worthless, inartistic, and untruthful effects.

COMPOSITION, PICTORIAL

Composition is the placing or arrangement of the different component parts of a picture in such a manner that the result is pleasing and harmonious. Much has been said and written about the so-called " laws " of composition. The use of the term " laws " is hardly justifiable. Even the most definite and emphatic rules may be broken with impunity, frequently to the advantage of the result. The most that can fairly be said is that some arrangements are found to be more pleasing than others in the impression they create. By studying the elements of these more pleasing arrangements certain generalities are deduced, but these should not be dignified by the name of laws.

It is safe to say that the best pictorial work is not the result of a rigorous application of some clearly defined code of " laws." It is rather the outcome of a kind of instinct, a natural feeling for what is harmonious, tasteful, and pleasing. Whether that instinct can be created is very doubtful ; but it can certainly be fostered and cultivated by careful study of Nature, and of graphic representations of Nature produced by others who have themselves studied and observed. Thus will be produced a perception or sense that certain things are " right " and that others are " wrong " ; and efforts can then be made to secure the right and avoid the wrong.

The natural limitations of photography impose severe restrictions on the worker in his attempts to secure what he considers to be good composition. Apart from combination printing and certain limited means of modification, he is almost confined to selection of subject and point of view to secure the result he desires. He should by all means familiarise himself with any available expedients that may assist him to reach the desired goal, but to a great extent he will have to content himself with what is before him rather than what he would wish.

Nevertheless, it may be helpful to give a few examples of what is, in a general way, to be sought for or avoided. A picture should contain one principal object, or group of objects, which should not be placed too far from the middle of the space. Everything else should be complementary and subordinate to this. Two or more objects of equal importance will distract the attention and produce a lack of unity. The eye should be led or attracted to the principal object—there should be nothing that forms a kind of barrier. There should be no strong patches of light, or anything else that irresistibly attracts the eye, at the edges of the picture. Neither should lines lead out of the picture or to the unimportant parts of it. Detached patches, either of light or shade, should not be scattered about over the space. The horizon line should not bisect the picture, neither should the space be divided into halves diagonally. One mass may advantageously be repeated by another similar but subordinate. Upright lines may be contrasted with, and broken by, horizontal ones ; and a line leading in one direction may be balanced by one running in the opposite direction. Balance, however, should not be too symmetrical and formal. An arrangement of masses that forms a rough triangle with the apex towards the top of the picture is generally effective ; as is also one in which the main lines radiate from the principal object.

Such general suggestions as these might be extended to great length. But no multiplication of them, or knowledge of them, will of itself be sufficient to ensure the production of pictures of satisfactory composition. Patient and careful study and analysis of pictures of acknowledged merit will be found interesting and helpful. It will aid in forming ideas as to the means by which certain satisfactory results may be obtained, and will strengthen those faculties of judgment and good taste without which the most elaborate series of rules of composition will be of no avail. (*See also* " Lines in Composition.")

COMPOUND LENS

An almost obsolete term used to denote the difference between the single or landscape lens and the double or triple combinations composed of more than one cemented element.

COMPRESSED CHEMICALS

For convenience of carriage when touring, many photographic chemicals are now obtainable either compressed into small glass or card packages or in the still more portable form of tablets, "tabloids," " scaloids," etc. The advantage of this method of packing chemicals, besides the small amount of room that they occupy, is that the worker is quite certain of having pure standard reagents, which only require dissolving in water to form the usual photographic solutions.

COMPRESSED GAS

For producing the oxy-hydrogen light (limelight), a hydrogen flame, supplied with oxygen under pressure, plays upon a small cylinder of lime, a spot on which is heated to incandescence. Some years ago the lanternist had to manufacture one or both of the gases employed, but the method is now obsolete, and it is usual to obtain the gases, compressed into steel cylinders, from one of the companies who make a specialty

of supplying them in this form. Photographic dealers and pharmaceutical chemists are generally prepared to obtain compressed gas to order, the charge being so much per cubic foot. Each cylinder needs to be fitted either with an automatic regulator, which will adjust the supply of gas to requirements, or with a reducing valve (*see also* "Cylinder, Gas"). To obtain the best results with a mixed jet, both the oxygen and the hydrogen should be under pressure, although an experienced lanternist can get good results with a mixed jet supplied from the gas main and from a cylinder of compressed oxygen. For ejector and blow-through jets, only the oxygen need be under pressure. For determining the content of a cylinder, a pressure gauge is used.

Compressed acetylene (the gas is dissolved under pressure in acetone) is obtainable, and can be used for lantern purposes.

CONCAVE LENS (Fr., *Lentille concave;* Ger., *Hohllinse*)

A lens that is depressed or hollowed out; known also as a divergent lens. When two faces are concave, as at A, it is described as "concavo-

A. Concavo-concave Lens B. Concavo-convex Lens C. Concavo-plane Lens

concave"; when one is concave and the other convex, as at B, it is "concavo-convex"; and when one of the faces of a concave lens is plane, as at C, it is "concavo-plane." The "biconcave lens" is the "concavo-concave." The "concavo-convex" is also known as a "meniscus" lens.

CONCENTRIC LENS

A lens patented in 1888 by Dr. Schroder and introduced in 1892 by Ross, being perhaps the earliest application of the new Jena glasses in Great Britain to photographic work. It is composed of two symmetrical combinations, each consisting of a plano-convex of glass of high refractive but low dispersive power, and a plano-concave of low refraction but higher dispersion than that used for the convex lens. The two plane surfaces are cemented and the inner and outer curves are concentric; hence the name. The lens has an excellent flat field over a wide angle, and is still esteemed for copying.

CONCENTRATED SOLUTION

A solution made up very strong, chiefly in the form of a stock developing solution, and needing to be diluted with water before use; it may or may not be saturated. It is not synonymous with saturated solution (*which see*), although sometimes thought to be so. Rodinal, certinal, azol, and similar developers are concentrated solutions. The single-solution developer given under the heading "Adurol" is a good example of a concentrated home-made developer. Concentrated solutions are handy

for storing; they do not take up so much room and as a rule keep better. Almost any developer with which the worker is instructed to take equal parts of Nos. 1 and 2 (or A and B) may be made in a more concentrated form by simply using half the water given in the formula, and adding the other half at the time of using. Hydroquinone cannot in the ordinary way be made up in a highly concentrated form, but for a "ten per cent." formula see "Hydroquinone."

Toning baths are not, as a rule, made up in a highly concentrated form, because of the danger of the gold precipitating, particularly when sulphocyanide is used; the following, however, has been recommended for the use of workers whose dark-room space is limited and who wish to keep a highly concentrated bath :—

Gold chloride .	8½ grs.	4·8 g.
Strontium chloride .	85 ,,	48 ,,
Distilled water .	1 oz.	250 ccs.

Heat the water to 200° F. (93° C.), add the gold, and then the strontium. Next add 7 drms. of water in which 25 grs. of potassium sulphocyanide have been dissolved. Heat again to the same temperature as before, filter, and make up to 2½ oz. with water. This is highly concentrated, and keeps well; when a toning bath is to be made up for use, add ¼ oz. of the concentrated solution to 5 oz. of water.

CONDENSATION (*See* "Lenses, Condensation on.")

CONDENSER

In optical projection the condensing lenses cause the rays of light emitted by the lamp or jet to pierce the transparency from all points, the rays being then transmitted to the objective or focusing lens. Diagram A shows the general optical system by which projection is accomplished, E being the illuminant, F condenser, G transparency or slide, and H objective or focusing lens. The condenser shown is the one commonly used. Light rays, unless intercepted, always travel in straight lines and, as indicated at E, in straight lines from their source. This holds good, no matter whether the illuminant be oil, limelight, acetylene, or electric light. For the purposes of optical projection, it is necessary to collect a large angle of these rays, transmit them through the slide, and pass them on to the projecting objective, by means of which a large image is brought to a focus upon the screen placed at some distance beyond.

A. Optical System of Optical Lantern

In cases where the illuminant may be regarded as a point, such as with the limelight or electric arc, many experts consider that the Herschel form of condenser B possesses advantages. Many years ago two lenses of somewhat long focus and shaped as at C, were employed, but this form has

long been obsolete. The forms shown at A, B, and C are capable of collecting a fairly large cone of rays; the lens next the light serves as the collecting lens and for transmitting the rays to the second lens, which bends and converges them towards the objective, as at A. The distance of the illuminant from the condenser governs the angle at which the rays are sent on towards the objective. The triple form of condenser D possesses many advantages for microscopic and other scientific work, inasmuch as it collects a greater angle of light.

In the best condensers the lenses are ground to a sharp edge. The lens next to the illuminant unavoidably gets very hot, and hence should be mounted loosely in the cell, for if at all tight it

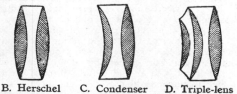

B. Herschel Condenser C. Condenser with Two Long-focus Lenses D. Triple-lens Condenser

will, in expanding with the heat, become cell-bound, and a crack will probably result. One method of preventing this is to provide the mounts with three or four spring clips or spring rebates, which allow of the expansion of the glass and also of ventilation. The intense heat arising from powerful arc lamps, such as are necessary in kinematograph projection work, tends to overheat the lenses in a very short time, and the danger of breakage is therefore increased. Several makers, recognising this fact, have provided means for the ready removal of the condensers from their cells, so that fresh ones may be substituted at intervals during a display, and this without serious interruption. When using all forms of condensers, sudden cold draughts must be guarded against, or cracking will almost certainly occur.

The bull's-eye condenser, as used in photomicrography, is described under its own heading.

CONJUGATE FOCI (Fr., *Foyers conjugués*; Ger., *Konjugierte Brennpunkte*)

The distances between lens and object, and lens and image; known respectively as the major and minor conjugate. They are always proportional to the ratio between the size of the object and that of the image. Thus, in enlarging from quarter-plate to whole-plate—a ratio of 2—the major conjugate, or distance between lens and bromide paper, will be twice the distance between lens and negative. If F = focal length of lens and R = ratio, then, whether enlarging or reducing, F × (R + 1) = the greater distance, or major conjugate; and the major conjugate ÷ R = the lesser distance, or minor conjugate. If, however, the image is full-size, the conjugate foci are each equal to twice the focal length of the lens.

CONTACT BREAKS

Mechanical devices for automatically "making" and "breaking" the current flowing through the primary winding of an induction coil (*which see*). Several forms of contact breaks are in use, the most popular being the hammer, electrolytic, and motor-mercury breaks. The first-named consists of a metal spring carrying a soft iron head and pressing against a platinum point which completes the circuit when no current is passing through the coil; but when the current is switched on the soft iron core becomes a magnet, attracts the block of soft iron, and draws the metal spring from the platinum point, thus "breaking" contact. The metal spring or "hammer" rapidly vibrates, "making" and "breaking" contact while the coil is working. In the electrolytic break, the current is completed by a platinum point projecting from a porcelain cylinder immersed in an electrolyte. When the current is turned on, electrolytic bubbles immediately form round the metal point and break the circuit; the bubbles disperse, and the contact of the platinum with the water again completes the circuit. The rapidity with which the bubbles form and disperse makes the electrolytic break a highly efficient one. The motor-mercury break consists of a jet of mercury rapidly revolving in a sealed chamber with two or more strips of metal fixed in the sides. When the jet strikes a metal strip the current flows through the coil; when the metal is passed the contact is broken.

Contact breaks make and break the flow of electricity through the coil from a few hundred to several thousand times a minute. In X-ray work an efficient contact break is of the highest importance.

CONTACT, OPTICAL (Fr., *Contact optique*; Ger., *Optische Berührung*)

When two substances are cemented so closely together that there is no air space between, and the four surfaces have apparently been reduced to two, they are said to be in optical contact. A typical example is a pair of lenses cemented with Canada balsam; while the silver coating on a mirror affords another instance. To mount prints in optical contact is to cause them to adhere to suitable glasses, usually bevelled, by means of a warm solution of gelatine. Prints mounted in this way are often known as opalines, presumably because they sometimes have a margin of white paper, which, when seen through the glass, resembles opal. (*See also* "Opalines.")

CONTACT PRINTING AND CONTACT PROCESSES

All printing papers and lantern slides may be printed by contact, the term indicating the placing of the sensitive surface of the paper or plate to be printed upon in contact with the film side of the negative. The alternative method is that of printing by enlarging or reduction through a lantern or camera.

CONTINUING ACTION OF LIGHT

This action occurs only in the carbon and kindred processes of photographic printing; that is, in those that depend on the fact that gelatine and other colloid substances become insoluble when impregnated with an alkaline bichromate and exposed to light. The process of rendering insoluble, once begun by exposure

to light, continues after the print is taken from the frame, even if stored in a perfectly dark place, so that a partially exposed print may be completed by this continuing action. It is, however, very slow and uncertain. It depends on the presence of dampness in the air; and, consequently, it is much more rapid in wet weather than in dry. This continuing action may be entirely prevented by storing the print in an absolutely dry receptacle, such as a calcium storage tube used for the platinotype process. When prints can be developed within a few hours from the time that they are taken from the frames, the keeping of them under moderate pressure between dry blotting-paper is sufficient to prevent any appreciable increase in depth.

CONTRAST

The range of tones in a negative or print, from the highest light to the deepest shadow. A print is said to be flat or lacking in contrast when the highest light is a pale grey, the deepest shadow a medium grey only, and the gradation between the various tones is very slight. A print possesses good contrast when the highest light is either pure white or a very pale tone, the deepest shadow a rich black, and well-marked gradations separate the various details and tones. In nature the range of contrast may be from one to several hundreds; in a print on matt-paper the range from pure white to deep black is about one to twenty-five. In a highly glazed print the range may extend from one to fifty.

CONTRAST, EXCESSIVE

This may exist in a negative or print when the scale of tones is too long for the sensitised film to record satisfactorily. The darker tones will be a mass of black, since the deepest have gone beyond the deepest tone of the paper, while the lighter tones will be a mass of plain white without detail. A familiar example is the blank white sky that is frequently seen in a print when the sky portion of the negative is over-dense. Reduction is the proper treatment for an over-dense negative. (*See* other headings, in particular " Bennett's Reducer.")

CONTRETYPE NEGATIVE

A negative produced by sensitising a gelatine plate with potassium bichromate, drying, exposing under an ordinary negative, and soaking in water containing Indian ink or any coloured dye. The colour is absorbed by those parts of the gelatine not affected by light; and in this way, after fixation, is obtained a duplicate of the original negative, but reversed.

CONTROL IN PRINTING

Methods of treating negatives, or methods of treatment adopted while printing, may be summarised under the above heading. The object in all cases is the same ; namely, to produce a better, a more harmonious, or a more satisfactory print than that which the negative would give if the ordinary course were pursued. It is quite incorrect to assume that it is only inferior or imperfect negatives that require such assistance. The more critical the worker becomes with regard to his results, the more will he adopt methods of control. In a large

proportion of subjects, the lighting or other conditions may render the resultant negative inharmonious—not necessarily harsh or imperfect technically, but inharmonious in the sense of there being strong lights, or emphasis, in parts where such strength is detrimental to the general effect. It is control for securing true balance of light and shade, and for obtaining the most artistic result, that is the object of the treatment described.

The most simple method of control consists in shielding those parts of a negative which tend to become too dark, while the remainder of the print attains its full strength. In some cases this may be a simple shielding of a small corner or one end, while in others it may be necessary to shield almost the entire plate while a small part prints out fully. In printing by diffused daylight, a piece of thin wood or card may be supported at about $\frac{1}{2}$ in. or 1 in. above the surface of the negative, and covering those parts that attain their full depth too soon. The light diffuses gradually under the edge of the shield, grading softly from full action through the unshielded portions to practically no action at all under the greater part of the shield. The manner in which the change is effected, the sudden or the gradual transition from full printing to no action at all, will be determined by the distance of the shield from the negative. Even if as close as $\frac{1}{4}$ in., no line or sudden mark will show. In the case of a bright window in an interior photograph, a hole may be cut in a sheet of card, and the card supported above the negative so that the hole is exactly over the window, allowing its details to print out fully while the other parts are restrained. The effects of slight halation may be entirely removed in this manner without any work on the negative.

In printing by artificial light, the same results may be obtained by keeping the shields in motion while they are in use. By that movement, the risk of a sharp line showing is entirely obviated. The greater the extent of the movement of the shield, the softer the transition of its effect.

A second method, which is very useful in those cases in which there is a well-marked line in the subject at which the change in strength of printing should be made, consists in covering the glass side of the negative with very thin tracing paper or ground-glass varnish. The paper or varnish is cut away from those parts that print too slowly. The tracing paper to employ is that sold by artists' colourmen under the name of *papier végétal*, or vegetable tracing paper. It is very thin and translucent. It should be slightly damped and attached to the glass at the margins by a little gum. When dry, parts may be cut away as desired, the edges of the cut parts being secured by a touch of gum. Matt varnish is finer in character, but more difficult to apply. The degree of restraint possible may be increased by using a yellow-tinted varnish. The extent to which parts of a negative are held back in printing by this method is not great, but still sufficient for all ordinary negatives. A negative that has been prepared in this manner can be printed quite successfully by artificial light by the simple expedient of keeping the frame moving slightly during the exposure. In diffused daylight, no movement of the frame

is necessary, the thickness of the glass plate being sufficient to diffuse the light and prevent hard lines showing at the edges.

A third method of controlling results consists in cutting out a mask that will fit exactly those parts which require holding back. The most satisfactory way of making the mask is to take a silver print from the negative, and, having cut out the parts that print too quickly, to fix them to a piece of plain glass the same size as the negative. They should be put on in such a manner that when the glass is laid exactly over the negative the cut pieces will be in the precise position necessary. The printing is commenced in the usual manner, and as soon as the parts that correspond with the mask are sufficiently dark, the glass that bears the cut-out pieces is placed in position, care being taken that the corners coincide with the corners of the negative, thus ensuring that the mask is exactly in position. Although it involves more trouble in printing than does the use of tracing paper or matt varnish, this method possesses the advantage of allowing any degree of restraint to be exercised.

CONVENTION, THE PHOTOGRAPHIC

The Photographic Convention of the United Kingdom was founded in the summer of 1886. Its object was to afford facilities to photographers, professional and amateur, for an annual gathering at some suitable town previously agreed upon, for the purpose of hearing and discussing papers of photographic interest, of holding exhibitions, social outings, etc. The founders were the late J. Traill Taylor and J. J. Briginshaw.

Conventions carried out on this model, but on a much larger scale, have long been popular amongst photographers in the United States.

CONVERGENT DISTORTION (See "Distortion.")

CONVERGING LENS

A positive lens, or one capable of bringing rays to a focus; a convex lens. In practice all convergent lenses are convex, or thicker at the centre than at the edges.

CONVERTIBLE LENSES

The single components of a doublet lens capable of being used alone or in combination with other lenses, as in the casket lenses (which see).

CONVEX LENS

A lens that is raised in the middle; the opposite to concave. The "convexo-convex" has

A. Convexo-convex Lens B. Convexo-concave Lens C. Convexo-plane Lens

two convex surfaces, as at A; the "convexo-concave," one surface of each kind, as at B

(identical with the "concavo-convex" and "meniscus"); and the "convexo-plane," one convex and one plane surface, as at C. The "biconvex" lens is the convexo-convex.

COOLING CHAMBER (Fr., Chambre réfrigérante ; Ger., Kühlzimmer)

An arrangement employed in dry-plate manufactories for cooling the emulsion on the plates and causing it to set as quickly as possible. It may consist of a tunnel-shaped compartment about 15 ft. long, open only at each end, and furnished with an ice tank at the top, while below is a cold slab resting on a metal tray filled with ice water. The plates on coming from the coating machine are received on an endless travelling band of woven wire, by which they are carried along the cold slab and through the cooling chamber, emerging with the emulsion sufficiently set to allow them to be removed.

COOPER-HEWITT LAMP (See "Mercury Vapour Lamp.")

COOPER'S PROCESS

A plain, salted paper printing process now practically obsolete. The paper was sized with an alcoholic solution of resin, the silver sensitising solution being afterwards applied. More simple sizing solutions are now used, as described under the heading, "Plain Paper Printing."

COPAL VARNISH (Fr., Vernis copal ; Ger., Kopalfirnis)

Gum copal is a natural product, which is described under the heading "Gums and Resins." Copal varnish is sometimes employed for photographic purposes, a good formula being :—

Copal	2 oz.	110 g.
Oil of turpentine	7½ ,,	375 ccs.
Linseed oil	5 ,,	250 ,,

But as such a varnish cannot properly be made by the cold process, and as the heating of oil and turpentine is attended by grave risk of fire, it is better to buy the varnish ready made, advice which applies to all oil varnishes.

COPPER (Fr., Cuivre ; Ger., Kupfer)

Copper has become a most important and almost universally used metal for photo-engraving. It began to supersede zinc, which was formerly used, as soon as the fish-glue enamel process came into vogue, it having been found that zinc deteriorated in the "burning-in" process to which the enamel was subjected. The copper used is mainly of American origin, and this kind is considered the best for the purpose ; a considerable amount also comes from the Continent, but this is generally harder, more brittle, and more difficult to etch. The copper comes on to the market in well-rolled and finely-polished sheets of either 16 or 18 B.W. gauge (·065 in. or ·049 in.; the higher the gauge number the thinner the metal). Copper is invariably etched with ferric chloride solution of a strength of 35° to 40° Beaumé (sp. g. up to 1·36).

COPPER ACETATE (Fr., *Acétate de cuivre ;* Ger., *Kupferacetat*)

Synonyms, copper subacetate, verdigris. $Cu(C_2H_3O_2)_2 H_2O$. Molecular weight, 199.5. Solubilities, 1 in 14 water, soluble in alcohol. It should be kept well stoppered. It is a poison, the antidotes being emetics and the use of a stomach pump, then white of egg, charcoal, iron filings, magnesia, or pure potassium ferrocyanide ; avoid milk and fatty acids. It takes the form of bluish-green crystals, obtained by dissolving copper carbonate in acetic acid. It is used as a colour screen in sensitometry. (*See* "Colour Sensitometry.")

COPPER AND AMMONIUM SULPHATE (Fr., *Ammonio-sulfate de cuivre ;* Ger., *Kupferammoniumsulfat*)

Synonyms, ammonio-cupric sulphate, ammonio-sulphate of copper. $CuSO_4 4NH_3 H_2O$. Molecular weight, 245.5. Soluble in water. It is a poison ; for the antidotes, *see* under the heading "Copper Acetate." It is in the form of a dark-blue crystalline powder, and is obtained by dissolving copper sulphate in a solution of ammonia and precipitating by alcohol. It is used as a light filter in sensitometry, and is then prepared in solution as follows :—

Copper sulphate .	. 175 grs.	20 g.
Distilled water .	. 15 oz.	750 ccs.

Dissolve, and add enough liquor ammoniæ (·880) to redissolve the precipitate first formed and give a deep blue clear solution. Filter, and add—

Distilled water to .	. 20 oz.	1,000 ccs.

COPPER BROMIDE (Fr., *Bromure de cuivre ;* Ger., *Kupferbromid*)

Synonym, cupric bromide. $CuBr_2$. Molecular weight, 223.5. Solubilities, very soluble in water, less so in alcohol. It occurs as a greyish black crystalline powder, but it is most easily made by double decomposition, as follows :—

A.	Copper sulphate .	250 grs.	29 g.
	Hot water .	10 oz.	500 ccs.
B.	Potassium bromide.	238 grs	27·6 g.
	Distilled water	10 oz.	500 ccs.

Mix the solutions and allow to cool. It has been suggested for use in the intensification of negatives and for bleaching bromide prints for subsequent sulphide toning.

In process work, the copper bromide intensifier is employed for intensifying half-tone negatives, chiefly for the reason that it is more amenable to the "cutting" or reduction which every negative has to undergo in order to sharpen up the dots.

The following is the formula generally employed for making up the copper bromide solution :—

No. 1—

A.	Potassium bromide	500 grs.	52 g.
	Water . . .	10 oz.	500 ccs.
B.	Copper sulphate .	500 grs.	52 g.
	Water . . .	10 oz.	500 ccs.

Dissolve A and B separately and mix together, allowing to stand twelve hours before using.

The negative is bleached in this solution, rinsed well, and placed until blackened in solution

No. 2—

Silver nitrate .	.	1 oz.	55 g.
Nitric acid .	.	40 mins.	4 ccs.
Distilled water to	.	20 oz.	1,000 ,,

Greater density is given by flowing over a solution of either ammonium or sodium sulphide. The copper bromide intensifier is usually employed in conjunction with the cutting or reducing solutions of iodine and cyanide.

COPPER CHLORIDE (Fr., *Chlorure de cuivre ;* Ger., *Kupferchlorid*)

Synonyms, cupric chloride, copper bi- or dichloride. $CuCl_2 2H_2O$. Molecular weight, 170·5. Solubilities, 1 in ·83 water, very soluble in alcohol and ether. It is deliquescent, and must be kept in well-stoppered bottles. It is a poison ; for antidotes, *see* "Copper Acetate." It takes the form of a greenish crystalline mass, obtained by dissolving copper carbonate in hydrochloric acid, or in a similar manner to the bromide, using 117 grs. of common salt in B solution. It is occasionally used as a reducer, Spiller's formula being :—(1) Alum, 2 oz. ; copper sulphate, 2 oz.; salt, 4 oz.; and water, 20 oz. (2) Saturated solution of common salt. Mix equal parts of 1 and 2, immerse negative, and wash.

Also, it has been suggested as an addition to printing out emulsions to increase contrast, and was used in Obernetter's process (*which see*).

COPPER, INTENSIFICATION WITH

A process for intensifying gelatine negatives. A solution of bromo-iodide of copper is prepared as follows :—

Copper sulphate	.	100 grs.	76 g.
Water .	.	3 oz.	1,000 ccs.

When dissolved, add with constant stirring the following, which must also be dissolved :—

Potassium iodide	.	8 grs.	18·2 g.
Potassium bromide	.	20 ,,	45·6 ,,
Water .	.	1 oz.	1,000 ccs.

A slight precipitate of iodide of copper of a deep yellow colour forms ; this is allowed to settle and the clear part poured off for use. The fixed and washed negative is placed in the above until bleached and of a canary-yellow colour, from five to fifteen minutes being usually required. The solution may be used repeatedly if strengthened occasionally with a few drops of a mixture made by dissolving 12 grs. of iodide and 36 grs. of bromide in 2½ oz. of water. After bleaching, the negative is washed well, and darkened by placing in a strong solution of sodium sulphite to which a few grains of silver nitrate are added. Good results may also be obtained by darkening with a hydroquinone developer. The colour of the resulting negative is strongly affected by the solution used for darkening after bleaching. The above usually gives a reddish deposit which is very non-actinic ; rodinal a brown image, and the sulphite-silver a darker one. Variations in colour when hydroquinone is used may also be obtained by altering the proportions of sulphite and hydroquinone

Both the bleaching and the darkening must be done in daylight; the stronger the light the better and quicker the results. After darkening, the intensified negative is well washed in water and finally dried. The process may also be used for slides and bromide paper. When used for prints, the paper turns blue when bleaching, owing to the formation of iodide of starch, but the colour disappears when the hydroquinone is applied, and the colour of the print is usually a good brown.

COPPER AND POTASSIUM FERRI-CYANIDE (Fr., *Ferricyanure de cuivre et de potassium;* Ger., *Kupfer-Blutlaugensalz*)

$KCuFe(CN)_6$. Molecular weight, 314·5. Soluble in water. It is poisonous; for antidotes, *see* "Copper Acetate." This salt is always prepared in solution by double decomposition, generally in the presence of an alkaline citrate. It is used for toning bromide prints and transparencies (*see* "Copper Toning"), and is then reduced to the double ferrocyanide, $K_2CuFe(CN)_6$ (a brownish-red powder insoluble in water), by the metallic silver; white silver ferrocyanide is also formed.

COPPER PRINTING PROCESS

A printing process introduced by Obernetter, based on the fact that copper forms with chlorine a green salt (copper chloride) soluble in water. This salt is sensitive to light, which reduces it to hypochloride of copper. Paper is saturated with a mixture of copper chloride and iron chloride, and when dry is exposed to light under a negative. Afterwards it is immersed in a solution of potassium sulphocyanide, and ultimately treated with red prussiate of potash, a brown picture being the result.

COPPER REDUCER FOR BROMIDES

A process of locally reducing over-dense bromide prints, introduced by Fourtier in 1905. A 5 per cent. solution of copper sulphate is mixed with enough solution of potassium carbonate until no further precipitate is formed. The precipitate is collected on a filter paper and washed with several changes of water, and then dissolved in water to which a few drops of hydrochloric acid have been added. To this clear solution a strong solution of ammonia is added until the precipitate first formed is re-dissolved, the resulting rich-blue liquid being a solution of ammonio-chloride of copper. The actual reducer is:—

Copper solution (as above)	. . .	½ oz.	25 ccs.
"Hypo" solution (5%)	.	½ ,,	25 ,,
Water	. .	20 ,,	1,000 ,,

The prints should be well soaked in water, laid face upwards on a sheet of glass or the bottom of a clean porcelain dish, and the reducer applied with a tuft of cotton-wool. The action of the reducer is stopped by washing the print in water, and the reducer made to work more or less rapidly by varying the quantity of water. The above is really a roundabout method of making copper chloride, and the same purpose is served by mixing solutions of copper sulphate and common salt.

COPPER SULPHATE (Fr., *Sulfate de cuivre;* Ger., *Kupfersulfat*)

Synonyms, cupric sulphate, blue vitriol. $CuSO_4 \cdot 5H_2O$. Molecular weight, 249·5. Solubilities, 1 in 2·5 water, 1 in 400 alcohol. It is efflorescent, and should be kept well stoppered. It is a poison; for antidotes, *see* "Copper Acetate." Large deep blue crystals, obtained by dissolving copper carbonate in sulphuric acid. It was occasionally used in the developer for wet collodion, and is now used chiefly for making the bromide, chloride, and ferricyanide salts. It forms a rich blue solution with excess of liquor ammoniæ, and is a useful filter for colour sensitometry and three-colour work.

In process work, copper sulphate is used as an addition to the wet-plate developer. Its action is said to be merely that of retarding the oxidation of the ferrous sulphate. Copper sulphate is also employed by process workers in the copper bromide intensifier. In electrotyping it is the salt used with sulphuric acid to form the depositing solution.

COPPER TONING

A process for toning bromide prints, originally introduced by Eder and Toth in 1876, and modified by Namias and others. The following method, introduced by W. B. Ferguson in 1900, is the most satisfactory. The colours obtained range from warm black, reddish sepia, brown, purple brown, purple crimson, reddish purple, through many shades of red to the so-called red chalk, according to the quality of the print and duration of toning. The Ferguson formula has appeared in many forms, a popular one being:—

A. Copper sulphate .	60 grs.	6 g.	
Potassium citrate	240 ,,	24 ,,	
Water to . .	20 oz.	1,000 ccs.	
B. Potassium ferricyanide . .	50 grs.	5 g.	
Potassium citrate	240 ,,	24 ,,	
Water to . .	20 oz.	1,000 ccs.	

Use equal parts of each and immerse the print until the desired shade is obtained. The toning is made more rapid by adding 5 grs. of citric acid per ounce of toner. Used in its normal state the bath produces the first tones very rapidly, while the final colour (red) requires from twenty to forty minutes, according to the quality of the print. Washing for ten minutes only is necessary to stop the action of the toner at any desired stage. The colours are produced by the formation of copper and silver ferrocyanides.

The following copper bath has also been recommended for rich red tones:—

Ammonium carbonate (saturated solution)	1 oz.	1,000 ccs.
Copper sulphate .	10 grs.	2 g.
Potassium ferricyanide	25 ,,	5 ,,

Owing to the alkaline condition of this bath it produces red tones more quickly than does the Ferguson formula.

COPPERAS

A common name for various sulphates. Thus, copper sulphate = blue copperas; iron sulphate = green copperas; zinc sulphate = white copperas.

COPPERING SOLUTION

A superficial coating of copper may be applied to etched zinc plates by neutralising copper sulphate with a strong alkali, such as ammonia or cyanide. Previously, the plate is well washed and scrubbed with caustic potash and whiting, and is then immersed in the solution for a few minutes, when it will be found coated with a sufficient covering of copper.

COPYING

Copying should present no serious difficulty provided suitable precautions are taken, and correct exposures given. It is essential that the print to be copied should be held perfectly flat on a board which is parallel with the sensitive plate. If this condition is not observed, a distorted image will result. The arrangement shown at A (p. 145) is simple, inexpensive, and answers well for copying and also for other photographic work. The direction of lighting is important. A direct front light minimises the effect of the grain of the paper, while a strong side light accentuates it. On the other hand, a direct front lighting cannot be adopted for glossy surfaced prints on account of the reflections. To avoid the sheen of the glossy surface, lighting from one side, slightly in front, is necessary.

For copying pictures under glass, the camera front should be covered with a black cloth, and a black or dark cloth should be hung up close behind the camera to avoid reflections. A side lighting is desirable for the same reason; but where the original is liable to show a grain, the lighting should be from two sides. (For copying oil paintings or water-colour drawings, *see* " Paintings, Photographing.")

For copying an ordinary silver print, or any strong photographic print with a glossy surface, a rapid plate will give the most truthful rendering of the gradation. If the print is faded or yellow an isochromatic plate should be used. For copying a line engraving or drawing, or a wash drawing, or a photographic print with very little contrast on matt-surfaced paper, a slow plate specially made for copying, such as a " process " plate or a fine grain ordinary plate, will give the most satisfactory negative. In all cases the plates should be backed. Correct exposure is most important, and the best method of determining this is by using a meter, which should be placed flat against the picture that is being copied and the time that is required for matching the standard tint noted. Using a plate of which the speed is 200 H. & D., the exposure for copying a glossy silver print the full size of the original, and using the aperture marked *f*/16 on the diaphragm scale, will be from one-fourth to one-half the meter tint if a Wynne meter is used, and from one-eighth to one-fourth with a Watkins meter. A dark or red-toned photograph will require longer exposure than a light or cold-toned print. For copying a line drawing, one-half the meter tint for a Wynne meter, and one-fourth for a Watkins will be the correct exposure for a slow plate, 40 H. & D. For a black-and-white drawing in wash, these exposures should be doubled.

The above exposures are for making a copy the same size as the original. For other proportions, the following will be the relative exposures, the lens aperture being the same throughout :—

	Times the scale of the original		Relative exposure
Enlarged to .	. 2	..	2¼
" " .	. 1½	..	1½
Copying same size	I	..	I
Reduced to .	. ¾	..	¾
" " .	. ½	..	9/16
" " .	. ⅓	..	7/16
" " .	. ¼	..	⅓

In process work, the art of copying has been brought to great perfection for photo-mechanical processes, where the reproduction has generally to be made from a print or drawing. The essentials that are carefully studied are : The lighting of the subject ; the parallelism of the original to the sensitive surface ; the sharpness in definition of the image ; and the opacity and clearness of the respective parts of the negative. The first condition is generally secured by electric arc illumination. The second is secured by the use of stands on which are rails, the camera and copyboard running on these rails to and from each other ; also by rigid and accurate construction of the camera. The third is secured by the choice of suitable lenses such as are specially made for process reproduction. The fourth is secured by the adoption of suitable plates or processes, the wet collodion process being generally considered the best for such work. Further, it is very important to avoid vibration (*see* " Copying Stand").

COPYING ILLUSTRATIONS FOR TRANSLATION INTO LINE DRAWINGS

A modification of the arrangement that is illustrated and described under the heading " Camera, Vertical " may be used for project-

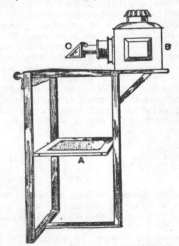

Arrangement for Projecting Illustrations for Translation into Line Drawings

ing book or newspaper illustrations, when such illustrations are taken from photographs and have to be translated into line. The

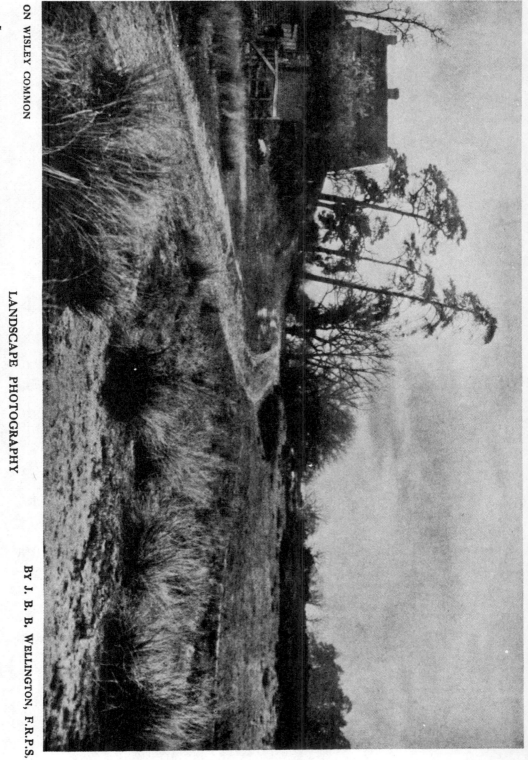

ON WISLEY COMMON LANDSCAPE PHOTOGRAPHY BY J. B. B. WELLINGTON, F.R.P.S.

5

glass platform **A** (*see* the illustration to the present article) is covered with a drawing-board, and upon this is placed the paper, etc., upon which the sketch is to be made. A transparency made from the illustration to be copied is placed in the lantern **B**, and by means of a sloping mirror **C** attached to the lantern lens hood an image of the illustration is projected upon **A**, where it can be drawn on the paper provided.

COPYING STAND (Fr., *Pied-table, Chevalet de reproduction ;* Ger., *Reproduciren-Stativ, Kopier-Stativ*)

An arrangement for keeping the camera and copy parallel when reproducing plans, drawings, photographic prints, etc. It usually consists of an upright copyboard or easel running on parallel rails, and capable of being clamped in any position. The camera may also be mounted to run on the rails, but is often stationary. Illustration A shows an ordinary copying stand.

In process work, the copying stands used are the products of considerable ingenuity, the occasion for which was the necessity of avoiding any want of sharpness through vibration. One

A. Ordinary Copying Stand

of the earliest and most usual methods for attaining this object was to suspend the copying base on ropes which depend from the ceiling ; but the ropes get hardened by constant tension and in time fail to neutralise the vibration. One way of overcoming this drawback was to insert spiral springs between the ends of the ropes and the suspension hooks ; and another was to suspend the base from a beam swinging like a scale beam.

The above methods are now considered clumsy and obsolete, and the usual form of apparatus now employed is the spring stand B. The base is swung on spiral springs F attached to a rigid stand. Where no vibration is anticipated, rails may be laid on the floor and the camera and copyboard placed on separate stands, with wheels running directly on the rails, or the copyboard may be fixed to the wall whilst the camera is on a running carriage. This system is largely used in Government offices for map reproduction.

Another plan often employed for large work is to have rails laid both inside and outside the dark-room, the copyboard being on a carriage outside, and a plate-holder being mounted on a carriage inside, whilst the lens is fixed in an opening made in the wall of the dark-room ; in this way the dark-room itself becomes the camera. Where daylight is used for illumin-

ation, tilting stands are sometimes employed in order to get the best light possible on the original.

A curious form of copying apparatus used for

B. Spring Copying Stand

copying large paintings in the open air is the revolving camera stand, which can be turned according to the direction of the sun's rays.

The vertical copying stand C is often used for copying from books, or from small natural objects which can be best arranged on a horizontal board. Levy's copying stand D and E combines not only the vertical, but also the tilting and horizontal forms. With these vertical stands a prism or mirror box must be used in conjunction with the lens.

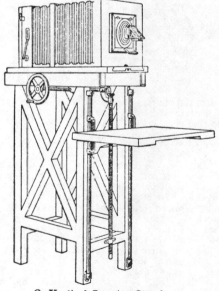

C. Vertical Copying Stand

For producing reversed negatives, which invariably have to be made for photo-mechanical processes, the camera stands must be provided with a turntable so as to place the camera side-

ways to the copyboard, the image being then reflected by mirror or prism, as shown in the vertical stand C. On the Continent, copying stands have been made for such reversal work with the copyboard and the camera carriage both placed across the stand at an angle of 45 degrees, but, of course, still parallel to one another and provided with reversing prism as before. In this way some floor space is saved with large cameras.

For copying transparencies a "transparency attachment" is usually connected up to the camera and stand; it is a simple light-tight conical bellows with provision for inserting the transparency. Rotary copyboards and rotary transparency holders are often employed in copying, especially in colour work, to place the negative at different angles from the vertical or

the term "colourable imitation." In other words, a copy need not be an exact copy. It is sufficient to be able to show in the case of the infringement of a copyright that the original photograph has been copied by a mechanical or hand method.

The period of protection granted by the Act is for the term of the natural life of the author and seven years after his death. It has no relation to the life of the owner of the copyright except in the case where he is also the author. Usually, there is no room for doubt as to who is actually the author, but in the case of a photographic firm, where the finished photograph passes through a number of hands, it has been held that the author is the person who effectively is as near as he can be the cause of the picture which is produced—that is, the person who

D and E. Combination Copying Stand

horizontal line. For correcting distortion a transparency holder with universal movement may be employed.

COPYRIGHT (Fr., *Droit d'auteur;* Ger., *Verlagsrecht, Urheberrecht*)

Protection against copying and other forms of reproduction is granted to photographs equally with paintings and drawings. The Act by which this protection is afforded is the Copyright Works of Art Act of 1862, the clauses of which Act, taken in conjunction with the judgments of the courts during the years that have intervened since then, cover the many incidents which may arise in the creation of copyright, in its assignment, and in the infringement of copyright works. The Act defines copyright as "the sole and exclusive right of copying, engraving, reproducing, and multiplying any photograph and the negative thereof by any means and of any size"—that is to say, the reproduction of a photograph by another graphic method, such as drawing or painting, may yet be an infringement of the copyright. The Act in another place uses

superintended the arrangements by putting the people into position. It has also been held that an absentee principal cannot be the author, even though, by the creation of system in his business, he may be actually just as responsible for the result as though he had been present.

The most important clause in the Copyright Act is that which describes the conditions as to payment when a photograph is taken, because upon these conditions the ownership of the copyright depends. The Act expressly states that when the negative of any photograph is made for or on behalf of any other person "for a good and valuable consideration," the copyright belongs to the person for or on whose behalf the work is done. Thus, in the case of an ordinary sitter in a studio, the copyright is his; in the case of a landscape photographer working for an employer, all copyrights in the views taken are the employer's. The question of what is "good and valuable consideration" has involved some nice points of law. Articles of value, or board and lodging, may be agreed upon as "valuable consideration," and there

is, in fact, one case in which the granting of permission to photograph certain premises was judged to be " valuable consideration " to the photographer because it gave him the opportunity to sell numerous copies of the photographs he had taken.

It should be noted that the Act does not say *on payment of* the consideration, and, so far as the ownership of copyright is concerned, non-payment to the photographer by his customer, or employer, does not give the first-named any rights in the photographs; the copyright remains with the customer or employer, whilst the photographer must sue in the usual course for payment or wages. In cases of doubt as to the ownership of a copyright this forms a useful test. If one is in a position to sue for payment one cannot then have any ownership in the copyright.

The portrait photographer should also note that in the case of negatives taken at the same time as others at the sitting, but not ordered by the customer, the copyright is nevertheless the property of the customer. In cases where this point has arisen it has been held that payment was for the labour of the artist as a whole, and, therefore, covered all the exposures made at the sitting. Any use made of such extra negatives will thus be an infringement of the sitter's rights.

Again, when, as sometimes happens, the portrait of a person is taken by the order and at the expense of a second person, the copyright naturally becomes the property of the person paying, or suable for payment. And, in the absence of any agreement that the photographer should make some negatives for himself at such a sitting, the whole of the portraits taken are the property of the person ordering the work.

Though the Copyright Act does not say anything about the ownership of the negative, it is perfectly clear on one point—namely, that the sale or disposal of the negative by the owner of the copyright to another person without the formal assignment of the copyright in writing to either buyer or seller causes the copyright to be destroyed. This fact should be borne in mind when purchasing negatives or acquiring them along with the purchase of a business. It is necessary to draw up an itemised list of the subjects, sufficient for separate identification, and to have the whole document signed by the vendor transferring the copyright to the purchaser, or by the purchaser reserving the copyright to the vendor, according as the copyrights are, or are not, to change hands.

Before referring to the assignment and registration of copyright, one minor clause of the Act must be noted—namely, that which enacts that any person may copy any work in which there is no copyright, and may represent any scene or object, notwithstanding that there may be copyright in other representations of such scene or object. This clause has a very practical application in the reproduction of the works of Old Masters, in which, of course, there is no copyright, but any number of photographers may make copies of such works and severally acquire rights in their copies, even though these latter are practically identical. Similarly, there

is nothing to prevent several photographers from photographing a landscape from a particular point of view; even though the negatives are almost identical, copyright may be obtained by each separate author.

Assignment of the copyright in a photograph may be whole or partial. The sole rights to reproduce in any form or place whatever may be sold with, or without, the negative, though there can be no object in the photographer retaining the negative, since his rights to make a single print from it have been disposed of. It is more usual, however, to assign specifically limited rights to reproduce, such as in a given issue of a journal or newspaper, as a calendar or window-bill, as a postcard, or as an advertisement for a particular class of goods. The nature of the assignment being clearly defined, the photographer is left free to dispose of other limited assignments in other ways, but a form of assignment loosely worded (for instance, the following : " Received of A. B. 10s. 6d. for the right to reproduce my photograph of Trafalgar Square.—C. D.") might be taken to mean the sole rights of reproduction. An assignment or licence to reproduce should clearly state the particular purpose for which the photograph is to be used. In the case of reproduction in newspapers, it is usually understood that the photographer's name should be acknowledged under the photograph, or on the same page, and that no use be made of the photograph without extra payment in extra issues of the paper, or any other publication of the same proprietorship.

Although anyone purchasing the sole copyright in a photograph or other work is thereby at liberty to reproduce it in any form, the Act forbids the alteration of such photograph, or the reproduction thereof in an altered form, during the life of the author and without his consent—that is to say, that such altered version must not be represented as the unmodified work of the originator.

The registration of a copyright is important to those who have business in selling rights of reproduction, inasmuch as the Act provides that " no proprietor of any such copyright shall be entitled to the benefit of the Act until such registration, and no action shall be sustainable, nor any penalty recoverable, in respect of anything done before registration." In other words, registration is a formal claim to rights in the photograph. It is made at Stationers' Hall, on forms provided for the purpose. On this form five columns are provided, but it is only necessary, when registering a copyright, to make entries in Nos. 1, 4, and 5 ; Nos. 2 and 3 are required only when a copyright is assigned by one person to another. In column 1 a short description identifying the photograph is given, in No. 4 the name and address of the proprietor of the copyright, and in No. 5 the name and address of the author. The author, as already pointed out, may or may not be the same person as the proprietor. This form, filled up on these lines, is deposited at Stationers' Hall, together with a copy of the photograph, the fee for registration being one shilling. The precise form of the photograph is immaterial ; a straight print from the negative suffices to protect the photographer's rights regarding the issue of enlarge-

ments or even of worked-up reproductions in colour by hand or by three-colour printing. It is simply necessary that the photograph registered should plainly identify the original work of the author.

Infringement of copyright may take a number of forms. The Act specifically forbids any person to "repeat, copy, colourably imitate, or otherwise multiply for sale, hire, or distribution," or to cause or procure these acts to be done. The phrase "colourably imitate" protects the photographer against piracy of his work by draughtsmen or artists, who might use the photograph as a basis for drawings; it is not necessary, to prove infringement, that the illegal copy should be identical with the original from which it was made.

The Act distinguishes between two classes of infringer : (1) those who in knowledge or ignorance commit one of the acts mentioned above, and (2) those who, with knowledge of the unlawful character of the copies, import or distribute the latter in the United Kingdom. The copyist, or person who employs a copyist, is regarded as liable whether he act in knowledge or ignorance of the copyright, whereas an importer is liable only when he acts with knowledge of the unlawful nature of the copies. It will thus be seen that a photographic enlarger, who prepares an enlargement of a photograph sent to him, is equally liable with the person who gave him the order, and this even though both may be in ignorance of the existence of any copyright. Under the Copyright Act there is no need that a photograph which has been registered at Stationers' Hall should be marked "copyright," but it is a natural assumption that any recent photograph is copyright, even though formal claim (registration) has not been made.

The remedies for unlawful copying granted by the Act are of two kinds : (a) penalties and (b) damages. As already stated, no penalty can be recovered for any such infringement committed before the copyright has been registered, but damages may be obtained in the case of copies which are *made* before registration and *sold* afterwards. The maximum penalty which can be obtained under the Act is £10 for each unlawful copy, together with the forfeiture by the infringing party to the proprietor of the copyright of all such copies. Formerly, this provision of the Act was interpreted to mean a payment of a coin of the realm for each unlawful copy, and on this basis large sums were formerly obtained in the case of unlawful reproduction in a newspaper of large edition. But a later judgment of the Court of Appeal has held that it is not necessary to fix the total penalty at a sum which, when divided by the number of copies, works out to a coin of the realm. When taking action for penalties it is only necessary to prove the infringement. The photographer must show that the copyright is his property by virtue of the fact that he took the photograph without payment in the original instance, or that it was assigned to him in writing at the time of taking, or that he had subsequently purchased it. In action for recovery of damages he must prove not only his ownership of the copyright, but the damage sustained by the infringement.

Where a registered photograph has been reproduced without permission, it is an easy matter to obtain satisfaction from the offending party, but when the photograph has not been registered the owner of the copyright needs to proceed with some care. He should first register the photograph immediately, and he is then in a position to take such action against the parties still producing, or those selling, the copies as will induce the infringer to settle the matter privately. Very frequently the infringement is the result of ignorance or carelessness, and it is usually good practice to assume that it is so, and to write pointing out the infringement and to ask what the party in question is prepared to do. In this letter it is not wise to name any specific sum which would be acceptable to the photographer. Where the infringement is clearly unintentional, many photographers are prepared to accept twice (or even the same) the fee payable had application for the use of the photograph been made by the publisher.

Copyright, created and registered in England, is secured *ipso facto* in the other countries subscribing to the Berne Convention of International Copyright. These countries are as follow : Algiers, Belgium, Denmark and the Faroe Islands, France and its colonies, German Empire, Hayti, Italy, Japan, Liberia, Luxemburg, Monaco, Norway, Spain, Switzerland, Tunis. Under this Convention the photographer in each country must comply with the formalities of his country (the country of origin), and he obtains in the other countries the degree of protection which is granted to natives in these countries. The degree of protection varies within wide limits among civilised countries. In France, for example, protection is granted only to such photographs which are adjudicated to be works of art, and it would appear that judgment in this respect must be given in regard to each particular photograph, apart from the reputation of the photographer as an artist. In some countries—Germany and Belgium, for example—it is not necessary to register, and therefore it is difficult to discover whether the formalities in the country of origin have been complied with in these cases. In Great Britain —and, indeed, whenever there is any doubt —the safest course is to assume that copyright exists in any photograph, painting, or drawing. G. E. B.

CORALLIN (Fr., *Coralline ;* Ger., *Corallin*)

Synonyms, pæonine, aurin. A mixture of several complex aniline dyes, which is interesting as being the first dye used to colour-sensitise collodion films. It is not used now, having an extremely weak action on gelatine plates.

CORONA PHOTOGRAPHY

The corona is the brilliant pearly-white luminescence observed round the eclipsed sun during a total solar eclipse, when the ordinary brilliant sunlight is obscured by the intervention of the dark moon. Many attempts have been made by astronomers to observe it visually or to photograph it in ordinary sunlight, but all these have hitherto been unsuccessful, and it is only during an eclipse that it can be examined. There is no limit, either of size or quality, to the apparatus.

which can be usefully employed to photograph this wonderful solar appendage, and as indicating what are perhaps extremes, excellent pictures of the coronal streamers have been made with ordinary camera lenses of about 5 in. focal length, and also with large mirror telescopes of more than 70 ft. focal length. Each variety, however, has its special advantages, and the general apparatus may be divided into two divisions according to the scale on which the pictures are primarily photographed. With the small scale cameras, lenses of very great angular aperture can be employed, with all the advantages of extensive flat field and light intensity. These will be most useful for recording the extreme limits of the coronal streamers or rays, which are found to be very different from eclipse to eclipse, so that as complete a record as possible is desirable.

With the large scale apparatus the programme is best confined to obtaining detailed pictures of the brighter regions of the corona near to the sun's disk, and as the light gradations in this region are very great, it is generally found necessary to take exposures of different lengths for the different zones, and develop accordingly, so that the intense portions are not rendered unprintable.

If possible, the most rapid panchromatic plates should be employed for photographing the corona, as the principal part of the corona radiations is in the green near wave length 5,303.

The exposures possible will, of course, depend on whether the observer has the use of an equatorial mounting and driving mechanism or not. If he has not, probably half a second will be the maximum exposure possible with a camera of about 7 in. to 9 in. focal length. When the more elaborate mounting is available, exposures of from ten seconds to four or five minutes are given so as to record the farthest outlying streamers.

Very interesting series of experiments have been tried at several eclipses. For comparison purposes two exactly similar photographic cameras have been used side by side, clamped firmly together so as to move as one. In front of one of these cameras, between the lens and the corona, there has been placed a special piece of apparatus for detecting polarised light, so that if any of the light coming from the solar corona is polarised in any particular direction, the difference will be clearly shown on the photograph by the presence of a series of bands as compared with the image taken with the other camera having the lens alone. By such means it has been satisfactorily proved that a large proportion of the light from the corona is polarised, and it is thought that this may be owing to its being light from the sun reflected from the minute particles of which the corona is assumed to be composed.

By obtaining comparable photographs with the same instruments at intervals during a long period of years it has been noticed that the form of the corona decidedly changes; and these changes are found to be in accord with the changes on the sun's surface as evidenced by the presence or absence of the dark irregular markings called sunspots. When these are very numerous, showing the sun to be very active, then the corona is found to be very extensive in all directions round the sun, long streamers passing off practically in all directions. When, on the contrary, the sun's activity is at a minimum, and there are few sunspots, then the coronal streamers are chiefly confined to the regions on either side of the sun's equator; the regions near the sun's poles are at these times occupied by very beautiful plumes or aigrettes, which have all the appearance of the stream lines shown by a series of filings congregating about the poles of a magnet. This fact has given considerable probability to the suggestion that the solar corona is due to some electro-magnetic discharge from the sun's surface.

CORRECTED LENS

A lens having the chemical and visual foci coincident. A properly achromatised lens is said to be *under*-corrected when, in spite of the addition of a second glass, the blue rays still come to a focus nearer the lens than the yellow, and *over*-corrected when the blue rays come to a focus behind the yellow ones.

CORRECTION COLLAR

A rotating collar sometimes fitted to high-class microscopic objectives. The varying thicknesses of the cover glasses placed over microscopic objects affect the value of the corrections of high-power objectives. The correction collar overcomes this difficulty by varying the separation of the combinations of the objective.

CORROSIVE SUBLIMATE (*See* " Mercuric Chloride.")

COSMICAL PHOTOGRAPHY

So many different subjects requiring special treatment are included in the general class of celestial or cosmical objects that for the majority of them it will be more satisfactory to describe the methods of photographing them under their respective special headings (*which see below*). As regards the actual photographic details of procedure, however, much that is common to all celestial photography may most conveniently be detailed here.

Apparatus.—This will vary from the hand camera to the powerful and specially adapted mechanical camera of the astronomer; they will all, however, have in common the feature of being focused for parallel rays, or, as it is usually termed, set for infinity. The reason for this is that for all practical purposes all celestial objects are so far distant from the earth that any differences between their respective distances are inappreciable. This fact will to many constitute a considerable simplification, as undoubtedly the use of a " fixed focus " camera admits of apparatus being efficiently used in a condition which would be much too rough for photographing objects whose distances were different. In photographic language there is no " depth of focus " difficulty in celestial photography, and the flatter the field of definition given by the lens the more satisfactory will its performance be. This leads at once to the fact that for photographing large areas of sky the modern anastigmat type of lens, giving

critical definition over a large angle, is the most efficient instrument.

In many cases the question of cost may serve to prohibit the employment of a sufficiently large lens camera—or refractor, as it is usually termed—and work of the highest type of accuracy has been done with concave mirror cameras. These involve only the optical working of one surface, and thus for a given sum the instrument may be of a much greater power. Two kinds of reflector have been principally used : speculum metal and silvered glass. The former were excellent, but when they tarnished it was exceedingly difficult to re-polish them without altering the *shape* of the reflecting surface and thus destroying the definition of the image. Most of the reflecting telescope cameras now in use consist of a surface of glass accurately ground to a parabolic form and then coated over with an exceedingly thin film of pure silver. This offers the important advantage that when it becomes tarnished it can be dissolved away in a few minutes and replaced very quickly with a new film without in any way interfering with the shape of the glass surface.

Plates.—For most kinds of celestial photography, excepting that of the sun and moon, it is advisable to employ the fastest plate obtainable, provided that the grain is not noticeably prominent. On account of the subjects being generally of special coloration, the isochromatic or panchromatic plates now so easily obtainable should be preferred to the non-colour sensitive brands, as without them it may be found impossible to render differences which are quite easily noticeable to the eye.

Development. — This will, in general, be exactly the same process as would be used for ordinary terrestrial photography. Again excepting photographs of the sun and moon, the general tendency will be for under-exposure to be experienced, so that the treatment recommended for this should be the normal procedure for astronomical work if harshness in the results is to be avoided. Any of the standard developers may be employed with practically equally good result. Pyro soda, metolquinol, and rodinal are all used by some of the best workers, and there is little to choose between them. In general, no bromide or other restrainer should be used ; the negative should be thin and full of detail rather than dense and contrasty. To further this, development should never be over-done, as it is practically impossible to remedy it by subsequent reduction, whereas a thin negative, with detail, may be gradually intensified and re-intensified, by means of mercuric chloride and ferrous oxalate, until the requisite density is obtained.

For copies all the usual media are available. Lantern slides of good astronomical subjects make beautiful and interesting records.

(For details of various subjects *see* " Comets, Photographing," "Corona Photography," "Eclipses," "Lightning," "Moon," "Nebulæ," "Rainbow," "Stars," "Sun," etc.) C. P. B.

COSMORAMA (Fr., *Cosmorama ;* Ger., *Kosmorama*)

An early arrangement for the inspection of photographs or pictures. These were laid horizontally on a semicircular table or platform, each picture having an inclined mirror to reflect it to a viewing lens, at which the spectator's eye was placed. The pictures were illuminated by concealed lamps and were inspected in turn.

COSMORAMA STEREOSCOPE (Fr., *Stéréoscope cosmorama ;* Ger., *Kosmorama Stereoskop*)

An early form of stereoscope made by Messrs. Knight, in which two large lenses were used having a segment cut off, so that they could be placed with their centres 3 in. apart.

COTTON-WOOL

Prepared from the hairs of the seed of *gossypium Barbadense* and other species of *gossypium*. It has many uses in photography, and the variety known as absorbent cotton and sold in rolls, wrapped in blue paper usually, is the best to use. The very common and coarse variety used for packing should not be used for wiping wet negatives, as it contains grit and other coarse foreign matter, which is apt to scratch gelatine. All negatives should be wiped after the final washing with a wet pad of cotton-wool.

This material also makes a serviceable filter for liquids, a tuft being lightly placed in the neck of a funnel and the liquid filtered through it. It does not filter as thoroughly as filter papers, but it will serve for some liquids, particularly varnishes.

In process work, cotton-wool has numerous uses, and the " absorbent " wool is commonly preferred. A wad of it is generally found the handiest means for cleaning zinc or copper with pumice powder or whiting to remove grease. The absorbent cotton is also used for filtering the albumen-bichromate or fish-glue solutions. The development of albumen-bichromate inked prints is effected with the help of a tuft of cotton. By its means, too, the scum which sometimes forms on wet-plate negatives can often be effectually removed without damaging the negative.

COVER GLASS

A plain glass bound up with a transparency (lantern slide) to protect the film. Also a plain glass used as a cover for the object on a microscopic slide.

COVERING POWER (Fr., *Pouvoir à couvrir ;* Ger., *Deckkraft*)

The extent, or boundary, to which a lens will produce a well-defined and properly illuminated image. The circle of illumination produced by a lens is practically the measure of its covering power ; but definition must also be considered, for this may not be equally good all over the circle. It is desirable to have a lens which will cover a slightly larger circle than is sufficient to include the size of plate used ; otherwise there will be a falling-off of definition and of light when using the rising front. The better the lens the more satisfactory should be its covering power ; a good modern anastigmat will readily cover, when stopped down, a plate at least a size larger than that for which it is intended.

COWAN'S DEVELOPER

A formula advocated many years ago by A. Cowan for use with negatives.

No. 1.—Pyrogallic acid	20 grs.	4 g.
Nitric acid .	2 drops	·5 ccs.
Water to .	10 oz.	1,000 ,,

No. 2.—Strong liquor		
ammoniæ .	¼ oz.	25 ccs.
Potassium bro-		
mide .	37½ grs.	8 g.
Water to .	10 oz.	1,000 ccs.

In cases of ordinary exposure mix in equal parts. For under-exposure add more of No. 2, and for over-exposure more of No. 1 and bromide.

A. Cowan also prepared a solution of pyrogallic acid which is always ready for use.

Pyrogallic acid .	. 1 oz.	18.3 g.
Citric acid .	. 60 grs.	2·25 ,,
Water to .	. 54½ oz.	1,000 ccs.

Dissolve the citric acid in water and add the pyrogallic. The solution will contain 8 grains of pyro to the ounce of water, and will keep good for many months. In using it dilute according to formula employed.

Another developer known as "Cowan's" is the following (known also as a citrate of iron developer), recommended for chloride lantern plates :—

No. 1. For cold tones—

Potassium citrate	. 100 grs.	200 g.
Potassium oxalate	. 30 ,,	60 ,,
Hot distilled water to .	1 oz.	1,000 ccs.

No. 2. For warm tones—

Citric acid	. 90 grs.	180 g.
Ammonium carbonate	60 ,,	120 ,,
Cold distilled water to .	1 oz.	1,000 ccs.

No. 3. For extra warm tones—

Citric acid	. 130 grs.	260 g.
Ammonium carbonate	40 ,,	80 ,,
Cold distilled water to .	1 oz.	1,000 ccs.

In mixing solutions Nos. 2 and 3 it is better to put the crystals into a deep vessel, and, after adding the water, leave alone until all effervescence ceases. It is advisable to make it overnight. To 3 parts of any of the above solutions add 1 part of the following at the time of using :—

Ferric sulphate .	. 120 grs.	240 g.
Sulphuric acid .	. 1 drop	2 ccs.
Distilled water to .	1 oz.	1,000 ,,

COXIN

A solution of crocein scarlet 3 B and a yellow dye, in which exposed plates were bathed, or which was added to the developer so that they could be developed in daylight; the subject of a German patent in 1902.

C.P.

The initial letters of the words "Candlepower" (which see). Also an American term placed after the name of a chemical to indicate that it is chemically pure.

CRACKED NEGATIVES

Negatives are easily cracked if cheap frames with uneven beds and imperfect springs are used. The crack may at first appear slight and unimportant, but in time it invariably extends across the plate. With care the film on a cracked negative need not be broken ; merely bind the negative to a piece of glass of the same size by means of gummed strips of paper, or cement it bodily to the glass by means of a mixture of Canada balsam and benzole or xylol, the crack being first of all filled in with the mixture.

Many workers duplicate cracked negatives in the following manner. First paint on the glass side and along the crack a fine line of Brunswick black or other opaque varnish, and then make a positive transparency, on which, of course, the crack will be represented by a thin white line. Then, by means of a retouching pencil or a camel-hair pencil and suitable medium, retouch the white line, and make a negative from the transparency. Much depends upon the position of the line and the degree of skill exercised.

There are two systems of taking a print from a cracked negative without the crack showing,

A. Printing from Cracked Negative on Revolving Frame B. Cracked Negative at Bottom of Deep Box

but the work must be done in daylight. One is to place the frame on a board attached to strings A, and to keep the board swinging or rotating in the shade while the picture is being printed. Another is to place the frame at the bottom of a deep box B, also in the shade. These methods are rather slow, but they give the best results possible with cracked negatives.

It is, of course, possible to remove an unbroken gelatine film from a cracked glass, and one of the best methods of doing so is the following : Carefully clean a sheet of glass one size larger than the negative to be treated, place the cracked negative, film side upwards, upon it, and coat evenly with enamel collodion.

Put on as much as the film will hold without its running over, allow to set thoroughly, and wash till the water runs freely off it ; drain, and coat with a solution of 20 grs. of gelatine in 1 oz. of warm water, and allow to set thoroughly. Then immerse the cracked negative with its prepared film in this mixture :—

Hydrofluoric acid	. 60 drops	6 ccs.
Glycerine	. 1 oz.	50 ,,
Alcohol	. 1 ,,	50 ,,
Water to	. 20 ,,	1,000 ,,

In a few minutes the film will be free at the edges, and it should then be carefully coaxed off the glass by means of a camel-hair brush and transferred to a dish of cold water. Slip under the released film a sheet of glass coated with gelatine solution made as already stated ; or use an unexposed dry plate that has been fixed and washed. Coax out any wrinkles with the camel-hair brush or by blowing, and allow to dry in a horizontal position. If the cracked negative has been varnished, all traces of the varnish must be removed before any attempt is made to remove the film. (*See* " Varnish, Removal of.")

It is possible to do without the collodion, and so simplify the work of transferring the film, but greater care will be necessary. Immerse the negative in 12 oz. of water to which 60 drops of hydrofluoric acid have been added, and after the film becomes loose at the edges, coax it off very gently in the manner already described. Wash for about ten minutes, at the end of which time the film will be enlarged considerably ; if required it can be left in the enlarged state, but otherwise it must be immersed in a solution of equal parts of water and methylated spirit until it has contracted to its original size. Then float it upon a gelatine plate as above described.

In the case of a cracked new negative the film may be removed by soaking for about thirty-six hours in a cold saturated solution of common washing soda ; all the after operations are as described in the preceding paragraph.

Cracked negatives other than gelatine are best treated as broken negatives (*which see*).

CRACKS IN VARNISH

Cracks upon varnished collodion plates are more common than upon gelatine plates. Negative varnish is essentially a gum or resin dissolved in a volatile solvent. When the varnish is spread over the surface of the film, the solvent evaporates and leaves a coating of the gum resin on the film ; as the resin dries it contracts and sometimes cracks. Circumstances that lead to cracking are (1) making the varnished negative too hot (either by heating for the purpose of hurrying the evaporation or by printing in a hot sun) ; (2) insufficiently washing after fixing ; (3) storing in a damp place ; and (4) using an unsuitable varnish.

Cracked varnish on a collodion negative may be remedied to an extent by rubbing finely-powdered lampblack, or soot, into the cracks by means of the dry finger-tip or a piece of chamois leather, and then revarnishing.

Cracked varnish on modern gelatine negatives may be treated in the same way, but it is better to remove the varnish entirely and then revarnish. To remove varnish, soak in the solvent which was used for the varnish ; if this is not known, methylated spirit may be tried, as most of the resins, etc., used for varnishes are soluble in spirit. After a good soaking rub with cotton-wool and give the negative one or two more soakings in spirit, so as to get rid of the last traces of the varnish. A little ammonia may be added to the second spirit bath with good effect.

CRAPE MARKINGS

A defect met with in wet collodion work, and taking the form of markings having the appearance of crape or fine net work. They are due to the use of too gelatinous collodion or a strong cadmium bromo-iodiser. Solvents too much diluted with water may also cause the defect.

CRAWLING

A developer is said to " crawl " when it does not flow evenly over the film, being prevented from doing so by the greasy surface caused by the faulty condition of the collodion bath ; crawling may also be due to an excess of alcohol in the developer. Printing paper is said to " crawl " when it expands or contracts during the progress of printing, as some papers are prone to do. If, for example, a bone-dry paper is put into a frame and placed out of doors in damp weather, the paper may expand during printing and cause blurred outlines of the image to appear. Damp paper put out to print under a negative on a hot day will sometimes show the same effect, through contracting while printing. The defect is more common with albumen paper than any other.

CRAYON ENLARGEMENT (Fr., *Agrandissement au crayon ;* Ger., *Stift-Vergrösserung*)

An enlargement usually on rough-surfaced bromide paper, worked up with crayons. The proportion of hand-work may vary greatly, from the mere removal of spots and blemishes to an elaborate amount. Much of the black-and-white work now seen on bromide enlargements is, however, done with the aerograph.

CRAYONS (Fr., *Crayons ;* Ger., *Stifte*)

Small pencils of pipeclay, kaolin, or chalk, incorporated with various mineral or metallic pigments, and used for drawing, working-up enlargements, prints, etc. They are obtainable in the form of chalks, as loose points for adjustable holders, or enclosed in cedar pencils. Those employed on enlargements are known as bromide pencils (*which see*). Coloured crayons are used for introducing backgrounds into carbon prints.

In process work, lithographic crayons, consisting of a mixture of wax, shellac, soap, and lampblack, are largely used. A wet-plate half-tone negative can be locally intensified by rubbing a crayon gently over the part where strength is desired. Half-tones can be stopped out for fine etching and vignetting by the use of the crayon wherever required. Lithographic crayons are preferred to black chalks for drawing on grained papers and scraper boards for reproduction, because the work is fixed, owing to its waxy or greasy nature, without further treatment.

CREAM OF TARTAR

A common name for acid potassium tartrate. (*See* " Potassium Bitartrate.")

CRESCO-FYLMA

A name given to a film-stripping and enlarging solution introduced in 1891, the patent on which has now, of course, expired. (For similar solutions, *see* " Film Stripping.")

CRISTOID FILM

A gelatine film introduced as a substitute for glass plates or celluloid, and consisting of two

coatings, the lower one being a slow emulsion and the upper one a fast emulsion. The chief advantage claimed was that errors in exposure were eliminated, because if the upper film was over-exposed a good negative would be obtained on the lower film ; also halation was entirely obviated. The film before development was treated with formaline, and, after the usual operations, squeegeed down to plate glass, a bath of alcohol and formaline being used to cause the film to contract to its original size. If this bath was omitted, the expansion of the gelatine due to the absorption of water during the operations of developing, fixing, and washing gave enlarged negatives.

CRITICAL ANGLE

The angle at which a ray passing through a transparent substance is totally reflected. If a thick plate of glass be held between the eye and a light the critical angle will be reached when the inner surface of the glass, either upper or lower, according to position, reflects as from a silvered surface.

CRITICAL ILLUMINATION

In microscopy, critical illumination is obtained by arranging the illuminant, mirror, and substage condenser in such a manner that the image of the lamp flame is seen in the centre of the field when looking through the microscope. Critical illumination is not practicable with low powers, but it is essential when obtaining the finest definition a lens which will give with high powers, and more especially when using the immersion lenses. Recent experiments have shown that critical illumination has been obtained when the back lens, on looking down the tube without an eyepiece, is just filled with light. Daylight cannot be used for critical work. The Nernst lamp is a convenient light for photo-micrography, but for visual purposes an oil-lamp with $\frac{1}{2}$-in. wick gives excellent results. The lamp, with the flame edgeways to the microscope, should be placed with the wick about 9 in. in front of the mirror, which must have the plane side turned to the light. The mirror is placed so that the light is reflected in a direct line through the substage condenser and objective. A diatom slide is placed on the stage and the substage condenser racked up and down till the image of the flame is seen in the centre of the field. If the eyepiece is now removed, the back lens should (providing the substage condenser is of sufficiently high aperture) be filled, or nearly filled, with light. That portion of the field of view only which contains the image of the lamp flame gives critical definition.

If the flame image is a disturbing factor to the work in hand, it can be removed by slightly lowering the condenser, but the definition suffers. Critical illumination is necessary only for powers of $\frac{1}{4}$ in. and upwards. Low powers should be worked without the substage condenser, and with the concave surface of the mirror turned to the light.

CROOKES' TUBE

The high-vacuum tube (named after the inventor) which produces the X-rays. In an X-ray tube the vacuum is brought to less than one-millionth of the density of the atmosphere. In the original Crookes' tube the cathodal rays were allowed to fall on the glass ; this was improved by Prof. Jackson, who caused the cathodal rays to fall on a metal plate connected with the anode (anti-cathode). Another improvement was the cupping of the cathode to allow all the cathode rays to fall on one spot on the anti-cathode, this arrangement constituting the "focus tube." (*See also* under the heading "X-ray Photography.")

CROSS FRONT (Fr., *Décentrement horizontal ;* Ger., *Kreuz-Objektivbrett*)

A provision for moving the lens of the camera sideways, so that a little more of the subject may be included at one side or the other, without having to shift the apparatus. It generally consists of a panel sliding in grooved rails, with a clamping screw to maintain its position when adjusted.

CROSSED LENS

A crossed lens is one having its two sides of a similar nature, either concave or convex, but

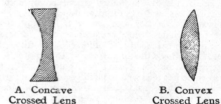

A. Concave Crossed Lens

B. Convex Crossed Lens

of different curvatures, as illustrated at A and B.

CROWN GLASS (*See* "Glass.")

CRYSTAL CUBE (Fr., *Cube de cristal ;* Ger., *Krystall Kubus*)

A stereoscopic device, invented by Henry Swan, depending on an application of the angle of total reflection of glass surfaces. Two rectangular glass prisms are ground to an angle of 39° or 40°, and are placed with their widest sides in contact, or nearly so. One of a pair of stereoscopic photographs is attached to one side of the prism combination, and the other behind. On inspection, the rays from the picture at the back of the glass are transmitted direct to one eye, while those from the second picture are reflected from the surface of the prisms where they touch to the other eye, and appear as if also coming from the back. The two pictures therefore coalesce, giving stereoscopic relief, the effect being as if a solid object were imbedded in the glass.

CRYSTAL MARKINGS (Fr., *Marques cristallines ;* Ger., *Krystall Bezeichnen*)

Crystalline or tree-like markings on or under the film of a collodion or gelatine negative. They are usually due to insufficient washing after fixing, and sometimes they do not appear till many days have elapsed.

CRYSTAL VARNISH

A particularly clear varnish, used mostly for lantern slides, autochromes, and other trans-

parencies. There are many different formulæ, and for lantern slides the following is one of the many suitable :—

Gum dammar .	. 125 grs.	52 g.
Benzole . .	. 5 oz.	1,000 ccs.

Apply this cold. For autochromes a stronger solution should be used, namely, 1 oz. of dammar in 5 oz. of benzole, and the plate should be warmed slightly before the varnish is poured on (*but see* "Autochrome Process," where a further formula will be found).

Equal parts of pale Canada balsam and rectified oil of turpentine make a good crystal varnish for maps and engravings, but for fixing pencil drawings 1 oz. of mastic dissolved in $6\frac{1}{2}$ oz. of rectified spirit is recommended. It is not advisable to use crystal varnish for negatives, shellac varnish being better. Another crystal varnish is that known as celluloid varnish, which is largely used for lantern slides. It is a solution of celluloid in acetone or other solvent.

CRYSTALLISATION (Fr., *Cristallisation;* Ger., *Krystallisation*)

A substance or salt when dissolved in water to saturation will gradually deposit crystals, or crystallise out if the water be evaporated. This is called "wet crystallisation." Sometimes a dry salt is fused and allowed to cool, when crystals will also form ; this is called "crystallisation by fusion." Again, a volatile salt may be heated, when it will go off in the form of vapour and crystallise on a cool surface ; this is "crystallisation by sublimation."

CRYSTALOTYPE

An old name for photographic transparencies upon glass, either in the form of lantern slides or larger plates for window decoration. It was the original English name, "hyalotype" being the American.

CRYSTOLEUMS

Photographs coloured to give the appearance of direct paintings upon glass ; known also as chromo-photographs. The system of colouring is about two centuries old, and, before the days of photography, engravings and prints were used as a base, the process being known generally as mezzotinto painting. The advent of photographic prints on paper did much to revive the interest in colouring processes. A modern crystoleum print properly finished looks, as is intended, like a painting upon glass, but actually a transparent photograph comes between the colouring and the glass. The diagram shows the construction of a crystoleum photograph. A is the front glass, on which a photograph B is pasted face downwards. When dry the photograph is made transparent, and delicate details coloured with ordinary oil colours, but the broad masses of colour are not put on. Another glass D, of the same size and shape as A, is put at the back, but is prevented from touching the photograph by means of strips of paper H, which leave a small space at C. On the back E of the second glass are painted the broad masses of colour. The whole is backed up with a piece of flat cardboard or other backing G, leaving a space F. When viewed from the front the colours

are seen through the transparent photograph, and the whole has the appearance of a delicately painted picture upon glass.

The working details are as follow : A suitable print is made upon albumen paper, which is the only photographic paper suitable, it being thin and tough. The print is placed in hot water until it becomes quite flaccid, and is then made surface dry by pressure between clean white blotting-paper. A piece of convexo-concave glass (flat glasses are not so suitable), sold specially for the purpose, is then made quite clean, and its concave side coated with clear starch paste or warm gelatine. The damp print is laid paper side downwards upon a flat piece of glass, and its face is coated with the adhesive selected. The print is then placed face downwards in contact with the inner (concave) and prepared surface of the glass, and pressed into close contact. The surplus paste must be removed from between the print and the glass, this being accomplished best by laying a piece of wet parchment over the back of the damp print, pressing out the adhesive with a knife handle or toothbrush handle. The paste must be expelled, also all air-bubbles, by a not too firm pressure, which must be worked always from the centre of the print to the extreme margin. When in perfect contact the parchment is taken away, the back of the print wiped free from any superfluous adhesive, and the whole put aside to dry thoroughly. The correct mounting of the picture is most important, as any errors will spoil the effect.

When dry the print must be made transparent, and this is accomplished in one of two ways—namely: (1) Rub the back of the print with glass-paper in order to remove as much of the paper as possible (the actual picture being, of course, underneath, next to the glass) ; a medium glasspaper is used at first, followed with a very fine one in order to remove all scratches, and to lessen the possibility of suddenly penetrating the actual picture on the albumen. When the bulk of the paper has been evenly rubbed away, the glass side of the picture is warmed before a fire, or over a gas-stove, and at the same time a piece of paraffin wax is rubbed on the paper side of the print, the object being to saturate the picture with warm wax. When the print appears equally transparent all over, all superfluous wax is removed with a piece of flannel and the picture allowed to cool. When cold the wax may be further polished, and if not evenly transparent it must again be glass-papered on the dense parts and waxed again. (2) The alternative process consists in leaving the paper print of its original thickness and making it transparent by rubbing into it a solution of $\frac{1}{2}$ oz. of Canada balsam in 3 oz. of either benzene or chloroform, the former being the cheaper. Another solution for the purpose is Canada balsam $2\frac{1}{2}$ oz., paraffin wax 1 oz.,

Section of Crystoleum

and white wax 1 oz., heated together and used in the same way as the wax in the first method.

Upon the print prepared as described all the fine details are now coloured, these including the lips, eyes, jewellery, etc. A finely-pointed sable brush is used, and ordinary oil colours slightly diluted with megilp. After the colouring, the second glass is put on at the back and bound by the edges to the first one to keep it in position. It must be as close as possible to the first glass, but not touching, and it may be kept from contact by sticking two or three thicknesses of stamp edging along the edges of the front of the second glass ; or a narrow strip of thin cardboard may be used in the same way. The colouring on the second glass may be very crude, the masses of colour being put on the back and care being taken not to overlap the outlines. No details or lights and shades are wanted, as they appear in the picture itself, but body colours only are wanted, these being mixed with a proportion of flake white. The colour already in the print must be considered ; consequently, to picture fair hair in a portrait, white tinted with yellow will serve. Upon viewing the picture from the front (holding it over white paper), one can easily judge whether the colouring is correct or not. If not, it may be corrected or removed with a rag and turpentine.

The final operation consists in attaching a piece of white cardboard to the back of the second glass and binding the whole together by means of narrow paper strips, and then framing. Fancy gilt frames are the most suitable, but obviously any may be used. Special solutions for mounting the pictures, making them transparent and colouring, and for preserving the transparency and colouring, are articles of commerce. P. R. S.

CUPRIC

An adjective derived from *cuprum*, the Latin word for copper. (*See* " Copper.")

CUPROTYPE

A printing process invented in 1857 by C. J. Burnett, of Edinburgh. It was on the lines of the ink process (*which see*), copper chromate (*cupric* chromate) being used.

CURVATURE OF FIELD (Fr., *Courbure du champ* ; Ger., *Bildwölbung*)

Synonym, aberration of form. A defect in a lens whereby the image of a flat object does not

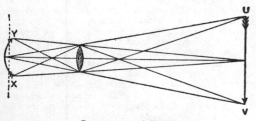

Curvature of Field

lie on a plane surface, but on a curved or saucer-shaped one. Thus, as shown in the diagram, the rays forming the image of the arrow U V render it in space at Y X as curved instead of straight, the result being that if the centre of the image is focused the margins will be out of focus, and vice versa. Curvature of field must not, however, be confused with curvilinear distortion (*which see*)—a not uncommon mistake—for the arrow will be shown as straight on the focusing screen, although of unequal definition along its length. When a lens is subject to curvature of field the best result is obtained by focusing for a point midway between the centre and the margins of the picture, as shown by the dotted line, and using a small stop. Curvature of field may be reduced in compound lenses by increasing the separation, but only at the expense of astigmatism. The introduction of the new Jena glasses has rendered it possible to obtain lenses at once free from astigmatism and possessing a flat field.

CURVILINEAR DISTORTION (Fr., *Distorsion* ; Ger., *Verzeichnung, Distorsion*)

An aberration occurring in a single lens, whether consisting of only one glass or of several cemented together, which causes straight lines at the margins of the picture to appear curved. If the diaphragm C is in front of the lens, as in A, the image of the square D shows " barrel-shaped " distortion ; while when it is behind the lens, " pincushion " distortion is present, as in B. The barrel distortion is usually considered less objectionable, and all single lenses are now fitted with the diaphragm in front. Distortion decreases as the focal length of the lens becomes

Barrel-shaped Distortion

B. Pincushion Distortion

greater, being most apparent in short-focus objectives. It is obviously objectionable for architectural work, or anything requiring accurate reproduction of straight lines. The position of the stop has an important influence ; if it is brought nearer to the lens distortion is reduced, but, unfortunately, at the expense of definition. Curvilinear distortion is completely cured in doublet or " rectilinear " lenses by placing the stop in the centre between the two combinations, when one kind of distortion neutralises the other. It is owing to this fact that distortion in a negative may be corrected in enlarging, if the same lens is used as the negative was taken with ; for in the enlarging lantern the previous position of the stop is reversed, coming between lens and image (enlargement), instead of between lens and object, which in this case is the negative.

CUTCH (See " Catechu.")

CUT-OUT MOUNT

A sheet of cardboard in which an opening—rectangular, circular, oval, etc.—has been cut, generally with a bevelled edge. The print is mounted on a second board, which is placed behind the other. This method of mounting is more generally employed for drawings and sketches than for photographs.

CUTTING

A term used in connection with the sharpening up of the dots in making half-tone negatives, as referred to under many separate headings. (See, for example, " Clearing Solutions.")

CUTTING SHAPE, OR MOULD (Fr., Calibre; Ger., Beschneidegläser)

A template used to guide the cutting knife in trimming prints. It is commonly made of plate glass, though zinc and other metals are occasionally employed. Cutting shapes are obtainable in all sizes, and may be square, oblong, circular, oval, etc. Curiously enough, it is difficult to get a rectangular glass cutting shape with absolutely true and parallel sides. This, combined with the unfortunate ease with which the shapes slip, even in practised hands, together with their liability to get broken or chipped, no doubt explains the growing popularity of guillotine cutters and print trimmers. Cutting shapes with the lower side ground are less slippery than those of plain glass.

CYANIDES

Salts formed by the combination of a metal with the radicle CN. An example is potassium cyanide, KCN.

CYANINE (Fr., Cyanine; Ger., Cyanin)

Synonyms, cyanine iodide, quinoline or chinoline blue, diamylcyanine. $C_{29}H_{35}N_2I$. Molecular weight, 544. An aniline dye obtained by the action of caustic potash on an alcoholic solution of lepidine-iodo-amylate and chinoline-iodo-amylate. It was for some years the only practical red sensitiser known, but its action was extremely uncertain and its sensitising power weak, and it has been entirely superseded by the newer isocyanines. It occurs in monoclinic crystals having a green metallic lustre, and gives a rich blue solution in water and a more reddish one in alcohol. The aqueous solution is extremely sensitive to light. Cyanine bromide, chloride, sulphate, and nitrate can be prepared by treating the iodide with the respective silver salts but they act in the same way as the iodide.

CYANOFER AND CYANOGRAPHIC PROCESS

Names sometimes given to the Pellet process (which see).

CYANOGRAPH

A photographic device for recording the blue light in the atmosphere; invented in 1903 by Maillard and Reiss, of Belgium. The apparatus consists of a driving clock which, at regular intervals, unrolls a short length of a band of sensitive paper, on which is made an exposure, a suitable blue filter being interposed. It has been used chiefly for attaching to captive balloons for the purpose of testing light in high altitudes. In X-ray photography a piece of card is used as a filter, and the rest of the apparatus enclosed in a lead casing.

CYANOTYPE PROCESS, NEGATIVE (See " Blue-print Process.")

CYANOTYPE PROCESS, POSITIVE (See " Pellet Process.")

CYCLOGRAPH (Fr., Cyclographe; Ger., Cyklograph)

A panoramic camera designed by A. H. Smith, by which the whole outer circumference, or any portion, of a cylindrical object—such as a vase—may be photographed on a single flat plate. The object is supported on a circular platform, which is made to roll along a straight guiding surface at a right angle to the axis of the lens, so that as it moves forward it also revolves, like a carriage wheel advancing. This is, in fact, making use of the principle of a cycloidal rotation. At the same time, an opaque screen having a narrow vertical slit is made to travel on a parallel path at a speed proportionate to that of the object, in such a manner that each successive portion of the object is exposed to the lens when nearest to the straight surface—or, in other words, when it is at the cusp of a cycloid, and its movement is consequently infinitesimal.

The name cyclograph is also given to a panoramic camera invented by Mons. Damoizeau, which turns in a complete circle, so that the entire horizon, or the inside of a circular building, may be photographed. A band of film is employed, and several circles may be taken in succession on the same band if required.

CYCLE, CAMERA ON

There are many opinions as to which is the best plan of carrying a camera on a cycle, much depending upon the size of camera and amount of apparatus it is desired to carry. Many of the pocket and folding cameras need not be considered, as they go into the pocket and do not inconvenience the rider in any way; but it is advisable to carry them in an inner pocket rather than an outside one, chiefly to protect them from road dust. A favourite method of carrying larger and unpocketable cameras is to strap them firmly to the middle of the back of the rider; very broad shoulder-straps will be found less tiring than narrow ones. If the camera is not held firmly it may work round under the arm, and cause considerable inconvenience when riding, and possibly an accident when dismounting or turning a corner. Commercial carriers are made to fix either in front of the handle bars or behind the saddle. Front carriers are to be preferred, as the camera is then always in sight; if placed behind the rider, it is apt to be forgotten when dismounting, and the rider may be thrown. Cameras when carried on a cycle should always be wrapped in a waterproof focusing cloth or other covering, or be enclosed in a proper bag or case, in order to protect them from road dust, which otherwise

will cause pinholes on the negative, and possibly interfere with the working of the shutter and plate‑changing mechanism. Tripods may be strapped to the handle-bar, on the fork of the machine, etc. ; some individuals prefer to strap them under the flap of the case, which rests on the front carrier, and attach the projecting ends to the handle-bars.

CYCLOL

A one-solution developing mixture introduced in 1892, and consisting of rodinal, eikonogen, and hydroquinone. (*See* "Developers, Mixed.")

CYLINDERS, GAS

Annealed steel cylinders, tested hydraulically to withstand a pressure of 3,000 lb. per square inch, and charged with compressed gas—oxygen, hydrogen (generally, coal-gas), dissolved acetylene, etc. Periodical re-annealing is necessary, and the gas compressing companies will not take the risk of filling cylinders unless their regulations in this connection are complied with. The construction of the valve is such that all dust and grit should be prevented from entering it ; and therefore before connecting the fittings the valve should be opened for an instant so that the rush of gas may dislodge anything in the way. Cylinders of compressed gas are used by the lanternist, who must become familiar with

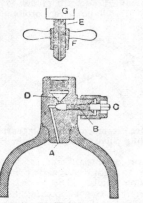

Section of Cylinder Valve and of the Stem
and Adapter of Fitting

the working of the valve, a cross section of which is shown in the illustration. The valve is screwed into the cylinder, the gas from which leaves by the narrow passage A when the spindle B is slightly withdrawn by turning its squared portion C by means of a key ; the gas passes to the lantern fittings through the inverted cone D. The gas-tight joint with the automatic regulator or reducing valve (one of these is necessary to reduce the pressure of the gas and provide a convenient means of attaching the rubber tubing), is made entirely by mechanical means, and all daubing of the screw threads with soap, grease, red-lead, etc., must be strictly avoided ; accidents have been caused in this way. The stem E of the regulator or reducing valve is itself threaded, and has an adapter F upon it. Screw this adapter close to the shoulder G of the fitting ; without any rela-

tive movement between stem and adapter, screw the latter into the cylinder valve ; in this way the cone on the end of the stem will go home into the inverted cone D of the valve. When it can go no further, it may be found necessary to undo the fitting by, say, the third of a turn, and then screw the adapter in as far as it will go. Cylinders and fittings for oxygen are frequently painted black, and for hydrogen red ; on the former the screw threads are right-handed, and on the latter left-handed. (*See also* "Limelight.")

CYLINDERS, LIME

Cylindrical pieces of lime, small portions of the surface of which are heated to brilliant incandescence by a flame supplied with oxygen under pressure. Limes are sold packed in tins, but those put up singly in sealed glass tubes are the most generally convenient. They rapidly disintegrate when exposed to air. The chief point in their use is to turn them frequently to prevent deep pitting. (*See also* "Limelight.")

CYLINDRICAL PERSPECTIVE

Photographs taken with cylindrograph or other panoramic cameras of the half circle form are said to be in cylindrical perspective. (*See* "Cylindrograph" and "Cylindroscope.")

CYLINDROGRAPH (Fr., *Cylindrographe* ; Ger., *Cylindrograph*)

A panoramic camera invented by Captain P. Moëssard, in 1889, with which photographs embracing an angle of 170° may be taken on a celluloid film bent to a semicircle. The film holder or dark-slide is flexible, so that it adapts itself to the required form when inserted in the camera. The lens is made to rotate on a vertical axis passing practically through its optical centre ; while a tube terminating in an upright slit near the surface of the film is rigidly attached to the lens setting. When a lens is swung on its optical centre the image remains stationary ; the various portions of the semicircular film therefore receive the parts of a continuous picture, while the moving slit ensures that only that part directly opposite the lens is exposed as the latter moves. This form of camera has been of much value in photographic surveying, for vertical lines may be ruled at regular distances apart on the photograph, to indicate the relative angular positions of the different objects on a horizontal plane ; or a glass ruled with similar lines can be laid on the photograph for the same purpose. To inspect the views in correct perspective, an instrument known as the cylindroscope (*which see*) is employed.

A panoramic camera on much the same principle was designed by Marten, of Paris, in 1845, for use with curved daguerreotypes.

CYLINDROSCOPE (Fr., *Cylindroscope* ; Ger., *Cylindroskop*)

An instrument designed by Captain P. Moëssard for the inspection or exhibition of panoramic views obtained with his cylindrograph camera (*which see*). The print is curved to a radius agreeing with that occupied by the film in the camera, and the point of view is in the centre, a suitable eye-lens being used if necessary.

D

DAGUERRE, LOUIS JACQUES MANDÉ

Born at Cormeilles, a village near Paris, November 18, 1789; died July 10, 1851. Inventor of the diorama (1822) and of daguerreotypy (1838). He began his photographic experiments about 1824 by unsuccessful attempts to fix the images in the camera obscura; his neglect of his diorama and scene-painting business caused his wife to seek advice with regard to his sanity. In December, 1829, he entered into partnership with Niepce, who for fifteen years had been working on the same subject, and who had made some important discoveries which he now shared with Daguerre. The two worked together up to the time of Niepce's death (1833), when Isidore Niepce took the place of his father. Five years after the death of the elder Niepce, Daguerre accidentally discovered the process which bears his name, and in the same year (1838) made an unsuccessful attempt to form a company to work the process. In July, 1839, Daguerre divulged his secret and published the process at the request and expense of the French Government, who awarded him a life pension of six thousand francs on the condition that the process should not be patented; notwithstanding this condition, a patent was taken out in England in 1839. Daguerre wrote *Historique et Description des Procédés du Daguerréotype et du Diorama* (1839), and *Nouveau Moyen de Préparer la Couche Sensible des Plaques Destinées à Recevoir les Images Photographiques* (1844).

DAGUERREOTYPE PROCESS

The earliest commercial photographic process, the invention of Louis Jacques Mandé Daguerre. By its means a photographic positive image is produced on a polished silver surface. It was published in France, in July, 1839, and during the next twelve years attained great popularity, but the introduction of Frederic Scott Archer's wet collodion process, in 1848, soon had the effect of rendering the older process obsolete, and it is now not practised except experimentally. Being the first in the field, extreme interest naturally attaches to it, and it has been thought desirable to explain its working in detail.

Daguerre's process, as slightly modified in details by the inventor in the course of its commercial practice, is the one here described, it being impossible in the space at command to discuss the many modifications introduced by other experimenters during the ten or twelve years following 1839. Briefly, a daguerreotype photograph is an image formed by mercury vapour upon a silver-coated copper plate. The process comprises five operations, namely, cleaning and polishing the silvered plate, sensitising, exposing in the camera, developing, fixing and finishing. The sheet copper was silvered either electrically or mechanically. In England, as a rule, Sheffield plate was employed, this being made by soldering silver to copper to form an ingot and then rolling to the required thickness. The most perfect polish upon the silvered surface was necessary, and to obtain this it was cleaned with weak nitric acid and polished with pumice powder, tripoli, and olive oil, the final polish being applied with buffs made of velvet, the plate having been previously heated to drive off the oil. For the purpose of heating during polishing, the plate was supported upon an iron wire frame A, and heated with a spirit lamp. It was essential to obtain a high polish, and dozens of methods of securing this were suggested.

The second operation, sensitising, was modified quite a number of times. In Daguerre's original plan the plate was subjected to fumes of iodine, until it assumed a definite golden yellow. If the action of the iodine was prolonged, a violet

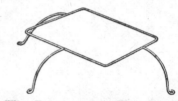

A. Wire Frame used by Daguerre for Supporting Silvered Plate While Polishing

colour was produced, and this was much less sensitive to light. Daguerre's iodising box B had double walls. The vessel of iodine H had over it a ring supporting a piece of wire gauze. The small lid J was in position only when the box was not in use. The plate to be iodised was attached to the underside of the proper lid K; the lid L enclosed the whole. The sensitising took a long time, as the crystals of iodine had to remain in their natural state, and must not be heated because of the possibility of moisture condensing upon the plate. The vapour caused silver iodide to be formed on the silver plate, which was then sensitive to light. Although Daguerre appeared to be satisfied with plates prepared in this way, many other photographers tried to increase the sensitiveness. Goddard, for example, in 1840 exposed the iodised plate to the action of bromine vapour, thereby forming silver bromide upon the plate in addition to the iodide; and in 1841 Claudet used chlorine vapour in the same way; either of these modifications reduced the exposure by about four-fifths. Bingham followed with bromide of lime, which for a time was widely used. These accelerators caused the yellow film to assume

other hues, and in each case the plate was put back again to the iodine fumes until it assumed a rosy hue.

The third operation was that of exposing the plate in a camera (for Daguerre's instrument, *see* "Camera"), and, as in the case of modern dry plates, the time of exposure depended upon the actinic value of the light, etc. Daguerre's times of exposure in Paris, and with plates prepared simply with iodine, are said to have been from five to thirty minutes; objects in shadow, even in the brightest weather, required twenty minutes at least. The daguerreotype plate, however, in its modified form needed only from five to thirty seconds, according to subject, light, etc. It was not an uncommon practice, when Daguerre's original process was used, to whiten the face of the sitter by means of powder in order to shorten the exposure for the face; then, in order to bring out the details of the dark objects, such as the dress, a piece of black cloth attached to a long stick was held in front of the sitter's face during the time the extra exposure was given to the dress.

An obvious defect in a daguerreotype picture

B. Daguerre's Iodising Box

taken in an ordinary camera was that the image was reversed, exactly as in a ferrotype (or tin-type) portrait. To obviate this, it was necessary to reverse the image by means of a mirror attached to the lens, thus increasing the already lengthy exposure by about one-third.

The fourth process was that of development, or "mercurialisation" of the image on the exposed plate. The latter was taken into the dark-room and placed in a dark box C in such a way that the surface was suspended over a saucer of mercury heated to a temperature of about 140° F. (60° C.). The box had under its bottom a lamp M, which heated a dish of mercury in which was a thermometer N. The plate P, as removed from the camera, was held in a grooved blackboard Q, where it could be viewed through the glass panel R. The lid of the box is shown by S. The fumes of the mercury "developed" the image in the course of about twenty minutes. The final operation consisted in removing the unused iodine from the plate of silver in order to prevent the further action of light. A saturated solution of common salt was first used, and later a weak solution of sodium hyposulphite. The developed plate was

placed in filtered rain-water for a second only, and then immersed in one of the fixers just named until the yellow colour had quite disappeared; warm distilled, boiled, or filtered rain-water was then allowed to run in a stream over the plate in order to wash it. The shadows were represented by the polished surface of the silver, and the lights by the adhering and very delicate film of mercury, which, if fingered in any way, would be wiped off. Therefore, in order to preserve the pictures, they were placed under glass and the air excluded. In some cases the picture was treated with a solution of gold and sodium hyposulphite, which brought out the details with greater force and brilliancy. This idea was originated in 1840 by Fizeau, of Paris, who used a solution of 7 grs. of gold chloride in 10 oz. of distilled water, this being mixed with a solution of 30 grs. of sodium hyposulphite in 4 oz. of water.

The expense of the silvered plates was a

C. Daguerre's Developing or Mercurialising Box

great drawback to the daguerreotype process. As late as 1853, the price charged for a quarter-plate daguerreotype portrait was fifty shillings, and for a half-plate eighty shillings. It was the custom to "improve" daguerreotype pictures by colouring them. Colours ground extremely fine were used and dusted on dry with a fine camel-hair brush, the process needing great care, as it was almost impossible to remove any of the colour applied. When the colours were on they were breathed upon to make them adhere. Claudet's method was to mix the colours with alcohol, and apply cautiously with a soft brush, and to dust on dry colours if the liquid colours were not dark enough. The colours chiefly used were gold, carmine, chrome yellow, and ultramarine, by combining which any desired tint could be obtained.

Major-General Waterhouse has found that daguerreotype plates can be developed with a wet collodion (physical) developer to give a

positive image as usual, or with an alkaline developer, or with ferrous oxalate, to give a negative image. If before exposure the plates are treated with an alcoholic solution of erythrosine, they show sensitiveness to the less refrangible end of the spectrum. Copper plates sensitised with iodine and bromine yield images if exposed and developed with ferrous oxalate or an alkaline developer, and the results are fairly certain.

DAGUERREOTYPES, CLEANING AND RESTORING

Cleaning and restoring a daguerreotype picture is at all times a risky process, and should not be attempted unless the worker is particularly careful and patient. Many methods have been advocated, but they all need care and thought, and rather than run the risk of ruining a picture it is better for the uninitiated to leave the work alone. It must be remembered that daguerreotypes are valuable relics, and that comparatively few modern photographers know how they were made. The pictures become indistinct and dull, not by fading, as the modern photographer understands it, but as a result of the oxidising influence of the atmosphere, which has been unwittingly allowed to act upon them, either because the hermetic sealing was imperfectly executed, or because it has become broken away. In this article is described the method of cleaning and restoring that is considered to be the most reliable, but before any attempt is made to improve the picture the processes by which it was produced should be thoroughly understood (see " Daguerreotype Process "), the restorer will then know the composition of the photograph. This photograph consists of a most delicate film on the surface of a silvered plate, not varnished or protected in any way, and susceptible of injury from any rubbing or abrasion. Flicking off the dust with a silk handkerchief, or lightly touching the surface with the finger or a camel-hair brush, may ruin the picture. The operator must first try to ascertain whether the picture is in its original state, and whether there has been an earlier attempt to clean or restore it, because should certain chemicals have been left in the film the picture may be ruined when others are applied.

The usual and best method of restoring a faded or discoloured daguerreotype is as follows : Take out the plate from the frame and immerse the discoloured picture in a 1 per cent. solution of potassium [cyanide in distilled water, carefully rocking the dish until the milky or smoky appearance caused by oxidation disappears. If the cyanide solution is not strong enough it may be strengthened, but particular care must be taken to use the purest of distilled water, and not to touch the picture with any solid substance, even with cotton-wool. As soon as the discoloration (oxidation) has vanished, the plate must be gently but thoroughly washed in several changes of distilled water, avoiding ordinary water. Finally, it is dried by gentle heat in an atmosphere as free from dust as possible, and in nine cases out of ten the simple treatment will have restored the picture and made it almost, if not quite, as good as new.

If, however, the restored picture lacks brilliance and detail, it may be redeveloped, but as the latter process is particularly risky it should be attempted only in extreme and very bad cases. Redevelopment is done by exposure to the fumes of mercury, and not by the application of any liquid. Procure an air-tight box about 3 ft. high ; at the bottom place a small spirit lamp, and over it a saucer of pure metallic mercury. Carefully fix the plate to be redeveloped to the lid of the box in such a way that the picture is face downwards when the box is closed. Close the box so that the picture may be exposed to the fumes of the mercury, and examine every minute to see how development progresses. When all detail is restored, remove the plate. Care must be taken during this process not to inhale the fumes, as they are poisonous. Lay the redeveloped plate on a piece of clean, clear glass, and bind the edges with silk strips, using Canada balsam as an adhesive ; this binding must be done thoroughly in order to exclude the air. Redevelopment is rarely necessary, and is to be avoided on account of the risk to both plate and operator.

DAGUERREOTYPES, COPYING

Daguerreotypes are difficult to copy satisfactorily because of the character of the image and the presence of the silvered plate. They must be illuminated by a strong sidelight, all other light being cut off, and the surroundings should be dead black, in order to prevent reflec-

Method of Copying Daguerreotype

tions. Professional copyists place the daguerreotype picture inside a deep box lined with velvet, black cloth, or painted a dead black, with a hole cut in one end, through which the camera lens peeps. At the end nearest the picture, part of the side of the box is cut away in order to admit the sidelight, which light should preferably be strong sunlight. As a general rule, the picture should lie on its side, with its top edge facing the direction of the light, because the marks of the buffer sometimes show upon the original picture, and as these lines run from top to bottom they would be accentuated by a light striking them at right angles. Focusing, stop, exposure, plate, etc., are the same as for ordinary copying, the whole secret of daguerreotype copying being in the arrangement of lighting.

DAGUERREOTYPES, ELECTROTYPING

(Fr., *Electrotypage des daguerréotypes ;* Ger., *Galvanoplastik der Daguerreotypen*)

The daguerreotype plate to be electrotyped is immersed in an acidified copper sulphate solution, as employed by electrotypers, and is connected by means of copper wires to an electric battery or other source of current. A sheet of soft copper is placed in the solution to form the anode, this being also connected to the

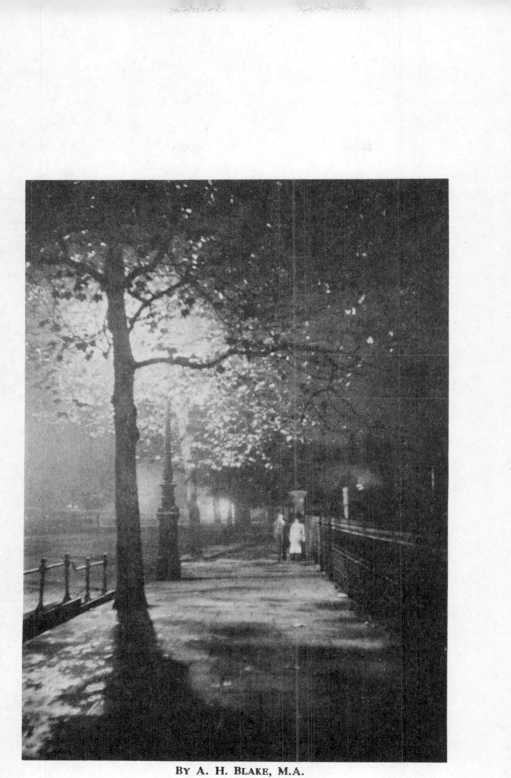

BY A. H. BLAKE, M.A.

NIGHT PHOTOGRAPHY

battery. A fine coating of copper is thus gradually deposited on the daguerreotype, but the relief obtained is naturally very slight.

DAGUERREOTYPES, ETCHING (Fr., *Gravure des daguerréotypes à l'acide chlorhydrique*; Ger., *Aetzen der Daguerreotypen*)

A process for obtaining intaglio plates from daguerreotypes, suitable for photogravure printing, was introduced in 1840 by Sir W. R. Grove the inventor of the Grove cell. The daguerreotype was immersed in a solution of one part of hydrochloric acid to two parts of water, and attached to a wire from the battery, which consisted of a pair of Grove cells. Opposite the daguerreotype, and about 2 in. away from it, was placed a platinum plate connected with the other pole of the battery. On the passage of the current, an oxychloride of silver was formed, and at the expiration of about thirty seconds the etching was complete. The oxychloride having been removed, the plate was ready for printing from in an ordinary press. The results obtained were, however, too shallow for anything but very delicate work, and proved unsuitable for commercial use. In 1843 A. J. F. Claudet patented a method of etching the daguerreotype plate with acid, but the specification is by no means clear.

DALLAS RUBBER-TYPE

An invention of Duncan C. Dallas, comprising the making of a swelled gelatine relief, and from it a plaster cast, the cast forming the mould for a vulcanised indiarubber cast to be used as a stamp, or in a press.

DALLASTINT, DALLASTYPE, ETC.

Duncan C. Dallas was the inventor of a number of processes based on the swelling of gelatine, when sensitised with bichromate and exposed to light. Dallastint was a process in which the half-tones of a photograph were reproduced by causing the gelatine to reticulate into a grain resembling that produced in the collotype plate. The effect was similar to that of aquatint, and it was capable of rendering fine detail and delicate gradation of tone. However, the process never came into practical use, and the details were kept secret. The inventor claimed that the process could also be used for decorative purposes by transfer to pottery, stone, wood, etc., and for printing on calico, linen, and other textile fabrics.

Chromo-Dallastint was an adaptation of the Dallastint process to colour printing by making blocks for each colour.

Dallastype was a process proposed for making relief blocks for typographic printing. The inventor made half-tone blocks, and used a ruled screen instead of, or sometimes in combination with, his reticulated grain. The blocks were made of type metal, evidently cast in plaster moulds taken from the gelatine relief.

DALLMEYER, JOHN HENRY

J. H. Dallmeyer (born 1830, at Loxten, near Versmold, Prussia; died off the coast of New Zealand, 1883) came to England in 1851 and entered the workshop of W. Hewitt, optician,

afterwards working for Andrew Ross. He started in business for himself in 1859, and in 1862 came to the front as a manufacturer of photographic lenses. He made many improvements in telescopes, and patented a single wide-angle lens (1864) and a lantern condenser. He married Hannah, daughter of Andrew Ross, was elected F.R.A.S. in 1861, and retired from active work in 1880.

DALLMEYER, THOMAS ROSS

T. R. Dallmeyer, son of J. H. Dalmeyer, born 1859; died December 25, 1906. Designed many important optical instruments, lenses for telephotography being perhaps the most important. Among his inventions are a rapid triple cemented landscape lens and a rapid rectilinear landscape lens. He was a prominent member of the Royal Photographic Society, and President of that body from 1900 to 1903.

DALLMEYER - BERGHEIM LENS (See "Bergheim Lens.")

DAMMAR (See "Gums and Resins.")

DAMMAR VARNISH

Gum dammar dissolved in benzole, chloroform or turpentine makes a clear varnish, which may be used cold and applied, if necessary, with a brush. It is particularly suitable for film negatives, transparencies, etc. (For formula, *see* "Crystal Varnish.")

DAMP, PRECAUTIONS AGAINST

Damp plays havoc with apparatus and sensitive material, which should always be stored in a dry, airy place. Camera bellows become mouldy in a damp place, lenses spotty, cameras may come to pieces, and dark-slides refuse to fit or draw out, and shutters to work. Preventives are obvious. Where possible, it is advisable to use, for home-made articles, a glue that has been damp-proofed by mixing with it while hot one-quarter its bulk of linseed oil, stirring rapidly during the addition. The addition of 1 part of potassium bichromate dissolved in the least quantity of water to 6 parts of melted glue, made with as little water as possible, makes a waterproof cement, which must be stored in the dark until required for use. A precaution against damp is to have cameras and dark-slides brass-bound. Dampness in a darkroom may cause the detachment of labels from the bottles of chemicals, unless these labels are protected by a coat of waterproof varnish extending over their edges upon the glass.

Plates and papers deteriorate quickly if not kept dry; and if damp is suspected they should be kept in a cupboard or in drawers, with some calcium chloride in a tin, either without a lid or with a perforated one; the chemical absorbs moisture, and when it becomes wet it may be dried on a hot shovel or in an oven and used over and over again.

Damp must also be guarded against while printing, as damp paper will probably spoil any negative with which it is placed in contact (*see* "Silver Stains"). When printing is carried out in wet weather, and there is a likelihood of the paper absorbing moisture, it is advisable to use

11

a pad of waterproof sheeting between the back of the paper and the frame back, or pads of blotting-paper may be used if dried before a fire after taking each print. Such a precaution is particularly necessary when P.O.P or platinum paper is used; and in very wet weather such papers may with advantage be dried before a fire previous to printing.

Carbon paper (tissue) is insensitive when wet and sensitive when dry; but it is not generally known that the film is insensitive when in a state of absolute dryness amounting to complete desiccation.

The walls—plain or papered—of dark-rooms or work-rooms where photographic material is stored may with advantage be covered with a waterproof varnish formed of naphtha and shellac, in the proportion of ¼ lb. of the former to 1 quart of the latter. The smell of the mixture is unpleasant, but soon wears off, and the wall is covered with a hard coating utterly impervious to damp, and to which wall-paper may, if desired, be attached.

A wooden erection used as a studio, dark-room, or store-room, can be given a waterproof coating with tar, which is as effective as, and cheaper than, anything else. The following is also suitable, and can be applied with a brush: equal parts of pitch and resin melted together in a bucket over a stove, and then, after removal, thinned with petroleum ether or paraffin oil. The fire risk in preparing this stuff is considerable, and the job should be done in the open air.

DANSAC-CHASSAGNE COLOUR PROCESS

A process of obtaining prints in natural colours, which was introduced in 1897, and originally said to be based on the selective absorption of the silver image for the colours used. On critical examination it proved to be nothing more than local painting with solutions of aniline dyes in albumen.

DARK-ROOM, OR DEVELOPING CHAMBER (Fr., *Laboratoire;* Ger., *Dunkelzimmer, Dunkelkammer*)

A room or cupboard devoted principally to the operation of development, and from which all white or actinic light is excluded. Until A. J. F. Claudet patented, in the 'forties, the use of coloured media, preferably red, the developing chamber was really in total darkness; but since then the name of "dark-room" has been somewhat of a misnomer.

The old idea that space is unimportant in the room used for developing is quite erroneous, particularly with respect to efficient ventilation, so necessary to the health and comfort of the operator. It is obvious, also, that greater convenience is secured when there is plenty of room for shelves and benches, and for moving about. Daylight, owing to its constant fluctuation, is not recommended, and does not add to the safety of the developing chamber, since sunshine or bright light tends in time to bleach non-actinic fabrics and materials, and mischief may be done before this is noticed. It is preferable to block out all daylight and to rely entirely on artificial illumination. It is now realised that, provided the colour of the light is carefully chosen to match that region of the spectrum to which the particular plate employed is least sensitive, a much better illumination is permissible with safety than was at one time imagined, so long as the plate is not unnecessarily exposed to the direct rays from the lamp. The old-style dark-room, where the operator fumbled uncertainly in a dim, ruby glimmer, knocking over bottles and breaking glass measures in his inability to see a foot before him, is rapidly giving way to saner arrangements. In a properly designed developing chamber some means should be adopted for preventing the admission of light when the door is opened. One way of doing this is to have a double door, as indicated in the illustration which shows how a room 12 ft. by 8 ft. may be fitted up as a dark-room. Another way is to curtain off a kind of alcove in front of the door, using a heavy opaque material.

An abundant and pure water supply is an important consideration if much work is to be done. Iron pipes should be avoided, as rust is objectionable in dealing with some sensitive surfaces. If a constant supply cannot be had, a portable tank with a tap or siphon, or even a couple of large pails, may be used. Swing rose

Plan of Fitted Dark-room

taps should be fitted if possible; ordinary taps are more troublesome, giving too forcible a jet and having a marked tendency to splash. But if an ordinary tap is provided as well, for use in filling bottles only, added efficiency is gained. The more shelves that can be fitted the better. Those which will hold the bottles or articles most frequently in use should be low down and well within reach. A small cupboard, with drawers to hold unexposed plates and papers, will be found extremely useful.

When a room cannot be kept permanently for developing, a bathroom, or even a cupboard, may be adapted temporarily for the purpose. If the work is done at night, and no outside lamps are near, there will be no need to obscure any windows that may be present; otherwise a wooden frame may be made to fit closely in the opening, and covered with any opaque or non-actinic fabric. This is readily removable when not in use, and may be replaced in a few seconds. Portable dark-rooms of various kinds are obtainable, and some of these fold into a very small space. (*See also* "Dark-room Illumination," "Dark-room Lamp," "Dark-room Ventilation," "Developing Bench," etc.)

DARK-ROOM CLOCK (*See* "Clock, Dark-room.")

DARK-ROOM ILLUMINATION

The colour of the light used for dark-room illumination is important, both as regards its purity and its general character. For ordinary negative work a pure red, that does not allow any blue rays to pass, is best, and for bromide printing a golden yellow or orange will give sufficient safety with comfort in working. For most colour-sensitive plates a pure deep red is best; but for some that are very sensitive to red a special screen for the dark-room lamp is sold by the makers of the plates. For all ordinary plates and papers the best method for working satisfactorily is to light the dark-room brilliantly, sufficiently well for seeing all bottles, measures, plate boxes, etc., clearly and distinctly. Unless there is sufficient light for working in comfort, inferior results are inevitable. The room should be lighted well, but the plate should be shielded or protected from the direct rays of the lamp, both in filling the slides and during development. The plate may be brought near the lamp the insertion of glasses or fabrics of different colours according to the work in hand. With transparent glass a good deal of light is often wasted; lamps with fabrics capable of diffusing the light, or fitted with sheets of ground glass or opal in addition, for the same purpose are to be preferred, as the room is then more comfortably and uniformly lighted, and the bench, shelves, etc., are more readily perceived. For temporary use, as when travelling, a folding lamp A burning a candle or night-light is convenient; but for constant work candles are troublesome and uncertain. Oil lamps are fairly satisfactory, if fitted with the wick adjustment outside, as in B, and kept scrupulously clean; but gas and electricity are the only forms of illumination that can really be recommended. From the facility with which it may be raised or lowered, gas is perhaps the best of all, if perfect ventilation is secured; and a good pattern of gas lamp is shown at C. A lamp for use with electricity is illustrated at D; hanging electric lamps are also obtainable. The worker should be warned that many of the red incandescent electric bulbs in the market are unsuitable for

A. Folding Candle-lamp

B. Oil-lamp with Outside Wick Adjustment

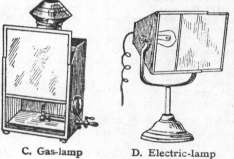

C. Gas-lamp

D. Electric-lamp

for a few seconds, when necessary, for examination, but otherwise should be shielded as much as possible. It is not necessary to cover the dish, as the light reflected from the walls has very little power; but the dish should be 2 ft. or 3 ft. from the lamp and shielded from the direct rays. Artificial light is very much safer for dark-room illumination than daylight, and should always be used when convenient.

DARK-ROOM LAMP (Fr., *Lampe de laboratoire*; Ger., *Dunkelzimmerlampe*)

On the satisfactory working of the dark-room lamp depends much of the operator's comfort when developing, while the "safety" of the light emitted is an important consideration. This is qualified to a great extent by the kind of plate or paper that is being used, and its particular region of colour sensitiveness. Thus, for wet collodion plates an amber-coloured glass may be used; for bromide paper, one or two thicknesses of yellow fabric; for ordinary plates, one thickness of orange fabric and two or three thicknesses of yellow, or an amber and a ruby glass together; while for orthochromatic plates a very deep ruby or a special shade of green may be employed. Obviously, therefore, the ideal dark-room lamp is one that will permit photographic employment, unless masked with non-actinic fabric.

With regard to the "safe light" used in the lamp, care must be taken that it is suited to the plate. A good way of ascertaining this is to place an unexposed plate in the dark-slide, with the shutter half-drawn, and to expose it close to the lamp for about four minutes. It should then be developed, when, if the light is unsafe, the exposed half will be fogged, and a clear line of demarcation will be evident between it and the unexposed portion. The exact matching of the light to the plate can only be done by photographing the solar spectrum on the latter, and noticing the region of the spectrum which has no photographic effect. It is then possible to obtain a dark-room light of the particular colour, or mixture of colours, to which the plate is insensitive, by bringing the spectroscope into service. Gelatine films, stained with aniline dyes, are much used as safe lights, as their colour may be nicely adjusted when staining. These require to be kept between two plain glass plates in the lamp. Since heat is detrimental to the stained gelatine films, lamps of special construction are made for use with them. Other lamps have glass cells in front, which may be filled with potassium

bichromate solution, or a solution of any selected aniline dye. (*See also* "Bichromate Lamp.")

DARK-ROOM VENTILATION (Fr., *Ventilation du laboratoire*; Ger., *Dunkelzimmer-ventilation*)

Adequate ventilation of the developing chamber is essential to health. Perhaps the simplest means of securing it is by the provision of light-traps (*which see*) at the top and bottom of the door, or in any other suitable places. Unless, however, these communicate with the outer air, the ventilation obtained will scarcely suffice. It is as important to secure egress for the foul air as to admit fresh, a fact which is often overlooked, and outlets should invariably be placed at the top. It is not at all uncommon to find small dark-rooms merely provided with ventilation apertures near the floor, in which case it is next to impossible for the vitiated and heated air in the upper part of the room to escape. A light-trapped cowl in the roof forms a very efficient outlet, but proper attention then requires to be paid to the provision of openings for the admission of fresh air at or near the bottom of the room ; or the cowl will merely serve to direct a stream of fresh air downwards, and will cause an unpleasant draught. It is often found necessary to use an external electric fan, either to drive in the fresh air or to draw out the foul, but care must be taken not to raise dust. Whenever dust is found to enter by ventilation openings, muslin stretched over a light frame should be interposed before the aperture.

DARK-SLIDE, PLATE-HOLDER, OR BACK (Fr., *Châssis, Châssis négatif*; Ger., *Kassette*)

A light-tight case to hold the sensitive plate or film, always furnished with a shutter or shutters, and made to fit closely at the back of the camera, from which it may be withdrawn at will. There are several kinds of dark-slides. That commonly used with studio cameras has a hinged door at the back for the insertion of the plate, and some of the larger and better-class studio slides have roller shutters instead of those that draw out. Field camera dark-slides are generally hinged in the middle, and open like a book, taking two plates with an opaque cardboard or metal separator between

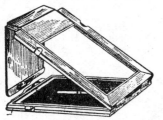

A. Double Book-form Dark-slide

them. These A are known as "double book-form" dark-slides. The shutters are usually cut across and hinged, so that they will fold over the back of the slide when drawn, and be out

of the way. Many hand cameras have solid double slides, known as the American pattern, with pull-out shutters of ebonite or aluminium. These are not always perfectly light-tight, especially when they get worn. An improved pattern is shown at B. The shutters do not pull right out, and particulars of the exposure may

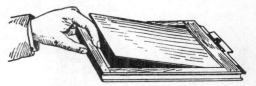

B. Improved Solid Dark-slide with Pull-out Shutters

be written on them. To insert a plate, a lever at the bottom is pressed downward (*see* illustration B), and the plate then drops into position, the lever returning and securing it. Metal and cardboard dark-slides are also made. There are many special kinds of slides or adapters, to take film-packs, plates in daylight-loading envelopes, etc. Roller slides (*which see*) are intended for use with roll-films, and are furnished with a winding key and spools.

In process work, the dark-slides are essentially different from those used in ordinary photography. The plate is generally held by means of adjustable bars, the bottom one being placed in a notch corresponding to the size of the plate, and the top one sliding down to rest on top of the plate (*see* illustration C). The metal catches to prevent the plate from falling outwards are of silver when the slide is used for wet-plate work. Sometimes the bottom bar is formed into a trough, to catch the silver drainings, and in an American dark-slide known as the Benster plate-holder a glass trough was let into the wooden bar. For half-tone work the dark-slides are provided with an additional pair of

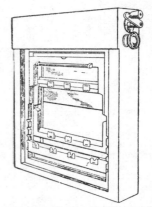

C. Wet-plate Holder for Process Work

bars to hold the ruled screen, and in some forms of holder these bars are adjustable so as to give more or less separation of the screen from the plate. Most of these process dark-slides have roller shutters.

DARK-TENT

Used for changing and developing plates. (*See* "Developing Tent.")

DARLOT

A noted French optician and lens maker, who made a speciality of casket lenses, under which heading they will be found fully described.

DAVIS FOCUSING SCREEN

A screen used for high-power work in photomicrography, invented by George E. Davis. It is used in place of a glass screen for final focusing, and consists of a piece of wood, preferably mahogany, containing seven holes, any one of which can take an "A" photomicrographic eyepiece.

DAVY, SIR HUMPHRY

Born at Penzance, December 17, 1778; died at Geneva, May 29, 1829. President of the Royal Society, 1820; made many important chemical discoveries and first decomposed chemical compounds by means of electric currents, preparing in this way sodium, potassium, etc. Assisted Thomas Wedgwood in his experiments with light upon silver and described them in the *Journal* of the Royal Institution (1802); in the same year he discovered that silver chloride gave better results than silver nitrate in the preparation of a sensitive surface. He made a number of photomicrographs, or macrographs, by throwing enlarged images of small objects through a solar microscope upon sensitised paper and white leather, but he failed to fix them.

DAYLIGHT CARTRIDGES

This term is applied to spools of flexible film used in cameras specially adapted for them. The strip of film is attached to a considerably longer strip of black paper. The spool is placed in position in the camera, and one end of the black paper is put through a slot in an empty spool and wound taut. The camera is then closed. By continuing the winding, the first section of the film is brought into position for exposure, and the successive sections are in turn wound along. A number on the black paper behind each section can be observed through an opening in the back of the camera, thus regulating the winding and indicating the number of the exposure. When the last section has been exposed, the rest of the black paper is wound on to the spool to protect the film, and the camera can then be opened, the exposed spool removed, and a fresh one inserted. The film thus exposed may be cut up into sections, or developed in the strip either by hand or by means of developing machines made specially for the purpose. The device is an exceedingly convenient and popular one. The smallness and lightness of the cartridges as compared with plates, and the ease with which successive spools may be used are strong points in their favour, especially with travellers.

One precaution in the use of film cartridges may be mentioned : care should be taken not to allow the black paper to run loose on the spool, as this will allow light to creep in at the edges. Also, in folding cameras, avoid winding the film while the camera is closed, as some part of the bellows or lens may touch the film and cause scratches upon it.

DAYLIGHT CHANGING

There are several methods by which plates or films may be changed in daylight without the necessity of resorting to a dark-room. Some that come more or less in this category are referred to under the headings "Changing Bags," "Film Pack," and "Daylight Cartridges." In addition to these, there are special slides made into which plates or films may be inserted singly. A popular form is one in which each plate or film is enclosed separately in a light-tight envelope. The drawing of the shutter of the slide opens the envelope, which is again closed as the shutter is pushed in. The exposed plate in its envelope may then be removed and a fresh one substituted. The number of exposures is thus only limited by the number of envelopes employed. This permits of the provision of plates and films of different character, which may be selected as required.

DAYLIGHT DEVELOPMENT (Fr., *Développement en plein air ;* Ger., *Tageslichtentwickelung*)

At various times many methods have been suggested for doing away with the dark-room for development, and they may be divided into two main types : (1) those depending on the use of a light-tight tank with ruby glass sides into which the plate and developer are introduced either in a dark-room or tent, the progress of development being observed through the red windows ; and (2) those in which red or non-actinic dye solutions were added to the developer so as to protect the plate from daylight. (*See* "Developing Machine," "Developing Tank," etc.)

DAYLIGHT ENLARGING

The oldest method of enlarging, details being published in the *Athenæum* dated July 9, 1853. A solar camera (*which see*) was used by the early workers, and enlargements were made upon albumen or other sensitive "contact" paper. Bromide paper, as used to-day for enlarging, was not commonly obtainable commercially until 1879 or 1880, although introduced five years earlier. (For modern methods of daylight enlarging, *see* "Enlarging by Daylight.")

DEAD BLACK

Recipes for dead blacks are given under the heading "Blackening Apparatus."

DECIGRAMME, DECILITRE, DECIMÈTRE, ETC. (*See* "Weights and Measures.")

DECOMPOSITION OF LIGHT (*See* "Light.")

DEFINITION (Fr., *Définition ;* Ger., *Definition*)

The degree of sharpness with which objects are rendered by the lens. As a rough standard for purposes of comparison, it is generally assumed that the allowable "circle of confusion" shall be one-hundredth of an inch in diameter —that is to say, a circle of that size shall be accepted as a satisfactory rendering of what should be a point. This only holds good for

contact prints from the negative, as it is obvious that any enlargement would increase the error proportionately and so bring it above the standard limit. Some forms of lenses give a curved or saucer-shaped field, so that when the centre is sharp the definition falls away towards the edges. This defect may be counteracted by using a smaller stop. Variation in definition also arises from the inability of a lens to bring to a focus objects on all planes at the same time. Improvement in this direction also is brought about by the use of a small stop. It is not always necessary or even advisable to have equally sharp definition in all parts of the subject, and judicious selective focusing is frequently of great advantage. Some lenses are specially constructed to enable the operator to introduce at will any required degree of softness or diffusion over the entire area. Such softness of definition is often most effective in portraiture and in some classes of outdoor work. It is generally out of place in architecture, copying, and the rendering of subjects for scientific purposes. In such cases the standard of critical definition should be one two-hundredth of an inch or less, and this standard is easily attained by good-class lenses. This matter is pursued further in the article appearing under the heading " Depth of Definition," which should be read in conjunction with the above.

When spherical aberration is entirely absent the centre of the field will be so sharply defined that the most delicate sensitive film is too coarse to register the smallest details. The structure of the sensitive film varies from that of the daguerreotype, which is practically grainless, through albumen on glass, collodion, and slow gelatine emulsions, until the rapid gelatine emulsions which show a granular structure even when magnified only a few diameters. (For the extent of definition which may be reasonably expected from a given type of lens at full aperture, *see* " Field of Lens.")

DEKAGRAMME (*See* " Weights and Measures.")

DELIQUESCENCE (Fr., *Déliquescence ;* Ger., *Zerfliessung*)

A property by which certain chemical salts, etc., absorb moisture and become " watery " on exposure to the air. Ammonium sulphocyanide and potassium carbonate are examples of deliquescent bodies. Such chemicals should be stored in a bottle tightly corked, or made up in solution. (For list of deliquescent substances, *see* " Chemicals, Storing.")

DEMENEY CHRONOPHOTOGRAPHE (Fr., *Chronophotographe Demeney ;* Ger., *Demeney Kronophotograph*)

A kinematograph machine introduced in October, 1893, by Demeney, and improved two months later by the addition of the " dog " or cam motion, which may be described as an eccentric roller that pulls down one picture-length of film each time it comes round. This is the first recorded instance of the employment of that now well-known movement in the kinematograph. Since then, the chronophotographe has been added to and elaborated. (*See also* " Kinematograph.")

DENSITOMETER (Fr., *Opacitémètre ;* Ger., *Dichtigkeitsmesser*)

An apparatus for testing the density of a given negative as compared with an average or standard negative, and estimating the time that will be required for printing. In Dawson's densitometer, a dense part of the negative to be examined is held in front of a suitable source of light, and a screen illuminated by the light that is transmitted is compared with a similar screen receiving light from the same source through a diaphragm, the aperture of which may be varied.

DENSITY (Fr., *Densité ;* Ger., *Schwarzung*)

The relative weight of silver deposited per unit area and expressed mathematically as $= -$ log. $_e$ T or log. $_e$ O, T $=$ transparency and O $=$ opacity, or, for convenience in working, it is usually taken as $= - $ log.$_{10}$ T. As defined by Hurter and Driffield, the law which would produce absolutely true tones would be expressed by saying that the quantity of silver reduced on the negative is proportional to the logarithm of the light intensity. Unfortunately, great confusion exists generally in the use of the terms " density " and " opacity," and the very common expression, " a very dense negative," is a typical example, inasmuch as what is really meant is a negative with great opacities—that is to say, the " opacity " of the silver deposited is so great that there is very little transparency. By the application of a simple factor, densities can be at once converted into the weight of silver per unit area.

DENSITY CALCULATIONS

In photo-chemical investigations it has been found that, assuming that the times of exposure can be divided into the four periods of under-, correct, over-exposure and reversal, the ratio of two densities in the period of under-exposure are exactly equivalent to the ratios of the two exposures, or that the amount of silver reduced per unit area is directly proportionate to the exposure. In the period of correct exposure the densities are exactly proportional to the logarithms of the exposures, and this is expressed by the formula—

$$D = \gamma \, (\log. \, It \pm C)$$

in which D $=$ the density, $\gamma =$ a constant depending on the duration of development, It $=$ the product of the intensity of the light and time, and C $=$ a constant dependent upon the speed of the plate.

The law connecting density with exposure may be calculated by means of the following formula—

$$D = \gamma \log. \,_e \left[O - (O - I) \, \beta \, \frac{It}{i} \right]$$

in which D $=$ density, O $=$ the opacity of the plate to the chemically active rays, $\beta =$ a fraction the hyperbolic logarithm of which is $- \frac{I}{O}$, It $=$ the exposure, and i $=$ the inertia of the plate.

DENSITY CURVE (*See* " Plates, Testing.")

DENSITY MEASUREMENTS

The measurements of densities are always effected with some form of photometer.

DENSITY, OR SPECIFIC GRAVITY (*See* "Specific Gravity.")

DENSOGRAPH

A photometric instrument designed by Dr. Goldberg, based on the use of neutral tint wedges, for obtaining automatically the characteristic curve of a plate—that is to say, for expressing the relations between the densities and their corresponding exposures.

DEPOSITS ON NEGATIVES AND PRINTS

Fine granular or chalky deposits, usually caused by lime in the tap water used for washing. Films allowed to dry with deposit adhering will feel rough to the touch, but the printing qualities of a negative are but seldom affected. Such deposits are best removed by gently wiping the surface of the negative, straight from the washing water, with a pad of wet cotton-wool. Methylated spirit or Baskett's reducer may be lightly applied to remove dried-on deposit.

The peculiar form of deposit that sometimes results from the use of an alum bath is due to insufficient washing, either before or after using the alum solution, a combination of chemicals forming with the alum deposits on, in, or under the film. Alum is very dangerous to the life of a gelatine film when it becomes mixed with certain other chemicals. Fixing baths containing alum may be decomposed by the alum and form deposits. There is no known method of removing deposits caused by alum. If a hardening bath is necessary, formaline should be used, as it does not form a deposit. (*See also* "Black Spots" for a peculiar form of deposit on prints.)

DEPTH OF DEFINITION, DEPTH OF FIELD, AND DEPTH OF FOCUS

"Depth of field" is sometimes used as synonymous with "depth of focus" and "depth of definition," the third expression more correctly indicating what is meant. Theoretically, objects on different planes, however small their separation, are brought to a focus by the lens at different points. In practice, however, it is found that there is a certain range within which objects are rendered with a satisfactory degree of sharpness. The distance between the nearest and the farthest sharp object is the depth of definition. The two chief factors regulating this are the focal length of the lens, and the size of the stop employed ; the shorter the first and the smaller the second, the greater is the depth of definition ; the longer the focal length and the larger the aperture, the smaller is the depth of definition. If a lens is focused on a very distant object, and then slightly racked away from the screen until the limit of critical definition in the distance is reached, it will then be in the position which gives the greatest depth of definition. The nearest point showing satisfactory definition will vary according to the focal length and the stop, as already stated. The rule for finding the exact distance (known as the hyperfocal distance) on which to focus to secure this greatest depth, is as follows : Square the focal length

of the lens (in inches), multiply by 100, and divide by the *f* number. The answer gives the hyperfocal distance (in inches). Halving this distance gives the nearest point of critical definition.

When a nearer object is focused upon there is a certain distance both before and behind it within which the definition is also up to the standard laid down. The amount of this depth for any distance, lens, and stop, may also be calculated. Let H be the hyperfocal distance (inches) for the given lens and stop, D the distance (inches) focused for. The nearest point of critical definition is then $(H \times D) \div (H + D)$; the farthest point is $(H \times D) \div (H - D)$. The range of good definition is always greater beyond than before the actual point focused upon. It follows that in estimating a distance to which the focusing scale is to be adjusted (as in hand-camera work) it is better to under-estimate it than otherwise.

A lens is sometimes said to have a deep focus when it renders both near and distant objects sharply at one time ; but as the focus of a pencil of rays should be a point, it is evident that

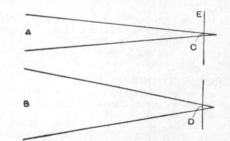

Diagram Showing, in Exaggerated Form, the Effect of Diameter of Aperture on Disc of Confusion

depth of focus is, strictly speaking, non-existent. In practice it is convenient to assume that an image composed of discs of confusion not more than ·01 in. in diameter is "sharp" ; so that in this case the depth of definition is the distance before or behind the true focal plane between which the plate intercepts a cone of rays (of which the lens diaphragm is the base) at less than the diameter above named (·01 in.). It thus follows that the larger the working aperture the less the depth of definition, as indicated in the diagram, in which A is the cone of rays from a small aperture, B the cone from a larger one, and C and D the diameters of the discs of confusion respectively formed ; the more acute the angle, the smaller is the disc. The surface of the sensitive film is indicated by the line E. By halving the diameter of the aperture depth of definition is doubled, and so on in the same proportion. It also varies inversely as the square of the focal length of the lens for the same intensity, or inversely as the focal length for the same aperture. (*See also* "Hyperfocal Distance.")

DEPTH OF TONE

A term used, somewhat loosely, in pictorial photography to describe the lowness of the tone

values, and in technical photography to describe the extent to which a picture has been toned or developed. A print is said to be deep or low in tone when, generally intentionally, it has no brilliant high lights, and the appearance is dark or gloomy. Black or cold tones appear deeper than warmer ones; in other words, assuming a black-and-white bromide print to be cut into two, and one half toned to a brown, the brown, as a rule, does not appear so deep in tone as the black part. The depth to which a picture is toned or developed influences considerably the final result. As a consequence of toning gelatino-chloride (P.O.P) and other print-out papers, the tone becomes less deep, due to (a) the negative being flat, foggy, or otherwise unsuitable, (b) quick (or surface) toning, in which case the tone is on the top and easily taken off by the fixing bath, and (c) the use of a "hypo" bath in an acid condition. A black-and-white bromide print that is not fully developed will lose much of its depth of tone in a sulphide toning bath.

DEREPAS MOUNTING (See "Dry Mounting.")

DEROGY

A French optician of the 'fifties and early 'sixties. In 1859, he made public a half-plate convertible lens, with combinations fitting together by bayonet joints instead of the usual screws. Six changes were possible.

DESICCATED DRY PLATES

Dried, or heated, dry plates. It is well known that dry plates, as ordinarily used, retain a considerable percentage of water, mainly in molecular combination with the gelatine. Howard Farmer, to whom the idea of desiccated plates is due, found that the water has a large influence on the image at the time of exposure, definition, detail, density, speed, etc., being affected. He found, moreover, that very small differences in the percentages materially affect the result, so that negatives vary with the atmospheric conditions, as to temperature and humidity, at the time of exposure. According to Farmer, "The drier the film, the better the definition, and the greater the power of rendering fine detail; in lesser degree, the greater the speed and facility of developing density. This property of the film can be utilised by desiccating dry plates for work where definition, detail, brilliancy, or maximum speed are desired, and in exposing plates wet where softness of image or the destruction of small textures and details are sought for. Extra rapid and orthochromatic plates, in which the former of these qualities is usually found lacking, gain them when desiccated to an extent hitherto only found in wet collodion or other specially prepared films."

A perfectly flat-topped kettle containing boiling water is a convenient appliance for desiccating plates; these are simply laid film side upwards on the kettle top with a piece of bibulous paper between to equalise the heating, and kept there for a few minutes at a temperature of 200° F. (about 93° C.) before being placed in the dark-slides. Or a thick copper slab with an asbestos cover can be used. Too great or too prolonged heating will crack the dry plate or induce fog.

Desiccation must be carried out in a dark-room, and the plates should be exposed while hot or as soon after the treatment as possible.

In process work, desiccated dry plates have been recommended for direct colour work.

DETACHABLE FRONT (Fr., *Planchette se détachant*; Ger., *Objektivbrett*)

A panel holding the lens and made to slip into a rebated opening in the camera front, in which it is secured by turn-buttons. It may be either square or circular. Any number of lenses, of different sizes, can thus be used on

Square Detachable Front

the same camera, a separate front being provided for each lens. For temporary use with a strange lens, when a panel is not forthcoming, a piece of stout cardboard may be cut to fit the opening in the camera front, a circular aperture being made in this to fit tightly on the lens. The inner side of the cardboard should be blackened.

DETAIL (Fr., *Détail*; Ger., *Einzelheit*)

The clear rendering of detail is largely dependent on focusing, and the defining power of the lens. A tree may be so rendered as to appear as a more or less homogeneous mass, or so as to indicate its leafy detail. The degree to which detail should be shown depends upon circumstances; in some cases the most minute details require to be clearly shown, and in others such a rendering is far from satisfactory. Suppression of detail results in the quality known as "breadth," but over-suppression leads to a loss of "texture." For example, a wicker-work basket showing every detail clearly would probably look hard and "fidgety"; on the other hand, the detail might be so suppressed as to make it difficult to recognise that the basket was of wicker-work at all. The direction and strength of the light and the state of the atmosphere are important considerations.

DETECTIVE CAMERA (Fr., *Chambre détective*; Ger., *Detectiv-Kamera*)

A term that appears to have been invented by T. Bolas, who in 1881 described a twin-lens magazine hand camera with focusing adjustment and pneumatic release, and having a reversing prism placed before the lens, so that the apparatus need not be directed at the person to be taken, who would remain quite unsuspicious of being photographed. Later, the name was applied loosely and inappropriately

to all box-form magazine hand cameras, which are still so designated in France. Practically the only cameras likely to be of real service in the detection of crime are those which are either entirely disguised, or are worked from a distance by the aid of a telephotographic lens. (*See also* " Disguising the Camera.")

DETERIORATION

Lenses, chemicals, and sensitive plates and papers all deteriorate more or less according to the length of time and manner in which they are kept. The commonest form of lens deterioration is due to the gradual depolishing of the glass surface by dust, the action being assisted by the careless or rough use of the dusting cloth. It is better to remove dust by blowing it off, but if wiping is necessary it must be done carefully (*see* " Lenses, Cleaning "). Sometimes when a lens is put on one side for a time an iridescence spreads over its surface, due to dampness. Lenses stored in a strong light often become slower in action, because of the yellowing action of light upon the balsam with which the lens glasses are cemented together.

Dry plates and sensitive papers deteriorate very quickly if not properly stored in a dry, airy place, the worst place being a high shelf where gas fumes can get to them. The effect of age on a plate much resembles that of a very slight exposure to light ; but dry plates keep remarkably well if stored carefully, and skilled workers can frequently get good results on plates as old as twenty years.

J. B. B. Wellington in 1905 pointed out that the popular sulphide toning bath has a deteriorating effect upon plates and papers ; everyone knows that the minute quantities of sulphur contained in a London fog will tarnish silver articles, producing upon them a thin film of silver sulphide, and that the sulphur in coal gas has the same effect when the gas is burnt. It is thus easy to understand how much more deleterious must be the large quantities of sulphur given off from the sulphurising bath of sodium sulphide on the still more delicate silver bromide and silver chloride which go to make up the emulsions coated upon plates, films, papers, etc. When these are kept in a room in which sodium sulphide is employed, they will become unusable in the course of a few weeks.

Plates affected by sulphur will develop with an iridescent stain, with general deterioration and fog. Bromide and gaslight papers are affected in practically the same way, producing a flat and dirty print. With P.O.P. the surface will assume a metallic lustre, and when printed will be difficult to tone. Self-toning papers appear to discolour more quickly than other papers, but frequently this defect disappears in fixing.

DEVELOPER (Fr., *Révélateur ;* Ger., *Entwickler*)

Any agent used to render visible the latent image, or, in other words, to reduce to silver or other metal the latent image produced by the action of light upon any sensitive salt. In ordinary photographic phraseology the term is applied to the solutions generally ; whereas strictly speaking it should be applied only to that chemical or agent which actually reduces the exposed silver salt.

The composition of the developing solutions varies considerably not only with each make of plates, but frequently with each worker ; but there is a definite quantity of developing agent which should at least be used, and this is undoubtedly largely dependent on the number of molecules in the active group, and the amido groups are more active than the hydroxyl groups. Von Hübl has given the following table based on this fact, which shows the best concentration of the actual developing agent and also the strength usually employed, assuming that a 5 per cent. solution of potassium carbonate is used as the alkali.

	Weight in every 100 *parts of developer*	
	Calculated	Generally used
Metol . . .	0·6 ..	0·6
Pyrocatechin . .	0·6 ..	0·6
Hydroquinone .	0·6 ..	0·5—1·0
Amidol .	0·4 ..	0·4—0·8
Paramidophenol .	0·5 ..	0·4—0·7
Pyrogallol .	0·5 ..	0·3—0·6
Eikonogen .	0·9 ..	0·8—1·5
Adurol . .	1·0 ..	1·0
Diogen . .	1·2 ..	1·2
Glycine .	0·5— 1·7 ..	1·0

The calculated quantities will give the maximum rapidity of development.

	I	II	III	IV	V	VI	VII	VIII
Pyrocatechin + caustic soda . .	15	100	0·6	5	10	20	slight	0·3
Metol + potassium carbonate . .	20	75	0·8	5	10	0	very slight	0·5
Hydroquinone + caustic potash. .	25	60	1·0	110	105	70	slight	0·4
Amidol	30	50	0·4	50	60	5	considerable	—
Adurol + potassium carbonate . .	30	50	0·6	30	45	25	considerable	0·6
Paramidophenol + potassium carbonate	40	38	0·5	70	30	30	considerable	0·5
Rodinal	40	38	0·5	45	40	30	slight	0·9
Pyro + potassium carbonate . .	40	38	0·5	35	55	40	considerable	0·3
Glycine + caustic soda . .	45	33	0·6	90	70	125	slight	0·8
Eikonogen + potassium carbonate .	50	30	0·5	85	55	80	slight	0·6
Pyrocatechin + potassium carbonate .	60	25	0·5	140	60	70	very considerable	0·6
Hydroquinone + potassium carbonate	70	21	0·7	95	80	120	slight	0·4
Diphenal	75	20	0·8	30	80	25	slight	0·7
Glycine + potassium carbonate .	75	20	0·5	210	130	115	very considerable	1·0
Ferrous oxalate	75	20	0·5	280	90	80	slight	0·8
Diogen + potassium carbonate .	95	16	0·4	115	120	80	considerable	0·7

A second table, also due to Von Hübl, is that at the foot of the preceding page. In column I. is given the duration of development to yield a certain density, in column II. the relative rapidity of development, in column III. the relative density-giving power, in column IV. the slowing of development in seconds by the addition of 2 per cent. of potassium bromide, in column V. the retardation in seconds due to cooling the developer to 50° F., in column VI. the retardation in seconds by diluting with an equal volume of water, in column VII. the action of bromide on the density, and in column VIII. the keeping power of the mixed developer, 1 being taken as that which keeps longest.

A developing solution should contain a certain quantity of alkali to form the actual developing salt or to increase the reducing power of the developer proper ; and for this reason it is called the accelerator. A preservative is required to prevent too rapid oxidation or the deposition of an organic stain due to the oxidation of the developing agent.

The alkalis generally used are sodium carbonate, potassium carbonate, and caustic soda and caustic potash. Some alkalis act better than others with given agents, and on the European Continent potassium carbonate is generally used, whilst in England the corresponding sodium salt is used. The preservative is usually sodium sulphite, whilst potassium metabisulphite is occasionally used also. Only a few years ago an alkaline bromide was recommended in almost all cases, but this was partly due to the fact that the plates then did not work quite free from fog. Of late years the use of bromide has become much less general. Formulæ for the various developing agents are given under the respective chemicals.

DEVELOPER, VISCOUS (See "Viscous Developer.")

DEVELOPERS, COMPARATIVE COST OF

The prices given below are approximate for each working quart (40 oz.) of developer at normal strength as prepared for pouring upon the exposed plate. The chemicals are taken at British retail prices.

	s.	d.
Adurol (one solution) . .	1	0
Adurol (two solutions). .	1	3
Amidol . . .	0	6½
Edinol . .	1	8
Eikonogen (one solution) .	0	9
Eikonogen (two solutions) .	1	3
Ferrous oxalate . .	0	5
Glycine (one solution) . .	0	7
Glycine (two solutions). .	0	10
Hydroquinone . .	0	5¾
Hydroquinone-metol .	0	7½
Imogen sulphite . .	0	5½
Kachin (one solution) . .	0	11
Kachin (two solutions) .	1	0
Metol	0	10
Ortol	1	1
Pyro-soda . . .	0	5
Pyro-metol . . .	0	6
Pyrocatechin (one solution) .	0	4
Pyrocatechin (two solutions)	0	9
Rodinal	0	7

Metol-hydroquinone, according to one maker's

formula, costs 10d. per quart, and according to another maker's only 5½d. In actual practice, and on the basis of developing a fixed number of plates, there is not much difference, as many of the more expensive solutions are capable of treating a far greater number of plates than the cheaper ones, bulk for bulk.

DEVELOPERS, MIXED OR COMBINED

Mixed developers—as, for example, hydroquinone and metol—have become popular. Developers are of two distinct kinds : (1. those that give detail quickly and density afterwards ; these include metol, rodinal, etc ; (2) those that give density first and detail gradually—for example, hydroquinone and pyro. Taking one of each class and blending, it is possible to obtain a combination of characteristics ; thus metol with hydroquinone gives detail without excessive thinness of the image or duration of development. The most is obtained with a combined developer by compounding it from one having a low factor number (see "Development, Factorial") with one of a high factor ; and while most developers may be mixed together, there is no advantage in combining two developers of practically the same factor numbers, as, for instance, pyro and hydroquinone, both of which may be said to have, roughly, the factor of 6. A better combination is hydroquinone (factor 6) and metol (factor 30).

The best known and most widely used combinations are hydroquinone and metol, and pyro and metol, but the following have also their advocates : Metol-adurol, hydroquinone-eikonogen, hydroquinone-pyrocatechin, hydroquinone-rodinal, hydroquinone-amidol, metol-glycin, and others. Formulæ for some of the best known mixtures are :—

Hydroquinone-Metol

Metol	.	.	. 33 grs.	3·4 g.
Sodium sulphite	.		99 ,,	10·2 ,,
Hydroquinone	.		40 ,,	4 ,,
Potassium carbonate	.	198 ,,	20 ,,	
Water to	.	.	. 20 oz.	1,000 ccs.

The above is a one-solution developer, ready for use. (See also "Metol-Hydroquinone.")

Pyro-Metol

A.	Pyrogallic acid	. 55 grs.	5·5 g.	
	Metol .	. . 45 ,,	4·5 ,,	
	Potassium metabisulphite	. 120 ,,	12 ,,	
	Potassium bromide	20 ,,	2 ,,	
	Water (boiled) to	20 oz.	1,000 ccs.	
B.	Sodium carbonate (crystals) .	4 oz.	200 g.	
	Water (boiled) to	20 ,,	1,000 ccs.	

Use equal parts of A and B.

Eikonogen-Hydroquinone

A.	Hydroquinone	. 40 grs.	4 g.	
	Eikonogen	. 120 ,,	12 ,,	
	Sodium sulphite	. 1 oz.	50 ,,	
	Citric acid	. 20 grs.	2 ,,	
	Water to	. 20 oz.	1,000 ccs.	
B.	Sodium carbonate	60 grs.	6 g.	
	Sodium hydrate	. 32 ,,	3·2 ,,	
	Potassium bromide	6 ,,	·6 ,,	
	Water to	. 20 oz.	1,000 ccs.	

Mix A and B in equal parts.

Metol-Glycine

Glycine	. .	. 50 grs.	5 g.
Metol	.	. 10 ,,	1 ,,
Sodium sulphite	.	2½ oz.	125 ,,
Potassium carbonate	.	2½ ,,	125 ,,
Water to	. .	. 20 ,,	1,000 ccs.

One solution, ready for use.

Edinol-Hydroquinone

Water to	. .	. 20 oz.	1,000 ccs.
Acetone sulphite	.	75 grs.	7·5 g.
Sodium sulphite	.	1 oz.	50 ,,
Edinol	.	. 30 grs.	3 ,,
Hydroquinone	.	. 15 ,,	1·5 ,,
Potassium carbonate	.	2 oz.	100 ,,

Dissolve in the order named, and for over-exposure add one drop of a 10 per cent. solution of potassium bromide to each ounce of developer used. The above is a one-solution, ready for use.

Hydroquinone-Rodinal

A.	Hydroquinone	. 120 grs.	13·6 g.	
	Sodium sulphite	. 1 oz.	54·5 ,,	
	Citric acid	. 5 grs.	·5 ,,	
	Potassium bromide	60 ,,	6·8 ,,	
	Water to	. 20 oz.	1,000 ccs.	
B.	Potassium carbonate	2 ,,	100 g.	
	Rodinal	. 1 ,,	50 ,,	
	Water to	. 20 ,,	1,000 ccs.	

For soft negatives use equal parts of A and B and water. For brilliant and harder negatives use equal parts of A and B without water. For detail increase the proportion of B, and for density increase that of A.

Pyro-Amidol

Sodium sulphite	. 198 grs.	20 g.	
Sodium carbonate	. 66 ,,	6·6 ,,	
Pyrogallic acid	. 20 ,,	2 ,,	
Amidol	. .	. 10 ,,	1 ,,
Water to	. .	. 20 oz.	1,000 ccs.

Add the amidol just before developer is required, and it will be ready for use. It will not keep.

Adurol-Metol

Metol	.	. 118 grs.	13·5 g.
Adurol	.	. 410 ,,	47 ,,
Sodium sulphite	.	7 oz.	383 ,,
Potassium carbonate	. 4·7 ,,	256 ,,	
Potassium bromide	. 21 grs.	2·4 ,,	
Water to	. .	. 20 oz.	1,000 ccs.

Dissolve the chemicals in the water in the order named. To develop plates add 1 part of the above to 2 parts of water.

Pyro-Hydroquinone

This is a mixed developer sometimes advocated, but both agents being slow-acting and somewhat alike, it is not particularly advantageous. It is included here chiefly because of the boric acid in the formula :—

A.	Hydroquinone	. 8 grs.	·8 g.	
	Pyrogallic acid	. 80 ,,	8 ,,	
	Potassium metabi-			
	sulphite	. 80 ,,	8 ,,	
	Boric acid (crystals)	10 ,,	1 ,,	
	Water .	. 20 oz.	1,000 ccs.	
B.	Sodium sulphite	. 1 ,,	50 g.	
	Sodium carbonate	1 ,,	50 ,,	
	Water 20 ,,	1,000 ccs.

The boric acid is used as a restrainer because of its remarkable corrective power in cases of over-exposure.

A mixture of hydroquinone and eikonogen was introduced in 1892 under the name of "Mixtol." The formula is :—

Sodium sulphite	. 924 grs.	92 g.	
Hydroquinone	. 115 ,,	11·5 ,,	
Eikonogen	.	. 77 ,,	7·7 ,,
Potass. ferricyanide	. 154 ,,	15·5 ,,	
Potassium carbonate	. 577 ,,	57·7 ,,	
Caustic potash	. 115 ,,	11·5 ,,	
Potassium bromide	. 8 ,,	·8 ,,	
Boiling water	.	. 18 oz.	1,000 ccs.
Glycerine to	.	. 5 mins.	5 ,,

Mix in the order named, allowing each to dissolve before adding the next. The solution is of a yellowish colour, and keeps well. For "instantaneous" work, add one-half water; for time exposures, two-thirds, or omit the caustic potash and increase the carbonate to 700 grs., and add more bromide if necessary. It may be used over and over again, and it is claimed not to stain or frill.

A mixture of rodinal, hydroquinone, and eikonogen, known as "Cyclol," was at one time popular. The formula is :—

Eikonogen	.	. 100 grs.	10 g.
Hydroquinone	.	. 30 ,,	3 ,,
Rodinal	.	. 9 drms.	·9 ,,
Sodium sulphite	. 2½ oz.	125 ,,	
Potassium carbonate	. 2½ ,,	125 ,,	
Water to	.	. 20 ,,	1,000 ccs.

The above is a stock solution. For use in warm weather, 1 part is mixed with 7 parts of water; in cold weather, less water is used; and in very cold weather, only 3 parts of water.

Two developers are sometimes used separately instead of mixing, but they have no advantages over the combined developers given above. Detail is first secured with a quick-working developer and density afterwards obtained with a slower-working one. The following is an example : Develop with rodinal of ordinary developing strength until all detail has been brought out; then finish with ordinary pyro-soda developer, or preferably with the following one-solution mixture of hydroquinone :—

Hydroquinone	.	. 120 grs.	12 g.
Sodium sulphite	. 1 oz.	50 ,,	
Potassium carbonate	. 1¾ ,,	88 ,,	
Water to	.	. 20 ,,	1,000 ccs.

DEVELOPING

This article will be devoted to a simple explanation of the ordinary method and practice of developing a dry plate. The exposure having been made, the closed dark-slide is removed to the dark-room, and the plate developed either at once or at any convenient time afterwards. The work must be done in a safe light. In front of the lamp place a cleaned earthenware developing dish of the required size, and near it a glass measure containing about 2 oz. of the developer. Into another dish pour some fixing solution, made by dissolving 4 oz. of sodium hyposulphite ("hypo") in 20 oz. of water.

As all photographic solutions work more slowly when cold, it is advisable to mix up all solutions some time before they are needed, as when freshly mixed they are very cold, particularly the "hypo" solution, which drops almost to freezing point when newly mixed. By standing some time, the solutions become of the same temperature as the room. Anything between 65° and 70° F. (18° and 21° C.) is the best for developing and fixing solutions.

The beginner is recommended to use the hydroquinone-metol developer (see "Developers, Mixed"), and he should be informed that each chemical in the formula plays its own part. Hydroquinone and metol are the developers proper; but they need the help of the other ingredients. Hydroquinone gives density, and metol detail; so by combining the two, density and detail are obtained at the same time. The sodium sulphite is included to preserve the solution, and is called the preservative. The sodium carbonate or potassium carbonate quickens the developing action, and is called the accelerator. Potassium bromide is frequently added, and this controls the action, and keeps the negative clear. As each has its own characteristic action, it will be obvious that were the chemicals in separate solutions, they could be so adapted, if necessary, to suit under- or over-exposure; but there is no need to trouble with separate solutions. A good mixture is given below:

Hydroquinone	.	.	30 grs.	7 g.
Metol	.	.	10 ,,	2·3 ,,
Sodium sulphite	.	350 ,,	80 ,,	
Sodium carbonate	.	350 ,,	80 ,,	
Potassium bromide	.	5 ,,	1·15 ,,	
Water to .	.	.	10 oz.	1,000 ccs.

Take particular care that no stray light enters the room, and that the only illumination comes from the red lamp. Remove the exposed plate from the slide and look at it, but not too near the lamp. Nothing on it will be seen; it will appear exactly as it did before the exposure. The image is latent (that is, concealed or hidden), and it needs to be brought out by the developer. Put the plate in the developing dish, the sensitive or creamy side of the plate being upwards and the glass side resting on the bottom of the dish. Then pour the developer over the plate in one quick sweep, so that the plate is completely covered in one sharp even flow, preferably from one corner. If the developer is properly applied, no air bubbles will form; but should any appear, break them quickly by touching them gently with the finger-tip, or, preferably, with a clean camel-hair brush. Then rock the dish from side to side and end to end, so that the developer flows evenly over the entire plate, taking care to expose it to the red light as little as possible. The brightest parts of the resultant picture, such as the sky, white collars, and white dresses, etc., will appear first of all. If the exposure is a landscape the sky will be the first to appear; but it will be black, as all lights and shades are reversed in a negative, the black or very dark parts of the actual scene appearing as almost clear glass and the whites almost or quite opaque. After the sky, the half-tones of the pictures will appear, and finally the details in the shadows. The developing dish must be gently rocked all the time. When the image has appeared, the plate must not be removed, but development continued for some little time longer, so as to add density to the negative. Continue for about a minute or so after the density appears to be correct, as this will be considerably reduced in the fixing bath.

It is important to know how long to continue development, and some experiments at the cost of a few plates will teach more than will many pages of printed matter. A negative that is taken out of the developer too soon is very thin, and will not give a good, clear picture; whereas a negative that has been left in the developer too long will be dense or harsh. As a general rule, when the negative is sufficiently developed, the dark parts in the negative, such as the sky, will show through the negative, and can be seen when the plate is examined from the glass side. The plate may also be taken out of the developer once or twice, and examined by holding it up to the red lamp, and its density judged by looking through it.

In cases of under-exposure, the image comes up very slowly, or only the high lights appear and not the half-tones and shadows. Development should be complete in ten minutes or even less. If after, say, fifteen minutes nothing, or very little, appears on the plate, try breathing on it, or warm the developer, but only very little, or the film will melt. If after a long time nothing appears, the plate may be destroyed as being useless. On the other hand, if the image appears extremely quickly, and the plate goes black all over in a minute or two, the plate has been over-exposed, or fogged by light other than that through the lens. A little extra potassium bromide added to the developer will sometimes save over-exposed plates if it is known that they are over-exposed before the developer is poured on; but after development has started it is a waste of time to add the bromide.

Subsequent processes, assuming that all has gone well, include a minute's rinsing in cold water, and transference, film uppermost, to the fixing bath, in which the plate remains for a period twice as long as that occupied by the whiteness in disappearing. Thus, if the whiteness disappears in ten minutes, allow the negative to remain for a further ten minutes. (See also "Fixing.") Finally, the negative, which may now be brought out into the daylight, is washed for at least thirty minutes in running water (see also "Washing"), while it stands on edge.

The beginner is recommended to adopt the factorial system of development. (See "Development, Factorial.")

DEVELOPING AFTER FIXING (See "Fixing before Development.")

DEVELOPING BENCH OR SINK (Fr., *Etabli de développement*; Ger., *Entwicklungsbank*)

A bench or table specially designed for developing, and usually provided with a stoneware or leaden sink. The top, if of wood, should be coated with shellac or other waterproof varnish. The height should be such that the operator can work at it without either stooping or straining, and there is no reason why it should not

be low enough for the worker to sit at, if this is desired. The continuous standing customary is merely fatiguing, and in no sense necessary. A very slight slope to the sides of the bench, so that spilt solutions may run into the sink, is useful; but this is often much overdone, so that bottles are liable to be upset, and the contents of full dishes to escape over one side. The developing bench may be either fixed or portable, but the essential features are practically

Developing Bench

the same in each case. A typical portable bench is illustrated. The sides are grooved so as to drain into the sink, which is of vitrified stoneware. The water is supplied by a swing-arm rose tap, under which may be placed a loose grid to hold dishes, etc. Convenient shelves for bottles, and racks for dishes, are fitted.

DEVELOPING DISH (*See* "Baths.")

DEVELOPING FILMS (*See* "Developing Machine," "Film Developing, etc.")

DEVELOPING AND FIXING COMBINED

A system of developing in which a sufficient amount of "hypo" is mixed with the developer in order that developing and fixing may be performed at the same time, a method thought much of at one time but little used nowadays. The secret of successful work is in the use of the correct amount of "hypo" to balance the developer. The "hypo" may be mixed separately and added to a developer, or made up in the developer itself. For the latter method edinol is perhaps the most suitable :—

Sodium hyposulphite	150 grs.	26 g.
Sodium carbonate	¾ oz.	62·5 ,,
Sodium sulphite	300 grs.	52 ,,
Edinol	¼ oz.	21 ,,

Dissolve the first three in 12 oz. of water, add the edinol, and use at once. The former method is to make up the "hypo" and developer proper separately and mix before use, as follows :—

| Ordinary developer | 5 oz. | 150 ccs. |
| Sodium hyposulphite sol. (20 %) | 2 or 3 drops | |

The following developer is one that is popular upon the Continent, and works well with "hypo" :—

Hydroquinone	60 grs.	8·5 g.
Metol	30 ,,	4·3 ,,
Sodium sulphite	450 ,,	64·5 ,,
Sodium carbonate	600 ,,	85 ,,
Water to	16 oz.	1,000 ccs.

The "hypo" solution is added in the proportions stated above immediately before use.

If properly mixed, development is completed at the time the plate is fixed, and the negative simply requires the usual washing. The method forms an interesting experiment, but is not recommended for valuable exposures, as with some plates it does not always work so well as could be wished. "Hypo" also acts as an accelerator with some developers. (*See* "Hypo in Developer.")

Kachin is one of the most suitable developers for combination with "hypo." J. McIntosh advocates the following :—

A.	Kachin	60 grs.	15·5 g.
	Sodium sulphite	600 ,,	155 ,,
	Water to	8 oz.	1,000 ccs.
B.	Caustic soda	40 grs.	18 g.
	Water to	5 oz.	1,000 ccs.
C.	Sodium hyposulphite	1 oz.	500 g.
	Water to	2 ,,	1,000 ccs.

For use take of A 160 minims, B 240 minims, C 20 minims, and water to make 1 oz.

DEVELOPING MACHINE (Fr., *Machine de développement;* Ger., *Entwicklungsmaschine*)

Various machines have been devised from time to time for the semi-automatic development of plates or films. One of the most successful for films was introduced in 1903 by Kodak, Ltd., and may be worked in full daylight. The spool of film having been inserted in the machine and the lid closed, a handle is turned which winds the film face outwards against a coiled "apron" of celluloid, with ribbed rubber edges acting as separators between the layers

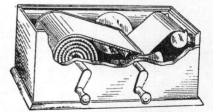

Kodak Developing Machine

of film. The developer is then introduced and the film slowly rotated for a given time. It may next be washed and fixed in the same way and removed from the machine. Development takes from four to eight minutes, according to the temperature. In a later pattern of the machine (*see* illustration), the film having been wound into the red celluloid apron, is placed

in an upright cylindrical tank, and left for a specified time in a dilute developer. A waterproof lid to the tank allows it to be reversed at intervals during development.

DEVELOPING TANK (Fr., *Réservoir de développement, Cuvette hermétique ;* Ger., *Entwicklungsbehälter*)

A metal or stoneware tank intended for stand or time development. There are many different patterns for both plates and films. In the Watkins developing tank a metal rack, holding one dozen plates, is attached to the lid in such a way that when inserted in the tank the plates are horizontal ; the advantage is that one or two plates only can be developed if desired, with but a small quantity of solution. The plates having been inserted in the dark-room, and the closely-fitting lid adjusted in position, the developer is poured in at a light-trapped delivery piece projecting at one end of the tank. This delivery piece serves not only for the admission and discharge of the various solutions, which may be done in daylight, but can be used to hold a thermometer to give the temperature of the developer and the consequent time of development. Another typical developing tank is Griffin's, in which the solutions are poured through a light-trapped funnel and run off by a tap at the side. A chain is attached to the tank by which it may be hung under a tap for washing the negatives after development.

Tanks for " stand " development, in which the negatives are left for a long time in a dilute developer, consist usually of a grooved stoneware trough with a lid ; these require a dark-room for the different operations. (*See also* " Developing Machine.")

DEVELOPING TENT (Fr., *Tente de développement ;* Ger., *Entwicklungszelt*)

A portable folding tent for development out-doors, or in any place where no dark-room is available. In the wet-plate period every photographer was obliged to carry a dark-tent with him, as the plate had to be sensitised directly before use and developed immediately after exposure. The few peripatetic ferrotype workers still remaining use a similar contrivance. Small portable developing or changing tents are often a great convenience to travellers and tourists.

DEVELOPMENT, CONFINED

A system of development advocated in 1898 by Colson, a Frenchman, but now rarely used. The principle was to restrict the amount of developer in contact with the plate. The latter was placed in the developer in the usual way; but suspended over it and nearly, if not quite, touching it was a sheet of plain glass ; or the exposed plate was soaked in water, and the plain glass in the developer, and the two placed in contact, repeating the process as often as necessary. Colson claimed that less fog and clearer negatives were produced in this way. The process was recommended for over-exposed plates, the first of the methods above noted being employed.

DEVELOPMENT, DAYLIGHT (*See* "Daylight Development.")

DEVELOPMENT, FACTORIAL

A system of determining the duration of development by noting the time of appearance of the first trace of an image on the plate and multiplying this time by a factor, the result being the total duration of development required to produce a negative of given density. This method was suggested by Alfred Watkins in 1893, and has been found in practice to be very reliable except in a few cases of exceptionally low temperatures and very dilute developers. It may be looked upon as one of the first practical steps to reduce development from mere happy-go-lucky guesswork to a definite and exact method. Like all methods based on laws it is elastic and capable of adjustment to the individual worker's ideas of what is a correct negative ; or, in other words, by reducing or increasing the factor a thinner or denser negative may be obtained suited to the particular printing process employed. It is an ingenious application of Hurter and Driffield's law of constant density ratios, and is based on the fact that with correct exposure the total duration of development for a given density bears a fixed ratio to the time of appearance of the image, assuming that the developing power of the solution remains constant, and this rule holds good for variations in strength of the developing agent, in the amount of the alkali, bromide, and temperature.

The following factors are those generally used for the principal developers :—

Adurol	5
Azol	30
Certinal	30
Cristoid pyrocatechin .	30
Diogen . . .	12
Edinol . . .	20
Eikonogen . . .	9
Glycine-potash . .	12
Glycine-soda . . .	8
Hydroquinone + bromide	5
Imogen sulphite . .	6
Kachin . . .	10
Kodak powder . .	18
Mequin . . .	12
Metol	30
Metol-hydroquinone .	14
Ortol	10
Paramidophenol . .	16
Pyrocatechin . .	10
Pyro-metol (Imperial Standard)	9
Pyro-soda . . .	4–15
Quinomet . . .	30
Rodinal . . .	30
Synthol . . .	30

PYRO-SODA AND PYRO-POTASH FACTORS

Pyro Grs. per oz.	Bromide Grs. per oz.	Factor
1	$\frac{1}{4}$	9
2	$\frac{1}{2}$	5
3	$\frac{3}{4}$	$4\frac{1}{2}$
4	1	4
8	2	$3\frac{1}{4}$
1	0	18
2	0	12
3	0	10
4	0	8
5	0	$6\frac{1}{2}$

Factors for soft, normal, and strong contrasts with " tabloid " formulæ (Burroughs and Wellcome) :—

	Soft	Normal	Strong
Amidol . . .	7	10	12
Edinol . . .	14	20	24
Eikonogen . .	8	12	15
Glycine . . .	9	13	16
Hydroquinone . .	3	4½	5
Metol . . .	20	30	35
Metol-hydroquinone .	10	14	16
Paramidophenol .	12	16	18
Pyro . . .	4	6	7
Pyro-metol . .	6	9	11

The factor for a combined developer with the developing agents in equal quantities is the mean of the two, for example :—

$$\text{Pyro } 6 \quad \text{Metol } 30$$
$$(6 + 30) \div 2 = 18$$

If the agents are not in equal proportions the factor for each is multiplied by the number of parts and the results added together and divided by the total number of parts of both agents; thus, supposing that the proportions were pyro 4 parts and metol 2 parts, it would be—

$$6 \times 4 = 24$$
$$30 \times 2 = 60$$
$$60 + 24 = 84 \div 6 = 14, \text{ the factor required.}$$

The above factors are given merely as guides, and those that have been found to give a negative of normal contrasts, that is, one with a $\gamma = 1$, but should the worker think that such a negative is too soft or too hard, he has merely to increase or decrease the factor to obtain greater or less contrasts. Supposing one were using a metol-hydroquinone developer with a factor of 15, and the time of appearance were 9 seconds, the total duration of development would be $15 \times 9 = 135$ seconds.

The great advantage of the factorial system is that it gives the beginner an excellent idea of how long to develop and enables even the advanced worker always to obtain negatives of similar character.

DEVELOPMENT, FACTORS FOR (See " Development, Factorial.")

DEVELOPMENT, FORCING

When a plate is under-exposed, many workers add more of the alkaline solution to the developer, and continue the development until the plate begins to fog, or until it is considered impossible to secure more detail. Although by this method of forcing development the utmost shadow detail is secured, it has the disadvantage of making the light tones much too strong and dense; and the result is a harsh negative, excepting in the case of subjects deficient in contrast, for which subjects this method is satisfactory. For all others, a better plan is to take the negative from the developer, let it rest in plain water for about five minutes, and then continue development in a considerably diluted solution containing a large proportion of alkali. The dilute solution is thought to yield much softer contrasts.

DEVELOPMENT PAPERS

The opposite to print-out papers; they are papers on which the image is brought out by development after exposure. The principal and most widely used development papers are those known as bromide and gaslight papers, described fully under separate headings. Phosphate paper is also a development paper, and in some cases this is sold under fancy names. The above are development papers proper. Carbon is in a sense a development paper as the image cannot be seen until the exposed tissue has been washed in hot water. Platinum, ferro-prussiate, and the ferric papers are usually referred to as partial development papers, because the image shows very faintly after exposure, and needs development in order to bring it to its full strength.

In the United States, the term " development paper " is applied exclusively to gaslight paper.

DEVELOPMENT, STAND (Fr. Développement dans les cuvettes verticales; Ger., Standentwickelung)

This term was applied by Meydenbauer in 1892 to a system of developing plates in upright grooved tanks in extremely dilute developers, though the system was first described by Wratten and Wainwright in 1882. It is claimed for this process that the grain of the silver image is much finer than by any other method, that the gradations are truer and the results more uniform; in addition to which no visual examination is required, and therefore the plates are freer from fog. On the other hand, unless the developer be occasionally agitated there is considerable risk of peculiar local markings and stains. For many years after its reintroduction by Meydenbauer, extremely dilute solutions were recommended so that the duration of development was prolonged even up to twenty-four hours. Recently, however, a more sane view of the matter has been accepted, and time has been so considerably reduced that it has now practically been merged into " time development." (See " Development, Time.")

It is often considered that the necessary increase in the duration of development is calculable from the dilution—that is to say, if a normal developer takes three minutes to obtain a certain density, it will, when diluted ten times, require $3 \times 10 = 30$ minutes; this statement is not borne out by careful photometric measurements, and Wratten and Wainwright have published certain researches on the subject based on such measurements which disprove this assumption. They point out that stand development cannot be considered economical, as most of the commercial tanks require far too much developer; with 29 oz. for six halfplates, after half an hour's development the solution is so oxidized as to be useless. The idea that a plate may be left in a stand developer for an indefinite time is also wrong; as is also the theory that a plate which should require only thirty minutes will be as much spoilt in an hour as the same plate developed for six minutes instead of three. It is as important, therefore, to know the correct duration of stand development as that of ordinary development. They further point out that the increase of time

required with rodinal is largely dependent upon the amount of air dissolved in the water to make the developer. For instance, a plate that required three minutes' development with 1 : 20 rodinal required forty-two minutes when developed with 1: 200 rodinal diluted with air-free distilled water, and not thirty minutes; forty-six minutes with ordinary distilled water, and fifty-two minutes with ordinary tap water. Pyro-soda and glycine are not dependent on the amount of air in the developer, but a ten times diluted pyro developer requires fifteen times the length of development with the strong developer.

Edge markings are very liable to occur, due to the plates being too near to the edges and the bottom of the tank, and thus being starved of developer. Plates are also as liable to chemical fog in stand development as in any other kind, and therefore too prolonged development should be avoided or bromide should be added to the developer, in which case the exposure must be increased, and not the duration of development. Zinc tanks should be avoided, as they are very liable to be attacked by alkalis.

DEVELOPMENT, THEORY OF

The old theory of development was that the reducing agent or developer reduced the exposed silver bromide or latent image to metallic silver, and that the bromine combined with the alkali to form an alkaline bromide, and this is usually expressed by the following equation :—

$$AgBr + DNa = Ag + Na Br + D$$

in which D merely stands for the developing agent. This was satisfactory as far as it went, but it really explains very little. The later theories, which involve a consideration of the ionic theory, assume that when a salt is dissolved in water it is split up into so-called ions, which are considered to be atoms of the elements carrying an electric charge. Metallic or basic ions are usually termed kations, and the acid ions are termed anions, the former carrying a positive and the latter a negative charge. Chemical reactions are now considered to take place between ions, and only when the substance goes into solution, and thus becomes dissociated or ionised. According to this we might represent the formation of silver bromide by the following equation :—

$$\overset{+}{K} + \overset{-}{Br} + \overset{+}{Ag} + \overset{-}{NO_3} = Ag\ Br + \overset{+}{K} + \overset{-}{NO_3}$$

which roughly shows the dissociation of potassium bromide into the potassion K carrying a + or positive charge, and bromion carrying a − or negative charge, silver nitrate being dissociated into positive Ag + and negative nitrion NO_3 − then the final result would be :—

$$\overset{+}{K}\overset{-}{Br} + \overset{+}{Ag}\overset{-}{NO_3} = AgBr + \overset{+}{K}\overset{-}{NO_3}$$

and as a positive and negative charge meet in AgBr this becomes unionised, and is precipitated as an insoluble precipitate.

If now we apply this to development, and we assume the formation of an alkaline phenolate,

as in the case of pyrogallol with only sufficient caustic soda to form this, we might represent the action as follows :—

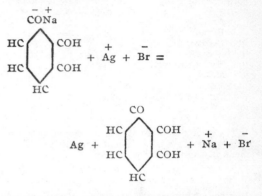

That is to say, the pyrogallol loses a negative charge which neutralises the charge on the silver ion. No account is here taken of any change in the pyro, though such must take place, but the oxidation products are not well known.

In the case of hydroquinone, however, where we know that the product formed from it in development is quinone, we can simply write the equation as follows :—

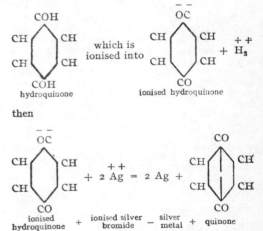

and the ionised hydroquinone has merely lost two negative charges which neutralise the positive charges of the silver in the ionised silver bromide, and the two oxygen ions combine to form quinone.

Obviously there are certain physical phenomena which one must take into consideration, and an emulsion consists of a number of particles of silver bromide embedded in a jelly. The modern theory of a jelly is that it consists of a number of minute cells with passages in between ramifying in all directions, and the cells and passages contain a weak solution of gelatine, whilst the cell walls are formed of a very strong solution. In each cell we may imagine a grain or particle of silver bromide, and for the developer to reach this it is obvious that it must first

traverse the passages, and then diffuse through the cell walls. The first is termed macro-diffusion, which takes place at a rapid rate, and the later action, which is comparatively slow, is known as micro-diffusion. It has already been pointed out that a chemical reaction can only occur when the silver bromide goes into solution and is ionised into $+ Ag$ and $- Br$. The instant the developer reaches the dissolved silver it is reduced to the metallic state and deposited, provided there be some nucleus or germ on which it can deposit. This nucleus is the latent image (*which see*). Were there no nucleus, then the silver would accumulate in solution till super-saturation occurred, and then the chemical action would cease. As soon as the dissolved silver is deposited, fresh silver takes its place, and so the process proceeds till the whole of the silver available is reduced.

In the above rough sketch of what is supposed to take place, we must not lose sight of the important fact that, as pointed out in the note on the latent image (*which see*), Scheffer has proved that the action of light is to cause the protrusion of filaments or threads from the sensitive salt grain, and therefore these would rupture the cell walls, and so render the access of the developing agent much easier.

Now, if we consider what happens when a plate is developed, we shall at once see that at first we shall have some silver halide grains, which are so affected by light as to be readily reduced by the developer, and some which are not affected. As development proceeds we shall have (*a*) some grains already reduced to metallic silver, (*b*) others not yet completely reduced, and (*c*) others which are not light-affected and therefore not attackable by the developer. Naturally, at first the progress of development will be rapid, as the whole of the light-affected grains will be capable of development, but as it proceeds there will be fewer and fewer of the (*b*) grains, so that development gradually gets slower and slower, and we may express this by saying that: the rate of increase of density = constant (maximum density attainable − density obtained).

Here the constant or velocity constant is usually termed K.

If the temperature of the developer be raised then the velocity constant, or K, increases, and this is termed the temperature coefficient, which is generally defined as the ratio for correct development at 10° C. (50° F.) difference of temperature.

The efficiency of a developer E is the velocity of development compared with ferrous oxalate at 20° C., divided by R, which is the reducing power, or the number of grain-molecules of AgBr reduced by one grain-molecule of the developing agent. The energy F is the concentration of bromide producing the same retardation of development as with ferrous oxalate for $0\cdot01\,n$ potassium bromide. For a complete mathematical treatment of the subject, the reader is referred to "Theory of the Photographic Process," by Sheppard and Mees.

Before leaving this subject it would be as well to consider the question of the chemical constitution of the actual developers or reducing agents.

12

Of late years the number of developers has been largely increased, and a glance at their true chemical names will at once prove that they are highly complex organic substances belonging to the benzole or naphthalene series.

Benzene or benzole has the formula C_6H_6, but in 1865 Kekulé, from a long series of experiments, came to the conclusion that the six atoms of carbon in benzene form a closed-chain or nucleus, and that the molecule of benzene is symmetrical, and that each carbon atom is directly united with one, and only one, atom of hydrogen. The graphic formula usually adopted is as follows:—

Now, in the above formula it is obvious that if two of the six hydrogen atoms were replaced by two other atoms or groups they might be arranged in one of five different ways, as shown in the accompanying diagrams, in which, for the sake of clearness, the C atoms are omitted and the added group or atom expressed by *x*.

I II III IV V

Then, if one *x* group occupies any given position, that numbered 1, for instance, the other may occupy 2, 3, 4, 5, or 6. But these five formulæ only represent three isomeric compounds, that is, compounds of the same composition $C_6H_4x_2$ and not five, because it is obvious that IV. and V. are practically identical with I. and II., which may be at once seen by writing them on thin paper and looking at them first in the normal way and then through the paper. In order to distinguish these three compounds, they are said to be in the ortho, meta, and para positions :—

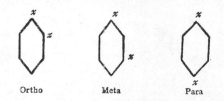

Ortho Meta Para

Now, obviously in the ortho position the two *x* groups are joined to carbon atoms which are directly united or are next to one another, so

that we could actually represent an ortho compound as

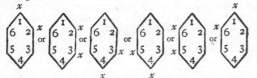

1-2 ortho 2-3 ortho 3-4 ortho 4-5 ortho 5-6 ortho 6-1 ortho

Exactly in the same way, the meta compounds could be represented by placing x x at 1—3, 2—4, 3—5, 4—6, 5—1 and the para at 1—4, 2—5, or 3—6 positions.

Now, it has been proved by Lumière and Seyewetz and by Andresen that a developer must have two hydroxyl OH groups or two amido NH_2 groups joined to the benzole ring, and that these groups must be either in the ortho or para positions to be developers. The latter compounds are the stronger developers, the ortho compounds the weaker, whilst the meta compounds are not developers at all. If one of the hydrogen atoms of a hydroxyl group be replaced by an alkyl radicle—that is, an alcohol radicle, such as ethyl C_2H_5—or by another radicle, then the developing power is destroyed, as, for instance, in phenetroin

If, on the other hand, one of the hydrogen atoms of an amido group be replaced by an alkyl radicle, then the developing power is increased, as in the case of

and

Para-amidophenol Monomethyl – para-amidophenol or metol

Besides the OH and NH_2 groups, the hydrogen atoms of the benzole ring may be replaced by other radicles, such as carboxyl COOH, and the sulpho group SO_3H, but these reduce the developing power, and in this case the position of the added or substituted radicle plays an important part, as in the instance of

and

Para-amidophenol— Para-amidophenol—
meta-carbonic acid ortho-carbonic acid

the former being but a very weak developer, whilst the latter is a vigorous one.

If a hydrogen atom be replaced by one of the halide atoms Cl or Br, then the developing power is increased, as in the case of

Para-dihydroxybenzole Monobrom or monochlor-para-
or hydroquinone dihydroxybenzole or adurol

If three hydrogen atoms in the benzole ring are replaced by three NH_2 or OH groups, then the developing power is increased, and here, as in the case of the di-substitution products, the ortho-, meta-, or para position plays an important part, thus

is weaker than

Ortho-dihydroxybenzole Ortho-trihydroxybenzole
or pyrocatechin or pyrogallol

because in the former there are only two OH groups in the ortho position, whilst in the latter there are three OH groups all in the ortho position. Again, if one OH and one NH_2 group be added to the ring, then we have a still more energetic developer, as in the case of

para-amidophenol, the base of rodinal;

whilst the addition of another NH_2 group increases the action still further, as in the case of

1-2-4 diamidophenol or amidol,

which is at once an ortho- and a para-amidophenol, and diamidoresorcin

1-3-4-6 diamidoresorcin

a double para-amidophenol, in which the OH and NH_2 groups, as shown by the lines, are in two para positions; this is still more energetic.

There are two developing agents which belong to the naphthalene $C_{10}H_8$ series, and naphthalene may be considered as two benzene rings joined together, and which at the points of junction

have lost their hydrogen atoms, so that we may write naphthalene graphically as

Here, too, the hydrogen atoms may be replaced by other atoms or groups, and we have

α_1 amido-, β_1 naphthol-, β_3 sulphonic acid or eikonogen,

and

α_1 amido-, β_1 naphthol-, β_2 β_3 acid sulphonate of soda or diogen.

It will be easily seen that the Greek letters and the numbers refer to the positions of linking of the substituted atoms. In the above sketch the developing bases only have been considered, for many of the actual developers are salts, such as chlorides, sulphates, oxalates, etc., of these bases.

DEVELOPMENT, THERMO

A name invented by Alfred Watkins for a system of developing in which the duration of development is varied as the temperature of the developer varies, to distinguish it from " time development " pure and simple. Although it had been known for a long time that development was prolonged in cold solutions, Houdaille in 1903 was one of the first to suggest a definite rule, in conjunction with hydroquinone, to the effect that a variation in temperature of the developing solutions of 1° C. caused a variation of 5 per cent. in the time of appearance of the image and the duration of development. In 1905 Ferguson and Howard published a method of obtaining a given gamma or degree of contrast with a developer of constant composition at varying temperatures by developing strips of a plate exposed behind a sector wheel for different times, measuring the gammas obtained and plotting them on a chart. Later, Ferguson suggested a simpler method, in which only two strips were developed for given times and the temperature coefficient of the developer found by a very simple logarithmic calculation. The objection to both these methods is that a sector wheel and photometer are required. As, however, Ferguson's method is simple, and the basis of that to be described later, it is briefly given here.

The first thing to determine is what is known as the temperature coefficient of the developer used, or the increase in velocity of development for a rise of 10° in temperature, from which the increase in rapidity of development for 1° can be found by dividing the logarithm of the temperature coefficient by 10. The usual mathematical expression for the temperature coefficient is—

$$\frac{\text{velocity at } (t + 10°) \text{ C.}}{\text{velocity at } t° \text{ C.}} = b^{10};$$

therefore b, or the increase for 1°, is—

$$\frac{\log. \text{ of temperature coefficient}}{10} = \log. b.$$

Ferguson has suggested that two strips of a plate should be exposed to the same graduated series of light and one developed at $t°$ C. and the other at $t° + x°$ C.; then the times required to obtain the same gamma or degree of contrast on each plate will be M and m, and as the times are inversely proportional to the velocities

$$\log. b = \frac{\log. M - \log. m}{x}$$

in which b = the temperature coefficient for 1° C., and 10 log. b will be the temperature coefficient for 10° C.

To make this quite clear two strips of a plate should be developed so as to show the same degree of contrast, one at a given temperature and the other at this temperature plus a certain number of degrees. Two strips A and B of a plate were exposed to the same graded series of light, and A took 3½ minutes to obtain a gamma = 1 at 10° C. and B took 2½ minutes at 18° C., then—

$$\log. 3 \cdot 5 = \cdot 5441$$
$$\log. 2 \cdot 5 = \underline{\cdot 3979}$$
$$\cdot 1462$$

Now the difference of temperature (\triangle as it is usually written) was $18 - 10 = 8°$

$$\therefore \cdot 1462 \div 8 = \cdot 0182 = \log. b$$

\therefore 10 log. $b = \cdot 0182 \times 10 = \cdot 182$ = the temperature coefficient for the plate and developer used. Having found the above, to find the necessary duration of development at 14° C. to obtain the same gamma the formula is—

$$\log. M - x \log. b = \log. m$$

or, in words, from the logarithm of the time required at 10° C. subtract $14 - 10 = 4$ times log. b, and the result will be the logarithm of the time required; assuming that log. $b = \cdot 0182$ as above, then—

$$\log. 3 \cdot 5 = \cdot 5441$$
$$4 \log. b = \cdot 0182 \times 4 = \underline{\cdot 0728}$$
$$\cdot 4713 = \log. \text{ of } 2 \cdot 96$$

minutes, the time required.

Watkins has done away with the sector wheel or graded series of lights and the finding of the gammas; he merely exposes a plate on a landscape including some sky and cuts it in two, or makes two exposures. It is essential to have some means for warming up the developer, dish, and measure, and also to have a thermometer. When the developer, dish and measure are warmed up, say to 75° F. (about 24° C.) the plate is placed in the dish and flooded with the developer, the time accurately noted, and the first appearance of any image also noted; the plate being now of no further use it may be thrown away. The second half of the plate is now developed in a developer of exactly similar composition, only colder, the time of appearance

noted, and we have all the factors necessary for finding the time of development for any temperature with that particular plate and developer if we know also the factorial number (*see* "Development, Factorial") of that developer. Suppose, for example, that a metol-hydroquinone developer with a factor of 15 is being used, and it is found that at 50° F. (10° C.) the first appearance of the image takes place in 40 seconds and at 66° F. (18·8° C.), the first appearance takes place in 28 seconds; then turning to a table of logarithms we find that log. 40 = 1·602060 and log. 28 = 1·447158, then—

$$1·602060 - 1·447158 = 0·154902.$$

Now the difference in temperature is 66 — 50 = 16, then 0·154902 ÷ 16 = ·009681 = log. of 28·3 seconds, and as the factor for this developer was 15, then 28·3 × 15 = 424 seconds = 7 minutes practically, which is the time required to develop the plate at 57° F. (14° C.).

It is obvious from this that we can calculate a table for every degree (or two degrees will be enough) rise or fall in temperature of the developer, by multiplying the log. factor by 2 and adding for every two degrees drop or subtracting in the case of a rise, and then multiplying the number by the factorial number. This may seem somewhat complicated, but the logarithms have merely to be read from a mathematical table-book and simple division, multiplication, and subtraction performed.

DEVELOPMENT, TIME

Practically, this method of development was established upon a sound basis by the researches of Hurter and Driffield, who proved that it was only necessary to reduce or increase the duration or time of development in order to obtain negatives of any desired degree of contrast, and that it was not necessary to tinker with the constituents of the developer. The outcome of this work was the slow recognition of the fact that it was advisable to use a given developer at a given temperature for a given time to obtain a particular class of negative. This method is particularly valuable in the case of colour-sensitive plates, which may be immersed in the developer completely protected from light, and at the end of the stated time washed and fixed. (*See also* "Development, Thermo.")

DEVIATION (Fr., *Déviation;* Ger., *Abweichung*)

An optical term denoting the alteration in the course of a ray of light when bent from its original path by refraction or reflection. The length of a prismatic spectrum alters according

Deviation of Rays Passing Through Prism

to the position of the prism with reference to the rays of white light falling upon it ("incident rays"). When the prism is so placed that the spectrum is practically at its shortest length,

which happens when the mean emerging rays (say the green, at the E Fraunhofer line) and the incident rays make the same angle with the prism, as shown in the illustration, the latter is said to be in the position of "minimum deviation."

DEXTRINE (Fr., *Dextrine;* Ger., *Dextrin*)

Known also as British gum. This white or yellowish-white powder, soluble in water, in which it forms a viscous and gummy solution, insoluble in alcohol and ether, has the formula $(C_6H_{10}O_5)_n$. The pure substance is made by submitting starch paste to the action of malt extract; after filtering, maltose is precipitated by repeated treatment with alcohol, and finally the dextrine is thrown out by adding sufficient absolute alcohol. It is also made by the action of heat or of nitric acid on potato starch. It has the same chemical composition as starch, but its properties are different. The principal use of dextrine is in the making of mountants (*which see*). There is a further variety, of a brown colour, but this is not used as a mountant.

In process work, dextrine has been advocated as an addition to the etching bath, the addition of gummy matter to the bath being claimed to facilitate etching and keep the etched surface bright. Dr. Albert has recommended a powder, which is believed to be a mixture of dextrine and powdered alum, for use with the nitric acid solution, to cause a frothing of the bath; the theory is that the solution is oxygenated and the hydrogen gas given off is absorbed.

DEXTROSE

Known also as glucose and grape sugar; a white crystalline solid, formula $C_6H_{12}O_6$, readily soluble in water. It has been recommended as an addition to mountants and as a preservative for plates, but is now rarely used. It is employed in some processes of silvering glass.

DIACTINIC (Fr., *Actinique;* Ger., *Aktinisch*)

Capable of passing actinic or photographically active light; the opposite of non-actinic.

DIAGONALS OF PLATES (See "Sizes.")

DIAGRAMS AS LANTERN SLIDES. (*See* "Lantern Slides, Diagrammatic.")

DIALYSER

A parchment, skin, or paper stretched over the open end of a glass or wooden vessel, which

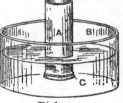

Dialyser

is then placed in an outer container of water (*see* illustration). Into the dialyser are poured liquids such as thin solutions of gelatine or other colloid containing salts, the latter diffusing

through the septum into the water, and leaving the gelatine or other colloid in the dialyser. In the illustration, A is the dialyser, B the outer vessel of water, and C the septum or skin.

DIAMIDOPHENOL (*See* " Amidol.")

DIAMIDOPHENOL HYDROCHLORIDE (*See* " Amidol.")

DIAMIDORESORCIN (Fr. and Ger., *Diamidoresorcin*)

C_6H_2 OH OH NH_2 HCl NH_2 HCl. Molecular weight, 153. Solubilities, soluble in water, more soluble in sodium sulphite solution. It is a complex organic salt, very similar in its action to amidol, and, like that, developing in the presence of sodium sulphite only. (*See also* " Diamine.")

DIAMINE

A form of diamidoresorcin (*which see*) introduced by Lumière as a developer. A formula is :—

Sodium sulphite (anhydrous) . .	. 250 grs.	30 g.	
Diamidoresorcin	. 85 ,,	10 ,,	
Water to .	. 20 oz.	1.000 ccs.	

DIAMOND LENS

In the early days of photographic optics experiments were made with every kind of transparent body which could be formed into a lens. Claudet had a small lens fashioned from a diamond, expecting much from the high refraction of this substance. However, it was not found to be of any practical value. It was destroyed in a fire at Claudet's Regent Street studio, London.

DIANOL

Lumière's preparation of oxalate of diamidophenol or amidol (*which see*), which is claimed to be rather more soluble than the hydrochloride, the usual salt employed.

DIAPHAN, AND DIAPHANOTYPE

An obsolete process used for obtaining transparent pictures for viewing in a diaphanoscope. Diaphan pictures were upon paper, and diaphanotypes upon glass, but the terms were often reversed, and in the end all the pictures were known as diaphanotypes. The process as advocated by Thomas Sutton (published December 15, 1856) was as follows : " Thin photographic paper must be employed. Immerse for half an hour in a solution of 20 grs. ammonium chloride ; hang up and dry. Sensitise by floating on a bath of nitrate of silver, containing 50 grs. of nitrate to 1 oz. of water ; hang up in the dark to dry. In printing, apply the back of the paper to the negative and print through the paper very deeply. In this way the silver in the heart of the paper becomes reduced. Wash well, and tone in a weak gold bath made by adding 15 grs. of gold chloride in 20 oz. of water to a solution of 50 grs. of hyposulphite of soda in another pint of water. Leave the print immersed till it is thoroughly toned, then fix it in one part hypo to ten parts of water. The hypo reddens it slightly, but it becomes perfectly black on drying. Wash as usual, dry, and wax." Sutton also advocated a develop-

ment process for producing the pictures. Other workers made an ordinary paper print transparent with wax or Canada balsam, backing it up with a duplicate print, while others coloured their pictures. At the end of the diaphanotype " craze," the pictures resembled crystoleum pictures.

The terms were also applied at one time to lantern slides and window transparencies, both plain and coloured.

DIAPHANOSCOPE (Fr., *Diaphanoscope ;* Ger., *Diaphanoskop*)

A contrivance, much resembling the alethoscope, pantoscope, or lanternoscope, intended for the exhibition of transparent positive photographs. It consists of an enclosed box, which may or may not be furnished with a lens, the pictures being placed inside at a distance from the eye preferably equal to the focal length of the lens with which the negative was obtained.

DIAPHRAGM SHUTTER (Fr., *Obturateur à diaphragme ;* Ger., *Blende-verschluss*)

A shutter made to work between the two combinations of a compound lens—that is, against the diaphragm, and opening from and closing to the centre. It is obvious that the shutter itself acts as an expanding and contracting diaphragm, though not necessarily circular, and that consequently a large part of the exposure is practically given with a smaller aperture than that of the fixed diaphragm. The definition of the lens is thus improved, but the efficiency of the shutter (the relative proportion of the exposure during which it is fully open) is rather low. When of good quality, diaphragm shutters give excellent results. They are much used on the better-class hand cameras, and are usually so fitted as to form part of the lens mount. The exposures marked on cheap diaphragm shutters are seldom reliable.

DIAPHRAGMS (Fr., *Diaphragmes ;* Ger., *Blenden*)

A diaphragm is the aperture, fixed or removable, used in front of a single lens and between the combinations of a double lens, generally referred to as the " stop." The various forms of diaphragms, systems of marking, values, etc., are as follow :—

Various Forms.—The three patterns in general use are known as " rotating," " Waterhouse," and " iris." Very cheap lenses, and those of obsolete patterns, are usually fitted with fixed stops, or pierced circles of metal which are let into the lens tube. Rotating stops are mostly fitted to wide-angle and landscape (single) lenses, and are employed in many hand cameras ; a series of circular holes of various sizes are pierced round the margin of a revolving disc fitted to the lens mount. Waterhouse diaphragms were invented by John Waterhouse, of Halifax, in 1858, a circular aperture being cut in a thin piece of sheet metal and inserted into a slot in the lens mount, a separate piece— called a stop—being required for each opening. The " iris," the most modern form of diaphragm, consists of a series of curved plates of metal, vulcanite, or other material, fitted inside the lens tube and attached to a ring on the outside

of the lens mount; by revolving the ring the plates are made to open and close, thus forming apertures of various sizes. Some Continental lenses have other forms of stops, but they are rapidly falling into disuse. The form in which the diaphragm is made does not affect its action on the lens in the least, and optically one stop is as good as another; it is in the matter of convenience where one pattern has any advantage over another. The iris pattern—so named, by the way, because it opens and closes like the iris of the eye—is undoubtedly the most convenient and popular pattern.

Systems of Marking.—There are at least half a dozen systems of marking. Stops are marked with numbers, such numbers, as a rule, appearing upon the iris ring or lens mount when the iris system is used, upon the top or handle of a Waterhouse diaphragm, and upon the circular revolving disc in the case of rotating diaphragms; in the last-mentioned case the number appears opposite to the aperture which it indicates, so that when the stop is in use in the lens itself its number is visible outside the lens tubes. Included in the stop-marking systems in vogue are the " f," " U.S.," " Dallmeyer," " Goerz," " Zeiss," and " Voigtländer," besides many others. The " f " and " U.S." systems are adopted for all but 1 per cent. of the lenses in general use, and of these the former is the more popular, especially in England, it being in a sense self-explanatory. The " f " number simply means the proportion of the diameter of the stop to the focal length of the lens. For example, $f/8$ is of a diameter one-eighth the " focus " of the lens. The " f " value of an unnumbered stop can be ascertained by dividing the focal length of the lens by the diameter of the stop. For example, a 1-in. stop with a lens of 8-in. focal length is known as $f/8$; a $\frac{1}{2}$-in. stop with the same lens, $f/16$; a $\frac{1}{4}$-in. stop with the same lens, $f/32$, and so on. Thus the " f " number is not a fixed dimension, but always a relative one, varying with the lens employed; obviously $f/8$ with a 16-in. lens would mean a diameter of 2 in., whereas with an 8-in. lens it would mean a diameter of 1 in. Strictly, the " f " numbers should be $\frac{1}{8}$, $\frac{1}{11}$, $\frac{1}{16}$, etc., but the fractional form is ignored, and the numbers spoken of as 8, 11, 16, etc. Stops of definite " f " values may easily be cut to the required size. Suppose, for example, that with a lens of 6-in. focal length, an $f/16$ stop is required, then, 6 divided by 16 $= \frac{6}{16} = \frac{3}{8}$; therefore, the stop must be $\frac{3}{8}$ in. in diameter.

While, in the above rough-and-ready system of measuring, the " f " value of a stop may be accurate enough in the cases of ordinary rapid rectilinear and single lenses, extreme accuracy is essential in the case of modern and improved anastigmat lenses; for while a slight error may be of little moment with a small stop, the same amount of error—which error is, of course, proportional to the aperture—becomes serious with large stops, which are a feature of anastigmat lenses. It is necessary in such cases to consider the *effective* aperture. The stops on a modern lens by a good maker are always correctly numbered, and it is only when a worker attempts to check the optician's calculations by dividing the focal length by the aperture that

he finds an imaginary error. The division system described above leads to false conclusions when some modern anastigmat lenses are measured by it, because of the great condensing power of the lens in front of the stop, from which lens measurements are taken. To quote an example; one of the most expensive of anastigmat lenses has a stop the value of, and marked, $f/8$; but the aperture of the stop is one-ninth the focal length, and, according to the rough and ready rule given above, would be $f/9$; while the stop marked $f/5$, although accurate, is $f/7$ according to the division method. The following method of finding the effective aperture of a stop is more reliable with all kinds of lenses. The camera is set at " infinity," or a distant object is focused upon the ground glass. A piece of card is then put in the place of the ground glass, or pasted thereon, so as to entirely cover it. In the centre of the card, and on the spot exactly opposite the lens, is made a hole the size of a pin's head. The camera is then taken into the dark-room, and by the assistance of a ruby or orange light a disc of bromide paper is cut to fit the inside of the lens cap. The cap, with the sensitive paper inside it, is then placed on the lens in the usual way, the sensitive side towards the stop. A lighted candle is then held against the hole in the cardboard for about half a minute, so that the light may travel through the camera, lens and stop to the bromide paper. The latter, after exposure, is taken out and developed, when a circular black spot will be found thereon, and the diameter of this spot will be the effective diameter of the stop used. If the exposure is made with the largest stop, the developed spot gives the effective aperture at which the lens will work, and the focal length of the lens divided by this, the true aperture, gives the " f " number.

Opticians have adopted standard " f " numbers, namely, 3·16, 5·66, 8, 11·3, 16, 22·6, 32, 45, and 64, but stops may be " in between " any of those named, or larger or smaller than 3·16 and 64 respectively. As a general rule, 11·3 is spoken of as 11 and 22·6 as 22, but in the case of larger stops the decimal point, when it occurs, is always mentioned, as, for example, 4·5, 5·8, 6·8, etc.

The " U.S." system (now practically obsolete in England) has long been popular in the United States, for which reason the initials are looked upon as indicating that country. Such, however, is not the case. " U.S." stands for " uniform system," as an attempt was made, first of all in 1881, by the Royal Photographic Society to induce all lens makers to adopt a uniform system of marking diaphragms.

The Royal Photographic Society's standards and recommendations (dated 1901) are as follow :—(1) That intensity ratio be defined as dependent upon the *effective aperture* (and not upon the diameter of the diaphragm) in relation to the focal length of the lens. (2) That effective aperture be determined in the following manner : The lens shall be focused for parallel rays; an opaque screen shall be placed in the principal focal plane, the screen being provided in its centre (in the axis of the lens) with a pinhole; an illuminant shall be placed immediately behind the pinhole and the diameter of

the beam of light emerging from the front surface of the lens shall be the measure of the effective aperture. *Note.*—It will be found, except when the diaphragm is situated in front of the lens, that the diameter of the diaphragm itself is seldom identical with the effective aperture. (3) That every diaphragm be marked with its true intensity ratio, as above defined, in the following order of sequence : $f/4$, $f/5·6$, $f/8$, $f/11·3$, $f/16$, $f/22·6$, $f/32$, $f/45·2$, $f/64$, etc., each diaphragm requiring double the exposure required by the preceding diaphragm. Should the greatest effective aperture of a lens not conform exactly to one of the intensities set forth above, this aperture should be marked in accordance with the definition of effective aperture, but all succeeding smaller apertures should be marked in uniformity with the above sequence.

Stops marked by the Uniform System are commonly known as Nos. 1, 2, 4, 8, 16, 32, 64, 128, and 256; the respective "f" values are 4, 5·6, 8, 11, 16, 22, 32, 45, and 64.

Most of the lenses produced in France are marked according to the method advocated by the Paris Congress of 1889. $f/10$ is taken as the unit aperture, the series advancing as the "Uniform" system ; No. 1 is $f/10$, No. 2 $f/14$, No. 4 $f/20$, and so on.

Influence of Diaphragms on "Rapidity."—The "rapidity" of a lens depends upon the stop used. The "U.S." numbers indicate relative exposures, but the "f" numbers do not, although the relative exposures are easily calculated from them. To find out the relative values of the "f" stops, first square them, and the exposure is then as one product is to the other. Thus, $f/16$, for example, requires four times the exposure necessary with $f/8$, because $16 \times 16 = 256$, which is four times $8 + 8 = 64$. When makers mark their stops as follows, $f/8$, 11, 16, 22, 32, 45, and 64, each stop requires double the exposure of the preceding one and half that of the succeeding one.

The Use of Diaphragms.—The main functions performed by stops are as follow :—(1) They govern the definition. A large stop, such as that generally used for focusing, may produce an indistinct image upon the focusing screen or sensitive plate, and it may be necessary to insert smaller stops into the lens in order to secure better definition. If, say, an object a few feet from the camera is sharply focused with a large stop, the background and surroundings may not appear sharply defined. The insertion of a smaller stop serves to cut down the area of the base of the cone of light formed by the lens, and the result is increased definition (*see* "Depth of Definition"). (2) To correct functional errors (as covering power) in a lens. Lenses not of the modern and improved anastigmat pattern have certain optical errors which show themselves when very large stops are used, and many of the older and even modern common lenses do not yield a sharp image all over the plate, a defect that is corrected by the use of a small stop and consequent increase in exposure. (3) To add to, or subtract from, the number of planes in a picture. All views are composed of various planes, or distances. When a large stop is used, only one plane is in focus, and the

smaller the stop the greater the number of planes made clear and sharp.

In process work, various forms of diaphragm apertures are used, with the object of promoting the dot formation. The principle is that the apertures in the ruled screen act as pinhole lenses and form an image of the diaphragm, so that in this way the shape of the dot image is controlled. The square diaphragm is most

A. Penrose Diaphragm System **B.** Adjustable Diaphragm

commonly used, but squares with extended corners are also employed to promote the joining up of the dots in the high lights. The Penrose diaphragm system A standardises the use of such stops, the apertures being arranged on the basis that each smaller stop requires an exposure of half as much again compared with the next larger size. The adjustable diaphragm B enables any size of square opening to be formed.

DIAPOSITIVE

An old name for a lantern slide or similar transparency made to be viewed by transmitted light. The name differentiated transparencies from positives upon opaque supports as, for example, daguerreotypes, ferrotypes, and wet collodion pictures backed up with black material.

DIATOMS, PHOTOGRAPHING (*See* "Photomicrography.")

DIAZOTYPE

There are several printing processes based on the light-sensitiveness of the diazo compounds, which, although not much used, are of considerable interest, as they give a great range of colours. The diazo compounds are extremely rich in oxygen, and are formed by the action of nitrous acid on the aromatic amines, amidosulphonic acids, amidocarbonic acids, etc., and readily combine with certain phenols and amines to form azo dyes. If a paper or material impregnated with a diazo compound is exposed under a negative, the diazo compound is decomposed by the action of light, and on immersion in a solution which forms a dye with the diazo compound a negative image is obtained.

The primuline process invented by Green, Cross and Bevan in 1890 is based on the light-sensitiveness of the diazo compound of primuline, a yellow water-soluble dye which gives material or paper without a mordant. Paper or material is immersed in a solution of :—

Primuline	. .	320 grs.	33 g.
Hot water to	. .	20 oz.	1,000 ccs.

and then washed and immersed in—

Sodium nitrite .	.	64 grs.	6·6 g.
Hydrochloric acid	.	150 mins.	15 ccs.
Water to .	.	20 oz.	1,000 ,,

It should then be dried in the dark and exposed under a vigorous positive till those parts under the bare glass are colourless. Then wash thoroughly with water, and treat with one of the following solutions :—

For Red

β-Naphthol	.	. 9·6 grs.	10 g.
Sodium hydrate	.	128 ,,	13·3 ,,
Water to .	.	. 20 oz.	1,000 ccs.

For Orange

Resorcin .	.	. 64 grs.	6·6 g.
Sodium hydrate	.	106 ,,	11 ,,
Water to .	.	. 20 oz.	1,000 ccs.

For Purple

α-Naphthylamine	.	190 grs.	20 g.
Hydrochloric acid	.	1 oz.	50 ccs.
Water to .	.	. 20 ,,	1,000 ,,

For Black

Eikonogen	.	. 125 grs.	13 g.
Water to .	.	. 20 oz.	1,000 ccs.

For Brown

Pyrogallol	.	. 113 grs.	12 g.
Water to .	.	. 20 oz.	1,000 ccs.

Wash well after development. Various coloured images can be obtained on the same print by local application of the above solutions with a brush. This process does not give pure whites.

Andresen suggested the following modification :—

Pyridine base (pure) .	110 grs.	23 g.
Boiling water .	. 10 oz.	500 ccs.

then add—

Sulphuric acid (pure) .	180 mins.	37·5 ccs.
Distilled water .	180 ,,	37·5 ,,

Benzidine sulphate is formed, and partially separates out. Cool the solution down to 100° to 120° F. (38° to 49° C.), and add—

Sodium nitrite .	. 86 grs.	18 g.
Water .	. 1 oz.	50 ccs.

in small quantities with continuous stirring. The benzidine sulphate is diazotised and dissolves. Filter the solution and pour into five times its volume of alcohol, which precipitates the diazo compound; filter out the precipitate, and dissolve (without drying, as it explodes when dry) in—

Distilled water to . 20 oz. 1,000 ccs.

The paper or material is sensitised in this cold solution by floating or immersion for two minutes, dried in the dark, and exposed under a positive, and then developed in a 2 per cent. solution of amidonaphthol sulphonic acid —5, or amidonaphtholsulphonic acid —9, containing 2 per cent. of sodium hydrate. Deep blue images with pure whites are thus obtained.

Feer's process uses aniline diazosulphonate, amidobenzols, etc., with phenolic alkalis,

amines, and phenylamines, the following being typical sensitisers :—

1. Sodium toluoldiazo-

sulphonate	.	240 grs.	25 g.
β-Naphthol .	.	240 ,,	25 ,,
Sodium hydrate .		76 ,,	8 ,,
Distilled water to		20 oz.	1,000 ccs.

2. Sodium ditolyltetrazo-

sulphonate	.	240 grs.	25 g.
μ-Phenylendiamin		190 ,,	20 ,,
Distilled water to	.	20 oz.	1,000 ccs.

3. Sodium ditolyltetrazo-

sulphonate	.	240 grs.	25 g.
Resorcin	.	211 ,,	22 ,,
Sodium hydrate .		154 ,,	16 ,,
Distilled water to	.	20 oz.	1,000 ccs.

The paper is immersed in these solutions, and after drying exposed for about five minutes to sunlight or electric light. On the exposed parts the insoluble azo dye is formed, whilst in the unexposed part the sensitiser remains colourless and washes out. The print should be fixed in hydrochloric acid.

Andresen discovered in 1894 another diazo printing process. The sensitiser is the diazo compound of α-naphthylamine or β-naphthylamine, the former giving brownish grey images and the latter brown-red. If the exposed paper is washed and treated with tetrazo-diphenyl ether, violet images are obtained.

Distilled water .	.	5 oz.	150 ccs.

heat to boiling, and add—

α- or β-Naphthylamine	.	. 220 grs.	14·3 g.

then add—

Hydrochloric acid (sp. g. 1·19) .	. 152 grs.	10 g.

and as soon as the salt has dissolved add—

Hydrochloric acid . 617 grs. 40 g.

with constant stirring, and cool the paste down to 40° F. An evolution of gas takes place, and a yellowish solution is formed which must be filtered into an ice-cold dish. Float paper on this for fifteen seconds and dry in the dark. Expose for two or three minutes under a negative in the sun and develop in a 10 to 20 per cent. solution of twice fused acetate of soda, and wash well.

These processes give rather pleasing effects when applied to silks and other materials.

DI-CARBOXYLIC ACIDS (*See* "Carboxylic Acids.")

DICHROIC FOG (*See* "Fog.")

DICHROMATIC PHOTOGRAPHY

A process of colour photography invented by Gurtner, in which only two constituent colours, blue and orange-red, are used. Two plates are placed film to film, the nearest to the lens being coated with a transparent emulsion stained yellow; on this only the blue rays act, and on the rear plate, which must be panchromatic, the yellow, orange, and red rays act. From these

two negatives are made prints, in orange-red for the front plate and blue for the rear one, and superimposed. Obviously it cannot give pure reds or pure yellows, but merely for landscape work some pleasing results have been obtained.

The same principle is used by Smith and Urban in kinematography and with far greater success, because as the pictures are now projected very rapidly, and the observer sits in a darkened room, one is not sensible of the absence of any colour or the failure to make pure white.

DICYANINE (Fr. and Ger., *Dicyanin*)

Solubilities, soluble in water and alcohol. This is a complex aniline dye prepared by the action of an alcoholic solution of caustic potash on a- γ-dimethylchinoline salts with the aid of atmospheric oxygen. It forms greenish glittering crystals which dissolve in alcohol with a greenish-blue colour, and in water with a more reddish tinge, both solutions being decolorised by acids. It is one of the best sensitisers known for the extreme red, particularly for the region about λ 7,200, the range extending through the orange and yellow, but it gives a deep minimum or lack of sensitiveness between E and F in the green and green-blue, and is not therefore so much in use as some of the other dyes. It is very easily decomposed in weak solution, and therefore should only be added to the sensitising bath immediately before use. (*See also* " Colour Sensitising.")

DIETZLER

An optician of Vienna, chiefly noted for his manufacture of the orthoscopic lens designed by Prof. J. Petzval, which was first issued in 1858, although calculated as early as 1841. (*See* " Lenses, Orthoscopic.")

DIFFRACTION (Fr., *Diffraction;* Ger., *Diffraktion, Ablenkung, Beugung*)

When light passes through a very narrow slit it apparently bends round the edges and spreads out on both sides. The subject is fully gone into under the heading " Diffraction Grating."

In process work, a theory advanced in regard to the action of the ruled screen used for the half-tone process is that diffraction plays an important part, especially with the finer screens, and some authorities claim that advantage can be taken of this action to promote the better formation of the half-tone dot. Diffraction is said to produce the effect of larger or smaller dot images instead of only stronger or weaker ones, as would be the case if there were no action of deflected light.

DIFFRACTION GRATING (Fr., *Réseau de diffraction;* Ger., *Diffraktions-Gitter*)

An opaque screen containing a large number of fine slits, or a transparent screen having opaque lines engraved upon it very close together. A pencil of light is formed of a wave front or a series of overlapping waves which may be represented by the diagram A, in which L is the light source and A B the main wave front in which every particle excites fresh secondary waves, as shown by the curve C D. Nearly all these

secondary circles mutually interfere one with the other, except in the main wave front C D. This interference cannot be seen, but its existence can be proved by limiting the size of the main wave front by an opaque screen S S, which stops out some of the secondary waves but not all, and the latter are seen as delicate fringes E F on each side of the main wave front. This can be experimentally proved in a very simple way. Take a black opaque card about 6 in. or 8 in. square, and cut in the centre a slit about 1 in. long and about ⅛ in. wide. Take also a piece of glass about 3 in. square and either smoke it or cover it with black varnish, and with a fine

A. Diagram showing Principle of Diffraction Grating

needle-point scratch a thin, clear line about ¼ in. long. On holding the card at arm's length close to a brilliant light, and examining it through the scratch on the glass, held close to the eye, there will be seen a bright central image of the slit, and on each side of it faint black lines, which are the diffraction fringes. If in front of the light source a violet glass is placed and then a deep red one, there will be obtained images, as shown in the diagram B, in which O is the central image, V the violet bands or fringes, and R the red ones, the violet being nearer together than the red. If a green glass is used the green fringes would fall midway between the red and violet.

The explanation of this phenomenon is as follows : In diagram C let A B represent an opaque screen with an aperture C D, L the beam of light, which, proceeding in a straight line, forms a bright central image at E F. Now diffraction, or the bending of the light waves round the edge of the opaque screen, will cause secondary waves to proceed in all directions from every particle of ether lying between C D. For the sake of clearness, let us consider only the waves in one direction, and represent these as straight lines C G D H. Let us further assume that between C and D there are eight ether particles acting as sources of secondary waves. If we now draw C W at right angles to the path of the rays, it will be at once seen that the waves from D have further to travel than those from C by the distance D W. Let D W be a wavelength, then obviously ½ D W is exactly half a wave length ; drawing a perpendicular from ½ W to the ether particles we at once see that the wave from 4 is exactly half a wave length from C, and the same distance in front of that from D. By the same reasoning it will be **found**

that 1 is half a wave-length in front of 5, 2 half a wave-length in front of 6, and so on; so that every ray is in opposite phase with another ray in the slit. Now two rays in opposite phase (*see* " Interference of Light ") produce interference or darkness, so that on the screen G E H F there would be a dark band. By similar

them, the rulings acting as opaque screens; those on metal are known as reflection gratings. Diagram B represents practically the spectra which are obtained with any diffraction grating. They are arranged on each side of the central white image o. The spectra nearest o are called the spectra of the first order, then there is a

B. Diagram of Diffraction Bands or Fringes

reasoning we could find beyond this particular angle a bright band where the secondary waves would be in the same phase.

It is obvious that the greater the number of apertures in an opaque screen the greater the number of secondary waves formed, and therefore the greater the chance of interference. Further than that, the narrower the slit the greater must be the obliquity or the angular distance from the central image, for the greater obliquity will be required to produce the necessary difference between the paths of the rays from a narrower slit; that is to say, the more slits there are in a unit length the greater the obliquity. Now we have already seen that the violet bands are closer together than the red, and that the green would lie in between, so that if we illuminate a series of slits by hetereogeneous white light the waves will be sifted out into their respective positions, and we obtain a spectrum in which the rays are arranged according to their wave length.

Fraunhofer was the first to utilise the phenomenon of diffraction, and he made his gratings of silver wire wound round two fine threaded screws placed some distance apart. The next

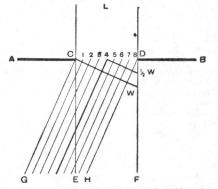

C. Diagram showing Cause of Diffraction Bands

forward step was the ruling of a series of fine lines with a diamond on glass, and later still the glass was silvered. Then Rutherford, of New York, ruled the lines on plane speculum metal, and later on spherical mirrors of speculum metal. Diffraction gratings on glass are called transmission gratings, as the light passes through

dark space filled by the invisible infra red and the invisible ultra violet; then we have the spectra of the second order overlapped even in the visible spectrum by the violet of the third order. Then follow the fourth and other order spectra, the number being dependent on the brilliancy of the light and the character of the grating.

A moment's consideration will prove that the spectra formed by a diffraction grating cannot be as brilliant as a prismatic spectrum, for although there is some loss of light with the latter, through the reflection from the front surface of the prism and by absorption in the glass itself, yet in the case of the diffraction grating not only does the bulk of the light proceed to the central image, which is useless, but the rest is split up into the various spectra on each side. Sometimes, too, in consequence of some peculiarity in the ruling, one or other of the spectra may be much more brilliant than the others.

A grating spectroscope or spectrograph is, however, much to be preferred to a prismatic, as the rays are arranged exactly according to their wave-length, whilst with the prismatic spectrum the violet and blue are spread out at the expense of the red and orange, which are cramped together. (*See also* " Spectrum," " Diffraction Grating Replicas," etc.)

DIFFRACTION GRATING REPLICAS (Fr., *Replicas des réseaux de diffraction;* Ger., *Diffraktions-Gitter-Abklatsche*)

Original gratings, whether on glass or metal, are extremely expensive, and numerous attempts have been made by Rayleigh, Abney, and others to reproduce these by photographic means, but the most successful way is that of taking casts in celluloid. Thorpe, Ives, and Wallace produce these, and the latter has given full working instructions, of which the following is an abstract :—

Pyroxyline .	.	18¾ grs.	3·9 g.
Pure amyl acetate .	1	oz.	100 ccs.

Add the pyroxyline in small quantities to the amyl acetate, shake well till dissolved, and allow to stand for twenty-four hours. At the end of that time the resultant collodion should be poured from a height of at least 3 ft. or 4 ft. in a very thin stream into a large tray filled with water, the latter being constantly stirred with a glass rod. In about twenty-four hours

the whole of the pyroxyline is precipitated in the form of white or light grey flocculent masses, which should be collected and dried. The purpose of this precipitation is probably to purify the pyroxyline, as any collodion poured into water gives up what Eder has called " pyroxyline gum." The particular pyroxyline recommended by Wallace is not obtainable in England, but Hopkins and Williams's high temperature pyroxyline gives excellent results, as does also Mawson and Swan's collodion when precipitated in this way. It is not necessary to use amyl acetate before the precipitation, the ordinary solvent of equal parts of alcohol and ether proving quite satisfactory, and the precipitation is instantaneous. When thoroughly dry the precipitated pyroxyline is again dissolved in the above proportions, and the collodion carefully filtered through paper. This, which is troublesome unless pressure is used, may be avoided by allowing the collodion to stand three or four days, when the whole of the impurities settle to the bottom of the bottle.

The grating should be carefully levelled in a drying cupboard, and this is absolutely essential to prevent the occurrence of dust; next, it is carefully dusted with a soft camel-hair brush, and the solution flowed over the surface. The exact quantity is a matter of experiment, too thin a film being difficult to handle whilst too thick a film gives a matt surface. About 1·5 ccs. is the right quantity to use for a 2-in. grating. The best method of applying the solution is with a fine pipette, which will hold just the necessary quantity. This enables one to distribute the solution over the surface without touching the grating itself, and the solution can be easily led to any part, or an air bubble brought to the edge and broken.

The coated grating should be left in the cupboard for at least twelve hours, and longer is preferable, even for three or four days; the longer it is left the easier it is to handle. To strip the cast, the grating should be placed in a dish of distilled water, when the edges will soon begin to show shadow bands. As soon as these are observed the grating should be taken from the dish, and any adherent water removed with a soft rag. Slight pressure with the thumb nail along one edge will cause the cast to spring from the metal, and it should then be grasped by a pair of wide-jawed forceps, as used in microscopy, and pulled off with a firm but even motion in a direction parallel to the lines of the ruling. The edges of the cast should be trimmed off, and it should then be lowered on to a piece of carefully cleaned and polished plate glass, which should be immersed in distilled water and lifted out with a small pool of water on its surface. One edge of the cast should be lowered on to the glass first, and then the rest gradually lowered so that it pushes the water in front of it without the occurrence of air bubbles. As soon as it is in position one edge should be clipped by a strong metal clip, and a piece of soft velvet rubber passed across it in the direction of the rulings; when contact is obtained everywhere the edges should be cemented down with some of the collodion as used for the cast. This can be applied with a very fine camel-hair brush. The cast may be cemented face up or face down,

but with the latter there is less chance of the rulings being damaged. When the cast has been cemented it may be dried by heat, gentle at first, but gradually increased to 167° F. (75° C.). The chief cause of failure is dust particles between the glass and the replica. If the replica is mounted face down, another piece of glass may be cemented to the back.

There is some contraction of the cast in drying, but this is small. Wallace found that with a grating of 28·867 mm. width and 16,397 lines the shrinkage was 0·176 mm. on the entire width, or about six lines more to every one thousand. The shrinkage can, of course, be easily determined by accurate measurement of the original grating and the cast; thus, in the case referred to above, the original width = 28·867 mm., width of replica = 28·691 mm.; therefore with a total of 16,397 lines in the original, 568 lines = 1 mm. On the replica obviously 16,397 ÷ 28·691 = 572 per mm. This shrinkage simply causes greater dispersion of the spectrum.

When examined in a quartz spectrograph these replicas were found to transmit up to λ 2,613 in the ultra-violet, but obviously their glass support absorbs up to about λ 3,400. Prof. R. W. Wood has suggested the use of thin mica sheets, and naturally quartz could be used for the support. This process of taking casts from a grating in no way damages it, it being, in fact, an excellent method of cleaning a grating.

DIFFUSED LIGHT (Fr., *Lumière diffusée* ; Ger., *Zerstreutes Licht*)

Light that is spread and softened by the interposition of any translucent medium, such as clouds, a misty atmosphere, a muslin screen, ground glass, opal, etc.; the opposite to direct light, coming unobstructed from the source of illumination. Printing in diffused light means printing in daylight other than direct sunshine.

Diffused light in the camera, tending to cause fog, is light that is reflected or scattered by the sides of the camera, etc.

DIFFUSING SCREEN (Fr., *Écran de diffusion* ; Ger., *Verbreitungschirm*)

Synonyms diffusion screen, diffuser. Any translucent material or fabric used to spread and soften light. Thus, a frame covered with tracing cloth, white muslin, or thin calico is employed in the studio to obtain a soft, round lighting. A circular diffusing screen is advisable in conjunction with the electric light for portraiture, as illustrated under the heading " Arc Lamp." A sheet of ground glass or opal is often used in enlarging by artificial light without a condenser, to distribute the illumination equally over the whole of the negative. The same method is frequently adopted in daylight enlarging, though an inclined white reflector is perhaps more usual. White tissue paper is sometimes pasted over the printing frame when a thin negative is required to print slowly. A piece of ground glass in the dark-room lamp, behind the ruby or orange glass, gives a more even and better distributed light.

DIFFUSION OF FOCUS

The soft effect obtained by throwing the image very slightly out of focus on the screen just before exposure, this producing " fuzziness."

DIHYDRIC PHENOLS

Derivatives of phenol or carbolic acid which contain another hydroxyl group, thus phenol or hydroxy-benzene is C_6H_5 OH, the dihydric phenol C_6H_4 $(OH)_2$. Catechol, resorcinol, and hydroquinone belong to this group, the last-named being of much photographic interest.

DILUTE DEVELOPMENT

A method in which very dilute developers are used, such as in stand development (*which see* under the heading " Development, Stand ").

DIMINISHING GLASS

A double concave lens mounted in a holder and used for examining drawings or photographs which have to be reduced by photographic processes. By its use it is possible to judge somewhat the effect of reduction.

DINITRO-NAPHTHOL

$C_{10}H_5(NO_2)_2$ OH. The sodium salt is known as Martius yellow, which is sometimes used for yellow filters. The sulphonic potassium salt is known as naphthol yellow.

DIOGEN (Fr. and Ger., *Diogen*)

Solubilities, soluble in cold water, insoluble in alcohol and ether. The acid sodium salt of a_1 amido-, β_1 naphthol-, β_2 β_3 disulphonic acid, introduced in 1897 as a developer. It freely dissolves in alkaline sulphite and carbonate solutions, giving a yellowish coloured developer, which is readily amenable to the influence of a bromide.

DIOPTICHROME PROCESS (*See* " Dufay Dioptichrome Process")

DIOPTRICS

The department of optics referring to the laws governing rays of light passing through transparent media, as air, water, glass, crystal, etc.

DIPHENAL (Fr. and Ger., *Diphenal*)

$C_6H_3OHNH_2$ $C_6H_4NH_2$. Molecular weight, 200. Solubilities, almost insoluble in cold water, very soluble in hot water; soluble in alcohol and glacial acetic acid. It must be kept in a well-stoppered bottle. It is a highly concentrated solution of the phenolate of diamido-oxydiphenyl in caustic alkaline solution, and was introduced in 1897 as a developer.

DIPPER (Fr., *Crochet* ; Ger., *Küvettenhaken, Silberhaken, Plattenheber*)

A kind of holder employed in the wet collodion process, to immerse the plate in the silver bath. It may be of glass, porcelain, ebonite, or silver wire, and is furnished with hooks or

A. Fluted Glass Dipper

projections at the bottom to hold the plate. Those of fluted glass A, though somewhat liable to breakage, are perhaps the cleanliest.

In process work, where the dipper is important for the wet-plate process commonly worked, various forms have been adopted. The usual styles are the fluted glass A and ebonite B. The forked dipper C is an American idea, the object being to support large plates more firmly than do the usual narrow dippers. Another kind of dipper is made of hickory wood ; by pressing the handle parts together the forks move apart

B. Ebonite Dipper

C. Forked Dipper

and allow the plate to be inserted. On releasing the pressure the forks press the plate between them, so that there is no chance of dropping it. A coat of shellac varnish makes the wood waterproof. A similar arrangement can be used as a developing holder. Silver wire or silver plate can be bent to the shape of a dipper, but becomes expensive in large sizes.

DIPPING BATH (Fr., *Cuvette verticale à bain d'argent* ; Ger., *Kuvette*)

The upright vessel of ebonite, glass, etc., for containing the silver bath in the wet-plate process. Those made of white glass are preferable.

DIPPING-BATH DEVELOPMENT

An early form of what is known as stand development. It was advocated in 1892 by a German, Dr. A. Meydenbauer, who described it under the name of "Standentwickelung." Its principle is found in the prolonged action of a very diluted developer contained in a dipping-bath. The early name " dipping-bath development" has been superseded by "stand development"; for full particulars, *see* "Developing Tank" and "Development, Stand."

DIRECT FINDER, OR DIRECT-VISION FINDER (Fr., *Viseur direct* ; Ger., *Direktsucher*)

A finder in which the view or object to be photographed is inspected direct, the camera

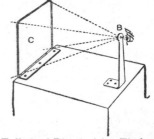

A. Full-sized Direct-vision Finder with Wire Frame

being held up to the level of the eye. The full-sized direct-vision finder A consists of a rectangular wire frame c the size of the plate used, and

having a small opening or sight B fixed at a distance from it equal to the focal length of the lens with which the camera is fitted. If the sight is at the correct height, the eye placed against it will see through the frame the exact view included on the plate. The frame and sight are either detachable or made to fold down when not in use. When the camera is not of fixed focus, the frame should be attached

B. Direct Vision Finder with Lens

above the lens, so that it may move with it, to suit different extensions and to agree with any rise or fall given to the front. Another form of direct finder B consists of a concave lens, the sides of which are trimmed to a rectangular shape, with a small sight to indicate the distance at which it must be inspected. This gives a small but brilliant image. Cross lines are usually marked on the lens to assist in holding the camera level.

DIRECT POSITIVES (See " Positives, Direct.")

DIRECTOSCOPE

A stereoscope for the direct observation of colour (screen-plate) transparencies without reversal; invented and patented by M. G. Balmitgere in 1911.

DISGUISING THE CAMERA (Fr., *Déguisement de la chambre*; Ger., *Camera verstellen*)

In detective work it is frequently necessary to conceal the presence of the camera. This may sometimes be done by causing it to resemble some other article, such as a brown-paper parcel, a bundle of books, a brief bag, an opera glass, etc. A box-form magazine camera is easily made to look like a parcel by wrapping it somewhat carelessly in brown paper and tying with string, to which a luggage label may be attached. Holes should be torn for the lens and finder, leaving, however, a flap of paper hanging loosely over them to hide them until actually wanted. Many special forms of cameras have been made for purposes of disguise, such as one to work behind the waistcoat of the operator, the small lens protruding through a buttonhole; an apparatus for concealment in the hat; another resembling a lady's reticule, and so on.

Sometimes, in natural history photography, it is required to prevent animals, birds, etc., from knowing of the camera's proximity, and there are many ways in which this may be done. It may, for instance be hidden by an arrangement of boughs and twigs, or a moss-covered heap of stones, and possibly operated from a distance by a pneumatic or electric release. The precise method chosen depends on the nature of the surroundings. Considerable patience is called for, and it is not unusual for the operator as well as the camera to be completely concealed.

DISHES (Fr., *Cuvettes, Cuves*; Ger., *Schalen, Tassen*)

Dishes are described under the heading " Baths." (See also " Cleaning Dishes.")

DISINFECTANT

Any substance which kills bacteria and microbes, such as carbolic acid, formaline, corrosive sublimate, etc. Rapid oxidisers, such as potassium permanganate, also act as disinfectants.

DISPERSION (Fr., *Dispersion*; Ger., *Zerstreuung*)

The breaking up of white light into the various colours forming the spectrum, as seen when a prism is interposed in the path of a beam of light proceeding from a narrow opening or slit. Sir Isaac Newton was the first, in 1666, to show that rays of various colours have different refrangibility. The shorter the wave-length of the light the greater is found to be its refrangibility; thus red rays, which have the longest wave-length, are less refracted than the violet rays, which have the shortest wave-length. The same law applies to the non-visible infra-red and ultra-violet rays, at opposite ends of the visible spectrum. There are, however, a few cases in which the law is departed from. If, for instance, fuchsine is prepared in the form of very thin prisms, it produces a spectrum in which the red and yellow rays are more refracted than the blue and violet. This phenomenon is known as anomalous dispersion.

Newton predicted that dispersion could not be eliminated without at the same time losing the property of refraction. This is now known to be erroneous, since different kinds of glass may give practically the same amount of dispersion, yet have varying refractive properties. It is thus possible, by combining lenses made of dissimilar kinds of glass, practically to neutralise the effects of dispersion, a lens in which this is done being known as achromatic. (See also " Lens.")

DISSOLVING CHEMICALS

There is a right and a wrong way of dissolving and mixing most chemicals, and in some cases the method of dissolving affects the working powers of the solution. The slowest and possibly the worst way of dissolving a chemical is to place it in a bottle of liquid and let it stand. The quickest way is to have the salt, particularly soda, near the surface of the water and suspended therein in a canvas bag. However, for most solutions, the simple addition of chemicals, when not in large quantities, and frequent shakings will be sufficient. Chemicals usually dissolve more quickly in hot water than in cold, though there are some notable exceptions to this rule. (See " Solubilities.")

The order in which chemicals are dissolved or mixed has its influence on the working and keeping qualities of the solution. As a general rule, ingredients are added in the order given in the formulæ, otherwise special instructions are given. The following general hints should be noted :—Metol should be dissolved in the water before any other chemicals are added. Hydroquinone should always be dissolved after sodium sulphite. When pyrogallic acid is used, the

preservative—acid, metabisulphite, etc.—should be dissolved in the water before the pyro. When gold toning baths are made, the gold should always be added last, dissolved in water. Sulphuric acid should always be added gradually to the water and not water to the acid, otherwise combination takes place so energetically as almost to resemble an explosion, and some of the acid may be driven in the face or over the clothes. The list of solubilities presented in the table that is given under the heading "Solubilities" will assist in deciding whether much advantage will be gained by using hot or cold water. In some cases the temperature of the water is not of much importance. Developers such as pyro, metol, adurol, etc., are best dissolved in water that has been well boiled in order to get rid of the air, and then allowed to cool slowly.

DISSOLVING-VIEWS

These are obtained by the use of two lanterns, one above the other, or placed side by side. The discs of light projected by the two lanterns must coincide. Whilst a picture is being shown in the first lantern, the illuminant is quite low in the second one. A slide is placed in the second lantern, and then the light of the first one is gradually lowered whilst that of the second one is gradually turned up; the first picture dissolves away during the blending of the lights, and at the same time the second picture makes its appearance on the screen, taking the place of the first. To facilitate the operation (especially when lime-light is in use) the rubber tubing from the two jets is connected to a duplex gas-cock having four ways or channels, through which the gases may be made to pass. Thus, the oxygen and hydrogen of one illuminant is partially diverted or reduced, whilst the tap allows a full supply to pass to the other jet.

Dissolving effects are sometimes produced with bi-unial lanterns with their objectives furnished with iris-diaphragms opened and closed alternately. This method is very effective, and saves having to interfere with the adjustment of the illuminants.

Dissolving effects of a kind may be produced by means of a single lantern. The special carriers for obtaining such effects are divided into two classes. In one, a translucent screen gradually obscures the light, and just at the moment when the obscurity is complete, the slide is quickly changed by means of a carrier of the "to and fro" type. In another class, a second slide is pushed into a carrier which already holds a slide that is being shown; the second slide passes in front of the first, the latter is withdrawn, and then, by means of a spring, the out-of-focus slide is quickly pushed back into the place previously occupied by the first slide. This form of carrier was invented by R. R. Beard, and still enjoys popularity.

Dissolving effects in kinematograph pictures may be produced in two ways. If it is desired to make provision for such effects at the time of taking the original negative film, it is accomplished as follows: An iris-diaphragm, capable of completely closing at the centre, is fitted to the camera lens, and a short length of film is run through at the commencement whilst the iris is completely closed. Proceeding to wind through the film, the iris is gradually dilated and finally brought to its full aperture. The effect upon the sensitive emulsion is that the image of the object to be photographed fails to impress itself at first, and as the aperture enlarges in the iris, the film is more and more impressed, till at full aperture a full exposure is secured. The negative is then developed in the usual way. Such a negative will yield a positive in which the image gradually grows in strength, and as, at the commencement, no image will be seen, on projection the subject upon the screen will appear to develop out of thin air. If the image is intended to dissolve away and thus give place to a different subject, the iris on the camera is closed gradually whilst continuing to wind the film. Thus, a reverse effect will result when the negative is printed. Any subject may be treated in a similar way at the printing stage by regulating the illuminant used whilst printing. Thus, at the commencement, the light is kept very low, and as the films pass through the printer the illuminant is gradually turned full on till sufficient light is produced to secure normal exposure. Yet another method is to keep the illuminant at a uniform brilliancy and to regulate the exposure by modifying the speed at which the films are wound through the apparatus.

To make one kinematograph subject dissolve gradually into another, double printing is resorted to. At that point where the first print commences to weaken, through reduced exposure, a second negative (of the second subject) is placed in contact and gradually printed up, till it reaches full vigour. Hence, instead of one subject dissolving away entirely before a second begins to make its appearance, the image of the second subject will make its appearance, weak at first, but gradually growing in strength and finally becoming of full vigour, and this whilst the preceding image melts away.

DISTANCE

That part of a picture farthest from the spectator, and generally quite subordinate to the rest of the view, to which, however, it must stand in proper relation. Occasionally it forms the *motif* of the subject. When a bluish distance is desired stronger than it would appear in the ordinary way, an orthochromatic plate with a deep yellow colour filter will be of great assistance. In telephotographic work it is often difficult, and sometimes impossible, to render distant objects clearly even by such means, on account of the interposition of large volumes of air of varying density.

DISTANCE METER, OR TELEMETER (Fr., *Télémètre*; Ger., *Entfernungsmesser, Distanzmesser*)

An instrument for estimating the distance of an object from the camera, so that it may be accurately focused by means of the focusing scale, without having to inspect the image on the screen. In one form A the distance is indicated on a scale by a small pendulum in the shape of a pointer. The appliance is held up to the eye, so that the latter looks along the sights towards the base of the object to be

photographed. The index then shows the angle made by the line of sight with a perpendicular drawn to the observer's feet, which angle varies with the distance of the object. By pressing slightly with the forefinger on the top of the pendulum it is prevented from moving when the telemeter is lowered for examination. Another type of distance meter consists of a small telescope which indicates the distances on which it is focused. In the pattern illustrated at B,

A and B. Two Forms of Distance Meter

the instrument has first to be fully extended and the eyepiece focused correctly on the grain of the ground glass inside the telescope. The eyepiece tube is then scratched with a knife, so that the observer may always in the future be able to secure the focus suited to his particular vision. This having been adjusted, the object glass is revolved until the object to be photographed is seen sharply on the ground glass. The arrow will then point to the correct distance of the object on the engraved scale.

DISTANCE SCALE (See " Focusing Scale.")

DISTILLED WATER (Fr., *Eau distillée ;* Ger., *Destilliertes Wasser*)

Pure water, obtained by vaporisation in a still and subsequent condensation of the vapour.

Distilled water is advised for many chemicals, and as it may be obtained so very cheaply from a chemist, it should be used when recommended, and most certainly for such chemicals as gold chloride, silver nitrate, and uranium nitrate, which are both expensive and prone to decompose in water containing impurities. Whether distilled water should be used for all developers, toners, etc., depends upon the character of the ordinary water available. With many of the common chemicals used in photography—all sodiums, potassiums, etc.—tap or other water good enough to drink will serve quite well.

In process work, distilled water is used in large quantities for making up the silver bath. The use of tap water is possible, but it occasions some amount of trouble.

DISTORTION (Fr., *Distorsion ;* Ger., *Verdrehung*)

It is a common error to attribute every unpleasing effect in the " drawing " of a photograph to distortion, but, as a matter of fact, true distortion is very limited in photography. The most common and the most serious form is known as curvilinear distortion, and is confined to single lenses and to certain forms of compound ones. In the case of the single lens this distortion is shown by a bending of the lines, which becomes more pronounced towards the edges of the field, the bending being out-

wards from the corners when the diaphragm is used in front of the lens, and inwards when the diaphragm is placed behind the lens. (See " Curvilinear Distortion.") Distortion by convergence of straight lines is treated under the heading " Swing Back." Violent perspective, which is sometimes wrongly called distortion, is quite distinct from it. If a photograph taken with a rectilinear lens however wide its angle may be, is tested by the inflexible rules of plane perspective, it will be found to be correct, no matter how ridiculous it may appear owing to the choice of too near a standpoint.

DIVERGENT RAYS

Practically all the light which the eye sees or which enters a lens is composed of divergent rays. Every point in an object emits rays which diverge in all directions from which it is visible, and the lens of the eye or of the camera causes them to converge and form an image. When an object is extremely remote the degree of divergence is very small, and such rays are termed parallel.

DIVERGING LENS

A concave lens, or one which is not capable of producing an actual image. It is often called a " negative " lens. The magnifying element of a telephoto lens belongs to this class.

DIVERSITY

In pictorial composition, the introduction of many varied objects each claiming more or less attention. Unless kept strictly within bounds it results in confusion.

DIVIDING BACK (See " Repeating Back.")

DODGING NEGATIVES AND PRINTS (See " Control in Printing.")

DOLLAND'S PROCESS

A method of toning and intensifying platinotype prints, worked out by A. W. Dolland. Its advantages are that it strengthens a weak platinum print, and at the same time changes it to a pure black or blue-black colour. The weak black picture to be strengthened and toned—the more recently made the better, as prints more than about ten weeks old are difficult to treat—is soaked in warm water and then laid face upwards on a sheet of warm glass. All superfluous water is blotted off, and a thin covering of glycerine is gently spread over the surface by means of the finger-tip or a broad camel-hair brush. A strong solution of gold chloride (15 grs. to 7½ drms. of water) is then made up, and a few drops of it brushed over the glycerine-covered print as evenly as possible. The print soon begins to gain strength, and at the same time the colour of the print gradually changes to a warm black, then cold black, and finally blue-black. As soon as the desired effect is attained the print is well washed in water in order to remove the gold and glycerine, care being taken during the treatment with gold that the high lights remain unaffected. After washing, and in order to ensure the reduction and elimination of any gold compounds which

are liable to be formed with the sizing of the paper, the toned print should be sponged back and front with any clean-working alkaline developer, the formula specially recommended by Dolland being:

A.	Metol.	. 100 grs.	10 g.	
	Sodium sulphite .	2 ,,	100 ,,	
	Water to .	. 20 oz.	1,000 ccs.	
B.	Potass. carbonate	240 grs.	24 g.	
	Water to .	. 20 oz.	1,000 ccs.	

Use equal parts of A and B, and finally wash for about a quarter of an hour. All the above operations are best carried out in the strongest daylight possible.

DONISTHORPE PROCESS

A printing method, invented by Donisthorpe, in 1908, a modification of the old hydrotype process. A negative is taken in the ordinary way and after developing, fixing, and washing is immersed in a mixture of vanadium chloride, potassium ferricyanide, ferric chloride, and oxalate. The silver image is probably converted into chloride and ferricyanide and dissolves, whilst vanadous salts are precipitated *in situ* which harden the gelatine. After washing, the negative is immersed in aniline dye solutions which are absorbed by the hardened gelatine, and not by any unchanged gelatine; the dye is finally removed by absorption by a film of damp gelatine, thus obtaining a print. After one print has been made, the negative is again dyed for a few minutes, rinsed, and another impression is taken.

DOPPLER'S PRINCIPLE

A principle discovered by Doppler, by means of which it is possible to tell with considerable accuracy the rate of travel of a star to or from the earth. It being assumed that a star at a fixed distance emits light waves of a given length at a uniform rate, it is obvious that the number of ether waves striking the observer's eye will be constant in a given time. If, on the other hand, the star be travelling away, fewer waves will meet the observer's eye in a given time, as the waves have further to travel. The converse naturally holds good with a light source travelling towards the observer. Now, if fewer waves strike the eye in a given time, the wave-length must be increased, whereas if more waves strike the eye the wave-length is decreased. In the first case the monochromatic light would incline towards the red, and in the latter case more towards the violet end of the spectrum. The displacement is naturally dependent on the velocity of movement of the light source, and this is usually measured for the F or H β line, and taking the velocity of light as 299,860 kilometres per second, it is obvious that about 61 kilometres per second would result in an increase or decrease of 1 Angstrom unit in the wave-length of this line.

DOT FORMATION

An expression used in relation to the half-tone process when describing the dot effect produced by photographing through the ruled screen. The ideal dot formation is such that in the deepest shadows of the negative (the

most transparent parts) the dots are reduced to mere pin points, and as the tones deepen towards the highest lights (the darkest parts of the negative), the dots grow in size until they join together and leave small transparent open-

Gradation Showing Ideal Dot Formation

ings between. Above is shown a diagrammatic representation of the ideal dot formation.

DOUBLE CONCAVE (*See* "Biconcave.")

DOUBLE CONVEX (*See* "Biconvex.")

DOUBLE DARK-SLIDE (*See* "Dark-slide.")

DOUBLE EXPOSURES

Two exposures may be made on one plate—each one filling half the plate—by having a shield of metal or thin wood fitted to the camera back close to the dark slide. The shield covers half of the plate while the other half is exposed; then the position of the shield is changed so that for the next exposure it covers the exposed half while the second half is exposed. The shutter of the slide may be drawn right out for each exposure; the shield forms a perfect protection for the part covered. By means of such a fitting a half-plate may be used for two quarter-plate exposures.

A few years ago this method of making two exposures on one plate was very frequently used by amateur photographers for producing a type of portrait that could not be attained by any other method excepting combination printing. (*See* "Doubles.") Another form of double exposure is that which is frequently utilised for obtaining "spirit" or "ghost" photographs. A plate is exposed in the usual manner on the subject in which it is intended that the "ghost" should appear. The lens is capped while the figure that is to form the ghost is introduced. Then a short supplementary exposure is made, care being taken to avoid moving any part of the subject between the two exposures. A transparent shadowy image of the added figure will appear, solid objects in the picture being visible through it.

An annoying form of double exposure is that obtained by exposing the same plate twice, by accident. The best method of avoiding this is to make it a rule to change the plate immediately after exposure when using a magazine hand

YELLOW

RED

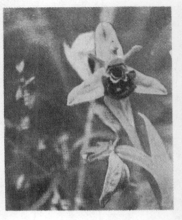

YELLOW + RED

A FOUR-COLOUR PRINT
AND THE
CONSECUTIVE STEPS
IN ITS PRODUCTION

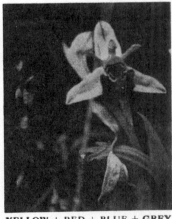

YELLOW + RED + BLUE + GREY

The original, of which this is a small portion, is an Autochrome Photograph by H. ESSENHIGH CORKE, F.R.P.S.

Especially taken for " Wild Flowers as They Grow"

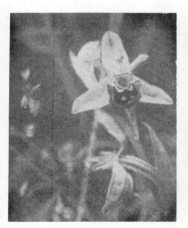

BLUE

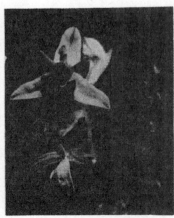

YELLOW + RED + BLUE

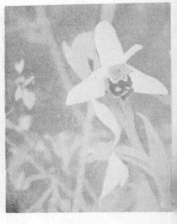

GREY

camera, and to expose all plates in rotation according to the number on the dark-slides when these are employed.

DOUBLE EXTENSION (Fr., *Double tirage;* Ger., *Doppel Ausdehnung*)

A camera is said to be of double extension when its construction allows the racking-out of the bellows to about twice the focal length of the lens that is fitted. The usual arrangement consists of an " extension frame " sliding in grooved rails on the baseboard, and worked by a rack and pinion. When two extension frames are provided, allowing the bellows to be racked out to about three times the focal length of the lens, the camera is said to be of triple extension. The advantages of a long extension are that near objects may be successfully photographed, copying done full size or even larger, and telephotographic work undertaken.

DOUBLE IMAGES

A double image on a negative is the result of one of two causes. Either the camera has moved during the exposure, or else the subject has moved. If the latter, any moving part of the subject will show a double outline, while the remainder of the subject will be sharp. If the whole of the image is doubled, it indicates movement of the camera, laterally or vertically, according to which outlines show the movement.

A double image in a print, if the negative is sharp, indicates that the paper has moved during printing, due to want of care in examining.

DOUBLE PRINTING (*See* " Combination Printing.")

DOUBLE REFRACTION

When a ray of light passes through certain materials it is not only refracted but divided into two parts, one of which, called the ordinary ray, obeys the ordinary laws of refraction, while the other, or extraordinary ray, does not. The most usual method of exhibiting this phenomenon is to place a cross or other figure behind a slab of Iceland spar, when it is seen to be duplicated. The polarisation of light depends upon double refraction. (*See* " Polarised Light.")

DOUBLE TONES

In silver printing these are frequently a source of trouble. Owing to the lighter portions of the subject toning more rapidly than the darker ones, the light parts will be quite cold in tone, a blue-grey, while the shadows may still remain a brick red ; for, as a general rule, when the light parts begin toning at a more rapid rate than the shadows, they continue in the same way throughout the operation, the shadows taking comparatively little gold. This defect most frequently arises from one of two causes. Either the toning bath is too weak, or there is too small a quantity of gold for the prints in hand. The combined toning and fixing bath does not give double tones.

DOUBLE TONING

This is a method frequently adopted in silver printing for obtaining tones that cannot be secured by a single bath. Almost any chloride

emulsion printing-out paper will give fine black or brown-black tones by first toning with gold and then with platinum. A simple and satisfactory method of working is to use a self-toning paper. The prints should be washed, toned with platinum, and then fixed, preferably in a fixing solution that has been rendered slightly alkaline with ammonia. A good toning formula is :—

Potassium chloroplatinite 3 grs.		·3 g.	
Sodium chloride	30 ,,	· 3 ,,	
Citric acid	30 ,,	· 3 ,,	
Water to	20 oz.	1,000 ccs.	

An entirely different double toning is that of toning bromides and lantern slides to two distinct colours. (*See* " Lantern Slides, Two-colour Toning of.")

DOUBLE TRANSFER

A term used in the carbon process to describe the method of working when the reversed print given by the ordinary single transfer method is inadmissible. The print is transferred first to a temporary support on which it is held during development. (*See* " Temporary Support.") After drying it is transferred to a paper which is to be its final support, and it is the necessity for this second transfer that gives it the title of double transfer. (*See also* " Carbon Process.")

DOUBLES

A popular form of freak photograph, showing two pictures of the same person on one plate, as, for example, a man playing cards with himself, etc. This kind of picture was at one time (1880) somewhat popular among professional photographers, but the work is now almost exclusively confined to amateurs. Each half of the plate is exposed separately, thus allowing the figure to be taken twice on the one plate. Many methods of making such exposures have been advocated and a few accessories placed on the market, but excellent doubles may be made with the simplest of fittings.

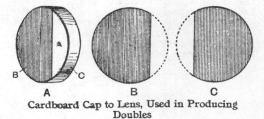

A B C
Cardboard Cap to Lens, Used in Producing Doubles

For the partial lens cap method a lens cap is made of blackened cardboard, as A, the ring C being made to fit easily the front of the lens, and then covered on one side with blackened cardboard B from which a segment is cut off as shown at A ; exactly how much to be cut away should be found by trial. Having cut away a very small portion, the partial cap is placed on the lens and the picture examined on the ground glass. The cutting away must be continued until one half of the picture is dark and the other half lighted. The dividing line as seen on the screen will not be cleanly cut, but will have a diffused or vignetted effect. About

the proportion shown on the right-hand side will have to be cut away, certainly not one half of the card, as might be supposed. During the cutting, the cap is revolved on the lens mount so that both halves of the view can be seen, and

D. Card in Reversing Back

when one half vignettes or merges into the other a trial plate may be exposed. It requires accurate cutting to allow of one exposure merging into the other, and to prevent the join between the two separate exposures being distinguished. If, for example, a thin under-exposed band shows down the centre of the plate the covering part B is too large, and not enough has been cut away; if, on the other hand, there is a dense over-exposed strip, the aperture A is too large, thus causing the centre to receive a double exposure. To use the cap, it is placed on the front of the lens with the opening on the right-hand side, as in B, and the sitter is then posed and focused on the half (left hand) of the screen on which the picture is seen, exposure shutter set, dark-slide put in, and the exposure made in the usual way, the shutter of the dark-slide being drawn out all the way. For the second half, the camera must not be moved, the slide is closed, taken out, and the partial cap revolved to the opposite side—that is, to the position shown at C. The sitter then assumes a position that will be visible upon the second half of the focusing screen, the partly exposed plate is again inserted in the camera, and the second exposure made on the unexposed half of the plate. Obviously the two exposures

E. Box to Fit on Camera Front

must be of exactly the same duration. For this method the camera must be provided with a shutter working behind the lens.

If the camera has no shutter, and exposures are made by removing the cap, a cut cap cannot be used. The circular card from which the

segment has been cut off, and without a ring, can be fitted into the lens hood itself, and of course covered over with the ordinary cap with which the exposures are made.

Another favourite plan of making doubles is to fix a card in the reversing back of the camera (see D), the card being blackened and of a size to cover one half of the plate. The first exposure is made with the card at B, so as to photograph the half marked A; the card is then removed to A in order that the remaining half of the plate B may be exposed. The card used at the back needs to be cut even more accurately than that used in the lens, because being so near the plate the dividing line between the two exposures is more clearly cut. It is desirable to select a background with vertical lines which will not clearly show the division—a bookcase or a door, for example—and the inevitable line between the two parts of the image is so arranged that it coincides with a strongly-marked natural line in the view.

Another accessory (somewhat analogous to the first method described) is shown at E. This is a box of very thin wood, blackened inside, about 6 in. long, 3 in. deep, and 4 in. high; it has a round hole cut in the centre of the back part so that it may be fitted on the front of a lens and used as a kind of partial lens cap. The front of the box is fitted with a sliding panel or half lid, which slides across the front in grooves, allowing each half of the plate to be exposed in succession. Over all there is a proper lid which serves as a cap. This box front is used after the manner of the partial cap, and the exact width of the sliding panel can only be found by experiment as before, one side of the sliding panel being cut accordingly. The latter may be worked by a knob on the centre of the panel itself, or by means of a wire.

In all cases it is advisable to arrange the whole scene first, and to allow the sitter to try both positions, examining the ground glass carefully to see that all is included, and that no part of the sitter—feet and legs, for example—gets beyond the centre, or the whole effect may be spoilt.

A style of "double" portrait (two or more positions at one sitting and with one exposure) is that known as a "polypose portrait."

DOUBLET

An old term used to denote a double combination lens, and usually composed of two cemented meniscus lenses. The ordinary portrait lens is classed as a doublet. The rapid rectilinear may be considered the typical doublet.

DRAGON'S-BLOOD (See "Gums and Resins.")

DRAINING RACK (See "Drying Rack.")

DRAM, OR DRACHM

In apothecaries' weight 60 grs., or one-eighth of an ounce; in avoirdupois weight $27\frac{11}{32}$ grs., or one-sixteenth of an ounce. In fluid measure one dram is 60 minims, or one-eighth of an ounce. The French equivalent to one dram (fluid measure) is $3\frac{1}{2}$ cubic centimètres. (See "Weights and Measures.")

DRAPER, JOHN WILLIAM

Born at St. Helens, Lancs, 1811; died on the Hudson River, 1882. Anglo-American author and scientist. Went to America in 1833 and became professor of physical sciences in Hampden Sidney College, Virginia (1837), and professor of chemistry in the University of New York (1839). He made researches into the chemical action of light, radiant energy, spectrum analysis, and photography. In 1839 (details published March 31, 1840) he was the first to make a portrait of a living person, the subject being his sister Dorothy Catherine Draper, whose face was made white by powdering and given an exposure of about half an hour in bright sunlight. Draper was also the first to photograph the moon (March 23, 1840); it was necessary to give an exposure of twenty minutes, a daguerreotype plate being used.

DRAPERY FOR FIGURE SUBJECTS

Portraits of draped subjects are popular with photographers chiefly because drapery offers so many opportunities for artistic treatment, being often more pleasing than everyday dress, which, more particularly in the case of feminine garments, goes so quickly out of fashion. As regards the material and colour of drapery, opinions largely differ; some photographers use ordinary muslin, others a cheaper fabric called tarlatan, while a few favour bunting and silk shawls. Cheese-cloth is probably the best drapery for the figure, and muslin for the head. The material used should not be quite new, and should have been washed, wrung out and rough dried; new materials contain too much stiffening to allow of their following the lines of the figure properly, and this is particularly the case with tarlatan, which needs a thorough washing in hot water to adapt it to the purpose. White flimsy material photographs too white in ordinary lighting, and it is therefore better to make it slightly dingy or less actinic by dyeing a pale yellow colour, by steeping it in coffee, or by allowing it to become somewhat soiled with usage.

Blue, yellow, and even black muslins are also advocated by many workers, but strong blues and yellows should be weakened by rinsing in water and hanging in the sunshine to rough dry. The lines of the figure show very well indeed through thin dark muslins, and good effects are obtainable by draping a thin white material over a dark one; but in all cases of head and shoulder drapery more depends upon the softness and the character of the lighting than upon the actual composition of the material. Upon the lighting, exposure, and development depends whether the material will photograph the same tone as the flesh.

Drapery for the full length figure need not be so thin as that used for head and shoulder studies. Muslin and tarlatan are available, but cheese-cloth is much more amenable to the production of artistic folds, the choice largely depending upon whether the more or less dim outlines of the figure are required to show or not. No attempt should be made to reproduce the lines of orthodox clothes with cheese-cloth, the best effects being obtained by, as it were, hanging the material upon the figure or by imitating the ancient Greek style. One of the many ways in which the Greeks differed from all other ancient peoples was in their method of covering their bodies. They did not make what may be rightly called clothes; apparently they cut the cloth to the proper sizes, hemmed the ends, decorated the pieces with lines of coloured embroidery, and sewed on buttons. To make a serviceable cheese-cloth garment in the Greek style, and suitable for full-length female figures, the width of the piece must be, for the long and flowing principal garment, equal to the height of the model. If seams are unavoidable, let them run vertically, they can then be more or less hidden in the folds. The width of the principal garment must be equal to double the distance between the extended finger-tips; the width will thus be found to be ordinarily a little more than twice the person's height. Fold the piece vertically. Next, on each side of the centre, and at such a distance apart as to leave an opening for the head, place a button and button-hole; this opening should be the width of the model across the shoulders. Along the upper edge other buttons or hooks and eyes may be placed at about 2 in. intervals extending to the ends. This garment, put on over the head, has a closed side at the left, leaving the right open. The draping of this garment will alone give all the vertical effects desired and can be made to expose either of the arms, either of the shoulders, or the whole of one side of the figure. Undoing one or more of the buttons or hooks allows it to slip from either of the shoulders, and with only two buttons there is a sleeveless garment. If all the fastenings are done up and the others are put close to the neck, the whole figure can be covered, and yet one side may be exposed at will. By putting a girdle or sash around the figure an entirely new set of folds is obtained; and pulling the garment up through the girdle and allowing it to fall gives a characteristic and Diana-like effect. With a crossed girdle or cincture over the shoulders still another series of folds is obtained which confines the garment to the figure and shows its outlines, and one has at the same time the alternative of bare or covered arms, and one side open. Over this, to add to the beauty and variety of the folds, is sometimes put a kind of mantle, consisting of a piece as long as the main garment, horizontally, but only half its vertical depth. This the ancient Greeks buttoned on the shoulders and made into the same artistic folds as the undergarment. When the ends are cut off diagonally they look very well, and may be made to form a series of folds like pleats. Add to this a very long strip or scarf, about 24 in. wide and of indefinite length, to throw over the shoulders, to twist about the arms, or to festoon about the figure, and the photographer has all the necessary materials for the ordinary drapery of the full-length figure.

DRAWINGS, COPYING

For methods of copying drawings, see under the headings, "Engravings, Copying," "Copying," "Copying Illustrations for Translation into Line Drawings," and "Copying Stand."

In process work, the copying of drawings is

brought to a high degree of perfection. Cameras, lenses, prisms, copying stands, arc lamps, and all other apparatus are specially designed for obtaining the most perfect negatives. Parallelism between the various parts of the camera and the copyboard is carefully studied. All possible means for overcoming vibration are adopted. Lenses are chosen to give extreme definition to the margins of the plate, as well as uniform illumination; and the prism or mirror employed for reversing must not in any way impair the definition of the lens. The arc lamps, which are generally preferred to daylight for commercial work, are very powerful, and reflectors are employed to concentrate the light on the copy. Care is taken to avoid reflections from the surface. Where the copy is a wash drawing or painting in colours, isochromatic plates and screens are employed. For copying bluish wash drawings, or drawings in which Chinese white has been used (tending to reproduce darker than the original), æsculin or quinine filters are used to correct the effect of ultra-violet light.

DRAWINGS MADE FROM PHOTO-GRAPHS

There are many methods of making line drawings from photographs, and most of them involve the destruction of the originals. In essence, the lines of the photograph are gone over with waterproof ink and the photograph then bleached. Matt prints on bromide, gaslight, or P.O.P. paper may be used, the last-mentioned being fixed and washed, but, if it can be avoided, not toned. The ink used must be waterproof, Indian or Chinese, applied in any convenient manner, as, for instance, with an ordinary pen, a mapping pen, a camel-hair pencil, etc. When sufficient work has been put on the print, the photographic basis is entirely destroyed with a powerful solvent of the silver image. Any reducer or bleacher may be used, but in practice one that acts quickly and without stain has its advantages, and therefore a mixture of iodine and potassium cyanide, both of which are poisonous, is the best. The formula is :—

10 % solution of iodine in methylated spirit	60 drops	125 ccs.
10 % solution of potassium cyanide in water	10 „	21 „
Water	1 oz.	1,000 „

This may be used stronger if the action is not quick enough. The solution should not be allowed to touch the fingers any more than is unavoidable. The mixture ought to destroy the photograph in half a minute; the picture is then washed for five minutes and afterwards dried.

The following process is used by many trade workers : Make ordinary prints on a smooth surface bromide paper, exposing and developing in the usual way; after developing, harden in an alum bath, wash and dry, but do not fix. Then draw over the picture with good waterproof Indian ink, and when the latter is quite dry bleach in a copper-bromide bath made by dissolving 50 grs. of potassium bromide in

1 oz. of water, 50 grs. of copper sulphate in another ounce of water, and mixing the two solutions together. If after bleaching the drawing requires further working up, it may be well washed and redeveloped with any weak dry-plate developer, dried, worked on, and again bleached. After a good rinse the bleached image may be totally destroyed, and the lines left permanently black upon a white ground by passing the bleached print through a potassium cyanide or "hypo" bath. A saturated solution of mercuric bichloride may also be used for bleaching out the silver image. When the results are required for use as originals in line photo-engraving, the bleached prints should be kept from the light as much as possible, or they may turn yellow.

A simpler process of drawing on a photographic base is that of using a blue (ferro-prussiate) print, preferably one that has not been made too dark by over-printing. As the light blue colour will not photograph, the drawing may be reproduced by line photo-engraving processes without any bleaching, although the blue image can be removed, if desired, by immersing in dilute liquor ammoniæ, by a prolonged washing in hard water, or better and quicker still, by immersing in a solution made by dissolving 1 part of potassium oxalate in 6 parts of water. Solutions of sodium carbonate and caustic potash will also bleach blue prints.

In process work, various methods are adopted for making drawings from photographs. If the photograph is mounted, and must not be removed from the mount, it is best to lay over it a piece of tracing gelatine, scratch the outline with a sharp point, and then to rub black-lead or red chalk into the lines. This drawing is turned face down on to a sheet of Bristol board, or other surface to be drawn upon, and rubbed down with the handle of a tooth-brush, or by other convenient means. The drawing is in this case reversed. It may be obtained the right way by re-scratching on the back of the gelatine and filling in this side instead of that originally traced, or it may be reversed by means of prisms when making the block.

A better way is by the use of the "Norwich Film," a gelatine with a matt surface which can be drawn on with pencil, crayon, or ink. The resulting drawing may be used as a photographic positive, or may be converted into a negative by flowing with a non-actinic varnish. When dry, the greasy ink or crayon is removed with benzole or other suitable solvent.

The bleaching-out process, already described, is perhaps the best way of converting a photograph into a drawing.

Unmounted prints may be traced down on to Bristol board or drawing paper by rubbing the back with blacklead or red chalk, or by putting common transfer paper between the print and the drawing surface. The outlines of the photograph are then gone over with a hard pencil or stylus.

DRESS FOR SITTERS

The part played by dress in photography is an important one; and a question put frequently to the photographer is: "What dress shall I wear?" As a general rule the more simple the

dress the better if the portrait is to be what may be termed a lasting one. Feminine fashions change rapidly, and a photograph taken of a sitter dressed in the prevailing fashion soon becomes "dated," as it were. Colour is not of the importance it used to be, as, with the modern isochromatic plates and screens, fairly correct interpretation of tone has become possible, and the rendering of a yellow dress as black, or a blue one as white, ought now to be a thing of the past. W. Ingles Rogers carried out, many years ago, some important experiments, and the salient facts in his report may be summarised as follow: A gentleman's ordinary dress is not sufficiently artistic to warrant a full-length presentment; its colour is preferably black. In the case of uniform and special dress, the full-length is preferable. Ladies require more careful treatment from the standpoint of dress. As a rule, long dresses make the best pictures, both because the length of drapery gives height and dignity, and because graceful and flowing lines are then more easily obtained. As a matter of fact, the female figure has no waist. It is a pure invention, and a conventionality of form. If, however, such a thing has to be considered and sustained, the best place for confining the dress is just below the armpits. This disguises any lack of length in the lower limbs, and grace and dignity are gained without the usual inartistic curving of the hips.

Next to form comes colour, and in this connection no rule can be laid down that will produce perfect results with unvarying fidelity. Much depends on style and complexion; but, all other things being equal, monochrome (black, white, or grey) gives the most favoured results. Gaudy tints are opposed to the principle on which the "science" of photography is based, and are only tolerated by the camera when neutralising an otherwise monotonous effect.

In cases of necessity—for example, where the sitter's wardrobe does not contain what the perfection of photographic art requires—the table of tints, with their relative photographic

Colour of Dress	Tint in Photograph	Combines best with
White ..	White ..	Black, dark blue, red, or brown
Yellow ..	Grey ..	Black or dark green
Salmon ..	,, ..	,, ,, ,,
Pink ..	,, ..	,, ,, ,,
Fawn ..	,, ..	,, ,, ,,
Scarlet ..	Dark grey	White or dark blue
Dark red ..	Black ..	White, light green, light blue or grey
Brown ..	Black ..	White, light green, light blue or grey
Light green	Light ..	Dark green, dark red, brown or black
Light blue or violet	,, ..	Dark blue, dark red, brown or black
Dark green	Black ..	Light green, yellow, or grey
Dark blue or mauve	Medium	Light blue, white, or grey
Grey ..	Grey ..	White or black
Black ..	Black ..	White, light blue, green, or grey

qualities, given in the preceding column, will repay a careful study.

As for materials, the following are the most suited to photography, arranged in the order of preference:—

Name of Material	Combines best with
Velvet	Linen, lace, crape, and fur
Silk	Crape, velvet, and fur
Cloth	Linen, lace, crape, and fur
Serge ..	Linen and silk
Calico goods ..	Linen and cloth
Woollen goods ..	Linen and silk
Fur	Silk, lace, and fringes

Silver ornaments are preferable to gold, and if diamonds are worn they should be slightly smeared with soap to deaden their reflection during the brief period of exposure. Long, drooping curls or waves are effective in semi-profile, but give to the full-face sitter an effect of solidity. The arrangement of the hair gives a man his individuality in appearance, and therefore should not be interfered with.

DRIFFIELD (See "Hurter and Driffield.")

DROP SHUTTER (Fr., *Obturateur à guillotine*; Ger., *Guillotine Verschluss, Fallverschluss*)

A shutter in which a panel, having a central opening and working in a pair of grooved upright rails, is caused to fall by gravity in front of the lens, uncovering and re-covering the latter as the opening passes it. This kind of shutter is simple and easily made, but is somewhat cumbrous, and will not give very rapid exposures. It has been quite superseded by the roller-blind shutter.

DROPPING BOTTLE (Fr., *Flacon compte-gouttes*; Ger., *Tropfglas*)

A bottle for the delivery of a liquid or solution in small quantities, or in separate drops. There

A. Dropping Bottle with Pipette B. Dropping Bottle with Slotted Stopper

are various patterns. In one, A, a pipette or dropping tube is let into the stopper. Another, B, allows the drops to pass to a suitable lip in the neck by turning the stopper, in which a slot is cut. When not in use, a second turn of the stopper shuts off communication with the lip. Schuster's dropping bottle resembles a flask

drawn out at the top to a fine curved point, and having a stopper at one side for the introduction of the solution

DROPPING TUBE (Fr., *Pipette compte-gouttes ;* Ger., *Tropfrohr*)

A tube having one end drawn out to a fine point, and provided at the opposite end with a rubber bulb, as illustrated. The bulb is compressed, and the tube dipped into the liquid or solution to be used ; on removing the pressure from the bulb the liquid rushes up the tube.

Two Patterns of Dropping Tube

Having withdrawn the tube, the liquid may be delivered in drops as required by a gentle pressure on the bulb. Another form is without a bulb. With this, the tube is dipped into the solution, its upper end closed with the finger, and the tube withdrawn. If the depth of solution does not allow of this, the liquid must be drawn up by suction with the mouth, and the upper end of the tube closed with the finger before withdrawing it from the solution, but this is very inefficient. On removing the finger the liquid is delivered in drops. It is risky to use this kind with poisons, lest the solution should reach the mouth. A fountain-pen filler is an excellent dropping-tube for quite small quantities.

DROPS (Fr., *Gouttes ;* Ger., *Tropfen*)

Drops and minims are supposed to be synonymous, but such is not the case. A minim is one-sixtieth part of a dram, but a drop may measure more than a minim, or less, as shown by the following list, which gives the average number of drops which go to make up one dram : Water, 71 ; nitric acid, 96 ; hydrochloric acid, 70 ; sulphuric acid, 100 ; ether, 290 ; alcohol, 130 ; turpentine, 220 ; castor oil, 157 ; olive oil, 168. Drops also vary according to the way they are dropped and the receptacle they are dropped from, but happily in most photographic operations extreme accuracy as to the size of a drop does not matter. A useful arrangement in the form of a squirt, and called a minim-meter, is sold by most chemists for the purpose of measuring drops, or, more correctly speaking, minims.

DRUMMOND LIGHT

An early name for the limelight, which is described under its own heading.

DRY COLLODION

This term is sometimes applied to collodion emulsion which has been precipitated and washed with water, and occurs in the form of fine flocks or granular masses, which only require solution in alcohol and ether to form a normal collodion emulsion. (*See also* " Collodion.")

DRY COLLODION PROCESS

An old process, not now used, in which plates were coated with an iodised collodion, sensitised in a silver bath, washed, and bathed in certain so-called preservative solutions, such as albumen, honey, beer, tannin, coffee, laudanum, etc., most of which were hygroscopic to some small extent, and thus kept the film slightly damp. The first of the dry collodion plate processes of any real service was that published by Dr. J. M. Taupenot, on September 8, 1855. The original method was to pour over the collodionised and sensitised plate a solution of iodised albumen, dry, and dip for a second time into a silver nitrate bath, wash, and dry. Plates prepared in this way kept good for six or eight weeks. Mayall suggested a similar process in May of the same year. The great drawback of the process was its slowness, the plates needing about five times the exposure of wet plates. On May 21, 1855, Dr. Hill Norris, of Birmingham, published his famous process, Fothergill following with his process in 1856. Dry collodion plates then became articles of commerce, the Hill Norris collodio-gelatine plate (patented September 1, 1856) becoming the most popular.

DRY ENAMEL PROCESS

A method used in printing the half-tone image on to zinc or copper for etching. The sensitive solution consists of—

Ammonium bichromate 125 grs.	25 g.	
Powdered white sugar 270 ,,	54 ,,	
Chromic acid . . 80 ,,	16 ,,	
Albumen, from 2 eggs	7 eggs	
Liquor ammoniæ . 120 mins.	24 ccs.	
Water . . . 10 oz.	1,000 ,,	

An alternative formula is—

Grape sugar . . 232 grs.	113·6 g.	
Albumen . . . 338 mins.	165·7 ,,	
Ammonium bichromate 46 grs.	22·5 ,,	
Chromic acid . . 36 ,,	17·6 ,,	
Liquor ammoniæ . 120 mins.	24 ccs.	
Distilled water . 4¼ oz.	1,000 ,,	

After coating the plate with this solution and printing, it is dusted with finely powdered anhydrous sodium carbonate, or magnesium carbonate, brushing with a soft flat brush until the image is clearly visible. A small room, in which the atmosphere can be kept moist by standing a bowl of water on the floor, is necessary, so that the plate can absorb the requisite amount of moisture to attract the powder. The plate is burnt in, as usual in the enamel process, and then placed in water, when all the parts which have absorbed the powder develop away quite clean. If any scum remains, a little moist salt or dilute caustic potash will remove it.

DRY MOUNTING

The Derepas is perhaps the most perfect method known of mounting prints and of building up multiple mounts. The surface of the print is not affected ; there is nothing that will harm the most delicate print by any process ; there is no cockling, even when a stout print is mounted on a thin paper ; and it is durable when properly carried out. A sheet of thin tissue is prepared with shellac, the prepared tissue being commercially obtainable. A piece of the tissue is

touched with a hot iron, which will make it adhere to the back of the print, and both print and tissue are then trimmed together. They are next placed in position on the mount, covered with a sheet of paper, and subjected to heat. This is accomplished either by going over it with a hot flat-iron, or subjecting it to pressure in a heated press made for the purpose. The heat causes the shellac to melt and so secure perfect adhesion between print and mount. Everything being dry there is no expansion with its subsequent contraction, and print and mount remain smooth and flat. There are no special difficulties attached to this method, and the results are excellent.

DRY PLATES (Fr., *Plaques sèches ;* Ger., *Trockenplatten*)

Sheets of glass of given sizes coated with gelatine emulsions. The term arose in the early days to differentiate them from wet collodion plates. The introduction of the gelatine dry plate marked a new epoch in photography. There is some difference of opinion as to who was the actual inventor, Burgess, Maddox, Kennett, Wratten, and others all working at the same time in practically the same direction. It was, however, on September 8, 1871, when Dr. Maddox published an account of his experiments, that the first hint was given. On July 18, 1873, J. Burgess, of Peckham, advertised and sold ready-made emulsion with which photographers could coat glass and so make their own dry plates ; Kennett followed, and on November 20 of the same year took out a patent for his " pellicle," with which photographers could make their own plates. Improvements followed rapidly, Bolton, Sayce, Wratten, Mawdsley, Berkeley, Abney, Bennett, and others doing much to bring the dry plate to perfection and to make it an article of commerce. As far as can be ascertained, the first ready-made dry plates were advertised in April, 1878, by Wratten and Wainwright and the Liverpool Dry-plate Company (Peter Mawdsley), the plates by the latter firm being called the " Bennett Plates," and the price for quarter-plates being 3s. per dozen. It was not until 1880 that gelatine dry plates became really popular.

In process work, considerable progress has been made of late years in the use of dry plates. Excellent commercial dry plates, specially made for line, half-tone, or colour work, are now obtainable. The methods of handling are not very different from those in ordinary photographic work, except that greater care has to be taken to avoid over- or under-exposure and fog ; the lines must be kept perfectly clear and sharp, and in half-tone work great care and skill have to be exercised to obtain sharp dense dots of the right size and quality. In this respect dry plates are more difficult to handle than wet collodion. Backing is found to be an advantage ; the negatives usually have to be cleared with ferricyanide and " hypo " (Howard Farmer's reducer) ; and intensification, preferably with silver cyanide, is generally necessary. For the making of dry plates, *see* " Coating," " Emulsion," etc. For the various manipulations, *see* " Exposure," " Developing," " Fixing," " Toning," " Washing," etc.

DRYING BOX OR CUPBOARD (Fr., *Étuve, Armoire ;* Ger., *Trockenofen*)

A light-tight box or cupboard used in drying gelatine plates after coating, and for other photographic purposes. The chief requirement is the circulation of a current of dry air, in order that the internal air may be continuously drawn away, carrying with it by degrees the moisture from the plates. The temperature of the drying cupboard requires to be raised, but perfect ventilation is of greater importance. A pattern recommended by W. K. Burton consists of a box with a closely-fitting light-tight door, and having light-trapped air openings at top and bottom. Beginning near the bottom, a bent channel or flue runs up against one side of the box, a gas burner being inserted in it near the top. When the burner is lit it draws a current of air through the flue from below, and consequently ensures a constant circulation of air in the box. Another kind of drying cupboard is warmed from beneath by a gas-ring or oil stove, a sheet-iron bottom being fitted. Light-trapped openings at the lower portion of the sides and a cowled ventilator at top furnish the necessary air current.

In process work, the arrangement for drying collotype plates is usually in the form of a box or trunk supported about 12 in. from the floor on four legs. The bottom consists of an inverted sheet-iron box, under which is placed a gas-ring or pipes. Holes are punched in the side of the box to prevent the gas becoming choked. The wooden part of the box is about 18 in. deep. About 6 in. from the top are two iron bars, resting on ledges at the sides of the box. These bars are provided with screws placed at suitable distances with their points upwards. The plates rest on these screws, and by adjustment of the latter can be levelled up, so that the gelatine solution on the plates will not run off. The bottom of the box is usually covered with sand to equalise the heat. The lid of the box is covered with gauze or an open-textured cloth, so that the moist air can pass through. A thermometer is inserted into the box through a hole in the lid.

Process workers find a drying cupboard necessary for quite a number of purposes; in one convenient form the bottom takes the form of an inverted sheet-iron box, and there are holes in the sides to allow the gas fumes to escape, or a flue pipe can be led out from the back. In the sides of the wooden part, just above the sheet-iron bottom, are holes for drawing in a current of air ; these holes are covered with a baffle-board sloping towards the bottom. Shelves or racks can be placed in the cupboard. On the top a metal cowl ventilator is placed. For heating, an ordinary gas-ring burner is placed underneath the bottom. The cupboard can be elaborated by placing an electric radiator inside and an electric fan on top to draw out the air. The incoming-air can also be made to pass through an opening packed with damp cotton-wool, so as to stop any dust entering. For colour-sensitising dry plates the cupboard must, of course, be made perfectly light-tight. Such a cupboard is very convenient for drying photo-lithographic paper and carbon tissue, and will be found generally useful.

DRYING MARKS

These in negatives are most frequently patches or portions which are stronger or weaker than the remainder of the image, such portions producing corresponding defects in the print. These markings may be due to defective working, or to causes beyond the worker's control. With regard to the first, a plate may be drying very slowly, and when partly dry the conditions of drying may be changed to accelerate the drying of those parts that still remain wet. The part accelerated will almost always show greater density than the remainder, and at times a well-defined mark may separate the two parts.

The second cause is uneven drying of the plate in the course of manufacture. When plates are racked for drying, no matter how perfect the ventilation of the drying-room may be, the edges, where the emulsion always tends to thinness of coating, will always dry more quickly than the centre, the result being that a line appears round the edges. The exact cause of this is a little obscure, but the most satisfactory explanation is that given by Homolka, who ascribes the foggy line—for this is what edge drying marks actually are—to a diffusion of the faint traces of soluble haloid left in the emulsion from the thin dry edge to the thicker and moister centre. Actual drying marks from uneven drying of plates during the manufacture are now rarely met with, though in the early days of dry-plate photography they were of frequent occurrence, and manifested themselves in precisely the same manner as in the unequal drying of negatives—that is, by central patches of greater or less density due to this portion being more or less sensitive than the margins.

DRYING NEGATIVES

Negatives should be dried as quickly as possible consistent with drying evenly—that is, with uniformity in the rate of drying. A current of dry air is best, but a drying cupboard is good. In any case, the air should have free and uniform access to their surfaces ; they should not be dried close together, as in a draining rack, neither should they lean against a wall face downwards. The place chosen should be as free from dust as possible, and not too warm, or the gelatine may melt. In summer and autumn particularly, it is necessary that the plates should be dried in a place protected against flies and other insects. Cockroaches are said to be fond of eating wet gelatine.

DRYING PRINTS

Prints in all processes should be freely exposed to the air in drying, so that the operation may be rapid. The most satisfactory method in most cases is to hang the prints from a line or a lath, either by means of clips or by pins through one or two corners. An alternative method is to blot off as much moisture as possible, either with a soft towel or blotting-paper, and then lay the prints face upwards on a clean white cloth until dry. A drying cupboard is the best place for the latter method. In any case, they should be dried in a place as free from dust as possible. (For imparting a high gloss to prints in drying, see " Glossy Surfaces.")

DRYING RACK, OR DRAINING RACK

(Fr., *Séchoir, Égouttoir* ; Ger., *Trocken-gestell*)

A wooden, metal, or porcelain stand with grooves, in which negatives, etc., are stood up to drain and dry after washing. The ordinary wooden folding pattern is shown at A, while B

A. Wooden Drying Rack

illustrates an ingenious expanding metal rack, which may be adjusted to hold various sizes of plates. Many washing tanks are fitted with a removable metal rack which may be used for drying. Negatives should not be placed closely together in the racks when drying, or the process

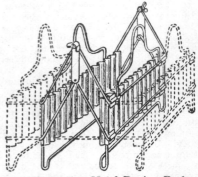

B. Expanding Metal Drying Rack

will be very slow, and uneven patches sometimes occur. The closeness of the usual grooves is in this respect somewhat misleading. It is better to spread out the negatives.

DUFAY DIOPTICHROME PROCESS

This employs a screen plate of French manufacture. A gelatinised glass is coated as to two-thirds of its surface with a greasy material, which acts as a temporary resist, in the form of lines, points, or grains of geometric or irregular shape. The present plate consists of lines with rectangles in between. The bare parts are dyed and the whole surface varnished and treated with a solvent of the greasy material so as to lay bare the unstained gelatine. Half this surface is then again covered with a greasy substance, and the bare gelatine again dyed, again varnished, the greasy material again dissolved, and the last portion of the unstained gelatine dyed. A compensating filter is used, and the plate is issued with a special panchromatic plate fitting into a frame with nickel pins which allow of complete registration of the positive and colour screen. Coloured plates to this work show the formation of the Dufay plate, and a typical result obtained with this plate.

The plates must be manipulated in absolute darkness or with the maker's special dark-room filter. The developer recommended is :—

Metol . . .	53 grs.	6 g.	
Sodium sulphite . .	1½ oz.	72 ,,	
Hydroquinone . .	17 grs.	2 ,,	
Potassium bromide .	17 ,,	2 ,,	
Liquor ammoniæ (·880) .	130 mins.	15 ccs.	
Distilled water to .	20 oz.	1,000 ,,	

For use, mix with an equal quantity of water and continue development for four minutes.

Rinse the plate for some minutes, and immerse in—

Potassium or ammonium bichromate	44 grs.	5 g.
Sulphuric acid . .	95 mins.	10 ccs.
Water to . . .	20 oz.	1,000 ,,

When the image has dissolved, wash for several minutes till all the yellow tint has disappeared, and immerse in the first developer or preferably in—

Metol . . .	22 grs.	2·5 g.
Sodium sulphite .	1 oz.	50 ,,
Hydroquinone . .	44 grs.	5 ,,
Potassium carbonate	220 ,,	25 ,,
Potassium bromide .	18 ,,	2 ,,
Distilled water to .	20 oz.	1,000 ccs.

Re-development takes about three minutes, and should be done in a bright light. The plate may be reduced with "hypo" and ferricyanide, and intensified with mercuric chloride followed by ammonia.

DU HAURON, DUCOS

A Frenchman, born in 1839, in Langon, Gironde, and one of the first to describe in detail the three-colour process (1867). In 1864 he patented a species of kinematograph. He was also the inventor of the anaglyph, and the first to describe a screen-plate process of colour photography.

DUOTYPE (Ger., *Duplex-Autotypie*)

A half-tone in two printings, one being with a light tint ink, and the other in a black or photo-brown, the idea being to imitate the tones of a photograph. Sometimes both printings are from the same block, but the best results are obtained from two blacks etched differently.

DUROLENE

A kind of unbreakable glass in which wire is embedded. It has been recommended for studio roofs, but its tint stops a large amount of actinic light.

DUST PREVENTION

Dust is often a great trouble in photographic work, both in the field and in the work-room. Dust in the camera and on the lens is the most frequent cause of trouble, hand cameras being more prone to the defect than others because of the usual practice of carrying them unprotected. Dusty lenses cause flat and misty pictures. Dust will find its way into the lens through the slits used for Waterhouse and rotating diaphragms, and the only preventive is to fit, when possible, a band of velvet ribbon round the lens tube to cover up the slots as much as possible ; in the case of Waterhouse diaphragms the band

may be kept completely over the slot when the diaphragm is not in use. Rubber bands have been recommended, but these contain substances that tend to mark and discolour the lens mounts. The plate-changing arrangements in hand cameras, and shutters working inside, are often the means of stirring up dust which settles upon the lens and plate. Frequent dusting of the interior of the camera and plate sheaths is advisable, but unless done carefully more dust will be deposited than removed. Coating the innermost parts of the camera with glycerine or vaseline has been suggested ; such a coating will naturally hold down the dust and prevent its flying about, but inasmuch as it is liable to become messy and to need frequent changing, the method is not recommended. The focusing screens of stand cameras are occasionally thinly coated with vaseline in order to make them more transparent, and the coat serves as a kind of trap for the dust ; in this case the cleaning is quite easy, but the cleaning of the interior of the bellows is quite another matter. Dark-slides invariably attract dust, but they can easily be dusted, and any coating of grease might interfere with the sliding shutter or find its way to the plate. Dark-slides having draw-out shutters are the greatest offenders ; the light-trap at the top of the slide, which closes the aperture when the shutter is completely withdrawn, is made usually of either velvet or rubber, and this scrapes or wipes the dust from the sides of the shutter as it is drawn out and returned, thus in time forming an accumulation. Thorough dusting of the light trap and the interior of the slides is an obvious remedy. Dust settling upon the plate causes many spots, and it is of but little use dusting a plate before putting it into the dark-slide if it is to be exposed to a miniature dust storm in the camera.

Plate dusters are articles of commerce, but if they are not kept scrupulously clean they put more dust upon the plates than they take off and do more harm than good. Plates rarely need dusting with a brush ; when taking them from the box or dark-slide, a gentle knock with the edge upon a table will do all that is necessary. Of dusters, an old well-washed silk handkerchief is one of the best.

Frequently unsuspected resting-places for dust are the top rims of bottles and the crevice between the cork and the bottle neck ; before pouring a developer from a bottle, the rim and mouth should be wiped, otherwise any accumulated dust may find its way to the plate and cause spots. The corks of bottles should be kept covered with a paper or cardboard cap.

Many professional dark-rooms and all plate-making rooms have their floors kept damp in order to prevent dust.

The utmost care is necessary when mixing chemicals, more particularly pyro and other developers, to prevent small particles of the developer in the form of dust flying about the room and settling upon sensitive surfaces.

DUST SPOTS

Miniature transparent spots on negatives due chiefly to the causes given in the preceding article. If the spots are actual holes in the gelatine, showing the bare glass beneath, they

are due to dust in the process of manufacture and are real pinholes; but these are very rarely met with nowadays. Dust spots are more or less numerous and of various shapes and sizes, and they occur where dust specks have rested on the plate during either exposure or development. In the former case they prevent the light from reaching the emulsion, and in the latter the developer is prevented from reaching it. The remedy for spots caused in this way (it is a mistake to call them " pinholes ") is careful spotting, but obviously prevention is better than cure. Particles of developer dust which may float about the dark-room and settle upon undeveloped plates and bromide papers invariably cause black spots, but such spots will also appear when the developer has not been properly dissolved, and it is very difficult at times to discover the real cause of the trouble. Black spots on a negative are best left alone, and the resultant white spots on the print touched out. Etching or pricking away with a needle on the negative has been recommended, but it needs particular care, as otherwise the film will be ruined.

DUSTER, PLATE (Fr., *Torchon aux plaques*; Ger., *Plattenabstaüber*)

A strip of wood having a piece of plush attached, and used for dusting dry plates before insertion in the dark-slide. Sometimes a wide camel-hair brush is employed, but this is still less satisfactory, being more liable to put dust on the plate than to remove it. Neither device is recommended. (*See also* " Dust Prevention.")

DUSTING OR GRAINING IN PROCESS WORK (Fr., *Grainage*; Ger., *Staub-kornung*)

There are several processes of photo-engraving dependent on the laying of a ground consisting of fine resin, bitumen, or other similar material. Such a method is used for aquatint etching instead of the old way of flowing on the resin emulsified in alcohol.

For a process of colour work much practised in France, called chromo-typogravure, a resin grain is laid on zinc plates, and a set-off is laid down on the plates from a key plate to guide the etcher in stopping out the various colours. This is done by means of an acid-resisting varnish, so that the resin ground forms the lighter tints.

In the photogravure process the laying of the ground is an important operation. Finely powdered bitumen is generally used, and after being deposited on the copper plate and fixed by heat, a carbon print is developed upon it to form the resist for etching.

The dusting for the foregoing processes is done by means of a dusting box. This may be of either the turnover pattern or the fan pattern, the former being suitable for small plates and mostly used by amateurs. The box is turned over and over to shake up the bitumen, then the plate is put in and the box allowed to stand for a shorter or longer time, as may be demanded by the character of the grain required. In the fan dusting box the powder is stirred up in the semicircular zinc bottom by means of a revolving brush, and, after allowing to stand for a few moments for the heavier particles to settle, the

plate is put in. The longer it remains in the box the finer will be the grain. Powdered lac is also sometimes used for dusting.

DUSTING-ON (POWDER) PROCESS (Fr., *Procédé aux poudres*; Ger., *Einstaubver-fahrung*)

Known also as the " Powder Process," based, as are the other carbon processes, upon the oxidising action of chromic salts upon organic matters. In the present instance, the organic matter loses its tackiness or stickiness under the action of light and refuses to retain dust. The process is largely used in the production of photo-ceramics and for the intensification and doctoring of faulty negatives when these are of great value. Various substances are available for the support of the powder picture, but none is better than ground opal or pot opal glass. As the effect of the light in the process is to cause the film to refuse to take powder, the parts acted upon remain light; this being the case, a transparency (positive) must be used for printing from and not a negative, as a print from the latter in this process would be a negative. The requisites are sensitising mixture, opals, powder, and a transparency of excellent quality. Although opal has been named and is recommended, glass, ferrotype, and other supports can be used. In any case, it must provide a proper contrast to the powder. Thus, if the dust or powder used is silver or gold bronze, the image may be produced on a dark background, for which a ferrotype tinplate will serve.

The support must be cleaned and sensitised in a solution consisting of a gum, a hygroscopic substance, and a light-sensitive medium. The following formula is one of a great number between which there is but little to choose:—

White sugar	.	. 200 grs.	20 g.
Gum arabic	.	. 250 ,,	25 ,,
Ammonium bichromate	200 ,,	20 ,,	
Methylated spirit	.	1 oz.	50 ccs.
Water	.	. 20 ,,	1,000 ,,

An old, and possibly the original, formula, still in use, is as follows:—

Water	.	. 10 oz.	1,000 ccs.
Dextrine	.	. 240 grs.	48 g.
Grape sugar	.	. 240 ,,	48 ,,
Potassium bichromate	240 ,,	48 ,,	

The first of these formulæ is said to possess many advantages. The gum and sugar should be covered by the water and dissolved by heat; when cool, the other ingredients are added. The spirit is used simply to make the solution flow over the plate more evenly, and more or less may be used as desired. After washing, the wet plate is flowed over with the sensitive mixture, drained for a few minutes, and then baked in an oven until bone dry. The operations up to baking may be carried on in daylight, but as the plate dries it becomes sensitive and should therefore be removed and examined in a dull light. The plate is then ready for exposure under a positive, and, as in many other cases, this is the most difficult part of the process, for so much depends upon atmospheric conditions.

The duration of exposure can be found only by experiment, but as a rough guide it may be

said to be one minute in bright sunlight on a summer's day, when a transparency of average density is used. When exposure is complete, the plate is "developed" by dusting on a powder. The choice of a powder is almost unlimited, but it must be exceptionally fine, to ensure which it should be sifted through a muslin bag. Ordinary powder colours from an oil-shop may be used. Ivory black and Indian red are good colours, used alone or mixed in varying proportions, while some use levigated graphite.

For printing, the sensitive plate should be warmed, or it may be warmed by being printed in strong sunlight. An image will be seen faintly upon the sensitive plate when removed from the frame. The plate is held in the fingers or on a pneumatic holder, and some powder sprinkled over the surface, immediately spread with a soft camel-hair brush, and kept on the move until sufficient detail and density have been secured.

Development proceeds rapidly as the plate cools, and it should be assisted by a gentle stream of air blown from the mouth across the plate, the current not being strong enough to disturb the powder or cause excessive moisture; the air must not be absolutely dry, and the powder must be kept on the move with the soft camel-hair brush. Almost any depth can be obtained in any part of the picture by patient re-application of the powder rather than by attempting to make too much powder adhere at one time. As the progress of development is visible and under perfect control, it is not difficult to bring out or keep back certain parts, and in this way very artistic results may often be easily obtained.

When development is complete, the powder picture may be coated with plain collodion and washed free from greasiness; the plate is now transferred to a 5 per cent. solution of potash alum until the yellow bichromate salt has been removed. Fixing with collodion as just described may be dispensed with when a duplicate negative is being made upon glass, all that is necessary being to expose it again to the light to get rid of all further tackiness. When, however, it is desired to fix the picture—as, for example, when it is upon an opal base—and it is not convenient to use the collodion "fixer," the picture may be washed over with the following solution :—

Water	.	.	.	1 oz.	100 ccs.
Sulphuric acid	.	.	.	2 drms.	25 ,,
Methylated spirit	.	.	.	2 oz.	200 ,,

Mix in the order given. The plate is treated with this until all the yellowness has gone, is then washed gently in water, and dried by gentle heat. The collodion fixer is preferable, as with the acid solution there is a risk of entirely losing the image. Flatness in a picture is caused by over-heating or over-exposing the plate or by developing in too dry an atmosphere; in this connection care must be taken to keep white light from the image before fixing.

This process has been used for the production of pictures in colour. In 1888 a process was introduced by Germeuil-Bonnaud which consisted in exposing a plate coated with treacle, sodium borate and potassium bichromate, under an ordinary positive transparency. It was then dusted with various coloured pigments which,

it was claimed, adhered selectively to the different parts of the picture, a claim that has not been substantiated. Dr. Miethe has worked out a variation of the idea. Glass plates are coated with the following mixture :—

Gelatine	.	.	.	9 grs.	5·8 g.
Sugar candy	.	.	300 ,,	194 ,,	
Potassium bichromate	90 ,,	58 ,,			
Water	.	.	.	3½ oz.	1,000 ccs.

The plates are dried in an oven and exposed under a positive while warm. Three prints will be required from three negatives representing the three different colour sensations. Development is performed by brushing on the plates suitable transparent powder colours. The yellow print is made first, stripped with collodion, and affixed to a card with gelatine solution. When dry, this is coated with a thin film of shellac, and the red and the blue prints superimposed upon it in the same manner.

A formula specially compounded for ceramic work, but which will also serve for all papers and articles, is :—

Gumming Mixture

A.	Fish-glue	.	.	1 oz.	100 ccs.
	Glucose	.	.	4 ,,	250 g.
	Glycerine	.	.	10 drops	·5 ccs.
	Water	.	.	10 oz.	1,000 ,,

Sensitising Mixture

| B. | Am. bichromate | . | 1 oz. | 100 g. |
| | Water | . | . | 10 ,, | 1,000 ccs. |

Mix together equal parts, and use as already described.

DYES AS COLOUR SENSITISERS

The peculiar property possessed by certain dyes of conferring upon the silver halides increased colour sensitiveness was discovered by Vogel in 1873, has had a most important influence on the advancement of photography in almost every branch, and since his time the number of dyes which act as sensitisers has been and is being continually increased, though the practically valuable ones are but few. It was but natural to expect that an examination of the chemical constitution of the various sensitisers would show some common property or grouping of elements to which might be ascribed the sensitising power, but up to the present no definite conclusion can be come to. It has been further suggested that the sensitiveness of the sensitisers themselves to light was the cause of their action, but some of the most fugitive dyes are not sensitisers, whilst others which are very stable are. Then, again, it has been pointed out that many of the dyes are photo-electric, and that here electrons may be set free which act on the silver halide, causing increased ionisation of that part of the silver halide which forms the latent image. The subject is so complicated, and the mass of material available for examination is so meagre, that the resulting definite conclusions are disappointingly small.

There are certain generally accepted facts as to sensitisers, and these have been most concisely summarised by Eder as follows :—(1) The absorption spectrum of neither the alcoholic nor of the aqueous solution of the dye nor of

the dyed gelatine agrees with the position of maximum action on the sensitive emulsion. (2) The position of maximum action of the dyed silver bromide always lies slightly nearer the red than the absorption maximum of any solution of the dye. (3) The position of maximum of absorption of the dye in gelatine and the maximum sensitising action generally differ by about 30 $\mu\mu$ or wave-lengths. (4) The absorption spectrum of a dyed silver halide coincides with the maximum sensitising action. (5) The dye must stain the silver halide itself to be a sensitiser, but all dyes that thus stain are not sensitisers. (6) Fluorescence, or fugitiveness to light, of the dye appears to play no part.

As most of the important sensitisers are briefly described under their respective names, reference should be made to these. The principal azo sensitisers are glycine red, benzonitrol brown, Pluto black, dianil black R, and wool black 4 B. To the rosaniline family belong ethyl violet and formyl violet. The phthaleine group is one of the most important, as it comprises the eosines and erythrosine. The acridine dyes are chrysaniline, acridine yellow, and acridine orange. The best sensitisers, particularly for red, belong to the chinoline or quinoline group, and are isochinoline red, dicyanine, and the isocyanines

orthochrom T, pinaverdol, pinachrome, homocol, isocol, etc.

DYES FOR COLOURING PHOTOGRAPHS

In choosing dyes for colouring photographs on a gelatine basis it is important to take into consideration first their stability when exposed to light, and secondly their affinity to gelatine. The following are the most suitable : acid violet 7 BN, wool blue N extra, patent blue, fast acid violet, acid green, alizarine cyanine (blue violet), tartrazine (yellow), chinoline yellow, brilliant orange, Ponceau 5 R (red with violet tinge), new coccine (bright red), erythrosine (bluish red), fast brown, water soluble fast blue and water soluble nigrosine (blue black). All these colours will take well on gelatine if it has not been hardened. For collodion prints it is advisable to use albumen as a vehicle for the dyes.

DYES, IMPROVING NEGATIVES WITH
(*See* " Retouching, Chemical.")

DYNACTINOMETER (Fr., *Dynactinomètre ;*
Ger., *Dynaktinometer*)

An instrument by which the actinic power of light may be measured, or the rapidity of different lenses compared.

E

EASEL, ENLARGING (Fr., *Chevalet d'agran-dissement, Chevalet à reproduction ;* Ger., *Vergrösserungs-Stativ*)

A support to hold the bromide paper during the operation of enlarging. In order to ensure parallelism with the negative in the enlarging camera or lantern, the easel is made to run on rails ; or it is fixed, the lantern or camera being moved instead. The easel may consist simply

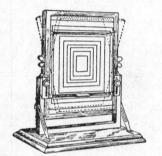

A. Typical Modern Enlarging Easel

of an upright board supported by a firm base or crosspieces, but it is a great convenience if it possesses a swing movement, which will permit the correction of vertical lines that are shown as slanting in the negative, through the tilting of the camera when taken. Formerly the worker was content to fasten up the bromide paper with pins ; now many easels are provided with spring clamping bars, which save time and also hold the paper flatter. Another arrangement is to attach

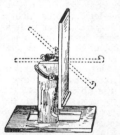

B. Enlarging Easel which Readily Assumes Horizontal Position

to the easel a hinged frame carrying a sheet of glass, this being fastened down over the paper. A illustrates a typical modern enlarging easel, with rising, falling, and swing movements ; while B shows an easel of very solid construction, which, besides allowing for rise and fall and for any degree of swing, may instantly be changed to a horizontal position for pinning the paper, and

as easily returned to its former upright position, in which it automatically catches. Some easels are made with a ground-glass focusing screen, so that the projected image may be focused from the back ; these may, or may not, be provided also with a dark-slide to carry the paper. The easel is preferably painted black ; otherwise, when only a part of the negative is to be enlarged, a good deal of stray light will be reflected from the easel. The white paper used to focus on should preferably be removed, or covered with something black, before fastening up the bromide paper. In the majority of cases, however, this may be omitted without any ill result ; but it is imperative if plates are used, as when making enlarged negatives, etc.

It is sometimes necessary in enlarging to correct the distortion in the original negative by swinging the easel out of parallelism. In a typical easel for process work, both a vertical and horizontal swing can be obtained, and the negative can also be turned in its own plane to any axis. Max Jaffé, of Vienna, has done some remarkable panoramic copying with an easel of this kind, securing pictures with an enormously wide angle by ignoring the original distortion in the negative and correcting it when copying, at the same time joining up the image on one negative to another to secure a large combination negative.

EAU BROME

Bromine water ; used at one time in the daguerreotype process, for stopping the action of light.

EAU DE JAVELLE (Fr., *Eau de Javelle ;* Ger., *Bleichwasser, Javellische Lang*)

A clear, colourless fluid smelling of chlorine, used as a reducer, " hypo " eliminator, and stain remover ; known also as sodium hypochlorite, ozone bleach, and Labarraque's solution. It was one of the earliest of the bleaching solutions, and was first made at Javelle, Paris ; hence its name. There are several methods of making it, the best for photographic purposes being : Add 1 oz. of sodium carbonate to 4 oz. of water, shake well, and add 320 grs. of bleaching powder (chloride of lime), and shake well again. Filter, shake up the residue with water, and again filter. The filtrate is a solution of hypochlorite (*eau de Javelle*). Acidified with oxalic acid, it forms an active stain remover, but it is safer to use it without the acid. Its use is not now recommended, safer methods having superseded it.

EBONITE

A black compound of indiarubber or caoutchouc, sulphur, and pigment, with occasionally certain filling substances, used for the shutters

of dark slides, developing dishes, etc. It is the same as vulcanite except that the latter is made in many different colours.

Ebonite has many uses in photography owing to its waterproof and acid-proof character. Its drawback, however, is its brittleness, though this can be overcome, and a flexible ebonite obtained, which is useful for some purposes. Ebonite has been used for dipping baths for wet collodion work, but has not proved popular because of a supposed tendency for the bath to be injuriously affected. More probably this is due to the difficulty experienced in cleaning such baths.

Ebonite dippers for the silver bath, however, survive, and have the advantage of not being so fragile as glass. Ebonite plate lifters for flat dishes and trays are also largely used. Draw-out shutters for dark-slides, iris diaphragms and Waterhouse stops, developing dishes up to about 15 in. by 12 in., and much larger flat trays (with an outer wooden casing) for silver baths, are made of this material.

In process work, ebonite is useful for parts of etching machines which have to be exposed to the acid.

EBONY STAIN

Ebony stain (Stephens's) is preferred to Indian ink by some pen-and-ink artists. It makes a good line, and dries with a glossy surface which photographs well. It has the drawback of not being waterproof, and of more quickly clogging drawing pens than does Indian ink. It is cheap, and if otherwise suitable it is worth while trying to waterproof it by adding a solution made by boiling together 2 oz. of shellac and ½ oz. of borax in 10 oz. of water, and straining.

EBULLIOSCOPE (Fr., *Ébullioscope ;* Ger., *Ebullioskop*)

An apparatus for testing the purity of a liquid or solution by ascertaining the temperature at which it boils. When a liquid contains dissolved substances its boiling point is usually higher, and a concentrated solution has a higher boiling point than a weaker one.

EBURNEUM PROCESS

An obsolete process invented in 1865 by J. M. Burgess, of Norwich, in which a carbon or collodion transparency, transferred from a sheet of waxed glass, was backed up with an ivory-like mixture, which gave it the appearance of being on ivory. Burgess's original instructions were, briefly, as follows :—A good collodion transparency is necessary, and the glass upon which it is taken should be waxed to facilitate stripping. Either an iron or pyro developer is used, preferably the following :—

Pyrogallic acid .	3 to 6 grs.	7 to 14 g.
Citric acid .	. 3 ,,	7 ,,
Glacial acetic acid	. 20 drops	42 ccs.
Water . .	. 1 oz.	1,000 ,,

Fix with cyanide, well wash, and tone with gold. When dry, strips of paper are pasted round the plate on the back and then turned up so as to form a dish. The plate is placed level and coated with the following mixture at a temperature of 100° F. (38° C.) :—

Gelatine	. .	5 ,,	500 g.
Glycerine	. .	½ ,,	50 ,,
Zinc oxide	. .	1 ,,	100 ,,
Water .	. .	10 oz.	1,000 ccs.

When set, the plate may be allowed to dry spontaneously and the film detached. The process was slow and difficult, for which reason it was little used. Imitation eburneum prints widely known as " Ivorytypes " (*which see*) were more popular.

ECLIPSES, PHOTOGRAPHING

The portrayal of the varying phases of an eclipse, whether of the sun or moon, is always of interest to the photographer. The exact times at which these phenomena will occur can always be ascertained a considerable time in advance from the almanacs, thus enabling the photographer to prepare any special apparatus he may desire to fit up for the occasion.

Dealing first with eclipses of the moon, the chief interest in these lies in the gradual change in shape as the moon traverses the earth's shadow. When fully eclipsed the moon may be either quite invisible, or showing of a more or less bright coppery colour. The most satisfactory manner of obtaining a picture of the eclipse with an ordinary camera is to set up the camera on its tripod and focus sharply ; then swing until the moon is near one end of the ground glass. The end chosen should be that *from* which the moon's image will travel in its motion across the sky owing to the earth's rotation. This is always from east to west, so that, remembering that everything is inverted in the camera, the first exposure should be arranged near the right-hand side of the plate if the observer is in the northern hemisphere. Load the dark-slide with isochromatic plates of medium rapidity ; draw the slide, and expose with the cap. Give about a quarter of a second exposure. After making one exposure, leave the apparatus as it stands, with slide still drawn, for say five minutes. During this interval the moon's image will have travelled towards the left on the plate, and another similar exposure may then be given. Repeat this procedure at intervals of about five minutes until the eclipse is over. On developing, which will be exactly like the development of an ordinary subject and needs no special description, a series of pictures of the moon will be found extending across the plate, and of varying shapes, from full circle, through crescents to the dusky total eclipse. A pleasing variation to the above procedure may be made if the observer has a telephoto equipment, as he can with it obtain larger pictures of the moon's phases, showing more details of the surface structure. It will not be possible, however, to obtain the whole series of pictures illustrating the progress of the eclipse on a single plate owing to the increased magnification. If the series is required, then several loaded plate-holders must be got ready to hand and the plates changed as found most convenient.

With eclipses of the sun, the problem is somewhat different, chiefly on account of the very great actinic power of even a small section of the uneclipsed solar disc. If the eclipse is only partial, the arrangement described above for the lunar eclipse may be repeated except in regard

to the exposure. This must be rendered as short as possible. If a focal plane shutter is to be employed, the slit in the blind must be made as narrow as possible, and the tension run up to the maximum. Should a diaphragm or cap shutter only be available, then it will be advisable to stop down the lens to the smallest aperture possible and also use the shutter at its greatest speed.

The greatest interest, however, becomes centred in the solar eclipse which becomes total, the dark moon blocking out all the usual brilliant white disc. Then it is that one is able to see that wonderful appendage to the sun, the corona, and the ring of ruddy atmosphere, the chromosphere. On a small scale these features may be photographically recorded by means of cap exposures, but they will have to be fairly rapid, say a quarter of a second, owing to the rapid motion of the moon. With a small mechanical stand having provision for driving the camera at the same rate as the drift of the moon much longer exposures may be given, and the coronal extensions portrayed to a greater distance from the moon's limb. Owing to the special nature of the coronal light isochromatic plates should be employed for this class of work, and, preferably, the most rapid variety available. For recording solar eclipses on a very large scale, special cameras with lenses of great focal length have been at various times employed. For example, cameras with lenses of 40 feet focal length were used by an American party under Professor Campbell in India. The lens was situated at the narrow end of a tube, propped up on the top of a wooden skeleton tower. The plate holder was in a canvas-covered portion near the ground, and in one case the moon's motion was counter-balanced by moving the plate-holder by a simple form of clepsydra.

One of the most interesting and instructive applications of photography to a total solar eclipse consists in the use of the prismatic camera. In its simplest form this is the ordinary camera with a simple prism adjusted outside the lens in such a position that the light from the eclipsed sun must pass through both prism and lens before it reaches the photographic plate in the camera. By this means is obtained a series of pictures of the sun's surroundings, instead of a single one as before. Every different substance present in the sun's atmosphere will show as a different ring or series of rings, and it is by a study of such photographs—or spectrograms, as they are technically called—that astronomers have been able to learn what substances are present in the solar atmosphere. In a particular example of the prismatic camera, the lens aperture is 6 inches, and the focal length of the lens is $7\frac{1}{2}$ feet. There is a single large prism of 45° refracting angle rigidly attached outside the objective, and the whole instrument is fixed to a strong equatorial mounting driven by a delicately adjusted clockwork movement, so that exposures of any desired duration can be given.

ECZEMA PROCURATA

A name given to the skin disease caused by the metol developer. For further particulars, see under the heading " Metol."

EDGING (Fr., *Bordure* ; Ger., *Einfassung*)

In wet collodion negative making, especially for process work, the glass plates are generally edged with indiarubber solution to prevent the film from being washed off during the operations of developing, intensifying, etc. Albumen and gelatine are also used for the same purpose, but with these materials it is generally the practice

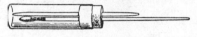

Edging Brush

to coat the plate all over as a substratum. A useful device for edging is shown above. A small camel-hair brush has a strip of wood bound to the side of it, and the two are pushed through a cork, which stoppers a bottle or test tube containing the rubber solution.

EDGING NEGATIVES FOR CARBON PRINTING

Negatives intended for carbon printing require an opaque margin, called a safe-edge. A narrow margin of the print must remain white, as otherwise it will be difficult to transfer the film. This opaque margin may be produced by painting the edges of the film with water colour, or opaque varnish may be applied to the glass side of the negative. Another method frequently adopted is to attach narrow strips of thin, opaque paper to the negative, or to a piece of plain glass. In the latter case this glass is placed in the printing frame outside the negative, and one glass may be used for many negatives.

EDINOL (Fr. and Ger., *Edinol*)

A developer, known also as " Paramol," under which name it was originally introduced in 1901, but the two agents are stated by some not to be exactly the same. It occurs in a faint yellowish crystalline powder, having the formula $C_6H_3 OH CH_2OH NH_2$, and it is soluble in twelve times its weight of water. Its factor number is 20, and it therefore stands midway between the slow-working developers, such as pyro, hydroquinone, and adurol, and the quick-working developers, metol, amidol, etc. It can be used as a single-solution or a two-solution developer, and works well when combined with hydroquinone. Edinol is extremely sensitive to the action of bromide as a restrainer, so much so that from 10 to 30 per cent. of a saturated solution of sodium bicarbonate instead of bromide has been recommended in cases of over-exposure. It is clean-working and is particularly suitable for bromide and gaslight papers and transparencies. The formulæ for one-solution and two-solution developers are as follow :—

One-solution

Sodium sulphite .	.	2 oz.	200 g.
Water	. .	5 ,,	500 ccs.

Dissolve and add—

Edinol	. .	$\frac{1}{2}$ oz.	50 g.
Sodium carbonate	.	$2\frac{1}{2}$,,	250 ccs.

and then add water to make 10 oz. This forms a concentrated developer, and for use is diluted with from five to ten times its volume of water.

Two-solution

A. Sodium sulphite . 2 oz. 100 g.
 Edinol . . . 96 grs. 10 ,,
 Water to . . 20 oz. 1,000 ccs.
B. Sodium carbonate . 10 % sol.; or
 Potassium carbonate . 5 % sol.

Use equal parts of A and B. Sodium carbonate works slowly, and for quicker working potassium carbonate may be substituted for it. (For use combined with hydroquinone, *see* " Developers, Mixed.")

EDISON'S KINETOSCOPE (*See* " Kinetoscope.")

EDWARDS'S FORMULÆ

These include a one-solution intensifier made up from the following :—

A. Mercuric chloride . 60 grs. 3·9 g.
 Water . . . 8 oz. 227 ccs.
B. Potassium iodide . 180 grs. 11·7 g.
 Water . . . 2 oz. 57 ccs.
C. Sodium hyposulphite 120 grs. 7 g.
 Water . . . 2 oz. 57 ccs.

When all are dissolved add A to B, shake well and add C; allow to stand for an hour or two before use. Soak the negative in this until intensified, and then immerse in a " hypo " fixing bath for half a minute, finally washing well. If local intensification is required, the solution may be applied to the parts with a camel-hair mop or a pad of cotton-wool. Edwards's reducer or clearing bath is used chiefly for removing yellow stains from negatives that have been developed with pyro. The formula is :—

Alum 1 oz. 55 g.
Ferrous sulphate . . 3 ,, 165 ,,
Sulphuric acid . . 1 drm. 6·25 ccs.
Water . . . 20 oz. 1,000 ,,

This gives an apple-green solution, which is used after fixing and washing. It keeps well if the used liquid is not returned to the stock solution. Another formula due to Edwards is given under the heading " Redeveloper."

EFFECT (Fr., *Effet* ; Ger., *Wirkung*)

The general impression given by a print apart from any examination of its details. It depends mainly on the disposition of its principal masses and its chiaroscuro (*which see*).

EFFLUVIOGRAPH

An invention by Mons. Tommasi, in 1886, by the use of which all the effects of photography were obtained through the electric effluvia or obscure discharge. Two metal brushes, placed parallel in front of one another, were each connected to the pole of a Holtz machine. A dry plate of about the same height was placed perpendicularly to the brushes; and on the discharge taking place in darkness an image was obtained by radiations.

The term effluviography is sometimes applied to images obtained by what is more commonly known as vapography (*which see*).

EGG, WHITE OF (Fr., *Blanc des œufs, Albumine* ; Ger., *Frisches Eiweiss, Albumin*)

Commonly referred to in photographic processes as albumen (*which see*). First used for coating glass plates by Niepce de Saint-Victor in 1848. About 1866 it was largely used for albumenised paper, and one maker stated at the time that he broke 2,000 eggs daily, merely to obtain the whites. Mayall, whose albumen negative process was widely used, stated that the white of a duck's egg is more sensitive than that of a hen's egg, and that the white of a goose's egg was more sensitive than either.

In process work the whites of eggs are largely used for making up the albumen-bichromate solution in preference to dried albumen.

EGYPTIAN VIGNETTES (*See* "Black Vignettes.")

EIKONOGEN (Fr., *Iconogène* ; Ger., *Eikonogen*)

A developer introduced by Dr. M. Andresen in 1889 ; it appears in a yellowish white powder or yellowish crystals when fresh, but rapidly changes to a brownish tinge. Its formula is $C_{10}H_5$ (OH) NH_2 SO_2 ONa. It is sparingly soluble in water, but readily so in the presence of alkalis, especially when heated. It can be used in a one-solution or a two-solution form, and is suitable for all kinds of plates and bromide and gaslight papers. It is widely advocated for very rapid exposures, for which the following one-solution mixture, which is ready for use, is particularly suitable :—

Eikonogen . . . 100 grs. 20 g.
Sodium sulphite . 200 ,, 40 ,,
Sodium carbonate . 100 ,, 20 ,,
Potassium bromide . 5 ,, 1 ,,
Water . . . 10 oz. 1,000 ccs.

The small quantity of bromide added appears to increase the density of the negative, but where there is a suspicion of under-exposure, and when soft portrait negatives are desired, it is better omitted. Bromide acts very powerfully with eikonogen, and further additions in cases of over-exposure should be made cautiously. The following is the formula for the two-solution form :—

A. Eikonogen . . 1 oz. 50 g.
 Sodium sulphite . 4 ,, 200 ,,
 Water . . . 20 ,, 1,000 ccs.
B. Sodium carbonate 3 ,, 150 g.
 Water . . . 20 ,, 1,000 ccs.

For use, mix 1 part of A, 1 part of B, and 2 parts of water. Potassium carbonate may be used in place of the sodium in the B solution, and a more energetic developer obtained. When eikonogen is used for wet plates they generally need to be intensified, preferably with pyro-silver. (For an eikonogen-hydroquinone combination, *see* " Developers, Mixed.")

EIKONOGEN PRINTING PROCESS

A process invented in 1895 by A. Frey, of Paris. Aniline, or toluidine, is treated with sulphuric acid, and the almost colourless product is dissolved in warm water. A mixture of this solution with eikonogen, applied to albumen paper, gives a reaction on exposure to light. Cherry or blackberry juice is bleached by mixing with eikonogen solution, but when paper coated with the mixture is exposed to light the colour returns. In the same way, several iron, copper, and tin salts, when mixed with eikonogen, are

CHURCH OF NOTRE DAME, CAUDEBEC-EN-CAUX By H. W. Bennett, F.R.P.S.

ARCHITECTURAL PHOTOGRAPHY (Exterior)

sensitive to light. Freshly prepared potassium formate with eikonogen also yields a sensitive substance.

EIKRONOMETER (Fr., *Eikronomètre;* Ger., *Eikronometer*)

An early form of the Watkins dark-room clock. (*See* " Clock, Dark-room.")

ELECTRIC INKLESS PRINTING

A process invented by W. Friese-Greene, in which the electric current was made to pass through the type forme and the impression cylinder of an ordinary letterpress printing machine. The paper was treated chemically, probably with an iron salt, and when impressed on the type was darkened by the electric action.

ELECTRIC LIGHT (Fr., *Lumière électrique;* Ger., *Elektrisches Licht*)

The electric light is the most practically useful artificial illuminant for photographic purposes. Where public mains are not accessible, a small dynamo, driven by a gas-engine, offers the most convenient means of installation. Apart from the initial expense of the dynamo and engine, this is naturally more economical than the public supply, though involving greater trouble and attention. The switches should be such as will stand hard wear and rough usage, and an adjustable resistance is an advantage. There are four principal types of lamps—the arc, the incandescent or glow lamp, the Nernst lamp, and the mercury vapour lamp. In portraiture, the arc lamp is most used. For studio employment and for ordinary black-and-white copying, the enclosed arc is best, but for photographing colour the open arc is superior. These two patterns are fully dealt with under the heading " Arc Lamps." Flame arc lamps, in which a brilliant golden yellow light is obtained by incorporating metallic salts in the carbons, or by introducing a central core of such salts, have also attracted some attention among photographers, it having been stated that colour values are better reproduced with them. A plate sensitised for yellow has, of course, to be employed. An arc lamp in use should not be examined or adjusted without a piece of smoked yellow glass before the eyes, or goggles of the same material.

The incandescent glow lamp is yellower and less actinic than the arc, but a number of these suspended inside a dead white spherical or parabolic reflector, having a muslin diffusing screen in front, can be used for portrait work, giving a soft and pleasing lighting. Several lamps of this kind are on the market. Ruby and orange glow lamps are much used in the dark-room. The new metallic filament lamps have greatly improved the efficiency of incandescent electric lighting, yielding better illumination with less current than carbon filament lamps.

The Nernst lamp makes use of a thread of yttrium and zirconium oxides, and similar metallic earths. These lamps are employed with the optical lantern and for enlarging; they are economical of current and carry their own resistances.

The mercury vapour lamp is dealt with under its own heading. It requires very little current,

and is a useful light for printing, copying, or enlarging. A certain prejudice exists against its employment in portraiture owing to its unpleasant colour, due to the absence of red rays, but this is easily remedied by using one or two ruby glow lamps in addition.

For copying, etc., the nearness with which the lamp can be placed to the easel is of importance from an economical standpoint, other considerations being equal. Thus, the enclosed arc can be brought closer than the open arc, the flame arc still nearer, and the mercury vapour lamp nearest of all.

In process work, the electric arc light is invariably used for copying in preference to daylight. (*See* " Arc Lamps.") Mercury vapour lamps are also used to some extent. Incandescent electric lamps are not sufficiently powerful.

ELECTRIC LIGHT FOR OPTICAL LANTERN (*See* " Optical Lantern.")

ELECTRIC RADIATIONS (*See* " X-ray Photography.")

ELECTRIC TELEPHOTOSCOPY (*See* " Transmission of Photographs Electrically.")

ELECTRO

A common abbreviation of the term " Electrotype " (*which see*).

ELECTRO ETCHING

Numerous processes have been put forward at various times for etching by means of the electric current, but none has come into regular commercial use. The earliest was a method of etching the daguerreotype plate. Fizeau gilded the image by depositing gold upon it, and then etched the parts not covered by the gold, which acted as a resist. Grove, Donne, and others produced engraved plates in this manner, performing the etching by galvanic action, but the difficulty of biting the delicate daguerreotype image to a sufficient depth and obtaining the requisite ink-holding grain soon led to the abandonment of the method. Prof. Jacobi, in 1839, engraved line plates into relief by electric etching, and about the same time Thomas Spencer, of Liverpool, described a process of galvanic etching by coating copper plates with a resist ground and scratching lines through it. In later times J. W. Swan used electric etching for photogravure plates. Images scratched with needle-points through an etching ground have often been successfully etched. Sanger Shepherd some years ago described a process of etching a bitumen print on copper by depositing gold on the parts laid bare by development and etching the other parts. Dr. Strecker has patented a process for electric etching with the solution of a zinc salt. Zinc, copper, and steel have been successfully etched, but the process is slower than ordinary etching, and does not appear to have any advantages.

ELECTROGRAPH (Fr., *Électrographe;* Ger., *Elektrograph*)

An apparatus for the telegraphic transmission of photographs, invented conjointly, in 1901, by H. R. Palmer, M. E. T. Mills, and Dr. W. P.

14

Dunlany. The receiving and transmitting machines are identical in construction, and may be used alternatively. The transmitter carries a zinc enlargement of a half-tone plate, curved to fit a cylinder, the depressed or etched portions of the plate being filled with an insulating material. Over the cylinder a stylus is made to travel, much after the manner of a phonograph stylus. At the other end of the wire, the receiving cylinder is fitted with a pen, which travels at the same rate as the transmitting stylus over a sheet of paper placed beneath. When the stylus is in contact with metal the circuit is completed, and the pen of the receiving instrument traces a dot or line corresponding with that on the zinc plate ; but when the stylus touches the insulating material in the etched portions the circuit is broken, and no mark is made by the pen. As a consequence, the picture on the half-tone plate is reproduced at the receiving end, and from the copy a smaller plate, suitable for press use, may be made by reduction in the usual manner. Each instrument is provided with a pen as well as a stylus, and either may be used at will.

ELECTROGRAVURE

A process invented by Jos. Rieder for etching on steel by galvanic means. It was shown at the Paris Exhibition of 1900.

ELECTROLYTIC BREAK (See "Contact Breaks.")

ELECTRO-PHOTOTYPY

A name given to Sutton's process (not used commercially) of making half-tone printing blocks. A half-tone negative was made by photographing through a ruled screen on to a gelatine plate. After being developed, and before it was completely dry, the plate was heated, this having the effect of swelling the dots into high relief. The plate was then used as a mould for electrotyping.

ELECTROTINT

A fancy name given to the half-tone process by an American firm.

ELECTROTYPE (Fr., *Électrotype, Galvano;* Ger., *Galvano, Galvanische Riederschlag*)

A copy or reproduction of a relief surface made by the electrotyping process.

ELECTROTYPING (Fr., *Electrotypage, Galvanoplastie;* Ger., *Galvanoplastik*)

A process by which engraved plates, type formes, etc., are reproduced. They are pressed into a layer of beeswax, the resulting mould is blackleaded by brushing or by spraying with a solution of blacklead, to make the surface conductive, and the mould is then suspended in a solution of copper sulphate, a copper plate being suspended opposite and near to the mould to form an anode. The two are connected to a source of electric current, and copper is then deposited in a thin shell on the mould until thick enough to be stripped off. This shell is filled up at the back with type metal to give it sufficient thickness and solidity, and after being planed at the back and mounted on a wood or metal block is ready for printing from.

Photographic reliefs in gelatine have also been electrotyped. (*See* " Swelled Gelatine Process.")

The late G. Scamoni, of St. Petersburg, succeeded in electrotyping from the image of a wet collodion negative. Nickel, nickel steel, iron, brass, and other metals have also been successfully deposited by electrotyping. In the Ordnance Survey Office, Southampton, original engraved maps are reproduced by electrotyping. The copper plate is silvered to prevent the copper from adhering, and a thick shell is deposited. This is in relief, and forms the matrix from which any number of duplicates may be made. The matrix is silvered and deposited on in the same way as upon the original. Major-General Waterhouse, when at the Survey of India, successfully electrotyped from a photographic carbon image developed on the copper plate. (*See also* " Daguerreotypes, Electrotyping.")

ELECTROTYPY

A process of reproducing daguerreotypes by electro-deposition.

ELECTRO-ZINCOGRAPHY

A process of engraving on zinc in which the electric current is used.

ELEMENT (Fr., *Élément;* Ger., *Element*)

This term has been applied by chemists to those substances which cannot, by any known means, be split up into other and simpler forms of matter. The following table is a list of them, with the symbol and atomic weight of each. The symbol, it may be explained, is the chemist's shorthand or grammalogue, whilst the atomic weight is that in which each element combines with others to form salts or compounds. Thus the chemist writes $AgNO_3$ for silver nitrate, and this formula means that there are 108 parts of silver, 14 parts of nitrogen, and 48 parts of oxygen combined to form 170 parts of silver nitrate. If now it is wished to form silver bromide from this, using potassium bromide, the equation or shorthand for the decomposition which would occur would be written :—

$$AgNO_3 + KBr = AgBr + KNO_3$$
$$\underbrace{108,14,48}\quad \underbrace{39,80}\quad \underbrace{108,80}\quad \underbrace{39,14,48}$$
$$170 \quad + \quad 119 \quad = \quad 188 \quad + \quad 101$$

and this shows that 119 parts of potassium bromide would be required to convert 170 parts of silver nitrate, and the result would be 188 parts of silver bromide, with 101 parts of potassium nitrate as a by-product ; and no matter what actual weight of silver nitrate was used, the combination would always take place in the above ratio—170 : 119.

Name	Symbol	Atomic weight
Aluminium .	. Al .	. 27
Antimony (Latin :		
Stibium) .	. Sb .	. 120
Arsenic .	. As .	. 75
Barium .	. Ba .	. 137
Beryllium .	. Be .	. 9·1
Bismuth .	. Bi .	. 208
Boron .	. B .	. 11
Bromine .	. Br .	. 80
Cadmium .	. Cd .	. 112

Name	Symbol	Atomic weight
Cæsium . . .	Cs .	133
Calcium . .	Ca .	40
Carbon . . .	C .	12
Cerium . . .	Ce .	140
Chlorine . .	Cl .	35·5
Chromium . .	Cr .	52
Cobalt . . .	Co .	59
Copper (Latin : *Cuprum*) . .	Cu .	63
Didymium . .	Di .	142
Erbium . . .	E .	166
Fluorine . .	F .	19
Gallium . .	Ga .	70
Germanium . .	Ge .	72·3
Gold (Latin : *Aurum*)	Au .	197
Helium . . .	He .	4
Hydrogen . .	H .	1
Indium . . .	In .	113
Iodine . . .	I .	127
Iridium . .	Ir .	193
Iron (Latin : *Ferrum*)	Fe .	56
Lanthanum . .	La .	138
Lead (Latin : *Plumbum*) . .	Pb .	207
Lithium . .	Li .	7
Magnesium . .	Mg .	24
Manganese . .	Mn .	55
Mercury (Latin : *Hydrargyrum*) .	Hg .	200
Molybdenum . .	Mo .	96
Nickel . . .	Ni .	59
Niobium . .	Nb .	94
Nitrogen . .	N .	14
Osmium . .	Os .	195
Oxygen . . .	O .	16
Palladium . .	Pd .	106
Phosphorus . .	P .	31
Platinum . .	Pt .	193·4
Potassium (Latin : *Kalium*) . .	K .	39
Rhodium . .	Rh .	104
Rubidium . .	Rb .	85
Ruthenium . .	Ru .	103·5
Samarium . .	Sa .	150
Scandium . .	Sc .	44
Selenium . .	Se .	79
Silicon . . .	Si .	28
Silver (Latin : *Argentum*) . .	Ag .	108
Sodium (Latin : *Natrium*) . .	Na .	23
Strontium . .	Sr .	87·5
Sulphur . .	S .	32
Tantalum . .	Ta .	182
Tellurium . .	Te .	125
Thallium . .	Tl .	204
Thorium . .	Th .	232
Tin (Latin : *Stannum*)	Sn .	118
Titanium . .	Ti .	48
Tungsten (Latin : *Wolfrunium*) .	W .	184
Uranium . .	U .	240
Vanadium . .	V .	51
Ytterbium . .	Y .	173
Zinc . . .	Zn .	65
Zirconium . .	Zr .	90

The Latin names in brackets are included to show the derivation of the symbols. Only the atomic weights generally used are given, as these are continually under revision, and some are still in doubt, although only to the first or second place of decimals. The newer gases and some of the latest discovered elements — such as radium, etc.—are not included.

ELEMI (*See* " Gums and Resins.")

ELIMINATORS (*See* " ' Hypo ' Eliminators.")

ELLIOTYPE

A process of painting a picture upon glass, in body and transparent colours, and printing therefrom as though it were an ordinary negative ; named after its introducer. It was never largely used, and is now obsolete.

EMERY (Fr., *Émeri* ; Ger., *Schmirgel*)

An exceedingly hard mineral, varying slightly in colour, a compact variety of corundum, and very generally regarded as an iron ore. Chemically it consists of alumina, silica, and iron. Its chief source is the Isle of Naxos. It is reduced to powder and used for grinding and polishing metal, glass, etc. Opticians use it for the first rough grinding of lenses. Square sticks of emery, called emery files, are sometimes used by wet collodion workers for taking the sharp edge off glass plates ; but carborundum sticks have been found better. Emery is sometimes used in the form of a very fine powder instead of pumice powder for cleaning copper and zinc ; and collotype workers grind the surface of their thick glass printing plates with fine emery to give a matt surface to which the film can adhere.

EMETICS (*See* " Poisons and Their Antidotes.")

EMISSION, NODE OF (*See* " Nodal Points.")

EMULSION (Fr., *Émulsion* ; Ger., *Emulsion*)

A liquid, usually viscous, containing in suspension an insoluble body in an extremely finely divided state. Plates, films, and bromide, gaslight and printing-out papers are coated with emulsions. To such perfection has the commercial manufacture of these articles attained that it will hardly pay the average worker to prepare his own ; but from an educational point of view the manufacture of emulsions is extremely valuable. In the following notes only tested formulæ are given, and it must be clearly understood that perfection is only attainable after considerable experience, and the tyro must not expect to prepare either papers or plates as excellent or as fast in working as those commercially obtainable.

The various stages in emulsion making will be outlined, and the reasons for each step explained. Let it be assumed, therefore, that it is wished to make a silver bromide gelatine emulsion. The bromide is formed by double decomposition or chemical interchange between an alkaline bromide, usually potassium or ammonium, and silver nitrate. If aqueous solutions of these two salts were mixed in a haphazard fashion there would certainly be obtained a coarse, granular form of silver bromide which would at once sink to the bottom of the vessel, and there might be an excess of either silver nitrate or bromide. To prevent the immediate deposition of the bromide,

and to obtain a fine grain, a vehicle—gelatine—is added to the alkaline bromide solution, and the fineness of grain largely depends upon the proportion of gelatine used. If too much gelatine, or too hard a kind, be used during mixing it is difficult to obtain high speed, as the gelatine acts as a mechanical restrainer; on the other hand, if too little is used, a coarse granular deposit is formed, and the emulsion tends to fog and thinness. When an alkaline bromide and silver nitrate are mixed together they combine in definite proportions according to their molecular weights. The molecular or combining weight of potassium bromide is 119, and that of silver nitrate is 170. If these quantities were weighed out exactly, whether in grains, ounces, pounds, or tons, or grammes or kilogrammes, exactly 188 parts of silver bromide would be formed, and there would be found in the water neither silver nitrate nor potassium bromide; but the slightest error in weighing might give an excess of silver nitrate, which would be fatal to the emulsion in development. It is customary, therefore, to use an excess of bromide or other salt in all emulsions intended for development; this excess varies in most formulæ, and is governed by the process used, the quality of the gelatine and the speed required. Some gelatines will give perfectly clean emulsions with a much smaller excess than others. Then, as one of the prime uses of the excess of bromide is to keep the emulsion free from fog, a reasonable excess is useful on this account, and increase may make an otherwise foggy-working formula satisfactory. Of recent years it has been considered that an increased excess of bromide tends to give faster emulsions for negative work, but it has at the same time a tendency to produce thinness in the high lights. A normal ratio is 100 of silver nitrate to 80 of potassium bromide, though it will be seen that the ratios given in the formulæ vary from this in some cases.

When first mixed the emulsion is very slow, no matter what formula is used, and would be quite unsuitable for anything but lantern plates. It is therefore subjected to a " ripening " process, either by continued application of heat or the use of ammonia. Exactly what occurs during ripening is a matter of doubt, but it is generally assumed that the silver bromide grain increases in size and that this increase is accompanied by greater sensitiveness to light; the change is probably more of a physical than chemical nature.

It has been already stated that there is a chemical interchange between the silver nitrate and bromide, and this is represented by the following equation, which may be said to be the chemist's shorthand method of explaining what occurs :—

$$AgNO_3 \quad + \quad KBr \quad = \quad AgBr \quad + \quad KNO_3$$

silver nitrate	pot. bromide	silver bromide	pot. nitrate
170	119	188	101

The figures here are the molecular or combining weight, and, as has already been explained, 170 parts of silver nitrate combine with 119 of potassium bromide to form 188 parts of silver bromide and 101 parts of potassium nitrate. Alkaline nitrate thus formed must be got rid of, and this is the purpose of the washing, which also removes the excess of alkaline bromide and the ammonia, if this latter has been used for ripening. Were these salts not washed out they would crystallise out on the plate during the process of drying after coating, and either prevent the access of light, or give rise to crystalline markings which would show in the negative.

There are two distinct systems of making emulsions: the acid or boiling process and the ammonio-nitrate process. The former, as a rule, is used for somewhat slow emulsions, and the latter for the faster negative kinds. As to the highest speed obtainable by the acid process, no definite data are available, but certainly 200 H. and D. may be considered the limit, whilst by the ammonia process from 300 to 400 H. and D. can be reached. In the acid process the mixing and the ripening are effected in an acid gelatine solution, whilst in the other process either the whole or part of the silver nitrate is converted into ammonio-nitrate of silver. For amateur work the ammonia process is somewhat easier, and, if excessive speed is not required, nice clean emulsions, giving good density, can be obtained.

Before treating further on the actual mixing of the emulsion, it should be stated that the

TABLE I

	Molecular Weights	Weight of $AgNO_3$ required to convert 1 gr. of haloid	Weight of soluble haloid required to convert 1 gr. $AgNO_3$	Weight of silver haloid produced by 1 gr. soluble haloid	Weight of soluble haloid required to produce 1 gr. silver haloid	Weight of silver haloid produced from 1 gr. of $AgNO_3$
Ammonium bromide . . .	98	1·734	·576	1·918	·521	} 1·106
Potassium bromide . . .	119	1·427	·700	1·578	·633	
Sodium bromide · . .	103	1·620	·606	1·825	·548	
Ammonium chloride . .	53·5	3·177	·315	2·682	·373	} ·844
Sodium chloride . .	58·5	2·906	·344	2·453	·408	
Ammonium iodide . .	143	1·172	·853	1·620	·617	} 1·382
Potassium iodide . .	166	1·023	·977	1·415	·707	
Sodium iodide · .	150	1·133	·882	1·566	·638	

alkaline bromides and iodides are interchangeable, though as a rule that given in a formula should be adhered to ; still, the accompanying tables, compiled by Ackland, will be found exceedingly useful, as they allow of the easy calculation of the necessary amount of haloid for any quantity of silver, or the substitution of one for another.

Table I. enables the worker to calculate the weight of haloid to convert any given quantity of silver, or, vice versa, the quantity of silver haloid produced from every grain of haloid, or the weight of silver haloid produced from every grain of silver nitrate. If, for instance, the formula is :—

Potassium bromide	.	.	150	
Potassium iodide	.	.	10	
Ammonium chloride	.	.	25	
Gelatine	.	.	.	200

The quantity of silver required to saturate the above can be calculated by taking the figures in the third column and multiplying by the above. Thus :—

Potassium bromide 150 × 1·427 = 214·05
Potassium iodide 10 × 1·023 = 10·23
Ammonium chloride 25 × 3·177 = 79·425

Weight of silver nitrate required 303·705

The fourth column enables the worker to calculate readily what excess of soluble haloid there may be present in the emulsion ; whilst

considerable influence on the final result, both as regards speed and density. If the speed required is approximately obtained in the first process of cooking, then pouring out the emulsion into flat pans to the depth of about 1 in. will quickly arrest the ripening action, especially if the pan or dish is stood in cold running water. In summer-time it is even advisable to pack ice around the pan, which for such small quantities as given in these pages may be a clean (most important) 15-in. by 12-in. dish. On the other hand, if the emulsion is allowed to set in its mixing pot, greater speed is obtained, especially when ammoniacal emulsions are made, because the heat is longer retained, and there is less chance for the escape of the ammonia. It is as well, however, in this case to cool the bulk of the emulsion by running cold water around the pot and constantly stirring ; ice water, too, may be used, but care must be exercised, as when an emulsion is poured out into flat, ice-cooled pans to set there is danger in the case of negative emulsions of a want of density in the highest lights.

Still more important with regard to the density and speed of the emulsion is the lapse of time between the setting and washing ; and in the case of negative emulsions the speed may be nearly doubled, and consequently the density of the high lights increased, by allowing the emulsion to stand in the solid state in cold for twenty-four to forty-eight hours. Except where otherwise advised, the normal time is about twelve hours ; that is to say, a negative emul-

TABLE II

	Ammonium bromide	*Potassium bromide*	*Sodium bromide*	*Ammonium chloride*	*Sodium chloride*	*Ammonium iodide*	*Potassium iodide*	*Sodium iodide*
Ammonium bromide . . .	1	·823	·951	1·832	1·675	·676	·59	·653
Potassium bromide . . .	1·215	1·	1·156	2·226	2·036	·821	·717	·794
Sodium bromide . . .	1·051	·865	1·	1·925	1·761	·71	·62	·684
Ammonium chloride . . .	·546	·449	·519	1·	·914	·369	·322	·356
Sodium chloride . . .	·597	·491	·568	1·093	1·	·403	·352	·39
Ammonium iodide . . .	1·479	1·217	1·408	2·712	2·478	1·	·873	·966
Potassium iodide . . .	1·695	1·394	1·612	3·104	2·839	1·145	1·	1·107
Sodium iodide . . .	1·53	1·259	1·456	2·803	2·564	1·034	·903	1·

columns 5, 6, and 7 enable him to work back when he has determined on a fixed content of silver haloid.

Table II. is extremely useful for finding the weight of one haloid that will replace another. Supposing, for instance, that it is desired to replace 80 grs. of ammonium bromide with the sodium salt ; then in the first vertical column headed " ammonium bromide " there will be found against sodium bromide 1·051, which is the weight of this salt that will convert as much silver nitrate as one grain of ammonium bromide. Therefore 1·051 × 80 = 84·08 would be the quantity of sodium haloid to use.

Before entering into the making of emulsions it may be as well to consider the subsequent operations first, as they play an important part in the quality of the finished emulsion. The method adopted for setting the emulsion has

sion made one evening is ready the next morning to be broken up and washed.

The easiest method of breaking up small quantities of emulsion is to use coarse-meshed canvas, the mesh being about ¼ in. square. The emulsion should be coarsely cut up by means of a silver knife (do not use a steel one), or scored through with a wide-pronged silver or plated fork, and then put into a sheet of the canvas, the ends of the latter being gathered together so as to form a bag. The bag is held under the surface of a dish of clean water and squeezed round and round so as to force the emulsion through the mesh. Failing the canvas, a fork can be efficiently used if the emulsion has been set in a dish, as it can be scored longitudinally and then across at right angles so as to cut it up into little cubes, which should not be too small, as otherwise they pick up too much water.

Commercially, when large quantities of emulsion have to be treated, a power or hand press is used, and the emulsion forced through a perforated plate.

After shredding, the emulsion is washed. According to the quantity to be treated, washing may be effected either in flat trays or by means of a calico or linen bag and a deep jar. In the first case, a sheet of linen should be placed over the dish or tray, and the emulsion placed in it and a stream of water allowed to run in at one corner and out at the diagonally opposite corner; it is as well to raise slightly that end of the dish at which the water flows in. In the case of the bag method a square of linen should be gathered up into a bag, the emulsion placed therein, and some stout string tied round with a sufficiently long loop to pass over a stick that rests on the mouth of the jar and allows the bag to hang down in the water. By this method the soluble and detrimental salts formed in the emulsion diffuse out into the water. Whichever method is adopted, it is important that the water should be frequently changed, and it is advisable to squeeze the emulsion gently at intervals so as to press out the water.

There is great diversity of opinion as to the best duration of washing, some workers maintaining that from eight to twelve hours is not too long, whilst others reduce the time to two hours or even less. The disadvantages of prolonged washing are that the emulsion, particularly in hot weather, picks up a large quantity of unnecessary water which, unless an extra quantity of gelatine is added afterwards, renders the emulsion so sloppy that it is difficult to coat it on glass, and, further—particularly with rapid negative emulsions—the ripening process goes on, and as the soluble bromides in excess are being removed, there is great danger of fog ensuing. From very careful tests the writer has found that all emulsions can be thoroughly washed by repeated changes (about twelve) of water in two hours, and small quantities—particularly if the weather is warm—can be thoroughly washed in one hour. The washed emulsion should be allowed to drain well, and is then ready for melting.

The emulsion shreds should be placed in a pot in a water bath at 90° F. (about 32° C.) and the temperature gradually raised to 120° F. (nearly 49° C.), at which temperature the final quantity of gelatine should be added and the whole well stirred till the gelatine is dissolved. It is just as well to keep the emulsion at this temperature for at least half an hour, and it can then be filtered through clean felt jelly-bags, or, failing these, swansdown calico or Canton flannel, previously washed to remove any dressing. If there is any difficulty in getting the emulsion to pass through the material, pressure may be applied by squeezing with the hands, but usually, with the emulsion at the temperature stated, there is no trouble providing the filter is first wetted with hot water and well wrung out.

GELATINO-CHLORIDE OR P.O.P. EMULSION.— The simplest form of gelatine emulsion is that used for P.O.P., and the following formulæ will give excellent results :—

Valenta's Formula

A.	Silver nitrate .	. 307 grs.	32 g.
	Citric acid .	. 77 ,,	8 ,,
	Hot distilled water	. 3 oz.	160 ccs.
B.	Hard emulsion gelatine . .	. 922 grs.	96 g.
	Distilled water	. 14 oz.	700 ccs.

Allow to soak for half an hour, and then melt in a water bath at 120° F. and add—

C.	Ammonium chloride.	28 grs.	2·8 g.
	Tartaric acid .	. 28 ,,	2·8 ,,
	Sodium bicarbonate	14 ,,	1·4 ,,
	Alum .	. 18 ,,	1·8 ,,
	Distilled water	. 3 oz.	140 ccs.

The ingredients in solution C must be dissolved in the order given, and care should be taken to use a sufficiently large vessel, as brisk effervescence ensues. Both B and C should be brought to 120° F. (nearly 49° C.) and mixed, and then A, at the same temperature, added slowly and with constant agitation. Allow the emulsion to stand for from two to four hours in a water bath at 110° F. (about 43° C.) with occasional stirring, and then add—

Alcohol	.	. 15 drms.	100 ccs.

and filter through glass wool or two thicknesses of Canton flannel or one thickness of swansdown. Care must be exercised as to the light used, as the fluid emulsion can readily darken in colour whilst digesting even in strong gaslight. The duration of digestion or ripening is dependent on the speed required. If coated when freshly mixed, the emulsion is slow and gives rich and vigorous prints; if, on the other hand, it is ripened for four hours it becomes much more rapid, and gives a longer scale of gradation. If it is desired to obtain a paper that will keep for some time without discoloration, an equal quantity of citric acid to that given above should be added after digestion.

Another excellent formula is the following :—

Wade's Formula

A.	Ammonium chloride.	25 grs.	2·6 g.
	Rochelle salts .	. 25 ,,	2·6 ,,
	Alum .	. 50 ,,	5·2 ,,
	Distilled water	. 2½ oz.	125 ccs.

Dissolve, and add—

B.	Gelatine .	. 820 grs.	86 g.
	Distilled water	. 15 oz.	750 ccs.

previously dissolved at 110° F., and finally add—

C.	Silver nitrate .	. 284 grs.	30 g.
	Citric acid .	. 150 ,,	15·6 ,,
	Distilled water	. 2½ oz.	125 ccs.

The coating temperature of the above emulsions should be about 95° F. (35° C.).

If an emulsion suitable for extremely thin, flat negatives is required, the addition of a small quantity of the chloride of uranium, of nickel or of cobalt, to any of the above formulæ will shorten the scale of gradation, but the most satisfactory agent is calcium chromate, which must be added with caution, as it is extremely energetic in its action, 0·1 per cent. reducing the scale of gradation by about one-third.

For matt surface papers the quantity of gelatine should be reduced so as to make an 8 per

cent. solution. More satisfactory matt emulsions can be obtained by incorporating with the emulsion 10 per cent. of fine rice starch. The necessary quantity of starch should be rubbed into a cream with a little water and a small quantity of gelatine, taken from the emulsion itself, and the whole should be heated to 160° F. (71° C.) for an hour and then added to the emulsion. (*See also* " Collodion Emulsion.")

EMULSIONS FOR DEVELOPMENT

These may be divided into those for positive work and those for negative work.

POSITIVE EMULSIONS

Positive emulsions may again be subdivided into chloride and bromide emulsions, the former including chloro-bromide also, and such as are suitable for gaslight papers and plates.

Chloride Emulsion (Eder)

A.	Sodium chloride	. 288 grs.	30 g.
or	Ammonium chloride	264 ,,	27·5 ,,
	Hard gelatine .	. 384 ,,	40 ,,
	Distilled water	. 8 oz.	400 ccs.
	Hydrochloric acid	. 5 drops	10 drops
B.	Silver nitrate .	. 576 grs.	60 g.
	Distilled water	2 oz.	100 ccs.
C.	Hard gelatine .	. 384 grs.	40 g.
	Distilled water	. 10 oz.	500 ccs.

Dissolve C by heating to 120° F. (nearly 49° C.), and add B at the same temperature; then add A, also at 120° F., and allow to stand at this temperature for ten minutes; then rapidly cool and set. This emulsion yields a satisfactory gaslight paper or plate, which readily gives warm tones. If the hydrochloric acid is omitted, and 240 grs. or 25 g. of citric acid is added, very warm tones, from yellow to reddish brown, are more easily obtained. If the above emulsion is cooled down to 95° F. (35° C.) immediately after mixing, and 60 minims or 6 ccs. of liquor ammoniæ (·880), and 2 oz. or 100 ccs. of distilled water are gradually added with constant stirring, a much more rapid emulsion is obtained, which gives black tones more readily.

The great trouble in mixing all chloride and chloro-bromide emulsions is the formation of a coarse grain, which is reduced by the developer without exposure to light. For this reason the beginner is advised to modify the above formula as follows : Add the whole of the gelatine to A and increase the quantity of water to 12 oz or 600 ccs., and add the silver nitrate dry, in small quantities at a time, with vigorous stirring. When all the silver is added continue stirring for fifteen minutes, and then add 8 oz. or 400 ccs. of distilled water. As an alternative the emulsion may be set and washed as usual, and then the extra quantity of water added. Either way, there is less chance of the occurrence of coarse grain, and the results are equally satisfactory.

There is but little difference in the final result whether the sodium or ammonium chloride be used; the former gives a little more contrast. Much harder working emulsions can be obtained by adding to the above quantity of chlorised gelatine 1·25 grs. or ·05 g. of pure copper chloride ; or greater contrasts may be obtained by increasing this still further.

For some gaslight papers an unwashed emulsion is used, but there is far greater liability to the formation of black spots.

Chloro-bromide Emulsions

Emulsions containing both bromide and chloride of silver are more sensitive than pure chloride emulsions, and whilst giving warm tones with increased exposure, they give better blacks, there being less tendency to greenish tones. The ratio of bromide to chloride is a matter of taste, but the more chloride the less the gradation, and the more bromide the faster the emulsion.

Wratten's Formula

Nelson's No. 1 gelatine 40 grs. 200 g.

rinse two or three times in water and add to—

Distilled water . . 4 oz. 856 ccs.

Dissolve at 125° F. (nearly 52° C.) and add—

Ammonium bromide (neutral)	. 110 grs.	55 g.
Sodium chloride	. 30 ,,	15 ,,
Hydrochloric acid (10% solution)	. 10 mins.	5 ccs.

Then add in a fine stream—

Silver nitrate	. 200 grs.	100 g.
Distilled water .	. 1 oz.	220 ccs.

with constant stirring. Digest for ten minutes at 150° F. (65·5° C.), and add—

Hard gelatine . . 175 grs. 87·5 g.

which has been previously washed and soaked in water for half an hour and well drained. When the gelatine has melted, set, and wash for half an hour with six changes of water, drain well and melt, and make the total bulk up to 1,750 ccs. by adding water. Finally add—

Tannin 1·03 g.

Wellington's Formula

Potassium bromide	. 384 grs.	40 g.
Sodium chloride	. 192 ,,	20 ,,
Citric acid	. 960 ,,	100 ,,
Hard gelatine .	. 1,344 ,,	140 ,,
Distilled water .	20 oz.	1,000 ccs.

Heat to 150° F. (65·5° C.), and add—

Silver nitrate	. 960 grs.	100 g.
Distilled water .	20 oz.	1,000 ccs.

heated to 150° F. Digest for ten minutes, and pour out into a dish to set.

Valenta's Formula

No. I. :—

Ammonium bromide .	480 grs.	50 g.
Ammonium chloride .	48 ,,	5 ,,
Nitric acid	. 10 drops	20 drops
Hard gelatine .	. 1,615 grs.	168 g.
Distilled water .	26 oz.	1,333 ccs.

Heat to 130° F (54·4° C.), and add—

Silver nitrate	. 960 grs.	100 g.
Distilled water .	. 26 oz.	1,333 ccs.

also at the same temperature. Allow to digest one hour, and then pour out and set.

No. II., for greater contrasts :—

The above formula with—

Ammonium bromide	50 grs.	5·2 g.
Ammonium chloride .	300 ,,	30 ,,

In mixing both the Wellington and Valenta formulæ the same procedure may be adopted as for Wratten's.

The ratio of the silver haloids in these three emulsions is as follows:—Wratten—chloride 1, bromide 2·1 ; Wellington—chloride 1, bromide 1·7 ; Valenta No. I.—chloride 1, bromide 8·7 ; Valenta No. II.—chloride 7, bromide 1. Wellington's gives very warm tones more easily than the others with increased exposures.

Lantern Plate and Bromide Paper Emulsions

These may be pure bromide emulsions, but it is preferable to use bromo-iodide, as the iodide tends to keep the whites free from fog. Some commercial bromide papers are also chlorobromide emulsions. The following gives a very satisfactory but slow emulsion, either with or without the iodide.

Ammonium bromide	672 grs.	70 g.	
Potassium iodide	. 15·3 ,,	1·6 ,,	
Hard gelatine .	2 oz.	150 ,,	
Hydrochloric acid (10% solution) .	. 144 mins.	15 ccs.	
Distilled water .	. 30 oz.	1,500 ,,	

Heat to 110° F. (about 43° C.), and add—

Silver nitrate .	. 960 grs.	100 g.	
Distilled water .	. 10 oz.	500 ccs.	

also heated to 110°. Digest at this temperature for one hour. If a more rapid paper is required, then after digestion cool the emulsion down to 95° F. (35° C.) and add—

Liquor ammoniæ	. 96 mins.	10 ccs.	
Distilled water .	. 1 oz.	50 ,,	

then set and allow to stand for twenty-four hours.

For enlarging, when a much more rapid paper is required, a slow negative emulsion, such as given below, may be used. For coating bromide paper the proportion of gelatine should not be too high, although this depends upon the surface required and the method of coating, about 1 : 18 or 20 being generally sufficient. For matt emulsions, rice starch may be added as already advised for gelatino-chloride paper. For lantern plates a little more gelatine is required, say about 1 : 14.

NEGATIVE EMULSIONS

The manufacture of negative emulsions is by no means such an easy matter as positive emulsion making, but with care slow emulsions of very satisfactory quality can be produced. The beginner is not advised to attempt very rapid emulsions, as they are extremely difficult. There are two principal methods for negative emulsion making—the acid or boiling process, and the ammonia method. The former will give, as a rule, the cleaner plate, but it is not possible to obtain so high a speed. With care equally clean plates may be obtained by the ammonia method and greater speed. The acid process will be treated first.

Slow Emulsion

Potassium bromide .	720 grs.	75 g.	
Potassium iodide .	15 ,,	2·75 ,,	
Nelson's No. 1 gelatine	317 ,,	33 ,,	
Hydrochloric acid .	10 ,,	1 cc.	
Distilled water .	. 11 oz.	550 ccs.	

Heat to 120° F. (nearly 49° C.), and add slowly with constant stirring—

Silver nitrate .	. 960 grs.	100 g.	
Distilled water .	. 11 oz.	550 ccs.	

also heated to 120° F. Digest in a water bath at boiling point for half an hour, and then add—

Hard gelatine .	. 1,200 grs.	125 g.	

which should have been well washed in water, soaked for half an hour, and drained for half an hour. Cool the emulsion, and set. This should give an emulsion of about 25 H. and D.

An emulsion of about double the rapidity, and giving somewhat greater contrast can be obtained by cooling the above emulsion down to 95° F. (35° C.) and adding—

Liquor ammoniæ (·880)	72 mins.	7·5 ccs.	
Distilled water .	. 1 oz.	50 ,,	

and stirring well for about fifteen minutes, then setting and allowing to stand for twenty-four hours.

Rapid Emulsion

Potassium bromide	. 1,200 grs.	125 g.	
Potassium iodide	. 24 ,,	2·5 ,,	
Hard gelatine .	. 480 ,,	50 ,,	
Distilled water .	. 10 oz.	500 ccs.	

Heat to 140° F. (60° C.) and add in a fine stream with constant stirring—

Silver nitrate	. 960 grs.	100 g.	
Distilled water .	. 7 oz.	350 ccs.	

also heated to 140° F. Digest in a water bath at boiling point for forty-five minutes, and then add—

Hard gelatine	. 480 grs.	50 g.	
Distilled water .	. 8 oz.	400 ccs.	

The gelatine should be well washed in two or three changes of water, drained, and then dissolved in the distilled water at 110° F. (43·3° C.). This should give plates of from 150 to 180 H. and D., which are rather soft working but clean. Greater contrasts can be obtained by adding ammonia as suggested for the slow emulsion.

Slow Ammonia Emulsion

Ammonium bromide .	816 grs.	85 g.	
Potassium iodide	. 29 ,,	3 ,,	
Hard gelatine .	. 1,392 ,,	145 ,,	
Distilled water .	. 20 oz.	1,000 ccs.	

Heat to 110° F. (43·3° C.), and add, with constant stirring—

Silver nitrate .	960 grs.	100 g.	
Liquor ammoniæ (·880) q.s.		q.s.	
Distilled water .	. 6 oz.	300 ccs.	

at a temperature of about 70° F. (21° C.). The silver should be thoroughly dissolved and enough ammonia added to redissolve the precipitate first formed. The exact quantity will, of course, depend upon the strength of the ammonia, but about 65 or 70 ccs. can be added at first, and then further additions made very cautiously, stirring well, till quite a clear solution is formed. The temperature rises to about 90° F. (32·2° C.), so that it is advisable to cool this silver solution down by standing the vessel in cold water for a short time. As soon as the emulsion is mixed, the vessel should be placed

in cold water, running water for preference, and the emulsion well stirred till quite thick and then put away in cold water to set. If allowed to stand for about sixteen hours before washing, this should give a clean working plate of about 30 to 50 H. & D., which will give great contrasts and wide latitude of exposure.

Medium Rapidity Ammonia Emulsion

Ammonium bromide .	864 grs.	90 g.	
Potassium iodide .	24 ,,	2·5 ,,	
Soft gelatine . .	480 ,,	50 ,,	
Hard gelatine . .	480 ,,	50 ,,	
Distilled water .	20 oz.	1,000 ccs.	

Heat to 120° F. (nearly 49° C.), and add, with constant stirring—

Silver nitrate . .	960 grs.	100 g.
Liquor ammoniæ (·880) q.s.		q.s.
Distilled water . .	6 oz.	300 ccs.

at a temperature of 80° F. (nearly 27° C.). This solution should be made as before described. When mixed, the emulsion should be digested in a water bath at a temperature of 120° F. for half an hour, and then—

Hard gelatine . .	480 grs.	50 g.

which has been well washed but not soaked, added. Cool down gradually and allow to stand for sixteen hours before washing. This should give plates of from 100 to 120 H. & D.

Rapid Ammonia Emulsion

Ammonium bromide .	1,152 grs.	120 g.	
Potassium iodide .	24 ,,	2·5 ,,	
Soft gelatine . .	480 ,,	50 ,,	
Hard gelatine . .	240 ,,	25 ,,	
Alcohol . . .	2 oz.	100 ccs.	
Distilled water . .	18 ,,	900 ,,	

Heat to 130° F. (54·4° C.), and add—

Silver nitrate . .	960 grs.	100 g.
Distilled water . .	6 oz.	300 ,,
Liquor ammoniæ (·880) q.s.		q.s.

at a temperature of 75° F. (nearly 24° C.). Digest in a water bath at 120° F. (nearly 49° C.) for one hour, and then add—

Hard gelatine (well washed only) .	1,680 grs.	75 g.

Cool the emulsion and pour out into flat dishes; allow to stand for twenty hours. This should give plates of from 200 to 225 H. & D.

There are many little dodges which can be learnt only by experience and experiment, but the following hints may not be useless.

In making acid emulsions it is advisable always to run the silver into the bromised gelatine in a fine stream with continuous stirring. In the case of ammonia emulsions, it is not so important to add the silver in a fine stream, but vigorous stirring should be continued all the time.

If regularity of results is required it is important that the water bath should always be kept at a constant temperature, and, further, that the emulsion should be stirred about every five minutes, otherwise the silver bromide may settle to the bottom of the vessel and give coarse-grained thin-working plates that are absolutely useless. It will be noted that distilled water is advised in all the formulæ given in this article;

this is important, as too often ordinary tap-water is contaminated with iron and other impurities, which lead to fog or loss of sensitiveness. It is advisable even to use distilled water for washing the gelatine.

Greater rapidity can always be obtained by reducing the quantity of gelatine during the mixing, but there is great danger of the formation of coarse grain and fog. If the gelatine is much reduced it is always advisable to add about 10 per cent. of the total bulk of alcohol, which not only prevents this but also obviates the occurrence of dichroic fog with the ammonia method.

Directions have already been given for setting and washing emulsions. When the emulsion has been washed enough it should be removed from the water and left to drain for about an hour, so as to free it from the adherent water as much as possible. In fact, it is as well to use a clean dry linen cloth, and after the emulsion has drained, place it in this and, collecting the whole into the form of a bag, squeeze thoroughly. The emulsion is then ready for melting and coating.

A test plate should always be coated first. Melt the emulsion in a water bath at 120° F. (nearly 49° C.), then take out a little and cool down to 95° F. (35° C.); coat a plate and put away to dry. The bulk of the emulsion can now be rapidly cooled down again and, when set, alcohol containing 0·1 per cent. of carbolic acid poured over the top to the depth of about half an inch, the emulsion being then put away in a dark, cool place. If it is to be used soon the alcohol may be omitted, but this will keep a stock of emulsion in good condition for a week or so.

ENAMEL, CERAMIC (*See* " Ceramic Process.")

ENAMEL COLLODION (*See* "Collodion, Enamel.")

ENAMEL SURFACES

Highly glazed surfaces. Printing papers having such surfaces are now obtainable, but formerly the worker had to produce the glaze himself. Enamel surface papers need careful washing, otherwise — especially in the case of collodion paper—they are liable to crack; they also need mounting with a quick-drying mountant, or else the moisture is liable to spoil the glaze. Methods of enamelling prints which in their normal state have ordinary or matt surfaces, will be found under the heading " Enamelling Prints." Proper photographic enamels—that is, burnt-in photographs upon porcelain, etc.—are known as " ceramics." [See " Ceramic Process.")

ENAMELINE, OR ENAMEL PROCESS (Fr., *Procédé émail* ; Ger., *Emailverfahrung*)

A process originating in the United States, by which a copper or zinc plate is coated with a solution of fish-glue and ammonium bichromate, exposed to light under a half-tone negative, developed so as to clear away all the soluble glue between the dots, and after being dried is " burnt-in "—that is, the plate is held over a gas flame until the image turns to a deep chocolate-brown, almost black. When cool, the

plate can be etched, the enamel image resisting the etching solution. Gum is sometimes used instead of fish-glue. A suitable formula for the fish-glue solution is:—

Glue	5 oz.	500 g.
Water	.	.	.	10 ,,	1,000 ccs.	
Ammonium bichromate	¼ ,,					25 g.

Add liquor ammoniæ (·880) until a golden yellow colour is reached.

Some workers prefer a formula containing albumen, and the following will serve:—

Le Page's fish-glue	.	3 oz.	375 g.	
Water	.	.	8 ,,	1,000 ccs.
Ammonium bichromate	180 grs.	47 g.		
Whites of 2 eggs				

Beat the egg whites, add to the glue solution, beat up again, allow to stand for eight hours and then filter through absorbent cotton.

ENAMELLING PRINTS (Fr., *Émaillure*; Ger., *Emailleiren*)

The process of enamelling prints must not be confused with burnishing, and other methods of glazing. Enamelling proper with collodion gives the highest possible gloss. The method described below is suitable for all kinds of prints, but particularly for collodion prints: Procure some commercial collodion specially made for enamelling, or make according to the instructions given under "Collodion, Enamel," Thoroughly clean a glass plate, rub it over with a little warm wax or vaseline, polish well with a soft cloth, apply a thick coating of the enamel collodion, and allow to set thoroughly. Coat the glass evenly and out of the way of dust. This coating is to be transferred to the face of the print. By the aid of gentle heat, make a solution of gelatine in water (20 grs. to 1 oz.), and slip the collodionised glass plate film upwards into the warm, not hot, gelatine solution; immerse a dried print also in the gelatine solution face downwards, allow it to soak, bring glass and print into contact, film to film, lift out and squeegee thoroughly until no air-bells are left, and then set up to dry. When quite dry cut round the edges of the print (through the collodion) with a sharp penknife, lift by one corner, and strip from the glass. If properly done, the print will come away easily, bringing the collodion surface with it.

As the collodion (enamel) surface is easily dulled if not mounted with a quick-drying mountant, it is the practice of some workers to back the print before or during enamelling with waterproof paper or thin Bristol board, so as to permit the use of any mountant. A good method is to soak the unmounted print in gelatine, squeegee upon the collodion plate, and then immediately after, while the print is wet, to squeegee waterproof paper or thin Bristol board on to the back of the print, using gelatine as the adhesive. When the print and mount are dry they can be stripped from the glass like an unmounted print, and then be trimmed and mounted.

ENAMELOID (Fr., *Énameloid*; Ger., *Enameloid*)

A dead-black varnish suitable for the inside of lens mounts, diaphragms, etc., said to consist of celluloid dissolved in acetone, with the addition of vegetable black.

ENCAUSTIC PASTE (Fr., *Colle encaustique*; Ger., *Enkaustische Kleister*)

Known also as cerate paste; a mixture for rubbing on to the surface of prints in order to give them a gloss, deepen the shadows, and brighten them up generally. The gloss obtainable is very pleasing, but not so high as that obtained by burnishing or enamelling. It is particularly suitable for matt bromide and platinotype prints, and at one time was widely used for prints on albumen paper. In its simplest form it consists of 1 part (by weight) of ordinary beeswax reduced to a paste with four parts of turpentine, the smell of which can be masked by substituting 1 part of oil of lavender for 1 part of turpentine. The wax is soaked in the solvent and then melted gently by heat. Another simple paste is that made according to Dr. Eder's formula:—

White wax	.	1 oz.	500 ccs.
Dammar varnish	. 200 mins.	209 ,,	
Oil of turpentine	. 1 oz.	500 ,,	

Dissolve by heat and mix well. A more elaborate mixture, and one widely used, is that made according to the Adam Salomon formula:—

Pure virgin wax	. 500 grs.	500 g.		
Gum elemi	.	10 ,,	10 ,,	
Benzole	.	.	½ oz.	240 ccs.
Oil of lavender	.	¾ ,,	360 ,,	
Oil of spike	.	1 drm.	60 ,,	

Melt in a hot-water bath, mix thoroughly, and strain through muslin; or the gum may be dissolved in the solvents and the melted wax added after filtration. A small quantity of any of the above mixtures is applied to the print by means of a small piece of flannel or linen, and is then worked into the print by continuous rubbing, a polish being obtained finally by rubbing with a clean piece of flannel or a pad of clean linen.

The following mixture was at one time largely used for painting with a brush over the shadows of a print in order to deepen them; it is not encaustic paste proper, but can be used when it is not desired to cover the whole of the print:—

Gum arabic	.	.	½ oz.	16·5 g.
Water	.	.	3 ,,	100 ccs.
Rock candy	.	1 drm.	4 ,,	
Acetic acid	.	10 drops	·7 ,,	
Alcohol	.	.	10 ,,	·7 ,,

ENDEMANN'S PROCESS (Fr., *Procédé Endemann*; Ger., *Endemann's Prozess*)

An aniline printing process, giving a black image on a white ground. The paper is sized with a solution of 1 oz. of sheet gelatine in 50 oz. of water, and sensitised with:—

A. Sodium chloride			
(common salt)	. 480 grs.	846 g.	
Potass. bichromate	. 480 ,,	846 ,,	
Sodium vanadiate	. 320 ,,	564 ,,	
Water	.	. 20 oz.	1,000 ccs.
B. Sulphuric acid	. 2 oz.	100 ccs.	
Water	.	. 10 ,,	500 ,,

The acid must be introduced gradually into the water, and the mixture, when cold, added to A.

The paper is floated on the surface of the sensitiser, and hung up to dry in the dark. It is exposed under a negative or tracing in a printing frame for about seven minutes, and development is carried out by exposing the print to the vapour arising from a heated mixture consisting of ½ oz. of aniline to 25 oz. of water (22 g. in 1,000 ccs.) for about one minute, which produces a brown image. The print is then placed in a room filled with steam for about two hours, or until the image turns black. To remove the green colour that usually remains, wash carefully in a solution of liquor ammoniæ (·880) 2 oz., to water 12 oz. (166 ccs. liquor ammoniæ to 1,000 ccs. water).

ENERGIATYPE

A process (now obsolete) invented and named by Robert Hunt about 1851. It has been called a ferrotype process, but ferrotypes are now understood to be pictures upon a blackened tin surface. Good writing paper was prepared by washing over with :—

Succinic acid . .	5 grs.	2·5 g.
Common salt . .	5 ,,	2·5 ,,
Gum arabic solution	½ drm.	30 ccs.
Water . . .	1 oz.	500 ,,

When dry, the paper was sensitised on a solution of silver nitrate 60 grs., water 1 oz., and dried in the dark. The paper was used in the camera as a plate, an exposure of about 30 seconds being enough for a brightly lighted landscape, and six times as long for a portrait. The image remained invisible until developed, the developer being made in the proportion of 1 dram of a saturated solution of iron protosulphate and 3 drams of gum arabic solution. The picture was then fixed with ammonia and finally well washed.

ENGINEERING PHOTOGRAPHY

Most of the technical considerations that apply to architectural photography apply equally well to engineering subjects. The truth of vertical lines must always be preserved by keeping the

features that cannot be seen from any other position. One of the most important considerations in engineering photography must always be to show the essential features of the work in an effective manner. Technical knowledge, or even a slight acquaintance with engineering practice, will be exceedingly valuable to the photographer who undertakes work of this

B. Camera Tilted Downwards

character. The object of the photograph is to illustrate the working of the machine; to show most plainly its principal working parts and the manner in which its object is attained. Subject to these considerations, an oblique view should always be taken, if possible, in preference to a full front or side view. By choosing a position that gives a good perspective, the relief and projection of the various parts are shown, as well as their solidity and their relation to each other. In a view taken from the front, the sense of relief is largely lost; the machine appears flat, its functions are not well shown, and its working is much more difficult to follow. The diagrams at A show plainly the reasons for this; they represent a plan of a machine with the camera F placed in different positions. Sharp definition throughout is essential. Whenever possible, machines should be painted a good medium grey or lead colour, this assisting in rendering detail effectively throughout, and particularly in the shadows and light parts. The colour should be quite dull, a glossy surface being very undesirable. Bright parts may generally be left untouched, as they then look more natural than if painted white, as sometimes advocated. Paint gives an effect suggesting wood.

In many subjects difficulties in working may present themselves, and require ingenuity combined with photographic skill to overcome. In

A. Diagrams showing the Influence of Viewpoint in Engineering Photography

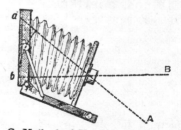

C. Method of Using Swing-back

sensitive plate vertical, whether the view of the machinery necessitates looking upwards or downwards. In many cases abnormal points of view have to be taken, and the camera may have to be raised several feet in order to show essential

photographing a subject with a long range of distances, the following method has been very efficient. The subject was some electrically controlled railway points, and it was very necessary to show the mechanism between the rails as large as possible. The camera was placed about eight or ten feet from the principal part of the subject, but signals and other objects five or six

hundred feet away were included, and all had to be sharply defined. The distance was entirely at the top of the picture, and the foreground at the bottom, the camera being placed as in diagram B. By tilting the camera downwards and using the swing-back, as shown at C, sharpness was obtained throughout by using a medium aperture, as the foreground A in the diagram was focused at *a* in the camera, and the distance B at *b*. Previously it was found that with the back and front of the camera parallel, $f/64$ failed to render the different planes reasonably sharp.

In all engineering subjects wide-angle lenses should be avoided as much as possible. In photographing complete workshops or very large pieces of machinery, they may be absolutely necessary, but for single machines of small or moderate size, a medium-angle or a long-focus lens should always be used.

In many cases machines can be photographed out of doors, and this is frequently preferable to the lighting in many workshops.

In most cases, engineers wish to have a clear white background for all isolated pieces of machinery; this necessitates painting out the background on the plate (*see* "Blocking Out, or Stopping Out"), unless the work may be left to the process-worker's retoucher.

Photographing workshops is treated in the article "Factories, Photographing in," and notes on the exposures for these subjects are given under the heading "Exposure Tables."

ENGRAVED BLOCKS

A term correctly applied to wood-engravings, but now commonly used to denote all kinds of blocks, whether engraved by hand or produced photo-mechanically.

ENGRAVING (*See* "Half-tone Process," "Photo-engraving," etc.)

ENGRAVING ON GLASS

Photographic processes have been employed to produce an image on glass as a resist for etching by means of hydrofluoric acid. The bitumen process is one of the best for the purpose of forming the resist image.

ENGRAVINGS, COPYING

In copying engravings and drawings the only difference in working arises from the fact that the subject consists of black lines on a white ground, a type of subject that is usually considered difficult on a gelatine plate, as it is far from easy to obtain sufficient contrast with ordinary plates. By adopting the following method of working little difficulty should be experienced in obtaining a negative that will give all the contrast required in the print. A slow plate of the kind specially prepared for this work should be chosen, and it should be backed. A fine-grain ordinary, or a process plate, will answer well. Correct exposure is very important. The following method of timing will ensure correct exposure. Place the exposure meter flat against the drawing to be copied, and note the time required to match the standard tint. Using $f/16$ and a plate of the speed of 40 H. and D., one half of the time that a Wynne meter requires, or one fourth of the time required

by a Watkins meter to reach the tint, will be the correct exposure for copying the same size as the original. For other plates or for different scales the proportionate exposures can easily be found from these data. Should the lines show distinct signs of veiling, development should be stopped, and the negative afterwards intensified, if necessary. (*See also* "Copying," etc.)

In process work, an engraving on thin, clean paper, and with good black lines, without printing on the back, may be copied by using it as a diapositive. It is placed in contact with a sensitised zinc plate and exposed to light for a sufficient time. A negative image will be developed, but this may be converted into a positive one by flowing with a shellac varnish containing some colouring matter to make it visible. The latter will attach itself to the bare zinc lines, whilst that which rests on the sensitive colloid film will be dissolved away by treating the plate in a bath of weak acid.

Playertype (*which see*) is also an easy process for copying engravings on to sensitive paper.

ENLARGING

The operation of enlarging consists simply in taking a print from a negative by means of a lens instead of by placing a paper in contact with the surface of the negative in the usual manner. The essential parts of the apparatus required are a holder for the negative from which the enlargement is being made; a camera body or similar arrangement of which the negative holder forms one end, a lens being fitted at the other; and a board or easel for holding the paper on which the enlargement is being

Principle of Enlarging

made. The positions of the easel and the lens should both be adjustable, so that enlargements of any desired size may be made. The illustration explains the arrangement fully. N is the negative, L the lens, and P the paper. The type of lens used for making an enlargement is not important, beyond the fact that it ought to cover the plate with crisp definition from corner to corner with a fairly large aperture. If it is necessary to use a small stop to obtain good definition, the exposures required may be inconveniently long. Also, a lens of long focus should be avoided, especially if very large pictures are desired from small plates, as the apparatus would have to be very long. If the focus of the lens is known, the apparatus may be set up approximately in position for any degree of enlargement by measurement, leaving only the fine focusing; it will then be easy to

ascertain what degree of enlargement forms the limit of the apparatus.

The distance A from the centre of the lens to the sensitive paper must be equal to the focus of the lens multiplied by the degree of enlargement, with the focus of the lens added to the result. The distance B from the centre of the lens to the negative must be the distance A divided by the degree of enlargement. The distance A bears the same proportion to B as the enlargement bears to the original negative. An example will render this clear. A lens of 6 in. focus is being used to enlarge a 4 in. by 3 in. picture up to 12 in. by 9 in. The degree of enlargement is three times linear. Three times 6 in. is 18 in., plus 6 in. brings the distance A up to 24 in.; and this distance divided by 3, the degree of enlargement, gives 8 in. as the distance B. These general principles apply equally to all methods of enlarging. Details of making enlargements on paper direct, or by means of enlarged negatives, are given in later articles.

It is useful to know the relative exposures for different degrees of enlargement, when all the conditions are equal. Beginning with the production of a print the same size as the original as a basis, and calling the exposure for this 1, the relative exposures for other degrees of enlargement, using the same stop throughout, will be :—

Degree of Enlargement			Exposure
1	1
1½	1½
2	2¼
2½	3
3	4
4	6¼
5	9
6	12

ENLARGING BY ARTIFICIAL LIGHT

The principal difference between enlarging by daylight and by artificial light consists in the method of illuminating the negative evenly and

Enlarging by Incandescent Gas Light

with sufficient strength to obtain an enlargement in a reasonable time. A necessary element is a condensing lens for collecting the light and presenting it in the form of an evenly and brilliantly illuminated disc immediately behind the negative from which the enlargement is being made. The source of light may be an oil lamp, a gas flame, or an electric lamp. The first-named is the least satisfactory by reason of its variable character and comparatively poor quality. An incandescent gas burner is one of the most satisfactory for general use. At times the light is projected in the form of an enlarged

image of the mantle, and a similar difficulty may arise with an incandescent electric lamp. This may be entirely obviated by interposing a sheet of ground glass between the light and the condenser, as near the latter as possible. Other methods of lighting the negative are sometimes adopted, but in practice they are far from satisfactory. The diameter of the condensing lens must be fully equal to the diagonal of the plate that is being used — for example, 5¼ in. or 5½ in. for a quarter-plate; but there is no advantage in any size in excess of this. The usual arrangement is to enclose the light in an iron casing, one end of which holds the condenser. By this method the light is excluded from the room, so that the paper can be handled freely, and the enlargements developed without any risk of fogging, excepting when an exposure is being made. As close to the condenser as possible there is a carrier for holding the negative; this carrier forms the back of a camera body, the opposite end holding the lens for projecting the image. Beyond the lens an easel or board is required for holding the sensitive paper, and, as the distance between this board and the lens, and between the lens and the negative, must be varied according to the degree of enlargement, a method of extending the camera body, and one for sliding the easel, have to be provided. The easel should slide on guides, as it is imperative that it should be quite parallel with the negative. The arrangement will be more easily understood from the illustration, in which G is an incandescent gaslight, C the condenser, N the negative, L the lens, and P the paper on which the image is received.

The exposure will depend on the negative, the paper, and the degree of enlargement. In enlarging from quarter to whole-plate by incandescent gas, with lens aperture $f/8$, the exposure will vary from ten seconds for a thin negative up to forty for a strong one, using a commercial bromide paper. A test exposure on a small piece of paper should always be made before making the enlarged print. The test piece should include the strongest part of the negative.

Any negative that will give a good contact print on bromide paper will yield a good enlargement by incandescent gaslight with a condensing lens for concentrating the light.

ENLARGING BY DAYLIGHT

This method gives greater opportunity for varied methods of working to suit the conditions of different photographers than does enlarging by artificial light. The apparatus and the manner of using it may range from the simple and inexpensive fixed-focus enlarger up to a permanently arranged apparatus in which the darkroom itself forms the camera in which the enlargement is made. The general principle is illustrated in the article " Enlarging." It is the method of adapting that principle to the requirements of the worker that varies. The most simple is the fixed-focus enlarger, a piece of apparatus in the form of a double box, which allows one degree of enlargement only. This is an inherent disadvantage of a fixed-focus instrument, but it has the advantage of great convenience; it is ready for use at a moment's

notice, without any focusing or arranging. The negative is placed film downwards at N (*see* illustration A), the paper put in position at P; the apparatus taken out of doors, so that the light from the sky overhead falls directly on

A. Diagram of Fixed-focus Daylight Enlarger

the negative, and the exposure made by operating the shutter that closes the lens L. This apparatus gives enlargements of one uniform size only, this size varying with its construction and the size of the negatives for which it is intended.

A second form of apparatus is an enlarging camera (*which see*). Illustration B shows how the apparatus is used: N is the negative, L the lens, and P the sensitive paper.

A third arrangement is one that is frequently adopted by those who do much enlarging, and who wish to have a much larger range in size than that which can be obtained in an enlarging camera. The dark-room, or a room that can be darkened by closing the window with a specially-made shutter, becomes the enlarging camera. The camera in which the original negative was taken, and an enlarging easel, are

B. Diagram of Enlarging Camera

practically all the apparatus that is required. The window of the room is closed by a shutter (*see* illustration C), in which is a small opening a little larger than the negative. Outside the shutter a reflector of white card or a dull white

painted board is fixed so as to reflect the light from the sky through the negative. Inside the room the camera is supported on a table opposite the opening in the shutter. The negative N is placed in the camera back, film

C. Showing use of Reflector in Daylight Enlarging

towards the lens, and a focusing cloth wrapped round the camera back so as to prevent any light leaking into the room. On the table an easel holding the paper P is arranged to slide in guides, the image being projected by the lens L in the usual manner.

A difficulty in daylight enlarging is the ever varying character of the light. A test should always be made by a meter immediately before making an exposure. It is only by this method, and small test pieces as described in "Enlarging by Artificial Light," that correct exposures can be secured. Any negative that will give a good contact print on bromide paper will yield an equally satisfactory enlargement by daylight.

ENLARGING CAMERA (Fr., *Chambre d'agrandissement*; Ger., *Vergrösserungskamera*)

A camera for making enlarged photographs on bromide paper, or enlarged negatives, from smaller negatives or positives. It consists essentially of a carrier or holder for the negative, a dark-slide or frame for the bromide paper, and, between these, a support for the lens, the whole being covered in except the end at which the negative is placed. In a fixed-focus enlarging camera, of which A is a typical example, the distance between negative, lens, and dark-slide cannot be varied, and only one size of enlargement is possible; but in other forms of appara-

A. Fixed-focus Enlarging Camera

tus, as in B, there is provision for altering these distances to obtain enlargements of different sizes. The cameras just considered do not require the room to be darkened if used indoors; they may, if preferred, be used outdoors. The

non-portable enlarging camera, however, as generally used in trade establishments, is placed close against a window, from which all actinic light except that illuminating the negative is blocked out. With this form of enlarger an

B. Adjustable-focus Enlarging Camera

easel is usually employed instead of a dark-slide. Any ordinary camera may be used in this way if a suitable holder or carrier is made for the negative; or the negative may be placed in the dark-slide, this being inserted in the camera with both shutters drawn, to serve as a carrier. To obtain a uniform light, a white card or reflector is fixed outside the window at an angle of 45°. An alternative is to use a sheet of ground glass, or to paste white tissue paper over the opening which admits light; when this is done the negative should be a few inches distant from the opening instead of close against it. Various lamps are obtainable to fit behind the negative carrier of daylight enlargers, thus enabling them to be used by artificial light.

ENLARGING EASEL (*See* " Easel, Enlarging.")

ENLARGING LANTERN (Fr., *Lanterne d'agrandissement*; Ger., *Vergrösserungs-apparat*)

A lantern used in enlarging by artificial light, to project a magnified image of the negative on the bromide paper. It consists of a body carrying the illuminant, a condenser to concentrate the light on the negative and cause it to pass out from the latter in a converging cone, and a projecting lens or objective to receive the cone of light from the condenser and to form the enlarged image. A illustrates the optical system of the enlarging lantern, A being the illuminant, B the condenser, C the negative, D the objective, and E the projected image. The condenser must be

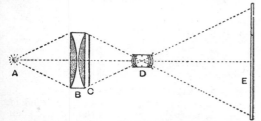

A. Optical System of Enlarging Lantern

of sufficient size to illuminate the whole of the negative, or part of the image will be cut off towards the margins of the enlargement; on the other hand, there is no advantage in having too large a condenser, but rather the reverse, as light is wasted. For a quarter-plate negative, a

5½-in. diameter condenser is required; for a half-plate, one of 8½ in. diameter; and for a whole-plate, one of 11 in. diameter. The condenser has nothing whatever to do with the size

B. Enlarging Lantern with Rack and Pinion Adjustments

of the enlargement; this depends, other things being equal, entirely on the distance of the bromide paper from the projecting lens or objective. The objective should be capable of covering the size of negative to be enlarged, and of sufficient diameter and aperture to pass the whole of the beam of light proceeding from the condenser. The lens used in making the nega-

C. Simple Enlarging Lantern

tive is usually suitable for enlarging, the best possible projection lens being probably a good anastigmat. There are numerous illuminants employed for enlarging, as oil, acetylene, incandescent gas, incandescent spirit, limelight, the electric arc, the Nernst lamp, etc. Of these, limelight and the electric arc are the most efficient with regard to illumination, owing to their approximating more nearly to a small

D. Lantern Body Attached to Camera

point of light; but from the point of view of general convenience and utility, incandescent gas is perhaps the favourite. The proper adjustment of the illuminant is of importance, or the enlargement will be unevenly lit. The

correct procedure is to place the negative in the carrier and to focus roughly to the required size, approximately centring the light and bringing it to that distance from the condenser which seems to give the best and most even illumination. The negative is then removed, and the illuminant moved back till a dark ring appears round the disc of light on the easel. The illuminant is now carefully centred till the ring is equal all round, and is then pushed toward the condenser

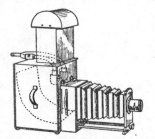

E. Ellipsoid Enlarging Lantern

till the ring disappears and a perfectly even lighting is secured, the negative being finally re-inserted and sharply focused. Any after alteration in the size of the enlargement will require a fresh adjustment of the illuminant.

B shows a typical high-class enlarging lantern which has rack and pinion adjustments throughout, including provision for moving the lantern body, the condenser, and the objective. The negative carrier is furnished with rising, falling, and swing movements, and a rise or fall is also permissible with the lens. C illustrates a cheaper enlarging lantern, of simple yet efficient construction ; while D represents a useful type dispensing with the extension bellows and projection lens, and intended to take an ordinary camera in front. In another form of enlarging lantern, known as the ellipsoid enlarger, no condenser is used, the negative being lit by reflected light from a curved opal reflector ; these enlargers are made either for use with the worker's own camera, or with a bellows and projection lens, as in E, where a pair of inverted incandescent gas burners form the illuminant.

ENLARGING NEGATIVES

In order to make a large negative from a small one, two operations are necessary. A transparent positive must be made from the original negative, and from that a new negative can be made by enlarging to any desired size. The character of the transparent positive is of the greatest importance in determining the character and quality of the new negative. The extreme shadows or densest parts should be moderately strong, but such an exposure should be given that the highest light is veiled. No part should be quite clear, and the transparency should be dull rather than brilliant. The best method for making the transparency is by contact printing by artificial light on a rapid plate, thus securing the truest reproduction of the gradation of the original. For the same reason—the desirability of reproducing all the gradations as correctly as possible—the enlarged negative should partake of the same character ; the deepest shadow

should be veiled, otherwise there will be a distinct loss of tone values. The method of working is given under " Enlarging by Daylight " and " Enlarging by Artificial Light," excepting that the transparent positive is placed in the position there described for the negative and a plate in the position given for the sensitive paper. Backed plates should be used for making the transparency and the enlarged negative, and the film side should be towards the lens in each case. Film towards film is the rule, as in printing. An exception to this is when a reversed negative is required for the carbon process. In that case the transparent positive is reversed in the carrier, the glass side being turned towards the lens.

Enlarged Paper Negatives.—Enlarged negatives may be made on bromide paper from lantern slides or other transparencies, the bromide paper after exposure being treated with a weak bichromate solution, as described under the heading " Sterry's Process," in order to obviate harsh results. By the W. Coats method, an enlargement is made on rapid smooth bromide paper, the exposure being short so as to keep the shadows clear ; amidol is used as the developer and the print is washed for two minutes ; the unfixed print is then toned in the following bath, in which it should remain for seven minutes, at least :—

A.	Pot. ferricyanide	.	40 grs.	8 g.	
	Glacial acetic acid	.	½ oz.	50 ccs	
	Water .	.	. 10 ,,	1,000 ,,	
B.	Uranium nitrate	.	40 grs.	8 g.	
	Glacial acetic acid	.	½ oz.	50 ccs.	
	Water .	.	. 10 ,,	1,000 ,,	

Take equal parts of each just before use. The solutions keep well separate, but not when mixed. When toning is complete, the print is well washed and immersed for one minute in a solution of 20 grs. (4 g.) of ammonium sulphocyanide in 20 oz. (1,000 ccs.) of water. The print is washed again for two minutes and then exposed to 4½ in. of magnesium ribbon burning at a distance of 12 in. from it. The print is next rinsed and redeveloped in the original amidol developer, fixed in " hypo," and washed. A metol-hydroquinone developer has been suggested in place of the amidol.

An important point which must not be overlooked in all enlarging processes is the increase in contrast in the resultant print or plate. This is caused by the scattering of the light by the silver grains of the negative, which practically act as points from which the light spreads or scatters out in fan-shaped bundles, and therefore does not reach the lens. This may be overcome by placing the negative film side next to a sheet of fine matt opal glass.

ENLARGING ON PAPER

The most simple and satisfactory method of enlarging is to produce an enlarged print on paper direct from the original negative. It is not only the most simple method, but it ensures the truest reproduction of the gradation and quality of the negative. There is only one printing medium sufficiently rapid for direct enlarging—at least, by artificial light—and that is paper coated with a silver bromide emulsion. (*See* " Bromide Paper.") Enlarged prints pro-

duced on this paper are in every respect equal to contact prints from the same negative, and the development, fixing, and after processes are precisely similar. The only difference is in the methods of obtaining the print. These are given under " Enlarging by Artificial Light " and " Enlarging by Daylight."

ENLARGING BY STRIPPING

A process of stripping a film from an ordinary unvarnished negative, enlarging it, and attaching it to a larger glass ; the process dates from 1882. The following enlarging mixture is required :—

Hydrofluoric acid	.	1 drm.	31	ccs.
Citric acid	. .	½ oz.	125	,,
Glycerine .	. .	1 drm.	31	,,
Acetic acid	. .	½ oz.	125	,,
Water	. . .	4 ,,	1,000	,,

The hydrofluoric acid needs careful handling. The negative is placed in the solution and the film will gradually become released from the glass and at the same time be enlarged. If necessary, the film can be assisted to leave the glass by means of a camel-hair brush. It is next carefully rinsed in water and floated upon, and squeegeed into contact with, a cleaned glass of the required size. In this way a quarter plate may be expanded to fill a half plate, and larger sizes in proportion. When in contact with the new and larger glass it must be allowed to dry naturally. As may be expected, films enlarged in this manner give slightly thinner results, and a rather dense original is therefore advisable. Films may be stripped from negatives without any enlargement. (See under the heading, " Film Stripping.") The older the negative the more difficult it is to strip and enlarge.

ENSEMBLE (Fr.)

The arranging or grouping of several figures or of the constituent parts of a picture.

ENVELOPE SYSTEM (See " Daylight Changing.")

EOSINE (Fr., Eosine ; Ger., Eosin)

Synonym, yellowish eosin or eosine. $C_6 H_4$ $(CO C_6 H Br_2 OK)_2 O$. Molecular weight, 708. Soluble in water, alcohol, and ether. It usually occurs as a red powder. The sensitising power of eosine lies between E and D in the green and yellow green, but does not reach the D line.

METHYLERYTHRINE is the methylic ether and primrose, or erythrine is the ethylic ether of tetrabromofluoresceïn.

The eosines are a somewhat large class of dyes known generally as the phthaleïn group, and derived from triphenylmethane. The first dye of this group is :—

FLUORESCEÏN (Fr., Fluorescine ; Ger, Fluoresceïn)

Solubilities, insoluble in water, soluble in alcohol. A brick red powder of little photographic interest except as the starting-point of other dyes. Its sodium salt is called :—

URANIN (Fr., Uranine ; Ger., Uranin)

$C_{20} H_{10} O_5 Na_2$. Solubilities, soluble in water, alcohol, and ether. A brownish red powder which is sometimes used for making yellow screens or dark-room filters.

Assuming the formula for fluoresceïn to be $C_6 H_4 (CO C_6 H_3 OH)_2 O$, the hydrogen atoms of the resorcinol group in brackets can be replaced by the halogens chlorine Cl, bromine Br, and iodine I. and according to the number of substitutions there are formed monobromofluoresceïn, dibromofluoresceïn, known as eosine extra yellow, and tetrabromofluoresceïn yellowish eosin ; these are used for sensitising collodion emulsion for yellow-green ; and the monobromofluoresceïn is an excellent green sensitiser. Their action on gelatine plates is less satisfactory than that of erythrosine. All these dyes have a greenish fluorescence in solution, and form salts when mixed with silver nitrate which are practically insoluble in water.

In process work, eosine is often used for dyeing the fish-glue image in the enameline process ; but methyl violet is more commonly employed, and is preferred because it shows up the image in greater contrast.

EPHEMERAL PHOTOGRAPH

A kind of phosphorescent photograph, produced by one of the many processes introduced by the late W. B. Woodbury. Largely quoting from his own words, the process is simple, and the same piece of sensitised paper may be used over and over again, while at the same time always retaining its sensibility. The material is the phosphorescent powder, calcium sulphide, obtained by calcining oyster-shells and treating with sulphur. A sheet of paper is coated with this by covering with gum or varnish, and dusting the powder over it. If this paper is exposed for a few seconds to light under a positive transparency and then removed to a dark-room, a luminous positive will be seen, lasting a longer or shorter time, according to the exposure given. Woodbury also produced luminous portraits and views by the dusting-on process, substituting the powder named for plumbago. (See also " Luminous Photographs.")

EPSOM SALTS

The common name for magnesium sulphate, which has been advocated as a preventive of frilling ; the dry plate previous to development is soaked in a saturated solution of the salts. Also, a saturated solution of the salts made with beer and a little gum water is used for "frosting" studio and other plain glass windows.

EQUIVALENT FOCUS (See " Focal Length.")

ERYTHROSINE (Fr., Érythrosine ; Ger., Erythrosin)

Synonyms, erythrosin, bluish eosin, iodoeosin. $C_6 H_4 (COC_6 HI_2 ONa)_2 O$. Molecular weight, 660. Soluble in water, alcohol and ether. It is a bluish red powder which, when pure, gives no fluorescence in aqueous solution, and but slight fluorescence in alcoholic. It forms an insoluble silver salt erythrosinate, or tetraiodofluorescinate of silver, which is used with collodion emulsion for colour sensitising. Erythrosine is the most energetic yellow-green and yellow sensitiser for gelatine emulsions, its action extending from E to beyond D ; it leaves, however, a characteristic minimum or lack of sensitiveness in the blue-green between b and F. It may be added

to the emulsion at the time of mixing, in which case 0·2 per cent. should be added to the bromised gelatine before adding the silver nitrate, or it may be added the last thing before coating, or it may be applied in the form of a bath to the finished and dried plate ; this method gives the greatest colour-sensitising effect. The plate should be soaked for two minutes in :—

Liquor ammoniæ	.	96 mins.	10 ccs.
Distilled water to	.	20 oz.	1,000 ,,

drained and immersed in—

Erythrosine	.	·96 grs.	1 g.
Liquor ammoniæ	.	192 mins.	20 ccs.
Distilled water to	.	20 oz.	1,000 ,,

and then well dried in the dark. A considerable saving of time is effected in the drying if one third of the quantity of water in the above formula be replaced by alcohol or acetone.

Erythrosine M is the sodium or potassium salt of tetrabromofluoresceïn as above ; erythrosine G is a similar salt of diiodofluoresceïn.

ESSENCE OF JARGONELLE (See " Amyl Acetate.")

ETCHING (Fr., *Morsure ;* Ger., *Aetzung*)

The incision of metals by means of acids or other corrosive fluids, as distinguished from engraving, which implies incision by cutting with a graver. Etching may be of two kinds : (1) The older form consists in spreading an acid-resisting coating, or " ground," on the metal plate and scratching through it by means of sharp points so as to lay bare the metal. This is the process used by artist etchers, from Rembrandt down to the present-day workers. (2) The other and more modern method, in which photographic processes play so large a part, consists in forming an image on the plate in ink, varnish, or other suitable acid-resisting medium, and then etching away the bare parts of the metal. The image may be applied by drawing direct on the plate, by transfer from a greasy ink image on paper, or by photography with a sensitive film. The last-mentioned method, now by far the most common, is called photo-etching. The methods of forming the image on the metal are treated under various headings—for example, " Albumen Process," " Fish-glue Process," " Enameline," " Bitumen," etc.—and the etching inks, solutions, metals, etc., are also separately described. Etching may be either in relief or intaglio, the former being necessary for typographic printing and the latter for copper and steel plate printing. There are two divisions—line etching, which reproduces lines, stipples, and solid patches of colour ; and half-tone etching, which interprets the tones of a photograph or painting by means of a dot system. Colour etching is merely an extension of one or other of these processes.

Photogravure etching (*which see*) is different in principle. In ordinary etching the sunk lines, or spaces between the lines, are practically of uniform depth, but in photogravure etching the depth is proportionate to the tones, the shadows being sunk the deepest into the plate.

ETCHING BATHS

This term is applied to the etching solutions and also to the troughs and trays used for holding them. To prevent confusion, the vessels themselves are treated in the present article, the solutions being described separately in the article headed " Etching Solutions." The baths are of wood, lined with pitch or gutta percha ; of slate ; or of earthenware ; and they are generally mounted on rockers, so that the solution may be washed to and fro over the plate. The ends are covered to prevent the splashing of the acid out of the trough. In large shops the troughs are mounted on a rocking machine driven by motor and worm gearing, this ensuring more uniform etching.

ETCHING INK

There are numerous formulæ for etching inks, these varying according to the particular branch or process of etching for which they are required. In America the term is limited to the ink used for rolling up the albumen bichromate print after exposure as a preliminary to development. Excellent commercial inks are obtainable, so that it does not pay to make one's own ink, but it may be useful to know that such an ink usually consists of beeswax, soap, shellac, lithographic ink, lithographic varnish, and similar ingredients well mixed together. Etching ink, as usually understood by English workers, may also mean " starting ink," or soft etching ink, and " finishing ink," or hard etching ink. These inks can also be purchased ready-prepared. The former consists of such ingredients as Russian tallow, yellow beeswax, asphaltum, lithographic or letterpress printing ink, and thin lithographic varnish. The object of this resist is to form a covering for the shoulders of the lines by running down the sides when the plate is heated. It is usually applied by inking the surface with a lithographic leather nap roller. The " finishing ink " consists of beeswax, resin, asphaltum, and lithographic printing ink. It is necessary to warm the plate in order to get the ink to " take," and it is applied by means of a lithographic glazed leather roller.

ETCHING MACHINES

Since about 1895 etching machines have come much into vogue in photo-engraving establishments. The earliest machine of the kind to be brought into commercial use is the Levy Acid Blast. (*See* "Acid Blast.") The Axel etching machine, invented by Axel Holmström, has a paddle-wheel working in the bottom of the etching trough and throwing the acid against the plate, which is placed almost vertically against the side of the trough. The Mark Smith machine is similar in principle, but the plate is placed horizontally over the etching trough, and remains stationary. The Albert etching machine consists of a horizontal trough which has a slow reciprocating motion. The plate is laid face up on a platform at the bottom of the trough. This platform is lifted out of the solution when the lid is raised. This lid has on its underside a series of ribs or vanes, and it is given a rapid reciprocating motion when laid down over the plate, so that the acid is put into a state of violent agitation, causing the plate to be etched more rapidly than it would be in a rocking trough. The " Holt " etching machine has a trough and a lifting plat-

form similar to the Albert machine, but the solution is agitated by means of a rotating disc, on the underside of which are vanes for churning up the solution. The "Danesi" machine rains the acid down on the plate from a trough above, into which the acid is pumped from the etching trough below.

Various other forms of etching machines have been proposed and patented, but the foregoing have come into regular use.

ETCHING METALS

The metals used for etching are generally zinc, copper, brass, and steel. Zinc is mostly used for line work, copper for half-tone and photogravure, brass for half-tone and for bookbinders' blocking plates, and steel for die printing. Carefully smelted and rolled metal is used, and the sheets are highly planished and polished. For line and half-tone the plates are usually from 14 to 16 B.W.G. (·083 in. to ·065 in.) in thickness, and the metal is purchased ready for use.

ETCHING SOLUTIONS

For zinc etching nitric acid is invariably used, the strength varying from 1 to 20 per cent. according to the stage of the etching and the nature of the work. The bath has to be constantly rocked whilst the plate is being etched. A "still" etching solution, which does not require rocking, consists of :—

Nitric acid	.	.	. 130 parts
Water	.	.	. 100 ,,
Sal ammoniac	.	.	. 20 ,,
Pyroligneous acid (wood vinegar) 20 ,,

The bath should stand two or three weeks after mixing. Another bath for zinc which need not be rocked is :—

Sulphuric acid .	.	.	6 parts
Potassium nitrate	.	.	2 ,,
Water	.	.	. 20 ,,

Dissolve the potassium nitrate in water, and then gradually add the acid. Dilute with water till bubbling ceases.

For etching an enamel film without "burning-in" the image, the following bath is recommended :—

Alcohol (40%)	.	.	400 parts
Nitric acid	.	.	. 5 to 7 ,,

For half-tone copper etching, iron perchloride is dissolved in water until the solution registers from 35° to 40° on the Beaumé hydrometer (up to 1·36 sp. gr.). About 1½ lb. perchloride to 1 pint of water will bring the solution to the required strength. The solution is improved for immediate use by adding ½ pint of an old bath to every quart of new. Rocking the bath makes the etching proceed more quickly. Heat also aids the etching. Sometimes the plate is etched face downwards, held in a clamp.

Brass is also etched with perchloride of iron at 35° Beaumé.

Steel can be etched with ferric perchloride at 40° Beaumé, or with a strong solution of chromic acid, or with acetic acid five parts, fuming nitric acid one part, diluted as may be necessary with distilled water.

The term "etching solution" is also applied to the solution of glycerine, with other ingredients, such as liquor ammoniæ, calcium nitrate, sodium chloride, etc., used for damping the collotype plate. Again, "etching" is applied to the operation of spreading over the lithographic stone or zinc or aluminium plate a slightly acid gum solution, which prepares the surface for clean inking and printing, though it does not actually etch into perceptible relief. Such etching solutions for zinc contain a decoction of nutgalls and phosphoric acid, and for aluminium phosphoric or hydrofluosilicic and other acids.

ETHER (Fr., *Éther sulfurique* ; Ger., *Aether*)

Synonyms, ethyl oxide, ethylic ether, sulphuric ether. $C_2H_5OC_2H_5$. Molecular weight, 74. Solubilities, 1 in 12 water ; miscible in all proportions with alcohol, chloroform, benzole, etc. It is a limpid, very light, and volatile transparent liquid with characteristic odour and burning, sweet taste. It is made by distillation from sulphuric acid and alcohol. The vapour being very heavy and inflammable, ether should be kept in a well-stoppered bottle in a cool place. In large quantities it and its vapour are poisonous, the antidotes being an emetic or the use of a stomach pump, free supply of fresh air, ammonia, and artificial respiration. It may be prepared from either ethyl or methyl alcohol, the latter giving the so-called methylated ether which can be used for all photographic purposes. The specific gravity should be ·720. It is used for making collodion and varnishes.

In process work, ether is largely used for making collodion and collodion emulsion, the kind usually employed being methylated ether, sp. gr. ·720, washed and redistilled. It is also used for washing bitumen to increase its sensitiveness, and with alcohol as a solvent for bitumen in a process for graining the plate by reticulation of the film.

ETHOXY LIMELIGHT

Limelight produced by raising a spot on a cylinder of lime to a state of incandescence by means of a non-luminous flame of mixed ether vapour and oxygen. The mixture is prepared in a saturator (*which see*). Oxyhydrogen is a corresponding term indicating that a mixture of hydrogen and oxygen is burnt.

ETHYL ALCOHOL (See "Alcohol.")

ETHYL OXIDE (See "Ether.")

ETHYLIC ETHER (See "Ether.")

EURYSCOPE

Under this name Voigtländer and other opticians have issued lenses of the rapid rectilinear type, of intensities varying from $f/4·5$ to $f/7$. Similar lenses were issued by Ross as "Universal Symmetricals" and by Dallmeyer as "Extra Rapid Rectilinears." The rectilinear portrait lens of the latter maker was really a euryscope with an aperture of $f/3$. Slower forms of euryscope for wide-angle work, copying, etc., have also been made. Their greatest intensity varies from $f/9$ to $f/15$.

EVAPORATING DISH

In wet collodion photography this is a most important utensil for evaporating the silver bath when it has become deteriorated by use or by impurities. Usually the silver bath is boiled to evaporate about half the volume of solution, and then made up to strength again with distilled water and additional silver nitrate. Any alcohol and ether is thus driven off, and the iodising salts dissolved out of the collodion film are reduced in proportion to the volume of

Porcelain Evaporating Dish

the new solution. Amongst English and Continental workers the common laboratory form of porcelain basin is used, the bottom, outside, to which the greatest heat is applied, being left unglazed. It is best to embed the basin in a sand bath to avoid fracture by the application of direct heat. In America stamped enamelled iron dishes, called Agate ware, are largely used without any apparent drawback, and of late many English workers have taken to using cast-iron enamelled dishes. A good way of testing for faults in the enamel is to fill the enamelled vessel with copper sulphate. The acid will attack the iron wherever it can reach it through the small pores, and little beads of copper are deposited in small spots, gradually increasing in size until they become plainly visible. Such dishes are obviously unsuitable.

EVERSET SHUTTER (Fr., *Obturateur toujours armé, Obturateur automatique ;* Ger., *Selbstthätiger Verschluss*)

Any shutter that does not require setting before an exposure can be made. An everset shutter is an obvious advantage, since an unexpected opportunity of photographing a moving object might be lost even in the short time occupied in setting the shutter.

EXCITING

The old and practically obsolete name for sensitising.

EXPANSION OF PAPER (*See* "Paper.")

EXPANSION, REDUCING DENSITY BY (*See* "Reduction, Mechanical.")

EXPLOSIVE POWDER (*See* "Flashlight Powders.")

EXPOSING, METHODS OF

The usual methods of exposing dry plates in a camera are by means of a cap or shutter. The cap method was the original one, and although it is considered old-fashioned it still has advantages. In landscape work the cap may be made to serve as a lens shade by holding it above the front of the lens during exposure. The correct way to uncap a lens is to imagine

that it is hinged to the top of the lens hood. The cap is loosened by twisting and the lower edge raised until it is clear of the lens, and replaced again when exposure is finished ; in this way the cap not only serves as a lens shade, but, by raising and lowering at a suitable speed, one can give more exposure to the foreground than the sky, and at times obtain clouds on the negative which would be missing on account of over exposure if the sky had the same amount of exposure as the landscape.

By the judicious use of a cap one may picture a busy street as being empty, and such a method is sometimes handy when one desires a photograph of a building in a busy street without showing the traffic. The lens in such a case is stopped down to its very smallest extent, the smaller the better, so as to require a very long exposure, the longer the better ; exposure is then made by a series of very brief exposures with a cap. Assuming, for example, that an exposure of one minute is considered to be necessary, the plate is exposed for two seconds and the cap carefully replaced, another two seconds is given, and so on until the plate is considered to be fully exposed. The brief exposures will not be enough to picture moving objects, and only those which have remained still during the greater part of the minute will show when the plate is developed.

Shutter exposures are invaluable in cases of portraiture, and of course absolutely necessary for instantaneous work, as the quickest " off and on " cap exposure possible is estimated to be one-fifth of a second, but in the majority of cases it is nearer half, or even a whole, second. Silent-working shutters, preferably those which work inside the camera, are the best for portraiture, as those which work noisily and outside the camera are apt to startle the sitter, or otherwise attract attention at the wrong time. Children, for example, when posed in a position looking away from the camera, will often turn their heads when hearing the click of the shutter. When exposing for portraits and giving a time exposure with a roller blind shutter, it is a good plan to pull the cord gently so as to raise the blind and to release it before it reaches the half-way click, at which it remains open ; the spring will pull the blind down again if the click is not passed, and in this way an absolutely silent exposure may be made. For exposures for self-portraiture, printing, enlarging, etc., see under those headings, and also " Exposure Tables."

EXPOSURE

It is scarcely necessary to emphasise the great importance of correct exposure in negative making ; but it may be remarked that when the plate has been correctly exposed, all subsequent work is comparatively simple and straightforward, whereas with an incorrectly exposed plate all the subsequent operations are difficult and unsatisfactory, and the production of a good print is sometimes impossible.

The correct exposure of a plate depends on four varying factors : the subject ; the light, which varies according to the season, the time of day, and the weather ; the speed of the plate ; and the " rapidity," or working aperture, of the lens.

In the earlier photographic days no attempt was made to work systematically from these four varying factors, but exposures were largely the result of guess-work. About 1880 the first attempts were made to systematise the data from which exposures were calculated, Dr. Scott's table of light values, and W. K. Burton's table of comparative exposures for different subjects being among the earliest examples of their kind. Dr. Scott determined the fact that the value of daylight varied in direct proportion to the height of the sun above the horizon. Consequently, in equally clear weather, exposures would require to be nearly four times as long in the middle of December as in June ; and also at six o'clock in June exposures would be three times as long as at mid-day. Dr. Scott published a table, about 1883, giving proportionate figures for each hour of the day for the middle of each month. Although these figures were necessarily incomplete, the interval from one month to the next being much too long, this table proved to be of valuable assistance for many years.

Burton's tables provided a series of comparative exposures for different subjects—landscapes, marine pictures, interiors, and portraits—under normal conditions. It gave the exposures under the best possible conditions, and these had to be multiplied by the figures given in Dr. Scott's table for all times excepting mid-day in June. (*See also* " Exposure Tables.")

The most modern method of determining the duration of an exposure is by means of a meter. (*See* " Exposure Meter.")

In process work, and colour work, the lengthening of exposure due to prisms, mirrors, colour filters, or ruled screens becomes an important consideration. The larger the prism the more light is absorbed. With a 3-in. prism the exposure in the case of wet collodion work and enclosed electric arc light is increased by about $2\frac{1}{4}$ times ; but this would not be true, for example, with an orthochromatic plate and green filter. Mirrors when in best condition do not greatly affect the exposure, but they will do so as they become tarnished and scratched. The ratio of exposures for colour filters should be determined by photographing black, white, and a scale of neutral greys, which should come alike on all three negatives. Ruled screens increase the exposure by about one-fifth, and as small stops are used the exposure will be much longer than in ordinary negative making, though proportionately the same. The nature of the " copy " (the original) influences the exposure in half-tone work. A deep red toned print will require the longest exposure.

EXPOSURE, EFFECT OF TEMPERATURE ON (*See* " Desiccated Dry Plates.")

EXPOSURE, INCORRECT

Correct exposure is the basis of all successful work in photography. But in some subjects, especially those with moving objects or very dark interiors, it may be impossible to expose sufficiently long ; and occasionally errors of judgment may lead to both under- and over-exposed plates.

Incorrectly exposed plates can always be more successfully treated if the error is known before development is begun than if it is only recognised when the operation has made considerable progress. Under-exposure is the more difficult to treat, as there is insufficient light-action. If the subject is one that is deficient in contrast, or exposed in a dull light, the best method is prolonged development either in a normal solution, or in one containing the normal amount of developing reagent and excess of alkali. If the subject is strong in its contrasts of light and shade, prolonged treatment in a normal solution considerably diluted, or in a diluted solution with extra alkali added, is the only satisfactory method. The diluted solution lessens contrasts considerably ; and it allows prolonged development without obtaining much strength in the light tones. Detail is obtained without density, and greater softness results than can be obtained by any other method. If the resultant negative is still too harsh, the methods given under the headings " Hard Negatives," " Harmonising Contrasts," etc., must be adopted.

Over-exposure within moderate limits comes within the latitude of the plate (*see* " Latitude in Plates "), and requires no special treatment, provided that the subject is one of good contrast of light and shade. If a plate has received an exposure from one and a-half times to twice the normal amount, development may be normal ; and though the plate will look very strong, and different from one that has been correctly exposed, the resultant print will be little, if any, inferior to that yielded by a normally exposed plate. The time of printing will be much longer, and that will be the only difference. In moderate over-exposure in subjects deficient in contrast, for copying, etc., the only efficient means of correcting over-exposure in development is by treating it throughout by a modified solution. Potassium bromide may be added to a normal developer in any quantity up to 2 grs. to each 1 oz. of solution ; or a more concentrated developer may be employed, and 3 grs. or 4 grs. of bromide added to each 1 oz.

Another method of working is to develop either with a normal or a concentrated solution until the extreme shadows begin to veil ; then stop development and fix the plate, afterwards intensifying to bring it to full printing strength.

EXPOSURE INDICATOR (Fr., *Marquer automatique, Compteur, Enregistreur ;* Ger., *Zählvorzichtung, Plattenzähler*)

A mechanical contrivance fitted to magazine cameras to indicate the number of plates that have been exposed. Usually, the number of the plate in position for the next exposure is made to show at a small opening, directly the previously exposed plate is moved out of the way by the changing arrangement. One pattern has the numbers of the plates engraved on a metal wheel inside the camera, which is moved round one step by the action of the changing lever or handle, each time this is worked. There are other patterns.

EXPOSURE METER (Fr., *Photomètre, Lucimètre, Actinomètre ;* Ger., *Expositionsmesser, Belichtungsmesser, Aktinometer*)

An instrument for ascertaining the necessary duration of exposure when taking a photograph.

The terms "exposure meter" and "actinometer" are often used interchangeably, but the latter refers to an appliance for simply testing the actinic power of light, whereas the former means an instrument that not only does this, but indicates also the exposure requisite under such conditions, with any given subject. While an exposure meter may be an actinometer, an actinometer is not an exposure meter. The term actinometer now tends to be restricted to appliances used for finding the light value when printing, as in the carbon and similar processes, where no visible image is at first obtained.

Of the many different kinds of exposure meters proposed the best are those that provide for an actual test of the light intensity; among these may be mentioned the Watkins and the Wynne

A. Watkins' Standard Exposure Meter

devices. The Watkins Standard Exposure Meter A has an enclosed chain pendulum for counting seconds or half-seconds, the cap or lid shown on the left forming, when removed, the weight of the pendulum. At the opposite end is an opening under which runs a coil of sensitive paper, which may be pulled out through a slot as required, in order to expose a fresh portion under the aperture. To use the meter, a new piece of paper is brought into position and quickly covered with the thumb, pointing the meter towards the source of the light that falls on the object to be photographed. The pendulum is then started swinging, and the finger

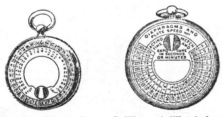

B. Watkins' Watch-form C. Wynne's Watch-form
Exposure Meter Exposure Meter

at the same time removed from the test paper. The number of seconds taken by the paper to darken to the depth of the standard tint, as painted in the circle beside the opening, is now carefully counted. The pointer P is then set against the plate speed number, the pointer D to the diaphragm number, and the pointer A to the actinometer time just obtained, when the correct exposure will be indicated by the pointer E. When the light is weak, or with specially dark subjects, the exposure of the camera and the meter may be carried out simultaneously, a second tint being provided, which the sensitive paper takes only one-quarter the time to match. This instrument is very complete, and permits

of special calculations for other than ordinary subjects, such as enlarging, copying, etc.

A simpler form of the Watkins meter B resembles a watch. Fresh paper is adjusted under the opening by rotating the back of the case, and the diaphragm number on the inner ring is set against the plate speed; the required exposure will then be found against the actinometer time.

Wynne's "Infallible Exposure Meter" C also resembles a watch. A small disc of yellow glass (not shown in the illustration) is cemented to the revolving dial to cover the sensitive paper until it is wanted. It is thus possible to see to adjust fresh paper under the aperture without its being prematurely exposed to light, and to have it always ready by merely sliding aside the yellow disc. The Wynne meter has the valuable feature of showing at once the necessary exposure with all the different stops. A table is supplied with the meter assigning to the various makes of plates a speed number, which represents also a diaphragm number. To use the meter, the actinometer time on the inner ring, as found with the sensitive paper, is set against the plate speed on the outer circle. Against each of the diaphragm numbers on the latter will then be indicated the correct exposure. Obviously, if a stop corresponding with the plate speed number is used, the exposure will be identical with the actinometer time, and the camera and meter may be exposed simultaneously.

EXPOSURE NOTEBOOK (Fr., *Registre des expositions*; Ger., *Expositionsbuch*)

A notebook specially ruled for entering full particulars of each exposure made, for the after identification of the different negatives, or in order that any particular plate may receive individual treatment. Spaces are usually provided for details of subject, date, time, light, plate, number of slide, lens, stop, exposure, etc.

EXPOSURE, OVER- (*See* "Exposure, Incorrect.")

EXPOSURE TABLES

Tabulated series of comparative exposures for different subjects, variations in the actinic value of the light due to the season, and the different lens apertures and plates. They materially assist experienced workers when attempting unusual subjects; to the inexperienced they are extremely valuable, rendering the problem of exposure comparatively easy.

Of the many tables that have been produced, attention will here be directed to the series designed by Henry W. Bennett, these comprising a table of comparative exposures for different subjects, and a diagram and table of the variation in the value of the light due to the season of the year and the time of day.

Exposures for lens aperture f/16, plate 200 Hurter and Driffield, and the best possible conditions of light, etc., at mid-day in June:—

TABLE I

Open-air Subjects								*Second*
Clouds	$\frac{1}{16}$
Boats at sea, distant	$\frac{1}{32}$

Second

Boats at sea, near 1/20
Sea beach, waves, etc. 1/15
Landscapes :—
 Open common ; or open subject with no strong objects 1/15
 Average landscape : cottages or trees in prominent position . . . 1/8
 Trees in full leaf near camera . . 1/4
 Trees in full leaf very near ; part of trees only included in picture . 1/2
 Woods : photographs taken under strong foliage 1 to 5
Buildings :—
 Large buildings, general views . . 1/12
 Cottages, small buildings . . . 1/8
 Street scenes 1/8
 Narrow streets 1/4
 Details of buildings . . . 1/8 to 1/4
Portraits :—
 Group or full-length figure . . . 1/2
 Head and bust 1
Still-life, flowers, etc., full-size . 2 to 8
Larger objects, according to distance . 1/4 to 1/2

Interior Subjects

Cathedrals and churches :—
 Nave or general view . 45 sec. to 2 min.
 Aisles, white glass windows. . 1 to 3 min.
 Aisles, stained-glass windows . 2 to 7 min.
 Choir 4 to 15 min.
 Crypt 10 to 60 min.
Ordinary rooms in modern houses . 1 to 3 min.
Workshops . . . 30 sec. to 1 min.
Rooms or workshops with skylights 10 to 20 sec.
Portraits in well-lighted room . 10 to 25 sec.
Still-life, flowers, etc., full-size, near window . . . 10 sec. to 1 min.

All the above times are sufficient to secure a fully-exposed plate. The boats at sea described as "near" are those that nearly fill the plate; those called "distant" are small in relation to the size of the picture. In the landscape subjects described as "open common," etc., are included all those that have no object with any depth of shadow within one hundred feet. Small bushes, lower than the camera, can be disregarded, as the camera, in looking downward, photographs them from above, the direction in which the light reaches them. In all landscape work, heavy foliage will require a longer exposure than

TABLE II

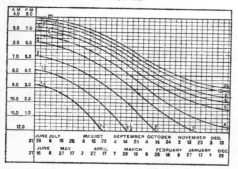

any other subjects at the same distance, on account of its colour and strong deep shadows.

In all the interior subjects, a range of exposure is given. The shorter is for a well-lighted subject with large and unobstructed windows,

the longer for one that is comparatively dark, with small windows or those seriously obstructed by outside objects. Dark woodwork in churches, especially if near the camera, will always necessitate a longer exposure than if the subject consists of light-coloured stone. In domestic interiors, the same principle regarding windows applies equally ; and the colour of the walls and the furniture will also affect the exposure. In the case of an unfurnished room, the exposure may be reduced to half that given in the tables. The exposure for flowers and still-life subjects will be influenced by the colour, the degree of contrast, and also by the manner in which the light from the window falls on it.

These exposures, being correct for the best possible light in June, must be multiplied by the figures obtained from the graph (called "Table II."), in which the thicker horizontal lines represent the hours and the fine horizontal lines quarter-hours. The fine vertical lines correspond to intervals of five days for each division, the dates being given under every alternate line. It is practicable to read off the correct figure for any day, and for any time in the day. Each thick curved line has its multiplying figure shown on it. This figure is indicated for any date and time by the point at which these curved lines cross the horizontal and vertical :—

TABLE III

VALUE OF DAYLIGHT THROUGHOUT THE YEAR

a.m.	p.m.	May 31 to July 10	May 20 & July 20	May 5 & Aug. 5	Apr. 20 & Aug. 20	Apr. 5 & Sept. 5	Mar. 20 & Sept. 20	Mar. 5 & Oct. 5	Feb. 20 & Oct. 20	Feb. 5 & Nov. 5	Jan. 20 & Nov. 20	Jan. 5 to Dec. 5	a.m.	p.m.
12.0		1	1	1	1¼	1¼	1½	2	2½	2½	3	4	12.0	
11.0	1.0	1	1	1¼	1¼	1½	2	2½	3	3½	4	4½	11.0	1.0
10.0	2.0	1	1¼	1¼	1½	2	2	3	4	5	6		10.0	2.0
9.0	3.0	1¼	1¼	1½	2	2½	3	4	5	8	10	12	9.0	3.0
8.0	4.0	1½	1½	2	2½	3	4½	6	12				8.0	4.0
7.0	5.0	2	2	3	4	5	8	20					7.0	5.0
6.0	6.0	3	3	4	6	12							6.0	6.0
5.0	7.0	5	6	10	20								5.0	7.0
4.0	8.0	20											4.0	8.0

In Table III. it is only practicable to give multiplying figures for each hour and for every fifteenth day. The variations for intervening times and dates can be estimated. This daylight table disregards the effect of the weather. When the light shows any appreciable departure from the best for the time of year, the exposure should be multiplied by 2 ; if the weather is dull, multiply by 3 ; and if very dull or gloomy, by 4 or 5.

These exposures are for a plate having a speed of 200 H. and D. Most modern rapid plates are about this speed, but the makers give the rapidities in almost all cases. The exposure for other plates will be directly proportionate to their

rapidity; thus a plate 100 H. and D. will require twice the exposure of one having a speed of 200 H. and D.

These exposures are for $f/16$, a medium aperture. The relative exposures for other apertures are given in Table IV.

TABLE IV

Value of Diaphragm Apertures

$f/5\cdot6$	$f/8$	$f/11$	$f/16$	$f/22$	$f/32$	$f/45$	$f/64$
$\frac{1}{8}$	$\frac{1}{4}$	$\frac{1}{2}$	1	2	4	8	16

The exposure for any subject is first found from Table I.; this is multiplied by the time value from Table II. or III.; the result is multiplied by 2, 3, etc., if dull weather, and finally the total is multiplied by the stop value from Table IV. Otherwise expressed :—

Subject × Time value × Weather × Lens aperture
Table I. Table II. or III. Table IV.

The result being the exposure required

Two examples will render the method of working more easily understood. (1) For open country lane with cottages in the mid-distance, September 14, 2 p.m., a fine, clear day, stop $f/32$, plate 200 H. and D. :—

Subject	Time: Sep. 14 2 p.m.	Weather	Stop $f/32$	Exposure
$\frac{1}{8}$ sec. ×	2 ×	1 ×	4 =	1 sec.

(2) A cathedral aisle, well lighted by stained-glass windows, April 17, 10.30 a.m., slightly dull [2], lens aperture $f/22$, plate 200 H. and D. :—

Subject	Time: Ap. 17 10.30 a.m.	Weather	Stop $f/22$	Exposure
2 min. ×	$1\frac{1}{2}$ ×	2 ×	2 =	12 min.

Instead of using Table II. or III. and multiplying again for the weather, a meter may be substituted as a means of measuring the intensity of the light. The multiple of the unit time that is required for darkening the sensitive paper to match the standard tint is the figure to be used in multiplying the unit exposure obtained from Table I. The meter should always be held in a vertical position, facing the camera. As an example, the same data may be taken as in No. 1 illustrating working from Tables I. and II. A country lane with cottages, September 14, 2 p.m., stop $f/32$, plate 200 H. and D. Assume that a Wynne meter is used to test the light, the unit time for matching the painted tint being four seconds. It is held vertically, facing the camera, and the time required for matching the tint is eight seconds, twice the unit time.

Subject (Table I.)	Meter (units)	Stop $f/32$	Exposure
$\frac{1}{8}$ sec. ×	2 ×	4 =	1 sec.

A meter can be used in a very simple manner for determining the exposure of objects within twenty feet of the camera, by giving a definite proportion of the time that the paper takes to darken to the standard tint. The Wynne standard tint requires four seconds, the Watkins standard eight seconds, and the lighter of the two tints supplied with the Watkins Bee meter four seconds for matching with the sensitive

paper in the best possible light. Consequently, in the following table, different proportionate figures must be employed according to the meter used.

To use this table, which is very useful for still-life, flowers, portraits, animals, machinery, etc., the meter is held close to the subject in a vertical position, facing the camera. The actual time that the paper takes to match the standard tint is noted, and a definite proportion of this time is the correct exposure without regarding it as a multiple of the standard time. This proportion varies according to the distance of the subject from the camera.

TABLE V

The exposure will be the following proportion of the actual time that the meter paper requires to match the standard tint :—

Distance of subject from camera	Wynne and Watkins Bee light tint	Watkins standard tint
3 feet	one-half	one-fourth
5 ,,	one-fourth	one-eighth
10 ,,	one-eighth	one-sixteenth
20 ,,	one-sixteenth	one-thirty-second

These exposures are for $f/16$, and a plate 200 H. and D.

These exposures are for objects of medium colour; for very dark subjects the exposure should be doubled; for very light, it may be reduced to one-half.

Two examples will illustrate the method. A portrait, head and bust only, is being taken in a garden. The sitter is about five feet from the camera, and a Wynne meter, held close to the sitter and facing the camera, requires four seconds to match its standard tint. The exposure for $f/16$ and a plate 200 H. and D. will be one-fourth of this time = 1 second.

A small machine is being photographed in a workshop, the same plate and stop $f/32$ being employed, and the machine being about ten feet from the camera. The day is dull, the workshop not well lighted, and the meter, placed on the machine while the camera is being arranged and the image focused, requires fourteen minutes to match the standard tint. One-eighth of this time for ten feet distance, one minute and three-quarters, multiplied by 4 for $f/32$, gives 7 minutes as the exposure required.

EXPOSURE, UNDER- (*See* "Exposure, Incorrect.")

EXPRESSTYPIE

A process of making grained half-tone blocks, invented by Cronenberg. It consists in the use of a grained screen, placed in contact with a gelatine dry plate so as to make a grained negative. This is printed on to zinc or copper in the usual way. The grain is of a reticulated character resembling collotype.

EXTENSION, CAMERA (Fr., *Extension*; Ger., *Ausdehnung*)

The distance between lens and plate, or the length to which the bellows will rack out. (*See* "Double Extension" and "Camera.")

Also the name given to an accessory for lengthening this distance, when the bellows do not rack

out far enough for the special work in hand. There are many different kinds of camera extensions, or "adapters," for this purpose, some fitting on the front of the camera, others at the back.

EXTERIORS, PHOTOGRAPHING

The general technical considerations that have to be observed in photographing exterior views of buildings, etc., are given under the heading "Architectural Photography." There are, however, several special considerations which cannot apply in the same manner in interior work. Speaking generally, a long-focus, rather than a short-focus, lens should be employed. At times there are advantages in using a short-focus lens for a comprehensive view of a high building, but in small details or portions the longer focus is always preferable when practicable. Of course, there are many cases where limited space or other conditions render it impossible to use any other than a wide-angle lens. There is one respect in which a wide-angle lens assists the photographer to secure an effect that cannot be obtained by any other means. In photographing a high building from the near point of view necessitated by a wide-angle lens, the impression is conveyed of looking upwards in a manner that cannot be given by any photograph taken from a more distant point. The effect is realistic.

Whether photographing a complete building or a small portion or detail, an oblique view should practically always be taken. A square front view is like an architect's drawing; it is never satisfactory, as it fails to give a fair impression. An oblique view gives at once a good impression of the relief and the form of the building or detail. It conveys the impression of solidity, and not simply the outline of the front elevation. Sunshine is very effective, and very useful in giving relief as well as good effect. More especially is this the case with large subjects; small details are frequently more satisfactory in diffused light. Very fine effects can sometimes be obtained by taking a photograph when the sun is shining almost along the surface of the subject, very slightly in front. The long cast shadows from projecting details are strikingly effective. A liberal proportion of foreground should be included in any pictorial view of a building, or doorway, or similar detail. And where possible, a foreground with lines running obliquely into the picture should be chosen. It is the most simple and telling manner of conveying the impression of the space that exists between the object and the observer. As in interior work, the point of view, the lighting, and the general conditions should be chosen so as to show in the most effective manner the character, the quality, and the special features of the architecture photographed.

EXTRA-FOCAL DISTANCE, OR "E.F.D."

The distance between lens and object, and lens and image, *minus* the focal length of the lens. The greater E.F.D. equals focal length multiplied by ratio. The lesser E.F.D. equals focal length divided by ratio.

EYE LENS

The lens, or combination of lenses, of an eyepiece which receives the image from the field lens and conveys it to the eye, as explained under the heading "Eyepiece."

EYEPIECE (Fr., *Oculaire;* Ger., *Okular*)

The lens, or combination of lenses, which receives the image from the microscope objective and conveys it to the eye. The best known types of eyepieces are the Huyghenian, the Ramsden, and the Kellner.

The Huyghenian, which is the most popular, is a negative combination composed of two plano-convex lenses separated by the distance of half the sum of their foci. The lower lens of an eyepiece, that nearest the objective, is known as the field lens, and the other is the eye lens. A stop is placed between the field and eye lens at the principal focus of the latter.

The Ramsden, which is a positive and achromatic eyepiece, is a combination of two plano-convex lenses with their convex surfaces inwards. This form is especially useful for micrometric purposes. The Kellner eyepiece is now rarely used; it gives a very large field, but the definition is not equal to that of the Huyghenian. The eye lens is a combination of a biconvex (field lens) and a biconcave lens (eye lens).

The projection eyepiece, as its name implies, is designed exclusively for lantern and photographic work. The field lens of a projection eyepiece consists of a plano-convex lens, the eye lens being a biconvex combination of three lenses. The field of this eyepiece is very limited, but it gives fine definition; the magnification is small, from 2 to 6 diameters. The compensating eyepiece is designed to be worked in conjunction with apochromatic objectives. This eyepiece derives its name from being over-corrected to compensate for the under-correction of the apochromats. The compensating eyepiece works well with high-power, but indifferently with low-power, achromatic lenses. The eye lens of the compensating ocular is plano-convex and the field-lens a biconvex triplet, the eye lens and field-lens being placed in close juxtaposition.

There are no universal standards for either diameter or magnification of eyepieces. The Royal Microscopic Society has adopted four standard sizes for eyepieces—namely, No. I. 0·9173 in. (23·3mm.); No. II. 1·04 in. (26·416 mm.); No. III. 1·27 in. (32·358 mm.); No. IV. 1·41 in. (35·814 mm.). The variety of methods of classifying the initial magnification or power of an eyepiece is even more unsatisfactory than the lack of uniformity in size. In most English eyepieces the initial magnification is indicated by letters A—E, A representing the lowest power listed by the particular firm, giving a magnification of 4 or 6 diameters; the initial magnification of E would be from 12 to 20. On the Continent figures, not letters, are used to classify the power of the ocular, but they give little clue to the magnification.

EYEPIECE, FOCUSING (*See* "Focusing Magnifier.")

F

"F" NUMBERS

A popular method of marking diaphragms or stops, the smaller f or the capital letter being used with the number, as, for example, $f8$, $f11$, etc. (For full particulars of measuring, relative values, etc., *see* under the heading "Diaphragms.")

FABRICS, DARK-ROOM

Canary, orange, or red translucent cloth, used instead of coloured glass for screening the light in dark-room illumination. They are more serviceable when used with artificial light, as sunlight causes them quickly to fade and become unsafe. The canary fabric is generally used for slow bromide papers; the orange for rapid bromide papers, lantern plates, and slow dry plates; and the red for rapid dry plates. Fabrics are, as a rule, quite as safe as glass, but pinholes must be watched for, and the fabrics not wetted in any way or exposed to strong sunlight.

FABRICS, PRINTING ON

Fabrics already sensitised for the bromide and platinotype processes may be purchased, and they are used in the same way as bromide and platinotype papers. Fabrics are easily prepared for photographic printing, and the blue-print process is perhaps the simplest. The fabrics mostly employed are cottons, linens, silks, nainsooks, etc., but silk that has been weighted with mineral matter is unsuitable; the finer the material the better. The fabric needs to be thoroughly washed in hot water, ironed, and, to prevent the image from sinking into the material, it should then be well sized, a suitable size being—

Arrowroot	.	. 80 grs.	8 g.
Gelatine .	.	. 33 ,,	3·3 ,,
Alum	.	. 18 ,,	1·8 ,,
Water to .	.	. 20 oz.	1,000 ccs.

The fabric is immersed in this solution for about five minutes, pinned down on to a flat board, and dried before a fire, it being then somewhat stiff. The ammonio-citrate and ferricyanide sensitising solution (*see* "Blue-print Process") is then brushed over it, and, after drying, it is ready for printing upon. Printing, washing (fixing), etc., are exactly as described for blue prints upon paper. The printed fabric will not withstand washing with soap and water, as the alkali destroys the blue image.

In order to get the best and brightest of blue prints upon fabrics, it is necessary to use a negative with strong contrasts—that is, one with clear shadows and dense high lights, and the negative should show broad effects of light and shade rather than an abundance of fine detail.

A process for the replacing of the blue ferro-prussiate image by various dyes was published in 1898 by Stewart E. Carter. Bleached cotton or linen is brushed over with a ferro-prussiate sensitiser, made as follows:—

A. Ferric ammon. citrate 164 grs.	164 g.	
Distilled water to . 1 oz.	500 ccs.	
B. Potass. ferricyanide . 164 grs.	164 g.	
Water to . 1 oz.	500 ccs.	

A and B are mixed in equal parts. The sensitised fabric is exposed and washed just as a print upon paper. The blue print is next immersed in a weak solution of caustic soda (5 grs. to 1 oz. of water) for a few minutes, then washed in hot water, and placed for three minutes in a solution of 13 grs. of sodium phosphate in 10 oz. of water at a temperature of 170° F. (about 77° C.). This is followed by washing, first in cold water and then in hot water, after which the print is ready to receive the dye. A weak gelatine solution is made (glue size 24 grs., water 10 oz.) and heated to 160° F. (71° C.), and the prints moved about in it for about three minutes; from 3 to 5 grams per litre (1·3 to 2·2 grs. per ounce) of dinitroresorcin (resorcin green) is added, and the temperature raised to 180° F. (82° C.). As soon as the shade is considered full enough for a strong picture, remove to boiling water to wash out all unfixed dye. The high lights (whites) are next cleared in a bath of neutral soap (used at a temperature of 160°F., 71°C), and the print again washed in hot water and finally in cold. Other dyes may be used in place of the green named. Gallo-cyanine gives blue and violet; alizarin gives purple, and also a brown sepia. The original blue print may be toned, but the dye method, although rather troublesome, gives the more pleasing effects.

Carbon prints may be transferred to any kind of fabric. This must be washed, dried, ironed, and given several coats of the following sizing mixture, allowing to dry after each coat:—

Cooking gelatine	.	2 oz.	133 g.
Sugar	. .	1 ,,	66·5 ,,
Glycerine .	. .	1 ,,	66 ccs.
Chrome alum	.	15 grs.	2 g.
Barium sulphate	.	4 oz.	266 ,,
Water to .	.	15 ,,	1,000 ccs.

Dissolve by heat and mix thoroughly. Transfer the carbon tissue thereon in the usual way. (*See* "Carbon Process.")

Fabrics can be sensitised and used as ordinary P.O.P. First soak the washed and dried fabric in the following size for about three minutes:—

Gelatine .	.	. 100 grs.	10 g.
Common salt .	.	. 100 ,,	10 ,,
Magnesium lactate	.	. 100 ,,	10 ,,
Water to .	.	. 20 oz.	1,000 ccs.

Dissolve by aid of heat and then well mix; after coating the fabric allow it to dry thoroughly. The sized fabric is then sensitised by soaking for three minutes in—

Silver nitrate .	.	25 grs.	52 g.
Distilled water to	.	1 oz.	1,000 ccs.

The fabric is next immersed for one minute in—

Citric acid	.	.	50 grs.	5 g.
Sugar	.	.	50 ,,	5 ,,
Water to .	.	.	20 ,,	1,000 ccs.

and dried in the dark. The sensitive fabric is then printed upon, toned, fixed, and washed exactly as ordinary P.O.P.

An easier method of coating fabric with a silver solution is the following : A salting or sizing bath is first made by rubbing up 180 grs. of arrowroot or dextrine in a little cold water until a smooth paste results; make this up to ¾ pint with boiling water. If the mixture does not at once become gelatinous it should be kept hot (not boiling) and stirred till it does. It should then be allowed to cool a little, and 160 grs. of ammonium chloride dissolved in about 4 oz. of water added to it. The mixture is applied while warm to the washed and ironed fabric, which is then dried and sensitised in the following bath :—

A. Citric acid .	.	25 grs.	50 g.
Distilled water	.	½ oz.	500 ccs.
B. Silver nitrate	.	60 grs.	125 g.
Distilled water	.	½ oz.	500 ccs.

Mix the two solutions. To sensitise the fabric use a Buckle or Blanchard brush. Pin the fabric to a flat board, pour upon it a little of the silver sensitising mixture rapidly and evenly, spread it over the entire surface, and dry in the dark. The fabric is printed upon as though it were P.O.P., toned with an acetate and gold toning bath, and fixed and washed like paper. It is desirable after washing and before toning to pass the print through a weak solution of sodium chloride (common salt), which gives reddish brown tones, or of sodium carbonate, which gives brownish purple tones. (*See also* "Diazotype," "Indigo Printing," etc.)

FACTORIAL DEVELOPMENT (*See* "Development, Factorial.")

FACTORIES, PHOTOGRAPHING IN

Taking photographs in factories or workshops presents difficulties from several independent causes. The first is that work in progress cannot always be stopped while the exposures are made, and the consequent movement cannot always be prevented. Then machinery and shafting in constant motion introduce the serious element of vibration, and, in addition, smoke and moisture are inseparable from some kinds of work, increasing the difficulties of securing good negatives. When the nature of the work will allow it, the negatives should be taken during the dinner-hour. The camera can be set, everything arranged as desired, the subject focused, and everything made ready for the exposure beforehand. Then the plate can be exposed under the best possible conditions. A small stop is almost always necessary for securing good definition throughout.

When figures have to be included and the work shown under its normal conditions, the case is different. The exposure must necessarily be short so as to avoid movement of the principal figures. Frequently, a large aperture is necessary in order to shorten the exposure sufficiently, and it may be quite impossible to secure the degree of sharpness in the different planes that the photographer would desire. In that case, the principal objects must be rendered as crisp and sharp as possible, and the other parts must simply take their chance. Considerable assistance may be given to the workmen that are included by the manner of posing. If they can be given a little support, by resting on a tool, or putting one of their hands on a machine, however slight the support may be, it will materially assist in avoiding movement during the exposure. A longer exposure can be given without appreciable movement. A single machine with one or two figures should cause no difficulty. In subjects of this kind, duplicate exposures should always be made.

Any windows that are in front of the camera and included in the picture should be covered during nine-tenths of the exposure, and, if possible, the covering should be outside. Windows in front of the camera, but not included in the picture, should be covered during the whole of the exposure, unless the lens can be shielded from them as described under the heading "Interiors, Photographing."

FADED NEGATIVES AND PRINTS, RESTORING

Faded prints are more commonly met with than faded negatives, but whichever is treated, success is more certain if the actual cause of fading is known (*see* "Fading, Causes of"). When negatives fade the trouble is usually due either to insufficient fixing or to insufficient or improper washing after bleaching with mercury for the purpose of intensification. During the year 1900 Sir William Crookes paid particular attention to the subject of restoring faded negatives—presumably those treated in the usual way and not intensified—and the following process is advocated by him. The faded dry-plate negative is soaked for three hours in distilled water, and then immersed for from ten to fifteen minutes (in the dark-room) in the following bath :—

Water	.	.	.	1 oz.	500 ccs.
Pyro	.	.	.	3 grs.	3 g.
Sodium metabisulphite			3 ,,	3 ,,	
Sodium carbonate	.		36 ,,	36 ,,	
Sodium sulphite	.		12 ,,	12 ,,	

The plate is next well washed, immersed in an ordinary "hypo" fixing bath for half an hour, and then washed in running water for from four to six hours. It is then toned with gold, for which purpose two solutions are required, one of ammonium sulphocyanide (10 grs. to the ounce), and one of gold chloride (1 gr. to the ounce) ; for use, 1 oz. of each is taken and 8 oz. of water added ; or, if desired, the complete bath may be made up as—

Water	.	.	.	10 oz.	1,000 ccs.
Am. sulphocyanide	.		10 grs.	2 g.	
Gold chloride .	.	.	1 gr.	·2 ,,	

The plate is immersed in this bath for about ten minutes and finally washed for half an hour and dried. The fixing in "hypo" can be omitted if so wished, although it is desirable. The gold toning bath has the property of precipitating gold on the image and rendering it of a blacker colour.

Negatives that have been intensified with mercury may fade quickly, and to restore them they should be treated with a solution of potassium sulphantimonate, commonly known as Schlippe's salt. The faded negative is first thoroughly soaked and then treated with 20 grs. of Schlippe's salt dissolved in 2 oz. of water, until the desired result is obtained; finally wash well.

The fading of prints has always been a troublesome matter. In the old days the necessity for thorough fixing and the complete removal of the "hypo" was not generally recognised, and the question of fading became so important that a committee was formed in May, 1855, to enquire into the causes, the Prince Consort contributing £50 to the expenses of the inquiry. Since then, of course, many improved papers have taken the place of the old ones, and different causes have arisen. Platinum prints are said never to fade, but nevertheless they sometimes appear to change their colour from the original pure black to a brownish or yellowish brown colour. According to Chapman Jones, such prints may be completely brought back to their original colour by unmounting and treating with a mixture of hydrochloric acid and chlorine water, made by adding a few drops of sodium hypochlorite solution to dilute hydrochloric acid (about one of acid to ten or more of water), until the odour of chlorine is distinctly noticeable. Neither hydrochloric acid nor chlorine water alone is effective, though each does something towards the desired end. Several other methods have been advocated, but all are more troublesome, and not nearly so effective.

The restoration of silver (printed-out) prints is at all times a very risky performance. If they are old and yellow, and of value, they should be copied—preferably through light blue glass—before any attempt is made to tamper with them, because of the risk of spoiling the originals. One process is to bleach the yellowed albumen print in a mercuric chloride solution as used for intensifying, well wash, and then to develop in an old hydroquinone or metol developer (without bromide), or preferably to immerse in a 5 per cent. solution of sodium sulphite, and finally wash well. This process is not reliable. An elaborate process of restoring silver prints, and one for which the inventor (H. Jandaurek) was awarded a silver medal in 1888, is as follows. Two solutions are required:—

A. Distilled water	.	35 oz.	1,000	ccs.
Sodium tungstate		608 grs.	5	g.
B. Distilled water	.	1 oz.	400	ccs.
Calcium carbonate (pure)		5 grs.	4	g.
Chloride of lime	.	1·2 ,,	1	,,
Gold and sodium chloride		5 ,,	4	,,

The B solution should be kept in a yellow bottle or in the dark for twenty-four hours. The faded prints are unmounted, well washed, and placed in 8 oz. of the A solution to which ¼ oz. to ½ oz. of B has been added. They should remain in this toning bath until they assume a good purple tone, and they are then well washed and fixed with "hypo" (1 oz. to 10 oz. of water) until all the yellowness has disappeared, which may take one hour or more; finally, they are washed well.

As stated above, all print restoration processes are more or less unreliable, and need to be used with great caution. Any details that have vanished from the faded print cannot be brought back, and all that the restoration process does is to strengthen the weak parts of the print, and as much as this can be done equally well by making a copy in a proper manner.

FADING, CAUSES OF

All silver images, whether negative or positive, are formed by metallic silver in an extremely fine state of division imbedded in a vehicle of albumen, gelatine, or collodion. Everyone knows how prone silver, even in the form of spoons and forks or ornaments, is to tarnish, and consequently it can be well understood how much more readily the metal in a finely divided state can be attacked. In many cases, particularly in that of prints, the fading is undoubtedly due to imperfect fixation or removal of the last traces of "hypo" or the hyposulphite of silver. It must not be overlooked that gelatine is a hygroscopic substance, and that "hypo" in the presence of moisture is decomposed, giving rise to sulphur compounds which readily attack the image. Whilst fading is not so commonly met with in negatives, it can still be detected sometimes, and it is then advisable to bleach the negative with a chlorising mixture, such as hydrochloric acid and potassium bichromate, wash well, and redevelop.

There is but little hope of saving a fading print, and care should be taken to ensure perfect fixation and thorough washing, the former being as essential as the latter. It will often be found that prints mounted on cards show fading more readily than those that are unmounted, and this may be due to the card containing "hypo" or some sulphur compound which is gradually decomposed by the mountant or moisture, and acts on the silver image. Frequently, too, prints—especially collodion prints—will fade in circular spots, and this can often be traced to small particles of metal, such as the bronze powder used for gilding the edges, etc., electrolytic action having been set up by the acid moisture in the air between the two metals. Varnishing negatives and prints is some protection. In the case of framed prints care should be taken to see that the backboard of the frame fits well, that the prints and mount are thoroughly dry before being framed, and that all round the edges, and over any cracks in the backboard, good stout brown paper is pasted or glued.

FAHRENHEIT THERMOMETER (*See* "Thermometer.")

FALLING FRONT (*See* "Rising Front.")

FALSE IMAGES, OR "GHOSTS" (Fr., *Images fausses*; Ger., *Falsche Bilder*)

Even the best doublet lenses sometimes show what is known as a false image or "ghost,"

when a bright object or light occurs in the picture. This is due to reflection of the bright object from the front surface of the back lens, and from this to the back surface of the front lens, whence it is again reflected towards the plate. In a properly designed lens, the distance apart of the glasses and the position of the stop are so arranged that the false image is diffused before it reaches the plate, and so is very rarely troublesome. To test for the presence of a false image, focus a gas flame or a lighted candle, placed at a distance from the camera equal to about eight or ten times the focal length of the lens. Cover the head with the focusing cloth, and bring the image of the flame into the centre of the ground-glass screen. If the camera is now turned slowly so that the image moves to one side, the ghost, if present, may on careful inspection be seen moving in the contrary direction, and exactly opposite the principal image. It very probably will not be in focus at the same time as the chief image, but it may usually be brought into focus by a slight movement of the screw, and will then be found to be distinguished from the primary image by being erect instead of inverted. This defect may often be cured by slightly altering the distance between the lenses, or by varying the position of the diaphragm, the false image being consequently spread over the whole of the plate and not allowed to come to a focus. (*See also* " Flare Spot.")

FALSE DISPERSION (*See* " Dispersion.")

FALSE PERSPECTIVE (*See* " Perspective, False.")

FARMER'S REDUCER AND INTENSIFIER

About the year 1883 Howard Farmer introduced what is undoubtedly the most widely used reducer. It consists of " hypo " and potassium ferricyanide in solution, and is sometimes referred to as the " ferricyanide " or "hypo-ferricyanide," but more frequently as the " Farmer " or " Howard Farmer " reducer. It will be found described under the heading of " Reducers."

Farmer's intensifier is not so well known. It is one of the " silver " processes, and will be found with others under the heading of " Silver Intensifier."

FEERTYPE

A printing process, patented by Dr. Adolf Feer in 1889, in which paper is sensitised with diazo-sulphonic salts of aniline, amido-azobenzol, benzidine, and their homologues, in conjunction with compounds of phenol, resorcin, or naphthol. The diazo compound is set free by the action of light, and forms a colouring matter ; thus a coloured positive print is obtained from a negative. After exposure, the print is washed in water or dilute hydrochloric acid, by which means the unacted upon and unchanged preparation is removed. (*See also* " Diazotype.")

FERGUSON'S TONER

A copper toning bath for bromide prints. (*See* " Copper Toning.")

FERNS AND LEAVES, PRINTING FROM

Ferns and leaves make effective and decorative photographs which are easily produced without a camera, lens, or negative, the leaves being printed direct upon the sensitive paper. Lace may also be photographed in the same way. Either fresh, preserved, or skeletonised flowers and leaves may be used. A piece of plain glass should be placed in a printing frame of the desired size and the leaf laid flat thereon, the sensitive paper (any kind answers, although P.O.P. is preferable) coming next ; the back of the frame is placed in position, and the whole put out to print in the usual way. When printed sufficiently, tone or develop, as the case may be, and afterwards fix and thoroughly wash. When the leaves are particularly moist it is advisable to place a thin sheet of celluloid—a clean film serves admirably—between the leaf and the paper in order to prevent the paper from becoming contaminated with the natural juices. Almost equally good results may be obtained from natural or skeletonised leaves, the difference being in the duration of printing. Bracken and virginia creeper leaves are particularly suitable, and a brief printing from fresh leaves gives the outline of the leaves only, the image appearing as white upon black. If, however, a reversal is wanted, the leaf may be placed in contact with a dry plate and a negative made which would produce a print showing black upon white. The longer the exposure the more light travels through the leaf, and the greater the detail obtained. New leaves when suitably printed give beautiful half-tones, because of the different densities of the various parts of the leaves ; whereas skeleton leaves produce only black and white prints. Talbot, in 1836, used a fern leaf when he produced the first silver print on paper.

FERRIC AMMONIO-CITRATE (Fr., *Citrate de fer ammoniacale* ; Ger., *Braune citronensäure Eisenoxydammoniak*)

Synonym, ammonium citrate of iron. $4Fe C_6H_5O_7 3(NH_4)_3 C_6H_5O_7 3Fe(OH)_3$. Molecular weight, 2,030. Solubilities, 1 in 4 water, insoluble in alcohol. It takes the form of brownish red scales, and is made by dissolving freshly precipitated ferric hydrate in excess of citric acid and neutralising with ammonia. It is sensitive to light, and should be kept in the dark. It is used in conjunction with potassium ferricyanide in the iron printing processes.

Valenta has recommended a green salt, which is a mixture of neutral ammonium ferric citrate, acid ammonium ferric citrate, and ferric citrate, and has the formula $5FeC_6H_5O_7 2(NH_4)_3 C_6H_5O_7 NH_4 C_6H_7O_7 2H_2O$. Molecular weight, 1,956. This occurs in bright, greenish yellow scales, and gives much more sensitive papers with purer whites than does the brown salt. It also is sensitive to light and must be kept in the dark.

FERRIC AMMONIO-OXALATE (Fr., *Oxalate ammoniaco-ferrique* ; Ger., *Ammonium ferricxalat*)

Synonyms, ammonium oxalate of iron, oxalate of iron and ammonia. $Fe_2(C_2O_4)_3 3(NH_4)_2 C_2O_4 8H_2O$. Molecular weight, 892. Solubilities, 1 in 2·1 water, insoluble in alcohol. It occurs in bright green crystals, and is formed by

dissolving ferric hydrate in ammonium oxalate solution, evaporating and crystallising. It is decomposed by light into ferrous ammonium oxalate, and is used occasionally for blue prints, a formula being :—

A. Ferric ammonium
 oxalate . . ½ oz. 250 g.
 Distilled water to 20 ,, 1,000 ccs.
B. Potassium ferri-
 cyanide . . ½ oz. 250 g.
 Distilled water to 20 ,, 1,000 ccs.

Mix in equal parts just before use. It is also used in the cold-development platinum and the print-out platinum processes.

FERRIC AMMONIO-SULPHATE (Fr., *Sulfate de fer ammoniacale ;* Ger., *Schwefelsäure Eisenoxydammoniak*)

Synonyms, ammonium sulphate of iron. $Fe SO_4 (NH_4)_2 SO_4 6H_2O$. Molecular weight, 328. Solubilities, 1 in 5 water, insoluble in alcohol. It occurs as pale greenish crystals, and is prepared by dissolving 139 parts of ferrous sulphate and 75 parts of ammonium sulphate in a minimum of water and afterwards crystallising. It has been suggested as a substitute for ferrous sulphate on account of its greater stability, and it has been used for developing wet plates.

FERRIC CHLORIDE (Fr., *Chlorure ferrique ;* Ger., *Eisenchlorid*)

Synonym, perchloride or sesquichloride of iron, iron trichloride. $Fe Cl_3 6H_2O$. Molecular weight, 270·5. Solubilities, 1 in ·63 water, 1 in 4 alcohol, 1 in 4 ether. It takes the form of yellow crystalline lumps, which rapidly deliquesce in the air. It is prepared by dissolving iron wire in hydrochloric acid and oxidising with nitric acid. It has been recommended for reducing negatives, but it gives rise to yellow stains due to the formation of basic ferrous salts. Its chief use is as a mordant in etching half-tone and photogravure plates.

FERRIC OXALATE (Fr., *Oxalate ferrique ;* Ger., *Ferrioxalat*)

Synonym, iron sesquioxalate. $Fe_2 (C_2O_4)_3$. Molecular weight, 376. Solubilities, very soluble in water, insoluble in alcohol. It occurs in greenish, glistening scales, which are extremely sensitive to light, and it is therefore usually preferred to mix it in solution and preserve in the dark. It is the most light-sensitive of any of the iron salts. It is used in the kallitype process, but its chief use is as the sensitive salt in the platinotype process. The following is the best method of preparing the normal ferric oxalate solution : Powder some ammonia-iron-alum, weigh out 500 grs. or 520 g., place in a tall cylindrical graduate, capable of holding 20 oz. or 1,000 ccs., and add 192 minims or 200 ccs. of liquor ammoniæ (·880), and an equal quantity of distilled water. Stir well for about five minutes, and allow to stand for a further five minutes. Then fill up with distilled water, stir well, and allow the precipitated ferric hydrate to settle down. Next decant or siphon off the clear supernatant liquid, and repeat the process until the wash water is no longer alkaline to litmus paper. Then allow the precipitate to settle till it occupies not more than 17 oz. or 850 ccs. Add 2,064 grs. or 215 g. of pure oxalic acid in powder, stir well, and allow to stand in the dark-room until the precipitate is completely dissolved. Now filter the solution, and wash the filter paper with distilled water so as to make the total bulk of the solution 20 oz. or 1,000 ccs. This forms the "normal iron solution" for platinotype, and contains 20 per cent. of ferric oxalate with about 1·2 per cent. of oxalic acid.

FERRIC PROTOACETATE (*See* "Ferrous Acetate.")

FERRIC PROTOSULPHATE (*See* "Ferrous Sulphate.")

FERRIC SALTS, PRINTING WITH

The light-sensitiveness of the iron (ferric) salts is the basis of a large number of printing processes, including chrysotype, cyanotype, kallitype, the sepia printing process, amphitype, the ink process, and platinotype. In all these the ferric salt is reduced by light to the ferrous state. The following table (due to Eder) shows the comparative light sensitiveness of the various iron salts :—

Ferric chloride and oxalic acid .	100
Ferric oxalate	89
Ammonium ferric oxalate . .	80
Potassium ferric oxalate . .	78
Ferric tartrate	80
Ammonium ferric tartrate . .	80
Ammonium ferric citrate . .	15
Ferric chloride and citric acid .	19
Ferric chloride and tartaric acid	25

Many of the inorganic ferric salts are comparatively stable to light, but in contact with organic matter are readily reduced, as in the case of ferric chloride with oxalic or citric acid. According to Abney the spectral sensitiveness of the iron salts is chiefly in the indigo blue, about G ⅓ F, and extends to E in the green and well into the ultra-violet.

Printing with salts of iron is known as the iron-printing or heliographic process. The four principal processes, each of which is described under its own heading, are : the blue print process (ferro-prussiate), white lines on a blue ground ; Pellet, blue lines on a white ground ; ferro-gallic, black lines on a white ground ; and brown line (better known as, and described elsewhere in this work under the heading of, "Kallitype"), white lines on a brown ground.

An interesting process of printing with a ferric salt is Shawcross's Amphitype (*which see*), in which advantage is taken of the fact that these salts have the property of attracting or repelling greasy inks. This is again shown in the black line "True-to-scale," or Ordoverax, process, where an undeveloped blue-print laid on a gelatinous surface will so affect the latter as to enable the lines to take ink while the other parts repel it.

The table on p. 239 (due to Eder) gives a very clear précis of the principal iron printing processes and the developers necessary to produce full vigour of the images, which as a rule are only faint. (See also separate headings.)

Sensitive salt	Product of light action	Developer used to produce full vigour of image	Colour of image	Name of process
Ferric oxalate, citrate, tartrate, etc.	Ferrous salt (ferrous oxalate), citrate, etc.	Potassium ferricyanide. (This gives insoluble Berlin blue with ferrous salts, but a soluble compound with ferric salts)	Blue	Cyanotype. (Gives white lines on blue ground from a tracing)
Ditto	Ditto	Potassium ferrocyanide. (This gives a blue precipitate with ferric salts, but a white with ferrous salts)	Blue	Pellet's process. (Gives blue lines on white ground from a tracing)
Ferric citrate	Ferrous citrate	Gold chloride. (Where the ferrous salt is formed metallic gold is precipitated)	Brownish	Chrysotype
Ferric oxalate	Ferrous oxalate	Potassium chloroplatinite. (Metallic platinum is precipitated where the ferrous salt is formed)	Black	Platinotype
Ferric oxalate	Ferrous oxalate	Silver nitrate	Brownish black	Kallitype or Argento-type
Ferric and cupric chloride	Cuprous chloride	Potassium sulphocyanide, followed by potassium ferricyanide. (The cuprous chloride is converted into brown cuprous ferrocyanide)	Red brown	Obernetter's process

FERRIC SESQUIOXALATE (*See* " Ferric Oxalate.")

FERRIC SODIUM OXALATE (Fr., *Oxalate de fer et de soude ;* Ger., *Natriumferrioxalat*)

Synonym, sodio-ferric oxalate. Fe (C₂O₄)₃ 3Na₂C₂O₄ 11H₂O. Molecular weight, 976. Solubilities, 1 in 1·69 water, insoluble in alcohol. It occurs as large green crystals, unaffected by the air. It is prepared by dissolving ferric hydrate in acid oxalate of sodium. It is used in the printing-out platinum process.

FERRIC SULPHATE (Fr., *Sulfate ferrique ;* Ger., *Ferrisulfat, Schwefelsäure Eisenoxyd*)

Synonym, sesquisulphate of iron. Fe₂ (SO₄)₃ 9H₂O. Molecular weight, 563. Soluble in water. It takes the form of greenish crystals, or, in the anhydrous form, it occurs as a greyish white powder. It has been suggested as a reducer, but it gives rise to yellowish basic iron salts in the film.

FERRICYANIDE OF COPPER (*See* " Copper and Potassium Ferricyanide.")

FERRICYANIDE OF POTASSIUM (*See* " Potassium Ferricyanide.")

FERRICYANIDE REDUCER (Fr., *Réducteur ferricyanure ;* Ger., *Rothes Blutlangensalz Abschwacher*)

The action and use of this reducer are described under the heading " Reducers."

FERRIER AND SOULIER PROCESS

A method of making lantern slides and stereoscopic transparencies, invented by Ferrier in the early days of the albumen process of making positives upon glass. The method has been kept a trade secret, but is said to be a modification of the albumen positive process.

FERRO-CUPRIC PROCESS

An iron printing process devised by Obernetter about the year 1865. Paper is coated by floating on the following sensitive mixture :—

Water.	. 100 parts
Copper chloride (crystals)	. 10 ,,
Ferric chloride solution (sp. g. 1·5)	. 1 ,,
Hydrochloric acid	. 1 ,,

The paper is then dried and exposed in the same way as " blue-print " paper, a faint image being visible. Immediately after printing it is floated on the following developing mixture :—

Potassium sulphocyanide	. 10 parts
Sulphuric acid	. 1 part
Water.	. 1,000 parts

To this is added 15 parts of the sensitive mixture given above. If the print is not developed immediately after printing the image is lost. Development at first should be by floating, and when the image has partially developed, the paper may be entirely immersed. The paper is afterwards well washed and toned. Red tones may be obtained by immersing the developed print in a 10 per cent. solution of potassium ferricyanide. For purple tones use—

Ferric chloride	. 1 part
Ferrous sulphate	. 2 to 2½ parts
Hydrochloric acid	. 2 parts
Water.	. 10 to 50 parts

This bath will give a range of tones from red through violet and purple to a greenish black. Finally wash in weak hydrochloric acid.

FERRO-GALLIC PROCESS

A method of printing with ferric (iron) salts, giving a black image upon a white ground ; known also as the black-line process and the Colas process. It is largely used by architects, engineers, etc., for multiplying drawings. The following mixture is made up, or larger quantities in proportion :—

Ferric chloride (syrupy)	30 grs.	60 g.
Ferric sulphate.	. 15 ,,	30 ,,
Gelatine .	. 15 ,,	30 ,,
Tartaric acid .	. 15 ,,	30 ,,
Water .	. 1 oz.	1,000 ccs.

Soak the gelatine in the water, melt by the aid of heat, and add the other ingredients. Coat paper in the way recommended for the blue-print process and dry in the dark. When dry, expose under negative or tracing till the ground is white and the lines appear yellow, and then immerse in the following developer :—

Gallic acid . . 20 grs.	4 g.	
Oxalic acid . . 5 ,,	1 ,,	
Water . . 10 oz.	1,000 ccs.	

till the lines are quite black ; wash, and dry by blotting off between clean blotting-paper and hanging up.

FERRO-GELATINE DEVELOPER

A solution of gelatine boiled with sulphuric acid so as to lose its setting power, used by Carey Lea as an addition to the wet - plate developer.

FERROGRAPHS (See "Ferrotype Process.")

FERROPRUSSIATE (See "Blue-print Process.")

FERROTYPE PLATES

Thin plates of metal coated on their face with a fine hard dark enamel. They were so called through being prepared as a basis for "ferro-types," or collodion positives taken direct in the camera. (See "Ferrotype Process.") They have, however, another use in modern photo-graphy. A glossy-surfaced gelatine print may be squeegeed while wet on to a ferrotype plate in exactly the same manner as on to a sheet of plate glass. No preparation of the ferrotype plate is necessary beyond washing and polishing with a soft fabric, and when the prints are dry they leave the plate easily with a surface scarcely inferior to that produced by contact with glass

FERROTYPE PROCESS (Fr., *Procédé ferro-type;* Ger., *Ferrotypie*)

About the middle of the nineteenth century the term "ferrotype" was applied to the process introduced by Robert Hunt as "Energiatype" (*which see*), but that process was but little used, and the modern ferrotype is quite different.

Ferrotypes (known also as "tintypes") are pictures taken on sheet-iron plates varnished or enamelled on both sides, the picture side being the more carefully prepared. They are of American origin, having been introduced by J. W. Griswold in 1855, and were also known as "Melainotypes" before the title of ferrotype was generally adopted. It is believed that the earliest reference made to ferrotypes is in *Photo-graphic Notes*, dated January 1, 1856, announc-ing the invention by a Prof. Smith, of Ohio, of a process of " producing a beautiful picture on a piece of common sheet iron, . . . equal to daguerreotypes, and much superior in some respects." The journal calls the pictures "Ferrographs."

Ferrotype pictures are positives produced by the wet collodion process, a black or chocolate enamelled iron plate being used as a support for the picture instead of glass. The latter needs backing up with black paper, velvet, or paint. The finished results have the same appearance in both cases, but the ferrotype image is reversed as regards right and left, and the process is there-fore not suitable for general application. Every-one knows that this process has been widely used for portraiture by itinerant photographers, since by its aid they can take and finish a por-trait in the space of a few minutes. The photo-grapher generally takes particular care to arrange the sitter "full face," or in any other position in which reversal is not at first detected. For ferrotype work proper the operator must be within easy reach of his dark-room, as the plates are prepared immediately before exposure.

The process, in brief, is first to prepare the plate with collodion, sensitise in a silver bath, expose while wet, develop with an iron developer, and fix in a solution of potassium cyanide ; all formulæ and working details will be found under the heading " Collodion Process (Wet)."

The Dry Process.—The introduction of ferro-type dry plates has largely displaced the old-fashioned wet process ; itinerant photographers use them in conjunction with automatic cameras, which comprise arrangements for developing and fixing, thus obviating the use of the old portable perambulator-like dark-rooms. Ferrotype dry plates are bought in packets and used like other dry plates, but instead of yielding a negative on glass they give a positive direct upon the black iron or tin support. An example of the developers used for such plates is :

Sodium carbonate (pure) 4 ,,	200 g.	
Sodium sulphite . 2 ,,	100 ,,	
Hydroquinone . . $\frac{1}{4}$,,	12·5 ,,	
Potassium bromide . 290 grs.	29 ,,	
"Hypo" fixing solution		
(as below) . . $\frac{1}{2}$ oz.	25 ccs.	
Warm water to . 20 ,,	1,000 ,,	

Allow to stand for two days and pour off the clear solution for use. In cold weather half the above quantity of bromide is required. After exposure, the ferrotype dry plate is developed until the high lights (which appear brown on a white background) and half-tones are well out, and the plate is then rinsed in water and fixed in a "hypo" fixing solution (sodium hyposulphite 4 oz., water 20 oz.). Development takes from eight to twelve seconds in hot weather, twelve to twenty seconds in a normal temperature, and twenty to sixty seconds in cold weather. After fixing (duration, ten to thirty seconds), the plate is rinsed for a few seconds and dried spontaneously or by gentle heat. It is next varnished, and then gives the appearance of having been pro-duced by the wet collodion process. Sediment sometimes appears on the film after washing, particularly when over-developed, and gives the plate a fogged appearance ; it may be removed, before drying, with a pad of cotton wool.

A positive on a ferrotype plate is sometimes used by artists as a means of tracing from. Where a photograph is not to the correct scale a positive enlargement can be more rapidly made than a negative and print. As the image is reversed in relation to right and left, it becomes correct when traced over on gelatine by scratch-ing the outline with a needle-point and filling with blacklead or other set-off powder, the gela-tine being then turned over and rubbed down on to drawing paper or Bristol board.

AFTER A STORM

SEASCAPE AND SKYSCAPE PHOTOGRAPHY

FERROUS ACETATE (Fr., *Acétate de fer;* Ger., *Ferroacetat*)

Synonyms, ferric protoacetate, acetate of iron. Soluble in water. Fe $(CH_3 COO)_2$. Molecular weight, 174. It occurs as green crystals, and is obtained by dissolving iron in acetic acid. It was occasionally used in the wet plate days, and was then formed in solution by adding lead acetate to ferrous sulphate, when ferrous acetate was formed and lead sulphate precipitated.

FERROUS AMMONIUM SULPHATE (Fr., *Sulfate de fer ammoniacale;* Ger., *Schwefelsaures Eisenoxydulammoniak*)

Synonyms, ammonio-ferrous sulphate, Mohr's salt. $FeSO_4 (NH_4)_2 SO_4 6H_2O$. Molecular weight, 392. It takes the form of pale bluish green crystals. It is made by crystallising ferrous and ammonium sulphate. It was used in the old wet plate days as being a more stable salt than the ordinary ferrous sulphate. Seven parts of the double salt are equal to five of the ferrous sulphate.

FERROUS CHLORIDE (Fr., *Protochlorure de fer;* Ger., *Eisenchlorid*)

Synonym, protochloride of iron. Fe $Cl_2 4H_2O$. Molecular weight, 199. Solubilities, 1 in 1·4 water, soluble in alcohol. It is a greenish crystalline salt, rapidly oxidised on exposure to the air into perchloride. It is made by dissolving iron wire in hydrochloric acid. It was suggested as a substitute for ferrous oxalate in the oxalate developer, and was occasionally used in the powder process.

FERROUS CITRO - OXALATE DEVELOPER

A modification of the ferrous oxalate developer suggested by Abney:—

1.—Neutral potassium
citrate . . 9 oz. 450 g.
Neutral potassium
oxalate . . $2\frac{1}{2}$,, 112 ,,
Distilled water to 20 ,, 1,000 ,,
2.—Ferrous sulphate. 4 oz. 200 g.
Distilled water to 20 ,, 1,000 ccs.

For use, mix in equal parts. Cowan suggested the following, and it is especially suitable for gelatino-chloride plates, as any warmth of tone may be obtained by variation of exposure and developer:—

1.—For cold tones :
Neutral potassium
oxalate . 1,200 grs. 125 g.
Neutral potassium
citrate . 400 ,, 42 ,,
Distilled water to . 20 oz. 1,000 ccs.
2.—For warm tones :
Citric acid . 3,200 grs. 333 g.
Ammonium carbon-
ate . . 2,400 ,, 250 ,,
Distilled water to . 20 oz. 1,000 ccs.
3.—For extra warm tones :
Citric acid . 4,800 grs. 500 g.
Ammonium carbon-
ate . . 1,600 ,, 166 ,,
Distilled water to . 20 oz. 1,000 ccs.

16

4.—Iron solution :
Ferrous sulphate . $6\frac{1}{2}$ oz. 333 g.
Sulphuric acid . $\frac{1}{4}$,, 12·5 ccs.
Distilled water to 20 ,, 1,000 ,,

For use, add 1 part of No. 4 to 3 parts of Nos. 1, 2 or 3.

FERROUS NITRATE (Fr., *Azotate ferreux;* Ger., *Salpetersaures Eisenoxydul*)

Synonym, protonitrate of iron. Fe $(NO_3)_2$ $18H_2O$. Molecular weight, 536. Solubilities, 1 in 6 water, soluble in dilute alcohol. It occurs as greenish white crystals. It may be prepared by dissolving iron wire in nitric acid, but the usual method is to mix 19 parts of ferrous sulphate with 36 parts of barium nitrate in solution, which gives 26 parts of ferrous nitrate. It was used in the wet collodion days, and gives an image much whiter in colour than does the ferrous sulphate.

FERROUS OXALATE (Fr., *Oxalate ferreux;* Ger., *Eisenoxalat*)

Synonym, oxalate of iron. $FeC_2O_4 2H_2O$. Molecular weight, 180. Practically insoluble in water, but soluble in alkaline oxalate solutions. Prepared by decomposing ferrous sulphate with oxalic acid, but generally obtained by mixing potassium oxalate and ferrous sulphate, in the form of ferrous potassium oxalate.

FERROUS OXALATE DEVELOPER

One of the oldest developers for plates and bromide papers, announced in 1877 simultaneously by Carey Lea and Willis, of America and England respectively, now almost entirely replaced by the newer organic developers. It has the great advantage of giving an image in pure metallic silver—that is, without any oxidised stain which is so often the defect of the newer developers; but, on the other hand, it oxidises rapidly, and gives in hard water a precipitate of oxalate of lime. Also, it raises the inertia of the plate, or, in other words, it does not bring so much out of a plate as do the newer developers. In the case of bromide papers, it is necessary to use an acid bath after development in order to prevent the deposition of basic iron salts in the fibres of the paper; and this disadvantage has led to its disuse. It can be prepared most conveniently by double decomposition between potassium oxalate and ferrous sulphate. The following may be considered a standard formula :—

1.—Neutral potassium
oxalate . . 5 oz. 250 g.
Distilled water to 20 ,, 1,000 ccs.
2.—Ferrous sulphate. $6\frac{1}{2}$ oz. 330 g.
Distilled water to 20 ,, 1,000 ccs.
Pure sulphuric acid 10 mins. 1 cc.

For use, add 1 part of No. 2 to 4 parts of No. 1. The iron must be added to the oxalate, and never vice versa, so that the oxalate is always in excess, because ferrous oxalate is insoluble in water and soluble only in excess of an alkaline oxalate. The developer is a deep orange solution which does not keep well. Another method of making it is by heating the oxalate solution to boiling point and adding dry ferrous oxalate until saturated, and then cooling and bottling;

but the first method is preferable. Bromides can, of course, be used as with any other developer, and the addition of a very small quantity of "hypo," ·06 per cent., acts as an accelerator.

FERROUS OXALATE INTENSIFIER

In this process of intensification the negative, after bleaching in mercuric chloride, is blackened by the application of the ferrous oxalate developer, which reduces the white silver and mercurous chloride image to metallic silver and mercury. The advantage of this process is that any amount of density may be obtained by repeating the bleaching and blackening, each repetition adding more mercury, and, so far as is known, the image thus obtained is quite stable, and there is no selective action either in the high lights or shadows. It is important to wash thoroughly, preferably in water acidified with hydrochloric acid, after bleaching and before blackening. J. Chapman Jones recommends bleaching the well washed negative in a cold saturated solution of mercuric chloride to each ounce of which one or two drops of strong hydrochloric acid have been added. Afterwards, the negative is washed for one hour, blackened with a developer composed of 6 parts, by measure, of a saturated solution of potassium oxalate and 1 part of a saturated solution of ferrous sulphate.

FERROUS POTASSIUM OXALATE (Fr., *Oxalate de potassium ferreux ;* Ger., *Kalium-Eisenoxalat*)

Synonym, potassio-ferrous oxalate. $K_2Fe(C_2O_4)_2H_2O$. Molecular weight, 328. Obtained in the ferrous oxalate developer by the admixture of ferrous sulphate and potassium oxalate. If the sodium salt is used, ferrous sodium oxalate results.

FERROUS SODIUM OXALATE (*See* the preceding article.)

FERROUS SULPHATE (Fr., *Sulfate de fer ;* Ger., *Schwefelsaures Eisenoxydul*)

Synonyms, sulphate or protosulphate of iron, green copperas, green vitriol. $FeSO_4 7H_2O$. Molecular weight, 278. Solubilities, 1 in 1·8 cold and ·5 boiling water, insoluble in alcohol. It occurs as large bluish green crystals, efflorescent in air, obtained by treating iron wire with dilute sulphuric acid. It is used as the developer for wet collodion plates and to prepare the ferrous oxalate developer. On exposure to air it becomes oxidised and covered with a rusty powder of basic sulphate, which should be rinsed off before the crystals are dissolved.

FERROUS SULPHATE DEVELOPER

A developer used for wet collodion plates, of which the following may be considered a typical formula :—

Ferrous sulphate	. 350 grs.	40 g.
Glacial acetic acid	. 310 mins.	30 ccs.
Alcohol . .	. 310 ,,	30 ,,
Distilled water to	. 20 oz.	1,000 ,,

A great many additions have been recommended, such as copper or magnesium sulphate, sugar, glycerine, albumen, etc., all of which are

supposed to have some special advantage. The development of a wet plate differs from that of a dry, in that it is what is termed "physical development"; that is to say, the latent image itself is not developed, but the silver nitrate adherent to the film is reduced by the ferrous sulphate and deposited *in situ* on the latent image, so that the growth of the image is from the top and not from the bottom or in the film, as with the chemical development of a dry plate.

FIELD CAMERA (Fr., *Chambre de touriste, Chambre de voyage, Chambre portative ;* Ger., *Reisekamera, Landschafts-kamera*)

Field cameras are necessarily designed to obtain the maximum of compactness and the minimum of weight consistent with steadiness.

A. Square-bellows Field Camera

Since they will be more exposed to atmospheric and climatic influences than indoor cameras, the workmanship must be good, and the wood of excellent quality and well seasoned. Rigidity is of great importance. When extended, there should be no shake or looseness at either front or back if grasped firmly with the two hands. The choice of pattern depends somewhat on the nature of the work to be undertaken.

For technical, engineering, and suchlike purposes, a square bellows camera of somewhat heavy construction is usually preferred. Illustration A shows an apparatus which can be used in the studio or on a tripod outdoors. The rigid front is suited for carrying heavy lenses, while the bellows racks backwards from the front, a useful movement in wide-angle work, where part of the image is sometimes liable to be cut off by the projecting baseboard of the

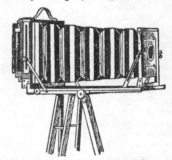

B. Tapering-bellows Field Camera

ordinary type of camera. The back focusing movement is also valuable in photographing small objects at close quarters. The baseboard folds over the focusing screen when closed, thus preventing it from getting broken.

A lighter, yet still substantial, type of camera, suitable for general work out of doors, is illustrated at B. The swing front is useful when

photographing high buildings, and a sufficient amount of rise is also provided for. The back, which can be swung either horizontally or vertically, is arranged to slide close up to the front if desired, for use with wide-angle lenses. A well-known camera, noted for its great range of movement and particularly adapted for archi-

C. Field Camera with Extreme Rise of Front

tectural photography, is shown at C. The back and front may be swung in every imaginable position with ease, and at once rigidly clamped or locked. The extreme high rise of front will be noticed. The front not only rises and falls by rack and pinion, but may be moved horizontally or diagonally by means of a compound sliding and revolving device.

A representative example of a moderate priced triple-extension camera is illustrated at D. A triple extension allows the bellows to be racked out to about three times the focal length of the average lens used with a camera of a given size, and is an invaluable feature when using long-focus lenses.

The cameras above mentioned are illustrative of the chief tendencies of design in modern field apparatus. A notable advance is shown on earlier ideals of construction, especially with regard to lightness, compactness, and the provision of mechanical conveniences. Double

D. Triple-extension Field Camera

book-form dark slides are usually preferred with field cameras, and they should work without either stiffness or looseness. (*See also* " Camera," " Dark-slide," etc.)

FIELD, DEPTH OF (*See* "Depth of Definition, etc.")

FIELD LENS

The lower lens of a microscope eyepiece that receives the image from the objective, as explained under the heading " Eyepiece."

FIELD OF LENS

The imaginary surface at which the sharpest image that can be given is formed. With a theoretically perfect lens, this would be a plane, but in practice the field is usually concave, occasionally convex, and in the case of most anastigmats, plane with an annular depression at a considerable distance from the centre. In the theoretically perfect field all the rays, axial and marginal, come to a focus on a plane which is at right angles to the axis of the lens. This condition is fulfilled by one or two of the modern anastigmats, especially those made for copying. The most ordinary type of field is concave, the concavity being away from the lens. Before the introduction of the special Jena glasses, this was considered normal, in fact, inevitable, for so eminent an optician as the late J. H. Dallmeyer stated that a lens having a perfectly flat field " does not exist, and cannot be made." The amount of curvature of field varies greatly in different types of lenses, being most pronounced in portrait lenses of large aperture, less in single landscape lenses, and least of all in well-constructed rapid rectilinears. Other things being equal, it will be found that separating the elements of a double combination lens has a tendency to flatten the field, at the risk of increasing the astigmatism present ; while in the case of single lenses the curvature is reduced to a minimum by placing the diaphragm as far as practicable from the lens. The field of a typical anastigmat is flat in the centre for a considerable distance from the axis, then comes a " dip " and then a recovery to almost the original plane. A field that is convex towards the lens is rarely found in practice, generally occurring in modern anastigmats which have been slightly over-corrected for flatness in the endeavour to attain other qualities.

FIGURE STUDIES

Portraiture is mainly directed to securing a " likeness," while figure studies are generally intended to show character, costume, occupation, and so on. Renderings of figures in homely surroundings, or engaged in somewhat humble everyday occupations, are generally classed as " genre." The great thing to avoid in successful figure work is any suggestion of posing or of camera-consciousness. Sometimes figures are dealt with as what may be called character studies, in which case care must be taken that position, lighting, view-point, and general treatment are all directed to securing the particular characterisation desired. In other cases the figures, singly or collectively, are treated in " settings," or surroundings suggestive of their habits and employments. Whatever their occupation, work, or play, they should appear natural, and not suggestive of merely performing for the occasion. This does not imply that a certain amount of posing and arrangement must not be resorted to, but that there should be no evidence of such.

In the case of character studies, careful observ-

ation of the subject is necessary to realise precisely what is to be rendered in each particular case. Study is also equally essential where occupation is to be suggested. There are certain poses and movements that are more effective and suggestive than others, and these must be watched for and noted. The sweeping movements of a mower, for example, cannot be shown completely, but the " arrested motion " should be suggestive of action and not of a stationary pose. A blacksmith with his hammer poised in the air is more suggestive of energy and force than if his hammer is resting on the hot iron. In every such case the most characteristic position must be diligently sought for. The human interest always makes figure studies attractive, but it is extremely difficult to secure unqualified success without careful observation and continued practice and experience. It is, in fact, a branch of photographic work that demands special aptitude, but one that well repays the utmost care that can be devoted to it.

FIGURES IN LANDSCAPES

There are some landscape subjects that appear quite complete without figures of any kind; in fact, in some cases, the introduction of the smallest figure would be detrimental. Frequently, however, a landscape without figures gives the impression of a mere setting—an empty stage. It has been said that in a perfectly composed landscape there is one, and only one, correct position for a figure or figures. It is, in fact, an exceedingly difficult matter to introduce figures into a landscape with complete success. They must be neither too prominent so that they attract undue attention, nor too insignificant so that they fail to take their place in the composition. Above all, the figures must be appropriate to their surroundings; they must not only be in the picture, but of it.

The relation which figures bear to the landscape varies. They may be so unobtrusive as merely to convey a necessary suggestion of life, or they may be so prominent as to claim more attention than the actual landscape. In the latter case, they are rather figures with landscape, although the landscape is an important integral part of the whole picture. When several figures are included they should not be scattered indiscriminately, but should bear some relation to each other as well as to their surroundings. To this end it is helpful to study the character, placing, and arrangement of figures in landscapes by good artists, and also carefully to examine photographic examples in which figures have been satisfactorily introduced.

FILIGRANE

A photographic process for water-marking paper, invented by W. B. Woodbury. A gelatine relief of the design is made by the Woodbury-type process, and when thoroughly hard and dry is passed through a rolling press with the paper to be water-marked. The result is that the paper is pressed thinner in some parts than in others, the thin parts appearing much lighter. On holding the paper up to the light a water-marked image is seen. The relief can be used a large number of times.

FILM (Fr., *Pellicule ;* Ger., *Film*)

This term is applied to the surface which carries the sensitive silver salt : thus the film side of a paper or plate (Fr., *Pellicule ;* Ger., *Schicht*) ; but it has also become very generally applied to distinguish any flexible support from glass plates. The subject of flexible supports can for historical purposes be most readily dealt with by dividing it into the following classes : (1) negative paper ; (2) stripping films ; (3) cut films ; (4) roll films.

Negative paper was, of course, one of the first forms of negative material, and was introduced by Fox Talbot, in 1839, who also suggested making the finished negative more translucent by waxing it. Le Gray, in 1854, introduced the wax paper process, in which the paper was waxed prior to sensitising. In 1849, Fox Talbot and Malone took out a patent for a resin-coated paper which was used by Newton in 1850, Le Gray in 1852, and Tillard in 1854. Crawford in 1854 used collodion-coated paper, and Geoffray in 1856 impregnated paper with rubber solution, fastened it to a glass plate coated with glycerine, coated it with collodion, and afterwards stripped it. Corbin in 1858 used collodionised paper ; and Marion in 1863 also used dry collodion paper. Laoureux in 1878 used a wax paper, which was rubbed with French chalk, coated with collodion according to the bath process, and the fixed negative was squeegeed down to a sheet of gelatinised glass whilst still damp, allowed to dry, and then stripped from the glass. In 1879, Ferrier, of Paris, patented a film of collodion and gelatine, and in the same year Stebbing introduced gelatino-bromide films on a hardened gelatine skin. Palmer, of Liverpool, in 1881 produced a film of gelatine and oxgall. In 1882 Morgan, of Morgan and Kidd, introduced negative paper, and Warnerke in 1884 made paper coated on both sides with emulsion, so as to avoid the curling of the paper and negatives. In 1885 Woodbury and Vergara utilised a paper made transparent with resins, etc. ; and ordinary negative paper was produced by Wilde, of Görlitz. Eastman in 1885, Moh in 1898, Lumière, the Thornton Film Co., in 1900 (paperoid films), and Gaedicke in 1889, used thin varnished tracing paper.

Stripping films were made by Milmson in 1877, Ferran and Pauli in 1880, Thiebault in 1886, Wilde in 1887, Moh in 1898, Balagny in 1898, Hofmann in 1901, Goldbacher in 1901, the Thornton Film Co. in 1901, and Wellington in 1901. In all these the paper was prepared either with a soluble gelatine film, or wax, rubber, or resin, which allowed the finished negative to be stripped from the paper support.

Cut celluloid films were first suggested by Fourtier (France) in 1881, but Carbutt (U.S.A.) seems to have been the first to introduce them commercially in 1888, though he had made some in 1884. In 1882 Pumphrey (Birmingham) introduced a "flexible glass" support, consisting of gelatine and collodion, and Moh in 1890, and Raphael in 1892, used thin sheets of mica. Froedman in 1887 introduced a support of bichromated gelatine which had been rendered insoluble by exposure to light ; Stebbing in

1879 used a hardened gelatine film between two films of collodion; and Wilde in 1883 used insoluble gelatine and collodion. Balagny in 1886 used alternate layers of collodion, varnish, and gelatine. In recent years most plate makers have produced cut celluloid films one-hundredth of an inch in thickness.

Roll films seem to have been first suggested by Melhuish and Spencer in 1854, and by Merritt and Warnerke in England and Captain Barr in India in 1875. Barr was the first to suggest the present system of using a black material at the back of the film, which was continued beyond the ends of the sensitive material (then paper) to protect it from light. Roll celluloid films appear to have been conceived first by Goodwin (U.S.A.) in 1887, although the patent was not granted till 1898; while this patent was lying in the American patent office, Reichenbach, of the Eastman Kodak Co., applied for a similar patent, which, like Goodwin's, included the "non-curling" layer of gelatine on the back of the celluloid. Cody, of the Blair Camera Co., patented in 1894 the use of the now well-known daylight loading cartridge. Many of the manufacturers who are mentioned as making cut stripping films also prepared roll films, but the celluloid, about $\frac{1}{1000}$ in. thick, is now almost universally used.

The treatment of films, as regards development and fixing, is precisely the same as for plates. The only point to which attention should be directed is the keeping power of the emulsion when this is coated on celluloid, and though this is generally recognised to be practically limited to twelve months after coating, instances have been recorded of films—especially cut films—being fit for use after five years. This possibly can be explained by the different state of dryness of the support.

In process work, the word "film" is applied in several ways. There is the film obtained by stripping negatives. The "Lotus" film was introduced by Mawson and Swan to facilitate the obtaining, by stripping, of film negatives, these films being of hardened gelatine of substantial thickness.

The gelatine films known as "Shading Mediums," often simply called "films," have lines, stipples, or patterns moulded on their surface, so that they can be inked and the pattern transferred by rubbing down with a stylus, or by pressure with a small rubber roller.

The "Norwich Film" is a transparent gelatine film grained on one side for drawing upon in pencil, crayon, or ink, according to the degree of fineness or coarseness of the grain. By making the drawing with a greasy ink the surface can afterwards be flowed over with a non-actinic alcohol soluble varnish, which will not affect the drawing. The latter can then be washed away with turpentine, leaving the lines or granulations transparent, so that the film becomes a negative which can be printed from by any photographic process. If the film is drawn on with lithographic crayon or lithographic transfer ink, the drawing may be transferred in the usual lithographic manner by damping the gelatine and running through a press in contact with stone or zinc.

FILM CAMERA (Fr., *Chambre à pellicule*; Ger., *Filmkamera*)

In its primary sense, a camera specially designed for use with films, whether flat or in the roll. Such cameras are mostly of the hand type, and typical examples of the various kinds will be found under the heading "Hand Camera." Any ordinary camera may, however, be used with films by the simple expedient of employing a roll-holder instead of a dark-slide; or, if flat films are preferred, a suitable changing box, adapter, or film pack may be used.

FILM CARRIER (Fr., *Porte-pellicule*; Ger., *Filmrahmen*)

A kind of sheath, usually of thin metal turned over at the edges on three sides, used for holding flat films in dark-slides or in hand cameras. Some carriers are indented from the back so that the film is kept close to the front, in order to be in register with the focusing screen; others require the insertion of a piece of black cardboard between the film and the carrier. Another type of carrier consists of a flat metal back over which folds a hinged frame. The film is laid on the back and the frame closed down on it, securing itself by a clip at the edge.

The term film carrier is also sometimes applied to roll-holders and adapters for holding films.

FILM HARDENERS (*See* "Hardeners.")

FILM HOLDER (Fr., *Pince à pellicule*; Ger., *Filmshalter*)

A metal or wooden clip used to hold the ends of roll films when developing in the length. Another kind consists of a flat piece of metal turned over at two edges, to hold a short portion of film, cut from the length, flat during developing. The term film holder is also sometimes given to the roller slide, or roll-holder (*which see*).

FILM MANIPULATION

The use of films, both flat and rollable, has become during recent years more and more popular, and there has been much discussion as to whether these or plates are the more advantageous, although, results alone considered, there is no difference between them. The developers, fixers, intensifiers, etc., suitable for dry plates will suit films also, for the reason that the emulsions are the same although the support is glass in the first case and celluloid in the second.

Flat Films.—Flat films are treated exactly as though they were plates. There may be difficulty in keeping them wholly immersed in the solutions, on account of their buoyancy, which tends to make them float on the surface of the liquid, thus leading to uneven development, markings, and yellow stains. It is best first to place the required amount of developer in a dish and to slip the film face upwards into it well under the surface; or the film may be placed in a dry dish and the developer poured on. By rocking the dish the film is kept on the move, and the developer made to flow evenly over it. Some workers use a narrow wooden frame A, which tightly fits the bottom of the dish; the film is then pinned face upwards to

the frame and the developer poured on. But this method ought not to be necessary except that films tend to curl very much when wetted. The disadvantage of using a false bottom entirely of wood is that unless it fits very tightly in the bottom of the dish it may float on the surface and do more harm than good.

Cutting Roll Films.—Only when roll films are

A. Frame to fit Developing Dish
B. Dish with Two Cross-bars.
C. Dish with Roller

threaded, the whole length of film being worked backwards and forwards through the developer, which should cover the bars. In a contrivance, C, embodying the same principle, a bent rod carries a roller acting as a bar to keep the film under the developer ; with both these contrivances it is necessary to hold one end of the strip in each hand after the manner shown at F. A con-

unrolled in a proper way is there little or no danger of cutting through the images. The cutting up of a roll film before development is necessary only when each exposure is to be developed separately, after the manner of flat films. D shows the proper and E the improper method of cutting up a roll film. The roll should be held in the left hand and the end of the wound-up film pulled with the right, the black paper being on the top and the film beneath. Only one number should be unwound at a time, and when the division marks at the edges are seen (between the numbers), the film is placed in contact with the black covering paper and both cut through evenly with a pair of scissors ; by this method the paper and film are in contact and in agreement as in the camera. The wrong way of cutting up a film (*see* E) is to bring the loose white film to the top of the black paper, because when this is done the images will invariably be cut through, as the division markings will not be true. The film must be swung round below the paper, in the direction shown by the dotted lines.

Developing Roll Films.—The object of cutting

trivance on a different principle is shown at G; one end of the film is attached to a spring drum, which is made to revolve, and the film passed through the developer by alternately pulling and slackening the other end. These and other accessories are very convenient, but in their absence the following method may be adopted. A dish is filled with the developer. The whole length of film is detached from the black paper, one end is taken in each hand, and the film is passed, sensitive (matt) side downwards, through the developer, a see-saw movement of the arms being maintained, and the film passed to and fro through the developer until the whole series of images is fully developed. It is a good practice to develop the whole strip until the barest outlines are visible, and the spaces dividing the pictures can be distinctly seen ; the film can then be cut with scissors, the partly developed pictures placed in cold water, and each one developed separately in an ordinary

D. Proper Method of Cutting Film

E. Incorrect Method of Cutting Film

up films is to avoid the awkward operation of developing them in the strip form. With the shorter lengths there is, however, no difficulty in developing them whole, but when longer than 36 in. it is better to cut them up or to use one of the numerous film-developing devices on the market, which, of course, are suitable for the shorter lengths also. At B is shown a dish having two cross-bars, under which the film is

flat dish. It is advisable to keep the partially developed films on the move while in the water, as, if allowed to stand, they may remain curled up or on the surface, in which case markings and stains would appear.

Fixing.—Films may be fixed in the strip, or cut up. Even if the film is developed in strip form, it may be advisable to cut it up before or during fixing, for the sake of convenient handling ; but

opinions differ on this point. Films need more care than plates when fixing, because, should the films float on the surface of the fixer, exposure to the air will cause markings, yellow stains, etc., which cannot easily be removed. An acid fixing

G. Film on Spring Drum

F. Developing Film

H. Film held in Cork Clip

bath (potassium metabisulphite and " hypo ") is better than an ordinary fixing bath of plain " hypo," as the metabisulphite prevents stains.

Washing and Drying.—Films cannot be washed and dried in a rack like plates, and some trouble is often met with in keeping them under the surface of the water. Numerous devices have been introduced for washing films properly. A useful contrivance is shown at H ; a cork is cut in halves lengthways, after cutting a notch in the top ; then an indiarubber band is placed around the halves as shown, the whole now forming a clip. The film is inserted in the cork, which will float on the surface of the water and

I. Films Pinned up to Dry

hold the film beneath the surface. Films are best dried by pinning them, face (emulsion surface) outwards, to a shelf, as shown at I, or special clips may be used in place of pins. All flat films should be kept under slight pressure when not in use. If a film is stored in a roll, it

should always be wound sensitive surface outside, as it will then lie flatter when printing. Films are better varnished, and for wet films a borax and gum lac solution is best, but for dry films a dammar varnish may be used. (*See* " Varnishes.") By the aid of special tanks, the development of films may be carried out in daylight.

FILM PACK

A device for exposing a number of cut films successively. A holder, somewhat similar to a dark-slide, is loaded with a packet of cut films. This can be done in daylight. Projecting from the packet are paper tabs, and by pulling these out and tearing them off the films are successively brought into position for exposing, and then carried round to the back of the pack. When all the films have been exposed, the pack may be removed from the holder (still in daylight), and a fresh one substituted. This provides a convenient means of exposing an indefinite number of cut films without having to resort to a darkroom. Some cameras are made for using a film pack only, in which case the holder is usually an integral part of the camera ; but the holder or adapter is also suitable for use on other cameras interchangeably with dark slides. A special tank has been devised for the development of cut films as used in the pack, although, of course, its use is a convenience rather than a necessity.

FILM SHEATH (Fr. *Étui à pellicule, Portepellicule* ; Ger., *Filmscheide, Filmrahmen, Blechrahmen*)

A metal sheath for holding flat films in magazine hand cameras ; practically identical with certain forms of film carrier (*which see*). Ordinary plate sheaths may be used for films if a piece of black cardboard is inserted behind each film. In some patterns of hand cameras, the changing mechanism is designed for use with sheaths of a definite thickness, and will not work with thinner sheaths.

FILM STRIPPING

Films may easily be stripped from their glass supports and transferred as required, this course often being necessary when the glass of a negative is cracked and the film is undamaged. In reversing a negative for single transfer carbon or collotype work, the stripping method is also useful. If desired the film may be enlarged in course of transference, as described under the heading " Enlarging by Stripping." In cases where it is not desired to enlarge the film, the hydrofluoric acid used for stripping must be diluted with methylated spirit, which, to some extent, counteracts the tendency to expand. The following is suitable :—

Methylated spirit .	5	oz.	1,000 ccs.
Water .	1½	drms.	37·5 ,,
Glycerine .	1½	,,	37·5 ,,
Hydrofluoric acid 1—1½	,,	25—37·5 ,,	

Make this up without the acid and keep as a stock solution, adding the acid just before using. The negative to be stripped should not have been varnished, or, if it has been, the varnish must be removed before treatment. It should be noted that hydrofluoric acid attacks

glass, and any mixture containing the acid must therefore be kept in an indiarubber or ebonite cup or dish, or in a glass vessel that has been coated internally with paraffin wax (the wax is melted, poured in and out again, leaving a coating on the sides). Some sheets of waxed paper are also needed before the work of stripping can be begun, also a glass plate coated with gum or gelatine on to which the film is to be transferred, for owing to the use of a large proportion of spirit the removed film will not adhere to plain glass. Lay the negative to be stripped on a perfectly level surface, and with the aid of a straightedge, and by means of a sharp penknife, cut through the film to the glass at $\frac{1}{8}$ in. from the edge all round; then pour enough of the stripping mixture on to the film and spread over evenly with a camel-hair brush, or a piece of paper or cotton-wool. In about five minutes the film will become loose, and the narrow bands of film at the edges may be stripped away, this being a good test as to how the stripping mixture is working on the film. If after five minutes the film refuses to move, a little more acid may be added to some more of the solution, and spread over the film. No attempt must be made to hasten the loosening of the film at the edges by pulling; the acid must do all the work. When the margin comes away without the slightest resistance, it is a sign that the main film is in a state to be removed. A penknife may be inserted under one corner of the film just to see if this will come away easily from the glass. The film being still on the plate, drain off superfluous acid, and pour on more of the stripping mixture, this time without the acid. This in turn is poured off, and a sheet of the waxed paper brought down upon the loosened film, and lightly squeegeed down. The film will adhere perfectly to the waxed paper, and they can be removed together on to the new glass and squeegeed over lightly; the paper is then pulled gently away, leaving the film upon the prepared glass.

When a reversal—as regards right and left—is wanted, the film on the original negative should be transferred to a plain piece of white paper covered with the spirit mixture minus the acid; the waxed paper is then laid over the removed film, and the two papers, with the film in between, squeegeed into contact; the papers are then separated carefully, in such a manner that the loose film remains on the waxed paper; it is then transferred to the prepared plate in the manner described above, care being taken to keep the film flat and in perfect contact with its support.

Owing to objections to the use of hydrofluoric acid, many prefer to do without it, and they employ some such method as the following. The film is liable to slight enlargement, by about one-thirtieth of its length, which matters little if it has been cut round the edges in the manner already described. The negative is placed in the following bath :—

Caustic soda	.	20 grs.	23 g.
Formaline	.	20 drops	21 ccs.
Water	.	2 oz.	1,000 ,,

The formaline toughens the film, and in about ten minutes the film could, if it were desired, be rolled back with the finger. But do not do so; instead, when it appears to be loose, transfer to the following bath :—

Glycerine	.	. 60—70 drops	63—73 ccs.
Hydrochloric acid	.	50 ,,	52 ,,
Water	.	2 oz.	1,000 ,,

in which it can be entirely detached, and as it floats in the liquid either side may be attached to the new glass. In order to ensure the film sticking to its new support, it is advisable that the following substratum should be applied to the glass :—

Formaline	.	. 10 drops	1 cc.
Gelatine	.	. 4 grs.	4·5 g.
Water	.	. 2 oz.	1,000 ccs.

Swell the gelatine in the water, dissolve by heating, and add the formaline; coat the glass, allow to dry, transfer the wet film to it, press down, and allow to dry naturally. A fixed and washed unexposed dry plate also serves as a support.

Films are removed from celluloid supports by soaking in the caustic soda and formaline mixture already given, and then in the hydrochloric acid and glycerine bath; the films, slightly enlarged, are washed and transferred to glass or celluloid.

A convenient method of using hydrofluoric acid for stripping is to manufacture it as required, which can be very easily done by making a solution of sodium, ammonium or potassium fluoride, about 10 grs. to the ounce of water (20 g. to 1,000 ccs.), and acidulating with a few drops of some strong acid, such as sulphuric or nitric, applying the mixture to the negative. Hydrofluoric acid is generated and strips the film, and the solution may be thrown away when it has done its work. The dry fluorides keep well in ordinary glass bottles.

FILMOGRAPH (Fr., *Filmographe*; Ger., *Filmograph*)

The name given to an early pattern of film camera by Humphrey.

FILTER (*See* "Colour Screen or Filter.")

FILTER PAPER (Fr., *Papier à filtrer*; Ger., *Filtrierpapier*)

Paper folded into a funnel for the purpose of filtering liquids. Practically only two kinds of filter paper are known to photographers, the

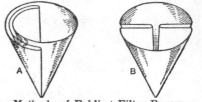

Methods of Folding Filter Papers

white and the grey, cut in circular form. They are sold in packets of one hundred, the size ranging from about $2\frac{1}{2}$ in. to 20 in., and the prices from about 3d. to 2s. 6d. per packet. There are many ways of folding such papers

into cones for fitting funnels, two of the most general being here illustrated. A shows the commonest style, the paper being first folded into halves and then into quarters; it is then placed in the funnel and one side opened out. In B the circle is first folded into halves and then laid flat again, leaving a crease to show the diameter. The ends of the diameter are then brought together and the halves opened out.

FILTER, VACUUM

A device by means of which liquid is forced through a filtering medium by atmospheric pressure.

A simple form of filter for viscous fluids, such as the fish-glue solution used by process workers, is that shown at A. A strong glass flask of about one litre capacity has a nipple connection blown into its side near the neck. To this nipple a Sprengel "pump" of glass is attached by means of a rubber tube. The construction of the "pump" is shown at B. The inner tube is not continuous, but consists of two tapering tubes,

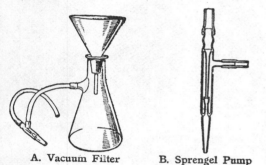

A. Vacuum Filter **B. Sprengel Pump**

one being sealed to the upper end of the outer tube and the other to the lower end, their tapered ends meeting and being enclosed one within the other for a short distance. The air drawn from the flask can thus pass between them. The vertical nozzle of the "pump" is connected with a water-tap. The rubber tubes must be tightly bound on, or they will be blown off by the pressure. The funnel containing the filtrate is thrust through a rubber bung placed in the neck of the funnel, and it is desirable to have a perforated porcelain plate in the funnel to prevent the filtering medium, which may be cotton-wool, glass-wool, or felt, being sucked down the neck of the funnel. The filtrate having been poured in, the water-tap is turned on and the rush of water through the "pump" draws the air out of the flask, creating a vacuum in it. Thus the filtrate is powerfully sucked through. It is desirable to have a clip on the tube leading from the flask to the "pump," so that the tube can be pinched when the water is turned off, or the water in the tube will be sucked back and dilute the filtered liquid.

FILTRATION (Fr., *Filtration*; Ger., *Filtrieren*)

A process used to remove from a liquid or solution any insoluble or extraneous matter. Usually an unsized, pure, porous paper is used. (See "Filter Paper.") For ordinary purposes

a small tuft of absorbent cotton-wool stuffed into the neck of a funnel will usually suffice. For filtering emulsions well-washed swansdown, or a felt filtering bag, may be used. It should be noted that developers should only be filtered—or strained, to use a more correct term—through loosely packed wool, otherwise they may oxidise. Glass-wool (finely spun threads of glass) is used for filtering collodion or corrosive liquids which would attack paper or cotton-wool.

FILTRATION, UPWARD

A method of filtration which it is convenient to adopt in the albumen process. A glass cylinder, open at both ends, has two thicknesses of washed muslin tied over one of the ends. The albumen is placed in a vessel slightly larger in diameter than the cylinder, and the latter is then lowered into the vessel, muslin end downwards. The weight of the cylinder forces the albumen solution to pass upwards through the muslin into the cylinder.

FINDER, VIEW (*See* "View Finder," "Direct Finder," "Iconometer," etc.)

FINGER - PRINT PHOTOGRAPHY (Fr., *Photographie à marque de doigt*; Ger., *Fingerspur Photographie*)

The photography and systematic registration of finger-prints has become of immense importance in the detection of crime. The methods employed may be divided into two classes: (1) those used when the individual whose finger-prints are to be examined or registered is present to give more or less voluntary assistance; and (2) those in which the finger-prints have been involuntarily left behind by their originator. The procedure adopted at New Scotland Yard under the first circumstances is very simple. The best black printers' ink is spread in a thin, even film on flat tin-plate or copper by means of a roller. The finger to be recorded is pressed down lightly and steadily on the film of ink, taking care not to move it sideways at all. After a few seconds the finger is raised and pressed down on a smooth white card or paper, when a sharp, clear impression should result. This is known as a "plain" impression. Another kind is obtained by placing the bulb of the finger on the inked slab, facing to the left, and turning it gently over until it faces to the right. The finger is then pressed gently on the paper, rolling it from left to right as before, thus making what is called a "rolled" impression. With an unwilling subject, trouble may arise from the finger being deliberately moved.

For experimental work, a good substitute for the above method is allow a drop of printing ink to fall on a smooth card or glass, and to spread it out with a finger. Finger-prints on white paper may be photographed on a photo-mechanical plate, giving a short exposure to secure contrast and developing with hydroquinone. Prints from the negatives may be made on gaslight paper. Another and quicker way is to have the inked finger pressed on a clean sheet of glass instead of on paper. Several thicknesses of gummed paper in strips are then stuck on the glass at the sides, and it is placed in a printing frame. In the dark-room, a slow, ordinary

plate, backed, is laid film side downwards on the glass, the gummed strips serving to protect the film from the still wet ink. Having inserted the back and fastened the frame, an exposure of about half a second is given at two feet distance from a fish-tail gas burner. This may be done by turning down the gas to an almost invisible blue point, holding up the frame, and then turning the gas up and off as rapidly as possible. On development with hydroquinone a good sharp negative should be secured. The frame must, of course, be kept still. The prints here shown were obtained from negatives made in this way; A, B, C, and D are finger-prints, E and F being thumb-prints. A and B are from the same finger at different times; the lines will be found to tally, and the mark of a slight cut at X is plainly seen in both.

If, however, the finger-prints have to be searched for patiently and carefully, and are eventually found in awkward places, on un-

Another class of finger-prints which call for great care, since the record is so easily disturbed and lost, are those in dust. If on a dark surface, these are readily photographed with a direct front lighting. When they occur on a window-pane or other colourless glass, a dark background should be placed at the back, a short distance away, and the light should come obliquely from behind. In rare cases semi-invisible finger-prints may sometimes be rendered conspicuous by chemical treatment, if there is any idea of the occupation of their suspected producer. Thus, for example, a tanner fresh from work might reasonably be expected to leave traces of tannin in his finger-prints, which, under favourable conditions, could be rendered black by treatment with a solution of a ferric salt.

It is found that a solution of silver nitrate, of say 6 per cent. strength, will occasionally cause the appearance of an unsuspected finger-

Finger and Thumb Prints

favourable surfaces, and in all probability faint and nearly invisible, the work becomes much more difficult. When trouble arises owing to any unusual colour of the ground on which the finger-print occurs, an orthochromatic plate must be used in conjunction with a suitable colour filter, to secure contrast, each case being treated, of course, according to its particular requirements.

The majority of involuntary finger-prints are greasy ones. To photograph these, if on a light surface, such as china, enamelled furniture, etc., they should be dusted lightly with dry, finely powdered plumbago or graphite; a flat, broad camel-hair brush is charged with a little of the powder, and, holding this a short distance above the finger-print, the handle is tapped gently with the forefinger of the disengaged hand. Or, instead, the hand holding the brush may be nudged or shaken. The surplus powder is carefully blown away with a small bellows; on no account should the breath be used. Greasy finger-prints on a dark surface—old oak furniture or black ironwork, for instance—may be treated in the same manner, using, however, dry, finely powdered whitelead instead of the plumbago.

Finger-prints in blood on a dark surface should be placed where there is no extraneous light, as in a cellar or dark room, and lit from the front with magnesium ribbon or the electric arc, of course screening the direct rays from the lens of the camera.

print on ordinary paper, or will intensify a semi-invisible one.

FINGER TIPS OR STALLS (Fr., *Doigtiers*; Ger., *Fingerlinge*)

Rubber sheaths, like the tips or fingers of gloves, worn when developing, working in wet collodion, sensitising with bichromate, etc., to protect the fingers from staining and as a safeguard against the entrance of poisonous chemicals into cuts or wounds.

FINISHING PHOTOGRAPHS

Photographs are frequently finished with crayon or water-colour, and of recent years, the aerograph (*which see*) has been extensively employed for the purpose, this providing an easy means of introducing soft backgrounds. While details of the actual methods will be found under the heading " Working-up Prints," it may be said here that photographs to be finished by hand should be on matt paper, as otherwise the touching-up shows prominently. Ordinarily, the medium (generally water-colour) should match the tone of the print, but for photo-mechanical reproduction this is not necessary. The aim in finishing a photograph should be to strengthen or to modify as may be necessary, and not to introduce work that is not of a photographic character; this naturally forbids all outlining.

In process work, many special considerations have their bearing upon the extent of the

finishing and the methods employed. Much information is given in the article under the heading " Aerograph," and further notes of a practical character will be found at " Working-up Prints."

FIRELIGHT EFFECTS

Effects represented in photographs appearing to have been taken by the fireside and by the light of the fire. Firelight is too weak to illuminate the sitter for photographic purposes without an undue exposure, and artificial aids are necessary. Daylight is the most satisfactory light for the purpose, and the illustration shows the method employed by H. Essenhigh Corke. A suitable window is selected and blocked up with brown paper or other opaque material, leaving, however, a space about 2 ft. square, the bottom of which should be level with the top of a table or platform arranged close to the window. The light admitted by the space is the " firelight," but the space itself does not show in the photograph. A fender and hearthrug may be arranged

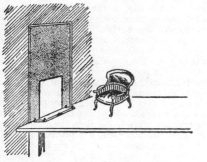

Arrangement for Firelight Effects

to make the deception more complete, loose tiles or wallpaper with a tiled pattern being placed in the fender. The sitter should be placed as near to the " fire " as possible, so that the light may be concentrated upon him. A dark background should be used.

Firelight effects may be taken at night by the aid of magnesium. Throwing magnesium powder into a real fire is rarely satisfactory, and a better way is to use a magnesium lamp in an empty fireplace, firing the powder when all is ready for exposure. Any other lights in the room may be left on, as the average artificial light will do no harm. In some cases it will be advisable to use a weak supplementary flash in the room in order to assist the very deep shadows. If there is a good draught up the chimney no magnesium smoke will escape into the room and show in the picture, but if the draught is poor it will be well to fit a sheet of plain glass in the fireplace, in such a way as to trap the smoke. The finished print should be stained with an aniline dye of a suitable tint, so as to give it a firelight colour, and various experiments in toning may be tried.

FIRES, PHOTOGRAPHING

The domestic fire is an awkward thing to photograph satisfactorily, owing to the moving smoke and the non-actinic colour of the red-hot coals. The best effects are obtained by allowing the fire to burn as bright and as smokeless as possible, and then scattering a little saltpetre on it.

The photographing of conflagrations is, in daytime, no more difficult than ordinary landscape or architectural work, the only precaution necessary being, in addition to getting out of the way of firemen and water, to take up, if possible, a position on the windward side, in order that the smoke blows away from the camera and appears more or less as background. Large fires at night generally give out sufficient light to allow of brief exposures.

FIREWORKS, PHOTOGRAPHING

Fireworks really photograph themselves when once the camera is ready. A stand camera must be used, or a hand camera fixed upon some suitable support, as it is impossible to hold a camera in the hand still enough for the necessary exposure. The camera must be focused for what is known as " infinity " ; this is best done in daylight by focusing some distant object and fixing the camera at that focus or making a mark on the baseboard, so that the lens may be put in position at night when there is little or nothing to focus. When the firework display begins, the camera is set up in the required position, and the first few rockets looked at on the focusing screen in order properly to judge the correct position. The plate is then inserted and a time exposure given—a minute or more, as desired, or until a sufficient number of discharges has been obtained on the plate. Only one or two fireworks on a plate would look very mean, and it is better to get a good number of discharges, not interfering to any extent with one another. As large a stop should be used as possible, and a rapid plate, backed so as to prevent halation, although with small stops and slow plates some of the very bright rockets may be obtained. The curves taken by rockets in their ascent are very graceful, and care should be taken to get far enough away to include them when they are high and burst. The plates are developed as usual, care being taken not to under-develop, but to secure as much contrast as possible. Firework exposures frequently appear disappointing when in the developer, and the plate may seem to be slow in developing and to lack density, but such exposures generally fix out well. Printing should be deep, so as to get a black background.

FISH, PHOTOGRAPHING

This is a branch of Nature photography offering a field of peculiarly interesting work. The most important part of the outfit is a good stand camera, with a modern anastigmat, working at $f/6$. Isochromatic plates should always be used, where possible, in conjunction with a compensating filter (isochromatic screen). The size of the aquarium or tank, in which the fish are to be placed for photographing, must necessarily be governed by the predominant size of the subjects. It is a great mistake to have too large a tank, for it will cause needless labour and trouble, but at the same time it must be kept in mind that unless the fish has ample room to move freely, it will become alarmed, and will certainly

assume unnatural positions, while in its struggles to escape from its cramped surroundings it may injure itself. The photographic tank should have all four sides of glass, so as to admit as much light as possible, and one of the long sides must be of good " patent plate " glass free from scratches, air-bells, and other blemishes, which would show in the photograph, as it is through this side that the photographs will be taken. This tank should be kept purely for photographic purposes, and not used as a regular stock aquarium, and must be kept perfectly clean inside and out. Cleanliness is most important. The water with which the photographic tank is filled should first be strained through a piece of linen, so that there are no floating particles. The fine shingle used for the floor must be well washed before being placed in the tank, to rid it of mud and fine sand. The plants must for the same reason be well washed; their roots may be cut away, and the base of the stems weighted with a strip of soft lead folded round and embedded in the shingle. It is as well to place the plants rather towards the back of the tank, as otherwise they are apt to get in the way and partially obscure the subject to be photographed. The subject itself will generally be found to look all the brighter and better for a gentle sponging to clean off any dirt that has deposited in the natural slimy secretion with which the body may be coated. The photographic tank should be placed in such a position that as good top and side lighting as possible are obtained. The camera should be placed directly in front of and at the centre of the long side of the tank that is fitted with the " patent plate." This glass must be perfectly clean and free from smears. It is a good plan to keep a soft washleather specially for the purpose. Instead of introducing plants into the photographic tank, a plain tinted background may often be used with advantage. If plants are used, care must be taken to select only those which would be found growing in the favourite haunt of the particular fish to be photographed, otherwise a most unnatural effect will be produced. Fanciful or elaborate backgrounds should never be employed, as they only serve to distract the attention from the fish, and produce a very artificial effect.

Before attempting to photograph a fish, it should be kept under observation for some time in a roomy, well-oxygenated aquarium, so that its habits and characteristic positions may be studied and noted down. When first placed in the photographic tank, the fish will probably dash wildly about, sink to the bottom, and skulk away into the corners. It is no use attempting to begin photographic operations until the fish has got over the fright of being transferred from the stock aquarium to the photographic aquarium, and has become somewhat accustomed to the strong light illuminating the latter. F. M-D.

FISH-EYE CAMERA (Fr., *Chambre à œil de poisson* ; Ger., *Fischenauge-kamera*)

J. Alan Stewart, M.A., has published a method of obtaining photographs resembling the views that would be seen by the eye of a fish. Objects against the light of the sky are only perceived by the fish when they fall within the limits of a right-angled cone, whose apex is at the fish's eye, while the base is a circle on the surface of the water, of a little larger radius than the depth of the fish. To produce a photographic imitation of these conditions, a box having a pinhole instead of a lens was employed. Although light-tight except to rays entering by the pinhole, the box was not watertight, but admitted water freely. The sensitive plate was placed 5 in. from the pinhole and the camera was immersed in a larger box filled with water, the exposure being then made on an object—a phantom minnow, for example—3 or 4 in. below the surface of the water in the exterior vessel. An isochromatic plate was used, satisfactory results being obtained with five minutes' exposure in bright sunlight.

R. W. Wood advises the following procedure : A small pail is taken, and into this, rather over half-way up, is fitted a metal disc having a perforated pinhole. The photographic plate is laid at the bottom of the pail in the dark-room, and the pail is filled with clean water, both above and below the metal disc. The pail, which is now practically a camera, is stood on the ground and covered with a sheet of glass, which must touch the surface of the water, so that air does not come between—this preventing ripples. Very interesting vertical pictures may be made with the apparatus. To work horizontally (in the manner in which a fish would observe things through the sides of an aquarium), a watertight box is made, with an opening in one end. A piece of looking-glass is then taken, and a pinhole is made in the film of amalgam on the back, the glass being then cemented over the opening in the box with the unsilvered side outward. In the dark room, a plate is inserted, the box filled with water and the cover replaced. A little more water is added, through a small hole provided for the purpose, in order to displace any air that is present. Some remarkable results are obtained with this camera, which will photograph objects close to the tripod, besides those nearly due right and left, and directly overhead. Naturally, there is a certain amount of distortion, especially at the margins of the view.

FISH-GLUE (Fr., *Colle de poisson* ; Ger., *Fischleim*)

The product obtained by boiling fish-skins and other waste remaining from fish-curing, and manufactured principally at Gloucester, Mass., U.S.A. The glue thus procured is permanently liquid, and in a more or less viscous form. It is largely used by photo-engravers for the enamel, enameline, or fish-glue process, but for this purpose it is clarified by boiling with albumen. The glue is preserved with oil of wintergreen.

FISH-GLUE PROCESS

This is described under the heading of " Enameline," by which name it was originally introduced as a secret process.

FITCH-HAIR BRUSH

A brush made from the hair of the polecat.

FIXED-FOCUS CAMERA

A camera in which the relative positions of lens and plate or film are fixed. Such cameras

are usually of a cheap class, although some of the smaller ones are fitted with lenses of high quality. The advantages of a fixed-focus camera are mainly simplicity and readiness for work at a moment's notice. These cameras are frequently fitted with supplementary lenses, or magnifiers, which permit of near objects being focused at fixed distances, usually 3, 6, 9 and 12 ft.

FIXED WHITE (See " Barium Sulphate.")

FIXING

The term " fixing " is a misnomer, as, instead of making permanent something that is desired, it removes something that is not desired, and which, if left in the negative or print, would seriously impair it. Fixing, in photography, means the removal of any sensitive salt unacted upon by light, or by the developer, thus rendering the negative or print unalterable by the further action of light. The quantity of silver reduced (developed) in a negative bears a very small proportion to that originally in the plate—very small both in film depth and surface measurement, only the highest lights going all the way through the film, while in the shadows and darker parts little more than the surface is touched. Thus in the average developed film there remains a large proportion—estimated at 75 per cent.—of unaffected silver bromide which must be removed before the negative can be examined with safety in daylight, or be used for printing.

Several substances possess the property of dissolving this unreduced silver. Sodium hyposulphite has the greatest solvent action except ammonia, which for many reasons it is not advisable to use. Although many solvents of silver are known, ammonia, potassium cyanide, and sodium hyposulphite (better known as " hypo ") are the most notable. Ammonia, however, is not practicable, because to remove the superfluous silver quickly a very strong solution must be used, and such a solution seriously damages a gelatine film. Potassium cyanide, though used as a fixer for wet plate and ferrotype work, is too expensive for modern dry plates and papers, and in addition is undesirable because of its exceedingly poisonous nature and its liability to eat into the half-tones. The colour of the negative after fixing with cyanide is by reflected light whiter than when "hypo" is used, but by transmitted light, as when printing, it is browner and consequently more actinic. All things considered, however, it is not so good as " hypo." It was in the year 1819 that Sir John Herschel discovered in sodium hyposulphite a solvent for unreduced silver, but the first use of it is credited to J. B. Reade, who in 1837 made the first fixed silver prints from paper negatives. " Hypo " was at that time a very rare salt, and expensive, costing about half a crown an ounce ; in 1845 it dropped to 6d. per ounce, in 1857 to 6d. per pound, since when it has become very cheap indeed.

The usual procedure in fixing negatives is to place them film upwards in a flat dish filled with the " hypo " solution, but while such a method serves very well, particularly when the solution is frequently agitated, the work is performed

more quickly and efficiently if the plates are held vertically in the solution, which should be in porcelain tanks (as B), or lead-lined zinc tanks. These tanks must be deep and formed with a ridge in the bottom (see B), on which the plates rest while the grit and other impurities settle below them. Plates fixed in flat dishes often appear correctly fixed except for small white (unfixed) patches caused by impurities resting on the film,

A. Wooden Tank B. Porcelain Tank

and preventing the action of the " hypo." In a vertical tank a dozen plates may be fixing at one time, and take up but little room. When a flat dish is used the plate should be film side down, but not with the film in contact with the dish, and then impurities cannot easily attach themselves to the film ; even this is not so good as vertical fixing. A shows a form of dish for fixing plates upside down ; the long V-shaped wooden trough, covered with pitch or made waterproof and watertight in some other way, is filled with the fixing solution, and the plates rested on the sloping sides film side downwards. An advantage of such a dish is that it may be used for any and all sizes. Such a dish is more cumbersome, and takes up more room, than a vertical trough.

It is not necessary to deal here with the composition of " hypo " fixing baths, as formulæ have been given under the headings " Acid Fixing Bath " and " Alkaline Fixing Bath." While fixing is apparently the simplest of all photographic operations, it is frequently done in an inefficient manner, thus leading to many failures. A common mistake is to remove the negative or print from the " hypo " solution too soon. A negative is not fixed the moment the silver appears to be dissolved away and the plate clear. The process of fixing with "hypo" includes two distinct and important functions. The first is the formation of a double salt of sodium hyposulphite and silver by the reaction of the creamy white silver bromide with the " hypo," at which stage the negative is clear and apparently fixed. The double salt so formed is insoluble in water, and therefore cannot be removed by any amount of washing ; it cannot be seen, and the negative appears perfect and ready for washing and drying, but if washed and dried at this stage the double salt will on exposure to light appear in due course as a yellowish stain, and in time the image will fade more or less to an extent corresponding to the amount of the double salt in the film. The second function is the dissolving away of the detrimental salt first formed. Although insoluble in water, a longer soaking in the " hypo " solution converts it into another double salt that water will easily remove ; hence the absolute necessity of leaving

the developed plate in the fixing bath for an additional time after the plate appears to the eye to be fixed and clear. Ordinarily, the proper length of time to secure perfect fixation is double that taken by the white substance to dissolve. Thus, for example, if it takes ten minutes' immersion in the " hypo " bath to clear away the last traces of the silver bromide, the plate must be allowed to remain for another ten minutes in order that fixation may be complete.

Some workers advocate a second fixing bath rather than a prolonged soaking in one bath, but if the first bath is fresh, properly mixed, and of the correct strength, a second fixing bath should be quite unnecessary. If the fixing bath is so weak or so loaded with impurities that it is unable to perform its work, it should be discarded, as it is in a condition to do harm a second bath cannot correct.

Where a variety of developers are in use, and if no care is taken to wash the plates thoroughly free from developer before placing them in the fixing bath, there is a possibility of trouble arising if the same bath is in use for all plates ; but there is quite as much risk of having the transparency of the gelatine impaired by failure to wash off the developer even when a freshly made bath is used.

A common mistake is to employ " hypo " fixing baths too strong. The silver bromide is less soluble in, say, a 50 per cent. solution than in a 25 per cent. solution. The latter, 4 oz. of " hypo " to 16 oz. of water, is a suitable strength for films and plates, but for papers half or even a quarter strength will serve. When a very weak " hypo " bath is used, the double salt referred to is likely to remain in the film, because there is no excess of " hypo " to act upon it. The bath should not be weaker than 1 in 5 for plates and 1 in 10 for prints. A fixing bath made of the usual strength, the ingredients being properly weighed or measured and not taken by guesswork, and used in sufficient quantity to cover the plate, will contain an excess of " hypo " that will act upon the double salt if time enough be given.

A solution of " hypo " will not attack the actual image which has been developed so long as the plate is well covered with the solution, but when a negative wet with the fixing bath is exposed to the air, the " hypo " in solution, in conjunction with the oxygen of the air, does attack the developed (reduced) silver which forms the image, with the result that the negative becomes thinner. This action is not very rapid, and no appreciable harm is done when the negative is taken out of the bath for examination, and a reasonable time may elapse before it is placed in the washing water ; but irreparable damage is done when the plate is left in the fixing bath, or in the washing water after fixing, only partly covered with the liquid. The covering of the plate with a solution of " hypo " and glycerine, and leaving it exposed to the air, is, in fact, a little-used method of reducing.

As regards the exhaustion of the fixing bath, Messrs. A. and L. Lumière carried out some experiments (published in February, 1907), and found that, to avoid subsequent yellowing of negatives on modern gelatine plates, it is advisable (1) to fix not more than one hundred 9 by 12 cm. plates in one litre of 15 per cent solution of " hypo " (this is roughly equal to about 120 quarter-plates in 35 oz.) ; (2) to fix not more than fifty of such plates (sixty quarter-plates) in one litre of a 15 per cent. fixing bath, plus 1·5 per cent. of bisulphite ; (3) to fix not more than seventy-five plates (ninety quarter-plates) in one litre of a 15 per cent. fixing bath plus 1·5 per cent. bisulphite and ·5 per cent. chrome alum. The moment when the fixing bath is used up and should be thrown away can be determined by placing a drop of the bath on white paper, and exposing for some time to light and air ; if the spot turns brown, the bath is exhausted.

The function of the fixing solution is the same for prints as for negatives, although the silver salts may differ chemically and may be attacked under different conditions. The porous paper allows the " hypo " to act on both sides of the film, but this is more than counterbalanced by the larger amount of water that must be displaced before the " hypo " can begin its work of dissolving the silver bromide.

While, on the whole, a plain solution of " hypo " is sufficient for the fixing of negatives and silver prints, several additions have from time to time been recommended, some with a view to hardening the film and so prevent frilling and blistering, others to prevent or remove stains from the film, and still others to keep the solution itself from being discoloured in cases where it is employed over and over again. The most harmful, and at the same time the most frequently recommended, addition is common alum, which decomposes the " hypo," liberating sulphur, and forming injurious compounds that may possibly interfere with the fixing, and lead to degradation of the negative or print.

As the result of a series of experiments, Messrs. Haddon and Grundy have stated that the best strength at which to use a " hypo " bath is 10 per cent., and that such a bath will at a normal temperature completely fix a print in ten minutes. As to the exact amount of " hypo " to be used for each print, this depends on many circumstances, but on an average 2 oz. of " hypo " dissolved in 20 oz. of water will thoroughly fix 420 sq. in. of print—that is, one sheet of paper 24 in. by 17½ in., equal to about thirty quarter-plate prints or about ten or eleven half-plate prints. Otherwise stated, it requires approximately from 80 grs. to 90 grs. of " hypo " in the form of a 10 per cent. solution to fix a half-plate print at normal temperature, immersing the print for ten minutes.

In process work, wet collodion negatives are invariably fixed in potassium cyanide, the usual formula being 1 oz. of 30 per cent. cyanide in 20 oz. of water.

FIXING BEFORE DEVELOPMENT

It has been found that whatever the action of light may be on the sensitive silver salts, the result is such that it is not destroyed by fixation ; and it has been suggested that when on tour it may be convenient or safer merely to fix the exposed plates and then develop them on the return home. In such a case the developer is a physical one, and the most satisfactory is that given on the next page.

A. Ammonium sul-
phocyanide . 2,304 grs. 240 g.
Silver nitrate . 384 ,, 40 ,,
Sodium sulphite . 2,304 ,, 240 ,,
" Hypo " . 480 ,, 50 ,,
Potassium bromide 57 ,, 6 ,,
Distilled water to 20 oz. 1,000 ccs.
B. Metol . 144 grs. 15 g.
Sodium sulphite . 3 oz. 150 ,,
Distilled water to 20 ,, 1,000 ccs.

For use, mix 6 parts of A with 54 parts of water, and add 30 to 40 parts of B. As a practical process this is hardly worth trial, as the exposures must be at least four to six times longer than usual.

FIXING BEFORE TONING (*See* " Toning after Fixing.")

FIXING, COMBINED DEVELOPING AND (*See* " Developing and Fixing Combined.")

FIXING, COMBINED TONING AND (*See* " Toning and Fixing Combined.")

FIXING, DEFERRED

A process for treating a negative after development so that fixing may be carried out later. The method is largely used by tourists who desire to see whether exposures have been correct, but who do not wish, for the time being, to go to the trouble of fixing and washing. The plate is developed as usual, washed for about five minutes, and placed in any one of the three following baths, thus rendering the developer inert :—

(1) Potassium bromide $\frac{1}{2}$ oz., water 5 oz.
(2) Alum $\frac{1}{2}$ oz., citric acid 30 grs., water 5 oz.
(3) Cadmium bromide $\frac{1}{4}$ oz., alcohol 5 oz.

In hot weather add 15 drops of formaline. Five to ten minutes' treatment is sufficient. The safest bath is the bromide bath (No. 1); should the alum bath (No. 2) be used and the plate not be properly washed, ugly stains may appear. With formulæ Nos. 1 and 2, a slight rinsing after the " deferring " bath is necessary, the plate being then dried and fixed at leisure. The advantage of the cadmium bath (No. 3) is that the plate need not be washed either before or after treatment, and the alcohol serves to dry the plate in a very few minutes. Daylight does not injure negatives temporarily finished in this way, and they may even be printed from, preferably upon bromide or gaslight paper.

FIXING WITHOUT TONING

All printing-out papers do not need toning, and in some cases good colours may be obtained by fixing only. (*See* " Self-toning Papers.") Plain salted paper fixes out a pleasing sepia colour, if not too heavily sized. Paper prepared with silver chloride alone comes out of the fixing bath a blue colour, while if the organic salt is chiefly used a foxy red results. A combination of these two colours in right proportion results in a pleasing tone on fixing. Effective red tones may be obtained on ordinary matt P.O.P. by fixing without toning. Printing should be deeper than usual, and the prints washed well before fixing, in order to remove the free silver.

FIXING-HARDENING BATHS

Solutions for hardening the films of plates and papers and at the same time fixing the image. Their use does not yield such permanent results as the use of separate fixing and hardening baths. (*See* " Hardeners.") The best known formulæ are :—

Alum " Hypo "

Alum (saturated sol.) 20 oz. 100 ccs.
Sodium sulphite (sat-
urated solution) . 6 ,, 30 ,,
" Hypo " sol. (1 in 5) 20 ,, 100 ,,

Chrome Alum " Hypo "

Add—

Strong sulphuric acid 60 drops ·1 cc.
Water . . . 2 oz. 50 ccs.

to—

Sodium sulphite . 2 oz. 50 ccs.
Water . . . 6 ,, 150 ,,

and pour the mixture into—

" Hypo " . . . 16 oz. 400 ccs.
Water . . . 48 ,, 1,200 ,,

Finally add—

Chrome alum . . 1 oz. 25 ccs.
Water . . . 8 ,, 200 ,,

" Hypo " Acid Sulphite

" Hypo " (in powder) 1 lb. 250 g.
Sodium acid sulphite 2 oz. 32 ,,
Water . . . 64 ,, 1,000 ccs.

The second and third baths, being in an acid condition, must not be used for printing-out papers, and are suitable only for plates and bromide and gaslight papers. The " hypo " and plain alum bath may, however, be used after toning. Another form of fixing-hardening bath, which is largely used in hot countries and in England during hot weather, is the following :—

Sodium hyposulphite . 2 oz. 220 g.
Potas. metabisulphite $\frac{1}{4}$,, 28 ,,
Chrome alum . . $\frac{1}{4}$,, 28 ,,
Water . . . 10 ,, 1,000 ccs.

First dissolve the "hypo" in 5 oz., half of the water made hot, next the metabisulphite in half the remaining water (cold), and add to the " hypo " mixture; lastly dissolve the chrome alum in the remaining water (cold), and add to the hypo-metabisulphite mixture. Careless mixing causes turbidity, whereas the solution should be clear and of a greenish colour. The above being acid is suitable for negatives and bromide and gaslight prints, but not for P.O.P.

FLAKE WHITE

Basic lead carbonate, used as a white pigment for retouching photographs, etc.

In process work, flake white has been superseded by other pigments, and is now seldom used for retouching photographs for reproduction owing to its tendency to become yellow. The more modern white pigments employed, such as albanine, ullmanine, blanc d'argent, etc., are described under their respective headings.

FLAP SHUTTER (Fr., *Obturateur à volet ;* Ger., *Klappverschluss*)

A shutter in which the exposure is made by the rise and fall of a hinged flap. In an early pattern, the flap was actuated by an elastic band stretched from the upper part of the shutter over

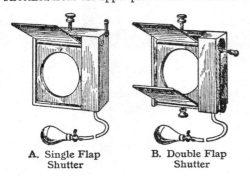

A. Single Flap　　B. Double Flap
　　Shutter　　　　　　Shutter

a peg or projection at the bottom of the flap, the latter being released by depressing a catch. The flap fell again by its own weight. This kind of shutter is now seldom seen, except in studio apparatus. A greatly improved modern pattern, arranged to work noiselessly by the pressure of a pneumatic ball, and remaining open as long as the ball is pressed, is illustrated at A. The catch seen on the right is to keep the shutter raised during focusing or for time exposures, by engaging with a bent wire. A double flap shutter is shown at B. Another form of flap shutter is really nothing more than a hinged covering for the lens, lined with velvet and worked by means of a rod projecting outside the camera. With this, however, exposures sufficiently quick for studio work are readily given.

FLARE SPOT

A light patch usually near the centre of a photograph, and caused by internal reflection in the lens. It may usually be obviated by altering the position of the diaphragm, so that the reflected light becomes evenly distributed over the entire field. One form of flare takes the shape of a well-defined inverted image of a window, portion of sky, or other bright object. This is usually termed a " ghost " and may be obviated by the method above indicated. Flare usually appears when using a small diaphragm ; hence many lenses which work satisfactorily down to $f/16$ exhibit flare when stopped down to a smaller aperture. (*See also* " False Images.")

FLASH LAMP (Fr., *Lampe éclair ;* Ger., *Blitz-lampe, Magnesiumlampe*)

In its original sense, a lamp for burning magnesium powder, which is blown through a spirit or gas flame. A simple type of flash lamp may be made as shown at A, with a short metal pipe bent to a right angle and surrounded with cotton-wool soaked in methylated spirit. A charge of powdered magnesium is placed in the pipe, and the free end is attached to a rubber tube terminating in a ball. The spirit is then lit, and pressure on the ball at the desired moment drives the magnesium into the flame and ignites it. A number of such lamps may be arranged

to flash simultaneously by connecting all the pipes to a single large ball, a pair of bellows, a bicycle pump, or an air reservoir. It is always preferable, when extra light is desired, to use several lamps, rather than to increase the charge of powder in a single lamp ; as, in the latter

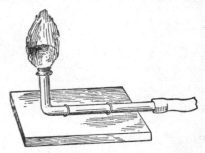

A. Simple Type of Flash Lamp

case, much of the powder may simply be driven through the flame without being consumed, and so be wasted. Flashlight mixtures should on no account be used in enclosed lamps ; these are only suitable for plain magnesium powder. A popular commercial flash lamp of the enclosed type, which gives either an instantaneous or a continuous flash, is shown at B. To use this, the metal chamber is half filled with magnesium powder, and about an ounce of methylated spirit is poured into the vessel holding the wick, taking care that none gets into the discharge orifice or over the sides of the reservoir. The rubber tube is then closed by means of the spring clip, and the bladder is inflated until it fills the net. The wick having been lit, a flash of the required duration can now be obtained by pressing the clip. After exposure, the flame is extinguished by replacing a metal cap.

The term flash lamp is now also used for open arrangements in which a flashlight mixture, consisting of magnesium powder mixed with potas-

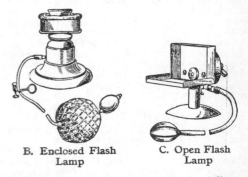

B. Enclosed Flash　　C. Open Flash
　　Lamp　　　　　　　　Lamp

sium chlorate, or other detonating ingredients, is burnt in a metal tray or pan, by means of a fuse which is operated from a small accumulator, the mechanical striking of a match or percussion cap, or other means. A typical flash lamp of the open type is illustrated at C. The ignition of the powder is obtained in a somewhat novel fashion. A milled disc of a special pyrophorous or spark-giving metal is caused to rotate against a similar

metal surface by means of a coiled spring, thus giving off a small stream of sparks as it revolves. The spring is wound up by a key and the powder is spread on the tray around the milled disc, when pressure on the pneumatic bulb at once starts the mechanism and ignites the flash mixture. For professional flashlight purposes, longer trays are commonly used, the powder being laid in a thin, heaped-up line. The lamp is raised to a suitable height by a jointed metal rod attached to a stand ; and a screen or cover of muslin, or other light, translucent material, is supported on a frame over the tray to diffuse the illumination.

FLASHLIGHT CANDLES (*See* " Candles, Flashlight.")

FLASHLIGHT PHOTOGRAPHY

The taking of photographs by means of flashes of artificial light, the light being generally produced by burning magnesium or flashlight mixtures. Magnesium was made known in 1808 by Sir Humphry Davy, but for half a century or more it was regarded as a curiosity. In 1859 Bunsen, of Heidelberg, and H. E. Roscoe, of Manchester, pointed out the value of magnesium as a source of light for photographic exposures. Improvements in the manufacture of the metal took place (a company being formed in Manchester for the purpose in 1863), but its expensiveness (magnesium in the form of ribbon then cost half a crown per foot) kept its use restricted. A. Brothers, of Manchester, has been credited with taking the first successful photographs with magnesium, for early in 1864 he obtained a stereoscopic negative of a Derbyshire mine, and in May of the same year a portrait of Prof. Faraday, at the Royal Institution. In the following year the interior of the great Pyramid was taken by Prof. P. Smith by magnesium light, since when the metal, in the form of both ribbon and powder, has become cheaper and consequently widely used. The light given off is of intense brilliancy and of high actinic power.

Magnesium for photographic illumination purposes may be obtained in three different forms— pure magnesium powder ; flattened wire, known as ribbon ; and a combination of magnesium and other substances, in powder. The ribbon is the safest, but does not allow of such short exposures as the powders ; however, it is commonly employed in photographing dark corners of rooms, caverns, cellars, etc., where the length of the exposure is not of much consequence, and it is sometimes useful as an accessory to daylight, as a means of illuminating objects in deep shadow, since, on account of its burning slowly, it may be moved about while the exposure is being made, and so give diffused lighting. Another advantage of using ribbon is that the actinic value of the light obtained by burning a definite quantity remains constant under the same conditions, so that by measuring the length —or, preferably, weighing the quantity—of the ribbon before burning, the photographer can easily obtain data that will assist him in making the results of later exposures sure.

For flashlight work proper—that is, for what are known as " instantaneous exposures "— the powders must be used. It is not necessary

17

to employ a shutter as in making instantaneous exposures by daylight ; in most cases the ordinary lights of an apartment are too feeble in actinic rays to affect the plate, and the lens is left open until after the flashlight. Magnesium flashes are open to objections : the quantity of smoke produced, and the difficulty of diffusing or spreading the light over a sufficiently wide area

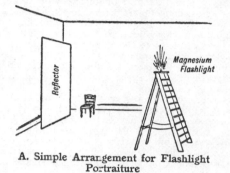

Magnesium Flashlight

Reflector

A. Simple Arrangement for Flashlight Portraiture

to obviate harsh shadows and hard contrasts. Again, there is the risk of explosion, but such an accident can scarcely occur with careful, proper firing. Pure magnesium powder gives a bright and highly actinic flash, but it must be *blown through a flame.* Flashlight powders containing substances in addition to magnesium are really explosive mixtures, and they must be ignited *by applying a light,* for should they be blown through a flame a dangerous explosion will result. A flashlight compound must not be used in a closed storage reservoir or magazine lamp, because in these the flame would travel to the bulk and explode it. Only the pure magnesium powder should be used in such lamps. For the beginner, the ribbon is the safest and the pure powder the next safe.

As regards the amount of powder to be used, this depends upon nearness of subject, stop, plate, etc., but the table given below (compiled by J. H. Crabtree) may be taken as a guide :—

Distance of main object	Size of Room			Weight of Magnesium required	
	Length	Breadth	Height		
Feet	Feet	Feet	Feet	Grains	Oz. (approx.)
9	15	6	10	15	—
15	20	6	10	30	—
20	25	10	10	75	—
25	30	12	10	120	¼ plus
30	35	12	10	180	—
35	40	15	10	230	½ plus
40	45	15	12	300	—
45	50	20	12	370	—
50	60	20	12	450	1 plus
55	65	20	12	560	1¼ plus
60	70	30	15	680	1½ plus
65	75	30	15	780	1¾ plus
70	85	30	15	900	2 plus
75	90	40	15	1020	2⅜ minus
80	95	40	15	1200	2¾
85	100	45	20	1340	3 plus
90	120	45	20	1500	3½ minus
95	125	50	20	1650	3¾
100	130	60	20	1850	4¼

The conditions assume a lens at $f/11$ and a fairly rapid plate, the exposure being so short as to be regarded as instantaneous. It is also important to bear in mind that the quantities specified must be completely burned in the flame with an ample supply of air, and not half consumed or wasted.

Lighting and Arrangement of Subject.—Success in group and portrait photography by flashlight depends chiefly upon the arrangement of the light and sitter. A frequent mistake is to have the light at too low a level; it should be at least 1 ft. above the level of the sitter's head, and not on a level with it or lower. The higher the light (in reason) the more truthful will be the effect, and the less like the generality of flashlight photographs, which are distinguished by the glaring whites of the eyes and the harsh blacks and whites. In portraiture it is a good plan to place the flash powder on steps as at A (*see* preceding page), or if ribbon is used the operator may stand on the steps and wave the ribbon about, or the ribbon may be tied to a stick and waved about on high. At B is shown the plan

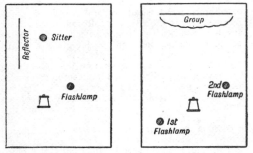

B and C. Plans and Arrangements for Flashlight Portraiture

of a suitable arrangement for taking portraits by flashlight; a reflector of white material is needed on the shady side of the face, or if there happens to be a white wall surface on that side it will serve the purpose. Whitewashed ceilings serve admirably as a top light, as they reflect downwards an enormous amount of actinic light when the magnesium is fired. The light is placed and fired at a point on one side of the camera, but slightly nearer than the camera to the figure, yet not so near as to be included in the view; the flash must not be reflected in the lens, or the plate will be fogged. By varying the positions of camera, sitter, light, etc., any number of different effects can be obtained in one room. If there is nothing acting as a reflector on the shady side of the sitter, it will be necessary to interpose a sheet of white tissue paper or muslin between the flash lamp and the subject in order to diffuse the light and obtain softness in the photograph. Frequently it is the nearness of the light as well as its low position that gives a ghostly effect to flashlight portraits. The diffuser is useful in the majority of cases, and although it stops a little of the light and may mean a few extra grains of powder, the results obtained will be softer and better. In group work, two or more lamps may be necessary, in which case one lamp should be much nearer to

the group than the others (*see* C), all the lamps being fired at the same moment. Professionals frequently employ electrical arrangements to synchronise the ignition when more than one lamp is in use. The near lamp serves as the main light, and the other as a kind of auxiliary lamp to assist generally and light up to a small extent what would be the shady side.

In flashlight photography all the gas, electric, and other lights may be left burning, as they do not much affect the plate during the extremely short exposure. If the image cannot be seen on the ground glass sufficiently distinct for focusing, the sitter or sitters can hold a candle or a lighted match on a level with the face, and the flame can then be focused. The plate is then put in, the dark-slide shutter is drawn, and the cap taken from the lens or the shutter opened, the exposure being made by firing the powder or ribbon. Only that part of the exposure made during the burning of the magnesium need be taken into consideration.

One of the great drawbacks to the use of flashlight is the immense amount of white smoke given off. All windows and doors may therefore with advantage be opened; and the smoke of one flash must be got rid of before another exposure is made. The smoke is quite harmless. Some of the patent commercial mixtures cause less smoke than others, while some of the more expensive and complicated flash lamps have smoke-catching devices. A home-made smoke-catching device is formed by placing the flash lamp in a large box stood on its end with its open side towards the subject; after exposure the lamp is immediately taken out, the box closed with a cloth or tightly fitting lid, and the whole taken to an open window or outside and emptied; but the arrangement prevents much valuable light reaching the ceiling and walls.

Outdoor work with flashlight differs but slightly from the above, but more light is required, and there is little or no trouble with the smoke. More powerful (consequently more explosive) mixtures, of the firework type, can be used, as the risk of danger to human beings is so much less.

Flashlight work is not confined to portraits, groups or evening work generally, but is of great service in illuminating dark corners in interiors, such as crypts, workshops, underground workings, etc., in the daytime. For this purpose ribbon is better than powder, but care must be taken to keep the naked light and the smoke from it out of the view of the lens, with which object the flash lamp may be fired behind a pillar or something of the sort.

Any developer will, with care, serve for developing flashlight exposures, but as there is always a risk of under-exposure and harsh contrasts, little or no bromide should be used, and the developer should be diluted with water. The following hydroquinone-eikonogen developer has been widely recommended for flashlight exposures, but metol-quinol and similar developers can be made to give equally good results:—

A.				
Hydroquinone	.	$\frac{1}{2}$ oz.	11·1 g.	
Eikonogen .	.	$\frac{1}{2}$,,	11·1 ,,	
Sodium sulphite .		$2\frac{1}{2}$,,	55·5 ,,	
Hot water to	. 45	,,	1,000 ccs.	

Dissolve the sodium sulphite, then the eikonogen, and finally the hydroquinone.

B. Sodium carbonate 2½ oz. 55·5 g.
 Hot water . . 15 ,, 333 ccs.

For use take 3 oz. of A, 1 oz. of B, and 3 oz. of water ; this forms a normal developer which should give a good negative in from eight to ten minutes.

FLASHLIGHT POWDERS

The chief two kinds of flashlight powders are (1) pure magnesium powder and (2) mixtures of magnesium and other substances. Magnesium powder used alone is blown through a flame, the brightness and duration of the flash depending upon the quantity of powder burnt and upon the length of time taken in passing it through the flame. Some arrangements for firing permit of a slow passage of the powder through the flame, in which case the light is continuous, and not an instantaneous flash ; others permit of a large quantity of the powder being passed through a flame very quickly, in which case there is frequently a risk of much of the powder being wasted.

Flashlight mixtures are explosive, and in their action behave like gunpowder ; they must not be blown through a flame, but must be placed in a heap or a ridge and the light applied, the result being a momentary flash of high actinic power. Such explosive mixtures must always be looked upon as being more or less dangerous. The addition of chemicals to the magnesium is for the purpose of increasing the rapidity of the combustion and the actinic power of the light. When such mixtures are made by the worker, the ingredients should be purchased in the powder form and then mixed carefully together on paper with a dry feather. Large quantities should never be mixed for fear of explosions, and for the same reason there should be no lumps of any kind in the mixtures. The ordinary photographer will be well advised in buying his flashlight mixtures ready prepared. Some of the best known formulæ are :—

(1) Magnesium . . 6 parts
 Potassium chlorate . . 9 ,,
(2) Magnesium . . 6 ,,
 Potassium chlorate . . 4½ ,,
 Potassium perchlorate . 4½ ,,
(3) Magnesium . . 6 ,,
 Potassium chlorate . . 12 ,,
 Antimony sulphide . . 2 ,,
(4) Magnesium . . 16 ,,
 Potassium perchlorate . 12 ,,
 Potassium nitrate . . 12 ,,
(5) Magnesium . . 48 ,,
 Ammonium nitrate . . 3 ,,
 Strontium oxalate . . 5 ,,
 Sodium oxalate . . 5 ,,
(6) Magnesium . . 40 ,,
 Potassium perchlorate . 60 ,,
 Sodium chloride (salt) . 5 ,,
 Barium tartrate . . 7 ,,

Nos. 1 and 2 are good average mixtures for home work or professional portraiture. No. 3 gives a very good light, but its fumes are poisonous, and it should therefore be used in the open air or in a well-ventilated room where the fumes can escape quickly. No. 4 burns rapidly, and is less liable to explode. No. 5 is for isochromatic plates, and a yellow screen should be used in the lens. No. 6 is for isochromatic plates, but a yellow screen need not be used.

Aluminium is said to give less smoke than magnesium, but it yields only about two-thirds of the actinic light. The following mixture of aluminium and magnesium not only gives less smoke than a mixture containing chlorate, but the smoke quickly passes away and the powder is non-explosive :—

Copper sulphate (anhydrous) 6 parts
Magnesium powder . . 3 ,,
Aluminium powder . . 1 ,,

This gives much less smoke than mixtures containing chlorate, and the smoke passes away quickly, thus allowing of a series of successive exposures in a room. (*See also* "Aluminium Flashlight.")

There are many other formulæ for flashlight mixtures, but they are similar to the above.

Great care is necessary when firing flashlight mixtures ; and when no proper lamp is used the powder is best placed on a small iron slab or tray and fired by means of touch-paper (*which see*), or by means of a long taper or of a match fixed to a stick, the operator turning his head away when the actual flash takes place.

Slow-burning mixtures may be made, the following being a typical formula :—

Magnesium powder . . 100 parts
Ceric nitrate . . 70 ,,
Strontium carbonate . . 30 ,,

Eighty grains of this powder burn in about six seconds.

Flash-sheets are made by soaking thin blotting-paper in a strong solution of saltpetre, drying, and then spreading over the paper pure dried, unoxidised magnesium powder, leaving the edges free. Such a sheet constitutes a combined slow-match and flashlight, it burning slowly until the smoulder reaches the powder, which then bursts into a bright flame. Flash-sheets are quite safe in use ; a commercial form is a mixture of fine magnesium powder and celluloid spread on glass and allowed to dry.

FLATNESS

A term applied to a print in which there is but little contrast between the lights and shadows. It is the opposite quality to brilliance. An over-exposed and under-developed negative gives a flat result.

FLATTENING PRINTS

Prints that are not dried under pressure invariably curl up. Prints on collodion paper may be dried between blotting-paper under pressure, but gelatine prints—ordinary P.O.P., bromide and gaslight papers—cannot be treated in this way, because of the sticky gelatine surface. Sometimes even collodion prints will curl badly when removed from pressure. A rough and ready method of flattening is to roll the dry prints all together film side outwards, and secure with an elastic band ; after a few hours they will be found on unrolling to be flat. A better method is here illustrated. The curled

picture is laid face downwards on a clean flat surface, and a flat ruler is then placed along one edge of the print and pressed down firmly.

Flattening Prints

Next, the whole print is drawn sharply under the ruler, as illustrated, the ruler being kept stationary. The process may need to be repeated once or twice.

FLEXIBLE SUPPORT (*See* "Temporary Support.")

FLORENTINE FRAMES (Fr., *Cadres florentins ;* Ger., *Florentinischer Rahmen*)

Ornate gilt frames with open-work foliated ornament ; suitable for photographs worked-up in water-colours, crayons, etc., when not on too large a scale.

FLOWERS OF SULPHUR (*See* "Sulphur.")

FLOWERS AND FRUIT, PHOTOGRAPHY OF

In this work success depends on the lighting, the arrangement of the subject, and the method of exposure. Flowers and fruit may be photographed indoors or out, in their natural surroundings or otherwise ; but the best results are obtained by arranging them indoors and in a suitable light. A convenient method of arranging the lighting is shown at A and B. On a table near a window on the shady side of the house the flowers (or fruit) are arranged, the background being a sheet of brown or other coloured paper, according to the tint required in the photograph. It is advisable to have papers of several different colours at hand, and to bear in mind their different photographic values. The light should come in at the window and be fairly strong, as then, by means of tissue paper over the lower half of the window and a white cardboard reflector on the shady side of the subject, the light may be controlled to a nicety. The positions of the camera, flowers, background, etc., are all subject to experiment in obtaining various effects. It is not always advisable to show the vase which contains the flowers or the means of supporting the fruit. In the case of a few blooms, they may be stood in a narrow-necked bottle in order to keep them upright, and the stalks must be long if the neck of the bottle is not to be included in the picture. Other supports include a bowl of wet sand ; bent strips of sheet lead ; and a large potato, the stalks in all these cases being long. For the purpose of picturing the

vase as well as the flowers or fruit lying upon the table, there should be no dividing line between table and background, for which purpose the paper forming the background should be brought in a gentle curve underneath the vase, etc. Even if a line would enhance the pictorial value of the picture, it should not be abrupt. The table-cloth must not be of a pronounced pattern, or of a colour contrasting too strongly with the background.

Cameras are sometimes used vertically for photographing flowers that are lying, for example, on the floor. Similar results may generally be obtained with an ordinary camera used in the usual way, by arranging the vertical background to take the fruit or floral sprays ; this may be done by using stout, stiff cardboard covered with coloured paper as the background and pushing pins through from the back, their points serving as rests and being covered by the objects photographed, although if they are not hidden they will be scarcely noticeable.

Cut flowers may be preserved for photographic purposes by sprinkling them with fresh water, and while wet placing in a vase containing the following solution : Water 4 oz., curd soap 2 drms., common salt 8 grs. The soap is cut into shreds and dissolved in the water, adding a small pinch of borax and the salt. If the flowers are to be kept for several days their stalks should be rinsed under the tap daily for a minute or so, the petals sprinkled, and the flowers put back into the vase.

The lens stop plays an important part in the pictorial rendering of flowers. $f/16$ gives general sharpness, but a smaller one may in some cases be necessary. Exposure should not be unduly prolonged, as some flowers—poppies, for example—are apt to droop during a long exposure and show signs of movement upon the plate. Isochromatic plates are the

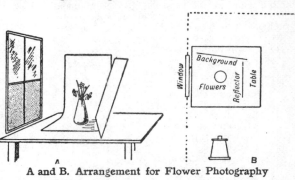

A and B. Arrangement for Flower Photography

best for most flowers, but ordinary plates may be used for some with good results, everything depending upon the colour of the flowers. For reds, blues, yellows, and various shades of green an isochromatic plate is indispensable to give the proper values of the colours. Much may be done on ordinary plates by giving a suitable exposure—that is, one sufficiently long to enable the colours of little actinic value to register themselves on the plate. E. Seymour has used a yellow screen and isochromatic plate for only about 10 per cent. of his exposures, as in

his opinion the use of a screen robs the picture of half-tone and gives an effect unsatisfactory to the observer of nature. Opinions differ, however, but there can be no doubt that to give the plate a full exposure for the deepest shadows and to develop until the highest light is of the correct density, is a thoroughly reliable method of working. In ordinary photography the goal of development is detail in the shadows, but if this is applied in flower photography, the high lights may become blocked up and too dense. Detail in the highest lights is the secret of successful flower and fruit studies ; there will always be detail in the shadows if the exposure has been sufficient. The plate should on no account be over-developed, and the following pyro-soda developer is specially recommended :—

A.	Potassium metabi-		
	sulphite . .	15 grs.	1·5 g.
	Pyro . . .	130 ,,	13 ,,
	Water . . .	20 oz.	1,000 ccs.
B.	Sodium sulphite .	2½ oz.	125 g.
	Sodium carbonate	2 ,,	100 ,,
	Water . . .	20 ,,	1,000 ccs.

For normal exposures take 3 parts of A and 1 part of B. For under-exposure, add more of B and dilute with water.

FLUID LENS

A glass shell, which may or may not have optical qualities in itself, filled with liquid. This arrangement is of considerable antiquity, and has from time to time had photographic uses. A fluid condenser made by Daguerre is still in

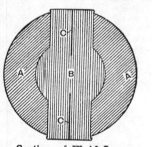

Section of Fluid Lens

existence ; while Scott Archer, Thomas Sutton, and later Dr. Grün, all constructed lenses in which liquids played an important part. With the Sutton lens (*see* illustration) an extremely wide angle was obtained, but in the Archer and Grün lenses the special object was to gain "rapidity." In the illustration, A indicates glass, B water, and C the diaphragm. The Grün lens was said to contain cedar oil.

FLUID MEASURE (*See* "Weights and Measures.")

FLUORESCEÏN (*See* "Eosine.")

FLUORESCENCE

Certain substances have the power of altering the wave-lengths of the light or electric rays which fall upon them. Such bodies, when illuminated by ultra-violet light, become visible in darkness to the naked eye by emitting yellow, green, blue

or blue-violet rays, commonly termed fluorescence. Quinine sulphate, calcium tungstate, and barium platino-cyanide are typical fluorescing substances. Many aniline dyes, particularly fluoresceïn, have considerable fluorescing properties, eosine, for instance, giving a green fluorescence. In most cases the colour of the fluorescence given by dyes is complementary to the colour of the dye itself.

FLUORESCENT SCREENS

These are largely used in radiography. They are made by coating a suitable fabric with barium platino-cyanide, calcium tungstate, or other substances which fluoresce when exposed to X-rays. These screens, when used in a dark chamber, permit of the visual examination of objects placed between the X-ray tube and the fluorescing screen, the form and, to a limited extent, the structure of objects appearing as shadows on the screen. Of late years fluorescing screens have been popular for shortening the exposure in X-ray photography ; they are placed in contact with the sensitive film of the dry plate, and the fluorescence in conjunction with the direct action of the X-rays on the plate materially shortens the exposure. Fluorescent screens made of quinine sulphate are used to detect the presence of ultra violet light.

FLUORESCENT TUBES

Vacuum tubes, for use with electric currents, which contain traces of gases after almost complete exhaustion. When a high potential current is passed through such a tube it glows with various colours, each gas giving off a distinctive fluorescence. Fluorescent tubes are much used in spectroscopic analysis to determine the nature of gases. These spectra consist of bright lines only. X-ray tubes fluoresce owing to the small quantity of residual air they contain after exhaustion.

FLUORHYDRIC ACID (*See* "Hydrofluoric Acid.")

FLUORIC ACID

Another name for hydrofluoric acid (*which see*).

FLUORIDE (*See* "Potassium Fluoride," etc.)

FLUOROTYPE

An obsolete process (invented by Robert Hunt in 1844) for obtaining pictures upon paper in the camera, so called from the introduction of the salts of fluoric acid. The solutions were :—

A.	Potassium bromide	20 grs.	20 g.
	Distilled water .	1 oz.	500 ccs.
B.	Sodium fluoride .	5 grs.	5 g.
	Distilled water .	1 oz.	500 ccs.

These were then mixed together, spread on plain paper, and dried ; the prepared paper was next treated with 60 grs. of silver nitrate dissolved in 1 oz. of water. The paper was given about half an hour's exposure in the camera, then soaked in water, a weak solution of iron protosulphate brushed over it, washed in water acidulated with hydrochloric acid, and fixed in either plain water or a weak solution of sodium hyposulphite ; finally it was washed well.

FLUOSILICIC ACID

More correctly known as "Hydrofluosilicic Acid" (*which see*).

FOCAL APERTURE

The effective aperture of a lens expressed as a fraction of its focal length. When the object is at a considerable distance from the lens this is a fixed quantity for each stop, but when copying, the focal aperture becomes less in proportion to the size of the image. Thus a lens working with its largest opening at $f/8$ on a distant object has its intensity reduced to $f/16$ when copying to equal size, and to $f/32$ when enlarging to three diameters. The relative exposure necessary with any given lens working at varying camera extensions may be obtained by increasing the exposure required for a particular aperture at the normal focus in the proportion of the squares of the normal and temporary focal lengths respectively. Thus, if a lens having a normal focal length of 6 in. is used with a camera extension of 9 in., the exposure with any stop will be increased in the proportion of 81 to 36; in other words, $2\frac{1}{4}$ times the normal exposure will be required.

FOCAL LENGTH (Fr., *Longueur du foyer*; Ger., *Brennweite*)

The distance between the centre of a lens and the screen or plate upon which the image of a distant object is sharply depicted. This definition, however, is only correct in the case of a very thin lens, in which the thickness of the glass does not come into consideration, and in which there is only one element. In the case of modern photographic lenses, "focal length" is often taken to mean "equivalent" focal length; that is to say, when a lens will render the image of a distant object on exactly the same scale as would a very thin spectacle lens, the two are said to be of the same equivalent focal length. Equivalent focal lengths vary in direct proportion to the size of the image obtained; thus, assuming that a 6-in. lens gives a 3-in. image of a distant object, an 18-in. lens will give a 9-in. image of the same object. This fact enables the measurement of the focal length of any lens to be effected by simple comparison of its image with a similar image made by a lens of known focal length, or, better still, with a pinhole image. A practical method is to substitute for the lens a fairly small pinhole, the camera being extended to a convenient length (a length of 10 in. simplifies the slight calculation necessary), and to take a negative of some distant object having two easily recognisable points, such as chimneys or telegraph poles, these being shown a few inches apart. The distance between these two points is carefully measured and becomes a constant factor in determining the focal length of any other lens which can be focused upon the same object. Assume that the distance between the points is 4·5 in. Taking a lens of unknown focal length, it may be found, for example, that the images of the two selected points are 3 in. apart; then as 4·5 is to 3 so is 10 to x. $3 \times 10 \div 4\cdot5 = 6\cdot66$ in. An approximately correct result may be obtained by focusing a near object so that it appears in natural size upon the screen; then one-fourth of the

distance between the object and the focusing screen is the focal length of the lens.

The focal length of negative lenses may be ascertained by neutralising them by placing positive lenses in contact with them until one is found that practically loses its convergent powers; then the concave lens is said to have a negative focal length equal to that of the positive lens which it neutralises. Dallmeyer's method is to place a diaphragm, containing two small openings, in contact with the negative lens, which is then turned to the sun; the light passing through these two small openings is received upon a white card, which is moved away from the lens until the two spots of light are double the distance apart as compared with the openings in the diaphragm; then the distance between the diaphragm and the card is the negative focal length

FOCAL PLANE SHUTTER

A shutter that works immediately in front of the plate, and now commonly fitted to the highest class cameras. It is believed to owe its practical form to B. J. Edwards, who in 1882 published a description of his apparatus; but some eighteen or twenty years previously the principles were known to William England, who used a crude device working on the same principle a long time before Edwards's ideas were published. England's device was a board containing a horizontal slit which travelled in front of the plate in the same manner as the drop shutter of the present day travels in front of the lens, and it was caught in a kind of bag suspended from the camera. A shutter of a similar nature had previously been experimented with by Dr. Mann, who recognised its power to utilise the whole of the light admitted by the lens. From 1882, in which year Edwards lectured upon his invention before the old South London Photographic Society, until 1892, the focal plane shutter seems to have been lost sight of, but in the latter year the Thornton-Pickard Company placed upon the market their now well-known shutter of this type, and, simultaneously, Stolze and Ottomar Anschütz, quite unknown to each other, were both working to the same end—the simplification and perfection of the shutter, more particularly, perhaps, in the means of adjusting the slit.

The principle of the shutter is as follows:— A roller blind, containing a slit or aperture the whole length of the plate, is made to travel immediately in front of the sensitive surface. Assuming that this gives an exposure of $\frac{1}{20}$th of a second, by reducing the slit to one-fifth of its original width the exposure is reduced to $\frac{1}{100}$th of a second; again, by increasing the tension of the spring by five or ten times an exposure of $\frac{1}{500}$th or $\frac{1}{1000}$th of a second respectively is obtainable. Most subjects come within the range of $\frac{1}{50}$th to $\frac{1}{800}$th of a second. The efficiency of the focal plane shutter is greater than that of the lens shutter; some types of lens shutter pass for only a very small proportion of the total exposure the whole of the light that the lens is capable of transmitting, much of the time of exposure being taken up by the shutter in uncovering and then covering the lens, there being only a brief period when the lens is quite

uncovered. With the focal plane shutter the whole of the light admitted by the lens is available for action upon any particular portion of the plate uncovered by the slit; and another advantage is the high speed at which the shutter can work, rendering it indispensable for "instantaneous" work of any kind.

It is sometimes affirmed that the focal plane shutter gives distorted results, but its advocates affirm that the distortion (if any) is practically negligible. In practice, distortion may be divided into two classes: (*a*) that in which the outline of any one body is rendered untruthfully, and (*b*) that in which the relative position of a group of figures or objects is incorrectly delineated; this latter may, of course, include the former, and of the two is the more serious. While it matters but little if an image of, say, a rapidly moving railway train is slightly longer or shorter than would be the case were the train photographed at rest, it is a serious matter if the result of a closely contested cycle race is rendered incorrectly. To minimise any possible error, the following points on the correct use of the shutter should be remembered. If the image (on the focusing screen) of the subject being photographed is rapidly moving in the same direction as the slit in the shutter, the slit must be made to move at a much greater speed than if the image and slit were travelling in opposite directions. The use of a shutter travelling at great speed in an opposite direction to that of the image has a tendency to shorten the object, while, on the other hand, the use of a shutter travelling in the same direction as the image may lengthen it. But such distortion is so trifling that it would be practically impossible to discover it. When engaged in high-speed work a good distance at which to work is about seven or eight yards from the subject. Using a 6-in. lens at a distance of eight yards, for objects moving at right angles to the camera these exposures would be about correct :—

Trains, horses galloping, cycle racing, etc.	$\frac{1}{1200}$ sec.
Men racing, jumping, etc.	$\frac{1}{900}$ sec.
Diving	$\frac{1}{800}$ sec.

If the object is taken end on—that is, coming towards, or receding from the camera—exposures three times as long as the foregoing may be given. By doubling the distance from the object, the length of exposure may be doubled.

To develop plates which have received a minimum of exposure, a very energetic developer must be employed. The following formula is recommended, using equal parts of A and B :—

A.			
Pyrogallic acid	40 grs.	4·4 g.	
Metol	35 ,,	3·8 ,,	
Potassium metabisulphite	90 ,,	10 ,,	
Potassium bromide	15 ,,	1·6 ,,	
Water to	20 oz.	1,000 ccs.	
B.			
Sodium carbonate	3 oz.	164 g.	
Water to	20 ,,	1,000 ccs.	

FOCI

The plural of focus (*which see*).

FOCI, CONJUGATE (*See* "Conjugate Foci.")

FOCI, VARIABLE (*See* "Telephoto Lens.")

FOCIMETER (Fr., *Focimètre*; Ger., *Fokusmesser*, *Brennweitemesser*)

An instrument invented by Antoine J. F. Claudet, and used to test whether the chemical and visual foci of a lens coincide, that is, whether the lens is achromatic. It consists of a series of cards with different letters or numbers arranged radially on a horizontal rod, one behind the other, as illustrated. The middle card is focused sharply with the full aperture of the

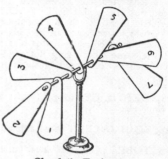

Claudet's Focimeter

lens to be tested, a plate being then exposed and developed. If the card focused is perfectly sharp in the resulting negative the lens is properly achromatic; but if one of the other cards is sharper, the chemical focus of the lens does not agree with the visual focus. By focusing the card that is rendered sharply in the negative and noticing the extent to which the screen has to be moved from its former position, the difference between the two foci and the exact degree of correction required will be ascertained. Several modifications of this apparatus have been suggested.

FOCISCOPE

A focusing eyepiece introduced by Penrose, the lens consisting of three elements cemented together, forming a very powerful magnifier of fairly flat field. It is useful for examining half-tone dot images.

FOCOMETER (Fr., *Focomètre*; Ger., *Fokomesser*)

A lens-testing apparatus designed by Thomas R. Dallmeyer, for ascertaining the focal length of a lens, and the degree to which the various aberrations are corrected, or otherwise. It is essentially a type of optical bench.

FOCOPLANE

Focal plane; see "Focal Plane Shutter."

FOCUS (Fr., *Foyer*; Ger., *Brennpunkt*)

Plural, foci. The point at which the rays of light emitted by any luminous body converge after passing through a lens to form the image of such a body. The position of the focus is simply demonstrated by using the lens as a burning glass. The focus of a lens is a position and not a distance, although the word is often so misused (see "Focal Length"). The focus for distant objects is often called the principal or solar focus.

FOCUS ADJUSTER (Fr., *Ajusteur de foyer ;* Ger., *Fokusordner*)

An arrangement for lengthening or shortening the focal length of a lens, by the use of a single supplementary lens, or a series of such lenses of varying foci. A device described by John Traill Taylor consisted of a movable brass sliding piece, for which an opening was provided in the lens mount between the combinations. In the sliding piece were four apertures, each fitted with a thin achromatic negative lens. The appliance was designed for use with a doublet composed of two slightly meniscus lenses, which by themselves did not give a flat field. With the focus adjuster, the focal length of the objective was increased to 7, 9, 12, or 15 inches, according to which of the four concave lenses was used, the field at the same time being flattened and the marginal pencils corrected at a fairly large aperture.

FOCUS, DEPTH OF (*See* " Depth of Definition, etc.")

FOCUS, EQUIVALENT (*See* " Focal Length.")

FOCUS TUBE (*See* " Crookes' Tube.")

FOCUSER (*See* " Focusing Magnifier.")

FOCUSING (Fr., *Mise au foyer, Mise au point ;* Ger., *Einstellung*)

The action of adjusting the extension of the camera until the image is sufficiently sharply defined on the ground-glass focusing screen. A focusing magnifier assists in determining when the image is sharp by allowing slight differences in crispness to be more easily seen. As all the planes of a subject cannot be equally well defined, it is important to recognise which should show the most critical definition. Objects near the eye should naturally show greater sharpness than those farther away. But, in addition, the principal object in a picture should show the best definition, should any differences exist. Where there is a number of objects at different distances, and it is desired to secure a uniform degree of sharpness between the nearest and the farthest, it is advisable to focus on a point beyond the nearest object, about one-fourth of the distance from the nearest to the farthest.

In process work, several schemes have been proposed for automatic focusing. Some elaborate mechanical inventions have been devised for moving the camera to and from the copyboard at the same time as the focusing screw is turned to move the ground glass of the camera, but none of these arrangements has come into practical use. A more convenient method, which can be applied to any camera and stand with little alteration of existing arrangements, is the Scalometer system, invented by L. Emmett. The scalometer is an instrument made in boxwood, opening like a two-foot rule, there being on the two limbs similar scales of equal divisions numbered from the ends of the limbs. A cross rule divided into inches or centimetres bridges the angle formed by the opening of the two limbs. In operation the points or ends of the limbs are applied compass-like to the sides of the original, and then clamped at this separation. The cross rule is then made to slide up and down until it indicates across the angle formed by the limbs the measure of the desired reduction. At this point the proportional number on the two limbs is read off, and is marked on the back of the original. Then all originals which bear the same proportional number can be photographed

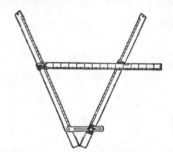

Scalometer for Facilitating Focusing

together. By means of a printed scale supplied with the instrument it is possible to mark off the copying stand with numbers corresponding to those on the limbs of the instrument, so that the camera can be instantly set to the proportion number marked on the original, without the necessity of focusing.

FOCUSING CAMERA (Fr., *Chambre à foyer réglable ;* Ger., *Einstellungs-kamera*)

Any camera in which different distances can be focused for, as distinguished from fixed-focus cameras, which do not permit of adjustment. Self-focusing cameras are those which extend automatically to the correct focus for any given distance, on setting a pointer or turning a key on a marked dial. Such adjustments are usually only to be found on hand cameras.

FOCUSING CLOTH (Fr., *Voile, Voile noir, Voile de chambre, Voile de mise au point ;* Ger., *Einstellungstuch, Kopftuch, Schwarze Leinwand*)

Synonym, black cloth. A cloth used to cover the back of the camera and the operator's head when focusing, in order to exclude extraneous light, which would interfere with the visibility of the image on the ground-glass screen. It is also employed to shield the top of the dark-slide when withdrawing the shutter, and not infrequently to wrap up the slides after the exposures have been made. It is usually made of black velvet or twill, which may or may not be lined with yellow or red cloth, or of waterproof cloth. A cloth is more convenient in use when provided with cords at the corners for tying to the camera in windy weather ; whilst a loop in the middle of one side, to slip over the lens, is always useful. For a small camera, the focusing cloth may be about 3 ft. square.

FOCUSING GLASS

A name for the focusing magnifier (*which see*). The term is applied occasionally to the focusing screen of the camera.

FOCUSING JACKET, OR RACK MOUNT
(Fr., *Tube à crémaillère* ; Ger., *Zahnstange Objektivrohr*)

A form of lens mount provided with an inner tube carrying the glasses, which slides to or fro by an attached rack and pinion. This kind of mount is found on lantern, enlarging, and kinematograph objectives, and some portrait lenses. For lantern and kinematograph use, the jacket is sometimes supplied empty, to allow of the insertion of different objectives in loose interchangeable tubes or cylinders.

FOCUSING MAGNIFIER (Fr., *Loupe, Loupe de mise au point* ; Ger., *Einstelloupe*)

Synonyms, focuser, compound focuser, focusing eyepiece, focusing glass. A lens used when more accurate focusing is desired than is obtainable on the ordinary ground-glass screen, as may be necessary in photo-micrography, process work, etc. It is usually composed of two plano-convex lenses of identical focal length, mounted with their plane sides outward at a distance apart equal to two-thirds of the focal length. The

A B C D
Focusing Magnifiers

lenses should preferably be achromatic, though this is not indispensable. To use the magnifier, a piece of plain plate glass having a few fine black lines ruled on it is substituted for the ground-glass focusing screen ; or, as an alternative, several microscopic cover glasses may be cemented at suitable spots on the ground glass by means of Canada balsam, having first made a pencilled cross on the ground surface where each glass is to be attached. The magnifier is adjusted by sliding or rotating the upper tube, till the ruled lines or pencilled cross, as the case may be, are in sharp focus, when it only remains to see that the image on the screen is in focus at the same times as the lines or cross. The magnifier gives an enlarged image, and naturally a brighter one than can be obtained on ground glass. A shows a magnifier with screw adjustment and clamping collar ; B shows one with an Archimedean screw movement ; C has an erecting lens to show the image the right way up ; while D is provided with a bayonet tripod by which the magnifier may also be raised to examine prints, half-tone blocks, etc., if required.

FOCUSING NEGATIVE LENS (See "Negative Lens.")

FOCUSING SCALE (Fr., *Échelle de mise au point* ; Ger., *Einstellskala*)

A graduated scale or dial fitted on hand cameras, enabling objects at various distances to be focused, by the movement of a pointer, without inspecting the screen.

FOCUSING SCREEN (Fr., *Verre douci, Glace doucie* ; Ger., *Visirscheibe, Mattscheibe, Mattglas, Mattglasscheibe*)

The screen upon which the image formed by the camera lens is focused, before exposing the plate, in order to secure sharp definition. It is usually of glass ground on one side to a matt surface. Some of the ground-glass screens supplied with the cheaper cameras are extremely coarse. A finely ground glass is, however, on the market in the usual cut sizes at very reasonable prices. A good substitute, having the advantage of being light and unbreakable, is a sheet of matt celluloid ; but care must be taken that this does not buckle, or it will not agree in register with the dark-slide. For this reason celluloid is scarcely suitable for large cameras.

Temporary makeshifts, to replace a broken focusing screen, are : white tissue paper or tracing paper stretched taut, a fine cambric handkerchief, or plain glass dabbed lightly with putty. For Lohse's method of forming a focusing screen the following is necessary :—

Gelatine .	. 45 grs.	450 g.
Barium chloride	. 15 ,,	150 ,,
Ammonium sulphate.	$7\frac{1}{2}$,,	75 ,,
Water to . .	. $3\frac{1}{2}$ oz.	1,000 ccs.

The gelatine, sulphate and three-fourths of the water are heated together until dissolved ; the barium, dissolved in the remaining fourth of the water, is then added. After mixing and cooling, the mass is pressed through muslin so as to form threads, then washed and melted again. Finally a trace of salicylic acid in alcohol is added, the whole is filtered, and is then ready for coating upon plain glass. The solution is slightly troublesome to prepare, but such a screen may with care last a lifetime. A less troublesome method, due to P. R. Salmon, is to apply to plain glass a varnish consisting of—

White lac . .	. 70 grs.	80 g.
Picked gum sandarac .	12 ,,	14 ,,
Alcohol . .	. 2 oz.	1,000 ccs.

C. Welborne Piper has suggested still another method ; a dry plate should be fogged uniformly all over by immersion in a developer for a long time, fixed, bleached in a solution of 5 grs. of iodine and 10 grs. of potassium iodide in 1 oz. of water, treated with very dilute ammonia, washed, dried, and varnished. A screen prepared in this way, or in any of the other ways above mentioned, is far superior to ground glass.

In process work, the ground-glass screen used has a transparent centre formed by cementing a thin microscopic cover glass to it with Canada balsam. Extremely fine focusing can then be done by means of an eyepiece. A cross should be made on the ground glass with a blacklead pencil before cementing down the glass, so that the focus of the eyepiece may be adjusted to it.

FOCUSING UNCORRECTED LENS

When using an uncorrected lens, that is, one in which the visual and actinic foci are not coincident, an allowance has to be made after focusing so as to bring the sensitive plate into the plane of actinic focus. The amount of this varies with the refractive index of the glass, but as such lenses are commonly made of crown

glass, it is usually safe to place the plate $\frac{1}{30}$ to $\frac{1}{40}$ of the focal length nearer to the lens. The correction may also be made, as in the case of Steinheil's original periscope, by focusing at full aperture and then stopping down to $f/44$, or smaller. Another method is to place a very weak lens in front of the working lens while focusing and removing it before exposure. This corrector must temporarily shorten the focal length to the necessary degree.

FOG (Fr., *Voile* ; Ger., *Schleier*)

A general reduction of the silver salt by the developer, particularly on those places which should be clear glass in the negative or white paper in the print. The various kinds of fog are discussed in later articles.

FOG, AERIAL (Fr., *Voile aérien* ; Ger., *Aetherisch Schleier*)

Mist, or fog, particularly noticeable in the distance in landscapes, due to the reflection of the ultra-violet and blue rays by minute particles of water, vapour and dust. It is a factor to be recognised, particularly in telephotography and mountain work, and in such cases the use of colour-sensitive plates and a yellow screen, which cuts out the ultra-violet and blue, is advantageous. On the other hand, the peculiar softening effect of aerial fog is extremely pleasing from an æsthetic point of view, and care should be exercised therefore not to eliminate its effects unduly.

FOG, CHEMICAL (Fr., *Voile chimique* ; Ger., *Chemischer Schleier*)

A reduction of silver all over the surface of the plate or paper, which may be due either to chemical fog inherent in the emulsion, to too strong a developer, or to the access of actinic light or the use of an unsafe dark-room light. Fog inherent in the emulsion cannot be cured, but its ill effects may be somewhat obviated by exposing fully and adding potassium bromide to the developer. A clean working plate should stand three minutes' development in the dark, without previous exposure to light, in a normal pyro-soda developer, and then present but the slightest trace of deposit. Chemical fog, caused by using too strong a developer, may be obviated by weakening the developer and by the addition of a little bromide.

FOG, COLOUR, DICHROIC, GREEN, AND RED (Fr., *Voile rouge* ; Ger., *Rotschleier*)

A peculiar form of fog, which is green by reflected light and red by transmitted light. It is in all cases due to silver deposited in a colloidal state, and shows itself most prominently in the shadows of a negative. It may be due to the emulsion itself, to traces of " hypo " in the developer, excess of a solvent of the silver haloid, such as sulphite, etc., or it may arise through partial fixation and reduction of the soluble silver salts by traces of the developer. This last form is often to be met with in films when one lies over another in the fixing bath. Dichroic fog is in almost all cases sensitive to light, and though this is not readily noticed, it can be proved at once by covering up part of the negative showing this defect, and exposing

to sunlight. It is extremely difficult to remove, but treatment with the following is the most efficacious remedy :—

Sodium sulphite	.	I oz.	50 g.
Potassium cyanide	.	100 grs.	10 ,,
Distilled water to	.	20 oz.	1,000 ccs.

Abney has suggested bleaching the negative in a mixture of ferric chloride and potassium bromide, well washing, and then redeveloping with ferrous oxalate, which reduces the dichroic to a general fog.

FOGGED DRY PLATES, RESTORING

Plates which have been accidentally exposed to light (lightstruck is a term sometimes used), may be made almost as good as new, with the exception that their speed is reduced, by treatment for about five minutes in either of the following restoring baths :—

Chromic acid	.	15 grs.	6·25 g.
Potassium bromide	.	30 ,,	12·5 ,,
Water to	.	5 oz.	1,000 ccs.
Potassium bichromate		20 grs.	8·3 g.
Hydrochloric acid	.	I drm.	25 ccs.
Water to	.	5 oz.	1,000 ,,

Afterwards, the plates are thoroughly washed and dried. All the operations must be carried out in the dark-room. Plates that have been exposed in the camera, but have not been developed, may be restored in the same way, but the immersion must be of longer duration. Plates restored in this way need from five to ten times the normal exposure. Several other methods are possible, one of which is to soak the plate in a 2 per cent. solution of ammonium persulphate ; Condy's fluid (as bought), with the addition of a few grains of potassium bromide, also answers. Abney has recommended a bichromate bromide mixture made by dissolving 10 grs. of potassium bichromate in 1 oz. of water, 10 grs. of potassium bromide in another ounce of water, and adding the two together.

Fogged dry plates can be made specially suitable for transparency work by soaking for about ten minutes in—

Potassium bromide	.	120 grs.	12 g.
Potassium iodide	.	15 ,,	1·5 ,,
Hot water	.	$\frac{1}{2}$ oz.	25 ccs.

When dissolved add—

Hydrochloric acid	.	$\frac{1}{2}$ oz.	25 ccs.
Potassium bichromate		120 grs.	12 g.
Water to	.	20 oz.	1,000 ccs.

Wash and dry.

The plates are made very slow by any of the processes named, and thus they give greater contrasts ; hence their suitability for copying black-and-white work. They should also be developed with a clean-working developer, such as adurol or hydroquinone.

FOGGED NEGATIVES, TREATMENT OF

The method of treating fogged negatives must depend on the cause or nature of the fog. Development fog, and fogging or staining caused by the plates being stale, are most successfully treated by thiocarbamide. A stock solution

may be prepared, as it will keep well. The formula is :—

Thiocarbamide .	.	$\frac{1}{2}$ oz.	31 g.
Common alum .	.	$\frac{1}{2}$,,	31 ,,
Citric acid	.	$\frac{1}{4}$,,	15 ,,
Water to .	.	16 ,,	1,000 ccs.

In very bad cases of fogging, this solution may be used without dilution ; but in ordinary cases one part stock solution to one or two parts of water will be preferable.

Fogging from over-exposure, or from exposing the plate too freely to the dark-room light, is best treated by Farmer's reducer, this consisting of "hypo" and potassium ferricyanide.

Fogging by exposing the plate too much during development or in loading the camera is most difficult to treat successfully. (*See also* "Exposure, Incorrect.")

FOGGED PRINTS, TREATMENT OF

Fogged prints are generally not worth the trouble of treatment, excepting bromide and gaslight paper prints in which the white parts are degraded through the paper being stale. In all other cases the prints should be thrown away and replaced by new ones. The treatment should be the same as that given for plates showing development fog, or fog arising from the plates being stale. (*See* "Fogged Negatives, Treatment of.") The thiocarbamide bath should be used, but the solution should be more dilute. In most cases, 1 part of the stock solution already given should be taken and 3 parts of water added. The thiocarbamide bath should be used after fixing and well washing the print.

FOLDING CAMERA (Fr., *Chambre pliante, Chambre folding ;* Ger., *Falte-kamera, Klapp-kamera*)

Any camera made to close by folding, as opposed to studio and process cameras, which do not close in this way, and to box-form hand cameras. A folding hand camera is commonly understood to be of a specially light and portable construction, although the term is used very indefinitely. A style of hand camera in which the front extends on four struts is known in Germany as a "klapp" camera. (*See also* "Hand Camera.")

FOREGROUND

The part of a subject nearest the spectator. The term is stretched to include water. As foreground objects are naturally seen with the greatest clearness, the treatment of this part of a picture demands careful attention. Especially is this the case with stereoscopic pictures. Foreground objects may be brought into greater prominence if the camera is lowered considerably, especially when (as in the case of a group of flowers) they are intended as the subject of the picture. It is sometimes difficult to get a near foreground and also the distance quite sharp without considerable stopping-down of the lens ; and in such a case the top of the camera back may be swung away from the lens. If there is to be lack of definition anywhere in the picture the foreground is usually the last place where it is permissible.

FOREGROUND SHUTTER (Fr., *Obturateur des devants ;* Ger., *Vordergrund-verschluss*)

A shutter designed to give a longer exposure to the foreground of a landscape, or similar outdoor composition, than to the sky, thus enabling both to receive a more correct exposure than would otherwise be the case.

FOREIGN PLATES, ETC. (For sizes, *see* "Sizes of Plates and Papers.")

FORMALINE, FORMALDEHYDE, FORMIC ALDEHYDE, FORMIC ANHYDRIDE, OR ANTIPYR (Fr., *Formol ;* Ger., *Aldehyde formique, Formalin, Formaldehyd*)

Best known as formaline. Ordinarily it is met with in aqueous solution, which is prepared by passing the vapour of methyl alcohol mixed with air through a heated tube containing copper gauze. The liquid is colourless, has a characteristic smell, and, as obtained commercially, contains about 40 per cent. of formaldehyde. Formaline vapour attacks the mucous membranes of the eyes, nose, and throat, and causes intense irritation.

Photographically, it is used chiefly for hardening gelatine films, it replacing and being safer than alum. A suitable strength is 10 per cent., and it may be used immediately after fixing for both negatives and prints. It has also been suggested as a constituent of developers, the most useful formula being—

Hydroquinone	.	40 grs.	16 g.
Sodium sulphite	.	400 ,,	160 ,,
Formaline	.	50 drops	20 ccs.
Water to .	.	5 oz.	1,000 ,,

The above is a one-solution developer ready for use, no bromide or alkali being required when formaline is present. The above developer is suitable for negatives of black-and-white drawings, or for giving strong contrasts in other subjects.

FORMIC ACID (Fr., *Acide formique ;* Ger., *Ameisensäure*)

Synonym, hydrogen carboxylic acid. H COOH. Molecular weight, 46. A clear liquid obtained by distilling oxalic acid with glycerine. It is a dangerous caustic, and must be handled very carefully. It was used in the old wet-plate days, and has been recommended as a preservative for pyro, but whilst a good preservative, the addition of an alkali turns the solution muddy and black.

In process work, formic acid is sometimes used instead of acetic acid for the stripping of wet collodion negatives. Its disadvantage is that it is injurious to the hands.

FORMOSULPHITE (Fr., *Formosulfite ;* Ger., *Formosulphite*)

One of Messrs. Lumière's patented products, which takes the place of an alkali in the developer. It is sold in the form of a white crystalline powder, and, as its name suggests, is a preparation of paraformaldehyde, sodium sulphite, and a small quantity of an alkaline bromide. It acts also as a preservative, prevents stain, and hardens the film.

FORMYL CHLORIDE OR TRICHLORIDE
(See " Chloroform.")

FOTHERGILL PROCESS (Fr., *Procédé Fother-
gill ;* Ger., *Fothergill's Prozess*)

A dry process introduced by Thomas Fother-
gill in 1858. The plate having been collodionised
and sensitised in a neutral silver nitrate bath,
as usual in the wet-plate process, was washed
with rain water and allowed to drain for about
half a minute. Some plain albumen, obtained
by well beating the white of 1 egg with 2 drms.
of water, and allowing to subside, was then
poured on the collodion film, and, after remain-
ing for thirty seconds, was washed off under a
gentle stream of rain water, sufficient remain-
ing in the pores of the collodion to answer the
purpose of preserving its sensitiveness. The
plate was then allowed to dry and was fit for use.
Such plates would keep some time, and could be
exposed dry without previous preparation.

FRAME (Fr., *Cadre ;* Ger., *Rahmen*)

The selection of a suitable frame for a finished
print is an important matter. Fortunately, the
special demands of photographers in this respect
have been fully met, and there is now no lack
of choice in appropriate frames. It must be
remembered that the chief purpose of a frame,
with or without a mount, is to isolate the picture
from its surroundings. Therefore, a frame
defeats its own end when it attracts attention
from the print to itself. For this reason an
ornate, or so-called "fancy" frame, is generally
unsuitable. The great majority of photographic
prints are seen to best advantage in a simply
designed frame of a dark colour. The various
mouldings may be roughly classified into those
that are flat and practically flush with the
picture, those that throw it forward, and those
that throw it back. If the print is framed close
up, that is, without showing any margin, a
wide moulding is generally best. A narrow one
in such a case does not adequately isolate the
print, and has a "skimpy" effect. On the other
hand, a mounted print demands a much narrower
moulding. The more mount there is the narrower
may the moulding be, as the mount and frame
may be regarded as a whole.

Gold frames, and those with a highly varnished
surface, are not often suitable. Far more effec-
tive, as a rule, are well-made frames of good
solid oak, stained brown or black, and polished
by friction with a brush or a rough cloth, or by
the sparing application of beeswax and turpen-
tine. (See also "Framing.")

FRAMES, PRINTING (See " Printing Frames.")

FRAMING

In addition to the actual selection of a suit-
able frame for a photograph (see "Frame"),
there are one or two other points to take into
account. First comes the question of the glass.
This should not only be free from flaws and
waviness, but it should be as colourless as possi-
ble. If a sheet of the usual picture-framer's
glass be laid down, so as to cover half of the
print only, a great difference will be noted
between the covered and uncovered halves. Not
only is the colour of the print affected, but there

is a marked alteration in the values. Generally
the tones are degraded or flattened, especially
in the case of delicate grey prints. When a
clearer glass cannot be used, the print should be
kept somewhat brighter than it is intended to
appear in its framed state. When the glass is
placed in the frame it is well to run a narrow
fillet of paper round the edge, pasting it down to
the glass and the sides of the rebate. Take care
that it does not show from the front, its object
being merely to keep out dust. The backboard
having been bradded securely down, glue or
paste brown paper over the entire back.

FRAUNHOFER LINES

When a solar spectrum is viewed in a spec-
troscope with a very narrow slit it will be seen
to be crossed by thousands of transverse dark
lines. The most prominent of these were named
by Fraunhofer according to the letters of the
alphabet, and are now called by his name.
No matter what the dispersing medium may be,
prism or grating, these lines always fall in exactly
the same colour ; they are therefore extremely
convenient "milestones" or data for naming
any colour, and enable one to define a colour
exactly. For instance, the term "yellowish
green" conveys no strictly definite idea ; whereas
the term "a yellowish green like D ½ E"—that
is, midway between the Fraunhofer lines D
and E—indicates a definite and fixed tint. The
cause of Fraunhofer lines was determined by
Kirchoff and Bunsen, who discovered that any
substance in a state of incandescent vapour
absorbed exactly those rays which it emitted
when in a state of luminescence. For example,
if a pellet of metallic sodium is burnt in an elec-
tric arc it emits two dazzling orange-yellow
rays, known generally as the D lines ; but if
the light thus emitted is allowed to pass through
a cloud of somewhat cooler sodium vapour these
brilliant yellow lines instantly become black—
that is to say, their light is absorbed. This
fundamental law applies to all substances, and
by its aid it has been possible to detect the
elements burning in the sun and in still more
distant stars. (See also "Spectrum.")

FREEZING OR COOLING MIXTURE (Fr.,
Mélange réfrigérant ; Ger., *Kältemischung*)

A mixture which, by absorption of heat in
liquefying, produces a low temperature. It is
largely used in hot countries, and sometimes in
England during hot weather, to cool solutions,
particularly for use with gelatine plates and
papers. The ordinary "hypo" fixing bath is
itself a cooling mixture, for when freshly mixed
the temperature of the water falls considerably.
The most common freezing mixtures are the
following :—

	Proportions by Weight	Temperature Produced
Snow or pounded ice .. 2		
Common salt (sodium chlor-ide) 1	}	−·4° F. −18° C.
Snow 3		
Crystallised calcium chlor-ide 4	}	−54° F. −48° C.
Water 1		
Ammonium Nitrate .. 1	}	5° F. −15° C.
Sodium sulphate 8		
Hydrochloric acid .. 5	}	1·4° F. −17° C.

A good method of lowering the temperature of solutions is to place the bottles containing them in a freshly made " hypo " bath.

FRENCH CHALK (*See* " Chalk, French.")

FRILLING

A trouble to which negatives are liable while undergoing treatment in the various solutions ; the edges of the gelatine film leave the glass plate and are cockled. It is due to the uneven temperature of the solutions, excess of soda or other alkali in the developer, handling the negatives with the warm fingers, the use of strong fixing solutions, or to rapid washing, the water being allowed to impinge upon the edges of the plates in such a way as to lift the films. Frilling may be prevented by hardening the film before or after development with formaline, or a combined fixing and hardening bath may be used. If no precautions are taken and the gelatine is found to be frilled, it may be more or less remedied by treating with methylated spirit. Frilling is allied to the far more common defect of blistering, and the remedies given under a separate heading for the latter apply equally well for the former. Frilling often appears on print-out papers when they are torn, as, for example, when a half-plate piece is torn into halves for use as quarter-plates. Printing papers should always be cut clean, because rough edges allow the water to get easily under the films, so causing frilling.

Two old-fashioned but serviceable methods of preventing plates from frilling may be mentioned. One is to soak the dry plate before development in a saturated solution of Epsom salts, and the other is to rub a wax or tallow candle round the exposed dry plate on the film side, before wetting it with the developer. Neither of these, however, is as reliable as immersion in a 10 per cent. solution of formaline. (*See also* " Hardeners " and " Blisters.")

FRONT, CAMERA (Fr., *Planchette d'objectif :* Ger., *Objektivbrett*)

That part of the camera which carries the lens. It should be provided with a rising and falling movement, and a cross movement is an additional advantage. In field cameras, it should preferably also be arranged to swing, in order that the lens may be tilted if desired without needing to incline the camera. The fronts of large cameras are commonly furnished with a removable panel for the lens, an arrangement which, by the employment of several panels, permits various lenses of different sizes or foci to be used interchangeably on the same camera. (*See also* " Cross Front," " Detachable Front," " Rising Front," and " Swing Front.")

FROST SCENES

The photographing of frost scenes is dealt with under the heading " Snow and Hoar Frost Photography." Frost on window-panes may be successfully photographed by placing a black cloth outside the window at an angle of 45° and photographing the frost from the inner side.

F.R.P.S.

Fellow of the Royal Photographic Society. The Fellowship was instituted January 1, 1895, and is open to those who, being already members, satisfy the Council of their ability in, or contributions to, any branch of photographic work, an annual subscription of two guineas being payable.

FULL APERTURE

When no stop is used, a lens is said to work at " open aperture " or " full aperture."

FULMINATING COTTON

Another name for gun-cotton (*which see*). Sometimes used in flashlight photography.

FUMING

Photographically, the exposing of albumen paper to the fumes of ammonia ; paper so treated gives brighter prints and tones to richer colours more easily. The sensitive paper to be fumed is pinned to the inner side of a box lid ; in the bottom of the box is placed liquor ammoniæ in a saucer, or it is sprinkled upon blotting-paper. The box is then closed, and the paper exposed (in the dark, of course) to the action of the ammonia fumes for about ten minutes, or longer if the weather is cold. Fuming is now almost obsolete, but at one time it was recommended for papers other than albumen, and even for plates.

FURNELL'S DEVELOPER

A developer widely advocated about 1890 for positive work ; it is claimed to keep for years, allow great latitude in exposure, give clear glass shadows, and not frill the film.

No 1 :—

Sodium sulphite	.	50 grs.	10 g.
Powdered alum	.	10 ,,	2 ,,
Distilled water	.	3 oz.	250 ccs.

Dissolve, filter, and then add—

Pyro	. .	24 grs.	4·8 g.
Sodium nitrate	.	36 ,,	7·7 ,,

This is made up as a stock solution, and it will keep indefinitely.

No. 2 :—

Liquor ammoniæ (·880)	1½ drms.	15 ccs.	
Ammonium bromide	30 grs.	6 g.	
Distilled water to	15 drms.	150 ccs.	

To develop, take ½ oz. of the No. 1 (pyro) solution, made up to 2 oz. with water, and add 10 drops of the No. 2 (ammonia) solution, and apply to the plate, adding more of the latter if necessary. After development, do not wash but rinse in a saturated solution of alum, then wash and fix in the following bath, after which wash and dry :—

Sodium hyposulphite	2 oz.	220 g.
Sodium carbonate	. ½ ,,	55 ,,
Alum (saturated sol.)	½ ,,	50 ccs.
Water to	. . 10 ,,	1,000 ,,

G

γ (*See* " Gamma.")

GAEDICKE'S INTENSIFIER

One of the silver intensifiers, the formula being :—

Ammon. sulphocyanide	100 grs.	46 g.
Silver nitrate .	. 48 ,,	22 ,,
Sodium sulphite .	500 ,,	230 ,,
" Hypo " . .	100 ,,	46 ,,
Potassium bromide	. 7 ,,	3 ,,
Water . .	. 5 oz.	1,000 ccs.

To prepare for use, mix as follows :—

Stock solution as above	48 drops	100 ccs.
Water to . .	. 1 oz.	1,000 ,,

Then add—

Rodinal . .	. 16 drops	33 ccs.

Immerse the negative therein until intensified and then wash.

GALL (*See* " Ox-gall.")

GALLATE OF IRON PROCESS

Better known as the " Ink Process " (*which see*). The term has been loosely applied to other iron processes of printing.

GALLIC ACID (Fr., *Acide gallique ;* Ger., *Gallischsäure*)

Occurs in fine, silky, yellowish crystalline needles. $C_6H_2 (OH)_3 COOH H_2O$. Solubility 1 per cent. in cold water, 33 per cent. in boiling water. Largely used in the early days of photography as a developer for paper negatives, and it was with this acid that Talbot in 1835 made some important discoveries in connection with the latent image. It is occasionally used in modern processes, as, for example, in the development of P.O.P., intensification of collodion and gelatine plates, and as an ingredient in the ferrous citrate developer for chloride plates.

Gallic acid is often used by lithographers for preparing the surface of zinc plates for printing, instead of the nutgall decoction recommended by the old workers ; the effect is the same, and the trouble of preparing the decoction is saved.

GALLO-NITRATE OF SILVER PROCESS

Another name for the old calotype or talbotype paper process, in which paper was sensitised with silver nitrate, immersed in potassium iodide, washed, dried, exposed, and developed with a mixture of silver nitrate, gallic, and acetic acids and water. (*See* " Calotype.")

GALLS (NUTGALLS)

In zincography—lithographic printing from zinc plates—a decoction of nutgalls, mixed with gum arabic solution, is used for preparing the bare parts of the zinc so that they repel the greasy printing ink used for rolling-up. To make the decoction, steep 4 oz. of nutgalls in 3 quarts of water for twenty-four hours, and then boil up and strain. For use, add ¾ pint of this solution to ¼ pint of gum solution, of the thickness of cream, and 3 drams of a solution of phosphoric acid.

GALVANOGRAPHY

Under this name there have been put forward several processes based on the idea of painting on a silvered copper plate with oil colour in thick masses so as to give relief. When dry, or nearly so, the surface is dusted with finely powdered blacklead to make it electro-conductive, and a thick copper shell is deposited on it. This is subsequently used as an intaglio printing plate. A process of this kind was patented by Prof. Herkomer and Henry T. Cox in 1898. The basis of the method was described by Franz von Kobell, of Munich, as early as 1842.

GALVANOGRAPHY, PHOTOGRAPHIC

A process of utilising a gelatine relief as a mould for making electrotypes. Several inventors have adopted the title, but Paul Pretsch had probably the best right to it. His process consists in coating a glass plate with gelatine containing bichromate, with a silver salt and other chemicals. When dry it is exposed under a transparency, and then immersed in cold water to dissolve out the unaltered chromium salts and cause those parts protected from the light to swell up in proportion to the tones of the picture. The high lights do not swell at all, and have no grain. The plate thus produced is, of course, an exact reverse of that required for printing. The surface is next made conductive with a metallic coating, so that an electrodeposit can be made upon it, thus producing a copper shell which can be backed up with type metal to form a printing plate.

GAMBOGE (Fr., *Gomme gutte ;* Ger., *Gummi-gutt*)

Synonyms, camboge, gummi gutte. A gum resin obtained from several species of guttiferæ trees, occurring in bright orange lumps with conchoidal fracture ; used as a colouring pigment.

The coating of lithographic writing transfer paper is coloured with gamboge in order that the prepared side may be distinguished from the unprepared one. Gamboge has been recommended as an addition to Indian ink for drawings intended for photo-reproduction.

GAMMA (Fr. and Ger., *Gamma*)

The term adopted by Hurter and Driffield to define the gradation, or degree of contrast, of a

negative. Gamma infinity, or $\gamma\infty$, as it is usually written, is the ultimate density-giving power of the plate. (*See* " Plate Testing.")

GAS CYLINDERS (*See* " Cylinders, Gas.")

GASLIGHT PAPERS

Papers coated with a chloride or chloro-bromide emulsion, which can be manipulated in weak gaslight. For suitable emulsions, *see* under the heading " Emulsions for Development." Gaslight paper (so called) is really a very slow bromide paper, and is developed, fixed and toned (if necessary) like bromide paper, except that the developer must be stronger, and the development is more rapid. Exposure can be made by putting the paper into contact with a negative which is held a few inches from a gas burner or good oil lamp, but development must not take place in a light equally strong or the print will be fogged ; either the light must be turned down during development, or the operation must be carried out at some distance from the light or in a shadow. Artificial lights other than gaslight, or even very weak daylight, will serve equally well ; in fact, the common practice is to expose to the light of magnesium ribbon and develop by aid of weak artificial light. A metol-hydroquinone developer is usual, and this must be accurately prepared, particularly as regards the potassium bromide ; too little bromide causes impure whites, while with too much the blacks will be of a greenish hue. Development should take place almost instantaneously. An acid fixing-bath is advisable, but not necessary. The colour of the print depends on exposure and development ; longer exposure and a weaker developer invariably produce warmer tones. With most papers a warm brown tone may be obtained by giving three times the normal exposure and diluting the developer with twice the bulk of water.

GASLIGHT, PORTRAITURE BY

The use of gaslight is possible for portraiture. With ordinary gaslight (without mantles), exposures are long even under the most favourable conditions, the light being poor in violet rays and comparatively non-actinic. Gaslight has advantages for isochromatic work, as without a yellow screen it gives practically the same result as daylight with a screen, isochromatic plates being used in both cases. With a very rapid plate, and the lens stopped down to $f/8$, the necessary exposure with two gaslights (not incandescent) 3 ft. from the sitter would be about two minutes. Particular care is necessary in posing, using a reflector, and in development, as the results are bound to be a trifle hard and " contrasty."

Incandescent gaslight is better for portraiture, as a full-size mantle gives an illumination of about sixty candle-power when at its best, and is about one and a-half times as effective photographically as a gas flame of the same visual intensity, because of the whiteness of the light and its richness in the blue or actinic rays. The exposure depends, of course, upon the number of burners. The special fittings obtainable from factors are in the form of brackets containing a score or more lights, which make possible quite

brief exposures—say one or two seconds ; but an enormous amount of heat is produced. Fair results may be obtained with one or more ordinary domestic burners, but the exposure is somewhat long, a minute at least, with two lights near to the sitter, a very rapid plate, and the lens at $f/8$.

It will be noted that *all* gaslights are incandescent, the light in a plain flame being produced by heating particles of carbon to incandescence ; but it is convenient to adopt here the ordinary nomenclature by which the term " incandescent " is restricted to burners of the Bunsen type, fitted with mantles of rare earths.

Acetylene outfits for portraiture are similar to the incandescent gas fittings in arrangement. The light is very actinic, and as a rough guide it may be said that when using fourteen acetylene lights, a rapid plate, and a lens at $f/8$, an exposure of about five seconds is required in an ordinary room ; the distance of the lights from the sitter greatly affects the length of the exposure. (*See also* " Artificial Light, Photography by.")

GAUGE, PRESSURE

The lanternist ascertains the contents of gas cylinders by means of a gauge. He may know that the cylinder is of 20 cubic feet capacity, and the full cylinder gives a gauge pressure of 120 atmospheres; after the exhibition, the gauge may indicate, say, 50 atmospheres. Then the content

equals $\dfrac{50}{120} \times 20 = \dfrac{50}{6} = 8\frac{1}{3}$ cubic feet.

A pressure gauge is used on the motor aerograph pump, the degree of pressure being indicated in pounds per square inch on a circular dial. With the aerograph foot pump a simple form of pressure gauge is used, consisting of a U-shaped tube filled with a coloured fluid, one end being closed and the other attached to the air reservoir. As the pressure varies it is indicated by marks on a scale placed behind the tube.

On the large vacuum and pneumatic frames used by process workers there is generally a pressure gauge, reading in pounds per square inch on a circular dial.

The Levy acid-blast etching machine has a gauge consisting of a column of mercury in a glass tube, communicating with a U-tube in the iron casting of the gauge. As the pressure increases or decreases the mercury rises or falls, and the pressure in pounds per square inch is read on a scale alongside the glass tube.

GAUSS POINTS (*See* " Nodal Points.")

GELACOL

A preparation of gelatine treated with acetic acid to destroy its setting property. It is used for coating glass plates with a substratum, particularly in collodion emulsion work.

GELATINE (Fr., *Gélatine ;* Ger., *Gallerte, Gelatin*)

A colloid of extremely complex nature, containing carbon, hydrogen, nitrogen, and oxygen, with a small proportion of sulphur. It is known commercially in fine shreds or thin, flat sheets, marked with the diamond pattern of the strings

on which it is dried. Photographic gelatine is usually prepared from selected hides, whereas inferior sorts are prepared from bones, tendons, and cartilages. It is insoluble in cold water, which it absorbs and then swells up to a slimy mass; it is soluble in all proportions in hot water, but insoluble in alcohol and ether. The principal constituents are two substances known as glutine and chondrine; the former is not precipitated by the alums, whilst the latter is, and gelatines rich in chondrine are the best for photographic purposes. A simple test for this is to add to a warm 10 per cent. solution of gelatine an equal volume of a saturated solution of chrome alum, when the solution should instantly set to a jelly. It is only possible to indicate the general characteristics of a gelatine suitable for photographic purposes, as the true test of its suitability is to make a practical trial with a small batch of emulsion. A good gelatine should absorb not less than six times its weight of water, and not much more than twelve or fifteen times.

There are three kinds of photographic gelatine: hard, medium or middle hard, and soft. Hard gelatines should not melt below 82° F.

Device for Determining Melting Point of Gelatine

(nearly 28° C.); if they do not melt at 88° F. (31° C.), there is a risk of their having been hardened with alum. Soft gelatines should melt at from 62° to 75° F. (say 17° to 24° C.). A 1 per cent. solution should set to a jelly when cooled down to 56° F. (13·3° C.), and remain without any sign of putrefaction for twenty-four hours.

The determination of the melting point is somewhat difficult, and Child Bayley has suggested an excellent practical device here shown in the testing position. This may be made of copper or zinc, and the sloping portion is to prevent heat from the Bunsen burner passing direct to the front of the tank. Across the front of the tank should be scratched a line about 1 in. from the top, and on this line should be placed some discs of gelatine. Gummed labels are cut into strips about ½ in. wide and about 1½ in. long, and their ends are then gummed together, with the gummed surface outside, so as to form rings. The tank should be placed with the front and marked surface up, and the paper rings placed on the line and then carefully filled by means of a pipette with a warm 10 per cent. solution of gelatine. When the gelatine is thoroughly set, the rings should be cut down with a sharp knife and stripped off, and the tank set upright and filled with cold water, and

this heated by means of the Bunsen burner. The discs must be carefully watched, and when they begin to melt and run down over the line the temperature should be noted. A mean of six trials may be taken as correct.

Another method is to use a thermometer in a very narrow test tube, just 1 mm. (1/25 in.) wider all round than the thermometer bulb, which should be of elongated shape. Then fill the tube with the gelatine solution and, while hot, immerse the thermometer well into the tube, and set. Afterwards place the tube in warm water, and gradually raise the temperature; then when the gelatine melts, the tube will drop off, and the temperature can be noted.

Gelatine is used for preparing baryta paper, for emulsions, both negative and positive, in collotype, photogravure, and other photo-mechanical processes, and it is the chief ingredient of an excellent mountant.

Solutions of sulphocyanides and barium chloride dissolve gelatine in the cold, as do also acetic, oxalic, hydrochloric, and sulphuric acids. Zinc chloride and chloral hydrate destroy its setting power. The setting is increased by the alums, magnesium sulphate, and numerous other salts. It forms a compound, gelatinate of silver, which is sensitive to light, with silver nitrate.

In process work, gelatine has numerous uses —namely, for coating collotype plates, for preparing photo-lithographic paper, for the carbon tissue in the photogravure process, for the making of gelatine reliefs, for use as a substratum on glass plates, for the making of films for shading mediums, for making litho-transfer papers and films for tracing, for stripping negative films, for making colour filters, for glazing prints, etc. Particulars of these applications and uses are given under the respective subject headings.

GELATINE, BICHROMATED

Gelatine treated with an alkaline bichromate forms the basis of the carbon process and of all photo-mechanical printing methods. Fish-glue is employed in some processes, but that is a substance closely allied to gelatine; and other colloids are sometimes substituted, as in the gum-bichromate process. Gelatine, in its normal condition, will absorb cold water readily, and dissolve easily in hot water. Gelatine treated with an alkaline bichromate retains these qualities if kept in the dark; but if exposed to light, it no longer absorbs cold water, or swells in consequence, and it also becomes insoluble. These properties are utilised in different printing methods. In the carbon process, and in some photo-mechanical methods, an image in gelatine is produced by exposing a film of bichromated gelatine under a negative, and then dissolving away those parts on which the light has not acted by means of hot water. In others, a gelatine relief is produced by means of the unequal swelling of a gelatine film that has been exposed under a negative when soaked in water. Details of the various processes in which these qualities are utilised are given under their respective headings.

In process work, many processes depend on the properties of bichromated gelatine. Among these may be mentioned collotype, photogravure,

photo-lithography, and photo-relief. For the half-tone process gelatine has not been found so satisfactory as fish-glue, the latter having no setting property, and being easily developed with cold water. An attempt was made of late to utilise for half-tone a gelatine in which the setting property had been destroyed, but it was found to be more subject than fish-glue to changes of temperature, and also liable to become putrid very readily.

GELATINE EMULSIONS (See " Emulsion.")

GELATINE MOUNTANTS (See "Mountants.")

GELATINE PAPERS

Printing papers which are coated with gelatine, which acts as a vehicle for the silver salts. All bromide and gaslight papers, and most makes of ordinary P.O.P., are gelatine papers. Some makes of P.O.P. are coated with collodion. Nearly all self-toning papers have collodion emulsions, but a few have gelatine. Gelatine papers are sticky when wet, and the emulsions dissolve in hot water.

GELATINE PLATES AND FILMS

Glass plates or celluloid coated with gelatine emulsions, as distinguished from collodion plates.

GELATINE RELIEFS

Probably more ingenuity has been displayed in devising processes for making gelatine reliefs to serve as printing surfaces than in any other form of photo-mechanical work, and yet there is not one of these processes that is in regular commercial use at the present day. These processes date from the experiments of Fox Talbot and Poitevin. In general the basis of the process is the preparation of a thick film of bichromated gelatine on plate glass, exposing it under a negative or positive when dry, and developing with warm water so that the unexposed parts wash away, leaving those portions standing that have been acted upon by light. The relief is hardened with alum or other agents, and dried. (This is the " Wash - out Gelatine Process," *which see*.) In some processes, however, the unaltered gelatine is not washed away, but is allowed to swell up, and thus form a matrix for casting in plaster. (See " Swelled Gelatine Process.")

The foregoing were chiefly used for line reproduction processes, but others are intended for making half-tone reliefs. Dallastype and Dallastint, and Pretsch's photo-galvanography are processes of the kind that are described under separate headings; and Woodbury also devised a process of this nature for typographic printing. The half-tone image is either formed by printing through a screen, or by reticulating the surface of the gelatine. In Woodburytype (*which see*) the gelatine relief is utilised, but in an essentially different manner from the foregoing; pigment is introduced into the film, and development is similar to that of carbon tissue. Stannotype is a variation of Woodburytype. Photo-filigrane (*see* " Filigrane") is another process depending on a gelatine relief. (*See also* " Acrograph," " Leimtype," " Mosstype," " Stannotype," etc.)

GELATINEGRAVURE

Transparent gelatine is placed over a photograph, and a drawing made by scratching. When this is complete the lines are filled with lithographic transfer ink thinned with turpentine and applied with a dabber. Printing is done by running the gelatine through a roller press in contact with paper.

GELATINO - BROMIDE PAPERS AND PLATES

Papers or glass plates coated with gelatinobromide emulsions.

GELATINO-BROMIDE PROCESS (Fr., *Gélatino-bromure*; Ger., *Bromsilbergelatin*)

A term used in the early days of dry-plate photography to distinguish the method of manufacture of the emulsion from collodion It is now also used to include bromo-iodide plates.

GELATINO-CHLORIDE PAPER

Paper coated with an emulsion of silver chloride in gelatine.

GENRE WORK

The word " genre " comes through the French from the Latin " genus," a kind. In painting it has been used to signify figure subjects of a homely or domestic character, generally engaged in their ordinary occupations. The term has been adopted to signify the same subjects treated photographically. Similar considerations apply as in dealing with single figures and groups. There are the same difficulties of securing satisfactory pose and arrangement, and a suggestion of natural action. The " setting " of the figures and the choice and arrangement of the accessories also play an important part. Careful studio arrangements and the employment of good models have frequently led to the production of excellent genre pictures, but the best and easiest way is to study and treat the real subjects and their ordinary surroundings both in and out of doors. The works of some of the painters of the Dutch school offer very fine examples of the effective treatment of genre subjects. The thing to aim at is harmony and unity. (*See also* " Figure Studies.")

GEOLOGICAL PHOTOGRAPHY

Photography as applied to geological investigation may be roughly classed under the following headings: (1) Photographs showing plains, valleys, escarpments, base levels, mountains, lakes, rivers, glaciers, etc., taken for the purpose of illustrating the origin of landscape, and the action of atmospheric and other processes of denudation. (2) Photographs of the faces of cliffs, quarries, railway cuttings, and other exposed surfaces, to show the way in which strata have been laid down, and changes which have taken place producing unconformity, overfolding, faults, dip and strike, anticline and syncline, crushing, cleavage, and joints. (3) Photographs of fossil remains, both *in situ* and after cleaning, to show the types of animal and plant life existing during the formation of the strata in which their fossil remains are embedded. (4) Photo-micrographs of thin sections of rocks, showing their structure, composition, and any

18

minute animal and plant remains that may be present.

For most geological photography, a good stand camera, having a long extension of bellows, swing back, and rising front, will be found most serviceable. A good lens is all-important, as the value of a geological photograph depends upon its perfect clearness and sharpness of detail. The lens should be provided with a deep hood for use in the field, which will prevent flare, and flat, foggy-looking negatives, caused by reflections and rays of light falling obliquely on the front surface of the lens. The tripod should be substantial and rigid, so that there will be no fear of vibration during exposure, for it is always best to stop down the lens and give a full-time exposure, so that a crisp, sharp negative, full of detail and gradation, may be obtained. It is often desirable when photographing a portion of the face of a cliff, or part of the strata laid bare in a quarry or railway cutting, to include in the photograph some familiar object of which the size is well known, to act as a kind of rough scale by which one may judge the relative thickness of a deposit, or the size of a fossil seen *in situ*. For this purpose, some workers use their geological hammer, but as hammers vary a good deal in size and shape, it is much better to include a twelve-inch or two-foot rule. Orthochromatic plates should always be used. F. M-D.

GERMEUIL-BONNAUD (*See* " Dusting-on (Powder) Process.")

GHOST IMAGES IN LENSES (*See* " False Images, or ' Ghosts.' ")

GHOST PHOTOGRAPHY (*See* " Psychic Photography.")

GIFFORD'S SCREEN

A so-called monochromatic light screen, made by immersing a slip of cathedral green glass, which is of bluish green tint, in a solution of aniline green. It is used in photo-micrographic work, and passes a spectral band about E in the green.

GIGANTOGRAPHY

A process of making enlarged half-tone negatives for poster printing. Two cameras are required—one a small one, according to the size of the original image, and the other large enough to take the enlarged negative. The lens of the small camera is connected to an aperture in the front of the large camera, on the principle of the usual enlarging camera. An evenly graded transparency, thin but full of detail, is placed in the dark-slide of the small camera, the shutters drawn out, and the slide placed in position. The half-tone screen is placed in its holder in front of the positive, and the distance of the screen is set proportionately to the extension of the camera to secure the desired enlargement. A powerful light is reflected through the positive by illuminating with arc lamps a sheet of white paper placed behind it. The image is then focused, and the ruled screen adjusted until the desired dot image is obtained. The advantage of the process is that it saves the necessity of a very large and expensive ruled screen.

GILLOTAGE

The earliest process of line zinc etching, invented by Charles Gillot, of Paris, and patented in France in 1850 ; known as panikonography, or the French or Parisian method of zinc etching. The principle of the method is that an image in lithographic ink on zinc is strengthened for acid resisting by repeatedly rolling up with ink and then dusting with resin, the plate being heated to melt the resin, so that it runs down the sides of the lines and protects them against undercutting by the acid.

" GIPHANTIE "

A book written in 1760 by a Frenchman, Tiphaigne de la Roche, the title being an anagram of his own name. It contains a forecast of photography. One paragraph says : " You know that the rays of light reflected from different bodies form pictures, paint the image reflected on all polished surfaces, for example, on the retina of the eye, on water, and on glass. The spirits have sought to fix these fleeting images ; they have made a subtle matter by means of which a picture can be formed in the twinkling of an eye. They coat a piece of canvas with this matter, and place it in front of the object to be taken. The first effect of this cloth is similar to that of a mirror, but by means of its viscous nature the prepared canvas, as is not the case with the mirror, retains a facsimile of the image. The mirror reflects images faithfully, but retains none ; our canvas reflects them no less faithfully, but retains them all. This impression of the image is instantaneous. The canvas is then removed and deposited in a dark place. An hour later the impression is dry, and you have a picture the more precious in that no art can imitate its truthfulness." A still earlier writer, Fénélon, had a vision of photography, but did not so clearly express it ; his book bears the title of " Un Voyage Supposé," and was written in 1690.

GISALDRUCK

A photo-lithographic process, invented by B. Gisevius, of Berlin, for direct printing on aluminium without a negative. The actual drawing is printed through on to a sensitive film on the metal, and the negative image is converted into a positive. It resembles the Vandyke process (*which see*).

GLACIAL ACETIC ACID (*See* " Acetic Acid.")

GLAISHER, JAMES

Born in London, April, 1809 ; died at Croydon, February 7, 1903. Was for twenty-three years (1869 to 1874 and 1875 to 1892) president of the (now) Royal Photographic Society. He was largely responsible for the photographic recording instruments in Greenwich Observatory.

GLASS (Fr., *Glace, Verre* ; Ger., *Glas*)

Ordinary glass is a fused mixture of silicates of calcium or lead with the silicates of sodium or potassium. While practically unaffected by acids, except hydrofluoric, it is attacked by strong alkalis, which dissolve out the silica. Some glasses are yellowed by prolonged exposure to light ; this is frequently the case with old lenses.

Crown Glass is made usually from sand, lime, and a sodium salt, with sometimes lead oxide.

Flint Glass contains potassium carbonate, red lead, sand, and saltpetre. It is easily fusible, and is not so suitable for chemical purposes, for which a soda-lime or potash-lime glass is preferable.

Opal Glass is obtained by fusing an oxide of tin or zinc with the pot-metal; a " flashed " opal, consisting of a thin opal layer united to plain glass, is also manufactured.

Optical Glass first received specific attention from Pierre Louis Guinand, of Les Brenets, in Switzerland (born 1748, died 1824), who obtained improved results by stirring the fused mixture with a rod of crucible clay. J. Fraunhofer (born 1787, died 1826) succeeded in avoiding striæ and in procuring glass of a uniform refractive index by the simple expedient of using larger pots for melting; he also investigated some of the optical effects resulting from variations in the ingredients and their proportions. In 1842 a son of Guinand introduced boracic acid into the glass, which, however, did not then meet with favour. In 1851 Maes, of Clichy, produced a colourless and homogeneous zinc crown glass, containing zinc oxide and boracic acid; this was used in Charles Chevalier's photographic objectives. L. Seidel in 1856, and J. Petzval in 1857, pointed out that new glasses, having a different relation between their refractive and dispersive powers to those then in use, were required for the perfection of the photographic objective, but it was not till Otto Schott and E. Abbé began their joint work in 1881 that any real progress was made. In 1886 the famous Jena works were started by Schott, Abbé, and R. Zeiss, under a liberal subvention from the Prussian Government. Since then the production of optical glass of almost any required refractive or dispersive power has been rendered possible by the use of new chemical ingredients.

People often talk loosely of the Jena optical glass, as if there were only one variety, although, as a matter of fact, several hundreds of different varieties of optical glass are known, these including all the ordinary flints and crowns, besides the special glasses that have made the manufacture of the modern anastigmats possible; it is these special glasses that are generally meant by the term " Jena glass." With the older makes of optical glass, increased refractive power was always accompanied by a high degree of dispersion, but in the new Jena glasses a very high refractive power is obtained with a comparatively low dispersion.

(For the optical properties of glass, *see* " Lens.")

Cements for Glass.—A cement for glass needs to be as colourless as possible, the best from this point of view being Canada balsam, which should be dried in an oven, allowed to cool, the glass gently heated, the remelted balsam thinly applied, and the surfaces brought together. This is the universal cement for lenses. Other excellent cements (but not suitable for lenses) are water-glass, which, however, tends to roughen the glass, and an emulsion of gelatine in sufficient acetic acid to cover it, the process of digestion being assisted by standing the bottle in warm water.

In process work, glass is an important material. To secure good contact between the negative and metal plate in direct printing, the glass must be flat, and plate glass is preferable, though for the general run of work a good selected sheet glass is used. Plate glass of about ¼ in. thickness is used for assembling a number of stripped films on to one plate. For process printing-frames, thick plate glass is used up to 1¼ in. thickness in the largest frames, and this glass must be well annealed in order to withstand the strain of the pressure and the heat of the arc lamps used for printing. The glass must also be free from surface scratches and other imperfections which would show in the print.

GLASS, CLEANING

Glass for photographic purposes must be scrupulously clean. Glass upon which prints are squeegeed for glazing is best cleaned by soaking in very dilute nitric acid and scrubbing with soap and water; after drying, it is dusted over with French chalk and polished. When glasses are to be used for coating and sensitising, as in the wet collodion process, rouge or whitening or fine tripoli powder mixed with methylated spirit to the consistency of thick cream is recommended; the paste is rubbed over the glass, rinsed off with water, and a final polish is given with chamois-leather.

A good mixture for thoroughly cleaning glass for ordinary purposes is—

Soft or rain-water	. .	1 part
Powdered pumice stone	.	1 ,,
Chalk or whitening	. .	1½ ,,
Liquor ammoniæ	. .	½ ,,

Apply with a piece of flannel, and polish with a soft rag, chamois-leather, or soft paper crumpled up.

To clean films off old negatives, soak in hot soda-water for a few minutes, and scrub with a brush; or, if they are not varnished, soak them for an hour or two in water made slightly acid with nitric acid; the films can then be rubbed off with a strip of wood, or placed in hot soda water and scrubbed. When the negatives have been varnished, it is necessary to use a strong and hot solution of common washing soda or caustic potash, and leave the negatives in this until cold, when the films will leave the glass. Do not let the caustic potash solution touch the fingers.

In process work, in which collodion and collodion emulsion are used so largely, it is necessary to take great pains in cleaning glass. New glass is best soaked in a 5 per cent. solution of hydrochloric acid contained in grooved lead-lined troughs; and it is then rinsed with plenty of water and polished with methylated spirit 20 oz., tripoli 10 oz., iodine 2 drams. Prepared chalk or whiting may be used instead of tripoli, and equal parts of methylated alcohol and ammonia instead of iodine.

For removing collodion films from old negatives, nitric acid is generally used in the proportion of 1 oz. acid to 6 oz. water. A good film-removing pickle, free from fumes, consists of—

Sulphuric acid	. .	4 oz.	200 ccs.
Potassium bichromate	.	4 ,,	220 g.
Water	20 ,,	1,000 ccs.

After treatment, swill and put in the draining-rack. Next, with a linen rag charged with whiting of the consistency of thick cream, rub well both sides of the partially dry negative glasses; then put into a clean bath composed of nitric acid 4 oz., water 40 oz. Finally, swill under a tap and then albumenise.

GLASS, ETCHING ON (See "Hyalography.")

GLASS, GREEN (See "Green Glass.")

GLASS, PHOTOGRAPHS ON

In 1848 Niepce de St. Victor produced photographs upon glass in the form of negatives, but glass as a support for photographs was suggested by Sir John Herschel in 1839. About 1850 Archer produced positives on glass by the collodion process.

Photographic negatives are now almost entirely upon glass or celluloid. Photographic positives on glass are produced in many ways, as described under the headings "Lantern Slides," "Window Transparencies," etc.

GLASS POSITIVES

Photographs on glass, such as lantern slides. The early glass positives were produced by the collodion process, and the deposit forming the image was white and the shadows clear glass, there being a backing of black velvet, cloth, or paint.

GLASS, RUBY (See "Ruby Glass.")

GLASS, SILVERED

Photographers and process workers are well advised not to prepare their own mirrors and prisms, but the question of silvering is important. The silvered surface must be thick and durable to withstand the frequent polishing for removal of tarnish. Mirrors should be thoroughly warmed before polishing, and the polishing pad and rouge must be quite dry and warm. The very finest optical rouge should be used, and the pad should be rubbed on a clean glass plate before applying it to the mirror. The pad should be kept in a wide-mouthed glass jar with glass stopper when out of use, so that no gritty dust can reach it. The silvering on the hypoteneuse of prisms should be backed with an electro-deposit of copper and then varnished.

GLASS, SOLUBLE (See "Water-glass.")

GLASS, YELLOW (See "Yellow Glass.")

GLASSWARE, PHOTOGRAPHING

Photographically, glassware is similar to silver ware, and the instructions for lighting, etc., given under the latter heading apply almost as well to glass vessels. Glass may sometimes be improved by frosting or dewing, as described for silver ware, but in most cases it is advisable to fill the glass vessels with a non-actinic solution, in order to prevent the details and high lights on the far side conflicting with those nearest the camera. A non-actinic solution may consist of a very dilute solution of potassium permanganate, but it must be only slightly tinged, otherwise it will appear as ink. Another plan

is to dust the glasses lightly with powdered talc, using this for partly filling up engraving in order to make it show more distinctly upon the negative. The background should be of a dark tint.

In process work, numerous expedients are resorted to for photographing glassware for catalogue illustrations. A piece of ice put inside the vessel will cause moisture to condense on the outside, and so stop reflections. Dabbing the glass over with putty is also effective on smooth surfaces, but does not avail with cut-glass. Coating the glass with a varnish and blackleading with a brush has also been resorted to. Spraying the glass with the aerograph also serves the purpose.

GLAZING PRINTS (See "Glossy Surfaces on Prints.")

GLAUBER'S SALT

Another name for sodium sulphate (*which see*). First produced by Johann Rudolph Glauber, a German chemist, about 1661; hence the name.

GLOBE LENS

One of the earliest non-distorting, wide-angle lenses, introduced by Harrison, of New York, in 1862, and highly esteemed until superseded by the wide-angle rectilinear. Its chief defects

Globe Lens

were slowness (full aperture $f/36$) and liability to flare. It was symmetrical in construction, the outer surfaces of the two components being so placed as to form part of a sphere, as shown.

GLOBE POLISH REDUCER (See "Baskett's Reducer.")

GLOSSY PAPERS

These are almost always prepared with gelatine. Their gloss may be enhanced in finishing by the procedure given under the heading "Glossy Surfaces on Prints." A glossy surface possesses the advantage of imparting great depth and transparency to the shadows, and of rendering all detail crisply throughout the scale of tones. It also gives greater visual contrast in the print. For this reason, prints with glossy surfaces are very desirable for reproduction purposes, and for many kinds of commercial photography, engineering subjects, architectural details, etc. There are several papers on the market, both for daylight and for artificial light printing, with semi-glossy surfaces.

GLOSSY SURFACES ON PRINTS

For finishing prints with a glossy surface, a paper prepared with a naturally glossy surface should be employed. The most simple and satisfactory method of working is as follows: The prints, after fixing and washing, should be immersed in a formaline bath (formaline ½ oz., water 5 oz.) for two or three minutes, washed

for a quarter of an hour, and then dried. A glass, celluloid, or ferrotype plate is washed and polished with a soft fabric, first rubbing on with a flannel a solution of 20 grs. of beeswax in 1 oz. of turpentine. The print is soaked in water until thoroughly limp, and then a liberal quantity of water is thrown on the polished plate, and the print placed face downwards on the plate, care being taken that there is plenty of water between the two surfaces. The print is next firmly squeegeed into contact, interposing a sheet of rubber cloth between the print and the roller squeegee. When quite dry, the print will leave the plate very easily, and its surface will possess a high gloss. This surface is hard and durable, due to the employment of the formaline bath, but it is well to back the print with a waterproof sheet so as to prevent the mountant from affecting the glaze.

GLUCOSE (Fr., *Glucose*; Ger., *Glycose*)

Synonym, dextrose, grape sugar. $C_6H_{12}O_6$. Molecular weight, 180. A thick, syrupy, yellowish liquid, obtained by the action of dilute sulphuric acid on starch. It was suggested as a developer or addition to developers for wet plates.

GLUE, FISH (*See* "Fish-glue.")

GLYCERINE (Fr., *Glycérine*; Ger., *Glyzerin*)

A colourless, odourless, thick liquid of characteristic sweet taste, miscible in all proportions with water and alcohol, and slightly soluble in ether. Glycerine as purchased from a chemist or at an oilshop is good enough for photographic purposes. It has many uses in photography, for example, in developing platinotypes, as a constituent of developers, as an addition to gelatino-chloride and collodio-chloride emulsions, in mountants, and to prevent films curling.

In collotype work, glycerine is used for the "etching" or damping of the plate previous to inking. A suitable solution consists of 3 parts glycerine to 2 parts water.

GLYCEROL (*See* "Glycerine.")

GLYCINE, OR GLYCIN (Fr., *Glycine*; Ger., *Glycin*)

A developer, known also as paraoxyphenylglycin, having the formula C_6H_4 OH $NHCH_2$ COOH. It appears in the form of glistening grey powder, which, when carelessly kept, turns to a brownish black and loses its developing powers. The powder is insoluble in plain water, but soluble in a solution of sodium sulphite, or on the addition of an alkali. It is a slow-working developer, having a factor of 7, and works after the manner of ferrous oxalate; it has the advantage of giving good clear negatives with little or no fog, and good density. It is widely used for stand and tank development and for the reproduction of black-and-white subjects; it may be used in a one-solution or two-solution form.

One-Solution Developer

Hot water	. .	30 oz.	1,000 ccs.
Sodium sulphite	.	1¼ ,,	45 g.
Potassium carbonate	2½ ,,	90 ,,	
Glycin .	. .	½ ,,	18 ,,

The above is ready for use.

Another one-solution formula gives a stock solution in the form of a cream, and is known as—

Hübl's Stock Glycine Solution

Sodium sulphite	.	2½ oz.	688 g.

dissolved in—

Hot water	. .	4 ,,	1,000 ccs.

then add—

Glycine	. . .	1 ,,	275 g.

Heat to boiling point, and add—

Potassium carbonate	.	5 oz.	1,375 g.

Add the potassium carbonate gradually in small quantities on account of the carbonic-acid gas. When cold, this forms a thin paste; when required for use, shake and dilute 1 part with 12 parts of water, using more water for soft development and less water for hard development. For stand development, mix with 50 to 55 parts of water.

Two-Solution Developer

A.	Glycine	. .	380 grs.	44 g.
	Potass. carbonate	.	144 ,,	16·5 ,,
	Sodium sulphite	.	5 oz.	275 ,,
	Water .	.	20 ,,	1,000 ccs.
B.	Potass. carbonate	.	2½ ,,	137 g.
	Water .	.	20 ,,	1,000 ccs.

For use, mix equal parts of A, B, and water. Potassium bromide is added in cases of overexposure.

Messrs. Newton and Bull have recommended glycine as a developer for all isochromatic plates, as follows:—

Glycine	. . .	192 grs.	18 g.	
Potass. carbonate	. .	2 oz.	88 ,,	
Sod. sulphite (anhydrous)	240 grs.	22 ,,		
Potassium bromide	.	12 ,,	1 ,,	
Water to	. .	25 ,,	1,000 ccs.	

Development is controlled by time, using a factor of 6.

In process work, glycine is an excellent developer for collodion emulsion and for process dry plates, but it is expensive compared with hydroquinone, which is more generally used.

GLYCOCINE (Fr., *Glycocine*; Ger., *Glykokoll*)

The decomposition product of the action of sulphuric acid on gelatine. It was used as a preservative for collodion dry plates. (*See also* "Amido-acetic Acid.")

GLYCOCOLL (*See* "Amido-acetic Acid.")

GLYPHOGRAPHY

An electrotyping process invented by E. Palmer, of London, about 1844. A copper plate is coated with a white composition consisting of white wax and zinc white, and the coating is scratched through with needles so that the lines are formed in deep furrows. The plate is brushed with blacklead, and forms a mould for electrotyping. (*See also* "Wax Process" and "Cerography.")

GODDARD, JOHN FREDERIC

Inventor of the polariscope; improved the daguerreotype process by discovering (in 1840)

the accelerating properties of bromine, by which, with iodine, he obtained a bromo-iodide of silver on the surface of the silvered plate, thereby reducing the necessary exposure to about one-sixtieth—from twenty minutes to twenty seconds. This invention, in conjunction with Fizeau's gold chloride and "hypo" invigorator, made the daguerreotype a commercial success, as it then became possible to give reasonably short exposures, whereas previously long exposures were needed, and the sitter's face had to be whitened with powder, and placed in full sunlight.

GOETZ'S REDUCER

A reducer for negatives introduced in 1894 by H. Goetz. A strong solution is made by mixing 1 oz. of copper sulphate with 5 oz. of distilled water:—

No. 1—			
Common salt	. .	$\frac{1}{4}$ oz.	28 g.
Copper sulphate solution .	$\frac{1}{2}$,,	55 ,,	
Distilled water	. .	10 ,,	1,000 ccs.

No. 2—			
Sodium hyposulphite	.	96 grs.	22 g.
Distilled water	. .	10 oz.	1,000 ccs.

The carefully washed plate is placed for from twenty to thirty seconds in solution No. 1, then rinsed and transferred to No. 2, in which the reduction takes place, and the process should be well controlled, the action being a rather quick one. The longer the plate has been left in No. 1 the more rapid will be the reduction in No. 2. For slight over-exposure increase the salt and decrease the copper sulphate in No. 1; the contrary holds good in a case of under-exposure. Finally, the negative should be thoroughly washed.

GOLD (Fr., *Or* ; Ger., *Gold*)

Au. Molecular weight, 197. It occurs native in grains or nuggets. A heavy yellow or orange-yellow metal, which, as a metal, is not used in photography. Its salts are used for toning prints. Most of its salts are sensitive to light, particularly the chloride, in the presence of organic matter, and therefore all gold solutions should be kept in the dark.

GOLD CHLORIDE (Fr., *Chlorure d'or* ; Ger., *Goldchlorid*)

Synonyms, trichloride or perchloride of gold, auric chloride. $AuCl_3 HCl 4H_2O$. Molecular weight, 412. Solubilities: very soluble in water, alcohol, and ether. It occurs as needle-like yellow crystals obtained by dissolving metallic gold in aqua regia and evaporating the solution. The crystals are very hygroscopic, and should be kept in a stock solution. There is a brown form of gold chloride, $AuCl_3 HCl xH_2O$, which contains less water than the yellow salt and is less hygroscopic. This should contain from 50 to 51 per cent. of metallic gold. Both salts are used in toning. Gold chloride has a great tendency to form double salts with the alkaline chlorides, which are more stable. (*See* "Gold and Potassium Chloride" and "Gold and Sodium Chloride.")

GOLD AND "HYPO" BATH (*See* "Gold Hyposulphite.")

GOLD HYPOSULPHITE (Fr., *Hyposulfite d'or et de sodium, Sel de Gélis et Fordos* ; Ger., *Unterschwefligsäure Goldoxydulnatron, Goldsalz*)

Synonyms, sel d'or, hyposulphite of gold and soda. $AuS_2O_3Na_2S_2O_3 2H_2O$. Molecular weight, 522. Solubilities, very soluble in water, almost insoluble in alcohol and ether. It occurs in white needles, and is obtained by adding a strong alcoholic solution of gold chloride to an excess of sodium hyposulphite. It was usually prepared in solution by adding a 2 per cent. solution of gold chloride to a 6 per cent. solution of "hypo." It was used for toning or "gilding" the old daguerreotype image, and is sometimes recommended for printing-out papers.

GOLD AND IRIDIUM BATH

The addition of iridium and potassium chlorides to a gold bath has been recommended for toning prints, but as it presents no practical advantages, and merely increases the cost, it has found no general use. The following is used for toning ceramic substitution pictures, and gives a warm, black tone :—

Iridium chloride	.	34 grs.	3·5 g.
Gold chloride	.	20 ,,	2 ,,
Lactic acid	.	22 mins.	2 ccs.
Distilled water to	.	20 oz.	1,000 ,,

GOLD AND PLATINUM BATH

The addition of chloroplatinite of potassium to the gold sulphocyanide bath was stated to give rich black platinum tones, whereas, as a matter of fact, all that takes place is the more rapid deposition of the gold. A bath similar in composition to that given under the heading "Gold and Iridium Bath," the iridium being replaced by potassium chloroplatinite, is also used in producing ceramic photographs. Platinum baths are sometimes used after a gold toning bath for P.O.P. papers.

GOLD AND POTASSIUM CHLORIDE (Fr., *Chlorure d'or et de potassium* ; Ger., *Kaliumgoldchlorid*)

$KCl AuCl_3 2H_2O$ or $KAuCl_2 2H_2O$. Molecular weight, 414. Solubilities, very soluble in water, alcohol, and ether. Yellowish needles obtained by mixing four parts of gold chloride in concentrated solution with 1·12 parts of potassium chloride, evaporating, and crystallising. It is used for toning.

GOLD RESIDUES (*See* "Residues.")

GOLD AND SODIUM CHLORIDE (Fr., *Chlorure d'or et de sodium* ; Ger., *Natrium goldchlorid*)

$NaCl AuCl_3 2H_2O$, or $NaAuCl_4 2H_2O$. Molecular weight, 398. Solubilities, very soluble in water, alcohol, and ether. Yellowish orange crystals, obtained in the same way as the potassium salt (*see* "Gold and Potassium Chloride"), using 4 parts of gold chloride and 1 part of sodium chloride. Both these salts may be adulterated with free potassium or sodium chloride, which may be detected by dissolving them in absolute alcohol, when any alkaline chloride will be undissolved.

GOLD TONING (Fr., *Virage à l'or*; Ger., *Tonen (Schönen) mit Goldsalz*)

The purpose of the gold toning bath is to convert the somewhat unpleasant yellowish red colour of the fixed silver image into a more pleasing brown, purple or bluish purple. This has been erroneously described as "gilding," whereas the action is purely chemical, the gold taking the place of the silver of the image, and the silver being converted into chloride in place of the gold. If instead of a plain solution of gold chloride the auric chloride $AuCl_3$ were used, the reaction could be expressed as follows:—

$$AuCl_3 + 3 Ag = 3 AgCl + Au$$

From this it will be seen that one atom of gold replaces three atoms of silver, and the fine details in the high lights would disappear and the image lose considerably in vigour. If, on the other hand, the gold is reduced to the aurous chloride $AuCl$, the reaction would be represented by—

$$AuCl + Ag = AgCl + Au$$

and one atom of gold would replace one atom of silver. It has been stated that an intermediate aurous chloride, $AuCl_2$, is formed, but it is such an unstable salt that its existence is doubtful. To convert any toning bath into the proper toning condition—that is, when the gold is reduced to the aurous state—it is "ripened" either by allowing it to stand or by the use of hot water to dissolve the salts, which should make the bath either neutral or distinctly alkaline. In the case of the sulphocyanide bath, a double salt of sulphocyanide of ammonium or potassium and gold is formed; this may also be in the auric or aurous state, and a similar chemical action takes place. Of recent years a more reasonable method of using the gold bath has been generally adopted, this allowing a definite quantity of gold to a definite area of print, instead of using one bath for a number of prints in succession and then adding fresh gold. It is important to wash prints well before toning, so as to free them from the excess of silver nitrate, which would decompose the gold chloride and prevent its deposition on the print. When a toning bath has been used, all the gold is not exhausted; but some which has passed into a stable aurate will not deposit. Obviously this may be collected for the sake of the residues, or the old bath may be used instead of water to make a new bath, the former plan being preferable. (*See also* "Residues.")

GOLD TRICHLORIDE OR PERCHLORIDE (*See* "Gold Chloride.")

GOLD AND URANIUM BATH

A mixture which has been frequently suggested for obtaining warm black tones on matt surface print-out gelatine or collodion papers:—

Gold chloride	.	2½ grs.	·25 g.
Uranium nitrate	.	2½ ,,	·25 ,,
Sodium chloride	.	10 ,,	1 ,,
Sodium acetate	.	10 ,,	1 ,,
Distilled water to	.	20 oz.	1,000 ccs.

Dissolve the gold and uranium in a little water,

neutralise with sodium bicarbonate, and add to a hot solution of the other salts. The bath is ready for use when colourless and cold.

GOUPIL PROCESS

A method of making facsimiles of water-colour drawings. A photogravure plate is carefully inked by hand with small dabbers or tampons, and in the more delicate parts with brushes, using differently coloured inks according to the character of the portions of the plate to be inked. When the inking is complete the coloured print is obtained at one impression. The plate is then cleaned and inked again for the next picture. This method of printing is very slow and costly, as skilled artists have to be employed for colouring the plates. The results, however, are very fine, and in some cases hardly distinguishable from the original water-colour drawing. The process is still practised.

GOUPIL GRAVURE

A photogravure process suggested to Goupil and Co., of Paris, by W. B. Woodbury, about 1870, and largely worked afterwards by that firm. A gelatine relief was made in the same manner as for the Woodburytype process, except that a fine gritty powder was added to the gelatine to give the necessary grain. From this relief a mould was taken and an electrotype shell deposited on it.

GRADATION

That variation of tones in a print by which are suggested differences in colour and in light and shade. A print has a long scale of gradation when there are many intermediate tones between deepest shadow and highest light. (*See* "Key.")

GRAIN IN COPYING

Copies of photographs frequently have a "grainy" effect, due to the dry plate reproducing the grain of the paper on which the original photograph was printed. To reduce the effect as much as possible, the original should be placed for copying in a good diffused front light; it is the character of the lighting that is generally to blame when the grain is reproduced prominently, as the stronger the light from one point, usually one side, the more pronounced is the grain. A method of obviating grain is to smear the face of the original with glycerine and squeegee it face downwards on plain glass, the copy being then made through the glass.

In process work, the suppression of grain is more easily attained, now that the use of the electric arc has become common, than it was when daylight copying was in vogue. By the use of two arc lamps, one on each side of the copy, the illumination can generally be adjusted to overcome the effect of the grain. Also the originals may be photographed under plate glass.

GRAIN IN NEGATIVES

In the early days of rapid plates a grain was perceptible in the negative, it being coarser as the speed of the plate increased; but the defect has now almost vanished, although it may still be produced under certain conditions. "Grainy" negatives are more frequent in hot weather than

in cold; in the summer, and particularly when development is forced and the plate happens to be under-exposed, excessive coarseness of grain may often be seen. The temperature of the atmosphere during the drying of the negative affects the grain, and the more quickly a negative is dried the coarser will be the grain; therefore, when a negative is to be used for printing upon glossy paper, or lantern slides are to be made from it, the cooler the atmosphere employed for drying the better. One theory (there are several) is that when negatives dry slowly on a hot day, the gelatine becomes partly decomposed, allowing the particles of the silver bromide to come together; these particles have an affinity for each other, and are enabled to come together when the gelatine which keeps them apart has been to some extent destroyed. Thus the particles form coarse particles, and impart to the negative a " grainy " or woolly appearance. Excess of alkali also increases grain; therefore, in order to produce a negative as grainless as possible, let the exposure be full, use a normal developer at no higher temperature than 65° F. (18° C.), and dry as quickly as possible in a cool, clean current of air.

In process work, it is a disadvantage to use a plate that gives too granular an image. Hence, process dry plates are relatively slow in order to secure a fine-grained emulsion. In collodion emulsion work also, the grain must be kept fine.

GRAINED NEGATIVE

A term often employed to denote a half-tone process negative, or a negative made through a ruled screen for breaking up the image into a fine grain.

GRAINS PER OUNCE

See under the heading " Solutions, Making up," where the number of grains per ounce of solutions of the usual " percentages " will be found.

GRAM, OR GRAMME

A metric weight, equivalent to 15·432 grains avoirdupois, apothecaries', or troy; written g. or gm. in formulæ. (*See also* " Weights and Measures.")

GRANULATION, OR GRANULARITY (Fr., *Granulation ;* Gr. *Granulieren*)

A term usually applied to an image of which the grain is coarse and distinctly visible to the naked eye. It may be due to the emulsion or to the action of the developer. It is also occasionally used for images broken up into a grain photo-mechanically.

GRANULOTYPE

A term applied to a half-tone etching on grained zinc, the image being formed by means of the bitumen process, printed under a tone negative.

GRAPHOSCOPE

An instrument containing a double convex lens large enough to permit both eyes at the same time to look through it at a single photograph, in this way obtaining, it is said, an illusion of relief, but not that solidity observable in a stereoscope. The suggestion of relief may be due to the non-achromatic lens causing overlapping of the different rays.

GRAPHOTYPE

A process suggested by A. H. Wall, in which a block of compressed chalk was drawn on with a specially prepared ink, which hardened the chalk wherever the lines were made, whilst the clear parts could be brushed away until a high relief printing block was obtained. The chalk no doubt contained size, and the ink some hardening substance, such as chrome alum, tannin, or formaline. In another process of this kind the block of chalk is treated with water-glass, to harden it after brushing it into relief.

GRATING, DIFFRACTION (*See* " Diffraction Grating.")

GRATING, PRISM

A diffraction grating on the hypotenuse of a prism of 60°, used for direct-vision diffraction spectroscopes. An ingenious method of making these gratings was devised by Thomas Thorp, of Manchester. He flows a plane metallic diffraction grating with celluloid, which when dry is stripped off as a film and cemented to the prism; it gives an image hardly inferior to that produced by the original grating.

GRATING, SCREEN

A term sometimes applied to the ruled screen used for half-tone process work.

GREEN FOG (*See* " Fog, Colour, etc.")

GREEN GLASS

Printing through green glass increases the contrasts on P.O.P. The use of coloured glasses was suggested by Lemann in 1861, since when it has been repeatedly adopted for obtaining rich prints from thin and flat negatives. About 1890 the use of greenish yellow glass was advocated for obtaining, in conjunction with matt papers and the uranium toning bath, not only vigorous prints, but also black tones resembling platinotype. Glossy P.O.P. also prints very much brighter and better under green glass, and the method is of great advantage when valuable negatives of a flat, thin, or ghostly character are used and intensification is not allowable. A green glass cuts out the violet and deep blue rays of light, allowing the bright blue, green, and yellow rays to travel through the negative and act upon the sensitive paper, with the result that the organic salts of silver are acted upon more than the chloride. The organic salts have a shorter scale of gradation than the chloride has, hence the prints have stronger contrasts and the shadows are richer than would otherwise be the case. The most suitable shade of glass for the purpose is that known as " signal green " or " single flashed chromium green." With the green glass, which is placed over the negative, printing is considerably prolonged. The method answers only with print-out silver papers. Green glass has also been advocated in place of ordinary glass for dry plate making; it has several advantages, one being that it prevents halation.

GREEN TONES

Green tones are generally difficult to obtain and not of great permanency except by the carbon process. Carbon tissue in many shades of green may be purchased, and greens by the process are easy to obtain, of even quality and quite permanent.

P.O.P.—The green tones obtainable on P.O.P. are uncertain as to exact tone, and they are not permanent. The best method is to tone as black as possible in the usual way, and then to stain the print with an aniline dye. Another method is to print very faintly, and then, without washing, immerse the print in a 10 per cent. solution of potassium bromide for three minutes. The faint image is then developed with a metol-hydroquinone developer as used for bromide paper, then washed and fixed in the usual way, without toning.

Bromide Paper.—The following is a typical method, which not only gives a good green, but intensifies considerably at the same time. Make 10 per cent. solutions (48 grs. in 1 oz. of water) of (1) uranium nitrate, (2) ammonio-citrate of iron, (3) potassium ferricyanide, (4) nitric acid. For use mix together No. 1 12 drops, No. 2 12 drops, No. 3 24 drops, No. 4 24 drops, and add water to make 1 oz. Immerse print until of the desired colour, wash, and dry. A much brighter green may be obtained by mixing together ½ oz. of No. 2, ½ oz. of No. 3, and 5 oz. of a 10 per cent. solution of acetic acid. Tone, rinse, and transfer to a 10 per cent. solution of chromic acid ; rinse, and immerse in a 5 per cent. solution of alum ; then wash and dry.

GREENHOUSE AS STUDIO (*See* "Studio Design and Construction.")

GREENLAW'S PROCESS

A modification of the calotype process for obtaining paper negatives. Thin paper was immersed for about an hour in a solution of potassium iodide and potassium bromide, containing sufficient iodine to give it a dark claret colour. It was then dried, sensitised as required in an acidified silver nitrate bath, rinsed, and again dried. After exposure in the camera, the paper was developed with gallo-nitrate of silver, rinsed well, fixed with "hypo," and washed.

GROUND GLASS

Besides its use for the focusing screen (*which see*), it is also employed to diffuse the light in dark-room lamps, in enlarging apparatus, and in printing. Sometimes it is employed in glazing the studio, when direct sunshine has to be excluded or an objectionable view blocked out. A piece of ground glass may be placed behind the negative in the retouching desk, to give a softer and more uniform light. Ground glass is also used to give a matt surface to P.O.P. prints.

GROUND GLASS, COPYING THROUGH

In making half-tone process blocks from a half-tone print, very finely ground glass may be used to prevent the crossing of the two dot images from forming an objectionable pattern. The plain side of the glass is placed in contact with the print, and the ground side is rubbed with a trace of glycerine.

GROUND GLASS PLATES (Fr., *Plaques à verre dépoli ;* Ger., *Mattglasplatten*)

Plates having the emulsion coated on finely-ground glass instead of plain glass, or on a specially prepared matt substratum. The latter idea was originated by E. J. Wall. Softer prints are obtained from the resulting negatives, while the matt surface offers great facilities for working on with pencil. Such plates are especially suitable for stereoscopic and other transparencies. Plates coated with a matt emulsion beneath the sensitive emulsion are obtainable commercially under the name of " Matt-ground," or " M.G."

In process work, thick plate glass ground on one side with emery powder is used as the support for the collotype printing film.

GROUP ARRANGEMENT

There is some truth underlying the saying that "two are a group, three a crowd." The difficulty of securing a perfect rendering of a single figure is enormously added to by every further addition. In fact, when many figures are to be included at the same time it is hardly possible to secure anything more than a number of mere portraits. When the group is a small one it is often possible to secure a natural arrangement in which each member has some common point of interest or occupation. In such a case, however elaborately the sitters may be " arranged," the result should appear natural and fortuitous, as though it had merely been taken at a happy moment. The figures must not be placed with any appearance of balance or symmetry having been deliberately aimed at, but at the same time they must not seem independent and isolated.

In the case of larger numbers, such a homogeneous composition is practically out of the question. The worst arrangement that can be made is, unfortunately, the most common one. This is placing the figures in one or more straight lines right across the picture. A narrow band of small figures with a wide expanse above and below is never satisfactory. It is better, whenever possible, to take advantage of a sloping bank or a flight of steps, so as to increase the height of the group on the plate. Such a group must not appear ill-balanced or lop-sided. Another common fault to be avoided is the use of a short-focus lens, which exaggerates the difference in apparent size between the nearer and more distant figures. A long-focus lens and a more distant standpoint give a more natural effect.

A football or cricket team, a wedding group, a family party, and so on. admit only of a more or less formal treatment, the desideratum being a collection of good portraits. This does not apply to renderings of groups for what may be called pictorial purposes, such as fishermen on the beach or women in a market place. In such cases any attempt at deliberate arrangement is often impossible, and oftener inadvisable. The only satisfactory method is to watch carefully the ever-varying arrangement of the figures composing the group and to seize the most promising opportunities that offer. Appropriate and characteristic poses should be watched for, with careful regard all the time to the relative positions of the members of the group. The

figures will from time to time naturally fall into satisfactory arrangements, and these moments must be waited for and taken instant advantage of. As has been said, the difficulty of obtaining a perfect arrangement increases with the number of figures included, but it is seldom possible to make this arrangement deliberately without introducing a suggestion of unnatural posing and stiffness. In a satisfactory group arrangement it must be remembered that all the figures must not claim equal attention; some should be prominent and others duly subordinate.

GRÜN LENS

A fluid lens (which see), said to be filled with cedar oil; it works at a large aperture and has been used for theatrical photography.

GUAIACOL (Fr., Gaïacol; Ger., Guajakol)

Synonym, methylcatechol. A faintly yellowish, limpid liquid obtained from beechwood creosote by fractional distillation. It was supposed to be a developer, but more careful purification proved that it was an impurity that acted, and not the guaiacol itself.

GUAIACUM RESIN

The resin obtained from guaiacum or lignum vitæ is sensitive to light, and North has patented a process in which guaretinic acid, obtained from the above, was the light-sensitive compound with or without the admixture of dyes. It has found no practical application.

GUM CUTCH (See "Catechu.")

GUM ELASTIC (See "Indiarubber.")

•GUM GALLIC PROCESS

A dry collodion process used by Hardwick in 1860, and improved by Manners Gordon in 1868. The plate is edged with albumen and coated with collodion, to each ounce of which is added 1 gr. of cadmium bromide; next it is sensitised in a silver bath in the usual way. After that the following gum gallic solution is used as a preservative:—

A.	Gum arabic .	.	20 grs.	1·3 g.
	Sugar candy .	.	5 ,,	·32 ,,
	Water .	.	6 drms.	21 ccs.
B.	Gallic acid .	.	3 grs.	·2 g.
	Water .	.	2 drms.	7 ccs.

A and B are mixed together and poured over the plate, this being next drained and allowed to take its own time to dry. The exposure necessary is from four to twenty times that for a wet plate. The developer specially recommended is :—

A.	Gelatine .	.	64 grs.	4 g.
	Glacial acetic acid .	2 oz.	57 ccs.	
	Water .	.	14 ,,	400 ,,
B.	Iron protosulphate .	30 grs.	2 g.	
	Water .	.	1 oz.	28 ccs.

One part of A is mixed with three parts of B, preferably one or two days before use. Before developing, immerse the plate in lukewarm water for a short time in order to soften the gum. Additional density is generally desirable and is obtained with a pyro-silver intensifier. The plate is finally fixed in "hypo," and washed.

GUM OZOTYPE (See "Ozotype Process, Gum.")

GUM PLASTIC (See "Guttapercha.")

GUM SILVER PROCESS

A "plain paper" printing process by means of which print-out pictures may be obtained on almost any kind of paper, ordinary writing-paper answering quite well. Three solutions are required for sensitising :—

No. 1.	Powdered gum arabic	1¾ oz.	54 g.
	Water . . .	3½ ,,	100 ccs.
No. 2.	Solution No. 1 .	84 mins.	5 ,,
	Glacial acetic acid .	50 ,,	3 ,,
No. 3.	Silver nitrate .	15 grs.	1 g.
	Water, distilled .	50 mins.	3 ccs.

In preparing solutions Nos. 1 and 3, the gum and the silver must be pulverised. Add No. 3 to No. 2, mix well together, and apply it with a fairly stiff brush to the paper, which is then dried in the dark; a brush bound in metal should not be used, but if none other is available see that the metal binding does not touch the solution or the paper. The paper prints well as soon as dry, but better still, and the tones are richer, if used about thirty hours after preparing. The paper is printed in the same way as ordinary P.O.P., and good red tones may be obtained by printing to a suitable depth and fixing in a weak "hypo" solution (48 grs. in 5 oz. of water). Colder and purplish tones may be obtained by toning in a gold or platinum bath, or even in a combined bath. The finished tone depends largely upon the quality of the negative.

GUMS AND RESINS

The photographer uses gums and resins chiefly in the form of varnishes.

Amber, a fossil resin, ranging in colour from colourless to reddish-brown, is slightly soluble in ether and turpentine; treated in the same way as copal in varnish making, it dissolves in turpentine, petroleum and benzine.

Anime, or Zanzibar copal, is of two kinds, fossil and "recent," the former being superior; of pale yellow or yellowish-brown colour and having a rough surface-called "goose skin." It is very hard, and, for varnish making, needs to be treated in the same way as copal; but it is slightly soluble in ether, benzine, chloroform, cold turpentine, etc.

Copal, a fossil gum, of pale yellow colour, hard and transparent; soluble slightly in cold turpentine and fully soluble in turpentine when fused or "run" in a copper pan over a fire, a process that must be left to the varnish manufacturer.

Dammar is known in several forms, ranging in colour from colourless or pale yellow to dark brown and black. It is soluble in oil, ether and benzene.

Dragon's blood is of various kinds, the chief being of blackish-brown colour and being in sticks about 1 in. thick; soluble in alcohol, benzene, chloroform, carbon bisulphide, etc.

Elemi is of many kinds and of a white or greyish appearance; it is soluble in alcohol.

Guaiacum is described under its own heading.

Gum arabic, small rounded nodules of yellow

or brownish-yellow colour, is soluble in water but insoluble in alcohol.

Gum benzoin, or gum benjamin, occurring in large blocks of grey or brown colour, with almond-shaped particles of a cream colour, is easily pulverised between the fingers, and has a fragrant odour; soluble in alcohol and slightly so in ether and turpentine.

Gum sandarach, a soft, bright gum, resembles tears or pears in shape, and is semi-transparent; soluble in alcohol, and slightly so in benzine, petroleum, and turpentine.

Gum tragacanth, or gum dragon, moss-like pieces of whitish colour, is opaque, hard, and tough; it forms a thick emulsion with water.

Lac is a brown gum, known in many forms—including shellac (shell lac), seed lac, lump lac, stick lac, etc.—which are prepared from a resinous incrustation on the twigs of certain trees. It is soluble in alcohol and ether, and partially so in turpentine. White lac or bleached lac is used in preparing colourless varnish.

Mastic is in the form of tears of a pale yellow colour, brittle, and easily melted; soluble in alcohol and turpentine. It is used in preparing mastic varnish.

Resin, an amber-coloured or brown oxidation product of turpentine, is brittle, easily melted, of lustrous appearance in a thin coat, and is soluble in alcohol, turpentine, etc.

GUM-BICHROMATE PROCESS

Familiarly known as "bi-gum," this process depends on principles first laid down by Poitevin in 1855. Briefly, it consists in coating paper with a mixture of gum and pigment sensitised with potassium bichromate solution. This paper is printed under a negative, the bichromated colloid becoming more or less insoluble in proportion to the light action. In this way a print may be obtained with a single coating, but it is usual to re-coat the print thus made and again print and develop. This may be repeated almost indefinitely, either for the purpose of reinforcing certain parts of the image, or for producing prints in more than one colour. The paper used must be well sized, in order that the pigment may lie on the surface and not sink into the substance of the paper so as to stain and degrade the high lights. If the paper is not already sufficiently sized a formula suggested by Mummery is 3 to 5 per cent. of gelatine in water with 5 drops of formaline to the ounce. This is brushed evenly over the paper.

The experienced gum worker frequently evolves his own formula for coating the paper. It is best to arrive at this experimentally by proceeding in some such manner as the following: 2 oz. of good clean gum arabic in tears is enclosed in a muslin bag and suspended in 6 oz. of cold water for about two days. This provides the gum solution. Next, a saturated solution of ammonium or potassium bichromate is made. Lastly, the pigment may take the convenient form of moist water colours in tubes. A mixture may then be made of 10 parts gum solution, 5 parts bichromate solution, and a quantity of the pigment to be judged always by the length of the "worm" of colour squeezed from the tube. Less bichromate will make the paper less sensitive. The ingredients of the mixture must be thoroughly incorporated by rubbing down on a slab or sheet of glass with a palette-knife.

The sized paper is coated with this mixture by means of a camel-hair mop, a hog-hair softener being passed over the surface afterwards in both directions to make it smooth and even. All this must be done quickly before the coating hardens. After about half an hour the paper should be thoroughly dried by heat and placed in a calcium tube if it is to be kept, although it is best to use it as fresh as possible. It must be borne in mind that the paper is very sensitive to light.

Duration of printing depends to some extent on the composition of the coating. As the image is not visible an actinometer must be used as in carbon printing, or a piece of P.O.P. exposed simultaneously under a negative similar in printing speed to the one in use. As a rule, the bichromate paper will be sufficiently exposed when the P.O.P. image looks of the right density.

The gum print is now placed face downwards in a dish of cold water. The pigmented gum will soon begin to leave the paper slowly. It is here that the worker begins to exercise that control over the development that constitutes the chief value of the process. He may employ cold or tepid water by laving, spraying, sponging, or brushing. By such means he retains only such of the pigmented gum as he requires for the rendering of his idea of the subject.

If further printing is contemplated the print is dried and the processes of coating, printing, and developing repeated as before. Here comes in the difficulty of obtaining perfect registration of the second or subsequent images, and some device is necessary for securing that the print shall be replaced exactly in its original position on the negative. Even then there is the expansion and contraction of the paper to be reckoned with.

When the final development is complete the print is soaked in a 5 per cent. solution of potash alum to remove the bichromate stain, and then rinsed in water.

The use of various papers, the number of pigments available, the different effects resulting from modifications in coating and development, the power of multiple printings in one or more colours—all these afford opportunity for considerable exercise of control over the final result. But the very existence of these variable elements precludes the possibility, even if it were desirable, of laying down any hard and fast rules for working the process. The individual worker must gradually formulate his methods by careful experiment and observation, in which case he will ultimately find the process most plastic, interesting, and valuable. (*See also* "Arabin Gum-bichromate Process.")

GUN AND REVOLVER CAMERAS (Fr.,

Fusil photographique, Révolver photographique, Chambre révolver; Ger., *Feuergewehr-kamera, Revolver-kamera*)

The photographic revolver—the first instance of an efficient automatic apparatus for chronophotography—was designed in 1874 by P. J. C. Janssen, the astronomer, to obtain a record of the transit of Venus. The observation was made in Japan, the instrument being placed

under cover, as shown at A, and directed on a heliostat, to keep the sun's image stationary. Forty-eight pictures were taken in succession on a circular plate, which was caused to make one revolution in seventy-two seconds, and stopped at the correct intervals by a Maltese

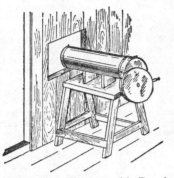

A. The Janssen Photographic Revolver

cross movement. The exposures were given by a rotating disc with twelve openings, moving at a different speed to the plate. A fixed partition, having a single aperture, was placed between the plate and the shutter disc, so that a different portion of the plate, then at rest, was exposed each time an opening in the shutter passed the fixed aperture. The operation was repeated four times to obtain a satisfactory record. On this model Marey founded later his photographic gun B. A long-focus lens was placed at the end of the barrel, thus rendering it feasible to photograph small objects from a distance, and the tube was arranged to telescope for focusing. The clockwork mechanism is illustrated at C, the back cover being removed. On pressing the trigger E, a circular shutter with one aperture commenced revolving. Be-

B. Marey's Photographic Gun

hind this rotated a disc F with twelve openings (only half is here shown), the sensitive plate revolving at the back of the disc by friction. The perforated disc and plate were moved intermittently by a pawl G, on an arm worked by an eccentric, and each time one of the openings in the disc F came to rest in line with the lens the aperture in the shutter passed in front of it, making an exposure. During its movement

the plate was protected from light by the opaque part of the shutter. (*See also* " Chrono-photography.")

Detective cameras and naturalists' cameras of various kinds have been proposed from time to time under one or other of the names given at the head of this article.

GUN-COTTON

A nitro-cellulose, the hexanitrate, which is extremely explosive. The term is sometimes wrongly applied to pyroxyline.

GUTTAPERCHA (Fr. and Ger., *Guttapercha*)

A natural product having many similarities to indiarubber, but capable of being made plastic and malleable by heat, and retaining, when cold, any shape given it while hot. Whereas guttapercha is plastic, indiarubber is elastic; and whereas indiarubber easily combines with sulphur, guttapercha will neither combine nor intimately mix with that substance. Guttapercha is the coagulated juice of the *Isonandra*

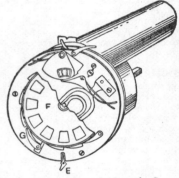

C. Mechanism of Marey's Gun

gutta, which grows in the tropics, particularly in the Malay district. Its principal uses in photography are as a material for dishes and bottles to contain hydrofluoric acid, and as a mountant. For the latter purpose, a piece of very thin sheet guttapercha, the size of the print, is placed on the mount, next the print is laid over it, and then comes a sheet of blotting-paper, over which a hot iron is passed slowly and firmly. The heat softens the guttapercha, which then adheres to both mount and print. An objection to the method is the liability of the guttapercha to perish.

A cement, made by dissolving 2 parts of shredded guttapercha and 2 parts of powdered Syrian asphalt in a mixture of 10 parts of oil of turpentine and 5 parts of carbon bisulphide, makes an excellent cement for leather and other materials.

Guttapercha has been used for coating paper in order to transfer collodion films. It has also been used for stripping negatives, instead of using rubber solution. By the addition of guttapercha to collodion the latter is rendered not only tougher, but more sensitive.

H

HADDON'S FORMULÆ

Many useful formulæ due to A. Haddon are in use, three of the best known being given below :—

Reducer for Negatives and P.O.P.—This consists of potassium ferricyanide and ammonium sulphocyanide, and is compounded as follows :—

For negatives—

Potassium ferricyanide	10 grs.	11 g.
Ammonium sulphocyanide	20 ,,	22 ,,
Water . . .	2 oz.	1,000 ccs.

This reducer has the merit of keeping well. The plate is immersed in the solution in the usual manner, rocked until reduction is sufficient, and then washed for ten minutes. A dry negative should be first soaked in water.

For P.O.P.—

Potassium ferricyanide	4 grs.	4·4 g.
Ammonium sulphocyanide	20 ,,	22 ,,
Water . . .	2 oz.	1,000 ccs.

Platinum Toning Bath for P.O.P.—This is a toning bath on the lines suggested by Henderson. The formula is :—

Platinum perchloride	15 grs.	1 g.
Sodium formate .	500 ,,	32·5 ,,
Water . . .	175 ,,	11·5 ,,
Formic acid . .	150 mins.	9 ccs.

Before treatment, the prints must be washed in a salt and water bath (salt 1 oz., water 20 oz.) prior to toning. Fix and wash as usual.

Mercury Intensification.—For the purpose of eliminating from a mercury-bleached negative the last traces of a compound formed by the mercuric salt combining with the gelatine, Haddon has strongly advocated the use of hydrochloric acid. The bleached negative must be washed for ten minutes, and then immersed for three or four minutes in a bath consisting of 1 dram of hydrochloric acid and 10 oz. of water. Next it is rinsed in water and transferred to a second acid bath, rinsed again, and placed in a third, then washed in several changes of water, and finally blackened as described under the heading "Intensification."

HALATION (Fr., *Halation, Auréolage*; Ger., *Lichtfleck*)

A halo-like, blurred effect, frequently seen surrounding a brightly lit portion of a photographic image, caused either by reflection from the back of the glass plate or by lateral spreading of light in the film. The defect has been observed from the earliest days of photography, but it became more common on the introduction of glass plates. It is believed that the first mention of the word in print occurred in the year 1859. Halation is usually seen in its most aggravated form in a photograph of a dark interior which includes a bright window. The latter will not be clearly outlined, and all round it there will be fog. Halation also appears sometimes when the roof of a house or a tree cuts against the sky ; around a white collar or dress in a portrait ; and, in fact, in all subjects where a very bright line comes in sharp contrast with a deep shadow. The chief cause of halation is the reflection from the back of the plate of the bright beam of light that reached it. In the illustration, the plate is shown in a vertical position, A being the film side and B the plain glass side or back of the plate. E F represents a ray of light coming from the lens and striking the film at F, part of it being reflected along the line F G and being dispersed in the camera. The light being strong and the sensitive film translucent, some of the light passes through the film and strikes the back of the plate at J. If all the light continued its way

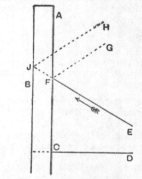

Diagram Showing Chief Cause of Halation

and went out at the back, it would do little or no damage, but instead at J another reflection takes place, as at J H, and the light passes again through the film and causes fog on the other parts. Assuming that a bright window in a dark interior is being pictured on the plate, and that the part below F represents the window, and the part above F the dark wall of the room, some of the light rays E F from the window would pass through the plate to J and be reflected to H, thus causing the sharp outline of the window to be blurred. When the bright object comes at the side of the plate, the halation is usually worse than when it comes in the centre, because rays of light which strike the plate almost at right angles to its surface at C D are reflected back through the film at practically the same places through which the light first passed. As the degree of obliquity increases, the amount of reflection increases also, until at a certain angle, varying with the refractive index of the glass, the whole of the light is reflected. The

thicker the glass plate the greater will be the extent of the halation, because of the wider angle formed by the reflected rays ; this explains in part why the thin celluloid films do not show appreciable halation. A contributory cause of halation is under-exposure and forced development, conditions that are more often responsible for the defect than are the direct causes. As a rule, the quicker a plate is developed the less will halation show.

It will be seen that the principal causes of halation are (a) the translucency of the emulsion, and (b) the reflective power of the back of the glass. Some remedies are at once obvious. (1) To replace the glass with paper or other non-reflecting support. (2) To stain the film or in other ways to make it so opaque as not to allow the rays to penetrate the glass. (3) To prevent the back reflection by coating the plain glass side with a non-reflecting or absorbing medium. Others have also been suggested. The third remedy, that of coating the back of the plate before exposure with some non-actinic and non-reflective substance, is in general use, and has been found the most convenient and effective in practice. Formulæ for suitable mixtures are given under the heading " Backings, Plate."

In process work, it is found advisable to back dry plates with caramel or other medium to prevent halation, which would rob the half-tone dots of their sharpness. A sharp dot is an essential in half-tone work.

HALF-PLATE

A commercial size of dry plate and printing paper, measuring $6\frac{1}{2}$ in. by $4\frac{3}{4}$ in., and largely used for " cabinet " portraits and occasionally as a stereoscopic size.

HALF-TONE PROCESS (Fr., *Procédé en demi-teintes* or *Simili ;* Ger., *Halbtonverfahrung* or *Autotypie*)

A process in which the half-tones of a photograph are reproduced by breaking up the image into dots of varying size, transferring this dot image to a metal plate, and etching the dots into relief for typographic printing. The shades of colour or tone between black and white in the photographic image are termed half-tones. To reproduce these half-tones in a block for typographic printing, in which a uniform layer of ink must be employed, it is necessary to break up the image into fine dots of varying size—largest, and therefore printing darkest, in the shadows, and smallest, therefore printing lightest, in the high lights ; the intermediate sizes printing the half tones.

The credit of the idea of breaking up the image into dots by means of a network screen is due to Fox Talbot, who proposed it in a patent dated 1852. He used crape, or gauze, but also suggested the use of a glass plate ruled with fine opaque lines, which latter is the means employed to-day for executing the process. Various experimenters carried on the process with gauze, or with lines on glass obtained by photographing lines ruled or printed on paper, and with lines ruled through a blackened ground on glass, but it was not until 1893, when Max Levy, of Philadelphia, patented and introduced commercially his process of engraving and etching the lines into the glass and filling in the furrows with black pigment that the process became a commercial success. The Levy screen consists of parallel lines ruled diagonally on two glasses, which are sealed together face to face with Canada balsam, thus forming a network of crossed lines. Varying degrees of ruling are used, from fifty-five lines per inch (for coarse newspaper work) up to 400 lines per inch, according to the degree of fineness required in the block. Ordinary magazine illustrations are made through a screen of about 133 to 150 per inch ; the half-tone plates accompanying this work were made through screens of 175 and 200.

In carrying out the process the screen is placed in a holder in front of the sensitive plate, and, by means of mechanism in the back of the camera, is moved nearer to or further from the plate according to the extension of the camera and the degree of the ruling—long extension of the camera requiring greatest distance of the screen, and fine rulings the smallest distance. Some cameras are fitted with screen adjustment gear. Square, cross, star, and other shaped diaphragms are put in the lens, alternately with the usual round diaphragm, the object being to promote the better formation of the dots.

The negative is made either by the wet or dry plate process, or with collodion emulsion, the first-named process being generally preferred, and it needs to be developed, intensified, and cleared to sharpen up the dots. A copper or zinc plate is coated with a solution of fish-glue and ammonium bichromate (*see* " Enameline " and " Fish-glue "), and exposed to light under the negative. The image is developed by dyeing the plate with aniline violet and washing with water until the dots stand out clear on the bare metal. The plate after being dried is held in pincers over a gas-stove until the image is " burnt-in " or converted into an enamel which is extremely acid-resisting.

The etching is done with dilute nitric acid for zinc, or with ferric perchloride for copper, and it is carried to such a depth as will prevent the printing ink from filling up the spaces between the dots.

To increase contrast and to bring out detail, the plates are usually " fine etched." Parts that are sufficiently etched in the first or " deep " etching are stopped out with acid-resisting varnish, and the remaining parts again etched ; this may be repeated several times.

The plate is finally trimmed to size, the edges bevelled with a special plane or machine, and fastened to a wooden mount or block by nails driven through the bevelled edge ; or a metal block may be used. The mount brings the plate to type height, so that the block can be printed along with type. W. G.

HALF-TONE SCREEN

A glass plate, or pair of plates sealed together, ruled with parallel lines, usually crossed, to form a network or grating, which is placed in front of the sensitive plate to break up the photographic image into a series of dots, in order that the half-tones may be reproduced. The commercial half-tone screen was introduced by Max Levy, as stated under the heading " Half-tone Process."

HALLOTYPE (*See* "Hellenotype.")

HALOGENS (Fr., *Halogènes ;* Ger., *Halogene*)

The four elements, bromine, chlorine, fluorine, and iodine, are thus called because they form very marked salts with metals.

HALOID (Fr., *Haloïde ;* Ger., *Halogenverbindung*)

Synonym, halide. Applied to compounds containing one of the four halogens; for instance, a silver or alkaline haloid or halide is spoken of.

HAND CAMERA (Fr., *Chambre à main, Chambre détective ;* Ger., *Handkamera, Detectiv-kamera, Geheimkamera.*)

A camera sufficiently light and portable to be used in the hand, instead of on a stand. A collapsible pocket camera having a cloth body was suggested by Edwards as early as 1855. In 1860 and 1861 hand cameras of fixed focus with bodies of wood or metal were constructed by Bertsch and by Ottewill, and in the latter year magazine changing-boxes were in use. Enjalbert in 1887 used a leather changing-bag attached to the camera, with a lever for lifting the plates as exposed. The first approximation, however, to the convenience of the modern hand camera appears to be due to Thomas Bolas, who in 1881 described several forms of what he termed "detective cameras," with twin lenses, a focusing arrangement, and a pneumatic release for the shutter. A reflecting prism was placed in front of the lens so that it might be pointed at a right angle to the direction of the object to be photographed, and thus worked without exciting suspicion.

The simplest pattern of hand camera is the box form, which is usually of fixed focus, the lens being incapable of movement and so adjusted that all objects beyond about seven yards distant will be rendered sufficiently sharp. A typical box form camera for films A has two finders K and L for sighting the object,

for plates being shown at B. In this model, focusing is effected by turning a milled screw O; a hinged door at the front allows access to the lens and shutter, and permits the storage of the pneumatic ball and tubing in the recess.

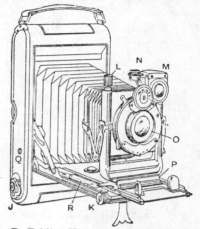

D. Folding Hand Camera for Films

A trigger release is worked by a push at the side ; P is the lever actuating the plate-changing mechanism, and Q, pivoted to the door, acts as a dust excluder.

The details of the plate-changing mechanism differ considerably : C illustrates one effective arrangement, introduced by McKellen. The metal sheaths S containing the plates have projecting pins T at their bottom corners, which rest on grooved guide plates U at the sides of the camera. At the end of each groove is a circular hollow, in which turns a revolving disc V, the two discs being mounted on the same shaft. Each disc has a notch in it capable of receiving the pins of the sheaths. The sheaths are pressed forward by the spring W, when the

A. Box-form Fixed-focus Camera

B. Box-form Focusing Camera

C. McKellen Plate-Changing Mechanism

one for vertical and one for horizontal pictures. The inner case is shown partly withdrawn, M being the key by which the film is wound. Box-form hand cameras are also made to hold a magazine of plates in sheaths or for use with ordinary dark-slides. Besides the fixed-focus type, they are obtainable with a focusing arrangement working by scale, one of this kind

front one bears at the top against a stop-rail X and is supported at the bottom by its pins engaging in the notched wheels. To change a plate, the wheels are turned simultaneously by means of a handle outside the camera, thus carrying down the front sheath, the pins of which remain caught in the notches until the top clears the stop-rail X. The sheath now falls

into the bottom of the camera, and the handle is turned in the reverse direction until the wheels engage with the pins of the second sheath, which is then in position for exposure.

A representative example of a folding hand

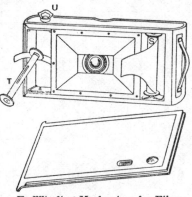

E. Winding Mechanism for Films

camera for films is shown at D. The principal movements and fittings are : J, key for winding film ; K, focusing screw ; L, rising-front pinion ; M, finder ; N, spirit level ; O, lens with diaphragm shutter ; P, cross-front movement ; Q, bush for tripod screw, for attaching the camera to a stand if required ; R, focusing scale.

The winding mechanism for films usually varies little from the system shown at E. Having removed the sliding back, a charged spool of film S is placed in a recess at one side of the camera and fits on two small pegs. An empty spool T fits a recess at the opposite side, and is turned by the winding screw U which engages in one of its ends. Having inserted both spools, the end of the black paper on the full one is drawn out until it can be pushed through the slot seen on the empty spool, and the key is given a single turn. The back is then replaced

F. Folding Camera for Plates

and the key turned until the first number on the black paper appears at the small ruby window in the rear of the camera ; it is then known that the first film is in position for exposure. The remaining numbers are wound forward as required, and when the last exposure

has been made winding is continued until all the black paper has been wound off the original spool, when the camera back may be opened and the exposed spool withdrawn.

A folding camera for plates is illustrated at

G. "Hand or Stand" Camera

F. A more substantial and elaborate example of what is known as the "hand or stand" type is shown at G ; this can be employed for nearly all descriptions of work, being either held in the hand or supported by a stand.

Yet another class of hand camera is that in which a focal plane shutter is used, for high-speed exposures, as required in press work and sports photography. A typical folding focal plane camera is shown at H. In use, it is held up to the level of the eye, the subject being viewed through a direct-vision finder, consisting either of a small concave lens with cross-lines and sight, as illustrated, or a rectangular wire frame. There is a growing tendency among press workers to prefer the focal plane to the reflex camera on account of its lightness and lesser bulk, besides the fact that it is held at a more generally useful height. The reflex and twin-lens cameras have, however, the great advantage of giving a full-size image in the finder, which may be watched and focused

H. Folding Focal Plane Camera

right up to the moment of exposure. These cameras form a class by themselves, and will receive separate treatment. (*See also* "Detective Camera," "Magazine Camera," "Pocket Camera," "Reflex Camera," "Twin-lens Camera," etc.)

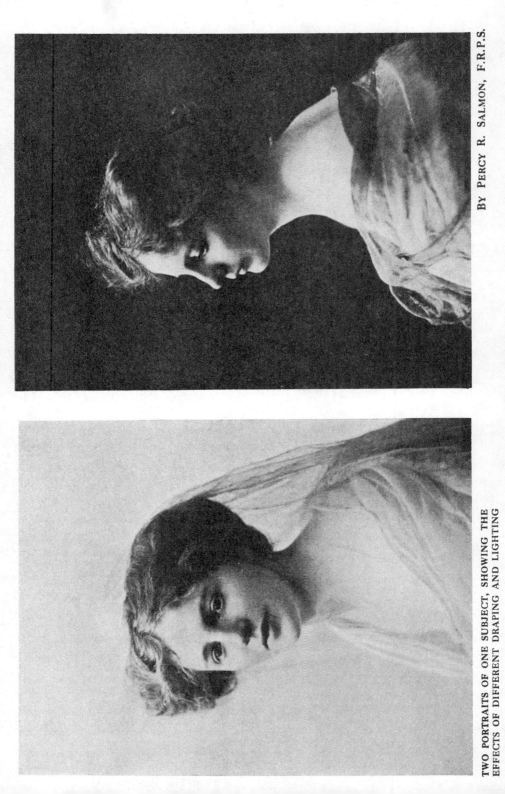

BY PERCY R. SALMON, F.R.P.S.

HOME PORTRAITURE

TWO PORTRAITS OF ONE SUBJECT, SHOWING THE
EFFECTS OF DIFFERENT DRAPING AND LIGHTING

10

HAND CAMERA, WORK WITH

It considerably enlarges the scope of the photographer's work to become expert in the use of the hand camera. But the hand-camera worker matures only with time, patience, practice and experience. Moreover, there are special considerations to be taken into account before it is possible to do consistently good work with a camera that not only has to be used in the hand, but has to be brought into operation with trying rapidity. One of the most important points is familiarity with the camera itself. It should be known and understood down to its smallest detail. Every operation involved in making an exposure and changing the plate or film must be so familiar that it can be performed rapidly and almost mechanically. There must be practically no risk of bungling or blundering.

The use of a reflex camera removes any doubt as to what is sharply focused and what is included on the plate. With other patterns it is necessary to learn to estimate distances with approximate accuracy. It is also useful to know the depth of focus at different distances and with different lens apertures; and to know the distance (with the particular lens in use) at which a full-length figure will come the right size on the plate. When there is any uncertainty as to the precise distance of the object to be focused, it is well to err on the near side, as the depth of focus is always greater on the farther side than on the nearer side of the point focused upon.

In the absence of a full-sized finder it is advisable to have the small finders as accurate as possible. In practice it is better that they should show rather less than is actually included on the plate. When the plate used is a very small one it is more than ever necessary that the subject should be accurately placed upon it, as there is no room to be wasted. Many failures result in the use of small cameras from this cause, particularly when reliance is placed on finders so minute as to be worse than useless. It is generally worth while to fit such small cameras with a removable finder that will show on a reasonably large scale just what will appear on the plate.

It is also of vital importance to be able to hold the camera level and steady during exposure. The duration of exposure that can be given with safety depends largely on the individual, but also to a great extent on the type of camera in use and on the position in which it is held. A large, heavy camera can generally be held steadier than a small, light one; and it is safer to hold the camera pressed against the body than at arm's length or at eye-level. The type of shutter and its smoothness of working must also be considered a factor. When all conditions are favourable, an exposure of a full second should be safely attainable. Another point that should be constantly borne in mind is that proper exposure is necessary. It may be thought that such a consideration does not apply particularly to hand-camera work. But, unfortunately, there is too often an idea that with a hand camera there is some magic property enabling much shorter exposures to be given than if the same camera happened to be set upon a tripod. Naturally, the exposures given with a hand camera are more or less rapid, but they are only properly effective when the conditions obtaining demand just those exposures. An exposure-meter, or some similar guide, is every whit as essential in work with the hand camera as with the stand camera. A further aid to successful hand-camera work is the cultivation of a quick eye. This in itself is but small gain without the addition of dexterity in manipulation. It is often imperative that the camera shall be used quite unobtrusively, and rapidity and certainty of working thus become a valuable asset.

The results obtained with a hand camera are largely employed for the production of either lantern slides or enlargements. Hence it behoves the hand-camera worker to aim at the most perfect technical excellence to which he can attain. He should keep his apparatus free from dust, pay the most extreme attention to exposure and development, and strive to produce a spotlessly perfect negative from every plate or film exposed. He should absolutely rid his mind of any idea that good work with a hand camera can be obtained in a haphazard and slipshod manner. All the judgment, consideration, and care that are devoted to work with the stand camera must equally be given to hand-camera work; and in addition further attention must be paid to the added difficulties arising from the often rapid use of a camera held in the hand. Only so can a high standard of excellence be achieved. W. L. F. W.

HARD NEGATIVES

Negatives in which the gradations are harsh, irrespective of the total range of contrasts. A thin negative may be hard, as the gradations may be very harshly rendered as a result of shortness of exposure. The term is frequently applied incorrectly to negatives that are too strong in contrast with good gradation. If the gradation is good the negative is not hard or harsh. Methods of treating hard negatives are given under the heading "Harmonising Contrasts."

HARD PRINTS

These naturally result from using hard or harsh negatives, or those that are too strong in contrast for the printing process employed, without being harsh. There is no satisfactory method of treating the prints when once made. The best course to follow is to modify the negative by the methods given under the heading "Harmonising Contrasts," or to modify the print during its exposure by the methods explained under the heading "Control in Printing." A negative may yield a harsh result in one process and possibly a more satisfactory print in another one.

HARD WATER (Fr., *Eau calcaire*; Ger., *Hartes Wasser*)

Water containing carbonates and sulphates of lime and other earthy salts. Some of these may be removed by boiling, allowing to cool, and then filtering; and all water for photographic purposes should be so treated, although it is far better to use nothing but distilled water for all solutions.

HARDENERS

Solutions used for hardening the films of gelatine negatives and prints with the object of preventing frilling and blistering. Their use is not so necessary now as it was in the early days of gelatine plates and papers, as means of hardening the gelatine during its manufacture are now employed. As, however, the melting point of wet gelatine is about 90° F. (about 32° C.), hardening solutions are still necessary in the tropics, and in colder parts of the world when the films are to be heated to beyond the normal temperature. Chemicals which possess the property of hardening gelatine may be mixed with the "hypo" bath or used separately. Baths which fix and harden at the same time will be found under "Fixing-hardening Baths," but frequently it would be fatal to leave the hardening until fixing, as the harm may be done in developing or toning. Formaline, ordinary alum, and chrome alum are the commonest hardeners, others being potassium nitrate, aluminium chloride, and aluminium sulphate. Formaline is by far the most satisfactory, 1 oz. of formaline being added to 10 oz. of water; this requires about five minutes for complete action, but may be used weaker if desired—say, one part in twenty—in which case fifteen minutes' immersion will be necessary. The stronger bath is the less safe of the two, and may cause the film to become horn-like, crack, and leave the support. The formaline solution should be distinctly alkaline, inasmuch as acid and neutral solutions have but very little hardening effect upon gelatine; also care should be taken that the hardening action goes right through the film and not merely half way.

Chrome alum is next best; a suitable strength is $\frac{1}{2}$ oz. to 15 oz. of water. Its tanning action is greater than that of ordinary white alum, and although it has a deep rich colour, it does not stain the film. Namias recommends the following chrome alum mixture, and states that it has great hardening action: Dissolve 1 oz. of chrome alum in $\frac{1}{2}$ pint of cold water, and add liquor ammoniæ slowly until a pale green precipitate is plainly visible. Then add $\frac{1}{4}$ pint of a 10 per cent. solution of ordinary alum, and boil the whole for about three minutes; when cool it is ready for use. Immerse negative or print from ten to twenty minutes. Ordinary alum (sodium, potassium, or ammonium alum) was at one time very popular as a film hardener, but it is not considered to be as safe as formaline or chrome alum. The proper strength is 1 oz. to the pint of water. The plate or print should be immersed for from ten to twenty minutes. Any of the above hardeners may be used either before or after developing, toning, etc., but it is always necessary to wash well before and after treatment, more particularly when ordinary alum is used after developing and before fixing; otherwise, ugly scum-like markings appear on the negative, and these cannot be removed. Alum markings are due to alkali from the developer remaining in the film, combining with the alum and precipitating aluminium hydroxide. When alum hardeners are used after development the alkali from the developer can be destroyed by rinsing the developed plate in a weak solution of citric acid.

In process work, hardening solutions are useful. In the Paynetype process the plate is immersed in a 5 per cent. solution of potassium bichromate for three minutes, which hardens the gelatine image to such an extent that it can be developed like a carbon print. In the enamel process on zinc it is recommended that, after developing thoroughly, the plate should be placed for three minutes in a bath of—

Ammonium bichromate .	2 oz.	44 g.
Chromic acid . .	$\frac{1}{2}$,,	11 ,,
Methylated spirit .	5 ,,	100 ccs.
Water . . .	50 ,,	1,000 ,,

Wash, dry, and burn in. The image then resists the acid better. (*See also* "Fixing-hardening Baths.")

HARDWICH, T. FREDERICK

Born at Wells, in 1829; died at Shotton Vicarage, Durham, 1890. Author of "Photographic Chemistry" (published March 12, 1855). Professor of Photography at King's College, London. He made important investigations (from 1854 to 1861) in the preparation of collodion, and made many improvements in the optical lantern. In 1861 he took holy orders.

HARMONISING CONTRASTS

Harsh contrasts may be softened by chemically treating the negative or by means of control in printing. As a general principle, when the contrasts are due to under-exposure, the plate should be treated with the ammonium persulphate reducer; but if reduction is carried too far, the weak shadow detail will suffer. When the contrasts that require harmonising are due to excessive contrast in the subject, or where some portions only are out of harmony with the greater part of the negative, it is preferable to adopt the methods described under "Control in Printing." By chemically reducing the negative, the contrasts throughout are softened, and the gradation of every detail is flattened. By control in printing, the gradation of the various parts remains unchanged in strength, and each is printed with full detail.

HARRISON, W. H.

Born 1841; died August 10, 1897. In 1865 he published his discovery of a bromide emulsion dry plate and the use of an alkaline developer. He was for many years editor of the *Photographic News*.

HARSH NEGATIVES

For a definition of a harsh negative, *see* under the heading "Hard Negatives." Harsh negatives may be improved by the methods given under the heading "Harmonising Contrasts" above.

HARTSHORN, SPIRIT OF (*See* "Ammonia.")

HAT CAMERA (Fr., *Le Photo-chapeau;* Ger., *Hutkamera*)

A detective camera, concealed inside a hat. The lens worked through a small opening in the side of the hat, normally closed by the shutter, while the exposure was given by pulling a cord made to resemble a hat-guard.

HEAD REST (*See* " Posing Chairs and Head Rests.")

HEAD SCREEN

A reflector used in portraiture for cutting off top light or for lighting the side of the face that is in shadow. Many shapes and styles are obtainable commercially, but essentially it is a frame, covered with light-coloured material, arranged to stand at any suitable angle.

HEATING SOLUTIONS

The important part which the temperature of photographic solutions plays as regards their activity cannot be overlooked, and much more reliable and uniform results will be obtained if they are always heated to a uniform temperature, about 65° F. (about 18° C.). As a rule, it will be found quite sufficient to place the stock bottle or measure full of the solution in any convenient outer vessel, which should then be filled up to the level of the liquid in the bottle with warm water.

HEAVY SPAR (*See* " Barium Sulphate.")

HECTOGRAM, HECTOLITRE ETC. (*See* " Weights and Measures.")

HELIAR LENS

A rapid anastigmatic lens introduced by Voigtländer. It consists of two cemented combinations, and a central negative lens It is made in focal lengths from 2 in. to 24 in., all sizes having an aperture of *f*/4·5.

HELIOCHROME (Fr., *Héliochrome*; Ger., *Farbenphotograph*)

A photograph in colours. (*See* " Heliochromy.")

HELIOCHROMY (Fr., *Chromophotographie, Héliochromie*; Ger., *Heliochromie, Farbenphotographie*)

The name given by Niepce de St. Victor to his method of colour photography, discovered in 1853, but now applied to all such processes. St. Victor, following Becquerel, used a film of silver chloride on a silver-coated plate. Various methods were employed to chlorise the plates, one being to dip them in a weak solution of sodium hypochlorite (sp. gr. 1·35) until of a bright, pinkish hue. The plates were then covered with a solution of dextrine saturated with lead chloride, dried, and subsequently submitted to the action of heat. Rather long exposures were required in the camera, the plate being then again heated to render the resulting pictures a little less fugitive. Some vivid colour reproductions were obtained, which unfortunately quickly faded, since no means of fixing could be found. A slight access of stability was secured by covering the plate with an alcoholic solution of gum benzoin.

HELIOGRAPH (Fr., *Héliographe*; Ger., *Heliograph*)

A photograph or engraved plate made by Niepce's bitumen process (*see* " Heliography "). All photographs were for some time called heliographs.

By means of the spectrum heliograph mono-chromatic images of the sun are obtained. Referring to the illustration, the image of the sun is formed by the lens C on the slit S₁, and is projected by the lens L₁ on the prism P; by this it is dispersed and reflected by the mirror M, and thence brought to a focus by the lens L₂ on the plate F. The whole arrangement is mounted on the platform A A A A, which is movable to and fro in the direction of the arrows. S₂ is used to isolate one particular Fraunhofer line in the spectrum, either the hydrogen F line

Diagram Showing Principle of Spectrum Heliograph

or H the calcium line. Now the image at S₁ is fixed, but S₁ itself moves ; therefore successive portions of the sun's surface are exposed exactly as though a narrow slit focal plane shutter were used. As the prism, mirror, and L₂ are all fixed, and S₂ is arranged to isolate one line, it is obvious that by moving the platform we obtain monochromatic images of the sun on the plate F, which is fixed and does not move with the platform. Some of the most successful photographs of the sun have been taken in this manner, which show most conclusively the distribution of hydrogen or calcium vapour on its surface.

HELIOGRAPHIC PROCESS

A term applied to any method of " sun printing," as used for copying plans, etc.

HELIOGRAPHY (Fr., *Héliographie*; Ger., *Heliographie*)

A process discovered in 1826 by Joseph Nicéphore de Niepce, in which a copper plate coated with silver and covered with a film of bitumen was exposed to light in the camera for some hours. Those parts of the film affected by light became more or less insoluble, according to the extent to which it had acted, whereas the shadow portions or unexposed parts could be dissolved away with oil of lavender. Besides silvered copper, plates of plain copper and other metals were used. Niepce tried to darken the bare portions of the silver, where the shadows should have been, by the application of iodine and other reagents, and also etched some plates with acid, for printing in the press. Such pictures, as well as engravings from the etched plates, were called heliographs, the word " heliography " being then used instead of the modern designation " photography." Niepce's method, in an improved form, is still in use for printing banknotes. The term heliography was for some time employed also in referring to photogravure, but this usage is practically obsolete. (*See also* " Asphaltum.")

Processes of etching in intaglio on copper by photographic methods are sometimes referred to under the name of heliography, more particularly a process of reproducing maps.

HELIOGRAVURE

Another name for photogravure (*which see*). On the Continent this process is invariably called heliogravure.

HELIOPHOTOGRAPHY

Solar photography. (*See* " Sun, Photographing the.")

HELIOSTAT (Fr. and Ger., *Heliostat*)

A mirror mounted on a central axis which rotates at the same rate as the earth, so that an image of the sun can be reflected to one constant spot. It is used in photo-micrography when a powerful light is required, and also in spectrography.

HELIOTYPE

A modification of the collotype process, invented by Ernest Edwards, of London. A glass plate is waxed and coated with a substantial layer of gelatine and potassium bichromate, containing a small quantity of chrome alum, which hardens the gelatine and renders it insoluble without destroying its permeability to water. When dry, the gelatine film is removed from the glass, and the surface that has been next the glass is exposed under a reversed negative in the usual way. Then the film is hardened at the back by exposure to light, is attached under water to a metal plate, preferably pewter, coated with indiarubber, and is then squeegeed into perfect contact. The bichromate salt is removed by washing, and the plate is ready to be printed from in an ordinary typographic press.

HELLENOTYPE (Fr., *Hellenotype ;* Ger., *Hellenotypie*)

A method of colouring photographs, at one time popular in America. Two finished prints were made from the same negative, one rather light and the other strong and vigorous. The lighter one was rendered transparent by the application of varnish and was tinted at the back. It was then adjusted over the stronger print, giving the impression of a photograph in colours.

A slightly different process, known as Hallotype, after its inventor, J. B. Hall, of New York, was patented in 1857. Two similar prints were used, one being made transparent by treatment with dammar varnish, and the other painted with washes of colour. The transparent print was laid over the painted one, and the two bound together with a glass and backing, in " passe-partout " style.

HENDERSON, ALEXANDER LAMONT

Born in Scotland, 1838; died at Bad-Nauheim in Germany, 1907. For many years one of the best-known figures in photographic circles. He was a recognised authority on ceramic enamels and emulsion making ; he was founder of the London and Provincial Photographic Association (1882), and private photographer to Her Majesty Queen Victoria.

There are many " Henderson " formulæ in use, among the best known being a hydroquinone-metol developer and a combined toning and fixing bath for P.O.P. :—

Hydroquinone-metol Developer.

A. Hydroquinone .	. 100 grs.	11·5 g.	
Metol . .	. 40 „	4·5 „	
Sodium sulphite	. 960 „	110 „	
Water . .	. 20 oz.	1,000 ccs.	
B. Sodium hydrate	. 100 grs.	11·5 g.	
Potassium carbonate .	120 „	14 „	
Water . .	. 20 oz.	1,000 ccs.	

Mix together equal parts of A and B and add potassium bromide as required. If over-exposure is suspected, begin development with an old developer and finish with fresh.

Combined Toning and Fixing Bath for P.O.P.

Sodium hyposulphite	. 1 oz.	110 g.	
Lead nitrate . .	. 60 grs.	14 „	
Chrome alum .	. 60 „	14 „	
Sodium formate .	. 20 „	4·5 „	
Formic acid .	. 30 drops	6 ccs.	
Hot water . .	. 10 oz.	1,000 „	

Dissolve the lead and sodium formate in a small quantity of water, add the " hypo " in solution and the formic acid, allow to stand for twenty-four hours in an open vessel, and add 1 or 2 grs. of gold chloride or platinum bichloride.

Henderson's process for the removal of green fog or reducing a negative was to place it over a solution of potassium cyanide for several hours.

HEPWORTH, THOMAS C.

Born, November 3, 1834; died 1905. A well-known writer and lecturer on photographic subjects; for some years proprietor and editor of the *Camera* and also editor of the *Photographic News.*

HERSCHEL, JOHN FREDERICK WILLIAM

Born at Slough, 1792; died at Collingwood, 1871. A famous scientist, who did much for photography in its early days. His name will always be associated with the discovery of the " hypo " fixing bath and of the " blue print " process ; he also suggested glass as a support for sensitive emulsion, and experimented with many printing processes, most of which, however, are now obsolete. Knighted, 1831.

HESEKIEL'S PAPER

A platinum paper made by Dr. Hesekiel, of Berlin, and introduced into England in November, 1893. It differed from the usual platinum papers chiefly because its surface was granular, and it gave results resembling those of a half-tone process block, owing to the " pyramidal grain."

HIGH LIGHTS

The most brightly illuminated parts of a subject. If these are represented by considerable areas of blank paper the effect is " hard " and unpleasant. High lights should not be scattered about the picture when avoidable, as they draw the eye from one to another, and do not permit of the attention being concentrated. Hence the frequent necessity of " toning down " some of the high lights to avoid " spottiness."

HILL, DAVID OCTAVIUS

Born at Perth, 1802 ; died 1870. A landscape and portrait painter, and one of the first to apply

photography to portraiture (on the recommendation of Sir David Brewster). Many of his calotypes of eminent men are still in existence.

HILLOTYPE (Fr., *Hillotype*; Ger., *Hillotypie*)

An alleged process of photographing in colours claimed to have been invented by the Rev. Levi L. Hill, of Westkill, New York State, in 1852.

HOAR FROST PICTURES (*See* " Snow and Hoar Frost Photography.")

HOFMANN'S COLOUR PHOTOGRAPHY

A process in which three constituent negatives were taken and printed on to carbon tissue containing red, yellow, and blue pigments, the developed prints being subsequently superimposed. It was introduced in 1900.

HOLIDAY PHOTOGRAPHY

There are one or two special considerations that press for attention in the case of photographic work undertaken during a holiday. Frequently the work then done is of special interest and importance, and any failure is more serious than in the case of work which can easily be done over again. In the first place, it is well to form some idea beforehand of the kind of subjects to be dealt with in the place visited, as this to some extent decides the best form of apparatus to take for the purpose. Whatever camera is used, it should be one with which the holiday-maker is already familiar. Many disappointments have arisen from the use of new and unfamiliar apparatus specially bought for the occasion. Even the usual brand of plates should be adhered to, and it is well to take a full and reliable supply of them rather than depend on local purchases.

Some workers make a point of developing their plates from day to day as they are exposed. This certainly indicates enthusiasm, but it demands a considerable encroachment on the holiday leisure, and, as a rule, the results suffer on account of the lack of home facilities for the work. If all the exposures are carefully timed, with the aid of a meter when necessary, it is pretty safe to defer development. In that case the exposed plates may be re-packed, carefully tied up, in the original boxes. They should be placed film to film, with cardboard separators or plain tissue paper (not printed matter) interposed. At the same time it is advisable to make occasional exposures in duplicate and develop one of the plates. This can easily be done with the aid of developers ready prepared in some small, handy form, " tabloid " or otherwise, its main object being to ascertain that no unsuspected defect has developed in the shutter or some other part of the apparatus in use. When roll film is being used it is equally advisable to develop an occasional strip.

HOME PORTRAITURE (*See* " Portraiture.")

HOMOCENTRIC LENS

A name applied by Ross to two distinct types of lens, one being an " air-space " anastigmat, and the other a cemented lens of the Goerz double anastigmat type. The former is made in four intensities—$f/4·5$, $f/5·6$, $f/6·3$, and $f/8$;

and the latter in one intensity—$f/6·8$. The chromatic correction of these lenses is excellent, and they are therefore well adapted for colour photography.

HOMOCOL (Fr., *Homocol*; Ger., *Homokol*)

A sensitising dye of good green sensitiveness, used for bathing plates or adding to emulsion for colour work. It is one of the isocyanine series. Collodion emulsion, sensitised with it, keeps well, and shows extremely clear working qualities. It yields an emulsion of only moderate speed.

HOMOGENEOUS IMMERSION OBJECT-IVES

These are described under the heading " Objective."

HONEY PROCESS

Honey was used in one of the methods for preparing albumen plates, but it was more widely used in the early days of collodion plates for the purpose of keeping them moist. The use of honey was advocated in 1854 by George Shadbolt and Maxwell Lyte, who independently discovered its usefulness. The plate was coated with a solution of honey after sensitising, and washed off before development ; it kept the plate moist and prevented the crystallisation of silver. Plates prepared with honey needed double the exposure of wet plates, but they could be kept several days before sensitising and exposing, and also between exposing and development. The sticky coating was a serious drawback, as it attracted dust.

HOOD, LENS (Fr., *Parasoleil*; Ger., *Sonnenblende*)

The front projecting rim of the lens tube or mount. A certain degree of such projection is useful, serving to exclude unnecessary light, but the hood should not be deep enough to cut off any of the image. Thus, in diagram A, the outer rays F G proceeding from the object barely clear the hood, and it is evident that if this were the slightest degree deeper some of the marginal rays would be stopped. Hand-

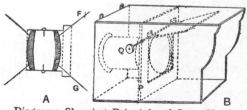

Diagrams Showing Principle of Lens Hood

camera lenses now tend to go to the opposite extreme by having no hood at all, so as to facilitate portability ; in consequence, flare becomes probable, and the brilliancy of the image is likely to suffer. Collapsible hoods are manufactured to fit on the lens in hand cameras and other apparatus. The use of an extended hood is especially necessary in telephoto work.

Another kind of hood consists of a blackened wooden or cardboard tube made to fit at the

front of a studio camera, as illustrated at B. The partition P, which comes before the lens, has an opening covered by a hinged shutter, which may be raised or lowered by turning the milled head at the end of the rod Q. Such an arrangement, besides affording a convenient means of exposure, greatly adds to the clearness and freedom from fog of the negatives, by its complete exclusion of all light except that coming direct from the sitter.

HOOD SHUTTER (Fr., *Obturateur avant-objectif;* Ger., *Vor-objektiv Verschluss*)

Synonym, before-lens shutter. Any shutter fitting on the hood or front of the lens, as, for example, the flap shutter and the outside type of roller-blind shutter. The term is also applied sometimes to the combination hood and shutter accessory often used with studio cameras, and described in the preceding paragraph.

HORIZON (Fr., *Horizon;* Ger., *Horizont*)

When a camera is level, with the lens centrally opposite the plate, the line of the horizon, if visible, will bisect the picture. This is generally considered a defect, and it is well to avoid it by raising or lowering the lens.

HÜBL'S PLATINUM INTENSIFIER

Used for intensifying weak prints on platino-type paper. The print is immersed for from ten to thirty minutes in a solution of platinum perchloride and sodium formate, the platinum being slowly reduced and deposited upon the small particles already present. The formula advised is :—

A. Platinum perchloride . 5 grs. 2·3 g.
 Water . . . ½ oz. 100 ccs.
B. Sodium formate . 25 grs. 11·5 g.
 Water . . . ½ oz. 100 ccs.

Add A and B to 30 oz. of water. Immerse the print, and when sufficiently dense wash well. Hübl has further suggested a method (*which see,* under heading "Platinotype Process") of obtaining tones between a slate grey and a bright blue.

HÜBL'S THREE-COLOUR PROCESS

The ordinary method of tricolour photography has been dealt with at considerable length, theoretically and practically, and with great exactness, by Baron von Hübl in his work "Three Colour Photography."

HUGHES, CORNELIUS JABEZ

Born 1819 ; died 1884. After an extensive business experience he became (1862) the official photographer to Queen Victoria. He was an authority on carbon work. His best known book is "Principles and Practice of Photography."

HUNT, ROBERT

Born 1806 ; died 1887. The most copious writer on photography in its earlier period. In 1844 he published "Researches on Light," in which he was assisted by Sir John Herschel ; and, in 1851, "Photography" ; in 1850 he compiled a history of photography for the British Association. In 1844 he discovered the developing powers of iron protosulphate, and later made photographic experiments with the salts of chromium, nickel, lead, manganese, copper, iron, mercury, gold, silver, and platinum. He was, in 1853, one of the founders of the (now) Royal Photographic Society and a member of its first council.

HUNT'S COLOUR PROCESS

Robert Hunt in 1844 published many interesting experiments on the action of the spectrum and coloured lights on silver chloride (" Researches on Light,'' 1844 ; " Researches on Light in its Chemical Reactions," 1854), thus following in the footsteps of Seebeck and Herschel.

HURTER AND DRIFFIELD, OR H. & D. SYSTEM

A system of determining the sensitiveness or speed of plates, suggested in 1890 by Hurter and Driffield, and based on the measurement of a series of densities instead of a single one. (*See* " Plate Testing.")

HUSNIK'S PROCESS (*See* " Leimtype.")

HUYGHENIAN EYEPIECE (*See* " Eyepiece.")

HYALOGRAPHY (Fr. and Ger., *Hyalographie*)

Synonym, hyalophotography. Photographic etching on glass. Rozsnyay's method (1875) is much more elaborate than that of Duchochois, and according to the latter, paper is coated with a solution of 100 grs. each of sugar, gum arabic, and ammonium bichromate in 2 oz. of water. The dried plate is exposed under a positive transparency and dusted with finely-powdered bitumen. The "developed" image is transferred to a warm glass, which softens the bitumen and causes it to adhere. The paper is soaked off, the glass dried, and etching done with hydrofluoric acid vapour.

Photo-hyalographs have been used both decoratively and for printing from in the press.

HYALOTYPES

The name by which albumen transparency positive pictures upon glass, in the form of lantern slides, were originally known. They were introduced into England by Messrs. Langenheim, of Philadelphia, and they were known in England as " Crystalotypes " (*which see*).

HYDRAMINE (Fr. and Ger., *Hydramin*)

C_6H_4 (OH)$_2$ (NH$_2$)$_2$ C_6H_4. Molecular weight, 218. Solubilities, 1 in 500 cold water, 1 in 20 hot water, 1 in 15 hot alcohol, readily dissolved by caustic alkalis. It occurs as white scales, and is obtained as the addition product of one molecule of hydroquinone with one of para-phenylendiamine. It was introduced by Lumière and Seyewetz as a developer, which works best with caustic lithia :—

Hydramine . . 44 grs. 5 g.
Sodium sulphite . 264 „ 32 „
Caustic lithia . 26 „ 3 „
Distilled water to . 20 oz. 1,000 ccs.

HYDRATES (Fr., *Hydrates;* Ger., *Hydrate*)

Salts in which a metal replaces one of the atoms of hydrogen in water. (*See* " Caustic.")

HYDRAZINE (Fr., *Hydrazine*; Ger., *Hydrazin*)

Synonym, diamidogen or diamine. $NH_2 NH_2$. Molecular weight, 32. This was proved to consist of a very faint developer in an alkaline solution, but neither it nor its organic derivatives are practically used. Some of its compounds have lately been suggested as an addition to haloid emulsions without free silver, in order to obtain intense, vigorous images.

HYDROBROMIC ACID (Fr., *Acide bromhydrique*; Ger., *Bromwasserstoffsäure*)

Synonyms, bromhydric acid, hydrogen bromide. HBr. Molecular weight, 81. It is a clear, colourless, or faintly yellow liquid, an aqueous solution of the gas HBr, of which it usually contains 40 per cent. It is occasionally used in 10 per cent. solution as an addition to emulsions.

HYDROCHLORIC ACID (Fr., *Acide chlorhydrique*; Ger., *Chlorwasserstoffsäure*)

Synonyms, chlorhydric or muriatic acid, hydrogen chloride. HCl. Molecular weight, 36·5. Miscible in all proportions with alcohol and water. It is a clear, colourless, fuming liquid, containing about 37 per cent. of the gas HCl. It is very poisonous, the antidotes being magnesia, alkaline carbonates, albumen and ice. It is also a painful escharotic; that is, it burns the skin. The worker should avoid breathing the fumes. It is used for acidulating the alum bath, for removing stains, and to remove the soluble iron salts from platinum prints after development. The impure acid, which is of a strong yellow colour, is known as spirit of salt, and is not used photographically except for cleaning dishes, etc., work which it does excellently.

HYDROFLUORIC ACID (Fr., *Acide fluorhydrique*; Ger., *Fluorwasserstoffsäure*)

Synonyms, fluoric acid, fluorhydric acid, and hydrogen fluoride. HF. Molecular weight, 20. A very dangerous acid in use, as it attacks glass, porcelain, cork, wood; also the nails and skin of the user. It must be kept in indiarubber bottles. The commercial acid is an aqueous solution of the gaseous acid. Practically its sole use in photography is for stripping films from glass plates; but on account of its dangerous nature, the use of potassium fluoride or sodium fluoride has been recommended instead, inasmuch as when an acid is added to either of these, hydrofluoric acid is set free. The negatives should be soaked in a 2 to 3 per cent. solution of the fluoride, rinsed, and then immersed in a hydrochloric acid solution of similar strength.

HYDROFLUOSILICIC ACID

Synonym, fluosilicic acid. H_2SiF_6. Molecular weight, 144. The product obtained by acting on silicon fluoride with water; it gives off acid fumes. It is used for the surface etching of aluminium plates in lithography.

HYDROGEN (Fr., *Hydrogène*; Ger., *Wasserstoff*)

H. Molecular weight, 1. A colourless, odourless gas prepared by the action of metals on water in the presence of acids or alkalis. Its only photographic use is when mixed or burnt with oxygen for the limelight. Nascent hydrogen—that is, when freshly generated—is an extremely energetic reducer. It is sometimes used to reduce the silver haloid residues, and is then formed by acidulating with sulphuric acid and immersing strips of zinc or magnesium, when metallic silver is deposited as a grey powder.

HYDROGEN DIOXIDE (*See* "Hydrogen Peroxide.")

HYDROGEN FLUORIDE (*See* "Hydrofluoric Acid.")

HYDROGEN LINES

The Fraunhofer lines given out by glowing or incandescent hydrogen gas generally under reduced pressure in a vacuum tube. They are frequently used for the calibration of spectrometers, to determine the refractive index of glass and scaling spectrograms. The visible ones are the first four in the following table:—

$H\alpha$	(C)	..	$\lambda 6562\cdot1$	Orange red.
$H\beta$	(F)	..	$4860\cdot7$	Bright blue.
$H\gamma$..	$4339\cdot5$	Deep blue.
$H\delta$	(h)	..	$4101\cdot2$	Violet.
$H\epsilon$..	$3969\cdot2$	
$H\zeta$..	$3888\cdot1$	
$H\eta$		••	$3834\cdot9$	
$H\theta$..	$3797\cdot3$	
$H\iota$..	$3769\cdot9$	
$H\kappa$..	$3750\cdot2$	
$H\lambda$..	$3734\cdot1$	
$H\mu$..	$3721\cdot1$	
$H\nu$..	$3711\cdot2$	

The first column gives the usual scientific method of naming the lines—that is, the hydrogen or H alpha; the second gives Fraunhofer's letters, the third the wave-lengths, and the fourth the colour of the line. A great many other lines have also recently been discovered as belonging to hydrogen, particularly in the ultra-violet.

HYDROGEN PEROXIDE (Fr., *Péroxyde d'hydrogène, Eau oxygénée*; Ger., *Wasserstoffperoxyd*)

Synonyms, hydrogen dioxide, hydroxyl, perhydrol. H_2O_2. Molecular weight, 34. Miscible in all proportions with water or alcohol. A colourless liquid with slightly acid taste, foaming in the mouth, prepared by the action of dilute sulphuric acid on barium peroxide. The commercial preparations are 3 per cent., corresponding to ten volumes of available oxygen, and 30 per cent. solutions, corresponding to 100 per cent. by volume. It should be kept cool and in the dark. It has been suggested as a "hypo"-eliminator; when rendered alkaline it is a weak developer. Finely divided silver and platinum act as catalysts on it and decompose it into water and oxygen. (*See* "Catatype.") To hydrogen peroxide has been ascribed the peculiar effect of wood, resins, etc., on dry plates.

HYDROGEN SODA CARBONATE (*See* "Sodium Bicarbonate.")

HYDROGEN SULPHATE (*See* "Sulphuric Acid.")

HYDROGEN SULPHIDE (Fr., *Hydrogène sulfuré ;* Ger., *Schwefelwasserstoff*)

Synonym, sulphuretted hydrogen, hydrosulphuric acid. H_2S. Molecular weight, 34. A colourless gas, with extremely unpleasant smell ; it is usually obtained by the action of an acid on ferrous sulphide. It is occasionally used to precipitate silver from old fixing baths.

HYDROMETER

An instrument for determining the specific gravity of a liquid ; used by floating it in the liquid which is contained in a tall glass cylinder. Twaddel hydrometers are adjusted for certain densities, and the degrees (°Tw.) are converted into specific gravities by multiplying by ·005 and adding 1. In the Beaumé hydrometer system (°B.), for liquids heavier than water, 0° equals a specific gravity of 1 ; 1° equals 1·007 sp. gr. ; 2° equal 1·013 ; 3° equal 1·02 ; and so on. For liquids lighter than water, 10° equal 1 sp. gr., and for every rise of 1 in the degrees there is a drop in the specific gravity of about ·005.

In process work, the Beaumé hydrometer is universally used by copper etchers for measuring the strength of the ferric perchloride solution. An instrument reading to 50° is the most convenient, as the density of the solution does not exceed 45°, and is more generally between 30° and 40°. The test is usually made in a tall and narrow glass jar made for the purpose.

HYDROQUINONE (Fr., *Hydroquinone ;* Ger., *Hydrochinon*)

A developer, known also as hydrokinone, hydrochinone, and quinol. The use of hydroquinone was suggested by Sir William Abney in 1880, but it was not possible to bring it into general use at that date owing to its expense. Since then, however, manufacturers have been able to produce it very cheaply. It occurs in greyish-white or yellow prismatic needles, which darken on exposure to light, and in chemical composition it is allied to pyrogallol, which is trihydroxybenzene, $C_6H_4(OH)_3$, whereas hydroquinone is dihydroxybenzene, $C_6H_4(OH)_2$. Its solubility is 5·8 per cent. in cold water, and about 10 per cent. in hot water. When used alone, particularly if bromide is added as a restrainer, hydroquinone has a tendency to give excessive contrasts, and although an excellent developer, it is more generally used with metol (*see* "Developers, Mixed"). A solution of hydroquinone is affected by temperature more than is any other developer, and works very slowly —sometimes not at all—when very cold. Hydroquinone may be used in one or two solutions, and the best results are obtained with a caustic alkali.

One-solution Developer (Concentrated)

Hydroquinone .	. 310 grs.	35·5 g.	
Sodium sulphite	. 5 oz.	275 ,,	
Potassium carbonate	8 ,,	440 ,,	
Hot water to .	. 20 ,,	1,000 ccs.	

The above is a concentrated developer, and for use requires to be diluted with from four to six times the quantity of water. Bromide will be required only in cases of over-exposure. Another one-solution form, in which sodium carbonate is used, is :—

One-solution Developer (Ready for Use)

Hydroquinone .	. 90 grs.	21 g.	
Sodium sulphite	. 2 oz.	220 ,,	
Sodium carbonate	. 2 ,,	220 ,,	
Water to .	. 10 ,,	1,000 ccs.	

Hydroquinone works more quickly with sodium carbonate than with potassium, but the latter is thought to give better gradation.

Messrs. Lumière have recommended the following one-solution (ready for use) formula. It gives absolutely clean negatives of great contrasts, which makes it specially suitable for the reproduction of black-and-white and line drawings, or for obtaining more contrasty positives from thin and weak negatives, care being taken in all cases to keep the exposure somewhat short :—

One-solution Developer (Ready for Use)

Hydroquinone .	. 40 grs.	18·3 g.	
Sodium sulphite	. 400 ,,	183 ,,	
Formaline	. 50 drops	20 ccs.	
Water	. 5 oz.	1,000 ,,	

No bromide or alkali is required. Dozens of other formulæ have been given, all more or less based on the above.

Probably the most popular of the two-solution forms—and some scores have been published—is the following :—

Two-solution Developer

A. Hydroquinone .	160 grs.	18 g.	
Sodium sulphite .	2 oz.	100 ccs.	
Citric acid .	. 60 grs.	7 g.	
Potassium bromide	40 ,,	4·5 ,,	
Water .	. 20 oz.	1,000 ccs.	
B. Sodium hydrate .	160 grs.	18 g.	
Water .	. 20 oz.	1,000 ccs.	

For use, mix together 1 oz of A, 1 oz. of B, and 2 oz. of water. More or less water may be added as desired, and the more water used the softer will be the result. By using A and B in equal parts without water very hard negatives will be obtained, such as are wanted when copying black-and-white work.

Two-solution formulæ embodying the use of sodium and potassium carbonates are as below :—

Two-solution Developer

A. Hydroquinone .	$\frac{1}{2}$ oz.	27·5 g.	
Sodium sulphite .	2 ,,	110 ,,	
Water to .	20 ,,	1,000 ccs.	
B. Sodium carbonate	1¼ ,,	69 g.	
Water .	. 20 ,,	1,000 ccs.	

Take equal parts of each. 1 oz. of potassium carbonate may replace the 1¼ oz. of sodium carbonate in the B solution.

Prof. Lainer has published many useful concentrated two-solution formulæ, five of which are given on the next page, and in order to economise space the quantities are given in "parts," but to those unaccustomed to the "parts" system it may be useful to know that if the solids are weighed in grains and the liquids in minims (480 to the ounce), the proportions will be about right.

	No. 1	No. 2	No. 3	No. 4	No. 5
A. Hydroquinone .	10	10	10	10	10
Sodium sulphite .	25	40	30	35	35
Potass. ferricyanide	60	120	90	25	25
Water . . .	600	900	950	1000	550
B. Potass. hydrate .	50	50	—	50	—
Sodium hydrate .	—	—	30	—	60
Water . . .	100	100	90	550	550

For use, A and B are mixed together in proportions as follow : No. 1—1 oz. of A, with 24 drops of B ; very rapid in action, but inclined to fog. No. 2—1 oz. of A, with 48 drops of B ; a rapid developer, and gives strong contrasts. No. 3—1 oz. of A, with 96 drops of B ; gives softer negatives. No. 4—1 oz. of A, with 50 to 70 drops of B ; slow working. No. 5—Mix in equal parts ; a good, normal developer, which works slowly and gives clean negatives.

One drawback to hydroquinone has been understood to be that it cannot be made up in a highly concentrated form, as, for example, a 10 per cent. solution. J. B. B. Wellington, however, as long ago as March, 1889, published the following formula for a 10 per cent. solution :—

A. Hydroquinone .	1 oz.	110 g.	
Methylated spirit	3½ ,,	350 ccs	
Sulphurous acid .	3½ ,,	350 ,,	
Water to . .	10 ,,	1,000 ,,	
B. Sodium hydrate .	1 oz.	110 g.	
Sodium sulphite .	1 ,,	110 ,,	
Water to . .	10 ,,	1,000 ccs.	

For use, add 1 drm. each of A and B to 2¼ oz. of water. In the above formula the methylated spirit is used to dissolve the hydroquinone and the sulphurous acid to prevent oxidation.

Hydroquinone may be used again and again for several negatives without fear of staining ; but ultimately it gets into a condition in which it stains badly. It keeps well in solution. It should always be dissolved after the sodium sulphite.

In process work, hydroquinone is regarded as the most useful developer for dry plates and collodion emulsion. For the former it is used either alone or in conjunction with metol.

HYDROQUINONE INTENSIFIER

This was recommended by Dr. Eder in 1890. The following two solutions are made :—

A. Hydroquinone .	20 grs.	11·5 g.	
Citric acid .	12 ,,	7 ,,	
Water (distilled) .	4 oz.	1,000 ccs.	
B. Water (distilled) .	1 oz.	275 g.	
Silver nitrate .	16 grs.	92 ,,	

Mix 3 oz. of A with 1 oz. of B, and immerse the well-fixed and washed negative until dense enough ; finally wash.

HYDROQUINONE WITH METOL (See
" Developers, Mixed," and " Metol-hydroquinone.")

HYDROSULPHITES, DEVELOPMENT WITH

Jules Breton experimented in 1890 with a rather intense developer, formed of a solution of sodium hydrosulphite, $NaOS_2O_3$, mixed with double sulphite of sodium and of zinc. There is some trouble with deposits, but it is possible to obtain dry plate negatives of a fine black, if care is taken.

HYDROTYPE

A reversed collotype process chiefly due to Cros. It has been used in a modified form for colour printing. A gelatine image is made to absorb dyes in proportion to the action of light, so that when paper is brought into contact with the stained plate whilst damp an image is obtained from the dye.

HYDROXYL (See " Hydrogen Peroxide.")

HYDROXYL CARBON COMPOUNDS

Carbohydrates containing the hydroxyl group OH for a hydrogen atom.

HYDROXYLAMINE (See " Hydroxylamine Hydrochloride ")

HYDROXYLAMINE HYDROCHLORIDE
(Fr., *Chlorhydrate d'hydroxylamine ;* Ger., *Salzaures Hydroxylamin*)

NH_2 OH HCl. Molecular weight, 69·5. Soluble in water and alcohol. It takes the form of colourless crystals, and can be prepared by reducing ethyl nitrate with tin and hydrochloric acid and chlorising. Both hydroxylamine and the hydrochloride are vigorous developers when rendered alkaline with caustic alkalis, but they are of no practical value as nitrogen gas is evolved during development, which either pits the film all over or strips it from the glass.

HYDROXYTRICARBOXYLIC ACID (See
" Carboxylic Acids.")

HYGIENE IN PHOTOGRAPHY

Photography does not now involve many risks to health, but it is necessary to remember that there are still a few chemicals used which injure the worker's hands if they come in contact with them, and of which the fumes become dangerous if inhaled. Should the dark-room be insufficiently ventilated the atmosphere will become stuffy and cause headaches ; and, of course, when strong-smelling chemicals are used—as ammonia, sodium sulphide, etc.—good ventilation is all the more important.

Many users of a red light find that it makes their eyes ache if employed for any length of time, and when this happens a weak solution of boracic acid should be made up (8 grs. to 1 oz. of water), and this should be mixed with an equal volume of hot water and applied to the eyes with a clean handkerchief or sponge.

When the daguerreotype process is worked by experimentalists, particular care should be taken not to inhale the fumes from the mercury, as they are most dangerous. The fumes from collodion (ether, really) and ammonia involve but slight risk to the health, but they affect the eyes. Should ammonia be found to affect the worker, he should sniff weak acetic acid or ordinary brown vinegar, and he may sip a little of the latter with helpful results.

The fumes from all acids, particularly hydro-

fluoric, and from potassium cyanide are more troublesome ; when these substances are used, the dark-room must be well ventilated, otherwise bad headaches will occur and the membranes of the eyes, nose, and throat be affected. The best remedy for acid fumes is to sniff weak ammonia.

Some chemicals injure the skin and the clothes if they come in contact ; particularly is this the case with nitric acid, which burns severely. The remedy is to apply a strong solution of common washing soda or weak ammonia, or, in fact, any alkali. Potassium bichromate affects the skin at times, and the subject will be found dealt with under " Bichromate Disease." Platinum solutions are not often looked upon as dangerous, but when using them or large quantities of platinum paper some workers suffer from a skin disease and also nasal catarrh. A warm and weak solution of salt and water sniffed up the nose occasionally will, as a rule, cure the catarrh, while the same solution of salt and water will soothe and possibly quite cure the skin trouble. Hydroquinone, amidol, and metol developers (more particularly the last named) affect some workers, and when they do the treatment as prescribed under " Bichromate Disease " may be tried, or the following ointment, which any chemist will make up, used :—

Ichthyol	.	.	.	1 part
Lanoline	.	.	.	2 parts
White vaseline	.	.	.	3 „
Boric acid	.	.	.	20 „

All developers are apt to affect the skin more or less, and, after developing, the hands should always be well washed with warm water and a good soap of the carbolic variety. Developer-stained fingernails may be cleaned by rubbing with ink eraser ; or in troublesome cases they may be rubbed with lemon juice or ammonium persulphate crystals. When using developers that stain, workers should wear rubber finger-stalls or gloves. To keep the hands white and soft they should be rubbed with new milk previous to developing. Should an irritation be felt after using a mercury and ammonia intensifier, the remedy is to wash the hands with warm water, dab—not rub—dry with a soft towel, and rub in the following soothing mixture :—

Glycerine	.	.	4 drms.	17 ccs.
Carbolic acid	.	.	1 „	4 „
Alcohol	.	.	5 oz.	1,000 „

HYGROMETER (Fr., *Hygromètre ;* Ger., *Hygrometer*)

An instrument for measuring the amount of moisture in the atmosphere, occasionally used in plate and paper factories and in collotype printing rooms.

HYPERFOCAL DISTANCE

Assuming an object at an infinite distance from a camera to be sharply focused, the object is next brought nearer to the camera, and the distance at which the image visibly loses its sharpness is the hyperfocal distance. Assuming the degree of permissible unsharpness to be a circle of confusion $\frac{1}{100}$ in. in diameter, the hyperfocal distance in inches for any given lens at any given aperture is arrived at in the follow-

ing way. Multiply the focal length by itself, multiply the product by 100, and divide the result by the f number. The focal length being 5 in. and the aperture $f/8$, $\frac{5 \times 5 \times 100}{8} = \frac{2500}{8} = 312\frac{1}{2}$ in. = about 26 ft. The hyperfocal distance is sometimes called the " fixed focus," and it becomes shorter as the aperture is reduced ; in the case of the 5-in. lens, it is about 13 ft. at $f/16$ and about $6\frac{1}{2}$ ft. at $f/32$.

HYPERGON LENS

A wide-angle, double anastigmat lens, consisting of two very thin single semiglobular lenses. The largest aperture is $f/22$, and the angle included about 135°, the diagonal of the plate covered being five times the focal length of the lens. In order to equalise the illumination over this large field, outside the lens is fixed a revolving star diaphragm, which, during part of the exposure, is made to revolve by a jet of air and then dropped out of the way. The hypergon is uncorrected for chromatic aberration.

HYPERSTEREOSCOPY

The making of stereoscopic views of distant objects from two separate and widely apart stations, with ordinary camera and lens.

HYPERTELESTEREOSCOPY

Hyperstereoscopy with telephoto lenses.

" HYPO "

The abbreviated and popular name for sodium hyposulphite (*which see*). For " hypo " fixing baths, *see* " Fixing," " Acid Fixing Bath," and " Alkaline Fixing Bath."

" HYPO " IN DEVELOPER

The addition of very small quantities of " hypo " to certain developers is sometimes advised ; with the ferrous oxalate it acts as an " accelerator," because it decomposes the ferric oxalate formed, which acts as a restrainer.

" HYPO " ELIMINATORS

Various chemicals have been suggested from time to time for the purpose of curtailing the washing of negatives and prints by chemically destroying the last traces of " hypo," such as hypochlorite of zinc, eau de Javelle, iodides, alum, lead acetate, hydrogen peroxide, potassium permanganate, etc., and recently several of the persulphates and percarbonates have been introduced under fancy names. Many if not all of these merely convert the hyposulphite into tetrathionate. It must not be forgotten that the hyposulphites of silver have to be dealt with as well as the hyposulphite of soda, and these are not necessarily more soluble. If rapidity of output regardless of permanency is the result, then the use of such chemical agents is warranted, but considering that all possible traces of the hyposulphites can be removed by an hour's washing correctly performed, it is an open question whether such means are justified.

" HYPO " STAINS (*See* " Stains, Removing.")

" HYPO "-ALUM TONING (*See* " Alum-'hypo' Toning.")

I

ICELAND MOSS

A moss or lichen found in the Arctic regions. It forms, when boiled in water, a jelly which has a few photographic uses, notably as a vehicle for sensitive salts when sensitising fabrics. Carrageen (Irish moss) has much the same properties.

In process work, the gelatinous nature of this substance has suggested its use as a substitute for fish-glue in the enamel process of photo-etching, but it was not found to have any advantages over fish-glue.

ICHTHYOCOL, OR ICHTHYOCOLLA

Fish-glue or isinglass.

ICHTHYOL

A bituminous substance which emulsifies quite easily with water, and can be added to collotype emulsions, with the object of strengthening the coating. Dissolved in a mixture of ether and alcohol, it leaves by evaporation a granular layer similar to resin grain or bitumen grain. Dissolved with an equal weight of water it forms an ink which has the property of attracting greasy ink and repelling water, so that it may be used for lithographic purposes.

ICONOMETER (Fr., *Iconomètre*; Ger., *Ikonometer*)

A view meter giving a direct image and enabling the best standpoint with a given lens to be ascertained without first setting up the camera. One form is a rectangular open frame of watch-spring set upright on a horizontal rod graduated in centimetres. On placing the eye at a sight at the zero end of the rod, the exact view given by the lens with the camera in that position is seen through the frame. The latter is movable on the rod by means of a slide, for use with lenses of different focal lengths. The rod itself is hollow, and when the instrument is not in use the frame can be folded up and inserted inside it, together with the sight, it being then placed in the pocket like a pencil.

ILLUMINANTS, LANTERN (See " Optical Lantern Illuminants.")

ILLUMINATION, DARK - ROOM (See " Dark-room Illumination.")

ILLUMINATION, INTENSITY OF (Fr., *Intensité d'illumination*; Ger., *Lichtstärke*)

The visual strength or brightness of light. The intensity of light passing through a lens or pin-hole is proportional to the area of the opening through which it is admitted, the opening, in the case of a lens, being the diaphragm or stop. It is also inversely proportional to the distance from the source of light of the surface receiving it, since the light obviously spreads out and becomes attenuated. The rule is, the intensity of illumination is inversely proportional to the square of the distance, but photographically this rule tends to break down if carried beyond certain moderate limits. The intensity is weakened when the light is made to cover a larger surface, as, for instance, if it strikes the plate at an angle instead of perpendicularly, which may happen when using the swing-back or swing-front. The margins of the view given by a wide-angle lens are often not so well lit as the central portion, because the marginal rays reach the plate at an acute angle. Printing frames should be placed square to the light; if inclined, not only is the light spread and weakened, but much lost by reflection.

IMAGE, LATENT OR INVISIBLE (See " Latent Image.")

IMMERSION LENS (See " Objective.")

IMOGEN SULPHITE (Fr., *Imogène sulfite*; Ger., *Imogen sulfit*)

A developer needing only a saturated solution of sodium carbonate to make it active. It occurs in a pinkish white powder which keeps well, both dry and in solution, owing to there being combined with it the necessary amount of preservative; it yields negatives of a good warm-black colour. Potassium bromide in small quantities acts only as a preventive of fog; larger quantities have a stronger restraining action and increase contrast. For correct exposures no bromide is required, but for over-exposure a 10 per cent. solution may be used. The imogen sulphite developer is made up in two solutions, the makers' instructions being as follow :—

A. Imogen sulphite 1 oz., warm water 12 oz.
B. A cold saturated solution of soda carbonate.

For correct exposures take of solution A 2 parts, and B 1 part. Add water, and use more of B for under-exposures. For bromide paper, the above solutions should be diluted with an equal amount of water, bromide being added. Fix in an acid fixing-bath.

IMPERIAL

A size of photographic mount which varies between 6¼ in. by 10 in. and 7⅜ in. by 9⅞ in.

IMPRESSIONISM

This term is often used vaguely and with great differences of meaning. The broad idea implied is that a subject is rendered as it first strikes the eye; as it appears at one particular time; or so as to convey, first and foremost, the general

mental impression created by its appearance under certain conditions. Now a hurried impression would be more or less general, and lacking in such detail as would be noted after prolonged or frequent examination. Hence the idea that impressionism means indistinctness, or involves " fuzziness." This is not necessarily so. The impression, or mental effect, might be one of brilliance, sharpness, and wealth of detail.

To take an example. A photographer's impression of a church tower might be that it was one white, gleaming mass, standing out vividly from all its surroundings. To convey this impression he would probably emphasise the darkness of the sky behind it, and suppress detail and light everywhere but in the tower itself. Under other conditions the same tower might convey the impression of a solid silhouette standing forth boldly against a brilliant sky. In neither case would the tower be rendered with the realism that an architect would require as a record of its design. In each case it would be treated so as to suggest as far as possible the particular impression it made at the time. This is, of course, a simple case to take. Carried farther, the desire for impressionistic renderings leads to the adoption of all sorts of devices to modify, control, and emphasise actual photographic results.

INCANDESCENT LIGHT (See " Artificial Light.")

INCIDENCE, ANGLE OF (Fr., *Angle d'incidence* ; Ger., *Einfallwinkel*)

The angle which a ray of light falling on a flat surface forms with the perpendicular to that surface, or to the tangent if the latter is curved. Thus, if a ray of light C D strikes a plane surface E F at the point D, as shown by diagram A, the angle C D G made by the ray C D with D G, a perpendicular to E F drawn from the point D, is the angle of incidence. The line C D is called the line of incidence. If the plane surface is a mirror, the light will be reflected from D in the

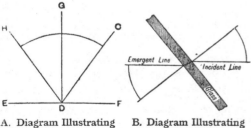

A. Diagram Illustrating Angle of Incidence B. Diagram Illustrating Line of Incidence

direction D H. The angle H D G, formed by the perpendicular with the line of departure of the light, is termed the angle of reflection, and is always equal to the angle of incidence. When the line of incidence is itself perpendicular to the receiving surface, the light is reflected back along its original course, or in the case of a transparent body passes straight through without refraction. When a ray of light strikes a transparent surface

of different density to that in which it was previously moving it is refracted. Provided the transparent body has parallel sides, as, for instance, a sheet of glass, the ray will emerge after refraction in a direction parallel with the line of incidence, and at the same angle as the angle of incidence, as shown at B. (*See also* " Reflection " and " Refraction.")

INCIDENCE, LINE OF (Fr., *Ligne d'incidence* ; Ger., *Einfall Linie*)

The straight line taken by a ray of light proceeding towards any surface, whether it strike the latter obliquely or at a right angle. (*See also* " Incidence, Angle of.")

INDEX OF REFRACTION (See " Refraction.")

INDIA TINT MOUNT

A mount that has pasted down on it a sheet of thin tinted paper slightly larger than the print which it is to carry. The mounted print thus shows a narrow margin of one tint with a wider border of another. A cheap imitation is made by printing the central tint by lithography.

INDIAN INK (Fr., *Encre de Chine* ; Ger., *Tusche*)

Indian ink is only so called ; actually it is Chinese ink, which formerly was available only in the form of cakes or sticks which had to be rubbed up with water for use, but which is now obtainable in the prepared liquid form, waterproof if desired. It is frequently used for painting out backgrounds, etc., in negatives, so that they appear white in the print. It is inferior to Indian red for this purpose, as it has a great tendency to crack badly after drying, and so render the work valueless.

To prevent work done in Indian ink running when touched with water, a tiny piece of potassium bichromate should be rubbed up with each saucerful.

Indian ink is not now used so much as formerly for process drawings, the modern waterproof inks having largely superseded it.

INDIAN RED

An opaque water colour composed principally of a natural earth. It is used for painting out backgrounds or portions of a negative that are to show as white in the print. The moist form, in tubes, is preferable, and the pigment should be applied to the film very thickly. It has no tendency to crack after drying.

INDIARUBBER (Fr., *Caoutchouc* ; Ger., *Kautschuk*)

Synonyms, caoutchouc, gum elastic, rubber. Insoluble in water and alcohol, soluble in carbon disulphide, chloroform, benzene, etc. A natural product, the coagulated juice of various plants belonging to the natural order *Euphorbiaceæ*. It occurs in brownish black cakes, balls or hollow-shaped pieces. It is very elastic and of characteristic odour. When heated with 10 per cent. of sulphur it becomes vulcanised. For photographic purposes, the pure washed and masticated rubber, not the vulcanised rubber, should be used. It is employed as an edging for

collodion plates and as a mountant. The most satisfactory solvent is carbon disulphide with 5 per cent. of absolute alcohol, in which the rubber, cut in small pieces, should be allowed to stand with agitation till dissolved. In order to save the trouble of making, the ordinary cycle tyre cement may be used and thinned down with disulphide or chloroform. The great drawback to its use as a mountant is that the rubber perishes in time, and the print leaves the mount.

In process work, a solution of indiarubber in benzole of 2 per cent. strength is used in stripping wet collodion films. The collodion negative is flowed with the rubber solution, and when this is dry it is again flowed with stripping collodion. The rubber solution prevents the solvents of the stripping collodion reaching the original collodion film, and at the same time increases the flexibility and toughness of the film.

Indiarubber solution is used in the collotype process for attaching to the negative the tinfoil used for masking.

In aerograph retouching, some workers use indiarubber solution for stopping-out certain portions of the print on which the aerograph spray is not wanted. After the spraying is done the rubber film easily peels off by rubbing with the finger-tip, and carries with it any spray that has overstepped the boundaries of the stopping-out medium.

INDIARUBBER CLOTH (Fr., *Drap de caoutchouc ;* Ger., *Kautschukzeug*)

Thin sheet vulcanised rubber, or fabric coated on both sides with a thin film of the latter. Indiarubber focusing cloths are of value in protecting the camera during bad weather. Cut pieces of rubber fabric or sheet rubber pads are employed to lay over prints when squeegeeing, and are placed at the back of platinotype paper in the frame when printing, to protect it from damp.

INDIARUBBER MOUNTANT (See "Indiarubber" and "Mountants.")

INDICATOR (See "Exposure Indicator," "Print Indicator," etc.)

INDIGO PRINTING

A process of photographic printing on fabrics by means of a mixture of indigo white, sodium bisulphite, soda, water, and gum. The image is developed in a caustic soda solution.

INDOOR PHOTOGRAPHY

Apart from actual studio work, a good deal of photography can be done indoors in almost every house, and that without any elaborate or unusual addition to the ordinary outdoor apparatus. Flashlight work comes under a special category. A good deal can also be done nowadays with the ordinary domestic means of artificial illumination. But still more can be done by daylight. Flowers, fruit, and all kinds of still-life subjects can be most effectively and conveniently dealt with indoors, and portrait and figure studies provide a wide and varied field of operations. Except in special cases, the ordinary window lighting requires some modification before it is

suitable. It is generally necessary not only to use blinds to shut out part of the light and control the direction of what is admitted, but to have a diffuser to soften it and make it even. This may be white muslin or buttercloth, which it is generally convenient to stretch on a light wooden frame. It is also necessary to have a second screen of more opaque fabric to act as a reflector on the shadow side. Considerations of space often compel the use of lenses of somewhat short focus, but every effort should be made to avoid this, especially in the case of work from the figure. Lenses of large aperture are also an advantage, as they not only facilitate focusing in what is frequently a subdued light, but permit of shorter exposures. Suitable backgrounds must also be considered. Sometimes the actual surroundings of the room are appropriate, but one or two plain backgrounds, both light and dark in tone, are almost essential. For still-life studies sheets of paper or cardboard of various colours are useful as backgrounds, and as the lighting is generally from the side it is easy to avoid cast shadows on them.

INDOTINT (Fr. and Ger., *Indotint*)

A photo-mechanical process resembling collotype, invented by Roche, of New York. A copper plate roughened by the sand-blast, to secure adhesion of the sensitised gelatine film, is used instead of the ordinary thick glass plate.

INDUCTION COIL (Fr., *Bobine ;* Ger., *Induktionsrolle*)

Induction coils are almost universally employed to produce the high potential currents necessary to excite the vacuum tube in X-ray work. An induction coil consists of three parts entirely insulated from one another. In the centre is the core, a bundle of soft iron wires laid longitudinally. Round this is wound, as on a reel, two layers of stout insulated copper wire to carry the primary current from the public main or accumulators. Round this primary winding, and well insulated from it, is wound the secondary, of very thin insulated copper wire, often many miles in length. Directly the current is switched on through the primary the core becomes magnetised, causing the secondary coil to give out a current which flows in the reverse direction. This induced current is only of momentary duration A greater though still momentary effect is produced when the current is switched off. In order to produce a rapid and continuous series of shocks or discharges from the secondary coil with which the tube is in circuit, the current through the primary must be interrupted and renewed several hundred times a minute.

This rapid starting and checking of the flow of current through the primary winding, technically known as "making" and "breaking" contact, is automatically accomplished by means of "contact breaks" (*which see*).

INERTIA (Fr., *Inertie ;* Ger., *Inertia, Trägheit*)

A term adopted by Hurter and Driffield to measure the slowness of a plate; the greater the inertia the slower the plate. (*See* "Plate Testing.")

INFINITE RAYS

Rays emerging from an extremely distant point and consequently practically parallel with one another.

INFINITY

Photographically, a distance beyond which no readjustment of focus is necessary to secure a sharp image of more distant objects. It increases in proportion to the focal length of the lens used. It is expressed on focusing scales by the sign ∞, the abbreviation INF, and occasionally the initial D (distance).

INFLECTION

Synonymous with "diffraction" (which see).

INFRA-RED RAYS (Fr., *Rayons infra-rouge* ; Ger., *Ultraroten Strahlen*)

A vast region of the spectrum lying beyond the red and to which our eyes are not sensitive, but which we are conscious of in the form of heat. Although we cannot see this region we know that it is traversed by absorption lines exactly in the same way as the visible spectrum ; they have been detected not only by direct photography by means of a special collodion emulsion (Abney), but also especially by means of the bolometer (*which see*). The absorption lines are indicated by the letters of the Greek alphabet. As most glasses are comparatively opaque to the infra-red rays, spectroscopes for the examination of this region have to be fitted with rock salt or sylvin lenses and prisms, or else transmission diffraction gratings with comparatively wide spacings, these gratings being in many cases made of silver or platinum wire.

INITIAL POWER

In photo-micrography, the initial power of a microscope objective is the magnification which the lens will give without an eyepiece at a distance of 10 in. from its back lens ; for example, if the image of an object thrown by the objective upon a screen at 10 in. distance magnifies the object 20 diameters the initial power of the objective would be 20. The initial power of an eyepiece or ocular is the magnification given by the eyepiece itself. The initial power of an objective multiplied by the initial power of the eyepiece gives the total magnifying power of the lenses used.

INK FOR GLASS, PORCELAIN, ETC.

Ink for writing names on glass bottles, porcelain dishes, tins, etc., may be made by dissolving 60 grs. of powdered copal in 1 oz. of oil of lavender made warm, and then mixing the solution, by means of a palette-knife on a stone, with 6 grs. of lampblack and 2 grs. of indigo ; if other colours are wanted, vermilion, ochre, etc., may be used. The mixture is applied with a fine camel-hair brush. To make the writing stand out prominently on glass it is advisable first to paint a shield or tablet on the glass, using white bath enamel for the purpose.

A mixture particularly suitable for lantern slides may be made by dissolving 1 drm. of shellac in $\frac{1}{2}$ oz. of methylated spirit ; then dissolve $\frac{1}{2}$ drm. of borax in $\frac{1}{2}$ oz. of water. The solutions should be mixed together very slowly, and if a precipitate forms the mixture should be heated until clear. Enough aniline dye of a suitable colour—methylene blue is generally used—should be added to colour the mixture. This dries quickly and is permanent.

INK FOR LABELS (*See* "Labels, Waterproof Ink for.")

INK PRINTING

Poitevin's pigment process depends upon three facts : *ferric* chloride renders gelatine insoluble, *ferrous* chloride has not that effect, and light converts the ferric into the ferrous chloride. If paper is coated with gelatine and ferric chloride, printed under a negative, and placed in warm water, the shadow portions (those acted upon by light) are made soluble. Thus a negative is made from a negative and a positive from a positive. 1 oz. of gelatine is soaked in 15 oz. of water, dissolved by heat, and 100 grs. of Indian ink mixed in very thoroughly. Paper is floated on the still warm mixture for three minutes, dried quickly, and immersed in the following sensitive mixture until limp :—

Iron perchloride	.	. 1 oz.	110 g.
Tartaric acid	.	. 140 grs.	32 ,,
Water	.	. 10 oz.	1,000 ccs.

The paper is dried in the dark, printed under a positive, and developed and fixed simply by washing gently in warm water.

Another method invented by Poitevin is to float plain paper for three minutes on a sensitive mixture prepared as follows :—

Iron perchloride	.	. 144 grs.	33 g.
Citric acid	.	. 96 ,,	22 ,,
Water	.	. 10 oz.	1,000 ccs.

The paper is dried quickly in the dark, printed under a positive and developed by immersing in a weak solution of Indian ink in glycerine. The ink will affect only those parts that have not been acted upon by light. The developed print is finally briefly washed and dried.

Most of the photo-lithographic and collotype processes may be described as ink-printing. The sensitised bichromate image is rendered susceptible to printing ink by exposure to light. The Amphitype process, and the Ordoverax processes (*which see*), also show that the iron salts are capable of being made to take up fatty inks.

INK PROCESS

A method of printing by which photographic pictures may be obtained in common writing-ink, sometimes referred to as the gallate of iron process. A sheet of white paper is immersed in a nearly saturated solution of potassium bichromate and dried, being now of a bright yellow colour. It is next placed under a negative and exposed to sunlight, which acts upon the bichromated surface and gives a pale brown picture. When all detail can be seen, wash in plain water for about an hour in order to remove the yellow and superfluous bichromate. This washing serves to fix the print, which should be of a pale yellow colour on a white ground. The print is given a colour and at the same time intensified by immersing for a few minutes in a solution of 5 grs. of iron protosulphate (ferrous

sulphate) in 1 oz. of water ; well wash, and place in a moderately strong solution of tannic acid, which will cause tannate of iron (writing-ink) to be deposited, a black image being formed. The difficulties of the process consist in thoroughly eliminating the chromium and ferrous salts, and in obtaining the writing-ink of a good black colour. There are other methods.

INK, WATERPROOF (See " Labels, Waterproof Ink for.")

INK, WHITE

White ink is used on black lantern-slide masks. To prepare it, take a cake of Chinese white water-colour, and rub it up with water by means of a camel-hair brush until of the consistency of ordinary ink. It is put into a pen with the brush and the title written with the pen. A white ink that may be stored in a bottle is made by taking :—

Isinglass	$\frac{1}{4}$ oz.	77 g.
Chinese white	1 "	310 "
Methylated spirit	1 drm.	35 ccs.
Water as required.		

Soak the isinglass in 1 oz. of water until soft, heat until dissolved, and rub up with the Chinese white in a hot mortar. Add water until the mixture is of the consistency of ordinary writing-ink. Finally add the methylated spirit and bottle for use. If the ink is to be kept for any length of time, add 2 drops of carbolic acid as a preservative. A passable white ink is made by rubbing up zinc white with gum arabic solution.

INKING-UP

In photo-mechanical processes this term is often used. For instance, in photo-lithography the transfer print after exposure is inked all over with a thin coating of ink, previous to development. The same is done in the case of direct printing on stone or metal. In line photo-etching the print on the zinc is inked-up after exposure by applying all over by means of a composition roller a thin coating of a special kind of transfer ink. The image, after it has been developed on the stone or plate, is often strengthened by keeping the plate moistened with gum water and passing over it a roller charged with lithographic ink, but although this is often spoken of as inking-up it is more correctly called " rolling-up " (which see).

INK-PHOTO PROCESS

A photo-mechanical process worked since about 1882 by a London firm. It is understood to be based on a grained image formed in a similar manner to the collotype process, a transfer being taken therefrom and put down on stone for printing in the lithographic manner.

INSECTS, PHOTOGRAPHING

The photographing of insects falls naturally under two heads—namely, photographing living insects, and photographing dead, set specimens. Living insects should be photographed in their natural environment, the caterpillars on their favourite food-plant, the butterfly or moth upon the flower, tree-trunk, wall, or other situation which it most frequents. The most interesting

and valuable results will be obtained by concentrating one's efforts upon one insect at a time, and working to produce a complete set of photographs which will show every stage in its life-history from the egg to the perfect insect. The reflex camera is undoubtedly the best type for photographing living insects, as it enables one to follow and focus the subject up to the instant of making the exposure, and, being fitted with a focal plane shutter, permits the maximum amount of light to reach the plate during exposure. A good lens of large aperture and fairly long focal length should be used, one with a working aperture of $f/4.5$ or $f/6$, and having, for a quarter-plate, a focal length of 7 in. Fast isochromatic plates should always be used.

For photographing dead, set specimens, an ordinary rigid stand camera, having a long extension of bellows, will be most useful ; and for all-round purposes a half-plate size will be most convenient, because of its greater bellows extension. The plate-holders can be fitted with adapters to carry quarter-plates, and the front of the camera should have two or three extra lens-panels, so that lenses of varying focal lengths may be used. By this means it is possible to obtain photographs direct of life size, and also of two or three diameters magnification. The set specimen should not be placed upon a drawing-board or similar support, as the shadows cast by the body, legs, and wings of the insect will give a very unpleasant and confusing effect. A good, clear sheet of glass should be used, and the insect can then be pinned on to a tiny piece of cork which will not be large enough to show and which has been cemented in place. A suitable coloured background can be placed eight or ten inches behind the glass, so that no shadow will be cast by the insect.

A notebook record should be kept of all work done in the field, and an entry made of each subject, giving particulars as to the plate used, lens and stop, exposure, lighting, time of day, day of month, result obtained, and any notes of interest concerning the subject itself. F. M-D.

INSENSITIVENESS

Occasionally a plate or film is found to lack in parts the general sensitiveness. This is almost always due to the local action of some desensitiser, generally a metallic impurity, such as iron, etc.

"INSTANTANEOUS " PHOTOGRAPHY

The term " instantaneous " is loosely used in photography, being generally understood to refer to exposures of less than one second. The photographing of ordinary views " instantaneously " was vainly attempted by Daguerre in 1841, and the first authenticated " instantaneous " photograph is that of New York harbour, taken in 1854.

The essential conditions under which " instantaneous " exposures, in order to be successful, must be made are : A good light, an efficient shutter, a suitable lens working at a large aperture, and a rapid plate. For average street work $\frac{1}{15}$th of a second is quite fast enough ; while if objects are moving to or from the camera direct and not at right angles, the exposure may be increased to $\frac{1}{15}$th of a second. According to the Thornton-Pickard Company, the following rule

answers for finding the " instantaneous " exposure for a moving object :—The distance of the object from the camera, measured in inches, is divided by the number of yards per hour at which the object is travelling, multiplied by the focus of the lens in inches. The result will be the fraction of a second, which is the longest allowable exposure that does not show movement in the resulting photograph. Below is given a table showing the correct exposure for various moving objects. The table is made out for a distance from the camera 100 times that of the focus of the lens : that is, for a 6-inch focus lens at 50 ft., a 7-in. at 58 ft., etc.

	Towards the Camera (sec.)	At right angles to Camera (sec.)
Man walking slowly, street scenes	$\frac{1}{15}$	$\frac{1}{45}$
Cattle grazing	$\frac{1}{15}$	$\frac{1}{45}$
Boating	$\frac{1}{20}$	$\frac{1}{60}$
Man walking, children playing, etc. ..	$\frac{1}{50}$	$\frac{1}{120}$
Pony and trap, trotting ..	$\frac{1}{100}$	$\frac{1}{300}$
Cycling, ordinary ..	$\frac{1}{100}$	$\frac{1}{300}$
Man running a race, and jumping ..	$\frac{1}{150}$	$\frac{1}{450}$
Cycle racing ..	$\frac{1}{200}$	$\frac{1}{600}$
Horse galloping ..	$\frac{1}{200}$	$\frac{1}{600}$

If the object is twice the distance, the length of allowable exposure is doubled, and vice versa. (*See also* " Focal Plane Shutter " and " Hand Camera, Work with.")

INSTANTANEOUS SHUTTER (Fr., *Obturateur instantané ;* Ger., *Moment Verschluss*)

Any shutter which, by pressing a trigger, push, lever, or pneumatic ball, will give a rapid exposure lasting only the fraction of a second. A " time and instantaneous shutter " is one that in addition to giving " instantaneous " exposures when required, can be set to remain open for exposures of any length and to close at the will of the operator by a further pressure of the release. (*See also* " Shutters.")

INTAGLIO PRINTING

Any method of printing in which the lines, dots, grain, or other elements of the engraving are sunk in the plate, so that the depressions are filled with ink for printing, as distinguished from relief plates or blocks where the printing elements are raised and are inked on their surfaces. Thus the old engraving or etching processes, such as mezzotint, aquatint, needlepoint etching, copper and steel plate engraving, and the like are intaglio printing processes. Photogravure and heliogravure are also intaglio methods. Of late, the term intaglio printing has come to be applied in a more limited sense to methods of forming a sunk engraving or etching by means of a ruled screen, and the printing of the same by mechanical power. For some years past there have been machines for printing from flat plates, the sunk image being inked and the surface being wiped clean by mechanical arrangements. Such machines have, however, not come into general use, there being almost insuperable

difficulties in efficiently wiping the flat surface. Rotary intaglio printing solves this problem very successfully, and the method has been successfully worked for some years by a Lancaster firm which was the first to carry out the experiments and devise suitable machinery for this work. Their methods are secret, but a number of later experimenters have proceeded on the assumption that a photographic carbon print, which has been also exposed under a ruled screen, is developed on a hollow copper cylinder. The carbon print forms a resist as in the photogravure process, and the image is thereby etched in intaglio. The spaces between the screen lines form minute cells which hold the ink, preventing its being wiped out during the printing operation. The hollow cylinder is placed on a mandrel and mounted in a machine similar to that which is used for wallpaper or calico printing. Under the engraved cylinder is an inking roller working in a trough of thin ink, and feeding the ink into the engraving. Above the engraved cylinder is an impression roller with an elastic covering of blanket or rubber. In contact with the engraved cylinder is a steel knife, called the " doctor," which scrapes the surplus ink quite cleanly from the surface, leaving it in the hollows of the engraving. Paper is fed from a reel, and passes between the impression cylinder and the engraved cylinder, thus receiving a print at every revolution of the latter. Mechanism is provided for delivering and cutting off the prints. The method has been found to present considerable difficulties.

Dr. E. Mertens, of Freiburg, has extended the process to newspaper printing by coupling up the intaglio machine to the ordinary rotary stereo printing machines, so that when the web of paper emerges from the intaglio printing machine it passes into the newspaper rotary to receive the impression of the text formes.

The rotary intaglio method has been applied to colour printing with very fine results.

INTAGLIOTYPE

A process for obtaining intaglio plates, patented in 1893 by Joseph Hines. A bichromated gelatine film on a metal plate is exposed under a negative and developed with heated sulphate of iron solution until the lines are clear. The plate is then mounted and printed from.

INTENSE NEGATIVES

A negative may be very dense from two or three causes. A plate that is considerably over-exposed and then developed normally will yield a very dense negative that takes so long to print as to be quite useless. If the exposure is correct, a plate can only be too dense through excessive or incorrect development. If the shadows are strongly veiled, the cause is excessive exposure ; and the best treatment is the " hypo " and ferricyanide reducer. If the shadows are moderately clear, the cause is excessive development, and the ammonium persulphate reducer should be employed. (*See also* " Reducing Negatives.")

A negative may be too intense as the result of intensification. If mercury has been used for intensifying, the effect can always be reduced by a weak solution of " hypo."

**KINEMACOLOR
POSITIVE FILM**

B. Through Red Filter

**KINEMACOLOR
NEGATIVE FILM**

A. Through Green Filter

**ORDINARY POSITIVE
FILM**

**ORDINARY NEGATIVE
FILM**

KINEMATOGRAPH FILMS

11

INTENSIFICATION OF NEGATIVES (Fr., *Renforcement ;* Ger., *Verstärkung*)

A process whereby density or contrast is increased. Intensification processes in common use vary in the degree of strengthening rather than in their character ; with slight exceptions they do not change the gradation, but strengthen all parts of the scale in a uniform ratio. The exceptions are some of the processes that depend on bleaching with a mercuric salt as the first part of the operation. With Monckhoven's intensifier very thin shadow detail becomes reduced, and tones with slightly more strength show no change, while the medium and stronger tones more than double their printing value. In bleaching with mercuric bromide or chloride, exceedingly weak shadow detail is not strengthened, but all other parts of the plate show a uniform increase in intensity.

A negative to be intensified must have been thoroughly fixed, as, otherwise, incurable yellow stains may appear. Thorough washing after fixing is desirable.

The following methods of working will yield negatives of a good black colour, free from any tendency to veiling, staining, or any loss of quality. And, in addition, the results are quite permanent. With all mercurial methods, however, the intensified negative should be varnished, so as to protect the metallic deposit in the gelatine film from atmospheric moisture, otherwise an iridescence will appear, but this may be removed by means of methylated spirit (*see* " Reducing Negatives by Mechanical Means "). A badly stained negative will not become black by intensification ; and, in addition, when a negative depends for its printing quality partly on silver deposit and partly on stain, the result of intensifying will always be uncertain. The intensifier strengthens the silver deposit only, and either decreases the staining or leaves it unchanged.

The chief methods of intensification are :— *Chromium.*—The negative is bleached in an acidified solution of a bichromate salt, and then re-developed. The printing value is multiplied by 1½. *Mercuric Chloride.*—The negative is bleached in a solution of mercuric chloride and then blackened with sodium sulphite, ferrous oxalate or by re-development. With sodium sulphite the printing value is only multiplied by 1 1/10 ; but with ferrous oxalate by 2. *Mercuric Bromide.*—The working is similar to the preceding, substituting bromide for the chloride, and blackening with sodium sulphite or by re-development ; the printing value is multiplied by 2. *Mercuric Iodide.*—The negative is strengthened in a solution of mercuric iodide, and then re-developed, the printing value being multiplied by 3. *Silver.*—Various methods of intensifying negatives by means of silver have been introduced. *Lead, Uranium, Copper Bromide, etc.*—These are treated under their own headings.

A method that has been extensively employed is bleaching in a solution of mercuric chloride and then blackening in ammonia. This method is generally considered to be unsatisfactory, and the results not permanent.

Of the above, the mercurial processes are the most used and will here be described. For the others, *see* separate headings.

Mercurial Processes.—Most of the mercurial methods are satisfactory, the intensified negative being a good neutral black or brown-black, according to the process ; there is no staining or veiling ; the increase of density is a definite and known quantity, and the result is permanent.

In all processes of mercurial intensification, the mercuric solution should be followed by an acid bath (first suggested by A. Haddon), its object being to prevent the mercury from combining with the gelatine to the detriment of permanency. When the plate is removed from the mercuric solution, it should be washed in two or three changes of water, and then placed in a bath consisting of 1 drm. of hydrochloric acid in 12 oz. of water, remaining in this solution for two or three minutes, being then placed in a second quantity, and finally in a third. Next it is washed for fifteen to twenty minutes, when it is ready for the second part of the treatment.

The following are the details of the principal methods of intensifying with mercury :—

First method—

A. Mercuric chloride	120 grs.	25 g.	
Hydrochloric acid	24 mins.	5 ccs.	
Water . . .	10 oz.	1,000 ,,	
B. Liquor ammoniæ .	¼ oz.	25 ccs.	
Water . . .	5 ,,	500 ,,	

Immerse in A until the image is thoroughly bleached, and then, after treating with acid and washing as above described, immerse in B until thoroughly blackened. Wash, and dry. This method is not recommended.

Second method—

The negative is bleached in solution A (above given), treated with acid, washed, and then thoroughly blackened in—

Sodium sulphite .	1 oz.	25 g.
Water . . .	10 ,,	250 ccs.

This solution must be used at once, as it will not keep. The intensified negative is a good black colour, free from veiling, and the result is permanent ; but the increase of density is very slight.

Third method—

H. Chapman Jones advocates this method. The plate is bleached in solution A, and then, after the acid baths and washing, is re-developed with ferrous oxalate. From the developer the negative passes to a weak acid bath for two minutes, and is then washed. This approximately doubles the printing value, and may be repeated as many times as desired, a corresponding increase of strength resulting each time. Care must be taken that the ferrous oxalate developer is freshly prepared and in good condition, or the negative will be badly stained.

Fourth method—

Bleach in solution A, and then, after the acid baths and washing, re-develop with amidol or any clean-working alkaline developer. Pyro is not suitable. The result is similar to that produced by the third method. The image is a good neutral black, there is no tendency to staining or loss of quality, and the result is permanent.

The increase of density is rather less than that given by the third method, but the operation may be repeated with a similar increase of strength.

Fifth method—

Bleach in

C. Mercuric chloride . 120 grs. 27 g.
Potassium bromide 120 ,, 27 ,,
Water . . . 10 oz. 1,000 ccs.

Treat with three acid baths, wash, and then immerse in a freshly prepared solution of—

D. Sodium sulphite . ½ oz. 55 g.
Water . . . 5 ,, 500 ccs.

until thoroughly blackened. The resulting negative is a good neutral black without the slightest staining or loss of quality, and it is quite permanent. The printing value is approximately doubled, and repeating the process will not produce any increase of strength.

Sixth method—

The working is as in the fifth method, but the bleached image is blackened in—

E. Sodium sulphite . ½ oz. 55 g.
Sodium carbonate. ½ ,, 55 ,,
Water . . . 5 ,, 500 ccs.

This solution will keep indefinitely. The result is exactly the same as that produced by the fifth method.

Seventh method—

Bleach in solution A, and then, after the acid baths and washing, re-develop in amidol or other clean-working alkaline developer. The gain in printing value is slightly less than that produced by methods 5 and 6, but the strength may be increased by repeating the operation as many times as desired.

Eighth method. Monckhoven's process—

Bleach in solution A, and then, after the usual washing, etc., blacken in

F. Silver nitrate . . 50 grs. 23 g.
Potass. cyanide (about) 50 ,, 23 ,,
Water . . . 5 oz. 1,000 ccs.

The silver nitrate is dissolved in the water, and potassium cyanide added, a little at a time, until the precipitate that forms is just dissolved. The plate must be taken from the cyanide solution directly it is blackened through, as a reducing action on the shadow details begins as soon as the blackening is accomplished. If the first washing is not rapid and effective, there will be a similar reduction. It is impossible to prevent a slight reduction in the extreme shadows. The original printing value is rather more than doubled, excepting in the shadows, where the strength is actually reduced. The operation may be repeated if the density is not sufficient, and a proportionate increase of strength will result each time.

Ninth method. Mercuric iodide, Lumière's method—

G. Sodium sulphite 20 grs. 46 g.
Mercuric iodide . 1 ,, 2·3 ,,
Water . . . 1 oz. 1,000 ccs.

The sodium sulphite must be dissolved first, and then the mercuric iodide, which is insoluble in water, added ; and the solution well shaken until the iodide is dissolved. The solution must be prepared when required, as it will not keep. Immerse the negative in this solution, rocking the dish to ensure even action, and a steady gain in strength will result ; the maximum intensity is attained in about seven or eight minutes, but the negative may be withdrawn at any time. Afterwards the plate is washed, immersed in the acid baths as already described, washed, and then re-developed in any alkaline developer. Pyro or any other developer may be used, the printing value not being affected by the choice of developer, but when pyro is used the plate is not quite so clean as with other developers. If the plate is not re-developed, the image will gradually bleach. If the action is carried out fully, repetition will not produce any increase of strength ; but if a smaller degree of intensification only is attained at the first operation, repetition at any future time will complete the work and produce the same strength that a full action would have secured in the first instance. The intensity is greater than that given by any other form of mercurial intensification at one operation, the printing value being multiplied by 3.

In all these methods of mercurial intensification, a moderate washing after the final operation of re-developing or blackening completes the work.

In all excepting the ninth method (Lumière's mercuric iodide process), the treatment with the mercuric solution must be thorough and the operation must be taken as far as it will go, the completeness of the work being judged by the thorough whitening of the image. If this bleaching is not thorough, the intensification will be irregular, some portions being fully strengthened and others only partially. It follows, necessarily, that the increase of strength is a fixed quantity ; one degree of intensification only can be obtained from any negative, neither more nor less, excepting in those modifications which can be repeated, in which cases the result of repetition is a series of regular steps.

In process work, the negatives have always to be intensified in order to get the necessary intensity for photo-mechanical printing. In wet collodion negatives for line work, the lead intensifier is generally used, followed by ammonium or sodium sulphide for blackening. For half-tone negatives, the copper bromide intensifier is more generally used, both with wet collodion and collodion emulsion, though the lead intensifier can also be employed. With both intensifiers the method known as " cutting " is adopted. This consists in treating the plate with a solution of potassium iodide and iodine, and afterwards applying a solution of potassium cyanide ; this cuts off the fringe of the dots or lines, and so sharpens up the image, at the same time clearing the transparent spaces. For dry-plate process negatives the silver cyanide intensifier is found best, and " cutting " is done with potassium ferricyanide and " hypo " solution.

INTENSIFICATION OF PRINTS

Prints by most processes cannot be intensified satisfactorily ; and generally intensification is more trouble than obtaining a new print.

Intensification is either impossible or undesirable in the carbon, platinotype, and many silver printing-out methods. Bromide and gaslight prints can be strengthened by bleaching with mercuric bromide and then blackening by means of sodium sulphite, or they may be bleached in mercuric chloride and then blackened by means of ferrous oxalate. Silver intensification has a tendency to stain the paper slightly; and in any method that requires redevelopment care must be taken to use a solution that has no tendency to stain. Another method of strengthening weak bromide and gaslight paper prints is given under the heading " Toning Bromide Prints."

INTENSITY OF LENSES

A term synonymous with angular aperture and focal aperture, and signifying the ratio of aperture to focal length.

INTENSITY RATIO

The ratio of focal length of a lens to the aperture.

INTERFERENCE HELIOCHROMY (See " Lippmann's Process.")

INTERFERENCE IMAGE (See " Lippmann's Process.")

INTERFERENCE OF LIGHT

Light is a wave-like motion in the ether, the waves proceeding in all directions precisely as when a stone is thrown into the centre of a pond. In order to grasp the subject of interference, considerations are here limited to waves proceeding in one direction only, from left to right. The transverse or to-and-fro motion of the ether particles may then be explained as follows: If a series of waves start from contiguous points their individual crests and troughs will coincide, or, in other words, they will be in the same phase, and the result will be that the light is intensified, as the resultant light effect is the sum of the individual wave motions. It is not necessary even for the waves to start from the same point as long as they are in the same phase. If, however, the path of the waves is such that crest falls on trough and trough on crest, then it is obvious that there must be equal forces acting in opposite directions. The result must therefore be no movements, or, in other words, there is an interference of light, and consequently darkness. The waves need not start from the same point; as long as they start from points half a wave-length apart they are in opposite phase.

Hitherto, the path of the light waves has been considered as being in the same direction; but when the direction is changed, as by reflection, then we have standing or stationary waves, which are of considerable interest in that they are the theoretical basis of the Lippmann process.

INTERIORS, PHOTOGRAPHING

In addition to the considerations given under the heading " Architectural Photography," there are a few special points that should be noted. The view of an interior of a room, of a church, or portion of a large building, must necessarily be taken from within its own limits; therefore a wide-angle lens is necessary. If too wide an angle is included, there is a risk of the perspective effect being exaggerated. About three-fourths of the longer side of the plate, or slightly less, should be the minimum focus employed; and a longer focus is preferable when possible. By care in selecting the point of view the exaggeration of the perspective effect may be minimised.

One of the greatest difficulties in interior work is the presence of windows in front of the camera, especially if they command a clear view of the sky, and form an important part of the lighting of the interior. These windows throw a glare of strong light upon the lens, rendering it practically impossible to secure clear negatives with good gradation and tending to fog the plate. When these windows are not actually included in the picture, a " sky-shade" should be fitted to the camera front; and if this sky-shade is adjustable in position it can be made to exclude all that part of the room where the undesirable windows are situated, without obstructing any part of the subject included on the plate. Another method of accomplishing the same purpose is to have a shield of card or thin wood. In either case, the value of the window in lighting the interior is fully retained.

Where a window commanding a clear sky view is included in the picture it should be covered, whenever practicable, during the greater part of the exposure. There will be no difficulty in doing this when there are other windows which partially light the interior; should it be the only window, it will be quite impracticable to include the whole of it and secure a successful photograph. If part of the window only is included, that part only should be covered, while a shield on the baseboard of the camera prevents the light from the remaining part from reaching the lens. At times, the sun may be streaming through a window that is not included in the picture, but the sunlight may fall on the floor within the field of view and cause an undesirable patch of light or an unequal lighting of the interior. A white blind drawn over such a window, or sheets of white tissue paper attached over that part on which the sun is shining, will form a remedy, these not only diffusing the light but illuminating dark corners in a way that cannot be attained by other means.

In all interiors the inclusion of a liberal proportion of floor or foreground assists in giving a sense of space.

When a wide-angle lens is used in a room which is ten or twelve feet high, or when photographing a small part of a large interior, the camera should be placed much lower than when photographing a large subject with the same lens. A high or normal point of view when including floor very near the camera gives the impression that the ground is running up-hill, this effect being quite obviated by lowering the centre of the lens to about three feet from the ground.

It may be necessary to work with a small stop, as some portions of the subject may be very near the camera, and sufficient depth of focus may not be possible otherwise.

Precautions against the camera tripod slipping must certainly be taken. (See " Tripod.") It

is necessary to acquire the art of capping and uncapping the lens as many times as may be necessary for casual obstructions—persons walking across, etc.—without shaking the camera.

Special points in photographing workshops are treated in the article " Factories, Photographing in." The subject of exposure in interior work is considered in detail under the headings " Exposure " and " Exposure Tables."

INTERMITTENCY ERROR (Fr., *L'erreur intermittente ;* Ger., *Intermittierender Fehler*)

The failure of a series of intermittent exposures to produce the same effect as an equivalent continuous exposure. This is of considerable importance in sensitometric work, where a sector wheel or other device is used for testing plates.

INVERSION, LATERAL (Fr., *Inversion latérale ;* Ger., *Seiten-Umkehrung*)

The reversal of right and left, as seen when objects are viewed in a mirror. A ferrotype photograph, taken direct on a metal plate, is laterally inverted, as was also the daguerreotype. Lateral inversion becomes serious in photographs of buildings, or where lettering occurs. A negative on a modern dry plate is laterally inverted, but the inversion is corrected in printing. In the carbon process (*which see*), special precautions are taken to avoid lateral inversion, either double transfer or a reversed negative being resorted to. Reversed negatives are also used in photo-mechanical processes, since if blocks or plates showed the picture the right way round it would obviously be inverted in the printed impressions. Strictly speaking, what is called a reversed negative is really unreversed ; it is the ordinary negative which properly deserves the name. It is the custom, however, to apply the term to negatives that give reversed prints. (*See also* " Reversed Negative.")

INVISIBLE IMAGE (*See* "Latent Image.")

INVISIBLE RAYS, PHOTOGRAPHING BY

The fact that photography can depict objects invisible to the eye has long been known. Fox Talbot referred to the subject in his book, " The Pencil of Nature," published in 1844, and his own words are : " Among the many novel ideas which the discovery of photography has suggested is the following rather curious experiment or speculations. When a ray of solar light is refracted by a prism and thrown upon a screen, it forms there a very beautiful coloured band known by the name of the solar spectrum. Experimenters have found that if this spectrum is thrown upon a sheet of sensitive paper, the violet end of it produces the principal effect, and, what is truly remarkable, a similar effect is produced by certain invisible rays which lie beyond the violet, and beyond the limits of the spectrum, and whose existence is only revealed to us by this action which they exert. Now I would propose to separate these invisible rays from the rest by suffering them to pass through into an adjoining apartment, through an aperture in a wall or screen. This apartment would thus become filled (we must not call it illuminated) with invisible rays, which might be scattered in all directions by a convex lens placed behind the aperture. If there were a number of persons in the room, no one would see the other ; and yet nevertheless if a camera were so placed as to point in the direction in which anyone was standing it would take his portrait." More than half a century later Edgar Senior, of the Battersea Polytechnic, took a most successful portrait under what are practically those conditions. The source of dark (invisible) rays was an arc lamp, the visible light being cut off at the lens by means of special screens invented by Prof. R. W. Wood ; the necessary exposure was five minutes. The " X-rays " discovered by Prof. Röntgen, of Wurzburg, in 1896 are invisible rays, and the work they will do is common knowledge. (For " X-ray " work, *see* under its own heading.)

The photographic spectrum therefore stretches out beyond both ends of the visible spectrum, and measures seven or eight times the length of the visible spectrum. Thus, not only do ultra-violet rays give results photographically, but the infra-red as well, although the latter are, of course, at the opposite end of the spectrum and below the visible red.

Prof. Sylvanus Thompson, at the Royal Institution in 1896, illuminated a piece of apparently white paper by means of a powerful arc-lamp. A photograph was then taken of the white paper, and the negative showed an inscription written thereon. This inscription had been written upon the paper with an acid (citric or sulphuric) solution of sulphate of quinine, which, being like water in appearance, could not be seen by the eye. The camera detected it, however, because the chemical liquid absorbed the ultra-violet rays, and they were not reflected to the plate, hence they appeared black. The experiment may be made by anyone, but it is important that a wet collodion plate be used and not a modern dry plate. Dr. Gladstone made similar experiments as early as 1873, and exhibited his results at the Bradford meeting of the British Association in that year.

There are many substances that are fluorescent, or that change the refrangibility of rays of light, and which have a light action upon a photographic plate. An unlighted incandescent gas-mantle gives off sufficient invisible rays to make an image upon a photographic plate. Among other substances are radium, mineral uranite, certain salts of uranium, canary glass, alcoholic solution of chlorophyll, æsculin, tincture of stramonium seeds, and of turmeric.

Prof. Wood, of the Johns Hopkins University (U.S.A.), has paid particular attention to the action of the invisible ultra-violet and infra-red rays, and his lecture before the Royal Photographic Society on September 27, 1910, should be referred to for full particulars.

IODIDE (Fr., *Iodure ;* Ger., *Iodid*)

A combination of iodine with a metal. All the iodides—with the exception of a few of the heavy metals, lead, silver, mercury, etc.—are soluble in water, and generally of bright colours. They are formed by treating the metal in powder with iodine direct. The alkaline iodides are prepared in the same way, or by acting on iron iodide by an alkaline carbonate. The following

table gives the equivalent quantity of the principal iodides used in photography and their corresponding proportion of iodine :—

Iodine	Ammonium iodide	Potassium iodide	Sodium iodide	Cadmium iodide	Zinc iodide
1·000	1·142	1·307	1·181	1·441	1·255
0·876	1·000	1·145	1·262	1·262	1·099
0·765	0·874	1·000	1·102	1·102	0·960
0·847	0·967	1·107	1·220	1·220	0·630
0·694	0·793	0·907	1·000	1·000	0·871
0·797	0·910	1·042	1·148	1·148	1·000

In process work, an iodide solution is used in the intensifying and "cutting" of line and half-tone negatives, as described under the heading of "Intensification of Negatives."

IODINE (Fr., *Iode*; Ger., *Iod*)

I. Molecular weight, 127. Solubilities, 1 in 5,000 water, 1 in 12 alcohol, 1 in 3 ether; soluble in carbon disulphide and solutions of alkaline iodides. It occurs as glistening steel-blue-black plates with peculiar odour; and it is obtained from seaweeds. It is poisonous, the antidotes being emetics, the use of the stomach pump, magnesia, starch solution, and "hypo." A solution of iodine in an aqueous solution of potassium iodide is used for bleaching bromide prints for sulphide toning, the formula being :—

Potassium iodide	. 200 grs.	20 g.
Distilled water	. 1 oz.	50 ccs.

Dissolve and add—

Iodine	. . . 10 grs.	1 g.

and when thoroughly dissolved add—

Distilled water to	20 oz.	1,000 ccs.

Immerse the print in this till the image is bleached. The paper becomes stained dark blue, which may be discharged by a 10 per cent. solution of sodium sulphite.

Small quantities of iodine are added to collodion to ripen it, and a few drops of a 1 per cent. alcoholic solution is recommended as an accelerator with hydroquinone.

In process work, iodine has important uses. When collodion becomes colourless or lighter in colour it is apt to give foggy plates. In this case add 1 min. of solution of iodine in alcohol (2 grs. in 1 drm.) to each ounce of collodion.

IODISER (Fr., *Iodo-bromure*; Ger., *Iodirungsflüssigkeit*)

A solution of metallic or alkaline iodides and bromides in alcohol, kept as a separate stock solution and added to collodion just before use. (See "Collodion Process (Wet).")

IODO-BROMIDE (Fr., *Iodo-bromure*; Ger., *Bromiodid*)

Applied to emulsions containing bromide of silver plus a small proportion of iodide.

IODOEOSIN (See "Erythrosine.")

IODOSE

In order to simplify the operation of iodising collodion, a compound called iodose has been introduced. A dry mixture of suitable iodising salts is made in the proper proportions, so that the compound has only to be dissolved in alcohol and added to the collodion.

IRIDESCENCE (Fr., *Iridescence*; Ger., *Scheinfärbung*)

The play of colours seen in thin films, such as oil on water, in the opal, mother-of-pearl, etc., and due to the interference of light in extremely thin films. Iridescent colours are occasionally seen between the cemented combinations of lenses, and are then due to partial separation; the remedy is to separate and re-cement them, which is work that is best done by an optician.

IRIDESCENT HELIOCHROMY (See "Lippmann's Process.")

IRIDESCENT MARKINGS

Chemical fog often seen in the form of green stains at or near the edges of plates and films; known also as green or dichroic fog. It may be due to stale plates, stale sodium sulphite, and forcing under-exposed plates with the pyro-ammonia developer. It rarely occurs when soda or potash is used as an alkali, or with any of the newer developers. It may be cured by bleaching the plate after well washing, in :—

Ferric chloride	. 20 grs.	23 g.
Potassium bromide	. 40 ,,	46 ,,
Water 2 oz.	1,000 ccs.

The plate will be reduced slightly in density as the iridescent fog disappears. It is afterwards well washed and re-developed, in daylight, with hydroquinone, metol, or ferrous-oxalate (the last-mentioned preferred), until of the desired density, it being finally re-fixed and washed.

In process work, the degree of contact obtained in the screw-pressure frames between the process negatives and the metal plates is judged according to the iridescent markings visible through the thick front glass of the frame. These markings are due to the phenomenon known as Newton's rings.

IRIDIUM CHLORIDE OR TETRACHLORIDE, IRIDIUM AND POTASSIUM CHLORIDE, AND IRIDIUM AND SODIUM CHLORIDE

$IrCl_4$; $IrCl_4 2KCl$; and $IrCl_4 2NaCl_2$ or Na_2IrCl_6 respectively. These are respectively dark brown, red, and brownish-black crystals which have been suggested for toning prints, and are occasionally used in ceramic work. Practically, however, they are of but very slight photographic interest.

IRIDIUM AND GOLD TONING BATH (See "Gold and Iridium Bath.")

IRIS DIAPHRAGM (See "Diaphragm.")

IRIS VIGNETTER (See "Vignetter.")

IRON PRINTING PROCESSES

Processes of printing by means of salts of iron are described under the heading "Ferric Salts, Printing with."

IRRADIATION (Fr., *Irradiation;* Ger., *Strahlenwerfen*)

A theory that has been propounded in regard to the formation of the dots in half-tone process negatives, especially in collodion emulsion and dry plates, accounts for the want of sharpness by irradiation of light from particle to particle of the silver forming the image.

ISINGLASS (Fr., *Ichthyocolle;* Ger., *Hausenblase Fischleim*)

A gelatine obtained from the swimming bladder of various species of fish. It occurs in thin plates or fine white shreds with a yellowish tinge. It is entirely soluble in boiling water, and sets to a jelly on cooling. It is occasionally used as a substratum and in mountants.

In process work, isinglass has been used instead of, or as an addition to, gelatine, especially in some old methods of collotype and photolithography. Also it has been suggested as a substitute for fish-glue in the enamel process, but it has no advantages.

ISOCHROMATIC PHOTOGRAPHY

Photography in which colours are rendered in a monochrome picture according to their true visual brightness. Known also as orthochromatic photography. It is well known that yellow or red objects appear very dark in an ordinary photograph. The ordinary plate is chiefly affected by violet and blue rays of light, and is comparatively insensitive to green, yellow, orange, and red rays. Hence, blue objects impress the plate far too strongly, comparatively, the result being that they appear much too light in the photographic print. This serious fault is very evident in photographs of vividly coloured objects, and isochromatic methods are adopted to overcome it. The plates used (*see* "Isochromatic Plates") have been treated in a way that renders them "colour sensitive," but as plates made sensitive to green, yellow, and orange-red rays are still too sensitive to blue-violet, a compensating screen is placed in front of the lens, so that the blue-violet rays are lessened in intensity. A further function of the screen is that it entirely absorbs the ultra-violet rays, which otherwise affect the plate ; and as they are invisible, it is of course necessary that they play no part in the formation of the photographic image.

Vogel and others discovered that by mixing certain aniline dyes with the silver bromide emulsion of a plate, the latter becomes sensitive to the colours absorbed by the dye (or the dyed silver bromide particles). It is hence possible to adapt a dyed or "isochromatic" plate and a screen so that the combination will result in objects of all colours being represented in the print in tones of visual brightness corresponding. Yellow-green being the brightest colour visually, objects of this colour will appear lightest in the print, and so on. Isochromatic photography as usually practised is more particularly a rough compromise, as to give accurate colour records too long exposures would be necessary, owing to the slowing effect of the yellow screen. (*See also* under the headings "Isochromatic Plates," "Isochromatic Screens," and "Monochrome, Rendering Colours in.")

ISOCHROMATIC PLATES

Plates specially sensitised for colour, and used with compensating light filters or isochromatic screens. They may be roughly grouped into three classes : (1) those which are sensitised for green and yellow rays of light, and give an approximately true colour rendering ; (2) those which are sensitised for the entire spectrum, often called "panchromatic" (*which see*) ; and (3) plates rendered sensitive to orange and red, but which lack green sensitiveness.

There are a great many varieties of the first type, but all possess what is termed a maximum of colour sensitiveness in the yellow-green region ; staining an ordinary plate with certain of the aniline dyes induces this sensitiveness, and erythrosine is characteristic of type 1 in its action. Panchromatic plates being discussed under their own heading, this article will deal only with the first and third types. The ordinary isochromatic or orthochromatic plate has a distinct maximum in every instance in the green-yellow region of the spectrum, and its sensitiveness generally ends off abruptly at about the D line ($= \lambda 5893$). Such a plate can be prepared by bathing, this process giving excellent results provided that the plates bathed are used a day or two after being treated. Two solutions should be made up as follow :—

A.	Erythrosine	. .	10 grs.	1 g.
	Alcohol	. . .	4 oz.	166 ccs.
B.	Liquor ammoniæ (·880)	1 drm.	5·2 „	
	Water	. .	24 oz.	1,000 „

For use, 1 drm. of A is mixed with 6 oz. of B a few minutes before use. Great care must be taken only to bathe clean working dry plates of medium rapidity, about 150 or 180 H. and D. (pyro-soda or pyro-metol speed). A "safe" ruby light must be employed for the illumination of the dark-room. (*See* "Colour Screen or Filter.") Scrupulous cleanliness must be observed, dishes etc., being thoroughly clean in the strict chemical sense. The quicker the bathed plates are dried, also, the better, so that a warm room in which they will become dry in two to three hours should be chosen if possible. The plates are placed in the dish, and flooded over with the solution, 2 oz. being allowed to each half-plate ; the dish is gently rocked for three minutes, and the plates are then placed in another dish and given six rinses in plain water or left under a running tap for two minutes. They should be placed in a new wooden rack to dry, and this rack should not be used for any other purpose. Dry in complete darkness.

A sensitiser for the green and blue-green rays, which tends to slow the plates, may be prepared thus :—

Auracin	.	. .	1 gr.	·23 g.
Boiling water	.	.	10 oz.	1,000 ccs.

Allow to cool, then filter the solution, and add ½ drm. of strong ammonia.

Plates of type 3 are difficult to prepare because, owing to their great red sensitiveness, the work must be done almost in darkness. A suitable solution for bathing may be made up as follows :—

Cyanine blue (ethyl cyanine or pinacyanol)	.	.	1 gr.	·28 g.	
Alcohol	.	.	.	8 oz.	1,000 ccs.

Add ½ oz. of this to 6 oz. of distilled water, add ½ drm. of strong ammonia, allow to stand for twenty minutes, and filter. Two ounces of solution will suffice as before for one half-plate.

There has been a tendency of late to produce plates so highly sensitive to greenish-yellow that when used without a screen quite satisfactory colour renderings can be obtained. Such plates are by no means perfect, but they show a marked improvement over ordinary plates. A "no-filter" plate may be prepared by means of the following solution :—

A. Erythrosine . . 1 gr. ·23 g.
 Distilled water . . 1 oz. 100 ccs.
B. Liquor ammoniæ (·880) ½ ,, 55 g.
 Distilled water to . 10 ,, 1,000 ccs.
C. Silver nitrate . . 2 gr. ·46 g.
 Distilled water . . 1 oz. 100 ccs.

Mix equal parts of A, B, and C, and dilute the mixture with an equal volume of distilled water. Select slow ordinary plates, bathe them for two minutes each, rinse them well under the tap, and put them in the rack to dry. Very intense green-yellow sensitiveness is thereby produced, but no such plate will give an accurate colour rendering, because it is still sensitive to ultra-violet rays, to extinguish which a yellow filter is necessary.

Isochromatic plates of commerce are made by adding carefully selected and purified dyes, dissolved in alcohol or water, to the liquid emulsion with which plates are coated. The sensitive particles of emulsion are thereby coloured, though often almost imperceptibly, and their colour absorption altered in conse-quence, so that rays of light for which the plates are "sensitised" are absorbed. One of the earliest descriptions of an isochromatic emulsion for plates was given in Tailfer and Clayton's patent specifications of 1882–3.

ISOCHROMATIC SCREENS

Only those rays of light that are visible to the eye should be allowed to affect the photographic plate ; besides the visible rays of the spectrum, there are two sorts of invisible ones—the ultra-violet and infra-red—situated respectively before the violet and after the red rays. The ultra-violet rays are particularly active photo-chemically, and are present in daylight and all the kinds of artificial light usually employed for photographic work. It is the primary function of the isochromatic (or orthochromatic) screen to absorb these rays, and the ordinary screen is therefore a yellow glass of the requisite shade, which is placed in front of or behind the lens, or immediately in front of the plate, or it is sometimes fixed in the lens diaphragm between the two components of a doublet or other com-pound lens. The next function of the screen is to cause rays of each colour to act upon the plate to an extent dependent on their visual bright-ness. Thus a yellow daffodil photographed against a dark blue background should appear as a light grey flower against dark grey ; with an ordinary plate the daffodil would appear darker than the background. The isochromatic screen is yellow, and therefore "damps down" the action of the blue rays by partially absorbing them, so that in the negative the blue background would come out faint and would therefore appear dark, as it should be, in the print.

No plate, however carefully colour-sensitised, is sensitive to all colours in degrees proportionate to their visual luminosity. The erythrosine type of plate, for example, is always deficient in the bluish-green region. The screen must compen-sate for such deficiencies by absorbing those colours to which the plate is most sensitive, to such an extent that the other colours are adequately recorded. The average "isochro-matic" plate is not red-sensitive, and only an approximately correct colour rendering can therefore be obtained, unless a panchromatic plate and a properly adapted light filter are employed.

For general working, a very fair "ortho-chromatic" effect is obtained by using a yellow-green sensitive plate, and a yellow screen which cuts out all ultra-violet rays and depresses the blue-violet, though it is, of course, better to use one special type of colour-sensitive plate and a screen adapted accurately to it. The yellow screen is more usually made by dyeing the film of a piece of optically flat glass which has been coated with pure neutral gelatine. The dye should give as transparent a filter as possible ; that is, the screen should be pale, and exposure only increased by a minimum amount. Thus, while naphthol yellow and tartrazine are good dyes for the purpose, a screen can be made with filter yellow K, or rapid filter yellow, which gives equally good results, while exposure is only increased perhaps half as much as it is in the former case.

Gelatine-coated glass may be stained with a 1 : 500 solution of the yellow dye selected, and filters of various intensities should be made ; the best one to use may be found by experimental exposures on an actual coloured subject.

To adapt a light filter or screen correctly to a given plate, two methods are available. One is to test the experimental screens by photographing the spectrum through them, and varying the colour until each portion of the spectrum is recorded in the negative with a density pro-portionate to its visual intensity ; the other is to photograph a test chart, which is most con-veniently made by drawing concentric circles on a card and dividing each of these circles into two parts, one painted black, the other coloured ; blue, green, and orange are the best colours to use if a panchromatic plate is being tested, or blue-violet, blue-green, and gamboge if a green-yellow sensitive plate. The circular card is attached to a small motor and revolved rapidly, and the amount of black in each ring is increased until all the rings appear of equal luminosity. If a correctly compensating screen be used, then each ring will appear, in a photograph taken of the disc, of equal density. The screen must be experimented with until this result is obtained.

A liquid filter is very convenient for experi-mental work, as its colour may be varied at will by adding concentrated dye solutions. Thus by adding, say, *m* ccs. of a 1 : 100 solution of filter yellow and *n* ccs. of a 1 : 100 solution of crocein scarlet to water contained in a flat glass cell of 16 sq. cm. area, a liquid screen is obtained which satisfies the tests for a good colour rendering. Flat glass can then be coated with a 5 per cent. solution of gelatine, allowing,

for example, 1 cc. to coat each 10 sq. cm. of surface; each cc. of the gelatine solution must therefore contain $\frac{18}{18} \times \frac{m}{100}$ or $\frac{m}{160}$ g. of the yellow dye, and $\frac{n}{160}$ of the orange dye, and so on. Stained gelatine filters are usually bound up with a cover glass, the two glasses being cemented together with Canada balsam.

Pot glass filters (made from glass coloured in the mass in course of manufacture) are usually inefficient, requiring prolonged exposures owing to a considerable percentage of grey in the glass.

The multiplying factor is important in iso-chromatic photography, as by under- or over-exposure and attempted correction in develop-ment, the colour contrasts in monochrome may be somewhat falsified. All yellow screens necessitate an increase in exposure of from two to ten or fifteen times the normal. A screen with which five times the normal exposure is required is often designated a $\times 5$ screen, and so on. The only satisfactory way to find the multiplying factor is to photograph a black-and-white object, giving varying times of exposure, and judging from the results which is the correct one. This should be verified then on a landscape.

ISOCYANINES (Fr. and Gr., *Isocyanine*)

A class of dyes for colour-sensitising plates, all complex derivatives of cyanine, which they have superseded. The group includes ortho-chrome T (introduced in 1903), pinachrome (1904), pinaverdol, pinacyanol, homocol, and dicyanine. These are treated under their respective headings. Pinacyanol is the best sensitiser for the extreme visible red, while dicyanine sensitises for the infra-red.

ISOTYPIE

A process of half-tone negative making pro-posed by Vittorio Turati, and expounded in an elaborate treatise. The system depends on the use of variously shaped diaphragms in con-junction with a suitable screen distance. The latter is determined by means of what the inventor termed a " finder " stop, having two small openings placed at a mathematically deter-mined distance apart. The image of this stop is viewed by means of a microscope through the ruled screen, whilst the latter is moved to and fro until a position is found where the images of the two openings coincide in the focal plane. The variously shaped diaphragms can be put in the lens, and different patterns of dot forma-tion are obtained on the negative, although the ordinary cross-ruled screen has been used throughout. The process has not come into commercial use.

" IT "

Sir William Abney in his presidential address before the Royal Photographic Society, in October, 1896, proposed the term " It " (the initials of intensity and time) as an expression of the unit of exposure. He used the term pro-visionally only, and suggested that a unit might be called " talbot," just as in other branches of physics the units were named after pioneers, as, for example, the " watt," the " volt," and the " ampère."

IVES' COLOUR PROCESSES

F. E. Ives, of Philadelphia, U.S.A., may be considered as one of the pioneer workers in practical three-colour work, as it was mainly by his efforts that the true theory of the processes was recognised and of recent years reduced to practical results. He laid down the principle, though it had already been enunciated by Clerk-Maxwell and Ducos du Hauron, that the object to be reproduced in colours should be photo-graphed through three separate screens or colour filters, which should give negatives that repre-sented by light and shade the degree to which light coming from different portions of the sub-ject excites a single primary colour sensation in the eye; and that for projection these three photographs should be projected simultaneously upon a screen, each by light which excites only the primary colour sensation which it represents, and in such manner that the three-coloured images are superimposed. This involves the production of one photograph by the joint action of the red, orange, yellow, and yellow-green rays, but chiefly by the orange, so as to represent the effect upon the red sensation; another by the joint action of the orange, yellow, yellow-green, green-blue rays, but chiefly by the greenish yellow rays so as to represent the action of the green sensation; and a third photograph by the joint action of the blue-green, blue, and violet rays, but chiefly by the blue rays to represent the action of the blue sensa-tion. Positives from negatives were projected, the first by pure red light, the second by pure green light, and the third by blue-violet light. Several cameras of varying types have been devised by Ives to obtain the negatives, some in which the image formed by one lens was split up by means of mirrors into three images, and others with three lenses. In his latest type only one lens is used, and a reflector splits the image up into two parts, and one image is received by one plate, and the other two by a plate and a celluloid film placed surface to surface with a colour screen in between.

IVES' HALF-TONE PROCESS

One of the early half-tone processes. It was invented by F. E. Ives, and patented in America in 1878. A gelatine relief was cast in pure white alabaster plaster, and brought into contact with an indiarubber sheet covered with pyramidal raised points or lines which had been inked. According to the amount of relief on the cast the rubber points were more or less spread out, and thus gave dots of ink of varying size on the surface of the cast. The light and shade of the image was thus reproduced, and the cast was then photographed, the negative being equivalent to the half-tone negative now secured through the ruled screen.

IVOIRE DUR

The name by which carbon pictures upon porcelain were once known, owing to their being an imitation of photographic prints upon ivory.

IVORY (Fr., *Ivoire*; Ger., *Elfenbein*)

The tusks of the elephant; a very hard white or creamy white bonelike substance which is occasionally used as a support for prints.

IVORY, ARTIFICIAL

Artificial ivory is either white vulcanite or white opaque celluloid.

IVORY BLACK (Fr., *Noir d'ivoire*; Ger., *Elfenbeinschwarz*)

Calcined ivory scrap, turnings, and powder, used as a pigment.

IVORY, PHOTOGRAPHS ON

Generally, photographs are printed on ivory by the carbon transfer process (*which see*). Other methods have been advocated, as, for example, sensitising the ivory and printing by contact or through a camera, but the carbon process is the easiest and best. Such pictures are largely used for the production of coloured miniatures, the print being made weak to serve as a base for the colours.

IVORYTYPE

An imitation of prints upon ivory. The working directions are as follow : Select a print upon plain salted paper, strong and brilliant ; prints from flat negatives do not give pleasing effects. Edge a glass plate with mountant to the extent of about ¼ in. ; damp the picture, and lay it face upwards upon the glass so that it becomes fastened by the edges. The glass should be of such a size as to leave about ⅛ in. margin round the print. When dry, the print will be found stretched tight upon the glass. It is then coloured with bright water-colours or aniline dyes. A flat slab of soap-stone is now taken, the glass bearing the print is mounted upon it, and the whole placed over a gas-stove or oil-stove until the glass is hot enough to melt wax. A cake of white (not paraffin) wax is then rubbed over the warm surface of the picture. The wax gradually melts and saturates the print, which at this stage presents a hopeless appearance, and appears to be ruined. The print is next cut round the edges, so as to detach it from the glass. A sheet of clean plate glass is heated in the same manner as the first piece, and the print, waxed face down, is laid upon it. The wax soon causes glass and paper to adhere, and any air-bubbles can be pressed out by using a piece of wax with a straightedge as a squeegee. The glass with the print upon it is then allowed to cool, and the print is next backed up with white cardboard, and bound at the edges with binding strips, or the card is attached by means of wax. Finally, the whole is framed.

Prints produced by the " Eburneum Process " (*which see*) have also been called ivorytypes.

J

JAFFÉ'S PAPER

A commercial photo-lithographic transfer paper, sized with hardened gelatine, which has to be sensitised in a bath of potassium bichromate. Max Jaffé recommends the addition of manganese oxysulphate to the bath in summer time. Two kinds of this paper are made, one having the natural gelatine surface and the other being highly glazed. The latter is recommended for half-tone and delicate line work.

JAFFÉTYPE

A half-tone process, invented by Max Jaffé, of Vienna, consisting of printing from an ordinary continuous tone negative on to a collotype-prepared plate, with a piece of gauze interposed. Thus a kind of half-tone print was obtained from which lithographic transfers were pulled and put down on metal for etching into relief.

JAUNE BRILLANT

A pigment consisting of a mixture of cadmium yellow, vermilion, and white-lead, and used occasionally for colouring photographs.

JAVELLE WATER (*See* " Eau de Javelle.")

JENA GLASS (*See* " Glass.")

JEWS' PITCH (*See* " Asphaltum.")

JOLY'S COLOUR PROCESS

A screen-plate process of colour photography, introduced in 1894, in which a glass plate ruled with parallel lines, about 150 to the inch, of red, green, and blue-violet, was placed in front of a panchromatic plate during exposure, and gave an image in lines corresponding to the distribution of the colours of the object. From this a transparency was made in the ordinary way and bound in contact with a viewing screen ruled with lines of similar width and adjusted till the object was seen in its natural colours. (*See* " Screen-plate Processes.")

JOSEPH, PAPIER

An extremely soft Japanese tissue paper of silky texture, used for cleaning glass.

JOUGLA PROCESS (*See* " Omnicolore Plate.")

JUNIPER RESIN (*See* " Gum Sandarac " under the heading " Gums and Resins.")

K

K SCREENS

A commercial name for yellow screens prepared with filter yellow K.

KACHIN (Fr. and Ger., *Kachin*)

A developer, possibly identical with and certainly resembling pyrocatechin. It is soluble in water (28 in 100); keeps well; does not stain fingers, plates, or papers; and gives good black images. The standard formulæ are:—

One-solution Developer

Sodium sulphite	.	½ oz.	27·5 g.
Sodium carbonate	. 1	,,	55 ,,
Kachin	. .	. 100 grs.	11·5 ,,
Water	. .	. 20 oz.	1,000 ccs.

The above is ready for use.

Two-solution Developer

A. Kachin	.	. 160 grs.	18 g.
Sodium sulphite	.	2½ oz.	137·5 ,,
Water .	.	20 ,,	1,000 ccs.
B. Sodium carbonate.		2 oz.	110 g.
Water .	.	20 ,,	1,000 ccs.

Use equal parts of A and B. Dilute with water for softer results. Use as a restrainer 10 to 30 drops of a 5 per cent. solution of borax to each ounce of developer.

Another popular form of a two-solution developer of a different character is :—

Two-solution Developer

A. Kachin	.	. 192 grs.	22 g.
Sodium sulphite	.	2 oz.	110 ,,
Water .	.	20 ,,	1,000 ccs.
B. Sodium phosphate		3¾ oz.	200 g.
Caustic soda.	.	192 grs.	22 ,,
Water .	.	20 ,,	1,000 ccs.

For use, mix 1 part of A, 1 part of B, and 1 part of water. A few drops of a 10 per cent. solution of potassium bromide per ounce of developer has very great restraining power, and is of use in cases of extreme over-exposure. A curious and valuable property of kachin is that it gives better results on very stale plates than any other developer. Kachin has been advocated for use in developing and fixing a negative in one operation. (For formulæ *see* "Developing and Fixing Combined.")

KALEIDOSCOPIC PHOTOGRAPHY

Photography of the multiple images produced by two mirrors placed at an angle with one another, as in the kaleidoscope. The symmetrical images given by the latter instrument are often photographed for the use of designers. (*See also* "Polyscope.")

KALLITYPE

A printing process invented by Dr. W. J. Nichol in 1899. Paper, coated with a mixture of a ferric salt and silver nitrate, gives, on exposure to light behind a negative, an image in ferrous oxalate and silver oxide which, on the application of a suitable developer, precipitates an image in metallic silver. The principle of the process is old, and was foreshadowed by Herschel's obsolete "Chrysotype" process. The instructions immediately following are practically those originally published by Nichol, who at one time placed the paper ready for use on the market but withdrew it because he was not satisfied with the permanency of the results; his fixer was a weak solution of ammonia, but later experiments proved that the use of "hypo" as a fixer gave more permanent prints.

The paper, preferably after sizing, is sensitised by coating with :—

Ferric oxalate	.	. 750 grs.	167·5 g.
Silver nitrate	.	. 300 ,,	67 ,,
Oxalic acid	.	. q.s.	q.s.
Distilled water	.	. 10 oz.	1,000 ccs.

Place the ferric oxalate in a bottle with the water, which stand in a saucepan of water, and gradually heat until the ferric oxalate dissolves. If there is need, add not more than from 5 to 10 grains of powdered oxalic acid to assist solution. Filter the hot solution, and add the silver nitrate to the clear filtrate; this will keep good in the dark for several months. The paper is then coated (in a yellow light) after the manner described under the heading "Blue-print Process," dried, and printed upon until of a bluish brown colour upon a yellow ground. At this stage the image consists of reduced iron (ferrous) salt which has the power of reducing the silver nitrate to a metallic state, which power, however, is latent until a developer (a solvent of the ferrous salt) is applied to the paper.

Of the many possible developers, the chief are sodium tungstate, Rochelle salt, sodium acetate, and borax.

(1) *For Black Tones*—

Borax	.	. 1 oz.	110 g.
Rochelle salt	.	. ¾ ,,	82·5 ,,
Potassium bichromate			
(1 % solution)		.7–9 drms.	87–112 ccs.
Water	.	. 10 oz.	1,000 ,,

(2) *For Sepia Tones*—

Rochelle salt	.	. ½ oz.	55 g.
Potassium bichromate			
(1 % solution)		.4–5 drms.	50–62 ccs.
Water	.	. 10 oz.	1,000 ,,

(3) *For Purple Tones*—

Borax	.	. ¼ oz.	27·5 g.
Rochelle salt	.	. 1 ,,	110 ,,
Potassium bichromate			
(1 % solution)		.7–9 drms.	87–112 ccs.
Water	.	. 10 oz.	1,000 ,,

(4) *For Maroon Tones*—

Rochelle salt	.	. I oz.	110 g.
Sodium tungstate	.	½ ,,	55 ,,
Water	.	. 10 ,,	1,000 ccs.

The print is immersed in the developer and the dish is rocked for from fifteen to thirty minutes. Although the image may appear quickly, the print must remain in the bath some time in order to render the iron salts completely soluble. The print is then passed direct, without washing, into the fixing bath, consisting of—

Sodium hyposulphite	I oz.	55 g.
Liquor ammoniæ (·880)	¼ ,,	12·5 ccs.
Water	. . 20 ,,	1,000 ,,

The print is kept on the move in this bath for about ten minutes, then washed for about twenty minutes, and finally dried. Some workers advocate a second immersion in a fresh fixing bath (as above) in order to be sure of thorough fixing, which is absolutely necessary to secure permanent pictures.

A finished kallitype picture has an image consisting of metallic silver, and it may therefore be toned with gold, platinum, or by the sulphide process, if desired.

Modified Kallitype.—Another and more modern paper is that known as " Water-developing kallitype," which is a good paper for home production, but the warm brown results cannot, as a rule, be said to equal those given by the proper kallitype process described above. Four solutions are necessary for sensitising :—

A. Green ferric ammonio-citrate	. 1,100 grs.	252 g.	
Water	. . 10 oz.	1,000 ccs.	
B. Tartaric acid	. 180 grs.	41 g.	
Water	. . 10 oz.	1,000 ccs.	
C. Silver nitrate	. 460 grs.	106 g.	
Water	. . 10 oz.	1,000 ccs.	
D. Gelatine	. 300 grs.	69 g.	
Water	. . 10 oz.	1,000 ccs.	

The A and C solutions keep well in the dark ; the B solution keeps for a few days only, owing to the formation of mould ; while the D solution should be made just before use, the gelatine being soaked in the water and dissolved by heat. Equal parts of the four solutions added together form the sensitiser ; A and B solutions should be added to the warm gelatine D, the whole being kept warm by placing the measure, say a 10 oz. graduate, in hot water. The C solution is then added very slowly, stirring the combined mixture with a glass rod the while. The warm solution is then coated upon the plain paper, and as soon as the coating has lost its wet appearance and begins to look dull the paper is hung up in a warm room and out of the way of actinic light to dry ; when dry it is ready for printing.

The print needs to be vigorous ; from the printing frame it passes into plain water for about two minutes, and in this the image develops up to a greater strength and of a reddish brown colour. It is then transferred to a weak " hypo " fixing bath (" hypo " 50 grs., water 5 oz.,) or to a 10 per cent. sodium sulphite solution, in which the print becomes a richer brown in colour. Finally, the print is washed for about half an hour, and dried.

American Kallitype.—In America much attention has been paid to kallitype, and many formulæ and improvements have been introduced. The Jas. Thomson process needs a " salting " and a " sensitising " solution :—

Salting Solution

Ferric-ammonio citrate	.	. 200 grs.	45 g.
Ferric oxalate	.	. 120 ,,	27 ,,
Potassium oxalate	.	. 120 ,,	27 ,,
Copper chloride	.	. 60 ,,	13·5 ,,
Oxalic acid	.	. 40 ,,	9 ,,
Gum arabic	.	. 100 ,,	22·5 ,,
Distilled water	.	. 10 oz.	1,000 ccs.

The paper (sized if velvety tones are desired) is coated with the above, dried, and treated with the sensitiser :—

Oxalic acid	.	. 20 grs.	4·5 g.
Citric acid	.	. 200 ,,	45 ,,
Silver nitrate	.	. 500 ,,	112·5 ,,
Water	.	. 10 oz.	1,000 ccs.

When surface dry, complete the drying by gentle heat, but excess of heat will convert the ferric salt to ferrous. For printing, three or four minutes in sunlight is generally sufficient. The image appearing is chestnut brown upon a yellow ground, and printing should be stopped before the half-tones appear. The print is placed direct into clear cold water, where it will develop fully ; four changes of water, or about three minutes in running water, will be sufficient. After washing, fix in a weak " hypo " bath (50 grs. to 32 oz.) ; a ten-minute immersion is generally sufficient. Wash in plain water for about half an hour and dry ; the resultant colour should be a good brown.

Single-solution Kallitype Sensitiser.—The following sensitiser is one of the simplest and most widely used for menu, note paper and postcard work. Geo. E. Brown, who has advocated it, gives the following directions : 55 grs. of silver nitrate is dissolved in 4 or 5 drms. of distilled water ; and liquor ammoniæ (·880), diluted with an equal quantity of water, is very carefully added. As the first drop or two is added, a copious precipitate of silver oxide is thrown down in the solution. Addition of more ammonia solution will re-dissolve this precipitate ; cease to add ammonia on the disappearance of the last traces of the precipitate. Weak sulphuric acid is next added drop by drop until the faint odour of ammonia disappears. 40 grs. of green ferric ammonium citrate dissolved in 6 drms. of water is then added, and the liquid is complete. Stored in the dark or in a stone bottle, it will keep good for several months. It is applied to paper in the same way as other kallitype sensitisers, dried, and the paper treated as before described, namely, with water and " hypo."

After-treatment.—Kallitype prints may be toned, reduced, re-developed, and intensified. For toning, a simple combined bath which works well is : Water, 8 oz. ; sodium hyposulphite, 1 oz. ; gold chloride, 1 gr. Over-exposed prints may be reduced by immersing in a weak solution of hydrobromic acid, a suitable strength being 30 drops of the strong commercial acid to 1 oz. of water. One immersion for a minute or two

will usually suffice; the print is then washed well. Another method is to immerse the print in the weak acid for a few seconds only, and then transfer to a weak fixing bath of "hypo" and water for a few minutes; this increases contrasts considerably, and much can be done in the way of getting good prints from weak negatives. As regards intensification, the image consisting practically of metallic silver, it can be subjected to the processes advocated for intensifying negatives and bromide prints, and even the uranium and sulphide processes of toning and intensification may be used. The kallitype print, unlike a bromide print or a negative, can be easily bleached in a solution of hydrochloric acid, and 10 drops of the acid added to 1 oz. of water rapidly removes the image and converts the silver into silver chloride. If the bleached picture is then well washed and exposed to a strong light, it may be developed with any clean working developer, as hydroquinone-metol, etc. In this way a strong developer may be employed to produce a cold tone, or a weaker developer one of a warmer tone, and the tones can further be modified in a gold or platinum toning bath.

KAMMATOGRAPH

An apparatus for taking and projecting kinematographic pictures, invented by Leo Kamm. A circular glass plate, 12 in. in diameter, is used as a support for the sensitive emulsion, at its centre being a hole about $1\frac{1}{2}$ in. in diameter, and the mechanism is such that the plate cannot race past the point at which it is required to be held momentarily stationary for purposes of exposure. The circular plate is given an intermittent rotary motion and also an horizontal displacement, which enables a series of pictures to be impressed upon it in a spiral form. The combined camera and projector is made in two patterns, both of the same size, but one taking 350 and the other 550 pictures on the disc. Each picture of the 550 series measures $\frac{1}{4}$ in. by $\frac{5}{16}$ in., while those of the 350 series are slightly larger.

The apparatus is fireproof, whilst the process of making the positive records from the negatives involves but little trouble, the printing of the positive images being done exactly in the same way as one would make an ordinary lantern slide—by contact, exposure, and development in one sheet. There is considerable novelty in the mechanism, but the principle of arranging pictures in a spiral form upon a disc is not new, this having been done by American and French inventors prior to the inception of the kammatograph.

Anthony's "spiral" lantern and Nelson's "spiral" camera may be mentioned here, although they were limited to a much smaller number of pictures in any one series.

KAOLIN (Fr. and Ger., *Kaolin*)

Synonyms, china clay, white bole. A native hydrated aluminium silicate which, when prepared, is a white powder that is used for clearing the silver bath and in the production of matt surface paper, and is added to emulsions for the same purpose. It is also employed in the manufacture of crayons.

KARTALINE

A modification of the crystoleum process in which the print is attached face downwards to glass for colouring. When coloured and removed, it is finished by varnishing.

KATA-POSITIVE

An obsolete name for a positive on an opaque base, as ivory, paper, etc. Positives upon glass, etc., were known as dia-positives.

KATATYPE (*See* "Catatype.")

KEITH'S PAPER PROCESS

A waxed-paper process (*which see*) introduced by Dr. Thomas Keith, of Edinburgh, in 1856; practically the same as Le Page's process.

KENNETT, RICHARD

Died 1896. Patented, November 20, 1873, a process for using gelatine instead of collodion combined with salts of silver. A prepared compound was cut into strips, washed to remove the free salts, and afterwards dried. In this state the "pellicle," as it was called, could be stored for use, and when required it was dissolved in water and plates coated with it in the usual way. Advertisements of the period stated that "R. Kennett is now issuing his patent sensitised gelatino-pellicle, in packets containing sufficient to make two, four or six ounces of emulsion, at one, two and three shillings respectively." In March, 1876, he placed "rapid pellicle plates" all ready for use on the market, but photographers failed to appreciate the extraordinary sensitiveness of the plates, as compared with the slow wet plates, and they invariably got fogged pictures, either on account of over-exposure or unsafe (yellow) dark-room lights.

KETONES

A class of substances derived from the secondary alcohols by a removal of two atoms of hydrogen, and distinguished by the divalent group CO united with two alkyl radicles, as in acetone CH_3COCH_3, which is practically the only one of any photographic interest, and which is described under its own heading.

KEY

A print is said to be in a high key when there are few gradations of tone, none of which is very deep; it is in a low key when the few tones are all at the dark end of the scale.

KILOGRAMME, KILOLITRE, KILOMETRE, ETC. (*See* "Weights and Measures.")

KINEMACOLOR

A system of producing kinematographic pictures in colour, devised by Charles Urban and G. Albert Smith. Only two colour filters are used, both in taking the negatives and in projecting the positives, but the projected pictures exhibit a remarkable range of intermediate tints, due partly to the fact that the green filter transmits a considerable amount of blue light, the pictures showing blue sky and water, besides black and white, and partly to the laws of persistence of

vision relative to colour perception. The camera resembles the ordinary kinematographic camera except that it is built to run at twice the speed, thus taking thirty-two images per second instead of sixteen, and that it is fitted with a rotating colour filter in addition to the ordinary shutter. This filter is an aluminium skeleton wheel A having four segments, two open ones, G and H, one filled in with red-dyed gelatine, E F, and the fourth containing green-dyed gelatine, A B. The machine is so geared that exposures are made alternately through the red gelatine and the green gelatine. The negative is printed from in the ordinary way, when the desired variations of tone become evident in the positive. (*See* a plate accompanying this work.) It will be understood that there is no colour in the film itself, which, indeed, resembles at first sight any ordinary kinematograph film; the filter is the medium by which the colour is obtained.

The projecting apparatus is shown at B. As in the camera, the mechanism is designed to work at double ordinary speed, projecting

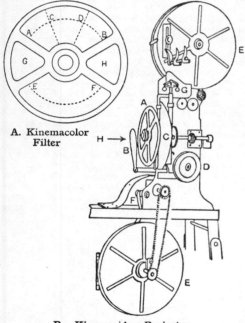

A. Kinemacolor Filter

B. Kinemacolor Projector

thirty-two images per second, sixteen being projected through the green segment of the colour filter A, and the other sixteen through the red segment. G shows the governing balls communicating with the safety shutter B, compelling the latter to drop out of the path of the lantern rays as soon as the film is passing at a safe speed through the apparatus. The arrow H indicates the direction of the light rays from the illuminant; c is a light guard, preventing stray light from passing to the screen; D the driving pulley, F the film, and E E safety spool boxes.

A special feature in the formation of the

colour filter must now be referred to. Supplementary to the green filter A B (in illustration A) an overlapping segment of green is filled from C to D with the object of obtaining balance of colour, since red is more vivid to the eye than green. The size of the supplementary segment, C D, is a matter of great importance if perfect results are to be obtained. If it is not large enough, the yellows will have a greenish hue; if it is too wide, the green will be too dense and the red will be in excess, giving to the yellow an orange hue. If the red and green filters have been rightly balanced, the revolving disc will transmit to the screen a neutral white "colour."

When taking the negative photographs, the speed of film through the camera must be maintained at 2 ft. per second, otherwise the object, when projected, will appear to move at an unnatural pace. Assuming a uniform rate of projection, increased speed of taking will cause an effect of abnormally slow motion in the projected pictures; while if the subject is taken too slowly, the projected images will show everything moving too fast. In addition to this, the too quick operation of the camera tends to under exposures and excessive vividness of colours, and too slow operating to over-exposures and dull results.

Turning now to the operation of the projecting machine, it will be understood that at the moment when a particular filter is opposite the optical centre, the monotone image belonging to that colour will be in the gate of the instrument and be projected upon the screen. The images following in this order at the high speed of thirty-two images per second, the combined effect upon the screen will be a picture reflecting not only red and green, but also their complementary or accidental colours intermixed with many other hues resultant from the blending of the red and green proper. Although the Kinemacolor system cannot be said to be absolutely perfect, it is the most successful system of colour projection combined with animated effects yet evolved. An ideal process would be that in which the three primary colours of the solar spectrum were embraced, taking the negative images through suitable colour filters and projecting positive images therefrom through yellow, blue and red filters; but at present the chemical, optical, and mechanical difficulties of doing this in a way that would meet conditions inseparable from kinematography are insurmountable. Not until the three requisite images are taken simultaneously and from a common optical view-point within the time-limit of persistence of vision, and the positives projected under similar conditions, can fully satisfactory results be expected.

KINEMATOGRAPH

A general outline of the whole process or manner of taking and projecting kinematograph pictures must be given to render intelligible a description of the necessary mechanism. Briefly, the camera consists of a light-tight chamber fitted at the top with a magazine for holding a long roll of negative film; a similar magazine at the bottom of the chamber for the reception of the film after exposure; mechanism for drawing

the unexposed film from the top magazine, passing it intermittently past the exposure aperture, and finally winding it up in the lower magazine; and an optical system for projecting the image upon the film. A negative obtained in this camera is taken under cover to a dark-room with the usual ruby illumination; wound on a frame, and developed in large tanks. After development and washing, the negative is wound on

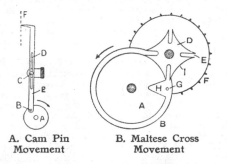

A. Cam Pin B. Maltese Cross
 Movement Movement

large drums, provided for the purpose, in hot-air chambers. When dry, it is put through a contact-printing-machine, in which an unexposed film (the positive stock) is placed in contact with the negative film and the two run together with the celluloid side of the negative next to the illuminant and the positive film behind the negative, both in contact, gelatine to gelatine. The positive, or so-called print, is treated in the same manner as the negative, and dried on drums or on frames. When dry the films are ready to be exhibited, for which purpose projecting machines are required. All projecting machines in general use are built on the intermittent principle. The entire apparatus consists of an arc-lamp (sometimes a high-power limelight jet), lantern body, film mechanism, and optical system. Projecting consists in feeding the mechanism with a positive film from spools designed for the purpose, and winding it up as used, the images being projected upon a screen.

In many of the early kinematograph machines the film travelled through its requisite path from spool to spool with a continuous movement, whilst the optical system was made relatively stationary by following the motion of the film and being then brought back to its starting point with a jerk. In practice this was unsatisfactory, and it has been superseded by what is known as the "intermittent movement," according to which the film comes to a standstill for a fraction of a second and is held stationary during exposure. Three distinct methods are now in general use, namely, the pin movement, the dog movement, and the Maltese-cross movement.

The three forms of intermittent movement will now be referred to. The pin movement mechanism is illustrated at A. A shaft E, slotted at D, and carrying a pin at the top, oscillates on a fixed point C. The lower end of the shaft E is pivoted at B to a cam A, which, on rotation in the direction of the arrow, causes the pin shaft to rise and fall, and at the same time to make a forward and backward move-

ment. The dotted line at F indicates the edge of the film, the alternate open spaces indicating the perforations. The figure shows the pin about to enter a perforation. On rotating the cam A, the pin will enter the perforation, and as the cam continues to revolve, the pin will pull down the film the distance of one picture space, being ultimately released as the revolution of the cam continues and brought into position for re-engagement with the film perforation. In practice, the cam A rotates sixteen times per second; hence the film will be moved sixteen times and as often allowed to remain stationary.

The Maltese-cross movement is shown at B. A sprocket-wheel F carries teeth which engage with the film perforations. Fixed to its side is a Maltese cross D. A disc B, carrying on its side a second disc A, and a pin at G, is made to rotate continuously in the direction of the arrow. During its motion, the pin G enters the slot E, and at a certain point begins to turn the Maltese cross; the points of the cross pass into the notch H of disc A and thus allow the sprocket-wheel to make one quarter revolution; then it is brought to a standstill and held steady by the concave edge I coming opposite to the convex plain edge of disc A. When disc A has made a complete revolution, the same action takes place, and so on, on each corner of the cross.

The dog movement, invented by Demeny, of France, and shown at C, has a disc G, centred at B, and carrying in a slot, so as to be adjustable, a semi-circular shaped pin A, which, on each revolution of the disc, comes into contact with the film F, drawing this down a distance of one picture space. The slack film is taken up by the continuously rotating sprocket-wheel D.

A diagrammatic view of the interior of a kinematograph camera is shown at D. The casing T is divided into three compartments: (1) A front compartment U, containing a rotating shutter N, pin mechanism O P, and other parts not shown; (2) a compartment V containing

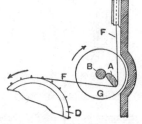

C. Demeny Dog Movement

the film mechanism and magazines; (3) and a compartment on the opposite side containing further mechanism communicating with the spools in the magazines, with the sprocket-wheels and with the parts in the front compartment. The two magazines A B, consisting of light-tight boxes, fit into the back portion, and carry bobbins W X, on which the film is wound. This apparatus works as follows: The roll of unexposed film L passes out of a small aperture H[1] at the corner of the top

magazine A, round guide rollers C D, engages by its perforations with the sprocket-wheel F, to which it is kept in contact by the roller E, is looped up at H^2, and then takes a downward course through the guide groove made in the gate G; it passes out at the bottom of the gate, where it forms a second loop H^3, and then

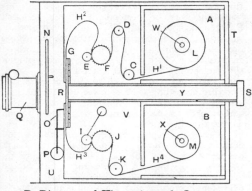

D. Diagram of Kinematograph Camera

passes between spring-roller I and sprocket wheel J, under the guide roller K, and enters at H^4 the bottom magazine B, where it is wound up on the bobbin X. The sprocket-wheels rotate continuously, drawing the film from the supply at I, and taking it up at M; the motion of the film in the gate G, however, is intermittent. During the period of rest, a surplus loop of film forms at H^2, which is then pulled down through the gate by the action of the pin O engaging with the perforations. The whole mechanism is so arranged and geared together that, just as the film is stationary, an open sector of the rotating shutter N comes opposite the lens and film aperture at R. Likewise, just as the film is making its intermittent move downwards, an opaque sector of the shutter N comes opposite the lens, so that being thus under cover, it is saved from being fogged. Through the centre of the camera and opposite the lens, a long tube Y extends, with a detachable cap at S. This tube forms the sight hole for purposes of inspecting the image upon the film prior to exposure. The gate G is a kind of hinged door with an aperture in it, and its function is to keep the film flat and vertical during exposure, and also to act as a channel or guide. After taking a subject, the operator presses a button, and in so doing punches a hole in the film, at a point just above the gate, this enabling him to determine where one subject ends and another begins.

Each individual photograph requires an exposure of from $\frac{1}{30}$th to $\frac{1}{100}$th of a second, the shorter the exposure the better, provided there is sufficient light to produce a well-exposed negative. The lens must give really excellent definition. A slight lack of sharpness caused by movement of the object during exposure will not seriously injure the effect, but the stationary surroundings repeated in the succes-sive pictures must be sharp. Rapidity in the lens is also a matter of importance; $f/6$ or thereabouts is sufficient for most purposes, and

at times $f/8$ or even $f/11$ can be used. The focal length will be short, so that the attendant defect of great rapidity, namely, lack of depth of definition, is not of great importance. The lens that is generally employed has a focal length varying from $1\frac{1}{2}$ in. to 4 in.

The lens that has been employed for taking the photograph is frequently used for its pro-jection upon the lantern screen; this is a mistake, for a lens with the largest possible aperture, at least $f/4$, and better $f/3$, of the Petzval form should be used for projection, unless the lens is of more than 4-in. focus, in which case it is not of so much importance.

Projecting machines vary as regards type and method of translation of the film, but all of them work on the intermittent principle. The film is brought to a dead standstill sixteen times per second, whilst within the same space of time it is also moved forward in a vertical direction downwards sixteen times; this movement is accomplished at the moments when the opaque sector of the rotary shutter is opposite the optical system. The essential parts of a kinemato-graph projector are shown at E, the main support and the gearing mechanism being omitted. A and B are the two spools to carry the film before and after passing through the machine, the top one being the feed-spool and the bottom one the take-up spool. An upper and lower sprocket-wheel C and D engage with the perforations of the film F. The latter passes from A, between sprocket C and spring pressure rollers E G, forms a loop at J, passes through gate G, past the exposure aperture L, goes past the dog M, between sprocket-wheel D and pressure spring rollers H I, and finally to the take-up spool B. Sprockets C and D work in

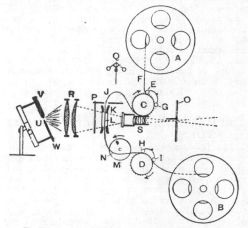

E. Diagram of Kinematograph Projector

unison. A surplus loop of film is provided at J, as in the camera already described. The top spool A rotates by reason of the pull made on the film and is free to revolve accordingly. The lower spool B is turned continuously by a slip-belt, so that the film is tightly wound thereon, as it comes from the sprocket D; the slip-belt compensates for the constantly increas-ing size of the roll of film on B. The gate K

has springs and pressure pads which hold the film steady after its downward motion; and the channel through which it travels is recessed, contact only obtaining at the edges where the perforations are. The gate turns on hinges after the manner of a door, in order to facilitate insertion and threading of the film, being fastened by a catch and held by a spring. A revolving disc with open sector constitutes the shutter O, which is geared in such a manner that the open portion arrives opposite the exposure aperture and optical system just at that moment when the film is brought to rest. Finally, a safety drop shutter P is situated between the gate and condenser R, its rise and fall being controlled by the governor Q. The governor does not allow of the shutter rising till the mechanism is running at the rate of showing sixteen pictures per second, at which speed it is safe to allow the emission of the lantern rays through the celluloid film. The objective lens for throwing the image upon the screen is at S, between the gate and the rotary shutter. The lantern situated immediately behind the condensing lenses R contains the necessary source of illumination, an electric arc-lamp, the carbon pencils V W of which create the arc at U, at which point also a crater forms exactly in a line with the centre or axis of the optical system; or a limelight jet can be used.

The film is threaded through the projecting machine with the gelatine surface turned towards the condenser, and with the pictures inverted. If on projection it is found that the halves of two pictures appear on the screen, the pressure rollers H I are raised, and the film lifted forward till the sprocket teeth engage with two perforations in advance of its previous position. Another way is to raise or lower the gate K by means of the pinion and rackwork provided for the purpose, but the picture is not then always exactly opposite the centre of the optical system. Equally important, in order to get the picture as steady and life-like as possible, is that the handle should be turned with the greatest regularity and at the rate of two revolutions per second. (*See also* "Kammatograph," "Kinemacolor," and other headings.)

KINEMATOGRAPH PICTURES IN BOOK FORM

The fundamental principle of the kinematograph picture is based on the fact that if a series of complementary images be presented to the eye in such a manner as to satisfy the laws of persistence of vision, these images will combine and thus produce the illusion of a single impression. Further, if each image or picture in such a series be slightly different, according to the changes presented by a moving object, the complete scene will have the semblance of life. These conditions are fulfilled in a primitive way by depicting on successive leaves of a book the phases of the subject it is intended to present, and then allowing the leaves to escape rapidly in succession.

KINEMATOGRAPHY

The art of photographing objects in motion and projecting the images upon a screen. It derives its origin from a toy called the "zoëtrope" and depends for its results on what is known as "persistence of vision." When light is reflected from a moving object it forms an image on the retina (or sensitive plate) of the eye, and creates a nerve current which passes along every one of the fibres which receive the image and collectively carry the impression through the optical nerve to the brain. This sensation may be divided into four periods: First, a latent period which is almost instantaneous, and during which nothing seems to happen; second, a very short period, estimated at less than $\frac{1}{100}$th of a second, during which the sensation reaches the maximum; third, a much longer period, $\frac{1}{30}$th to $\frac{1}{10}$th of a second (varying according to the power of illumination) during which the sensation slowly diminishes; and, fourth, a short period of decline, during which the effect dies away. It is found that in the case of a moving object on which attention is directed the fourth period remains unnoticed, owing to the fact that a new image takes up the place of the old one before that period begins. Prof. Tindall estimated the time of persistence of an impression on the retina to

| A. Skeleton Drum for Drying Film | B. Frame for Negative Film |

be $\frac{1}{15}$th of a second, that is, the impression remains for $\frac{1}{15}$th of a second after the source of excitation is removed. Upon this all kinematograph apparatus is based.

The kinematograph camera and projecting apparatus are described under the heading "Kinematograph."

The three chief requisites to final success are: (1) A photographic emulsion sufficiently sensitive to receive latent impressions at the rate of sixteen per second; (2) optical systems capable of forming the negative images in the camera and the positive image upon the lantern screen; and (3) mechanical means for suitably translating the films through the camera and afterwards through the projector.

The emulsion is supported on celluloid cut into ribbons $1\frac{3}{8}$ in. wide, and in lengths of about 150 ft. The inner portion of the surface, 1 in. in width, is devoted to the pictures, the margins being used for the perforations by means of which the film is held in position during its progress through the camera or projector. Each image is 1 in. wide, and $\frac{3}{4}$ in. high, there being sixteen pictures to 1 ft., and four perforations on each side per picture. Slightly thicker celluloid is used for the positive film than for the negative, the former being subjected to more wear and tear than the latter.

Having decided on the type of camera to be

employed and the make of negative stock film to be used, the operator may proceed to work much in the same way as he might when taking ordinary snap-shot photographs in an ordinary magazine film camera. The negative stock film can be obtained in rolls of 150 ft. in length, ready perforated, and supplied in sealed tins, in which it is wrapped in lead sheets and light-tight paper. The magazines A B (see D, p. 319) are detached, and the unexposed film opened in the dark-room, with ruby light, and placed in magazine A, the centre of the roll being slipped over the bobbin W. The starting end of the film is drawn through the small aperture at the corner of the magazine, and the lid secured. The short length of the film projecting at the corner serves as lead film to facilitate drawing out, when it is desired to thread through the camera mechanism just before actual operations. When about to make the exposures, the side of the camera is opened and the film threaded as indicated at D (p. 319), taking care to arrange for the loop at H^2 and at H^3. The bobbin X has a clip which holds the end of the film securely. The lid of the magazine B is, of course, removed during these operations, and the length of film extending from C is unavoidably fogged. The operating handle of the camera should be turned a few times in order to make sure that everything is working properly; then the lid of B and the side of the camera may be closed. It now remains to see that the picture is sharply focused and, to do this, the handle should again be turned so as to bring an unexposed portion of the film opposite the exposure aperture R, and at the same time cause an open section of the shutter N to arrive in a line with the lens. By removing the cap S from the sight tube V, the operator may now have a view of the image on the film. If a focusing scale is provided on the lens itself, this operation is, of course, unnecessary; a separate view finder is provided on the camera. See that the cap S is replaced. The handle must be turned at the requisite speed, and as the mechanism is generally geared to make eight exposures for each complete turn of the handle, two turns should be made per second. Too fast camera operating will result in abnormally slow motion of objects in the projected picture, and vice versa. The most important point is the question of steadiness, for if the camera has been allowed to vibrate during the work of turning the handle, no afterwork can rectify such an error. Manufacturers supply very rigid and somewhat heavy stands for the camera. The screw holding the camera to the stand should be very tightly fastened. (See also "Theatrical and Kinematograph Photography.")

Development of kinematograph films is carried out in precisely the same way as that of ordinary film negatives; but some special appliances are necessary. The frame B is one. The pins top and bottom serve to hold the film in place, it being wound in spiral fashion and secured at each end by clips or drawing-pins. The emulsion side is turned outwards, so that only the celluloid surface comes into contact with the frame. A tank sufficiently large to take the frame is provided for the developer, another for the fixing solution, and a third for washing

purposes. The latter is furnished with a siphon overflow so that proper circulation of the water is secured; a tap provides a constant supply of fresh water at one end of the tank, the overflow siphon being situated at the opposite end. The washed film is wound on a skeleton drum A in spiral fashion, and placed in a warm room free from dust, and kept rotating for fifteen minutes. When the emulsion is thoroughly dry, the cleaning process is carried out, all finger marks being polished off from the celluloid side by means of a pad of soft material fixed to a bench over which the gelatine surface may pass without injury. A hole cut in the bench, through which the light of an incandescent electric lamp is directed upwards, enables the cleaner to detect smears and other marks. The film is wound up into coils by means of special winders.

The positive film is made by contact printing from the negative. Special machines are provided for the purpose, in which the action of the mechanism is approximately the same as that in the camera. Exposed positive stock is developed, fixed, washed and cleaned in the same manner as the negative.

If through accident a subject becomes broken in the middle, cutting out should be done so that when the two ends are rejoined, pictures follow on consecutively as before the accident. The ragged part of one end should be cut away exactly at the juncture of two pictures, and the end to be joined thereto should have an $\frac{1}{8}$th portion of a picture left on. The gelatine on this $\frac{1}{8}$th part should be removed, leaving the bare celluloid exposed. Film cement is then applied with a brush to the scraped-off portion, and this is quickly laid against the celluloid backing of the piece to be joined, firmly pressed, and allowed to dry. The cement dries within a few seconds after application. See that the perforations on the overlapping portions of the film exactly register. The blank spacing of film subjects is a source of many troubles if not correctly carried out. There are four perforations each edge to each picture and any length of blank film joined between succeeding subjects should correspond in length to a given number of complete pictures; otherwise, it will be necessary to make an adjustment in the machine when projecting.

KINETOSCOPE

Edison's apparatus for exhibiting his "kinetographs," pictures on a continuous band of film lighted by an electric lamp behind them.

KINOCYANINE

A developing agent discovered in 1891 by Noël, a French chemist, whilst preparing kyanol or bleu de Paris; so called because of its similarity to vegetable cyanine and quinone. $C_{25}H_{12}C_{10}$. It takes the form of an amorphous powder or ill-defined small crystals of a bluish violet with grey tinge. The original formula is:

Sodium sulphite	. .	50 parts
Sodium hydrate	. .	1 part
Sodium carbonate	. .	140 parts
Kinocyanine	. .	10 ,,
Water	. .	1,000 ,,

KITE PHOTOGRAPHY (Fr., *La photographie par cerf-volant*; Ger., *Drachenphotographie*)

Photography by means of a camera attached to, or suspended from, a kite is of frequent use in obtaining bird's-eye views for military purposes, and as an aid to the surveyor and meteorologist. A. Batut, of Enlaure, France, was the first to devote special attention to this class of work. In 1887 he employed a large diamond-shaped kite, as illustrated, having a long tail to give stability. The camera A was fastened to the kite by a triangular support, and had a shutter B of the guillotine type, working horizontally by means of two rubber bands. The shutter was held in tension by a thread, which was burnt through by a slow fuse C, ignited before flying the kite. In its passage across the lens the shutter was made to release a paper streamer, thus announcing that the exposure had taken place. Flat films were used. To prevent obstruction of the view by the cord, this was attached by a kind of double bridle to

Camera attached to Kite

a bar D. A self-registering barometer E indicated the height attained.

E. Wenz, in Germany, used shortly afterwards a kite of similar shape, but with the camera fastened to the bridle cords. Since then, kite cameras of a much more elaborate kind have been employed. As an example may be mentioned one made in 1899 by L. Gaumont, of Paris, for the use of A. Lawrence Rotch, of the Blue Hill Meteorological Observatory, near Boston, Massachusetts. While primarily intended for photographing the under surface of clouds, this could be employed also for obtaining views of the surrounding country. Clockwork allowed of successive exposures on a roll of film at predetermined intervals. Electric releases and simple cord releases operated from the ground have also been used.

The kite employed for photographic purposes must be steady in the air, the box kite and the multicellular oblique type being now preferred to the older pattern. The camera, which should be as light as possible, and of the fixed-focus box-form variety, carrying films, is now usually

attached to, or hung from, the cord. A simple method of making the exposure, suitable for experimental use, is as follows: A rubber band, one end of which is fastened to a small staple, is stretched over the trigger release of the shutter, and the latter is set back against the pull of the rubber by a thread tied to another staple as far away from the lens as possible. A sufficient length of ordinary wool soaked in a strong solution of potassium nitrate and dried is then tied to the further end of the thread, and ignited when the kite is ready to be flown. The slowly-burning fuse will eventually sever the thread, and thus enable the rubber band to work the trigger release of the shutter.

KLIC PROCESS

The process of photogravure (*which see*) as invented by Karl Klic, of Vienna.

KNIFE, RETOUCHING

A small knife of any convenient shape used for reducing the over-dense parts of a negative by cutting or scraping, for which purpose the film must be bone-dry and the light particularly good. The work must be done gently.

KNIFE, TRIMMING (*See* "Trimming Prints.")

KODAK

A trade name which is so familiar that many suppose it to apply to all hand cameras, although, as a matter of fact, the Courts decided in 1903 that it is the registered property of one particular company.

KOENIG'S COLOUR PROCESS (*See* "Pinachromy.")

KRÖHNKE'S INTENSIFIER

A method of intensification without mercury, advocated by Herr Kröhnke. The negative is made yellow in a ·3 per cent. solution of iodine and potassium iodide in water, washed, and made brown by flooding with a solution of Schlippe's salt, 15 grs.; caustic soda (10 per cent. solution), 2 to 3 drops; and water 3½ oz. Finally, the negative is washed and dried, the process being claimed to give clear shadows and to remove entirely any yellow stain.

KROMAZ

The viewing instrument used in connection with a process of stereoscopic colour photography invented by Barnard and Gowenlock, in which different colours were viewed by each eye.

KROMOGRAM

A name given to the transparencies used in the Ives Kromskop.

KROMSKOP

The name given to two forms of apparatus invented by Frederick Ives for projecting photographs in natural colours. Three slides taken through certain filters are simultaneously projected to give the effect of a single picture, there being for each slide a colour filter, respectively red, green, and blue-violet.

KRUSS CAMERA (*See* "Magic Camera.")

L

LABARRAQUE'S SOLUTION

Another name for "eau de Javelle" (*which see*).

LABELLING BOTTLES

Special care is necessary in labelling bottles that are to contain photographic chemicals. First make the outside of the bottle perfectly clean and dry; use gummed labels, or attach by means of liquid gum, and smooth into close contact. When quite dry, write on the label with ordinary or waterproof ink, or even with pencil, which is more permanent than some inks. Coat, when dry, with size made by dissolving $\frac{1}{2}$ oz. of common glue in $2\frac{1}{2}$ oz. of water, and when this is dry apply a thin coat of oak or hard carriage varnish. A label varnish much used in laboratories, etc., is the following :—

Sandarac	.	$2\frac{1}{2}$ oz.	78 g.
Mastic	.	1 ,,	31 ,,
Camphor	.	24 grs.	1·5 ,,
Oil of lavender	,	$3\frac{1}{2}$ drms.	12·25 ccs.
Turpentine	.	2 ,,	7 ,,
Ether	.	3 ,,	10·5 ,,
Alcohol	.	$2\frac{1}{2}$ oz.	8·75 ,,

Macerate for several weeks, agitating until dissolved.

A less efficient method is to attach the paper label in the usual way, warm it, and smear with wax by rubbing with the end of a candle. Another plan is to coat the attached label with celluloid varnish, made by dissolving celluloid (old films will serve if the gelatine is cleaned off) in acetone, amyl-acetate, or methylated spirit.

The bottle itself may be written upon, using one of the inks given under the heading "Ink for Glass, Porcelain, etc."

There are many special recipes for pastes for attaching labels to chemical bottles. Caustic soda and nitric acid are sometimes included with the object of breaking up the starch granules, and alum and sugar to increase the adhesive properties. One of the best of the many formulæ is :—

Wheat flour	.	2 oz.	220 g,
Powdered alum	.	160 grs.	37 ,,
Cold water	.	10 oz.	1,000 ccs.
Formaline	.	40 drops	8·5 ,,

Mix the first three ingredients together, boil in an enamelled saucepan, and when cold stir in the formaline.

In America it is common to label flat bottles in the following way. A strip of glass is cut $\frac{1}{8}$ in. narrower than the flat side of the bottle, and the paper label should be about $\frac{3}{8}$ in. smaller than the glass strip. The written side of the label is pasted to the glass strip, the edges of which are then smoothed. Both bottle and strip are then warmed, and the two attached together with a cement made by melting 1 part of beeswax with 3 parts of resin.

Names may be etched on bottles and the etching left plain or filled with Brunswick black or other pigment. Mix up the two following solutions :—(1) Sodium fluoride, 36 grs.; potassium sulphate, 7 grs.; distilled water, 2 oz. (2) Zinc chloride, 14 grs.; hydrochloric acid, 65 drops; distilled water, 1 oz. Mix the two solutions and write on the bottles with a quill or camel-hair brush; leave for about five minutes and then wash off.

LABELLING TINS

It is more difficult to attach paper labels to tins than to bottles. A plan that is often recommended is to gum the label in the usual way, but before attaching it to rub the part of the tin where the label is to go with a piece of freshly cut onion. Another method is to use a piece of fixed P.O.P.; write on the plain side and then wet the gelatine surface and place in contact with the tin. It is desirable to use waterproof ink and to varnish the labels.

LABELS, POLYGLOT

These are a convenience to the travelling photographer, but hardly a necessity, as English or French inscriptions are sufficient for the Customs authorities practically all over the world. The following is a polyglot label for a box of dry plates, the only photographic material that there should be the slightest desire to label in this way :—

English—Photographic Plates. Sensitive to light. *France and Belgium.*—Plaques Photographiques. Craint la lumière. *Germany and Austria.*—Trockenplatten. Nur bei rothem Licht zu öffnen. *Holland.*—Droge Platen. Slechts in sene donkere kamer te openen. *Denmark.*—Törreplader. Maa kun aabnesi mörkkammaret. *Norway.*—Fotografiplader. Maa kun aabnes vid rothlys. *Sweden.*—Törrplåtar. Oppnas endast i mörktrum. *Finland.*—Walokuvauslevyja. Saapi avata ainoastaan pimeässä huoneessa. *Italy.*—Lastre Fotografiche. Teme la luce. *Spain.*—Placas Fotograficas. No abrir sino en el cuarto oscuro. *Portugal.*—Chapas Photographicas. So' se deve abrir n'um quarto escuro.

LABELS, WATERPROOF INK FOR

Dissolve in 2 oz. of hot water $\frac{1}{4}$ oz. of borax, add $\frac{1}{4}$ oz. of shellac, and simmer gently until as much of it as possible has dissolved. When cool, decant the clear liquid and mix with Indian ink or finely powdered lampblack to a suitable consistency.

LAC (*See* "Gums and Resins.")

LACMUS (*See* "Litmus.")

LACTIC ACID (Fr., *Acide lactique;* Ger., *Milchsäure*)

$C_3H_6O_3$ or $CH_3CH(OH)COOH$. Molecular weight, 90. Miscible in all proportions with water and alcohol. A colourless, thick liquid, obtained from sugar by the lactic ferment, and used in the platinum toning bath.

LAMBERTYPE

A carbon print with an enamelled surface. A glass plate is polished with a solution of 5 grs. of beeswax in 1 oz. of benzole and is then coated with enamel collodion and dried. The exposed carbon tissue is squeegeed on the plate, developed in the usual way, and the final support for the tissue is squeegeed into contact. When quite dry the collodion-supported image is detached from the glass.

LAMPLIGHT EFFECTS

Lamplight scenes which do not include figures present no difficulty, providing a sufficiently long exposure can be given. Out-of-door lamplight effects are described under the heading "Night Photography." Indoor lamplight effects, with figures, may be obtained by concealing a piece of magnesium wire in the lamp, which is preferably provided with a globe or shade, or by having the magnesium in such a position as to give the effect of the light coming from the lamp, as described in the article, "Candle-light Effects."

Daylight can also be used, and the following is H. Essenhigh Corke's method. An imitation or dummy lamp is used. First, a real lamp, alight, is photographed and the image enlarged to the same size as the lamp. The enlargement is mounted on cardboard, which is then cut to the outline and a strut placed at the back. The dummy lamp can be placed anywhere in the scene, and in the finished photograph cannot be told from a genuine lamp. The lamp and sitter are arranged near a window, of which all except a small space is blocked up in such a way that a strong light appears to come from the lamp and fall upon the sitter, the light tones graduating into darker ones on parts of the drapery and surroundings. The "lamp," being of thin cardboard, does not throw a perceptible shadow; but a certain amount of light must fall upon its face, in order that the details may be shown. It may be necessary to use reflectors, as in ordinary portraiture. For lamplight effects it is more natural to retain almost all the shadow detail, and not, as in firelight effects, regard only the high lights and half-tones. Exposure will vary, and must be a matter for experiment. The prints should be stained with an orange-coloured dye, such as eosine and methyl-orange aniline colours, or carbon prints on a suitably coloured support may be made.

LAMPS, ARC (*See* "Arc Lamps" and "Electric Light.")

LAMPS, DARK-ROOM (*See* "Dark-room Lamp.")

LAMPS, MAGNESIUM (*See* "Flash Lamp.")

LAMPS, SPIRIT (*See* "Spirit Lamps.")

LANDSCAPE, CLOUDS IN

Clouds in landscape photographs not only fill a space that might otherwise be blank, but they form an essential element in completing a picture, in its composition, and its balance of light and shade. Careful attention must be given to the depth or general tone of the sky, and also to the intensity or contrast in the clouds themselves. Clouds may appear brilliant to the eye, but it must be recognised that their scale of tones is short when compared with that of the landscape. When clouds are included successfully on the same plate as the landscape, their depth of tone may be made to harmonise with the landscape by the methods given under the headings "Harmonising Contrasts" and "Control in Printing." When they are printed in from a separate negative (*see* "Clouds, Printing in"), the depth of printing can be controlled so that they may still appear to be in harmony with the tones of the landscape. A common fault is the rendering of clouds much too strongly, in tones that are too heavy or too brilliant for the picture. The forms of the clouds and their grouping are frequently of the greatest value in completing the composition of a picture, especially in simple subjects that consist of a few well-defined masses, and have, in addition, a large proportion of sky. The masses of cloud may form a line that will balance or harmonise with the principal lines in the picture, or the clouds may be so grouped that their principal points or lights may balance the chief point of interest in the landscape.

LANDSCAPE, FIGURES IN (*See* "Figures in Landscapes.")

LANDSCAPE LENS (*See* "Lens.")

LANDSCAPE PHOTOGRAPHY

In modern landscape photography the hand camera has naturally taken a very prominent place, but it must be recognised that the best work in landscape photography results from studying and arranging the picture on the focusing screen, this generally involving the use of a stand. As on many occasions good subjects can be obtained when the use of a stand and the deliberate arrangement of the picture are impracticable, a "hand or stand" camera is the most convenient for landscape work. At times, a picture may be studied on the focusing screen, the best point of view selected, and then the exposure made when all the conditions are favourable by holding the camera in the hand. This method is specially applicable to village scenes, and occasionally to landscapes with animals.

For general landscape photography the camera should have a rising front, a swing back, and should be capable of extending to twice the length of the plate. In all positions it should be quite firm and rigid. The tripod should be firm and capable of adjustment to any height from 3 to 5 ft. The lens should preferably be a modern anastigmat with a full aperture of $f/8$; this will cover the plate with uniform sharpness without reducing the aperture, and at $f/11$ the rising front may be used to a considerable extent without loss of definition. The best proportion

of focal length is about $1\frac{1}{4}$ times the longer side of the plate, this giving good perspective effect without unduly dwarfing the distance. A lens of longer focus prevents many subjects from being composed satisfactorily, owing to various obstacles making it impossible to take a point of view sufficiently far from the principal part of the subject to secure a satisfactory proportion ; while a lens of short focus has a tendency to exaggerate the difference between the near and distant parts of the picture. At times, however, a wide-angle lens having a focus a little shorter than the longer side of the plate is very useful, especially when the subject includes tall trees or high buildings and the space is limited. The shutter should be of the "time and instantaneous" pattern ; and it is desirable that all exposures of less than five seconds' duration should be made by the shutter rather than by the cap. It is difficult to make a short exposure by means of the cap in brilliant sunshine without causing slight fog through the sun striking the photographer's hand, and being reflected into the lens when removing or replacing the cap ; with a shutter there is no such risk. At times, too, the wind is very troublesome, and it is necessary to wait patiently for foliage to be reasonably still, even for an exposure of one second. With a shutter provided with a pneumatic or an Antinous release, the photographer can watch the moving foliage carefully, and as soon as the conditions are favourable for making the exposure he can press the bulb without turning or giving any attention to the camera. By pressing and releasing the bulb of a shutter set for "time" as quickly as possible, an exposure of a quarter of a second can be given, this allowing of photographing figures in the mid-distance, moving slowly towards the camera, without showing movement. The plates used should be rapid, and be backed.

It is in the selection, the arrangement and the method of treatment of a subject that the photographer shows his individuality. A feeling for composition is essential for successful landscape photography. The necessity for composition arises from the fact that the photographer takes a small portion of the landscape and encloses that portion in an artificial boundary composed of four lines forming a rectangle. It is essential that the small fragment of the landscape should convey the impression that the photographer desired to express, and one of the first conditions is that attention should be drawn from the boundary lines and into the picture towards the principal part of the subject. Every picture should consist of foreground, mid-distance and distance, the principal object or point of interest being in the near mid-distance. This will naturally demand primary attention, but the foreground requires almost as much. Most landscape photographers pay too little attention to the foregrounds of their pictures, thereby sacrificing much of their quality. In the foreground the gradations of light and shade are much more strongly rendered than in any other plane ; and this strength has very great value in giving the effect of atmosphere and in causing the other planes to recede and take their correct position.

In selecting the point of view, it should be remembered that the lower the point of sight the more the foreground is shortened, and small foreground objects appear more important ; while a very high point of view will frequently give the impression of the ground running uphill.

Reducing the aperture of the lens becomes necessary in almost all landscape photography to secure sufficient sharpness of definition in the various planes. The nearer the foreground to the camera, the smaller will be the stop necessary ; but the shorter the focus of the lens, the greater will be the range of distances that can be rendered sharply with a given value of stop.

Sunshine is very effective in most landscape work, especially when striking shadows break up an uninteresting foreground, or cause unequal lighting of the important and unimportant parts of a subject. Frequently, an oblique light—strong sunshine almost at right angles to the direction of the view—is very impressive.

LANGE'S DEVELOPER

The "washing soda" or "dry pyro" developer once popular ; recommended by Paul Lange, of Liverpool, in 1890, for developing "snapshots" taken on ordinary plates. It is still a favourite amongst many photographers, who have no objection to yellowish negatives, and who prefer to add dry pyro at the time of use. The formula is :—

Washing soda	$2\frac{1}{2}$ oz.	137·5 g.
Potass. bromide	25 grs.	3 ,,
Water (boiling)	20 oz.	1,000 ccs.

For developing a quarter-plate, to $\frac{1}{2}$ oz. of above, add $1\frac{1}{2}$ oz. water, and 2 to 4 grs. of pyro, according to density required.

LANTERN

By this term is nearly always meant the optical or projecting lantern, for which, *see* "Enlarging Lantern" and "Optical Lantern." For the opaque lantern, *see* "Aphengescope." Many dark-room lamps are actually lanterns.

LANTERN PLATES

Specially prepared plates used for making lantern slides, and much slower than those used for negative work. In their manufacture the one object in view is their capacity for producing a clean and sparkling image of good gradation, with a very transparent character of the deposit of silver. The British standard size is $3\frac{1}{4}$ in. by $3\frac{1}{4}$ in. ; American and Continental, 4 in. by $3\frac{1}{4}$ in. But in both cases the slide is usually masked to give an image not exceeding 3 in. by 3 in.

There are two distinct kinds of lantern plates : (1) ordinary, for contact printing by artificial light and for reduction in the camera by daylight or artificial light ; and (2) "gaslight," for contact printing only. The former must be manipulated in the dark-room illuminated as for bromide paper ; the latter may be developed, etc., in weak white light, the same as gaslight paper. For details of working, *see* "Lantern Slides."

LANTERN SLIDES

Transparent positives, for projecting by means of the optical lantern, are made in England

to a standard size of $3\frac{1}{4}$ in. square. Specially prepared slow plates are used, the object being to secure a fine transparent quality in the image, combined with good rendering of gradation and cleanliness in working. A good slide should be very transparent ; that is, there should be an absence of any tendency towards clogging or opaque appearance ; the deepest shadows should be strong so as to give a rich colour when projected. There should be scarcely any part absolutely white or free from deposit, and the range of gradation should be as perfect as possible, with full detail in both light tones and shadows.

Plates of two kinds are used. One corresponds in speed and character with the papers used for developing in weak gaslight, while the other is similar to a slow bromide paper in speed, but differs materially in character. The first kind will be considered later. For the second kind a yellow light is the most satisfactory when developing, etc., and there is a wide range in speed, the faster varieties yielding black tones only, while the slower ones give readily any tone from warm brown to black by simple modifications in exposure and development. These plates are sufficiently rapid for producing slides by reduction in the camera by daylight or artificial light, using a condenser in the latter case ; or they may be employed with equal facility for contact printing by artificial light. An ordinary camera is employed for making slides by reduction in daylight.

Any adjustable camera may be used, provided that it is not smaller than $3\frac{1}{4}$ in. square. There must be a frame to hold the negative parallel with the sensitive plate, and at a suitable distance in front of the lens. In adjusting the distances of the various parts of the apparatus, the same proportion of the focal length of the lens will be required as in enlarging, but with this difference : the greater distance will be that between the lens and the negative ; the smaller, the distance from the lens to the sensitive plate on which the image is produced. The space between the lens and the negative must be correct in so as to exclude as much extraneous light as possible, or the slides will suffer considerably, both in gradation and brilliancy. The apparatus should be pointed towards a window, preferably one that commands a clear sky view, in the same manner as in enlarging by daylight.

In making slides by reduction in an artificial light enlarging apparatus, the only difference in setting will be the distance from the lens to the easel and the extension of the camera body, these distances being the same proportion of the focus of the lens as in enlarging by daylight. With some enlarging lanterns in which the source of light is an incandescent gas mantle there is much greater risk of an image of the mantle being projected on to the easel in reducing for slide making than in enlarging. This can be entirely prevented by interposing a piece of ground glass between the condenser and the light.

Definite data for exposures cannot be given. With the slowest of the plates suitable for camera reduction, the exposure may range from fifteen seconds on a clear spring day, using $f/16$, and a thin negative, when working for black tones, up to as much as eight times as long for warm colours. Strong negatives will require much

longer, and some of the more rapid plates will be fully exposed with one-fourth of these times. For artificial light, as described, these exposures would be correct if $f/8$ were the lens aperture used.

For contact printing, magnesium ribbon forms the best illuminant, especially when warm colours are desired. The colour and quality of the light influence the colour produced by development. For black tones, 1 in. of ribbon at a distance of 6 ft. will be sufficient for a medium or thin negative, or 4 in. at 3 ft. will yield a good warm tone.

The colour of the image depends on two factors, exposure and development. The minimum exposure that will produce a well-graded image with sufficient strength in the shadows and full detail without any mass of clear glass in the high lights is that which must be given for pure neutral black tones. For a warm black, the exposure must be doubled, and for various tones of brown, deep or rich, from four to eight times the minimum exposure will be necessary. The exposure may be increased even beyond this with some plates, very warm brown and red-brown colours being obtained by increasing the exposure up to sixteen times the minimum. For neutral black tones any of the developers given for bromide printing will give the best result. For warm black and brown, pyro and soda will give excellent transparency and quality. Potassium bromide will be found the best restrainer. Most of the additions suggested by some photographers for obtaining warm tones clog the shadows and produce a semi-opaque deposit that spoils the effect of a slide when projected. Potassium bromide added liberally will produce the same degree of warmth combined with great transparency and fineness of quality. Other developers may be used instead of pyro by adding potassium bromide in the same way.

The following are typical formulæ, the developer being prepared from the usual stock solutions :—

For deep brown tones—

Pyro	.	.	15 grs.	3·5 g.
Potassium bromide		$7\frac{1}{2}$,,	1·75 ,,	
Sodium carbonate	60–120	,,	14–28 ,,	
Sodium sulphite	60–120	,,	14–28 ,,	
Water	.	.	10 oz.	1,000 ccs.

For rich brown tones—

Pyro	.	.	15 grs.	3·5 g.
Potassium bromide	15–30	,,	3·5–7 ,,	
Sodium carbonate	60–120	,,	14–28 ,,	
Sodium sulphite	60–120	,,	14–28 ,,	
Water	.	.	10 oz.	1,000 ccs.

Begin with a small quantity of the sodium carbonate solution, increasing to the larger amount if necessary. Development will take from six to twelve minutes. If the development is begun in the more highly restrained solution, and the exposure should prove to be insufficient, the plate may be transferred to the less restrained, and a good slide should result ; and, if development is begun with a small quantity of sodium carbonate, and this should prove insufficient, adding more will not detract from the quality of the slide, but will modify the colour. This method of working allows very great latitude in exposing, as the

development may be modified, during its progress, to suit the exposure.

After development, the plate should be washed in two or three changes of water and then fixed, preferably in an acid "hypo" bath containing 1 oz. of potassium metabisulphite to 1 lb. of "hypo," diluted so that 1 pint of solution will contain 3 oz. of "hypo." The plates should remain in the fixing bath for ten or twelve minutes. The developer for use with plates that are developed in weak gaslight is the same as that given for gaslight papers. Restraining by means of bromide may be adopted for securing warm tones. The same pyro developer may be used, or an equally large proportion of bromide may be added to an amidol or other developer. With these plates a longer range of tones may be secured, a good red and red-brown being easily obtained by increase of exposure and restraining. The image produced on these plates is exceptionally transparent and fine in grain. Even when strong, the image presents the appearance of a stain rather than a deposit.

The clearing of lantern slides should be unnecessary, if an acid fixing bath is used; otherwise proceed as explained for negatives under the heading "Clearing Solutions."

LANTERN SLIDES, DIAGRAMMATIC

Lantern slides of diagrams and other line subjects may be made in many ways, as, for example, the following : (a) Copying through the camera and printing the slide by contact from the negative ; (b) printing from the drawing itself, which serves as a negative ; and (c) the use of specially prepared glasses on which the diagrams may be drawn direct and serve as slides.

(a) The copying of the diagram through a camera is advisable in most cases, because the image can be reduced if necessary so as to come well within the limits of a lantern slide. Take care to obtain strong contrasts—the whites opaque and the lines clear. Should it be desired to show the diagram reversed as regards white and black—that is, white lines upon a black ground—the negative itself may be cut down to 3¼ in. square and used as a slide, or the diagram may be copied on a lantern slide direct, through the camera.

(b) The second method is of particular service when drawings are to be made specially for lantern slide work. A piece of white paper, thin and comparatively grainless, is cut to the size of a lantern slide. The drawing is then made on the paper in black ink, and used as a negative, a lantern slide being placed in contact with it and printed in the usual manner. The slide will show the blacks and whites reversed. Should a black line slide be required, the slide just prepared may be used as a negative and another slide printed by contact from it.

(c) This is not strictly a photographic process. Plain glass plates are coated with ground glass varnish, made as follows :—

Sandarac	.	100 grs.	23 g.
Gum mastic	.	100 ,,	23 ,,
Methylated ether	.	10 oz.	1,000 ccs.
Benzole	.	2 ,,	200 ,,

When dry it gives a surface which takes the pencil well, and any drawing or writing may be made. The slide may then be made transparent again by flooding with :—

Sandarac	.	150 grs.	34 g.
Gum mastic	.	150 ,,	34 ,,
Methylated ether		10 oz.	1,000 ccs.

which destroys the grain and leaves the drawing on what appears to be plain glass. Another plan is to use a special ink (see "Ink for Glass, etc."), while another is to use the finest ground glass obtainable, and after making the drawing, to destroy the grain by coating it with gum dammar dissolved in benzole. If white lines on a black ground are wanted, plain glass plates may be smoked by holding them over burning camphor, or by coating them with Brunswick black or other opaque pigment, and then scratching with a needle-point.

LANTERN SLIDES, MASKING, BINDING, AND SPOTTING

When a lantern slide is developed, fixed and washed, it requires finishing in such a manner that it can be shown effectively in the lantern, and handled without injury. The picture requires masking, that is, the portion of the plate not required needs to be covered with opaque paper, so that the picture is isolated on a dark screen, the edges being sharp and true as in a well-trimmed print. Lantern-slide masks are obtainable with openings of various shapes and sizes, but a serious worker soon finds it difficult to adapt them to his requirements. A print should be trimmed to a nicety, so as to include the amount of subject desired, and no more. Using commercial masks is like using untrimmed paper of a uniform size for prints ; while it might answer in many cases, it fails frequently. A favourite plan with some workers is to cut a number of slips of thin opaque paper slightly less than 3¼ ins. long, and varying in width from ¼ in. to ¾ in. Four such slips can be attached to the film of the slide with a touch of gum at each corner, they can thus be arranged to cut off the subject exactly as required. By keeping these slips true to the edges of the plate, rectangularity of the opening is secured.

Before or after binding, the slide requires spotting. Two prominent spots have to be applied for the purpose of indicating to the lanternist the correct position for inserting the slide in the lantern. These spots must be at the two top corners on the face of the slide, film side towards the operator.

There are two methods of binding a cover glass to the face of the slide so as to protect the film from injury. The first is adopted by those who make lantern slides commercially on a large scale. A strip of gummed paper about 15 in long is moistened and attached to the four edges of the two plates, the corners being deftly mitred. The second method is to apply four separate short slips, one for each side, and it is much easier to bind a slide neatly and securely by this method. Short binding slips for attaching in this manner are obtainable, or binding slips may be made by the worker. A thin paper should be used, and gum has to be applied when ready for using. An advantage of cutting binding slips is that they may be made wider, and so hold the plates together more firmly.

LANTERN SLIDES, TWO-COLOUR TONING OF

In slides showing floral pictures, Somerville tones the leaves green by means of vanadium, and the flowers to another colour, say red or brown, which is given by the copper or sulphide toner, all the solutions being applied with a brush. A light or blocked-out background.

LANTERNOSCOPE

A viewing box for lantern slides, fitted with eyepiece or magnifying lens.

LAPIS INFERNALIS

An old name for silver nitrate (*which see*)

LATENT IMAGE (Fr., *Impression latente;* Ger., *Latentes Bild*)

The action of light upon many sensitive substances is at once visible by a change of colour, as in the darkening of silver or bichromate salts on paper. This is known as a direct light action. In other cases there is no visible change, and the exposed material has to be treated with some agent, usually termed the developer, which renders the action of light visible. The action of light is thus said to produce a latent image, which is of such a nature that the result of the light action cannot be quantitatively or chemically recognised.

The exact nature of the latent image has been a subject of much dispute, but the theories may be divided into two sections, the physical and the chemical. Advocates of the former consider that the action of light is to produce some change in the physical character of the silver salts, whilst the adherents to the chemical theory assume that there is an actual chemical change and the formation of a lower haloid salt, which is usually called a subhaloid.

Bearing in mind that it has been proved by Dewar that a photographic plate possesses the power of forming the latent image at temperatures closely approaching absolute zero, whilst every other known chemical action ceases at a much higher temperature, it may be asked why the photo-sensitive salts of silver should be an exception. Dr. Bose, a well-known physicist, would liken the formation of the image to the strain of the silver salt under the electric force in the light-wave, a theory known as that of molecular disturbance or strain theory. According to this, the silver bromide is converted into an allotropic form, which is more readily reduced to the metallic state than the normal silver haloid, and the function of the sensitiser is then to retard the recovery from the strain. There are undoubtedly many parallels between the strain phenomena in metallic silver and other substances under the electro-magnetic radiation of light and the effects of exposure of the photographic plate. But this theory hardly explains the various latent images which may be formed on the silver haloids, for instance with silver bromide and iodide. In the former case, so far as experience goes, the latent image is permanent, whilst with iodide there is retrogression of the image or it fades away, and the sensitive salt returns to its non-developable original state. It is stated above that the physicist looks upon the sensitiser as a substance which prevents the recovery from the strain, and a correlative action has been found in the case of calcium oxalate for pure electric response from mechanical and light stimuli. When the action of light is permanent—that is to say, no matter how long the exposed sensitive material be kept the product of the light action, the latent image, may be developed. This is then known as an irreversible action; but if, on the other hand, the latent image reverts to its original and undevelopable condition, the action is reversible, and assuming that the formula for silver subiodide be taken as Ag_2I, then this may be expressed by the following equation :—

$$5\,AgI \underset{\text{In darkness}}{\overset{\substack{\text{In light}\\ \longrightarrow}}{=}} 2\,Ag_2I + AgI_3$$

That is to say, in light the five molecules of AgI are split up into two molecules of subiodide, Ag_2I, and one molecule of silver triiodide, AgI_3, whereas if such a mixture be kept in the dark, the two molecules of subiodide and one molecule of triiodide rearrange themselves and reform five molecules of silver iodide. Now as this action takes place in the presence of gelatine, but does not take place in the case of silver bromide, it seems a somewhat difficult point to explain from the point of view of the physicist.

Another physical theory is that the silver salts are charged electrically, and that the action of light is to ionise them or set free the electrons, and in support of this theory is advanced the fact that the photo-salts of silver are vigorously electric and in the order of bromide, chloride, and iodide, which is the same as their order of sensitiveness to ultra-violet light. As considerable support to this theory is also adduced the fact that eosine, fuchsine, cyanine, and other dyes set free electrons under the stimulus of light, and that the particular wave-lengths absorbed by these substances are those which are most effective in liberating the electrons. In other words, the photo-electric activity displayed is dependent upon their colour absorption, and there is thus an exact parallel with the sensitising power of these dyes for the photo salts of silver.

The chemical theories assume the decomposition of the silver bromide, and that bromine is given off; and if the formula for silver bromide be written Ag_xBr_x, in which x merely represents a given number of atoms of each element, the latent image could be described as Ag_xBr_{x-y}, in which y is merely a certain number of bromine. In support of this theory it must be noted that it is by no means so easy to destroy the latent image; nitric acid, potassium cyanide, ferricyanide, and acid bichromate do not entirely destroy it, and it is possible to fix an exposed plate, and yet physically develop it afterwards so as to obtain a good image.

Other chemical theories are that metallic silver is produced, but this has been proved to be untenable, as strong nitric acid would dissolve silver, but does not destroy the latent image. Another chemical theory is that a subsalt is formed, but the latter forms a solid solution with the silver bromide in varying proportions.

At present, at any rate, no definite conclusion as to the nature of the latent image can be formed, and the position is probably best summed up in the words of Dr. Joly in his presidential address to the Photographic Convention in 1905 : " The latent image is built up of ionised atoms, or molecules, the result of the photo-electric effect upon the illuminated silver haloid, and upon these ionised atoms the chemical effects of the developer are subsequently directed. It may be that the liberated electrons ionise molecules not directly affected, or it may be that in their liberation they disrupt complex molecules built up in the ripening of the emulsion. With the amount that we have to go upon, we cannot venture to particularise. It will be said that such an action must be in part of the nature of a chemical effect."

In connection with this subject it should be pointed out that Dr. Scheffer, of Berlin, has been able to obtain photo-micrographs of the image on silver bromide, and these prove that there is some sort of thread formation or protrusion of a filament from an exposed sensitive grain, which would certainly point to disruption of the complex ; but this might agree with both the physical and chemical theories, as in the former case it would represent the disruption of the particle, and in the latter case the extrusion of the sub-bromide.

Meldola has assumed the formation of an oxy-haloid, but the objection to this is that the latent image can be formed under gases and in the presence of substances which preclude entirely free oxygen, which would be necessary for this formation.

From a series of experiments on development with the indoxyl compounds, Homolka advances the theory that the latent image is an equi-molecular mixture of sub-bromide and per-bromide of silver, which is formed according to the equation :—

$$3AgBr = AgBr_2 + Ag_2Br$$

| silver bromide | sub-bromide | per-bromide |

The existence of per-bromide has also been tentatively established by Lumière and Seyewetz, but further proof is required.

LATERAL INVERSION (See "Inversion, Lateral.")

LATITUDE OF PLATES AND PAPERS

In negative-making variations may be made in exposure, within moderate limits, without any loss of printing qualities. The latitude is, however, influenced considerably by the subject and the conditions. A subject with good contrast, or exposed in a clear and brilliant light, will allow more latitude than one deficient in contrast exposed in a dull light. With the latter and in copying, there is practically none at all.

It must be recognised that it is only in over-exposure that latitude can really exist. Loss of quality is inseparable from under-exposure. In all subjects, however, it is possible to compensate for errors in exposure to a moderate extent, if the error is known before commencing to develop. A modified solution may be applied that will have the property of compensating for the extra exposure given. (See also " Exposure, Incorrect.")

With regard to papers, in a platinotype print there is practically no latitude ; in a cold bath the development may be shortened to save an over-exposed print, but the result is distinctly inferior. An over-exposed silver print may be slightly reduced by a long immersion in the combined toning and fixing bath, but the quality suffers. A carbon print has more latitude than any other photographic printing process, as errors can be compensated when the print is partially developed : that is, the stage at which the error is discovered. Within moderately wide limits, the loss of quality is inappreciable. With bromide prints a moderate latitude could be secured by modifying the developer before commencing to develop. After development is commenced, compensation can only be made for over-exposure by shortening the duration, but this produces results that are so inferior to those produced by correct exposure and full development, that it cannot be called true compensation.

LAURUS CAMPHORA

Camphor or, more accurately, the botanical source from which camphor is obtained.

LAVENDER RAYS

A term (now practically obsolete) applied to the commencement of the ultra-violet rays just beyond the visible violet.

LAVENDER, OIL OF (See " Spike Oil.")

LEA, M. CAREY

Born at Philadelphia, 1823 ; died at Philadelphia, 1897. Experimentalist and writer on photographic matters, who spent much of his time in England, and did much valuable work in photography. One of his early inventions was a plate-cleaning solution, composed of potassium bichromate and sulphuric acid, often referred to as the " Carey Lea " mixture. His ferrogelatine developer (1865) consisted of a chemical combination of gelatine with the ordinary iron developer as used for the wet-plate process. He published (also in 1865) a process of intensification by means of Schlippe's salt. In 1875 he worked out a washed collodion emulsion, and in June, 1877, published the first formula for a ferrous-oxalate developer. His investigations regarding the properties of red silver chloride are of great interest to the student of colour photography.

LEAD (Fr., *Plomb* ; Ger., *Blei*)

Pb. Molecular weight, 207. A bluish-grey soft metal obtained from native lead ores by roasting. It is used for making dishes and sinks owing largely to its acid-resisting properties and to its softness.

LEAD ACETATE (Fr., *Acetate de plomb* ; Ger., *Bleiacetat*)

Synonyms, sugar of lead, normal plumbic acetate. Pb. $(CH_3COO)_2 3H_2O$. Molecular weight, 379. Solubilities, 1 in 2·3 water, 1 in 30 alcohol ; insoluble in ether. All lead salts are poisonous, the antidotes being emetics and the use of the stomach pump, and also sodium,

potassium or magnesium sulphate, milk or white of egg. Efflorescent colourless crystals or masses with acetous odour and sweet taste obtained by dissolving lead carbonate in acetic acid. It is used in some combined toning and fixing baths.

LEAD CHROMATE (Fr., *Chromate de plomb*; Ger., *Chromsaures Blei*)

$PbCrO_4$. Molecular weight, 323. Insoluble in water and alcohol. Poisonous (*see* "Lead Acetate"). A yellowish brown powder obtained by precipitation from a soluble lead salt and a chromate. It is used as a pigment, and also forms the colouring matter of orange fabric—a dark-room medium. A good orange safe light may easily be prepared by immersing a fixed-out dry plate for five minutes in 5 per cent. potassium chromate solution, rinsing, and then immersing in lead nitrate or acetate solution, washing and drying.

LEAD FERRICYANIDE

This is always prepared in solution by mixing lead nitrate with potassium ferricyanide, and it is used for intensifying collodion negatives.

LEAD INTENSIFIER

An intensifier used for negatives of line or black and white subjects in which no half-tones appear; it gives great contrasts and is not recommended for ordinary negatives. Immerse the well-fixed and washed negative, until thoroughly bleached, in the following :—

Potassium ferri-		
cyanide . .	300 grs.	68 g.
Lead nitrate .	200 ,,	45 ,,
Nitric or acetic acid	50 mins.	10 ccs.
Water . .	10 oz.	1,000 ,,

Next rinse in weak nitric or acetic acid (1 in 15), wash thoroughly and blacken with ammonium sulphide, 1 part; water, 10 parts. Clear again in weak acid and wash thoroughly. The bleaching and blackening may be repeated until sufficient density is obtained, if care is taken always to wash thoroughly, as any trace of lead remaining in the negative will inevitably cause fog. Great care is also necessary when handling the film, as the acid makes the film very tender.

Other blackening agents besides the ammonium sulphide given above may be used after bleaching in the lead solution. The following have been recommended :—

(*a*) Water, 20 oz.; sodium sulphide, 1 oz. (*b*) Water, 20 oz.; Schlippe's salt, 90 grs.; ammonia, ¾ oz. (*c*) Water, 20 oz.; liquor ammoniæ, 1 oz.; potassium bichromate, 2 oz.

In process work the lead intensifier is largely used for wet collodion negatives for line reproduction. It is not so generally used for half-tone, but has been recommended in collodion emulsion work. Lead intensification has been largely superseded by the copper bromide intensifier in half-tone work; it survives for line work because of its cheapness.

LEAD NITRATE (Fr., *Azotate de plomb*; Ger., *Bleinitrat*)

$Pb(NO_3)_2$. Molecular weight, 331. Solubilities, 1 in 1·85 water; almost insoluble in alcohol.

White translucent crystals prepared by the action of nitric acid on lead or lead carbonate. Poisonous (*see* "Lead Acetate"). It is used in the lead intensifier and in the combined toning and fixing bath.

LEAD, SUGAR OF (*See* "Lead Acetate.")

LEAD TONING

Albumen and gelatino-chloride prints may be toned with lead acetate. The colouring is due to sulphuration and the results are not permanent. A simple formula is :—

Lead acetate	. .	½ oz.	27·5 g.
Sodium hyposulphite	.	4 ,,	220 ,,
Water	. . .	20 ,,	1,000 ccs.

The above is a "combined" toner and fixer as well. The tone obtained is due to the formation of lead sulphide. There are many other formulæ.

Messrs. Lumière have found that by employing salts of lead made from di-, tri-, tetra- and penta-thionic acids, mixed with a solution of "hypo," a toning and fixing compound can be obtained, which, without gold, gives warm tones, and with gold colder tones.

Lead acetate is often used in conjunction with gold in many of the combined toning and fixing baths. The following is typical :—

Sodium hyposulphite.	5 oz.	275 g.	
Citric acid	.	60 grs.	7 ,,
Lead acetate	.	60 ,,	7 ,,
Ammonium sulpho-			
cyanide	.	200 ,,	23 ,,
Gold chloride	.	3 ,,	·35 ,,
Water	. .	20 oz.	1,000 ccs.

Dissolve all but the gold chloride in the order named in hot water, boil, filter, and then add the gold chloride.

LEATHER, PHOTOGRAPHS UPON

White leather was used by Wedgwood, Reade, and others in the early days of photography as a support for the sensitive silver salts. In the wet plate days collodion positives were sometimes made on black patent leather, the image appearing, of course, of a white or cream colour, like a modern ferrotype picture. Modern photographs upon leather are usually produced by the carbon transfer process, or by sensitising the leather with a suitable bromide or other emulsion.

Unless special precautions are taken emulsions will soon decompose when ordinary leather is prepared direct with a sensitive emulsion; in the same way the gold of toning baths decomposes, and the prints soon become spotty because of the chemical action of substances contained in the leather. To overcome this, it has been recommended that the leather be given a substratum of collodion of ½ to 1 per cent. strength. After twenty-four hours the leather may be coated with any sensitive emulsion and then treated in the same way as plates and papers.

LEIMTYPE

A process commonly associated with the name of J. Husnik, of Prague, who took out a

patent in 1887, but a very similar process was patented in Boston, U.S.A., in 1871, by W. H. Mummler. The object is to obtain images in high relief for direct typographic printing. A thick layer of bichromatised gelatine is exposed under a line negative, next attached by means of guttapercha to zinc or wood, and then developed with a solvent such as a saturated solution of an alkaline bichromate. This not only dissolves those parts acted on by light, but also strengthens the relief parts. After development, the plate is dried, and the hollow parts are filled with an opaque printer's ink by means of a camel-hair brush. The plate is then exposed for a second time to the action of light, by which it is hardened and strengthened in the lines.

LENGTHENING CAMERA

For copying, and in photographing small objects at close quarters, the bellows extension of an ordinary camera sometimes proves insufficient. The professional photographer in such a case makes use of a wooden tube or cone, fitting on the front of the camera and carrying the lens at the outer end, as illustrated. But

Wooden Extension to Camera

a good modern studio camera will usually have an extension adequate for any probable requirements. For smaller cameras, extension accessories of various kinds are obtainable, some being made to fit the front and others the back of the camera. (*See also* " Extension, Camera.")

LENS (Fr., *Lentille, Loupe, Objectif;* Ger., *Objectiv, Linse*)

Photographically, a lens is a combination of two or more glasses capable of producing an

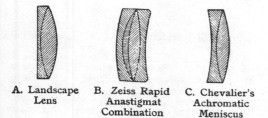

A. Landscape B. Zeiss Rapid C. Chevalier's
Lens Anastigmat Achromatic
 Combination Meniscus

image. Simple or " spectacle " lenses, consisting of one piece of glass, are occasionally used to obtain special effects, but the single achromatic combination may be taken as the starting point in the evolution of the modern

photographic objective. The elementary forms of lenses, as illustrated under the headings " Concave Lens " and " Convex Lens," made in a great variety of glasses and with widely differing curves, are used in combination to

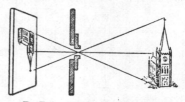

D. Principle of the Pinhole

build up the more or less complex objectives now in use. The simplest combination of these elements is found in the single " landscape lens " A, which is composed of a double convex lens of crown glass cemented to a plano-concave of flint glass, thus securing achromatism (*see* " Chromatic Aberration "); while the latest and most complex combination is found in the Zeiss anastigmat B, composed of four elements cemented together, two of such combinations forming the " Series VIIa Rapid Anastigmat." It will be convenient to deal with the principal types of lenses in groups, showing their gradual development, as improvements in the various forms have been and are proceeding simultaneously.

The action of a photographic lens may be better understood by considering what happens when a small bevelled opening is made in the shutter of a darkened room, as at D. Rays of light from all parts of any object outside—say, a church—are admitted by the aperture, cross each other, and proceed in straight lines to form an inverted image on the wall opposite. Photographs can, in fact, be made with a pinhole instead of a lens. Except with a very small opening, however, which means a long exposure, the image is blurred. By using a convex lens, as at E, which has the property of converging light rays and bringing them to a focus, a much larger aperture becomes possible, together with improved definition.

Single or Landscape Lenses.—In its primitive form, the single combination was nothing more

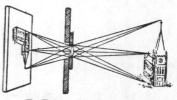

E. Principle of the Lens

than the object lens of a field glass. The first lens made specially for photography was of this model, and was issued by Chevalier, of Paris. This maker soon issued an improved model, now generally known as an achromatic meniscus C, which had a much wider field of definition and greater rapidity than its

predecessor. This was followed by Grubb's aplanatic F which departed from the telescope lens construction, being composed of two meniscus elements ; in this lens the relative positions of the crown and flint glasses were reversed, greater covering power and rapidity being thus

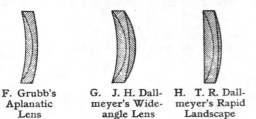

F. Grubb's
Aplanatic
Lens

G. J. H. Dall-
meyer's Wide-
angle Lens

H. T. R. Dall-
meyer's Rapid
Landscape
Lens

obtained as well as portability. The next forward step was made when J. H. Dallmeyer constructed a wide-angle landscape lens of three elements (see G), a concave flint being between two crown meniscus glasses. This covered the widest angle ever attained by any single lens, the longest side of the plate being equal to the focal length of the lens, while the curvilinear distortion was reduced to a minimum. By the use of different glasses, T. R. Dallmeyer constructed a lens on the same lines, covering a narrower angle, but working at the large aperture of $f/10$. This was known as the Rapid Landscape lens (see H) and was recommended for distant views, large heads, and subjects where pleasing perspective was preferable to wideness of angle. Still later, the same optician produced a non-distorting " single " lens, the " Rectilinear Landscape " I, which, although fitted with an outside diaphragm, was absolutely rectilinear. Its comparatively small aperture ($f/14$) prevented its general adoption, the rapid rectilinear with an intensity of $f/8$ being preferred. There is an internal air-space in this lens. A somewhat similar lens was produced by J. T. Goddard, but did not appear on the market.

Portrait Lenses.—At a very early period in the practice of the art the necessity for a rapid

concave flint. Both these early forms of portrait lenses were comparatively slow in action, and were superseded by the Petzval portrait lens K (introduced by Voigtländer in 1840), which, with little modification, is the standard lens for studio work at the present day. It gives greater

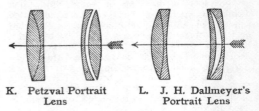

K. Petzval Portrait
Lens

L. J. H. Dallmeyer's
Portrait Lens

flatness of field, and the presence of an air space between the flint and crown elements of the back combination, gives perfect correction for spherical aberration. The only important modification in the design of the portrait lens was patented by J. H. Dallmeyer in 1886, improved covering power being obtained together with less liability to flare. This lens is shown in diagram L. In the Dallmeyer lens the position of the crown and flint elements is reversed, the crown element being a meniscus instead of a " crossed " double convex lens. These lenses are fitted in an adjustable cell so that the distance between them can be varied at will ; when placed closely together, sharp definition is obtained, while by separating them more or less " softness " results. The front combination of both types of portrait lens is frequently used alone, either for landscapes or for portraits, especially large heads. Small lenses of this form were used for rapid landscape work in the earlier days of the art, but at the present time they are rarely used except by naturalists and for night photography.

Doublet Lenses.—The want of rapidity and rectilinearity of the single lens and the bulk and cost of the portrait lens, caused attention to be directed to the production of lenses for copying, outdoor work, etc., which should be free from these defects. One of the earliest of these was the Orthoscope or Orthographic lens of Petzval

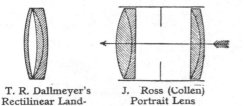

I. T. R. Dallmeyer's
Rectilinear Land-
scape Lens

J. Ross (Collen)
Portrait Lens

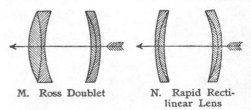

M. Ross Doublet

N. Rapid Recti-
linear Lens

lens was felt by portrait photographers ; and in 1841, Andrew Ross constructed a double combination lens J for Henry Collen. This consisted of two cemented combinations, one being placed at each end of a tube to which central diaphragms were fitted. In the same year Thomas Davidson produced a symmetrical lens for portraiture, this being composed of two similar combinations, each composed of a plano-convex crown cemented to a plano-

(made by Voigtländer in 1859). For this lens great claims as to flatness of field, rectilinearity and other virtues were made, although actually it possessed but little advantage over the single landscape lens. It had a greater equivalent focal length than the distance between any part of the lens and the focusing screen, or, in other words, it was to a certain extent a telephoto lens, the back combination being of the negative form. The orthoscope was succeeded, in 1864, by several doublets of various rapidities, but all

somewhat similar in type, designed by Thomas Ross (see M), and these enjoyed considerable popularity for many years, some being still in use. The next great stride towards perfecting the photographic lens was made in 1866 when Dallmeyer, in London, and Steinheil, in Munich, almost simultaneously issued lenses of the type which is so well known under the name of Rapid Rectilinear (see N), the original uncorrected form of Steinheil being designed for wide-angle work only. This lens, working at an intensity of $f/8$ or more, gave perfectly rectilinear images, having a fairly flat field and being free from flare or "ghost," and achieved immediate success. Lenses on similar lines, but slower in action, were constructed for wide-angle work, and no considerable improvement was made until the Zeiss and Goerz anastigmats appeared on the field in the early nineties of the nineteenth century. Rectilinear lenses were made by J. H. Dallmeyer with an intensity as high as $f/3$, while other forms, known as the "euryscope," "extra rapid rectilinears" or "universal symmetrical" had intensities of about $f/6$. The wide-angle rectilinears or portable symmetricals usually had a maximum aperture of $f/16$. An "actinic doublet" was achromatised for actinic effect; but modern doublets are achromatised for both the visual and actinic effects.

Anastigmatic Lenses. — Lenses of greatly improved design were introduced in 1890 by Carl Zeiss, of Jena, the first model being an apochromatic triplet, this being followed by a double combination which was greatly superior to all lenses then existing. Improvements have followed in rapid succession. The Series VII (see B) may be considered as being the most useful type of the Zeiss anastigmats, being truly universal in its character. The single lenses are perfectly corrected for astigmatism, spherical aberration and curvature of field, and are practically rectilinear. Their intensity is $f/12\cdot5$. Used in combination to form doublets they retain all their good qualities with the addition of greatly increased covering power, angles of 80° to 90° being obtained, while the intensity varies from $f/6\cdot3$ to $f/8$, according to whether lenses of similar or dissimilar focal lengths are combined. In 1893 an excellent series of double anastigmats was introduced by Goerz with an intensity of $f/7\cdot7$ afterwards increased to $f/6\cdot8$. Each combination is composed of three glasses cemented together. The single combinations may be used for landscapes, but do not work at the same large aperture as the Zeiss lenses. The Goerz "Pantar" lens, recently introduced, corresponds in rapidity to the Zeiss Series VIIa. Other opticians have placed on the market lenses corresponding to the Goerz model under various names.

The foregoing may be considered as the principal groups of lens types, but many other forms are described under separate headings.

In process work, it is essential that the lens should give perfect definition uniformly all over the plate, that it should be free from distortion and astigmatism, and give even illumination; and that it should be colour-corrected. For line reproduction it is not necessary to work with a large aperture, and therefore by stopping down extreme sharpness is obtained. In half

tone large apertures are not permissible on account of the action of the ruled screen. For the same reason the focus must not be too short; an equivalent focus of about 18 inches is usually considered best for a 15-inch by 12-inch plate. In colour reproduction without the ruled screen interposed large apertures are desirable to counteract the considerable lengthening of exposure due to the action of the colour filters. Process lenses have to be fitted with Waterhouse diaphragm slot in order to permit of variously shaped stops being used.

LENS ADAPTERS

Threaded brass rings which enable a lens to be screwed into other flanges than those for which it was originally screwed. In cases where the screw-threads on the lens and flange do not agree, and in the absence of an adapter, it is necessary to have for each lens a detachable front (*which see*).

LENS, POSITION OF STOPS IN

With the majority of lenses the position of the stop or diaphragm is determined by the maker, and in many modern lenses there is only just sufficient room to allow the iris to be fitted. In the case of a compound lens having front and back components of equal focal length, the diaphragm should be placed equally distant from each, but in the case of components of unequal focal length the diaphragm should be placed at a distance proportionate to the focal length from each lens—that is to say, a little nearer to the lens of shorter focal length—otherwise, the combination will not give rectilinear images. The diaphragms of single lenses are usually placed at a distance equal to the diameter of the lens, but this distance may be varied at discretion, a flatter field with a reduced circle of illumination being obtained when the diaphragm is placed farther from the lens. Flare spot is often due to an incorrect position of the diaphragm. Portrait lenses usually have the diaphragm midway between the glasses; but for outdoor work, the tendency to flare is greatly reduced by placing the diaphragm slightly in front of the lens, this somewhat reducing the size of the field covered.

LENSES, BRASSWORK OF

The term "brasswork" is applied generally to the metal cell which holds in place the various glasses of which a modern lens is composed, although both aluminium and brass are used for the purpose. The production of the brasswork demands the application of highly-trained skill and the use of machines which work with scientific precision. The screw threading must be efficient, and it is a matter for regret that all lenses are not threaded uniformly to one system. The Royal Photographic Society has recommended certain measurements and standards, which will be found under the heading "Mounts, Lens." It is necessary that the inside surfaces of the brasswork should be blackened to avoid producing cross reflections, which would seriously interfere with the efficiency of the lens. (For a method of blackening camera brasswork, see "Blackening Apparatus.")

LENSES, CEMENTING AND UNCEMENTING

Lens glasses are cemented together with Canada balsam, which needs to be specially prepared for the purpose. The balsam as bought should be put in a saucer and baked in an oven until, when cold, it will be hard. The hard balsam needs to be broken up, placed in a bottle and covered with benzene, allowed to stand for about twenty-four hours, and then gently heated over a water-bath until fluid. The lens glasses, having been cleaned with extreme care, should be gently warmed, and a drop of the warm balsam placed in the centre of the concave glass. Next the convex glass is pressed down into the concavity until the balsam has spread and oozed out at the edges. The lens is left for the balsam to harden, or this process may be hastened by gently heating in an oven of which the door is open. At the end of a few days any surplus balsam on the edges may be removed with a rag moistened with benzene.

A safe method of uncementing a lens is to place it (minus its mount) in a glass vessel, and to pour warm water upon it; the water is kept warm, by means of a spirit lamp or Bunsen burner, until the glasses can be slid apart. Should this fail, soak in turpentine.

LENSES, CLASSIFICATION OF

In the past, when photographic lenses were more limited in their capabilities, it was usual to designate them according to the class of work for which they were best adapted. Thus there were view lenses which were not adapted for architecture; portrait lenses of great rapidity but limited covering power; group lenses which were usually portrait lenses of a slower variety; copying lenses which were rectilinear but still slower in action, etc., etc. Under modern conditions the necessity for such classification has almost disappeared, as a good anastigmat will answer for practically any class of work, subject only to the angle which it is capable of embracing. Lenses for copying still form a class by themselves, as slight modifications in design are necessary to obtain the best possible covering power when the back and front conjugate foci are equal or nearly so.

LENSES, CLEANING

Careless cleaning must always be guarded against, and such a thing as vigorous rubbing with a harsh duster most strictly avoided. The proper methods of cleaning lenses are explained under the heading " Cleaning Lenses."

LENSES, CONDENSATION ON

In a damp atmosphere, moisture rapidly condenses upon a lens which is colder than the atmosphere itself. The trouble is especially likely to occur in early morning and towards evening, and in photographing in certain kinds of factories, underground workings, and at great heights where the atmosphere is highly charged with moisture. It is not a bad plan to carry the lens, enclosed in a wash-leather or other case, in a pocket of one's clothes to ensure its temperature being higher than that of the atmosphere. But in addition to this precaution, which may not always answer, it is necessary to watch for the condensation and, should it form, to remove it at once. The presence of condensed moisture on a lens makes photography hopeless.

The lanternist has especially to guard against moisture condensing upon either objective or condenser; and he should make it a rule to examine the lenses immediately before beginning an exhibition. A lantern brought from the cold street straight into a hall where people are congregated is sure to need attention.

LENTICULAR STEREOSCOPE (See " Stereoscope.")

LERMANTOFF'S STEREOSCOPE (See " Stereoscope.")

LETTERING NEGATIVES AND PRINTS

The advantage of lettering a negative rather than a print is that the work requires to be done but once, and then any number of prints can be made, each with the lettering printed upon it. The usual way of writing on a negative to produce white letters on the print is to write the title backwards on the film side with opaque pigment, such as red water-colour or Indian ink, applied with a finely pointed camel-hair pencil, in this way obtaining effective titles upon the shadow (clear) portions of the negative. The backward writing needs some little practice, and it may be found helpful to write the title properly upon the glass side, and then to follow the outline of the letters on the film side; while another plan is to write the title properly upon a piece of glass, lay the titled glass, inscription side downwards, upon white paper and use as a guide for the eye. Many methods of transferring the title to the film have been recommended; a good one is to write the title properly upon white paper with a fine pen and an ink made by dissolving either methyl-violet or eosine in water. When the ink is dry, the paper and the wet or damp film are brought into contact by pressing with the finger; the paper is then pulled away and the reversed lettering will be found on the film; it may easily be strengthened if necessary. A copying-ink pencil has been recommended in place of the dyes.

A transfer paper can be made by coating smooth paper with a thin solution of rubber in benzol, allowing to dry, coating with a thin solution of gelatine, and again drying. The title is written upon the gelatine surface with waterproof ink, and is transferred by trimming the paper to the proper size, and soaking it for a minute in cold water. It is then pressed on the film side of the negative, the superfluous water being removed with clean blotting-paper. The transfer paper is allowed to dry upon the negative, and is then moistened at the back with benzol, which dissolves the film of rubber, enabling the paper to be stripped off, leaving the thin gelatine film with the title beneath it upon the negative. Another method is to write the title upon a thin film of celluloid or tracing paper, and to stick it face downwards upon the film with a transparent adhesive.

To letter a negative so as to produce a black title upon the print, it does not suffice to scratch

the film with a sharp point, as this causes ragged lines; it is better to use a bleaching solution made by adding equal quantities of glycerine and liquid gum to tincture of iodine; the fluid should flow evenly from a quill pen. The title

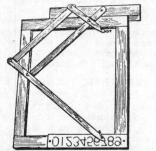

Numbering Negatives with the Pantograph

is written in the reverse way with this solution, which must be used with care and not allowed to spread. Immediately the lettering appears white right through the gelatine, wash the negative quickly in water to stop the bleaching action and immerse in a "hypo" fixing bath, which dissolves out the bleached letters and leaves clear glass; finally, wash and dry.

Numbering is not so difficult as lettering, and is, of course, done in the same way. The illustration shows how the well-known pantograph can be applied to the work. In a frame the negative is laid film upwards. At the lower end is placed a strip of metal on which is engraved a set of numerals reversed. The lower end of the pantograph is made to follow the outline of the desired numeral, this being reproduced on a small scale at the upper end by a pencil, stylus, or needle-point.

The following method may be adopted where the titles are required in neat type characters: Set up the titles in type and get a good proof on enamel paper. Photograph this impression, using a wet plate for preference. Then from this negative make a transparency. When this is dry, strip the film and attach it to the negative with an adhesive. This will give white lettering on dark ground. Black lettering on a light ground can be obtained by printing from a separate negative on to the paper or plate, using register marks to ensure exact position.

Titles on prints may be written in waterproof ink, black or white, each print being done separately, of course. The sensitive paper may be written on before printing, using Indian ink, red water-colour, etc., which, when toning and fixing, becomes washed away, leaving white lines. Finished prints may be written upon with the following chemical ink :—

Potassium iodide	.	170 grs.	40 g.	
Iodine	.	17 ,,	4 ,,	
Gum arabic	.	17 ,,	4 ,,	
Distilled water	.	1 oz.	1,000 ccs.	

This written upon the dark part of a silver print discharges the colour and appears white. Or, if preferred, a white pigment ink may be used. Black letters upon finished prints are made with black waterproof ink or by letterpress printing.

LEVEL, CAMERA (See "Camera Level.")

LEVELLING SLAB (Fr., *Dalle à niveler*; Ger., *Nivellierplatte*)

A flat, smooth plate of glass, slate, marble, or other material, either attached to a framework that may be levelled accurately by means

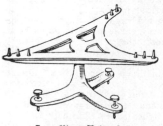

Levelling Slab

of screws at the corners, as illustrated, or intended for use on a levelling tripod (*which see*). Employed as a support for plates to be coated with emulsion, or for other purposes where a perfectly even distribution is indispensable.

LEVELLING TRIPOD (Fr., *Support à niveler*; Ger., *Nivelliergestell*)

A stand in the shape of a tripod, with screws at the feet for accurate levelling, as illustrated. It may be either large enough to support a

Levelling Tripod

levelling slab (*which see*), or sufficiently small to hold single plates, and is used to ensure a film of even thickness when coating plates with emulsions, etc.

LICHTDRUCK (Ger.)

An early name for the collotype process (*which see*).

LICHTKUPFERDRUCK

A photogravure process invented by J. B. Obernetter, of Munich, about 1886. From the original a negative was made and converted into a silver chloride positive, which was then placed in contact with a perfectly flat copper plate. The quantity of silver chloride thus deposited on the metal corresponds exactly to the intensities of the original; thus, in the darker parts there is a denser, and in the lighter parts a less deposit. By a simple galvanic process, the silver chloride is decomposed and is replaced by a soluble chloride and metallic silver.

The copper is by this means etched out, the depths corresponding to the amount of silver chloride in the different tones. The hollows of the plate are filled with ink for printing in the usual copper-plate manner.

LIGHT (Fr., *Lumière ;* Ger., *Licht*)

Light is generally considered to be due to minute undulatory waves in the ether that pervades all space. The molecules of any luminous body are in a state of rapid vibration, this movement being communicated to the adjacent ether particles and transmitted by a wave-like motion to the eye, the impact of the waves on the retina giving the sensation of light. In free space light moves with the velocity of 186,000 miles per second. It travels invariably in a straight line, in a medium of uniform density. Light falling on a mirror or other polished surface is either wholly or partially reflected, at an angle equal to that at which it strikes the reflecting surface. (*See* " Reflection."*) White light is not homogeneous, but a mixture of various colours, of different wavelengths. The colours of objects in Nature are not inherent in themselves, but due simply to their absorbing certain rays and transmitting others. (*See* " Colour."*) If a beam of light is caused to pass through a small opening or slit and to fall upon a prism, it is separated into its constituent colours. (*See* " Dispersion."*) Besides the visible rays of the spectrum so obtained there are others that are invisible. Those beyond the violet end of the spectrum are known as the ultra-violet rays, and are of great actinic power ; at the opposite end are the infra-red rays. If a prismatic spectrum is thrown on a sheet of white paper in a darkened room, and the region beyond the violet is painted with a solution of quinine sulphate, it will at once be illuminated with a violet light. It is thus seen that certain substances have the power of reflecting or emitting rays quite different from any that are originally thrown upon them. (*See* " Fluorescence."*) When a ray of light passes obliquely from one transparent medium into another of different density it is bent aside from its course. (*See* " Refraction."*) If light falls at an angle on a very thin film or plate it is partly reflected at the first surface, while part passes through, undergoes refraction, and is reflected back from the second surface in a direction parallel to the portion first reflected. The two sets of light waves will interfere with each other at certain points, in such a manner that the waves appertaining to one or more of the colours will be extinguished, so that the reflected light appears of a colour complementary to the missing rays. The particular rays extinguished will vary according to the obliquity of the incident ray and the thickness of the film or plate, so that if the film is of varying thickness a number of colours will be seen. It is in this way that the play of colour in a soap-bubble is caused, as also the phenomenon known as Newton's rings, which is turned to account in testing the figuring of lenses. (*See* " Interference of Light."*) When light from a bright point or slit passes through a minute aperture it emerges as a series of coloured bands ; the same effect occurs when light is reflected from a surface covered with a number of very fine indentations or scratches. (*See* " Diffraction."*) Certain crystals, such as Iceland spar, have the property of dividing a ray of light into two distinct refracted parts, one obeying the ordinary law of refraction, while the other has a peculiar law of its own. (*See* " Polarisation."*) Many substances continue to give out light in darkness after removal from the exciting source of light, a phenomenon known as phosphorescence (*which see*). (*See also* " Absorption " and " Spectrum.")

LIGHT, ABSORPTION AND REFLECTION OF

Absorption is dealt with under its own heading ; but, in one sense, it may be regarded as involving the obstruction of light. Thus, for example, a glass window absorbs the light falling upon it in the following percentages :—

Plain glass, clean	7 to 10 per cent.
Plain glass, dirty	40 per cent. and upwards
Ribbed glass	15 to 30 per cent.
Opaline glass	15 „ 40 „
Ground glass	30 „ 60 „

The following table gives the percentage of light reflected by various mediums. In nearly all cases the figures are merely approximate :—

	per cent.
Mirror	95
White blotting-paper	82
White cartridge paper	80
Ordinary foolscap	70
Newspapers	50 to 70
Planed deal (clean)	40 to 50
Yellow wall paper (clean)	40
White tracing cloth	35
Blue paper	25
Planed deal (dirty)	20
Yellow wall paper (dirty)	20
Brown paper	13
Macadam road	8
Chocolate paper	4
Black surface	1

To obtain the same density for the various colours on an ordinary plate as that given by white or blue light, the following approximately relative exposures must be given :—

Violet	2
Green	4
Greenish-yellow	30
Yellow	36
Orange	120
Red	1,600

LIGHT, CONTINUING ACTION OF (*See* " Continuing Action of Light.")

LIGHT, DIFFRACTION OF (*See* " Diffraction.")

LIGHT FILTER (*See* " Colour Screen or Filter.")

LIGHT FOG (*See* " Fog.")

LIGHT INTENSITIES, DIFFERENCE IN

Daylight varies in intensity according to the time of day and year, and also according to the

PORTRAIT BY H. ESSENHIGH CORKE, F.R.P.S.

A photograph in natural colours, taken on the Thames plate, and reproduced
by the four-colour process.

latitude. Further, the freedom or otherwise of the sky from clouds has an important influence. As the exposure of a sensitive plate is dependent on the intensity of light, it is important that this should be determined, and numerous tables have been published giving the variations, but of recent years the plan of actually testing the actinic power of the light by exposure meters has come into general use, thus doing away with the personal equation in the estimation as to whether the light is " bright," etc.

LIGHT RAYS, COLOURS OF

Every ray of the spectrum has its own particular colour, although the human eye is not sufficiently sensitive to differentiate between rays that are closely contiguous. (*See* " Spectrum.")

LIGHT, REFRACTION OF (*See* " Refraction.")

LIGHT STANDARDS (Fr., *Étalons de la lumière ;* Ger., *Licht-einheiten*)

Various units have at different times been adopted or recommended for comparing light intensities, such as the standard sperm candle, the amyl-acetate lamp, the Carcel lamp, the Methven screen, the pentane lamp, etc. These are dealt with under their respective headings. Acetylene has also been suggested for use. The British unit, the sperm candle (1 c.-p.), is subject to slight variations from different causes, and scientific workers now commonly prefer to use the pentane lamp. The Methven screen and the pentane lamp are each equal to 1 c.-p. and are equivalent to 1·14 Hefner-Kerze, or " H. F." (amyl-acetate lamp) ; while the Carcel lamp gives a light equal to about 9·5 standard candles. (*See also* " Sensitometry" and "Unit of Light.")

LIGHT, UNIT OF (*See* " Unit of Light.")

LIGHTING OF LANDSCAPES

An astonishing variety of effects may be obtained from the same landscape, due entirely to differences in its lighting. Some views are most effective as seen under a soft grey light, whereas in other cases a strong lighting gives the best result. In a bright light the most unsatisfactory position for securing the view is with the light directly behind the camera, and, therefore, full on the subject, as the shadows are concealed by the objects casting them. A side lighting is far more satisfactory as giving more relief and allowing the shadows to play their part in the arrangement of the picture. It is often possible to secure a striking and pleasing effect by photographing "against the light "—that is, with the sun more or less opposite the camera— but it is necessary to protect the lens from the direct rays of light. Another opportunity for variation in effects comes when there are clouds through which the sun breaks at intervals in such a manner as to light up this or that portion of the view, while the rest remains in shadow. Such a play of light and shade on a landscape must be accounted for in the print by a sky that corresponds ; so that, if it is not possible to record the sky on the same plate as the land-

22

scape, a second plate should immediately be used to secure the sky with a shorter exposure. Not only are the amount and the direction of the light important considerations in landscape work, but also the condition of the atmosphere. A certain amount of haze or mist veiling the distance is often of the greatest value in the pictorial effectiveness of the result. There is much educative value in taking a series of views of the same landscape under as many different conditions of lighting as possible and carefully studying the results.

LIGHTING OF SITTERS (*See* " Portraiture," and other headings.)

LIGHTNING, PHOTOGRAPHING

The first successful photograph of a lightning flash was taken on a dry plate on September 2, 1882. Lightning cannot be photographed during the daytime, as, however dark the sky is, the sun is behind it and actinic enough to have an action upon the dry plate, and make the flash invisible. At night the sky may be black and have no action upon the photographic plate, the flash appearing to stand out prominently. It is not advisable to photograph lightning through a closed window. Coming storms exhibit the best flashes, although at the seaside good flashes may often be obtained from storms disappearing seawards. The finest lightning photographs have been taken looking seawards, there being no obstructions between camera and horizon. The latter should always be included in the picture, as when taking clouds ; otherwise, in the photographs, it may not be easy to tell the top from the bottom of the flash. The camera must be supported, either by a stand or other means ; if it is of fixed focus, there will, of course, be no focusing necessary, but if of the focusing pattern, the lens should be racked out to the position it would occupy if a distant view were being photographed. It is desirable to focus during the day and to make a mark on the baseboard, so that the focus may be instantly ascertained at night, when accurate focusing is impossible. Having made all ready and fixed the camera with the lens pointing in the direction of the flashes, the dark-slide is inserted, the shutter drawn, the plate exposed, and the flash waited for ; when it does appear, providing that it is within the range of the lens, it photographs itself ; the lens is then capped and the plate changed. It is advisable to use wide-angle lenses so as to include as much of the sky as possible, as forked lightning has a way of disappearing from a narrow field of view. The largest possible stop should be used, and a rapid plate, well backed so as to prevent halation. Detail is not so much wanted as contrast in the negative, and development should therefore not be continued long enough to produce fog, as a flash showing but faintly on a negative may easily be intensified, preferably with mercury and ammonia. One developer is as good as another for negatives of this class, but hydroquinone and a mixture of hydroquinone and metol appear to be the favourites. The plate should be changed after every flash photographed, no matter of what kind ; one may be unfortunate enough to expose a dozen or more plates on weak

sheet flashes, which are useless photographically, while, on the other hand, one may be fortunate in securing a forked flash every time. Sheet lightning will fog a plate and make it quite useless.

LIGHT-STRUCK

A term applied to sensitive plates or papers that have been fogged by exposure to actinic light. The term is sometimes applied to dark foggy streaks upon the negative caused by the dark-slide not being perfectly light-tight. (*See also* " Fogged Dry Plates, Restoring.")

LIGHT-TRAP FOR DARK-ROOMS (Fr.,
Trappe-lumière ; Ger., *Lichtfalle*)

A ventilator admitting air to the dark-room while excluding light. A common form is that illustrated. A row of holes is bored at the bottom or top of the door, or in any other suitable place, and a three-sided case of wood A

Light-trap

is made having a similar series of holes. In the middle of the case is a partition B reaching nearly across. The case, blackened inside, is attached to the door by screws or angle-pieces and the two ends are boxed-in. Since light can only travel in a straight line it is effectually blocked, whereas the air proceeds uninterruptedly into the room, as shown by the arrows. It is usually necessary to have at least two light-traps, one at the bottom to admit fresh air and another at the top for the exit of foul air. (*See also* " Dark-room Ventilation.")

LIGNIN (Fr. and Ger., *Lignin*)

Woody fibre. Formed from the cellulose of plants by incrustation with other compounds, probably aromatic, during the change into wood. It was at one time believed to be identical with cellulose ($C_6H_{10}O_5$) in chemical composition, but later research has shown that this is not so, the true formula being approximately $C_{12}H_{18}O_9$. It is decomposed by sulphuric acid, forming dextrine.

LIME, CARBONATE OF (*See* " Calcium Carbonate.")

LIME, CHLORIDE OF (*See* " Calcium Hypochlorite.")

LIME, CHLORINATED (*See* " Calcium Hypochlorite.")

LIME IN WATER

The presence of lime in the washing water sometimes causes a scum to appear on the dried

negative ; and although the deposit is of but little importance in itself, it may interfere more or less with the proper working of an intensifier or reducer. Lime scum appears mostly when the ferrous oxalate developer is used, and is due to precipitation of lime oxalate. It may be removed by placing the negative before drying in a weak solution of hydrochloric acid (4 drops of acid to 1 oz. of water). Some workers use alum water, as it dissolves the lime without softening the gelatine. When the presence of lime is suspected, the negative should be wiped with a pad of wet cotton-wool before drying.

Water may be tested for lime by adding to it a solution of ammonium (or potassium) oxalate ; a milkiness or white precipitate indicates the presence of a calcium salt.

LIME WATER

Known also as *liquor calcis*, and prepared by shaking up pure slacked lime in distilled water and decanting. Commercial lime water contains half a grain of calcium oxide (quicklime, CaO) per ounce.

LIMELIGHT

An illuminant for use in optical lanterns, etc., in which a spot on the surface of a cylinder of lime is heated to incandescence by a gas flame fed with oxygen under pressure. Oxyhydrogen limelight has a photometric value of 16·6, as compared with that of a multiple-wick lamp 1, and of a 50-ampere arc lamp 160. When an ordinary flame, as of hydrogen, coal-gas, alcohol, etc., plays upon a piece of lime, the latter becomes dull red-hot, but when the combustion is forced and made more complete by means of a supply of oxygen under pressure, the heat of the flame is increased to such an extent that a small part is raised to such a high temperature that it emits a blinding white light. In the past, the combustible gas for limelight has been supplied in a number of different ways. The best known of these, hydrogen, was made by acting with dilute sulphuric acid on scrap zinc ; the gas was stored in a collapsible bag which, when required, was connected to the limelight jet. By other systems, special forms of jets were necessary ; for example, in one was a simple spirit lamp through the flame of which a jet of oxygen was forced ; in another was a vessel containing ether, through which was passed a current of oxygen, which thereby became laden or saturated with particles of the ether and was then burnt at a nipple. All such arrangements are, or should be, obsolete, as by the modern system of supplying gases in steel cylinders (*see* " Compressed Gas ") a convenient and safe supply of a combustible gas is easily secured. These cylinders are periodically tested and annealed, and their use is attended by a minimum of risk, which is not the case in the oxy-alcohol and oxy-ether systems, especially the latter.

Limelight jets are of two main kinds—the blow-through and the mixed. In the former, A, the gases do not mingle until they reach the point of combustion ; in the latter, B, the gases mingle in a mixing chamber at the base of the actual jet. The more intimately the gases mingle, the greater is the heat of the flame

produced, and therefore the high-power jet is always of the mixed type, the blow-through jet being practically restricted to the use of the beginner. The jet is supported on a vertical pin projecting from a sheet-metal tray which slides into the lantern body from the back. One nozzle H is connected by rubber tubing to the hydrogen supply, which in the case of a mixed jet is a cylinder, and in the case of a blow-through jet either a cylinder or an ordinary gas bracket. The other nozzle o is connected to the oxygen supply, which, nowadays, is always a cylinder. In the case of the blow-through jet, the nozzles are connected to the gas supplies in such a way that the oxygen issues in a stream from the central nipple, whilst the cone of burning hydrogen surrounds it. The taps are generally stamped with either " O " or " H," indicating the proper connections. The lime cylinder (*see* dotted lines C) is supported on a pin at an adjustable distance from the nipple, there being provision for rotating the lime by means of the rod D, so as

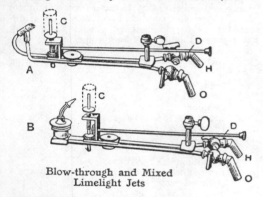

Blow-through and Mixed
Limelight Jets

to obviate the formation of deep pits in the lime while the jet is in use. When a flame plays upon a deeply-pitted lime, there is a risk of the lime cracking or of the flame being deflected upon the condenser. The distance of the lime from the nipple is a matter for experiment and varies with the class of jet; it has a great influence upon the quality of the light. Simple jets are here illustrated, but very elaborate appliances are obtainable, these being fitted with screw-down adjustment valves and various mechanical devices for regulating the light as regards its height, distance from condenser, distance of lime from nipple, etc.

The following matters should receive attention when managing a limelight exhibition. An automatic regulator or screw-down adjustment valve regulator must be screwed into the valve of each cylinder (*see* " Cylinders, Gas "), it being necessary to reduce or check the pressure of the gas as it issues from the cylinder. High quality rubber tubing connections should be used, and if an automatic pressure regulator is not used, these tubes should not be tied on, in which case, also, the taps on the jets should be opened wide, and the whole of the adjustment done from the cylinder valves. A lime (*see* " Cylinders, Lime ") is put in place, a small flame allowed to play upon it, and the lime

turned occasionally so that it gets warm right through, the object being to prevent cracking when the oxyhydrogen flame is turned on. Then the hydrogen flame is increased slightly, and the oxygen gently turned on, adjusting the two taps and the distance of lime from nipple until the best effect is observed upon the screen. Push in the jet or withdraw it from the condenser until there is an even field of light; if the jet is not central, there will be coloration or a shadow somewhere on the screen and the jet should be moved in the opposite direction to the defect until this is removed. Three minutes' experimenting will teach all that it is necessary to know in this matter. The adjustment of the light should preferably take place after a slide has been roughly focused and withdrawn. Always, when turning off the light, cut off the oxygen first, as otherwise there will be a slight pop in the hydrogen tube of a mixed jet.

It is advisable to retain a key on the valve stem of each cylinder so that in the case of a burst rubber tube or other similar accident the gas can be cut off immediately.

LIMES (*See* " Cylinders, Lime," and " Lime light.")

LINE DRAWINGS (*See* " Copying," " Copying Illustrations for Translation into Line Drawings," " Copying Stand," " Drawings Made from Photographs," and " Engravings, Copying.")

LINE NEGATIVES

Negatives of line drawings. Commercially, they were usually produced by the wet-plate process, but photo-mechanical gelatine dry plates are now widely used. A good test for a line negative is to lay it film side down on a sheet of white paper, and note whether all the lines and blacks on the original appear quite transparent. Veiled lines are sure to give trouble later. Every endeavour should be made also to secure negatives free from yellow stain, as this will retard the printing and make it difficult to obtain the correct exposure, so that the lines will wash away in the development of the prints, or if sufficient exposure is given to retain the lines there will be a difficulty in clearing the ground.

LINEN, MOUNTING PRINTS ON

In this work it is desirable to strain the fabric on a frame, and the prints need to be rubbed into close contact, as explained under the heading " Canvas, Mounting Prints on."

LINEN, PHOTOGRAPHS ON (*See* " Fabrics, Printing on.")

LINES IN COMPOSITION

What are spoken of as lines in the composition or arrangement of a photograph may not exist as actual lines at all. For instance, the tops of a row of trees would not be connected by a line, but they would none the less suggest one. Similarly, various masses suggest boundary lines which roughly enclose them, while detached objects, which carry the eye along from one to another, also suggest a line of direction. More

or less clearly defined lines may also be actually present—the horizon, the banks of a river, the edge of a path, tree trunks, hill-sides, roofs, and so on. The principal lines, present or suggested, are generally most evident when the print is viewed from such a distance that minor details do not obtrude themselves. The position, arrangement, and direction of these lines decide whether the general composition is satisfactory or otherwise. Even the points where certain lines reach the margins play an important part. A good arrangement generally results when the lines indicating the masses of the principal object, or objects, are grouped somewhere near the middle of the picture space, with the other principal lines radiating therefrom. The lines are unsatisfactory when they tend monotonously in one direction ; when they are too symmetrical; when they lead the eye out of the picture towards the edges ; or when they lead the eye to a part of the picture that does not contain the main objects.

Although no very definite rules can be laid down on this question of the lines of a subject, it is a good plan to make analyses of pictures in this way from time to time. No skill in draughtsmanship is required for the purpose. It is sufficient to mark out a space proportionate to the print under study, and mark, in their relative positions, the general (not detailed) outlines of the principal masses, and to add any lines that attract the eye, whether those lines are actually indicated or only suggested. The sort of pattern thus formed should then be studied, noting the way in which the eye is attracted to, or led to, certain points, and the effect that the lines have in suggesting harmony, monotony, contrast, stability and so on. By degrees a sort of instinctive perception of the principal lines of a subject will be acquired. (*See also* " Pictorial Composition.")

LINES, FRAUNHOFER (*See* " Fraunhofer Lines.")

LINING BEVELLER

A machine made by Royle, of Paterson, N.J., for bevelling half-tone plates, and forming ruled lines round them. The bevelling is done by means of a rotating head carrying two cutters, one of which makes the flat of the bevel, and the other parts off the waste margin of the metal. Another cutter, shaped like a graver, is arranged to work parallel to the bevel, and mechanical adjustments permit of the tool being placed at any distance from the bevel. Thus several lines can be made one after the other to form a border.

"LINKED RING," THE

The managing committee of the original Photographic Salon. The first Salon was held at the Dudley Gallery, London, in October, 1893, and there were annual exhibitions in that place until 1904 ; in 1905-9 the exhibition was held at the gallery of the Royal Society of Painters in Water-colours, London.

LINOTYPE

An early and now almost obsolete name for photographs on linen and other fabrics.

LIPPMANN'S PROCESS

A process of colour photography in which the phenomenon of stationary or standing waves is utilised. The process consists in exposing a transparent emulsion in contact with a reflecting surface, such as mercury. Prof. Gabriel Lippmann first used Taupenot's albumen process, and Krone, who has been extremely successful with this process, gives the following method :—

Albumen from whites			
of 6 eggs .	.	4 oz.	130 ccs.
Pot. bromide (10 % sol.)	51 mins.	4·3 ,,	
Liq. ammoniæ (strongest)	51 ,,	4·3 ,,	

Beat to a froth, and allow to stand for twelve hours to liquefy, and then carefully decant or filter through some glass-wool. Unused glass plates should be thoroughly cleaned with alcohol, and then evenly coated with the above and drained, allowing them to dry in a horizontal position. When thoroughly dry they should be heated to 140° F. for two minutes, and then allowed to cool down to normal temperature and sensitised by bathing for two minutes in a 10 per cent. solution of silver nitrate acidulated with 10 per cent. of glacial acetic acid. The plates should next be washed for ten minutes and rinsed with distilled water, well drained, and colour-sensitised in one of the following baths :—

A. Chinoline red sol.
(1 : 500) .	. 27 mins.	1·6 ccs.
Cyanine sol. (1 : 500)	7 ,,	·4 cc.
Ammonia (2 % sol.)	50 ,,	3 ccs.
Distilled water to .	7 oz.	200 ,,

B. Erythrosine sol.
(1 : 500) .	. 17 mins.	1 cc.
Cyanine sol. (1 : 500)	17 ,,	1 ,,
Ammonia sol. (2 %)	51 ,,	3 ccs.
Distilled water to	7 oz.	200 ,,

C. Chinoline red sol.
(1 : 500) .	. 25 mins.	1·5 ccs.
Malachite green sol.		
(1 : 500) .	. 8½ ,,	·5 cc.
Ammonia sol. (2 %)	51 ,,	3 ccs.
Distilled water to	7 oz.	200 ,,

D. Erythrosine sol.
(1 : 500) .	. 17 mins.	1 cc.
Malachite green sol.		
(1 : 500) .	. 17 ,,	1 ,,
Ammonia sol. (2 %)	51 ,,	3 ccs.
Distilled water to	7 oz.	200 ,,

The plates should be bathed for three minutes in absolute darkness, allowed to drain for a minute or two, and then dried at 140° F. (60° C.). For normal work A is to be preferred, but with decreasing height of the sun B or D is better. The developer recommended is—

A. 10 per cent. alcoholic solution of pyro.

B. Ammon. carbonate 772 grs. 50 g.
Distilled water to 10 oz. 268 mins. 300 ccs.

C. 10 per cent. solution potassium bromide.

For a 7 × 5 (13 × 18 cm.) plate, mix freshly of—

A 128 mins.	7·5 ccs.
B 338 ,,	20 ,,
C 15 drops	15 drops
Distilled water	1 oz. 27 mins.			30 ccs.

When developed, wash and fix in a 1·5 solution of "hypo," and if the plate appears too thin, intensify with acid pyro and silver intensifier. Valenta was the first to publish a gelatine emulsion formula :—

A. Distilled water 10 oz. 268 mins. 300 ccs.
 Gelatine . . 154 grs. 10 g.
 Silver nitrate . 93 ,, 6 ,,
B. Distilled water 10 oz. 268 mins. 300 ccs.
 Gelatine . . 309 grs. 20 g.
 Potassium bromide 77 ,, 5 ,,

Heat both solutions to 95° F. (35° C.) and add A slowly to B with vigorous agitation. Valenta recommends pouring the emulsion immediately into 35 oz. or 1 litre of alcohol, stirring well with a glass rod and then washing for a short time in running water the precipitated emulsion, next placing in a vessel and adding enough water to make 21 oz. or 600 ccs., melting at as low a temperature as possible, filtering and coating the emulsion. Later be suggested coating the plates without washing the emulsion, and washing the plates when the emulsion had set. The sensitiser used was :—

Cyanine sol. (1 : 500) 68 mins. 4 ccs.
Erythrosine sol. (1 : 500) 34 ,, 2 ,,

and 1 to 2 parts of this were added to every 100 parts of the emulsion. Increase of sensitiveness was obtained by bathing the plates just before use in :—

Silver nitrate . . 48 grs. 5 g.
Glacial acetic acid . 48 mins. 5 ccs.
Alcohol . . . 20 oz. 1,000 ,,

Valenta also stated that the addition of 31 grs. or 2 g. of sodium sulphite to the above quantity of emulsion, and digestion for a short time, increased the sensitiveness without increasing the size of the grain.

Messrs. Lumière in 1893 published their method of making the emulsion, and valuable contributions also came from Valenta, Neuhauss, and Senior. The last named specially recommends the following :—

A. Nelson's No. 1 gela-
 tine . . 77·15 grs. 5 g.
 Distilled water . 7 oz. 7 drms. 2·1 ,,
 Potassium bromide 32·4 grs. 225 ccs.
B. Nelson's No. 1 gela-
 tine . . 77·15 grs. 5 g.
 Silver nitrate (re-
 cryst.) . . 46·29 ,, 3 ,,
 Distilled water 7 oz. 7 drms. 225 ccs.

Bring each solution to 95° F. (35° C.), and add B to A with continual stirring.

Lippmann's later formula is as follows :—

Potassium bromide . 8·1 grs. ·53 g.
Gelatine . . . 62 ,, 4 ,,
Distilled water . . 3½ oz. 100 ccs.

For colour sensitising add :—

Alcoholic solution cyan-
 ine (1 : 500) . . 90 mins. 6 ccs.
Alcoholic solution chino-
 line red (1 : 500) . 45 ,, 3 ,,

Mix the above at 95° F. and add :—

Silver nitrate (dry) . 11½ grs. ·75 g.

and stir until dissolved. Filter through glass-wool and coat the plates, allow to set, place each plate in alcohol, then wash for half an hour, drain, and dry. The plates will keep a long time.

Senior increases the general sensitiveness of the emulsion by adding to every 3½ oz. or 100 ccs., 3 grs. or ·2 g. of silver eoside.

For fixing all plates a 15 per cent. solution of "hypo" may be used, or a 5 per cent. solution of potassium cyanide, but the latter must only be allowed to act for 15 to 20 seconds.

The heliochromes may be intensified with dilute mercuric chloride followed by amidol and sulphite, or the latter alone, and they may be reduced by a very weak "hypo" and ferricyanide bath.

One of the most exhaustive researches of the Lippmann process has been undertaken by H. E. Ives, whose conclusions will be found in the *British Journal of Photography* (1908).

As already stated, the sensitive film must be in contact with a reflecting surface such as mercury, and special dark-slides can be obtained commercially for this process. These have usually a hard rubber rebate in the front of the slide, against which the glass is pressed, and behind the film is another washer which clips the plate all round the edges so as to form, with the recessed back, a shallow trough into which the mercury is allowed to flow from a reservoir bottle connected with the slide by a rubber tube. Nothing but chemically pure mercury must be used, but even this is liable to oxidation, and this causes streaks and marks on the film on development. It is advisable, therefore, either occasionally to treat the mercury with sulphuric acid, which dissolves the oxide, or, better still, to form a bag of fine chamois leather by gathering together the ends and then shake the mercury to and fro in this, the leather having been thoroughly freed from grease by washing with soap and water and petroleum ether. In all cases it is advisable to rub gently the gelatine film of the plate after removing it from the dark-slide with a tuft of cotton-wool, to remove any adherent globule of mercury. In filling the slide with mercury great care should be taken to obtain an even flow of the latter, as stoppage in the flow will generally show as a line across the plate.

A finished heliochrome, when examined by looking through it, generally appears as a more or less dense negative of a brownish or brownish black hue, and it is only when looking at the film at a particular angle that the colours can be seen. As a rule they appear very pale, and they are actually diluted with white light reflected from the front surface of the film. For preliminary examination of the results the heliochrome may be immersed at an angle in a vessel containing benzole, but for permanent examination it is advisable to cement to the film (with Canada balsam or gum styra) a prism of glass of about 10° angle.

The pictures must be viewed by parallel light, and all side light cut off ; this may be effected by cutting a hole in a window shutter and standing with the back to the hole with the heliochrome held in the hand at arm's length and shifted till it reflects the sky light. Obviously, somewhat similar results can be obtained by

enclosing the heliochrome in a box and reflecting sky light on to it by a mirror.

For projection on to a screen by means of a lantern the aphengescope may be used.

LIQ. AMMON. FORT. (See " Ammonia.")

LIQUID GLUE (See " Fish-glue.")

LIQUID LENS (See " Fluid Lens.")

LIQUOR AMMONIÆ (See " Ammonia.")

LITHIA, CAUSTIC (See " Lithium Hydrate.")

LITHIUM BROMIDE (Fr., *Bromure de lithium ;* Ger., *Bromlithium*)

LiBr. Molecular weight, 87. Solubilities, 1 in ·6 water ; very soluble in alcohol and ether. A white granular powder obtained by dissolving lithium carbonate in hydrobromic acid. It is very deliquescent, and must be kept in well-stoppered bottles. On account of its great solubility in alcohol and ether it is used in collodion emulsion making.

LITHIUM CARBONATE (Fr., *Carbonate de lithium ;* Ger., *Lithiumcarbonat, Kohlensaures Lithium*)

Li_2CO_3. Molecular weight, 74. Solubilities, 1 in 75 water ; insoluble in alcohol. A light, white granular powder, occasionally used in collodio-chloride emulsion making, and to form the other lithium salts.

LITHIUM CHLORIDE (Fr., *Chlorure de lithium ;* Ger., *Chlorlithium*)

LiCl. Molecular weight, 42·5. The hydrated salt has the formula, $LiCl \, 2H_2O$. Molecular weight, 78·5. Solubilities, 1 in 2·5 water ; very soluble in alcohol and ether. Colourless granular crystals obtained by dissolving lithium carbonate in hydrochloric acid. Used in collodio-chloride print-out emulsions.

LITHIUM HYDRATE (Fr., *Lithium caustique ;* Ger., *Aetzlithium*)

LiOH. Molecular weight, 24. Soluble in water and slightly in alcohol. A caustic white powder, which readily absorbs carbonic acid from the air, and must, therefore, be kept well stoppered. Suggested by Lumière as the alkali for use with hydramine.

LITHIUM IODIDE (Fr., *Iodure de lithium ;* Ger., *Iodlithium*)

LiI. Molecular weight, 134. Solubilities, 1 in ·61 water ; very soluble in alcohol and ether. A white coarse powder occasionally used in collodion emulsions. Very deliquescent.

LITHIUM TONER

A toning bath for gelatino-chloride paper (P.O.P.) but little used. The formula is :—

Lithium carbonate .	2½ drms.	17 g.
Gold chloride . .	5 grs.	·6 ,,
Water . .	20 oz.	1,000 ccs.

The bath is ready for use as soon as made. Prints should be washed before and after toning and fixed as usual.

LITHOGRAPHIC PHOTOGRAVURE

A photo-mechanical printing process, invented by Carl Eckstein, of The Hague. A polished lithographic stone is covered with an etching ground, and is then ruled with very fine lines, about ·04 in. apart, scratched through the ground with a diamond point, operated by an engraving machine. The lines are then etched and filled with ink. A photo-lithographic transfer is next laid down over the lines, thus forming a kind of half-tone effect, and the stone is rolled up and printed from by the ordinary process of lithography.

LITHOGRAPHY (See " Photo-lithography.")

LITMUS

Synonym, lacmus. A colouring matter yielded by a process of fermentation from various lichens, and is obtainable in soluble violet-coloured lumps, a decoction of which is used to stain sheets of absorbent paper, which paper is cut up into strips and made up into little books. Litmus papers are used for testing the acidity and alkalinity of solutions, and those known in photography are of a blue or red colour, the blue for acids and the red for alkalis. Should red litmus paper be turned blue by a solution, this is proof that the solution is alkaline and not acid ; but if it remains red the solution is either acid or neutral, to ascertain which blue litmus paper is introduced, this turning red if the solution is acid, but remaining unchanged if neutral. Although litmus paper is suitable for photographic purposes, it is a fact that some acids do not affect it.

Litmus paper should be kept in a tightly corked bottle, so as to exclude the air, and should the blue paper become red by exposure to air, as it sometimes does, the colour may be restored by holding it over the fumes of ammonia. Litmus is also made up in the form of a pencil, which is used for making a mark on a scrap of paper, which is then used in the same way as litmus paper.

LITRE

A standard measure of capacity in the metric system, equivalent to 1,000 cubic centimetres (ccs.), 1·7598 British pints, or 2·113 American pints. (See also " Weights and Measures.")

LIVER OF SULPHUR (See " Potassa Sulphurata.")

LOCAL DEVELOPMENT

The development of some portions of a negative to a greater extent than others. There are two methods of working, opposite in their character and effect. The first, which is more correctly termed " local development," consists in applying to certain parts of the negative a stronger solution than that in the dish, this being kept weak—that is, either dilute or containing but little alkali. The plate is taken from the dish, and some strong solution, kept separately in a measure, is applied by means of a soft camel-hair brush to the parts that are to be strengthened, taking care to prevent the strong solution from spreading or running ; tilting the plate may sometimes help in this

connection. The negative must not be kept out of the developer for more than a minute at a time, and preferably less, there being always the risk of the solution settling in patches and of the developer in the film oxidising and causing stains. Therefore, it is best to brush the strong solution on the parts of the negative for about thirty or forty seconds, rinse the plate under the tap for a few moments, and return to the developing dish. After about a minute, the local work may be repeated, observing the same precautions, and then again repeated as many times as desired.

The second method consists in developing the plate in a normal solution and then, from time to time, applying a 10 per cent. solution of potassium bromide to those parts that need to be held back, taking all necessary care as explained in the preceding paragraph. This method is frequently employed for holding back the sky part of a negative, so that clouds may retain their printing value.

A serious objection to these methods is that the plate has to be exposed freely to the dark-room light, and it is almost impossible to avoid fogging. The photographer may decide, therefore, to adopt, instead, the methods given under the headings " Control in Printing," " Harmonising Contrasts," or even to adopt local intensification or local reduction, although the local application of chemicals to negatives is not advised if the desired results can be obtained by other means.

LOCAL INTENSIFICATION

Intensification of parts of a negative only, performed by applying solutions by means of a brush. It is desirable to select well-marked outlines at which the intensification should begin and end, and then to work carefully in a good light. The solution used must be one that can be applied perfectly evenly, or one in which slight unevenness will not show appreciably in the finished result. Intensification by means of mercuric bromide is suitable ; first brush on the bleaching solution until the uneven markings caused by the brush disappear in an even bleaching. Then wash for a minute under the tap, next in a dish, and then immerse in the blackening solution in the usual manner. For strengthening only small parts of a negative the bleaching solution should be brushed on without previously wetting the plate. For larger parts, the plate should be soaked in water for half an hour before beginning to intensify. (*See also* " Intensification of Negatives.")

Local intensification is delicate work, and difficult to carry out successfully ; while if it is unsuccessful the negative is ruined. In general, and if the photographer is not highly skilled, it is better to avoid local chemical treatment ; similar results can often be secured without running risks by the methods that are described under the heading " Control in Printing."

LOCAL REDUCTION

Reduction of parts of a negative only, performed by brushing on solutions, as in the case of local intensification. For treating small parts only, work with the negative dry, and

continue to apply the solution with the brush until the reduction is sufficient. Great care must be exercised in keeping exactly to the outlines of the parts under treatment. On a large surface even working is easier after the plate has been soaked in water for half an hour. Compared with local intensification, the work is more easily controlled, and the solutions are less liable to deteriorate or produce erratic results by acting unevenly. The Howard Farmer reducer—" hypo " and potassium ferricyanide—is the most suitable for local treatment. As soon as the desired result is attained, the negative should be washed in two or three changes of water, and then placed in an acid " hypo " fixing bath for about ten minutes, finally washing as usual. Many of the notes on local intensification apply equally to local reduction.

LOCOMOTIVES, PHOTOGRAPHY OF

The general principles that govern the photography of machinery apply equally to such subjects as locomotives. (*See* " Engineering Photography.") Although, at times, a flat side view is required by engineers as a record of the elevation or outline of the engine, an oblique view will always make a more interesting photograph, taking it from the front end of the engine and showing the front buffer-beam very much foreshortened. For such a position a lens should be used having a focus at least one-third longer than the long side of the plate ; and one of still longer focus will be preferable. Modern locomotives are so long that the far end is dwarfed considerably if a lens too short in focal length is used. The subject is long in proportion to its height, and unless the print is made very long and narrow there will be a wide expanse of foreground ; but this assists in giving the impression of size and dignity. In order to give it its fullest value, a position should be chosen, whenever possible, in which this foreground consists of rails forming other lines in front of the engine photographed. A man standing near the cab of the locomotive will assist in conveying an idea of size, and an engine-driver or fireman in working clothes is the only suitable figure. The camera should not be more than 5 ft. from the ground, and a little less is generally preferable. A higher point of view dwarfs the engine.

LOGWOOD

A dye-wood obtained from the heart-wood of the logwood tree, *Hæmatoxylon campeachianum*. The extracted dye is of a red colour, and known as " hæmatein." Under certain conditions a decoction of logwood will precipitate gelatine. It was used for experimental purposes in the early days of photography.

LORRAINE MIRROR (*See* " Claude Lorraine Glass.")

LUBRICANT

A mixture of Castile soap and alcohol is used as a lubricant when burnishing prints with a bar burnisher ; and a solution composed of equal parts of linseed oil, liquor ammoniæ and

water has also been recommended. Encaustic pastes are sometimes referred to as lubricants. French chalk and blacklead are used for lubricating apparatus.

LU-METER

An instrument invented (1911) by J. S. Dow and V. H. Mackinney for the purpose of estimating the surface brightness of an object compared with the light of a standard candle, and for determining the necessary exposure required for such object.

LUMIÈRE, ANTOINE

Born 1839; died in Paris, 1911. Founder of the famous photographic firm of A. Lumière et ses Fils, which, with his two sons, Auguste and Louis, he established at Lyons in 1883.

LUMIÈRE COLOUR PROCESSES

Reference is made elsewhere to the starch grain process (see " Autochrome Process " and " Screen-plate Colour Photography "), but the brothers Lumière had worked out various processes before this. In the bleach-out process they suggested (1894) the use of cyanine, quinoline red and turmeric, and also a partial fixation of the results by means of metallic salts. In 1895, they exhibited prints produced from negatives taken through the usual set of red, green and violet screens, the positives being printed on bichromated films of gelatine or glue, soluble in cold water, which also contained some silver bromide or other inert insoluble matter, which increased the relief of the images. After development of the print, the silver bromide was dissolved out and the reliefs stained up and superimposed.

The process above described was introduced commercially, thin celluloid films being coated with the gelatine so that the printing could be done through the celluloid, thus obviating the necessity of double transfer or lateral inversion of the pictures.

In 1900, the brothers Lumière exhibited a series of fine prints produced by the superposition of bichromated reliefs on collodion supports, the following being an outline of the process : The screens for taking the negatives can be prepared by coating plate glass with a 10 per cent. solution of gelatine. When the gelatine is quite dry the plates should be immersed in the following baths, which should be at a temperature of 68° F. (20° C.), for about five minutes, then rinsed and dried. Two glasses of each colour should be cemented together with Canada balsam to form the screen :—

Green Bath

Methylene blue N
 (·5 % sol.) . 2 oz. 411 mins. 143 ccs.
Auramine G (·5 % sol.) to 20 oz. 1,000 „

Blue-violet Bath

Methylene blue N
 (·5 % sol.) . . 10 oz. 500 ccs.
Distilled water to . 20 „ 1,000 „

Orange Bath

Erythrosine J (·5 % sol.) 9½ oz. 474 ccs.
Metanil yellow (sat. sol.) to 20 „ 1,000 „

The dish should be well rocked whilst staining up the gelatine. The above colours are obtainable, methylene blue from Casella, auramine G and erythrosine J from the Badische Anilin und Sodafabrik, and the metanil yellow from Hepp and Oehler. The papers are prepared as follows : Plate glass should be well cleaned, dusted with French chalk, edged with rubber solution, and then coated with an enamel collodion of the following composition :—

Alcohol	.	.	9 oz.	444 ccs.
Ether	.	.	11 „	556 „
Pyroxyline	.	.	105 grs.	11 g.
Castor oil	.	.	24 mins.	2·5 ccs.

When the collodion is dry, the plate should be immersed in a 7 per cent. solution of gelatine at 110° F., and a sheet of baryta paper cut to the same size also placed in the gelatine. The baryta side of the paper should be brought into contact with the collodionised plate, and the two thoroughly squeezed together and then dried. When dry, the back of the paper should be varnished with Soehnée's white varnish A, diluted with an equal quantity of alcohol. After twelve hours drying the paper should be coated with the following mixture :—

Emulsion gelatine .	.	2½ oz.	120 g.
Hard glue (Coignet)	.	2½ „	120 „
Ammonium bichromate	1¼ „	60 „	
Potassium citrate, neutral			
(25 % sol.)	.	.384 mins.	40 ccs.
Cochineal red	.	. 9½ grs.	1 g.
Alcohol	.	. 4 oz.	200 ccs.
Water	.	. 20 „	1,000 „

Soak the gelatine and glue in the water and dissolve at 120° F., allow to cool down to 95° F., and then add the other ingredients, and finally the alcohol in small quantities. Filter the mixture and coat the paper, whilst on the glass, with the mixture, allowing about 90 mins. or 2 ccs. for every 100 sq. in. or 100 qcm. The paper is then thoroughly dried exactly as in the carbon process, stripped from the glass, and exposed beneath the three negatives, an actinometer being used to determine the duration of insolation. After exposure the print should be squeegeed into contact with a sheet of glass which has been previously collodionised with the above-mentioned collodion, and then coated with a ·75 per cent. solution of rubber in benzole. The coated glass and the exposed print should be immersed in a dish of cold water, squeegeed into contact and placed under pressure for five minutes, then soaked in cold water for two hours so as to allow of complete expansion of the gelatine and paper. Development should be effected in water at 100° F., and the print allowed to soak for about half an hour, when the paper can be readily detached and the print developed as in the carbon process, and finally washed in cold water and immersed in alcohol for five minutes and dried. The relief prints thus obtained are dyed respectively red, yellow and blue, the necessary baths being as follows :—

Red Bath

Erythrosine J (3 % sol.) ½ oz. 25 ccs.
Water to . . . 20 „ 1,000 „

Yellow Bath

Chrysophenine G	.	32 grs.	3·3 g.
Water	. .	16¾ oz.	833 ccs.

Dissolve at 160° F. and add—

Alcohol	. .	3¼ oz.	167 ccs.

Blue Bath

Diamine blue F, pure			
(3 % sol.)	.	432 mins.	45 ccs.
Hard glue (15 % sol.).	1¼ oz.	63 ,,	
Water to .	. 20	,, 1,000 ,,	

The relief prints should be left in these baths for about twelve hours, then rinsed, and the red and blue impressions immersed in a 5 per cent. solution of cupric sulphate and then rinsed and dried. The yellow print must not be treated to the copper bath. It is possible to superimpose temporarily the images whilst on the glass supports and see if they are sufficiently stained ; corrections can then be made by deeper staining, or washing out some of the dye. The dyed impressions should be coated with a 1·5 per cent. solution of rubber in benzole, then collodionised with a 1 per cent. collodion, and the yellow print transferred to paper by means of a warm 15 per cent. solution of gelatine, the paper being stripped when dry and the red and blue impressions superimposed on this also.

In a later process MM. Lumière suggested the making of the blue impression by conversion of the image of a bromide print by bleaching with potassium ferricyanide followed by ferric chloride, then coating this blue print with collodion containing tetrazotolylsulphite or tetrazoanisidinesulphite of soda and the chlorhydrate of β-naphthylamine-ether. Exposing under the red printing negative and the action of light produces the red image. Another coating with collodion containing diazo-orthotoluidine sodium sulphite with metamidophenol or resorcin gave the yellow image. MM. Lumière have also paid considerable attention to Lippmann's process

LUMINIFEROUS ETHER

An extremely elastic and subtle medium generally assumed to pervade all space and permeate all matter, the undulations of which, communicated to the eye, give rise to the sensation of light. Information of value in this connection is given under the headings "Light" and "Natural Colours, Photography in."

LUMINOUS PHOTOGRAPHS

Photographs which appear luminous or phosphorescent at night. They may be prepared in several ways. The simplest is that of making a positive transparency—as, for example, a lantern slide—varnishing the film side, and coating with luminous (Balmain's) paint. When dry, the transparency is backed with thin wood or cardboard, with a ring for hanging, and the whole bound together with strips of gummed paper or cloth. If exposed to light during the day the picture will appear luminous at night. Another plan is to spread a thin coating of glue upon cardboard and sprinkle with powdered barium or calcium sulphide, or to coat with Balmain's paint. A print is then made upon

thin sensitive paper which, after finishing in the usual way, is made transparent with castor oil, the excess blotted off, and the print attached to the treated cardboard with thin glue or strong paste, and dried by heat.

A method popular in Germany is to coat a piece of thin transparent celluloid with the following :—

Gelatine.	. .	436 grs.	100 g.
Potas. bichromate .	48 ,,	11 ,,	
Calcium sulphide	.	½ oz.	55 ,,
Water .	. .	10 ,,	1,000 ccs.

The gelatine is soaked in the water, melted by heat, the other ingredients added and dissolved, and the mixture filtered through cottonwool. When dry, the coated celluloid may be printed upon from a positive through the celluloid film, and the image developed in warm water in the same way as in the carbon process, a print being obtained which shows as a negative by transmitted light. This needs to be backed with black velvet or black paper, when it will appear as an ordinary black-and-white positive by daylight, and as a luminous or phosphorescent picture by night.

LUNAR CAUSTIC

A synonym for silver nitrate (*which see*).

LUNAR CORNEA

Latin for "Horn Silver." A form of silver chloride occurring naturally in an almost colourless mass, somewhat resembling horn, for which reason it received the name of *lunar cornea* from the old alchemists. It was first described by Fabricius (*d.* 1571), director of the college at Meissen, in a book on metals, published in 1556. It is often stated that Fabricius was the first to notice that horn silver became suddenly black on exposure to light, but, according to Major-General Waterhouse, none of his writings bears out this statement and, as a matter of fact, horn silver does not blacken suddenly, the change being gradual. (*See also* "Silver Chloride.")

LUNAR PHOTOGRAPHY (*See* "Moon, Photographing the.")

LUXOTYPE

A half-tone process patented in 1883 by Brown, Barnes and Bell, a Liverpool firm of photographers. A photographic print was pressed against a metal plate engraved with a stipple in relief, it thus becoming embossed with a stipple. It was then strongly lighted from one side so that the stipple could be photographed, and a negative suitable for making a half-tone block was thus obtained. A modification of the process was to rub in the sunk parts of the embossed surface of the print with a pigment, so that it could be copied by direct lighting.

LYSOL (Fr. and Ger., *Lysol*)

A mixture of alkaline compounds of the higher phenols obtained by boiling a mixture of heavy tar oils, fat, and resin with alkalis. It is used chiefly as a disinfectant, and is soluble in water and alcohol.

M

MACHINERY, PHOTOGRAPHY OF (*See* "Engineering Photography.")

MACKENZIE-WISHART SLIDE

This is a special form of slide which makes possible daylight changing (*which see*). The plates are enclosed in light-tight envelopes.

MACROPHOTOGRAPHY (Fr., *Macrophotographie, Agrandissement ;* Ger., *Makrophotographie, Vergrösserungs-verfahrung*)

A term applied to enlarging with the solar camera ; now synonymous with enlarging generally. The opposite of microphotography

MADDOX, RICHARD LEACH

Born at Bath, 1816 ; died at Southampton, 1902. He became well known for his work in photo-micrography, and was the originator of the gelatino-bromide plate. His experiments with gelatino-bromide of silver emulsion were published on September 8, 1871, and a modification of his process is in use to-day. The original plates were slow because the emulsion was not washed, and the lack of density was due to the absence of a restrainer and the presence of ammonia in the developer.

MAGAZINE CAMERA (Fr., *Chambre magasin ;* Ger., *Magazinkamera*)

A camera carrying a number of plates or flat films in metal sheaths, with provision for exposing these successively. Magazine boxes and cameras for stand work were known as early as 1861, but such cameras are now mostly of the hand type. Many different changing systems are in use, the simplest being that having a

Magazine Camera

leather changing bag attached to the camera ; this, although reliable, is somewhat slow in use, and automatic arrangements are now commonly preferred. The illustration shows the interior of a typical modern magazine camera, A being an exposed plate in its sheath, falling into the bottom of the apparatus, B the next plate in position ready for exposure, and C the changing lever. (*See also* "Hand Camera.")

MAGDALA RED (Fr., *Magdala rouge ;* Ger., *Magdalaroth*)

Synonyms, naphthalene red, naphthalene rose; naphthalene scarlet, Sudan red, rose naphthylamine. A mixture of naphthylnaphthorosinduline and naphthyldinaphthosaframine hydrochlorides. It is a dark brown powder, soluble in alcohol and slightly soluble in boiling water. It has been used as a sensitiser for gelatine emulsions and gives a strongly marked maximum at the D lines, but the gap in the blue-green is wider than with erythrosine.

MAGIC CAMERA

An aphengescope, known also as the magic camera, named after the inventor, Kruss, of Hamburg. The original instrument was a tin

Diagram of Kruss Magic Camera

box divided into two compartments, A and B. In the division A was a lamp whose light was concentrated by a condenser C upon the object at D, an image of which was projected by the focusing lens E upon a screen.

MAGIC LANTERN (*See* "Optical Lantern.")

MAGIC PHOTOGRAPHS

Bleached photographs that suddenly appear on contact with a reagent. Of the possible processes, the easiest is to make a print on albumen paper, fix without toning, and to bleach in a solution of mercuric chloride. Soak pieces of blotting-paper in an ordinary fixing bath (a "hypo" solution), and, on placing the photograph between them and pressing together in the hands, the original image will once more appear.

MAGIC VIGNETTES (*See* "Black Vignettes.")

MAGILP (*See* "Megilp.")

MAGNALIUM (Fr. and Ger., *Magnalium*)

An alloy of magnesium, 15 to 20 parts, and aluminium, 100 parts, which is harder than aluminium, but not much heavier. It is easier to work, and has, therefore, been used for lens mounts, etc., instead of the pure aluminium.

MAGNESIUM (Fr., *Magnésium* ; Ger., *Magnesium*)

Mg. Molecular weight, 24. A lustrous, silvery white metal, which is used in the form of powder and of ribbon for flashlight, etc. The light emitted by burning magnesium is extremely rich in actinic rays, and is the nearest in spectral composition to daylight of any artificial light ; one-sixty-fourth of a grain of magnesium burnt in air gives as much photographically active light as 300 standard candles burning for one second, assuming that the light has to pass through the glass of a negative as in printing. (For information on using magnesium, *see* under the headings "Flash Lamp," "Flashlight Photography," etc.)

MAGNESIUM BEADS

Beads of dried paste, made with magnesium powder and distilled water, at one time used in an oxyhydrogen flame in much the same way as a lime to produce a powerful white light. They are not deteriorated by the atmosphere, as in the case of limes.

MAGNESIUM BROMIDE (Fr., *Bromure de magnésium* ; Ger., *Brommagnesium*)

$MgBr_2 6H_2O$. Molecular weight, 291. Solubilities, 1 in 1 water ; slightly soluble in alcohol. It is in the form of colourless crystals, obtained by dissolving magnesium carbonate in hydrobromic acid, and crystallising ; it is very deliquescent, and must be kept in well-stoppered bottles. Occasionally used in collodion emulsion making.

MAGNESIUM CARBONATE (Fr., *Carbonate de magnésium* ; Ger., *Kohlensaures Magnesium*)

$MgCO_3$. Molecular weight, 84. It is of small photographic interest, but, known as calcined magnesia, it is used in compressed blocks by photo-engravers for rubbing into the hollows of an etched plate, so that the state of the work may be seen. Also, in the form of a fine powder, it is used for the dry enamel process.

MAGNESIUM CHLORIDE (Fr., *Chlorure de magnésium* ; Ger., *Chlormagnesium*)

$MgCl_2$ or $MgCl_2 6H_2O$. Molecular weight, 94 or 202. Solubilities, 1 in ·6 water, 1 in 5 alcohol. Colourless, bitter crystals or deliquescent mass obtained by dissolving magnesium carbonate in hydrochloric acid and evaporating ; it is very deliquescent and must be kept in well-stoppered bottles. A 15 per cent. solution was suggested by Liesegang as a fixing agent, but it is not so powerful as "hypo." It is also occasionally used in collodion-emulsion making

MAGNESIUM FLASHLIGHT MIXTURES

Mixtures of magnesium powder and other chemicals, particulars of which are given under the heading "Flashlight Powders."

MAGNESIUM IODIDE (Fr., *Iodure de magnésium* ; Ger., *Iodmagnesium*)

$MgI_2 8H_2O$. Molecular weight, 421. Soluble in water and alcohol. A deliquescent white crystalline powder that has been used in collodion-emulsion making.

MAGNESIUM LAMPS (*See* "Flash Lamp.")

MAGNESIUM LIGHT

The light emitted when burning magnesium (*which see*).

MAGNESIUM POWDER

Metallic magnesium in the form of a silvery white powder. It keeps indefinitely, and should be stored in a well-corked bottle. For the methods of burning it *see* "Flash Lamp." It should be dried before use, as otherwise it will not fire properly. The impurities often present in it do not generally affect the value of the light, but they cause more smoke. Pure powder should feel soft and not gritty when passed between the fingers, and should not leave a dirty mark when rubbed on white paper.

MAGNESIUM RIBBON OR WIRE

Metallic magnesium in the form of ribbon or wire. Lamps are supplied for holding the ribbon, but it is sufficient to cut or break off the length required, hold in pincers or in any other way, and apply a light. The ribbon will give slightly more light, weight for weight, than the pure powder, unless the latter is burned in a form of lamp insuring complete combustion. When using magnesium ribbon for printing by contact, 1 in. of ribbon may be considered equal to four minutes' exposure to an ordinary flat gas flame at the same distance. The average weight of magnesium ribbon is 1 gr. per 5 in., or about ·5 g. per 100 cm. Ribbon burned in oxygen gives a remarkably powerful light ; a lamp for burning ribbon in this way was devised by McLellan in 1882, and an improved form was placed on the market by the Platinotype Co. in 1899. Ribbon tarnishes and, consequently, deteriorates quickly, and should be kept in an air-tight vessel ; the tarnish can be removed by drawing the ribbon between smooth folded glasspaper. The ribbon gives off a considerable amount of smoke. Sometimes a pad of damp cotton-wool lint is supported over it, this absorbing most of the products of combustion.

Woven Magnesium Ribbon

A method of making ribbon into a net of coarse mesh has been recommended for convenience when burning a large quantity and to produce more even illumination, particularly when enlarging. Two L-shaped pieces of tinplate or copper are cut, and the ends of the strips of ribbon are then fastened on one of the L-shaped pieces by pasting on a strip of paper. When the mesh is complete, the other piece is clamped on top. The lower, free corner of the network may then be lighted, and the whole burns rapidly.

MAGNESIUM SULPHATE (Fr., *Sulfate de magnésium ;* Ger., *Schwefelsaures Magnesium, Bittersalz*)

Synonyms, Epsom salts, bitter salts. $MgSO_4 7H_2O$. Molecular weight, 246. Solubilities, 1 in 1·5 water, insoluble in alcohol. It takes the form of small, colourless prisms or needles, obtained from sea water and certain springs, or by dissolving magnesium carbonate in sulphuric acid. It is used in making barium sulphate, and has an extraordinary hardening action on gelatine.

MAGNETOGRAPH (Fr., *Magnétographe ;* Ger., *Magnetograph*)

An apparatus employed by meteorologists to give a photographic record of the oscillations of a magnetic needle.

Also the name applied to an image obtained on a photographic surface by means of a magnet, as explained in the next article.

MAGNETS, PHOTOGRAPHIC ACTION OF

The fact that magnets are capable of affecting a photographic (daguerreotype) plate was first asserted by Baron Karl von Reichenbach, about 1850. William Brooks, in 1877, placed a horseshoe magnet, poles upwards, in a light-tight box, a blackened perforated card being supported $\frac{3}{8}$ in. above the poles, and a sensitive emulsion plate $\frac{1}{4}$ in. above the card. After leaving the plate for from 3 to 15 minutes, an image of the perforations on the card could be developed. Braham and others have also experimented in this direction.

MAGNIFICATION (Fr., *Amplification ;* Ger., *Vergrösserung*)

Degree of enlargement. A term used principally in photomicrography and telephotography. The diameter of the enlarged image divided by the diameter of the original equals magnification ; or, in telephotography, the linear measurement of any object in the picture divided by the measurement of the same object as rendered by the positive lens alone. (*See also* "Photomicrography" and "Telephotography.")

MAGNIFIER (Fr., *Verre grossissant ;* Ger., *Vergrösserungsglas*)

A supplementary lens which increases or diminishes the focal length of the lens with which it is employed. The arrangement has advantages from the points of view of economy and convenience, as further explained under the heading "Supplementary Lenses."

MAGNIFIER, FOCUSING (*See* "Focusing Magnifier.")

MAHOGANYTYPE

A facetious term indicating the result of inserting an empty dark-slide into a camera, and going through the operations of drawing the shutter, making the "exposure," etc.

MALACHITE GREEN (Fr., *Vert Malachite ;* Ger., *Malachitgrün*)

Synonyms, benzaldehyde, new, Victoria, fast, diamond B, solid O, benzoyl or benzal green. Soluble in water and alcohol. It is a complex aniline dye occurring in yellowish crystals with bluish-green reflection, or as a brown powder. It has been used as a sensitiser, and also for filters.

MALT PROCESS

Malt was one of the many preservatives recommended in the days of collodion plates. A mixture of 7 oz. of malt with 24 oz. of water was kept at a temperature of 156° F. (69° C.) for half an hour, allowed to cool, was then filtered, and finally applied to the plates.

MANGANESE DIOXIDE (Fr., *Péroxyde de manganèse ;* Ger., *Manganperoxyd, Braunstein*)

Synonyms, manganese peroxide or binoxide, black oxide of manganese. MnO_2. Molecular weight, 87. Insoluble in water and alcohol. Occurs native. It is a heavy, black powder or in steel-grey lumps containing about 90 per cent. MnO_2, used for flashlight powders and preparing oxygen.

MANGANESE PEROXIDE (*See* "Manganese Dioxide.")

MANGANESE, PRINTING WITH: MANGANIC LACTATE PRINTING

A novel printing process worked out by the Brothers Lumière in 1895. For the sensitising solution, 100 grs. of potassium permanganate are dissolved in 2 oz. of water, the measure being placed in cold water so as to keep the solution as cool as possible ; $4\frac{1}{2}$ drms. of lactic acid are then added, a drop or so at a time, and the solution swirled round after each addition ; these precautions will prevent the solution from becoming hot and frothing over. Allow to stand until all effervescence has ceased, and a thick brownish-black liquid results. Add a solution (cool) of 1 drm. of glucose or grape sugar in $\frac{1}{2}$ oz. of hot water, and filter through cotton-wool. The paper should be gelatine-coated, and fresh P.O.P., fixed and well washed, answers the purpose ; it is prepared by applying the solution with a broad camel-hair brush and, after half a minute, blotting off the excess and drying in the dark. The paper must be evenly coated, and none of the solution allowed to reach the back. It yields a negative image from a negative, and, therefore, a good positive or lantern slide should be printed from ; print in daylight. Develop by immersing the print in a saturated solution of aniline sulphate in water, to obtain a green colour ; add a few drops of liquor ammoniæ for a violet colour. By using orthotoluidine sulphate solution, rendered slightly acid with hydrochloric acid, a deep blue image results ; or, if the acid is replaced by liquor ammoniæ, a violet one. Paramidophenol develops an image something like an ordinary silver print. All the solutions used for developing should be as strong as possible. Development is complete in about thirty seconds, the prints being finished by washing in water.

MANGANESE SULPHATE (Fr., *Sulfate de manganèse ;* Ger., *Schwefelsaures Mangan*)

Synonym, manganous sulphate. $MnSO_4 4H_2O$. Molecular weight, 223. Solubilities, 1 in ·8

water, insoluble in alcohol. It is in the form of transparent rose-red efflorescent crystals, obtained by dissolving manganese dioxide in sulphuric acid. It has been suggested as an addition to the bichromate sensitiser for carbon tissue, etc.

MARBLE MARKINGS

Stains that sometimes appear on wet collodion negatives, due to the film becoming partially dry before or during exposure.

MARBLE, PHOTOGRAPHS ON

Many methods have been advocated for reproducing photographs upon marble, but the best and simplest is by the carbon process (*which see*). Processes for sensitising marble and printing thereon direct have been worked, but with these there is the difficulty of examining the progress of printing.

MARÉCHAL'S COLLOTYPE PROCESS

The earliest collotype process worked out after Poitevin's experiments in Paris, 1856, was that of Tessié du Motay and Ch. R. Maréchal, in Metz, in 1865. Their method was similar in principle to that in use at the present day.

MAREY'S GUN (*See* "Gun and Revolver Cameras.")

MARINE PHOTOGRAPHY

The first supposed successful instantaneous photograph is of a marine subject—New York Harbour, taken in the 'fifties. In the same year Baron Gros, of Athens, made some daguerreotypes of breaking waves on the shores of Greece —in Phalerum Bay. Marine work in general resembles other hand camera work, but the exposures are short owing to the usually excessive brightness of the sea and sky. Backed plates should be used, and there is no necessity to have extra rapid plates; the consensus of opinion is in favour of isochromatic plates and the use of a pale yellow screen, but many workers prefer ordinary plates. The isochromatic plate should have the advantage on a bright day, and in the case of a blue sky. Should clouds be present (and these often make a seascape a success) there should be no difficulty in photographing them, inasmuch as sea and sky require about the same exposure, whereas in landscape work the foreground requires much longer exposure than the sky. Breaking waves, and seascapes with rocky or other dark foregrounds, are more difficult subjects because of the great differences in the correct exposures for the dark foreground and comparatively brilliant sea and sky. A foreground shutter—that is, a shutter allowing of the foreground receiving a longer exposure than the sky—should be an ideal accessory for such work; but when photographing breaking waves, the operator may not know whether the rocks in the foreground will remain in their natural state or be covered with a seething mass of white foam, a foam which would be whiter, and require less exposure than any other part of the picture. The shutter should work at such a speed as to give a naturalistic effect to the sea and waves. If a shutter works too fast the water will appear too sharp and have a frozen appearance, whereas

an exposure that is too long will show movement and the sea will be blurred. One-hundredth of a second is a good average speed, and if this is found to be correct the exposures may be otherwise corrected with larger or smaller stops. F/16 is a good average stop, and with a medium plate and good diffused light (not bright sun) the exposure above mentioned will be about right. In brighter weather a smaller stop may be used and vice versa, and if the waves are comparatively quiet a longer exposure may be given.

Hand cameras of any kind are best for this work, and a good view-finder is essential; stand cameras are next to useless. Sea air affects leather and metal fittings considerably, and the camera should be protected as much as possible, especially from sea spray. Seascapes, particularly those with dark foregrounds, need careful development because of the great contrasts in the subject. A soft working and well-diluted developer should be used; adurol is good, while metol, with or without a little hydroquinone, has its advocates. If the dark parts lag behind, local development may be resorted to or the lagging parts helped by breathing upon them.

MARION'S GUM PROCESS

A modified form of carbon printing, now obsolete, similar to the modern "Ozotype," introduced by A. Marion, in 1873. Transfer paper coated with bichromated gelatine was exposed under a negative, and a visible image printed. The unsensitised carbon tissue and print were then immersed in a 2 per cent. solution of potassium or ammonium bichromate and squeezed together; after remaining under pressure for several hours, or until nearly dry, the carbon tissue was developed in the usual way. The reduced chromium compounds were absorbed by the tissue and produced a developable image exactly the same as though the tissue itself had been sensitised and printed. The advantage was that the printing on the paper could be watched and no transfer, as generally understood, was needed.

MARIOTYPE

A gum print produced by Marion's gum process.

MARS BROWN, MARS ORANGE, ETC.

Brown, orange, red and yellow pigments prepared from natural earths. The colouring property is chiefly due to iron oxide. They are occasionally used for colouring photographs.

MARTIUS YELLOW [Fr., *Jaune de Martius*; Ger., *Martiusgelb*]

Synonyms, Manchester yellow, naphthalene yellow, jaune d'or. Solubilities, soluble in water and alcohol. The sodium salt of dinitro-α-naphthol, which was used for making yellow screens.

MASKS AND MASKING

Masks, in the form of pieces of thin opaque paper pierced with openings, have various uses. In lantern slides a mask is used to shut off those parts of the image not required. It consists of

a square of thin paper the same size as the plate pierced with an opening corresponding with the amount of picture desired. (*See* " Lantern Slides, Masking, Binding, and Spotting.")

In printing, a similar mask is frequently applied to a negative, especially when printing a small picture with a broad white margin.

Masks of somewhat different character are very useful in combination printing, adding clouds to landscapes, etc.

MASTIC (MASTICH) (*See* " Gums and Resins.")

MATT PAPERS

Papers with a matt surface are made for almost all kinds of photographic printing, silver printing-out papers for daylight, and bromide and gaslight for working by artificial light. Carbon prints always have a slight effect of gloss in the shadows, even when developed on a rough surfaced paper. Platinotype prints, though devoid of gloss, are not absolutely matt ; the print presents the actual surface of the paper without any film or coating to give the lifeless quality that distinguishes the true matt surface.

MATT SURFACE

A matt surface is one that is quite dull, not simply devoid of gloss like the natural surface of a good paper, but dead and smooth. It is considered by many to be more artistic than a glossy surface, but it possesses a serious disadvantage. The shadows of a print on matt paper are always devoid of depth and transparency, the darker details being all lost in one mass of uniform dark grey, and the dark masses of tone appearing dead or lifeless. The shadow details are visible while the print is wet, but they disappear as it dries. A very slight suspicion of gloss is sufficient to give depth and transparency to the shadows of a print, and to render the dark details in their true value.

MATT VARNISH

Generally used on the backs of negatives for softening the light, particularly in the shadows. A common practice is to coat the whole of the back of the negative with matt varnish, to scrape it away over the high lights, and either to paint on the varnish over the shadows with carmine water colour or to rub a soft lead pencil on the varnish. The two following formulæ will be found satisfactory, and the coarseness of the grain is dependent on the quantity of benzole added, so that it is advisable to add a small quantity first and test the grain :—

1. Gum sandarac 1½ oz. 70 g.
 Gum mastic . 144 grs. 15 ,,
 Ether . 15 oz. 750 ccs.

Dissolve and add—
 Benzole to . 20 oz. 1,000 ccs.

If the ether is anhydrous, add to it—
 Water . . ¾ oz. 50 ccs.

2. Gum sandarac 1 oz. 50 g.
 Gum dammar 144 grs. 15 ,,
 Ether . 12½ oz. 625 ccs.

When dissolved, add—
 Alcohol . . 10–50 mins. 1–5 ccs.
 Benzole to . 20 oz. 1,000 ,,

This makes a softer varnish than No. 1, and the alcohol gives a very fine grain. These varnishes are coloured yellow by adding to every 200 parts 1 part of aurantia or chrysoidine. Asphaltum gives a brown colour.

MAXWELL (*See* " Clerk-Maxwell.")

McDONOUGH'S COLOUR PROCESS

A process of screen - plate photography patented by McDonough, of Chicago, in 1892, and introduced for a brief period in 1897. Sheets of glass were ruled with alternate lines of red, green, and blue-violet, and placed in front of a panchromatic plate during exposure. The exposed plate was then developed in the ordinary manner, and positives made therefrom which were bound up with similarly ruled viewing screens. In consequence of the somewhat coarse ruling of the lines, they were rather obtrusive, and owing to the want of absolute contact between the viewing screen and the photographic positive parallax existed, so that the colour of an object changed with the angle at which the picture was viewed.

MEALINESS

Albumen paper that has been sensitised in a bath weak in silver has a mealy appearance when printed, and density and brilliancy are lacking. Very rarely a badly made toning bath and one weak in gold will cause mealiness. Improperly kept platinum paper also gives mealy effects.

MEASLES

A peculiar defect met with in all kinds of printing-out papers, but usually with albumen paper. The prints have a mottled appearance, and on being viewed by transmitted light the interior of the paper appears to be covered with opaque blotches, which, if allowed to remain, will afterwards discolour. The cause is generally a weak " hypo " fixing bath, or insufficient or acid fixing, but sometimes it is fixing in a strong light. The measle spots cannot be cured when once they appear, but they may be prevented by fixing thoroughly, and the use of an alkaline bath.

MEASURES, GRADUATED (Fr., *Mesure graduée, Vase gradué ;* Ger., *Mensur, Messglas*)

Vessels of glass, opal or celluloid of various

Graduated Measures Measuring Jug

shapes, used for measuring solutions. They are graduated either in ounces and drams, as at A,

or in cubic centimetres, a combination form B containing both scales being also made. Those of white glass with black graduations are most visible in the dark-room. Measuring jugs C are convenient for large quantities. (*See also* "Burette," "Dropping Bottle," etc.)

MEASURES, WEIGHTS AND (*See* "Weights and Measures.")

MEDALLIONS, ETC. (*See* "Bas-reliefs" and "Coins and Medals, Photographing.")

MEDICAL PHOTOGRAPHY

Every year sees the wider application of photography to medical science. At the present day photomicrography and radiography are of the very greatest importance, the first making it possible to obtain a permanent and exact record of the normal and abnormal appearance of the tissues, of the blood corpuscles, and of those blood-parasites and bacteria which are the cause of various diseases; while the second assists in the diagnosing of fractures of the bones, the presence of foreign bodies within the thoracic and abdominal regions, and calculi in the kidney, etc., etc. Radiography is fully treated under the heading of "X-Ray Photography," but the application of photomicrography to medical research calls for some consideration here. The microscope must have a centring sub-stage, and should also have a good mechanical stage fitted with vernier scales which act as "finders." The most useful objectives will be, for medium and high-power work, a $\frac{1}{6}$th, $\frac{1}{4}$th, and $\frac{1}{12}$th in. oil immersion; while for large sections and low-power work generally, a 2 in., 1 in., and $\frac{1}{2}$ in. The selection of eyepieces will be governed by the type and quality of the objectives. It is most important that both eyepieces and objectives be kept perfectly clean and free from dust, dust on the lenses of the eyepiece giving rise to the appearance of out-of-focus marks on the negative. The sub-stage condenser must also be carefully cleaned from time to time. As it is important to bring out as much detail as possible in the resulting negative, and all pathological and bacteriological preparations are stained with one or more stains, it is absolutely necessary not only to use carefully and thickly backed orthochromatic plates, but also suitable compensating filters, that the maximum amount of detail, coupled with sufficient contrast, may be obtained. While visual observation of the subject, with the compensating filter placed immediately behind the sub-stage condenser, will serve as a rough guide to the amount of detail and contrast likely to be obtained, unless the dyes used for the filter are spectroscopically true, and the photographic plate properly orthochromatised, the photographic result will not be as satisfactory as the visual examination promised. Long experience has shown that the most satisfactory results, as regards both the quality and resolution of the image, are to be obtained with a camera extension of 10 in. from the eyepiece of the microscope to the focusing screen of the camera. In photographing such subjects as skin eruptions and rashes, careful attention must be paid to the colour of the eruption. For instance, a pink, yellow, or red rash will show up much better if photographed with an ordinary plate of medium speed, than with an orthochromatic plate, for the simple reason that the ordinary plate being less sensitive to these colours, they will be rendered darker, and, therefore, more conspicuous, than if photographed on an orthochromatic plate. To photograph culture tubes of bacteria that have been inoculated by "stab" or "streak," place the tube in a large water bath or lantern alum trough filled with water. This will be found to do away with the unpleasant, bright, vertical reflections down the front and sides of the culture tube, and to facilitate the successful photographing of the growth within the tube.

MEDIUMS

The composition of mediums for colouring, retouching, and spotting are given under separate headings.

MEGASCOPE (*See* "Aphengescope.")

MEGATYPE (Fr., *Mégatype*; Ger., *Megatypie*)

A term at one time applied to a process of enlarging, and to the resulting enlargements.

MEGILP

Synonyms, M'Guilp, magilp, and magilph. A mixture of linseed oil and mastic varnish, used as a medium for oil colours and occasionally for rubbing upon platinotype and bromide prints for the purpose of increasing the depth and richness of the shadows.

MEISENBACH PROCESS

The earliest half-tone process commercially exploited. By the method patented in Germany in May, 1882, by Josef Ritter von Schmaedel and G. Meisenbach, a single-line screen was made from the proof of an engraved plate ruled with lines, and the screen was placed in front of a photographic positive of the picture and the two photographed together. Half-way through the exposure the screen was turned so that the lines crossed. A half-tone negative was thus obtained from which a zinc block was made. Afterwards the process was modified by placing the screen in front of the sensitive plate and photographing direct from the original print, the screen being turned half-way as before.

MELAINOTYPE

An early name for the ferrotype process.

MENISCUS LENS (Fr., *Ménisque*; Ger., *Meniskus*)

The concavo-convex lens. (*See* "Concave Lens" and "Convex Lens.")

MERCURIAL INTENSIFICATION (*See* "Intensification of Negatives.")

MERCURIC BICHLORIDE (*See* "Mercuric Chloride.")

MERCURIC CHLORIDE (Fr., *Bichlorure de mercure*; Ger., *Quecksilberchlorid*)

Synonyms, perchloride or bichloride of mercury, corrosive sublimate. $HgCl_2$. Molecular

weight, 271. Solubilities, 1 in 16 water, 1 in 3 alcohol, 1 in 12–14 ether. White crystalline masses or small crystals prepared by dissolving calomel in hydrochloric acid. Very poisonous, the antidote being white of egg, followed by an emetic. Its solution is decomposed by light, and should therefore be kept in the dark. It is used as the bleaching agent in mercurial intensification.

MERCURIC IODIDE (Fr., *Iodure de mercure ;* Ger., *Quecksilberiodid*)

Synonym, red iodide of mercury, biniodide of mercury. HgI_2. Molecular weight, 454. Solubilities, insoluble in water, 1 in 116 alcohol, 1 in 85 ether, very soluble in potassium iodide solution. A heavy scarlet red amorphous powder precipitated from mercuric chloride solution by potassium iodide. Poisonous (*see* " Mercuric Chloride " for antidotes). It is used in intensification, and is then usually prepared direct as follows :—

| Mercuric chloride | . | 54 grs. | 6 g. |
| Potassium iodide | . | 33 ,, | 4 ,, |

Dissolve each in a little water, mix, and add—

| Sodium sulphite | . | 4 oz. | 220 g. |
| Water to . | . | 20 ,, | 1,000 ccs. |

Mercuric and Potassium Iodide, $HgI_2 2KI$, is sometimes used instead of the above, and can be made by adding 2 parts of potassium iodide to 1 part of mercuric iodide in dry powder, or it can be made in solution by adding 99 parts of potassium iodide to 54 parts of mercuric chloride.

MERCURIC PERCHLORIDE (*See* " Mercuric Chloride.")

MERCURIC AND POTASSIUM IODIDE

This is described under the heading " Mercuric Iodide," above.

MERCUROGRAPHY

Many lithographic processes have been based on the fact that if those parts of a zinc plate which are not covered with ink are treated with mercury or a mercuric salt, the amalgam formed has the property of repelling ink.

MERCURO-URANOTYPE

A printing process (practically obsolete) in which uranic salts are employed, they being sensitive to light. Two saturated solutions, of uranium chloride and mercuric chloride respectively, are required ; 1 oz. of the first is mixed with 1 dram of the second and applied to paper, which is next dried in the dark. After printing, the paper is toned by floating on a very weak solution of gold chloride or potassium chloroplatinite, immersed in very dilute hydrochloric acid, and finally washed in plain water. (*See also* " Uranium Printing.")

MERCUROUS CHLORIDE

Synonym, calomel. Hg_2Cl_2. Molecular weight, 471. Prepared by precipitating a solution of mercurous nitrate with a solution of sodium chloride, and of but the slightest photographic interest.

MERCURY (Fr., *Mercure ;* Ger., *Quecksilber*)

Synonym, quicksilver. Hg. Molecular weight, 200. Solubilities, insoluble in alcohol and water, soluble in nitric acid and hot sulphuric acid. A heavy, silvery liquid element found native or obtained by roasting its ore, cinnabar. It was used as the developer in the daguerreotype process, and is also used in the Lippmann process.

MERCURY BATH

A dark box in which daguerreotypes were developed by mercury fumes. The mercuric chloride solution used for intensifying gelatine negatives is also known by this term.

MERCURY INTENSIFICATION (*See* " Intensification of Negatives.")

MERCURY PRINTING

By this process of printing (now obsolete) pure mercury is covered with nitric acid, and in the course of a few days the thick crust of moist crystals which will form should be removed and dried, as much as possible, on blotting-paper. Dissolve 230 grs. of these crystals in 5 oz. of water, and add nitric acid to dissolve any precipitate. Coat plain paper with starch paste, dry it, and in a very weak light float it on the above solution. Dry quickly and keep until required in a calcium tube. Print for two or three minutes and develop in :—

Ferric sulphate	.	65 grs.	15 g.
Tartaric acid	.	65 ,,	15 ,,
Water	.	10 oz.	1,000 ccs.

Fix for five minutes in a solution of 90 grs. of sodium chloride in 4 oz. of water, and tone the greyish image to a black one in :—

Potassium chloroplatinite	.	3 grs.	1 g.
Tartaric acid	.	60 ,,	20 ,,
Water	.	7 oz.	1,000 ccs.

MERCURY SULPHOCYANIDE (Fr., *Sulfocyanure de mercure ;* Ger., *Rhodanquecksilber*)

Synonyms, mercuric sulphocyanate and rhodanide. $Hg(SCN)_2$. Molecular weight, 316. Solubilities, slightly soluble in water, soluble in alcohol and solutions of alkaline chlorides and sulphocyanides. Poisonous (*see* " Mercuric Chloride "). It is a white powder, but is easily prepared in solution as follows :—

Mercuric chloride	.	2 oz.	100 g.
Potassium sulphocyanide.	.	768 grs.	80 ,,
Distilled water to	.	22 oz.	1,000 ccs.

For use dilute 1 part of the above with 10 parts of water. It is used as an intensifier for negatives, and gives a good black image, but it is preferable to apply a developer afterwards

MERCURY THERMO REGULATOR

For collotype ovens and drying boxes heated by gas a heat regulator, which depends on the expansion of mercury, is sometimes used. The simplest form consists of a U-shaped tube containing mercury A. Branch B is attached by a

THE MOON <small>PHOTOGRAPHED AT THE PARIS OBSERVATORY</small>

CELESTIAL PHOTOGRAPHY

rubber tube to a glass bulb c inside the drying box. Branch D is connected to the burners. E F are rubber stoppers, a glass tube G passing through F to the gas supply, whilst its end inside

Mercury Thermo Regulator

the U-tube is ground off at an angle. As the mercury expands through the heating of the bulb inside the box, the sloping end of the tube G is more or less closed, thus regulating the gas supply.

MERCURY VAPOUR LAMP (Fr., *Lampe à vapeur de mercure*; Ger., *Quecksilberlampe, Quecksilberdampflampe*)

A lamp in which the vapour of mercury in a vacuum tube is raised to incandescence by the passage of an electric current. The illustration shows the Cooper-Hewitt lamp. In this, four tubes are supported in a frame on an upright stand, the mercury being contained in the large bulbs, which form the negative ends

Mercury Vapour Lamp

or cathodes. When the switch has been closed the tubes are reversed, so that the mercury runs to the opposite end. This short-circuits the two electrodes and the tubes immediately light up, being then returned gradually to their previous position. The lamp must not be left with the bulbs uppermost; and the tubes must be connected up to the right polarity, or they will be destroyed in a few minutes. The light obtained is highly actinic, being rich in violet rays, and excellent for copying, printing, and enlarging. Owing to its great diffusion and coolness it is well suited for portraiture, the sole objection being the ghastly colour of the light. This effect is visual only, and does not appear in the photograph; since it is due

to the absence of red rays, it is easily rectified by using a few ruby or light-red incandescent lamps in addition. (*See also* "Electric Light.")

In process work, this lamp has been used for process copying and printing, but the liability of the tubes to break down rendered its general employment impracticable, and, on the point of economy, tests showed that whilst the lamps only took one-fourth of the current of "enclosed" arcs the exposure was four times longer, so that there was actually no gain. An advantage of the mercury lamps was, however, that in photographing wash drawings in which Chinese white had been used the reproduction was much more faithful than that obtained with arc lamps. For printing purposes with bichromate films the exposures were not more rapid than with the enclosed arc on account of the absorption of much of the actinic intensity of the light by the yellow stain of the bichromate.

MERCURY-SILVER PRINTING

A process of French origin (1892). Paper is floated on a solution of $\frac{1}{4}$ oz. of mercuric chloride in $6\frac{1}{4}$ oz. of distilled water. It is washed, dried, and sensitised on a bath of 48 grs. of silver nitrate in 1 oz. of distilled water. The paper, when dry, is printed under a negative for about a minute, and developed with the following, after which it is washed, fixed in "hypo," and again washed:—

Acetic acid	.	$\frac{1}{2}$ oz.	37 g.
Ferrous sulphate	.	$\frac{1}{2}$,,	37 ,,
Water	.	15 ,,	1,000 ccs.

METAFORMALDEHYDE (*See* "Trioxymethylene.")

METAGELATINE (Fr., *Metagélatine*; Ger., *Metagelatin*)

A name given by Lyte, in 1857, to a solution of gelatine boiled with dilute acid, usually sulphuric, so that it has entirely lost its setting power. The acid was subsequently neutralised with chalk, and the solution filtered and used as a preservative in the old collodion dry process.

Many vain attempts have been made to substitute metagelatine for fish glue in the enamel photo-engraving process.

METAL DISHES (Fr., *Cuvettes métalliques*; Ger., *Metallplatten*)

Enamelled iron or steel dishes are used for heating the alum-"hypo" toning bath, and for hot-bath platinotype, as well as for other purposes. Compared with porcelain dishes of similar size, they are light, unbreakable, and readily cleaned. The only danger is the chipping of the enamel, in which event the solutions act on, and are affected by, the iron beneath. Enamelled dishes will, however, last a long time without this happening, with ordinary care. If the fault is suspected, a little dilute sulphuric acid may be poured in the dish, when small bubbles of hydrogen gas will arise from any part where the metal is exposed. Leaden dishes are sometimes used for stripping solutions containing hydrofluoric acid.

METAL, PHOTOGRAPHS ON

Photographs may be obtained on metal by the bitumen process (see "Heliography" and "As-

23

phaltum "), or on silver plates by the daguerreo-type process. Ferrotypes—collodion photographs on enamelled sheet-iron—are another familiar instance. Carbon prints may be developed on metal plates as a final support, giving very effective results.

METALLIC FILMS, FLEXIBLE

A process invented in 1892 by Brandweiner and Lautensall, of Vienna. A photographic image is obtained on a highly polished copper or brass plate, which is then etched, the protecting film removed, and a polished image is seen on a matt ground. A deposit of some metal is now electrically produced, a sheet of paper, linen, etc., is made to adhere, and both sheet and thin metal deposit stripped off, leaving the plate ready for making another duplicate.

METALLIC SPOTS (See " Black Spots.")

METAMORPH PRINTS

Distorted or trick photographs produced either by warming the wet film and partially melting it, taking the film off the plate and stretching it, or by the use of curved mirrors. (See also " Anamorphoscope.")

METEOR PHOTOGRAPHY

The photographic delineation of meteors or shooting-stars forms one of the most fascinating branches of astronomical study. The fact that one of these visitors from outside space may flash through our atmosphere at any moment lends additional zest to the attempts made to portray them ; the only help one has to prepare for them is that past experience has shown that they occur in families, as it were, at certain fixed times of the year, and more or less concentrated in definite regions of the sky. Thus we have the Perseids in August, radiating in all directions from the constellation Perseus, and the Leonids in November, radiating from the sickle-like con-stellation of Leo. Apart from this help as to probable time and location, one must trust to patience and an ever-ready camera. The camera must be directed to the sky with the lens open, and immediately a meteor is seen to cross the field, the lens is capped and the plate developed. No special apparatus or plates are necessary ; the most rapid plates and a wide-angle lens of as large an aperture as possible are to be recom-mended. If the observer is fortunate, he may chance to photograph a fireball, that is, a meteorite in the act of exploding owing to the heat developed by friction with the atmosphere.

METEOROLOGICAL PHOTOGRAPHY (Fr., La photographie météorologique ; Ger., Meteorologische Photographie)

Photography is of great service to the meteor-ologist in connection with automatic recording instruments, among which may be mentioned the photo-barograph, or barometrograph, which registers the fluctuations of the barometer ; the thermograph for recording changes of tempera-ture ; the psychrometer, a measurer of the amount of watery vapour in the air ; and the magnetograph, for indicating the oscillations of the magnetic needle. Photography is also em-ployed to record the positions and forms of clouds, in making observations of the solar spectrum, etc.

METER (See " Actinometer," " Exposure Meter," " Opacity Meter," etc.)

METHOL

An early name for the metol developer.

METHVEN SCREEN

A sheet of metal pierced with an aperture placed in front of a standard light to limit the effective portion to the part which burns the most steadily, this usually being at the centre

METHYL ALCOHOL (See " Alcohol.")

METHYL ORANGE (Fr., Hélianthine ; Ger., Methylorange)

Synonyms, dimethylaniline orange, gold orange, tropæoline D, orange III., helianthine, Poirrier's orange 3 P. Soluble in water. Sodium or ammonium dimethylaminoazobenzenesul-phonate. A yellowish powder giving an orange-coloured solution, which is not affected by car-bonic acid, turned bright red by mineral acids and yellow by alkalis. It has been suggested for making yellow screens. It is also the mother substance from which eikonogen is prepared.

METHYL VIOLET (Fr., Violet de méthyle ; Ger., Methylviolet)

Many dyes are known under this name, and they are distinguished from one another by the suffix 5B, 4B, etc., R, 2 R, 3R, B meaning that the dye has a more or less bluish shade which is shown by the figure affixed to the B ; whilst R means red, the increase in red being shown by the figures. They are essentially mixtures of the hydrochlorides of pentamethylrosaniline and hexamethylpararosaniline. They generally occur in greenish glistening crystals or lumps, very soluble in water and alcohol. Used for making three-colour screens.

In process work, methyl violet is used for dye-ing the print in the fish-glue enamel process, so that the progress of development may be seen.

METHYLATED ETHER (See " Ether.")

METHYLATED SPIRIT (See " Alcohol.")

METHYLCATECHOL (See " Guaiacol.")

METHYLENE BLUE (Fr., Bleu méthylène ; Ger., Methylenblau)

Synonyms, methylthionine or tetramethyl-thionine hydrochloride. Soluble in water. A dark-green crystalline powder used for making the blue screen, and also the blue positive print, in three-colour work. Various shades of the dye are dis-tinguished by the suffixes, B, BB, R, RR, etc., as with methyl violet.

METHYLEOSINE

The " BN " or " Scarlet B " variety of eosine, giving with water a scarlet solution.

METHYLIC ALDEHYDE (See " Formaline.")

METHYLPYROCATECHIN

A synonym for guaiacol.

METOL (Fr. and Ger., *Metol*)

A salt, generally the sulphate, of methyl-paramidophenol $C_6 H_4 (OH)(NH CH_3)$ according to Andresen, and of methylparamidometa-cresol $C_6 H_3(OH)(CH_3)(NH CH_3)$ according to Hauff. It is a white, greyish or pinkish-white powder easily soluble in water. When mixed with an alkali it forms an energetic developer.

bromide) is often advisable. Sodium hyposulphite may be used with caution in any metol developer, and Eder recommends the addition of from 2 to 4 per cent. of a 10 per cent. solution for obtaining great contrasts and preventing fog.

Metol is largely used in combination with pyrogallic acid, hydroquinone, glycine and other developers, and formulæ for these combined

	METOL.		METOL—HYDROQUINONE.			
	1.	**2.**	**3.**	**4.**	**5.**	**6.**
	Andresen One-solution.	*Hauff One-solution.*	*Average One-solution.*	*One-solution for Winter Use.*	*One-solution for Bromide Paper.*	*One-solution for Gaslight Papers.*
Metol	180 grs. 20 g.	130 grs. 15 g.	15 grs. 1·7 g.	75 grs. 8·5 g.	50 grs. 6 g.	20 grs. 2·2 g.
Sodium sulphite	3½ oz. 195 ,,	3 oz.70 173 ,,	1 oz. 55 ,,	1½ oz. 70 ,,	1 oz. 55 ,,	700 ,, 80 ,,
Potassium bromide	22 grs. 2·5 ,,	8¼ ,, 1 ,,	5 grs. ·6 ,,	10 grs. 1·2 ,,	10 grs. 1·2 ,,	7 ,, ·8 ,,
Potassium carbonate	600 ,, 70 ,,	550 ,, 63 ,,	1½ oz. 82·5 ,,	—	—	—
Hydroquinone	—	—	60 grs. 7 ,,	38 grs. 4·4 g.	25 grs. 3 g.	50 grs. 6 g.
Sodium carbonate	—	—	—	—	1 oz. 55 ,,	700 ,, 80 ,,
Sodium hydrate	—	—	—	150 grs. 17 g.	—	—
Water	20 oz. 1,000 ccs.	20 oz. 1,000 ccs.	20 oz. 1,000 ccs.	20 oz. 1,000 ccs.	20 oz. 1,000 ccs.	20 oz. 1,000 ccs.
For use	Mix 1 part with 3 parts of water.	Mix 1 part with 1 to 2 parts of water.	Ready for use for negatives.	Ready for use.	Ready for use; may be diluted.	Ready for use; do not dilute.

On account of the rapid appearance of the image there is a risk of taking the negative from the developer too soon. In accordance with the factorial system of development a negative developed with metol must be allowed to remain in the developer about thirty times as long as the image takes to appear, and density will then be assured. The table given above includes formulæ for one-solution developers, and the formulæ here given are for two-solution developers :—

Two-solution Developers

(Andresen)

A. Metol . . . 180 grs. 20 g.
 Sodium sulphite . 3½ oz. 195 ,,
 Water . . . 20 ,, 1,000 ccs.
B. Sodium carbonate 560 grs. 64 g.
 Water . . . 20 oz. 1,000 ccs.

For use, take 1 part of A and 3 parts of B.

(Hauff)

A. Metol . . . 130 grs. 15 g.
 Sodium sulphite 3 oz. 70 grs. 173 ,,
 Water . . . 20 oz. 1,000 ccs.
B. Sodium carbonate 3 oz. 70 grs. 173 g.
 Potassium bromide 14 grs. 1·6 ,,
 Water . . . 20 oz. 1,000 ccs.

With regard to Hauff's two-solution developer above, for normal exposures and quick and vigorous development, take equal parts of A and B; but for slow development take equal parts of A, B, and water, and add to each 3½ oz. of mixed developer, 5 to 10 drops of either a 10 per cent. solution of potassium bromide, or of a 10 per cent. solution of sodium hyposulphite. When using this modified developer density and detail (surface and depth) develop approximately simultaneously. The addition of a few drops of citric acid (which is a more powerful restrainer than potassium

mixtures will be found under the heading "Developers, Mixed," as well as, in the case of metol-hydroquinone, in the table which is given above.

Metol has an irritating effect upon some skins, and it is, therefore, wise not to wet the fingers with the developer more than is necessary. The irritation is sometimes felt when metol is used for the first time, but generally it is not experienced until metol has been used frequently over a long period. It is wise to discard metol immediately the trouble occurs, as the pain and inconvenience are likely to increase every time the metol is used. The hands should always be washed with warm water and soap, preferably carbolic, after using metol, and wiped with a dry, soft towel. Many remedies for the disease have been recommended, such as rubbing the fingers with lemon juice, vaseline, cold cream, etc., when the itching is first felt. An ointment (to be made up by a chemist) specially recommended is :—

Mercuric nitrate . 60 grs. 60 g.
Carbolic acid . . 10 mins. 10 ccs.
Zinc oxide . . 30 grs. 30 g.
Lanoline . . 1 oz. 480 ,,

The fingers should be smeared with the above at night, and an old pair of kid gloves worn. Coal-tar ointment is also recommended.

METOL - HYDROQUINONE (METOL-QUINOL)

A mixture of metol and hydroquinone is a popular developer, being clean in working and suitable for most kinds of plates and bromide and gaslight papers. It is sometimes known as metol-quinol, quinol being another name for hydroquinone. Scores of one, two, and even three solution formulæ have been given, but

there is very little difference between them. Taking a dozen of the best known formulæ, the average one-solution developer is as No. 3 in the table given in the preceding article, this developer being ready for use and of the correct strength for negatives, lantern plates and gaslight papers, but when used for bromide papers an equal amount of water is required. The hydroquinone and metol are not in equal proportions, but many prefer to have the hydroquinone in excess, the metol being the more expensive of the two. The proportions may be altered to suit the temperature, it being advisable to have more metol than hydroquinone in cold weather, because hydroquinone is apt to work very slowly in winter, especially when sodium carbonate is used, and, moreover, is apt to crystallise from its solution. Formulæ for two- and three-solution developers are given below :—

Two-solution

A. Metol	.	.	40 grs.	4·6 g.
Sodium sulphite	.	120 ,,	14 ,,	
Potassium bromide	.	10 ,,	1·2 ,,	
Hydroquinone	.	50 ,,	6 ,,	
Water	.	.	20 oz.	1,000 ccs.
B. Potassium hydrate		40 grs.	4·6 g.	
Water	.	.	20 oz.	1,000 ccs.

For use, take equal parts of each.

Three-solution

A. Metol	.	.	100 grs.	11·5 g.
Sodium sulphite	.	300 ,,	34·5 ,,	
Water	.	.	20 oz.	1,000 ccs.
B. Hydroquinone	.	100 grs.	11·5 g.	
Citric acid	.	25 ,,	3 ,,	
Water	.	.	20 oz.	1,000 ccs.
C. Potass. carbonate	.	1 oz.	55 g.	
Water	.	20 ,,	1,000 ccs.	

Normally, use 1 part each of A and B and 2 parts of C; in cases of over-exposure, add potassium bromide, and for under-exposure increase the proportion of C.

When making up solutions of metol, sodium sulphite, and hydroquinone, always dissolve the chemicals in the order given.

METOL-SILVER INTENSIFIER

An intensifier specially suitable for wet or dry collodion negatives, either before or after fixing. Dr. Eder's formula is :—

A. Metol	.	.	72 grs.	16·5 g.
Citric acid	.	48 ,,	11 ,,	
Water (distilled)	.	10 oz.	1,000 ccs.	
B. Silver nitrate	.	48 grs.	11 g.	
Water (distilled)	.	1 oz.	100 ccs.	

The well-washed negative is dipped in A and then covered with a mixture of 10 parts of A and 1 part of B. Density increases rapidly. The opaque portions of the negative will appear blue by transmitted light when wet, and brown after drying.

METOL-SULPHITE

A commercial form of the metol developer to which alkali does not need to be added. For use, it is mixed with water. 1 oz. dissolved in 40 oz. of water makes a good stand developer.

METOQUINONE

Under this name Messrs. Lumière introduced into England, in 1903, a metol-hydroquinone developer, but in the same year the name was altered to " Quinomet " (*which see*). In other countries, metoquinone still refers to the Lumière preparation.

METOTYPE (Fr., *Métotype*; Ger., *Metotype*)

A paper or card coated with gold, silver, copper or bronze powder, beneath the sensitive emulsion, so that finished prints appear as if on a metallic surface. A similar result is obtained by coating ordinary stout gold or silver paper with celluloid varnish to isolate the metal, and allowing to dry thoroughly. Any P.O.P. emulsion may then be applied.

METRE

A metric measure of length equal to 39·370113 in. (about 39⅜ in.).

METRIC SYSTEM (*See* "Weights and Measures.")

METZOGRAPH SCREEN

A screen placed in front of the sensitive plate for breaking up the image into a grain in order to reproduce the image on a printing block, both screen and process being the invention of James Wheeler. In making the screen the surface of a sheet of plate glass is covered with a fine reticulated resinous grain as a result of burning pyrobetulin and holding the glass over the vapour. This grain forms a resist to hydrofluoric acid, so that the plate can be etched, after which the resinous grain is cleaned off and the granulations on the glass stand up in relief. Each grain point then acts as a tiny prism or lens deflecting the light and causing a grain effect to be imparted to the plate.

MEZZOCHROME

A process of intaglio printing in colours worked on the basis of the Rembrandt photogravure process.

MEZZO-RELIEVO

A term used principally in photo-sculpture. When the figures project in relief more than half their true proportions, the effect is termed alto-relievo ; when exactly one-half the term used is mezzo-relievo; and if less than half, basso-relievo (English, bas-relief).

MEZZOTINTO

A process of colouring engravings, etc., and the prototype of the crystoleum process (*which see*).

MEZZOTINTOGRAVURE

A name given by Bruckmann, of Munich, to his process of rotary intaglio photogravure printing, which is supposed to be done after the style of the Rembrandt process.

MICA (Fr., *Mica*; Ger., *Glimmer*)

Various double silicates of alumina and alkalis, occurring naturally in blocks which split up into transparent sheets, each composed of laminæ. Mica has been used as a support for gelatine emulsions, etc.

MICROMETRY

The measurement of minute divisions of space. The best known device for obtaining micrometrical measurements in microscopy and photomicrography is the stage micrometer ruled into lines to $\frac{1}{100}$ or $\frac{1}{1000}$ in., or $\frac{1}{10}$ and $\frac{1}{100}$ mm. A fairly accurate estimation of the size of an object can be made by focusing the ruled lines of this micrometer on the stage and carefully noting the space in the field taken up by a certain number of lines. The object to be measured is then substituted for the micrometer slip and focused with, of course, the same objective, eyepiece, and length of draw-tube. The approximate size of the object can then be gauged by comparing the diameter of the specimen with the space previously taken by the ruled lines. For accurate work a micrometer eyepiece is necessary to measure off the rulings of the stage micrometer. In the micrometer eyepiece a small plate of equidistant ruled lines is fixed in the focus of the eye lens of the eyepiece, the lines being then visible when the microscope is in use. The stage micrometer is focused in the usual way, and the number of its lines which take up the same space as a certain number of the eyepiece divisions is noted. The stage micrometer is then replaced by the specimen, and the diameter of the latter is compared with the previously noted eyepiece divisions. It is not necessary to have fixed numbers of lines per inch in the eyepiece rulings; in fact, two points in the focus of the eye lens are all that is required. Two small ink marks on a cover slip will answer the purpose. The cover slip is dropped on to the stop of the eyepiece and the number of rulings of the stage micrometer which fill the space between the ink spots noted; the size of the object can then be calculated.

For extreme accuracy the mechanical-screw eyepiece micrometer is necessary. In this eyepiece are two wires, one of which is fixed while the other, worked by a travelling screw turned by a milled head, traverses the field. Across the field is fixed a plate provided with minute teeth, and each revolution of the milled head moves the wire from one tooth to the next. By this means the stage rulings can be compared with the distance between the two wires with extreme accuracy.

In photomicrography the magnification of an object is easily found without the aid of a ruled eyepiece. The object is first focused on the ground glass of the camera, and its diameter marked by ink spots. The stage micrometer then replaces the object and, after focusing, the number of lines between the ink spots is read off. This gives the size of the object, and the magnification is then easily calculated by measuring the distance between the two ink marks.

MICROPHOTOGRAPHY

The production of photographs of microscopic size by means of the microscope. Microphotographs were at one time produced in large numbers for inserting into penholders, etc., but since the introduction of dry plates microphotography has become practically obsolete. The wet collodion process is essential for this work owing to the structureless nature of the collodion film, and the extremely fine grain of the silver deposit. An objective of 1 in. or $1\frac{1}{2}$ in. focal length is the most suitable lens. A camera is not required, as the prepared plate can be fixed to the microscope stage and exposed in that position. The operation must, of course, be carried on at night time, or in the dark-room. A clean, bright negative of the object is first made on an ordinary dry plate. The microscope, with the eyepiece removed and the objective in place, is put into a horizontal position, and the negative is placed at a distance of about 2 ft. from the lens. The open end of the microscope tube faces the negative. The most convenient arrangement for staging and illuminating the negative is a large box with one hole, slightly smaller than the negative, cut in the side, and another in the top, to serve as a chimney. The negative is secured in front of the hole by drawing-pins with a piece of ground glass or tissue paper behind it to diffuse the light. A lamp is placed behind the diffuser to illuminate the negative. The image of the negative given by the objective is now roughly focused on a piece of white card placed on the stage of the microscope, which is moved to and fro until the image is of the required size. The centre of a glass slip is coated with collodion and sensitised and transferred to the microscope stage. A sheet of cardboard is placed over the negative while the sensitised slip is being placed in position. The card is removed, and the image carefully refocused on the sensitised collodion, which makes an excellent focusing screen. As a small portion of the film will be fogged during focusing, before the exposure is made the card is replaced, and the slide moved slightly to replace the fogged part of the film by a fresh piece. Several trial exposures of varying length are made on different portions of the film, and the slide is then developed and fixed. Pyro and acetic acid should be used for development, as the deposit given by this reducer is of finer grain than that produced by an iron developer. The microphotograph, of course, requires the microscope or magnifying lens to resolve its details. The amount of reduction which the process will allow is limited by the size of the granules of the silver deposit, but the details of a half-plate negative are easily visible in a micro-photograph having as small a diameter as $\frac{1}{34}$ in.

MICROSCOPE (Fr., *Microscope*; Ger., *Mikroskop*)

The simple microscope, which was the earliest type of instrument, consists of a stand provided with a single lens or combination of lenses known as the objective, which is focused by mechanical means. This type of microscope is still used in laboratories for dissecting work. The compound microscope is fitted with an arrangement by which the image given by the objective is still further magnified by another lens or combination of lenses known as the eyepiece or ocular. A compound microscope is usually provided with a coarse and fine adjustment for focusing, the former being used for low magnifications and the latter for high magnifications. The illustration shows a typical instrument. The foot or base is usually of

either horseshoe or tripod form. The "limb" carries the focusing apparatus and the body-tube with objectives and eyepiece. The draw-tube, a smaller tube, sliding or moving by rack and pinion, inside the body-tube, receives the eyepiece or ocular, and enables the separation of objective and eyepiece to be varied at will. The draw-tube is also useful for objectives of very low power which require a longer working distance than the coarse adjustment will allow, the lower end of the tube being provided with a thread to receive the objective. The stage, which supports the object, is provided with clips to secure the glass slides, and is sometimes fitted with mechanical movements to enable the object under the lens to be accurately adjusted. The sub-stage condenser, for use with high powers, is fixed beneath the stage and focuses the light upon the object which is being examined. In the stage is an aperture in order

Compound Microscope

that transparent specimens may be illuminated by light reflected from the mirror beneath the stage. To facilitate the operation of changing the objective for one of another power, a swivel lens holder, known as a nosepiece, and allowing of the use of several objectives of various powers, can be screwed into the lower end of the microscope tube, and high or low power objectives can be brought into use by merely turning the nosepiece on the pivot. Most microscopes are inclinable; that is, the instrument can be brought over to a horizontal position for photomicrography.

MICROSCOPE, PHOTOGRAHY WITH
(*See* "Photomicrography.")

MICROSCOPE SLIDES FOR SPECIMENS
Glass slips measuring 3 in. by 1 in., on which sections intended for microscopic examination are mounted. Such objects and transparent sections are mounted in Canada balsam or glycerine. Opaque substances are mounted in cells. (*See* "Cells for Microscopical Specimens.")

MICROTOME
An instrument designed for cutting extremely thin sections of any tissue which is to be examined or photographed through the microscope. Two types of microtomes are used. One form merely holds, and pays out, the preparation, the actual cutting being done by hand. The other includes a razor which automatically cuts sections to the required thickness. Some kind of support is necessary to hold the material in the microtome. The method generally adopted is known as "imbedding"; the specimen is placed in melted paraffin wax till the tissues are permeated. The wax is allowed to set and, with the contained specimen, is then transferred to the microtome for cutting. The wax is subsequently dissolved from the tissues with turpentine. Another method of supporting the tissue is by placing the material to be cut in gum water on the stage of a microtome and freezing the mucilage by means of ether vapours.

MID-ANGLE LENS
A lens having a field of view of about 50°, or having a focal length equal to the longest side of the plate. The term is, however, very elastic.

MIDDLE ANGLE LENS (*See* "Mid-angle Lens.")

MIDDLE DISTANCE
That part of a picture intermediate between the foreground and the distance.

MILK PROCESS
Milk was one of the many substances used for preserving collodion plates. Twenty grains of condensed milk were mixed with each ounce of water, filtered, and flowed over the collodionised plate.

MILLIMETRE, MILLIGRAMME, MILLI-LITRE, ETC. (*See* "Weights and Measures.")

MINERAL PAPER
Synonym, papier minéral. A translucent paper which is pasted upon the glass side of negatives for the purpose of working upon in pencil or crayon.

MINES, PHOTOGRAPHY IN
With the advent of the dry plate, the modern lens and the actinic flash powders, photography in mines has become much more easy. The bunch of magnesium ribbon, lime-light apparatus and portable lamps have all been superseded. In gassy mines, the use of flashlight mixtures is inadmissible, but it answers well, for example, in the tin mines of Cornwall, which are deep, hot, smoky, wet and dirty, with grease, mud, and slime in abundance, in some places stagnant air in which the tallow candles will not burn, in others a draught so strong that naked candles cannot be kept alight. The hanging walls from which water drips from every jagged point of rock, the slippery footwalls, open stopes, deep gunnies, perpendicular ladders with iron staves, the low, narrow levels, etc., etc., present the most unpromising conditions for successful

photography. The miners work by the light of tallow candles stuck in a lump of clay which adheres to the hard hat they wear, or against the rock on arriving at the scene of their operations. These candles give out little illumination, but plenty of smoke. The angular rocks of a dull brown, non-actinic colour require powerful illuminants to bring out their structure. The mine photographer should be something of a mining engineer so as to grasp intelligently the idea which the photograph is intended to illustrate. In Cornwall he becomes familiar with mineral lodes and cross-courses, shafts, levels and winzes, air currents and ventilation. The principal features of mining, or the natural position of the miner at his work, must not be sacrificed in order to compose an artistic or sensational picture. Neither must he be fastidious about his dress, hands or apparatus, nor object to crawl on his hands and knees over the rough rocks, through narrow openings, and oftentimes dangerous places. The camera must be strong and well made, capable of enduring without serious damage the inevitable contact with points of rock. Double dark-slides filled with plates sufficient for the day's use should be taken. Plates could be changed underground as absolute darkness exists when the candles are extinguished, and it is quite easy to feel to do this work, but other conditions are not favourable to this course. It rarely happens that more than six plates can be exposed in one "shift," and as a rule only one exposure can be made in one place by reason of the smoke caused by the combustion of magnesium. At least three lenses are necessary, respectively of 10 in., 7 in., and 5 in. focal lengths. The greatest trouble with lenses is caused by moisture condensing on their cold surfaces, and in order to avoid this as much as possible they should be carried in the inner pocket of the flannel shirt next the skin. As soon as the cap is put on after focusing, condensation immediately covers the front of the lens, and this can scarcely be wondered at in a temperature exceeding 100° F. (about 38° C.), with steam rising from the water which runs at one's feet, or dropping from the jagged points of rock above the camera. A piece of soft silk kept in the trousers pocket should be used to wipe the lenses. In some places, where the heat is almost unbearable, drawers are the only garments worn by the miners at work.

In the past magnesium ribbon and the oxy-hydrogen light were used; now, after repeated experiments, triple flash lamps of great power have been found to give the best results. From two to four of these lamps are generally sufficient, with an exposure of about three or four seconds. By a judicious use of lamps some unique lighting effects can be obtained, but special attention must be given to air currents, which, if possible, should be upward, or else towards the camera. When it is not possible to photograph a gunnies (a large chamber) from one standpoint, it often answers to move the camera to the other end; this is probably due to the admission of good air at one end driving the foul air to the other, which, although not perceptible to the eye, is revealed by the lens and produces a foggy effect. Flash candles are useful when placed

behind a rock so as not to produce a glare in the lens.

The most sensitive plates are not the best for the purpose, because of their tendency to fog in forced development; there is usually more than enough of fog surrounding the object itself. A plate of medium speed, say 100 H. and D., backed, has been found to possess all the qualities necessary.

For photographing coal mines, the general arrangements are the same as in tin mining, but naked lights can only be used in those few collieries that are free from gas; otherwise, the difficulties are not so great, the mines are drier, the coal surfaces reflect the light, and very little trouble is experienced with coal dust.

In the slate mines of North Wales and other places, where there are vast excavated chambers a hundred fathoms from the surface, the conditions are easier still, the air is good, and it is a question only of sufficient lamps to light up the dark caverns.

The subsequent printing from the negative is a matter of ordinary practice, but the picture should represent as clearly as possible the colour of the rock or material photographed. By the carbon process, for instance, bluish tones representing slate can easily be obtained, or brown tints will depict the darker rocks in Cornish mines, and blue-black the coal deposits.

J. C. B.

MINIATURE (Fr., *Miniature*; Ger., *Miniatur*)

A term loosely applied to any small portrait. The best photographic miniatures are usually carbon prints of a suitable depth transferred to ivory and then coloured. The commoner forms of miniatures are prints upon ordinary P.O.P., coloured by means of aniline dyes.

MINIM

The one-sixtieth part of a dram, and the one-four hundred and eightieth part of an ounce. The idea that drops and minims are the same is erroneous, although when drops are mentioned minims are often meant. (See "Drops.")

MIRROR, BLACK [See "Black Mirror" and "Claude Lorraine Glass")

MIRROR BOX (See "Mirror, Reversing.")

MIRROR CAMERA (Fr., *Chambre miroir*; Ger., *Spiegelkamera*)

A camera devised by J. W. Draper in the early daguerreotype days, in which a large concave

Mirror Camera

mirror was used instead of a lens, the plate **A** (see illustration) being placed in a small box facing the mirror, and receiving an image by

reflection. The advantage gained was the possibility of shorter exposures than were feasible with small aperture lenses, and the absence of chromatic aberration ; but it is difficult to avoid a certain amount of stray light, and the mirror has to be large to compensate for the obstruction of illumination caused by the plate and its support.

Concave mirrors are of value in stellar photography, where any stray light met with is but feeble.

MIRROR PHOTOGRAPHY

The art of photographing objects reflected in a mirror, enabling one at times to obtain photographs which would otherwise be impossible owing to confined space or the use of a long focus lens. For example, and as shown at A, in a small room and using a long focus lens, the only way of photographing a sitter would be to place a mirror at a suitable angle opposite the sitter, and to arrange the camera so as to photograph the reflection. In convenience, the distance of camera from sitter is doubled, whereas in fact the camera is nearer the model but pointing in another direction, namely, that of the mirror. The law of regular reflection is that the angle of reflection is equal to the angle of incidence, as can be proved by a minute's experimenting. A mirror placed as shown at B would reflect D at d, C at c, B at b, and so on. D is at the same angle with E E as is d, and the

A. Arrangement for B. Diagram showing Prin-
Mirror Photography ciple of Mirror Photo-
 graphy

same holds good with regard to C and c and B and b. Therefore, to photograph an object at, say, C, the camera should be placed on the line c, but not necessarily at the same distance from the mirror as the object photographed. Much depends upon the size of the mirror. As is well known, a mirror reverses the objects as regards left and right, and therefore to secure a correct image in the print the negative must be reversed, either by stripping the film or by inserting the plate into the dark-slide glass surface outwards, care being taken that the glass is perfectly clean.

MIRROR, REVERSING (Fr., *Miroir de renversement* ; Ger., *Umkehrspiegel*)

A surface-silvered plane mirror is frequently used, at an angle of 45°, in front of or behind the lens when reversed negatives are required. Behind the lens is the best position, as the mirror is then better protected from air and dust, and one lens can be changed for another without disturbing the mirror. The mirror is usually enclosed in a box, as illustrated, the open side fitting on the camera front and the lens

being placed at the side of the box, at a right-angle with the focusing screen or plate. The

Mirror Box

copy or object is arranged sideways to the camera. (*See also* " Prism.")

MIRRORS, DISTORTING

The use of distorting mirrors is described under the headings " Anamorphoscope " and " Caricature."

MISCHEWSKI'S REDUCER

A cerium reducer introduced in 1900, and consisting of a solution of 1 oz. of cerium sulphite and 3 drms. of sulphuric acid in 10 oz. of water ; to be kept in the dark. One part of this stock solution is diluted with 3 parts of water for use. It works rapidly, and does not alter the colour of the negative.

MIXTOL

A " mixed " developer of Continental origin (1892), and containing hydroquinone and eikonogen as the developing agents proper. (For formula, *see* " Developers, Mixed.")

MODELLING

A term used to indicate that the play of light and shade has been so rendered as to suggest accurately the contours and surfaces of the subject.

MODELS (Fr., *Modèles* ; Ger., *Modelle*)

The professional artist's model frequently has objections to posing for the photographer, especially if the photographs are intended to be reproduced commercially in large numbers, for which purpose the model's permission in writing should always be secured, even when the photographer undoubtedly owns the copyright of the pictures in which the model is shown. A professional model, whose especial business is to pose, will thoroughly enter into the spirit of the business and will frequently, as the result of experience, be able to offer valuable suggestions. The amateur model is often somewhat prone to look camera-conscious. There has been a general feeling that actors make but poor models, but the development of the art of kinematography has brought into being a special class of motion picture actors who, generally speaking, are excellent in every way.

MOGUL VARNISH

A waterproof and acid-resisting varnish of American origin, used by process workers. It is believed to be a bituminous by-product from petroleum wells, and is dissolved or thinned

with coal-tar naphtha. Spread on glass and etched through with a needle-point, it is the means of making excellent lantern slides of diagrams, etc. It may be used for coating trays of wood, metal, or cardboard for developing and other purposes.

MOISTURE (*See* "Damp, Precautions against.")

MOLECULAR DISTURBANCE AND STRAIN THEORY (*See* "Latent Image.")

MOLYBDENUM PRINTING

Several of the molybdenum salts, such as the chloride and ammonium molybdate, are sensitive to light, and give faint images, usually of a bluish tinge, which can be developed or toned to various colours with ferricyanide, chloride of gold, etc. The processes are, however, of purely theoretical interest.

MONCKHOVEN'S INTENSIFIER

An intensifier by means of which the image is bleached with mercury and blackened with a solution of silver nitrate and potassium cyanide. It intensifies the lights to a greater extent than the shadows, and is best suited to an over-exposed and under-developed negative. The formula is :—

A. Mercuric chloride	10 grs.		2 g.
Potass. bromide .	10 ,,		2 ,,
Water . .	1 oz.		100 ccs.
B. Silver nitrate .	10 grs.		2 g.
Potass. cyanide (about) . .	10 ,,		2 ,,
Water (distilled) .	1 oz.		100 ccs.

In making up B the water should be halved and the cyanide dissolved in one half and the silver in the other. The cyanide is then poured into the silver solution and the mixture shaken. A white precipitate will be formed, and will gradually become almost but not wholly dissolved. If it should be quite dissolved, add a drop or so of silver nitrate solution until a slight precipitate remains. The mixture is next filtered, or the clear portion (actually somewhat discoloured) poured off for use. The negative is immersed in A until bleached, washed for about fifteen minutes, blackened in B, and finally washed. The process may be repeated if necessary, but the negative must not be left in the cyanide-silver mixture too long, or a gradual reduction will take place. The colour of the intensified image is a good black or brown black, no matter what the original colour may have been.

MONO-CARBOXYLIC ACIDS (*See* "Carboxylic Acids.")

MONOCHROMATIC LIGHT

Literally, this means a light of the colour of one ray of the spectrum, but in the general sense it is applied to light of one colour, though this may comprise a fairly wide band in the spectrum. It has been very usual to speak of the monochromatic sodium light, though this actually comprises several blue and violet rays as well as the two familiar D lines in the orange yellow. It is possible to obtain pure monochromatic light by isolating one individual Fraunhofer line in the spectrum of a metal or gas, such as thallium, which gives a single isolated line at λ 5348, or the hydrogen F line λ 4861. These lines may be isolated either by means of a prismatic spectrum and metal screens so pierced as to allow only the one ray to pass, or by colour filters which absorb all but a narrow band in the spectrum coincident with the line in question.

MONOCHROMATIC SCREEN

A term applied to colour filters usually prepared with aniline dyes so that they pass light of one colour, but not strictly monochromatic if reference is made to the spectrum. As a rule, such screens pass a band comprising about ten wave-lengths, but the eye is not sufficiently sensitive to distinguish them, and they, therefore, appear monochromatic, or of one colour. They are used in photomicrography, and for special spectroscopic and astronomical work.

MONOCHROME (Fr., *Monochrome* ; Ger., *Einfarbige Gemälde*)

Literally, one tint or colour. Practically all photographs are in monochrome ; that is to say, the image is black, brown, red, green, etc., according to the process employed. The exceptions are prints made by the three-colour processes, by multiple gum printing, or by the oil-pigment process. Photographs in colour on glass plates are, of course, in a different category.

MONOCHROME, RENDERING COLOURS IN

The ordinary photograph is limited in the sense that the various colours of the original are all recorded by different shades of grey or monochrome. Should a yellow daffodil be placed in front of a violet screen, the yellow of the flower and the violet of the screen both being equally bright, the eye would at once differentiate them owing to the colour contrast. A fully iso- or ortho-chromatic plate would record them in the negative as of exactly equal tone. An ordinary plate would render the violet screen almost white, the yellow daffodil almost black. Both results would be wrong.

The ordinary photograph is all of one colour, hence the rendering is in monochrome, and we are dependent on monochrome contrasts to represent both light and shade, and colour contrasts. How a correct rendering in monochrome of a coloured subject can be effected will be seen by a reference to a plate accompanying this work : "Various Renderings of Daffodils in a Blue Vase." The left-hand top picture shows an absolutely incorrect rendering, as is inevitable when using an ordinary plate which is practically insensitive to yellow, hence the flowers appear nearly black. The blue of the vase is intensely actinic, and in consequence appears white. In the top right-hand picture is shown the same subject recorded orthochromatically, the vase appearing dark and the flowers light grey. By slightly overdoing the colour correction a picture is obtained (bottom right-hand figure)

which gives an excellent contrast between flowers and vase. It will thus be seen that by intentional wrong rendering in monochrome it is possible to suggest to the eye the colour contrasts that it would see in the original subject.

In the spectrum, the brightest colour, to the eye, is the greenish-yellow; apple green and orange are the next brightest; blue-green and orange-red less bright; and violet and ruby least bright. When a perfectly correct colour rendering is required, the plate and the screen must be so combined that on photographing the spectrum the various pure colours would be recorded in monochrome in the order given, greenish-yellow (lightest), green and orange, blue and red, violet and ruby.

The monochrome gradation is again altered according to the colour of the print. An ordinary subject, such as a cottage or house, appears very "flat" in a yellow carbon print, and much brighter or more contrasty if printed in pink, green or blue. The tone values in each print, relatively to each other, would be the same, but the apparent contrasts to the eye would vary greatly. Where subtle contrasts require emphasis, a warm colour such as sepia should not be employed for the print, but either a bright grey, such as would be given by a gaslight print, or a blue tone.

MONOCLE (Fr., *Monocle;* Ger., *Monokel*)

A single or "spectacle" lens used as an adjunct to an ordinary lens, either to lengthen or shorten its focal length, or to serve as a telephoto attachment.

Also a graphoscope for viewing pictures, the lens being too small to allow both eyes to be used.

MONOCULAR (Fr., *Monoculaire;* Ger., *Einäugig*)

Literally, one-eyed. Monocular vision is vision with one eye, as distinct from binocular vision, which is vision with two eyes. (*See also* "Stereoscopic Photography.")

MONOL

A trade developer containing a dark red aniline or other colouring matter allowing of plates being developed therein in daylight.

MONOMETHYLPARAMIDOPHENOL

The original name for what is now known as metol (*which see*).

MONUMENTAL WORK, PHOTOGRAPHING

The difficulty in this branch of photography is common to all subjects that are either uniformly light or uniformly dark in colour. Sunshine is not desirable; it is rarely successful in small subjects photographed from a near point of view; and there is a risk of an entire absence of good light and shade if too uniform a lighting be adopted. The best results will be obtained by selecting a time of day when the principal side is in strong light, and then making the exposure while the sun is temporarily obscured by a light cloud. (*See also* "Sculpture, Photographing.")

MOON, PHOTOGRAPHING THE (Fr., *Photographie de la lune;* Ger., *Mondphotographie*)

The photographer who wishes to apply his art to astronomical matters cannot do better than begin with the portrayal of the features of the moon, which, as is well known, is our nearest celestial neighbour. Creditable work may be done with the ordinary hand or stand camera, but it will be understood that with lenses of short focal length it is impossible to obtain images of the exquisite detail which is known to be present on the moon's surface. To obtain such images, a large equivalent focal length is indispensable, but it is immaterial whether this is attained by a long-focus objective or by a telephoto combination. Excellent images showing all the main features of the craters, etc., may be taken with an equivalent focal length of about 10 ft., giving an image of the moon about 1 in. in diameter. Many of the standard photographs obtained for charting purposes, however, have been taken with equivalent focal lengths of as much as 300 ft. For minute study, enlargements can, of course, be employed, but they have the disadvantage of showing up the grain of the original negative, so that if a large scale picture is desired, it is best to use an amplifying lens in the camera. The first successful photographs of the moon were made by Rutherfurd. Later pictures have been produced by Common, Barnard at the Lick Observatory, Ritchey at the Yerkes Observatory, and Loewy and Puiseux at Paris.

Except when working with instruments of very large aperture, rapid plates should be employed, so that the minimum exposure may be given, thereby minimising the risk of failure on account of movement of the image. Backed plates are essential. The range of contrast between the bright limb and the craters near the moon's terminator is considerable, and development should be so arranged that the gradation is kept without having to force out detail. As the exposures will, in general, be of minimum duration, a soft developer will be most likely to give greatest satisfaction.

Quite recently, a new field of research on the moon has been opened by the discovery by R. W. Wood that certain regions of the lunar surface exercise considerable selective absorption. This is especially noticeable when the photographs are taken through screens which only pass ultra-violet light. If a quartz lens is coated with a very thin film of pure silver, it will allow the ultra-violet components of light to pass uninterrupted, but all the visible light rays will be absorbed. Under such circumstances he has found that certain portions of the moon's surface appear darker than when photographed in ordinary white light, and thus it may be inferred that such parts of the moon are composed of some substance which absorbs ultra-violet radiations.

MOONLIGHT EFFECTS

Real moonlight views are possible in very favourable circumstances, but most of the so-called moonlight photographs are taken in daylight, the usual method employed being to take the photograph with the sun facing the

lens, but not included in the view. A cloudy day should be chosen and the exposure made when the sun is just disappearing behind a cloud, or re-appearing therefrom. Should the sun be included it will appear as a reversed (black) spot and the plate will probably be fogged. A very brief exposure should be given (the plate must, in fact, be under-exposed) and the developer should be restrained with potassium bromide in order to give great density to the bright edges of the clouds and other high lights, without permitting detail to be over-pronounced in the shadows. The object is to emphasise the high lights, more particularly those in the sky and at other reflecting points.

The task of photographing a view illuminated by moonlight is not difficult if long enough exposure is given, but it is not easy to include the moon itself. The fastest of isochromatic plates, backed, should be used. As a rule, the best time is one or two evenings before the moon is full, as it then rises early enough to allow of the photographer making use of the diffused light of the after-glow to shorten the exposure, and if the moon is to be included the slight flattening of the disc will be hardly noticeable. In marine work, in harbours, or tidal rivers, where vessels are shown at a wharf or the water-line along a flat shore is included (such subjects and winter scenes make the best pictures), it is better, if possible, to make the exposure either at full or low tide, as then objects will not be blurred by a change of water level during exposure. An average subject, using $f/8$ and a rapid isochromatic plate, will need from ten to thirty minutes' exposure on a clear night. Do not under-expose; rather give double or even treble the exposures named.

W. S. Davis, of the United States, advocates two ways in which the moon may be included in the photograph without showing movement. One method is to wait until the moon is high enough to be out of the field of view included by the lens; focus and expose for the fore-ground as usual, remove the plate, then tilt the camera and raise the front until the moon comes where it is wanted in the composition, replace the plate and give a short exposure for the moon itself—from ten to thirty seconds will be ample with the lens at full aperture. The moon and the foreground are thus obtained upon one plate. For early moonrise effects, W. S. Davis exposes a separate plate on the moon, and puts it at the back of the foreground when printing. The first-named method is to be preferred, but care must be taken to locate the moon exactly where it is wanted. To do this properly take some gummed black paper and, before moving the camera for the second part of the exposure, decide upon the spot on the focusing screen it is to occupy, and attach a piece of gummed paper, in which a small hole has been made, so that when arranging the exposure for the moon, the latter can be seen through the opening.

If wide-angle or medium-angle lenses are used, the image of the moon in the photograph will not appear so large, in proportion, as it does to the eye, and for this reason it is often advisable to use a longer focus lens for the moon than for the rest of the view; otherwise the moon may be made to appear larger by having it a little out of focus.

Moonlight photographs are usually printed on sea-green or blue carbon, or bromide prints are made and then toned to those colours. Prints on P.O.P. may be stained by means of an aniline dye.

MORENO'S DEVELOPER

A pyro-soda developer which aroused con-siderable interest in 1894, when it was published in America. Moreno advocated the use of saturated solutions, with which he developed batch after batch of plates in the same bath; on one occasion, it is said, he developed 100 half-plates in 16 oz. of solution. Two pint bottles are filled respectively with saturated solutions of sodium carbonate and sodium sulphite; in a third, say a 5 oz. bottle, is placed 4 oz. of the sulphite solution, and to this is added pyrogallic acid so long as it dissolves readily—in most cases 1 oz. will be the correct quantity. The three stock solutions may be thus represented in the orthodox way:—

A. Sodium sulphite (saturated solution.)
B. Sodium carbonate ,, ,,
C. Solution A . 4 oz. 100 ccs.
 Pyrogallic acid . 1 ,, 25 ,,

To make up a developer ready for use, mix together 1 oz. of A, ½ oz. of B, and ¼ oz. of C; do not add water.

MORPHIA PROCESS

An old dry collodion process. The plate was sensitised with bromo-iodised collodion, washed and placed in acetate of morphia 15 grs., water 17 oz. Having been dried, it was exposed twice as long as a wet plate, and developed with pyrogallic acid.

MOSSTYPE (Fr., *Mosstype*; Ger., *Mossdruck*)

A method of making half-tone blocks invented by J. C. Moss, of New York. Plate glass was coated with bichromated gelatine, dried, exposed under a dense half-tone negative and soaked in water, which was absorbed only by the parts that had been protected from light, these swelling and forming a half-tone relief. From this was taken a plaster or wax cast, and from the cast a plaster mould, which was used to make a stereotype.

MOTAY'S COLLOTYPE PROCESS (See "Maréchal's Collotype Process.")

MOTIF

This French form of the word motive is generally used to denote the idea, phase, or particular presentment which the photographer intended to convey by his picture.

MOTION (See "Action.")

MOTION PICTURES (See "Chrono-photo-graphy" and "Kinematography.")

MOTIONAL PERSPECTIVE (See "Stereo-scopic Photography.")

MOTTLING

A defect seen occasionally upon the dense portions of a negative. Unless the developer is kept moving in a gentle wave backwards and forwards over the plate mottling is almost sure to occur.

MOULDING (Fr., *Moulure*; Ger., *Kehlung*)

This is the name given to lengths of wood used for making into frames. Such mouldings are generally sold with the wood in its natural state; that is, neither stained nor polished. Some mouldings are faced with composition— a kind of hard plaster—and these, of course, are sold in their finished state; there is some danger of this surface chipping. In selecting wood mouldings for photograph frames, it is generally wise to confine the choice to the simpler patterns, rather than those that are elaborate or ornate. The wood should be sound and well-seasoned, and the mouldings sharply cut, without roughness or irregularity. (*See also* " Frame " and " Framing.")

MOUNT (Fr., *Monture*; Ger., *Einrahmung, Einfassung*)

Mounts may be broadly classified as paste-on or slip-in, and both kinds may be obtained commercially in large variety; although some patterns are everything that a photographic mount should not be, there are many that are quite tasteful and suitable. The serious objection to any ready-made mount is that it necessitates the dimensions of the print being kept to one of the standard sizes. As the great majority of properly trimmed prints vary more or less from any stock size, it is advisable to resort very frequently to a mount specially made. Fortunately, excellent papers and boards for this purpose are readily obtainable, and it is well to have these in reserve for use when the ready-made mount is not quite satisfactory. Both trade mounts and mounting papers should be of good quality, and specially prepared for photographic purposes, so that they may be free from anything deleterious to the print.

Oxford line, plate-sunk, India-tint, circular and oval mounts are all made in endless variety, as are also the usual stock mounts for carte-de-visite, cabinet, and other standard sizes for portrait work. There are also embossed and fancy mounts, with and without inscriptions. All of these have their uses; but, as in the case of frames, it is necessary to bear in mind that the print itself is the thing, and that its surroundings should be such as to display it to the best advantage, and neither to minimise its effect nor distract attention from it. (*See also* " Multiple Mounting.")

MOUNTANTS (Fr., *Colles*; Ger., *Kleisters*)

The adhesive by means of which a print is attached to its mount. Of the very many mountants available, starch is by far the most widely used, yet it keeps badly and is unsuitable for glazed prints. A glazed P.O.P. print mounted with plain starch may lose its glaze and show markings, whereas if an alcoholic solution were used the print would be unaffected.

Arrowroot.—This is an excellent mountant when a little gelatine is added :—

Bermuda arrowroot	2 oz.	122 g.
Gelatine . .	90 grs.	11·5 ,,
Water . .	18 oz.	1,000 ccs.

Soak the gelatine in some of the water for an hour or two, and melt by heat. Mix the arrow-root into a cream with a little water, and add to the gelatine, stirring all the time. Boil the whole in an enamelled saucepan or in a water-bath till a clear jelly forms, and add slowly 2 oz. of methylated spirit and 6 drops of carbolic acid. Allow to cool, and keep as airtight as possible.

Dextrine.—This is a good mountant of a white, creamy character; it keeps well. A formula is :—

Best white dextrine	25 oz.	900 g.
Alum . .	1 ,,	36 ,,
Sugar . .	4 ,,	144 ,,
Water . .	30 ,,	1,000 ccs.
Carbolic acid (10 %)	1½ ,,	54 g.

Mix the dextrine with the water, boil for five minutes, add the sugar and the acid, and finally the alum dissolved in about 2 oz. of hot water. The alum may be left out if desired, as it may injure some prints, particularly those on collodio-chloride paper. Inferior dextrine is likely to remain sticky and not dry properly.

Another and a more simple dextrine formula which will meet all requirements is to rub up 1 lb. of best white dextrine with enough cold water to make a stiff paste and add 10 oz. of water, and 60 drops of oil of winter-green. Bring the whole to a boil, when it should be like clear gum. Pour into pots or jars, and in about twenty-four hours it should set in the form of a good white creamy paste. Use cold.

Dextrine and Gum.—This has no advantages over dextrine alone. The best formula is :—

Gum arabic (best white) . .	½ oz.	70 g.
Dextrine . .	2¼ ,,	315 ,,
Liquor ammoniæ .	2 mins.	·5 ccs.
Carbolic acid	60 ,,	15 ,,
Water . .	8 oz.	1,000 ,,

Powder the gum and mix thoroughly with the dry dextrine, and rub up with 2 oz. of the water to make a smooth paste. Add the remaining 6 oz. of water and boil for ten minutes; when cool, stir in the ammonia and carbolic acid. This will keep for months.

Gelatine.—Most gelatine mountants have to be heated before use. A standard formula is :—

Gelatine . .	1 oz.	110 g.
Glycerine . .	½ ,,	50 ccs.
Alcohol . .	1½ ,,	150 ,,
Carbolic acid	20 mins.	4 ,,
Water (about) .	1 oz.	100 ,,

Cover the gelatine with the cold water and allow to soak for twenty hours or more. Pour off any excess of water, place the gelatine in a jar stood in a saucepan, and heat till melted; then add the glycerine, alcohol and acid with constant stirring. If too stiff, add water.

A liquid gelatine mountant, and one always ready for use, is made by soaking 1 oz. of gelatine in 3 oz. of water for twenty-four hours, melting by heat, and adding ½ oz. of chloral hydrate, afterwards heating for half an hour and adding sufficient washing soda to render the gelatine mixture neutral to litmus.

Gum.—Ordinary office and commercial mixtures of gum are likely to cause fading because of the chemicals used to preserve such mixtures. A suitable formula for a photographic mountant is :—

Best gum arabic	5 oz.	275 g.	
Glycerine	1¼ ,,	69 ,,	
Alcohol	4 ,,	220 ,,	
Water	12–20 ,,	600–1,000 ccs.	

Dissolve the gum in the water, add the glycerine and finally the alcohol.

Indiarubber.—Indiarubber solution (*see* "Indiarubber") is useful for mounting glazed and dried prints without cockling. Cut a piece of paper ¼ in. smaller than the print in both dimensions, place it centrally upon the back of the dry print, coat the exposed margin with the solution, remove the paper, and press the print down on the mount. In course of time, the rubber perishes and the print leaves the mount.

Shellac.—A good shellac mountant is made by mixing 4 parts of shellac with 1 part of mastic, powdered, and dissolving in from 10 to 15 parts of spirit of wine. It must be put in a warm place, and after a few days the gums will be dissolved. If too thick, add more alcohol. The print must be quite dry, and the back brushed over with the mountant, immediately placed on the mount, and allowed to dry. A thin print can be thus mounted without cockling.

Starch.—Rub up 1 part of good white starch with 2 or 3 parts of cold water into a perfectly smooth cream-like paste, and then with constant stirring pour this into from 6 to 8 parts of boiling water and continue the heat for five minutes, stirring constantly. Allow to cool, and if not free from lumps squeeze it through muslin. Another plan is to rub the starch into a paste, as above, and to pour boiling water upon it, stirring constantly until it jellifies. All starch mountants should be allowed to cool and the top skin be taken off before use. Such pastes keep good for two or three days only, but the addition of a few drops of oil of cloves or carbolic acid will preserve them for a longer period.

Starch and Gelatine.—This is a stiff, smooth paste which does not cause cockling when properly applied. Take 2 parts of wheat starch and 1 part of rice starch, and mix thoroughly. Soak 60 grs. of gelatine in 10 oz. of water and heat till dissolved. When the latter has cooled to about 70° F. (21° C.), add the mixed starches in small quantities, stirring all the time until the mixture is of the consistency of thin cream. Heat slowly, in a jar placed in a saucepan of water, until the starch thickens; and continue the heat until about one-fifth of the water has evaporated. Then add slowly, with constant stirring, 1 oz. of alcohol and about 45 drops of oil of cloves.

Starch and Gum.—A suitable formula is :—

Gum arabic	1 oz.	100 g.
Rice starch	1 ,,	100 ,,
White sugar	4 ,,	400 ,,
Water	q.s.	q.s.

Dissolve the gum in as small a quantity of water as possible, add the sugar, stir in the starch, which has been rubbed up into a cream with water, and boil the mixture until the starch is jellified.

Adhesive Prints and Mounts.—Adhesive mounts are made by spreading a thick solution of gum tragacanth upon them and allowing to dry. When the damp print is pressed into contact with the gummed surface, there is immediate adhesion. Similarly, glazed prints, while still on the glass or ferrotype plate, may be coated with :—

A. Bleached shellac	2 oz.	200 g.	
Alcohol	4 ,,	400 ccs.	
B. Borax	24 grs.	5 g.	
Curd soap powder	24 ,,	5 ,,	
Water	100 mins.	20 ccs.	

Allow A to stand for a week and agitate frequently; then add B, thoroughly shake, and use the clear part, or filter. After the prints have been coated and allowed to dry, they are stripped from the support, pressed into contact with the mount, and attached by passing a hot iron over them, interposing a piece of blotting-paper between iron and print.

MOUNTING (Fr., *Montage;* Ger., *Einfassung*)

There are many ways of sticking down a print smoothly on a support or mount, but all of them are not necessarily suitable in the case of photographs, where the image is often of such a character as to be readily and seriously affected by substances harmful to it. For example, glue, gum, and paste, that may be proper for certain uses, may have disastrous effects when used as photographic mountants.

In the case of glazed prints, whose surface would be affected by moisture, indiarubber solution is sometimes used. Gelatine, which had to be warmed for use, was once fairly popular. The favourite professional mountant was, and to some extent still is, starch paste. If this is used it should be made freshly every day and used cold. The prints are generally mounted while still wet, the starch being applied to the back, the print placed in position and rubbed down, and the surface gone over with a wet sponge. This is a clean and effective method of mounting, but there is the serious drawback that the contraction of the print on drying warps or curls the mount considerably unless precautions are taken against it, and such precautions mean additional time and trouble.

Specially prepared mountants can be obtained that not only contain very little moisture, but will keep in good condition for a long time. If such a mountant is used with dry prints the risk of cockling and warping is reduced to a minimum. The mountant should be well rubbed over the back of the print with a stiff brush, using as little of the paste as can be made to cover the surface perfectly. If the print is then applied quickly to its position (previously marked) on the mount, it can be at once brought into perfect contact by the use of a roller squeegee. With care there should be no trace of mountant on the face of the print, especially if a sheet of thin paper be placed over it to protect it from possible traces of paste on the roller. This method of mounting is probably the best for the beginner, especially

as the mountant is always ready when an occasional print has to be dealt with. When large prints are being treated it is generally advisable to thin the paste very slightly by dipping the brush into water before rubbing up the paste with it, but for small prints simple rubbing up with the brush is sufficient.

Another method of mounting photographs, and one which has distinct advantages, is "dry mounting" (*which see*). Multiple mounting is described under its own heading.

In process work, the term "mounting" is also applied to fixing the etched zinc or copper plates on to a wood or other mount for the purpose of bringing the plates up to type-height. It also applies to the various operations of trimming and squaring up the plate or block. In America the equivalent term is "blocking."

MOUNTS, LENS

Photographic lenses are usually mounted in brass, but in certain cases, especially with tele-photo combinations, the lighter metals, aluminium or magnalium, may be used. The iris diaphragm should be made of metal, especially in a lens for use in an enlarging lantern, as the heat is liable to distort, and even to destroy, iris leaves constructed of vulcanite or ebonite. Lenses should always be fitted with the standard threads of the Royal Photographic Society, and in the case of Continental makes it is convenient to have a fixed adapter made to the next larger standard thread. The lens hood may be considered a part of the mount; unfortunately, it has now fallen into disuse, but in these days of large apertures and rapid plates it is more than ever necessary; however, it is obtainable as a separate accessory, which may be made to serve for several lenses.

The following are the measurements and standards recommended by the Royal Photographic Society. The recommendations are :—

(1) That the equivalent focal length of a lens be engraved upon its mount.

(2) That the following series of screws for photographic lens flange fittings be adopted, it being understood that, in order to secure free interchangeability, every male screw should be made at least as small as these sizes and every female screw at least as large :—

Diameter in inches.	No. of threads per inch.	Core diameter in inches.
1*	24	·9466
1·25	24	1·1966
1⅜	24	1·3216
1·5	24	1·4466
1⅝	24	1·5716
1·75	24	1·6966
1⅞	24	1·8216
2	24	1·9466
2·25	24	2·1966
2·5	24	2·4466
3	24	2·9466
3·5	12	3·3933
4	12	3·8933
5	12	4·8933
And upwards, advancing by inches	12	

* For screws less than 1 inch in diameter, the Royal Microscopical Society's Standard screw should be adopted.

The form of thread is that known as Whitworth's angular thread, and is designed as follows :—Two parallel lines, at a distance apart equal to ·96 of the screw pitch, are intersected by lines inclined to each other at fifty-five degrees, as shown in the figure at A. One-sixth of the vertical height of the triangular spaces so obtained is rounded off both at the top and bottom, leaving the form of the screw thread as at B. The depth of this thread is ·64 of the screw pitch. This is the theoretical form of the Whitworth thread, but for the purpose of securing real interchangeability it is

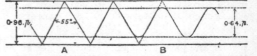

Whitworth's Angular Thread for Lens Mounts

generally found necessary to use chasers or other threading tools which have additional prominence upon those points which come first into operation and are subject to most wear. For this purpose an addition may be made to the amount of one-tenth ($\frac{1}{10}$) of the theoretical depth of thread or to any less amount that may be sufficient.

(3) That every flange and adapter have a mark upon its front to indicate the position of the diaphragm slot or index of any lens when screwed home. The mark on any adapter should coincide with the mark upon any flange into which it is screwed. This mark should be placed at the point at which the thread becomes complete at the shoulder of the flange or adapter.

"M.Q."

The meto-hydroquinone developer (*which see*) "M" indicating metol, and "Q" hydroquinone (quinol).

MUCILAGE (*See* "Mountants.")

MULTI-COLOUR OR MULTIPLE GUM PRINTING

An elaborate and somewhat complicated form of gum-bichromate printing. It consists in coating paper with the sensitive pigment, printing and developing, and then, when dry, re-coating, printing, and developing again, repeating the process as many times as is considered necessary. In this way the image is built up and parts brought out more prominently. It is a common practice not to recoat with the pigment used the first time on the paper, but to use a different colour for each coating and so obtain a print in colours. Lighter colours are used at first and the shadows built up with deeper colours. By varying the thickness of coating and depth of printing, masking during printing, and developing with a brush, highly effective results become possible. Considerable practice and artistic skill are required to produce a satisfactory print. One of the greatest difficulties is in registering the various printings; some workers prefer stout card to paper, as the registering is easier, while others use special frames. The process opens up a wide field for the display of individuality.

MULTIPLE MOUNTING

In the simplest form of this style of mounting a trimmed print is mounted on a sheet of paper, which is then trimmed so as to show a narrow margin all round the print. This in its turn is mounted on another sheet of paper, preferably already laid down on a piece of stout board. The margins then being measured off and trimmed, the print will be found to be effectively mounted, provided the mounting papers harmonise with each other and with the print. There is the obvious advantage that the mount is made to fit the print, and not the print trimmed to fit the mount, as in the case of ready-made mounts.

A simple and effective mounting may be secured by laying down a warm print on a brown paper, which may be called No. 1, and trimming to show a fairly wide edge. This is now laid down on another sheet, No. 2, either lighter or darker than No. 1, and trimmed to give a narrow edge. The whole is then finally mounted on a sheet of No. 1. A few experiments of this kind will soon give an idea of the wide possibilities of this style of mounting when it is carried out with restraint and good taste. When several sheets of paper are superimposed it is frequently the practice to attach them by their top edges only, but as it is then impossible to keep all the sheets in perfect contact, there is an inevitable irregularity in the various margins that considerably detracts from the beauty of the result. A good stock of suitable papers is required for the work, together with facilities for accurate trimming and perfect mounting. The "passe-partout" style of framing is often the most suitable finish for this class of mounting, but if a frame is used the moulding should generally be very narrow and simple.

MULTIPLE PHOTOGRAPHY (Fr., *La photographie multiple*; Ger., *Vielfachephotographie*)

Under this heading are included many methods whereby a number of photographs, whether alike or in different positions, are obtained on a single

Arrangement for Multiple Photography

plate. A number of similar photographs may be made at once by means of a camera with a battery of lenses (*see* "Postage Stamp Photo-

graphs"), or in succession with a repeating back. A method at one time popular in America, and still used in France for photographing criminals, is to place the sitter in front of two large upright mirrors joining at an angle of 72°, the result being that five different positions are secured. The camera is set in line with the junction of the mirrors, a screen being adjusted at each side of the lens to prevent reflections from objects behind the operator. The arrangement of the apparatus, and the method in which the mulitple reflections are formed, is shown in the diagram, N being the camera, O P the mirrors, S the sitter, and T U the screens. With sufficiently long mirrors, full-length photographs are obtainable.

MULTIPLE-COATED PLATES

Plates coated with two or more layers of emulsion of different degrees of sensitiveness, introduced in 1891, to prevent halation. The topmost film was a rapid emulsion, the second of medium sensitiveness and more opaque, whilst the third was a lantern emulsion of very slow speed and very opaque, so that on exposure in a camera the light from a brilliantly-lit object would penetrate the first and second films and possibly partly through the third, but would not reach right through to the back of the glass, so that it could not be thence reflected to give rise to halation. The shadows and less brilliantly illuminated parts would be recorded on the top and second films only.

MURIATES (*See* "Chlorides," "Ammonium Chloride," "Mercuric Chloride," etc.)

MURIATIC ACID (*See* "Hydrochloric Acid.")

MUTOGRAPH

Casler's camera for obtaining pictures for his biograph (*which see*).

MUTOSCOPE

Casler's "Mutoscope," here shown, consists of a receptacle having an opening in its face, under which a set of pictures, made on bromide paper, is made to pass. The pictures radiate

Coin-in-the-Slot Form of Mutoscope

from a common centre, on which they turn on an axis. A coin-freed mechanism is fitted to the apparatus, which is operated by turning a handle. There are other forms.

N

NAKAHARA'S PROCESS

A Japanese "black line" process.

NAMIAS' REDUCER

The permanganate reducer, which, under certain conditions, has a similar action to that of the ammonium persulphate reducer.

Sulphuric acid (20 % sol.)	40 mins.		8 ccs.
Potass. permanganate			
(20 % sol.) . .	.80 ,,	16 ,,	
Water . .	.10 oz.	1,000 ,,	

It gives even reduction when applied to a wet negative, whereas a dry negative immersed in the solution, is reduced more in the high lights. Greater softness is obtained by treating the dried negative quickly with the reducer, washing, drying and re-immersing. Red or brown stains are caused by insufficient sulphuric acid, and may be removed with a 10 per cent. solution of sodium sulphate containing 2 per cent. of oxalic acid. The use of impure permanganate causes irregular action.

NAPHTHA (Fr., *Naphte*; Ger., *Naphtha*)

Mineral naphtha is known as petroleum ether or benzine (see "Benzine"). Coal-tar naphtha is chiefly benzole (see "Benzene"). Wood naphtha is impure methyl alcohol (see "Alcohol").

NAPHTHALENE RED (*See* "Magdala Red.")

NAPHTHOL GREEN (Fr., *Vert naphthol*; Ger., *Naphtholgrün*)

The ferrosodium salt of nitrosobetanaphtholsulphonic acid, used for making colour screens. It is soluble in water, with yellowish-green colour. It is especially useful as it is about the only green aniline dye which satisfactorily absorbs the extreme red of the spectrum. There are various kinds, naphthol green 2·6 being the most satisfactory.

NAPHTHOL YELLOW S (Fr., *Jaune de naphthol S*; Ger., *Naphtholgelb S*)

Synonyms, citronine A, sulphur yellow S, acid yellow S. Several aniline dyes are sold under the generic name of naphthol yellow. Naphthol yellow S is the potassium salt of dinitroalphanaphtholsulphonic acid, and is used for making colour screens.

NAPLES YELLOW

A mixed pigment used in colouring photographs. Commercial Naples yellow is made by mixing zinc white with cadmium yellow, by mixing white lead, cadmium yellow and yellow ochre, and in other ways. The true Naples yellow is a basic lead antimoniate, which has the disadvantage, when used as a water-colour, of soon being affected by foul gases.

NARROW-ANGLE LENS

A lens having a focal length at least twice that of the longest side of the plate.

NATROL

A solution, German in origin, used instead of a preliminary washing for P.O.P. prints; supposed to assist the gold in giving rich tones and to prevent spots. The formula is :—

Sodium chloride (salt) .	2¾ oz.	150 g.	
Fused sodium acetate or			
sodium bicarbonate .	2 ,,	110 ,,	
Water	20 ,,	1,000 ccs.	

Dilute 1 oz. with 15 oz. of water. Immerse the prints for about five minutes, wash, and tone as usual.

NATURAL COLOURS, PHOTOGRAPHY IN

This subject is of such vast extent and is divided into so many branches, which are treated of individually, that a mere sketchy outline of the whole subject can be given here. The subject may be divided into four main heads : (a) direct heliochromy, (b) interference heliochromy, (c) the bleach-out process, and (d) three-colour work.

Direct heliochromy and interference heliochromy.—Senebier, in 1785, had pointed out that when a spectrum was thrown on to silver chloride, violet and blue were reproduced, but he carried the experiments no further. However, in 1810, Seebeck, the great German physicist, sent to the poet Goethe a treatise of the action of coloured illumination (" Wirkung farbiger Beleuchtung ") which is printed in Goethe's *Geschichte der Farbenlehre*, Vol. II., p. 716. Seebeck details the effect of allowing " the spectrum from a perfect prism to fall for 15 to 20 minutes on white damp silver chloride spread on paper and kept by a special device in the same place. I found the silver chloride to be altered in the following manner : in the violet it became reddish-brown (sometimes more violet, sometimes more blue), and even beyond the previously marked limits of the violet this coloration extended, but it was no stronger than in the violet ; in the blue of the spectrum the silver chloride had become pure blue, and this colour extended, increasing and becoming brighter right into the green ; in the yellow I found the silver chloride frequently unchanged, but occasionally it happened to be more yellow than at other times ; in the red, on the other hand, and frequently beyond the red, it had assumed rose-red." Seebeck then describes the effect of two spectral lights—red and violet—and also tests with coloured glasses. The importance of this work must not be overlooked, for it was thirty years before the discovery of the daguerreotype, and the results were photographs on paper. But little notice seems to have been taken of

this work, though this was probably due to its being published in Goethe's book, which is very poor in facts but rich in arguments. Seebeck's work also confirmed Ritter's statement (1801) that there were invisible radiations at both ends of the spectrum.

John Herschel, the son of the renowned astronomer, was the next to discover anew the curious property of silver chloride of reproducing colours ("Philosoph. Transactions," 1840, p. 28, *Athenæum*, 261), and followed Fox Talbot's suggestion of using alternate baths of silver nitrate and sal ammoniac, but Herschel preferred to sensitise his paper just before use, and pressed it in the camera obscura against a glass plate, which prevented any wrinkling of the paper.

He did not succeed in fixing these colours; yet they were half fixed by merely washing with water, and could then be examined by diffused daylight or lamplight without deteriorating. Herschel also discovered that silver bromide gave the same colours as, though less distinct than, the chloride, whilst silver iodide gave the complementary colours. Robert Hunt, in his *Researches on Light*, details numerous experiments both on silver and other substances, and records the occurrence of colours; but the next investigator to warrant attention was Edmond Becquerel, and to his papers (*Annales de Chimie et de Physique*, third series, Vols. XXII., XXV., XLII., 1849—1855) we are indebted for the real foundation of successful heliochromy; his researches are collected into two volumes: *La Lumière et ses Effets*. He exposed to the spectrum silver plates coated with silver chloride which gave a fairly satisfactory rendering, but the uneven film of chloride caused unevenness of colouring; ultimately, he found it better to obtain an electrolytic deposit of chloride. He also used a solution of cupric chloride (copper sulphate 1 part, salt 3 parts, water 10 parts), and in this the silver plates assumed a violet-white coloration, and gave, on subsequent exposure, not only the spectral colours, but white also. He says: "I think that the substance formed on the surface of the metallic silver is a special chlorine compound, perhaps violet silver subchloride or a mixture of white silver chloride and subchloride."

Niepce de Saint Victor carried on similar experiments to those of Becquerel; Eder states that one of his heliochromes in his possession still shows brilliant colours, forty years after its preparation. Niepce started with the theory that those chlorides that gave a definite colour to a Bunsen flame were the best for reproducing the colour when used for chlorising the silver plate. He not only obtained the spectrum, but also copied objects in the camera and obtained excellent reproductions of the shimmer of glass and polished metal objects, and also reproduced black, which in many cases reflects the ultra-violet or infra-red or both. He used a varnish of dextrine and fused lead chloride, which was a great protection, and this was further increased by subsequently coating the plate with tincture of Siam benzoin, and heating till some of the benzoic acid was driven off; his results are recorded in the *Comptes Rendus*, 1851—1859, etc.

24

In 1851, an American clergyman named Hill claimed to have discovered photography in colours, but eventually the process was proved to be useless. In 1855 and 1856, Testud de Beauregard brought forward the view that a silver photograph without colour possessed a latent power for colour; but no one has ever been able to produce colours by his process—save the discoverer.

Poitevin (*Comptes Rendus*, 1865, p. 1,111) describes his process for obtaining colours on paper, and the following is his final method: "I form upon non-albuminised paper a film of ordinary silver chloride by floating one side of the paper on a 10 per cent. solution of salt; when dry, I float this on an 8 per cent. solution of silver nitrate, or the back of the paper is painted with a mixture of equal volumes of a saturated solution of potassium chromate, and a 10 per cent. solution of cupric sulphate, dried in the dark, and then floated on the silver bath. Chromate of silver is now formed; I wash with plenty of water in order to remove excess of the nitrate salt and add to the last washing water a few drops of ordinary hydrochloric acid till the red chromate salt is converted into white silver chloride. Both these methods of preparing the silver chloride film are equally good. Now, in order to obtain the violet subchloride, I pour into the dish, which contains the paper soaked in water, a small quantity of 5 per cent. stannous chloride solution; about 20 ccs. (about ¾ oz.) are required for a whole sheet. Now I expose the sheet, without taking it out of the bath, to the action of light, and preferably in the shade than in the sun; its surface quickly discolours and after five or six minutes, has assumed the desired dark violet colour. It is not advisable to allow the light to act still longer, otherwise a greyish black tone would be obtained, which is not suitable for heliochromy. After the action of light, I wash the sheet in several changes of water, and then allow it to dry in the dark. In this condition it is very little sensitive to light, and can be kept for a long time." Poitevin used water acidulated with sulphuric acid, or a very dilute solution of mercuric chloride diluted with sulphuric acid for fixing, and subsequently glazed the pictures with albumen.

Wharton Simpson followed with a suggestion to the use of an emulsion of silver chloride in collodion (1867). Saint Florent (*Bull. Soc. Franç.*, 1874) also suggested a method of using collodio-chloride paper, which was exposed to sunlight for 80 to 100 seconds, or till reddish-black; immersed in a bath of alcohol 100 ccs. (3½ oz.), glycerine 7 ccs. (126 mins.), 1 per cent. tincture of iodine 7 ccs. (126 mins.), and ammonia 6 drops, for 10 minutes; dried in a dark place; exposed under a coloured transparency for about one hour in sunshine; fixed in a 10 per cent. solution of "hypo"; washed and dried in sunshine. In the fixing bath the colours disappear, but reappear when exposed to the sun, or ironed with a hot iron.

Veress, in 1890, followed up on Poitevin's lines, and in the following year Kopp, of Münster, certainly made some advances, which promised well. The best report of his work is found in Valenta's work, *Die Photographie in Natürlichen Farben*, 1894.

He floated raw paper on salt solution, then on silver nitrate and again on salt solution, thus obviating any excess of silver nitrate, which both Becquerel and Poitevin had pointed out as prejudicial to the purity of the colours; the paper was then well washed and exposed, under an acidulated ·1 per cent. solution of zinc chloride, to diffused daylight till it had assumed a blue-grey colour. The paper is washed and dried, and made sensitive to all colours, as well as white and black, by treating with a solution made as follows:—

Potassium bichromate	.1,940 grs.	150 g.
Cupric sulphate .	.1,940 ,,	150 ,,
Distilled water to .	. 20 oz.	1,000 ccs.

Dissolve by the aid of heat, and when boiling, add

| Mercuric nitrate . | .1,940 grs. | 150 g. |

dissolved in as small a quantity of water as possible, and acidulated with nitric acid. A red precipitate forms, which should be filtered out when the solution cools down; then make the filtrate measure 20 oz. or 1,000 ccs. by adding water. This solution will keep well in well-closed bottles. The blue-green paper should be immersed in this for half a minute till completely decolorised, drained and immersed in a 3 per cent. solution of zinc chloride till it again becomes blue, then well washed in running water, superficially dried between blotting-paper, and exposed whilst still damp. The yellow and green of the spectrum appear at once—that is, with about 30 minutes' exposure—and the picture should then be coated as to these colours with a shellac or celluloid varnish, well heated, immersed in a 2 per cent. solution of sulphuric acid till all the colours appear, thoroughly washed and dried between blotting-paper; fixed in the above-given mercury bath, in which the colours disappear, and finally immersed in a sulphuric acid bath and coated with a solution of gum arabic containing 5 per cent. of sulphuric acid. Valenta's improvement was the use of ·5—1 per cent. solution of sodium nitrite instead of the zinc chloride solution, and excellent results are attainable.

The above process is also applicable to many of the commercial printing-out papers, both gelatine and collodion, if they are immersed in a solution of acidulated zinc chloride, are then well washed and treated with a 10 per cent. solution of hydroquinone.

Krone (*Darstellung der Natürlichen Farben*) has confirmed Valenta's statements, and also Poitevin's and Becquerel's.

So far, merely the practical side of the question has been considered. Schule assumed that the dark silver subchloride was oxidised on exposure to yellow silver chloride, and this chemical view was supported by many chemists, though physicists considered that the colours were due to thin films, as in Newton's rings, and this was confirmed by the very thin films obtained by Becquerel in the electrolytic chlorising of his plates. The true explanation was first propounded by Wilhelm Zenker in his *Lehrbuch der Photochromie* (1868), and this has been purposely disregarded till this particular stage, because it forms a fitting connection to the next process to be here considered.

Zenker examines the various methods which, up to 1868, had been suggested, and in most cases gives his criticisms of the processes founded on actual experiments; his book (reprinted, 1900), therefore, is extremely valuable. Zenker states: "When different coloured rays penetrate a light-sensitive substance with equal intensity, they must act on the same in absolutely equal manner; every ray, no matter what its vibration may be, must act on all the particles of the substance which lie in its path, set them in motion, and thus chemically alter them. Thus, there may be a general darkening, coloration or bleaching; these must be under one colour the same as under the other; a difference of colour is not conceivable. The facts are, however, quite different when the incident rays meet again outgoing rays of the same phase, that is to say, if we consider that with all these photographic processes the incident rays are again reflected. This takes place most strongly with the daguerreotype, but also with sensitive surfaces lying on other supports, and one can convince oneself of the quantity of reflected light by merely looking at it. Now, if two waves of the same phase meet they give rise to the phenomenon which is called, in the case of water, 'stationary or standing waves.'"

The formation of these waves is shown in diagram A, in which the incident rays are shown in continuous lines, and the returning rays in

A. Stationary or Standing Waves

dotted lines. In E it is assumed that the ray is reflected from a substance with higher refractive index, and in F with a lower refractive index, than G, the sensitive surface. At the points *b b* the reflected ray augments the incident, whilst at *a a* the pull on the ether particles is in contrary directions; consequently there is no movement, and therefore no light. As a matter of fact, in standing waves, the ether particles rise and fall, but there is no propagation of light. Now, it is obvious that if G is a film of sensitive substance, the action of light will be to cause a deposit of silver at the internodal planes *b b*, as shown by the hatched lines, and this deposit is exactly half a wave-length of the incident light apart; therefore, it can only reflect light of that colour which has a wave length of double the distance *b b*.

The truth of this theory was disputed by Schultz-Sellack (*Annalen d. Phys. u. Chem.*, 1871, p. 449), following which further doubt was created by Carey Lea's production of the photosalts, as he was able to prepare the coloured

substances, produced by the action of coloured light on silver chloride already exposed, by purely chemical means in the dark. Otto Wiener (Wiedeman's *Annalen d. Phys. u. Chem.*, 1890, p. 203) was able to prove experimentally the formation of Zenker's standing waves, and the following is a brief summary of his work : With homogeneous illumination, there is formed in front of a reflecting surface a series of standing waves parallel to the reflecting plane. This is shown at B, in which R R is the reflecting surface, and the planes of equal phase are shown in section, the nodal points in dotted lines, and the waves in maximum action in continuous lines. Now, if a light-sensitive film be coated on the glass, the metallic silver resulting from the light action must be $\frac{\lambda}{2}$ apart, but as this distance, one half wave-length for red light, would be about ·3 μ, it is obvious that it would be invisible to the naked eye. Wiener, therefore, coated his sensitive film, *a b*, at an acute angle with the reflecting surface, and it will be at once seen that the distance of the silver laminæ is increased, for if $\frac{\lambda}{2}$ is the distance between two maximum wave planes, the separation, *b*, of the silver laminæ would be : $b = \frac{\lambda}{2}$ sin *a*. Wiener used collodio-chloride of silver emulsion thinned down with about 15 to 20 parts of solvent, and thus obtained a colourless, transparent emulsion in which the silver laminæ were distinctly visible. Later, he was able to confirm this with silvered glass plates fumed with iodine.

In 1895, Wiener (*Annalen d. Phys. u. Chem.*, 1895, p. 225) examined the question of the Seebeck and Poitevin processes on paper, to determine whether the colours were apparent or body colours—that is to say, whether they were produced by interference or absorption. To determine this question, he used a right-angle prism of highly refractive glass, μ=1·75 for D, with its hypotenuse on the colour pictures, the intervening air space being filled with benzole so as to prevent total reflection, and thus securing for light rays entering normal to the side surfaces an angle of incidence of 45°, so that the ray entering the silver chloride must form a considerable angle with the normal to the surface. The difference in path of the interfering light waves will, in comparison with vertical incidence, be greatly changed, and according as the colours are thus altered or not they are interference or body colours. The prism was so placed upon one half of the photographed spectrum that the line between the hypotenuse and the side face I (diagram C) cut similar colour lines at right angles. The eye of the observer was placed in the prolongation of the same surface I (the arrow indicates the line of vision) so that a line, s, drawn before the experiment, in the direction of a single colour—as, for example, the yellow—appeared straight when viewed through the air and prism. D shows another arrangement, in which the spectrum reproduction was cut in half perpendicularly to the reference mark after drawing the latter in the yellow. One of the parts was placed upon the side of an auxiliary prism, I I, fastened to a level glass plate, upon which

the other half of the sheet was so placed that the marks came together. Finally, prism I, with the high refractive index, was set upon the second half, benzene poured between, and the eye placed in line with the reference mark and with the surface of the principal prism. Wiener thus sums up his conclusions drawn from the above experiments : In the Seebeck and Poitevin processes there is no change of colour under the above conditions, and they are, therefore, body colours ; this is also confirmed by the fact that these pictures show the same colours by transmitted as by reflected light. The colours of the Becquerel pictures, produced on an underlying silver mirror, were chiefly produced by interference. Carey Lea and Krone proved that the substances present in the Seebeck and Poitevin processes were capable of yielding compounds which embrace almost all the spectral colours, if not all their tones, and the reason why they

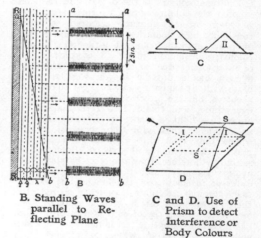

B. Standing Waves parallel to Reflecting Plane

C and D. Use of Prism to detect Interference or Body Colours

agreed in hue with the illumination-producing decomposition is that of all the coloured substances capable of being produced, only those will be stable which agree in colour most nearly with the incident light, since these will best reflect and least absorb it, and can, therefore, be least changed. Decomposition products of other colours, on the other hand, absorb this light, and will be again decomposed. Proof of this was found when a spectrum was thrown at right angles on a colour photograph of the spectrum. It was then found that a correctly-reproducible illuminating colour was capable of decomposing all colours differing from it, but similar colours remained unchanged. It is, therefore, fundamentally possible that coloured illumination shall, in suitable substances, produce similar body colours, and such substances Wiener termed " colour receptive."

In 1891, Prof. Gabriel Lippmann, lecturing at the Académie des Sciences (*Comptes Rendus*, 1891, p. 274), explained at length the theory of interference, and exhibited actual photographs in colours produced by his method, which is essentially that of Wiener, and theoretically described by Zenker. He used a transparent gelatine emulsion of silver bromide with the sensitive

film in contact with a film of mercury and the glass of the plate presented to the lens. From what has already been said, it will at once be seen that here was the ideal method of recording, if possible, the formation of standing waves, and if formed they would naturally reflect the colours of the incident light.

Lippmann's own description (*Phot. Journ.*, 1897) is by far the easiest to grasp, and he says: "Now, how is it that we see the colour? The photographic operations are the same as in ordinary photography, the result of the operations is the same, a similar deposit of reduced silver is obtained, and the materials of which the image is composed are the same as those in a colourless plate. The difference is that the plate has acquired such a structure that it decomposes the light by which it is illumined, and sends back to the eye of the observer elements of white light, which together make the natural colours of the object. In the same manner the colourless drops form the rainbow. A soap bubble appears coloured, although consisting of a colourless solution, and mother of pearl appears coloured although made of colourless carbonate of lime. It is a phenomenon of interference due to the structure which the deposit has acquired; if you were to use a plate without a mirror you would get an ordinary negative, but the presence of the mirror changes everything, and this is how it is done: You know that light is made up of vibrations, just as sound is; these vibrations give rise to light waves that rush through the ether and the plate with a velocity of 300,000 kilometres per second; therefore, they impress the plate more or less strongly, and thus leave a design of different intensities of the image, but as they rush through the plate they leave no record of their form. And this is what I mean by their own form: Each ray of light of a certain colour has a certain structure; it is made up of waves which have a certain wave-length; you know a wave-length is the distance between the crests of two succeeding waves; red has a comparatively great wave-length, blue has a much smaller one, and the intermediate colours have each a distinct and intermediate length of wave. If you put no mirror, each train of waves rushes through the plate and wipes off every record of its own form by reason of its velocity; you cannot expect a thing which moves with a velocity of 300,000 kilometres in a second to give a photograph of itself. If you put a mercury mirror behind the plate, then the following phenomena occur: The light is reflected back on itself; the light rushes in with a velocity of light and rushes out again with the same velocity; the entering and issuing rays interfere, and the effect of the interference is that vibration takes place, but the effects of propagation are stopped, and instead of having propagated waves we get stationary waves—that is, the waves now rise and fall, each in its own place; they pose, therefore, in the interior of the film and impress their form upon it, the largest movement giving the strongest impression, and where the movement is naught the impression is naught. So that you have the form of the vibration impressed in the interior of the film by the photographic

process, and the photographic film has really now acquired the structure of the incident rays, because they have become stationary, and impressed their form upon it. The result is, that if you look through the film you see nothing special; it looks like an ordinary negative; but if you look at it by reflection, then you see it coloured. And this for the following reason: Suppose at one place the plate has been impressed by red light, the red light has impressed its structure on that part of the plate, and that part of the plate is now able to reflect back to our eyes only the red part of the white rays—only the red element which is a component part of white light, and similarly with every part of the spectrum; it is a mere mechanical adaptation of the form of the deposit to the form of the light vibrations."

Now, if the capability of one of the Lippmann heliochromes to reflect the colour of the original incident ray back to our eyes is dependent on the distance of the laminæ of silver one from the other, it is obvious that if we could increase this distance the colours should change. This is precisely what takes place. It is only necessary to expose a heliochrome to steam or aqueous vapour, which is absorbed by the gelatine; this swells, and the distance between the laminæ is increased. Now, assuming that this distance of separation for the extreme violet be half one wave-length, 4,000 ten-millionths of a millimetre, that is, 8,000, and we steam it so as to increase the distance by one-fourth, then our 8,000 becomes 10,000, and one-half of this would be 5,000, which is the wave-length of the bright blue; therefore, this would be the colour reflected to the eye. This change of colour with steaming or absorption of aqueous vapour can be proved with any heliochrome. It is obvious that there might well be heliochromic effects produced on daguerreotypes, with which a polished silver plate with a sensitive film is used, and such coloured results have actually been observed (J. Nicéphore Niepce).

Bleach-out Process.—A. Vogel (*Schweigger's Journal*, 1813, pp. 229–236) recorded the fact that under coloured glasses the colours of tinctures of certain flower petals were bleached, but that under glasses of the same colour as the tinctures there was no change. This subject was studied by Herschel (*Philos. Trans.*, 1842) and Robert Hunt (*Researches on Light*, 1844, p. 170), and the former propounded the law that dyes were bleached when exposed under their complementary colours, but were not bleached when exposed to light of the same colour. In 1889, R. E. Liesegang (*Phot. Archiv.*, No. 633, p. 328) recommended the admixture of three fundamental colours—red, yellow and blue—and in 1891 (*Phot. Almanach*, 1891) he stated that the bleaching took place more rapidly in oxygen. Two years later (*Phot. Archiv.*, 1893, Nos. 729, 730) he also published a series of experiments on the increase of rapidity of bleaching aniline dyes by the addition of certain sensitisers, such as stannous chloride, oxalic acid, hydroxylamine, ammonium sulphocyanide, etc.

Wiener, in his already cited paper (*Annalen d. Phys. u. Chem.*, 1895, p. 225), includes a special

chapter on " the theoretical basis of a method of colour photography with body colours," and says : " In order that a substance sensitive to light can be chemically changed by the action of any kind of light, it must absorb it." The converse proposition is not general. The absorbed light can, for example, be exclusively formed into heat. A distinction is, therefore, made between thermal and chemical absorption of light. For the sake of simplicity of expression I shall designate as a regularly absorbing light-sensitive substance one which is sensitive to all colours which it absorbs, and is affected by each colour in proportion to the capacity for absorption. That there are such substances, at least to a considerable degree of approximation, is known. Upon their existence is based the important law of optical sensitisers established by H. W. Vogel. It is conceivable that the regularly absorbing light-sensitive substance may be decomposed by the action of light to form coloured substances also regularly absorbing and light-sensitive. I will designate as a colour-receptive substance a black regularly absorbing light-sensitive substance whose products of decomposition consist only of monochromatic regularly absorbing light-sensitive substances of at least three radically different colours, and, besides these, of a white substance which, however, is the least readily formed. These colours must be radically different in order that by their mixture with one another and with white all compound colours may be possible. In distinction from these compound colours the unmixed colours will be called ground colours. The monochromatic substances reflect only one colour well. They must absorb the others the more completely they differ from them. With these preliminaries it may be shown that a colour-receptive substance reproduces the colour of the illumination correctly. First, let the colour of the illumination agree with a ground colour. It will be absorbed by the black body and produces a decomposition substance which, by hypothesis, is regularly absorbing and light-sensitive. In this decomposition different coloured substances are formed. Those not agreeing in colour with the incident light absorb it, since, by the hypothesis, they are monochromatic, and must absorb all illumination different from their colour. Since these are regularly absorbing light-sensitive substances, they are also decomposed by the light which they absorb. On the other hand, the substance of the same colour as the incident light is not decomposed, since it does not absorb. In the end, therefore, it alone can remain in company with the white substance. The amount of the latter is, by hypothesis, very slight, and its effect upon the colour is, therefore, noticeable only under strong illumination. Where the colour of the illumination differs from that of a ground colour, but is intermediate between two ground colours—as would, for example, be the case with green, and if yellow and blue were ground colours—the coloured substances would suffer least decomposition which reflect green best—that is, the yellow and blue. A green mixture would thus arise besides the small quantity of white. In white light all the colour substances would be decomposed, leaving white alone. In the absence of illumination the substance would remain black."

Incited by Wiener's theorising, Vallot (Mon. d. la Phot., 1895, p. 318) used aniline purple (red), Victoria blue and turmeric on paper and exposed for three or four days to sunlight and obtained coloured results. The subject was followed up by Worel, who published (Auz. K.K. Akad. Wissent. Wien, 1902) details of his process, though he had shown results at the end of 1901, and he used anethol as a sensitiser. Neuhauss followed up the subject (Phot. Rund., Jan., 1902, and Eder's Jahrbuch, 1902-3-4), using oxidising substances, such as hydrogen peroxide and the persulphates, as sensitisers. Szczepanik (Phot. Korr., 1902), instead of mixing the dyes, coated them in three superimposed layers, and in 1906 a commercial paper, " Uto," was placed on the market by Smith and Co., of Zurich. From a practical point of view all these preparations leave much to be desired, but such a paper with reasonable sensitiveness would be of great practical interest.

Three-colour Processes.—These are dealt with separately (see " Three-colour Photography " and " Screen-plate Colour Photography "). The only other process with which it is necessary to deal is the—

Prismatic Dispersion Process, which practically splits up the light reflected from any object into its spectrum, and allows this to act on the sensitive surface, and then reconstitutes the image. In this process no dyes or filters are used, and it may be considered to be nothing more than a method of optical synthesis, in which the whole spectrum and not three colours are used. The first suggestion for the process was made in an English patent, No. 16,548 of 1895, taken out by F. W. Lanchester. The essentials of the process are as follow : A grating of black lines with clear interspaces is arranged between the object and the camera, a prism is arranged behind the lens with its axis parallel to the bars of the grating, the dispersion of the grating being such that when the lens is focused on the grating the images of the clear interspaces form a series of spectra on the plate, which are broken up by the light reflected from the object so that the image consists of lines of shaded intensities. From this negative a transparency is taken on an ordinary lantern plate and placed in the position occupied by the original dry plate, and the coloured picture is then reconstituted by placing a light behind the grating and viewing the picture at the distance of normal vision. In the British Journal of Photography for Jan., 1904, Dr. Rheinberg suggested a similar process, and it has since been taken up by Cheron, Bruignac and Raymond, and the latter seems to have obtained the most practical arrangement. The following description is taken from " Colour Photography," the supplement to the British Journal of Photography for Mar. 1, 1907 : To an ordinary camera is fitted a diaphragm behind the lens, and this diaphragm should preferably be a narrow rectangle. In front of the plate is fitted an ordinary cross-line screen, with preferably opaque lines wider than the interspaces ; behind the screen is placed a prism of

from 3 to 8 degrees, and then the plate. The exposure is made in the usual way, and a positive from a negative made and placed in the position of the negative. At present the process is but in its infancy, but it promises well, the only disadvantages being the prolonged exposures required, and the difficulty of exhibiting the pictures to more than one person at a time.

NATURAL HISTORY PHOTOGRAPHY

The equipment of the naturalist photographer largely depends upon the subjects to which he intends to devote attention. (For example, the reader will find further useful and suggestive hints under such headings as "Insects," "Fish," "Birds," etc.) For much natural history photography a good reflex camera is essential. For photographing very shy birds and beasts, the improved type of telephoto lens, having an aperture of $f/7$ or $f/10$, and requiring only a comparatively short extension of camera to obtain on a small plate a large image of an object at a considerable distance, will be found of the greatest service. All cameras and tripods used should be strongly made and not have any bright metal fittings or highly polished surfaces to reflect the light and attract attention. The tripod may with advantage be painted a dull, dark green, and the camera and fittings dead black. A good, deep, easily-fitted hood for the front of the lens is desirable to cut off strong reflections on the front surfaces of the lens, which are often responsible for general flatness or hazy definition. The whole of the apparatus should pack into thoroughly water-proof cases, for the naturalist photographer may frequently have to face inclement weather. A well-made Alpine ruck-sack is a convenient receptacle for parts of the outfit when long distances have to be covered on foot. In selecting apparatus, weight must be considered, but for the sake of lightness and portability, strength and rigidity must not be sacrificed. The use of aluminium for any parts of photographic apparatus to be used in the field for natural history is a questionable advantage. If one is working within reach of the salt spray of the waves, or where sea water is likely to come in contact with the outfit, there will soon be trouble with any aluminium fittings. The tripod should be of well matured wood, and of the three-fold type, closing to a small space, and capable of considerable adjustment for varying heights and inequalities of the ground. As it is important to obtain as faithful a monochrome rendering of the colours of the original subject as possible, isochromatic plates should always be used if there is sufficient light to obtain a good exposure. Prints should be made upon platinotype for preference, or bromide paper, so as to obtain all possible detail and gradation.

"NATURALISTIC PHOTOGRAPHY"

Under this title a book was published by Dr. P. H. Emerson, in 1888. Its effect was to lead to the production of a class of photographic work which had hitherto received little attention. The hollow artificiality of much of the photographic work that had been accepted with approval was realised, and a school of workers

sprang up who gave their attention to the beauties of Nature. Many strikingly fine land-scape subjects were produced which demonstrated that photography was fully capable of taking its stand firmly as a graphic art of no mean capacity. Pictorial photography in the true sense sprang into being. Less and less reliance was placed on the theatrical accessories of the studio, and photographers went direct to Nature for their subjects and effects.

NATURE PRINTING

Printing on paper prepared with flower juices (see "Anthotype") and upon fruit; for the latter purpose, flexible stencil plates are attached to the green fruit, chiefly apples and peaches, the sun then printing the pattern as the fruit ripens over a period of several weeks. Film negatives may be used, but they must possess extreme contrasts.

NEBULÆ, PHOTOGRAPHY OF (See "Stars, Photographing.")

NEEDLEHOLE (See "Pinhole.")

NEGATIVE (Fr., *Négatif*; Ger., *Negativ*)

An image in which the lights and shades are reversed; a term first used by Sir John Herschel, in 1840, to describe Talbot's pictures upon calotype paper. The first negatives were upon paper made translucent by waxing, but glass and celluloid have now almost wholly replaced paper.

NEGATIVE ABERRATION

The opposite of ordinary (positive) aberration in a lens. A concave lens showing negative spherical aberration can be used to correct positive aberration in a convex lens.

NEGATIVE BOX (See "Box, Negative.")

NEGATIVE CARRIERS AND HOLDERS (See "Enlarging Camera," "Plate Holder," etc.)

NEGATIVE COLLODION PROCESS (See "Collodion Process (Wet).")

NEGATIVE ENVELOPE (Fr., *Enveloppe aux clichés*; Ger., *Negativ-kouvert*)

Thin paper envelopes used for storing negatives. Particulars of the subject, date of exposure, and other details may be written outside. (*See also* "Negative Storing.")

NEGATIVE LENS

A concave (diminishing) lens, which cannot focus rays upon a screen to produce an image.

NEGATIVE NUMBERER (Fr., *Numérateur aux clichés*; Ger., *Negativenzähler*)

There have been several devices for numbering negatives. In one, a small stencil which changes automatically to a higher number at each exposure is fitted to the camera or dark-slide, so that it comes against a corner of the plate, the number therefore appearing on development. The sheaths of some hand cameras have notches indicating their respective numbers, which show at the edge when

developed; this, of course, only indicates the order in which each dozen plates are exposed. Some studio operators have a set of separate printed numbers, to slip in a small grooved frame, after the principle of a church hymn-board. This is laid near the sitter so as to come at the margin of the plate, and is changed at each exposure.

NEGATIVE, PAPER (*See* " Paper Negatives.")

NEGATIVE, PERFECT

The term " perfect negative " is frequently met with in photographic literature; but a negative that is perfect for one printing process may be quite unsuitable for another one. A nice-looking, clean negative, say, one developed with hydroquinone, will often give a print far inferior to one sometimes obtained from a yellow-stained pyro-developed negative. Of the good average negative, R. Child Bayley says that, placed film side down, upon a sheet of white paper, and looked at from above, the edges on which the light did not fall in the camera ought to be almost clear; a slight trace of greyness is unavoidable, unless a backed plate is used. There must be an appreciable quantity of greyness in the very deepest of the shadows, or the plate has not had sufficient exposure; if there is too much the plate has been over-exposed. The highest lights, the most opaque portions, are tested by placing the film in contact with printed matter; the print must be considerably darkened as compared with the lighter parts of the negative, but it should be possible to read it through even the most opaque portions without difficulty; otherwise, whether the plate was over-exposed, correctly exposed, or under-exposed, it has been over-developed.

At one time the wet-collodion negative was thought to give the effect to be aimed at in the dry plate; but at the present time the Hurter and Driffield dictum, that the negative should be judged by its printing qualities alone, is generally accepted.

In process work, various classes of negatives are used. They may be in " half-tone," " grain," or in " continuous tone." The last-named resembles an ordinary negative, with gradated tones, not broken up into dot or grain, but must be of very good quality, with full range from almost clean glass in the shadows to perfect opacity in the lights. Such a negative for photogravure or collotype should not be hard, but somewhat thin and full of detail, with a uniform gradation throughout.

NEGATIVE, REVERSED

A negative from which is produced a print that represents the object reversed as regards left and right. It is easily produced by placing the plate in the camera glass side towards the lens. Photo-mechanical workers use, as the daguerreotype workers did, a reversing mirror or prism fitted to the front of the lens and throwing a reversed image direct upon the plate. Negatives already made may be reversed by stripping the film and replacing it in a reversed position. Reversed negatives are largely used for carbon and collotype work. (*See also* " Inversion, Lateral.")

NEGATIVE STORING (Fr., *Magasinage des clichés* ; Ger., *Negativenlagern*)

Negatives are best stored in wooden or metal boxes. (*See* " Box, Negative.") Grooved boxes and drawers are favoured by some, others preferring boxes without grooves and placing each negative instead in an envelope bearing the number, title, and other particulars. This takes up much less room, but the negatives cannot be inspected without removal from the envelopes, unless these are transparent. Films are preferably stored in albums with stout leaves, in which slits are cut to hold the four corners; envelope albums are also made.

NEGATIVES, OWNERSHIP OF

Questions as to the ownership of the copyright in negatives and the ownership of the negatives themselves constantly arise in professional work. Taking the ordinary case in which a photographer makes, to the order of a customer, a negative and supplies prints from it, the copyright is the customer's, but the negative itself is the property of the photographer, and the latter is free to retain it, destroy it, or apparently do anything with it short of printing from it, enlarging from it, or copying it unless ordered to do so by the customer. (The term " customer " is here synonymous with " sitter," except in cases where the person who remunerates the photographer is not the person who is photographed.) This applies also to all the superfluous and rejected negatives made by the photographer in the course of producing a satisfactory photograph. When such negatives are sold, the buyer acquires the rights held by their maker; that is, he can do with the negatives as he pleases short of infringing copyright; in this connection, though, it is of interest to read the article under the heading " Copyright." Naturally, the buyer does not buy the right to reproduce the negatives, because that right was not possessed by the maker of the photographs; and no greater title in any property can be conveyed to a second party than was possessed by the first party. The English law has always upheld the photographer in retaining the negatives of photographs supplied; in one case, for example, the High Court decided that duplicate negatives made by a photographer for the purpose of executing an order for prints, the duplicate negatives being charged to the customer, must remain the property of the photographer.

NEOMONOSCOPE (Fr., *Néomonoscope* ; Ger., *Neomonoskop*)

Bean's viewing apparatus for photographs, invented about 1862, and consisting of a conical box, with a lens or lenses at the upper end and a portion of one side removed to admit light. The bottom could be withdrawn for the inspection of transparent objects.

NEPHOGRAPH (Fr., *Néphographe* ; Ger., *Nephograph*)

An apparatus used by meteorologists for photographically registering the height and position of clouds. It is furnished with a camera, having an electrically-operated shutter, which may be

worked from a distance. Two or more of the instruments are placed at different stations, sometimes far apart, the separation and exact relative position of which have been accurately ascertained, and exposures are made simultaneously from each. The resulting negatives or prints enable the required data to be calculated by photogrammetric methods.

NERNST LAMP (Fr., *Lampe Nernst*; Ger., *Nernst-Licht*)

A lamp in which a stout filament composed of magnesia and the oxides of rare earths is rendered incandescent by the electric current. It was invented by Walther Nernst, in 1897. This illuminant is excellent for enlarging, optical projection, and cinematography with a

Nernst Lamp

small disc. It is very economical of current, carries its own resistance, and is usually furnished with a short length of flexible wire and a connection that merely requires insertion in the bayonet catch of an ordinary incandescent glow lamp from which the bulb has been removed (*see* illustration). The filaments when broken are readily replaced with fresh ones. Various useful modifications by R. W. Paul and others have rendered the lamp still more adaptable for photographic and projection purposes.

NESSLER'S SOLUTION

Used for testing certain chemicals—the ammonium salts, for example, with which it gives a coloration or brownish precipitate. It is made by dissolving 30 grs. of potassium iodide in 1½ drms. of distilled water, and boiling with successive portions of solid mercuric iodide until some of the latter remains undissolved. The liquid is then added to 1½ oz. of distilled water, filtered, and the filtrate mixed with 120 grs. of caustic potash dissolved in 4 drms. of water, and the whole again filtered. There are other formulæ.

NEUHAUSS'S BLEACH-OUT PROCESS

Dr. Neuhauss, of Berlin, has paid particular attention to the bleaching-out process, and gives the following instructions for working the same :—

Soft emulsion gelatine . . .	2 oz.	110 g.	
Distilled water to .	20 ,,	1,000 ccs.	

Allow to soak in the water, melt by the aid of a water-bath, and add with constant stirring—

Methylene blue BB (Bayer) (·2% sol.)	528 mins.	60 ccs.	
Auramine, concentrated (Bayer) (·2% alcohol sol.). .	132 ,,	15 ,,	
Erythrosine (Schuchardt) (·5% sol.) .	264 ,,	30 ,,	

Then filter and heat for four or five hours to 104° F. (40° C.) before coating. When dry, the plates must be bathed in—

Hydrogen peroxide (30% sol.) . .	660 mins.	75 ccs.	
Ether to .	20 oz.	1,000 ,,	

for at least five minutes. Instead of the ether solution, the following may be used, and gives greater sensitiveness :—

Chloral . . .	176 grs.	20 g.	
Caustic soda (10% sol.)	5 mins.	·5 ccs.	

Instead of bathing the plate in the peroxide solution, the latter may be added to the gelatine, and then the following formula should be used :—

Methylene blue BB (as above) .	480 mins.	50 ccs.	
Auramine (as above)	192 ,,	20 ,,	
Erythrosine ,,	384 ,,	40 ,,	

Add these to the gelatine solution at as low a temperature as possible, and add 10 per cent. of the total quantity of 30 per cent. solution of hydrogen peroxide, and immediately coat the plates.

NEUTRAL OXALATE (*See* "Potassium Oxalate.")

NICKEL (Fr. and Ger., *Nickel*)

The electro-deposition of nickel has lately come into considerable use in the graphic arts. Zinc etchings are often nickelled to prevent corrosion. Stereotype plates are nickel faced to make them wear and print better. Nickel and nickel steel electrotypes are being produced by direct deposition on the wax mould.

NICOL PRISM

Used in microscopy for polarising light, and consisting of a small block of Iceland spar one of the edges of which is cut to an angle of 68° to the long axis. The prism is divided to form two prisms, which are cemented together by Canada balsam. A ray of light passing through the cemented surfaces is split up into two portions; one, known as the ordinary ray, passes out at the side and is lost, whereas the other, the extraordinary ray, emerges from the end of the Nicol prism and through the object which is being examined into the microscopic objective. The prism is mounted in a revolving cell under the stage of the microscope. (*See also* "Polarised Light.")

NIEPCE, JOSEPH NICÉPHORE

Born at Châlons-sur-Saone, 1765; died 1833. A French chemist who began his photographic experiments about the year 1814. In 1824 he obtained light impressions on bitumen spread upon plates of metal. Six to eight hours' exposure was necessary, when the parts acted

upon by light became hardened and were rendered insoluble, while the rest could be dissolved away. The exposed portions of the metal were then etched and used as printing plates. On December 5, 1829, he entered into an arrangement with Daguerre to exchange with one another information regarding all their attempts to fix the pictures obtained by the camera obscura. Niepce and Daguerre worked together until the former's death, when his son Isidore took his place.

NIEPCEOTYPE

One of the earliest photographic processes, and called by the above name after its discoverer, Niepce. He found that bitumen became insoluble by the action of light (*see* " Asphaltum "). Pewter plates were coated with bitumen and exposed to light under a print. Afterwards, efforts were made to expose the plates in the camera, but the necessary exposure was found to be excessive, so that the process had only a limited application. Niepce at first only endeavoured to get a picture on the plate in the bitumen varnish, but afterwards he etched the plates to make printing blocks, and thus was the first to make photo-engravings. The earliest photo-engraving by Niepce is a portrait of Cardinal d'Amboise, now preserved in the museum of Châlons. It was copied by contact from a print.

NIEVSKY'S PROCESS

A ferrotype process in which ferrotype dry plates are used instead of wet collodion. Introduced by L. Nievsky in 1891.

NIGHT EFFECTS

These, both artificial and real, will be found described under various headings; for example, " Night Photography," " Moonlight Effects," " Candle-light Effects," " Firelight Effects," etc.

NIGHT PHOTOGRAPHY

Photography by the aid of the artificial light of towns or by that of the moon. The practice of producing " night photographs " by what is known as a double exposure—a very short one by day and then by leaving the camera in position and giving a long exposure at night—does not give true night pictures. The exposure necessary for true night photography is not so protracted as might be supposed, and it is possible nowadays to take " snapshots " in well lighted streets at night, the camera being held in the hand, and a very large aperture and the very fastest plates being required. Ordinary night work can be done easily with an ordinary camera and lens, and the fast plate used for daylight work. With a lens working at $f/8$, a plate of a speed of about 250 H. and D. and the time about one hour after sunset, the exposure required for different classes of subjects will work out somewhat at follows : Illuminated shop windows, decorations, etc., two minutes ; the same subjects, not including the lights themselves, but only the effects of lights on the objects, five minutes. Open subjects, such as streets and squares in towns well lighted, ten minutes ; the same subjects, when heavy dark objects have to be registered with a certain

amount of detail, 20 minutes. The country-side on a bright moonlight night, 30 minutes ; but this subject is very variable in character and conditions, so that this estimate is only approximate. These exposures are given only as bases to start from, and each worker must find out his own exposure data. If snow is on the ground the exposure, as a rule, can be halved. If the ground is wet with rain water (not merely greasy), one-third can be taken off the exposure. Moonlight or its absence makes a great difference in the duration of exposure, and at least one third can be taken off when strong moonlight is present. On the country-side, where there is little artificial light available, the absence of moonlight will make night work, when there is no snow on the ground, almost impossible. The nature of the subject again will greatly influence the time of exposure. If night exposures are to be accurately and quickly determined, one must be able to consult his record of exposures, each of which must be kept with the time, place, state of the weather, plate, aperture of lens, etc., all recorded for future reference. If instead of using the lens at $f/8$ it is possible to expose at $f/3$, as in the case of certain modern but expensive lenses, the exposure will be reduced to at least one-eighth of those before given ; and by using a plate working at 400 H. and D., then the exposure can again be halved. To be able in $2\frac{1}{2}$ minutes to take a subject which under the former conditions required 40 minutes makes a wonderful difference to the photographer's comfort on a cold and inclement night ; to reduce $1\frac{1}{2}$ minutes to 5 seconds is to be able to get figures showing little movement ; while to give one-third of a second instead of a minute is to take " snapshots " in the streets with the camera held in the hand.

It is now a matter of common practice in London and other well-lighted towns to take moving figure subjects by the light of the street lamps. There is much difference of opinion as to whether isochromatic plates give better results than the non-colour-sensitive. The photographer should experiment with the fastest plates obtainable, including Extra Speedy (not the press variety, which are designed to give too much contrast) and the Super Speed Ortho. The developing of negatives of night subjects is as difficult as the exposing. Plenty of water should be used. Perhaps the plan most favoured is to begin development with a developer of ordinary strength (without any bromide), and after detail is fairly out to pour off the developer and, after rinsing the plate, cover it with water and leave it to progress by itself. Many get excellent results by diluting the developer with three to four times the usual amount of water and letting the development proceed very slowly. Anyway, a night negative will look a poor, weak thing to a day worker. Some night workers find that the warming of the developer tends to reduce halation, and to soften the hard results caused by fog. Taking the normal temperature of the developer to be about 65° F. (18° C.), it may with many plates be gradually raised to 80° F. (27° C.) without the film leaving the glass, but great care must be taken in handling the film in its softened con-

dition. As to developers, metol alone, pyro soda, rodinal, etc., are used. When a negative shows bad halation, it should be bleached with the ordinary mercury bath, and then "surface developed" only with some quick-acting developer, whipping out the plate before the developer has time to work through to the halated parts.

NITRE (*See* "Saltpetre.")

NITRIC ACID (Fr., *Acide nitrique ;* Ger. *Salpetersäure*)

Synonyms, aqua fortis, hydrogen nitrate. HNO_3. A colourless, fuming liquid when pure, which strongly attacks the skin, causing painful burns, or with short contact a brown stain. It is prepared by distillation from saltpetre and sulphuric acid. Used as a preservative in the pyro developer. The acid should always be kept in a glass-stoppered bottle. Should the acid be spilled upon the clothes or skin, apply chalk, lime, or magnesia.

In process work, nitric acid is the universally-used mordant for etching zinc. From 5 to 20 per cent. is the range of baths employed.

NITROCELLULOSE (Fr., *Cellulose nitrée ;* Ger., *Nitrocellulose*)

Formed by the action of nitric acid on cellulose, and important as forming the basis of all collodions and celluloid. (*See* "Pyroxyline.")

NITROGEN IODIDE

A black, extremely explosive powder. NHI_2. It is of purely theoretical interest as being very light-sensitive.

NITRO-HYDROCHLORIC ACID (Fr., *Eau régale ;* Ger., *Königswasser*)

Synonyms, aqua regia, nitro-muriatic, chloro-nitrous or chloroazotic acid. Miscible in all proportions with water and alcohol. A fuming yellowish liquid made by mixing 1 part of pure nitric and 3 parts pure hydrochloric acid. It is used to dissolve gold and platinum, and should be kept cool and in the dark. The fumes cause intense irritation to the mucous membrane.

NODAL POINTS, OR GAUSS POINTS

A ray of light falling obliquely upon a plate of glass or other transparent medium does not pass through in a straight line, but is refracted and emerges in a direction parallel to its original

Diagram showing Nodal Points

path. The same thing occurs when a ray falls obliquely upon the surface of a lens, as shown in the diagram. A ray of light proceeding from A enters the lens at B, is refracted and

leaves it at C, proceeding to D in a parallel direction. A B and C D extended to the principal axis of the lens give the two nodal points N N. That nearest the object is called the "node of admission," and that nearest the image the "node of emergence," or "node of emission." It is from the latter that the focal length of a lens or combination of lenses is measured, and at this point a lens for use in a panoramic camera must be pivoted. The nodal points are not necessarily situated within the lens. They may be before or behind it, and they may be crossed; that is to say, the node of emergence may be farther from the plate than the node of admission. With many modern anastigmats the nodes are so far outside the lens that considerable difference in the camera extension is necessary, according to whether the convex or concave side is turned to the object.

NORRIS'S COLLODION PLATES

One of the earliest forms of collodion dry plates, introduced by Dr. Hill Norris, of Birmingham, in May, 1855.

NORWICH FILM (*See* "Film.")

NUDE, PHOTOGRAPHY OF THE

The nude figure, male and female, is extensively and successfully treated by painters and draughtsmen. To photographers, however, this particular class of work offers less opportunity for successful effects. In some hands results have been secured that are quite pleasing and satisfactory, but in the ordinary way the chances of complete success are remote. The great difficulty lies in the fact that the photographer does not possess the unlimited facilities of the artist for idealising, for combining, modifying, emphasising, and suppressing, to secure the final satisfactory result. For purposes of figure study, good photographs of the nude have a real value and use. The introduction of nude figures into landscapes has also been successfully accomplished in some cases. But the treatment of the single nude figure for pictorial purposes is seldom satisfactory in the photographer's hands, although this is not because photography is not eminently capable of rendering the beautiful contours, texture, and delicate light and shade of the human body. The difficulty lies rather in first securing the perfectly artistic model, and then rendering it by photographic means with that ideal perfection and purity which should characterise all renderings of the nude figure. Too often the result is mere nakedness, which is a different thing altogether. On the whole, therefore, this class of work is better left alone by the ordinary photographer.

NUMERICAL APERTURE

Usually written N.A. The present system, almost universally adopted, of describing the aperture of microscopic objectives and substage condensers was devised by Abbé, in 1873. The numerical aperture of an objective is the sine of half the angle of aperture multiplied by the refractive index of the medium in which the objective works (air in dry lenses, water, oil, etc., in immersion lenses).

O

OBERNETTER'S PAPERS

A collodio-chloride paper, introduced in 1868, and a gelatino-chloride paper, in 1884, both by J. B. Obernetter, of Munich.

OBERNETTER'S PROCESSES

A photogravure process (see "Lichtkupferdruck") and a printing process (see "Ferric Salts, Printing with").

OBJECT GLASS

Abbreviation, O.G. The image-forming lens of a telescope or microscope. (See "Objective.")

OBJECTIVE

The lens in any optical system—such as a telescope, microscope, or photographic camera—which forms or projects an image either for examination by means of an eyepiece or for reception by a sensitised surface. The objectives of ordinary telescopes and microscopes are usually corrected for visual use only, and require a small allowance to be made when used for photography, so as to bring the surface of the plate into the position of sharpest focus. Supplementary lenses for effecting this correction are sometimes fitted to telescopic objectives, and compensating eyepieces, or oculars, to microscopic objectives. Many objectives of both classes are now made especially for photography.

The projecting lens of an optical lantern or cinematograph is usually called the objective.

The focal lengths of the microscope objectives in general use range from 3 in. to $1\frac{1}{2}$ in., but lenses of both lower and higher powers are manufactured. These figures refer to the equivalent focal lengths and not to the distance of the lens from the object when the latter is in focus.

Objectives of less than $\frac{1}{4}$ in. focus are almost invariably immersion lenses; that is, a medium, generally oil, fills the space between the front lens of the objective and the cover slip over the object; by using in this way a medium of higher refractive index than air, a higher numerical aperture, and consequently increased definition, can be obtained. In some older types of lenses water was the immersion medium, but cedar oil is now almost universally used, as it is of practically the same refractive index as crown glass. The depth of focus given by microscope objectives, which is of more importance for photographic than visual work, is extremely limited, especially with high powers. The penetration or depth of focus of a lens is approximately $\frac{1}{10}$ of its focal length; thus the penetration of an objective of $\frac{1}{10}$ in. focal length would be about $\frac{1}{100}$ in. In photomicrography the depth of focus would be considerably less than this, but stops can be placed in low-power microscope objectives to increase the depth of focus, and when thick sections or specimens are photographed, this plan is often necessary.

In microscopy the magnifying power of a lens refers to the number of diameters by which the image given by the objective at a distance of 10 in. from the back lens magnifies the object; this is easily estimated when the focal length is known, as an objective of 1 in. focal length gives a magnification of ten diameters at a distance of 10 in. from the lens; therefore, a $\frac{1}{6}$ in. objective would magnify 60 diameters at the same distance. These figures represent the magnifying power of the objectives without the eyepiece, and are termed the initial power of the lens. When an eyepiece is used, the initial power of the objective multiplied by the magnifying power of the eyepiece, gives the total magnification of the lenses.

The resolving power of an objective—that is, the number of lines per inch which the lens will separate or resolve—does not depend upon its magnification, but upon the numerical aperture (which see), and a lens with a high N.A. will give better definition than a lens of higher magnifying power with a lower N.A.

Objectives with high N.A. have a small working distance between object and lens, and consequently less depth of focus. In photomicrography a good working distance and depth of definition are often extremely useful, and on this account an objective of high N.A. is not always desirable.

The best type of objective is known as the apochromat, which is expensive, and in practical work but little superior to first-class achromats, especially when colour filters are used. All modern objectives are fitted with the R.M.S. screw, that is, the worm at the back of the lens which is screwed into the body tube always has the same number of threads per inch, and any objective can be used with any microscope

OIL LAMPS (See "Dark-room Lamp.")

OIL TESTER (See "Acrometer" and "Oleometer.")

OIL OF VITRIOL (See "Sulphuric Acid.")

OILED NEGATIVES (See "Paper Negatives.")

OIL-OZOBROME (See "Ozobrome, Oil.")

OIL-PAINTINGS, PHOTOGRAPHING (See "Paintings, Photographing.")

OIL-PIGMENT PROCESS

A method of producing prints in pigment or ink applied with a brush. As contact printing is an essential part of the process it follows that an enlarged negative must be made before

such a print can be obtained of a subject originally taken on a small plate. It was to obviate this that the bromoil process was evolved. The steps preceding the actual pigmenting are few and simple. Special paper made for the purpose may be obtained, but a variety that is perfectly satisfactory is that supplied for the final support in the double-transfer carbon process. In any case it is simply a paper coated with gelatine. This has to be sensitised. It should then be stored in a calcium tube, but it is preferable to use it the next day if possible, so that it is best only to sensitise such quantities as are wanted for immediate use.

A 10 per cent. solution of potassium bichromate is an effective sensitiser. It should be applied by means of a Blanchard brush (see "Brushes"). Equal quantities of potassium bichromate solution and of methylated spirit are placed in a clean porcelain dish, which is tilted so that the solution lies at one end. One ounce of each is more than sufficient for half a dozen 12 in. by 10 in. sheets. A piece of the paper is laid face upwards on a pad of folded newspaper, and the brush is charged with solution and drawn across the paper first in one direction and then at right angles to it. Only enough solution should be taken to cover the surface. The stroking action in two directions is continued until the streaks on the surface practically disappear as the gelatine absorbs the sensitiser. The sheet is then pinned up, by one corner only, to dry, and the other sheets treated similarly. The sensitising should be done by a yellow light that would be fairly safe for bromide work, and the drying completed in the dark-room. When dry, the sheets may be placed in a box or tube, and should be protected from actinic light with the same care as in the case of platinotype paper. In fact, the paper resembles platinotype in its sensitiveness to light, and in the character of the image that prints out under the negative. Printing is continued until all that is required in the finished print is visible.

The prints are now washed in several changes of water. The yellow bichromate stain first disappears, but washing should be continued until there is practically no trace of colour even in the darkest shadows. In cold weather the temperature of the later washing waters should be raised to 60° or 65° F. (15·5° or 18° C.). The paper finally shows the subject as a gelatine relief, the high lights appearing considerably raised. Pigmenting may be proceeded with at once, or the prints may be dried and stored away for future treatment. In the latter case it is only necessary to re-soak the prints until the relief is again evident. For the method of finishing the print, see the outline of procedure given under the heading "Pigmenting."

OLEOMETER (Fr., *Oléomètre*; Ger., *Oleometer*)

Another name for the acrometer, a form of hydrometer specially graduated for testing the specific gravity of oils.

OMNICOLORE PLATE

This is a screen colour plate of French manufacture, the patent of Ducos du Hauron and De Bercegorol. By means of a printing machine two lines in greasy ink are printed on gelatinised glass at right angles to one another, thus leaving little rectangles between the lines of gelatine, which is alone permeable to aqueous dye solutions. A compensating yellow screen or filter is used with the plates, and this and the filter elements reduce the speed of the emulsion to about 2½ Watkins, 1·7 H. and D., or 27 Wynne. It is advisable to manipulate the plates in the dark, and they must be placed with the glass towards the lens and a piece of opaque card in contact with the film to prevent it from being injured. The compensating filter should be placed behind the lens and the ground glass reversed, or with fixed-focus cameras the insertion of the screen behind the lens sufficiently lengthens the focus for ordinary purposes. The developer recommended is :—

Metol	. . .	36 grs.	4 g.
Sodium sulphite (anhydrous)	. .	1 oz.	50 ,,
Hydroquinone	. .	18 grs.	2 ,,
Potass. carbonate (dry)	264 ,,	30 ,,	
Potassium bromine	.	8½ ,,	1 ,,
"Hypo" sol. (1 : 1000)	145 mins.	15 ccs.	
Distilled water to	.	20 oz.	1,000 ,,

Development should be continued for five minutes, the plate washed for 15 to 20 seconds, and then immersed in the reversing bath of—

Potassium or sodium bichromate	. .	70 grs.	8 g.
Sulphuric acid	.	114 mins.	12 ccs.
Distilled water to	.	20 oz.	1,000 ,,

In which it should be left for about two minutes with gentle rocking. If a negative is required, naturally the plate is fixed after the first development and not reversed. If a positive is required, then the plate in the bichromate bath should be taken out into daylight for three or four minutes, or for five or six minutes to artificial light, and as soon as the whole of the image is dissolved, immersed in a 5 per cent. solution of bisulphite lye or metabisulphite, or 20 per cent. solution of sodium sulphite. The plate should then be re-immersed in the developer for five or six minutes, and when sufficiently dense, washed for about 30 seconds and fixed in—

Sodium hyposulphite	2½ oz.	125 g.	
Sodium metabisulphite	. .	265 grs.	25 ,,
Water to	.	20 oz.	1,000 ccs.

Next wash for 20 to 30 minutes in running water, dry, and varnish with a 15 per cent. solution of mastic or dammar in benzole.

Under-exposed or too dense pictures may be improved by reducing in a "hypo" and ferricyanide reducer; or weak pictures may be intensified with mercuric chloride followed by sulphite.

OPACITY (Fr., *Opacité*; Ger., *Schwarzung*)

The optical property of a substance, such as silver, to impede the passage of light through it. In sensitometry it is termed—

$$O = \frac{I_0}{I} = \frac{\text{Intensity of incident light}}{\text{Intensity of transmitted light}}$$

Thus, if we assume the intensity of the incident

to be 1 and that of the transmitted light ¼, obviously $\frac{1}{\frac{1}{4}} = 4$, which is the opacity of silver that reduces the light to one-fourth.

OPACITY BALANCE

An instrument devised by Chapman Jones for measuring the opacities of bromide prints and other surfaces.

OPACITY METER

There are various instruments for measuring the opacities of negatives, etc., such as spectro-photometers, polarisation photometers, the modified Bunsen photometer of Hurter and Driffield, and the Chapman Jones opacity meter. In the last named (*see* the diagram) an

Opacity Meter

incandescent gas light shines through aperture B upon an Abney screen C, a beam also being carried round the velvet-lined tube (by means of the mirrors D) to illumine the translucent part of the screen to which a negative is clipped. As a rule, in practical sensitometry (*which see*), the logarithms of the opacities are termed "densities" and are plotted.

OPALINES

Photographs mounted under glass and then upon plush or other supports. The glasses and all other necessary materials are supplied by dealers. A print, preferably P.O.P., is mounted, while wet, face downwards upon the cleansed bevelled glass; it may or may not have been treated with formaline or other hardening solution. For mounting, use ¼ oz. of gelatine in 5 oz. of water, allowing this to stand for a time, and then melting by gentle heat. Strain the warm gelatine solution through muslin into a flat dish, and while still warm soak each print in it bodily for about a minute and transfer, face downwards, to the glass, avoiding air bubbles. Should bubbles form, slide the wet print nearly off the glass and then back again over the edge, or roll the print with a rubber squeegee. If the original gelatine of the print is soft, no additional gelatine mountant may be necessary. The edges of the print should be flush with those of the glass, but when there is a gilt border, the print may be a trifle smaller. If desired, an ungilt, plain, bevelled glass may be used, the print being of such size as to leave a margin of clear glass all round; a backing of white or coloured paper can then be applied.

OPALS, OR OPALOTYPES (Fr., *Opales ;* Ger., *Opals*)

Photographs may be transferred to opal glass by the carbon process, or the opals sensitised (or bought ready prepared) and printed upon direct, exactly as when using bromide paper. To ensure a perfectly clean and even

border, use a printing frame a size larger than the opal, and prepare a suitable mask having a clean-cut opening. Place a piece of cleaned glass in the frame and upon it the negative. Then, in a good light, place the mask in a suitable position on the film side of the negative, being careful not to move it when it is once in position. By the light of the ruby lamp, place the sensitive opal over the mask in such a way that the image, as seen through the mask, is in the centre, and that the margin of the opal, covered by the mask, is even. Put on the back of the frame, expose, develop, and finish.

For vignetted opals, use artificial light, and place an ordinary vignetter about ¼ in. in front of the frame ; then expose to a weak light, such as that of a match or a candle, moving the light so as to soften the vignetting effect. To assist in securing clean margins, use fresh developer ; but if stains or markings appear, clean them off with the iodine-cyanide reducer. After fixing and drying, coat with crystal varnish.

OPAQUE, OR OPAQUE PIGMENT

A blocking-out material for use on negatives, and consisting of any mixture sufficiently opaque to prevent the light acting through the covered parts of the negative. Brunswick black and red water-colour paint, such as Indian red, are largely used, the latter when working on the film side of the negative, because of the ease with which it may be washed off with water. For the glass side, use Brunswick black, or the following :—

Turpentine	.	.	2½ oz.	250 ccs.
Asphaltum	.	.	¼ ,,	28 g.
Beeswax	.	.	40 grs.	9 ,,
Carbon black	.	.	20 ,,	4·5 ,,

Mix well and apply with a brush.

OPEN APERTURE (*See* "Aperture.")

OPEN LANDSCAPE

A view in which there is no near foreground; for example, that seen from an elevated spot.

OPERA-GLASS CAMERA (Fr., *Chambre lorgnette ;* Ger., *Opernglas-kamera*)

A camera resembling an opera- or field-glass, and so designed that it may be worked while

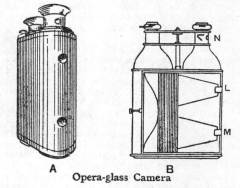

A B
Opera-glass Camera

held close to the eye. A illustrates a modern pattern of stereoscopic binocular, which permits

the pictures to be taken at a right angle to the direction in which the glass is ostensibly pointed. The two concealed lenses of the camera are at L and M, while one eyeglass, N, acts as a finder by means of a mirror inclined at an angle of 45°, as shown at B, a sectional view of the apparatus. The camera takes a dozen plates in a magazine.

OPHTHALCHROMAT LENS

A biconvex fluid lens patented in 1905 in Germany. It worked at $f/9$.

OPTICAL AXIS

A straight line joining the centres of curvature of a spherical lens is called the principal optical axis. In the case of a lens having one plane surface, the principal axis passes through the centre of curvature of the spherical face and is perpendicular to the plane face. It is, of course, highly necessary in combining glasses to form a photographic lens that the principal optical axes should be absolutely coincident.

A straight line passing through the optical centre of a lens, and making with the principal axis a more or less large angle, is called the " secondary axis."

OPTICAL CENTRE

The point at which rays passing through a lens cross each other. It is only in the case of a symmetrical lens that the mechanical and optical centres coincide. According to the form of the lens and the position in which it is placed, the optical centre may be within the lens, or considerably before or behind it. It is often stated that the focal length of a lens should be measured from its optical centre, but this is not correct; the point measured from should be the node of emission.

OPTICAL CONTACT

The condition existing when the surfaces of two pieces of glass, or those of a piece of glass and another substance, are in such intimate contact that all air is excluded. Under these conditions the surface of the glass that is in optical contact with the other substance, or the two glass surfaces that are in contact, cease to reflect light. But light is reflected by an opaque substance in optical contact with glass. Backing on a dry plate must be in optical contact if it is to be efficient; hence a piece of black velvet or paper at the back of a plate, sometimes advocated as a substitute for backing, is of small efficiency. The various glasses which form the combinations of a lens are cemented together in optical contact by means of Canada balsam. Prints are sometimes mounted in optical contact with glass, producing a very brilliant result. Prints on albumenised paper and on collodion emulsion paper, do not require preparation; but those on gelatine printing-out or on bromide or gaslight papers should be hardened in a bath of formaline 1 part and water 10 parts. The glass that is to receive the print must be thoroughly clean and, after slightly warming, should have a solution of gelatine (about 15 grs. per 1 oz. of water) poured upon it. A print is laid face down on the gelatine, and squeegeed into contact so as to expel most of the gelatine and all the air.

OPTICAL GLASS (See " Glass.")

OPTICAL INTENSIFICATION

A process for obtaining an intensified negative without the employment of chemical intensification. The details of a thin negative may be more plainly seen if the negative is laid film side downwards upon white paper, the light being reflected through the negative and giving the same effect as if two identical negatives were superimposed and held up to the light. A thin negative so backed is copied in the camera and the resultant positive is, in turn, copied (backed up with white paper as before), or a negative is made from the positive by direct contact. Lord Rayleigh, in 1897, recommended backing up a thin negative with mercury, or with a flat, polished reflector, and illuminating in a special way, but the process first named above gives as good results.

OPTICAL LANTERN

An appliance, popularly known as the " magic lantern," by means of which transparencies are optically projected by artificial light upon a screen, the diameter of the image being thereby increased by from 24 to 150 times. The enlarging lantern (*which see*) is an optical lantern, but the increase in the size of the image rarely exceeds from 20 to 30 times, and is generally much less. An optical lantern comprises a body, an illuminant, an optical system, and means for holding the transparency (slide) in the path of the light. The body may be of wood or metal, the former (generally mahogany) being the stronger, and the latter being the lighter, and therefore having advantages from the point of view of portability. A typical high-class lantern having a wooden body is here illustrated. There should be a door on one or both sides, and a close-fitting cowl or crinkle as light-tight as possible. When an oil-lamp is the source of light, the chimney projects at the top. The

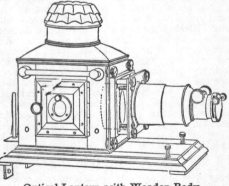

Optical Lantern with Wooden Body

illuminant (*see* the next article) is supported by the body in line with the optical axis of the lenses, and the lamp or jet is mounted on a metal plate or in a metal tray, which slides in grooves formed in the lantern body, it being necessary to provide for adjusting the distance between the condenser and the illuminant. The condenser, consisting in its commonest

form of two plano-convex lenses mounted in a brass cell with the convex surfaces facing each other (*see* "Condenser"), collects the light rays and causes them to illuminate the transparency evenly; thence the rays pass to the objective lens, which projects them upon the screen. (For a diagram explaining the optical principle involved, *see* "Condenser.") The objective is a lens of the Petzval portrait type (*see* "Lens"), but it is not wise to use it for photography, as its visual focus may not coincide with the actinic focus. The draw-tubes in the front of the lantern, and the rack and pinion on the jacket of the objective tube, allow of proper focusing. Frequently, in front of the lens mount is a "flasher," consisting of a hinged or pivoted disc serving as a lens cap. The transparency, carried in a wooden slide carrier having a to-and-fro movement, is inserted into the stage of the lantern immediately in front of the condenser, the carrier being held in place by a spring plate.

To shield the audience from stray light rays, it is usual to fit a heavy curtain to the back of the lantern.

A "single" lantern has but one illuminant and optical system; a "biunial" has two, one above the other; and a "triunial" (now but rarely used) has three. When oil is the illuminant it is necessary to have the systems (actually separate lanterns) side by side. Biunial and triunial lanterns were much used in earlier days for the production of the then popular dissolving views (*which see*).

The screen may be a white sheet, or a plastered wall painted "flat" or "dead" white. Collapsible frames for sheet screens are commercial articles. When the lantern is behind the screen and the audience in front, the screen should be wetted to make it more translucent, and the slides should be inserted into the carrier with the fronts facing the screen. Ordinarily, when both lantern and audience are in front of the screen, the slides are inserted with their fronts facing the operator, who stands to one side of and slightly to the back of the lantern stage. Always, the slides are inserted upside down, but unless they have been carefully "spotted" beforehand (*see* "Lantern Slides, Masking, Binding, and Spotting"), some of them are sure to be shown upside down on the screen. The lanternist should accept unspotted slides only at the lecturer's risk.

In connection with the calculation of the size of the disc on the screen, of the distance of the lantern from screen, or of the focal length of the lens to be employed, it should be said that the use of a set of interchangeable objectives renders the lanternist largely superior to the difficulties frequently caused by particularly small or large halls, and by the inconvenient placing of pillars, lights, etc., in the building.

The size of the disc of light projected by a lantern upon a screen depends upon the focal length of the lens and the distance between lantern and screen. Assuming the diameter of the slide to be 3 in., the size of the disc under certain conditions is found by multiplying 3 by the distance (in feet) between lantern and screen and dividing by the focal length of the lens in inches. Thus, at a distance of 40 ft., a 7-in. lens gives a picture more than 17 ft. in diameter, as $\frac{3 \times 40}{7} = 17\frac{1}{7}$. To determine the focal length of lens necessary under certain conditions, multiply 3 by the distance and divide by the diameter of the desired disc. Thus, at a distance of 24 ft., and to produce an 8-ft. disc, a lens of 9-in. focal length would be necessary, as $\frac{3 \times 24}{8} = 9$. To determine the distance at which a given lens will produce a given disc, multiply the focal length by the diameter of the disc and divide by 3. Thus, a 9-in. lens would produce a 10-ft. disc at a distance of 30 ft., as $\frac{9 \times 10}{3} = 30$. A simple calculation on the lines of the above saves the lanternist the trouble of trying different lenses or of shifting his apparatus.

The "opaque" lantern—that is, a lantern for projecting images of opaque objects—is described under the heading "Aphengescope."

OPTICAL LANTERN ILLUMINANTS

Given in the order of their efficiency, optical lantern illuminants include the oil-lamp, incandescent gas, acetylene, limelight, and the arc lamp. Metallic filament electric incandescent lamps are also used occasionally, but these share with the oil-lamp and incandescent mantle the disadvantage of the light being emitted by relatively large surface instead of coming from a point, or, at most, a spot. The oil-lamp is becoming more and more a thing of the past. It has two, three or four wicks, and much of the light emitted by it is wasted; in addition, if not kept scrupulously clean it is smelly, many patterns are liable to smoke, and the heights of wick and chimney are matters for careful adjustment. The incandescent gas mantle is much more cleanly in use, but the illumination is not much increased, and the mantle, after one use, is very fragile. Acetylene (*which see*) gives a much more intense light than either oil or incandescent gas, but it needs a generator, to the employment of which many people have objections, but which, if of reliable make and properly used, is a perfectly safe device; the use of compressed (actually dissolved) acetylene, obtainable in cylinders, opens up possibilities where the light itself is preferred, but the generator objected to. Limelight (*which see*) was, until quite recent years, the most popular and the most generally convenient illuminant, but in all places where electric current is available it must now give place to the arc lamp (*which see*). Lantern arc lamps are generally of the hand-feed type, it being necessary to adjust the distance apart of the two carbons as they burn away, as otherwise the unequal consumption would cause the arc to shift its focus and the illumination of the image to suffer. For low powers, the Nernst electric lamp has proved useful.

OPTICAL SENSITISERS

Dyes which have the property of modifying colour sensitiveness. Treatment of a sensitive photographic film with certain dyes in solution has the effect of increasing its sensitiveness

to different regions of the spectrum; thus eosine or erythrosine will make an "ordinary" plate sensitive to yellow, as in the original isochromatic plate of Tailfer and Clayton, while cyanine increases the sensitiveness to red. The dyes may be added to the emulsion before coating the plate, or a finished plate may be bathed in the solution. The latter procedure is generally adopted in the case of panchromatic plates. (*See also* "Colour Sensitising," "Isochromatic Plates," etc.)

OPTICS (*See* "Lens" and various other headings.)

ORANGE BICHROMATE

A synonym for potassium bichromate.

ORANGE LIGHT

Orange light for dark-room illumination was in general use before the introduction of dry plates, for which, however, it was found not to be sufficiently safe, and ruby light was substituted. Orange or yellow light (light filtered through orange- or canary-coloured fabric or glass) may safely be used for most of the modern bromide papers and lantern plates and also for very slow plates. (*See also* "Canary and Orange Medium.")

ORDOVERAX

A proprietary name for a process of reproducing line drawings; the process is allied to ink printing (*which see*). A clean, flat zinc plate is coated with a colloid of special composition; an exposed but undeveloped blue-print (made from the drawing) is then laid downwards on the plate for a moment and removed. The parts that were in contact with the unexposed lines of the blue-print will now take ink from a roller, while the ground repels the ink. The plate is inked, and paper, cloth, etc., is pressed into contact to produce an excellent reproduction of the original drawing.

ORGANIC COLOURS

A term applied generally to aniline colours to differentiate them from colours obtained from inorganic or metallic sources.

ORGANIFIER

A preservative applied to the sensitive surface. The word is used more frequently than preservative. The organifiers or preservatives recommended in the early days of the collodion process (about 1864) were solutions or infusions of tannin, gum, tea, coffee, beer, tobacco, and albumen, and also sherry wine. (*See also* "Ceramic Process.")

OROHELIOGRAPH (Fr., *Orohéliographe*; Ger., *Oroheliograph*)

A panoramic camera designed by Noe for taking photographs of the whole visible horizon. The lens points upward to the sky, the plate being beneath it in a horizontal position. Above the lens is adjusted a convex paraboloid mirror —that is, a mirror of circular cross-section and parabolic vertical section. This mirror reflects a view of all surrounding objects downward to the lens, which forms a circular image on the plate.

The arrangement much resembles that adopted in some forms of periscopes for submarines. Such views, though distorted, are useful for checking surveying and photogrammetric observations.

ORTHOBORIC ACID (*See* "Boric Acid.")

ORTHOCHROM T (Fr. and Ger., *Orthochrom T*)

Synonym, *p*-toluchinaldin-*p*-toluchinolinethylcyanine-bromide. Soluble in water and alcohol. One of the isocyanine dyes introduced by the Hoechst Dye Works as a sensitiser. It is most satisfactory, giving with reasonable exposures a closed band from the blue to the D lines; that is, it sensitises for blue-green, green and yellow, with a much less marked drop in the blue-green than erythrosine, but with practically no red sensitiveness. The best results are obtained by bathing the plates in—

Orthochrom T solu-
tion (1 : 1,000) . 192 mins. 20 ccs
Distilled water to . 20 oz. 1,000 ,,

for three to four minutes, and then rinsing and drying. These operations must be conducted in the dark or in a very faint red light. By replacing one-third of the above quantity of water with alcohol, clean-working and quicker-drying plates which do not require rinsing are obtained.

ORTHOCHROMATIC (*See* "Isochromatic.")

ORTHOCHROMATISM

The quality possessed by plates that are sensitive to parts of the spectrum besides the violet and blue. Practically synonymous with isochromatism, and fully treated under the headings "Colour Sensitising," "Isochromatic Plates," etc.

ORTHODIHYDROXYBENZENE

A synonym for pyrocatechin.

ORTHOGRAPH AND ORTHOGRAPHIC LENSES

Names given at one time to lenses of the rapid rectilinear (doublet) type. (*See* "Lens.")

ORTHOHYDROXYBENZOIC ACID

A synonym for salicylic acid.

ORTHOMETHYLAMIDOPHENOL

One of the constituents of ortol.

ORTHOSCOPIC LENS

A rapid rectilinear doublet lens. (*See* "Lens.")

ORTHOSTIGMAT LENS

A series of cemented anastigmats introduced by Steinheil, of Munich, and manufactured in England by Beck. They were made with initial intensities of $f/6 \cdot 3$ and $f/6 \cdot 8$, and were convertible, the single lens having an aperture of $f/12 \cdot 5$; in addition there was a rapid wide-angle lens (nearly $110°$) with an intensity of $f/11 \cdot 3$.

ORTOL (Fr. and Ger., *Ortol*)

Hauff's developer, containing orthomethylamidophenol, C_6H_4 OH NHCH$_3$, and hydroquinone

introduced from Germany in 1897; in character, intermediate between metol and pyro-soda. It is a yellowish-white crystalline powder, very soluble in water, with which it forms a colourless solution which gives a blackish image. It will not work alone; combined with sodium sulphite it works very slowly, some hours being required to produce an image; but in conjunction with sodium or potassium carbonate it forms a steady working developer, with a factor of 10. It is suitable for all dry plates, lantern plates, and bromide and gaslight papers. When properly used, it does not stain the negative, but when ammonia or acetone is used, or sulphite is added to the ortol solution, a reddish stain sometimes appears. The use of metabisulphite and of a carbonate, however, tends to prevent staining, but should it appear it may often be removed with methylated spirit.

Ortol may be used in a one- or, preferably, two-solution form :—

One-solution

Ortol . . .	80 grs.	9 g.
Potass. metabisulphite	20 ,,	2·25 ,,
Sodium sulphite .	2 oz.	110 ,,
Potassium carbonate .	640 grs.	73 ,,
Potassium bromide .	4 ,,	·5 ,,
Water . . .	20 oz.	1,000 ccs.

This is best made up as required, the ortol and metabisulphite being dissolved in one half of the water, the remainder of the chemicals in the other half, and the two solutions mixed together.

Two-solution

A. Ortol . .	140 grs.	16 g.
Potassium meta-bisulphite .	70 ,,	8 ,,
Cold water .	20 oz.	1,000 ccs.
B. Sodium carbonate	2½ oz.	138 g.
Sodium sulphite .	2½ ,,	138 ,,
Water . .	20 ,,	1,000 ccs.

or—

B. Potass. carbonate	1 oz.	55 g.
Sodium sulphite .	2½ ,,	138 ,,
Water . .	20 ,,	1,000 ccs.

Use equal parts of A and B.

If a restrainer is needed, add a few drops of a 10 per cent. solution of potassium bromide, or embody the bromide in the developer when making it by adding to either of the B solutions from 8 to 16 grs. per 20 oz. (1 to 2 g. per 1,000 ccs.). A weak solution of " hypo " has been recommended as a restrainer, but it needs to be used with great caution. A 10 per cent. solution of a caustic alkali may be used as an accelerator in cases of under-exposure. By increasing the proportion of A, harder negatives will be produced; and the converse also holds good. A lower temperature than 66° F. (19° C.) will retard development, and during very cold weather the potassium bromide may with advantage be omitted. The high lights of the image appear normally in from 20 to 30 seconds, and then the half-tones and shadows, the density being added at the same time; development is usually complete in from four to five minutes.

OUNCE

In apothecaries' weight (by which formulæ are made up), 480 grains, or one-twelfth of a pound; 31·106 grammes. In avoirdupois weight (by which chemicals are bought and sold), 437½ grains or one-sixteenth of a pound; 28·4 grammes. In fluid measure, 480 minims, or one-twelfth of a pound; 28·4 cubic centimetres. (See also " Weights and Measures.")

OVALBUMEN

A synonym for egg albumen.

OVALS, MARKING AND CUTTING

The so-called oval seen in photographic cut-out mounts is strictly an ellipse, an oval being really egg-shaped. The easiest way of marking an ellipse is by means of two pins and a piece of string, as shown in the illustration. The pins, C and D, are stuck tightly in the cardboard to be marked, and a pencil, E, is placed in the

Marking an Oval

loop and moved round, keeping the string taut. This is done first on one side and then on the other, thus tracing an ellipse. If an endless piece of string is used, the ellipse can be drawn without withdrawing the pencil from the loop. The length (major axis) of the ellipse is always equal to that of the greatest stretch of the string, while the width (minor axis) depends on the distance apart of the pins and may be regulated by a few trials. It is preferable to mark the ellipse on a sheet of thin metal, using this as a template and keeping it for future use. For cutting the mount a mount-cutter's knife is employed, but a keen penknife may be used.

A machine has been constructed for the use of process workers for cutting and marking ovals. Any dimension may be obtained by shifting the bed out of the centre, and also by shifting the tool along the bar. The former movement registers the difference between the major and minor axes of any determined oval, whilst the latter movement sets the tool to the major axis.

OVEN, DRYING (See " Drying Box or Cupboard.")

OXALATE DEVELOPER

Better known as the ferrous oxalate developer (which see).

OXALIC ACID (Fr., Acide oxalique; Ger., Oxalsäure)

$C_2H_2O_4 \cdot 2H_2O$. Occurs in colourless and odourless prisms with strong acid and bitter taste. Solubility, 12 per cent. in cold and 100 per cent. in hot water; insoluble in alcohol.

It is used in the sensitising of platinotype paper, and as a preservative for the pyro developer, from 2 to 3 per cent. being used. It is very poisonous, the antidotes being chalk or magnesia mixed with milk or water.

OX-GALL

The purified and evaporated gall of the ox ; used when tinting prints with water colours in order to overcome the greasy or repellent surface of the print. The gall is purchased either in a solid form, or as an evil-smelling sticky mass. A small quantity of it is dissolved in warm water, and when cold brushed over the print and dried. It was used largely in the days of albumen prints, for which it is particularly suitable.

In process work, ox-gall is used for preparing the surface of glossy prints for taking the retouching colours, or for admixture with the colours. It is also sometimes used in blocking-out negatives for preventing the colour from running. It is used in collotype work for preparing the plate.

OXYCALCIUM LIGHT

An early name for the limelight.

OXYCHLORIDE OR OXYHALOID THEORY

The theory that the latent image consists of the oxychloride, oxybromide, or oxyiodide of silver. The objection to this theory is mentioned in the article under the heading "Latent Image."

OXYETHER LIGHT

A system of limelight in which oxygen, saturated with ether, is burnt in a jet to provide the heat for raising the lime to incandescence.

OXYGEN GAS FOR LIMELIGHT (*See* "Compressed Gas" and "Limelight.")

OXYHYDROGEN LIGHT (*See* "Limelight.")

OXYMAGNESIUM LIGHT

A system resembling limelight, but employing magnesium instead of lime. (*See also* "Magnesium Beads.")

OXYMEL (Fr. and Ger., *Oxymel*)

A mixture of honey and dilute acetic acid, used in the old collodion dry-plate days as a preservative.

OXYPHENYLGLYCINE

A synonym for glycine.

OYSTER SHELL MARKINGS

A defect met with in the wet-plate process, and caused by unequal drying.

OZOBROME

A method of producing carbon pictures from bromide prints, patented by Thomas Manly, in 1905. Its advantage is that it makes the worker independent of daylight. Bromide enlargements can be made for producing carbon pictures, thus saving the trouble and expense of making enlarged negatives. Whether the carbon image is produced upon the bromide print or whether the pigment image is transferred to another support, the resulting picture is correct with regard to right and left. An ozobrome pigment plaster (paper coated with pigmented gelatine) is soaked in a bath of diluted ozobrome pigmenting solution, transferred to an acid bath for a few seconds, squeegeed to a wet bromide print and left for about twenty minutes for the insolubilising action to take place. The method of working is as follows : Place the bromide print in a dish of water, immerse the pigment plaster in the diluted ozobrome pigmenting solution until soft and limp (about one or two minutes), and then withdraw the plaster and immerse it for ten to fifteen seconds in a bath of—

Chrome alum (pure) .	36 grs.	16·5 g.
Bisulphate of potass. (cryst.) . .	12 ,,	5·5 ,,
Citric acid . .	5 ,,	2·3 ,,
Water . . .	5 oz.	1,000 ccs.

An immersion of, say, 20 seconds will produce a soft, delicate picture from a strong bromide print, and an immersion of, say, 7 to 10 seconds will give a strong, deeply-coloured picture from a weak and grey bromide print. For a good, well gradated bromide print, an immersion of from 12 to 15 seconds would be sufficient. After removal from the acid bath, the soaked pigment plaster is brought into contact with the bromide print lying in the dish of water. The two papers (clinging together) are quickly withdrawn, squeegeed together, and allowed to remain in contact for 15 to 20 seconds. One of two methods may then be selected to produce pigmented pictures. In the non-transfer method, the bromide print itself forms the support of the gelatine image. The adhering papers are plunged into water at about 160° F. (41° C.), the plaster backing is removed, and the development carried out as in the ordinary carbon process. In the transfer process the plaster and bromide print are separated in cold water, the pigment plaster carrying an impression of the image. The plaster is squeegeed to a soaked piece of transfer paper and left for 10 to 15 minutes, when the development is carried out in hot water in the usual way. The second method is preferable to the first one, as it yields a pure carbon picture with a choice of paper support, and leaves the bromide print, after redevelopment, available for further transfers.

OZOBROME, OIL

Oil ozobrome is a modification of bromoil. A bromide print is treated in such a manner that the altered image will retain greasy ink while the unchanged portions will repel it. A bromide print is bleached in the following bath :—

Ozobrome pigmenting solution . . .	1 oz.	30 ccs
Chrome alum acid bath	5 ,,	150 ,,
Sodium chloride (salt)	½ ,,	17 g.
Water . . .	4 ,,	120 ccs.

The bleached print is rinsed for a few seconds and transferred to a fixing bath of "hypo"

3 oz., and water 20 oz., where it should remain for five to six minutes. After washing for five minutes, the print may be inked up, but it is better to allow it to dry and then resoak for five to ten minutes in water at 65° to 70° F. (about 18 to 21° C.).

Oil Transfer Process.—In this process the resulting image will be reversed in regard to right and left; therefore, in enlarging, the negative should be reversed in the lantern. A sheet of ozobrome transfer paper is immersed in the bleaching bath specified above, whilst the bromide print is soaking in water. The transfer paper, saturated with the bleaching solution, is placed face upwards on a sheet of glass, and the wet bromide print carefully laid down upon it and squeegeed into contact. The bleaching takes from 10 to 45 minutes to complete, the progress of the action being easily observable by holding the adhering papers in front of a strong light. When bleached, the papers are separated and washed for about ten minutes until all yellow coloration has disappeared. The transfer paper, carrying a copy of the image, should be hung up to dry and the bromide print redeveloped. When dry the impressed transfer paper is soaked for 20 to 30 seconds in cold water, and after removing the superfluous water it is ready to ink up. The bromide print is available for further transfers.

OZONE BLEACH

A synomym for "Labarraque's solution" and "eau de Javelle."

OZOTYPE

A pigmented gelatine process, patented by Thomas Manly in 1899, differing from the usual carbon method. Sized paper is coated with a solution containing a bichromate and a manganous salt. This preparation is sensitive to light, and under a negative produces a positive image in manganese chromate. A pigment plaster (paper coated with pigmented gelatine) is soaked in an acidulated solution of a reducing agent, such as hydroquinone or ferrous sulphate, and applied to the washed image. The action of the acid produces chromic acid which is immediately reduced by the hydroquinone or ferrous sulphate, with the result that the gelatine is tanned. In practice, the ozotype process is carried out by coating well-sized drawing paper with the ozotype sensitising solution, thoroughly drying, and printing under a negative in daylight. The image is of a light brown colour and distinctly visible. When all details appear the image is carefully washed for a limited time,

as it is slightly soluble. A piece of pigment plaster is then soaked for 30 to 60 seconds in the following bath :—

Glacial acetic acid	.	50 mins.	4 ccs.
Hydroquinone	.	12 grs.	1 g.
Copper sulphate	.	12 ,,	1 ,,
Water .	.	25 oz.	1,000 ccs.

As soon as the pigment plaster is quite limp the chromium print is expeditiously brought into contact with it in the bath, and both papers, clinging together, are withdrawn and squeegeed gently together. The adhering papers are left for 30 to 60 minutes for the action to take place, when they will be ready for development, which is carried out by separating the papers in water at about 110° F. (about 43° C.), and dissolving away all soluble gelatine. The advantages are (1) a visible image; (2) no reversal of the image; (3) almost unlimited control with the brush.

OZOTYPE PROCESS, GUM

The application of the ozotype principle to the production of images in pigmented gum was easily foreseen after the introduction of gelatine ozotype. The paper is prepared and the image obtained as in ordinary ozotype, but a rather stronger printing is required. A pigmented gum mixture is made up as follows :—

Water	2 parts	
Gum arabic	. . .	1 part	
Powdered colour	. . .	q.s.	

Also make up the following acid reducing bath :—

Sulphuric acid	.	½ drm.	10 ccs.
Copper sulphate	.	180 grs.	72 g.
Hydroquinone	.	60 ,,	24 ,,
Water .	.	6 oz.	1,000 ccs.

The gum and pigment are worked and ground together with a palette knife on a sheet of glass, and about the same quantity of the acid reducing solution added. The mixture is pounded in a glass mortar, evenly spread over the image with a flat hog-hair brush, and finished off by means of a badger-hair softener. The coated paper is then allowed to dry slowly in a cupboard, in which a wet cloth is hanging with the object of keeping the atmosphere moist. When dry, the image is developed in cold or tepid water. The advantages of the process are : (1) A visible image; (2) the tanning action proceeds from the image upwards through the film of gum, resulting in the preservation of all detail; (3) the operation can be carried out in full daylight.

P

PACKHAM'S CATECHU STAINING (*See* "Catechu Toning.")

PACKING NEGATIVES FOR POST

The following is considered one of the safest ways of packing negatives to be sent by post. Put the bottom one film up and on it a sheet of clean white paper, then the next negative film side downwards, then another sheet of paper, and so on, all the negatives, except the bottom one, being film side down. Wrap the whole tightly in brown paper, and force into a plate box in such a way that the negatives cannot rub together. Tie tightly and wrap the box in a strip of corrugated paper, cut to the length of the box, and then in another strip cut to its width. In this way the corrugated folds are at right angles, and prevent twisting and breakage. Finally, wrap in brown paper and tie firmly. It is advisable to use a tie-on label.

PACKING PLATES

The question of packing—or, rather, re-packing —plates after exposure is of importance to the tourist. He should remember not to throw away the outer wrapper and the inner packings, as these will come in useful. The best way to remove the outer wrapper from a box is to cut across the centre all round with knife or pocket scissors, so that each half may then be slid off, as shown. When required, the two halves may

Plate Box Cut Open

be replaced and bound together with strips of gummed paper, thus making it practically impossible to open the box accidentally. Exposed plates should be placed film to film, and the pairs—usually six—wrapped in a solid block in brown or other opaque paper and pressed into the original box, using paper pads at the ends and sides of the box to prevent the plates rubbing together and shaking about loose in the box; the lid is then replaced, then the outer wrapper, and the whole tied with string or bound with gummed paper. It is a common practice to put pieces of paper between the film sides of the plates, but newspaper or other printed matter must not be used, because the printer's ink has an action upon the sensitive film and becomes transferred to the picture, invariably showing badly when the plate is developed. If the printer's ink is seen upon the plates before development, it may sometimes

be removed—in the dark-room, of course—by rubbing with benzene upon cotton-wool. Even when white paper is used between the plates there is a risk of fogged patches appearing, and cigarette papers have been known to fog plates very badly. It has been suggested that white paper possesses luminiferous or phosphorescent properties—extremely faint, of course, but sufficient, over a period of several weeks, to cause fogging. In spite of this, however, white paper is commonly employed.

Other errors in packing are due to ignorance of the fact that pressure will exert an influence upon the sensitive emulsion. An envelope containing an exposed plate is often written upon, and if the writing is done upon the side resting upon the film a reproduction will more often than not be found upon the negative. Should it be necessary to mark exposed dry plates, the writing should be done in very small characters on one of the extreme corners of the film side.

PAINTINGS, PHOTOGRAPHING

The general principles to be observed in photographing paintings are given under the heading "Copying," but the arrangement for holding the original and the camera so that the picture and the sensitive plate are parallel cannot often be employed. Carefully ruled pencil lines on the focusing screen, forming perfectly true rectangles, will assist in avoiding inaccuracy. Glass should always be removed from glazed paintings, if possible, it being so difficult to kill reflections entirely. When the glass may not be removed, a black screen should be hung immediately behind the camera, and the last-mentioned should be covered with a black cloth; or the screen should be hung close in front of the camera, with a small aperture through which the lens may project. Folds or undulations in the surfaces of screen and cloth should be avoided, so that the picture reflects only a uniformly dark mass. A lens of long focal length is preferable, it being then easier to avoid the sheen on an oil painting interfering with the rendering. In the case of water-colour drawings, the chief consideration is that the lens should cover the plate with crisp definition, and the proportion of focus to plate is immaterial.

After the image has been focused, the lens and focusing screen should be removed and the picture examined through the lens opening from the back of the camera. In the case of an oil painting without glass this examination determines whether sheen on the surface is visible; in the case of a picture under glass, it shows whether reflections are destroying the image. Sheen or reflections at the top of a picture can frequently be avoided by raising the camera; those at either side can be obviated at times by means of a screen.

Isochromatic plates should be used for this work, together with a yellow screen or light filter. A green screen is an advantage with some subjects. (*See also* " Monochrome, Rendering Colours in.") The screen should be used behind the lens when possible, and the final focusing should be done with the screen in position.

The exposure must be gauged by the aid of a meter held with its back flat against the picture. For an oil painting in good, bright condition, using a plate of the speed of 200 H. and D., and a lens aperature of $f/16$, the exposure should be half the time necessary for matching the meter tint in the case of a Wynne meter, or one-fourth the meter tint in the case of a Watkins meter. For an old or very dark picture, from twice to three times this exposure will be necessary. For a water-colour drawing the exposures will be shorter. For a very dark or solidly painted picture the exposure will be about one-third the meter tint of a Wynne meter, and one-sixth that of a Watkins, using the same plate and lens aperture as given above. For a light and delicate sketchy drawing these exposures may be reduced to one-eighth of the Wynne meter tint, and one-sixteenth of the Watkins. All the above exposures are those necessary without a colour screen or light filter ; and they must be multiplied by the number of times extra exposure that the screen necessitates. They are all given for copying the same size as the original, the lens aperture being that marked $f/16$ on the diaphragm scale, and not calculated from the extra extension. Proportionate exposures for other scales will be found under the heading " Copying."

PALLADIOTYPE (Fr., *Palladiotype;* Ger., *Palladiotypie*)

A printing process resembling platinotype, but employing palladium instead of platinum ; originated by Alleyne Reynolds.

PALLADIOUS CHLORIDE (Fr., *Chlorure de palladium ;* Ger., *Palladiumchlorid*)

Synonyms, palladium chloride, dichloride of palladium. $PdCl_2$. Molecular weight, 177·5. A dark brown mass or powder, very deliquescent, obtained by the action of aqua regia on palladium. Occasionally used for toning prints.

PALLADIOUS POTASSIUM CHLORIDE (Fr., *Chlorure de palladium et de potasse ;* Ger., *Kaliumpalladiumchlorid*)

Synonyms, chloropalladinite of potash, palladium and potassium chloride. $PdCl_2 2KCl$. Molecular weight, 326·5. Solubilities, soluble in water, slightly soluble in alcohol. Prismatic crystals obtained by adding potassium chloride to a hot solution of palladious chloride. They are dichroic—that is, they appear red or green as seen across or along the axis. Occasionally used for toning prints.

PALLADIUM (Fr. and Ger., *Palladium*)

Pd. Atomic weight, 106·5. A silvery white, hard, but ductile metal, obtained from its ores. Used to prepare the chlorides which enter into a few toning formulæ.

PALLADIUM TONING (Fr., *Virage à palladium ;* Ger., *Schönen mit Palladium*)

Palladium toning is expensive and has no advantages over gold and platinum toning. It gives tones of various shades of brown. The print is reduced slightly, and loses a little colour in the fixing bath ; allowances must therefore be made. For ordinary P.O.P. the bath is :—

Palladious chloride .	2 grs.	·45 g.
Sodium chloride .	20 ,,	4·5 ,,
Citric acid .	20 ,,	4·5 ,,
Water . .	10 oz.	1,000 ccs.

The sodium chloride (salt) may be omitted from the bath if desired, in which case the prints should be washed in a weak solution of salt in water before toning. The salt ensures the conversion of any free silver remaining in the paper, although it retards the toning action, and sometimes is apt to stop it entirely. It is also advisable to put the prints after toning in a bath of $\frac{1}{2}$ oz. of common soda in 20 oz. of water in order to neutralise the acid and prevent sulphur toning, afterwards fixing and washing in the usual way.

A toning bath for plain salted paper, giving tones similar to those of platinum, is :—

Palladious chloride .	1 gr.	·22 g.
Sodium sulphite .	60 grs.	13·5 ,,
Water . .	10 oz.	1,000 ccs.

Use as above.

For chocolate-brown tones on glossy papers Mercer advises :—

Palladious chloride .	1·6 grs.	·36 g.
Ammonium molybdate	16 ,,	3·6 ,,
Citric acid .	16 ,,	3·6 ,,
Water . .	10 oz.	1,000 ccs.

For matt papers, substitute common salt for the molybdate. The fixing bath must be distinctly alkaline.

PANAPLANATIC

A term applied to a lens exceptionally free from spherical aberration. A microscope condenser by Swift is sold under this designation.

PANCHROMATIC LENS

A lens corrected for the secondary as well as the primary spectrum, and therefore suitable for use in three-colour work. (*See also* " Apochromatic.")

PANCHROMATIC PLATES

Plates made sensitive to the entire spectrum, and used either for isochromatic photography with a suitable screen where a full colour rendering is required, or for colour photography by the three-colour process. They can be made by bathing slow ordinary plates with certain aniline dyes, particularly some of the isocyanine derivatives. Either of the two following baths is suitable for panchromatising :—

A. 1 : 1000 alcoholic solution of pinachrome . .	8 mins.	2 ccs.	
Ammonia (·880) .	4 ,,	1 ,,	
Distilled water .	400 ,,	100 ,,	

B. 1 : 1000 alcoholic
solution of homo-
col (Bayer) . 12 mins. 3 ccs.
Ammonia (·880) . 8 ,, 2 ,,
Distilled water . 480 ,, 120 ,,

Instructions for bathing will be found under the heading "Isochromatic Plates." Particular care must be exercised as to cleanliness, pure air for drying, and rapidity of drying in the case of red-sensitive plates, as they are liable to fog on the least provocation. A truly panchromatic plate should be evenly sensitive to the whole visible spectrum, but with practically all plates there are "gaps" in the sensitiveness—that is, comparatively less sensitiveness towards certain regions, particularly the bluish-green—due to minima of absorption in the dyes used. Both pinachrome and homocol plates exhibit two minima in their spectrum sensitiveness, which can be filled up to some extent by the use of supplementary dyes.

Colour filters for either three-colour work or isochromatic photography must possess minima in their absorption spectra to compensate for any minima in the spectrum sensitiveness of the plates to which they are adapted.

Development should always be carried out with a cool solution, and in darkness or in a green "safe" light.

In process work, panchromatic dry plates are largely used for the three-colour process, the exposures being made directly through the colour filter and the half-tone ruled screen.

PANEL

A commercial size of photographic mount which accommodates whole-plate prints trimmed to panel shape, and measuring about 8 in. by 4 in. Therefore, ordinarily, a panel mount may measure about 9 in. by 5 in., but it may be much larger, according to the margin allowed ; 13 in. by 7½ in. is a common size. "Large Panel" mounts measure about 17 in. by 10½ in. ; "Grand Panel," 23 in. by 13¾ in. ; and "Paris Panel," 10 in. by 7¼ in. There are also "midget panels," the term panel being somewhat loosely applied to any mount which is of panel shape.

PANEL LENS

A lens adapted for the production of panel-sized portraits. Any good portrait lens or anastigmat of about 20 in. focal length answers well for a 12-in. by 10-in. plate, if it covers it.

PANIKONOGRAPHY

Gillot's process of zinc etching. (*See* " Gillot-age.")

PANNOTYPY, OR PANNOTYPIE

A process of transferring a collodion negative film to a dark oilcloth, so that a positive effect is obtained.

PANORAM CAMERA (Fr., *Chambre Panoram ;* Ger., *Panoram Kamera*)

A camera invented by Colonel Stewart, R.E., by means of which a complete circle, or several circles in succession, could be photographed on a band of film. It rotated in one direction on its optical axis, while the film revolved in an opposite direction, the two movements being so synchronised that a stationary image was obtained.

Also the name given to a daylight-loading Kodak hand camera, with which long, narrow, panoramic pictures are obtainable. The lens swings round on its nodal point during the exposure, so that the image remains motionless and the celluloid film is bent to a curve.

PANORAMIC CAMERA (Fr., *Chambre panoramique ;* Ger., *Panorama-kamera*)

Cameras for obtaining panoramic views were made at quite an early date, perhaps the first being that constructed by Marten, of Paris, in 1845, for use with curved daguerreotype plates. Other important panoramic cameras are treated under separate headings. (*See* "Cyclograph," "Cylindrograph," "Oroheliograph," "Panoram Camera," "Pantascopic Camera," etc.)

PANORAMIC VIEWS (Fr., *Vues panoramiques ;* Ger., *Rundgemälde*)

Panoramic views are best obtained with a camera intended for that class of work, or with a very wide-angle lens, such as the pantoscope. They may also be made by revolving a stand camera on its tripod, and taking a series of photographs, each one continuing the subject at the point where the previous picture left off. Prints from the resulting negatives are trimmed carefully so as to join satisfactorily, and are then mounted to form a continuous picture. Panoramic views have been obtained by taking a series of negatives from slightly separated standpoints, keeping the camera in line, and joining the prints as before. This, however, is much more difficult than the previous method and only of limited utility.

PANTASCOPIC CAMERA (Fr., *Chambre pantascopique ;* Ger., *Pantaskopische-kamera*)

A panoramic camera, invented in 1862, by J. R. Johnson, arranged to rotate on a circular base by means of clockwork, and which photographed the entire horizon on a flat plate.

PANTOGRAPH

Besides the well-known drawing instrument for proportionally enlarging a photograph or sketch, the term designates an apparatus used by lithographers for enlarging or reducing transfers. A rubber sheet is stretched on a metal frame with mechanical arrangements for stretching the rubber from all four sides, either equally or unsymmetrically. Thus, after a print is transferred to the rubber it can be stretched to enlarge it or unstretched to reduce it, after which the altered image can be transferred to a stone or plate for printing from. Pantograph machines are also used by engravers for enlarging or reducing designs or lettering, and for copying relief objects (such as medals) on to a flat surface. These machines are on the principle of the drawing instrument, but are much more elaborately constructed.

PANTOSCOPE (Fr., *Pantoscope ;* Ger., *Pantoskop*)

A lens first made about 1865 by Emil Busch, of Rathenow, and still esteemed for its special purpose. It consists of two symmetrical achro-

matic combinations of deep curves, works at $f/22$, and gives the very wide angle of from 100° to 110°. It is extremely useful for work in confined situations, architectural subjects, panoramic views, etc.

The name pantoscope was also given to a viewing apparatus for photographs, much resembling the alethoscope, lanternoscope, and neomonoscope.

PAPER (Fr. and Ger., *Papier*)

The raw material of paper is linen, cotton-wool, hemp, flax, esparto grass and wood pulp; but for photographic purposes the absence of the last two substances is essential, save in such processes as carbon, where the paper only forms a temporary support for the tissue. The raw material is mechanically torn up, bleached, and then mixed into a pulp with water and the pulp spread on fine-meshed wire, so that the water can drain off and the paper pulp or felt be dried. All paper, except blotting and filter paper, is sized to prevent the undue absorption of water, and very frequently, in addition, filling is used to render the paper more opaque and give it a greater glaze, but at the same time lessening somewhat its strength. The filling may be either silicates, such as kaolin, the carbonates of lime, barium, zinc or lead, or sulphates, such as those of calcium and barium.

Paper contains as a rule about 5 to 10 per cent. of water, and is always more or less hygroscopic, and according to the sizing so it will absorb a greater or less amount of water. Photographic papers are almost always sized in the stuff or mass, but in some cases, especially with the so-called drawing or water-colour papers, the sizing is so poor that it is necessary to remove it by treatment with acid and subsequent washing, and then to re-size with a colloid-like gelatine, agar-agar, etc., in order to keep the photographic image on the surface.

Paper for photographic work must be free from wood pulp, which rapidly yellows on exposure to light, and spoils the emulsion coating or decomposes the free silver salts of printing-out papers. Equally important is the absence of metallic particles—iron, brass, copper, etc.—which might be introduced from the paper-making machine; such particles cause black spots in the case of papers containing free silver nitrate, and generally white insensitive spots in the case of development, though often in the latter case the little white spot will be seen to have a minute black centre, when examined microscopically. The quality of the water used in preparing the paper pulp is also of great importance, as this may introduce foreign matter which acts prejudicially on emulsions. Naturally, too, the absence of "antichlor" is all-important, as in every case this spoils the sensitive film and usually results in spots.

Many photographic papers are primarily coated with an emulsion of barium sulphate (*see* "Baryta Paper"), which prevents the sensitive film from penetrating the paper, and gives the prints a special surface. The preparation of this coating is as important as that of the paper, and it may also be the cause of peculiar markings and spots, but even this will not allow of a poor quality raw stock being used. One important point in connection with baryta paper is the homogeneity of the coating, for if the coating is not absolutely even in thickness or hardness, the sensitising material, especially in the case of printing-out papers, will penetrate more or less deeply into the same, and the results are that the prints show a peculiar and characteristic defect known as measles or mealiness.

In process work, the expansion and contraction of paper is of serious importance. For instance, in photo-lithography by paper transfers it affects the scale in such work as map reproduction, and makes the joining up of sections difficult. To overcome this it is usual to allow a definite amount for expansion whilst the paper is damped for transferring, the sheet being measured between two points by means of a trammel rule provided with needle-points. The paper is further damped if it does not reach the required measurement. In colour work the risk which paper undergoes often affects the registering of the colour, and has to be allowed for. As the expansion is greatest in the direction of the web, and is fairly uniform, it is a good plan to mark this direction and use it always the same way, when several pieces have to join or to register.

(For the preparation of the various kinds of papers, *see under* separate headings. The coating of paper is described under its own heading.)

PAPER NEGATIVES

Fox Talbot, in his calotype process, worked extensively between 1841 and 1856, made his negatives from paper coated with a sensitive silver salt, but this system became almost obsolete when Archer introduced his collodion process on glass. About 1885, however, paper as a medium for negatives again came to the front owing to the increasing popularity of bromide paper, which originally was intended solely for printing by development. In 1884 a specially rapid bromide paper was introduced for negative work, and the Eastman Company and other firms followed with improvements. At the present time celluloid films, roll or flat, have almost superseded paper as a support for the emulsion, but there are still a few photographers who use bromide paper for negative making. Compared with glass, paper is lighter, halation is impossible, it is not brittle, it can easily be stored, it is cheap, and it can be easily cut; but it is not transparent, and, consequently, the time taken in printing is rather long; the grain may be troublesome, and print at the same time as the image, although, if the printing is done on a matt or rough paper, it will be considerably minimised, and possibly caused wholly to disappear. Paper cannot be obtained with so high a rapidity as the fastest plates, and there is a slight difficulty in keeping it flat in the dark-slide and in developing and fixing it.

Generally, bromide paper can be used in exactly the same way as a dry plate, the thinnest, with a semi-matt surface, being the most suitable. Up to half-plate it may be kept flat in the dark-slide without difficulty, but beyond that size some little care is necessary, while it will be advisable to place a sheet of glass or cardboard at the back of the paper, and it may be necessary to coat the extreme edge of the glass or card

backing (or the division plate, if a backing is not used) with a mixture of gelatine and glycerine or similar adhesive. The exposure with an average paper is about three times as long as with an average dry plate; but it depends on the circumstances. Under-exposure must be particularly guarded against. The developers advocated by the paper-makers should be used, and not those specially for plate work; those most suitable are the clean-working developers, such as metol, hydroquinone, amidol, rodinal, etc. Pyro is unsuitable, as it tends to give the shadow (white paper) parts a yellowish tinge, thus prolonging the period of printing. When developing, remember to judge the density by looking through the paper and not upon it. The developed negative is fixed in an acid fixing bath in order to avoid stains, and make the negative as clear as possible. The paper negative is washed, dried, reduced, intensified, toned, etc., in the usual way. Printing is facilitated by waxing the paper to render it more translucent, but most makes of thin smooth bromide paper do not need this treatment.

Four methods are here given for increasing the translucency of paper negatives :—

(1) Rub on warm vaseline with a clean rag to the back of the negative, and apply a warm flat-iron, interposing a sheet of blotting-paper. Should any vaseline get on the film side, remove with benzine. (2) Use white wax and a warm iron as above. Any superfluous wax may be partly removed with turpentine. (3) Apply, as above, a mixture of alcohol 4 oz., and castor oil 1 oz. Ironing is not necessary in this or in the next method. (4) Apply, as above, a mixture of turpentine 5 oz., and Canada balsam 1 oz.

PAPER, VARIETIES OF (See under separate headings.)

PAPIER JOSEPH (Ger., *Seidenpapier*)

A term of French origin and designating a fine tissue paper of a silky character, similar to the best Japanese tissue paper. Used for polishing glass.

PAPIER MÂCHÉ (Ger., *Papiermaché*)

A term of French origin, and designating a material manufactured from paper pulp mixed with size and other substances, and then forced into a mould previously oiled. After drying, the articles are soaked with linseed oil and dried at a high temperature. Largely used for making dishes, trays, and studio accessories.

PAPIER MINÉRAL (See " Mineral Paper.")

PAPIER SEPIA (See " Sepia Paper.")

PAPIER VÉGÉTAL (Ger., *Papier zum Durchzeichnen*)

Tracing paper. A term of French origin, and designating a very transparent tracing transfer paper used in lithography.

PAPIER VELOURS

A pigmented paper used in the Artigue process (*which see*), and introduced in 1892 by V. Artigue, of Bordeaux. The pigment appears to be held to its paper support by means of gum, gelatine, etc.

PAPYROGRAPHY, OR PAPYROTYPE (Fr. and Ger., *Papyrographie*)

The name given to various methods of transferring impressions on paper, secured by photographic means from line negatives, to stone for photo-lithography. According to Sir W. Abney, any stout paper may be coated with a thin layer of gelatine and hardened in a chrome alum bath. It is then coated with :—

Potassium bichromate .	1 oz.	44 g.
Nelson's flake gelatine .	1½ ,,	66 ,,
Water . . .	25 ,,	1,000 ccs.

When dry, the paper is exposed under a line negative, and drawn through (not soaked in) cold water, being then squeegeed down on a zinc plate. The surplus water is blotted off and the paper inked over with lithographic chalk ink mixed with one-fourth its bulk of palm oil, this being applied with a gelatine roller. The ink takes on the lines which have become insoluble by exposure to light, but is repelled by the moist ground. The inked print is suspended to dry and is exposed to light, in order that the bichromate, which has not been completely washed out of the film, may exert a hardening effect. The print is then transferred to stone by the usual lithographic methods. There have been many variations of this process.

PAPYROTINT (Fr. and Ger., *Papyrotint*)

A process of photo-lithography invented by Husband, in which paper or tinfoil coated with bichromated gelatine and other ingredients is used to obtain a print by exposure to light under a half-tone or line negative. The print is then placed in water for a few minutes, blotted off, and rolled in with a soft lithographic ink, which takes on the lines or image only. Having been dried the print may be transferred to stone or metal for lithographic printing. The method is a modification of the papyrotype process.

PAPYROXYLINE (Fr., *Papyroxyline*; Ger., *Papyroxylin*)

Pyroxyline prepared from paper, usually pure tissue or filter papers, instead of from cotton-wool. It was first introduced by Pelouze in 1838, and used by Crookes, Lyte, Elliott, Sutton, and Liesegang. It presents no particular advantage over pyroxyline prepared from cotton-wool, and has fallen into disuse.

PARA-AMIDO-PHENOL

Para-amidophenol, para-amido phenol, and paramidophenol are other forms of this term. In the form of a preparation by Lumière, this developer is also known as " Paranol." It is a white crystalline compound, really para-amido-phenol hydrochlorate ($C_6H_4OHNH_2$), which is widely used for making up highly concentrated developers in liquid form; for example, rodinal. Amidol resembles, but is not identical with, para-amido-phenol. A concentrated one-solution developer like rodinal may be made as follows :—

Potass. metabisulphite .	3 oz.	33 oz.
Para-amido-phenol .	1 ,,	110 ,,
Distilled water (hot) .	10 ,,	1,000 ccs.

Dissolve in the above order and add slowly a very strong solution of caustic soda or potash until

the precipitate first formed is dissolved. For use, dilute with 10 to 30 parts of water, an average strength being 24 drops to each ounce of water (1 in 20).

Developers may also be made up in an ordinary one- or two-solution form as follows :—

One-solution

Sodium sulphite	.	2 oz.	220 g.
Sodium carbonate	.	1 ,,	110 ,,
Para-amido-phenol	.	55 grs.	12 ,,
Water	. . .	10 oz.	1,000 ccs.

The above is ready for use.

Two-solution

A. Para-amido-phenol	.	100 grs.	23 g.
Potass. metabisulphite		50 ,,	11·5 ,,
Distilled water .		10 oz.	1,000 ccs.
B. Sodium sulphite	.	300 grs.	69 g.
Potass. carbonate		300 ,,	69 ,,
Water . .	.	10 oz.	1,000 ccs.

For use, mix 1 part of A with 2 parts of B. Para-amido-phenol developers are suitable for all makes of papers and they do not stain. Solutions keep good for a long time even in uncorked bottles.

PARA-AMIDO-PHENOL CITRATE

A developer advocated by Dr. Liesegang, who found that citric acid is an excellent solvent for para-amido-phenol, 97 parts (by weight) of which are soluble in 200 parts of a 50 per cent. solution of citric acid in water. The para-amido-phenol should be added gradually at a temperature of from 65° to 68° (18° to 20° C.). The citrate of para-amido-phenol so formed is employed as a developer in the following proportions :—

Para-amido-phenol citrate sol.	.	1 part
Sod. sulphite sol. (concentrated)		5 parts
Sodium carbonate .	.	5 ,,
Caustic potash (10 % sol.)	.	2 ,,
Water	50 ,,

This is ready for use, and may be employed repeatedly. It gives blue-black images with normal exposure, and is said to be suitable for all kinds of plates and papers.

PARABOLIC LENS

A lens whose curves are those of a parabola and not spherical. It has not been found practical to manufacture photographic lenses of this form with the necessary degree of accuracy, although they have been employed in the illuminating systems of microscopes.

PARABOLIC REFLECTOR (Fr., *Réflecteur parabolique;* Ger., *Parabolischer Spiegel*)

A mirror or reflector ground or bent to a parabolic curve, a parabola being the section of a cone cut parallel to its slant side. If an illuminant is placed in the focus of such a mirror or reflector the reflected rays are perfectly parallel, which is only approximately the case with a spherical mirror. Parabolic mirrors are used in photomicrography and for various purposes where parallel rays are necessary, while white reflectors of parabolic or paraboloid curve are employed to secure even illumination of the negative in enlarging by artificial light when a condenser is not used.

In process work, parabolic reflectors are used on arc lamps, but not so generally since the "enclosed" type of arc lamp has come into use, a semi-parabolic shade reflector being commonly used instead.

PARABOLOID REFLECTOR (*See* "Parabolic Reflector.")

PARAFFIN (Fr., *Paraffine;* Ger., *Paraffin*)

A solid crystalline mass, translucid, odourless and tasteless, obtained by dry distillation from wood or bituminous minerals, such as petroleum. It is insoluble in water, 3 per cent. soluble in boiling alcohol, soluble in ether and oils, benzole and chloroform. It is used for making paper translucid and waterproofing wooden dishes.

PARAFORMALDEHYDE

$(COH_2)_3$. A white crystalline substance, known also as metaformaldehyde and trioxymethylene. Slightly soluble in water, alcohol or ether, soluble in an aqueous solution of sodium sulphite. Advocated in 1903 by Lumière and Seyewetz as an addition to developers. Formosulphite contains paraformaldehyde.

PARAHYDROXYGLYCINE

A synonym for glycine.

PARALLAX STEREOGRAM

An invention of F. E. Ives, of America. The parallax stereogram photograph consists of a single transparent image divided into lines (100 to 150 to the inch), alternate lines forming one of a stereoscopic pair of images, and the intermediate lines forming the other image, so that it has the appearance of a pair of stereoscopic images mechanically superposed. In order that each eye may see only the lines belonging to its respective view-point, the transparency is covered by a line-screen, with a definite separation from the surface of the photograph such that lines of the photograph covered by screenlines to one eye are seen by parallax of vision by the other eye. The combination of the photograph and line-screen in suitable adjustment constitutes the parallax stereogram, which, when viewed from a suitable distance, directly in front, shows the object in stereoscopic relief. The method of production is by means of a camera having at the front a single plano-convex lens about 3 in. in diameter, behind which are two

A. Camera for Producing Parallax Stereograms

small openings about 2½ in. apart in a horizontal plane (*see* A); thus an image is formed from two view-points, corresponding to the separation of the eyes. The image thus formed may be a perfectly sharp single image of objects at some

one distance from the camera, in which case objects at every other camera distance will form two images laterally displaced and superposed, exactly as in two ordinary stereoscopic images mechanically superposed. It is then only neces-

B. Inverted Prisms in Front of Lens Apertures

sary to cover the plate with an opaque line-screen suitably adjusted with reference to the spacing of the lines, separation of view-points, and camera extension, in order that the light coming from the two camera apertures may form separate images in juxtaposed lines. A transparency from the negative thus obtained is covered by a line-screen with adjustment like that in the camera, and viewed from a point corresponding to the position of the lens apertures, in order to produce the effect of an ordinary double stereogram in the stereoscope. If, however, these conditions are strictly adhered to, the result will be pseudoscopic instead of stereoscopic, just as in ordinary stereoscopic photography the results are pseudoscopic unless the photographic prints are cut apart and transposed before mounting them for inspection in the stereoscope. The stereoscopic effect is obtained by shifting the cover-screen laterally the width of one screen-line, but with the result that the perspective is distorted when a moderately large angle view is embraced. In order that the path of the rays to or from every point of the stereogram may be absolutely identical in photographing and in viewing, the image formed through each aperture in the camera should be laterally inverted, so that the two pencils of light belonging to near objects bisect before reaching the screen, and pencils from far objects after passing through it. This may be effected by placing laterally inverted prisms in front of the lens apertures, as shown at, B in which w represents the path of rays coming from an object more distant from the lens on one side than the screen and sensitive plate on the other. With this arrangement, the objects will be laterally reversed, unless photographed from an intervening mirror, but in other respects the results are much better than without the inverting prisms. The use of the inverting

| **C. Using Two** | **D. Using Two** |
| Separate Lenses | Pinholes |

prisms also permits of the large lens being dispensed with. The fact that the prisms may be disposed so as to direct the two pencils of rays towards the axis of the camera in the same manner as the prismatic edges of a single lens,

permits of the use of two separate lenses C, or even of pinhole apertures without lenses D, and this method of controlling the parallax independently of the focal length of the lenses possesses certain practical advantages. Objects can be photographed so as to appear to be at the plane of the photograph, or within or beyond it, at will. When the arrangement shown at C is employed, it is advantageous to have pairs of lenses of various foci, in order to keep to one camera extension, and owing to the small size of the apertures, simple lenses may be used.

The most perfect screen for this work is a 100 line to the inch uncovered Levy single-line screen with " hard filling," and opaque lines twice as broad as the clear spaces. A card-mat separator is used, and the sensitive plate pressed flat by a thick plate-glass at the back in the dark-slide. The requisite thickness of the card separator depends upon the camera extension, which can be readily calculated. The cover screens for the parallax stereograms are made by contact printing on transparency plates from a negative made by contact printing from the original Levy screen, and intensified by mercury and ammonia. The lines should be quite opaque, and the spaces perfectly clear, and, while good enough for this purpose, such screens are not good enough for use in making the negatives. Owing to the fact that neither the transparencies nor the cover-screens are ordinarily flat, it is necessary, in mounting them together, to use a third glass, convex side (preferably ground) against the back of the transparency.

PARA - METHYL - AMIDO - PHENOL-SUL-PHATE

A synonym for metol.

PARAMIDOPHENOL (*See* " Para-amido-phenol.*"*)

PARAMOL (*See* " Edinol.*"*)

PARANOL (*See* " Para-amido-phenol.*"*)

PARAPHENYLENE-DIAMINE

$C_6H_4(NH_2)_2$. One of the hydroquinone series of developers.

PARCHMENT (Fr., *Parchemin;* Ger., *Pergament*)

Paper which has been superficially treated with sulphuric acid, and thus converted into so-called parchment, has been occasionally used for printing, but has not come into general use.

Parchment is used by process workers for covering the tympans of typographic proof presses. It is also used instead of glass, for the autocopyist collotype process.

PAROLOGRAPH

An instrument used for obtaining photographic records of the voice.

" PARTS," FORMULÆ IN

The system of stating formulæ in " parts " has some advantages. A " part " may mean anything : a drop to a gallon in liquids, or a grain to a ton in solids ; and as long as one keeps to the same unit and multiplies this by the number

in the formula it is impossible to go wrong. The following table will be found useful, as it will save some calculations when quantities are expressed in "parts":

| | BRITISH | | METRIC | |
Parts	Solids Grains	Liquids Minims	Solids (g.) or Liquids (ccs.)
1	1	1	1
2	2	2	2
3	3	3	3
4	4	4	4
5	5	5	5
10	10	10	10
20	1 scr.	20	20
50	50	50	50
60	1 dr.	1 dr.	60
100	1 ,, 2 scr.	1 ,, 40 mins.	100
250	* ½ oz. 32 grs.	½ oz. 10 ,,	250
500	1 ,, 62 ,,	1 ,, 20 ,,	500
1,000	2¼ ,, 16 ,,	2 ,, 40 ,,	1,000
2,500	5½ ,, 94 ,,	5 oz. 1 dr.	2,500
5,000	11¼ ,, 79 ,,	10 ,, 3 ,, 20 ,,	5,000
10,000	1 lb. 6¾ oz. 49 ,,	20 ,, 6 ,, 40 ,,	10,000

* Avoirdupois oz. of 437·5 grs.

This table may be used to some extent for roughly converting amounts in one system to the other. Say, for example, it is required to convert the following or any similar "part" developing formula into one for a solution containing 10 oz. of water:—

Kachin	.	.	.	16 parts	
Sodium sulphite	.	.	24	,,	
Sodium carbonate	.	.	50	,,	
Water	.	.	.	1,000	,,

The water is to equal 10 oz., then 1 part is equal to 4·8 mins., or 4·5 grs. (precisely, 4·37), for 1 oz. is equal to 480 mins. or 437·5 grs.:

Kachin	.	.	.(16 ×4½) = 72 grs.	
Sodium sulphite	.	.(24 ×4½) = 108 ,,		
Sodium carbonate	.(50 ×4½) = 225 ,,			
Water	.	.	.	= 10 oz.

It is near enough in photographic formulæ to take a "part" as meaning 1 gramme or 1 cubic centimetre. Thus, the formula above given will work out as follows:—

| Parts | British approx.) | Metric | | |
		Calculated from British (approx.)	Calculated direct from formula	
Kachin .	16	72 grs.	16·5 g.	16 g.
Sodium sulphite .	24	108 ,,	25 ,,	24 ,,
Sodium carbonate	50	225 ,,	50·5 ,,	50 ,,
Water .	1,000	10 oz.	1,000 ccs.	1,000 ccs.

Of course, there is a percentage of error, but this is of small importance in the generality of photographic solutions.

PASSE-PARTOUT

This is a cheap and very effective method of preparing prints for the wall, and is a good substitute for the more orthodox method of framing. The chief drawback is that the absence of the support given by a stout wooden frame results in fragility; so that while passe-partouts are quite satisfactory for home use, they run serious risks if sent to exhibitions. Briefly, the method consists in binding together by the edges a sheet of glass, a mounted print, and a backboard, and providing a means for hanging up. The actual work is carried out with many variations, but the outline of one course of procedure will be sufficient to indicate the general lines to be followed.

The mount of the print should be sufficiently stout to ensure its lying flat, as with a thin paper mount it is difficult to secure such close pressure against the glass as to prevent buckling. A sheet of glass the size of the finished picture is cut, taking care that the edges are as clean-cut as possible, and the shape truly rectangular. This glass is used as a template for trimming the print and for marking out a rectangle on a piece of very stout strawboard. If this latter is of the right kind and thickness it will have less "give" in it than a similar piece of wood. It is extremely hard to cut with a knife, and those who have a fine-cut saw, or even a fret-saw, available will find it an advantage. Glass, mount, and backboard should now be of the same size, with the edges flush and even all round.

Before binding up, the backboard is fitted with a hanging arrangement. Tapes are sometimes glued on for this purpose, but a better method is to use paper fasteners and curtain rings. The former should be of large size, say about 1¼ in. or 1½ in. long; the latter are hollow brass rings about ¾ in. in diameter. The backboard is pierced with two holes, a ring is slipped between the forks of the fastener and drawn tight up to the head, and the fastener is then pushed through the hole, opened out, and hammered down flat. If the rings are so held as to occupy the best position for taking the pull of the cord, it will be found that the flattened paper fasteners incline towards each other, and are not parallel to the sides of the backboard. They will resist a pull very much greater than will be put upon them by the weight of the finished picture.

Excellent binding for the edges can be bought in rolls, and of different colours. Grey, black, and brown are the most useful. The strips are of tough "pebbled" paper, already gummed with a strong adhesive. The glass having been thoroughly cleaned the three component parts are put evenly together, and laid, glass side up, so that one side projects very slightly over the edge of a table. A piece of edging the length of this side is cut from the roll, drawn under a straight-edge or through the fingers to remove the curl, and the gummed side moistened with a brush, being careful not to take off the adhesive. With a little practice this strip can be laid evenly along the edge of the glass, using the thumbs at each end to adjust it, and keeping about one-third of the width on the glass. The strip is then thoroughly rubbed down into close contact with a duster. The whole thing is now turned carefully over, and the free edge of the strip

drawn tightly over and rubbed down on to the backboard. The opposite edge is done in the same way, and then the other two edges, allowing time between each for the last strip of edging to set. Some prefer to mitre the corners of the strips, but if one is placed over another the difference cannot be detected at a little distance. Should alternations of wet and dry weather subsequently cause the edging to leave the glass in places it can be re-damped and rubbed down again. In extreme cases it is a simple matter to renew the binding altogether.

PASTE (*See* "Encaustic Paste" and "Mountants.")

PASTELS

Prints, upon paper or opal, coloured with crayons; the pastel proper, however, has no photographic basis. Pastel colours are opaque, and the print selected for colouring should be light and of a cold tone. Details are hatched or stippled with the point of the crayon, but broad tints are rubbed in with the finger or stump. Such pictures when coloured are liable to injury because of the colours being in a kind of powder on the surface. If not mounted up at once in a frame and behind glass the work should be sprayed with a weak solution of rice water, or with the following:—A. Mastic, 24 grs.; amyl acetate, 3 oz. B. Celluloid (old photographic films washed free from emulsion), 7 grs.; amyl acetate, 3 oz. Dissolve, and when, after some hours, both solutions are clear, mix together and keep in a tightly corked bottle. Another method is to strain over the crayon work a piece of thin nainsook, and then rapidly and lightly to brush over a weak solution of isinglass.

PATENTS

The governments of the civilised countries grant inventors the sole right to their inventions for a term of years, in consideration of a full disclosure of the invention, the payment of certain fees, and conformity to certain regulations. Application for a British patent may be made in two ways. (1) By lodging what is known as a provisional specification, to be followed within six months by a complete specification. (2) By lodging a complete specification in the first instance. In most cases it is best to adopt the first course, as the period ensuing between a provisional and complete application affords the inventor an opportunity of developing his ideas and ascertaining by practical tests the best ways and means of carrying his invention into effect. The provisional specification, however, must clearly foreshadow the object of the invention and indicate to some considerable extent the methods to be adopted in carrying the invention to a practical issue; hence, as the provisional forms the basis for the complete patent, it should be prepared with the utmost care, especially as nothing which has not been intimated in the provisional may be included in the complete specification. If the inventor discovers improvements after filing his provisional, he cannot include them in his complete specification, but he may (in virtue of the Patent Act of 1907) apply for a patent of addition, in respect of any

modifications or improvements upon the invention as originally patented, and no renewal fees beyond those in respect of the original patent will be involved. Official patent forms are supplied free of charge. For a provisional application, one copy of Patent Form No. 1 and two copies of Patent Form No. 2 are required. Before it is lodged at the Patent Office, No. 1 will require the Government stamp (cost £1) to be impressed thereon. No stamp is required on the two copies of Form No. 2; and No. 1 may be obtained already stamped before filling in the form, if desired.

The provisional specification is commenced on Form No. 1, and continued on wide-ruled foolscap paper, leaving a margin of 1 in. on the left-hand side. It may be delivered by hand or sent by post, on receipt of which it will be officially dated and numbered.

A provisional specification is not published, but remains secret during the period of provisional protection, and until the acceptance of the complete specification. As soon as a provisional application has been filed the inventor may safely show his invention to any interested party, but he should be quite certain that he has properly described his invention and satisfactorily covered his idea. Provisional protection lasts for six months, or seven months by payment of a fine, and at any time before the expiry of the period of provisional protection the inventor must file his complete specification, otherwise the application is considered to be abandoned.

Complete specifications, with their all-important claims, should not be filed without expert assistance. It is a good plan for the inventor himself to make a preliminary search for novelty, before involving himself in the necessary expenses of completing the patent through a qualified agent. The Patent Office in Chancery Lane, London, offers every facility to visitors to make their own searches, but it is a long task to anyone unacquainted with the system, and in any case involves time and patience. For this reason the services of special search agents are useful. Persons who cannot go to the Patent Office in person, and yet have time at their disposal for the search, may obtain copies of all specifications filed, in either the original or an abridged form. For example, suppose an inventor of some photographic appliance wishes to ascertain how much novelty exists in his invention; he may purchase ten volumes at 1s. each, post free, in which he will find tabulated and conveniently indexed all patents in photography from the year 1617 almost to date. The abridgments relating to photography come under Class No. 98. From the index he may find all inventions which have any serious bearing on his particular apparatus. After selecting any which may be thought to encroach upon his ideas, he may further obtain the full specifications for 8d. each. Having satisfied himself with respect to these he may bring his search up to date by engaging an agent, to furnish information of any other specifications a view of which can only be got by visiting the Patent Office itself. Such a procedure often saves an inventor the expense of lodging a complete specification and then

in the end discovering that he has been completely anticipated. The Comptroller of Patents causes a search to be made through British specifications for fifty years back from the date of every application for a patent. Only complete specifications, either after provisional, or complete in the first instance, are subject to the search, and the Comptroller has the power to insist on the amendment of the specification or on the insertion of a reference to existing patents, and so to place it in interference therewith. A preliminary and independent search by the inventor before filing a complete specification often reveals prior applications with which he may be able to avoid clashing by means of judicious wording in his complete specification, thus obviating the addition of troublesome references to prior patents—references which are likely to discount the value of his patent.

A sealed Royal Letters Patent alone enables an inventor to obtain absolute protection for fourteen years, and allows of legal action being taken against infringers, annual renewal fees being payable from the end of the fourth year. The complete specification must be begun upon Patent Form No. 3 (stamp, £3), and continued on foolscap paper. An unstamped duplicate copy is also required. The specification should contain a full and detailed description of the invention, of such a nature that the invention could be carried into practical effect by a competent workman. Drawings are also required where a mere description would fail to make everything absolutely clear. Instructions to applicants for patents (supplied free) give clear directions not only for drawings but also for the mode of applications, provisional and complete. The complete specification, together with its claims, is a most important document. The drafting of claims is a task that should be done by a fully qualified and registered patent agent, because when a specification comes to be construed in a court of law, the wording of the claims is subjected to a searching scrutiny, and if there is any flaw the patentee will generally fail to support his monopoly. Further than this, the claims should always be drafted in the first instance as wide as is reasonably possible, because there will then be an opportunity of reconsidering them in the light of the fuller knowledge of prior patents disclosed by the Patent Office search.

The total amount of Government stamp duty for a British patent is £1 on provisional application, £3 on completing same; or £4 on complete application in the first instance. A further fee of £1 is payable in order to obtain the issue of a patent on an accepted application. Before the end of the fourth year, dating from the first application, £5 becomes due in respect of the fifth year; before the end of the fifth year £6 in respect to the sixth year, and so on, increasing £1 each year during the period (fourteen years) the patent may be kept in force. The period is extended only in very special circumstances.

PAUL'S ANIMATOGRAPH

One of the earliest commercial kinematograph machines, patented by R. W. Paul, and at first called the " Theatrograph."

PAYNETYPE

A photo-mechanical process invented by Arthur Payne. Zinc plates are coated with a gelatino-bromide emulsion and exposed direct in the camera. In order to obtain the necessary reversal of the negative image the plate is coated, before the application of the emulsion, with a resinous varnish. After exposure and development with an alkaline developer, the image is treated with a 5 per cent. solution of potassium bichromate, which hardens the image so that it can be developed with hot water, like a carbon print. Thus the soluble gelatine forming the half-tone dots or lines of the negative image is washed away, leaving the varnish ground clear in those parts. The plate is then dried and immersed in methylated spirit, which dissolves the varnish in the places uncovered by the gelatine, the zinc thus being left bare. A coating of ink is next applied and attaches itself to the bare zinc, whilst it can be developed away in the parts which are still covered with varnish and gelatine. The plate is then ready for the etching process.

PEARL-ASH

Impure potassium carbonate.

PELLETONES

An early name for chemicals sold in a compressed form. Pyrogallic acid was the first to be sold in this way. The term has also been applied, but very rarely, to the results of the Pellet iron-printing process.

PELLET PROCESS

An iron (blue-print) process—the true cyanotype, which gives blue lines on a white ground when a copy is made from a line tracing. It is a " positive from positive " process, and unsuitable for use with ordinary negatives because negative prints would then be obtained. The process is also known by various other names, such as " Cyanofer," " Positive Ferrotype " and " Cyanographic," and is largely used for the reproduction of technical drawings. Pellet's own formula has always been kept a trade secret, but Dr. Liesegang gives the following, which answers quite well :—

Common salt	.	.	144 grs.	33 g.
Tartaric acid	.	.	156 ,,	36 ,,
Ferric chloride	.	.	384 ,,	88 ,,
Gum arabic	.	.	2·5 oz.	275 ,,
Water	.	.	10 ,,	1,000 ccs.

Dissolve the gum in one half of the water, the other ingredients in the remaining half ; mix, apply to paper in the manner described under the heading " Blue-print Process," and dry quickly. An exposure under the tracing, of one or two minutes is sufficient in bright sunlight. The print is developed by floating it face downwards on a saturated solution of potassium ferricyanide (none must reach the back of the print) ; then wash for a minute or two in water and immerse for about ten minutes in a clearing solution of water 100 oz., hydrochloric acid 8 oz., sulphuric acid 3 oz., finally thoroughly washing and drying.

A modern formula, due to Pizzighelli, is given on the next page

A. Pure gum arabic . 264 grs. 60·5 g.
 Water . . . 3 oz. 300 ccs.
B. Ferric ammonio-
 citrate . . 220 grs. 50 g.
 Water . . . 1 oz. 100 ccs.
C. Ferric chloride
 (crystals) . . 220 grs. 50 g.
 Water . . . 1 oz. 100 ccs.

The gum solution does not keep well, but the others do, if stored in the dark. For sensitising paper take of—

Solution A (gum) . 2½ oz. 250 ccs.
 ,, B (citrate) . 1 ,, 100 ,,
 ,, C (chloride) . 5 drms. 1 ,,

Add B to the gum, shake well, add C, and shake again. If mixed in any other way the gum may coagulate. The paper is coated and dried like blue-print paper and exposed under a tracing. Exposure is very brief (a minute to a minute and a half in strong sunlight), the image showing faintly. The print is developed in a solution of 1 oz. of potassium ferrocyanide (yellow prussiate of potash) in 10 oz. of water. The lines should develop to a brilliant blue, without any blueness in the ground, which would indicate under-exposure ; broken and feeble lines are due to over-exposure. The print is washed for a few seconds in order to remove most of the developer, and then fixed in an acid bath, sometimes called a bleaching bath, made by mixing ¾ oz. of strong sulphuric or 2 oz. of hydrochloric acid with 20 oz. of water. The prints, face upwards, remain in this bath for five or six minutes, and are then thoroughly washed. A light blue deposit is often seen upon the white parts of the paper, but this washes off, or it may be removed with a very soft brush or cotton-wool. Any blue stains (or, in fact, the whole of the image) may be removed with a solution of about 70 grs. of potassium oxalate in 1 oz. of water (4 g. in 250 ccs.), washing well afterwards. (For selection of suitable papers, method of sensitising, etc., see " Blue-print Process.")

PELLICLE PROCESSES

Early dry-plate processes in which the prepared emulsion was supplied for the purpose of melting up and coating plates at home. Kennett patented a pellicle (a compound consisting of gelatine, silver nitrate, bromide, etc.) in November, 1873.

PENCIL, BROMIDE

A specially prepared pencil for spotting and working-up bromide prints, for particulars of which see " Bromide Pencils."

PENCIL, RETOUCHING (See " Retouching.")

PENTANE (Fr. and Ger., *Pentane*)

Synonym, amyl hydride. C_5H_{12}. Molecular weight, 72. A colourless, mobile liquid, obtained from coal tar or petroleum. Boiling point, 98° to 100° F. (36·6° to 37·7° C.). Its vapour is extremely inflammable. It is used in the pentane lamp.

PENTANE LAMP

A special form of lamp adopted by the Board of Trade as a standard light. Ordinary coal gas is passed over the surface of pentane, of which it absorbs some, and thence to an Argaud burner. If precautions are taken as to the pressure and height of flame, it gives a very constant light source, which, however, is open to the objection that its spectrum is very poor in violet and ultra-violet, and therefore not comparable to daylight for photographic purposes. It is frequently known as the Dibdin-Harcourt pentane lamp, and may be obtained of either ten or one candle-power. It is used as a primary light standard for photo-chemical work.

PENTATHIONIC ACID (Fr., *Acide pentathionique* ; Ger., *Pentathionsäure*)

$H_2S_5O_6$. Molecular weight, 258. One of the higher sulphur acids, of very little practical interest. Lumière and Seyewetz suggested the use of lead pentathionate dissolved in " hypo " as a toning agent instead of gold ; but it has found no practical use, as the final image consists of lead, silver, and sulphur, and is somewhat liable to change.

PEPPERTYPE

A process of making ceramic enamels.

" PER CENT " SOLUTIONS (*See* " Solutions, Making up.")

PERCHROMIC ACID

A term sometimes used as a synonym for chromic acid (chromic anhydride), though the formula for perchromic acid is written $Cr_2O_7 H_2O$ and that of chromic acid is CrO_3.

PERIOD

A term proposed by Scheffer to denote the size of the units of screens and screen-plates. The period for lines equal in width to the interspaces is twice their separating distance. Thus, in the diagram, which represents a black-and-white screen of equal spacing, the period is shown at

Diagram of Black-and-white Screen
of Equal Spacing

the top by P ; the elements of the screen are indicated at S. Any screen of which the period is $\frac{1}{1500}$ of the distance from the eye can be resolved into separate lines. From this it is obvious that, assuming 8 in. or 20 cm. as the distance of normal vision, the screen period will be $\frac{1}{125}$ in. or ⅛ mm. Therefore the separate units of the screen will be invisible if they are not larger than $\frac{1}{250}$ in. or $\frac{1}{16}$ mm.

PERISCOPE, OR PERISCOPIC LENS

Usually an uncorrected rectilinear lens. The earliest model was made by Steinheil, in 1865, and consisted of two very thin meniscus lenses mounted closely together. It embraced a very wide angle (nearly 100°), and had an initial intensity of $f/40$. The modern periscopes are

usually more rapid in action, say $f/9$ to $f/11$, but their visual and chemical foci do not coincide.

PERMANENCY

The stability of a photographic image is determined primarily by the process by which it was produced, but it is limited by the durability of the medium on which the image is supported. If the image will endure without serious loss of quality as long as the medium will last, it may be regarded as permanent. In some cases the image is almost indestructible, and therefore has much greater durability than its support. Deterioration is far more frequently the result of defective or careless working than an inherent weakness of the process. Gelatine, thoroughly hardened, is an enduring substance. Paper of good quality and purity will last for hundreds of years without other change than a mellowing of its colour. In silver processes, imperfect fixing is a frequent cause of fading in negatives and prints, even the washing being of secondary importance. A properly fixed and washed negative should be permanent, especially if varnished to protect it from the atmosphere. Properly made carbon and platinotype prints are quite permanent; imperfect adhesion of the carbon tissue to its final support, or incomplete removal of the iron salts from platinotype, will cause rapid deterioration, although metallic platinum is absolutely permanent. A sulphide-toned bromide print should be as enduring as any photographic print, silver sulphide being a most stable substance. An ordinary bromide print should be as enduring as a negative, but all prints on gelatine papers should have the gelatine coating hardened; in its soft condition it will absorb moisture from the air, and this is prejudicial to its stability. Silver prints on the various printing-out papers are generally considered to be far from permanent; but the trouble is invariably due to imperfect work, and is not inherent in the process. Silver prints have been kept for nearly twenty years without showing any change beyond the mellowing of the paper.

PERMANENT SUPPORT

The paper used for the second transfer in the double-transfer method of the carbon process.

PERMANGANATE INTENSIFIER

A process of intensification by means of potassium permanganate, described by T. Thorne Baker before the Royal Photographic Society in 1905. In the result, the contrasts are slightly reduced. The negative is washed and placed in the bath given below for between one and three minutes, during which time the image is transformed into a reddish-pink, and apparently loses very much in density :—

Potass. permanganate.	96 grs.		22 g.
Hydrochloric acid (concentrated)	.	. 50 mins.	10 ccs.
Water	.	. 10 oz.	1,000 ,,

It is rinsed in water and developed, preferably by hydroquinone with caustic soda. The red plate, when immersed in the developer, quickly becomes brown, and finally black, the whites again becoming perfectly clear. Finally, the negative is washed.

PERMANGANATE REDUCER (See "Reducing Negatives by Chemical Means.")

PERSAL

An etching mordant for copper, based on ferric perchloride, and obtainable in either solid or liquid form.

PERSISTENCE OF VISION

The impression made by light upon the retina of the eye does not instantly disappear when the light is removed, but remains for an appreciable length of time which largely depends upon the length of the period during which the eye has been exposed to the light and also upon the intensity and colour of the light. A sentence, which is probably the first written, having reference to persistence of vision, is contained in the fourth book of "De Rerum Natura," by Lucretius, written about 65 B.C. He there says : "This [perception of movement] is to be explained in the following way : that when the first image passes off, and a second is afterwards produced in another position, the former then seems to have changed its gesture. This we must conceive to be done by a very rapid process," etc. There are many simple and familiar illustrations of the phenomenon of persistence of vision. Thus, a flash of lightning appears much longer than it really is, and a burning stick whirled rapidly round appears to be a circle of fire. If the seven prismatic colours be properly arranged in their due proportions in a circle, and this turned rapidly on a central axis, a white surface is the result. This law of the persistence of vision constitutes the fundamental basis upon which the kinematograph exhibition rests, and the motion picture is the finest demonstration of the facts it is possible to conceive, though not, perhaps, so self-evident as it becomes in the simpler appliances, such as the so-called "Wheel of Life," or the phenakistoscope.

PERSPECTIVE (Fr., *Perspective*; Ger., *Perspektive*)

Assuming that lenses are free from distortion, that they are opposite the centre of the plate, and that the plate is vertical, all lenses will give the same drawing or perspective from the same standpoint. If the focal lengths vary, more or less of the subject will be included, but such objects as are rendered by all will be identical in perspective.

A good deal of misapprehension has arisen from the fact that, more often than not, lenses include far more than can be seen clearly by the eye from the same standpoint. If a lens of very short focus is used on a large plate, the resulting picture is sometimes said to have incorrect perspective. It is only incorrect in the sense that the eye, placed in the same position as the lens, is not adapted for seeing the same amount of the subject. If the eye could include as much as the lens, it would see precisely what the lens renders. As, however, photographs are made to be looked at, it is desirable to avoid this "unnatural" perspective. This can be done by using lenses of such focal length that the pictures they draw approximate to those seen by the eye. When a lens has included so much

that the effect to the eye appears strained and unnatural, the exaggeration may be removed by trimming away more or less of the outer parts. Another cause of abnormal drawing is the taking of what was originally a subject at one side of a picture and presenting it apart, as though the lens had originally been directed straight at it.

The point of view has a great deal to do with the perspective or " drawing " of an object. In every case the perspective will be accurate for that particular viewpoint, but the resulting arrangement will not necessarily be pleasing simply because it is correct. So that, inasmuch as the photographer does not have to concern himself at all with the correctness of the " drawing," he must direct his efforts to the consideration of such a point of view, and the use of such a lens, that the result shall appear natural and pleasing to the eye.

The unnatural appearance of a wide-angle picture is accentuated if the whole of the subject is enlarged. This is because a large print is generally viewed at a greater distance than a small one, whereas the shorter the focal length of the lens employed the closer to the print should the eye be placed for the perspective to appear natural. The unnatural appearance is also emphasised when some of the objects included were comparatively close to the lens. For example, an upright picture on a near wall may apparently be elongated into a horizontal one, and only assumes its natural proportions if it can be viewed at a distance something like that of the focal length of the lens used. (*See also* " Perspective, False.")

PERSPECTIVE, AERIAL (*See* " Aerial Perspective.")

PERSPECTIVE, FALSE

That the photographic lens cannot render a scene in false perspective has been stated under the heading " Perspective," but it is there pointed out that photographic images are not always pleasing to the eye. The terms "false perspective" and " distortion " are often applied to views which show " violent " or " sudden " perspective, due to the use of a wide-angle lens. Perhaps the nearest approach to false perspective which can be obtained in photography is by the use of the swing back, which is often brought into operation in order to secure depth of definition when using a comparatively large aperture. An example of this may be found in an ordinary street view, in which one side of the road is much nearer to the camera than the other, and consequently is out of focus when the centre is sharp. To remedy this, one side of the swing back is pulled out, thus bringing the near portion into focus, but of course on a larger scale than it would have been if the plate had been kept at right angles to the axis of the lens. Something similar occurs when the vertical swing is used to obtain covering power in portraiture, general sharpness being obtained by tilting the back to bring the hands and knees into focus at the cost of truthfulness.

PETROLEUM SPIRIT

A synonym for benzine.

PETZVAL, J.

A Viennese mathematician who, in 1841, devised the first " rapid " portrait lens. It was of short focal length, worked at what was then a large aperture, and was manufactured by F. Voigtländer, of Vienna. It consists of a front combination formed by a biconvex lens of crown glass cemented to a plano-concave lens of flint glass. The back combination is composed of two separated lenses, a concavo-convex of flint glass and a biconvex of crown glass. (For illustration, see " Lens.") It enabled exposures to be reduced to one-tenth that previously necessary. In 1858, Petzval worked out the " orthoscopic" lens for landscape work, but this lens was little superior to the single landscape lens, although the subject of great claims. (*See also* " Lens.")

PHANEROGENE

A developer introduced in 1894 by Reverdin and De la Harpe, and having a character resembling that of amidol ; now of but small importance.

PHANTASMOGRAPH (Fr., *Phantasmographe ;* Ger., *Phantasmograph*)

An early apparatus used for printing lantern slides, consisting of a long box or tube having a hinged door at one end to admit light, the negative, with the lantern plate in contact, being placed at the opposite end. Apparently, the object was to exclude all possible extraneous light.

PHANTOM DEVELOPMENT

A fanciful term applied to a method of development with a solution strong in the developing agent but weak in alkali, so that a faint image is first obtained, and then continuing with a solution strong in reducer, alkali, and restrainer.

PHENAKISTOSCOPE

Synonym, stroboscope. An instrument invented simultaneously, by, Plateau, of Ghent, and Stampfer, of Vienna, in the year 1832. It has been made in various forms, an example of which is illustrated. Two discs are mounted on a common spindle ; they rotate in the same

Phenakistoscope

direction and at an equal speed. One disc is perforated with slots, through which an observer may view a series of pictures depicted on the inner surface of the companion disc. The series of pictures consists of successive phases of

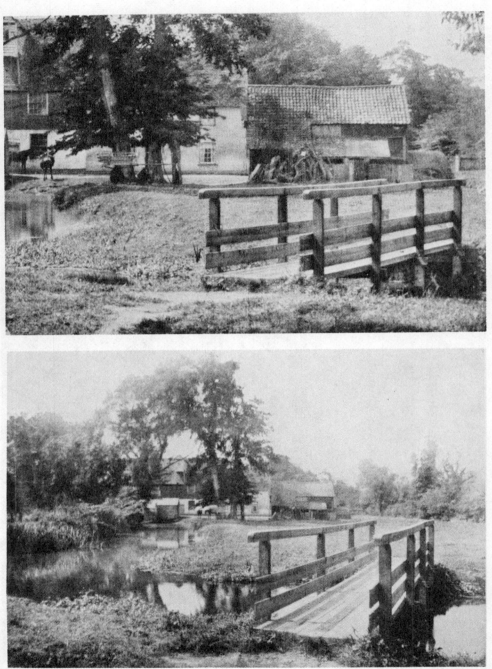

BY P. R. SALMON, F.R.P.S.

INFLUENCE OF THE LENS ON PERSPECTIVE

The upper view, taken with a narrow-angle lens, conveys but little idea of distance between the footbridge and the farm. In the lower view, however, taken with a wide-angle lens and from a much nearer standpoint, the distance appears to be greater. The bridge is of approximately the same scale in both views.

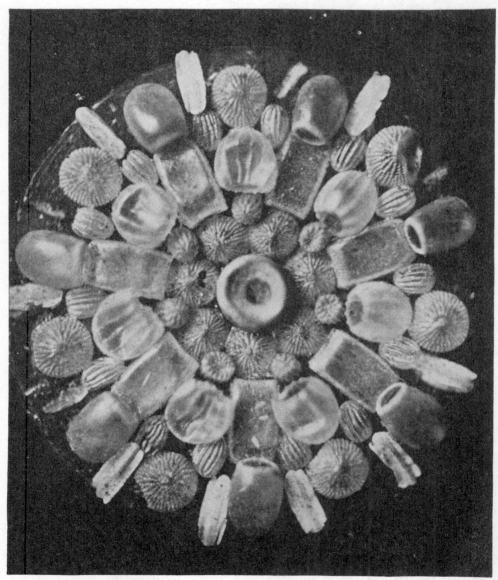

GROUP OF INSECTS' EGGS　　　　　　　　　By J. I. PIGG, F.R.M.S., F.R.P.S.

PHOTOMICROGRAPHY

any object in motion ; as for example, a girl skipping. The number of phases corresponds to the number of slots in the viewing disc. On making the discs rotate rapidly, the observer gains a momentary view of each picture in the series as each slot arrives opposite its respective image. In virtue of the law of persistence of vision, therefore, a blending of all the pictures in the series takes place on the retina of the eye, giving the impression of a single figure invested with life or motion. In a modified form of the instrument, the disc bearing the pictures, as shown in the figure, is dispensed with, by depicting the pictures on one side of the slotted disc and viewing them through the slots by reflection in a mirror ; this, indeed, was the earliest form of the apparatus. Phenakistoscope is the name given to the instrument by Plateau, while Stampfer calls it by the name of stroboscope. As an early instance of confusion of terms it may be mentioned that Snell, writing in 1835, calls the stroboscope by the name of "Phantascope" or "Kaleidorama." Müller, in 1846, applied this instrument for the demonstration of wave-motion, and Poppe, Savart, and others employed it for the synthesis of other natural motions. The first attempts at projecting animated effects upon the lantern screen were founded on the type of machine here illustrated, the disc bearing the series of pictures being on transparent material, and light thrown first through it, then through slots, and finally on to the screen by means of an objective. This was done by Uchatius between 1851 and 1853, but Plateau himself had practically attacked the same problem in 1849 in a modification of his anorthoscope, in which apparatus he produced four non-distorted images from a distorted original by the introduction of compensating lenses. Plateau placed sixteen images in progressive series round the margin of a glass disc, and in front of this, in a reversed direction, revolved, at a four times greater speed, an opaque disc with four slots. The front of the apparatus could be observed by many people at once, and to prevent confusion the parts of the disc showing the non-erect images were screened off. It will be seen that as a slot passed the aperture in the screen one image would be viewed and the light then cut off while the transparent disc turned one-sixteenth of its diameter and the opaque one one - quarter. The next image would then be revealed, by its coincidence with the slot, in the same position as that in which the previous image was observed. (See also "Zoëtrope.")

PHENIC ACID, PHENOL, PHENYLIC ALCOHOL, AND PHENYL HYDRATE

Synonyms for carbolic acid.

PHENYLAMINE

A synonym for aniline.

PHLOXINE

A variety of eosine.

PHOSPHATE PLATES AND PAPERS

Plates or papers coated with an emulsion in which silver phosphate is practically the light-sensitive salt. The light-sensitiveness of this substance was discovered by Stromeyer about 1830, but Fyfe, about nine years later, was the first to use it for printing out, and he salted his paper with sodium phosphate, sensitised on silver nitrate and again floated on sodium phosphate. He also used an ammoniacal solution of silver phosphate, and recommended merely washing with water or ammonia for fixing.

Many years later, Lyte used this salt for albumenised paper and employed nitric acid for fixing ; later (published 1856) he used a mixture of sodium phosphate and tartrate, Rochelle salts in sugar of milk and gelatine, and stated that there was no precipitate formed, thus antedating the later use by Meyer of silver phosphate dissolved in an organic acid. It was also tried by Hunt and Hardwick. Meyer (Brit. Journ. Phot., 1899 and 1900) precipitated his phosphate and dissolved it by the addition of an organic acid, such as citric, tartaric, acetic, etc., and used it with and without a vehicle on paper. Silver phosphate alone or with excess of silver nitrate, however, gives an exceedingly long range of gradation, so that unless extremely vigorous negatives are used the prints are very flat, wanting in intensity, and without any whites. Valenta, in 1900, took up the study of the subject, and suggested a collodion emulsion by adding silver nitrate to phosphoric acid collodion, but this also possessed the same fault, though to a less degree. Further experiments were made to increase the intensity and reduce the gradation by mixing it with varying proportions of collodio-chloride emulsion, or by the addition of uranyl and cupric chlorides ; and finally, in 1905, he gave a satisfactory working formula, which can not only be printed out, but also physically developed :—

Raw collodion (3–3½%)　20 oz.　1,500 ccs.
Phosphoric acid (20%)　128 mins.　20 　,,

Mix, and add—

Citric acid　.　.　384 grs.　60 g.
Alcohol　.　.　.　640 mins.　100 ccs.

Then add—

Silver nitrate
　(powdered)　.　384–512 grs.　60–80 g.
Liquor ammoniæ (·88c) q.s.　　q.s.

Enough ammonia should be used to form a perfectly clear solution, and then—

Absolute alcohol　.　3½ oz.　250 ccs.

added, the mixture being added in small quantities at a time to the acid collodion, shaking all the time. Then add—

Ether　.　.　.　3⅓ oz.　250 ccs.
Glycerine alcohol (1 : 1) 128 mins.　20 　,,

This may be coated in the usual way on matt or glossy baryta paper. It may be fully printed out or only until the outlines of the image are just seen, and should then be developed with the following :—

Metol　.　.　.　155 grs.　35·5 g.
Glacial acetic acid　.　10 oz.　1,000 ccs.
Distilled water　.　10 　,,　1,000 　,,

For use, 40 drops of this should be diluted with

26

$3\frac{1}{2}$ oz. or 100 ccs. of water. The colour of the prints thus obtained varies from sepia to brownish black or purple.

Recently, several makers have placed phosphate papers on the market which may be treated as outlined above.

PHOSPHATES (Fr., *Phosphates*; Ger., *Phosphats*)

Salts prepared by the combination of a metal with phosphoric acid. There are generally three forms: the mono- or acid phosphate, such as sodium orthophosphate, $NaH_2PO_4 H_2O$; the di-orthophosphate, $Na_2HPO_4 12H_2O$; and the tri-orthophosphate, $Na_3PO_4 12H_2O$; these are obviously formed by the replacement of one, two, or three hydrogen atoms respectively of orthophosphoric acid H_3PO_4.

PHOSPHORESCENCE

The researches of T. A. Vaughton and others seem to have demonstrated that the sensitive silver salts, such as the bromide, iodide and chloride, if precipitated and kept in the dark, have the property, under certain conditions, of emitting light in degrees proportionate to their sensitiveness. In a red light, an unexposed bromide plate is placed in an ordinary pyro-soda developing solution for ten minutes, removed and washed. Next, in total darkness, plunge it suddenly into a dish containing a saturated solution of aluminium sulphate, and the plate and the solution will immediately become phosphorescent, the light dying away in the course of a minute or two. On pouring the solution into a bottle, the whole body of the liquid becomes luminous and remains so for several minutes, the light being increased by shaking. If half the plate is exposed to the action of white light for a second before treating with the pyro-soda solution, that half remains dark and emits no light when the plate is put into the aluminium sulphate. If the plate is given a short exposure in the camera, and developed and put into the aluminium sulphate solution, the image will appear dark on a phosphorescent background. Precipitated silver bromide (which has been kept a few days in a corked test-tube in the dark), contained in a porcelain dish and exposed to a bright-red light while adding the pyro-soda solution, appears black, but on pouring off the solution the precipitate gradually assumes a bright green appearance under the red light, while in white light it appears dark grey or black.

As the result of a series of supplementary experiments, H. Edwards has stated that not only the plate itself, but also the used developer, will give phosphorescence with alum solution. Quinine sulphate or hydrochloride is not luminous when the used developer is added, but becomes so if a few drops of sulphuric acid are subsequently introduced. The experiment may be still more easily made by mixing potassium bromide and silver nitrate solutions in dim gaslight, decanting, and shaking up the resulting silver bromide with pyro-soda. A red liquid results which gives a luminous effect when poured into alum solution or dilute sulphuric acid.

Dr. J. Precht explains the phenomenon of phosphorescence as follows: (1) The alkaline pyrogallic acid solution liberates oxygen on the addition of acids, by which the sodium sulphite is oxidised to sulphate, this oxidation being accompanied by phosphorescence. (2) The acid pyro solution suddenly takes up oxygen on the addition of sodium sulphite and soda, and also this oxidation is accompanied by phosphorescence. Thus easily reducible substances produce phosphorescence with an alkaline pyro solution.

Potassium permanganate, for instance, is phosphorescent when a mixture of pyrogallic acid and soda is added to it. It is assumed that an intermediary product is formed of alkaline pyro solution and oxygen, which gives off again the oxygen only on the addition of acid, and that the then liberated oxygen gives rise to phosphorescence by combining itself with the sulphite to form sulphate. Phosphorescence is liable to fog gelatine plates should these retain traces of the pyro developer, and therefore, in practice, such plates should not pass from the pyro developer into a solution of alum or of citric acid, or, indeed, to any other solution, before the last traces of the developer have been removed from it by careful washing. Exceedingly small quantities of pyro, less than ·005 per cent., are sufficient in some cases to cause a bright phosphorescence of the film.

PHOSPHORESCENT PHOTOGRAPHS (See "Luminous Photographs.")

PHOSPHORIC ACID (Fr., *Acide phosphorique*; Ger., *Phosphorsäure*)

Synonym, orthophosphoric acid. H_3PO_4. Molecular weight, 98. Solubilities, miscible in all proportions with water and alcohol. Obtained from phosphorus by oxidation. It occurs in a crystalline state, and is then nothing else but phosphoric acid; but usually the so-called "syrupy" acid is met with, and this contains 85 per cent. of phosphoric acid, and has the specific gravity of 1·725. Another acid, of specific gravity 1·347, contains 50 per cent.; and the dilute, of specific gravity 1·057, contains 10 per cent. A 20 per cent. solution, having a specific gravity of 1·12, is the one usually employed for acidulating the platinum toning baths.

In process work, phosphoric acid is used in photo-zincography as an addition to the gum and nutgalls solution used for damping the plate before rolling-up with ink, its object being to preserve the cleanliness of the white parts of the plate. Also it is used in preparing aluminium for lithographic printing.

PHOTO SALTS

A name given first by Carey Lea to the coloured reduction product formed by the action of light on silver chloride, and later applied generally to the coloured salts obtained chemically by Lea, who considered the coloured reduction product to be a chemical combination of silver chloride AgCl and silver subchloride Ag_2Cl. Hodgkinson, on the other hand, ascribed to it the formula $Ag_2Cl_3 Ag_2O$, as he considered that the ever-present aqueous vapour or water played an important part in its formation. According to the latest theories, this product is a solid solution of Ag_2Cl in AgCl. Lea prepared the dark-

coloured products by the action of an alkaline hypochlorite or ferric chloride on finely divided metallic silver, by partial decomposition of silver oxide by heat and treatment with hydrochloric acid, by reducing silver chloride dissolved in ammonia by ferrous sulphate, or by the action of cuprous chloride on silver nitrate, etc. The colour of these photochlorides varied from purple to golden or rose red, and they were then capable of assuming the colours of the spectrum or any coloured objects to which they were exposed. These salts are of great interest, as no doubt they play an important part in the formation of the colours in the Seebeck or Poitevin processes of heliochromy on paper. Photo-bromide and photo-iodide have also been prepared, but they are not so colour-sensitive as the photochloride.

PHOTO-ALGRAPHY

The application of photo-mechanical reproduction processes to aluminium lithographic printing.

PHOTO-AQUARELL

Photogravure printing in colours by inking the plate locally with tampons, masks being used to indicate the portion to be inked.

The term has also been applied to a lithographic process of printing in colours from three etched stones.

Also a process of making coloured photographs on Whatman paper.

PHOTO-AQUATINT

A modification of the photogravure process, worked out by Thos. Huson, R.I., and fully described in his book entitled "Photo Aquatint." The principal difference between this process and ordinary photogravure is that, instead of using different densities of etching solution, practically only one strength is used, and the negative, transparency, and carbon resist have accordingly to be adapted to the process.

PHOTO-AUTOCOPYIST (See "Autocopyist.")

PHOTO-AUTOGRAPHY

A process of printing from lithographic stones on etched plates in colour, the image being applied by photo-mechanical means.

PHOTO-BIOSCOPE

An instrument constructed on the lines of the thaumatrope, and invented by Chevalier Bonelli, of Milan, in 1867. By its means both stereoscopic and kinematographic effects could be produced.

PHOTO-CERAMICS (See "Ceramic Process.")

PHOTO-CHROMATIC

One of the terms applied to the process of photography in natural colours.

PHOTO-CHROMATIC PRINTING

A process for printing photographically upon textile fabrics, the invention of R. Smith, of Blackford. The fabric is treated with a sensitive solution, and is wound off a roller, passing under a glass plate on which the design has been drawn;

the material is thus exposed one section at a time, then passing through guiding rollers to a fixing trough, finally being washed. According to the fixing solution used, various colours are obtained. To produce a design pale blue on a white ground, or white on a blue ground, solutions of the citrate or tartrate of iron with potassium ferrocyanide are used. Brown or buff tints are obtained with a solution of potassium bichromate. The fabric is afterwards plunged in a dilute solution of sulphuric acid.

PHOTOCHROME PROCESS

A method of lithographic colour printing worked out and operated by the firm of Orell Fussli, Zurich. It is believed to be a process of printing a bitumen film on stone under a continuous tone negative, and treating in such a way that a reticulated grain image is formed.

PHOTOCHROMOSCOPE

A name by which the kromskop was at one time known.

PHOTOCHRONOGRAPHY

Chrono-photography, which is described under its own heading.

PHOTO-COLLOGRAPH

A term applied to any kind of collotype print, especially to prints made by Albert's photo-lithographic process.

PHOTO-COLLOGRAPHIC PROCESS

A synonym for collotype, but it has been more particularly used by the inventor of the Sinop photo-collographic process.

PHOTO-COLLOTYPE

A synonym for collotype or photo-collography.

PHOTO-CORRECTOR

An arrangement for preventing distortion in portraits, invented by H. Van der Weyde in 1892. It consists in the employment of an additional lens immediately in front of the plate, as shown in the diagram. The dotted

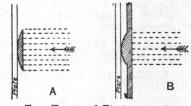

Two Forms of Photo-corrector

lines indicate light rays proceeding from the lens and falling upon the plate. Local reduction of size is produced by placing a plano-convex lens close to the plate and covering the part to be reduced. Used as at A, a halo would appear on the plate round the lens, and to overcome the difficulty the lens is embedded in a sheet of glass (see B) as large as, or larger than, the plate. By using lenses of different shapes and sizes—plano-concave and plano-convex—it is possible to produce a variety of effects. The accessory has not come into general use.

PHOTO-CRAYON

A style of portrait at one time popular; originated by Sarony, of Scarborough, in 1870. A transparency was made upon glass, finished in the usual way, and backed up with white paper on which crayon colours had been placed, the effect being that of a coloured photograph.

PHOTO - DYEING (See "Phototincture.")

PHOTO-ELECTRICITY (Fr., *Photo-électricité*; Ger., *Photo-elektrizität*)

Electrical phenomena excited by the action of light. The converse—optical phenomena set up by electrical action—are classified as belonging to electro-optics. Modern research leads to the conclusion that light and electricity are identical, a fact first asserted in 1864 by Clerk-Maxwell, according to whom light waves are due to magnetic and electric strains in the ether that pervades space. Maxwell prophesied that, under suitable conditions, magnetic waves could be propagated through space with the same speed as those of light. This was experimentally verified by Heinrich Rudolph Hertz, in 1888, who proved the existence of electrical waves, of similar velocity to those of light, and, although invisible, capable likewise of reflection, refraction, diffraction and polarisation. These waves were turned to practical account in G. Marconi's system of wireless telegraphy (1895). In the same year Konrad Wilhelm Röntgen showed that invisible electric rays of another kind—the X-rays—were able to penetrate opaque substances, forming an image or shadow on a photographic plate. A familiar instance of an electrical effect influenced by light is afforded by the behaviour of selenium, the resistance of which to the passage of an electric current is greatly reduced when light impinges on it—a fact utilised for the telegraphic transmission of photographs.

PHOTO - ELECTROGRAPH (Fr., *Photo-électrographe*; Ger., *Photoelektrograph*)

An apparatus used by meteorologists to obtain a photographic record of variations in the electrical condition of the atmosphere, as indicated by the movements of a sensitive gold-leaf electroscope.

PHOTO-ELECTROTYPE (See "Electro-phototypy" and "Electrotyping.")

PHOTO - ENGRAVING, AND PHOTO-ETCHING

Synonymous terms applied generally to line and half-tone etching; fully discussed under many separate headings.

PHOTO-FILIGRANE (See "Filigrane.")

PHOTO-GALVANOGRAPHY (See "Galvanography, Photographic.")

PHOTOGASTROSCOPE (Fr., *Photogastroscope*; Ger., *Photogastroskop*)

An instrument employed in surgery for photographing the interior of the stomach, by means of a tube introduced down the throat and having a small electric lamp at one end to furnish the necessary illumination. Mirrors are utilised to transmit the image to the camera, an air supply tube inflates the stomach, and the lamp is kept cool by a water-circulating device.

PHOTOGENE

The name given by Gaudin in 1861 to a sensitive preparation made by him for coating upon glass or paper. "The name," he stated in *La Lumière* (April 15, 1861), "can be applied to any sensitive compound containing iodide of silver with excess of free nitrate of silver." He prepared photogene by dissolving silver nitrate in hot alcohol with a little water, adding it to collodion, and finally adding a few drops of iodised collodion. It was not satisfactory.

The word was also used by J. Moule to describe a pyrotechnic compound for burning in his lamp (patented February 8, 1857) for the purpose of taking photographs at night. The powder was composed of pure and well dried potassium nitrate 15 parts, flowers of sulphur 5 parts, powdered antimony sulphuret 1 part, and powdered red orpiment 2 parts. After well mixing, the powder was passed through a fine sieve.

PHOTOGENIC DRAWING, OR PHOTOGENY

The name given by Fox Talbot in 1835 to the results of his early experiments, which consisted in coating paper or white leather with a silver nitrate solution and obtaining thereon, by the action of light, images of leaves, etc. Talbot communicated his experiments and showed examples of his photogenic drawings to the Royal Society, on January 31, 1839, six months prior to the publication of Daguerre's process. The following description of the process of producing photogenic paper is adapted from his own words. Paper of a good, firm quality and smooth surface is dipped into a weak solution of common salt and water (25 grs. to the ounce) and wiped dry, by which means the salt is uniformly distributed. A solution of silver nitrate is spread on one surface only, and dried before a fire. This paper, if properly made, is suitable for all photogenic purposes. A sheet thus prepared is washed with a saturated solution of salt and then dried. It will be found, especially if the paper is kept for some weeks before the trial is made, that its sensibility is greatly diminished, and in some cases is quite extinct. But if it is again washed liberally with the solution of silver, it becomes again sensitive to light, and even more so than it was at first. In this way, by alternately washing the paper with salt and silver and drying, Talbot succeeded in increasing its sensibility to a degree that is requisite for receiving the images of the camera obscura. The prints were fixed in a strong solution of common salt, or in a solution of potassium bromide or iodide. Later improvements resulted in the introduction of the calotype process (*which see*).

PHOTOGLYPHIC ENGRAVING, OR PHOTOGLYPHY

A process of photogravure invented by Fox Talbot, but now entirely superseded by the Talbot-Klic process. The metal plate was coated with gelatine, sensitised with potassium bichromate, and exposed to light under a negative. It

was then dusted with finely powdered copal resin and warmed until this melted. When cold, the plate was treated with a suitable etching fluid, which soaked through those portions of the film unacted upon or only partially acted upon by light, attacking the plate underneath in proportion to the varying thickness and hardness of the gelatine.

PHOTOGLYPTIE

The French name given to the Woodburytype process.

PHOTOGRAM

By some people considered the correct name for a photographic picture of any kind. They contend that "graph" is a termination indicating the active verb, whereas "gram" indicates the noun. For example, "telegraph," to write at a distance; "telegram," the writing made at a distance. Several attempts have been made to oust the older term, but with small success.

PHOTOGRAMMETRY (Fr., *Photogrammétrie*, *Métrophotographie;* Ger., *Photogrammetrie*, *Messbildverfahrung*)

The science of measuring and surveying by the aid of photography. The camera is extensively used in the preparation of maps and for other topographical purposes. With a high-class lens free from distortion, a rigid camera and stand, and a fixed vertical position of the plate with regard to the lens, the size and arrangement of objects in the negative will bear a constant ratio to those of the original subject. If two or more photographs are taken, for instance, of any prominent building or natural feature from different standpoints, noticing carefully the part of the compass to which the camera is directed in each case, it is possible by means of the various points appearing in the resulting negatives or prints, and by a series of triangulations, to draw an accurate dimensioned plan. The camera for photogrammetric purposes is generally provided with levelling screws and a graduated circular scale at the base, while four fixed points are arranged at the back to register on each plate exposed the position of the horizontal line and of the lens axis. It is usual, also, for a magnetic compass and a theodolite to be attached to the camera.

The subject is too large to treat otherwise than briefly, but a few of the simpler formulæ used in photogrammetry may be quoted. It is assumed that the lens is at its principal focal distance from the plate and that the camera back is strictly vertical. Let O = height of object, I = height of image in negative or print, F = focal length of lens, and D = distance of object from lens, measured from nodal point. Then, to find height of object, $O = \dfrac{I\,D}{F}$. The width may be found in the same way, provided the plane of the object is known to be parallel to the focusing screen. If the size of the object is known the distance may be calculated, $D = \dfrac{O\,F}{I}$.

The distance and size of an inaccessible object may be found by taking two photographs at a measured distance apart, but each in line with the object—i.e. the latter should be central in both negatives. The distance apart may be measured either from the nodal point of the lens, or more conveniently from the focusing screen. Let S = the distance between the two standpoints, and I_1, I_2 = the heights of the two images in the photographs, then $O = \dfrac{S \times I_1 \times I_2}{F \times (I_2 - I_1)}$; while $D = \dfrac{OF}{I_1}$, or $\dfrac{OF}{I_2}$.

PHOTOGRANULOTYPE

An American process of graining an ordinary photographic negative by the application of the air brush, so that a granular negative image was obtained for printing on stone or metal.

PHOTOGRAPHY

The art of obtaining images by the chemical agency of light upon sensitive surfaces. The word itself cannot be traced farther back in English literature than the title of a paper read before the Royal Society by Sir John Herschel on March 14, 1839. Derived from φωτος, genitive of φαos or φωs, "light," and γράφω, "I draw." Hermann Schnauss, however, states that Nicéphore Niepce was the first who used the word photography, who indeed created it. On May 9, 1816, Niepce wrote to his brother Claude that it is not necessary that there should be bright sunshine when *photographing* objects out of doors.

PHOTOGRAVURE (Ger. and Fr., *Heliogravure*)

The process of photogravure as now generally understood and practised is that known as the Talbot-Klic process. Talbot's original method (*see* "Photoglyphic Engraving") with modifications is still worked in France. The following is an outline of the photogravure process :—A well-cleaned and polished copper plate is put into a dusting box, in which it receives a deposit of a fine dust of asphaltum or resin, which is next fixed by heating. A piece of carbon tissue is printed under a transparency and transferred to the grained copper plate on which the image is developed, and, when dry, etched with ferric perchloride in successive baths of varying degrees of strength (from 43° down to about 33° Beaumé). The weaker solutions penetrate the gelatine the most easily. After clearing off the resist the plate is seen to be etched in different depths in proportion to the tones of the picture, the shadows being deepest and consequently holding most ink. The plate is inked and printed from in the usual copper-plate manner.

PHOTO-HELIOGRAPH

A combination of telescope and camera used in solar photography. The exposure is made by the passage of a narrow slit.

PHOTOHYALOGRAPHY AND PHOTO-HYALOTYPY

Processes based on the transfer of the collotype image, described by G. Scamoni, of St. Petersburg. (*See also* "Hyalography.")

PHOTO - LITHOGRAPHIC TRANSFER PAPER

Paper coated with hardened gelatine for sensitising with potassium bichromate in order that

it may be printed under a negative to form a transfer. Ready-made photo-lithographic papers of excellent quality are obtainable, those of Jaffé, Albert, and Husnik being among the best known, and it does not pay the worker to prepare his own paper. The double transfer paper used in carbon printing answers well for transfers.

PHOTO-LITHOGRAPHY

Under this term is included a large number of processes which may be classified into two leading divisions—namely, transfer processes and direct processes, both of which may be subdivided into line and half-tone.

The transfer processes are all based on the principle that light acting on a bichromatised colloid, such as gelatine, will render the lines or other elements of the image capable of attracting greasy ink, whilst the other parts will repel it. The simplest method is to coat a good tough paper, such as bankpost, with gelatine, and after drying immerse it in a bath of potassium bichromate (usually about 5 per cent. strength). When dry, this sensitised paper is exposed under a line negative for a sufficient time. The paper is then thinly coated with transfer ink applied with a roller. On immersion in water, and by gentle rubbing with a tuft of cotton-wool, the surplus ink comes off, leaving the image in lines of ink. The print is dried, and is then ready for transferring to stone or metal. For half-tone work the paper may be exposed under a negative made through a ruled screen, or the half-tone may be formed by means of a reticulated grain, as in the papyrotint process.

In the direct process the stone or metal (usually zinc) is prepared with a sensitised coating of bichromatised glue, gelatine, or albumen, or with bitumen, exposed under either a line or half-tone negative, inked over if a bichromatised film, and developed with water; if a bitumen film it need not be inked, and it is developed with turpentine. The bitumen attracts the greasy ink so that the image can be rolled up for printing. To obtain grained half-tone images, various ingredients are added to the colloid coating, as in the papyrotint or Pretsch processes; or, in the case of bitumen, the image may be made to reticulate by dissolving the bitumen in a mixture of ether and alcohol.

In several processes of photo-lithography the image is prepared on a glass or metal plate similar to collotype, and transfers are pulled therefrom for re-transfer to stone or metal.

PHOTO-LITHOPHANE

The production of photographic transparencies from semi-transparent material (porcelain), the lights and shades of which depend on the greater or lesser thickness of the material employed. The photographic part in this process consists in the production of a swelled chrome-gelatine relief from a photographic negative, and a plaster-of-paris cast from it. The rest is done by the porcelain worker.

PHOTO-MECHANICAL PROCESSES (Fr., *Procédés photomécaniques;* Ger., *Photomechanische Verfahrungen*)

A term applied to all processes in which the action of light upon chemical substances is the means of preparing printing surfaces, from which many impressions can be made without any further assistance from light action. Generally, the photographic image is made capable of giving impressions in greasy inks by typographic or lithographic methods, but the term also includes Woodburytype, although the printing in this case is not done with greasy inks. Particulars of photo-mechanical processes will be found under the headings of "Collotype," "Photo-lithography," "Photogravure," "Half-tone Process," etc.

PHOTO-METALLOGRAPHY

A term applied to processes of printing from photo-mechanical images on zinc or aluminium by the lithographic method.

PHOTOMETER (Fr., *Photomètre;* Ger., *Photometer*)

An instrument for comparing the intensity of two light sources. (*See* "Sensitometry.")

PHOTOMETRY (*See* "Sensitometry.")

PHOTO-MEZZOTINT

A name given to the gum-bichromate process of Maskell and Demachy.

PHOTO-MEZZOTYPE

A fancy name for one of the early half-tone processes.

PHOTOMICROGRAPHY

The photography of minute objects by the aid of the microscope. The essential apparatus includes microscope and stand, lenses and camera, and it may be said that many kinds of hand cameras can be utilised. A stage or baseboard is necessary to receive the microscope and camera (with lens removed), which are placed in position on the stage as shown at A. A small platform is fixed on the stage to bring the lens

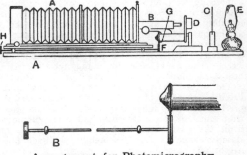

Arrangement for Photomicrography

flange of the camera, A, to the level of the microscope tube when the latter is brought over to a horizontal position. If a fairly long camera extension is used, the fine adjustment of the microscope will be out of reach of the hand; consequently a connecting-rod will be necessary for focusing purposes. A brass rod, B, fitted with a grooved wheel at one end and a milled head disc at the other may be fixed on the camera stage; the grooved wheel, F, is placed immediately

beneath the fine adjustment of the microscope and the milled head disc, H, below the focusing screen of the camera. A band or small strap G is placed over the groove of the fine adjustment of the microscope, and passed round the groove in the connecting-rod wheel. The image can then be focused by turning the milled head below the focusing screen. If the camera has a short bellows extension, no connecting-rod will be necessary, as the fine adjustment can be reached by the hand while the operator examines the image on the focusing screen. When transparent objects are photographed the light is placed behind the camera stage in a direct line with the objective and focusing screen. For low power work, an oil lamp, E, is a convenient illuminant. With high powers, the Nernst, incandescent gas, or acetylene lamp is preferable. As the mirror is not used, some kind of condenser is necessary to focus the light on the object. If no sub-stage condenser, D, is available, a bull's-eye condenser will answer the purpose.

For experimental purposes some well-mounted object with which the operator is perfectly familiar should be selected. Failing this, the wing of a house fly can be mounted (dry), and being very transparent, with opaque lines, is easily focused. An objective of low power should be used. The object is placed on the stage and focused; the eyepiece and draw-tube are removed, and the microscope brought over to a horizontal position. The inside of the tube must be lined with black paper, or the light reflected from the microscope tube will be found to give a flare spot on the plate. The microscope is now placed in position on the baseboard with the body-tube, B, projecting into the lens flange of the camera, the camera lens of course being removed. The photograph can be taken with the eyepiece in the microscope, but the consequent loss of light is considerable, and the difficulty of focusing proportionately increased. The lamp is placed in position behind the microscope, and the light is focused by the condenser on to the object.

When the focusing screen is examined no image of the object may be visible. The coarse adjustment is turned slowly to bring the objective nearer the object, and, when the image appears, sharp focus is obtained by means of the fine adjustment. If the lamp and condenser are properly arranged, the image will appear brightly and evenly lighted. If there is any unevenness of illumination, the position of lamp and condenser must be readjusted.

When the operations of arranging the illumination and focusing are completed, a dry plate is inserted in the dark-slide and a trial exposure made. No definite rules can be given for calculating exposure, but the following data of a trial exposure will assist the beginner in forming an estimate :—

Object photographed, head of gnat larva, clear specimen, mounted in Canada balsam ; oil-lamp, ¾-in. wick ; objective, ⅔ in. ; bull's-eye condenser, 1½ in. diameter ; distance of object from focusing screen, 26 in. ; distance of flame from object 7 in. ; rapid plate ; exposure, 10 seconds.

For photomicrography with high powers, a sub-stage condenser, a more powerful light, and for critical work a projection eyepiece are necessary. Colour filters, C, are often of great assistance in photomicrography, especially when, as sometimes happens, the visual and actinic foci of the objective do not coincide. In the older types of objectives this fault was not uncommon. A yellow screen will overcome this difficulty, but except orthochromatic plates are used, the exposure is unduly prolonged. Objects which have been stained with a blue or violet dye should always be photographed with a yellow screen. When opaque objects are to be photographed, unless the objective is furnished with a Lieberkühn, the light must be placed at the side of the object, upon which it is focused by means of a bull's-eye condenser. A strong light is necessary, and unless a Nernst or incandescent gas lamp is available magnesium wire should be used.

A Lieberkühn is a parabolic mirror, named after the inventor, for illuminating opaque objects. It is fitted on to the objective, which projects through the centre of the mirror.

The approximate comparative actinic values of the various illuminants are as follow :— Oil lamp, ¾-in. wick, 1 ; incandescent gas (new mantle), 15 ; Nernst, 20 ; acetylene, 30 ; arc lamp, 5 amps., 1,000 ; magnesium ribbon, 1,500. The oil lamp is somewhat feeble, and its yellow colour is a serious drawback. Incandescent gas is convenient, but in critical work some difficulty is caused by the pattern of the mantle. Acetylene gas gives perhaps the best all-round light, but the trouble of manufacturing the gas before beginning work militates against its popularity. The arc lamp is excellent ; small arc lamps for use with an ordinary 16 c.-p. plug and switch are now available. The Nernst lamp, with its small bright flame, gives an excellent light, but the filaments are fragile and are liable to give a troublesome image. The metallic filament electric lamp gives a fairly actinic light, but the long zigzag filament is a serious objection to its use. The use of ground glass or tissue paper to obviate the formation of a pattern is not satisfactory, as direct rays from a small illuminating area are essential.

Transparent objects or sections are photographed by transmitted light ; opaque objects by reflected light. In the former case the source of light is placed in a direct line with the objective and object, and the light, brought to a focus by some form of condenser, passes through the object into the lens. In the photomicrography of opaque objects the light is concentrated by means of mirrors or condensers upon the object, and is reflected by the object into the lens. Opaque objects require a much more powerful illuminant than transparent ones, and the difficulty of obtaining sufficient light renders the work extremely difficult. A method of illuminating opaque objects which is especially useful for high powers is by means of a cover-glass fixed diagonally inside the tube of the microscope. The light reaches the cover-glass through an aperture in the side of the body tube, and is deflected, from the surface of the glass, through the objective to the object, which reflects it through the microscope to the camera. Thus the light has to pass twice through the objective, in this way producing much scattered light, which mars the brilliancy of the image. J. I. P

PHOTOPHANE (Fr. and Ger., *Photophane*)

A fancy name given to the collotype process as worked by a London firm.

PHOTOPLASTIC

An electrotype obtained from a chromated gelatine photo-relief. (*See* "Galvanography, Photographic.")

PHOTOPOLYGRAPHY

A process resembling pinatype, but much older, having been described in 1897. A glazed paper is coated with gelatine, sensitised in a bichromate bath, dried, printed under a negative, and washed. The outstanding relief is stained with methyl violet, and the dyed image transferred by pressing into contact with ordinary paper.

PHOTOTOPOGRAVURE

The reproduction of maps by photographic means.

PHOTORADIERUNG

A German name for a process of coating a negative with a yellow varnish and scratching, with an artist's etching needle, through the film in lines which interpret the tones of the photograph. The numerous processes of this kind put forward may be classified under the term of "factitious negatives."

PHOTO-RELIEF ENGRAVING

A term given to processes in which, by photography and subsequent manipulation, a printing surface is obtained in which the parts receiving ink stand up in relief like type characters. Thus line and half-tone etched blocks may be said to be photo-relief engravings, but the term is properly applied to processes of making a hardened gelatine relief which may be printed from as in the Pretsch process, Dallas process, Husnik's Leimtype, and the swelled-gelatine process. The Woodburytype process is often termed a photo-relief one, although here the image itself is in relief, the printing block being an intaglio one. The acrograph process may be correctly described as photo-relief engraving.

PHOTO-ROTOSCOPE

An instrument on the old peep-show principle, for enabling a number of persons simultaneously to view animated photographs in daylight.

Also the name of a particular make of kinematograph machine invented by W. C. Hughes.

PHOTO-SCULPTURE

A term which had its origin in 1863, when the sculptor Willème, of Paris, patented his process and set up a studio for the work. He photographed his models with a number of cameras placed at the sides and top of a kind of building having a cupola : and he afterwards utilised the photographs in constructing the model, employing pantographs in order to facilitate his work. Poetschke, in 1891, improved the process, and Selke, a year later, substituted for the ordinary photographic apparatus the kinematograph, and projected on to the sitter a shadow which advanced progressively in the direction of the kinematographic camera. In this manner, according to Carlo Baese, the apparatus registered a considerable number of silhouettes corresponding to the number of parallel planes in the model. Each of these negatives, about 500 in all, had to be enlarged separately upon bromide paper, and each was then pasted upon card and cut out with scissors. When these silhouettes had been cut into sections, they were stuck one over the other, and so built up, it is said, to form the portrait, but exactly how it was done has not yet been made clear. The use of bichromated gelatine (discovered in 1851) is more satisfactory. (*See* "Relief, Photographs in.")

For artificial reliefs—that is, prints that appear to be in relief—*see* "Plastic Photographs." Carlo Baese, who has paid particular attention to the production of portraits in the form of medallions, works on the lines described under the first named heading, and secures better modelled effects than are possible in the ordinary way, by the use of an optical lantern and mirrors, by which he projects and reflects light upon certain parts of the face which it is desired to show in high relief. His process was described before the Royal Photographic Society, on October 11, 1910, and by its means wonderful results are obtainable.

The term "photo-sculpture" is also applied to a kind of trick photography. A sketch of a bust without the head is made, natural size, on a sheet of cardboard, which is then cut out or, preferably, a papier mâché arrangement may be purchased ready for use, and placed on a pedestal of a convenient height, the sitter being posed behind it in such a way that the living head "sits" realistically. A photograph is next taken. Parts of the image that are not required may be scraped from the dry negative, or a print is made, blocked out with black or red water-colour paint, and copied in the camera. Another method is to cover the parts (arms, etc.) of the figure not required with a black cloth. The background should be quite black, and it may be necessary to powder the hair, eyebrows, etc., to give them, in the photograph, the appearance of stone.

PHOTO-SENSITIVE

A term applied to a substance that is sensitive to light.

PHOTO-SPECTROSCOPY (*See* "Spectro-photography.")

PHOTO-STEREOTYPE

A stereotype made from a plaster cast taken from a gelatine relief. (*See* "Swelled Gelatine Process" and "Wash-out Gelatine Process.")

The term has also been applied in America to a block made by reproducing a drawing obtained from a photograph by the bleaching-out process.

PHOTOSTONE

A photo-chromo-lithographic process worked by an English company some years ago. It is understood that transfers were pulled from a collotype plate and put down on as many zinc or aluminium plates as colours were required. These plates were worked on by artists to stop out or remove all but the parts required to print

the particular colour for which the plate was to be worked.

PHOTO-SURVEYING (See "Photogrammetry.")

PHOTOTEGIE

A process introduced by Cousté, in 1904, for making transparencies, and reversed or duplicate negatives. The negative should be exposed as usual and developed with any developer except pyro till the deepest shadows are seen on the back of the film; it is next well washed, and the following operations may then be conducted in daylight. Make up a solution of—

Hydrochloric acid	. 1 oz.	100 ccs.
Barium peroxide	. 250 grs.	57 g.
Water . .	. 10 oz.	1,000 ccs.

This should be mixed in a glass bottle, standing in cold water to keep it cool; add the acid to the water, and then the barium in small quantities at a time, with constant stirring or shaking. The developed negative (not fixed) should be immersed in this solution, which should be kept rocked. The film begins to dissolve gradually, and as soon as this has well begun the barium solution is poured back into the bottle and the negative placed in water. The gelatine and reduced (developed) silver slowly dissolve away, and should any of it stick it can easily be rubbed off with a pad of cotton-wool, or the finger tip, or the barium solution may be again poured on. The result is an image consisting of various thicknesses of gelatine and unreduced (undeveloped) silver salt. The last named can be dissolved out in an ordinary fixing bath, and after well washing, the film should be stained in a solution of dye. Or, if desired, the unreduced silver may be left in the film and redeveloped with any ordinary developer. For making duplicate negatives, it is first necessary to make a positive by contact and treat this in the manner described above, so as to reverse it—that is, turn the positive into a negative. The dyed gelatine relief serves as a negative or a positive as the case may be, the dense parts being dyed deeper than the clear parts where the gelatine is thin.

PHOTO-TELEGRAPHY

The transmission of a photographic image from one place to another by means of telegraphy. The idea of telegraphing pictures dates back to 1860, and even earlier, but it is only during the last few years that any successful results have been obtained commercially.

There are two systems which have been used extensively by newspapers: one is the invention of Prof. Korn, who was the first to produce a really practical system; the other is the invention of T. Thorne Baker.

Professor Korn's Systems.—(1) By means of the original selenium process, the photograph to be telegraphed is printed as a transparency on celluloid, and this film is attached to a glass cylinder, C in diagram A. Light from a Nernst lamp N is made to pass, by the lens L, through the cylinder where the beam comes to a focus; what light passes through the cylinder reaches a prism P, and is reflected on to a selenium cell

s s. As the cylinder is rotated spirally (by means of a motor) different consecutive portions of the image intercept the light beams, and hence the intensity of the illumination falling on the cell s s varies. The cell has the peculiar property of varying in its electrical resistance, according

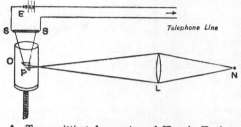

A. Transmitting Apparatus of Korn's Early Photo-telegraphy System

to the strength of light falling upon it; hence the current from an electric battery, E, which passes through the cell into the telephone lines connecting the sending apparatus with the receiver, also changes, and at the receiving apparatus, B, one gets an electric current varying in intensity each instant, according to the density of the photograph, as the image is traversed by the beam of light. The current received is passed through an exceedingly fine silver wire W suspended between the poles of a powerful electromagnet M; to this wire is attached a small shutter, which cuts off a beam of light passing from a lamp N through lens L and a hole in the magnet poles. When a current passes through the wire W it is magnetically displaced, and light consequently passes through the magnet and arrives at a lens T, which concentrates it upon a sensitive film attached to a drum D; this drum rotates in a light-tight box synchronously with the transmitting cylinder, C in diagram A. The wire, W W, is displaced to a distance depending on the current, which itself is regulated by the density of the photograph at each instant. Hence, the light acting on the sensitive film varies always according to the density of the picture being transmitted. On developing the

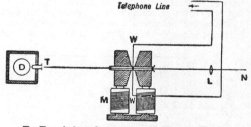

B. Receiving Apparatus of Korn's Early Photo-telegraphy System

film, a replica of the original photograph is obtained. There are, of course, various electrical complications in the process, but these need not be dealt with here.

(2) Prof. Korn's more recent apparatus is his telautograph, by means of which half-tone

photographs prepared with a single-line screen can be telegraphed. The photograph is printed in fish-glue on a thin copper sheet, developed, and attached to the metal drum, D, in diagram C.

A metal stylus s traces a spiral path over the photograph, and as it travels over each glue line

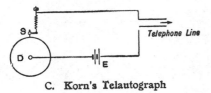

C. Korn's Telautograph

the flow of current from a battery, E, through the cylinder and stylus is interrupted. The same form of receiving apparatus is used, but a great many improvements have been made in the galvanometer used, with the result that a picture 7 in. by 5 in. can be telegraphed in a few minutes, with as many as 150 lines to the inch.

T. Thorne Baker's System.—The telectrograph has been largely used commercially between Manchester, London and Paris. Its great advantage over other systems is that it does away with the reception on a photographic film. The whole operation, therefore, is conducted in full light, and the image can be watched during its entire reception. A portable transmitter was designed in 1910 by the inventor, and this was used between Brighton and London in that year. The system is shown diagrammatically at D. A and B are the metal cylinders of the transmitter and receiver. A is provided with a steel stylus s, and B with a platinum stylus T. A half-tone single-line photograph printed on lead foil and pressed perfectly smooth is attached to A, and a piece of chemically prepared paper is wrapped round B. The battery E supplies the electric current. Whenever the steel stylus is in contact with the metal of the picture, that is, when it is not travelling over a glue line, current flows through the wires to the receiver, and a black dot appears under the stylus T. The original picture is thus reproduced, dot for dot, at the receiving machine, and a picture 8 in. by 5 in. can be transmitted in from ten to fourteen minutes. The system is explained here in its simplest form ; in practice, the receiving apparatus is complicated, owing to the fact that the electric currents, in passing through long-distance wires, become lengthened in period and

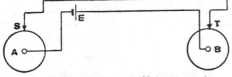

D. T. Thorne Baker's Telectrograph

changed in intensity, with the effect of distorting and blurring the received photograph. The various difficulties have been overcome by means of the line balancer invented by T. Thorne Baker, to which the success of a system based on many earlier attempts has been due.

PHOTOTINCTURE

Villain's process, invented in 1891, for the production of photographs on fabrics and paper by means of dyes. The fabric is sensitised by a few seconds' immersion in a solution of—

Ammon. bichromate	.	5 oz.	550 g.
Ammon. vanadate	.	240 grs.	55 ,,
Water	. .	10 oz.	1,000 ccs.

The material is dried in the dark at a temperature not exceeding 75° F. (24° C.), for at 85°F. (29° C.) the transforming action begins and shows itself by veiling the whites. The dried material is exposed to daylight under a negative, the time being found by experiment, the image being visible, and washed to eliminate the chromium salt not acted upon by light, leaving the fabric mordanted where exposure has fixed upon it the chromium and vanadium oxides. Next the fabric is boiled in a dye bath, preferably of alizarine or purpurine, this being gradually heated to boiling point, at which it is maintained for fifteen minutes. The fabric is then washed and, if the whites are not pure, passed through a warm bath of soap and sodium carbonate, or a cold bath of chloride of lime to which has been added a few drops of hydrochloric acid, it being necessary before drying to drive out every trace of the acid by the use of a bath slightly alkaline. The fabric is finally washed and dried. The dyes fix themselves only on the parts where the mordant is fixed ; and the parts where the light has not acted (high lights) will give the whites, unless the materials were impure or a mistake has been made. The colouring products used by Villain were the artificial alizarine sold under the name of alizarine for violet, alizarine for red ; alizarine blue S ; alizarine black S ; gallo-flavine ; purpurine ; anthracene brown (anthogallol) ; alizarine orange ; alizarine yellow A ; alizarine chestnut ; alizarine green S ; alizarine blue indigo S, and galleine.

PHOTOTINT

A name given both to a collotype and a half-tone block process. Cocking's process of phototint consisted in printing from two negatives, one being an ordinary photographic negative and the other prepared by hand. Striking effects of light and shade were thus produced.

PHOTOTYPE

A name formerly given to a secret process of carbon printing invented by Joubert ; has since been applied to collotype, and also to half-tone blocks.

PHOTO-TYPOGRAPHY

A general term applied in photography to a large number of processes in which relief printing surfaces for letterpress printing are produced by the aid of the chemical action of light.

PHOTO-VERROTYPE

A modification of the collotype process, worked about the year 1870.

PHOTO-XYLOGRAPHY

Processes of photographing on boxwood blocks as a guide for the engraver instead of drawing the image. The blocks may be prepared

with albumen and sensitised on a silver nitrate bath; or a silver emulsion may be spread on the block; or a carbon tissue may be developed upon it; or a film, developed on a glass plate, may be transferred to it; or a greasy ink transfer may be applied.

PHOTO-ZINCOGRAPHY

A process worked out by Col. Sir Henry James at the Ordnance Survey Office in Southampton, and at first simply a method of preparing a photo-lithographic transfer and applying it to a zinc plate, afterwards printed from. Direct prints from negatives are now made on the zinc plates, and the Vandyke process is largely employed for map and plan work. In this process the original drawing is printed through, instead of using a glass negative.

PHOTO-ZINCO PROCESS

Line etching on zinc was originally called by this name, but the term is not now often used.

PHOTO-ZINCOTYPY

Ordinary line etching on zinc.

PHYSICAL DEVELOPMENT

The formation of the image by chemical deposition *on* the film of the plate, instead of by a chemical decomposition of the haloid salts *in* the film, as is generally the case. For example, in the wet collodion process the silver image is not formed from the bromides or iodides in the film, but by reduction of the silver nitrate sensitising solution on the surface by the ferrous sulphate developer, the latent image forming in some way a nucleus for this deposition, although not itself reduced. Another instance is afforded by the possibility of developing a gelatino-bromide plate after it has been fixed, by means of an alkaline developer containing silver nitrate (*See also* "Fixing Before Development.")

PHYSIOTYPE

Nature printing from leaves, flowers, etc.

PICRIC ACID (*See* "Tri-nitro-phenol.")

PICTORIAL COMPOSITION (*See* "Composition, Pictorial.")

PIGMENT PLASTER

A paper coated with a mixture of soft gelatine and pigment. It resembles insensitive carbon tissue, and is used in the ozobrome process.

PIGMENT PROCESSES

Various printing processes in which the image is formed of a pigment primarily embodied in a sensitive support—for example, carbon, ozotype, gum-bichromate, and similar processes. A. L. Poitevin, in 1855, was the first to suggest the use of a pigment with chromated gelatine or its equivalent. J. Pouncy, of Dorchester, followed in 1858; he used a vegetable carbon with gum and potassium bichromate, and is supposed to have been the first to produce a really successful pigment (carbon) print. Beauregard patented a method of obtaining pigment prints in 1857. In the dusting-on process, pigment is applied after exposure.

PIGMENTING

Under the headings "Oil-pigment Process" and "Bromoil" have been indicated the means by which a print is obtained in gelatine relief, and in each case it remains to produce the actual picture by the application of a pigment or ink.

At least one brush of pole-cat hair, of fair size, is necessary, and smaller brushes will be found useful for local work. A small quantity of ink (a piece the size of a pea will be ample for even a 12 in. by 10 in. print) is taken and rubbed down with the palette knife on a piece of clean glass or opal until of such a consistency that it can be spread on the glass in a thin film. If the pigment is too hard it may be thinned down with a softer ink, or with a trace of megilp or Roberson's medium. A thick ink tends to give hardness and brilliance, a thin ink softness. Black and Venetian reds are useful pigments, as by their use colours can be obtained ranging from black, through warm black, sepias and browns, up to red. The print is pigmented on a support made as follows: The foundation is a sheet of glass or zinc, or a pulp slab; over this are placed two or three smooth sheets of wet blotting-paper; and on top is stretched a piece of damp muslin. The soaked print is placed on this, and the moisture removed from the gelatine surface by gently wiping with a moistened pad of soft linen. A brush is now dabbed once or twice on the film of pigment, and then on a clean portion of the glass. The object is to secure that each hair-tip holds a minute trace of pigment. The charged brush is then applied to the print with a gentle dabbing motion, and if all is right the image will gradually appear as the gelatine accepts or rejects the pigment in accordance with the light action that has taken place on the bichromated gelatine. The print must be worked upon patiently and systematically all over. It is best after each re-charging of the brush to work first on the stronger parts of the subject and then pass to the more delicate parts (such as the sky) when the pigment in the brush is diminished Gentle brush action and a thin ink will cause the print to accept colour more readily than a more vigorous dabbing and thicker pigment. High lights may be brightened by taking a clean flat-cut brush and "bouncing" or "hopping" it vertically on to the print. The more patiently the ink is applied in small quantities by continued and gentle dabbing the finer will be the deposit and the better the gradations of tone. Variations in brush action, the use of pigment of a different consistency, the ability to lighten or strengthen parts locally, all provide means of exercising control over the final result. But the beginner would be well advised to direct his efforts at first to obtaining "straight" prints with a fine deposit and a full scale of gradations.

The finished print is hung up to dry. The ink will set almost as soon as the paper is dry, but the prints should be carefully handled until the image is thoroughly hardened. The brushes should be cleaned immediately after use. This is easily done by rubbing their surface on a piece of fluffless material moistened with petrol. The blotting-paper should also be dried after use or it will develop mould.

PIGMOIL

A somewhat inharmonious term invented to indicate the oil-pigment process (*which see*).

PINACHROME (*See* "Isocyanines.")

PINACHROMY (Fr. and Ger., *Pinachromie*)

Koenig's three-colour printing process introduced in 1904 by the Hoechst Dye Works, founded upon the light-sensitiveness of the leuco bases of aniline dyes. These are colourless bodies formed by the reduction of dyes especially of the triphenyl-methane series, and differing from them by the addition of two hydrogen atoms; they oxidise, or in other words form dyes, much more quickly in light than in the dark. Ostwald Gros was the first to discover the light-sensitiveness of these bodies, and that they became strongly coloured, more especially by those rays which were complementary to the colour of the dyes from which the leuco bases were formed. The leuco bases were dissolved in collodion to which was added nitro-glycerine, nitro-mannite, or some other nitrogenous body, and then printed under the constituent negatives one after the other, a different leuco base being coated between each printing. The process is theoretically interesting but practically valueless, as the colours formed were not stable to light, and the stock leuco base solutions extremely fugitive.

PINACYANOL

A dye of the isocyanine group, used for colour-sensitising plates. It gives sensitiveness up to the extreme visible red.

PINAKOL (*See* "Amido-acetic Acid.")

PINATYPE (*See* "Three-colour Photography.")

PINAVERDOL (*See* "Isocyanines.")

PINHOLE PHOTOGRAPHY

Photography by means of a pinhole camera, that is, a camera in which (*see* A) instead of a lens there is a small hole made by a needle in a metal plate, card, etc. If a pinhole is pierced through one side of a light-tight box, the light rays proceeding from any object (say a candle flame) placed in front of the hole will form an image of the object on the opposite wall of the box inside; the size of the image depends upon its nearness to the camera, and its distinctness or definition depends upon the size of the hole. Photographs obtained through a pinhole possess a pleasing softness of outline, distortion is absent, and any angle may be included upon the plate, a wide angle by having the hole near the plate (*see* A) and a narrow angle by having the hole farther from it (*see* B). On the other hand, the definition is not critically sharp, and the necessary exposure is so long that it is impossible to photograph moving objects. Within certain limits a pinhole has no plane of focus, as proved by the fact that results practically as good as one another can be obtained by having the sensitive plate at different distances from the hole.

Any camera may be used for outdoor pinhole photography, as may also any light-tight box, but the former has the advantage that the distance between pinhole and plate is easily altered, remembering that, while this is not necessary for focusing, the shorter this distance the greater the angle of view, and consequently the more of the subject included upon the plate. For indoor work, failing a regular camera, any light-tight box C may be used, the plate being supported by means of a printing frame or drawing pins.

The pinhole must be circular, with perfectly

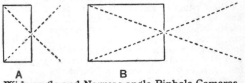

A B

Wide-angle and Narrow-angle Pinhole Cameras

clean edges without the slightest burr; at its edges the thickness of the material must be less than the diameter of the hole. The presence of a burr on the edge would give precisely the same effect as photographing through a tube, namely, to limit the angle included. A pinhole of $\frac{1}{12}$ in. diameter bears the same relation to metal $\frac{1}{24}$ in. thick that a 1-in. lens bears to a tube 4 in. long. The reflections from the interior of the hole in a comparatively thick plate of metal would also interfere with the brightness and definition of the image. Tinfoil is the material often used, but it is very fragile when mounted up in place of the lens. Many prefer to use thin brass, in which a boss (*see* D) has been made by means of a steel punch. The boss is rubbed or filed down and the pinhole made through the thinnest part (*see* E). The "pin"-hole is best made with a needle, which should be inserted gradually and alternately from both sides of the hole so as to obviate burr. Any other way of making the hole may be adopted as long as the result is a circular hole with clean edges.

The effect of the distance between plate and hole has been referred to. The diameter of hole should vary with the distance, and the rule proposed by Sir W. Abney is very useful in this connection. To find the diameter of the hole, divide the square root of the distance by 120. To find the distance, multiply the diameter of the hole by 120 and square the result. Thus, assuming the distance to be 25 in., the square root

C. Improvised Pinhole Camera Production of Pinhole in Metal Plate

is 5, and this divided by 120 equals $\frac{1}{24}$ in., which is the diameter of the required hole. In the case of a hole $\frac{1}{40}$ in. in diameter, the distance will be 9 in., since $\frac{1}{40} \times 120 = 3$, and $3^2 (3 \times 3) = 9$. But extreme latitude is possible because of the great depth of focus.

With regard to determining the diameter of the pinhole, it may be measured more conveniently if pierced with a needle of standard size The following table is based on Abney's rule :—

Size of Pinhole	Distance of Plate from Hole	Ratio of Aperture to Focal Length or Distance
in.	in.	
$\frac{1}{100}$	1½	f/150
$\frac{9}{1000}$	2	f/180
$\frac{8}{1000}$	2¼	f/180
$\frac{7}{1000}$	3	f/210
$\frac{6}{1000}$	4	f/240
	5	f/250
$\frac{4}{1000}$	7	f/315
$\frac{4}{1000}$	9	f/360
$\frac{3}{1000}$	11¾	f/411
$\frac{3}{1000}$	16	f/480
$\frac{2}{1000}$	23	f/575
$\frac{2}{1000}$	36	f/720

The following tables of needles, their sizes and diameters, are due to Messrs. Alfred Watkins and E. J. Wall :—

Hall & Co.'s Needles		Kirby & Co.'s Needles	
Number	Diameter	Number	Diameter
	in.		in.
1	$\frac{1}{22}$	2	$\frac{1}{25}$
2	$\frac{1}{23}$	3	$\frac{1}{27}$
3	$\frac{1}{28}$	4	$\frac{1}{30}$
4	$\frac{1}{28}$	6	$\frac{1}{35}$
5	$\frac{1}{31}$	7	$\frac{1}{47}$
6	$\frac{1}{34}$	9	$\frac{1}{60}$
7	$\frac{1}{39}$	10	$\frac{1}{80}$
8	$\frac{1}{44}$	12	$\frac{1}{77}$
9	$\frac{1}{49}$	16	$\frac{1}{84}$
10	$\frac{1}{54}$		

For most practical purposes pinholes of $\frac{1}{50}$ in., $\frac{1}{75}$ in., and $\frac{1}{100}$ in. will be sufficient, and they can be used at any distance from 1½ in. to 30 in., although theoretically the respective distances are 5 in., 2¼ in., and 1½ in. The largest hole will be useful for all out-door work, the medium hole for architecture, both interior and exterior, and the smallest for copying and short focus work.

The pinhole having no definite plane of focus it is obviously unnecessary to focus on a ground glass, but the photographer will need to know the amount of view included upon the plate. The amount of light coming through the pinhole is generally so small that it will not be easy to examine the image on the ground glass. By far the most practical plan is to take a piece of millboard just large enough to slide into the grooves in which the dark-slide is usually carried, and in the card to cut an aperture the size and shape of the plate used. If a half-plate is used in a half-plate camera there will be no need for the card, but smaller plates than the camera usually takes are often used for ex-perimental pinhole work. Turn back the focusing glass from the camera, slide in the card (if necessary), direct the back of the camera towards the view, and look through the pinhole from the front. It is then possible to judge the suitability of the pinhole, and, by racking in or out, the amount of view included. Then swing round the camera, insert the plate, and make the exposure.

The usual method of exposing is to fit the pinhole in a pill-box arrangement, using the lid as the cap, or to fit a flap or revolving disc over the pinhole. In the first of the tables the ratio aperture (" stop value ") is given for a certain extension of the camera ; if any other extension is used the ratio aperture must be found by dividing the distance between pinhole and plate by the diameter of the pinhole. The usual law relating to exposure holds good, namely, that the exposure varies as the square of the aperture number ; thus, if a lens working at f/8 requires a quarter of a second, with f/600 the exposure would be $\frac{\frac{1}{4} \times 600^2}{8^2} = \frac{\frac{1}{4} \times 600 \times 600}{8 \times 8} =$ (approx.) 1,400 secs. = (approx.) 24 minutes.

The calculation of the exact exposure fortunately does not matter so very much, as, owing to the smallness of the aperture, there is an immense amount of latitude.

PINHOLE THEORY IN HALF-TONE WORK

The formation of the half-tone dot on the negative is explained in the pinhole theory, it being assumed that each opening in the network of the ruled screen acts as a pinhole.

PINHOLES IN NEGATIVES

Small transparent spots in the image and gelatine on the negative generally caused by dust. (*See* "Dust Spots.")

PINT

In British measure this is equal to 20 fluid ounces (160 drams, or 9,600 minims), and the eighth part of a gallon. In America the pint is equal to 16 fluid ounces (128 drams, or 7,680 minims). One pint (British) equals 568 ccs. and the American pint 454·5 ccs.

PIPETTE

A glass tube drawn to a point at one end; used for measuring small quantities of liquids. (*See also* "Dropping Tube.")

PITCHBLENDE

Synonym, uraninite. A native ore containing uranium, helium, radium, and other rare elements. It is the main source of uranium salts.

PITCH, BURGUNDY

A resinous pitch used in etching inks and etching grounds. (*See* "Burgundy Pitch.")

PITCH, JEW'S

Bitumen of Judea or asphaltum (*see* the last named).

PITCH, MINERAL

A synonym for asphaltum or bitumen.

PITS IN NEGATIVES

Holes in the gelatine film on negatives, fortunately rare, but sometimes found after drying; they must not be confused with pinholes. They vary in size from a pin's-head to a threepenny piece, and usually appear at a time when the air is laden with moisture and the negatives take a long time to dry. They are said to be due to the decomposition of the gelatine, and the best preventive is to soak the negative after washing in a 10 per cent. solution of formaline.

PIZZIGHELLI'S PROCESS

In this is used a print-out platinum paper invented by Capt. Pizzighelli, of Vienna, in 1887. The exposure may be judged as accurately as with ordinary P.O.P., and development of the paper is unnecessary. Any good plain paper may be used, and the sensitiser may be as follows :—

A. Potass. chloroplatinite	734 grs.	168 g.
Distilled water	10 oz.	1,000 ccs.
B. Ammonium ferric oxalate . .	3¾ oz.	412 g.
Powdered gum arabic	3¾ ,,	412 ,,
Potass. oxalate (5 % sol.)	7 ,,	700 ccs.
Glycerine . .	100 mins.	21 ,,

Heat the potassium oxalate solution to about 115° F. (46° C.), and dissolve in it the ferric salt and glycerine; then add to the gum and stir well.

C. Solution B . .	3½ oz.	1,000 ccs.
Potass. chlorate (1 in 20 sol.) . .	135 mins.	80 ,,
D. Potass. oxalate (5 % sol.)	11 drms.	535 ccs.
Merc. chloride (5 % sol.)	338 mins.	200 ,,
Gum arabic (powdered)	370 grs.	242 g.
Glycerine . .	34 mins.	20 ccs.

C and D are sensitive to light and should be kept in the dark. For black images, sensitise the plain paper with the following :—

A solution (platinum) .	100 mins.	100 ccs.	
B solution (iron and gum)	120 ,,	120 ,,	
C solution (gum and chlorate) . . .	40 ,,	40 ,,	

For sepia prints use—

A solution . . .	100 mins.	100 ccs.	
C solution . . .	80 ,,	80 ,,	
D solution . . .	80 ,,	80 ,,	

Lay the paper on a sheet of glass, working in a yellow light, and apply the sensitiser with a pad of cotton-wool. Dry quickly and preserve in a calcium tube. Print under a negative in daylight until the image is fully out, and then clear by passing through dilute hydrochloric acid (1 in 80); finally wash for from fifteen to twenty minutes in clear water.

The time of printing Pizzighelli paper may be shortened if, after the deepest shadows have appeared, the prints are developed in a cold 5 per cent. solution of potassium oxalate or common washing soda. The following bath has also been recommended in place of the hydrochloric acid bath : Copper sulphate, 154 grs.; water, 34 ozs. The Pizzighelli process cannot be depended upon for regular tones.

Pizzighelli also invented a paper of the " Pellet " type. (*See* " Pellet Process.")

PLAIN (SALTED) PAPER PRINTING

This employs a paper sensitised by immersing in a soluble chloride, and floated afterwards in a bath of silver nitrate. The paper is either only slightly sized or not sized at all, with the result that the original surface or texture of the paper is retained, and the prints appear to be on plain paper, hence the term. Such papers are printed out under a negative in daylight, and then toned and fixed. Good writing paper serves well for small prints and Whatman's or any other good drawing paper for large ones. When sizing is omitted some workers add just enough potassium bichromate to the salting solution to colour it faintly.

Arrowroot and gelatine sizes appear to be the most popular. For the latter use—

Gelatine . . .	100 grs.	23 g.	
Chrome alum . .	4 ,,	1 ,,	
Ammonium chloride .	50 ,,	11·5 ,,	
Water . . .	10 oz.	1,000 ccs.	

The gelatine is soaked for thirty minutes in 8 oz. of the water (cold) and the chrome alum dissolved in the remaining 2 oz. The gelatine is next heated on a water bath, the ammonium chloride stirred in, the whole strained through fine muslin, the chrome alum solution poured very gradually into it, and the whole stirred. It is now ready for coating upon the paper, and should be stood in hot water to keep it fluid. The paper is pinned to a flat board or laid upon glass and weighted at the corners. The salting solution is sponged on as quickly and as evenly as possible, being finally gone over with a squeezed sponge to remove superfluous solution. Three minutes should be ample time in which to salt a 20-in. by 16-in. sheet ; and the quantity of solution above given can be made to coat ten such sheets. They should be kept flat for a few minutes until the gelatine has penetrated, and then hung up to dry in a warm place. The prepared paper will keep good for several months.

When required, the paper is sensitised with a silver nitrate solution :—

Silver nitrate . .	600 grs.	138 g.	
Citric acid . .	300 ,,	69 ,,	
Distilled water . .	10 ozs.	1,000 ccs.	

Sensitising is done in a weak or yellow light' and the mixture is applied by floating, or preferably by brushing, and not by total immersion. Any brush used must be in wood and not in metal. Apply the sensitiser evenly and liberally, and hang the coated paper in a warm dark place for about ten minutes in order that it may become surface dry, and then repeat the application in order that there may be an excess of silver nitrate, which is necessary for rich and brilliant prints.

Printing can be done from almost any kind of negative, thin or flat ones being the least suitable. The prints lose but little in toning and fixing, therefore the printing need not be carried very far beyond the result desired. When taken from the printing frames, the prints should be well washed, say, for fifteen minutes, to remove the acid and free silver salt, and are then

ready for toning, for which any gold or platinum bath may be used if weakened with water, the following being specially recommended :—

Sodium acetate	.	. 30 grs.	4 g.
Gold chloride	.	. 1 gr.	·13 ,,
Water 16 oz.	1,000 ccs.

Mix about twelve hours before use. Toning is very rapid, one minute's immersion giving, as a rule, the best brown or sepia tones. Overtoning is the commonest cause of failure, but as prints always dry a colder tone than they appear when wet, allowance should be made. The toned prints should be placed in a solution of ½ oz. of common salt in 60 oz. of water, in order to stop the toning action ; they are next washed for a few minutes, fixed for ten minutes in a "hypo" bath, and finally washed again. *Alternative Baths.*—The following is a good sensitiser :—

Silver nitrate	.	. 600 grs.	138 g.
Water 10 oz.	1,000 ccs.

Add liquor ammoniæ drop by drop, until the precipitate first formed is dissolved.

The following sensitiser is suitable for papers sized with arrowroot; in the case of agar-agar papers the citric acid should be increased to 100 grs. or 117 g. :—

Silver nitrate	.	. 140 grs.	164 g.
Citric acid	.	. 55 ,,	64 ,,
Distilled water	.	. 2 oz.	1,000 ccs.

Alternative toning baths are as follows :—

1.
Potass. chloroplatinite	20 grs.	4·5 g.
Nitric acid	. 10 mins.	2 ccs.
Distilled water	. 10 oz.	1,000 ,,

Tone and fix as usual.

2.
Citric acid	.	. 36 grs.	8 g.
Common salt .	.	12 ,,	2·7 ,,
Potass. chloroplatinite	1 gr.	·23 ,,	
Distilled water	.	. 10 oz.	1,000 ccs.

Tone and fix as usual.

3.
Borax	.	. 30 grs.	7 g.
Gold chloride .	.	½ gr.	·1 ,,
Distilled water	.	. 10 oz.	1,000 ccs.

Use as soon as mixed; tone and fix as usual.

4.
Sodium phosphate .	10 grs.	2 g.
Gold chloride .	. ½ gr.	·1 ,,
Water .	. . 10 oz.	1,000 ccs.

Use as No. 3, above.

The following is a plain paper which may be called "self-toning," as excellent tones may be obtained simply by fixing in a 2½ per cent. solution of "hypo"—say, 12 grs. to 1 oz. of water. The paper (without water-marks) is given an extra coating of size, made by rubbing up 90 grs. of arrowroot with 5 oz. of cold water, adding a solution of 20 grs. of glucose in 5 oz. of hot water, and boiling in an enamelled saucepan for two minutes. When cool, immerse the paper till thoroughly saturated, dry, and sensitise with

Nelson's gelatine	.	. 60 grs.	14 g.
Tartaric acid.	.	. 80 ,,	18·5 ,,
Silver nitrate	.	. 90 ,,	21 ,,
Ferric ammonio-citrate	. 400 ,,	920 ,,	
Water 10 oz.	1,000 ccs.

The solution, made as described earlier in this article, should be stored, if required, in a black bottle. After proceedings are as already described.

PLANAR LENS

A lens of symmetrical construction consisting of two three-lens combinations, two glasses of each being cemented and the third separated by an air space (*see* illustration). The smaller sizes are especially useful for photomicrography,

Planar Lens

while the larger ones are suitable for all classes of rapid work, portraiture, etc. There is an apochromatic series suitable for three-colour work. Planars are made by Zeiss in a range of focal lengths from ¾ in. to 18¼ in., while the intensity varies from *f*/3·6 to *f*/6·3.

PLANE TABLE (Fr., *Planchette photographique ;* Ger., *Photographisch Messtisch*)

A panoramic camera invented by Chevalier and used in surveying by photography. A vertical lens fitted with a reflecting prism or mirror was made to revolve above a horizontal plate, a complete circular picture of the surrounding country being thus obtained. To prevent overlapping, a revolving disc with a narrow radial slit moved over the plate in synchronism with the motion of the lens, its centre being in line with the lens axis.

PLANES (Fr., *Plans ;* Ger., *Flächen*)

The different positions or distances occupied by the various parts of a subject. The nearer planes contain the strongest light and shade and the most pronounced detail ; as the planes recede, the detail, light, and shade become less apparent. The adequate rendering of the values of the various planes produces good aerial perspective. Lighting and the state of the atmosphere influence the tone and quality of the planes. Lack of differentiation between one plane and another gives an appearance of flatness.

PLANISCOPE (Fr., *Planiscope ;* Ger., *Planiskop*)

A series of supplementary lenses intended to be placed in front of an ordinary camera lens, to shorten or increase the focal length. Four different kinds are obtainable, for wide-angle, copying, portrait, or telephoto work respectively, and each consists of a single achromatic lens mounted in a metal rim provided with two bow springs, by means of which the planiscope may be fitted on the hood or body of the camera lens.

PLANO-CONCAVE LENS (*See* "Concave Lens.")

PLANO-CONVEX LENS (*See* "Convex Lens.")

PLANT LIFE, PHOTOGRAPHY OF

The life history of a plant from the first shoot to the mature growth, the opening of a leaf-bud, and the unfurling of the leaves, the expansion of a blossom, and the various types of fruits are examples of plant life that will yield interesting photographs. A rigid stand camera provided with a long extension of bellows is the most suitable all-round instrument for the work, and quarter-plate size will be found generally useful. The lens should not be of less than $5\frac{1}{4}$ in. focal length for a quarter-plate, and a lens of $6\frac{1}{4}$ in. or 7 in. focal length would give more natural perspective. If an anastigmatic lens working at $f/5$ or $f/6$ is not too costly, it should be used, since its large aperture is of great advantage when working out of doors, though it must be remembered that the larger the aperture, the less the so-called depth of focus, and, therefore, the greater care is necessary in focusing the object. A rapid rectilinear lens will answer very well for indoor work, and for the field in bright weather. The most useful type of shutter is one that can be fastened to the front of the camera, and is fitted with removable lens panels, so that lenses of different focal lengths can be quickly placed in position. Orthochromatic plates should always be used, and generally a yellow filter is desirable, especially for flowers. If much flower work is contemplated, obtain a set of three filters—a pale yellow, a medium, and a heavy one, such as Wratten's KI, KII, or KIII. A panchromatic plate will generally be found to yield the best results with flowers, but some skill and judgment will be required in the selection of the filter to be used.

The autochrome process of colour photography lends itself particularly to photographing flowers, and most beautiful results may be obtained, showing every delicate shade of colour.

PLAQUE PHOTOGRAPHY

A method in which prints were given a concave shape with the object of imitating the appearance of a porcelain plaque. The print was pressed whilst wet between rubber covered dies respectively of convex and concave shape.

PLASTER CASTS FROM PHOTO RELIEFS

Numerous processes have been based on the principle of obtaining a relief in chromated gelatine, and taking therefrom a plaster cast, which might be used by itself as a plaque for decorative purposes, or be the means for obtaining a porcelain plaque, or for making an electrotype or stereotype. (*See* "Galvanography, Photographic," "Gelatine Reliefs," "Photolithophane," "Photo-stereotype," etc.)

PLASTIC PHOTOGRAPHS

Photographs upon flat glass or paper and giving the effect of bas-reliefs. A negative of the subject is made in the usual way, then a transparency (positive) by contact from the negative, and when the positive is dry it is again placed in contact with the negative (film to film). On being held up to the light, one of the plates is shifted very slightly to one side, so as to be a trifle out of register, and the two are bound together and then framed, printed from, or copied in the camera. Profile portraits give the best results. The effect is due to one side of the image being represented as a white line and the opposite side as a dark one, just as a bas-relief would be if illuminated by a strong side light.

PLATE

A term loosely applied, but generally understood to mean a dry plate. When the plate has been exposed, developed, etc., it is known as a "negative," "positive," "transparency," etc., as the case may be.

In process work, the term "plate" is generally applied to the surface to be printed from, and also to the actual print from the plate, as illustration plates in books, and plates for framing. Plate-printing is distinguished from letterpress or lithographic printing by its understood reference to printing from intaglio, etched, or engraved copper and steel plates.

PLATE ADAPTERS

The name given to various kinds of dark-slides which render possible the daylight loading and changing of plates, in light-tight envelopes or in other ways. In addition, the term is often applied to accessories which enable plates to be used in cameras intended for films. (*See also* "Plate Carrier.")

PLATE BACKINGS (*See* "Backings, Plate.")

PLATE CARRIER

Also known as an adapter. A light frame of wood or metal fitting inside a dark-slide and permitting the use of a smaller plate than that

Plate Carrier

for which the slide is made. The illustration shows the usual form. Large slides are frequently fitted with a nest of carriers.

PLATE CHANGING (*See* "Daylight Changing.")

PLATES, COATING (*See* "Coating" and "Emulsion.")

PLATE HOLDER (Fr., *Porte-plaque*; Ger., *Plattenhalter*)

A clip of metal, celluloid, or other material, used for holding and lifting plates during development, washing, etc., in order to avoid touching them or immersing the fingers in the

solutions. A typical pattern is illustrated. (*See also* " Pneumatic Holder.")

Plate Holder

This term is also often applied to the dark-slide, plate-adapter, and, indeed, to anything else that contains, holds, or supports plates.

PLATE LIFTER

A kind of lever of metal, ebonite or celluloid, used for raising plates from the developing or other solution, in order that they may be

Plate Lifter

examined or removed. Some developing dishes have a lever attached at one side, as illustrated. The device is made in many forms, and the term is also often applied to the plate holder.

PLATE MARK

The indentation made in paper by the metal plate when printing engravings, etc. Some mounts for photographs have a similar impression made upon them. Sometimes a print which has been made from a masked negative so as to show a wide margin of paper has an imitation plate mark made around it by pressing into the paper a sheet of card or metal slightly larger than the print itself. In the case of a photograph such a mark has no real meaning or justification.

PLATE SHEATH (*See* " Sheath.")

PLATE SPEEDS (*See* " Sensitometry.")

PLATE TESTING (*See* " Sensitometry.")

PLATE VICE

A screw vice or clamp used at one time to hold the daguerreotype plate while buffing or polishing, and still sometimes employed when cleaning glass plates previous to coating with collodion in the wet-plate process, and for other purposes. It consists of a square wooden frame with a sliding block adjusted by a screw, usually of beechwood.

PLATE WHIRLER (*See* " Whirler.")

PLATES, VARIETIES OF (*See* separate headings; for example, " Albumen Process," " Collodion Process (Wet)," " Ferrotype Process," " Isochromatic Plates," etc.

27

PLATE-SUNK

A term used to describe a mount made with a depression in imitation of the indentation in the paper caused by the pressure of the metal plate in printing etchings and engravings. (*See* " Plate Mark.")

PLATINIC CHLORIDE (*See* " Platinum Perchloride.")

PLATINO-BROMIDE

A grade of bromide paper with a matt surface giving an effect intended to resemble platinotype.

PLATINO-MATT

The term applied to the surface of some grades of bromide and gaslight papers which are made to give an effect in imitation of platinotype. (*See also* " Platinum Paper, Substitutes for.")

PLATINOTYPE PROCESS

A printing process in which the image is partially printed out and then developed to its full strength, based on the light-sensitiveness of iron salts and not directly upon that of a platinum compound. The ferric salts are reduced by the action of light to the ferrous state, in which condition they partially reduce the platinum salt, the conversion to metallic platinum being completed by the ferrous salt in the " developer." The salt usually employed is ferric oxalate, the light action upon which is shown in the following equation :—

$$Fe_2(C_2O_4)_3 + Light = 2FeC_2O_4 + 2CO_2$$

Ferric Ferrous Carbonic
oxalate oxalate acid.

The action occurring during development may be represented by the following equation, which Berkeley (at one time manager of the Platinotype Company) gave in 1882 :—

$$6FeC_2O_4 + 3PtK_2Cl_4 =$$

Ferrous Potassium
oxalate chloroplatinite

$$2Fe_2(C_2O_4)_3 + Fe_2Cl_6 + 6KCl + 3Pt$$

Ferric Ferric Potassium Platinum
oxalate chloride chloride

Hübl pointed out (1883) that whilst the above may be taken as the simplest form of equation and practically correct, formic acid probably is produced during exposure of the print to light, and that this acid plays a part in the development of the image, as follows :—

$$H_2CO_2 + PtK_2Cl_4 =$$

Formic Potassium
acid chloroplatinite

$$CO_2 + 2HCl + 2KCl + Pt$$

Carbonic Hydro- Potass. Platinum
acid chloric acid chloride

Although the process is based on the sensitiveness of the iron salts and not on that of the platinum compound, the latter certainly undergoes some little change, and assists the decomposition of the ferric salt, since a mixture of the two is undoubtedly more sensitive than the oxalate alone.

The first discovery of the action of light upon a platinum salt is said to have been by Gehlen, about 1804. But the first communication of any importance was by Sir John Herschel before

the Oxford meeting of the British Association, in 1832. Robert Hunt, in 1844, also experimented. The simple platinum process as it is now known is due to W. Willis, who patented it on June 5, 1873 (No. 2011), and who, in 1878, 1880, and 1887, took out further patents for improvements.

Few photographers care to attempt to make their own platinotype paper, as the materials are expensive and extreme care and cleanliness are necessary. However, all necessary instructions for doing so are here given. The late W. J. Warren advocated the following sensitising solution, which must not be acid :—

Potassium chloroplatinite solution (1 in 6) .	3	oz.	300 ccs.
Ferric oxalate solution (as below) . .	2¾	,,	275 ,,
Water . . .	½	,,	50 ,,

The ferric oxalate solution consists of oxalic acid 1 part, ferric oxalate 15 parts, water 60 parts.

A strong paper is sized with 15 grs. of arrow-root, which is made into a cream with 1 oz. of water and poured gently into 30 oz. of boiling water, the whole being then boiled for eight minutes. The paper is immersed in the size for three minutes, dried, re-sized, dried again, laid on a sheet of glass, and the sensitising solution applied (in a yellow light) with a tuft of cotton-wool, preferably wrapped with fine silk. The paper is then dried at a temperature of 100° F. (38° C.), for which no variation is allowable, the drying taking only from two to four minutes.

Beanland recommends an arrowroot sizing of 30 grs. in 4 oz. of water, prepared and used as above, and the following sensitising formulæ, which, by a little modification, may be used in the preparation of " cold bath " papers for cold tones and " hot bath " paper for sepia tones :—

A. Potassium chloro-platinite . .	60 grs.	15 g.	
Distilled water .	360 mins.	84 ccs.	
B. Ferric oxalate .	84 grs.	21 g.	
Oxalic acid . .	8 ,,	2 ,,	
Distilled water .	720 mins.	168 ccs.	

For cold bath paper mix A and B and add 60 mins. or 14 ccs. of water. For sepia paper mix A and B and add 60 minims or 14 ccs. of a five per cent. solution of mercuric chloride. The addition of a few grains of potassium chlorate (one grain to the ounce is advised by Warren) will give increased contrasts to the print when either of the above formulæ is used. According to Beanland, 140 to 170 mins. are sufficient to coat a sheet of paper 26 in. by 20 in. The coating and drying are important as before.

The addition of a very small quantity of gold chloride to the sensitising solution is said to be of great advantage, the following sensitising mixture being recommended highly by some American workers :—

Ferric oxalate . .	90 grs.	90 g.
Chloroplatinite solution (70 grs. per oz.) .	60 mins.	60 ccs.
Gold chloride solution (5 grs. per oz.) .	3 ,,	3 ,,
Potass. chlorate (saturated solution) .	2 ,,	2 ,,

Coat the sized paper with this and dry quickly. For thin negatives the quantity of gold may be slightly increased, but too much gold will spoil the bath and precipitate the platinum. The paper is developed on a cold solution of potassium oxalate, but if a hot bath is preferred gold must be omitted.

The following qualities of ready sensitised papers are manufactured by the Platinotype Company :—

For the cold bath process : AA, smooth, medium thickness. KK, smooth thick paper, fine surface, gives bright prints. CC, rough-surfaced, thick and strong, suitable for large work. TT, rough, thick, gives greater contrast than CC. YY, very thick and smooth. ZZ, very thick and slightly rough. *For the hot bath process :* S, smooth, to give rich sepia colour. RS, rough-surfaced for sepia, same substance as CC. The qualities TT, YY, and ZZ can also be coated for sepia. In addition there is a platinotype paper having a hard and resisting surface with an ivory-like sheen, of a brilliant black or sepia, and of a warmer tone than that afforded by the matt papers. These papers are supplied in air-tight tins, each containing a piece of calcium chloride to absorb any moisture. The paper should be stored in the original tin with the calcium, or transferred to a calcium tube. It is a good plan to place a wide rubber band round the joint between the lid and the tin box. The paper needs careful handling as the sensitive surface when dry is liable to crack ; usually the sensitive surface is easily distinguished by its yellow colour, and is rolled outwards. Some workers keep platinotype paper a long time and in a damp condition in order to get certain effects, but technically perfect prints can only be obtained upon paper kept perfectly dry. Should paper become damp it may be dried in a warm oven or by keeping it in a calcium tube.

Platinotype paper is printed in daylight under a negative; the latter may with advantage be warmed, and a piece of vulcanised rubber (also warmed) placed between the paper and the back of the frame. A clear and brilliant negative, free from fog, gives the best results ; flat negatives should be avoided.

The depth to which printing needs to be carried can be ascertained only by experience. The paper is more rapid than P.O.P., and prints in approximately about one-third the time. When the paper is sufficiently printed the image will be very faint and of a pale orange or a delicate purple colour on a yellow ground. Owing to this faintness there is a tendency to over-print and over-develop. The rule is to print until all the details can be seen except those in the highest lights, and this applies to both the " cold bath " and " hot bath " papers. After printing and before development the prints should be kept bone dry, as otherwise they will lack vigour, and the purity of the whites may be impaired. The paper should never be roughly torn, as there is a risk of the particles of platinum falling on the paper and causing black spots upon the print.

Cold Bath Process.—This gives black-and-white prints. Development should be conducted in a feeble white light or by gaslight, to avoid

any degradation of the whites. The paper makers' special developer, or an ordinary potassium oxalate developer, may be used. The special salts supplied by the makers are known as " D " salts; the contents of one tube ($\frac{1}{2}$ lb.) are dissolved in 48 oz. of water, which forms a stock solution. One part of this is mixed with 1 part of water, which then acts as a developer. A popular developer is—

Potassium oxalate	3 oz.	330 g.
Hot water	10 ,,	1,000 ccs.

For use, mix 1 part with 2 parts of water. The addition of 1 part of a saturated solution of oxalic acid to 20 parts of mixed developer tends to give warmer tones. Use the best neutral potassium oxalate, because if alkaline the blacks will not be good. Another good developer is—

Potassium oxalate	1 oz.	110 g.
Potassium phosphate	$\frac{1}{4}$,,	28 ,,
Hot water	10 ,,	1,000 ccs.

When cold it is ready for use. Although the process is known as the " cold bath," the developer may be used warm if desired, and in no case must the temperature be lower than 60° F. (15·5° C.). By raising the temperature of the bath, even to 100° F. (about 38° C.), under-exposed prints may often be saved.

A. Developing Platinotype Print

The correct way to develop a platinotype print is just to fill a flat dish with the developer, and to take the dry print by the ends and hold it face downwards near the surface of the solution as at A; then with one hand draw one end along the surface of the bath (*see* the arrow), bringing the opposite end on to the surface of the solution gently and evenly so that no air bells form between the two. After a few seconds' treatment turn over the print in order to see whether the solution is working properly. A correctly exposed print may take half a minute or more to develop. Although development may be arrested before all the ferrous oxalate is reduced by the potassium oxalate developer, generally it is found that when development is cut short the picture will not be entirely satisfactory. A scum is apt to form on the surface of the developer, and when this happens it should be skimmed off with a stiff piece of paper; if allowed to remain it may cause marks upon the print. The liquid should also be stirred or rocked between each development in order to break up any scum which may be left by a previous print.

A fully developed platinum print must be placed face downwards, and without washing,

into the following bath, which acts both as a clearer and fixer :—

Hydrochloric acid (pure, sp. gr., 1·16)	1 oz.	16 ccs.	
Water	60 ,,	1,000 ,,	

Citric acid (1 oz. per 20 oz. of water) may be used instead. The print remains in a portion of the acid solution for five minutes; the discoloured solution is then poured away and a second portion used, following in the same way with a third, so that the print is immersed in three acid baths for five, ten, and fifteen minutes respectively. The acid bath before use should be perfectly clear, but the effect of introducing a print is to turn it yellow, which fact affords a method of testing whether the print is sufficiently cleared or not. Until the print ceases to give a tint to the acid bath it is safe to conclude that it is not sufficiently cleared. So long as yellowness can be seen, traces of iron (which it is the function of the acid to remove) remain in the paper, and the treatment must be continued.

The print is next washed in four or five changes of water to clear away the acid, and the print dried between clean white blotting-paper. Common soda is sometimes added to the washing water to neutralise the acid, but with proper washing it should be unnecessary.

Sepia Prints by Cold Development.—Baron Von Hübl gives the following particulars for producing a special paper and for working it: " Take 1 gr. of yellow oxide of mercury and 5 grs. of citric acid, add 20 ccs. of water, and dissolve by heat. Filter the colourless fluid. This is kept as a stock solution for addition to the sensitising bath. The paper should be prepared with arrowroot and sensitised with 8 ccs. of normal iron solution, 4 ccs. of platinum solution (1 in 6), 1 to 4 ccs. of citrate of mercury solution. The addition of a little citrate or oxalate of ammonium will keep the high lights pure, and the gradation may be modified by adding sodium chloroplatinite, or bichromate of potash. The paper should be sensitised in the usual manner. The developer should be strongly acidulated with oxalic acid, and the strength of the solution of oxalate of potash may vary between 12$\frac{1}{2}$ to 25 per cent. The formula may be stated as follows: Water, 1,000 ccs.; neutral oxalate of potash, 120 to 250 grs.; oxalic acid, 10 grs. The development may take place in a dish in the ordinary way, or a brush may be used. The prints must, however, be at least five minutes in contact with the developer to effect complete reduction, otherwise they will lose considerably in the fixing bath, which should be a 1 per cent. solution of hydrochloric acid. Leave the prints for half an hour in the fixing bath, and then wash thoroughly. The colour and gradation of the image may be modified considerably by the composition of the sensitising solution, the developer, and the peculiarities of the paper used." In Baron Von Hübl's work, " Der Platindruck," the normal iron solution is given as composed of 20 per cent. of ferric oxalate, to each 100 ccs. of which 1 to 2 grs. of crystallised oxalic acid are added.

The Hot Bath Process.—The paper used for the hot bath process gives sepia prints. The paper is sold, stored and printed in the same

way as cold bath paper. The sepia paper is a trifle more sensitive than the black paper, and more easily affected by faint light. The Platinotype Company's " D " salts may be used for developing, in which case the half-pound is dissolved in 32 oz. of water. The stock solution of potassium oxalate is the same as that first given, but for use 10 parts are mixed with 1 part of a saturated solution of oxalic acid ; this mixture should be thrown away after use, as it soon loses quality. The solution, in use, should be maintained at a temperature of from 160° F. to 170° F. (71° C. to 77° C.), although good results are obtainable with a cooler bath ; the solution can be heated in a porcelain dish, or, more safely, in an enamelled iron vessel supported over a spirit lamp or gas ring (B). A tinplate, asbestos sheet, or sand bath should be interposed between the flame and a porcelain dish in order to prevent cracking. The developing and clearing (fixing) are precisely the same as for cold bath paper. Owing to the temperature of the bath some evaporation takes place and it becomes necessary to add from time to time sufficient water or more solution to bring the liquid up to practically its

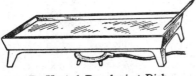

B. Heated Developing Dish

original bulk. A cracked enamel dish must not be used, as any exposed iron would cause the prints to be discoloured ; the sepia developing bath after use must be kept in the dark and not used for cold bath (black) pictures. As the sepia prints, unlike the black ones, may be affected by light when in the acid bath, and in the developer, they must be manipulated in a very weak light. The black and sepia papers should not be kept together in the same tin, and neither should the two kinds of prints be cleared and fixed together in the same bath, as otherwise the purity of the blacks in the cold bath paper will suffer.

Red Prints by Development.—The *Photo Zeitung* published the following formulæ :—

A. Oxalate potash (neutral) .	.	1 oz.	120 g.	
Water .	.	4 oz.	154 mins.	480 ccs.
B. Copper chloride .		32 grs.	8 g.	
Water .	.	2 oz.	77 mins.	240 ccs.
C. Mercuric chloride .		120 grs.	30 g.	
Water .	.	2 oz.	77 mins.	240 ccs.
D. Lead acetate	.	8 grs.	2 g.	
Water .	.	1 oz.	38 mins.	120 ccs.

Take 12 parts of A and 4 parts of B, stir together, and add 4 parts of C and 1 part of D ; heat until the precipitate is dissolved, filter, and use at a temperature of 185° F. (85° C.). Fix in dilute hydrochloric acid, follow by a weak bath of ammonia, and finally wash in water.

Development with Glycerine.—The addition of glycerine to a developer allows of considerable control and of local development. The print is laid flat and the shadow parts coated with glycerine. Three vessels are filled as follows :— No. 1, with full strength developer ; No. 2, with a developer weakened a little, together with an equal quantity of glycerine ; and No. 3, with a still weaker developer with glycerine. No. 1 is painted over the portions which are likely to be too light, and then the other parts are rapidly brushed over with the weaker solutions, using strong or weak developer afterwards to get the desired effect. Care should be taken to blend the parts together so as to prevent the occurrence of sharp dividing lines. Where backgrounds are very light it is possible to get effective vignettes simply by not working upon the edges with the developer. Some American workers have paid particular attention to this process, particularly Messrs. Stieglitz and Keiley, who give the following as their method of working :— Using the heavier grades of paper, printing should be carried further than for ordinary development, as far, in fact, as to record the half-tones in the high lights. When printed, the print is laid upon a sheet of glass, a little glycerine being smeared on the glass to keep the print flat and from slipping about. The face of the print is then evenly coated with pure glycerine, and blotting-paper is pressed down upon it ; the print is then thinly recoated and developed by means of brushes, two solutions being used, one (A) consisting of equal parts of normal developer and glycerine, and the other (B) pure developer. A is just used on those parts which it is thought desirable to bring up first ; B is used where a pronounced shade is required. When development has been carried far enough, the print is blotted at that place, which should be re-covered with glycerine and not again touched. To introduce warm tones and so produce a print in two colours, three additional solutions are required :—(1) A strong solution of mercuric chloride ; (2) ordinary developer plus the mercury solution, and (3) glycerine developer plus the mercury solution. The print is treated at one place with mercurised developer and at another with ordinary developer. The mercury tone is more transparent than the ordinary black tone so that development may be carried farther. The work must be carried out in a subdued light, as otherwise the high lights will be discoloured. When development is complete, the prints should be cleared in the ordinary hydrochloric acid bath and washed.

Intensifying and Reducing.—The following method, invented by Hübl in 1895, will give vigour to an under-exposed and pale black print. Make up :—

A. Sodium formate .	48 grs.	11 g.	
Distilled water .	1 oz.	100 ccs.	
B. Platinum per-chloride .	.	10 grs.	2·3 g.
Distilled water .	1 oz.	100 ccs.	

Add about 15 drops of each to 1 oz. of water, immerse the weak print therein, rock the dish until the picture is dark enough, and then wash and dry. Some processes of intensifying weak platinum prints alter the tone. One worker has advocated an acid mixture of gallic acid and silver nitrate, another an acid hydroquinone and silver intensifier, and another a ferrous oxalate developer to which a few drops of a

chloroplatinite solution have been added. Some of the toning processes (Dolland's, for example, *which see*) intensify as well.

To reduce over-printed platinotype prints, immerse them in a saturated solution of chloride of lime, and when sufficiently reduced transfer them to a 5 per cent. solution of sodium sulphite to stop the action of the lime, then wash and dry. This reducer causes the paper to deteriorate and is recommended only in extreme cases.

Toning.—There are many processes for toning black platinotype prints to other colours. Both the Packham and Dolland processes are good (*see* under the headings " Catechu Toning " and " Dolland's Process "), the former giving brown tones and the latter rich black ones. Uranium is widely used for brown, red, and blue tones, but does not give very permanent results. An excellent formula is that advocated by Hübl:

A. Uranium nitrate	.	96 grs.	28 g.
Glacial acetic acid		96 ,,	28 ,,
Water .	.	2 oz.	250 ccs.
B. Potass. ferricyanide		96 grs.	28 g.
Water .	.	2 oz.	250 ccs.
C. Ammonium sulpho-			
cyanide	.	1 oz.	138 g.
Water .	.	2 ,,	250 ccs.

For brown and red tones, add 5 drops of each to 1 oz. of water. Thoroughly clear and wash the prints, place in the toner, and allow to remain until they are of the colour desired; they go from black to brown, and then to a red. The process slightly intensifies the print, the darkest portions gaining more in proportion than the light ones. For blue tones the A bath is not wanted, the following being used instead:—

D. Ammonia-iron-alum	96 grs.	28 g.
Hydrochloric acid	96 mins.	25 ccs.
Water .	2 oz.	250 ,,

Add 12 drops of D to 5 oz. of water, then add successively 5 drops of B and 12 drops of C. Immerse the print therein and rock the bath until of the desired tone. The dish must be thoroughly cleaned before using for brown tones.

Stale Platinum Paper.—When stale paper must be used, potassium bichromate may be added to the oxalate developer, but a more satisfactory salt is the neutral potassium chromate, $\frac{1}{2}$ gr. of which should be added to 1 oz. of the ordinary developer diluted with one-third water. Paper five years old has been known to give good bright prints by this treatment. $\frac{1}{4}$ gr. per ounce has been known to give good results on paper two years old.

PLATINOUS CHLORIDE (*See* " Platinum Bichloride.")

PLATINOUS POTASSIUM CHLORIDE (*See* " Potassium Chloroplatinite.")

PLATINUM (Fr., *Platine ;* Ger., *Platin*)
Pt. Atomic weight, 193·4. A white heavy metal native in the state of impure ores. It is very infusible and practically unaffected by the atmosphere or most acids, but readily soluble in aqua regia. When deposited in a finely divided state it is an intense black and forms the image in the platinotype process.

PLATINUM BICHLORIDE (Fr., *Bichlorure de platine ;* Ger., *Platindichlorid*)
Synonyms, platinous chloride, platinum dichloride, platinochloride. $PtCl_2$. Molecular weight, 264·4. Solubilities, insoluble in water, soluble in hot hydrochloric acid. A greyish green or brown powder obtained by reducing platinum perchloride by heat or sulphurous acid. It is not used in photography, but it is used to prepare potassium chloroplatinite.

A solution of this salt in hydrochloric acid yields chloroplatinous acid H_2PtCl_4 or $PtCl_2$ 2HCl.

PLATINUM PAPER, SUBSTITUTES FOR
Many attempts have been made to produce on bromide and other papers effects similar to those given by platinotype. A number of the platino-matt papers may be made to produce platinum-like prints, but the two can always be distinguished by applying a drop of a solution of mercuric chloride as used for intensifying. The solution bleaches the part of the bromide print to which it is applied, but has no effect upon a platinum print.

Special papers have been made for yielding prints resembling platinum, and of the home-made kinds, that prepared according to the formula worked out by Dr. Vollenbach, and published in the *Deutsche Photo. Zeitung*, is considered one of the best. It is said to yield rich deep platinum-like blacks even from weak negatives. Paper is immersed for three or four minutes in :—

Gelatine .	.	.	22 grs.	5 g.
Citric acid	.	.	13 ,,	3 ,,
Chrome alum (sol. 1 : 20)	220 mins.	50 ccs.		
Aluminium chloride				
(10% sol.)		.	44 ,,	10 ,,
Distilled water	.	.	10 oz.	1,000 ,,

After immersion hang up to dry. It is sensitised (in yellow light) with :—

A. Gelatine	.	.	2·2 grs.	$\frac{1}{2}$ g.
Salicylic acid	.	.	·4 ,,	1–10 ,,
Distilled water	.	.	1 oz.	100 ccs.
B. Green ammonia				
citrate of iron	.		38 grs.	20 g.
Distilled water	.		1 oz.	100 ccs.
C. Silver nitrate	.		55 grs.	12·5 g.
Distilled water	.		1 oz.	100 ccs.
D. Uranium nitrate	.		38 grs.	20 g.
Distilled water	.		1 oz.	100 ccs.

By using more of C, softer prints are produced; more of B gives hard prints; less of D gives browner tones ; and more of D gives blue-black tones. For greyish-black resembling platinotype, use 1 part of A and B and 2 parts of C and D. Mix in the order above given, or else a precipitate is formed and a muddy solution results. Pour the solution on the paper, pinned to a board, in a little pool and then distribute with a wad of cotton-wool; finally dry quickly but evenly. Expose the same as with platinum paper until detail is faintly visible, and develop with—

Ferrous sulphate	.	188 grs.	43 g.
Acetic acid	.	67 mins.	14 ccs.
Distilled water .	.	10 oz.	1,000 ,,

When sufficiently developed, place the print in a

1 per cent. solution of nitric acid for three minutes and then fix in—

Sodium hyposulphite	785 grs.	180 g.	
Sodium sulphite (cryst.)	110 ,,	25 ,,	
Sulphuric acid . .	14 mins.	3 ccs.	
Water . . .	10 oz.	1,000 ,,	

The prints are apt to reduce slightly in the fixing bath.

PLATINUM PERCHLORIDE (Fr., *Chlorure de platine*; Ger., *Platinchlorid*)

Synonyms, platinic chloride, platinum tetrachloride, chloroplatinic acid, muriate of platina. $H_2PtCl_6 6H_2O$ or $PtCl_4 2HCl 6H_2O$. Molecular weight, 516·4. Solubilities, 1 in 1 water, soluble in alcohol and ether. A dark brown mass or red crystals obtained by dissolving platinum in aqua regia and evaporating. It is chiefly used as the starting point for the manufacture of potassium chloroplatinite, but is also occasionally used for toning.

PLATINUM TETRACHLORIDE (*See* "Platinum Perchloride.")

PLATINUM TONING

The theory of platinum toning is the same as that of gold toning, explained under that heading, except, of course, that platinum is substituted for gold. The earliest form of bath consisted of 1 gr. of platinic chloride in 15 oz. of water, and it was not until the introduction of the platinotype printing process, when potassium chloroplatinite was made available, that platinum toning became almost if not quite as popular as gold for silver prints, particularly those upon matt papers. As with gold, almost any tone may be obtained.

Print-out Silver Papers.—Two stock solutions are necessary :—

A. Common salt .	½ oz.	55 g.	
Alum . . .	½ ,,	55 ,,	
Water . . .	10 ,,	1,000 ccs.	

This may be made up with hot water, and is ready for use when cold.

B. Potassium chloro-			
platinite . .	40 grs.	9 g.	
Water . . .	10 oz.	1,000 ccs.	

The chloroplatinite is sold in sealed glass tubes containing 15 grs. Soak off the label, place the unbroken tube in the bottle or measure with the water, and break the tube while in the water. Each quarter ounce (120 drops) of the solution will contain 1 gr. of the chloroplatinite; the mixture should be kept in the dark. Tones may be varied from red-brown to warm black by using a mixture of from 10 to 160 drops of B, 1 oz. of A, and 10 oz. of water, this quantity being sufficient for ten half-plate prints or their equivalent. The prints dry of a darker tone than they appear when wet; and therefore toning should be stopped just before the desired tone is reached, judging the tone by looking through the prints. Toning invariably continues in a slight degree during the washing previous to fixing, unless a " stop bath " be used, such a bath consisting of 100 grs. of sodium carbonate crystals in 10 oz. of water.

After toning, prints are washed and fixed as usual.

Alternative Baths for Silver Prints.—Some alternative baths will now be given.

Cowan's Bath

Common salt . .	10 grs.	2·3 g.	
Potass. chloroplatinite	1 ,,	·23 ,,	
Chrome alum (1% sol.)	10 oz.	1,000 ccs.	

Phosphoric Bath

Potass. chloroplatinite	4 grs.	2 g.	
Phosphoric acid (sp. gr.,			
1·120) . . .	1 drm.	28 ccs.	
Distilled water .	4½ oz.	1,000 ,,	

The phosphoric acid is the " acidum phosphoricum dilutum " of the British Pharmacopœia. Wash and fix as usual. (Many other acids can be used in this way.) Prof. Namias states that the phosphoric acid may be advantageously replaced by oxalic acid.

Platinum may be used in the combined toning and fixing form. A good formula is :—

Sodium hyposulphite	1 oz.	110 g.	
Lead nitrate . .	60 grs.	14 ,,	
Alum . . .	60 ,,	14 ,,	
Sodium formate .	20 ,,	4·6 ,,	
Formic acid . .	½ drm.	6 ccs.	
Platinum bichloride .	2 grs.	·5 g.	
Hot water . .	10 oz.	1,000 ccs.	

Dissolve the lead and sodium formate in a small quantity of the water, then the " hypo " and the other ingredients (except platinum) in the remainder. Mix together, allow to stand in an uncorked bottle for 24 hours, and then add the platinum bichloride. The prints (P.O.P.) should be passed through a weak salt and water bath before toning.

A formula for the " Haddon " platinum toning bath is given in an article under that name. For platinum and gold baths (combined) *see* under " Gold and Platinum Bath."

Bromide Papers.—Most of the above baths may be used for bromide papers, and the following is recommended :—

Hydrochloric acid .	50 mins.	1 ccs.	
Potass. chloroplatinite	5 grs.	1 g.	
Distilled water .	10 oz.	1,000 ccs.	

Toning for about twenty minutes should give a good black image. Wash, fix in " hypo," and wash again thoroughly.

C. W. Somerville's toner (1902) is as follows :—

Potass. chloroplatinite	20 grs.	4·6 g.	
Mercuric chloride .	10 ,,	2·3 ,,	
Citric acid . .	90 ,,	200 ,,	
Distilled water .	10 oz.	1,000 ccs.	

1 oz. of this will tone three or four half-plate prints in about twenty minutes; the print is previously fixed and washed, and after toning, again fixed and washed. If the sepia toned print is immediately subjected to an ordinary developer as used for bromide paper, the black colour will return with great intensification, but washing will prevent this.

Lantern Slides.—Lantern slides of the gelatine variety may be toned by any of the above processes, but the most widely used bath is—

Hydrochloric acid	.	1 min.	·2 cc.
Platinum chloride	.	1 gr.	·2 g.
Water	. . .	10 oz.	1,000 ccs.

This tones rapidly, but reduces slightly.

PLATYSTIGMAT LENS

An anastigmatic lens introduced by Wray, and consisting of two nearly symmetrical cemented triple combinations. It has an initial intensity of $f/7·3$ and an extreme angle of 90°. The back lens may be used alone, and has a focal length about double that of the complete combination.

PLAYERTYPE

A process for the direct copying of engravings, invented by J. Hort Player in 1896. The engraving (line drawing) to be copied is laid face downwards upon a perfectly flat surface, the sensitive (bromide) paper is laid film side downwards upon it, and a sheet of glass placed over all. A yellowish light is then held over the glass, the exposure being made through the glass and the sensitive paper. From three to ten minutes may be necessary in yellow light according to the sensitiveness of the paper ; with white light the exposure is much shorter. The developer recommended for this work is :—

Hydroquinone .	.	30 grs.	7 g.
Sodium sulphite	.	120 ,,	28 ,,
Sodium carbonate	.	240 ,,	56 ,,
Water	. .	10 oz.	1,000 ccs.

Development is continued until the image appears to be buried. Having obtained a negative in this way, prints may be obtained from it by contact printing. The method has the advantage of giving a direct copy (a paper negative) of the same size as the original, and, of course, without using a camera. The clearer and more contrasty the original drawing or engraving the better will be the copy on the bromide paper, but should the latter be faulty, it may be intensified, reduced or cleared. The process was modified somewhat in 1900, when a sheet of green glass was laid over the paper and the exposure, of from five to ten minutes, made through that.

PLUMB INDICATOR (Fr., *Plomb photographique ;* Ger., *Photographische Bleiwage*)

An appliance fitted to stand cameras to enable the back to be rendered truly vertical. The

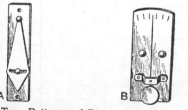

A B
Two Patterns of Plumb Indicator

pattern shown at A consists of a swinging pendulum or pointer attached to a brass plate,

which is screwed to the side of the camera with its edge parallel to the back. The bottom of the pendulum will then point to a notch on the plate when the back is vertical. Pattern B has a pivoted needle weighted at the lower end, and attached to the side of the camera as before described ; the point of the needle indicates on a scale whether or not the back is upright.

PLUMBAGO

A synonym for blacklead.

PLUMBAGO PROCESS

The " dusting-on " process, with plumbago (blacklead or graphite) used as the powder. Employed in the ceramic process and for making duplicate negatives. Wood engravers sometimes make use of it as a means of obtaining prints on wood.

PNEUMATIC HOLDER (Fr., *Ventouse pneumatique ;* Ger., *Pneumatischer Plattenhalter*)

A rubber bulb with a flat disc at one end, as illustrated. It is used to hold plates by " suction " when coating with collodion, varnishing, etc. The bulb is pressed to expel the air and the disc is held against the plate, to which, on

Pneumatic Holder

releasing the pressure on the bulb, it immediately clings, enabling the latter to be lifted as if by a handle and supported in any required position. Those of red rubber are best. It is advisable to immerse the holder in lukewarm water before using, or the part of the plate directly over the bulb may be chilled, and uneven coating result.

PNEUMATIC RELEASE (Fr., *Poire pneumatique ;* Ger., *Pneumatische Birne*)

A rubber ball with tube connection, by means of which the camera shutter can be operated without the necessity of touching it, or, if needful, worked from a convenient distance by having a sufficient length of tubing. Many diaphragm shutters have a metal tube at one side, in which a piston connected to the mechanism slides up and down. The free end of the rubber tubing is stretched over this metal tube, when pressure on the ball at the other end compresses the air, pushes up the piston, and releases the shutter. Roller-blind shutters usually work on a different principle ; these have at the end of the tubing a small rubber bulb, which is adjusted beneath the catch that retains the wheel regulating the spring blind. In this case pressure on the ball inflates the bulb, which pushes up the catch and releases the wheel. Studio pneumatic shutters mostly have a tap next to the ball ; this, if turned after pressing the latter, prevents the return of the compressed air, so that the shutter remains open

for focusing, etc., until the tap is turned in the contrary direction.

POCKET CAMERA (Fr., *Chambre de poche* ; Ger., *Taschenkamera*)

Very small hand cameras are now made, some of them capable even of going in a waist-coat pocket. When well-made and fitted with a first-class lens they are apt to be expensive, as the mechanism and adjustments call for great neatness and accuracy. The shutters are usually marvels of compactness and ingenious design. With the short-focus lenses used, great depth of definition is attainable, and the small negatives will bear any reasonable degree of enlargement. Such cameras call for considerate handling. If one is constantly carried, it is well to have a small leather bag to protect it from dust and grit.

POISONS AND THEIR ANTIDOTES

The table given below is due to J. V. Elsden, and is reprinted from the *Brit. Journ. Phot. Almanac.* Dr. R. J. Hillier, in commenting upon Elsden's table, which he regards as reliable and accurate, recommends that in all cases of poisoning a doctor should first be sent for, and in the meantime an antidote given, and vomiting induced by tickling the throat or by drinking strong mustard and water or lukewarm water. Acids are antidotes for alkalis and vice versa, but there is danger in giving strong acids and alkalis as antidotes, and unprofessional treatment should seldom go beyond some such emetic as mustard and water. Except where strong acids and alkalis have been taken, 25 grs. of zinc sulphate forms a good emetic. If a highly irritant poison, such as a strong acid (not pyrogallic) or alkali, or potassium cyanide, has been swallowed, the only hope of saving life is the prompt application of the antidote.

POISONS, SALE OF

The following statement is due to E. J. Wall, and is reprinted from the *Photographic Dealer.* According to the Pharmacy Act, 1868, it is illegal for any person not being a duly registered pharmaceutical chemist or chemist and druggist, to sell certain chemicals and substances, which are included in a schedule, this being divided into two parts. In the first part are included those substances which can only be sold when the purchaser is known to the seller, or is introduced by some person known to the seller, who must enter the date of sale, name and address of purchaser, name and quantity of article, purpose for which it is required, which must be attested by the purchaser's signature ; and the parcel or vessel must be labelled with the name of article, the word "Poison," and the name and address of the seller. For those articles included in Part 2 of the schedule only the three last requirements have to be fulfilled. There are really very few photographic chemicals included in the schedule, and not any that are used in considerable quantities. Corrosive sublimate, mercuric perchloride or mercuric chloride, is included in

THE CHIEF PHOTOGRAPHIC POISONS AND THEIR ANTIDOTES

	Poisons	Remarks	Characteristic Symptoms	Antidote
Vegetable Caustic Acid, Alkalis.	OXALIC ACID, including POTASSIUM OXALATE	1 dram is the smallest fatal dose known.	Hot burning sensation in throat and stomach ; vomiting, cramps, and numbness.	Chalk, whiting, or magnesia suspended in water. Plaster or mortar can be used in emergency.
	AMMONIA POTASH SODA	Vapour of ammonia may cause inflammation of the lungs.	Swelling of tongue, mouth, and fauces ; often followed by stricture of the œsophagus.	Vinegar and water.
Metallic Salts.	MERCURIC CHLORIDE	3 grains the smallest known fatal dose.	Acrid, metallic taste, constriction and burning in throat and stomach, followed by nausea and vomiting.	White and yolk of raw eggs with milk. In emergency, flour paste or "hypo" solution may be used.
	LEAD ACETATE	The sub-acetate is still more poisonous.	Constriction in the throat and at pit of stomach ; crampy pains and stiffness of abdomen ; blue line round the gums.	Sulphates of soda or magnesia. Emetic of sulphate of zinc.
	POTASSIUM CYANIDE	a. Taken internally, 3 grs. fatal.	Insensibility, slow gasping respiration, dilated pupils, and spasmodic closure of the jaws.	No certain remedy ; cold affusion over the head and neck most efficacious.
		b. Applied to wounds and abrasures of the skin.	Smarting sensation.	Sulphate of iron should be applied immediately.
	POTASSIUM BICHROMATE	a. Taken internally.	Irritant pain in stomach and vomiting.	Emetics and magnesia, or chalk.
		b. Applied to slight abrasions of the skin.	Produces troublesome sores and ulcers.	
	SILVER NITRATE		Powerful irritant.	Common salt to be given immediately, followed by emetics.
Concentrated Mineral Acids.	NITRIC ACID	2 drams have been fatal. Inhalation of the fumes has also been fatal.	Corrosion of windpipe and violent inflammation.	Bicarbonate of soda, or carbonate of magnesia or chalk, plaster of the apartment beaten up in water.
	HYDROCHLORIC ACID SULPHURIC ACID IODINE	½ ounce has been fatal. 1 dram has been fatal. Variable in its action ; 3 grains have been fatal.	Acrid taste, tightness about the throat, vomiting.	Vomiting should be encouraged, and gruel, arrowroot, and starch given freely.
	ETHER	Poisonous when inhaled.	Effects similar to chloroform.	Cold affusion and artificial respiration.
	PYROGALLOL	2 grains sufficient to kill a dog.	Resembles phosphorus poisoning.	No certain remedy. Speedy emetic desirable.

ACETIC ACID, concentrated, has as powerful an effect as the mineral acids.

Part 1. "Cyanide of potassium and all metallic cyanides and their preparations" is another item in Part 1. It is an open question whether this term may not be strictly held to include the ferri-, ferro-, and sulpho-cyanides; as a matter of fact, however, it is held that these preparations are not to be classed as *scheduled* poisons. Part 2 includes preparations of mercuric chloride; therefore any intensifier containing this cannot be sold except by a registered chemist. It also includes oxalic acid, which is but rarely used, and mercuric iodide and sulphocyanide.

Under the Poisons and Pharmacy Bill, 1908, Section 5 states, "It shall not be lawful to sell any poison to which this section applies by retail, unless the box, bottle, vessel, wrapper or cover in which the poison is contained is distinctly labelled with the name of the substance and the word 'Poison,' and with the name and address of the seller of the poison." The poisons here enumerated are sulphuric, nitric, and hydrochloric acids, and the soluble salts of oxalic acid. Presumably this would include even the dilute acids, although no differentiation as to strength is made. "Soluble salts of oxalic acid" naturally includes neutral potassium oxalate, and the oxalates of ammonium, sodium, and iron, also presumably potassium ferric oxalate and all preparations in which these may be contained. It will be seen that really there are very few scheduled poisons used in photography, but it must not be forgotten that there are many chemicals which are poisonous beyond these, and it would be as well to label as "Poison" all ferro-, ferri-, and sulphocyanides, bichromates, pyro, and all preparations of copper, uranium and cerium. If this is thought too drastic, then at least a warning label should be devised, somewhat on the following lines, "Care should be exercised in the use and storing of this chemical, as when taken internally it is poisonous." There is no difficulty in a firm of dry plate makers, etc., selling a poison to a wholesale house so long as it is marked "Poison." The Act only applies to sale to the public.

POITEVIN, ALPHONSE LOUIS

Born at Conflans, France, 1819; died at the same place 1882. He was a chemist and engineer, and took up the study of photography immediately after Daguerre's discovery was made known. He secured an award for a method of photo-chemical engraving upon plates coated with silver and gold. In 1855 he patented a "helio-plastic" process, by which films of bichromated gelatine were exposed to light under a negative and then soaked in water; parts of the picture were then in relief and a mould was taken. In the same year he discovered that bichromated gelatine which had been exposed to light would allow greasy ink to adhere to it, although it repelled water. Upon these facts he in 1856 based a photo-lithographic process, and he is looked upon as the practical founder of the carbon process, photo-lithography and collotype printing. In 1867 he was awarded the greater part of a prize of 10,000 francs for the discovery of permanent photographic printing processes.

POLARISATION

The splitting up or division of a ray of light into two distinct refracted parts.

POLARISCOPE (Fr., *Polariscope* ; Ger., *Polariskop*)

When a ray of light falls on a crystal of Iceland spar in a direction not parallel with the principal axis, it is doubly refracted and split into two parts. One part, known as the ordinary ray, obeys the usual laws of refraction; the other, known as the extraordinary ray, behaves in quite a different manner. For examining the phenomena of polarised light a polariscope is employed; this usually consists of two Nicol prisms mounted in separate tubes, the lower

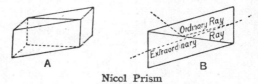

Nicol Prism

one being known as the polariser and the upper as the analyser. A Nicol prism is a rhomb of Iceland spar cut along the long diagonal, as shown at A, the two halves being then cemented together with Canada balsam. The ordinary ray has a higher refractive index than the balsam and is accordingly got rid of by total reflection, as at B, while the extraordinary ray passes through without interruption. If the analyser is rotated above the polariser the field is gradually darkened, and when the two planes are at right angles the light is extinguished. The polariscope is frequently used with the microscope. (*See also* "Nicol Prism.")

POLARISER

A Nicol prism mounted in a tube, as described under the heading "Polariscope."

POLARISED LIGHT

Light rays that have been doubly refracted or split up.

POLYCHROME, POLYCHROMATIC, AND POLYCHROMOTYPE

Terms applied to photographs and photographic reproductions in several colours.

POLYPOSE PORTRAIT

A portrait in which the sitter appears in two or more different positions. (*See* "Doubles" and "Multiple Photography.")

POLYSCOPE (Fr., *Polyscope* ; Ger., *Polyskop*)

An apparatus patented by Robert H. Baskett. A suitable box contains two surface-silvered mirrors, with provision for adjusting these to any angle, which must, however, be capable of dividing into 360° without remainder. On placing a suitable object, such as a piece of lace, filagree work, floral decoration, or, in fact, almost anything of pleasing outlines, at the end of the box, the pattern is repeated symmetrically as in the kaleidoscope. If the subject

is then suitably lighted and a camera placed with its lens pointing into the box at the junction of the mirrors the ornamental arrangement may be photographed. Such patterns are of great assistance in making commercial designs.

PONTON, MUNGO

Born at Balgreen, 1802 ; died at Clifton, 1880. He was the first to observe the effects of the sun's rays on potassium bichromate, and on May 29, 1839, he communicated to the Society of Arts for Scotland " a cheap and simple method of preparing paper for photographic drawing in which the use of any salt of silver is dispensed with." His process was to spread a solution of potassium bichromate upon paper and expose it with a suitable object laid upon it to the sun's rays ; the light acted upon and hardened certain parts, while those which were not acted upon could be dissolved away, leaving the object white upon a yellowish brown ground. He obtained copies of drawings and images of dried flowers in this way, and fixed them simply by washing in water. In 1849 he published a method of registering the hourly variations of the thermometer by means of photography.

P.O.P.

Printing-out paper. Generally understood to mean gelatino-chloride paper, used for all-round work. The initials were first used by the Ilford Company in 1891.

P.O.P. GASLIGHT PAPER

Ordinary P.O.P. can be made into gaslight paper by a process of converting the soluble silver salts into silver bromide, or into a mixture of silver haloids with a predominance of bromide. The P.O.P. should be immersed in the following solution for five minutes in the dark-room or in a very weak light and then washed and dried in the dark :—

Potassium bromide	.	36 grs.	3·3 g.
Potassium iodide	,,	12 ,,	1·1 ,,
Copper sulphate	.	1 gr.	·1 ,,
Water	.	25 oz.	1,000 ccs.

A 5 per cent. solution of potassium bromide may be used with some papers instead of the above. After drying, the paper may be treated as gaslight paper.

PORCELAIN CLAY (See " Kaolin.")

PORCELAIN DISHES (See " Baths.")

PORCELAIN, PHOTOGRAPHS ON

The usual method of producing photographs upon porcelain is by the carbon transfer process. They may also be produced by the photo-ceramic and blue-print processes, etc., when the porcelain can be coated and sensitised. Photographic opals are sometimes referred to as porcelain plates. (See also " Photo-litho-phane.")

PORCELAINOGRAPHY

A name given in the early 'fifties to the art of printing photographs upon porcelain, opal, and similar substances.

POROTYPE (Fr., Porotype ; Ger., Porotypie)

A Continental process of copying engravings, depending on the fact that the ink lines are practically impervious to a certain gas as compared with the paper. A paper coated with a chemical pigment that is bleached by the gas is pressed into contact with the engraving, and the back of the latter is subjected to the gaseous fumes, which are obstructed by the lines of the picture ; these therefore remain pigmented in the copy, while the unprotected ground is bleached.

PORTA, GIAMBATTISTA DELLA

An eminent Italian naturalist ; born 1543, died 1615. He is the reputed inventor of the camera obscura (1569), but he more probably only improved the instrument.

PORTRAIT LENSES

Almost any lens working at an aperture of $f/6$ or larger is suitable for portraiture provided that its focal length is not less than $1\frac{1}{4}$ times that of the longest side of the largest plate which it will have to cover. The name is, however, by common consent confined to the Petzval form, known as the " ordinary " portrait lens, and also to the Dallmeyer, or " patent," portrait lens. The principal features of this type of lens are great rapidity, some lenses having an intensity of $f/2$, and extremely good definition over a moderate angle. The field of a portrait lens is usually curved, and this may in some cases be regarded as an advantage, inasmuch as it allows the knees and feet of a sitting figure to be focused equally well with the head without reduction of aperture. The Dallmeyer type of portrait lens has a great advantage over the original Petzval, as it allows the focus to be softened and distributed over several planes by turning the back cell, and thus increasing the difference between the two glasses which compose the back combination. Starting with absolute sharpness, the definition may be softened by degrees until fuzziness ensues by simply rotating the back cell. The latest model of this lens has the back cell fixed, and the softness is obtained by rotating the entire lens tube. The front combination of most portrait lenses may be used alone, and if they are to be employed for portraiture it is advisable that they be left in their normal position—that is to say, with the convex side to the sitter. By so doing sharper definition over a limited, but sufficient, field is obtained, without serious reduction of aperture. Should it be desired to use the front lens for landscape work, it is desirable that the flat side should be turned to the view, and the diaphragm closed until the desired sharpness is obtained. Portrait lenses may be used for outdoor work, and latterly have been in demand for reflex cameras. Portrait lenses are liable to give " flare spot " when used out of doors with small apertures, but this tendency is minimised if the diaphragm is placed in front of the lens instead of in the ordinary position. In selecting a portrait lens care should be taken not to choose one of too short a focal length. If possible this should be about twice that of the trimmed print, say 8 in. for cartes, $11\frac{1}{2}$ in. for cabinets, and 20 in.

to 24 in. for panels. Besides the recognised portrait type, special portrait lenses are made on the Cooke model, and these have the " diffusion of focus " adjustment. Most enlarging objectives are of the Petzval portrait lens construction, and may be used in the camera with good results. Magic-lantern lenses are also of this type, but are usually corrected for the visual rays only, and will not give a sharp image on the photographic plate.

PORTRAITURE, COMPOSITE (*See* "Composite, Analytical, or ' Average ' Portraits.")

PORTRAITURE

In all portraiture, the question of apparatus is not nearly so important as those of posing and lighting. The camera should preferably be of the stand variety, but hand cameras are also capable of producing good work ; the ordinary fixed-focus pattern without magnifiers is not to be recommended for the work, as unless a very small stop is used the image will not be in focus, although such a camera answers for full-length portraits if the subject is sufficiently far enough away. Lenses that work at a fairly large aperture are the best for indoor portraiture. (*See* " Portrait Lenses.") The focal length of the lens is a matter of importance ; the greater the focal length the more truthful is the result, as a rule ; if a lens embracing a very wide angle is used, distortion is almost sure to occur, and the size of the nose, ears, hands, or feet will appear exaggerated. The question of isochromatic *versus* ordinary plates for portrait work need not be discussed here. Either may be used ; but an isochromatic plate will do all an ordinary plate will do and a little more. More truthful rendering of colour is obtained by using a screen, but the exposure is thereby prolonged. Many professionals use isochromatic plates for certain subjects—such, for example, as very freckled faces, yellowish hair, coloured dresses, etc. A rapid plate is the most suitable for indoor work where the exposure is to be perhaps somewhat lengthy. Many of the plate makers give in their instructions special developers for portrait work, and photographers cannot do better than use them. They are compounded to give soft negatives, and are specially suitable for the plates with which they are issued. If no such special formula is given the usual developer will generally serve, but if the results are too hard the developer may be diluted with water so as to secure a softer result. Adurol, pyro-soda, and pyro-ammonia are very suitable. When " single solution " developers, patent concoctions or otherwise, are used, the safest way of securing a soft result is to develop until the image just appears, and then to transfer to a dish of clear cold water in which the image will go on developing slowly, giving it if required a moment or so in the developer occasionally and then transferring to the water. This method of developing brings out detail and gives softness in a remarkable manner. When the negative has sufficient detail and density it should be fixed in the usual manner.

Outdoor Portraiture.—This is one of the commonest forms of photography and one in which failure frequently occurs. The old rule of placing the sitter in the brightest light possible does not in these days of rapid lenses and plates give the best results as a rule. It is the too strong light that spoils many attempts at outdoor portraiture, and the more the light can be con-

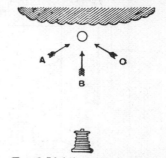

A. Equal Lighting, causing Flatness

trolled, the better and more artistic are the portraits likely to be. Outdoor portraits frequently lack character, are flat, and devoid of any effects of light and shade which characterise professional studio work ; and yet by working carefully one may easily obtain an effective portrait of a sitter. With two sitters this is more difficult, and it increases as the number of sitters grows. The usual defect in the outdoor portrait is flatness, caused by the light reaching the sitter from both sides and the top alike, as in A. Here it is supposed that the model is placed against a wall, hedge or other foliage to serve as a background, there being nothing on either side of or above the sitter to stop the immense flood of light, as represented by the arrows A, B and C. What is wanted is a trifle more light on one side of the face than the other, in order to obtain " roundness." It is sometimes difficult to get the required light and shade in the open, but a big tree is a useful accessory when utilised as shown at B. If the sitter is placed by the side of the trunk it may serve to cut off some of the side-light, while the boughs above will cut off superfluous top light. More portraits are perhaps taken in back yards or gardens than in the field ; in such cases a dark folding screen, or even an open umbrella,

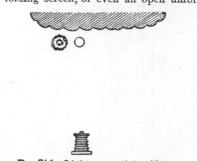

B. Side Light cut off by Tree

may be used with advantage to check the excessive light, but more often the trouble is overcome by arranging the positions of the camera and sitter. C represents the plan of part of a garden or back yard of the ordinary type. Against a

door is a favourite place to pose a model, say as at B, and success will depend upon the lighting, type of door or portico, etc. Doors may be made to serve admirably if the portrait is professedly an outdoor one and the figure three-quarter or

C. Portraiture at
Back of House

D. Portable
Studio

full length. It is, however, almost hopeless to take a bust portrait with an artificial background placed as at B, because ordinarily there would be an equal amount of light on each side of the face. If a portrait head is to be taken and the effect aimed at is an artistically lighted studio effect, it would be better to place the sitter in the angle, as at A, and the camera parallel to the wall as shown. By so doing, the wall acts as a screen, and one side of the face is slightly in shadow. By allowing the camera to remain in the same position and placing the sitter at C, the result would even be flatter than at B, because the sitter is at a greater distance from the wall. In cases where the precise positions shown cannot be taken up, it is possible to carry out the same principles of lighting in other ways. The sitter could, for example, be placed in the angle A, and the camera parallel to the house at C, in which case the wall, possibly with foliage, would serve as a background, and the house itself as a screen for the light. There are many other obvious ways of securing more light on one side of the face than the other, which system of lighting will alone give the necessary roundness and lifelike appearance to portraits taken out of doors.

E. Frame for Portable Studio

Backgrounds are usually required for studies of heads, particularly when taken out of doors, as any bricks, foliage, etc., appearing behind the head are apt to distract the attention. For full and three-quarter figures, however, natural back-

grounds serve very well, but in no case should they be so sharply focused as the subject. Ugly and unpromising backgrounds may very often be made to serve by placing the sitter well in front, using a large stop in the lens,

F. Side Light causing Harsh Lighting

and focusing the eyes of the model and not the background.

When much portrait work is to be done out of doors, as in the case of pageants, bazaars, fêtes, etc., it is advisable to make a kind of portable studio, as shown at D and E, a useful size for which is 8 ft. by 6 ft. Three frames are made of 3-in. by 1-in. wood, 8 ft. high and 6 ft. broad; one serves as the back and the two others are hinged thereon to serve as wings; a fourth frame is made to fold over the top, and is covered with white muslin, as are also the two top halves of the wings. The bottom halves are covered with dark material. Blinds are fitted over the white muslin at the side and top, in order that the amount of light reaching the interior may be regulated. Hooks or bolts keep the wings and top in position during use. A plain cloth background is then fitted to the back frame, or, if preferred, it may be left open and when in use pushed back against a suitable natural background.

A common defect in amateur portraits taken out of doors is the dark appearance of the sitters' faces, usually due to under-exposure, or to the use of a too brilliant background. When the sky is the background for a person's head, the face invariably comes out very dark, and halation often occurs. Models without hats are usually represented as having darker faces than those who wear large hats, because the latter act more or less as backgrounds and serve to isolate the face from the sky. An open umbrella or sunshade may occasionally be used to make the face appear clearer.

G. Room used as Studio

Indoor Portraiture.—Home portraiture indoors is a difficult branch of photography, because of the limited amount of light admitted by an ordinary window, and because what light there is comes from one point, which, in the absence

of precautions, gives harsh black-and-white
effects. A simple experiment, and one which
embodies all the principles of indoor lighting
for portraits, is the following: In a darkened
room place a lighted candle upon a table and

window is a large bay or French window, and
the glass goes almost to the ground level. All
sorts of lighting may be obtained in a home
studio such as that described, as the sitter can
be placed at any spot between s and a with

Six Kinds of Lighting Available in Room-studio

beside it an orange or a ball, as shown at F.
The sphere is strongly lighted on one side only.
If a sheet of tissue paper or muslin is held at
A B, not only is the light softened on the candle
side of the sphere, but it is also diffused, so that
the shadow side does not appear so dark. If,
in addition, a sheet of white paper or cardboard
is held at C D the light will be reflected on to
the shadow side of the sphere, to the great
advantage of the lighting or modelling. This
illustrates both the principles and practice of
indoor portrait lighting, the window being
represented by the candle and the sitter by the
sphere. The only way of securing satisfactory
results is by diffusing the light and using a
reflector. G is a diagram of an ordinary room
having corners D, E, F, G. Should there be two
or more windows on opposite sides, all but one
of these should, in most cases, be blocked up,
as otherwise the cross-lighting will produce
unsatisfactory results. One window is really all
that is required, and it must be one into which
the sun does not directly shine. By placing
the camera at C against the blocked-out window
(the background at B) and the sitter at S, one
would, if neither reflector nor diffuser be used,
get a harsh result because all the light would
come from the window side. Therefore, tissue
paper is placed over the bottom half of the
window and the top half is left clear. The blind
can be worked over the top half so as to admit
or block out top light as desired. A reflector—
white paper, cardboard, or a sheet—should be

equally good results, and the position of the
camera can also be altered. Even the difficult
" Rembrandt" lighting can be secured by
placing the camera and sitter somewhere about
H and I respectively. Diagrams H to M (based
on illustrations appearing in the *Photo Revue*)
show six kinds of lighting obtainable in such
a room. The letters indicate the position of
window W, sitter S, camera C, background B,
and reflector R, and the arrow indicates the
direction in which the model is looking. The
lightings illustrated are: H, ordinary lighting
with one window; I, normal lighting with two
windows; J, "Rembrandt" lighting; K and
L, profiles with different lightings; M, "against
the light" effect.

In some cases a large and suitable window
may be available at the end of a corridor or in
a room which does not permit of the camera
being placed in the positions shown in the
diagrams. An American worker (W. C. Vivian),
who produces excellent work, has such a window
and he adapts it as shown in diagram N. He
uses two curtains, one, A, dark and opaque, to
pull up from the floor high enough to serve as a
background for the figure; this will necessitate
the camera being pointed directly at the window
The top curtain, B, which is drawn down and into
the room to reflect the light from the window
on to the figure, should be drawn far enough
below the top of the dark curtain to prevent
direct rays of light from entering the lens. The
top of a white curtain rests on brackets which
project out from the wall several feet, with
notches to enable one to shift the curtain to or
from the window top, by which means there may
be obtained an over-head light or a more direct
light on the face, as may be required.

A very simple system of lighting heads is
shown at O. A window should be fitted with a
long white blind, which is pulled down (or out)
as far as possible, and suspended above a sitter
posed against the window. The top part
serves as a reflector for top light, while the
lower acts as a reflector for side light. The
light at the window is controlled by means of
tissue paper or muslin.

Hints on work in the studio are given under
the heading "Studio Portraiture."

N. Controlling Lighting　　O. Simple Arrange-
　with Two Curtains　　　　ment for Lighting
　　　　　　　　　　　　　　　　　Heads

used at R, and the degree of reflection regulated
by its size and the angle at which it is placed.
Too much, however, must not be expected
from the home studio, and the beginner will do
well to attempt nothing but busts unless the

POSING

In photography the posing of the figure has
to be considered from a different standpoint from

what would be suitable in painting, on account of the exaggeration of perspective in short-focus lenses. Care should be taken so to pose a figure that the whole arrangement of figure and dress is as much in the same plane as possible. With sitting figures, the chair should be placed slightly turned to one side, so that the legs and feet do not unduly extend into the foreground. The arms and elbows should rarely be allowed to rest on both arms of the chair, but ease of pose is often obtained by resting on one arm—the one farther from the camera; in photographing ladies, it is in most cases better to avoid the use of chairs with arms, as a much more graceful pose can be obtained by allowing the dress to fall over the side of the chair. The standing figure allows of much variety of pose, in which the hands play a very important part, but great care must be taken to see that they are so arranged as not to appear awkward. If the body is turned so as to present a side view to the camera, one foot—preferably that farther from the camera—should be advanced in front of the other. Should one arm hang down at the side towards the camera, it should be slightly bent. The hand should be in such a position that the breadth of the back of the hand does not show, but turned so as to show its side and therefore narrowest view; the fingers should be arranged so that the index finger forms a continuation of the chief line.

When the profile is pretty, the head may assume a looking-down position, but such poses need careful arrangement, and there should be an obvious reason for the position. In such a position, and should a book be held, avoid any parallel position of the two arms; this is easily done by holding a top corner of the book with one hand and with the other the diagonal corner. Sunshades, fur boas, and ribbons, all provide useful accessories for obtaining graceful poses by giving opportunities for the arms to be raised in many different positions, always remembering to avoid straight lines and sharp angles which are particularly undesirable.

For head and shoulder pictures, the model may sit on a chair having a small and somewhat high seat. Allow the figure to lean slightly forward away from the back of the chair, as this avoids any appearance of rigidity. The head turned in a slightly different position from the direction of the body gives a suggestion of alertness.

POSING CHAIRS AND HEAD RESTS

Various kinds of chairs are made for studio use, with a head-rest attached, a revolving seat, and sometimes a platform on castors so that the sitter may be moved to where the best lighting is obtainable without altering the pose. In these days of rapid plates, however, with artificial illuminants to render the operator independent of dull weather, such mechanical aids as the head-rest are falling into disuse, the more so as they tend to render the average sitter uncomfortable and constrained. The modern aim is to make the studio as much like an ordinary room as possible, and to avoid fussy preparations or too deliberate posing. But with some sitters, or where a perfect light is not obtainable, such accessories are very necessary.

POSITIVE

The direct opposite to a negative; a reproduction of the object with lights and shadows as in nature. A photographic print is a positive, but the term is rarely used except to describe pictures upon glass—chiefly transparencies. The word was first used by Sir John Herschel in 1840.

POSITIVE ABERRATION

The most usual form of spherical aberration, in which the marginal rays come to a focus nearer the lens than do the central rays.

POSITIVE BATH (Fr., *Bain positif*; Ger., *Positivbad*)

An indefinite and practically obsolete term applied to the silver nitrate solution used for sensitising collodion positives, to the sensitising solution employed with albumenised and plain salted papers, and also to the tanks or dishes holding these.

POSITIVE FERROTYPE (*See* "Pellet Process.")

POSITIVE FOCUS

The focal length, or the position of the sharpest image of a distant object when projected by a positive lens. Negative focus is the reverse of this, a negative lens having a degree of concavity sufficient to neutralise a positive lens of any given focal length.

POSITIVE LENS

A lens capable of producing a convergent beam of rays or of projecting a real image. All photographic lenses, and telescopic and microscopic objectives are positive lenses. Formerly a positive lens was necessarily convex in its external form, but recent improvements in glass manufacture have rendered it possible for a positive lens to be made with two blank surfaces, or even to have a small amount of concavity.

POSITIVE PROCESSES

Processes that produce a positive result from direct exposure, as distinguished from processes that yield a negative. The term is correctly applied to all methods of obtaining a positive result, whether by optical means or printing from the negative. The first photographic process, the daguerreotype, was a positive process, and for many years collodion positives were very largely produced, but, strictly, the latter are negatives, the images being formed of a light coloured deposit, while the dark colour of the enamel of the ferrotype or a piece of dark velvet placed behind the glass forms the shadows. A similar result can be obtained on an ordinary dry plate by developing lightly, bleaching the image in mercuric chloride after fixing and washing, and, after again washing and drying, backing it up with a piece of dark velvet. The autochrome and other screen-plate processes are positive after the reversal.

POSITIVES IN COLOURS

There have been many methods of obtaining positives in colours. E. J. Wall, in *American Photography*, has summarised them as (1) the

so-called diazotype processes (fully described under the heading " Diazotype "), in which the action of light on diazo compounds is utilised by the formation of dyes from the compounds thus formed or decomposed by light. (2) That class in which a silver image is obtained in the ordinary way, and then converted into a salt which acts as a mordant for the dye. The second class was first described by Georges Richard in *Comptes Rendus*, 1896, and ten years later Traube, of Munich, patented a process, known as " diachrome," which is the application of Richard's principle. Traube converts a silver image into silver iodide by immersion in—

Iodine	.	87 grs.	20 g.
Potassium iodide	.	218 ,,	50 ,,
Distilled water to	.	10 oz.	1,000 ccs.

and then after washing immerses the positive in a solution of a basic dye which immediately precipitates or forms a lake with the iodide and gives a coloured image. Dissolve the iodide in a fifth of the water, add the iodine, stir till dissolved, and add the remainder of the water. The silver iodide is of course opaque, but this may be dissolved out by potassium cyanide or a " hypo " bath containing tannin or tartar emetic, the action of these substances being to prevent the washing out of the dye. After fixation the positive is merely washed, and the image consists of a perfectly transparent dye and is of extraordinary brilliancy and transparency in the shadows. Basic dyes must be used, as so far the only acid dyes which give satisfactory results are those of the triphenylmethane series to which the eosines belong. The following dyes are therefore available: acridine orange, chrysoidine, rhodamine 6 G, rhodamine B, xylene red B, methyl and crystal violet, victoria pure blue B, and all the other victoria blues, methylene blues, methylene green, brilliant, emerald, diamond, and victoria greens, and all the eosine group of dyes which comprises eosine, erythrosine, rose bengal, phloxine, uranine, etc. Compound tints are best obtained by successive baths of different dyes, as mixtures are apt to stain unequally. Frequently, too, good effects may be obtained by first staining up with a basic dye and then applying an acid dye ; and if the combinations are suitably chosen, very intense colours may be obtained in this way, as the basic acts as a mordant for the acid dye.

Traube's process has been modified by many workers, Tauleigne and Namias being notable among them.

POSITIVES, DIRECT

The simplest method of obtaining a direct positive upon a dry plate is to expose (avoiding over-exposure) and develop in the usual way, but not fix. After washing, immerse in

Potassium perman-ganate	.	5 grs.	1 g.
Sulphuric acid	.	10 mins.	2 ccs.
Water	.	10 oz.	1,000 ,,

until the image disappears. Next soak in a weak solution of oxalic acid (4 grs. per ounce, or about 1 g. per 100 ccs.) until the brown stain is cleared from the gelatine. The plate is then

well washed, exposed to actinic light, again developed, fixed in " hypo," and washed. For the re-development the following is excellent :—

Metol	.	50 grs.	11·5 g.
Sodium sulphite	.	100 ,,	23 ,,
Caustic soda	.	50 ,,	11·5 ,,
Water	.	10 oz.	1,000 ccs.

The permanganate reversing (or reducing) bath may be replaced by a 5 per cent. solution of ammonium persulphate with 5 per cent. of alum, the weak oxalic bath being omitted.

Major-General Waterhouse recommends reducing the exposure to one-thirtieth of the normal, developing and fixing as usual, but using the following developer :—

Lithium carbonate	.	50 grs.	11·5 g.
Sodium sulphite	.	50 ,,	11·5 ,,
Eikonogen	.	50 ,,	11·5 ,,
Thiocarbamide (saturated solution)	.	Few drops	
Water	.	10 oz.	1,000 ccs.

Another method suitable for very slow plates is to expose, develop until the image is seen on the glass side, wash, and immerse in—

Potassium bromide	.	500 grs.	115 g.
Iodine	.	100 ,,	23 ,,
Water	.	10 oz.	1,000 ccs.

until the image is bleached. Then wash, develop with any developer in strong daylight, wash and fix.

Lantern Slides and Bromide Paper.—The above methods may be used, but the late Douglas Carnegie worked out what is considered to be a more certain process. The lantern plate or other slow plate should be backed ; it is exposed (avoiding over-exposure), developed with metol-hydroquinone, washed, and immersed for about two minutes in the following reversing bath, which, in hot weather, needs to be diluted :—

Potassium bichromate	.	75 grs.	17 g.
Nitric acid (pure)	.	45 mins.	9 ccs.
Water	.	10 oz.	1,000 ,,

After bleaching in this bath for a moment only, replace in the developer, rock the dish for about 30 seconds, and then, while still in the developer, expose to light, for say 20 or 30 seconds, at a distance of 1 ft. from an ordinary No. 4 burner. The second development must not be pushed to the point of fogging the background. Fix in an acid fixing bath. Bromide prints may be obtained direct in the camera in the same way, using " glossy " paper ; a weaker light (equal to one candle) is placed 2½ ft. distant from the print lying in the dish, and allowed to act until the edges of the paper protected by the rebate begin to darken. The colour is not very pleasing and should be modified by toning, sulphide being preferable.

Balagny recommends developing a plate with acid-amidol (*see* " Amidol, or Diamidophenol "), washing thoroughly, exposing for 30 to 45 seconds to diffused daylight, and then immersing (in the dark-room) in—

Potass. bichromate	.	150 grs.	35 g.
Nitric acid	.	60 mins.	13 ccs.
Water	.	10 oz.	1,000 ,,

This converts the image into silver chromate, which is dissolved out by a 10 per cent. solution of sodium sulphite plus 3 per cent. of acid bisulphite. The plate is next well washed, when nothing remains but the exposed silver haloids, which are developed with acid amidol minus the bromide.

POSTAGE STAMP PHOTOGRAPHS

For producing these professionally, a camera containing a battery of small lenses may be used, its interior being partitioned into as many sections as there are lenses, thus securing a number of images on one negative. The illustration shows a camera for taking nine photo-

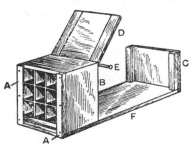

Postage Stamp Camera

graphs on a quarter-plate. The back of the camera has brass plates A to take the dark-slide; the front is at B; and an easel for supporting the original photograph at C. The box is 6 in. by 5 in., its depth depending on the focal length of the lenses used. For a one-third scale reduction, as in reducing a quarter-plate original to one-ninth that size, the distance between lens and plate will be the focal length of the lenses plus one-third that focal length; the result multiplied by three gives the distance between lens and copy. Thus, with a 3-in. focus lens,

$3 + \dfrac{3}{3} = 4$ in., the distance between lens and plate; while $4 \times 3 = 12$ in., the distance between lens and copy. The divisions are of blackened wood or cardboard partitions. In the front, but not illustrated, are circular openings to take the nine small lenses, and the hinged shutter D is worked by the projecting rod E. The box is attached to a baseboard F. Pinholes could be used instead of lenses, but the exposure would be greatly prolonged.

The camera can be adapted for direct portraiture by providing focusing adjustment, and omitting the easel. Printing from a negative produced in this camera can be done in an ordinary printing frame, using a suitable mask and a multiple border negative for producing the stamp effect. The perforations are done by a special machine, after the backs of the sheets have been brushed over with dextrine and allowed to dry.

In the absence of a special camera, a succession of images can be printed on a single sheet of paper, using a repeating printing frame, and the result may, or may not, be copied in the camera to produce a negative from which a large number of images can quickly be printed.

POSTCARDS

The popularity of the postcard (invented in 1869 by Dr. E. Hermann, of Vienna) has increased enormously since about 1894, owing to the introduction of picture postcards, the authorising of private postcards, and the withdrawal of the

A. Arrangement for Printing Postcards

regulation confining the written matter to one side only. As to who first produced a picture postcard there appears to be some difference of opinion; it is known that at the time of the Franco-German war a French stationer published such a card to commemorate the visit of a popular regiment to his city.

Postcards ready sensitised are supplied by the dealers, or any good cards may be sensitised at home by the blue-print, kallitype, silver or other processes. Plain postcards are sometimes not pure enough to produce the best effects, and it is always better to purchase them ready sensitised with bromide or print-out emulsion, or to obtain the unsensitised cards from a manufacturer of sensitised postcards.

As negatives may be larger or smaller than the average postcard ($5\frac{1}{2}$ in. $\times 3\frac{1}{2}$ in.) care is necessary in printing and masking. Many special kinds of postcard printing frames are obtainable, but an ordinary large printing frame can be made to serve. Half-plate is a handy size from which to print a postcard, as the image can then extend right to the edges. Smaller plates than postcard size need masking, which may be done by using a half-plate frame and placing in it a piece of plain glass and a piece of white or light cardboard. In the cardboard is cut an aperture large enough to take the plate. Lantern binding strips are then placed over the junction of the card and the negative (*see* A), to hold it in position and to serve as a mask for giving a straight edge to the picture. When the correct position of the image on the postcard has been found guide marks C are made on the cardboard to enable cards to be placed in posi-

B. Using Corrugated Paper as a Rack for Drying Postcards

tion quickly (*see* diagram A). Packets of postcards very often contain black paper masks with openings of various shapes, and these are extremely useful. For the addition of borders, *see* " Border Printing " and " Borders, Fancy,"

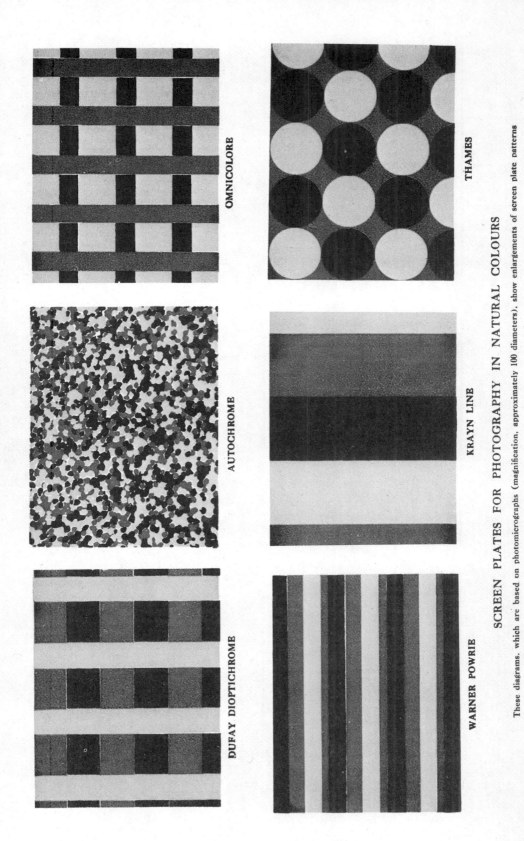

OMNICOLORE

THAMES

AUTOCHROME

KRAYN LINE

DUFAY DIOPTICHROME

WARNER POWRIE

SCREEN PLATES FOR PHOTOGRAPHY IN NATURAL COLOURS

These diagrams, which are based on photomicrographs (magnification, approximately 100 diameters), show enlargements of screen plate patterns

and for the addition of titles, *see* " Lettering Negatives and Prints." Postcards are exposed, developed, toned, etc., in the same way as other prints, but there is sometimes difficulty in causing them to dry flat. Collodion and most self-toning cards may be dried under pressure between blotting-paper, but gelatine-surfaced cards would be spoilt by such treatment, although the risk would be reduced by hardening with formaline. One of the best ways of drying gelatine cards is to bend them archways, picture side outwards, and catch the ends in corrugated paper as at B. Large producers sometimes nail laths to a board and use the board in the same way as the corrugated paper. The cards generally flatten out naturally when released, or may easily be made to do so, whereas if allowed to dry naturally, they curl inwards and often crack, especially in the case of collodion cards, when any attempt is made to flatten them after drying.

POST-MORTEM PHOTOGRAPHY

Downey's photograph of the body of King Edward VII., the most widely published post-mortem photograph known, indicates that the best results are to be obtained by placing the camera on a level with the head or only very slightly above that level, and showing the face in profile. There should be a dark background, or, failing this, the light should enter the room from behind the camera so as to illuminate the profile, the background being then dark by comparison. The full-face view is less pleasing and more difficult to obtain in the absence of special facilities, which, however, are common on the Continent, where post-mortem photography is widely practised; but photographs of bodies for identification purposes are nearly always taken full-face, and usually in a coffin, the latter enabling the body to occupy a more suitable position for photographing. One of the most serious difficulties in this work is due to the loss of brilliancy in the eyes, which has a large part in determining the characteristic expression of the individual. Bertillon (of finger-print fame) has recommended the injection of glycerine into the eyes, and the restoration of the colour of the lips with carmine.

POTASH ALUM OR POTASSIUM ALU-MINIUM SULPHATE (*See* " Alum.")

POTASSA SULPHURATA

An old name for potassium sulphide.

POTASSIUM AMMONIUM CHROMATE (*See* " Ammonium and Potassium Chromate.")

POTASSIUM BICARBONATE (Fr., *Bicarbonate de potasse ;* Ger., *Saures Kohlensaures Kalium*)

Synonym, acid potassium carbonate. $KHCO_3$. This must not be confounded with potassium carbonate. Molecular weight, 100. Solubilities, 1 in 3 water, almost insoluble in alcohol. A fine white dry powder obtained by treating a solution of potassium carbonate with carbonic acid. It is rarely used in photography. It should not be confused with the carbonate, K_2CO.

POTASSIUM BICHROMATE (Fr., *Bichromate de potasse ;* Ger., *Kaliumbichromat, Saures Rotes Chromsaures Kalium*)

Synonyms, potash or potassium dichromate ; acid or red potassium chromate. $K_2Cr_2O_7$. Molecular weight, 294. Solubilities, 1 in 10 water, insoluble in alcohol and ether. Large orange-red translucent crystals obtained from chrome iron ore. It is poisonous, the antidotes being emetics and the use of the stomach pump, soap, magnesia, or calcium saccharate. It is readily absorbed by the skin, and gives rise in some people to extremely painful indolent ulcers all over the body, but particularly on the hands and arms. Citrine ointment is recommended as the best remedy to apply to the sores, but it is stated that a liberal washing of the hands with salt or sodium bisulphite solution will prevent any ill effects from its use. It is employed in the carbon process and many photo-mechanical processes, as when in contact with organic matter, such as gelatine, fish-glue, and other colloids, it is decomposed by light and renders them insoluble. According to Lumière and Seyewetz the action of light may be represented by the following equation :

$$K_2Cr_2O_7 = Cr_2O_3 + K_2O + 3O.$$

The potash immediately acts on excess of the bichromate and forms potassium chromate, which is much less sensitive.

In process work, potassium bichromate is used for sensitising photo-lithographic paper, carbon tissue, collotype plates, and the albumen coating for zinc. The ammonium salt has largely, if not entirely, superseded it for the fish-glue enamel coating. In some formulæ a mixture of the potassium and ammonium salts is used. By the addition of liquor ammoniæ to bichromate sensitising solutions, the double compound of potassium ammonium bichromate is formed and makes a more stable solution. In the Paynetype process a 5 per cent. solution of potassium bichromate is used as a hardening bath. It is also used with sulphuric acid as a glass-cleaning pickle.

POTASSIUM BISULPHITE (Fr., *Bisulfite de potasse ;* Ger., *Saures Schwefligsaures Kalium*)

Synonyms, acid potassium sulphite, potassium hydrogen sulphite. $KHSO_3$. Molecular weight, 120. Solubilities, soluble in water, insoluble in alcohol. A white crystalline powder smelling of sulphurous acid and obtained by passing sulphurous acid gas into potassium carbonate solution. Occasionally it is used as a preservative.

POTASSIUM BITARTRATE

Synonyms, cream of tartar, acid potassium tartrate. $(CHOH)_2$ COOH COOK. Molecular weight, 198. It is but seldom used.

POTASSIUM BOROTARTRATE (Fr., *Tartrate boro-potassique ;* Ger., *Kaliumborotartrat*)

Synonym, soluble cream of tartar. $C_2H_2(OH)_2$ $(COO)_2BOK$. Molecular weight, 214. Solubilities, 1 in ·75 water. A fine white powder, composed of equal parts of potassium metaborate

28

and bitartrate. It has been recommended as a restrainer in development, but is rarely used.

POTASSIUM BROMIDE (Fr., *Bromure de potasse ;* Ger., *Bromkalium*)

Synonyms, bromide of potassium or potash. KBr. Molecular weight, 119. Solubilities, 1 in 1·5 water, 1 in 750 alcohol. White cubical crystals prepared by adding bromine to caustic potash or decomposing ferrous iodide with potassium carbonate. It is used as a restrainer in development, and in gelatine emulsion making to form silver bromide. When added to a developer it actually slows the plate—that is to say, it prevents the developer from bringing out the very faintest traces of light action, unless the development is very prolonged.

In process work, potassium bromide is used in making up the copper-bromide intensifying solution for wet-plate negatives. This solution is also sometimes used for bleaching out silver prints which have been drawn upon with pen and ink.

POTASSIUM CARBONATE (Fr., *Carbonate de potasse ;* Ger., *Pottasche, Kohlensaures Kalium*)

Synonyms, potash, pearlash, subcarbonate of potash, salt of tartar, salt of wormwood. K_2CO_3. Molecular weight, 138. Solubilities, 1 in ·9 water, insoluble in alcohol and ether. A white granular hygroscopic powder, obtained from wood ashes. It is used as the accelerator in development.

POTASSIUM CHLORATE (Fr., *Chlorate de potasse ;* Ger., *Chlorsaures Kalium*)

Synonym, chlorate of potash. $KClO_3$. Molecular weight, 122·5. Solubilities, 1 in 16·7 water, slightly soluble in dilute alcohol, insoluble in absolute alcohol. Colourless tabular crystals, obtained by passing chlorine gas into a mixture of milk of lime and potassium carbonate or chloride, or electrolytically from potassium chloride. It is used in the sensitiser for platinotype paper to give brilliancy to the image, but its chief use is in flashlight mixtures. For the latter purpose the powdered salt should be obtained, and great care must be taken in mixing, which should be done with a feather on a sheet of paper, as the chlorate is very liable to explode with friction.

In process work, it is used with hydrochloric acid to form an etching solution for copper and steel, known as the Dutch mordant.

POTASSIUM CHLORIDE (Fr., *Chlorure de potasse ;* Ger., *Chlorkalium*)

KCl. Molecular weight, 74·5. Solubilities, 1 in 3 water, insoluble in alcohol. It occurs in white cubical crystals, and is prepared by neutralising hydrochloric acid with potassium carbonate. It is occasionally used in emulsion making.

POTASSIUM CHLOROPLATINITE (Fr., *Chloroplatinite de potassium ;* Ger., *Platinchloruskalium*)

Synonyms, chloroplatinite or platinochloride of potash. K_2PtCl_4. Molecular weight, 413·4. Solubilities, 1 in 6 water, insoluble in alcohol.

It is in the form of ruby-red deliquescent crystals obtained by reducing platinum perchloride with sulphurous acid gas or cuprous chloride and adding potassium chloride. It is used chiefly in the platinotype process and also for toning silver prints.

POTASSIUM CHROMATE (Fr., *Chromate de potasse ;* Ger., *Chromsaures Kalium*)

Synonyms, neutral or yellow chromate of potash. K_2CrO_4. Molecular weight, 194. Solubilities, 1 in 2 water, insoluble in alcohol. It takes the form of lemon-yellow rhombic crystals, and is obtained from chrome iron ore. It is occasionally used as a light filter for sensitometric or three-colour work. The acid chromate is potassium bichromate.

In process work, the chromate has been suggested as a sensitiser in place of bichromates, but it has not come into favour.

POTASSIUM CITRATE (Fr., *Citrate de potasse ;* Ger., *Citronensaures Kalium*)

Synonym, tribasic citrate of potash. $K_3C_6H_5O_7$ H_2O. Molecular weight, 342. Solubilities, 1 in 0·6 water, slightly soluble in alcohol. It is an extremely deliquescent granular powder, prepared by neutralising citric acid with potassium carbonate. It is used as a restrainer in alkaline development, and also in the copper toning bath. In consequence of its deliquescent nature it is as well to prepare this salt in solution. To make 480 grains or 480 g., dissolve 295 grs. or g. of citric acid in 2 oz. or 960 ccs. of hot water, and add gradually with constant stirring 290 grs. or g. of potassium carbonate, or enough to make the solution neutral to litmus paper after heating. Filter the solution and make the total bulk up to 4 oz. or 1,920 ccs., which will give a 25 per cent. solution. The stronger the solution the longer it will keep ; when dilute, it is extremely liable to grow myelium fungus, which may be prevented by the addition of a little salicylic acid.

POTASSIUM CYANIDE (Fr., *Cyanure de potassium ;* Ger., *Cyankalium*)

Synonyms, cyanide of potash, cyanide. KCN. Molecular weight, 65. Solubilities, 1 in 2 water, decomposed by heat, slightly soluble in alcohol. It is very poisonous, the antidotes being chlorine water, cobalt nitrate, 10 grains of iron sulphate with 1 dram of tincture of iron in 1 oz. of water, emetics, and ammonia. It should be noted that the gas given off by it is very poisonous also. Occurs in white amorphous deliquescent lumps, and is prepared by fusing potassium ferrocyanide with potassium carbonate in an iron crucible. It is used as a fixing agent in collodion processes, also in Monckhoven's intensifier, and occasionally as a clearing agent for bromide prints.

In process work, it is almost exclusively used for fixing wet collodion negatives, and for the " cutting " or reducing solution. Potassium cyanide is also largely used in electro-deposition, especially in plating with brass and copper, and for cleaning the work before depositing on it.

POTASSIUM DICHROMATE (See " Potassium Bichromate.")

POTASSIUM FERRIC OXALATE (Fr., *Oxalate potassico-ferrique;* Ger., *Kalium-ferri-oxalat*)

$Fe(C_2O_4)_3K_33H_2O$. Molecular weight, 491. Solubilities, 1 in 16 water, insoluble in alcohol. It is in the form of bright green crystals, and is prepared by acidulating potassium ferrous oxalate and exposing to light. A convenient solution can be made by adding ferric chloride to potassium oxalate; thus to make 480 grs. or g., dissolve 690 grs. or g. of neutral potassium oxalate in 5 oz. or 2,000 ccs. of distilled water and add 322 grs. or g. of lump ferric chloride dissolved in a little water, and make the total bulk measure 10 oz. or 4,800 ccs. This will be a 10 per cent. solution. It is used in some iron printing processes, but chiefly in Belitski's reducer.

POTASSIUM FERRICYANIDE (Fr., *Cyanoferride de potassium;* Ger., *Ferrid-cyan-kalium*)

Synonyms, ferricyanide of potash, red prussiate of potash. $K_3Fe(CN)_6$. Molecular weight, 329. Solubilities, 1 in 2·5 water, insoluble in alcohol. It takes the form of deep red rhombic crystals, prepared by passing chlorine gas through a solution of potassium ferricyanide. Very frequently the crystals become covered with a yellow powder, which should be rinsed off before use. It is employed in several iron printing processes, but mainly as a reducer for negatives and to bleach bromide prints before sulphiding.

In process work, it is largely used in making up the lead nitrate intensifier, and in conjunction with "hypo" as a reducer for dry-plate negatives.

POTASSIUM FERROCYANIDE (Fr., *Cyanoferrure de potassium;* Ger., *Ferrocyan-kalium*)

Synonyms, ferrocyanide of potash, yellow prussiate of potash. $K_4Fe(CN)_6 3H_2O$. Molecular weight, 422. Solubilities, 1 in 4 water, insoluble in alcohol. It consists of large yellow pyramidal crystals which are obtained by fusing potassium carbonate with horn clippings, wool or hair, and stirring with an iron rod. It is used as a developer in some iron printing processes, and has been suggested as an addition to pyro and hydroquinone developers on the ground that it prevents fog and gives greater density, but it is rarely used for this purpose.

POTASSIUM FERROUS OXALATE (Fr., *Oxalate de fer et potasse;* Ger., *Kalium-ferro-oxalat*)

$Fe(C_2O_4)_2K_2 H_2O$. Molecular weight, 328. Solubilities, insoluble in water and alcohol, soluble in solutions of an alkaline oxalate or citrate. It is a sandy-yellow powder, obtained by adding potassium oxalate to excess of ferrous sulphate. Although it forms the actual developing agent in iron development, it is rarely used in the dry state, it being more convenient to make it as described under the heading "Ferrous Oxalate."

POTASSIUM FLUORIDE (Fr., *Fluorure de potassium;* Ger., *Fluorkalium*)

$KF 2H_2O$. Molecular weight, 94. Soluble in water. It is a white granular powder, prepared by saturating hydrofluoric acid with potassium carbonate. It is used for stripping films from glass negatives; the negative to be stripped should be immersed in a 2 per cent. solution for 5 minutes and then immersed in a 2 per cent. solution of sulphuric acid, when the film readily lifts. It is more convenient than hydrofluoric acid, as it keeps better and is less liable to attack the mucous membranes, lungs, or skin.

POTASSIUM HYDRATE (Fr., *Potasse caustique;* Ger., *Aetzkali*)

Synonyms, caustic potash, potassium hydroxide. KHO. Molecular weight, 56. Solubilities, 1 in ·4 water, slightly soluble in ether, 1 in 2 alcohol. It is poisonous, the antidotes being vinegar, lemon juice, oil, and milk; it should not be handled, as it is an extremely powerful escharotic and burns the skin. It is in the form of white sticks, which are obtained by decomposing potassium carbonate with milk of lime. It is extremely deliquescent, and readily attacks both corks and glass stoppers, so that these should be well paraffined or vaselined. It is chiefly used in alkaline developers.

In process work, the crude caustic potash (American black ash) is largely used for cleaning old negative glass, for cleaning the resist and ink off zinc and copper plates after etching, and for cleaning work previous to electro-deposition.

POTASSIUM HYDROGEN SULPHITE (*See* "Potassium Bisulphite.*)

POTASSIUM IODIDE (Fr., *Iodure de potassium;* Ger., *Iodkali*)

Synonym, iodide of potash. KI. Molecular weight, 166. Solubilities, 1 in 0·75 water, 1 in 18 alcohol, ·8 per cent. in collodion. It is in the form of white cubical crystals, which are obtained by adding iodine to caustic potash solution. It is used in emulsion making and for preparing the mercuric iodide intensifier.

POTASSIUM METABISULPHITE (Fr., *Métabisulfite de potassium;* Ger., *Kalium-metabisulfit*)

Synonym, metabisulphite of potash. $K_2S_2O_5$. Molecular weight, 222. Solubilities, 1 in 3 water, insoluble in alcohol. It takes the form of clear transparent crystals smelling of sulphurous acid gas, and is obtained by passing sulphurous acid gas through potassium carbonate solution and adding absolute alcohol. It is used as a preservative in developers and for acidulating the "hypo" bath.

POTASSIUM NITRATE (Fr., *Azotate de potasse;* Ger., *Salpetersaures Kali*)

Synonyms, nitrate of potash, nitre, saltpetre. KNO_3. Molecular weight, 101. Solubilities, 1 in 3·8 water, very slightly soluble in alcohol. It occurs native and is also obtained by decomposing lime clays with urine. It is usually met with in a fine white powder or prismatic needles, and is used in the manufacture of pyroxylin and in flash powders.

POTASSIUM NITRITE (Fr., *Azotate de potassium;* Ger., *Kalinitrit*)

KNO_2. Molecular weight, 85. Solubilities, 1 in 1 water, insoluble in alcohol. It occurs in

white deliquescent sticks. It is occasionally used for making actinometer paper. It must not be confounded with potassium nitrate.

POTASSIUM OXALATE (Fr., *Oxalate neutre de potasse ;* Ger., *Neutrales Oxalsaures Kali, Kaliumoxalat*)

Synonym, neutral oxalate of potash. $K_2C_2O_4 H_2O$. Molecular weight, 184. Solubilities, 1 in 3 water, insoluble in alcohol and ether. It occurs in white crystals, and is obtained by saturating oxalic acid or acid oxalate of potash with potassium carbonate. It is used in the ferrous oxalate developer and for developing platinotypes, and must be either acid or neutral.

POTASSIUM PERCARBONATE (Fr., *Percarbonate de potasse ;* Ger., *Kaliumpercarbonat*)

$K_2C_2O_6 H_2O$. Molecular weight, 216. Solubilities, 1 in 15 water. It is a white crystalline powder obtained by electrolysis of potassium carbonate. It is used as a " hypo " eliminator, and is sold under fancy trade names.

POTASSIUM PERCHLORATE (Fr., *Perchlorure de potassium ;* Ger., *Ueberchlorsaures Kali*)

$KClO_4$. Molecular weight, 138·5. Solubilities, 1 in 65 water, insoluble in alcohol. It is in the form of colourless rhombic crystals or powder. It is used in flashlight mixtures, and the same precautions should be taken in mixing this as with potassium chlorate.

POTASSIUM PERMANGANATE (Fr., *Permanganate de potasse ;* Ger., *Uebermangansaures Kali*)

Synonym, permanganate of potash. $KMnO_4$. Molecular weight, 158. Solubilities, 1 in 16 water, decomposed by alcohol. It occurs in violet-black needle-like crystals with green metallic lustre, obtained by fusing manganese peroxide with potassium hydrate or nitrate. It is used to reduce negatives, and when acidulated with sulphuric acid tends to reduce the high lights more than the shadows. In a neutral solution it practically acts as an intensifier, as a manganese salt is precipitated on the silver image which gives it a more nonactinic colour. It is also used as a test for " hypo," as a " hypo " eliminator, and to produce reversal of the image in the Lumière autochrome process.

In process work, a few drops of a 10 per cent. solution of potassium permanganate added to the wet collodion silver bath, when it is suspected of being charged with organic matter, neutralises the bath and combines with the foreign matter, precipitating it as a black powder. The bath should be stirred whilst the solution is being added, and when it assumes a pale violet colour it should be exposed to sunlight. As soon as the bath is clear, it should be filtered and re-acidified.

POTASSIUM PERSULPHATE (Fr., *Persulphate de potasse ;* Ger., *Ueberschwefelsaures Kali*)

Synonyms, persulphate of potash, anthion. $K_2S_2O_8$. Molecular weight, 270. Solubilities,

1 in 50 water, insoluble in alcohol. It is in the form of white crystals obtained by electrolysis of potassium sulphate. When dissolved in water it readily parts with its oxygen, and is used to eliminate the last traces of " hypo."

POTASSIUM PHOSPHATE (Fr., *Phosphat de potasse ;* Ger., *Phosphorsaures Kali*)

Synonym, monopotassic orthophosphate. K_2HPO_4. Molecular weight, 174. Solubilities, soluble in water, insoluble in alcohol. It consists of colourless crystals, and is used as an addition to the developer for platinotype paper.

POTASSIUM PLATINOUS CHLORIDE OR POTASSIUM PLATINO-CHLORIDE (*See* " Potassium Chloroplatinite.")

POTASSIUM SILICATE (Fr., *Silicate de potasse ;* Ger., *Kaliwasserglas, Kieselsaures Kali*)

Synonyms, soluble glass, potash water glass. Solubilities, 1 in 3 water, decomposed by alcohol. It takes the form of vitreous masses with greenish tinge, and is obtained by fusing fine sand and potassium carbonate. It is usually met with in the form of a syrupy yellowish liquid. It is occasionally used as a substratum for dry plates and for collotype plates.

POTASSIUM AND SODIUM TARTRATE (Fr., *Sel de Seignette ;* Ger., *Seignettesalz, Rochellesalz, Weinsaures Kalinatron*)

Synonyms, Rochelle or Seignette salts. $KNaC_4H_4O_6 4H_2O$. Molecular weight, 282. Solubilities, 1 in 1·4 water, almost insoluble in alcohol. It is in the form of colourless transparent crystals or white powder, and is obtained by boiling together cream of tartar and sodium carbonate. Chiefly it is used in printing-out emulsions, to form silver tartrate.

POTASSIUM SUBCARBONATE (*See* " Potassium Carbonate.")

POTASSIUM SULPHIDE (Fr., *Foie de soufre ;* Ger., *Schwefelkalium, Schwfelleber*)

Synonyms, liver of sulphur, sulphurated potash, potassium trisulphide. K_2S_3. Molecular weight, 174. It consists of amorphous masses with the colour of liver, and is obtained by fusing together sulphur and potassium carbonate. It is very deliquescent, and absorbs carbonic acid from the air and gives off sulphuretted hydrogen. It is used to precipitate silver sulphide from spent " hypo " baths. Its old name was potassa sulphurata.

POTASSIUM SULPHOCYANIDE (Fr., *Sulfocyanure de potassium ;* Ger., *Rhodankalium, Schwefelcyankalium*)

Synonyms, potassium thiocyanate, sulphocyanate, or rhodanide. $KCNS$. Molecular weight, 97. Solubilities, 1 in ·46 water, soluble in alcohol. It is in the form of transparent deliquescent crystals, and is obtained by fusing together sulphur, potassium carbonate, and ferrocyanide. It is chiefly used in the sulphocyanide toning bath. It is also a solvent of gelatine, and has been therefore suggested for developing over-exposed carbon prints.

POUNCE

A name for pulverised sandarach.

POUNCY'S PROCESSES

Pouncy, of Dorchester, was the first to work in England the carbon process in the form it was invented by Poitevin, the French pioneer in photo-mechanical work. Pouncy invented several processes of photo-lithography. In 1863 he patented a carbon tissue for photo-litho-graphic transfers. The tissue was made by coating tracing-paper with a mixture of print-ing ink, asphaltum, benzole, and fatty matter, with or without potassium bichromate. The paper is exposed to light with the plain side next to the negative, developed in turpentine, dried, and transferred to a damp, cold stone.

POUND

In apothecaries' weight, by which formulæ are made up, a pound is 5,760 grs. or 12 oz., and is the equivalent of 373·276 g. (say 373¼ g.). In avoirdupois weight, by which chemicals are sold, it is 7,000 grs. or 16 oz., and is the equiva-lent of 453·59 g. Approximately, 1 kg. = 2·2 lb. avoir. In fluid measure, it is 5,760 mins. or 12 oz., and is the equivalent of 340·8 ccs.

POWDER (OR DRY) DEVELOPERS

Powders which need only to be dissolved in water to form workable developers. Almost any developer may be made up in this way, the quantities sufficient for 10 oz. of water being mixed together and divided into 10 parts, each of which, when required, is dissolved in 1 oz. of water. The powder must be kept as airtight as possible, and should always be packed in waterproof paper and also in tinfoil. The in-gredients should be very fine, quite dry and well mixed, and thoroughly dissolved before they are applied to the plates or papers. In many formulæ, of course, it will be necessary to have two packets of powder, one containing the developer proper and the other the alkali, and it is advisable to use distinctive papers— "Seidlitz powder" style. Anhydrous chemi-cals should be used when possible.

A two-powder metol-hydroquinone developer is given below as a sample formula :—

A. Metol	.	.	. 240 grs.	50 g.
Hydroquinone	.	. 480 „	100 „	
Boric acid.	.	. 120 „	25 „	
B. Sodium sulphite	. 480 grs.	100 g.		
Borax	.	. 120 „	25 „	
Sugar of milk	.	. 120 „	25 „	

Make up A into 10-gr., and B into 20-gr. papers, and, for use, dissolve one of each in 1 oz. of water.

POWDER PROCESS

This is better known as the dusting-on pro-cess (*which see*).

The following, however, was introduced as a powder process, and is based on the reduction of the persalts of iron into proto-salts by the action of light. It was invented in 1858 by H. Garnier and A. Salmon, of Paris, in competi-tion for the award offered by the Duc de Luynes for the purpose of solving the problem of pro-ducing absolutely permanent photographs. Well-sized paper is coated with a strong solution of ferric ammonio-citrate in water; having been dried in the dark, it is exposed under a positive transparency to daylight until the image is faintly visible. The paper is pinned to a flat board, and, by diffused daylight, very dry and fine lampblack or other pigment is brushed over the paper with a pad of cotton-wool or a camel-hair brush. By breathing upon the paper the parts not acted upon by light become somewhat sticky and retain the black pigment; thus, details of the image appear and in time the pic-ture is complete. The print is fixed by immers-ing in water, which washes out the sensitive iron salts. The print is then dried and varnished.

In process work, there are several methods of powdering to form acid resists. For instance, the so-called "dry enamel" method is a powder process, development being performed by dust-ing a hygroscopic film of gum and bichromate so that the parts which have not been acted upon by light absorb the powder. These parts are readily cleared away after the plate has been burnt in. There is also the dragon's-blood powdering process, which is very largely used for zinc etching. The Austrian process of zinc etching depends on a method of building up the image with asphaltum powder.

PRAXINOSCOPE

An appliance resembling the phenakistoscope and zoëtrope, the motion pictures being seen in mirrors.

PRECIPITATION

The separation of any solid from a solution. It may be chemical, as in the case of the sub-sidence of barium sulphate from a mixture of sodium sulphate and barium chloride; or it may be due to the lowering of temperature, as when a saturated solution of any salt at a given temperature becomes colder and unable to hold so much in solution.

PRESERVATIVES

Substances which preserve or keep unaltered the original character of any substance. In the early days of collodion dry plates a great num-ber of preservatives (some of which are named under the heading "Coffee Process") were used, which kept the sensitive film moist and acted as halogen absorbers during exposure. In the pre-sent day of alkaline developers, such chemicals as sodium sulphite, potassium metabisulphite, nitric acid, etc., are used to preserve the actual developing agent from oxidation. In sensitised papers containing free silver nitrate, citric or other organic acid is used for the same purpose.

PRESS PHOTOGRAPHY

Photography with the object of obtaining illus-trations for use in newspapers, magazines, books, etc. All important papers that make a special-ity of printing photographs of current events have a permanent staff of photographers, are in touch with agencies which also have a similar staff, and have representatives here, there and everywhere; they keep a keen look-out for sub-jects of interest, and make arrangements for recording everything that can be known before-hand. Thus almost the only chance for the

outsider is to be fortunate enough to secure a subject that could not be got by the usual press photographers. Even then he must make haste to turn his advantage to account. It is often advisable to send the undeveloped plate or film with all expedition to the paper likely to use the subject; and, failing that, the negative must be developed, and clean bright prints made at once and dispatched. There are several means of expediting the production of a finished print from a negative, and these must be taken advantage of. Any necessary description or explanation must also be supplied. Then there is the class of work adapted for use in weekly papers and magazines. This sometimes allows of a little more time for preparation and dispatch; but, as before, clean bright prints are essential. Next comes the work that can be used at leisure by various magazines. This often takes the form of a set of prints, probably accompanied by an article which they illustrate. They vary in character according to the publication for which they are intended. They may illustrate tours, travel in out-of-the-way places, various forms of sport and pastime, persons and places of interest, architecture, curiosities, and so forth. Lastly, there is a limited opening for work of a purely pictorial character, and in this class alone is it sometimes possible to employ processes that permit of some control and modification to secure the effect desired.

Although books are frequently illustrated wholly or in part from photographs, it is obvious that such work is already arranged for and does not allow opportunity for casual contributions.

The photographer who aims at supplying prints to the press must possess a keen eye, an alert intelligence for likely subjects and their adaptability for use, and must be a good technical photographer. He must be familiar with the exact class of work likely to be acceptable to any given publication; he must know the addresses of the papers, and the times when matter must be to hand to admit of publication. He should also know the prices to be expected for various kinds of contributions.

The press photographer's outfit depends entirely on the class of work he intends to undertake; and all necessary information is given under separate headings. Cameras of the reflex pattern or with direct-vision finders are the favourites for the usual run of newspaper work. The points to be borne in mind in choosing the lens are definition, covering power, and ability to work at large apertures to allow of short exposures. Quarter-plate, 5 in. by 4 in., and half-plate are useful sizes, as enlargement is an easy matter; in urgent work, enlargement should be left to the process-block maker.

PRESSURE FRAME

A name by which the printing frame is often known, inasmuch as the back portion is so arranged that it presses the sensitive surface into contact with the negative. For paper prints springs are generally employed to give the pressure; but for printing on glass, metal, etc., in process work, screws, wedges, or levers are employed, and in some cases pneumatic or atmospheric pressure.

PRETSCH, PAUL

Born in Vienna, 1808; died, 1873. One of the pioneers of photo-engraving, and an experienced printer. In 1842 he joined the Imperial State Printing Office in Vienna under the direction of Herr Auer, whom he assisted in working out the process of Nature printing. In 1850 he was sent to Paris and London, and in 1851 to London in charge of the Austrian printing exhibits at the Great Exhibition. In 1852, after his return home, he began working out his idea of obtaining galvanoplastic reliefs by the swelling of insolated chromated gelatine films. In 1854, having perfected his discovery so far as to be convinced of its success in a wider field, he gave up his appointment in Vienna and went to London, where he took out an English patent for his process and started to work in 1855. Many of his plates are exceedingly good, but he found it difficult to make the business pay, and after a serious illness he returned to Vienna in 1863. He was re-engaged at the Imperial State Printing Office, but his health had broken down, and he made no further progress in perfecting his methods. His processes, though no longer worked, laid the foundation of modern photo-engraving. He invented numerous processes; for the one chiefly associated with his name see "Galvanography, Photographic."

PRIMULINE PROCESS (See "Diazotype.")

PRIMULINE YELLOW (Fr., *Primuline*; Ger., *Primulin*)

Synonyms, carnotine, polychromine, thio-chromogen, aureoline, sulphine. Soluble in water. It is an aniline dye, bright yellow in colour, consisting of a complex mixture of thiotoluidine sulphonates. It is used in the Diazotype process.

PRINCIPAL AXIS (See "Optical Axis.")

PRINT

An image produced by the action of light on a sensitive surface in contact with a negative or positive transparency. It is usually restricted to an impression on sensitised paper, prints upon glass being known as positives or transparencies.

In process work, the term "print" denotes the image on the metal plate in line and half tone etching.

PRINT INDICATOR (Fr., *Enregistreur*; Ger., *Indikator*)

A device for attachment to the printing frame to register how many prints have been

Print Indicator

made from a given negative. The form illustrated consists of a small metal numbered dial

with a movable hand that catches in slots at each number. Every time a print is removed from the frame the hand is moved one figure forward by the printer, until it is seen that the number of prints it is desired to make have been secured. Other types of print indicators are obtainable.

PRINT MEASURER (Fr., *Mesureur des épreuves* ; Ger., *Positivermesser*)

An apparatus for measuring the light reflected from different portions of photographic prints. In that designed by Chapman Jones two mirrors, one on each side of an incandescent gas burner, give two beams of light, which enter a velvet-lined box by separate openings, illuminating the print to be tested and a white comparison patch placed beside it. A shadow rod is employed, as in Rumford's photometer, to ensure each patch receiving light only from its own beam. One mirror moves along a graduated scale while the other is fixed. The light on the white patch is reduced by drawing back the movable mirror until the two patches are of equal brightness, when the distance read off on the scale enables an accurate comparison to be made.

PRINT METER (*See* " Actinometer.")

PRINT TRIMMER (Fr., *Coupe-épreuves* ; Ger., *Beschneideapparat*)

A small machine of the guillotine type, used for trimming prints. The ordinary pattern, shown at A, consists of a baseboard to one side of

A. Print Trimmer with Movable Blade

B. Print Trimmer with Movable Platform

which is pivoted a steel cutting blade having a handle. At a right angle to the blade a graduated rule is fixed to the baseboard. The print is laid on the baseboard and each side is then trimmed in turn by pressing down the blade, using the rule as a guide to the size. Another type of trimmer, B, has a fixed blade and a movable platform or desk. The print is laid on the latter, placing its edge under a steel bar until the part to be cut off projects, and is cut by pressing down the platform, which, on removing the

pressure, springs back ready for the next cut to be made.

The term " print trimmer " is also frequently applied to any kind of knife or wheel-cutter for trimming prints.

PRINT WASHER (*See* " Washers.")

PRINTER'S INK, PHOTOGRAPHS IN

Apart from the large number of processes by which photographs are reproduced photo-mechanically, there are many on the lines of the following, differing perhaps in matters of detail, but based on the use of a gelatine film, supported by paper or other substance, sensitised with potassium bichromate, printed upon under a negative, washed, and dried. The film is next soaked until the surface repels greasy litho-graphic ink, applied with a roller, except those parts initially affected by the light through the negative.

PRINTING

The exposing of a sensitive surface in contact with a negative or positive transparency to the action of light. The negative and sensitised paper are held in contact in a printing frame, which is described in a later article, where will be found any necessary instructions for the extremely simple task of taking a print.

In process work, " printing " is the process of exposing the sensitised plate, paper, or tissue under a negative or positive. The taking of a print on paper from the plate after inking-up is termed " proofing " or " proving."

PRINTING BOX

Whilst in ordinary printing it is desirable to avoid parallel rays of light, a diffused light being much preferable, in process work it is sometimes necessary to exclude all except the parallel rays and to cause these to fall at right angles to the negative. This is especially the case in gelatine relief processes, and the method adopted is to place the printing frame at the bottom of a tube or box of from 1 ft. to 2 ft. in length and blackened inside. The box is then tilted to the best angle for receiving the incident light, usually from the sky. J. Wheeler, the inventor of the Metzograph screen, devised such a box for use in connection with his screen. In this box is placed a continuous-tone negative with its glass side in contact with the Metzograph screen, and its firm side in contact with a sensitised zinc or copper plate. A grained image is thus obtained, much the same as would result from printing from a grained negative. Carriers are placed at intervals in the box and at the mouth to mask the light to suit the size of the negative. Wheeler has also suggested the use of this box and screen for silver printing, claiming that it dispenses with retouching of portrait negatives and gives a better modulation of the image.

The use of a printing box in printing from a cracked negative is illustrated under the heading " Cracked Negatives."

PRINTING BY ARTIFICIAL LIGHT

Printing by the ordinary forms of domestic artificial light can be conveniently carried out

only in two processes, bromide and gaslight. The former is sufficiently rapid to give a fully exposed print from a good negative of medium density in twenty to thirty seconds at a distance of three feet from a 16 candle-power light. The latter is much slower, and the same negative would probably require an exposure of one minute at 6 inches from the same light; but this slowness carries with it the advantage of permitting the development, etc., to be performed in very weak white light. When shielding or controlling is necessary, certain differences in working have to be adopted when printing by artificial light, as explained under the heading, "Control in Printing."

Daylight printing processes can be successfully worked by electric arc light.

PRINTING BY DAYLIGHT

The silver printing-out, platinotype, and carbon process and their many sub-divisions are daylight methods; their sensitiveness is too slight for artificial light to produce any useful impression. The electric arc light may be used for any of these processes. Daylight printing should not be carried out in direct sunshine, because any slight scratch, bubble, or mark on the glass side of the negative would cast a definite shadow during printing and show a white line or mark in the finished result. Printing in the sun is quite impracticable for negatives that have been covered with matt-varnish or tracing paper on the glass side, or that require to be shielded or masked during printing. These methods would always cause definite and harsh lines. A bright diffused light is best for all ordinary printing, the frame lying quite flat, exposed to the sky, when shielding or masking is necessary. It is frequently stated that sunshine will assist in securing soft prints from harsh negatives, and a very feeble light enable more brilliant results to be obtained from weak negatives. Careful experiments have, however, failed to confirm this, the best results being invariably those taken in a very bright diffused light.

PRINTING, COMBINATION (*See* "Combination Printing.")

PRINTING FRAMES (Fr., *Chassis positif, Chassis de tirage, Chassis presse;* Ger., *Kopierrahmen*)

Appliances for keeping the negative and sensitised paper in close contact during exposure to light in printing. The ordinary pattern, A, is made of teak or other hard wood, and the divided hinged back, the inner side of which is usually covered with cloth or felt, is fastened by means of two metal springs that engage in bent wire staples. To examine the progress of printing, one spring is unfastened and half the back is raised, keeping a firm pressure meanwhile on the remaining half with the fingers of the other hand in order that the print may not be shifted. Many workers prefer to have the back unequally divided, so that the greater portion of the print may be examined at once. Various frames are now made with a non-slip back, one of the best being that shown at B, in which projecting metal pegs extend from the hinges and fit in metal grooves at the sides of the frame,

effectually preventing slipping. In another pattern the back is hinged directly to the frame. C shows a heavier type of frame, suitable for large sizes, and holding a sheet of plate-glass,

A. Ordinary Pattern of Printing Frame

so that a negative of any size can be used; this has two hinged pressure-bars with springs on their lower side, the bars being fastened down by brass strips which fold over their ends.

For copying plans, etc., large frames are used, with the back divided into several sections, each with its own pressure-bar, as at D.

A great variety of frames are specially designed

B. Printing Frame with Non-slip Back

for combination, multiple, and border printing, as well as for postcard, lantern slide, and stereoscopic work.

In process work, considerable inventiveness has been displayed in the design of printing frames. For paper prints, spring pressure is relied upon; but for printing on metal plates, etc., screw and wedge pressure is resorted to.

C. Heavier Type of Printing Frame

The oldest form of frame for printing on plates has a number of wooden screws inserted in several heavy bars across the back (*see* E). The screws are now generally iron, threaded into iron bushes

let into the wooden crossbars (*see* F). A further improvement is to make the crossbars of iron and connect them together into a frame or " spider," with crab-like castings attached to

D. Printing Frame for Copying Plans, etc.

the back for taking the thrust of the screws, the number of which has been reduced to two and even to one. The frames are usually made of wood, strengthened by iron clamps to take the strain of the crossbars, or heavy steel screw bolts are passed through from back to front. The front is of plate-glass of from ½ in. to 1½ in. thick, while the back is usually of wood heavily clamped, although in America iron backs have been used with the multi-screw frames. For collotype, a wedge pressure is generally preferred, the frame having no back and the wedges pressing directly on the thick glass printing-plate. Frames operating by leverage have come into general use in America ; in a popular pattern the bars are pressed down on to heavy pads of rubber by means of a quick-acting cam lever. Vacuum frames are found effective for blue printing, photo-litho transfers, and for printing direct on thin zinc for photo-lithography. These frames consist essentially of a wooden frame in which is mounted a glass plate to form the front. The negative and sensitive surface are laid upon this and backed by a sheet of india-rubber, which is pressed down by another frame around the margin. The air is then exhausted from between the front glass and rubber sheet by means of a vacuum pump, the pressure of the atmosphere on the rubber sheet then producing contact. For thick zinc and copper plates, a pneumatic cushion covering the back of the frame and held down by a heavy back

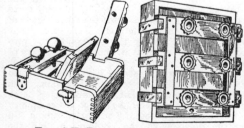

E and F. Process Printing Frames

board and crossbars is found more effective ; after the frame has been shut down the cushion is more fully inflated by means of a pump. A hydraulic pressure frame has also been employed.

PRINTING-IN (*See* " Backgrounds, Printing-in " ; " Clouds, Printing-in " ; and " Combination Printing.")

PRINTING-OUT

Any method of printing in which a visible image of full depth is obtained by exposure to light. The best-known print-out process is that employing gelatino-chloride silver paper, better known as " P.O.P." (printing-out paper).

PRINTS STICKING TO NEGATIVES

If negatives or gelatine silver papers are put to print in a damp condition, or if moisture, as from rain, gets in between the negative and print, they will become stuck together. They should not be forcibly pulled apart, but at once plunged into a " hypo " fixing bath and allowed to soak, after which the print (quite ruined) may be pulled away from the negative, which, if the work has been done carefully, ought to be quite unharmed.

In process work, sticking is prevented sometimes by rubbing the negative over with paraffin, or with a trace of vaseline.

PRISM, REVERSING (Fr., *Prisme de renversement ;* Ger., *Umkehr Prisma*)

The prism used by process workers and others for reversing images laterally is a block of optical glass free from striæ and cut in triangular form (*see* A), so that two of its faces form a right

Reversing Prism

angle to one another, and its hypotenuse is at an angle of 45°. The angles must be correct and the surfaces ground and polished with as much care as those of a lens. The hypotenuse is silvered, and the prism is mounted in a metal box (*see* B) provided with a screwed ring for attaching it to the lens. Usually it is fitted on the front, but some workers prefer it behind the lens. The prism reverses the image laterally, so that it appears the right way on the negative ; thus the metal plate printed from the negative has an inverted image which in the final print again comes right. If a prism were not used, any lettering in the final result would read the wrong way round, just as printed matter appears in a mirror. Prisms are preferable to mirrors (*see* " Mirror, Reversing "), as they remain permanently in good condition, whilst mirrors soon become tarnished and require repolishing or resilvering. A slight disadvantage of the prism is that it increases the exposure, but with the powerful electric arc illumination used by process workers this is not noticed.

PRISMATIC SPECTRUM (*See* " Spectrum.")

PROCESS BLOCK

A typographic printing block produced by photo-mechanical processes, as distinguished from a block produced by wood engraving.

PROCESS PLATES

Dry plates prepared specially for photo-mechanical work. They are slower than plates used in general photography, the emulsion being compounded with the object of giving a hard black-and-white image. Two kinds of plates are issued by some makers—" process " for line reproduction, and " half-tone " for making half-tone negatives · in a typical case the speed of the " process " plates is 16 Watkins, $f/28$ Wynne, or 25 H. and D., and that of " half-tone " plates 30 Watkins, $f/39$ Wynne, or 47 H. and D.

PROCESS WORK

A general term embracing all kinds of photo-mechanical reproduction processes.

PROFESSIONAL

Anyone who gets his living by the practice of photography; not necessarily anyone who accepts remuneration for photographic work, as explained under the heading " Amateur Photographer."

PROGRESS MEDAL (See "Royal Photographic Society.")

PROJECTION

The art or act of projecting or throwing an image by means of an optical system. Examples are the projection of a transparency for viewing purposes by means of an optical lantern or kinematograph (see under both of these headings); the projection by an enlarging apparatus of a negative upon a sensitive surface (see " Enlarging "); the projection of an image by the lens of a camera upon the dry plate; and other methods described under various headings.

PROJECTION, STEREOSCOPIC (See " Stereoscopic Projection.")

PROMENADE

A commercial size of photographic mount, usually 8¼ in. by 4 in., but subject to variation. A " promenade midget " generally measures about 3⅛ in. by 1⅝ in.

PROOF SPIRIT

A term which took its origin from an old test for the strength of alcohol, in which a heap of gunpowder was wetted with the spirit and then a light applied. If the gunpowder did not fire, the spirit was " under proof," or " U.P."; if it just fired it was " proof "; and if it immediately fired it was " over proof," or " O.P." At the present time proof spirit should contain 49 per cent. of pure alcohol at 62° F. (nearly 17° C.) (See also " Alcohol.")

PROPORTIONAL SCALES AND RULES

Various forms of proportional scales or rules have been suggested for the use of photographers and process workers, principally with the object of calculating exposures and the proportions of

reductions and enlargements. J. A. C. Branfill's proportional rule, A, has three members, A, B, and C, which form a triangle graduated on three sides. When C is slid along A, any triangle formed will be similar to the original one, and all its sides will be proportional. This enables a fourth proportional to three known quantities to be found. Thus, if it is required to find $\frac{5}{14} \times 6$ by the rule, place C to 14 on A, set B to 6 on C, slide C to 5 on A, when B will be found to cut C at the dimension required. A shows the positions of the members for this calculation.

Another form of proportional rule, but with a definite purpose, is the scalometer of W. Laurence Emmett, for determining which originals are in the same scale of proportion, so that they may be photographed together on the same plate. This instrument is illustrated in the article under the heading " Focusing," and is used as there described. By its means the operator groups up on his copyboard all originals which bear the same proportional number. By

B. Emmett's A. Branfill's Proportional Rule
Sizeometer

a slight variation of the method enlargements may be similarly dealt with. By means of a printed scale sent out with the instrument, it is possible to mark off the base of camera and copying stand with numbers corresponding to those on the instrument, so that the camera can be instantly set to the proportion number marked on the original, no focusing being then required. A rule and system having the same object was designed and introduced in America by A. Fruwirth, who also applies scales to the base of the camera. Geo. H. Benedict, of Chicago, has a system worked with a chart of curves. All these methods have the same object, that of setting the camera to the proportion of the original without the necessity of focusing.

Various rules and scales have been devised for determining the second dimension of a reduction or enlargement, one dimension being given. The sizeometer, B, is a good example of a rule for this purpose. The slotted rule is laid on the diagonal of the photograph, and the right angle rule is then brought down to the dimension of one side of the picture. The second dimension is then read off on the other limb. Carl Norman's proportional rule consists of a strip of stretched elastic bearing a numbered scale, the elastic being mounted between two

clamps, so that one of them can be made to slide along and thus alter the length of the elastic ribbon, the scale on it altering proportionally. Thus, the elastic is stretched until a number on it corresponds to the required dimension of the original. Then without altering the elastic the other dimension of the original is measured, and the result is the second dimension.

A further series of proportional scales are those used for measuring the surface area of blocks. Branfill's chart (it consists of a series of curved lines) is a good example. The block to be measured is placed up to the top and left-hand border line, and the required dimension read off on the curved line adjoining the lower right-hand corner of the block. Geo. H. Benedict, of Chicago, is the author of a similar chart. Another form of chart for the same purpose is ruled off into ¼-in. squares, and the figures denoting the square measurement are placed progressively in these squares.

PRUSSIAN BLUE (Fr., *Bleu de Prusse*; Ger., *Berliner Blau, Preussischer Blau*)

Synonyms, ferric ferrocyanide, Paris blue, mineral blue, Berlin blue. $Fe_4Fe_3(C_6N_6)_3$. Molecular weight, 860. Insoluble in water and alcohol. A dark blue powder obtained by precipitation of ferric salts with potassium ferrocyanide. It forms the blue image in the cyanotype and other iron printing processes.

PSYCHIC PHOTOGRAPHY

Known also as "spirit photography." Many persons have claimed to be able to photograph psychic and astral forms; hence the name. Psychic photographs are divided into many classes, including (1) Portraits of psychic entities not seen by normal vision. (2) Pictures of objects not seen or thought of by the medium, photographer or sitter, such as flowers, lights and emblems. (3) Pictures having a flat effect and the appearance of having been copied from others. (4) Pictures of materialised forms visible to normal sight. (5) Pictures of the "wraiths" or "doubles" of persons still in the flesh. (6) Portraits on plates which developers have failed to bring into view, but which, it is said, can be seen on the prints by certain persons; and (7) Portraits that cannot be classed as photographs because no camera is used. The art originated in America in the year 1861, when W. H. Mumler, of Boston, opened a studio specially for the work. The first psychic photographs to be taken in England, it is believed, were those produced by Mr. and Mrs. Guppy, in March, 1872.

Psychic photographs are often called ghost photographs, but the latter term is more often used to describe "faked" or "trick" pictures, which may be produced in many ways, the easiest being to dress up a person in ghostly attire, pose the "ghost," give a very brief and incomplete exposure, cap the lens, and allow the "ghost" to move out of the scene, and then complete the exposure. When the plate is developed a faint image of the ghostly figure is seen, and objects appear through the figure, more or less according to the relations of the exposures.

Another method to adopt is to draw a ghost, or to paste a drawing of a ghost, upon a piece of dead-black card, and to copy this in the camera. The undeveloped plate is then used to take a photograph in the usual way and developed, when the two images will appear together. Much depends on the relations of the two exposures, as experiment will easily show.

PSYCHOGRAPHY

The photographing of images retained in the retina of the human eye. Many experiments have been made—notably those by W. Ingles Rogers, in 1896—in this particular direction. The method, in brief, is to gaze steadily at some bright object—say, a shilling—in a good light, and then to enter the dark-room and gaze for about three-quarters of an hour on an unexposed dry plate, whereon, it is claimed, a faint image of the shilling will appear on development. Whatever may be thought of the method, it is quite a simple matter for any photographer to put it to the test.

PUDDY'S REDUCER

An ammonium persulphate reducer for which the formula is given under the heading "Ammonium Persulphate."

PULL

A proof of a block or of type matter obtained in a hand press in which the platen is lowered to obtain an impression upon the paper by pulling a lever.

PULP SLABS

Thin slabs of polished vulcanite or enamelled composition, to which wet P.O.P. prints are squeegeed in order to obtain a glazed surface. Glossy celluloid sheets are also used. (See "Glossy Surfaces on Prints.")

PUMICE POWDER (*See* "Abrading Powder.")

PUSH PINS

Glass-headed pins used for fixing bromide paper to the easel in enlarging, pinning up prints and films to dry, etc.

PYRAXE

Pyrogallic acid in a compact and crystallised form, which occupies about one-fifteenth the space of ordinary sublimed pyrogallic acid. It is used with potash or soda exactly like ordinary pyro, and any pyro developer can be made up with it by using the same weight of pyraxe as pyro.

The two forms of developer, however, specially recommended are :—

Pyraxe-soda

A. Pyraxe.	.	70 grs.	16 g.
Sodium sulphite	.	2 oz.	220 ,,
Sulphuric acid	.	6 mins.	1·25 ccs.
Or Citric acid	.	13 grs.	3 g.
Water to .	.	10 oz.	1,000 ccs.
B. Sodium carbonate .		1 oz.	110 g.
Water to	.	10 ,,	1,000 ccs.

For use take 1 part A, 1 part B, and 1 part water.

Pyraxe-potash

A. Pyraxe.	.	1 oz.	110 g.
Sodium sulphite	.	2½ ,,	275 ,,
Citric acid	.	7 grs.	1·6 ,,
Water to	.	10 oz.	1,000 ccs.
B. Sodium sulphite	.	1¼ oz.	138 g.
Potassium carbonate	4½ ,,	495 ,,	
Hot water to	.	10 ,,	1,000 ccs.

This is highly concentrated, 14 drops each of A and B being sufficient for 1 oz. of water. Potassium bromide is used for over-exposure, and more water is added for under-exposure.

Use an acid fixing bath after development with pyraxe.

PYRO, PYROGALLIC ACID, PYRO-GALLOL, OR TRIHYDROXYBEN-ZENE (Fr., *Acide pyrogallique* ;. Ger., *Pyrogallol, Pyrogallussäure*)

$C_6H_3(OH)_3$. Molecular weight, 126. It occurs in fine white feathery crystals produced by sublimation, and in heavy prismatic crystals of a more compact form (*see* " Pyraxe "). It is sold generally in blue bottles containing 1 oz. It is easily soluble in water, alcohol, and ether. It is not actually an acid, being neutral to litmus. It was introduced as a developer by F. Scott Archer, in 1851, at which time it was very expensive, the price, six years later, being one shilling a dram. For many years it was the principal developer used in the earlier processes, and later for dry plates. In its earlier days it was generally used with ammonia, which was gradually superseded by sodium carbonate, and to only a slight extent by potassium carbonate. As it readily oxidises when exposed to the air, the action being still more rapid in solution, it is necessary to use a preservative, which is generally potassium metabisulphite or sodium sulphite ; in the latter case the solution should be acidified with citric, sulphuric or sulphurous acid. The most convenient way of keeping pyro is in a 10 per cent. solution, an average formula for which is :—

Pyro	.	1 oz.	110 g.
Potass. metabisulphite	36 grs.	8 ,,	
Water	.	10 oz.	1,000 ccs.

The pyro is added last. Every 10 drops will contain approximately 1 gr. of pyro. Should other preservatives be preferred the following formula may be used :—

Pyro	.	1 oz.	110 g.
Sodium sulphite	.	4 ,,	440 ,,
Citric acid	.	30 grs.	7 ,,
Water (warm) to	.	10 oz.	1,000 ccs.

The citric acid may be replaced by 10 mins. of sulphuric acid or 60 mins. of sulphurous acid. Dissolve the sodium sulphite in about 7 oz. of water, add the acid, then the pyro, and finally the remainder of the water. This will also contain about 1 grain of pyro per 10 drops, so that any formula containing pyro can be made up from it. Pyro combines with ammonia, soda, potash, metol, acetone, etc. It may stain negatives, hands and linen badly. Pyro-developed negatives have a more or less strongly pronounced yellow or greenish-yellow stain, and therefore print more slowly and give greater contrast than clean negatives in which the image consists of plain developed silver, although the density may appear the same.

PYRO FOR BROMIDE PAPER

Pyro when properly used gives exquisite brown tones on bromide papers, the pyro-acetone formula being perhaps the best :—

A. Pyro	.	220 grs.	50 g.
Sodium sulphite	.	1,320 ,,	300 ,,
Sulphuric acid	.	30 mins.	6·25 ccs.
Water to	.	10 oz.	1,000 ,,
B. Acetone	.	½ oz.	55 g.
Water to	.	10 ,,	1,000 ccs.

Use equal parts of A and B. The tone can be altered by varying the quantity of acetone.

The following formula also gives good colours, but the mixed developer should be used for one print only. Solutions A and B, mixed in equal parts, may be used for lantern slides. Four solutions are required, from which two working solutions are made up, one for the actual development and one for clearing :—

A. Pyro	.	55 grs.	13 g.
Potassium meta-bisulphite	.	40 ,,	9 ,,
Sodium sulphite	.	1 oz.	110 ,,
Water to	.	10 ,,	1,000 ccs.
B. Sodium carbonate.	640 grs.	146 g.	
Water	.	10 oz.	1,000 ccs.

A developer ready for use consists of equal parts of A and B.

C. Potassium perman-ganate	.	240 grs.	55 g.
Water	.	10 oz.	1,000 ccs.
D. Common salt	.	1 oz.	110 g.
Water	.	10 ,,	1,000 ccs.
Sulphuric acid	.	4 drms.	50 ,,

The clearing solution is made by adding ¼ oz. of D and 15 mins. of C to 10 oz. of water. The developer (A and B) is poured over the bromide paper, which, when fully developed, is rinsed in water and then flooded for not longer than 30 seconds with the clearing solution. It is next washed for about a minute and fixed in an acid fixing bath, preferably potassium metabisulphite and " hypo."

Dr. Just's pyro developer is as follows :—

A. Pyro	.	20 grs.	4·5 g.
Glacial acetic acid	18 mins.	4 ccs.	
Potassium meta-bisulphite	9 grs.	2 g.	
Sodium sulphite	.	150 ,,	34 ,,
Water	.	10 oz.	1,000 ccs.
B. Potass. carbonate	.	85 grs.	20 g.
Water	.	10 oz.	1,000 ccs.

Use equal parts of each. The developer is almost colourless at first, but rapidly turns brown. For many papers the addition of 6 drops of a 1 in 50 solution of potassium bromide to each 4 oz. of mixed developer is necessary. After development the print should be rinsed in a clearing bath of very weak acetic acid in order to remove stains, and is then washed and fixed in an acid bath. The addition of a few grains of hydroquinone to the pyro solution has been advocated.

PYRO STAINS ON NEGATIVES

These are of a yellow colour, and are caused by exposure of the film when wet with the developer to the air, or by using insufficient sodium sulphite in the developer. It is not all workers who object to them. To obviate them, use a 10 per cent. solution of sodium sulphite or a 2½ per cent. solution of potassium meta-bisulphite instead of plain water for diluting the stock developer. If a stained negative has not been dried, the use of a 2 per cent. solution of caustic soda will remove some of the stain. If it has been dried, it is rather more difficult; but the following will be of help :—

Thiocarbamide .	. 30 grs.	7 g.
Citric acid .	. 60 ,,	14 ,,
Chrome alum .	. 30 ,,	7 ,,
Water to .	. 6 oz.	600 ccs.

Soaking in the following (introduced by B. J. Edwards, in 1883), clears the stain to some extent :—

Alum .	. ½ oz.	55 g.
Citric acid .	. ½ ,,	55 ,,
Ferric sulphate.	. 1½ ,,	165 ,,
Water to .	. 10 ,,	1,000 ccs.

Berkeley's solution will act if the stains are not of long standing :—

Alum .	. 1 oz.	110 g.
Sulphuric acid .	. 2 drms.	25 ccs.
Water .	. 10 oz.	1,000 ,,

Wash thoroughly after any of the above baths.

Namias recommends dissolving 48 grs. of ammonium persulphate in 5 oz. of water, and, in order to destroy the reducing action, adding a few drops of liquor ammoniæ. The stained negative is immersed in this, rocked until the stain disappears, and then well washed.

Chapman Jones, in 1890, stated that all clearing solutions hitherto proposed were founded upon wrong principles, as alum (first used for the purpose by Sir W. J. Newton in 1855) actually retards the washing away of stains, inasmuch as it hardens the film ; further, acids, although they lighten the colour of the stains, render them insoluble. He considers a weak solution of caustic soda to be the best clearing solution, as the staining matter is kept in a soluble condition, so that it may really be washed away, and it is also kept in its original highly coloured form, so that its removal can be noticed.

PYRO-ACETONE

A one-solution pyro-acetone developer is given under the heading " Acetone." The following is a two-solution form :—

A. Pyro .	. 180 grs.	41 g.
Sodium sulphite	. 4 oz.	440 ,,
Water .	. 10 ,,	1,000 ccs.
B. Solution A .	. 5 oz.	500 ccs.
Water .	. 15 ,,	1,500 ,,
Acetone .	. 2 ,,	200 ,,

B is the developing solution proper, and it must be neutral or faintly alkaline, certainly not acid ; if, on testing, there is any acidity, add sodium carbonate.

Metol combines well with pyro and acetone as follows :—

A. Pyro .	.	60 grs.	14 g.
Metol .	.	80 ,,	18 ,,
Citric acid .	.	7 ,,	1·6 ,,
Sodium sulphite	.	360 ,,	84 ,,
Water, hot .	.	10 oz.	1,000 ccs.
B. Acetone .		240 grs.	55 g.
Water .		10 oz.	1,000 ccs

Add 1 dram of each to 1 oz. of water when required for use.

PYRO-AMMONIA

The use of pyro with ammonia as a developer dates from 1862, and it had its origin in America, where ammonia was first used for fuming dry plates before the application of an acid solution of pyro. Major Russell, the author of the tannin process, was the first (in 1863) to publish full working particulars. The composition of an average developer, ready for use, is much as follows :—

Pyro .	. 15 grs.	3·5 g.
Ammonium bromide 14 ,,		3·25 ,,
Liquor ammoniæ (·880) 30 mins.		6 ccs.
Water .	. 10 oz.	1,000 ,,

The following are two-solution developers :—

A. Nitric acid .	. 2 mins.	·4 cc.
Water .	. 10 oz.	1,000 ccs.
Then add pyro .	20 grs.	4·5 g.
B. Liq. ammoniæ (·880) 120 grs.		28 g.
Potassium bromide 30 ,,		7 ,,
Water .	. 10 oz.	1,000 ccs.

Use equal parts of each.

A developer which nearly corresponds to 10 per cent. solutions is the following, given by Sir William Abney :—

A. Pyro .	. 50 grs.	11·5 g.
Sodium sulphite	. 150 ,,	34·5 ,,
Citric acid .	. 10 ,,	2·3 ,,
Water .	. 1 oz.	100 ccs.
B. Potass. bromide	. 50 grs.	11·5 g.
Water .	. 1 oz.	100 ccs.
C. Liq. ammoniæ (·880)	2 drms.	25 ccs.
Water .	. 2¼ oz.	225 ,,

Take of A 20 mins., B 30 mins., C 60 mins., and water 2 oz.; 1 oz. of the mixed developer contains approximately 1 gr. of pyro, 1¾ grs. of potassium bromide, and 3¼ mins. of ammonia.

Pyro-ammonia is largely used for developing lantern slides because of the excellent brown tones which it yields. The J. A. Hodges formula is excellent :—

A. Pyro .	. 1 oz.	110 g.
Sodium sulphite	. 4 ,,	440 ,,
Citric acid .	. 2 drms.	25 ccs.
Water .	. 10 oz.	1,000 ,,
B. Liq. ammoniæ (·880)	1 oz.	100 ccs.
Water .	. 10 ,,	1,000 ,,
C. Ammonium bromide 1 oz.		110 g.
Water .	. 10 ,,	1,000 ccs.
D. Ammon. carbonate	1 oz.	110 g.
Water .	. 10 ,,	1,000 ,,

This will give brown tones on a plate made for black tones if the exposure is prolonged. A mixture of 30 mins. each of A and B and 60 mins. each of C and D should give a rich brown,

inclining to purple. Increasing D and decreasing B gives warmer and more reddish tones.

It should be noted that, while in some formulæ an alkaline bromide is recommended, it is rarely necessary for modern dry plates.

J. B. B. Wellington's two-solution formula gives rich sepia tones :—

A. Pyro	. .	. 240 grs.	55 g.
Sodium sulphite	.	2 oz.	220 ,,
Water to	.	. 10 ,,	1,000 ccs.
B. Am. carbonate	.	480 grs.	110 g.
Potassium hydrate		360 ,,	82 ,,
Am. bromide	.	240 ,,	55 ,,
Water to	.	. 10 oz.	1,000 ccs.

Take 1 dram of each, and add water to make 1 oz.

PYROCATECHIN (Fr., *Pyrocatechine ;* Ger., *Brenzcatechin*)

Ortho-dihydroxybenzene; known also as oxyphenic acid and catechol. $C_6H_4(OH)_2$. Solubility, 1 in 1·25 of cold water. It was suggested as a developer in 1880, and came into use in 1899. It occurs in prismatic colourless crystals. It does not stain or fog; it turns brown in solution and on exposure to air, but its developing powers are not impaired. It can be used with the carbonates or caustic alkalis, either in one or two solutions, and is not influenced by temperature. The following is a simple one-solution formula for negatives :—

Pyrocatechin	.	. 50 grs.	11·5 g.
Sodium sulphite	.	120 ,,	27·5 ,,
Sodium carbonate	.	240 ,,	55 ,,
Water to	.	. 10 oz.	1,000 ccs.

This is ready for use.

It may be made up in a highly concentrated form, as follows :—

Sodium sulphite	.	1 oz.	110 g.
Caustic soda	.	. 67 grs.	15 ,,
Hot water	.	. 3 oz.	300 ccs.

Dissolve, and add—

Pyrocatechin	.	. 96 grs.	22 g.
Water	.	. 1 oz.	100 ccs.

For use, dilute 1 part with 15 parts of water.

A two-solution formula is :—

A. Pyrocatechin	.	50 grs.	11·5 g.
Sodium sulphite	.	1 oz.	110 ,,
Water to	.	10 ,,	1,000 ccs.
B. Potassium carbonate or sodium carbonate	.	288 grs.	66 g.
Distilled water to		10 oz.	1,000 ccs.

For use, mix together equal parts.

Sodium tribasic phosphate is recommended by Messrs. Lumière as an accelerator :—

A. Pyrocatechin	.	96 grs.	22 g.
Sodium sulphite	.	1 oz.	110 ,,
Water	.	. 10 ,,	1,000 ccs.
B. Tri-sodium phosphate	.	60 grs.	14 g.
Water	.	. 10 oz.	1,000 ccs.

Add 1 part each of A and B to 1 part of water.

For bromide paper the following one-solution formula is recommended :—

Sodium sulphite	.	60 grs.	14 g.
Sodium carbonate	.	120 ,,	28 ,,
Pyrocatechin	.	. 20 ,,	4·6 ,,
Water	.	. 10 oz.	1,000 ccs.

This is ready for use.

PYROLIGNEOUS ACID

Crude acetic acid.

PYRO-METOL (*See* "Developers, Mixed or Combined.")

PYRO-POTASH

Dr. Eder and others have recommended the use of the alkali potash to take the place of ammonia or soda in the developer. Several advantages have been claimed for it—namely, the stable nature of the alkali and its freedom from fog or stain, but its drawbacks are slow working and possibility of frilling. The average of the many formulæ advocated is :—

Pyro	. .	. 30 grs.	7 g.
Potassium carbonate	.	120 ,,	28 ,,
Water	.	. 10 oz.	1,000 ccs.

Bromide is added as required.

Eder's formula is in a two-solution form, and is much as follows :—

A. Pyro	.	. 436 grs.	100 g.
Sodium sulphite		1,090 ,,	250 ,,
Sulphuric acid	.	10 mins.	2 ccs.
Water	.	. 10 oz.	1,000 ,,
B. Potass. carbonate		2,000 grs.	460 ccs.
Sodium sulphite	.	550 ,,	126 ,,
Water	.	. 10 oz.	1,000 ccs.

For use, add 135 drops of each to 10 oz. of water. There are many other formulæ.

PYRO-SODA

A developer that is popular on account of soda having many advantages over ammonia, which in 1862 was introduced as an accelerator for pyro. Washing soda is largely used in place of crystallised sodium carbonate, but the latter should always be used when sodium carbonate is mentioned. This developer gives off no fumes as ammonia does, and may therefore be used with greater comfort; it rarely produces chemical fog, and negatives properly developed are of a good printing colour.

The average of twelve of the best-known formulæ is :—

Pyro	. .	. 30 grs.	9 g.
Sodium sulphite	.	240 ,,	55 ,,
Sodium carbonate	.	240 ,,	55 ,,
Water to	.	. 10 oz.	1,000 ccs.

Some workers prefer to make up the developer except the pyro, and add the latter just before use. Lange's (*which see*) is typical.

The Hurter and Driffield standard pyro-soda developer for plate-speed testing is :—

Pyro	. .	.	8 parts.
Sodium carbonate (crys.)	.		40 ,,
Sodium sulphite	.	.	40 ,,
Water to	.	.	1,000 ,,

This should be used at a temperature of 65° F. (18° C.).

PYROTECHNIC LIGHTS (Fr., *Lumières pyro-techniques ;* Ger., *Pyrotechnisches Licht*)

Chemical mixtures giving a brilliant light on ignition, at one time used for photography at night and in dark interiors, but now completely superseded by magnesium and the various forms of electric light. Typical formulæ were : (A) Potassium nitrate 28 parts, sulphur 7 parts, arsenic trisulphide (orpiment) 2 parts. This gives off poisonous fumes, and if burnt in a room provision must be made for carrying these off by a chimney. (B) Potassium nitrate 7 parts, sulphur 2 parts, black antimony sulphide 1 part, red lead 1 part. All the ingredients must be dry, and the potassium nitrate not too finely powdered. In this case also the fumes require to be led away.

PYROXYLINE (Fr., *Pyroxylin ;* Ger., *Pyroxlin*)

Synonyms, nitrocellulose, collodion cotton, soluble gun-cotton, collodion wool. Solubilities, insoluble in water and in alcohol, soluble in equal parts of alcohol and ether, and in amyl acetate, acetone, and glacial acetic acid. It is a white flossy substance, resembling cotton, but harsher to the touch and much more friable. It is prepared by the action of nitric acid (or of potassium nitrate) in the presence of sulphuric acid on cotton-wool. The actual chemical formula for this substance is a disputed point, but nearly all photographic pyroxyline consists chiefly of cellulose-tetranitrate with a small quantity of tri-nitrate ; the formula for the former would be $C_{12}H_{16}O_5(NO_3)_4$, and for the latter $C_{12}H_{17}O_7(NO_3)_3$. In the collodion days, it was of paramount importance, but has now—except in process work—become of secondary interest, and is used for prepared collodion, for negative and positive work, and for enamelling prints.

In process work, from 1 to 4 per cent. is used in collodion, but 2 per cent. is general. Celloidin is replacing it more and more on account of its greater uniformity.

Q

QUADRICOLOUR

A trade name adopted by an American firm for the four-colour process, the fourth printing being a black, which is printed last. The building up of a four-colour print is exemplified in a plate accompanying this work.

QUARTER-PLATE

A commercial photographic size, $4\frac{1}{4}$ in. by $3\frac{1}{4}$ in., one quarter of a whole plate.

QUARTZ (Fr., *Quartz ;* Ger., *Quarz, Bergkrystall*)

Synonym, rock crystal. Native anhydrous silicates of potash and soda, used for the construction of lenses, prisms, etc., for the examination of the ultra-violet rays.

QUICK PRINTS FROM WET NEGATIVES

The work of taking a print from a wet negative. A sheet of bromide or gaslight paper is soaked in water until quite limp, and the negative placed in the water with it. The two are then brought into contact, film to film, while under water and of course in the dark-room. The negative and paper are removed from the water, the glass side wiped dry, exposure made to the light, and the print developed and fixed in the usual way. A printing frame is not necessary, but if the light used for exposing is very strong it is advisable to shield the back of the paper with a piece of cardboard. The paper should be taken from the wet negative very carefully, and preferably under water. Another plan is to immerse the rinsed negative for five minutes in a 10 per cent. solution of formaline, then in hot water for about two minutes ; it should take about five minutes to dry.

The arrangement for enlarging or reducing direct from the wet negative, shown in the diagram, may be much simplified if set sizes are always used. In one end of an oblong box is cut an aperture to take the wet negative, or it may be dropped into grooves as shown. At the opposite end is a hinged door, to which the paper is pinned. A sliding partition holds the lens. The wet negative is placed in position, ground glass substituted for the hinged door,

Arrangement for Enlarging or Reducing from Wet Negative

and the image focused by moving the partition holding the lens. The box is then taken into the dark-room, where a piece of bromide paper is pinned to the door, which is then closed and the box taken into daylight for the purpose of making the exposure. The size of the box will depend upon the focus of lens used, size of negative, and degree of enlargement or reduction. The advantages of such an arrangement are that the negatives do not need lengthy washing before the print can be made, and that the picture may be reproduced of any size upon the paper. A fixed-focus enlarger for wet negatives is on the lines of the apparatus shown at A in the article " Enlarging by Daylight."

QUICK STUFF

A term applied, in the early days, to accelerators, which hastened development.

QUILLAIA (Fr., *Écorce de quillay;* Ger., *Quillajarinde*)

Synonyms, quillaja, soap, Panama, China or Murillo bark. The dried bark of *Quillaia saponaria* deprived of its peridermis. It is met with in large flat pieces about ⅛ in. thick, brownish white outside, and smooth, shiny white inside. The powder causes violent sneezing. A semi-alcoholic tincture is sometimes used as an addition to paper emulsions, or the active principle saponine is used in the same way, its purpose being to give smooth, even coating. It has also been used as a vehicle for the pigments for colouring prints.

QUININE SULPHATE (Fr., *Sulfate de quinine;* Ger., *Schwefelsaures Chinin*)

$(C_{20}H_{24}N_2O_2)_2H_2SO_4\ 7H_2O$. Solubilities, insoluble in water, soluble in dilute acids. It is in the form of white, lustrous, fragile, needle-like crystals, obtained from cinchona bark. It is occasionally used when dissolved in dilute sulphuric acid as a screen to cut out the ultra-violet.

In process work, when reproducing drawings in which Chinese white has been largely used, it has been found advantageous to employ a liquid filter consisting of a 1 per cent. solution of quinine sulphate dissolved by the aid of a few drops of sulphuric or nitric acid.

QUINOL

A synonym for hydroquinone.

QUINOLINE AND QUINOLINE BLUE

Synonyms for cyanine.

QUINOLINE RED (*See* "Chinoline Red.")

QUINOMET (Fr., *Métoquinone;* Ger., *Metochinon*)

Synonym, metoquinone. $C_6H_4(OH)_2 + C_6H_4(OH)(NHCH_3)_2$. Solubility, 1 in 100 of water. A developing compound composed, it is said, of metol and hydroquinone, and introduced by Messrs. Lumière and Seyewetz, of Paris, in 1903. It can be used with or without an alkali. The following is suitable for time exposures :—

Quinomet.	.	.	24 grs.	5·5 g.
Sodium sulphite (anhydrous)	.	.	144 ,,	33 ,,
Water	.	.	10 oz.	1,000 ccs.

This is ready for use. For "instantaneous" exposures, 300 mins. of acetone should be added, or 100 grs. of sodium tribasic phosphate, or 50 grs. of caustic lithia. The quinomet must be dissolved in the water first.

QUINONE (Fr., *Quinone;* Ger., *Chinon*)

Synonym, benzoquinone. $C_6H_4O_2$. Molecular weight, 108. It is in the form of golden-yellow prisms obtained by oxidising aniline with sulphuric acid and potassium bichromate. Solubilities, slightly soluble in water, soluble in alcohol and ether and alkaline solutions. It hardens gelatine, but stains it deep brown. When dissolved as in the following formula,

Quinone	.	.	24 grs.	5·5 g.
Sulphuric acid	.	.	96 mins.	20 ccs.
Water to	.	.	10 oz.	1,000 ,,

it acts as a reducer, and, like ammonium persulphate, acts on the high lights more than the shadows. With potassium bromide, thus—

Quinone	.	.	24 grs.	5·5 g.
Potassium bromide	.	120	,,	28 ,,
Distilled water to	.	10 oz.	1,000 ccs.	

it converts a silver image into a reddish brown compound, probably silver oxybromide Ag_2Br_2O, which can be treated with ammonia to form a dark brown image; sodium or potassium carbonate also gives dark brown, and at the same time intensifies; "hypo" reduces the image without changing the colour; sodium sulphite or bisulphite gives greenish brown; and amidol behaves in the same way.

QUINONE INTENSIFIER AND TONER

Introduced in 1910 by Messrs. Lumière and Seyewetz. By adding to solutions of quinone and its sulphonic derivative a sufficient quantity of a bromide or a chloride, and immersing a negative therein, the silver image attains a certain degree of intensification, its colour becoming gradually reddish brown in the case of quinone, and yellowish brown when using the sulphonic quinone. The following are the original formulæ :—

Quinone

Quinone	.	.	22 grs.	5 g.
Potassium bromide	.	110	,,	25 ,,
Water	.	.	10 oz.	1,000 ccs.

Quinone Sodium-sulphonate

Quinone sodium-sulphonate	.	45 grs.	10 g.	
Potassium bromide	.	110	,,	25 ,,
Water	.	.	10 oz.	1,000 ccs.

The image thus obtained has slight general opacity, which disappears on immersing the plate after a brief rinse in a solution of liquor ammoniæ 1 part and water 10 parts. The quinone-sulphonate gives a more yellowish and less intense action, and the first formula is preferable to the second.

QUINONE REDUCER

Certain quinone bodies in acid solution have been found by Messrs. Lumière and Seyewetz to act as reducers, giving effects similar to those of ammonium persulphate. A formula is given under the heading "Quinone"; another is:—

Sulphuric acid	.	.	90 mins.	17 ccs.
Benzo-quinone	.	.	22·5 grs.	5 g.
Water	.	.	10 oz.	1,000 ccs.

The action is arrested by rinsing in water and then in a sodium sulphite solution (1 oz. in 5 oz. of water), afterwards washing well.

QUINONE SODIUM-SULPHONATE (Fr., *Quinone sulfonate de sodium;* Ger., *Chinonnatriumsulfonat*)

Synonym, benzoquinone sodium sulphonate. $C_6H_4O_2\ SO_3Na$. Molecular weight, 211. For its use, *see* "Quinone Intensifier and Toner."

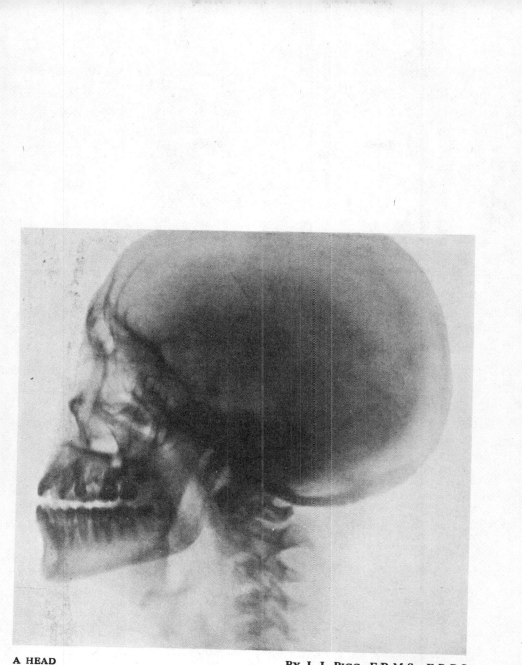

A HEAD BY J. I. PIGG, F.R.M.S., F.R.P.S.

RADIOGRAPHY, OR X-RAY PHOTOGRAPHY

R

RACK AND PINION (Fr., *Crémaillère*; Ger., *Zahnstange und Getriebe*)

The mechanical device by which the distance between lens and focusing screen is usually regulated. It consists of a steel pinion A working on a brass rack B, the grooves in which engage with the teeth or flutings on the pinion. Generally, two racks are fitted underneath the extension frame of the camera, one at each side,

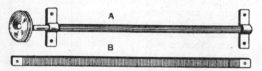

Rack and Pinion

the pinion being let into the baseboard at a right angle with the racks and worked by a milled-head screw at the side of the camera. For accurate focusing, it is important that the rack and pinion should not be too coarse, and there should be no looseness or shake. Modern cameras have frequently a rack and pinion adjustment to other parts besides the focusing arrangement—for example, on the rising and cross front movements. Rack and pinion adjustments are also fitted to enlarging lanterns, etc.

RACKS, DRYING AND WASHING (See "Drying Rack.")

RADIOACTIVE SUBSTANCES

Substances from which minute particles are continually being propelled at a high velocity. These particles affect the sensitive film of a dry plate or the crystals of certain chemicals which fluoresce when brought into close proximity to the radioactivity; this fluorescence is visible to the eye in a darkened room.

The most important radioactive elements are radium, uranium, actinium, polonium and thorium, and from these three kinds of radiations are emitted, known as alpha, beta, and gamma rays. The alpha rays are readily absorbed by air or any solid matter which may lie in their path. The alpha particles are of comparatively large size, comparable to that of an atom, and carry charges of positive electricity. They are slightly deflected by a magnetic field. The beta rays are negatively charged, and are strongly deflected by a magnetic field. The particles are much smaller than those of the alpha rays, and are known as electrons. The beta rays are similar to the cathodal rays of an X-ray tube. Gamma rays do not seem to be deflected by a magnetic field, and have the greatest penetrating powers of any of the rays; they are probably the product of the beta rays.

RADIOGRAPH

A photograph produced by the X-rays.

RADIOGRAPHY (See "X-ray Photography.")

RADIOTINT PROCESS (See "Dansac-Chassagne Colour Process.")

RADIUM (Fr. and Ger., *Radium*)

Atomic weight, 226·5. Radium occurs in pitchblende, an oxide of uranium, in association with uranium, lead, barium, and other metals. It is prepared from pitchblende, or from the residues after uranium has been extracted therefrom. In the preparation of radium, a barium chloride which is highly radioactive is extracted from pitchblende; from this barium chloride, radium chloride is isolated by elaborate processes of fractional crystallisation. One ton of pitchblende yields fifteen pounds of barium chloride, from which only a few grains of radium chloride can be separated.

RAPID DEVELOPERS

Metol, rodinal, and other developers of the newer type (so-called) are often referred to as rapid developers because they produce the image far more quickly than some of the other developers—pyro, for example. As explained, however, under the heading of "Development, Factorial," those images which appear very quickly need developing for a considerable time in order to secure proper density, so that, after all, one normal developer is not so very much more rapid than another. The following table was compiled by Alfred Watkins after making some comparative tests; the final density or printing power was about the same, but the results at the various stages before the desired density was arrived at were very different:—

Developer	Time of appearance in seconds	Factor	Total time (in minutes) of development
Pyro	16	7	1¾
Metol	5	22	1⅞
Ortol	15	8	2
Adurol	50	5	4
Kachin	42	9	6¼
Hydroquinone	62	5	5¼
Glycine	62	6½	7
Metol-hydroquinone	7	13	1½

Thus a mixture of metol-hydroquinone is under normal circumstances the most rapid developer, even though the image takes longer to appear than with metol alone. Pyro-acetone (see " Acetone ") without bromide makes a very rapid developer, and gives good negatives of excellent density in three or four minutes. This at first sight appears longer than the time given for pyro or metol-hydroquinone developers in the Watkins table on p. 449, but Watkins used test slips for judging density, and not actual negatives ; therefore the times of development given in the table are only comparative, and a rough calculation shows that were pyro-acetone included in the table it would be about 1.

RAPID EMULSIONS (See " Emulsions for Development.")

RAPID PLATES (Fr., *Plaques ultrarapide ;* Ger., *Hochempfindliche Platten*)

Plates coated with a highly sensitive gelatino-bromide emulsion. Of recent years, the advances in emulsion making have given us plates of very high speed and of general satisfactory freedom from fog. At the present time there is a great craze, particularly among amateurs, for very rapid plates, but in many cases equally as good —if not better—results can be obtained on slower plates, which are usually less prone to chemical fog and possess a much finer grain.

RAPID RECTILINEAR LENS

This, the most popular type of photographic lens, was introduced almost simultaneously by J. H. Dallmeyer and Steinheil in 1866, and held the premier position for all classes of outdoor work until the arrival of the anastigmat. Even now, most moderate-priced cameras are fitted with R.R. lenses, mostly of excellent quality. The rectilinear lens is composed of two cemented combinations, usually symmetrical, and has an initial intensity of $f/8$ (approximately). Either of the combinations may be used singly, but require stopping down to about $f/22$ ($f/11$ of the complete lens) to secure an absolutely sharp image. The rectilinear is an excellent lens for copying, architectural, and process work, while the larger sizes are useful for portraiture. (See also " Rectilinear.")

RAPID SYMMETRICAL LENS

A rapid rectilinear lens, having both combinations of similar construction and of equal focal length.

RAPIDITY

A term applied to the working aperture of lenses (Fr., *Rapidité, Clarté ;* Ger., *Lichtkraft*), and also the speed of plates (Fr., *Sensibilité ;* Ger., *Lichtempfindlichkeit*).

RAY

In optics, a ray of light may be assumed to have the properties of a line in geometry—that is to say, it has length without breadth or thickness. A bundle of rays which converge to or diverge from a given point is called a pencil of rays.

RAY FILTER (See " Colour Screen or Filter.")

RAYOMETER (Fr., *Rayonmètre ;* Ger., *X-Strahlen Messer*)

An appliance used in testing the sensitiveness of plates to X-rays. One form consists of a quadrant of aluminium of graduated thickness, the different thicknesses being in concentric steps. The sensitiveness of the plate, as compared with another, is indicated by the thickness of aluminium through which the rays are shown to have penetrated when the plate is developed. The rayometer may also be used to compare the power of different vacuum tubes, by placing it between the excited tube and a fluorescent screen, the thickness penetrated being visible on the screen.

READE, JOSEPH BANCROFT

Born at Leeds, 1801 ; died at Bishopsbourne, 1870. Chemist, microscopist and photographic experimentalist and discoverer. He was the first to employ " hypo " as a fixing agent (1837), and tannin as an accelerator ; he was also the first to produce a negative on paper by means of gallic acid and silver nitrate (1837). He was the first to take photomicrographs with the solar microscope, and these he called " solar mezzotints."

RECORD PRINTS

Photography has unique advantages as a means of producing graphic records of persons, places, and things, for future reference. In spite of the enthusiasm and industry of several associations, the work of securing permanent records is still far from being attacked with systematic completeness, and it is highly desirable that some effective co-ordination of work and control of the results should be instituted. Meanwhile, it would be well if every possible opportunity were seized of making photographic records of any worthy subject, making careful notes of necessary data for future reference. The best view-points and lighting should be considered, and the resulting prints should be made in some permanent process, such as platinum or double-transfer carbon. The work can only be done adequately when the record maker has a knowledge of what is desirable for his attention, and this knowledge is frequently most easily acquired by local workers. Hence the need for a widely distributed army of capable photographers with an interest in record work.

Attention should be devoted first of all to old buildings and their details when there is any likelihood of their near disappearance ; to objects of antiquity or historical interest ; to natural scenery about to vanish before the builder ; to interesting local customs and ceremonies ; to obsolete forms of dress and equipment ; in short, to anything interesting that is not likely to be seen by future generations and of which a pictorial record will be of value. The results should be entrusted only to the custody of those who appreciate their value and will assure their preservation.

RECTIFIED SPIRIT (See " Alcohol.")

RECTIGRAPH (Fr., *Rectigraphe ;* Ger., *Rektigraph*)

A name given to certain makes of doublet lenses. The term is equivalent in meaning to rectilinear.

RECTILINEAR

Capable of reproducing straight lines correctly and without distortion. The term can be correctly applied to any non-distorting lens, including all the anastigmats, but it is usually associated with the older types of doublets known as rapid or wide-angle rectilinears.

RED CHROMATE OF POTASH (See "Potassium Bichromate.")

RED FOG (See "Fog, Colour, etc.")

RED LIGHT (See "Dark-room Illumination" and "Safe Light.")

RED PRINTS

These can be produced by several processes. Carbon prints in red chalk or terra-cotta red are the most perfect and the most satisfactory. Bromide prints toned by the sulphide process can also be made to yield a good red, similar to red chalk. Silver prints, very lightly toned, will be a good red brown, but all rich colours in silver printing tend towards purple brown rather than a pure red brown.

Red prints are often made by printing on plain paper and simply fixing with a "hypo" bath for the purpose of drawing upon in waterproof ink for the bleaching-out process.

RED PRUSSIATE OF POTASH (See "Potassium Ferricyanide.")

RED SILVER CHLORIDE (See "Silver Chloride.")

REDCOL

A "cold" enamel process for zinc, introduced by Penrose. The zinc is first coated with a red varnish of a resinous nature forming an acid resist; this is covered with bichromated fish-glue, dried, and exposed under a half-tone negative. The unaltered fish-glue is washed away in development, leaving the red varnish exposed between the dots. The plate is immersed in methylated spirit, which dissolves the red varnish uncovered by the fish-glue image. Next, the fish-glue covering is wiped away, and the image remains in the acid-resisting varnish, and can be forthwith etched, without the burning-in necessary in the fish-glue enamel process.

RE-DEVELOPER

A second development of a plate, either with a similar developer to that first applied or with a modified solution, is possible. Many years ago B. J. Edwards introduced a special method of re-developing over-exposed plates which was very effective.

His special developer should take the place of the normal developer as soon as the over-exposed image flashes up:—

A. Pyro . . . 170 grs. 39 g.
 Sodium metabisul-
 phite . . 170 ,, 39 ,,
 Water to . . 10 oz. 1,000 ccs.

B. Sodium carbonate 3 oz. 100 grs. 353 g.
 Potassium bromide 340 grs. 78 ,,
 Water to . . 10 oz. 1,000 ccs.

Use equal parts of A and B. The solution is so highly restrained that it will hardly develop detail, but density goes on increasing.

Re-development forms an essential feature in Wellington's silver intensification process, and also in re-halogenisation. It is also used in some forms of mercurial and chromium intensification.

REDUCERS

Solutions used for reducing the density of negatives, etc. They include potassium ferricyanide in a solution of "hypo" (this is the "Howard Farmer reducer"); potassium permanganate, acidified (this is "Namias's reducer"); ammonium persulphate; ammonium persulphate in combination with sulphite, acidified (this is "Bennett's reducer"); ferric chloride; cerium peroxide. Details of the methods of working will be found under the heading "Reducing Negatives by Chemical Means," and at the references there given.

REDUCERS, COMBINED

Potassium ferricyanide and ammonium persulphate reducers, having respectively different actions upon the density of a plate, have been combined by Coustet (1905). The ferricyanide increases and the persulphate reduces contrast, and the combined reducer is suggested for use with flat and uniformly fogged negatives. For over-exposed or over-developed negatives, Coustet's formula is:—

Ammon. persulphate	200 grs.	46 g.
Potass. ferricyanide	25 ,,	5·75 ,,
Sodium hyposulphite	250 ,,	57·5 ,,
Water . . .	10 oz.	1,000 ccs.

The proportions of ferricyanide and persulphate may be varied. Throw away after use. When the negative is of correct density, immerse it in a 10 per cent. solution of sodium sulphite. For the two-solution form use:—

A. Potass. ferricyanide	96 grs.	22 g.
Sodium sulphite .	2 oz.	220 ,,
Water . . .	10 ,,	1,000 ccs.
B. Ammonium persul-		
phate .	192 grs.	44 g.
Water . . .	10 oz.	1,000 ccs.

The negative is placed in A until the brightening action is complete, and then in B until the high lights are reduced, finally well washing.

REDUCIN

A developing substance of German origin, introduced in 1893. It acts very much like amidol. Vogel's formula is:—

Reducin . .	26 grs.	6 g.
Sodium sulphite .	218 ,,	50 ,,
Sulphuric acid .	5 mins.	1 cc.
Water . . .	10 oz.	1,000 ccs.

REDUCING NEGATIVES BY CHEMICAL MEANS

Most of the methods of reducing negatives modify the gradation by acting to a greater degree at one end of the scale than at the other. The special character of each being known, advantage may be taken of its properties to improve or modify an unsatisfactory negative. The following are the chief methods of reducing negatives by chemical means:—

(1) *Potassium Ferricyanide* in a solution of "hypo" (Howard Farmer's reducer). Prepare a 10 per cent. solution of potassium ferricyanide (red prussiate of potash) ; this solution will keep indefinitely. When required for use from 10 to 60 mins. of the solution are added to an acid solution of 2 oz. or 2½ oz. of "hypo" in 20 oz. of water. The "hypo" must not have been previously used for any purpose. A solution strong in ferricyanide should be employed if considerable reduction is required ; for less reduction a weak solution is more under control. The ferricyanide should be added to the "hypo" at the moment of commencing reduction, as the mixed solution deteriorates rapidly. Soak the plate in water for half an hour before treatment, and rock the dish during reduction to ensure even action. When desired, the negative is withdrawn and well washed. The general quality will be improved by immersing it, after a slight rinsing from the reducing solution, for a few minutes in an acid "hypo" bath of the same strength as that used for mixing the reducer.

This reducer acts more on the weak tones, or shadow portions, of a negative than on the strong tones, or high lights. A moderate reduction of the high lights may be accompanied by complete obliteration of the feeble details in the shadows. It is a very valuable method for dealing with over-exposed, foggy or veiled negatives, since it increases contrasts as it reduces density. The character of the result is not affected by the strength of the solution or proportion of ferricyanide present. A weak solution acting for a long time gives the same result as a strong solution for a shorter time.

(2) *Ammonium Persulphate.*—H. W. Bennett's method is to prepare a stock solution containing ammonium persulphate, sodium sulphite, sulphuric acid (pure), and water ; the exact proportions will be found under the heading "Bennett's Reducer." The working solution is a mixture of 1 part of the stock solution and 4 to 8 parts of water.

The negative must be soaked in water for an hour, immersed in the solution, and the dish rocked until sufficient reduction has taken place. The solution will become slightly opalescent or milky in appearance, but this is an indication of its working satisfactorily. When desired, the plate is removed from the solution, rinsed rapidly, and placed for not longer than six minutes in an acid "hypo" bath of the strength already stated, afterwards well washing. A shorter immersion in the "hypo" solution would be sufficient to check the progress of the reduction, but by remaining for six minutes the plate is left in such a condition that subsequent intensification or any other treatment can be successfully applied if desired. Without the "hypo" bath after treatment is practically possible.

The character of the result given by reducing with ammonium persulphate varies according to the degree of reduction. In the early stages the dense parts of the plate only are attacked, and they may be appreciably reduced without any perceptible action on the weak shadow details. With a moderate degree of reduction, the high lights will decrease considerably in strength

with only a slight loss in the shadows. After this, however, the action gains in force in the shadows, and prolonged reduction results in a loss of strength in the shadow details equal in proportion to that of the strong tones. The most useful character of ammonium persulphate is that of correcting or harmonising harsh contrasts, which it accomplishes by reducing the strong tones to a much greater degree than the weak details. But in order that full advantage may be derived from this quality, it is essential that the action should not be prolonged. The plate must be carefully watched, and withdrawn from the solution as soon as any action can be detected in the weaker parts.

(3) *Potassium Permanganate.*—The use of an acidified solution of potassium permanganate followed by a weak solution of oxalic acid for reducing negatives is due to Prof. Namias. The oxalic acid bath, however, is injurious to some plates, particularly those composed of soft gelatine. It softens the film and causes the more transparent parts to become opalescent and useless for printing. With some plates it works satisfactorily. The following modified method of working is quite satisfactory and free from the objections that apply to oxalic acid. Two stock solutions are necessary :—

A. Potassium permanganate	.	.	20 grs.	4·5 g.
Water .	.	.	10 oz.	1,000 ccs.
B. Sulphuric acid (pure)	.	.	100 mins.	21 ccs.
Water .	.	.	10 oz.	1,000 ,,

Take 1 dram or 10 ccs. each of A and B, and add sufficient water to make 1 oz. or 80 ccs. For considerable reduction use a larger proportion of A and B. The negative should be soaked in water for an hour, placed in the solution, the dish being rocked until the reduction is sufficient, rinsed rapidly in two or three changes of water, immersed in an acid fixing bath for a few minutes, and then washed and dried. A solution of potassium metabisulphite may be substituted for the acid "hypo," but the latter is preferable. The reduction effected by acidified potassium permanganate is almost uniform throughout the scale, but there is slightly greater reduction in the strong tones than in the weak shadow details.

(4) *Cerium Peroxide.*—This is obtainable in the form of a concentrated solution which keeps moderately well. To 1 drm. of this solution add sufficient water to make 1 oz. ; immerse the negative in this until the desired reduction has been attained ; then wash and dry. It acts in a greater degree on the shadow details than on the stronger parts, but the difference is not quite so great as in the case of the ferricyanide reducer. The plate, after reduction, is very clean and the image is of a good colour.

(5) *Ferric Chloride.*—This reducer is different in character from the preceding ones. The following stock solution may be prepared, but it does not keep well for more than a few weeks :

Ferric perchloride	.	60 grs.	14 g.
Citric acid	.	120 ,,	28 ,,
Water	.	10 oz.	1,000 ccs.

For use, add to ¼ oz. of this solution enough water

to make 1 oz. Allow the negative to remain in the bath for about two minutes, rinse, transfer to an acid " hypo " bath for a few minutes, and wash and dry. Longer immersion in the reducing solution will produce no greater effect, as the reduction is a fixed quantity. The degree of reduction is slight, the negative losing about one-eighth of its density uniformly throughout the scale. The operation may be repeated, one-eighth of the strength being removed each time.

Reduction by re-halogenisation is treated in the article on re-halogenisation.

REDUCING NEGATIVES BY MECHANICAL MEANS

These methods are suitable only for local work. One method is to rub down the part that it is desired to reduce by means of a soft rag moistened with methylated spirit. Two thicknesses of soft rag may be stretched over the finger-tip, moistened with the spirit, and rubbed on the plate with a firm pressure. For smaller portions the rounded end of a pen-holder may be substituted for the finger; while for very small details the rag may be held on a small, pointed stick. The film will not be scratched or torn if the rag is kept thoroughly wet with the spirit. Use a new portion of the rag each time fresh spirit is applied, as the used part will probably be black from the deposit worked off the negative. The work should be done on a retouching desk, so that its progress can be watched. As it is purely mechanical, the effect can be graded or varied as desired, and no line of demarcation will show either at the beginning or the end. Halation and similar defects can be very successfully treated by this method.

Baskett's reducer (*which see*) can be substituted for methylated spirit, and used in the same manner. Instead of the metal polish, fine tripoli powder may be used if preferred.

Both of these methods of reducing by mechanical means may be employed very effectively for removing iridescence or surface staining from negatives.

REDUCING PRINTS

Prints can seldom be reduced satisfactorily. Silver prints on P.O.P. may be slightly reduced by means of Farmer's reducer, but if considerable change is attempted the general quality of the print suffers, and the colour is spoiled. It is better to make a new print when possible. Bromide prints may be reduced the same way, or with ammonium persulphate, but it is not desirable to carry the action far or the print will be ruined. For reducing prints, the solutions should be used very much weaker than for negatives, one-fourth of the strength being ample.

REDUCTION AND ENLARGEMENT, CALCULATING DISTANCES IN

The rule for finding distances when reducing is: Divide the longer base of the image to be reduced by the longer base of copy desired, which will give the number of times of reduction; to this add 1 and multiply by the focal length of lens used. The result will be distance between lens and object, and this distance divided by the ratio of image to object will give distance between lens and plate. As an example, assume that a

picture measuring 8½ in. by 6½ in. is to be reduced to a base of 2¼ in. using a lens of 11 in. focal length. Then 8½ ÷ 2¼ = 3⅘, number of times of reduction; (3⅘ + 1) × 11 = 48⅘, distance from lens to picture; 48 ÷ 3⅘ = 14¼, distance from lens to plate. It will be seen from this that the working distance of lens is increased from 11 in. to 14¼ in., and therefore the working aperture of the lens is reduced; thus $f/11$ becomes $f/14¼$, and this factor has to be taken into account when estimating the exposure.

The accompanying table supplies the data for reducing or enlarging a copy, when the focal length of lens is known. The figures given are for linear enlargement; for example, 3 in. to 12 in. = an enlargement of four times, or, vice versa, a reduction to one-fourth. It is important to note that when reducing (copying, slide-making, etc.) the greater of the two numbers given in each square of the table is the distance from the original to the lens, and the smaller number is the distance between plate and lens. When enlarging, the greater of the two numbers is the distance from the lens to sensitive paper, and the smaller number is the distance between lens and negative.

The figures in each square in line with the focal length of lens give the distances on each

TABLE FOR ENLARGING AND REDUCING

Focal length of Lens	\[Times of Reduction and Enlargement\] 1	2	3	4	5	6	7	8
In.	In.	In.	In.	In.	In.	In.	In.	In.
2	4 / 4	6 / 3	8 / 2⅔	10 / 2½	12 / 2⅖	14 / 2⅓	16 / 2²⁄₇	18 / 2¼
2½	5 / 5	7½ / 3¾	10 / 3⅓	12½ / 3⅛	15 / 3	17½ / 2¹¹⁄₁₂	20 / 2⁶⁄₇	22½ / 2¹³⁄₁₆
3	6 / 6	9 / 4½	12 / 4	15 / 3¾	18 / 3⅗	21 / 3½	24 / 3³⁄₇	27 / 3⅜
3½	7 / 7	10½ / 5¼	14 / 4⅔	17½ / 4⅜	21 / 4⅕	24½ / 4¹⁄₁₂	28 / 4	31¼ / 3¹¹⁄₁₆
4	8 / 8	12 / 6	16 / 5⅓	20 / 5	24 / 4⅘	28 / 4⅔	32 / 4⁴⁄₇	36 / 4½
4½	9 / 9	13½ / 6¾	18 / 6	22½ / 5⅝	27 / 5⅖	31½ / 5¼	36 / 5⅐	40¼ / 5¹⁄₁₆
5	10 / 10	15 / 7½	20 / 6⅔	25 / 6¼	30 / 6	35 / 5⅚	40 / 5⅝	45 / 5⅝
5½	11 / 11	16½ / 8¼	22 / 7⅓	27½ / 6⅞	33 / 6⅗	38¼ / 6¹⁄₁₂	44 / 6⅜	49½ / 6¹¹⁄₁₄
6	12 / 12	18 / 9	24 / 8	30 / 7½	36 / 7⅕	42 / 7	48 / 6⁶⁄₇	54 / 6¾
7	14 / 14	21 / 10½	28 / 9⅓	35 / 8¾	42 / 8⅖	49 / 8¼	56 / 8	63 / 7⅞
8	16 / 16	24 / 12	32 / 10⅔	40 / 10	48 / 9⅗	56 / 9⅓	64 / 9¼	72 / 9
9	18 / 18	27 / 13½	36 / 12	45 / 11¼	54 / 10⅘	63 / 10½	72 / 10²⁄₇	81 / 10⅛
10	20 / 20	30 / 15	40 / 13⅓	50 / 12½	50 / 12	70 / 11⅘	80 / 11⅗	90 / 11¼
11	22 / 22	33 / 16½	44 / 14⅘	55 / 13¾	66 / 13⅕	77 / 12½	88 / 12⅖	99 / 12⅜
12	24 / 24	36 / 18	48 / 16	60 / 15	72 / 14⅘	84 / 14	96 / 13⅞	108 / 13⅓

side of the lens for copying same size and for enlarging up to eight times. Assume that a whole-plate print is to be reduced to a quarter of its size and that a lens of $5\frac{1}{2}$ in. focal length is to be used. Look for the 4 on the top line (number of times) and for the $5\frac{1}{2}$ in the left-hand column (focal length of lens); where the two columns meet will be found the numbers $27\frac{1}{2}$ and $6\frac{7}{8}$, indicating that the distance between print and lens will be $27\frac{1}{2}$ in. and between lens and plate $6\frac{7}{8}$ in. If, however, a negative is being enlarged four times, $27\frac{1}{2}$ in. will represent the distance between sensitive paper and lens, and $6\frac{7}{8}$ in. the distance between lens and negative.

REDUCTION AND ENLARGEMENT: CALCULATING SIZES OF IMAGES

By means of the simple rule of proportion, sizes of reduced or enlarged images can readily be found. If a print 9 in. × $4\frac{1}{4}$ in. is to be reduced to measure $2\frac{3}{4}$ in. on its longer edge, then the shorter edge will be as 9 to $2\frac{3}{4}$ so is $4\frac{1}{4}$ to x. Or, $9 : 4\frac{1}{4} :: 2\frac{3}{4} : x$. $\dfrac{4\frac{1}{4} \times 2\frac{3}{4}}{9} =$

$\dfrac{17}{4} \times \dfrac{11}{4} \times \dfrac{1}{9} = \dfrac{187}{144} = 1\frac{43}{144}$, say $1\frac{1}{3}$ in.

A booklet published by Penrose gives tables arranged as here shown:—

$$4 \times 3\frac{1}{2} \times 3 \times 2\frac{1}{2}$$
Reduces to

$3\frac{1}{2}$	$\times 3\frac{1}{8}$	$\times 2\frac{5}{8}$	$\times 2\frac{1}{4}$
3	$\times 2\frac{5}{8}$	$\times 2\frac{1}{4}$	$\times 1\frac{7}{8}$
$2\frac{1}{2}$	$\times 2\frac{1}{4}$	$\times 1\frac{7}{8}$	$\times 1\frac{5}{8}$
$2\frac{1}{4}$	$\times 2$	$\times 1\frac{3}{4}$	$\times 1\frac{3}{8}$

Assume that a print 4 in. × 3 in. is to be reduced. Select a table in which the black figure in the top left-hand corner corresponds to the largest dimension of the original, in this case 4 in. Assume that this has to be reduced to $2\frac{1}{2}$ in. Run down the column under 4 until $2\frac{1}{2}$ is reached. Also run along the top line to the right of 4 until the other dimension (3) of the original is reached. Then at the intersection of the columns will be found the desired dimension—namely, $1\frac{7}{8}$, so that the 4 in. × 3 in. print will reduce to $2\frac{1}{2}$ in. × $1\frac{7}{8}$ in., as can be proved by the rule of proportion previously given.

REDUCTION, MECHANICAL

This includes the method of slightly reducing density by expansion of the film (*see* "Enlarging by Stripping"), and also those methods described under the heading "Reducing Negatives by Mechanical Means."

REFLECTED LIGHT

Light which does not reach the object direct, but which is reflected thereon. The table given under the heading "Light, Absorption and Reflection of," shows the amount of light reflected from various substances as compared with that which falls upon their surfaces.

REFLECTING SCREEN

A reflector, usually of white material, and used in portraiture. (*See also* "Reflectors for Portraiture.")

REFLECTION (*See* "Mirror Photography.")

REFLECTIONS IN CAMERA

Unless a circular plate is used, and the camera is so designed that all rays from the lens reach the plate without obstruction, a certain amount of reflection will be caused by light striking the bellows or the internal woodwork. The bellows should be coated with a dead black to minimise those reflections that are unavoidable, and it should not be allowed to get shiny. Reflections are almost certain to occur when using a lens capable of covering a larger plate than the size for which the camera is intended. The superfluous light all round the image falls upon the surrounding bellows and woodwork, and is reflected and re-reflected from one part to the other—sometimes even to the lens and back again. Much of the reflected light is absorbed by the dead black or trapped by the folds of the bellows, but what escapes tends to fog or degrade the brilliancy of the negatives. Reflections may be caused also by brasswork, such as portions of the lens tube or diaphragm, from which the black has worn off. When such places are noticed they should be re-blackened. Where reflection is suspected, remove the focusing screen and place the eyes at the back of the camera, covering the latter and the head with a cloth to exclude all light but that coming through the lens. After a few seconds, to get accustomed to the comparative gloom, a fairly good idea may be obtained whether or not the fault is present to any detrimental extent.

REFLECTOR CAMERA (*See* "Reflex Camera.")

REFLECTORS FOR PORTRAITURE (Fr., *Écran d'éclairage*, *Réflecteur*; Ger., *Beleuchtungsschirm*, *Reflektorschirm*)

White or light-coloured screens used to prevent heavy shadows on the sitter's face at the side

Studio Reflector with Head Screen

farthest from the light. They usually consist of canvas, calico, muslin, or other suitable fabric stretched on a frame supported by feet or by a stand, and having provision for adjustment at any desired angle. A typical studio reflector with a head screen above it is here illustrated. A pure white reflector is seldom desirable, cream

or very light grey being preferable. For some special purposes, though very rarely, mirrors are used. The principle involved in the employment of reflectors is explained under the heading "Portraiture."

REFLEX CAMERA (Fr., *Chambre miroir*; Ger., *Spiegel-reflex Kamera*)

Synonym, reflector camera. A camera in which the image is focused on a horizontal ground glass screen by the aid of a surface-silvered mirror inclined at an angle of 45°, the latter being automatically swung out of the

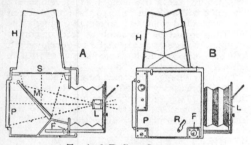

Typical Reflex Camera

way when exposing the plate. The reflector principle was suggested very many years ago (*see* "Camera" and "Camera Obscura"), but it is only of recent years that the mechanical perfection of the reflex hand camera has been achieved. A and B show respectively the exterior and interior of a typical reflex camera, the lettering being the same in both; M is the hinged mirror, L the lens, S the horizontal focusing screen, H the hood shielding the last-named from extraneous light, F the focusing pinion, R the release that operates both shutter and mirror, and P the position of the plate. The dotted lines show the manner in which the image is reflected to the screen. The hood folds down flat when not in use. In designing these cameras great care has to be taken to secure identity of focus on the screen and at the position of the plate. The mirror is usually arranged to swing upward by means of springs or levers directly the shutter release is pressed, and to resume its former position after the exposure. In the majority of reflex cameras a focal-plane shutter is fitted. The advantages of the reflector principle are that a full-size image is seen, and may be accurately followed or focused up to the very moment of exposure, using if desired, and seeing the effect of, the rising or swing front, or any other adjustment. Large aperture lenses and lenses of long focus may also be used on near objects without stopping-down, as may frequently be necessary in press work, whereas with an ordinary hand camera it would be next to impossible to secure sharp focus by scale under such conditions.

Another form of reflex camera, but with a fixed mirror, is the twin-lens camera.

REFRACTION

When a ray of light falls upon any transparent medium it may be reflected, or it may pass through it, but in the latter case the waves of light are retarded in their passage, exactly in the same way as the wind is retarded in passing through a clump of thick trees. Take first a sheet of glass, shown in section by A, B, C, D in diagram A, on which falls a beam of parallel light, the successive positions of the wave front being represented by the transverse curves. On meeting the glass at right angles to the surface, A B, there is a slight retardation, but as practically the whole of the wave front meets the glass simultaneously the relative positions remain the same and the direction of the ray is unaltered, although there is retardation in the glass, as shown by the curves being closer. If the beam strikes the glass at an angle, it is obvious that

A B

Diagrams illustrating Cause of Refraction

part of the wave front strikes the glass before the other; thus, as in diagram B, the point E will strike the glass before the point F; as the wave is retarded in the denser medium, E moves to G, whilst F is moving to H; therefore, the wave swings round slightly, or, as it is termed, is refracted. Again, after passing through the glass, I will meet the rarer medium, air, before J, and will, therefore, have moved to K before J has reached L, and once more the ray swings round. Now, take only one surface of the glass, A B, as in diagram C, A B, and let L be the ray incident at the point D, which is refracted to E; then, with D as centre, describe the circle. Draw the normal C, D, F at right angles to the surface, A B, and from the point where the circle cuts the incident and refracted rays, L and E, draw the dotted lines L, M and E, N. Now it is obvious that the angle L, D, M is greater than the angle of incidence, L, D, C, or sine i = $\frac{L, M}{L, D}$, and the sine of the angle of refraction

or sine r = $\frac{E, N}{D, E}$ and the index of refraction is $\frac{\text{sine } i}{\text{sine } r}$; but it has just been shown that

$$\text{sine } i = \frac{L, M}{L, D} \text{ and sine } r = \frac{E, N}{D, E}$$

$$\therefore \frac{\text{sine } i}{\text{sine } r} = \frac{\frac{L, M}{L, D}}{\frac{E, N}{D, E}}$$

but L, D and D, E are radii of the same circle, and, therefore, are equal to one another

$$\therefore \frac{\frac{L, M}{L, D}}{\frac{E, N}{D, E}} = \frac{L, M}{E, N},$$ which is the index of refrac-

tion; this is generally measured for the D line (mean λ 5.893), and is denoted by the symbol μ.

Suppose in diagram C L, M is 2 in. and E, N is 1·25 in. ; then

$$\frac{L, M}{E, N} = \frac{2}{1·25} = 1·6$$

which would be the index of refraction for this particular glass. The index of refraction is

C. Diagram Showing How Index of Refraction is Found

practically the ratio of the velocity of light in one medium to the velocity in another medium. In general, this refers to the velocity in the given medium and in air, though the absolute index of refraction is obtained when the medium is in a vacuum.

REFRACTIVE INDICES (See " Refraction.")

REFRANGIBILITY

The quality or property of being refracted. (See " Refraction.")

REGISTER (Fr., Registre ; Ger., Register)

A term employed to denote complete agreement between the position of the ground glass focusing screen and that of the plate in the dark-slide, without which the negatives will not be in focus. Lack of register between the dark-slides and focusing screen is seldom met with in good modern apparatus. To test the register of a suspected slide, focus sharply, then take a piece of ground glass the size of the plate, place it in the dark-slide ground side outward, and insert the slide in the camera with both shutters drawn and the separator removed. The ground glass should be pressed close to the front of the slide with the fingers, when if the image is still in sharp focus that side of the slide may be assumed to be in register.

REGISTRATION OF PHOTOGRAPHS (See " Copyright.")

RE-HALOGENISATION

A method of converting into a haloid salt the silver which forms the image of a negative, and then, by re-development, obtaining a negative of, if required, reduced density compared with the original. One of the most simple and satisfactory formulæ is :

Potassium ferricyanide	80 grs.	18 g.
Potassium bromide .	120 ,,	27 ,,
Water . . .	10 oz.	1,000 ccs.

The negative is immersed in this solution until the image is thoroughly bleached, as in mercurial intensification, and then well washed for about twenty minutes. It is now ready for re-develop-

ment Any developer may be used. The plate must be exposed to light after bleaching ; but exposure during the washing will be found sufficient. If the negative is fully re-developed, the re-halogenised plate will be practically unchanged from its original character. But shorter development will naturally convert only a portion of the haloid salt into metallic silver, thereby producing a negative possessing less density than the original. It is somewhat difficult to judge the degree of strength produced, although the development is carried out in white light ; the unchanged haloid adds so much to the apparent strength in the early stages of development. The time will assist in judging the proportion of the silver salt developed into metallic silver ; the full time would be the same as that originally occupied in development. After re-development, fixing is necessary in the same manner as with an ordinary negative.

The only change that can be effected by this method of working is reduction of density, and this takes place uniformly throughout the scale. The re-halogenised plate may be afterwards intensified or reduced by any other method.

REHNERT'S PAPER

Particulars of producing this sensitive paper for enlargements were published, it is believed, by Rehnert, in 1897. Rives paper is immersed in a solution of magnesium iodide, 2 parts ; magnesium chloride, 1 part ; alcohol, 100 parts ; and when dry sensitised by floating until white on a 1 in 12 solution of silver nitrate, strongly acidulated with acetic acid. It should be exposed while wet, developed in a 1 in 200 solution of pyro, fixed in " hypo," and washed. If more brilliant results are wanted, the paper should first be sized with starch before sensitising.

REJLANDER, OSCAR G.

Born in Sweden, 1803 ; died in London, 1875. Began photography in 1853, and practised at Wolverhampton for many years. He was the first to use a number of negatives in the production of one picture, and to photograph the nude. His first combination picture (1855) was from three negatives. In 1857 he sent " The Two Ways of Life " to the Manchester Exhibition of that year ; thirty negatives were employed in printing it, each being laid in turn upon the sensitive paper and exposed, while the rest of the paper was covered with black velvet. He was one of the first to use photography for the purpose of book illustration, his illustrations to Charles Darwin's book, " The Expression of the Emotions," being, perhaps, the best known.

RELIEF, GELATINE (See " Gelatine Reliefs.")

RELIEF, PHOTOGRAPHS IN

In the many processes of making photographs in relief, the well-known property of chromated gelatine losing its water-absorptive power after exposure to light is taken advantage of. Negatives having over-strong contrasts give the most satisfactory results ; in producing such a negative, the background should be black and the sitter's face and hair powdered, and lighted in such a way that the head stands out in the greatest possible contrast to the background.

The negative is printed upon a plate prepared as follows : Mix together 2 oz. of gelatine, 1 oz. of gum arabic, 10 oz. of water and 48 mins. of glacial acetic acid, and melt by the application of heat. Pour a quantity on a bevelled sheet of glass to the thickness of two or three millimetres, and let it set and dry in a horizontal position. The plate is sensitised by immersing it for a few minutes in a 3 per cent. solution of ammonium bichromate, with an excess of ammonia, and dried in the dark. The plate requires a longer exposure than if bichromate alone is used, from a quarter to half an hour being required in full sunlight, the printing frame being so placed that the sun's rays fall upon it as perpendicularly as possible. After printing, in which a certain amount of guesswork is necessary, the prepared plate is taken from the frame and placed in a 2 per cent. solution of alum to which a 2 per cent. solution of citric acid has been added. After soaking for several hours considerable relief is obtained, which is suitable for casting in plaster-of-paris, or, after dusting with graphite, can be electrotyped. In the latter case, varnish the edges of the relief plate before or after printing, so as to prevent the film from stripping when it is in the acid sulphate of copper bath. (*See also* " Acrograph," " Cameo," " Bas-reliefs," " Electro-phototypy," " Galvanography, Photographic," " Gelatine Reliefs," " Photo - lithophane," " Photopolygraphy," " Photo-sculpture," " Plaster Casts from Photo Reliefs," " Woodburytype," etc.)

RELIEVO

A type of photograph invented in 1857 by Thos. C. Lawrence, of Greenwich. The sitter, in monochrome, or slightly tinted, stands out in a kind of stereoscopic effect against a coloured hand-painted background. A wet collodion plate is made in the usual way, and when dry the whole of the photographic background is scraped away. A suitable landscape or other background is then painted in by hand on white card, which is bound up not quite in contact with the photograph proper and then suitably framed.

REMBRANDT EFFECTS

So named after the painter Rembrandt, who lighted his portraits in a characteristic manner. Almost any shadow portrait is now said to be in the Rembrandt style. The sitter is so arranged that the chief light comes from behind, rendering most of the picture in shadow, which, however, must not be so intense as to lose all detail. In ordinary rooms this lighting is fairly easy to obtain by placing the sitter between the camera and the window, but not in the same direct line ; the window should be at the side and behind the sitter, so that it is out of the field of view of the lens. A reflector is often needed to show up details in the shadows. By far the best effects are obtainable in the studio, by screening off all front light ; especially must care be taken to shade the lens so that no direct light enters it, as otherwise fogging of the picture will ensue. This style of lighting is very favourable for photographs of ladies having an extra fullness of the chin and neck, as owing to the face being mostly in shadow such fullness is not so noticeable.

REMBRANDT PROCESS

An adaptation of the photogravure process to rotary mechanical printing, invented by Karl Klic, and worked in England since about 1895 by a Lancaster firm. The details of their method have been kept secret, but it is assumed that a print on carbon tissue is made under a transparency in the usual way, except that, either before or after the print of a picture is made, the tissue is exposed under a negative line screen—that is, a screen with transparent lines, instead of the network of black lines used in the half-tone process. The printed tissue is squeegeed on to a copper cylinder, and there developed with hot water as in the carbon process. After being dried, the image is etched through by means of ferric perchloride, as in the ordinary photogravure process, the cylinder being rotated in the bath, and solutions of different strengths being used. On the resist being cleaned off, the copper cylinder is seen to have on it an intaglio etching which varies in depth, being deepest in the shadows. The image is cut up by thin lines formed by the screen, and the square spaces between the lines serve to hold the ink better than would the grain of the ordinary photogravure plate. The cylinder is mounted in a machine similar to that used by wall-paper or calico printers. Above the copper printing cylinder is the impression cylinder, covered with an endless blanket, and below the printing cylinder is an inking roller running in a trough of thin ink. A steel knife-edge presses against the printing cylinder and wipes off the ink from the surface, whilst leaving the ink in the hollows of the engraving. Paper in a long band is drawn from a reel through the machine, passing between the printing and impression cylinders, and thereby being printed. After leaving the machine, the paper is led off to a drying-room, where it is suspended in festoons, or it is rewound on another reel, or it may pass straightway into a cutting machine.

Recently the process has been developed into colour printing under the name of mezzochrome, and some very fine results have been produced. Whether the foregoing correctly describes the Rembrandt process or not, it is known that several other firms have imitated the results in this way, notably Bruckmann in Munich, Löwy in Vienna, and Saalburg in America. The process is also known under the name of mezzotintogravure, altogravure, Similiheliogravure, and Vandyck-gravure.

REPAIRING APPARATUS

Owing to a fall, or similar accident, cameras and other apparatus sometimes call for repair. If the damage is serious, it is best to send the apparatus to the manufacturer, or to a photographic dealer who undertakes repairs ; but there are many trifling injuries within the power of the amateur worker to rectify. The most useful tools are a sharp penknife, a fretsaw, and a small, thin screwdriver, together with some good quality glue. When portions of woodwork come asunder a little thin hot glue is usually all that is necessary, applied very sparingly, and left until thoroughly set. Lost screws, if small, can generally be matched at any ironmonger's, but milled-head screws and special

brass fittings need to be ordered of a photographic dealer. Pieces of woodwork chipped off can frequently be matched by cigar-box wood, cut carefully to shape, glass-papered, and glued on, treating the part, when the glue has set, with a little water-colour paint to match the tone of the camera, and then rubbing on a trace of ordinary negative varnish with a rag, or a little French polish if handy. Ground glass can be purchased cut to size to replace a broken focusing screen.

REPEATING BACK (Fr., *Chariot multiplicateur ;* Ger., *Multiplikator*)

An arrangement enabling two, or a larger number, of photographs to be obtained on the same plate. It is made in many different patterns, some of them being extremely ingenious. The illustration shows a simple type, for obtaining two cartes-de-visite on a half-plate. A is a

Repeating Back

panel attached to the back of the camera, having an aperture the size of the required picture, and furnished with grooved rails B and C for the dark-slide or the focusing screen. At D is a spring bolt, engaging in either of two slots in the edge of the dark-slide, these being so placed as to bring either half of the plate alternately into position against the opening in the panel. The photographs are, of course, taken separately.

REPTILES, PHOTOGRAPHY OF

The most useful camera for photographing reptiles is a reflex, fitted with as silent a release as possible, and a lens of fairly long focus. Snakes and lizards, toads, frogs, and tortoises are all more or less shy creatures, easily alarmed (the first-named are easily angered), so that some amount of caution and patience is necessary. When startled, a snake generally retreats, but should it find escape difficult or impossible, it may turn and strike at its pursuer ; and this is more particularly the case with poisonous snakes. Therefore a long focus lens which will enable one to obtain a fair-sized image on the photographic plate, without approaching too close, will be found an advantage in many ways.

The wall and sand lizards at their play, or capturing the insects upon which they feed, make most charming and interesting subjects for photography, but on account of their extremely rapid movements and shyness, present many difficulties. Tortoises are particularly exasperating models at times, either shutting themselves up tightly in their shells or marching off in such a hurry that it is impossible to get a satisfactory pose. The best chances of success are when the tortoise first awakens in the morning, before the sun has had time to warm

him thoroughly ; when he is busy feeding ; or in the afternoon when he is about to go to sleep.

Frogs are best photographed in an aquarium with rocks placed on the bottom so that they can sit with their head and shoulders out of the water—a very favourite position in their natural state. In the spring of the year they may often be photographed sitting on the banks of shallow ponds and ditches. A few weeks later in the season they will not be so easily found, while masses of their spawn will be seen floating in the shallow water. The life history of the tadpole can be easily watched and photographed by placing some of the spawn in an aquarium, and keeping it in a cool place.

Toads are not nearly so difficult to handle or photograph as are the frogs. They are much bolder, and soon become quite tame if regularly supplied with worms, caterpillars, or mealworms. The toad has very considerable character, and therefore always makes an interesting model.

Orthochromatic plates should always be used for photographing reptiles, and as full an exposure as possible given, so that a negative with a long scale of gradation may be obtained. It is rarely necessary to use a compensating filter, except in such cases as the chameleon, when the gradual changes of colour and re-arrangement of spots and bands of colour may be brought into greater contrast by the use of a suitable screen. F. M-D.

RESIDUES (Fr., *Résidus ;* Ger., *Rückstände*)

The collection of residues, from the amateur's point of view, is hardly worth the trouble unless he uses a very large quantity of material, though probably about 60 to 70 per cent. of the total sensitive salts are not used in the formation of the actual images. Residues may be divided into four kinds : (1) emulsion residues, (2) fixing bath residues, (3) gold residues, and (4) platinum residues.

(1) *Emulsion residues.*—The general method of collecting spoilt emulsions, etc., is to mix them with plenty of water acidulated with impure nitric or hydrochloric acid, and boil till the setting property of the gelatine is destroyed. The sensitive salts settle to the bottom of the vessel in time, allowing of the decanting or syphoning off of the supernatant fluid ; then the silver salts are collected and dried.

(2) *Fixing bath residues.*—The fixing baths both from negative and positive work should be saved and mixed together, and when a sufficient quantity is obtained they may be mixed with a saturated solution of liver of sulphur, which precipitates the silver as sulphide. This process should be done outdoors, as sulphuretted hydrogen is evolved, which is not only evil-smelling but is detrimental to any sensitive surfaces. A better method is to add zinc filings or magnesium powder, which decompose the silver hyposulphites with the precipitation of metallic silver.

(3) *Gold residues.*—Spent toning and combined toning and fixing baths should be acidulated with hydrochloric acid, and then an acidulated saturated solution of ferrous sulphate added till a precipitate is no longer caused.

(4) *Platinum residues.*—The developer **and**

first washing water of platinotype should be collected and preferably boiled down to a smaller bulk, a saturated solution of ferrous oxalate added, afterwards boiling.

The various precipitates may be collected and all the silver ones mixed, but the gold and platinum should be kept separate, and they can then be sent to the refiners, who will allow the market value of the metals less a small percentage for smelting.

Paper clippings of all kinds should be burnt and the ashes added to the general residues.

Silver is obtained from the residues by fusing with borax, charcoal, etc.

RESIN DRY PROCESS (Fr., *Procédé résine ;* Ger., *Harz Prozess*)

An early dry collodion process, due to the Abbé Pujo, in which resin was used as a preservative. In each ounce of bromo-iodised collodion half a grain of ordinary resin was dissolved. The plate was then coated, sensitised, and washed, being ready for use when dry.

RESINISED PAPER (Fr., *Papier résiné ;* Ger., *Harzemulsionspapier*)

The use of resin for photographic paper was first suggested in 1863, and the method adopted was to make an alcoholic solution of resins with a chloride and brush this over the paper or immerse the latter in the solution, dry, and sensitise subsequently by floating on a solution of silver nitrate. Three years later an aqueous solution of shellac in borax or sodium phosphate was used. Later still, Cooper suggested the emulsification of bleached shellac in gelatine. In 1891, Valenta suggested the following method of working, which gives excellent matt surface prints :—

Hard gelatine . . 350 grs. 80 g.

Soak in water for half an hour and drain well.

Pale French resin . 350 grs. 80 g.
Liquor ammoniæ . q.s. q.s.
Distilled water . 10 oz. 1,000 ccs.

Powder the resin, rub up with the ammonia and a little water, add the rest of the water, boil, and add ammonia from time to time till a clear solution is obtained. Add the gelatine, stir till dissolved, and add—

Ammonium chloride . 88 grs. 20 g.

and filter. Finally add enough saturated solution of citric acid to give a strong acid reaction. The acid precipitates the resin as an impalpable powder, which is suspended in the gelatine. The paper should be brushed over with the solution and then floated on the surface for three minutes and dried, and then sensitised in the usual way by floating.

A variant was suggested by E. J. Wall, and consisted in the use of an ammoniacal alcoholic solution of resin, which was added to an ordinary gelatino-chloride print-out emulsion. These papers are particularly suitable for platinum toning, and give fine black tones.

RESINS (*See* " Gums and Resins.")

RESORCIN (Fr., *Résorcine ;* Ger., *Resorcin*)

Synonyms, resorcinol, metadihydroxybenzene. $C_6H_4(OH)_2$. Molecular weight, 110. Solu-

bilities, 1 in ·6 water, 1 in ·5 alcohol, soluble in ether. It is in the form of white prismatic crystals obtained by the action of caustic soda on sodium dibenzene sulphonate. It has the same formula as hydroquinone, but the hydroxyl groups $(OH)_2$ are attached at different points to the benzene ring, and it has no developing power. It has been used as an addition to emulsions without excess of silver nitrate to obtain vigour in printed-out images.

RESORCINPHTHALEÏN

A synonym for fluorescein.

RESTORING NEGATIVES (*See* " Broken Negatives," " Cracked Negatives," " Cracks in Varnish," " Scratches on Negatives," etc.)

RESTORING PHOTOGRAPHS (*See* " Faded Negatives and Prints, Restoring.")

RESTRAINER (Fr., *Modérateur ;* Ger., *Zurück halter*)

Any compound which will check the too energetic action of a developer. The most popular restrainer for alkaline developers is a soluble bromide, which works well with the caustic alkalis, and in some cases with the carbonates. When the alkali is ammonia, ammonium bromide may be used ; otherwise, potassium bromide may be employed. Bromide has more effect in restraining the least exposed portions of a negative—that is, the shadows—than on the better lighted portions, and as a result it gives greater contrast and brilliancy. In cases of overexposure, where normally a flat and lifeless negative would be the result, this property of bromide is turned to account, the addition of a very few drops of a 10 per cent. solution to the developer often sufficing to save an underexposed plate. The generally accepted theory is that the bromide forms a double compound with the silver salt in the film, and that this double compound is less readily acted upon by the developer. With stale plates, a restrainer is absolutely necessary, as the silver salts in the film seem to undergo a certain amount of decomposition, and reduction (development) takes place where the light has not acted. Bromide is also necessary with bromide and gaslight papers, as it serves to keep the white parts of the print clear while the image is being developed to its proper density.

Some authorities recommend the omission of a restrainer from the developer entirely, while others advise its use with extreme caution. Watkins, for example, says that the use of a restrainer, such as potassium bromide, is a legacy left from the early days of pyro development, that its use introduces complication and variation from the usual simple course of development, without sufficient compensation, and that with a good modern dry plate and sodium carbonate as the alkali, the restrainer is best omitted from the normal developer and used only exceptionally to " hold back " the lowest tones or fog. Watkins illustrates this " holding-back " power with two diagrams, A and B, the former representing four steps of gradation, A, B, C, and D, produced by, say, five minutes'

development without bromide. B gives an idea of the result of the same exposure if the same developer, with a little bromide added, is used for the same length of time. The steepness of gradation (and therefore the contrast in the print) is identical in the two cases; but the bromide has retarded all the tones and prevented the lowest one, A, from appearing at all. It has, in fact, at this stage reduced the speed of the plate. If development with bromide were continued, the tone A would develop out, and in due time take exactly the same place as if no bromide were used. To utilise the restraining power of a bromide, therefore, development must be terminated while the holding-back power is still in force. Watkins also points out that with high factor developers the lower tones come out so early in development, they rush up, so to speak, that the holding-back power of bromide is exhausted before a useful degree of contrast is attained, and bromide is of very little

"Holding Back" Power of Restrainer

use with this class. But if a low factor developer is used, the tones naturally come out very late in development, and the bromide decidedly alters results. It is with a low factor developer and plenty of bromide that gross over-exposure can be made to give good negatives. But when once the tones have appeared it is quite useless to add a bromide with the idea of holding back fog or the lower tones. With high factor numbers, bromide has practically little result, except to make development slower.

The only restrainers that are of any service when development has once started are the citrates (which see); they stop the shadows and allow the high lights to go on developing.

The usual dose of potassium bromide is 5 drops per ounce of mixed developer; and, of course, the ammonium and sodium bromides may be used in a like manner. Potassium bromide is bulk for bulk the weakest restrainer; ammonium bromide the strongest; and sodium bromide the medium, the most suitable proportions being potassium 120, sodium 103, and ammonium 98.

RETARDATION

A restraining of development by the addition of a restrainer.

RETARDER

A synonym for restrainer. The addition of plain water and the chilling of the developer are the simplest retarders.

RETICULATION

Peculiar wavy markings in relief which are common to colloids; they sometimes appear on gelatine negatives. In some photo-mechanical processes reticulation is purposely brought about, but it often occurs when not wanted and

ruins the negative, there being no known cure for it. It appears mostly during intensification with mercury, and is thought to be due to the use of a too strong mercury solution which tans the film; this, when placed in ammonia for blackening, breaks up into pinholes or forms ridges.

In process work, the reticulation of the gelatine film is the basis of several photo-mechanical processes—namely, Poitevin's photo-lithographic process, the Pretsch process, the collotype process, Dallas process, papyrotint, and numerous others. It is believed that the reticulation of the film is due to unequal contraction, due to the various parts being variably acted upon by light according to the depth of the tones of the picture. It has been noticed that on the collotype plate the grain or reticulation occurs just at the last moments of drying. Reticulation is also promoted by the addition of chemical substances, usually of an astringent nature, to the film, and in this case the reticulation is probably due to a tanning action influenced by the action of light.

RETOUCHER, AUTOMATIC

A retouching pencil or holder in which the lead is made to move rapidly up and down by an electric current, so that a fine stipple is obtained on portrait negatives in a shorter time than if applied by hand alone. The guidance of a skilled retoucher is, however, still necessary; the automatic pencil merely facilitates work— it does not supply the place of artistic discrimination.

RETOUCHING

The working up of negatives and prints by hand. In this article only the retouching of negatives will be considered. For prints, *see* "Working-up Prints."

It is rarely desirable to retouch a landscape negative, but portrait negatives are commonly retouched by professional workers. The easiest way of improving portrait negatives in a small degree is to coat the glass side with matt varnish, and then, when dry, work on it lightly with a lead pencil or a stump and powdered blacklead. The parts covered with lead pencil print lighter. This work is, however, not true retouching, and will serve only for remedying broad patches in the negative.

For retouching proper, a retouching desk, pencils, and a bottle of medium will be required. Retouching desks (*see* A) may be bought ready made, or may easily be converted from an ordinary box, as shown at B. A hole, P, is cut with a rebate in the lid to hold the negative, and the lid fixed at a convenient working angle by means of narrow strips of wood, Q, at each side. An extra piece of wood, R, is fixed to the top in order to shield the light from the surface of the negative. All the light must come through the negative, and it is advisable to place white paper in the bottom of the box.

The worker should experiment with three retouching pencils—hard, medium, and soft; and they should have a point literally as sharp as a needle, to obtain which very fine glass-paper or emery cloth is used. Place a piece flat on a table, take the pencil between the thumb and fingers, and carefully roll the point round and round on

the rough surface until the lead tapers to a fine point. Retouching medium may be bought, or it may be made according to one of the following formulæ : No. 1.—Turpentine, 2 oz. ; powdered resin, 60 grs. No. 2.—Sandarach, 80 grs.; alcohol,

A. Retouching Desk
of Modern Design

B. Home-made Re-
touching Desk

1 oz. ; castor oil, 1½ oz. ; venice turpentine, 40 drops.

The majority of beginners have an erroneous idea of retouching, hence their failures. The secret is not to attempt too much at first, but to be satisfied if even only one freckle or wrinkle has been removed. Now the general idea is that the whole of the negative—or, rather, the face—is worked on by the retoucher with his pencil, which is wrong. Only the blemishes require to be worked on, so as to bring such clear spots up to the density of the surrounding parts ; diagrams C and D explain this. C represents in a highly magnified form a spot or freckle on a negative which is to be worked out, the blemish appearing as a clear spot in an almost opaque part of the negative. If the pencil is worked, and the lead is put on in even quantities all over the face, the opaque surroundings would be even more dense, and the spot would contain only as much lead as the dense parts ; therefore the spot would still show, say, as in D. The correct thing

The Retoucher's Various Strokes and Touches

to do is to leave the surrounding parts alone for the time being, and to work the pencil only on the blemishes, putting sufficient lead in them to bring them up to the required density. The result, if carefully and properly done, would then be as shown at E, that is, a perfectly even surface.
It is advisable to take a rough print of the

negative to be retouched on glossy paper, which will show up the defects and serve as a guide to the work. Dust the negative, put a drop of retouching medium on the film side, and then, with the finger-tip, rub the drop of medium in a circular motion over the whole of the face to be retouched ; continue rubbing gently until the surface feels " tacky," and put the negative on one side to dry. Place the negative film side upwards over the hole in the retouching desk, so that a good light comes through it, and, having sharpened the pencil, begin filling up the clear holes, taking particular care that the lead does not go on the outside of the hole, or the result will be as at F. The particular " stroke " or movement of the pencil needs consideration. The four most used strokes are shown, G to J ; G is known as the scribbling touch, and is most useful for softening up and bringing together high lights and shadows, such as the lines under the eyes and down the nose ; H is a " comma " touch suitable for large freckles and blemishes ; I is the " cross hatch " used for filling up comparatively large spaces ; and the " dot " J is the most useful touch of all for filling up freckles.

Begin, then, by dotting the smaller freckles and continually take rough prints to note the progress of the work. Be particularly careful not to do too much or to lay on the lead too thickly, or the working will show. When the freckles and other blemishes are dotted out, smooth the rough skin, soften the wrinkles and places where shadows meet the high lights with the scribbling touch G. This is all a beginner should attempt for some time, and even this requires considerable practice and care to do properly. Work done roughly and unsuitably can easily be rubbed off with a clean rag wetted with the retouching medium, and a fresh start made.

Negatives are also retouched with the knife. (See " Knife, Retouching.")

RETOUCHING, CHEMICAL (Fr., *Retouche chimique ;* Ger., *Chemische Retouchier*)

Modifying or removing portions of a photograph, usually in the negative, by means of chemical solutions applied with a brush. Thus in developing, any details that come up too rapidly may be kept back by draining the negative and painting the parts with a 5 per cent. solution of potassium bromide, afterwards returning the plate to the dish and completing the development. To reduce harsh lights or dense portions, or to introduce clouds or shadows in a finished negative, a solution of ammonium persulphate (10 to 20 grs. to 1 oz. of water) may be employed, placing the negative after reduction in a 5 per cent. solution of sodium sulphite for a few minutes before washing. An alternative is to use Farmer's ferricyanide and hypo reducer (*see* " Reducing Negatives, etc."). To obtain a local increase of density, to insert high lights, to strengthen thin portions, etc., a solution of mercuric chloride or other intensifier may be used. The negative, after washing, is pressed with blotting-paper to remove the excess of moisture, and is supported on a retouching desk, as nearly horizontal as possible ; the solutions, which should not be too strong, are applied quickly with a brush, and the negative washed directly the desired result is obtained.

Negatives are also improved by the use of dyes, etc. Stain matt varnish with aniline dye, red, green, or yellow being suitable. Flow the varnish over the glass side of the negative. Place the negative in a frame film (not varnish) side outwards, and expose to strong sunlight for some days or until the dye has partially faded, when the negative will give brighter and better prints. This is really a dye process of intensification. The light going through the outward film to the dye beneath naturally causes it to fade, the amount of fading being governed by the density of the image.

REVERSAL, OR SOLARISATION (Fr. and Ger., *Solarisation*)

A phenomenon occurring as the result of extreme over-exposure, a positive instead of a negative image being produced on development. Abney has stated that preliminary exposure to diffused daylight, the use of a powerful developer, and the treatment of the plate with a solution of an oxidising agent before exposure, facilitate reversal; and, in his opinion, it can only be produced when there is atmospheric oxidation. The addition of thiocarbamide to a well-restrained developer will produce reversal, especially if hydroquinone or eikonogen is used.

REVERSED NEGATIVE (*See* "Negative, Reversed.")

REVERSING BACK

An adjustment whereby the back of the camera may be turned, in order to obtain either upright or horizontal pictures. Before the introduction of the reversing back the only way of doing this was to turn the whole apparatus on its side. The usual form of reversing back consists of a square wooden frame rebated on the inner side to fit closely in the camera, and having on the outer side suitable grooves to take the focusing screen or dark-slide. The corners of the frame are slightly recessed, two of them fitting under brass plates on the camera, while the other two are secured by turn catches. To reverse the back, the catches are unfastened, the frame lifted out, turned half-way round and re-inserted, being then re-fastened as before. An improved form, the revolving back (*which see*), does not need to be removed from the camera.

REVOLVER (*See* "Gun and Revolver Cameras.")

REVOLVING BACK (Fr., *Cadre de verre dépoli rotatif*; Ger., *Rotations Visirscheibe*)

An arrangement whereby the focusing screen or dark-slide may be changed from a vertical to a horizontal position, or vice versa, without removal from the camera. The frame carrying the rails or grooves to take the focusing screen or slide is attached to a circular turntable let into the camera back, and having ball catches to check it at the two positions. With such a movement it is possible to change from one position to another with scarcely a second's delay, even with the plate inserted and the shutter of the slide drawn. The one disadvantage of the revolving back is that the camera needs to be slightly larger.

RHODIUM TONING

A method of toning with salts of rhodium (a rare metal resembling palladium and, in a less degree, platinum), was advocated about 1890, in America, but it did not come into general use. A formula is :—

Rhodium and sodium			
chloride . . .	22 grs.	5 g.	
Acetic acid . .	96 mins.	20 ccs	
Water (distilled) .	10 oz.	1,000 ,,	

The metallic silver of the prints slowly takes a yellowish-red colour which deepens in the fixing bath.

RIPENING

Photographic sensitive emulsions undergo a process known as ripening, as explained under the heading "Emulsion."

The term is also sometimes applied to toning baths; an acetate and gold toning bath, for example, is ripened by allowing it to stand for twenty-four hours or more before use, while the alum-"hypo" toning bath for bromides is ripened by adding a few pieces of torn waste silver prints.

RISING FRONT (Fr., *Décentrement vertical*; Ger., *Verschiebbares Objektivbrett*)

An adjustment enabling the lens to be raised or lowered with respect to the plate, in order to include more of the subject at the top or bottom of the picture. It usually consists of a panel carrying the lens and moving freely between two grooved upright posts. The sides of the posts are generally slotted, so that milled-head screws inserted in the panel may move up or down with it, and enable it to be clamped at any desired height. The rising front is, however, made in various forms, some modern high-grade cameras having even the luxury of a rack and pinion movement to the front. Frequently, the lens panel is separate from the front, upon which it slides in horizontal grooves, thus giving a "cross" adjustment as well as a rise and fall. The whole front is often made also to swing. (*See* "Swing Front.") A rising front is almost indispensable for practical work, but in using it care must be taken that the lens is not raised too far, otherwise the upper portion of the negative will be badly lit, or perhaps will show blank corners.

RIVES AND SAXE PAPERS

Specially pure raw papers, free from imperfections such as metallic particles, used for coating with sensitive emulsions. Both of them are Continental productions. Rives paper had its origin at Rives, France, and is thin and tough. Saxe paper had its origin at Saxe, Germany, and is thicker and heavier; sometimes it is referred to as "Steinbach" paper.

ROBINSON, HENRY PEACH

Born at Ludlow, 1830; died at Tunbridge Wells, 1901. He exhibited at the Royal Academy when twenty-one. He began business as a professional photographer at Leamington, in 1857, and later (1868) built a studio at Tunbridge Wells, where he practised until his retirement in 1888. He produced many "combination"

pictures, of which "Fading Away" (1858) and "Dawn and Sunset" (1885) were among the best known. The latter is reproduced as a plate to this work, and was awarded a medal by the (now) Royal Photographic Society. Three separate negatives were used, and the original measures 30 × 21 in. His most ambitious effort was "Bringing Home the May" (1863). He was Vice-President of the Photographic Society of Great Britain (now the Royal Photographic Society) in 1887 ; President of the Photographic Convention of the United Kingdom (Leeds Meeting), 1896. He was a writer on the art and business sides of photography, his best-known works being "Pictorial Effect in Photography" (1869), "Picture Making by Photography" (1884), "The Studio and What to Do in It," and "Letters on Landscape Photography."

The developer sometimes referred to as the Robinson pyro - ammonia developer is as follows :—

A. Pyrogallic acid . 1 oz. 144 g.
 Citric acid . . 40 grs. 12 ,,
 Water . . . 7½ oz. 1,000 ccs.
B. Potassium bromide . 120 grs. 36 g.
 Liquor ammoniæ ('880) 1 oz. 143 ccs.
 Water . . . 7 ,, 1,000 ,,

Take 3 oz. of water and add 1 dram each of A and B.

ROCHELLE SALTS (*See* "Potassium and Sodium Tartrate.")

ROCK AMMONIA (*See* "Ammonium Carbonate.")

ROCK CRYSTAL

A synonym for quartz.

ROCK SALT

An impure variety of common salt, which, chemically, is sodium chloride.

ROCKER

An appliance for automatically rocking the developing dish, so that the operator may leave the plate in it while attending to other matters. A simple form consists of a pivoted platform below which a weighted pendulum is attached. If set swinging by an, occasional touch, this keeps in motion for some time. Many clockwork rocking devices have been invented.

ROCKING DISHES

Dishes containing photographic solutions require occasional rocking, otherwise the plate or prints may not be properly covered and the action of the solution is likely to be uneven, while air-bubbles and sediment have also a chance to settle in one place. But continual or excessive rocking is not necessary, and tends to cause frilling.

RODINAL

A one-solution developer consisting of a concentrated solution of para-amido-phenol ($C_6H_4OHNH_2$), introduced by Andresen ; it needs only the addition of water to make a working solution. Formerly it was obtainable in powder form, under the name of "unal."

The following is one of the formulæ given by the *Chemische Zeitung* for making rodinal :—

Potass. metabisulphite or sodium
 sulphite 3 parts
Para-amido-phenol chlorohydrate 1 part
Sodium hydrate (sat. sol.) . q.s.
Hot distilled water . . 10 parts

When the first two are dissolved in the water, a saturated solution of sodium hydrate (caustic soda) is added very gradually until the precipitate first formed is dissolved and the solution quite clear. Few photographers attempt to make it, however, as the commercial article is so cheap and good. It keeps well, darkening in colour with age. When diluted with water, however, it assumes a reddish tinge and gradually loses its developing powers, but if diluted with a 5 to 10 per cent. solution of pure sodium sulphite instead of water it will keep quite well. For normal exposures, use rodinal 1 part and water 20 parts. In cases of over-exposure, use less water, and add a few drops of a 10 per cent. solution of potassium bromide. In cases of under-exposure use from 30 to 40 parts of water. The more dilute the rodinal the softer will be the negative, and vice versa. When the extent of the exposure is not known, it is well to begin development with a 1 in 30 solution, and then, if necessary, to correct over-exposure by adding, drop by drop, a solution composed of 3 parts each of rodinal and water and 1 part of potassium bromide. The solution should be added to the developer in a measuring glass, and not direct into the developing dish. It is better, in a case of known over-exposure, to add the bromide to the developer before it is applied to the plate.

Many fail to get density with rodinal simply because they do not develop long enough. The image appears very quickly, and there is a temptation to remove at once the negative from the developer instead of giving time for density to be attained. Negatives developed with rodinal appear to lose much of their density during fixing.

For bromide and gaslight papers rodinal should be used in the proportion of 1 part to 20 to 30 parts of water, adding 2 drops of a 10 per cent. solution of potassium bromide to each ounce of developer. The tone or colour of the print varies according to the exposure and strength of the developer, strong solutions giving blue-black and weak solutions grey ; with too little bromide the high lights may not be clear, while with too much bromide there will be greenish blacks. These remarks apply also to lantern plates. For stand development the strength usually employed is 1 part of rodinal to 100 to 200 parts of water. Rodinal may be mixed with other developers, as explained under the heading "Developers, Mixed or Combined."

ROLL FILMS (*See* "Cartridge Film" and "Film Manipulation.")

ROLLER BURNISHER (*See* "Burnisher.")

ROLLER SLIDE (Fr., *Chassis à rouleaux* ; Ger., *Roll-cassette*)

A dark-slide specially designed for use with roll films. First suggested by Relaudin, in

1855, roller slides were constructed by Melhuish in 1856, Burnett in 1857, Audineau in 1862, and Warnerke in 1875. These were all for use with negative paper. It was, however, the Eastman Company in 1885 who rendered this form of slide really popular by the introduction of their roll-holder, which also was at first used with paper films. It consists of a box made to slide into the dark-slide grooves of the camera back, and having a draw shutter in front. Two rollers or spools are contained in the box, one holding the unexposed film, and the other furnished with an external winding key by means of which the film is wound off as exposed. Suitable means are adopted to keep the film taut and to indicate how far it is to be wound for each exposure. The spools are interchangeable.

ROLLER SQUEEGEE (See "Squeegee.")

ROLL-HOLDER (See "Roller Slide.")

ROLLING PRESS (Fr., *Presse à satiner à froid*; Ger., *Satinirmaschine*)

A machine for flattening and giving a glossy surface to mounted prints. It consists of a large flat steel plate moving under a single polished roller, or with the roller moving over the plate. The term is also applied to a machine having two rollers, one of which is nickelled.

ROLLING PRINTS

The passing of mounted prints through rollers, or between a roller and a steel plate, for the purpose of improving their appearance and making them lie flat. The process is often confused with that of burnishing, but is much more simple.

ROLLING-UP

The passing of an ink-charged roller over a lithographic stone for the purpose of strengthening the image. (*See also* "Photo-lithography.")

RÖNTGEN RAYS (See "X-ray Photography.")

ROSE BENGAL

Formula, potassium tetra-iodo-chloro-fluorescin, one of the eosine group, and formerly used considerably for sensitising gelatine dry plates and collodion emulsion for yellow and green. It has been used alone, and also in combination with eosine. Soluble in water and alcohol. Von Hübl gives the absorption of rose Bengal as approximately 542 μ (middle) from 563 μ (maximum). This writer recommends, for the negative for the red print, adding to 100 ccs. of collodion emulsion 2 ccs. of the following dye mixture, and bathing the plate before exposure in $\frac{1}{2}$ per cent. silver nitrate solution :—

Eosine yellow (1 : 150)
 alcoholic sol. . 90 mins. 30 ccs.
Rose Bengal (1 : 150)
 alcoholic sol. . 30 ,, 10 ,,

A 1 in 500 solution of picric acid in water is used as a filter in a tank $\frac{1}{6}$ in. (5 mm.) thick, or a gelatine plate coloured with naphthol yellow G.

ROTARY SCREEN

For the three-colour half-tone process the ruled screen is preferably of circular form and mounted in a rotating carrier, so that the ruling may be turned to a suitable angle for each colour. If the angles are not properly chosen the superimposing of the colours will cause a moiré pattern on the resulting print. The Levy rotary

Rotary Screen Carrier

screen, here illustrated, provides means of altering the angle with precision.

ROTARY SHUTTER (Fr., *Obturateur rotatif*; Ger., *Dreh-verschluss*)

A shutter in which a circular disc with an aperture towards the side is caused to revolve across the lens by a coiled spring or similar means, the opening exposing the plate as it passes.

ROTATING BACK (See "Revolving Back.")

ROTATING STOPS (See "Diaphragms.")

ROTUNDITY

A quality usually associated with the images produced by lenses of large diameter and aperture which are believed by many practical portraitists to give an impression of plasticity and relief, almost approaching a stereoscopic effect.

ROTTENSTONE

A Derbyshire mineral, reduced to a fine powder and used for polishing metals. It was used for polishing daguerreotype plates.

ROUGE (Fr., *Rouge*; Ger., *Rot*)

Red oxide of iron, used for polishing metals and glass, including lenses. Process workers use the very finest jewellers' rouge for polishing the surface-silvered optical plane mirrors. The rouge should be thoroughly sifted, warmed, and broken up before applying.

ROUGHENING PRINTS

The roughening of prints to give them a matt surface is now rarely resorted to. The simplest method is to rub the surfaces gently with an abrading powder, such as finely powdered and sifted pumice stone or cuttle-fish bone. Another method is to squeeze the wet and glazed print down upon very finely ground glass or matt-surface celluloid, the surfaces of the medium selected and the prints themselves being treated in precisely the same way as for glazing. (*See* "Glossy Surfaces on Prints.")

ROUILLÉ-LADEVÈZE PRINTING

A pigment process for the production of permanent photographs, invented by Rouillé-Ladevèze, of Paris. Prepare two solutions : (A) 200 grs. of pure gum arabic in 1 oz. of water ; (B) 30 grs. of ammonium bichromate in 1 oz.

of water. Mix together, filter through flannel, and add, say, 300 grs. of tube water-colour, the actual quantity depending upon the strength and quality of the colour. The paper is brushed over with the mixture in a weak yellow light, dried in the dark, printed under a negative (average time, 30 minutes), and developed by washing in water at about 80° F. (27° C.), which removes the gum not insolubilised by the action of light. The print is fixed on a sheet of glass by wooden clips, immersed in water, and moved to and fro until the image appears. Finally it is dried.

ROUNDNESS

That quality in a print, and strongly desirable in portraiture, which suggests proper modelling and relief. The chief means to this end are suitable lighting and the use of a large aperture.

ROUTING

In process work, a routing machine (first introduced by Royle) is used for the purpose of removing from the blocks the large spaces which are to print white. This can be done by etching, but is more quickly and efficiently done by the routing machine. There are two forms of these machines : one in which the cutter is stationary while the bed carrying the plate is moved, and the other in which the plate is fixed to the bed of the machine, whilst the cutter is mounted on an arm which can be moved radially with a kind of pantograph motion over any part of the plate. The cutters resemble fluted drills, and by moving the arm a channel the width of the cutter is made in any direction.

ROYAL PHOTOGRAPHIC SOCIETY

The premier photographic society, founded in 1853, under the title of " The Photographic Society of London," which, in 1874, was changed to " The Photographic Society of Great Britain," and in 1894 was further modified by Queen Victoria's commands to " The Royal Photographic Society of Great Britain." The objects for which the Society was established may be summarised in the phrase " the advancement of photography." Meetings for lectures, demonstrations, etc., are held at regular and frequent intervals, and the members have the use of a studio, dark-rooms, library, etc. A monthly *Journal* is published and exhibitions are held. Its first President was Sir Charles Eastlake, P.R.A. (1853 to 1855). The Society awards a " Progress " medal nearly every year in recognition of any important invention, research, or publication, the first to receive it being Captain W. de W. Abney (1878) for his scientific work in the advance of photography. The Fellowship (F.R.P.S.) is open only to those members who are able to satisfy the Council that they have ability in one or other of the many branches of photography ; elections to the Fellowship take place twice a year. Photographic societies may, by the payment of one guinea per year, become affiliated with the Royal Photographic Society.

RUBBER SOLUTION (*See* " Indiarubber.")

RUBY GLASS

Glass " flashed " with ruby (red) colouring matter ; that is, the colouring does not go right through the glass, but the surface is coated with vitreous colouring matter. It is used as a screen or filter to stop the passage of actinic rays. The subject of " safe " light is gone into fully under the headings " Safe Light," " Bichromate Lamp," " Dark-room Illumination," etc.

RUBY LAMP (*See* " Dark-room Lamp.")

RUBY MEDIUM

A ruby or red fabric used in the place of ruby glass in the production of a " safe " light. Sunlight has a bleaching action upon it and pinholes are so easily caused that its use should be restricted to artificial light.

RUBY VARNISH

A varnish for application to windows, incandescent electric bulbs, etc., for dark-room use ; it is inferior to ruby glass. Mix equal parts of ordinary white hard varnish and methylated spirit, and to every pint add ¼ oz. each of chrysoidine and coralline rouge, two aniline dyes ; shake well, allow to stand for a day or two, and then, if all the dye is dissolved, add more. If the dye does not completely dissolve, use the clear solution.

RUSSIAN DEVELOPER

A developer of Russian origin, and introduced about 1889. It is said to give with dry plates negatives which cannot be distinguished from those yielded by wet plates. The formula is :

A.	Sodium sulphite	.	150 grs.	34 g.
	Pot. ferrocyanide	.	350 ,,	80 ,,
	Sodium carbonate	.	350 ,,	80 ,,
	Distilled water	.	3¾ oz.	375 ccs.
B.	Pyro	.	75 grs.	17 g.
	Ammonium chloride	.	75 ,,	17 ,,
	Distilled water	.	1½ oz.	150 ccs.
C.	Trimethylamine	.	5 mins.	1 g.
	Distilled water	.	95 ,,	22 ,,

To prepare the working developer, take of A, 300 mins. ; B, 40 mins. ; and C, 15 mins. More of C can be added if great density is desired.

RUSSIAN VIGNETTES (*See* " Black Vignettes.")

RUST SPOTS

Small black metallic spots which usually appear on gelatino-chloride papers (P.O.P.), and caused by particles of rust in the first washing water, the rust coming from water pipes, tanks, etc. They may be prevented by giving the prints (before toning) a bath of salt, soda and water :

Common salt	.	.	1 oz.	110 g.
Washing soda	.	.	½ ,,	55 ,,
Water	.	.	10 ,,	1,000 ccs.

Immerse the prints for five or ten minutes, wash, tone, and fix. This bath is not suitable when platinum is employed for toning.

RYTOL

A " tabloid " developer, supplied with an accelerator, also in tabloid form. For dry plates and bromide papers one of each of the tabloids— Rytol and accelerator—is dissolved in 4 oz. of water ; for gaslight papers and lantern slides (black tones) the water is reduced to 2½ oz.

30

S

SAFE EDGE

The opaque edging on negatives necessary for carbon printing.

SAFE LIGHT (Fr., *Eclairage inactinique ;* Ger., *Sicheres Licht für Dunkelzimmerbeleuchtung*)

A term applied to the light obtained with the use of coloured filters placed in front of the dark-room illuminant. The ordinary commercial coloured glass is rarely of any practical use, except for the manipulation of positive materials, and even for these specially made safe lights usually give greater safety combined with greater brilliancy. It is as well to divide them into the several classes—namely, for positive, ordinary, isochromatic and panchromatic plate work.

For positive work, such as lantern slide and bromide print making, the light may be of a bright orange or green colour, as these materials are not very sensitive.

Tartrazine or naphthol			
yellow	.	. 200 grs.	20 g.
Rose Bengal or eosine	.	10 ,,	1 ,,
Distilled water to .	.	20 oz.	1,000 ccs.
Gelatine	. .	. 800 grs.	80 g.

Soak the gelatine in the water till soft, melt in a water bath, add the dyes, and when thoroughly dissolved, filter and coat, allowing 20 mins. per sq. in., or 20 ccs. for 100 qcm. of surface.

For a green light, the eosine or rose Bengal in the above formula may be replaced by the same quantity of naphthol green. For isochromatic plates, one sheet should be coated with :

Tartrazine	.	. 200 grs.	20 g.
Rose Bengal, or fast red	.	100 ,,	10 ,,
Gelatine	. .	. 800 ,,	80 ,,
Distilled water to .		20 oz.	1,000 ccs.

and another glass with :

Methyl violet	.	. 100 grs.	10 g.
Gelatine	. .	. 800 ,,	80 ,,
Distilled water to .	.	20 oz.	1,000 ccs

This red screen transmits from the red to λ 5,900 in the yellow and the violet absorbs from λ 6,500 to λ 5,000, so that only the extreme red from λ 7,000 to λ 6,500 passes.

For red-sensitive and most commercial panchromatic plates use :

Naphthol green	.	. 115 grs.	12 g.
Filter blue (Hoechst 1 %			
solution)	.	. 460 mins.	48 ccs.
Gelatine (8 % solution) to	20 oz.	1,000 ,,	

For pinacyanol and dicyanine bathed plates, the quantity of dyes may be reduced by one-third in the above formula. The same quantity of dyed gelatine per area should be allowed as stated above.

For liquid filters, that is for solutions of dyes in 1-in. thick cells, the following may be used :

Naphthol yellow S (Bayer)	9 grs.	1 gr.
Violet dahlia B O (Bad-		
ische) . .	. 1·75 ,,	·18 ,,
Glycerine or water to	. 20 oz.	1,000 ccs.

This gives a deep red only beyond about λ 685 —λ 690.

A good green liquid filter is :

Acid green .	.	. 12 grs.	·25 g.
Naphthol green	.	. 12 ,,	·25 ,,
Tartrazine	.	. 144 ,,	2·00 ,,
Glycerine or water to	.	20 oz.	1,000 ccs.

In all cases, it is advisable to soften down the direct light by a sheet of ground glass or tissue paper. Although a light is called safe, it is so only in a relative sense, and, therefore, care should be taken to expose the plate to it as little as possible.

SAL-AMMONIAC (See "Ammonium Chloride.")

SAL-SODA (See " Sodium Carbonate.")

SALICYLIC ACID (Fr., *Acide salicylique ;* Ger., *Salicilsäure*)

Synonym, ortho-oxybenzoic acid. $C_6H_4(OH)$ COOH. Molecular weight, 138. Solubilities, 1 in 450 water, 1 in 2·4 alcohol, 1 in 2 ether. It is a light, fine, white crystalline powder, either obtained from oil of wintergreen or sweet birch, or by the action of caustic soda and carbonic acid on phenol. It is occasionally used as a preservative in emulsions and solutions.

SALMON AND GARNIER'S PROCESS

One of the early iron or powder printing processes, introduced about 1857, based on the fact that the ferrous or iron salt resulting from ferric citrate is more hygroscopic than citrate itself. Paper was coated with ferric citrate, exposed under a positive transparency, and covered with plumbago or other impalpable powder. The surface was breathed upon, the powder then adhering to the parts acted upon by light, while the surplus could be lightly brushed off. The unacted-upon citrate was then washed out, the picture in powder being left. A later improvement was the mixing of loaf sugar or sugar of milk with the citrate. The dichromates subsequently were found to answer better than the ferric salts. (See also " Dusting-on (Powder) Process.")

SALON, PHOTOGRAPHIC (See " Linked Ring.")

SALT (Fr., *Sel ;* Ger., *Salz*)

The common name for sodium chloride. There is a slight difference between the pure chloride and common salt, but the latter may be employed

in most cases when sodium chloride is named. A weak solution of salt is often used to remove or decompose the last traces of silver salts before the toning of prints, to prevent black metallic spots appearing on the pictures and, sometimes, blisters. It is perhaps the most widely used for self-toning papers, a preliminary bath of salt influencing the resultant tone considerably. Before the introduction of " hypo " a strong solution of salt was used for fixing. Salt acts more or less as a restrainer in a developer.

In process work, salt has its uses as described under the heading of " Dry Enamel Process " ; further, it is used as an etching mordant for aluminium, and for making red prints for the bleaching-out process.

SALTED PAPER (*See* " Plain (Salted) Paper Printing.")

SALTING (*See* " Sizing and Salting.")

SALTPETRE (*See* " Potassium Nitrate.")

SALTS, HALOID (*See* " Haloid.")

SAND BATH

Actually a bed of sand supported in an iron vessel upon which is placed a dish containing the material that is to be heated, it being frequently undesirable to expose the dish or its contents to the direct heat of a flame. A saucepan or deep frying-pan almost filled with silver sand and heated over a gas burner or open fire, makes a good sand bath. A sand bath is recommended as a support for evaporating basins when boiling down the silver bath in the wet collodion process. Its object is to prevent the naked flame impinging on the basins and to diffuse the heat more uniformly. A layer of sand is also recommended at the bottom of collotype ovens.

SANDARACH (*See* " Gums and Resins.")

SANDELL PLATES AND FILMS (*See* " Multiple-coated Plates" and "Cristoid Film.")

SANGER-SHEPHERD COLOUR PROCESS

A process of obtaining three-colour transparencies by printing on to celluloid coated with bichromated gelatine containing a little silver bromide, developing, staining, and superimposing the results, after removal of the silver salt by " hypo." A method of obtaining colour prints on paper has been introduced by the Sanger-Shepherd firm, in which a hard gelatine relief is stained up and the dye transferred to a soft, moist gelatine film.

SATIN, PHOTOGRAPHS ON (*See* "Fabrics, Printing on.")

SATURATED SOLUTION (Fr., *Solution à saturation ;* Ger., *Gesättigte Losungen*)

A solution of a salt in any vehicle of such a strength that it will not hold any more of the salt in solution. The great disadvantage of saturated solutions is that their strength varies with the temperature, most salts being more soluble in hot than in cold liquids. Their use

should be avoided as far as possible, and all solutions made up of a definite and standard strength.

SATURATOR

An appliance for carburetting oxygen with ether and so forming a combustible gas to be burnt in a special form of limelight jet. It is a dangerous and now almost obsolete appliance. (*See also* " Limelight.")

SATZ LENSES

A synonym for casket lenses, applied by Zeiss to the sets of single anastigmats which could be used alone or to form combinations of various focal lengths.

SAVING WASTES (*See* " Residues.")

SAXE PAPER (*See* " Rives and Saxe Papers.")

SAYCE, B. J.

Born, 1837 ; died 1895. Secretary and, later, President of the Liverpool Photographic Association. With W. B. Bolton, of Liverpool, he discovered the collodio-bromide of silver emulsion process (published 1864).

SCALE, FOCUSING (*See* "Focusing Scale.")

SCALES AND WEIGHTS (*See* "Balances.")

SCALOL

A registered name for a preparation of methyl-paramidophenol (metol), for use in combination with hydroquinone.

SCALOMETER (*See* " Focusing.")

SCHIENDL'S INTENSIFIER

A mercuric chloride intensifier. The negative is bleached in a 1 in 20 solution of the chloride, washed, and blackened in a 1 in 100 solution of " hypo," to which a few drops of a gold chloride solution and of ammonia have been added. The method is said not to block up delicate detail in the high lights.

SCHLIPPE'S INTENSIFIER

An intensifier introduced by Carey Lea for wet-plate negatives, but now seldom used. An iodine solution (water, 2 cz. ; potassium iodide, 3 grs. ; iodine, 1½ grs.) was first flowed over the plate and then a solution of Schlippe's salt, a scarlet deposit being produced.

SCHLIPPE'S SALT

A synonym for sodium sulphantimoniate.

SCHWELLENWERT (Ger.)

A term used by Eder to designate that quantity of light which is necessary to produce a distinctly noticeable photographic effect. This is usually translated " threshold " in English, and is practically confined to the smallest amount of exposure necessary to give a visible image after development. It was at first assumed that this Schwellenwert was a physical constant below which no action whatever occurred, but it is quite easy to measure far below it by counting the number of silver grains under a microscope (Mees and Sheppard).

SCOLIK'S INTENSIFIER

A mercuric chloride intensifier. The washed negative is immersed until whitened in a solution of 48 grs. of mercuric chloride and 48 grs. of potassium bromide in 5 oz. of water, blackened in a sodium sulphite solution, and finally washed.

SCRAPING NEGATIVES (See " Knife, Re-touching.")

SCRATCHES ON NEGATIVES

A scratched negative is repaired satisfactorily only if the photographer is expert with the pencil. If the scratch is clean and shows as a black line only in the print, the negative should be varnished, a little retouching medium applied, and the scratch gradually worked out with a finely-pointed hard pencil. Avoid working beyond the scratch, or filling it up too solidly, and it is better to stop while the scratch can still be seen as a faint grey line, rather than to obliterate it completely, when it may print as a white line. Abraded edges to a scratch, which print white at each side of the black line, should be carefully scraped away with a sharp knife before varnishing the plate.

SCREEN, COLOUR (See " Colour Screen or Filter.")

SCREEN, FLUORESCENT (See " Fluorescent Screens.")

SCREEN, FOCUSING (See " Focusing Screen.")

SCREEN, GRADUATED

A screen or light filter of glass or celluloid, graduated in density (colour) from the top to the bottom, the top part being as a rule, of a deep yellow colour, which gradually decreases in density until at the bottom quite clear glass is reached. Such screens are used for placing in front of the lens when photographing landscapes, the denser part being so adjusted in the holder, which fits on the front of the lens, as to cover the sky portion, in order to retard the action of the blue rays upon the plate. The use of such a screen makes it possible to get foreground and skies, both correctly exposed, on one plate; without it, if the foreground were properly exposed, the sky would probably be over-exposed and any delicate clouds lost.

SCREEN HOLDER

Process workers use various forms of holders for fixing the colour filters parallel to the lens.

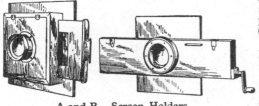

A and B. Screen Holders

Some of these holders are arranged to work in front, but behind the lens is the more common and the better position. Circular colour filter cells are attached to the front of the lens by means of a holder which clamps together the glass components of the cell. A is a wooden holder, which is attached to the front of the camera, the lens being mounted in front of the box. B is a box to hold three filters in line, so that they may be pushed successively past and behind the lens. In addition to these, circular fittings of metal are used.

SCREEN, ISOCHROMATIC (See " Isochromatic Screens.")

SCREEN - PLATE COLOUR PHOTO-GRAPHY

The process of producing photographs in the colours of Nature by means of a screen plate is based on the three-colour process enunciated by Clerk-Maxwell, but instead of using three separate colour filters and three separate plates and prints, the colour filters are distributed on one surface in small areas, coated with a panchromatic emulsion, and the picture obtained on this support either by chemical reversal of the negative into a positive or by printing on to another plate of similar character.

The first idea of such a plate was conceived by Ducos du Hauron, in 1862, in a letter which, however, was not published till 1897. In his French patent (No. 8,361, of Nov. 23, 1868) du Hauron says : " There is another method by means of which the triple operation can be done on one surface. The separation of the three elementary colours may be effected, no longer by three coloured glasses, but by means of one translucid sheet covered mechanically by a grain of the three colours." In a little work by him, *Les Couleurs en Photographie, Solution du Problème* (1869), he also deals with this subject, but a more elaborate description of this idea is given by Alcide du Hauron in *Triplice Photographique des Couleurs*, in which will be found the germ of all screen-plate processes, and any introduced of late years have been but variations of du Hauron's ideas.

In dealing with this subject the writer cheerfully acknowledges that he is following to a great extent and sometimes borrowing freely from a valuable paper on " Some Experimental Methods Employed in the Examination of Screen Plates," by Dr. Kenneth Mees and J. H. Pledge (*Phot. Journal*, May, 1910, p. 197). Screen-plates may be classified under two headings : regular and irregular, or line and mosaic ; and can be further subdivided into the following methods of manufacture : (1) ruled lines, (2) dusting-on methods, (3) bichromated colloid methods, (4) section cutting, (5) mechanical printing or mechanical methods and dyeing, (6) other processes.

The first line screen by a ruling method was patented by Joly in 1895, patent No. 14,161, '95. In 1896, Jas. W. McDonough took out patent No. 12,645, '96. The Joly screen was composed of lines having a width of $\frac{1}{200}$ in. (·12 mm.), and a separate viewing screen, with slightly different colours, was issued. The taking screen was placed in contact with a panchromatic plate, and from the line negative thus obtained a positive was made and bound up with a viewing screen so adjusted that the lines of the latter

fell into contact with the correct lines of silver deposit on the positive. The McDonough lines were $\frac{1}{300}$ in. (0·8 mm.) wide, and some even as fine as $\frac{1}{420}$ in. were made. The dusting-on method was first patented by McDonough (No. 5,597, '92), and he claims the use of particles of glass, transparent pigments, gelatine, resin, or shellac suitably stained and subsequently coated with a panchromatic emulsion.

The autochrome plate, patented (22,988 and 25,718 of 1904, and 9,100 of 1906) by Messrs. Lumière, is prepared by sifting suitably stained starch grains over a tacky surface, rolling them, and then filling the interspaces with a black filling. The average size of the starch grains is $\frac{1}{1600}$ in. (·015 mm.). The plate is issued coated with an emulsion, and the image needs to be reversed after exposure, so that the original plate serves as the positive.

According to Mees and Pledge, Fawcett suggested in the *British Journal of Photography* (February 22, 1901) the use of a screen plate with the emulsion coated thereon.

Palmer's patent (22,228, 1907) claims the use of ceramic colours or fluxes dusted on a tacky glass plate, and then fired in a kiln; also in another plate he uses gum elemi. The Aurora screen plate (introduced by the inventor, E. Fenske, in February, 1909) uses a mixture of three dyed materials dusted on a tacky plate, and fills the interspaces with a black filling. The fragments vary in size from $\frac{1}{800}$ in. (·03 mm.) to $\frac{1}{160}$ in. (·15 mm.), the average being about $\frac{1}{360}$ in. (·07 mm.).

In Bamber's patent (3,252 of 1908) dyed gelatine is hardened with formaldehyde, dried, immersed in water, heated to 212° F. (100° C.), ground to powder, and sifted into varying sizes by elutriation with petroleum spirit; then it is dusted on tacky glass and expanded by absorption of moisture from the air, the interspaces being then filled up with black filling. The average size of the particles is about $\frac{1}{300}$ in. (·01 mm.).

The use of bichromated colloids was outlined by Du Hauron, and the first plate manufactured on these lines was the Warner-Powrie or Florence plate. The lines in this had a width of about $\frac{1}{300}$ in. (·04 mm.), and the green lines were formed first, then the red, and the interspaces were filled with blue. Another Warner-Powrie experimental screen plate had green lines with red and blue rectangles in between, thus following more closely still the Du Hauron method; the diameter of the green line was $\frac{1}{500}$ in. (·05 mm.), the narrow diameter of the red areas being $\frac{1}{360}$ in. (·07 mm.) and that of the blue $\frac{1}{500}$ in. (·05 mm.).

Dr. Smith, of Zurich, patented (6,881, 1906) a screen plate with regular geometric pattern, triangles, hexagons, or rhombi. The Thames plate (Finlay's patent, 19,652 of 1906) consists of a series of red and green circles of about $\frac{1}{24}$ in. (·11 mm.), with a blue filling. It is interesting to note that in an American patent (561,687 of 1896) McDonough claims the use of " a negative or positive photographic plate made with recurring patterns—as dots, lines, or figures—and having a portion where there is a fixed or invariable and distinctive characteristic which is produced in the sensitive material

of the plate, and by which the plate may thereafter be registered or adjusted in position in use."

The Wratten patent (28,406 of 1907) has one distinctly novel feature in that the matrix, whether a linear or dot pattern, has the figures in black, semi-opaque, and clear, and therefore one would have, in printing on a bichromated dyed colloid, a quite insoluble, a half soluble, and a completely soluble film. After exposure, the insoluble gelatine would be stained deep blue, the half soluble only half that depth, and a clear line left; by immersing such a plate in a yellow dye the half soluble line would absorb the yellow and give green, and the clear line could be subsequently coated with a red colloid and rendered insoluble. Practically this did not work out so well as it promised.

The Dufay dioptichrome plate (patents No. 11,698 of 1908 and 18,744 of 1908) is prepared by exposing a bichromated colloid under a line screen, dyeing, and inking up with a greasy ink which does not adhere to the stained lines; and this plate is now pressed against a gelatine-coated plate and the ink and dye are transferred. This second plate is coated with a varnish which does not adhere to the greasy ink, and then treated with a solvent which dissolves the ink and does not attack the coloured line; and the plate then has one third of its surface red and two-thirds plain. A second printing at right angles to the first gives the second colour, and then the unstained gelatine is dyed by pressure against another plate stained with the third colour. The green line has a diameter of $\frac{1}{420}$ in. (·06 mm.), the red rectangle $\frac{1}{360}$ in. × $\frac{1}{250}$ in. (·07 mm. × ·1 mm.) and the blue area $\frac{1}{400}$ in. × $\frac{1}{280}$ in. (·065 mm. × ·09 mm.).

The only plates prepared by the fourth method so far have been experimental ones. Señor Cajal, of Madrid, suggested the use of coloured fibres embedded in celluloid rendered opaque by metallic silver and cut across with a microtome. In 1893, Dr. Otto N. Witt applied for a German patent (W. 14,564, iv., 57A, November 1) for preparing linear filters by the superposition of sheets of dyed celluloid, cementing them together and then rolling them out to thin veneers. On April 6, 1899, R. E. Liesegang applied for a similar patent, in which the block of superposed sheets of celluloid was to be cut across at right angles to the direction of the lines, and mosaic filters could be produced by cementing such veneers into a block and again cutting across. R. Krayn took out two English patents (1,938 of 1906 and 495 of 1907) for precisely the same ideas, and experimental films of this character were issued.

The Krayn screen, which has been actually issued, belongs, like the Omnicolore plate, to the fifth method, in which mechanical printing is employed. The method is practically as follows: a greasy ink or waterproof varnish is ruled over two-thirds of the surface of a gelatine-coated or celluloid film (Krayn), and the exposed gelatine is dyed and the water-repellent material removed and again applied so as this time to cover the dyed gelatine and half the unstained gelatine. The exposed gelatine is dyed and mordanted and then the remaining clear gelatine stained up. In the Omnicolore plate there

are continuous blue lines of $\frac{1}{500}$ in. (·05 mm.) width with green and red rectangles in between at right angles, the area of the former being about $\frac{1}{360}$ in. \times $\frac{1}{420}$ in. (·08 mm. \times ·06 mm.), and that of the latter $\frac{1}{420}$ in. \times $\frac{1}{600}$ in. (·06 mm. \times ·04 mm.). In the Krayn celluloid film the lines are red and about $\frac{1}{600}$ in. wide, and the blue and green rectangles are not at right angles, but about an angle of 135 with the horizontal red line, and the space between the two red lines is about $\frac{1}{230}$ in. (·11 mm.). Lumière's patent (20,111 of 1908) for a regular grain screen is based on the use of a greasy ink, which is applied to two-thirds of the surface of a gelatine film, the remaining third being dyed; then the whole plate is varnished and the greasy ink and the overlying varnish dissolved. A second greasy ink is now applied in the form of lines at right angles to the first set, so that half the surface is covered, and the exposed gelatine is dyed in the second colour, again varnished, and the greasy ink removed; and the plate, which now bears two colours, is dyed up as regards its remaining surface with the third colour.

With regard to screen plates made by other processes, there are not at present any on the market, though several patents have been taken out, such as Joly's (19,388 of 1895) for dyed threads laid on a transparent support, Beeton and Gambs' patent (20,834 of 1906) for a woven tissue, and Szczepanik's (17,065 of 1908) on the same lines.

The Szczepanik-Hollborn screen plates are based on the affinity of basic dyes for acid tissues and acid dyes for basic tissues; the former have a decided preference for collodion and acid dyes for gelatine. Three solutions of gelatine or other colloid are dyed, dried, powdered, mixed in proper proportions, and dusted on to a moist collodion plate. The dyes pass from the colloid into the collodion, and the former is washed off, leaving a mosaic of coloured areas. In the second form only two colours are applied in this way and the third applied by a dyeing bath.

There are certain factors in the manufacture of screen plates which are extremely important for the successful reproduction of colour, and the first is that the screen itself should be free from colour when examined by white light; that is, it should be of a neutral shade. This has been defined by Mees as the " first black condition," and it must be attained by adjustment of the areas of the colour units, and not by varying the depth of staining which controls their absorptions. The second point is that the photo-chemical effect of the spectrum through the screen elements and compensating filter must correspond with the luminosity curve, though this point may be of less importance, as the retina is able to perceive small variations from the correct curve. The third point is the total visual absorption, as this affects the duration of exposure, for, naturally, the greater the absorption of light the longer will be the exposure. The above-mentioned authors state that in order to fulfil the first black condition the green area must transmit about two-thirds of the light transmitted by the plate, and under the best conditions for the other filters it may occupy half the area of the plate, and therefore half the plate will only transmit one-third of the incident green light

or two-ninths of the incident white light, so that the whole plate will transmit only one-sixth of the incident white light as a maximum.

The question of invisibility of the filter elements depends upon what has been termed the " period," which is twice the distance of separation for lines equal in width to the spaces; and this must be less than $\frac{1}{1000}$ of the distance from the eye; and if this be taken as 20 cm. the screen period will be 0·2 mm.; therefore the separate filter elements will be invisible if they are not larger than $\frac{1}{375}$ in. (·066 mm.), or approximately $\frac{1}{400}$ in., this naturally applying to results examined in the hand. When, however, it comes to the projection of the pictures, one has to take into consideration the magnification, and assuming this to be 40 diameters or a 10-ft. screen, and the nearest observer to be $12\frac{1}{2}$ ft. away, the screen elements must not be more than $\frac{1}{20}$ in., which requires the actual screen elements to be $\frac{1}{800}$ in. When dealing with irregular grain screens in which the units are distributed by a dusting-on method, then there may be clumping of the grains; as many as twelve grains may be clumped together, and therefore the unit may become much larger.

The resolving power—that is, the power of the screen plate to resolve a coloured object into its form and colour—may be divided into three heads. First, the objects are resolved both in form and colour, when the images of the objects are as large as or larger than the screen period; secondly, the images may be of the same size as the screen elements, then they will be resolved as to form but indeterminate as to colour; thirdly, if the images are smaller than the screen units, they may or may not be resolved, according to the resolving power of the emulsion.

The spectral absorptions of the filter elements can only be those which are generally recognised in three-colour work—that is, having a slight overlap in the yellow and blue, considering the taking of negatives only; but as, in the majority of cases, the screen is also used for viewing, the spectral absorption should be as pure as possible, and should agree as nearly as possible with the three fundamental colours—red, green, and blue. A compromise has therefore to be made, and probably the red should transmit from the extreme red to λ 5,900, the green from λ 5,900 to λ 4,900, and the blue from λ 5,000 to λ 4,000.

The limitation of the size of the filter element is determined by the invisibility of the element, which has been previously dealt with, and this should be not larger than $\frac{1}{400}$ in., or in the case of irregular grain screens about one-tenth of that, because of the clumping. One of the factors governing the minimum size of grain is the thickness of unit necessary to give sufficient depth of colour, which is determined as to its diameter by parallax. If the thickness is equal to the diameter, any ray passing through the screen at a greater angle than 10° will not only pass through the particular element which it first struck, but also the next, as shown in the following diagrams.

A shows a screen plate in which the thickness of the filter elements R, G, B (red, green, and blue) is equal to their diameter. The ray striking the blue element B passes only through this; but as the emulsion is of slightly greater refractive

index it encroaches slightly on the neighbouring green element, and therefore in the final result the blue would have a very slight green tinge. In diagram B the thickness of the elements is one and a half times their diameter, and the ray here passes not only through the blue, but

A *Emulsion* B

Light Rays striking Screen Plates

through nearly the whole of the green; therefore the final colour would be strong greenish blue. This is an important point because when using a bichromated colloid, such as gelatine, it is difficult to get sufficient depth of colour with less than 54·5 mins. of 5 per cent. gelatine solution to every 10 sq. in. (= 1 cc. per 20 qcm.), which gives a thickness of dry film of $\frac{1}{1000}$ in. The second factor limiting the size of the elements is the irradiation of light in the emulsion film itself, by which the light may be scattered from the silver halide particles, underlying the particular screen element, to those under the adjacent ones.

Finally, in order to obtain correct colour rendering, assuming that the first black condition is fulfilled, it is essential that the action of light should be to give equal deposit under all three elements. Now, as it is not possible to sensitise any emulsion for red and green, so as to give equal sensitiveness to these regions as to the original blue-violet sensitiveness of the emulsion, therefore a compensating filter is used to cut down the excess blue-violet sensitiveness, and at the same time even up the sensitiveness of the red and green. This is called the "second black condition."

The final speed of a plate is determined by (a) the speed of the emulsion, (b) the multiplying factor of the screen, and (c) the multiplying factor of the compensator. Mees and Pledge give the following table of these factors :—

	Auto-chrome	Thames	Omni-colore	Dufay
Emulsion speed (Watkins) . . .	35	120	22	13
Screen factor .	12	8	7	5
Compensator factor .	2	$1\frac{1}{2}$	$1\frac{1}{4}$	$1\frac{1}{2}$
Effective speed . .	$1\frac{1}{2}$	10	$2\frac{1}{2}$	2

They also give the following very valuable summary of the essentials to be fulfilled in the manufacture of a screen plate : (1) The size of the units.—For regular screens these should not be larger than $\frac{1}{300}$ in., nor smaller than $\frac{1}{400}$ in. For irregular screens not larger than $\frac{1}{500}$ in., nor smaller than $\frac{1}{5000}$ in. It is quite needless to strive for exceedingly small units. (2) The

interstices.—If these exist at all, they must be filled in ; white interstices are fatal, even if they only occupy one-twentieth of the arc of the screen plate. (3) The colours of the units.—These must be primary red, green, and blue violet. (4) The relative area occupied by each colour.—This must be adjusted to fulfil the first black condition. (5) Emulsion.—This must be coated, for which purpose insulating varnishes will have to be selected, as they must not act upon it. Turpentine and ether, especially the former, are inadmissible as solvents ; resin varnishes are suspect. (6) The sensitising.—This must be performed so that the actions under the red and green filters are equal. (7) The compensator.—This must be adjusted to fulfil the second black condition.

SCREEN, RULED (*See* " Half-tone Process " and " Half-tone Screen.")

SCREWS AND SCREWTHREADS (*See* " Camera Screw " and " Mounts, Lens.")

SCULPTURE, PHOTO. (*See* " Photo-sculpture.")

SCULPTURE, PHOTOGRAPHING

The principal points that require attention in photographing sculpture are given under the heading " Statuary, Photographing " ; but it is desirable to give a hint in this place on the photographing of sculptured panels. With most of these panels, a direct front position is almost imperative ; the panel must be regarded almost as a picture and photographed in the same manner. Care must be taken to get the outlines of the panel perfectly rectangular, the corners square and the opposite sides parallel. The most simple method is given under the heading " Paintings, Photographing." The front position does not always show the relief so effectively as an oblique view, consequently, when possible, the work should be done at the time of day when the natural lighting gives the desired effect.

SECONDARY AXIS (*See* " Optical Axis.")

SECRET CAMERAS (*See* " Detective Camera " and " Disguising the Camera.")

SEED LAC (*See* " Gums and Resins.")

SEL D'OR (*See* " Gold Hyposulphite.")

SELECTIVE SENSITISERS

A synonym for optical sensitisers, under which heading they are described.

SELENIUM

Se. A non-metallic element. Atomic weight, 79. It is used in phototelegraphy.

SELF-DEVELOPING PLATES

Dry plates carrying the developer in or on the film, or on the glass side, and requiring only to have water applied for the developing action to take place. An early form was that introduced by Dr. Bæcklandt, who soaked dry plates in a solution containing salicylic acid and pyrogallic acid. The systems by which the developer

is in the form of a dried paste on the glass side of the plate are far more satisfactory. Thomas Bolas patented (in 1907) a dry developer, to be applied to the glass side of the plate or used as a separate sheet. In addition to claiming the distribution of different portions of the developer in different parts of the area, the use of hydroxyl-amine and an ammonium salt is named, also the use of acid sulphite, and the use of bicarbonate as an alkali. The acid constituent (A) may contain the reducing agent :—

Metol 1 part	
Hydroquinone . .	. 2 parts	
Milk sugar, mannite, or other		
sugar-like preservative	. $1\frac{1}{2}$,,
Sodium bisulphite . .	. $1\frac{1}{2}$,,
Starch, partly boiled and partly		
in grains 6	,,

and water in sufficient quantity to give a paint-like consistency on a thorough incorporation or grinding of the ingredients. Instead of metol and hydroquinone, other reducing (developing) agents may be employed. The alkaline accelerator (B) may contain the following ingredients :—

Sod. carbonate or bicarbonate .	5 parts
Gum arabic	1 part

and water in sufficient quantity to give a paint-like consistency to the mixture upon grinding. The inert or slightly acid separating material (C) may contain the following ingredients :—

Sulphate of lime or sulphate of	
baryta 4 parts
Gum arabic 1 part

and water as before.

SELF-PORTRAITURE

When there are no bright objects in the background and the duration of exposure is of little or no importance, a small stop may be inserted in the lens in order to make a comparatively long exposure necessary. The operator may then open the shutter or uncap the lens and take up his position at a suitable spot previously arranged opposite the camera, stay there while the exposure is being completed, and then go back to the camera and close the lens. The brief period during which the operator is not in position will make no appreciable difference to the plate if the stop used is small enough, the plate slow enough, and the background dark enough. Another and a better plan, suitable for outdoor groups when the operator wishes to be included, is to make the exposure through the agency of black thread. Two lengths of black thread, long enough to reach from the camera to the operator should be taken. One is attached to the lens cap (a shutter cannot be used), and the other is tied to one corner of the focusing cloth, the latter being folded on the top of the camera in such a way as to be easily pulled over the lens. When all is ready for the exposure the thread attached to the cap is pulled, the cap then falls to the ground and the exposure begins; when sufficient exposure has been given the thread attached to the black focusing cloth is pulled and the cloth falls in front of the lens; the operator then hastens back to the camera and caps the lens.

SELF-TONING PAPERS

Printing-out gelatino-chloride emulsions containing some salt of gold, which is reduced in the fixing bath and thus tones the image and does away with the necessity of separate toning. Ashman and Offord suggested this addition in 1885 ; but Bachrach, three years later, published the fact that the addition of gold obviated subsequent toning. Most of these papers require merely fixing or immersion in a preliminary salt bath to vary the tone obtained. In some cases the gold is accompanied by lead or other metallic salts, which doubtless play an important part in the toning of the image.

SELLA'S PRINTING PROCESS

A process published by M. V. J. Sella, of Biella, in 1857. It was an "ink" process, in which the salts of silver and gold were superseded by salts of iron and chromium.

SEMITONE (Fr., *Demiteinte ;* Ger., *Halbton*)

A half-tone. In photography, the shades intermediate between the lightest parts of the picture (high lights) and the deepest shadows.

SENSITISED PAPER (Fr., *Papier sensible ;* Ger., *Gesilbertes Papier*)

An old term applied to plain salted and albumenised paper after sensitising with silver nitrate.

SENSITISERS (Fr., *Sensibilsateur ;* Ger., *Sensibilisatoren*)

There are practically two classes of sensitisers, the so-called chemical, and the optical sensitisers. The former are generally halogen absorbers, which increase the sensitiveness of the negative emulsion or increase the intensity of the printed out image. For colour sensitisers, *see* "Colour Sensitising."

SENSITISING

Rendering sensitive to light. Methods for sensitising are given under the various processes, as for example, blue-print, kallitype, carbon, albumen, etc.

SENSITIVENESS OF PLATES AND PAPERS

The question of the sensitiveness of plates is dealt with under "Sensitometry." At present there is no generally accepted method of testing papers for their sensitiveness, the usual commercial method being merely to give the exposures to certain lights.

SENSITIVENESS, RESTORING (*See* "Fogged Dry Plates, Restoring.")

SENSITOMETER

A device for testing the sensitiveness of plates and paper, and described in the following article.

SENSITOMETRY (Fr., *Sensitométrie ;* Ger., *Empfindlichkeitsmessung*)

Soon after the introduction of the gelatine dry plate, it was usual to express the speed of the emulsion as "*x* times," which meant that it was *x* times the speed of a wet collodion plate. This

speed was no fixed quantity, and the expression consequently meant but little. Warnerke introduced a sensitometer, consisting of a series of numbered squares with increasing quantities of opaque pigment. The plate to be tested was placed in contact with this, and an exposure made to the light emanating from a tablet of luminous paint, excited by burning magnesium ribbon. After development and fixation the last number visible was taken as the speed of the plate. The chief objections to this method were that practically no two numbered tablets agreed, that the pigment possessed selective spectral absorption, and that the luminosity of the tablet varied considerably with the lapse of time between its excitation and the exposure of the plate. Various other methods were proposed, but none found any practical use. In 1890, Hurter and Driffield published a series of papers on the subject of speed determination, and proposed a method of exposing a plate to a series of lights of known intensities and measuring the densities obtained on development. This method has become very general in England, though possibly it is not strictly adhered to by all its users. Notwithstanding various attacks, the main principles of the

46 $^{m}/_{m}$

A. **Chapman Jones Plate Tester** B. **Gauge for Height of Candle Flame**

H. and D. system, as it is briefly termed, remain uncontroverted. On the Continent, another system, known as Scheiner's, has been elaborated by Eder, and in this a rotating sector wheel is used, the steps of which bear a ratio of 1 : 1·27. After exposure, the last number visible, when the negative is placed film downwards on white paper, is taken as the speed of the plate.

Chapman Jones has introduced a modified Warnerke tablet containing a series of twenty-five graduated densities, a series of coloured squares, and a strip of neutral grey, all being of approximately equal luminosity, and a series of four squares passing a definite portion of the spectrum; finally, there is a square of a line design, over which is superposed a half-tone negative. This "plate tester," A, is used with a standard candle as the source of light, and is useful for rough tests of both plates and printing papers. Definitions of the leading terms employed must here be given. "Opacity" is the suppression or absorption of light by the silver image. "Transparency" is the remnant of the original light which passes through the negative image. "Density" is the relative quantity of silver deposited per unit area. The existing confusion is well shown by the term "a very dense negative," when really what is meant

is that the "opacities" of the silver deposited are so great that they possess very little "transparency"; that is to say, the negative absorbs the greater portion of the incident light. It is true that the "denser" a negative the greater the opacity, but it must not be forgotten that, as defined above, density is the quantity of silver deposited. Density is the logarithm of the opacity; thus, a negative which has an opacity of 100 has a density of 2·00, as this is the common logarithm of 100, and it has a transparency of $\frac{1}{100}$.

The usual mathematical expression of the above facts is as follows, but in the following pages, as far as possible, mathematics will be excluded and everyday working instructions given :—

$$\text{Transparency, } T = \frac{\text{Intensity of light transmitted}}{\text{Intensity of incident light}} = \frac{I}{Io}.$$

$$\text{Opacity, } O = \frac{\text{Intensity of incident light}}{\text{Intensity of transmitted light}} = \frac{Io}{I} = \frac{1}{T}.$$

$$\text{Density, } D = -\log_{10} T = \log_{10} O.$$

The last term is also frequently expressed as :—

$$D = -\log_e T = \log_e O,$$

Napierian, instead of common, logarithms being used.

Hurter and Driffield pointed out that in a perfect negative the opacities of the different gradations were strictly proportional to the light reflected by those portions of the subject which they represented when the plate had received correct exposure, and that a true representation of the tones of the original is only possible when the density or the quantity of silver is proportional to the logarithm of the light intensity. To use the H. and D. system correctly, it is essential to have a standard light, an exposing instrument, and a photometer or instrument for measuring the densities.

The Standard Light.—The light adopted by Hurter and Driffield was the British Standard candle, burning 120 grains of spermaceti wax per hour. This candle gives satisfactory results as regards the speeds of ordinary (non-colour sensitive) plates for amateur use; but the flame is subject to fluctuations, and obviously will give totally incorrect readings with colour-sensitive plates, on account of the spectral composition of the light, this being very yellow, or much richer in yellow, orange, and red rays than is daylight. If the candle is used for speed reading, it is always advisable to expose with the plate to be tested one of a known speed, then any variation of the speed of the latter can be allowed for in calculating the speed of the unknown plate. It is important to see that the candle is burning regularly at the base of the wick, with a well-formed cup of wax, free from match-heads, bits of charred wick, etc. The wick should burn over at its top to the edge of the flame, the latter being 45 mm. in height from that place where the wick begins to blacken to the tip of the flame. It is as well to make a steel metal gauge, as shown at B, for measuring this height, and it is also desirable to shield the candle flame from draughts. As it must be kept at a constant height, a retort stand with a slip arm to hold the candle, or a sliding holder, must be provided. Another standard light, more generally used

on the Continent, is the Hefner amyl-acetate lamp, a small lamp which burns pure amyl-acetate that gives a flame much like the candle in spectral composition, and, therefore, open to the same objections on this score as the standard candle.

The most satisfactory standard light is acetylene, used under a pressure of about ½ oz. The burner to be used is a Bray's "Elta," which shows no tendency to carbonise, and in which the gas escapes from two pinholes in the steatite caps. These caps contain airholes. The rod-like flames impinge against one another and produce a brilliant flat flame of about 1 in. diameter. Whereas in the candle the whole flame is used, in the case of acetylene it is important to screen off the margins and the tip of the flame as these flicker considerably, and it is also necessary to screen off the blue base of the flame. This can be conveniently done by a Methven screen or metal plate pierced with a square hole of 36 sq. mm. area. This screen should be as near the flame as possible (about 12, or not more than 18 mm.), and the bottom of the aperture should be slightly above the dark or blue area of the flame, so that it is central with the whitest and most luminous part of the flame. For exact photometric investigations, the correct position must be found by exposing a series of plates and measuring the densities, but for practical speed testing it will be sufficient if the eye, when placed at the extreme edges of the dark-slide, can see no trace of the tip, edges or base of the flame. Renwick, of the Ilford Research Laboratory, states that there is a variation in density over the plate strips due to the variation in the intensity of the light and the small area of the flame exposed by the aperture. While this has not been confirmed by any other writer, Sheppard and Mees have confirmed the general fact that such a burner is liable to variation, and have, therefore, suggested a modification of the Fèry cylindrical flame, obtained by means of a Bray burner taking ·25 ft. of acetylene per hour, and constructed to give a cylindrical flame with the admixture of air. The burner is enclosed by a metal hood in which is an aperture ·04 mm. and a cone reaching from this to within ¼ in. of the flame itself, the latter being 35 mm. in height.

The correct distance between the standard light and the sensitive surface should be 1 metre; if this is not adhered to a correction must be made in estimating the intensity of the light falling upon the plate. This correction, for varying distances is found from Schwarzschild's formula and table, given below.

$$I = \left(\frac{100}{D}\right)^2 f$$

TABLE OF CORRECTION FACTOR f.

G	D					
	400 cm.	200 cm.	100 cm.	50 cm.	40 cm.	30 cm.
0 cm.	0·989	0·992	1·000	1·017	1·023	1·337
4 „	0·989	0·991	0·997	1·007	1·009	1·01
8 „	0·989	0·989	0·990	0·978	0·965	0·935
12 „	0·988	0·986	0·979	0·934	0·899	0·829
16 „	0·986	0·982	0·962	0·879	0·818	0·712

D = the distance of the light, G = the distance of any point of the plate x centimetres from the perpendicular drawn through the centre of the flame to the plate. A reference to and explanation of this table will be found under the description of the exposing instrument.

The experimenter must not overlook the danger of the intensity of the light decreasing as the gas supply and, consequently, the pressure diminish, and he should take care that the evolution of gas has ceased before exposure is made. Another point is that when the carbide receptacle is freshly charged, some air is always introduced into the gas chamber, thus leading to a decrease of luminosity of the flame. This trouble may be overcome by generating a small quantity of gas first and burning this, with the water supply cut off, and then admitting more water to the carbide till the bell is fully charged, making the exposure when the generation of the gas has ceased.

Although the acetylene light approximates more nearly to daylight than the standard candle, it is still too rich in red and orange rays, and it should be screened down with absorbent solutions. The necessary dyes are gentian violet, acid green, mandarine orange and rose Bengal, which can be obtained in conveniently small quantities. Some pure copper acetate will also be required.

The dyes can be most conveniently made up into stock solutions as follow:—

A.	Gentian violet .	14 grs.	2 g.
	Distilled water to .	16 oz.	1,000 ccs.
B.	Acid green . .	7 grs.	1·g.
	Distilled water to .	16 oz.	1,000 ccs.
C.	Mandarine orange .	7 grs.	1 g.
	Distilled water to .	16 oz.	1,000 ccs
D.	Rose Bengal .	28 grs.	4 g.
	Distilled water to .	16 oz.	1,000 ccs.

These stock solutions must be kept in the dark.

The actual filter or screen is made as follows:

A	solution	10 mins.	1 cc.
B	„	10 „	1 „
C	„	10 „	1 „
D	„	10 „	1 „

Distilled water to 2 oz. 138 mins. or 100 ccs.

When mixed, this will not keep more than 24 hours, and it should be used in a cell 10 mm. internal width.

The copper acetate solution is made as follows:

Pure copper acetate .	105 grs.	15 g.
Glacial acetic acid .	. 35 mins.	·5 g.
Distilled water to .	. 16 oz.	1,000 ccs.

This will keep indefinitely, and must be used in a cell of 10 mm. internal width. It must not be mixed with the aniline dyes, but used in a separate cell.

The Exposure Instrument.—The instrument for obtaining the series of graduated exposures consists essentially of a sector wheel, 11 in. in diameter, in which each sector is exactly half the preceding one; the angles should be: 180°, 90°, 45°, 22·5°, 11·25°, 5·625°, 2·8125°, 1·4062° and ·7031°. Obviously the 180° is made up of the single quadrant below the centre and the quadrant next above. These angles must be accurately cut, an extremely difficult and costly

matter. The metal should be blackened and the edges of the angles bevelled, so that the edge of the bevel comes next the plate. The wheel is mounted in a box so that it can rotate as close as possible to the plate, and it will be found more convenient in practice if the space between the wheel and light is boxed in and the light also enclosed so that it can be used in a dark-room. Such an arrangement obviates any possible source of error from light reflected from the walls and ceiling of the room, and enables one to attend to other matters whilst the plate is exposing.

Diagrams C and D show an instrument made by E. J. Wall, which may be taken as a guide. The two dark-slides, D D, enable the experimenter to expose four plates at once, using the halves of quarter-plates, that is, strips of plates, measuring 4¼ in. by 1⅝ in. The light is placed central with s_1 the axis on which the sector wheel revolves. This introduces a small error, which can be calculated from Schwarzschild's table already given, but for practical speed testing this may be neglected as it is less than the probable error in reading the density. For accurate photochemical work, the perpendicular from the centre

per minute the intermittency error is practically negligible. The sector wheel may be driven by hand, a small electric motor, a small water turbine or hot-air gas-engine. Hurter and Driffield used the treadle table of an ordinary sewing machine; but some mechanical arrangement will be found most convenient, as it allows the operator to attend to other matters.

To use the apparatus, attention should first be paid to the light to see that it is burning correctly, the sector wheel should then be set in motion and the exposing shutter withdrawn. For fast plates, an exposure of 40 candle-metre-seconds will be sufficient as a rule, whilst for slow plates 80 C.M.S. may be given. For lantern plates this may be even doubled or quadrupled, so as to obtain the characteristic curve of the plate. Even with the largest sector, only half the circle, or 180°, is used for the exposure, so that no matter what exposure may be decided upon, it must then be doubled; in other words, ignoring the intermittency error, if the actual exposure is 80 secs. the effective exposure will be only 40 secs., as half the time the plate is covered by the opaque portion of the sector wheel. If the candle is used, then we may give

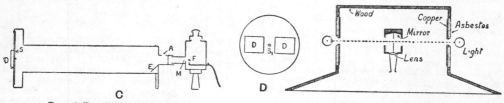

C and D. Wall's Exposure Instrument

E. Grease-spot Photometer

of the flame should coincide with the centre of the plate.

It will be found advisable to provide the dark-slides with ½-in. strips of black paper or thin metal, along the two sides, so as to have two fog strips, the use of which will be explained later. The dark-slides should be made in the form of a printing frame with solid back; the ordinary form may be used, but it rarely permits of one plate being placed behind the other, as sometimes required. C and D are practically self-explanatory; s is the sector wheel; D D the dark-slides; M the Methven screen with circular aperture; and F the acetylene flame. Small pieces of wood are fastened to the sides, top and bottom of the box, inside, to prevent scattered light reflections. The inside of the box must be blackened. A is an aperture cut in the top of the narrow portion of the box into which the two liquid cells for screening the light are inserted. As the flame is so near the aperture in the screen, this gets very hot, and it is advisable to have the outer sleeve, into which the projecting piece of the lamp slides, lined with asbestos cloth. E is an exposing door which, by means of a milled head outside the case, can be raised or lowered so as to admit or shut off the light at will.

A series of intermittent exposures does not produce the same effect as the equivalent continuous exposure, but it has been shown by Sheppard and Mees that if the wheel is not driven at a greater speed than 100 revolutions

actual seconds, but in the case of the screened acetylene light, it is necessary to find by actual test of a plate of known speed what is the equivalent exposure. Thus, with the instrument as described above, it has been found that an actual exposure of 340 secs. gave exactly the same result as an effective exposure to a standard candle of 40 secs.

For true speed reading the emulsion must be coated on plate glass; the plates should be backed, and the strips to be tested should be cut out of the middle of a whole-plate. The glass generally used for plates is so uneven as to give rise to considerable errors, and if not backed, halation occurs; the backing should be black and not red.

The Photometer.—This instrument is used for measuring the densities of the plates. The simplest type, and the one used by Hurter and Driffield, was a modification of the Bunsen grease-spot photometer; its main fault is that the two spots that have to be compared are not contiguous. The instrument consists essentially of a box with one side open and the edges splayed out to protect the operator from the light, whilst measuring the densities. E shows a plan. The case may be made of wood, but those parts near the lamps should be of asbestos millboard, inside which should be two sheets of copper or zinc perfectly plane and blackened, as should be the whole of the inside of the box. At each end in the centre of the sides is a hole 6 mm. in diameter; between these holes should be a plane

block of wood, with either a rack or a smooth piece of metal on top ; and the small box shown should be provided with a pinion or small rollers so that it may run easily to and fro. In both diaphragms should be placed either ground glass or preferably opal, just behind the copper plate. To the centre of the little box should be affixed a pointer passing along a graduated scale, fastened to the bed on which the box moves. The little box is of light wood with two mirrors at the back placed at a low angle, whilst between them is the grease spot, which can be fixed to a piece of stout card with a hole cut in it, or between two thicknesses of card. Some instruments are not provided with the lens and eyetube ; these are to be preferred, although far better still is a low-angled bi-prism, which brings the images of the spots into juxtaposition.

The making of a grease spot is by no means an easy matter at first, but as the materials are nothing but a hard carriage candle, a big darning needle and a spirit flame or gas, plus the paper, it is merely a question of practice to produce a large number of spots, the best of which can then be chosen. The paper should be thin, with a matt surface, and not too hard, and it should be cut into 1-in. discs, which should then be placed round the candle, the eye end of the darning needle made hot and placed as nearly as possible in the centre of the paper ; the heat melts the wax, which is absorbed by the paper, and forms a semi-translucent spot, preferably not more than 1 mm. in diameter. Make a number, and choose the best and most regular. A very translucent spot enables one to read very high densities, but it is not so sensitive. After using the instrument for a short time, it will soon be found whether the grease spot chosen is satisfactory or not, for as the highest density that is usually required is about 3·60 this should be the limit of sensitiveness required. The chosen spot should be placed between two thin opaque cards, with a ⅜-in. hole cut in them, and the spot should occupy the centre of this aperture. The cards may be slid into the little box as shown at E, through the top. The box should measure about 2 in. by 1½ in., with ¾-in. holes in the sides. These holes, the grease spot and the holes in the sides of the photometer box itself, must be absolutely axial one with another.

At the left hand of the instrument is a couple of weak brass clips, fastened to the side to hold the negative to be measured against the aperture. At this side, also, is a small door, on the inside of which is a mirror that reflects the light on to the scale. At the right hand of the instrument is a circular plate pierced with openings which can be rotated in front of the aperture exactly like the old wheel diaphragms of lenses so as to reduce the luminosity of the one light, as this considerably facilitates the readings.

With the grease spot photometer, the distance between the two diaphragms at the end of the scale bed must be 12 in. ; with the two Lummer-Brodhun rhombs and the Martens heads, described below, this distance must be increased to 20 in. To mark the scale (preferably of ivory or celluloid), the following formula is used : let z = half the distance between the two diaphragms, D = the density, and x = the distance the grease spot is shifted to obtain equality of illumination, then

$$D = \log \left(\frac{z + x}{z - x}\right)^2$$

Example : let the distance between the two diaphragms = 20 ins., then z = 10, then D for any distance, say 5·6 in., will be

$$D = \log \left(\frac{10 + 5·6}{10 - 5·6}\right)^2 = \left(\frac{15·6}{4·4}\right)^2$$

$$
\begin{array}{rl}
\log \text{ of } 15·6 = & 1·193125 \\
\log \text{ of } 4·4 = & ·643453 \\
\hline
& 0·549672 \\
& 2 \\
\hline
& 1·099344
\end{array}
$$

which is the density required.

In order to save calculations, the following table gives the distances and the corresponding densities :—

Distance		Density		Distance		Density
$z \times 0·057$	=	0·1		$z \times 0·519$	=	1·0
$z \times 0·114$	=	0·2		$z \times 0·560$	=	1·1
$z \times 0·171$	=	0·3		$z \times 0·599$	=	1·2
$z \times 0·226$	=	0·4		$z \times 0·634$	=	1·3
$z \times 0·280$	=	0·5		$z \times 0·667$	=	1·4
$z \times 0·332$	=	0·6		$z \times 0·698$	=	1·5
$z \times 0·382$	=	0·7		$z \times 0·726$	=	1·6
$z \times 0·430$	=	0·8		$z \times 0·752$	=	1·7
$z \times 0·476$	=	0·9		$z \times 0·776$	=	1·8

To use the table, z is merely the exact centre of the scale, and if this is 6 in. or 10 in. from either diaphragm, then the above distances must be merely multiplied by 6 or 10, and marked off on the scale in the corresponding densities. Each division or density space should be further divided into four equal parts, which enables one to read the densities to every ·25.

It has been assumed above that the centre point is marked zero or 0 ; obviously, then, the readings to the right will be *minus* readings, and those to the left *plus* readings. This leads to trouble and confusion, and it is better to mark the extreme right of the scale zero, and the numbers will then run up to 3·60, the centre being 1·8. This enables the densities to be read off direct.

The diaphragms at each end of the photometer box should be of equal diameter ; when the lights are equal the zero point will fall in the centre. It is preferable, however, to reduce the right-hand light by a diaphragm of smaller diameter or by increasing the distance of the light. In any case, it is advisable to provide extra diaphragms on the right-hand side so as to be able to reduce the light here for reading high densities. It will be found convenient to reduce the light to densities of ·5, 1·0, and 1·5 respectively. To find the diameter of the smaller apertures, square the logarithm of the diameter of the original aperture, deduct ·5, 1·0, and 1·5 respectively, and divide the remainder by 2, and the quotients will be the logarithms of the diameters of the new diaphragms. For instance, suppose that the original diaphragms are 6 mm. in diameter, then

$$
\begin{array}{rl}
6^2 = & 36 \\
\log 36 = & 1·556302 \\
\text{and } 1·556302 - 0·5 = & 1·056302 \\
1·056302 \div 2 = & 0·528151
\end{array}
$$

which is the logarithm of 3·374, the diameter of the new diaphragm, which will reduce the densities by 0·5. In exactly the same way we find that the diameters for 1·0 and 1·5 would be 1·897 and 1·06 mm. In any case, it is advisable

F. Wedge

to test these diaphragms by actual readings, the mean of six readings being taken.

Instead of circular apertures, rectangular ones may be used, and a square of about ·203 mm. is convenient. As the density patches on the plate measure approximately 2·5 × 1 cm., it is obvious that the diaphragms may be considerably larger than stated above, but it is convenient to keep them small, as this enables one to shift the plate about over the aperture and thus avoid any local defect, such as a pinhole or black spot.

If rectangular apertures are used, then a strip of metal, 10 in. long, with a wedge cut out as shown at F, will be required. The wedge should taper from ½ in. to a point, and this can be marked with the densities according to the following rule :—

$$D = \text{log. of wedge length} - \text{distance from apex.}$$

Far superior to the grease spot in accuracy of reading are the photometer heads of Lummer and Brodhun and of Martens. The former is made in two forms, one of which gives an image similar to the grease spot G, the second kind being still more sensitive, as, with experience, readings to about 0·5 per cent. or even to 0·22 per cent. are possible. Instead of the grease spot two right-angled prisms are used (J and K in diagram H). J has a small ring c c etched out, whilst the central circle is left polished ; the other prism K is placed in contact with J, and the passage of the light is shown by the lines and arrows ; at D, where there is optical contact, the light from the source at R passes straight through the prism, but at c, where it meets with a thin film of air, it undergoes total reflection and forms the outer circle, shown grey in G. Exactly in the same

G. Grease-spot Image

H. Photometer Head having two Right-angled Prisms

way, the light from L meets at c a film of air, is reflected at right angles, and is lost in the mounting of the prism, whilst the central beam passes straight through to the eyepiece.

In the still more delicate instrument, the rhomb, shown at Y in diagram I, is used. The light proceeds from two sources M and N ; two

right-angled prisms are placed with their hypotenuses together. On one of the prisms the surfaces α, γ, and ε are etched to a matt surface ; at β, δ, and ζ the surfaces are left polished, and are in optical contact. At G R and G L are two small plates of glass which reduce the light about 8 per cent. The field, as seen in the eyepiece, presents the appearance of z, and if the intensity of the light on D B and B C is the same, H R and H L are equally bright, and the fields D R and D C are also equally bright but stand out darker than the background. If, on the other hand, the intensity on B C is greater than on D B, the contrasts in the right half of the field of view are increased and those in the left-hand field are lowered. With both these heads, the operator sees the field of view not at right angles to the scale but at about an angle of 45°, but the makers, Schmidt and Haensch, of Berlin, supply a form of direct-vision head.

I. Lummer & Brodhun J. Martens's Photometer
 Photometer Head Head

Martens's photometer head, made by the same firm, is shown in diagram form by J ; in this, the light from the two sources L and R falls upon two plaster-of-paris screens S_1 S_2, and is thence reflected to the two mirrors M_1 M_2 and the two right-angled prisms P_1 P_2. There is total reflection to the plano-convex lens F, to which is cemented the bi-prism B, by which images are brought into juxtaposition in the eyepiece E.

In the photometer as suggested by Hurter and Driffield two oil lamps with flat flames, fed from a common oil receptacle, were used, but unless the lamps are outside the photometer room the heat is too great to be comfortable. With electric light the trouble of the heat is more easily avoided, but accurate readings cannot be obtained with a lot of stray light about the room. In any case the use of two separate lights introduces an element of uncertainty through the variation of the lights themselves, and it is better to use one light, such as a 150 candle-power electric or powerful incandescent gas, and reflect it by means of mirrors through diaphragms as

shown at K, in which L is the light, M M the mirrors, and P the photometer.

A simple and ingenious photometer has been devised by Chapman Jones, called by him an opacity meter, and illustrated and described

K. Arrangement for Photometer with only One Light

under its own heading. In this case the screen is opal glass, against which the plate is clipped ; the scale may also be in opacity logarithms or densities. Another instrument, introduced by F. F. Renwick, is used for measuring densities, and is a simple form of comparison photometer, in which a uniformly and strongly illuminated area of fine ground glass is viewed through two small square apertures close together in the front of the instrument, one of which is covered by the density to be measured, and the other by a sliding wedge of neutral tinted glass compensated to give a uniform field by a very thin wedge of the same kind and angle. The two apertures are brought into contact by means of an Albrecht rhomb.

Spectrophotometers are numerous and costly. Briefly the light passes through two apertures, the two beams split up into contiguous spectra, and the luminosity of one reduced to that passing through the density to be measured, by means of Nicol prisms. An instrument that has been highly recommended is the Martens's polarisation photometer or " absorptionsmesser," made by Schmidt and Haensch, which is shown at L. The quality of the fields or the zero point is first obtained by revolving the upper prism A ; then the reading of the angle is taken, the negative strip B is then placed on the bed on an opal plate (not shown), A revolved till even illumination is again obtained, and the reading taken. The density is log $\tan^2 \theta'$ — log $\tan^2 \theta$, in which θ' is the angle with the negative plate and θ the angle without the negative. The log tan can be obtained from any book of mathematical tables.

Such calculations may seem formidable, but they consist really of reading logarithms from an ordinary book of mathematical tables, and the application of the three simple rules of arithmetic.

Development of the Plate.—The plate strips having been exposed, the next step is their development. Originally, Hurter and Driffield suggested the use of ferrous oxalate as the standard developer but, recognising that this was no longer in practical use, they adopted a non-staining pyro-soda developer, and this should be adopted now as the standard. The formula is :—

Pyrogallol	.	56 grs.	8 g.
Sodium sulphite cryst.	280 ,,	40 ,,	
Sodium carb., pure	. 280 ,,	40 ,,	
Distilled water to	. 16 oz.	1,000 ccs.	

This will not keep as one solution, but it can be easily prepared in two-solution form, the pyro and sulphite being dissolved in half the water and the carbonate in the remainder, and the two mixed just before use. A constant temperature must be maintained, and 65° F. (18° C.) may be adopted. Not only the developer, but the dish, the measures, and the plate itself, should be at this temperature. It is possible to use a properly constructed thermostat, but equally satisfactory results can be obtained by using a zinc or copper tank sufficiently large to contain dish, measures, and developer. Diagrams M and N represent a tank used by the author. The zinc tank holds half a gallon of water ; the dish made of copper is provided with projecting edges E, which are turned over so as to fit loosely on the edges of the tank. Sufficient room is provided in the tank to allow of the measure and the bottle of developer being placed in it to warm up. The water is heated to about 68° or 75° F., according to the season of the year, and the dish and the measures cool it down to 65° F. in about ten minutes. After exposure, the plate is also placed in the dish, covered with the opaque cover, and left for two or three minutes to warm up. The developer is flowed over the plate, the opaque cover replaced, and the dish gently rocked. There is not the slightest advantage in looking at the plate, and the opaque cover prevents any possible light fog. The duration of development is a matter of choice ; if too short the resulting densities are thin generally and difficult to measure, whilst if too long the higher densities are beyond the power of the photometer. For the above pyro-soda developer four minutes will be found to be about correct.

There is one point which is of considerable practical importance, and that is the use of two strips for speed determinations. For this reason it is strongly advised to cut the plate into two lengthwise before exposure. A fixed frame can be made with a guide for the diamond, and the

L. Martens's Polarisation Photometer

plate may be cut and put in the dark-slide and exposed as one. This will obviously yield two strips, the second of which should be developed for double the time of the first ; that is, eight minutes with pyro-soda. Of course, any other developer may be adopted as the standard, but then it is a question as to whether the system

can be correctly termed that of Hurter and Driffield. It has been repeatedly stated that certain developers will enable exposures to be reduced to one-third, one-fourth, and so on ; this is tantamount to saying that a particular developer will treble, quadruple, or otherwise increase the speed of the plate. This question has been examined by Sheppard and Mees, and they found that there were practically two classes of plates on the market—one that gives the same speed with all developers, and the other with which the speed is increased by using an organic developer instead of ferrous oxalate. They found that practically the second class of plate showed an increase of speed with organic developers over ferrous oxalate of 1·75 : 1.

Whatever be the developer adopted, it is important that no bromide be used.

As soon as development is finished the plate should be thoroughly fixed in an acid fixing bath, washed, immersed for a minute or two in a 5 per cent. solution of hydrochloric acid, rinsed under the tap, and the film gently rubbed with a

M. and N. Wall's Developing Tank

wet pledget of cotton wool and put away to dry. As soon as dry the back of the glass should be well cleaned with cotton-wool or a rag, and the dividing lines between the densities marked with a pen and ink, as this considerably facilitates the adjustment of the strip in the photometer.

Reading the densities.—The first thing to do is to calibrate the photometer. For accurate reading it is essential to work in a dark-room, and at least five minutes should be allowed to elapse before attempting to read so as to allow the retina to recover from the fatigue caused by bright light. To calibrate the photometer—that is to say, to find the zero—the spots or patches formed in the photometer box are compared, and the box shifted to right or left till they are of equal luminosity. At least three readings should be taken or six for preference, and the mean of these adopted.

The strip of plate should be thoroughly warmed, as this prevents the condensation of moisture on it, which is apt to occur if the heat from the lamps is great. The plate should then be slipped into the spring catch at the left hand

of the box or in its proper position and adjusted till the fog strip is over the aperture. The fog strip is that portion of the plate protected from any light action by the opaque card at the edges of the dark slide, and the reading of this is the density due to the glass, the gelatine and any fog inherent in the emulsion itself. Then the greatest density should be read, and all the others in turn, each being jotted down in a note-book kept for the special purpose. For the sake of convenience the decimal points may be neglected whilst reading, as they can always be inserted afterwards.

The following is an example of the reading of a plate developed for three minutes with a metol-hydroquinone developer at 65° F. (18° C.) :—

Plate A

Zero point, ·10 ; fog point, ·35 ; actual fog = ·35 − ·10 = ·25

Exposure C.M.S.	Reading	True density = Reading − (zero + fog = ·35)
40	2·65	2·30
20	2·67	2·32
10	2·65	2·30
5	2·55	2·20
2·5	2·35	2·00
1·25	1·90	1·55
·625	1·45	1·10
·312	1·05	·80
·156	·75	·40

Another plate gave the following readings :—

Plate B

Zero point, ·15 ; fog point, ·30 ; actual fog = ·30 − ·15 = ·15.

Exposure C.M.S.	Reading	True density = Reading − (zero + fog = ·30)
40	2·80	2·50
20	2·42	2·12
10	1·90	1·60
5	1·70	1·40
2·5	1·32	1·02
1·25	·98	·68
·625	·60	·30
·312	·40	·10
·156	·34	·04

A third plate gave the following :—

Plate C

Zero point, ·10 ; fog point, ·55 ; actual fog = ·55 − ·10 = ·45.

Exposure C.M.S.	Reading	True density = Reading − (zero + fog = ·55)
40	1·95	1·40
20	1·90	1·35
10	1·77	1·22
5	1·57	1·02
2·5	1·39	·84
1·25	1·20	·65
·625	·85	·30
·312	·65	·10
·156	·59	·04

If it is impossible to obtain equality of the fields with the highest densities, the luminosity of the right-hand side can be reduced by bringing

one of the smaller diaphragms into position and adding its value to the density reading. Thus, if with the largest supplementary diaphragm the density is found to be 3·45, the real density will be 3·45 + ·5 (the value of the supplementary diaphragm) = 3·95. It may be as well to point out that the accuracy of such high density readings as this is very doubtful. Having jotted down the readings, first the zero point is deducted from the fog, then the fog and zero are deducted from all the readings in turn, and the true densities thus found. The densities are then plotted out on charts, and the points joined up by holding a flexible rule along them and drawing pencil lines. The charts (see O, P, Q, and R) can be drawn on paper or scratched on a

bottom of the chart, as shown in O by the dotted lines; this gives the " inertia " of the plate.

The " inertia " of the plate is its slowness, and the speed of the plate is found by dividing 34 by the inertia. Frequently the inertia is expressed in logarithms, and is then called log I.

Turning to chart O, consider the three plates. First with regard to A, the straight line portion obviously lies between 2·5 and 0·312 C.M.S. or candle-metre-seconds. The density corresponding to 0·156 is too high, and this is the period of under exposure. From 2·5 to 5 C.M.S. the curve begins to flatten, and had the exposure been increased it would have turned right down again. This flattened portion from 2·5 to 40 C.M.S. is the period of over-exposure. The point

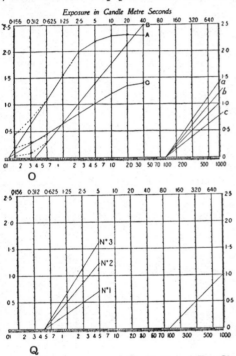

O

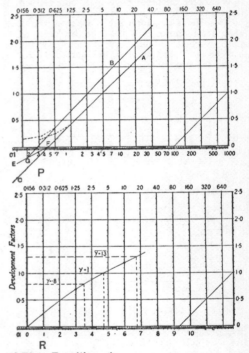

P

Q

R

O, P, Q and R. Charts of Plate Densities, etc.

slate. The inertia scale is merely the log scale of an ordinary slide rule repeated four times instead of twice. At the points 0·156, 0·312, 0·625, 1·25, etc., are drawn the vertical equidistant exposure lines, and the exposures can be written at the top. The " density " and " development factor " scales on the right and left respectively are exactly similar, and the distance from 0 to 1·0 should exactly correspond with the length of the inertia scale from 10 to 100 or 100 to 1,000. From the 100 point on the inertia scale draw the heavy line to 1·0 on the development factor scale. Having marked the densities corresponding to the exposures and joined up the points by straight lines, the characteristic curve of the plate is obtained. The speed is found as follows: by means of a transparent celluloid ruler or a piece of black thread find that portion that lies on a straight line and continue it till it cut the inertia scale at the

where the straight portion on being continued cuts the inertia scale is 0·15, therefore the speed of this plate was 34 ÷ 0·15 = 226 H. and D.

In plate B there is a totally different character; here the straight portion extends from ·625 to 40 C.M.S. As a matter of fact, it extended to 80 C.M.S., although this was not charted. The inertia is obviously 0·36, and the speed consequently 34 ÷ 0·36 = 95 H. and D. This would be an excellent landscape plate with considerable latitude of exposure, as the straight portion extends from ·36 to 40 C.M.S., or the range is 1 : 111. Plate A, on the other hand, has only a range of 1 : 25.

Plate C is peculiar, as it will be seen that the curve begins to fall off at 10 C.M.S.; the highest density is comparatively low, 1·40 for 40 C.M.S., yet the inertia is 0·15 and the speed therefore 226 H. and D.

It will be noted that the reading of plate A

BY H. ESSENHIGH CORKE, F.R.P.S.

FIRELIGHT EFFECT

at 10 C.M.S. was 1·60, obviously too low, as the straight line cuts at 1·76 ; here there is probably some little error in the plate coating which has given this low reading. The dotted portion of the curve is known as the " period of under-exposure," the straight portion that of " correct exposure," whilst the reverse or turning over of the curve as in A (diagram O) is known as " the period of over-exposure," the whole forming the characteristic curve of the plate.

The latitude of a plate can be easily calculated if the range of light intensities in a subject is known. For instance, with a landscape the range is usually about 1 : 30, and with plate B the latitude would be therefore 111 ÷ 30 = 3·7, so that it would be permissible to give an exposure from 1 to 3½ seconds and yet obtain a good negative.

Sheppard and Mees have given a mathematical expression and formula for finding the latitude of the plate, which they define as its opacity for blue violet light. They also suggest a much simpler method, which is to expose another plate of known inertia underneath the plate of which it is desired to know the latitude, and measure the apparent inertia ; the difference between the known inertia and that obtained will be the latitude of the plate.

It will be noted that on the right-hand side of the chart O are three lines a, b, c, drawn from the 100 point of the inertia scale and parallel with the straight portion of the curves A, B, and C. When a line thus drawn coincides with the line drawn from 100 to 1, which is obviously at an angle of 45°, the negative is correct as regards the rendering of the tones of the subject. If this development factor or gamma λ, as it is called, is above 1, as with plates A and B, the contrasts of the subject are increased ; whereas if below, as with C, the contrasts of the subject are reduced.

The development factor or λ is important, and may be calculated in various ways, as will be seen later.

It has already been advised that two strips should be exposed and developed together, the one for double the time of the other. This enables the operator to determine whether the plate contains free bromide, as this is sometimes added to the emulsion by the manufacturer, either in the shape of potassium or ammonium bromide or hydrobromic acid, to keep the plate clean. Free bromide in the film or added to the developer actually lowers the speed of the plate with a given time of development. If, then, on reading the second strip, developed for double the time, it is found to have a different inertia, the true speed of the plate can be found by charting the two readings and continuing the straight portion of the curve of the strip developed for the shorter time, which we will call A, to a point c below the inertia scale P. c may be any convenient point. Then from c draw the ordinate C D to the inertia scale and bisect this at E, connect E with F the inertia of A, and having charted B, the plate developed for double the time, continue the straight portion till it cuts E F at G ; then an ordinate from G to the inertia scale gives the true inertia of the plate. In P this operation is shown, and the inertia of A = ·46, that of B = ·29, whilst the true inertia is ·185. Bromide added to the developer increases the inertia in

the same way, though with continued development the true inertia is obtained.

The duration of development may be fixed at any convenient length, the only consideration limiting it being the ease of reading the densities. Prolonged development has no effect upon the inertia or speed of the plate. The sole result of shorter or longer development is the attainment of a lesser or greater development factor, provided the emulsion and developer contain no free bromide. This is clearly seen from the accompanying table and chart Q, the former being taken from an early issue of the *Photo-Miniature* by Driffield.

	1	2	3	4	5
	Exposure C.M.S.	Density	Density ratio	Opacity	Opacity ratio
Strip No. 1 developed 4 mins.	1.25	.310	1.0	2.04	1.0
	2.5	.520	1.67	3.31	1.62
	5.0	.725	2.33	5.30	2.59
Strip No. 2 developed 8 mins.	1.25	.530	1.0	3.38	1.0
	2.5	.905	1.70	8.03	2.37
	5.0	1.235	2.33	17.18	5.08
Strip No. 3 developed 12 mins.	1.25	.695	1.0	4.95	1.0
	2.5	1.140	1.64	13.80	2.78
	5.0	1.625	2.33	42.17	8.51

In column 1 are the exposures, in column 2 the densities, in column 3 the ratios between the densities, whilst in column 4 are the opacities, and in column 5 the ratios between the opacities.

As all the strips were exposed at once there is no question of variation here, but varying the length of development has produced densities which vary very widely, the increase being as much as 2 : 34. The densities given by Driffield have been charted, and it will be at once seen that the inertia obtained with all three strips is the same, but the gammas are very different. The fact of the inertias being the same proves that prolonged development will not " fetch more out of a plate," and the variation of gamma proves that by reducing or prolonging the time of development the photographer is in a position to alter the character of his prints by using a higher or lower gamma. For instance, assuming that a negative was developed to a gamma of ·7 as strip 1, it is obvious that the negative would be what is generally termed " thin," and therefore probably most suitable for gaslight paper. If it had a λ = 1·14 as strip 2, then it would be much denser, and probably suitable for P.O.P. ; whereas if it had a λ = 1·5 as No. 3, then it would be dense and suitable for rapid bromide paper. In the last case most probably the lower tones—that is, the shadows—would be much blocked up by the time the high lights were sufficiently printed, whilst in the first case high lights would be printed out before the shadows had obtained sufficient depth.

The Development Factor.—The development factor or gamma has already been defined as the degree of contrast in the negative. This is dependent in part on the plate and also on the

duration of development. Gamma may be found graphically as already described, or W. B. Ferguson's method may be adopted, this being to multiply the means of the highest densities by $3 \cdot 3$.

For instance, taking plate B (chart O), the upper densities and differences are :—

Densities	Differences	
$2 \cdot 50$	$3 \cdot 8$	
$2 \cdot 12$	$3 \cdot 6$	
$1 \cdot 76$	$3 \cdot 6$	mean $\cdot 3625$
$1 \cdot 40$	$3 \cdot 5$	
$1 \cdot 05$		

Then $\cdot 3625 \times 3 \cdot 3 = 1 \cdot 207$, which coincides with that found graphically.

The gammas usually adopted in practice are $\cdot 8$ for portraits, $1 \cdot 0$ for architecture, and $1 \cdot 3$ for landscapes. To find the necessary time to develop to any given gamma, plot out on a chart the gammas obtained by developing the two strips or by Ferguson's calculation, this chart being exactly the same as our speed chart, only the development factors are written on the left-hand side and the time of development at the bottom instead of the inertia scale (see R). Suppose that we obtain for the A strip $\lambda = \cdot 7$ with three minutes' development, and for B $\lambda = 1 \cdot 2$ with six minutes' development, plot these, and draw a curve connecting these points with the zero point (see R). Then, to find the necessary time to obtain any given gamma, draw a straight line from the required development factor and another at right angles to it till it cuts the time scale at the bottom, when, as will be seen from R, the times would be $3 \cdot 6$ minutes for $\gamma = \cdot 8$, $4 \cdot 6$ minutes for $\gamma = 1$, and 7 minutes for $\gamma = 1 \cdot 3$.

A moment's consideration will show that there must be a limit to the density obtainable on a plate, and this is termed $D\infty$, or gamma infinity $\gamma\infty$.

The Velocity Constant, or κ.—The velocity of development is the speed with which a plate develops; usually ferrous oxalate is used as the developer for photochemical investigations, but pyro-soda or other organic developer may be used instead. The mathematical expression for this factor is

$$\kappa = \frac{1}{t} \log \frac{D\infty}{D\infty - D}$$

or

$$\kappa = \frac{1}{t} \log_e \frac{\gamma_1}{\gamma_2 - \gamma_1}$$

In order to save calculation, Sheppard and Mees have given a table (reproduced in the next column) which enables κ to be found with very little trouble.

An example will make the use of this table clear. Two strips are developed, the first say for four minutes, and the second for double that time—that is, eight minutes. The gammas are found, as previously described, and assuming them to be $1 \cdot 5$ for the strip developed for the shorter time and $2 \cdot 1$ for that developed for double the time, then

$$2 \cdot 7 \div 1 \cdot 5 = 1 \cdot 8$$

In the second column of the table, headed

κ	$\dfrac{\gamma_2}{\gamma_1}$	Δ for Δ $0 \cdot 001$ in κ	κ	$\dfrac{\gamma_2}{\gamma_1}$	Δ for Δ $0 \cdot 001$ in κ
0·005	1·977	0·0050	0·205	1·358	0·0018
0·010	1·952	0·0048	0·210	1·349	0·0016
0·015	1·928	0·0050	0·215	1·341	0·0018
0·020	1·903	0·0046	0·220	1·332	0·0016
0·025	1·880	0·0044	0·225	1·324	0·0016
0·030	1·858	0·0042	0·230	1·316	0·0016
0·035	1·837	0·0040	0·235	1·308	0·0014
0·040	1·817	0·0040	0·240	1·301	0·0014
0·045	1·797	0·0038	0·245	1·294	0·0016
0·050	1·778	0·0038	0·250	1·286	0·0016
0·055	1·759	0·0036	0·255	1·278	0·0014
0·060	1·741	0·0034	0·260	1·271	0·0014
0·065	1·724	0·0034	0·265	1·264	0·0014
0·070	1·717	0·0032	0·270	1·257	0·0012
0·075	1·691	0·0032	0·275	1·251	0·0012
0·080	1·675	0·0030	0·280	1·245	0·0012
0·085	1·660	0·0032	0·285	1·239	0·0012
0·090	1·644	0·0032	0·290	1·233	0·0012
0·095	1·628	0·0032	0·295	1·227	0·0012
0·100	1·612	0·0032	0·300	1·221	0·0010
0·105	1·596	0·0032	0·305	1·216	0·0012
0·110	1·580	0·0030	0·310	1·210	0·0010
0·115	1·565	0·0028	0·315	1·205	0·0010
0·120	1·551	0·0028	0·320	1·200	0·0010
0·125	1·537	0·0028	0·325	1·195	0·0008
0·130	1·523	0·0026	0·330	1·191	0·0010
0·135	1·510	0·0028	0·335	1·186	0·0008
0·140	1·496	0·0024	0·340	1·182	0·0008
0·145	1·484	0·0024	0·345	1·178	0·0008
0·150	1·472	0·0024	0·350	1·174	0·0010
0·155	1·460	0·0024	0·355	1·169	0·0008
0·160	1·448	0·0022	0·360	1·165	0·0008
0·165	1·437	0·0022	0·365	1·161	0·0008
0·170	1·426	0·0020	0·370	1·157	0·0006
0·175	1·415	0·0018	0·375	1·154	0·0008
0·180	1·405	0·0018	0·380	1·150	0·0006
0·185	1·396	0·0020	0·385	1·147	0·0008
0·190	1·387	0·0020	0·390	1·143	0·0008
0·195	1·377	0·0018	0·395	1·139	0·0006
0·200	1·368	0·0020	0·400	1·136	0·0006

$\dfrac{\gamma_2}{\gamma_1}$ we find $1 \cdot 40$, and against this in column 1 under κ we find $\cdot 180$, but this is for 5 minutes.

$$\therefore (5 + 4) \times \cdot 180 = \cdot 225 = \kappa.$$

Column 3, headed Δ for Δ $\cdot 001$ in κ, is used as follows : supposing $t \dfrac{\gamma_2}{\gamma_1} = 1 \cdot 373$, the nearest number to this is $1 \cdot 377$, and Δ or the difference $= 1 \cdot 377 - 1 \cdot 373 = \cdot 004$, then $\cdot 004 \div \cdot 0018$, from the third column $= 2 \cdot 2$, therefore we take the κ of $1 \cdot 377$ and add $\cdot 0022$, thus—

$$\cdot 195 + \cdot 0022 = \cdot 197.$$

This table does not apply for any developer with a Watkins factor of over 15 ; if γ_2 is $1 \cdot 8$ times greater than γ_1, two other strips must be developed for twice as long as before.

We may now proceed to find $\gamma\infty$. The formula for this is

$$\gamma\infty = \frac{\gamma_1}{1 - e - \kappa t_1} \text{ or } \frac{\gamma_2}{1 - e - \kappa t_2}$$

In order to save calculation, Sheppard and Mees have given the table on the opposite page. An example will make the use of this table clear. The two strips having been read and γ_1 and γ_2 having been found, κ is calculated as just described, and we found in the case assumed $\kappa = \cdot 225$, then $\kappa t_1 = \cdot 225 \times 2 = \cdot 450$, in the second column headed $1 - e - \kappa t$ against this we find $\cdot 3617$, then

$$\gamma\infty = 1 \cdot 5 \div \cdot 3617 = 4 \cdot 14.$$

The higher the gamma infinity the more a plate may be forced in development, and for very fast

κt	1−e−κt	Δ for 0·01 in κt	κt	1−e−κt	Δ for 0·01 in κt
0·000	0·0000		2·000	0·8647	
0·025	0·02		2·025	0·8680	0·0013
0·050	0·046	0·0095	2·050	0·8712	
0·075	0·073		2·075	0·8744	
0·100	0·0952		2·100	0·8776	
0·125	0·1174	0·0086	2·125	0·8805	0·0012
0·150	0·1387		2·150	0·8834	
0·175	0·1600		2·175	0·8863	
0·200	0·1813		2·200	0·8892	
0·225	0·2082	0·0077	2·225	0·8919	0·00105
0·250	0·2252		2·250	0·8945	
0·275	0·2422		2·275	0·8971	
0·300	0·2592		2·300	0·8997	
0·325	0·2769	0·0071	2·325	0·9021	0·00096
0·350	0·2945		2·350	0·9045	
0·375	0·3121		2·375	0·9069	
0·400	0·3297		2·400	0·9093	
0·425	0·3458	0·0064	2·425	0·9113	0·00086
0·450	0·3617		2·450	0·9135	
0·475	0·3776		2·475	0·9157	
0·500	0·3935		2·500	0·9179	
0·525	0·4085	0·0057	2·525	0·9197	0·00078
0·550	0·4234		2·550	0·9217	
0·575	0·4373		2·575	0·9237	
0·600	0·4512		2·600	0·9257	
0·625	0·4641	0·0052	2·625	0·9274	0·00071
0·650	0·4772		2·650	0·9292	
0·675	0·4903		2·675	0·9310	
0·700	0·5034		2·700	0·9328	
0·725	0·5158	0·0047	2·725	0·9344	0·00064
0·750	0·5281		2·750	0·9360	
0·775	0·5394		2·775	0·9376	
0·800	0·5507		2·800	0·9392	
0·825	0·5613	0·0042	2·825	0·9408	0·00058
0·850	0·5714		2·850	0·9412	
0·875	0·5827		2·875	0·9426	
0·900	0·5934		2·900	0·9450	
0·925	0·6031	0·0038	2·925	0·9463	0·00052
0·950	0·6128		2·950	0·9476	
0·975	0·6225		2·975	0·9489	
1·000	0·6322		3·000	0·9502	
1·025	0·6485	0·0034	3·025	0·9513	0·00047
1·050	0·6547		3·050	0·9525	
1·075	0·6609		3·075	0·9537	
1·100	0·6671		3·100	0·9549	
1·125	0·6741	0·0032	3·125	0·9559	0·00043
1·150	0·6830		3·150	0·9570	
1·175	0·6909		3·175	0·9581	
1·200	0·6988		3·200	0·9592	
1·225	0·7059	0·0029	3·225	0·9601	0·00039
1·250	0·7131		3·250	0·9611	
1·275	0·7203		3·275	0·9621	
1·300	0·7275		3·300	0·9631	
1·325	0·7339	0·0026	3·325	0·9639	0·00036
1·350	0·7403		3·350	0·9648	
1·375	0·7469		3·375	0·9657	
1·400	0·7534		3·400	0·9666	
1·425	0·7592	0·0024	3·425	0·9674	0·00032
1·450	0·7651		3·450	0·9682	
1·475	0·7710		3·475	0·9690	
1·500	0·7769		3·500	0·9698	
1·525	0·7822	0·0022	3·525	0·9706	0·00029
1·550	0·7875		3·550	0·9713	
1·575	0·7928		3·575	0·9720	
1·600	0·7981		3·600	0·9727	
1·625	0·8029	0·0021	3·625	0·9732	0·00026
1·650	0·8077		3·650	0·9739	
1·675	0·8125		3·675	0·9746	
1·700	0·8173		3·700	0·9753	
1·725	0·8215	0·0017	3·725	0·9758	0·00023
1·750	0·8259		3·750	0·9764	
1·775	0·8303		3·775	0·9770	
1·800	0·8347		3·800	0·9776	
1·825	0·8387	0·0016	3·825	0·9780	0·00022
1·850	0·8426		3·850	0·9786	
1·875	0·8465		3·875	0·9792	
1·900	0·8504		3·900	0·9798	
1·925	0·8539	0·0014	3·925	0·9802	0·00019
1·950	0·8575		3·950	0·9807	
1·975	0·8611		3·975	0·9812	
			4·000	0·9817	

Extreme care must be used in employing the foregoing tables for finding γ∞, as a very small error will make a considerable difference in the result. Almost as satisfactory results may be obtained by adding 1 per cent. of potassium bromide to the developer and continuing development for half an hour, and after reading the strip finding γ∞ graphically by the chart. The quantity of bromide to be used depends upon the plate, the important point is that the plate should be as free from fog as possible, even with the prolonged development. Should the development—thirty minutes—be not long enough, this will be apparent from the inertia obtained from this long development being less than for the same plate without bromide, then the development must be longer still. The effect of bromide in the developer is at first to increase the inertia and decrease γ, but with prolonged development these effects disappear, and both the inertia and γ are the same as if no bromide were used.

The Photometric Constant.—Hurter and Driffield proved that the density was directly proportional to the amount of silver deposited, and this has been termed the photometric constant = P the quantity of silver in grammes per 100 square centimetres. Hurter and Driffield found that this was = ·0131, Eder obtained ·0103, and Sheppard and Mees found P = ·01031.

The Watkins and Wynne Plate Speeds.—Whilst the Hurter and Driffield system is generally used for plate testing, there are two other systems of plate speeds which are used with the Watkins and Wynne exposure meters, which are founded upon purely arbitrary standards. As it is often useful to know how to convert the one system into the other, the following rules can be used:—

To convert—

H. and D speed Nos. into Watkins, multiply by 50 and divide by 34; or practically H. and D. × 1½.

Watkins P Nos. into H. and D., divide by 50 and multiply by 34; or practically P No. × ¾.

Wynne F Nos. into Watkins, extract the square root and multiply by 6·4.

Wynne F Nos. into H. and D., extract the square root and multiply by 7·7.

In order to save trouble, the table on page 484 gives the inertias, the H. and D. Nos., and Watkins and Wynne in parallel columns. The inertias are those marked on the scale of the charts.

SEPARABLE LENS

A lens of which the front and back combinations may be used independently, either alone or in combination with other lenses. Rapid and wide-angle rectilinears, Zeiss VIIa anastigmats, Goerz double anastigmats, and Dallmeyer stigmatics may be taken as types of this class; while the Cooke, Tessar, and Aldis lenses belong to the non-separable class.

SEPIA BROMIDES (See "Sulphide Toning," "Blake-Smith Process," and "Alum-'hypo' Toning.")

SEPIA PAPER

A printing paper coated with a compound containing salts of silver and iron; development

shutter work—such as focal plane work, where practically the whole of the exposure falls in the period of under-exposure—a plate with a high γ∞ will give as good results as a very fast plate.

INERTIAS AND COMPARATIVE PLATE SPEEDS (*See* SENSITOMETRY)

Inertias	H. and D. Speed	Watkins P. No.	Wynne F. No.	Inertias	H. and D. Speed	Watkins P. No.	Wynne F No.	Inertias	H. and D. Speed	Watkins P. No.	Wynne F. No.
34.0	1.0	1.4	7.7	4.2	8.1	11.9	21.9	0.60	56.5	83.0	58.3
32.0	1.062	1.56	7.93	4.0	8.5	12.5	22.4	0.58	58.5	86.0	59.5
30.0	1.13	1.66	8.2	3.8	8.9	13.08	23.0	0.56	61.0	89.7	60.5
28.0	1.225	1.8	8.5	3.6	9.4	13.8	23.6	0.54	63.0	92.6	61.6
26.0	1.307	1.92	8.8	3.4	10.0	14.7	24.3	0.52	65.5	96.3	63.0
24.0	1.35	1.98	8.9	3.2	10.6	15.6	25.0	0.50	68.0	100.0	64.0
22.0	1.54	2.26	9.5	3.0	11.3	16.6	25.2	0.48	72.0	105.0	66.0
20.0	1.7	2.5	10.0	2.9	11.7	17.2	26.3	0.46	74.0	109.0	67.0
19.0	1.79	2.6	10.3	2.8	12.2	17.9	26.9	0.44	77.0	113.0	68.0
18.0	1.88	2.76	10.5	2.7	12.6	18.5	27.6	0.42	82.0	120.0	70.0
17.0	2.0	2.9	10.8	2.6	13.1	19.2	27.9	0.40	85.0	125.0	71.5
16.0	2.12	3.1	11.2	2.5	13.6	20.0	28.4	0.38	89.0	131.0	73.3
15.0	2.26	3.3	11.5	2.4	14.2	20.9	29.0	0.36	95.0	140.0	75.5
14.0	2.42	3.56	12.0	2.3	14.8	21.8	29.6	0.34	100.0	147.3	77.6
13.0	2.63	3.86	12.5	2.2	15.5	22.8	30.3	0.32	103.0	151.0	78.8
12.0	2.8	4.1	13.0	2.1	16.2	23.8	31.0	0.30	113.0	166.0	82.5
11.0	3.1	4.5	13.5	2.0	17.0	25.0	31.7	0.29	117.0	172.0	84.0
10.0	3.4	5.0	14.2	1.9	17.9	26.3	32.5	0.28	121.0	178.0	85.5
9.5	3.55	5.2	14.5	1.8	18.9	27.7	33.5	0.27	126.0	185.0	87.3
9.0	3.7	5.4	14.8	1.7	20.0	29.4	34.7	0.26	131.0	192.0	89.0
8.5	4.0	5.8	15.4	1.6	21.25	31.25	35.8	0.25	136.0	200.0	90.5
8.0	4.25	6.2	15.8	1.5	22.6	33.2	37.0	0.24	141.0	207.0	92.0
7.5	4.45	6.5	16.2	1.4	24.3	35.8	38.2	0.23	148.0	217.0	95.0
7.0	4.85	7.1	17.0	1.3	26.15	38.5	39.7	0.22	154.0	226.0	96.3
6.8	5.0	7.3	17.2	1.2	28.3	41.6	41.3	0.21	162.0	238.0	98.7
6.6	5.15	7.5	17.5	1.1	31.0	45.6	43.2	0.20	170.0	251.0	100.0
6.4	5.30	7.8	17.7	1.0	34.0	50.0	45.25	0.19	179.0	263.0	104.0
6.2	5.47	8.0	18.0	0.95	35.5	52.2	46.3	0.18	189.0	277.0	109.0
6.0	5.66	8.3	18.3	0.90	37.7	55.5	47.7	0.17	200.0	294.0	110.0
5.8	5.85	8.6	18.6	0.85	40.0	58.5	49.0	0.16	215.0	316.0	114.0
5.6	6.1	8.9	19.0	0.80	42.5	62.5	51.8	0.15	227.0	334.0	117.0
5.4	6.3	9.2	19.3	0.75	46.0	67.7	52.6	0.14	242.0	356.0	120.0
5.2	6.5	9.5	19.6	0.70	48.5	71.3	54.0	0.13	262.0	385.0	125.0
5.0	6.8	10.0	20.0	0.68	50.0	73.5	55.0	0.12	283.0	416.0	130.0
4.8	7.1	1.04	20.5	0.66	51.5	75.7	55.7	0.11	319.0	469.0	138.0
4.6	7.4	1.08	20.9	0.64	53.0	78.0	56.5	0.10	340.0	500.0	143.0
4.4	7.7	1.13	21.3	0.62	54.4	80.0	57.2				

being effected with plain water and fixing in a weak " hypo " bath, toning being optional. The finished prints are of a good sepia tone. The Namias process is recommended; for this two solutions for sensitising are required:—

A. Green ferric ammonio-citrate . 4 oz. 440 g.
 Citric acid . 1 „ 100 ccs.
 Distilled water . 10 „ 1,000 „
B. Silver nitrate . 1 oz. 110 g.
 Distilled water . 4 „ 400 ccs.

These are mixed together, made up to 20 oz. or 2,000 ccs., and applied to the paper with a Blanchard or Buckle brush, and then dried; the whole of the operations must be carried out in the dark-room. A second coating is sometimes advisable. The paper is printed in contact with a negative in daylight in the usual way, but not very deeply, because in the washing after printing a slight intensifying action takes place. After about five minutes' washing the print must be fixed for one to two minutes in an 8 per cent. solution of " hypo." The print is finally washed for about twenty minutes and then dried. The print previous to fixing is of an unpleasant yellow colour, but the operation of fixing changes the yellow colour to a good brown, such change being due, it is thought, to slight sulphurisation. If the fixed prints are not of a pleasing colour they may be toned in an alkaline sulphocyanide bath containing 1 gr. of gold chloride and 50 grs. of ammonium sulphocyanide per 5 oz. of water.

SEPIA PLATINOTYPES, OR SEPIATYPE
(*See* " Platinotype Process.")

SERUM PROCESS
An early process (about 1856) for preparing plain paper for printing. The paper was prepared with serum of milk, then salted or sensitised. The prints were of purple tone.

SHADING MEDIUM
A film of gelatine, bearing on its surface a pattern of stipple or line in relief; used in process work, etc. This film is stretched tightly on a wooden frame and backed with celluloid varnish. The surface of the film is inked, and the pattern can then be transferred to any part of a plate or stone requiring shading with stipple or line.

SHADOWGRAPHS
Silhouette photographs have been called shadowgraphs, but the name has been more generally applied to X-ray photographs.

SHAPE, CUTTING (*See* " Cutting Shape.")

SHAPES OF PHOTOGRAPHS
There is a strong tendency to restrict the shape of a photograph to some form of the rectangle, although an oval, a circle, and even a lunette, may be employed effectively at times. The rounding of two corners to form a " dome," or of four corners to form a " cushion," is still resorted to at times, but it is rarely desirable, and is probably a survival from the days when lenses frequently left the corners of the plate unexposed. The relation between the length and breadth of a rectangle is of distinct importance; a narrow upright panel, for instance, often

emphasises a suggestion of height. But the chief consideration is that the shape shall include only what is necessary to the making of the picture, and it would be distinctly wrong to include blank or uninteresting parts of the print simply to attain a particular proportion in the resulting rectangle.

SHARPNESS

The usual standard of sharpness, or critical definition, is that a point shall be represented by a circle not exceeding $\frac{1}{100}$ of an inch in diameter. This standard is easily attained, and, indeed, is far surpassed. Even at full working aperture lenses of a certain type will give satisfactory sharpness over the whole of the plate they are intended to cover. The focal field being practically a plane, there is no loss of sharpness towards the edges. On the other hand, lenses with a curved focal field will only give general sharpness of definition when a smaller stop is used.

To secure sharpness in every detail of the image the aperture of the lens is reduced until a satisfactory definition results. This may be done either to counteract poor marginal definition, or to secure sharpness in objects situated in different planes. It is desirable in certain cases to vary the degree of sharpness in different parts of the subject, the parts having the greatest sharpness generally being emphasised thereby. In other cases, sharpness is rather a drawback to a pleasing rendering of a subject. To throw the whole out of focus is not a satisfactory method of modifying sharpness; but there are types of lenses with an adjustment by means of which any required degree of softness or diffusion may be secured. Objectionable sharpness may be modified during printing by interposing between negative and paper one or more thicknesses of celluloid (clear or matt), or even by printing from the glass side of the negative. In enlarging, bolting silk is often used for a similar purpose. (*See also* "Definition.")

SHEATHS

Flat metal cases to hold plates, used in magazine cameras; each exposed plate is caused to fall into the bottom of the camera, leaving the next one in position for exposure. (*See also* "Magazine Camera.")

SHELLAC (*See* "Gums and Resins.")

SHELLAC MOUNTANT (*See* "Mountants.")

SHELLAC VARNISH

A solution of shellac in alcohol is used in process work as an acid resist for backing the plates, or stopping out margins or other parts to be protected from the etching. For 4 oz. of shellac about 6 oz. of methylated spirit is required. Sometimes about 2 drms. of methyl violet dye is added to colour the varnish. Formulæ for shellac varnishes for negatives are given under the heading "Varnishes."

SHINGLE MARKS

Defects met with in the wet-plate (collodion) process, and caused by the presence of water in the collodion, or by excessive coldness of the sensitising bath.

SHOP FRONTS, PHOTOGRAPHING

Shop fronts are always difficult subjects to photograph, because of the many reflections. A method often recommended is to have a black cloth larger than the window, and to place the lens through a hole in the cloth, the latter being fixed or held in such a way as to stop all reflections from the opposite side. This method, however, is rarely possible, because of the large size of some windows and the difficulty of arranging the cloth. The only practical and satisfactory method is to choose a time of day when the sun is not shining on the opposite buildings.

SHORTENING THE FOCUS (*See* "Focus Adjuster" and "Supplementary Lenses.")

SHUTTERS (Fr., *Obturateurs*; Ger., *Verschlüsse*)

Mechanical devices for exposing the plate. Their use is necessitated by the fact that exposures shorter than one-quarter of a second cannot be given by hand, nor even that without risk of

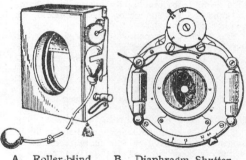

A. Roller-blind Shutter B. Diaphragm Shutter

shaking the camera. There are many kinds of shutters, a convenient classification being that which groups them into those working before the lens, between the lens combinations, and behind the lens, though this division is not rigid since many before-the-lens shutters can be used equally well behind. The earlier shutters, such as the flap, drop, and combined drop and flap shutters, belonged to the first class, and are practically obsolete, excepting the first-named, which is still found useful in studio work. The drop shutter has been completely superseded by the roller-blind shutter A, in which a spring blind with a central aperture is caused to pass before the lens. The speed is varied by altering the tension of the spring by means of a winding knob, a given number of turns corresponding to a given speed.

The focal plane shutter (*which see*) is also a roller-blind shutter, but is placed close to the plate. In this, not only can the spring tension be altered, but provision is made for varying the width of the slit or opening, thus giving a greater range of speed. This shutter has a higher efficiency, and is capable of greater rapidity than any other type; but is liable in some cases to cause distortion of moving objects, since the plate is exposed a portion at a time.

In the second class of shutters are included

those known as diaphragm shutters, which work between the combinations of the lens usually by the opening and closing of thin metal or vulcanite plates. The speed is varied either by adjusting the tension of a spring, by a pneumatic brake, or by altering the size of the aperture. Such shutters form part of the lens, as at B.

The rotary shutter, C, which may work either

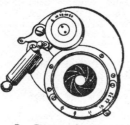

C. Rotary Shutter

between or in front of the lens, consists of a circular disc with an opening towards the side. This is made to revolve by means of a spring, the opening passing across the lens during the revolution.

The behind-lens bellows studio shutter consists of two semi-circular bellows, which open silently from the centre when the pneumatic ball is pressed, closing again as the latter is released. A clip prevents the return of the air when it is desired to keep the shutter open. (*See also* " Pneumatic Release," and other headings.)

SHUTTERS, EFFICIENCY OF

The proportion between the length of the exposure and the time during which the lens is fully uncovered. Two shutters may give exposures of the same rapidity, but of very different efficiency. Thus, one may take up the greater portion of the time in opening and shutting, while the other is fully open for the best part of the exposure. It thus results that with the first shutter a longer exposure is required to produce the same light effect as the second. The focal plane shutter is the most efficient, since the whole of the light from the lens reaches the plate.

SHUTTERS, INSTANTANEOUS (*See* " Instantaneous Shutter.")

SHUTTERS, TESTING

There are many different ways of testing shutter speeds. One is to photograph a wheel revolving at a known rate, and having at its margin a white spot or bright metal disc. On developing the negative, the spot or disc will be found to have formed a curve on the plate, and the length of this curve as compared with the circumference of the image of the wheel, divided into the time of revolution, gives the speed of the shutter. This can readily be carried out by setting a bicycle upside down and attaching a small silvered disc or bright button to one of the spokes close to the edge. The wheel is now set revolving until the disc or button reappears regularly at one place at intervals of exactly a second, the exposure being then made in bright sunshine or by burning magnesium

ribbon. Then, if the curve on the resulting negative measures, say, one-tenth the circumference of the image of the wheel, the exposure is obviously one-tenth of a second. For very rapid exposures the wheel may be revolved at a faster rate.

A bright spot or disc on a pendulum has also been used, allowance having to be made for the fact that the rate of swing is not uniform throughout the beat. A pendulum-testing device for use with a suitably graduated scale is on the market. A. Lockett, in 1909, suggested the employment of a bright ball on a conical pendulum, which revolves in a circle at a regular rate. There are numerous other methods, most of which, however, call for special apparatus.

SIDE SWING

An arrangement whereby the camera back may be inclined in a sideways direction. This adjustment is useful when photographing buildings or other objects that recede from the camera. In such a case, one side of the picture will be out of focus as compared with the other, unless the lens is stopped down; but by using the side swing the definition is equalised, although a slight distortion is introduced.

SIDEBOTHAM'S PROCESS

A waxed paper process introduced by J. Sidebotham, of Manchester, in 1855.

SIDEREAL PHOTOGRAPHY

The photography of stars, the term " sidereal " being derived from a Latin word meaning a star. The methods of photographing stars, planets, nebulæ, etc., are described under the heading " Stars, Photographing."

SIDEROSTAT

An instrument used in astronomical photography, photomicrography, spectrography, etc., and known also as a heliostat (*which see*).

SILHOUETTES (Fr., *Silhouettes ;* Ger., *Schattenbilder*)

Black profile portraits (as A) showing outline only and no details, so-called from the Frenchman Etienne de Silhouette. They may be produced photographically, as shown in B. A white sheet B is hung in an open doorway; the room

A. Silhouette

being darkened, the sitter D is posed in profile in the room and against the sheet, the camera E being in the room as shown. A short exposure is given, and a strong developer used in order to procure a negative showing the black (clear glass in the negative) profile against a perfectly white (black in the negative) back-

ground. A longer exposure will produce faint details, but these are not required in a true silhouette. At night, flashlight may be used behind the sheet and the same effect produced. The curve at the bottom of the silhouette picture is obtained by painting over the bare glass on the negative with opaque pigment or by covering it with red or black paper. Full-length figures may also be taken.

Another and a widely used method of taking silhouettes is shown in sketch C. Two dark screens A are placed parallel to one another, and a white background B is placed so as to catch the light from the window C. The sitter D is then placed between the screens so as not to

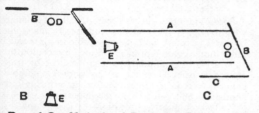

B. and C. Methods of Producing Photographic Silhouettes

catch the direct light from the window; the camera is placed at E, and a dark cloth or curtain is thrown over the screens so as to form a tunnel. The sitter is in the shade, while a brilliant light falls upon the background. Focusing must be accurate in order that the outlines of the figure may be perfectly sharp. Any printing process may be used, but one giving a black-and-white effect is best.

SILK, PHOTOGRAPHS ON (See "Fabrics, Printing on.")

SILVER (Fr., *Argent*; Ger., *Silber*)

Ag. Atomic weight, 108. A white, comparatively soft metal, obtained from numerous ores. It is not attacked by weak acids, but dissolves in cold nitric acid and hot sulphuric acid. It forms a large number of salts, all of which are more or less sensitive to light, and are the bases of most printing processes and the sensitive materials for negative work. Silver exists in various states of fine powder, and can then be either black or coloured.

SILVER ACETATE (Fr., *Acétate d'argent*; Ger., *Silberacetat*)

$AgC_2H_3O_2$. Molecular weight, 167. Solubilities, 1 in 100 water, insoluble in alcohol. It is in the form of fine white powder or crystals, obtained by adding an alkaline acetate to silver nitrate solution or by dissolving silver carbonate in glacial acetic acid. It has been occasionally used in printing-out papers, but it gives yellowish grey images of low intensity, and its sensitiveness is only about one-fifteenth that of silver chloride.

SILVER ACETO-NITRATE

A solution of silver nitrate containing glacial acetic acid, used in the old wet plate days.

SILVER ALBUMINATE (Fr., *Albuminate d'argent*; Ger., *Silberalbuminat*)

A very ill-defined compound of silver nitrate and albumen, which was supposed to form one of the sensitive compounds in the old sensitised albumen paper.

SILVER AMMONIO-NITRATE (Fr., *Ammonio-nitrate d'argent*; Ger., *Salpetersaures Silberoxydammoniak*, or *Silberoxydammoniak*)

Synonym, ammonio-oxide of silver. $AgNO_3$ $2NH_3$. Molecular weight, 204. Solubilities, very soluble in water and alcohol. It takes the form of colourless needles, and is obtained by mixing a solution of ammonia with a silver nitrate solution and carefully evaporating, but nearly always it is prepared in solution by adding ammonia to silver nitrate solution till a clear solution is obtained; at first, on the addition of the ammonia, a blackish brown precipitate of silver oxide is formed, which dissolves in excess of ammonia to form a clear solution. A solution thus prepared is used for sensitising plain paper, and also to form silver bromide in emulsion making. According to the above formula, two molecules of ammonia are required for every molecule of silver nitrate, but it is possible to obtain a clear solution with only half the quantity of ammonia by dividing the silver solution into two equal parts, to the one adding enough ammonia solution to obtain a clear solution, and then adding the other half of the silver nitrate. The solution containing the lesser quantity of ammonia gives emulsions freer from fog, but usually of lower sensitiveness.

SILVER AMMONIO-CARBONATE (Fr., *Ammonio-carbonate d'argent*; Ger., *Kohlensaures Silberoxydammoniak*)

Ag_2CO_3 $4NH_3$ (ascribed to it by Eder). Molecular weight, 229. Solubilities, soluble in water and alcohol. It is not found in the solid form, but always in solution, and is prepared by adding a solution of ammonium carbonate to a silver nitrate solution, when a yellow precipitate of silver carbonate is first formed, which dissolves in excess of the ammonium carbonate, carbonic acid being evolved. It is occasionally used in emulsion making, particularly for slow, clean-working emulsions.

SILVER AMMONIO-CITRATE (Fr., *Ammonio-citrate d'argent*; Ger., *Citronensaures Silberoxydammoniak*)

Solubilities, very soluble in water and alcohol. It is prepared by adding citric acid to silver nitrate solution, and then a solution of ammonia; a white, curdy precipitate of silver citrate first forms which is soluble in excess of ammonia. It is used in preparing slow, clean-working negative and positive emulsions, and also for printing-out emulsions.

SILVER BATH (Fr., *Bain d'argent*; Ger., *Silberbad*)

A solution of silver nitrate used for sensitising wet collodion plates and albumenised and plain papers, which is frequently designated "48-grain bath," "60-grain bath," etc., this referring to the number of grains of silver nitrate dissolved

in 1 oz. of water. The following are typical formulæ :—

Silver Bath for Line Work

Silver nitrate	. 300 grs.	69 g.	
Distilled water to	10 oz.	1,000 ccs.	
Potass. iodide sol. (8 grs. per oz.)	. 7½ mins.	1·56 ,,	
Sod. carbonate crystals	15 grs.	3·45 g.	

Silver Bath for Half Tones

Silver nitrate	. 350 grs.	80 g.

Other ingredients as above.

Dissolve the silver in one-fourth of the water, add the iodide solution, and shake till the yellow precipitate is dissolved, then add the carbonate and shake well, and then the rest of the water. Place the bath in a bright light for twenty-four hours, filter, and add enough dilute nitric acid to render acid, using methyl orange as an indicator.

Silver Bath for Albumen Paper

The silver bath for albumen paper is usually made thus :—

Silver nitrate	. 350 grs.	80 g.
Citric acid	. 500 ,,	114 ,,
Distilled water to	. 10 oz.	1,000 ccs.

SILVER BROMIDE (Fr., *Bromure d'argent ;* Ger., *Bromsilber*)

Synonym, bromide of silver. AgBr. Molecular weight, 188. Solubilities, practically insoluble in water, alcohol and ether, soluble in ammonia, potassium cyanide and sodium hyposulphite. It is a yellow amorphous powder, obtained by adding any soluble bromide to silver nitrate solution. For photographic purposes it is always prepared in the presence of some vehicle which holds it in suspension in the form of an emulsion and prevents it from forming coarse granules. If, as is usually the case, the bromide is precipitated in the presence of ammonia, a much more sensitive salt is obtained, and the sensitiveness can be increased by digestion in the warmth for some time or merely by allowing the emulsion to stand. Under these conditions the grain of the silver bromide probably increases in size, and also the light which it absorbs alters in character. Freshly prepared gelatino-bromide emulsion is transparent and a deep ruby colour ; by the action of ammonia or heat it becomes more opaque, and the light transmitted changes to orange, and by further ripening to yellow, green, greenish blue, and blue, these changes being accompanied by increases in sensitiveness.

Silver bromide is the most light-sensitive silver salt, but, unlike silver chloride, does not give rise to dark-coloured products on prolonged exposure, except in the presence of some halogen absorber such as silver nitrate, potassium nitrite, or metabisulphite. Its spectrum sensitiveness varies with its method of preparation and degree of ripening, but practically it may be considered to extend from the ultra-violet to about F in the bright blue, with the maximum about F½ G.

SILVER CARBONATE (Fr., *Carbonate d'argent ;* Ger., *Kohlensaures Silberoxyd*)

Ag_2CO_3. Molecular weight, 276. Solubilities, insoluble in water and alcohol, soluble in potassium cyanide, ammonia, and sodium hypo-sulphite. It is a yellow granular powder, prepared by adding an alkaline carbonate to silver nitrate solution. Occasionally it is used in printing-out and negative emulsions.

SILVER CHLORATE (Fr., *Chlorate d'argent ;* Ger., *Silberchlorat*)

$AgClO_3$. Molecular weight, 191·5. Solubilities, 1 in 20 water, insoluble in alcohol and ether. It is a white granular powder or minute crystals obtained by dissolving silver oxide or carbonate in chloric acid. It cannot be made by adding a chlorate to silver nitrate. Practically of no photographic importance.

SILVER CHLORIDE (Fr., *Chlorure d'argent ;* Ger., *Chlorsilber*)

Synonym, chloride of silver. AgCl. Molecular weight, 143·5. Solubilities, practically insoluble in water, alcohol, and ether, soluble in ammonia, potassium cyanide, and sodium hyposulphite. It is a white granular powder, obtained by precipitation from silver nitrate by adding a soluble chloride. It is used principally for printing-out emulsions and positive development processes.

Red silver chloride (one of Carey Lea's " photo-salts ") is produced by acting on ordinary silver chloride with a reducing agent.

SILVER CHROMATE (Fr., *Chromate d'argent ;* Ger., *Silberchromat*)

Ag_2CrO_4. Molecular weight, 332. Solubilities, insoluble in water, alcohol, and ether ; soluble in ammonia and " hypo." It is in the form of a red amorphous powder, obtained by adding potassium chromate to silver nitrate solution. The addition of a very small proportion of this salt to a printing-out emulsion reduces the gradation, and makes the paper more suitable for thin, flat negatives.

SILVER CITRATE (Fr., *Citrate d'argent ;* Ger., *Silbercitrat, Citronensaures Silberoxyd*)

Synonym, citrate of silver. $AgC_6H_5O_7$. Molecular weight, 297. Solubilities, insoluble in water, alcohol and ether, soluble in ammonia, potassium cyanide and " hypo." It is a curdy, white powder, obtained by adding an alkaline citrate to silver nitrate solution ; practically but little citrate is formed by using citric acid. It is employed in printing-out emulsions.

SILVER CUTTINGS (*See* " Residues.")

SILVER CYANIDE (Fr., *Cyanure d'argent ;* Ger., *Silbercyanid*)

AgCN. Molecular weight, 134. Solubilities, insoluble in water, alcohol, and ether, soluble in ammonia, potassium cyanide, and " hypo." It is a white powder, obtained by adding an alkaline cyanide to silver nitrate solution ; it is the blackening agent in Monckhoven's intensifier.

SILVER FLUORIDE (Fr., *Fluorure d'argent ;* Ger., *Silberfluorid*)

$AgF 4H_2O$. Molecular weight, 199. Solubilities, very soluble in water and alcohol. It takes the form of yellow conglomerate crystals, obtained by dissolving silver oxide or carbonate in hydrofluoric acid ; it cannot be made by adding an alkaline fluoride to silver nitrate.

SILVER IMAGE (Fr., *Image d'argent*; Ger., *Silberbild*)

A term applied to negatives or positives produced by the action of light on a silver salt.

SILVER INTENSIFIER

The silver intensifier has the advantage that the density is under control, and either little or much intensification can be given. The film should be hardened in a 10 per cent. solution of formaline for three minutes and then washed in water. Wellington's formula (1889) is :—

A. Silver nitrate	120 grs.	28 g.
Water (distilled)	2 oz.	200 ccs.
B. Ammonium sulpho-cyanide	240 grs.	56 g.
Water	3 oz.	300 ccs.

Add B to A, and keep in a dark place. The bottle is shaken immediately before use, and some of the liquid poured into a vessel. A strong " hypo " solution is then added very slowly till all but a trace of the precipitate has dissolved. To each ounce of this solution 3 grs. of a 10 per cent. stock solution of pyro (preserved with sodium sulphite) and 4 mins. of liquor ammoniæ are added, and the solution poured upon the plate and allowed to act until the desired density is obtained. A few drops more of ammonia may be added if the action is slow in beginning, but too much will spoil the bath by precipitating the silver. The plate is then refixed for ten minutes in an ordinary " hypo " bath and then well washed. As the intensifier contains " hypo," a prolonged washing is not necessary after the first fixing and previous to intensifying. Many modifications of the above formula have appeared, but all are much alike in the results they give. Some workers recommend the rinsing of the intensified plate in a bath of 6 mins. of hydrochloric acid and 1 oz. of water before re-fixing, using an alkaline fixing bath.

For Farmer's silver intensifier, solutions of 1 oz. of silver nitrate in 12 oz. of distilled water and ¾ oz. of potassium bromide in 2 oz. of distilled water are mixed together, and the precipitate is removed, washed with water, and stirred into a solution of 2 oz. of " hypo " in 6 oz. of water. In a few hours' time, filter and make up to 16 oz. with distilled water. In this immerse the negative for five minutes, and then develop with ferrous oxalate or with a pyro-silver bath, consisting of pyro, 4 grs.; distilled water, 2 oz.; silver solution, 60 mins.; and 10 per cent. solution of ·880 ammonia, 30 mins. Wellington's improved formula (1911) is given under the heading " Wellington's Silver Intensifier." For Monckhoven's intensifier, *see* under its own heading.

SILVER IODIDE (Fr., *Iodure d'argent*; Ger., *Iodsilber*)

AgI. Molecular weight, 235. Solubilities, practically insoluble in water, alcohol, and ether, soluble in potassium cyanide, and " hypo." It is obtained by adding a soluble iodide to silver nitrate solution; when precipitated in the presence of excess of alkaline iodide it is a pale yellow powder, whilst with excess of silver nitrate it is a deep orange, curdy precipitate; the latter darkens in light, whilst the former undergoes no visible change. It is but very slightly soluble in strong ammonia, 1 in 2,500 parts, but it is readily soluble in potassium iodide solution, forming a double salt AgIKI, or AgI2KI, both of which are decomposed by the addition of water, depositing pale yellow powdery silver iodide. It is also soluble in silver nitrate solution, forming the double salt 2AgNO₃AgI, which is more soluble in cold than in hot solutions. A 10 per cent. solution of the nitrate dissolves ·053 per cent. AgI, an 8 per cent. solution ·077 per cent., and alcoholic and ethereal solutions dissolve more. The negative silver bath for sensitising wet collodion plates should always be saturated with silver iodide before use, otherwise the iodide will be dissolved from the film.

Silver iodide is chiefly employed for the wet-plate process, and as an addition to gelatino-bromide emulsions, in which it acts as a restrainer of fog during digestion and produces greater sensitiveness. It is usually mixed with the alkaline bromide, and it is supposed to form a double salt generally known as bromo-iodide of silver, and this is confirmed by the fact that such an emulsion only shows one maximum of sensitiveness in the spectrum, whereas the two salts separately emulsified and then mixed show two distinct maxima.

SILVER LACTATE (Fr., *Lactate d'argent*; Ger., *Silberlactat, Milchsaures Silber*)

AgC₃H₅O₃ H₂O. Molecular weight, 215. It is in the form of white crystals or powder, obtained by dissolving silver carbonate in lactic acid. It is very rarely used, and then in printing-out emulsions.

SILVER METER (*See* " Argentometer.")

SILVER NITRATE (Fr., *Azotate d'argent*; Ger., *Silbernitrat, Salpetersaures Silber*)

AgNO₃. Molecular weight, 170. Solubilities, 1 in 1 water, 1 in 26 alcohol, 1 in 5 boiling alcohol. It is in the form of colourless rhombic plates, and is obtained by direct solution of silver in nitric acid or by dissolving the oxide or carbonate. It is not in itself sensitive to light, but is readily reduced to the metallic state in the presence of organic matter, such as gelatine, paper, or the skin. It is the salt from which are formed all sensitive materials in photography in which silver is used.

In process work, silver nitrate is sometimes used for etching baths for steel, and the following formula is recommended :—Alcohol 6 parts, distilled water 6 parts, pure nitric acid 16·6 parts, silver nitrate ·83 part.

SILVER NITRITE (Fr., *Azotite d'argent*; Ger., *Salpetrigsaures Silber*)

AgNO₂. Molecular weight, 154. Solubilities, 1 in 300 water. It is a crystalline white powder, obtained by precipitation from silver nitrate by an alkaline nitrite, and is of no photographic importance.

SILVER OXALATE (Fr., *Oxalate d'argent*; Ger., *Silberoxalat, Oxalsaures Silber*)

Ag₂C₂O₄. Molecular weight, 304. Solubilities, practically insoluble in water and alcohol,

soluble in nitric acid. It is a white crystalline powder, obtained by adding an alkaline oxalate to silver nitrate. It has been suggested for printing-out emulsions, but is rarely used.

SILVER OXIDE (Fr., *Oxyde d'argent ;* Ger., *Silberoxyd*)

Ag_2O. Molecular weight, 232. Solubilities, practically insoluble in water, alcohol, and ether. It is a heavy, brownish-black powder, obtained by precipitation from silver nitrate by a caustic alkali, and is practically of no importance photographically.

SILVER PHOSPHATE (Fr., *Phosphate d'argent ;* Ger., *Silberphosphat*)

Synonym, normal silver orthophosphate. Ag_3PO_4. Molecular weight, 419. Solubilities, insoluble in water, alcohol, and ether, soluble in organic acids, ammonia, potassium cyanide, and "hypo." It is used for printing-out emulsions, and gives an extremely long scale of gradation—that is, very soft flat prints from strong negatives. It occurs as a heavy yellow powder and can be prepared by adding phosphoric acid to silver nitrate or by using ordinary sodium phosphate (Na_2HPO_4); the reaction that takes place is
$3AgNO_3 + Na_2HPO_4 = Ag_3PO_4 + 2NaNO_3 + HNO_3$. The resulting liquid contains free nitric acid, which dissolves some of the silver phosphate.

SILVER POISONING

All silver salts are more or less poisonous when taken internally, and the antidotes are table-salt or any soluble chloride followed by emetics and mucilaginous drinks, or white of egg and milk, and the use of the stomach pump.

SILVER PRINTS

A generic term, including all prints of which the image is metallic silver, such as plain or salted paper, collodio-chloride, gelatino-chloride, bromide and gaslight and kallitype prints.

SILVER PROCESSES

All processes or methods in which silver is used.

SILVER RESIDUES (*See* "Residues.")

SILVER SALTS

A description of the individual silver salts is given under their respective headings. Practically all the silver salts are sensitive to light either *per se* or in contact with organic matter. Marktanner Turneretscher compiled the following table, which gives an extremely useful outline of the sensitiveness of the various salts and the intensity of the printed-out image. He used a Vogel photometer, exposed the paper for an equal time, took the last visible number as the speed, silver chloride on paper being set as 100.

SILVER SALTS : TURNERETSCHER'S TABLE OF SENSITIVENESSES, ETC.

Name and chemical formula (solubility)	I.—With Excess of Silver				II.—With Excess of Salt				Remarks
	A.—*Without ammonia fuming*		B.—*With ammonia fuming*		A.—*Without ammonia fuming*		B.—*With ammonia fuming*		
	Sensitiveness for AgCl=100	*Colour and intensity of the same*	*Sensitiveness for AgCl=100*	*Colour and intensity of the same*	*Sensitiveness for AgCl=100*	*Colour and intensity of the same*	*Sensitiveness for AgCl=100*	*Colour and intensity of the same*	
1. Silver chloride, AgCl (insoluble)	100	Blue black ; very intense	100	Blue black ; more intense than without fuming	80	Violet ; very intense	200	Violet ; very intense	Although very intense with excess of salt, yet less than with excess of silver
2. Silver bromide, AgBr (insoluble)	700	Bluish grey; not intense	900	Bluish grey ; not intense	250	Bluish grey ; not intense	300	Bluish grey ; not intense	Scarcely more intense with than without ammonia fuming
3. Silver iodide, AgI (insoluble)	300	Greenish grey ; not intense	450	Reddish grey ; not intense	40	Yellowish grey; not intense	75	Yellowish grey; not intense	Fuming scarcely increases the intensity
4. Silver chloride freed from excess of silver by washing before exposure	95	Slightly reddish violet ; very intense	100	Slightly reddish violet ; very intense					Less intense than normal paper ; scarcely more intense with fuming
5. Silver chloride, washed as in 4, then floated on a solution of potass. nitrite	80	Near the normal paper in intensity	130	Equal to the normal paper					Prepared according to Abney's process
6. Silver chloride, washed as in 4, then floated on sodium sulphite solution	100	Violet ; very intense	100	Violet ; very intense					Does not quite equal the intensity of the normal paper, but much more intense than washed paper.

SILVER SALTS : TURNERETSCHER'S TABLE OF SENSITIVENESSES, ETC.
—continued

Name and chemical formula (solubility)	I.—With Excess of Silver				II.—With Excess of Salt				Remarks
	A.—Without ammonia fuming		B.—With ammonia fuming		A.—Without ammonia fuming		B.—With ammonia fuming		
	Sensitiveness for AgCl=100	Colour and intensity of the same	Sensitiveness for AgCl=100	Colour and intensity of the same	Sensitiveness for AgCl=100	Colour and intensity of the same	Sensitiveness for AgCl=100	Colour and intensity of the same	
7. Silver nitrate, $AgNO_3$ (on paper)	6	Reddish ; not intense	8	Reddish ; not intense					Silver nitrate does not darken alone, only in the presence of organic matter
8. Silver albuminate without silver nitrate	13	Red ; slightly intense	30	Bluish ; slightly intense					Prepared by floating paper on whipped albumen, then on $AgNO_3$
9. Silver chloride albumen paper, freshly sensitised	50	Purple brown ; very intense	60	Purple brown ; very intense					So-called " Rosabrilliant " paper was used
10. Preserved commercial silver chloride albumen paper	70	Purple brown ; very intense	80	Purple brown ; very intense					
11. Gelatino-bromide dry plate					600	Greenish grey ; not intense			
12. Silver formate, H—COOAg									The sensitised paper darkened even in an absolutely dark room
13. Silver acetate, CH_3—COOAg (1 : 97)	6	Yellowish grey ; slightly intense	20	Reddish grey ; tolerably intense	4	Yellowish grey; not intense	15	Reddish grey ; slightly intense	
14. Silver propionate, CH_3—CH_2—COOAg (1 : 119)	6	Red brown ; slightly intense	10	Yellow brown ; slightly intense	7	Red brown ; slightly intense	15	Yellow brown ; slightly intense	
15. Normal silver butyrate, $CH_3(CH_2)_2COOAg$ (1 : 200)	8	Reddish yellow ; moderately intense	22	Red brown ; moderately intense	10	Reddish grey ; moderately intense	20	Grey brown ; moderately intense	Colour more intense than with the isobutyrate
16. Silver isobutyrate, $(CH_3)_2$—CH—COOAg (1 : 108)	7	Yellowish red ; not intense	18	Brownish ; slightly intense	6	Reddish brown ; slightly intense	18	Red brown ; slightly intense	Colour somewhat less intense than with the normal salt
17. Silver valerianate, $(CH_3)_2CH CH_2$—COOAg (1 : 540)	8	Violet brown ; moderately intense	14	Reddish grey ; tolerably intense	14	Reddish grey ; moderately intense	30	Grey brown ; moderately intense	
18. Silver caproate, $(CH_3)_2CH(CH_2)_2$—COOAg (soluble with great difficulty)	9	Grey ; moderately intense	15	Grey ; moderately intense	14	Reddish brown ; tolerably intense	24	Grey ; moderately intense	
19. Silver heptylate, $CH_3(CH_2)_5COOAg$ (soluble with difficulty)	10	Brownish violet ; tolerably intense	14	Grey violet ; tolerably intense	14	Brown violet ; tolerably intense	16	Grey brown ; intense	
20. Silver octylate, $CH_3(CH_2)_6COOAg$ (scarcely soluble)	12	Grey ; slightly intense	5	Grey ; not intense	17	Reddish brown ; tolerably intense	6	Grey brown ; slightly intense	
21. Silver pelargonate, $CH_3(CH_2)_7COOAg$ (insoluble in cold water)	25	First red, then grey ; tolerably intense	30	Grey ; tolerably intense	20	First red, then grey ; tolerably intense	25	Brown ; tolerably intense	

SILVER SALTS : TURNERETSCHER'S TABLE OF SENSITIVENESSES, ETC.
—continued

Name and chemical formula (solubility)	I.—With Excess of Silver				II.—With Excess of Salt				Remarks
	A.—Without ammonia fuming		B.—With ammonia fuming		A.—Without ammonia fuming		B.—With ammonia fuming		
	Sensitiveness for AgCl=100	Colour and intensity of the same	Sensitiveness for AgCl=100	Colour and intensity of the same	Sensitiveness for AgCl=100	Colour and intensity of the same	Sensitiveness for AgCl=100	Colour and intensity of the same	
22. Silver caproate, $CH_3(CH_2)_8COOAg$ (insoluble)	5	Brown violet; slightly intense	6	Reddish grey; not intense	14	Reddish brown; tolerably intense	18	Reddish grey; tolerably intense	The paper remained white for several weeks when kept in the dark
23. Silver palmitate, $CH_3(CH_2)_{14}COOAg$ (insoluble)	5	Yellowish; not intense	6	Yellowish grey; not intense	3	Yellowish; not intense	8	Yellowish grey; not intense	The salt solution was used $\frac{1}{10}$ normal
24. Silver stearate, $CH_3(CH_2)_{16}COOAg$ (insoluble)	14	Grey; not intense	22	Grey; not intense					In one *whole* day's exposure the paper turns velvet brown; solution of the salt $\frac{1}{4}$ normal
25. Silver cerotate, $CH_3(CH_2)_{25}COOAg$ (insoluble)	1	Yellowish grey; slightly intense	5	Yellowish; slightly intense	2	Yellowish; not intense	5	Yellowish; not intense	The salt solution was used $\frac{1}{10}$ normal
26. Silver oleate, $C_{18}H_{33}COOAg$	10	Reddish grey; slightly intense	11	Greenish grey; slightly intense	9	Reddish grey; slightly intense	6	Grey; slightly intense	The salt solution was used $\frac{1}{4}$ normal
27. Silver glycollate, $CH_2OH.COOAg$ (soluble with difficulty)	6	Yellow red; tolerably intense	11	Brownish; slightly intense	4	Yellowish grey; not intense	7	Brownish; not intense	
28. Silver lactate, $CH_3CHOHCOOAg$ (1 : 20)	8	Yellowish red; tolerably intense	16	Yellow red; tolerably intense	17	Rusty yellow; tolerably intense	18	Grey; tolerably intense	On account of the insolubility of the salt alcohol was used to prepare the paper
29. Silver paralactate, $CH_3CHOHCOOAg$	7	Yellowish red; tolerably intense	17	Yellow red; tolerably intense	17	Rusty yellow to brown; tolerably intense	17	Grey brown; tolerably intense	The paper prepared with excess of salt was rather more intense than with excess of silver
30. Silver oxalate, $COOAg-COOAg$ (insoluble)	2	Reddish; not intense	80	Red brown; very intense	20	Dark brown; intense	70	Dark brown; very intense	
31. Silver malonate, $CH_2OH(COOAg)_2$ (soluble with difficulty)	4	Reddish grey; slightly intense	8	Grey; tolerably intense	5	Reddish yellow; slightly intense	13	Reddish brown; tolerably intense	
32. Silver malate, $C_2H_3OH(COOAg)_2$ (soluble in hot water)	2	Red brown; slightly intense	18	Grey brown; intense	7	Red brown; intense	13	Red brown; very intense	
33. Silver tartrate, $(CHOH)_2(COOAg)_2$ (soluble with difficulty)	7	Red brown; intense	17	Red brown; intense	6	Reddish brown; tolerably intense	24	Red brown; very intense	
34. Silver citrate, $C_6H_5O_7Ag$ (soluble in boiling water)	15	Grey brown; moderately intense	18	Red brown; intense	6	Brown; moderately intense	12	Grey brown; intense	
35. Silver hippurate, $CH_2 < {NHC_7H_5O \atop COOAg}$	12	Rusty brown; tolerably intense	24	Grey brown; tolerably intense	16	Rusty brown; tolerably intense	50	Grey brown; tolerably intense	

SILVER STAINS

Dark brown or red stains which appear on negatives during or after printing upon P.O.P. or other paper containing soluble silver salts, either the paper or the negative being damp. To prevent them the negative should be varnished. To remove them, immerse the negative in a solution of 20 grs. of potassium iodide in 1 oz. of water for ten minutes, rinse thoroughly, and transfer to a solution of 30 grs. of potassium cyanide. Dab the stains with a tuft of cotton-wool soaked in the solution until they disappear, when the negative should be rinsed thoroughly and dried. (*See also* " Stains, Removing.")

SILVER SUBBROMIDE, SUBCHLORIDE, ETC. (See " Silver Subhaloids.")

SILVER SUBHALOIDS

Chemists have usually considered that the action of light upon the silver haloids was the splitting off of a molecule of the halogen and the formation of a salt with consequent lower proportion of halogen, which may be represented by the formula, $2AgCl = Ag_2Cl + Cl$ or $4AgCl = Ag_4Cl_2 + Cl_2$. They named the new compounds subhaloids. For many years the existence of such subsalts was denied, because the actual existence of silver suboxide could not be definitely proved. In 1891 Guntz was able to prepare the subfluoride Ag_2F or Ag_4F_2 by heating silver fluoride AgF in a sealed tube at a temperature not above 194° F. with finely divided silver and also by electrolysis of a saturated solution of silver fluoride, using silver electrodes. By treatment of this salt, a yellow crystalline powder, with steam he was able to prepare the suboxide Ag_4O, and Weltzien prepared a silver hydroxide $Ag_4(OH)_2$ by treating it with hydrogen peroxide. From the subfluoride Guntz also prepared the subchloride by passing dry hydrochloric acid gas over it, or by treating it with the volatile chlorides of carbon, silicon, and phosphorus, etc. The subchloride varies in colour from deep violet red to violet black, and when heated it splits up into ordinary silver chloride and metallic silver potassium cyanide; and sodium hyposulphite produces a similar reaction with the solution of the chloride. Silver subiodide was also prepared by Guntz by the action of hydrogen iodide. The actual formation of these subhaloids is a strong argument in favour of the subhaloid theory of the latent image (*which see*). The subbromide may be prepared in the same way as the subchloride, or by treating the subfluoride with phosphorus tribromide (Heyer). Lüppo-Cramer claims to have prepared a subbromide, Ag_4Br_3, by treating mercurous bromide with silver nitrate.

SILVER SULPHATE (Fr., *Sulfate d'argent*; Ger., *Silbersulfat, Schwefelsaures Silberoxyd*)

Ag_2SO_4. Molecular weight, 312. Solubility, ·58 in 100 water. White crystals obtained by mixing concentrated solutions of silver nitrate and sodium sulphate.

SILVER SULPHIDE (Fr. *Sulfure d'argent*; Ger., *Silbersulfid*)

Ag_2S. Molecular weight, 248. Solubilities, insoluble in water and alcohol. It is a brownish-black powder, and is obtained by mixing an alkaline sulphide with silver nitrate solution. It is also obtained when liver of sulphur is added to spent fixing baths, and is supposed to form the brown or sepia image in sulphide toned bromides.

SILVER SULPHOCYANIDE (Fr., *Sulfocyanure d'argent*; Ger., *Silber-rhodanat*)

AgCNS. Molecular weight, 166. Solubilities, very soluble in water. Yellowish white crystals obtained by adding silver nitrate to an alkaline sulphocyanide. It is of no photographic importance.

SILVER TARTRATE [Fr., *Tartrate d'argent*; Ger., *Silbertartrat, Weinsteinsaures Silber*)

$Ag_2C_4H_4O_6$. Molecular weight, 364. Solubilities, slightly soluble in water. It is a fine, white powder, obtained by adding silver nitrate to an alkaline tartrate. It is used in printing-out emulsions.

SILVER TESTER (See " Argentometer.")

SILVER WASHINGS (See " Residues.")

SILVERLINE PROCESS

A French process of line engraving. A zinc plate was coated with an etching ground, a drawing scratched through with a needle point, and the lines etched deeply. The resist was then cleaned off, and the lines filled in with soft solder consisting of a mixture of bismuth, tin, and lead. The solder was melted by heating the plate with buttons of solder on it, and rubbing the molten solder in the lines with a rag. The surface was polished and the plate again etched in nitric acid, which attacked the zinc without touching the solder, and thus the lines were left in relief.

SILVERWARE, PHOTOGRAPHING

The task of rendering silver as silver is a difficult one, and the secret of success lies in the lighting and the use of backed plates. The operator should remember that the angle of reflection is always equal to the angle of incidence; thus, at whatever angle the light falls on a reflective surface, it is reflected back at the same angle. It will therefore be obvious that, if the silver object be illuminated by a strong front light, the reflections will come back into the lens. The most suitable angle at which the strongest light should reach the bright objects is one of about 45°; then the reflections will be well away from the direction of the camera. The shadow sides will be rather dark as compared with the bright high lights, but this will be modified by using a reflector, which may be a sheet of white cardboard.

If the silver objects can be treated to prevent reflections, the task of getting a satisfactory photograph of them becomes easy. Many methods have been advocated for dulling the surfaces. One of the best is to hold the silver over a piece of burning magnesium ribbon, the white smoke from which will deposit upon the silver; the magnesium can easily be removed. A method frequently adopted is to dab the surfaces with putty, but this is rather messy and

troublesome to clean off. A better plan is to place a piece of ice in each vessel; this causes the metal to cool rapidly, and if there is moisture in the atmosphere, as upon a wet or damp day, dew will soon deposit upon it; in exceptionally dry weather the cold metal could be sprayed, using water in an ordinary scent sprayer, or could be steamed.

Any lettering on the articles can be brought out by arranging the light and the reflector, or the lettering may be filled up with black printers' ink, which can be quickly cleaned out with benzole or turpentine after the negative has been made.

Exposures should be full in order to soften the contrasts, as under-exposure would mean brighter and glaring high lights and black shadows. The developer used—say, metol or rodinal—should bring out the details in the shadows before the high lights become too strong.

SIMILIGRAVURE

A French name for the half-tone process.

SIMPSONTYPE

A printing process—the collodio-chloride—discovered by George Wharton Simpson, in which silver chloride contained in collodion was employed (published 1864). The original formula was : A. Silver nitrate ¾ oz. and distilled water ¾ oz.; warm gently until dissolved, and add 5 oz. of alcohol. B. Calcium chloride, 160 grs.; absolute alcohol, 5 oz. C. Citric acid 160 grs., absolute alcohol 5 oz. Take 40 oz. of plain collodion of medium density and add to it solution A, a little at a time, with considerable shaking. This may be done in daylight, but the following operations must be carried out in the dark-room or by weak artificial light. Next add B and C in the manner described for A. The emulsion is applied to glass, opal or paper. G. W. Simpson was for many years editor of the *Photographic News ;* he died in 1880.

SINGLE LENS

The so-called landscape lens; an achromatic meniscus, composed of flint and crown glass. When cameras are listed with " achromatic " lens, a single lens is usually meant, not a rapid rectilinear.

SINGLE TRANSFER

The method of working the carbon process by transferring the film from the paper on which it is printed to a second paper which forms its final support.

SINKS (*See* "Developing Bench or Sink.")

SINOP PROCESS

A simplified method of collotype printing, invented by Pousin, of Rheims. Plates are sold ready coated with an emulsion, which is believed to be gelatine containing a mercurous salt. These plates, which keep indefinitely, are sensitised by bathing in a potassium bichromate solution. They are dried and exposed under a negative, then washed to remove the unaltered bichromate, soaked in glycerine, the surplus moisture removed, and the plate inked up with a gelatine roller and greasy ink. Impressions on paper are then pulled off in an ordinary letter-copying press.

SIZEOMETER (*See* " Proportional Scales and Rules.")

SIZES OF PLATES AND PAPERS

The accompanying tables give the sizes and diagonals of British and Continental plates and of films, and sizes of drawing papers and of mounts. It should be remembered that Continental dark-slides are to the sizes given, the plates being made from 1 to 1½ mm. smaller so as to fit. In Great Britain plates are made to the sizes stated, and there is an allowance in the dark-slide.

The diagonals of plates are often referred to when condensers for enlarging are being considered, as a suitable condenser should have a diameter equal to the diagonal of the plate. Thus, a half-plate negative needs a condenser at least 8 in. in diameter, in order to cover the corners of the negative.

BRITISH PLATES				CONTINENTAL PLATES				FILMS			
Dimensions		*Diagonals*		*Dimensions*		*Diagonals*		*Dimensions*		*Diagonals*	
In.	Cm.	In.	Cm.	In.	Cm.	In.	Cm.	In.	Cm.	In.	Cm.
3¼ × 2½	8·9 × 6·3	4¼	10·9	1·5 × 1·5	4 × 4	2·25	5·7	2 × 1¼	5 × 3·8	2¼	6·3
3¼ × 3¼ (*Lantern plate*)	8·3 × 8·3	4⅝	11·7	1·77 × 2·36	4½ × 5	2·9	7·5	2¼ × 1½	5·7 × 3·8	2¾	6·9
4¼ × 3¼ (*Quarter-plate*)	10·8 × 8·3	5⅛	10·6	2·56 × 3·5	6½ × 3·9	4·6	11·1	2¼ × 2¼	5·7 × 5·7	3¼	8·1
5 × 4	12·8 × 10·1	6⅜	16·2	3·54 × 4·7	9 × 12	5·9	14·9	2¼ × 1⅝	6·3 × 4·2	3	6·9
5½ × 3½ (*Post card*)	14·0 × 8·9	6½	16·6	3·54 × 7·08	9 × 18	7·9	20·0	2¼ × 3¼	5·7 × 8·3	3¹⁵⁄₁₆	10·0
6½ × 4¼ (*Double quarter*)	16·5 × 10·7	7¾	19·6	4·3 × 5·90	11 × 15	7·3	18·6	4¼ × 2½	10·8 × 6·3	4⅞	22·5
				4·7 × 6·29	12 × 16	7·9	20·1	3½ × 3½	8·9 × 8·9	5	12·6
6½ × 4¾ (*Half-plate*)	16·5 × 12·0	8¹⁄₁₆	20·4	4·7 × 7·87	12 × 20	9·2	23·3	4¼ × 3¼	10·8 × 8·3	6⅜	16·2
6½ × 3¼ (*Stereoscopic*)	17·2 × 8·2	7½	19·0	5·1 × 7·08	13 × 18	8·7	22·1	5½ × 3¼	14·0 × 8·3	6½	16·2
7 × 5	17·8 × 12·7	8⅝	21·9	5·9 × 8·26	15 × 21	10·2	26	5 × 4		7¾	19·6
8½ × 6½ (*Whole-plate*)	21·6 × 16·5	10¹¹⁄₁₆	27·1	7·08 × 9·45	18 × 24	11·9	30·1	6½ × 4½	16·5 × 10·7	8⅝	21·9
10 × 8 *and larger*	25·3 × 20·3	12⅞	32·7	8·26 × 10·63	21 × 27	13·5	34·2	7 × 5	17·8 × 12·7	8¾	21·9
				9·45 × 11·8	24 × 30	15·3	39	3½ × 2½	8·3 × 5·7	3¹⁵⁄₁₆	10
								3½ × 4¾	8·9 × 1·77	5¾	14·6
				and six larger sizes, 24 × 36 cm., 27 × 33 cm., 30 × 40 cm., 36 × 48 cm., 40 × 50 cm., and 50 × 60 cm.				9 × 3¼	22·8 × 8·9	9¾	24·5

Sensitised Papers

Sensitive papers may be had cut up to almost any size, from about 2½ by 1¾ in. to 21 by 25 in., rectangular, square, or circular. The full sizes of complete sheets vary somewhat, but the following may be taken as the average :—

Bromide and gaslight paper.—Rolls, 10 and 25 ft. long ; 15, 20, 22, 25, 30, and 40 in. wide.

P.O.P.—Sheets, 24½ by 17 in. Rolls, 25 ft. long and 12 and 25 in. wide.

Platinotype.—Sheets, 26 by 20 in.

Carbon.—In " bands " 12 ft. long, 30 in. wide.

Ferro-prussiate.—Rolls, 32 ft. long, 30 and 40 in. wide.

Drawing Papers

Demy	.	.	.	22 × 17 in.	
Royal	.	.	.	25 × 20 „	
Cartridge	.	.	.	26 × 21 „	
Double crown	.	.	.	30 × 20 „	
Imperial	.	.	.	30 × 22 „	
Double demy	.	.	.	35 × 22 „	
Double elephant	.	.	.	40 × 27 „	
Antiquarian	.	.	.	53 × 31 „	

	In.	Cm.
BRITISH MOUNTS—		
Midget	1⅜ × 2¼	3·3 × 5·7
C. de V.	2½ × 4¼	6·3 × 10·5
Cabinet	6½ × 4¼	16·5 × 10·8
Imperial {	6⅝ × 10 and	17·5 × 25·4 and
Promenade	7⅞ × 9⅝	20 × 25·1
Boudoir	8¼ × 4	21 × 10·16
	8¼ × 5½	21·5 × 14
Panel {	13 × 7½ and	33·0 × 19 and
Stereoscopic	8¼ × 4	21 × 10·16
Royal	7 × 3½	17·7 × 8·9
Large Panel	10¾ × 5½	27 × 13
Grand Panel	10½ × 17	26·7 × 43·1
Victoria Midget ...	23 × 13¾	58·4 × 34·9
Cabinet Midget ...	2⅜ × 1½	6 × 3·8
Promenade Midget ...	2⅛ × 1¾	6·8 × 4·4
Boudoir Midget ...	3⅛ × 1⅝	7·9 × 4·1
Panel Midget ...	3⅜ × 2	8·6 × 5·08
	4⅛ × 1¾	10·5 × 4·4
CONTINENTAL MOUNTS—		
Carte Mignonnette ...	1⅜ × 2·3	3·5 × 6
Carte de Visite	2½ × 4¼	6·3 × 10·5
Carte Malvern	3·1 × 6½	8 × 16·5
Carte Victoria	3·1 × 5	8 × 12·6
Carte Album	4·3 × 6¼	11 × 16·5
Carte Cabinet	4·7 × 6·2	12 × 16
Carte Promenade ...	3·9 × 4·7	10 × 12
Carte Paris Portrait ...	5¼ × 8·66	13·3 × 22
	3·5 × 4·7	9 × 12
Carte Amateur ... {	5·11 × 7·08	13 × 18
	5·9 × 8·26	15 × 21
	7·08 × 9·4	18 × 24
Carte Artiste ... {	7·8 × 10·2	20 × 26
Carte American	7·4 × 12·9	19 × 33
Carte Family ... {	9·05 × 11·4	23 × 29
	8·2 × 13·3	22 × 34
Carte Excelsior ... {	10·2 × 12·5	26 × 32
	9·8 × 14·9	25 × 38
Carte Panel ... {	11·02 × 14·9	28 × 38
	11·02 × 17·7	28 × 45
Carte Royal ... {	14·9 × 18·8	38 × 48
	14·9 × 21·6	38 × 55
Carte Portrait-Nature {	18·8 × 22·8	48 × 58
	18·8 × 23·6	48 × 60

SIZING

Raw papers generally need to be sized before sensitising, because the size fills up the pores and keeps the image on the surface ; in some cases, also, it increases the sensitiveness. As a general rule, sizing improves any raw paper. The sizes most used are arrowroot and gelatine, and the paper can be floated on one of these or brushed over with the substance. In the case of gelatine the paper may be wholly immersed.

Arrowroot.—Of the many formulæ known, that due to Duchochois is as follows :—

Arrowroot	.	.	. 100 grs.	25 g.
Glucose	.	.	. 20 „	5 „
Water	.	.	. 10 oz.	1,000 ccs.

Mix the arrowroot and glucose with a little cold water, add the remainder hot, and boil up the whole in a porcelain dish. Cool, skim and strain through muslin before use. The above is suitable for the iron printing processes, namely, blue print, kallitype, etc. Other formulæ are given under separate headings.

Gelatine.—The following is suitable for printing with iron salts :—

Hard gelatine	.	.	50 grs.	25 g.
Water	.	.	10 oz.	1,000 ccs.
Alum	.	.	15 grs.	7·5 g.
Alcohol (pure)	.	.	2 oz.	220 ccs.

Soak the gelatine in about 9 oz. of the water for about an hour, heat until dissolved, dissolve the alum in the remaining water, add to the gelatine, and lastly the alcohol. After coating, dry for three minutes and coat again. For plain silver paper, dissolve 5 grs. of gelatine in 10 oz. of water, by aid of heat, and then dissolve therein 60 grs. of ammonium chloride. Immerse twice as above.

Gum Arabic.—For iron papers, prepare a weak solution of gum arabic (5 or 6 grs. to the oz. of water), and brush over the paper.

Resin, Iceland moss, and agar-agar are also used.

SKETCH EFFECTS

A term applied to pictures in which a part is photographic, and the remainder hand-work with pencil, crayon, etc. The usual plan is to work up the picture and then to copy and print duplicates. Sometimes the sketch effects are obtained by using platinotype or bromide paper, and developing only that part of the image desired by brushing on a developer mixed with glycerine. The usual plan is to make a print upon rough bromide paper, and to brush over any parts that are to be reduced with a " hypo "-ferricyanide or other reducer. The work calls for great care, and the print must be frequently rinsed in water and finally washed. It may be found easier to have the print half dry when brushing the reducer round delicate outlines, as the face, for example ; but the methods employed depend upon the worker's skill. When portraits are taken specially for sketch effects a white background should be used. Sketch effects needing no pencil work are largely produced on platinotype paper owing to the facility with which such prints can be developed in parts with the ordinary platinotype developer mixed with glycerine, but bromide prints may, of course, be developed in a similar way. The objection to bromide paper for direct sketch effects by development is that the image is not faintly visible after printing, as it is upon platinum paper ; but any part of the image may be reduced at a later stage.

The " hypo "-ferricyanide reducer is rather apt to stain, and the following will be found to be more serviceable :—

A. Iodine, resublimed . $\frac{1}{2}$ oz. 55 g.
Potassium iodide . I ,, 110 ,,
Water . . . 4 ,, 400 ccs.
B. Potassium cyanide . I oz. 110 g.
Water . . . 4 ,, 400 ccs.

Two-thirds fill a saucer with water, add a few drops of the A solution until the water is of a deep sherry colour, and then add just enough of the B solution to decolorise. Apply this with a tuft of cotton-wool, the work being done near to running water so that the reducer may be washed off quickly; the reducer leaves the paper white if allowed to act long enough. Reducers cannot be used for platinotype paper.

SKIAGRAM
A radiograph, or X-ray photograph.

SKIAGRAPHY
Radiography, or X-ray photography.

SKIN, EFFECTS OF CHEMICALS UPON
A few photographic chemicals in common use have a harmful effect upon the skin, as explained under separate headings. (*See*, for example, " Bichromate Disease," " Hygiene in Photography," " Metol," " Poisons and their Antidotes," etc.)

SKY NEGATIVES (*See* " Cloud Negatives.")

SKY, PRINTING IN (*See* " Clouds, Printing in.")

SKY SHADE
Commonly a hinged flap attached to the top of the lens hood, and used to screen the lens from the too bright light of the sky, and from the sun if present. It permits of the sky portion of the negative being so shaded that both foreground and sky are correctly exposed on the same negative.

SKY SHUTTER
This has the same purpose as the foreground shutter (*which see*).

SLIDE CARRIER
A bag or case to carry the dark-slides. Usually it is of leather lined with velvet or baize and fastening with straps or by a lock and key. Loose lined partitions are often provided to prevent the slides rubbing against each other. Sometimes there is also a pocket for the lens or lenses. Generally, however, both slides and lens are carried in the same bag as the camera.
Also a name given to the plate carrier.

SLIDE, DARK- (*See* " Dark-slide.")

SLIDE, LANTERN (*See* " Lantern Slides.")

SLIDE RULE, PHOTOGRAPHIC (Fr., *Règle mobile photographique;* Ger., *Photographisches Rechen-lineal*)
An instrument invented by A. Lockett, and shown at the Royal Photographic Society's Exhibition of 1909. It consists of a graduated right angle with a pivoted rule that may be made to move diagonally over it. By its use many photographic and optical calculations are quickly and automatically carried out, as, for instance, ascertaining measurements of objects from photographs; finding the conjugate foci for enlarging, copying, or reducing with a given lens; determining the length of studio necessary for portraiture with a stated objective; discovering the focal length obtained by combining two lenses, etc.

SLIP-IN MOUNTS
A mount composed of two boards, the upper having a cut-out opening, fastened together by the edges on three sides, while the fourth side is open to admit of a print being slipped in and adjusted in position behind the opening. This kind of mount is suitable only for glazed prints, or such as will lie quite flat. As no mountant is required, the gloss of the surface of a glazed print is unaffected. The mounts are made in standard sizes, and do not, therefore, admit of any trimming down of the print. As it is possible for the print to shift in the mount, it is well, when it is properly adjusted, to apply a touch of adhesive to two points on one edge of the print, and rub it down so that it adheres to the back board. This may be done by means of a knife slipped in at the opening through which the print was passed.

SMOKE BOX
A form of flash lamp for burning magnesium ribbon, and recommended by E. Seymour. The bottom of a box is replaced with a sheet of glass covered with white tissue-paper; this, in use, is the front of the box, as illustrated. The lid is hinged, as shown. Holes are cut at the base

Smoke Box

for ventilation, and the inner side of the top of the box is lined with tinplate and fitted with a hook or other device for holding the ribbon. The lid or door is closed immediately the ribbon is lighted, and the smoke box held in the hand and moved about as desired. Afterwards, the box can be taken out of doors and the smoke allowed to escape.

SNAPSHOTS
A common term designating so-called " instantaneous " exposures made with a camera held in the hand. Unfortunately, it suggests a random and unconsidered operation into which a large element of chance enters; whereas the mere fact that the actual exposure given was a short one does not imply that no thought, study, or observation was devoted to the subject. Moreover, the possibility of taking " snapshots " has

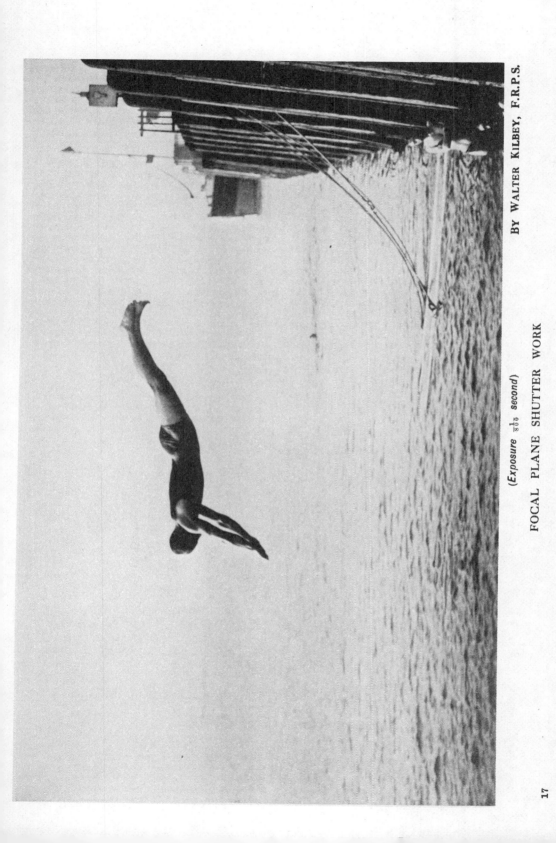

(*Exposure $\frac{1}{500}$ second*)

FOCAL PLANE SHUTTER WORK

By Walter Kilbey, F.R.P.S.

17

afforded the keen-eyed photographer number-less opportunities of recording transient effects and arrangements which would otherwise have been missed. It is to be hoped that the word "snapshot" will either be replaced by a more appropriate one, or will speedily live down the unfortunate significance it acquired in early days.

Absurd as it may seem, the notion is by no means obsolete that because a shutter will work at a certain high speed it will give a satisfactory result at that speed in all circumstances. This is a serious mistake, but a not uncommon one. In any given case there is a certain requisite exposure that can only be widely departed from to the detriment of the result. In the early days of so-called snapshot work the commonest fault was under-exposure. Since that time, however, there has been a tremendous increase in the sensitiveness of plates; lenses have been made with larger working apertures; and shutters have been improved in design and efficiency; and yet there are still occasions when the "snapshot" is necessarily under-exposed—either the lighting demanded a longer exposure than could be safely given in the hand, or an unduly short exposure had to be given on account of rapid movement in the subject. It is only in such cases that the development of snapshots differs from the normal. Harshness in the result is what has to be guarded against. The use in such circumstances of, say, a strong hydroquinone developer would probably result in dense, clogged high lights and shadow masses void of detail. Potassium bromide or other restrainer should be avoided, the developer should be well diluted, and plenty of time given to the developing action. While, of course, no possible alteration of developer can compensate for absence of effective light action, all the developable detail in the shadows should be secured. This may result in too great density in the high lights, but this may be modified afterwards with practically no detriment to the softer shadow detail, by the use of such a selective reducer as ammonium persulphate, or by mechanical reduction with Baskett's reducer or methylated spirit. The printing paper chosen should have been specially made to give softness of gradation from negatives of undue harshness. (*See also* "Focal Plane Shutter," "Hand Camera, Work with," and "Instantaneous Photography.")

SNOW AND HOAR FROST PHOTOGRAPHY

The characteristic of average snow views is the unusual degree of light contrast. Freshly fallen snow in direct sunlight causes the whitest of paper to appear grey by comparison. Thus, in a snow scene the tree-trunks, buildings, etc., appear much darker than usual, and should the photographer be led to under-expose he will get an inky blackness in the shadows and an intense whiteness in the snow. A broad expanse of freshly fallen and unbroken snow can rarely, if ever, be effectively photographed. The sparkling snow cannot be properly interpreted by white paper. In composing a snow view, spottiness and patchiness must be guarded against and special attention paid to the foreground. Plain freshly fallen snow rarely makes an interesting foreground, but tree stumps, gates, farm imple-

ments, etc., under a mantle of snow are often of great pictorial value, and cart-wheel ruts and lines of footprints will be found to serve admirably in breaking up a foreground; it is an old dodge to select the view-point and then to make a line of footprints to suit the composition of the desired picture. Of the greatest importance is the lighting. While a flat, dull sky with no sun may suit some subjects, more effective results are obtained in sunlight, and more particularly when the sun is near the horizon; it will be obvious, then, that the best-lighted effects are obtained in the early morning and in the afternoon. The low lighting breaks up broad expanses of level and white snow, and causes footprints, ruts, etc., in the foreground to stand out more prominently.

Either ordinary or isochromatic plates may be used, and they must be well backed, because of the risk of halation. Isochromatic plates used with a yellow screen may sometimes be of advantage, because of the frequent yellowness of winter light, and because a blue sky may be interpreted dark, so bringing out any hoar frost or snow effects on trees standing against the sky. Many of the snow-scene photographs taken in the Alps have black skies, owing to the use of a deep yellow ("many times") screen. The exposures are not much shorter than for ordinary views, because generally there are deep shadows in the scene, and under-exposure would cause these to be almost clear glass in the negative, and any attempt to force development for the purpose of bringing out detail would ruin the soft effect. An under-exposed negative of a snow-scene is practically useless, and it is better to expose fully and to get all detail possible in the shadows. Details are more important than density. The latter can be added to a negative, but details cannot. An exposure meter of the Watkins type may be used with success; it is held 12 or 15 in. from the body and turned towards the sky, but not in such a way that direct sunlight falls upon it. For an open scene the exposure so estimated may be divided by three or four; but when there are many trees or other deep shadows the exposure may be increased up to the full time given by the meter.

With careless development the delicate gradation and detail in the snow is likely to be blocked up and rendered unprintable. Mrs. Aubrey Le Blond, who has had a long experience in snow and ice photography, uses a metol-hydroquinone developer. She pours it into two half-pint bottles, one labelled "Old" and the other "New." The former is used over and over again for developing, and as it becomes used up it is kept full by adding from the new solution. The method is economical and gives excellent results. Sir W. Abney recommends beginning with—

Ammonia	.	.	.	30 mins.	6 ccs.
Potass. or amm. bromide	.		50 grs.	12 g.	
Pyro	.	.	.	1 „	·24 „
Water	.	.	.	10 oz.	1,000 ccs.

Allow this to act until all detail is out, and finish with—

Ammonia	.	.	.	30 mins.	6 ccs.
Bromide	.	.	.	80 grs.	19 g.
Pyro	.	.	.	40 „	9·5 „
Water	.	.	.	10 oz.	1,000 ccs

SOAP (Fr., *Savon*; Ger., *Seife*)

Soap is used as a lubricant when burnishing prints. Hofbauer has stated that the addition of Castile soap to a pyro developer prevents fog in cases where excessive alkali is used. A solution of 100 grs. of the soap in 10 oz. of water is used instead of plain water when making up the developer.

A good soap should always be used for washing the hands after working with such chemicals as amidol, metol, potassium bichromate, etc.

SODA, ALUM (*See* "Alum.")

SODA, CAUSTIC (*See* "Sodium Hydrate.")

SODA SALTPETRE (*See* "Sodium Nitrate.")

SODIUM ACETATE (Fr., *Acetate de soude*; Ger., *Essigsaures Natron*)

Synonym, acetate of soda. $NaC_2H_3O_2$ $3H_2O$. Molecular weight, 136. Solubilities, 1 in 1 water, 1 in 23 alcohol. Obtained by neutralisation of acetic acid with sodium carbonate or hydrate. Colourless transparent efflorescent crystals. It is used principally in the gold toning bath.

Twice-fused sodium acetate is also occasionally used; it has a slight alkaline reaction which makes the toning bath act more quickly, and at the same time the double-fusing destroys any organic impurities, such as sodium formate, etc., which tend to reduce the gold.

SODIUM BIBORATE (*See* "Sodium Borate.")

SODIUM BICARBONATE (Fr., *Bicarbonate de soude;* Ger., *Doppelt Kohlensaures Natron*)

Synonyms, monosodic carbonate, acid sodium carbonate, $NaHCO_3$. Molecular weight, 84. Solubility, 1 in 11·3 water, insoluble in alcohol. It takes the form of rhombic tabular crystals or fine white powder, obtained by passing a stream of carbonic acid gas through a solution of carbonate of soda. Occasionally it is used in gold toning, but it must not be confounded with sodium carbonate.

SODIUM BICHROMATE (Fr., *Bichromate de soude*; Ger., *Doppelt Chromsaures Natron*)

Synonyms, dichromate of soda, acid sodium chromate. $Na_2Cr_2O_7$ $2H_2O$. Molecular weight, 298. Solubilities, 1 in 1 water, insoluble in alcohol. It consists of red deliquescent crystalline fragments, obtained in a similar manner to the potassium salt, and used for the same purposes. 1·10 parts of sodium bichromate will replace 1 part of the potassium salt.

In process work, this salt has been suggested as a substitute for the potassium and ammonium salts in sensitising, but it has no advantages; indeed, its deliquescence is a disadvantage.

SODIUM BISULPHITE (Fr., *Bisulfite de soude* ; Ger., *Saures Schwefligsaures Natron, Natrium Bisulfit*)

Synonym, acid sulphite of soda. $NaHSO_3$. Molecular weight, 104. Solubilities, 1 in 3·5 water, 1 in 70 alcohol. It is a white, crystalline powder or prismatic crystals, with faint sulphurous odour, obtained by passing sulphurous acid gas through a solution of carbonate of soda.

It is used for acidulating fixing baths and solutions of sodium sulphite, and for preserving stock solutions of developers.

A thick, yellow liquid, known as bisulphite or acid sulphite lye, ozone bleach (Fr., *Bisulfite lye ;* Ger., *Sulfitlauge*), which is a saturated solution or sodium bisulphite, is obtainable commercially. This can be made as follows :—

Sodium sulphite	. 10 oz.	550 g.
Warm distilled water	20 ,,	1,000 ccs.

Dissolve, and add slowly when cold—

Sulphuric acid .	. 1¾ oz.	87·5 ccs.

SODIUM BORATE (Fr., *Borate de soude ;* Ger., *Borax, Borsaures Natron*)

Synonyms, borax, sodium tetraborate, pyroborate, biborate, tincal or tinkal. $Na_2B_4O_7$ $10H_2O$. Molecular weight, 382. Solubilities, 1 in 17 cold, 1 in ·5 boiling water, insoluble in alcohol, very soluble in glycerine. It is in the form of hard, white crystals or powder, obtained from the native borax or neutralisation of native boric acid. It is used principally in gold toning and as an accelerator with eikonogen and hydroquinone developers.

SODIUM BROMIDE (Fr., *Bromure de soude ;* Ger., *Bromnatrium*)

Synonyms, bromide of soda or sodium. NaBr. Molecular weight, 103. It is a white crystalline powder, which readily absorbs moisture from the air without deliquescing, and cakes into a hard, semi-translucent mass. It is obtained in the same way as the potassium salt, and it is occasionally used in emulsion making, but its hygroscopic qualities render it less certain than the potassium and ammonium salts.

SODIUM CARBONATE (Fr., *Carbonate de soude ;* Ger., *Soda, Kohlensaures Natron, Natriumcarbonat*)

Synonyms, soda, washing soda, carbonate of soda. Na_2CO_3 $10H_2O$. Molecular weight, 286. Solubilities, 1 in 1·6 water, insoluble in alcohol. It is in the form of large prismatic crystals or fine white powder, obtained on a large scale by converting salt into sodium sulphate, and then decomposing the latter by roasting with limestone and coal. It is the favourite alkali for development.

Washing soda is an impure variety which contains variable quantities of water, sodium sulphate, and other impurities.

An anhydrous salt (Fr., *Carbonate de soude anhydre ;* Ger., *Kohlensaures Natron Wasserfrei*), Na_2CO_3, molecular weight 106, is obtained as a fine white powder by heating the ordinary carbonate. Practically 37 parts of the anhydrous salt are equal to 100 of the ordinary soda.

SODIUM CHLORIDE (Fr., *Chlorure de soude, Selmarin ;* Ger., *Chlornatrium, Sal Gemmæ*)

Synonyms, muriate or chloride of soda, salt, common or table-salt. NaCl. Molecular weight, 58·5. Solubilities, 1 in 2·7 water, almost insoluble in alcohol. It is a fine white crystalline powder or transparent crystals, obtained native or by purification from sea water. It is used to prepare chloride emulsions and as a weaker restrainer than the alkaline bromides in developers.

SODIUM CHLOROPLATINATE (Fr., *Chloroplatinate de soude, Chlorure double de sodium et de platine ;* Ger., *Natrium-platinchlorid*)

$PtCl_4$ 2NaCl $6H_2O$ or $PtCl_6Na$ $6H_2O$. Molecular weight, 560·4. Solubilities, soluble in water and alcohol. It is a yellow crystalline powder, obtained by adding sodium chloride to platinum chloride. It is used in the platinotype process to produce greater contrast in the prints.

SODIUM CITRATE (Fr., *Citrate de soude ;* Ger., *Citronensaures Natron*)

Synonym, citrate of soda,· neutral citrate of soda. $2Na_3C_6H_5O_7$ $11H_2O$. Molecular weight, 714. Solubilities, 1 in 1·1 water, slightly soluble in alcohol. It is a white crystalline or granular powder, obtained by neutralising citric acid with sodium carbonate. It is used as a preservative for albumen paper, to form silver citrate in printing-out emulsions and as a restrainer in developers.

In consequence of its deliquescent nature it is best prepared in solution by adding about 266 grs. or g. of sodium carbonate to 162 grs. or g. of citric acid in solution; the result will be 480 grs. or g. of sodium citrate; about 3 oz. or 1,440 ccs. of water should be used, and the total bulk made up to 4 oz. or 1,920 ccs., when the solution will be 25 per cent. A little salicylic acid will prevent it from growing mouldy.

SODIUM FLUORIDE (Fr., *Fluorure de soude ;* Ger., *Natrium Fluorid*)

Synonym, fluoride of soda. NaF. Molecular weight, 42. Solubilities, 1 in 23 water. It takes the form of clear lustrous crystals or white powder, obtained by neutralising hydrofluoric acid with carbonate of soda. It is used like the potassium salt to strip the film from gelatine negatives.

SODIUM FORMATE (Fr., *Formiate de soude ;* Ger., *Ameisensaures Natrium*)

Synonym, formiate of soda. $NaCHO_2 H_2O$. Molecular weight, 86. It is a white deliquescent crystalline powder, obtained by neutralising formic acid with soda. It has been suggested as an ingredient in the platinum and gold toning baths.

SODIUM HYDRATE (Fr., *Soude caustique ;* Ger., *Aetznatron*)

Synonyms, caustic soda, sodium hydroxide. NaOH. Molecular weight, 40. Solubilities, 1 in 1·62 water, soluble in alcohol. It is poisonous, the antidote being water, followed by lemon or lime juice and milk or oil. It usually occurs in white sticks or lumps obtained by decomposing sodium carbonate with lime. It is used as an accelerator in development. It should be kept in bottles with rubber or paraffin stoppers, and should not be handled with the fingers.

SODIUM HYPOCHLORITE (Fr., *Eau de Javelle ;* Ger., *Javellesche Lauge.*)

Synonyms, eau de Javelle, Labarraque's solution, chlorinated solution of soda, ozone bleach. It is a liquid possessing a strong chlorine odour, containing sodium hypochlorite, salt, and carbonate of soda, obtained by decomposing bleaching powder with sodium carbonate :—

Sodium carbonate	1 oz.	110 g.
Bleaching powder	320 grs.	73 ,,
Water to	4 oz.	400 ccs.

Shake thoroughly, allow to stand for an hour, and filter. It is used to remove stains from negatives and destroy the last traces of " hypo."

SODIUM HYPOSULPHITE (Fr., *Hyposulfite de soude ;* Ger., *Fixirnatron, Unterschwefligsaures Natron*)

Synonyms, " hypo," sodium thiosulphate, hyposulphite of soda. $Na_2S_2O_3$ $5H_2O$. Molecular weight, 248. Solubilities, 1 in ·65 water, insoluble in alcohol. It is in the form of white transparent crystals, obtained by various processes on a large scale, in which sodium sulphite is the starting point. Its chief use is as a fixing agent for negative and positive work.

SODIUM HYPOSULPHITE, TESTING FOR

The water in which negatives, etc., are being washed after fixing is often tested to ascertain whether " hypo " is present; that is to say, whether the negatives, etc., have been washed long enough to remove all the " hypo." The best method of so doing is to use the following solution :—

Potassium carbonate	5 grs.	1 g.
Potassium permanganate	½ ,,	·1 ,,
Distilled water	10 oz.	1,000 ccs.

A few drops of this pinkish-purple liquid added to a sample of the washing water will turn green when " hypo " is present; the smaller the proportion of " hypo " in the water, the longer the change takes; and if there are very slight traces present, the change will be to blue, not green. The water to be tested should be the last the negatives or prints have been washed in, and preferably that which has been standing still for about ten minutes with the negatives therein ; take the water as much as possible from the bottom of the tank.

For the starch iodide test, powder and boil a piece of starch about the size of a pea in two or three drams of water until a clear solution is obtained ; add one drop of a tincture of iodine (iodine dissolved in alcohol), which will produce a dark blue colour. Fill one test tube with distilled water, and another with the water to be tested, and add to each tube one drop of the solution. If any " hypo " be present, the blue colour will disappear. The tubes should be warmed slightly and examined side by side against white paper, as the test is very delicate.

The Bannon or silver test is to let a negative or print drain into a test tube, then heat the drainings, and add a few drops of a silver nitrate solution. A black precipitate will be formed if $\frac{1}{10005}$ part of " hypo " is present, while a smaller amount will give a yellowish precipitate.

A rough and ready test is to taste the drainings ; the sweeter the taste the more " hypo " present. For the zinc and sulphuric acid test, dilute the acid to twice its bulk with water ; put some zinc into a flask, with the washing water, and add the dilute acid. If " hypo " is present, sul-

phuretted hydrogen is produced, as demonstrated by holding over the flask a piece of blotting-paper moistened with a solution of lead acetate, which will be blackened. Chromic acid also gives a test; about 4 grs. are dissolved in 5 oz. of water, and a few drops of sulphuric acid added. If on adding the washing water a greenish cloud appears, "hypo" is present. Potassium ferricyanide in a weak solution and ferric chloride in a stronger solution, mixed in equal proportions and added to the washing water, gives a greenish colour if "hypo" is present.

SODIUM IODIDE (Fr., *Iodure de soude* ; Ger., *Iodnatrium*)

Synonym, iodide of soda. NaI. Molecular weight, 150. Solubilities, 1 in ·5 water, 1 in 3 alcohol. It is in the form of white crystalline powder or cubical crystals. Very rarely used in place of the other iodides in consequence of its deliquescent nature.

SODIUM NITRATE (Fr., *Azotate de soude* ; Ger., *Salpetersaures Natron*)

Synonym, cubic, Chili, or soda nitre or saltpetre. $NaNO_3$. Molecular weight, 85. Solubilities, 1 in 1·1 water, 1 in 100 alcohol. It takes the form of colourless rhombohedral crystals, obtained native. It is rarely used in photography, though it is stated to give a rich brownish black tone to developed silver images.

SODIUM NITRITE (Fr., *Azotite de soude* ; Ger., *Salpetrigsaures Natron*)

Synonym, nitrite of soda. $NaNO_2$. Molecular weight, 69. Solubilities, 1 in 1·4 water, slightly soluble in alcohol. It is in the form of white opaque sticks or colourless crystals, prepared by fusing the nitrate or neutralising nitrous acid. Occasionally used to obtain a permanent standard photometer paper and in the diazotype process. It must not be confounded with the nitrate.

SODIUM NITROPRUSSIDE (Fr., *Nitroprussiate de soude* ; Ger., *Nitroprussidnatrium*)

Synonym, sodium nitroprussiate. $Na_2Fe(CN)_5$ (NO) $2H_2O$. Molecular weight, 298. Solubilities, 1 in 2·5 water, soluble in alcohol. It is in the form of deep ruby red transparent crystals, obtained by the action of nitric acid on potassium ferricyanide. It is one of the most light-sensitive iron salts, and is occasionally used for iron printing and photometric work.

SODIUM OXALATE (Fr. *Oxalate de soude* ; Ger., *Oxalsaures Natron*)

Synonym, oxalate of soda. $Na_2C_2O_4$. Molecular weight, 134. Solubilities, 1 in 33 water, insoluble in alcohol. It is a white crystalline powder, obtained in the same way as the corresponding potassium salt. It is rarely used, on account of its low solubility, but is occasionally employed in the platinotype process.

SODIUM PERSULPHATE (Fr., *Persulphate de soude* ; Ger., *Ueberschwefelsaures Natrium*)

$Na_2S_2O_8$. Molecular weight, 238. Soluble in water. It is a white crystalline powder, obtained like the corresponding potassium salt, and used for the same purposes.

SODIUM PHOSPHATE (Fr., *Phosphate de soude* ; Ger., *Phosphorsaures Natron*)

Synonyms, phosphate of soda, disodium orthophosphate. Na_2HPO_4 $12H_2O$. Molecular weight, 358. Solubilities, 1 in 6·7 water, insoluble in alcohol. It takes the form of colourless transparent crystals or white granular powder, obtained by treating calcium phosphate with carbonate of soda. It is used in the gold toning bath.

SODIUM PYROBORATE (*See* "Sodium Borate.")

SODIUM SILICATE (Fr., *Silicate de soude* ; Ger., *Natronwasserglas*)

Synonyms, soluble glass, soda water-glass. Na_2SiO_3 + Aq. It is in the form of white to bluish grey hard flat pieces, obtained in the same manner as the corresponding potassium salt and used for the same purposes. It is also met with commercially as a syrupy yellowish liquid containing 20 per cent. silica and 10 per cent. soda.

In process work, sodium silicate is used either alone or in combination with albumen or other ingredients as a substratum to make the gelatine film hold better on the collotype printing plate. The substratum may consist of water $3\frac{1}{2}$ oz., gelatine 46 grs., sodium silicate $\frac{1}{8}$ oz., chrome alum, 8 grs. The silicate is added after the other ingredients are mixed and dissolved.

SODIUM SULPHANTIMONIATE (Fr. *Sulfoantimoniate de soude, Sel de Schlippe* ; Ger., *Schlippesche Salz*)

Synonyms, Schlippe's salt, sodium thioantimonate. Na_3SbS_4 $9H_2O$. Molecular weight, 479. Solubility, 1 in 3 water. It is in the form of large colourless or yellow crystals, obtained by boiling milk of lime, sulphide of antimony, and carbonate of soda. It is used to tone bromide prints and for darkening negatives after mercurial bleaching. It is rapidly decomposed by absorption of carbonic acid from the air.

SODIUM SULPHATE (Fr., *Sulfate de soude* ; Ger., *Schwefelsaures Natron*)

Synonym, Glauber's salt. Na_2SO_4 $10H_2O$. Molecular weight, 322. Solubilities, 1 in 3 water, insoluble in alcohol. It is in the form of colourless efflorescent crystals, obtained as a by-product in the salt cake process. It is used to prepare barium sulphate.

SODIUM SULPHIDE (Fr., *Sulfure de soude* , Ger., *Natriumsulfid*)

Synonym, sulphide of soda. Na_2S $9H_2O$. Molecular weight, 240. Solubility, soluble in water. It consists of colourless, transparent, deliquescent crystals, obtained by fusing sodium carbonate with sulphur. It is used for sulphide or sepia toning of bromide prints. It should not be kept near any sensitive materials, and the bottle should be well stoppered.

In process work, a 5 per cent. solution of sodium sulphide is used as a blackener in the intensification of wet collodion negatives, in preference to the ammonium sulphide. Being a dry salt, it is more portable and convenient to handle.

SODIUM SULPHITE (Fr., *Sulfite de soude;* Ger., *Natriumsulfid*)

Synonym, sulphite of soda. $Na_2SO_3 7H_2O$. Molecular weight, 252. Solubilities, 1 in 2·2 water, slightly soluble in alcohol. It takes the form of colourless crystals or powder, obtained by passing sulphurous acid gas over damp sodium carbonate. The crystals are efflorescent and are readily oxidised to sulphate. It is an energetic absorbent of oxygen, and is therefore used to preserve developing agents; the effloresced salt should not be used for this purpose, as it is a weaker preservative, and the sulphate acts as a restrainer.

The anhydrous salt—(Fr., *Sulfite de soude anhydré;* Ger., *Wasserfrei Natriumsulfid*), Na_2SO_3; molecular weight, 126; solubility, 1 in 4 water—occurs as a fine white powder, and is prepared by heating the crystalline sulphite to 212° F. One part of the anhydrous salt is equal to 2 parts of the crystalline.

SODIUM TARTRATE (Fr., *Tartrate de soude;* Ger., *Weinsaures Natron*)

$Na_2C_4H_4O_6 2H_2O$. Molecular weight, 230. It consists of white crystals, obtained by neutralising tartaric acid with sodium carbonate or hydrate. Occasionally it is used in printing-out emulsions.

SODIUM THIOSULPHATE (*See* "Sodium Hyposulphite.")

SODIUM TRIBASIC PHOSPHATE (Fr., *Phosphate tribasique de soude;* Ger., *Dreibasisch Phosphorsaures Natron*)

Synonym, tribasic phosphate of soda, normal sodium or trisodic orthophosphate. $Na_3PO_4 12H_2O$. Molecular weight, 380. Solubilities, 1 in 5·1 water, insoluble in alcohol. It consists of large, six-sided, colourless crystals, obtained by adding caustic soda to sodium phosphate. It has been suggested by Lumière as a substitute for the caustic and carbonate alkalis in developers, but has not found general use. Add 453 grs. or g. of sodium phosphate to 51 grs. or g. of caustic soda, both in solution, and make the total bulk to 10 oz. or 4,800 ccs., and the result will be a 10 per cent. solution of the tribasic salt.

SODIUM TUNGSTATE (Fr., *Tungstate de soude;* Ger., *Wolframsaures Natron*)

Synonyms, tungstate of soda, sodium wolframate. $Na_{10}W_{12}O_{41} 28H_2O$. Solubilities, 1 in 4 water, insoluble in alcohol. It takes the form of transparent tabular crystals, prepared by fusing wolframite with sodium carbonate. It is used in gold toning.

SODIUM VANADATE (Fr., *Vanadate de soude;* Ger., *Natriumvanadat*)

Synonym, sodium orthovanadate. Na_3VO_4. Molecular weight, 184. Soluble in water. It is a white crystalline powder, which is rarely used, but which has been suggested to increase contrast in printing-out emulsions.

SOFTNESS

A term generally used to indicate an abundance of middle tones without loss of detail in either the high lights or the shadows. The absence of softness means harshness; its exaggeration produces flatness. Under-exposure and over-development will give the former; over-exposure and under-development the latter. The selection of special printing papers aids in securing a bright result from a soft negative, or a soft result from a hard negative, as the case may be.

SOL LAMP

A lamp in which vaporised methylated spirit is burnt in an incandescent mantle. The spirit is contained in a reservoir, which may be raised or lowered on an upright rod to adjust the pressure, a bend in the supply tube being carried over the burner so that the spirit continues to be vaporised once the lamp is alight. To start the lamp, a band of asbestos soaked in spirit is placed below the burner and ignited. The lamp is suitable for enlarging and for use in the optical lantern.

SOLAR CAMERA (Fr., *Chambre solaire, Chambre à héliostat;* Ger., *Solar Kamera, Sonnenkamera*)

An apparatus for enlarging by the direct rays of the sun, now practically obsolete. There were two forms, one resembling an ordinary daylight enlarging camera, while the other had, in addition, a condenser in front of the negative to concentrate the rays. Sometimes a heliostat was used to keep the sun's rays constantly directed on the condenser.

SOLAR ENLARGING

Sometimes referred to as solar printing. Enlarging with the solar camera, that is, by sunlight.

SOLAR PHOTOGRAPHY (*See* "Sun, Photographing the.")

SOLAR SPECTRUM (*See* "Spectrum, Solar.")

SOLARISATION

A term with many photographic meanings. It is synonymous with reversal (*which see*), and it is also applied to halation and to bronzing.

SOLUBILITIES

The table on pages 502–505 gives a list of the chief photographic chemicals, with formulæ, molecular weights, and solubilities in cold and hot water. For other information, consult articles under separate headings.

SOLUBLE GLASS (*See* "Potassium Silicate" and "Sodium Silicate.")

SOLUTIONS, CONCENTRATED

Solutions made up of a greater strength than that required for use; developers, for example, to which water is added before use. They are often confused with "saturated solutions," which, indeed, are concentrated solutions, although a concentrated solution need not be saturated. Concentrated solutions keep better than those diluted to working strength, and almost any photographic solution can be made up in a concentrated form simply by using less

TABLE OF FORMULÆ AND SOLUBILITIES OF PHOTOGRAPHIC CHEMICALS

Name	Chemical Formula	Molecular weight	No. of parts of cold water in which 1 part is soluble	No. of parts of hot water in which 1 part is soluble
Acetone	C_3H_6O	58	sol.	—
Acid, sulphite	$NaHSO_2CO(CH_3),H_2O$	162	v. sol.	—
Acid, acetic	$HC_2H_3O_2$	60	v. sol.	—
„ benzoic or boracic	C_6H_5COOH	122	29	15
„ boric or boracic	H_3BO_3	62	29	2·9
„ carbolic (phenol)	C_6H_5OH	94	15	—
„ chromic (anhydride)	CrO_3	100	v. sol.	v. sol.
„ citric	$C_6H_8O_7,H_2O$	210	·75	·5
„ digallic (tannin)	$C_{14}H_{10}O_9$	322	·8	·5
„ fluosilicic (see Hydrofluosilicic)				
„ formic	$HCOOH$	46	100	—
„ gallic	$C_6H_2(OH)_3COOH,H_2O$	188	100	3
„ hydrobromic	$HBr + water$	81	sol.	sol.
„ hydrochloric	HCl	36·5	sol.	sol.
„ hydrofluoric	HF	20	sol.	sol.
„ hydrofluosilicic	H_2SiF_6	144	sol.	sol.
„ lactic	$C_3H_6O_3$	90	sol.	sol.
„ muriatic (see Hydrochloric)				
„ nitric	$HNO_3,2H_2O$	63	sol.	sol.
„ oxalic	$H_2C_2O_4,2H_2O$	126	9·5	3
„ pentathionic	$H_2S_5O_6$	258	sol.	sol
„ phosphoric	H_3PO_4	98	sol.	
„ picric (see Paraformaldehyde)				
„ pyrogallic (pyrogallol)	$C_6H_3(OH)_3$	126	e. sol.	v. sol.
„ salicylic	$C_6H_4(OH)COOH$	138	450	12·5
„ sulphuric	H_2SO_4	98	—	—
„ sulphurous	H_2SO_3	82	—	—
„ tannic (see Digallic)				
„ tartaric	$C_2H_4(OH)_2(COOH)_2$	150	·75	3
„ tetrathionic	$H_2S_4O_6$	225	sol.	
„ trithionic	$H_2S_3O_6$	194	sol.	
Adurol	$C_6H_2(OH)_2Cl(or\ Br)$	46	sol.	sol.
Alcohol, ethyl	C_2H_5HO	32	sol.	sol.
Alcohol, methyl (wood alcohol)	CH_3OH	46	sol.	sol.
Aldehyde	CH_3CHO	58	sol.	·24
Alum, ammonia	$(NH_4)_2SO_4Al_2(SO_4)_3\ 24H_2O$	906	8·5	dec.
„ chrome	$K_2SO_4Cr_2(SO_4)_3\ 24H_2O$	916	6·25	dec.
„ iron ammonia	$(NH_4)_2SO_4Fe_2(SO_4)_3\ 24H_2O$	964	v. sol.	v. sol.
„ potash	$K_2SO_4Al_2(SO_4)_3\ 24H_2O$	948	7·5	v. sol.
„ soda	$Na_2SO_4Al_2(SO_4)_3\ 24H_2O$	916	2·2	—
Aluminium chloride	$Al_2Cl_6,\ 12H_2O$	483	sol.	v. sol.
„ sulphate	$Al_2(SO_4)_3\ 18H_2O$	666	2	1·1
„ sulphocyanide	$Al_2(CNS)_6$	402	sol.	sol.
Amidol (diamidophenol)	$C_6H_4OH(NH_2)_2$	124	4	v. sol.
Ammonia	NH_3OH	34	sol.	sol.
Ammonium bichromate	$(NH_4)_2Cr_2O_7$	252	4	·25
„ bromide	NH_4Br	98	1·4	v. sol.
„ carbonate	$(NH_4)HCO_3(NH_4)NH_2CO_2$	60	1·57	dec.
„ chloride	NH_4Cl	53·5	3	1·4
„ citrate	$(NH_4)_3C_6H_5O_7$	243	v. sol.	v. sol.
„ fluoride	NH_4F	36	v. sol.	v. sol.
„ hyposulphite	$(NH_4)_2S_2O_3$	148	v. sol.	v. sol.
„ iodide	NH_4I	145	·6	v. sol.
„ molybdate	$(NH_4)_2MoO_{24}\ 4H_2O$	1236	—	dec.
„ nitrate	NH_4NO_3	80	2·5	v. sol.
„ oxalate	$(NH_4)_2C_2O_4H_2O$	142	25	24
„ persulphate	$(NH_4)_2S_2O_8$	228	2·5	dec.
„ phosphate	$(NH_4)_2HPO_4$	132	4	sol.
„ (hydro) sulphide	NH_4HS	51	·6	sol.
„ sulphocyanide	NH_4CNS	76	·6	v. sol.
„ sulphydrate	NH_4HS	50	sol.	—
„ thiomolybdate	$(NH_4)_2MoS_4$	260	sol.	v. sol.
„ vanadate	NH_4VO_3	116	s. sol.	insol.
Amyl acetate	$C_5H_{11}C_2H_3O_2$	130	insol.	insol.
„ alcohol	$(CH_3)_2CHCH_2CH_2OH$	88	insol.	insol.
Aniline (see Potass. persulphate)	$C_6H_4NH_2$	93	—	
Antimony sulphide	Sb_2S_3	336	insol.	sol.
Aurantia (hexanitro-diphenylamin ammonia)	$C_{12}H_5(NO_2)_6NNH_4$	456	s. sol.	—
Aurin (trioxy-triphenyl carbinol)	$C_{19}H_{14}O_3$	290	insol.	insol.
Barium bromide	$BaBr_2\ 2H_2O$	333	1·3	—
„ chloride	$BaCl_2\ 2H_2O$	244	2·5	·5
„ iodide	$BaI_2\ 2H_2O$	427	·5	1·3
„ monoxide	BaO	153	12	v. sol.
„ nitrate	$Ba(NO_3)_2$	261	12	3·1
„ peroxide	BaO_2	169	insol.	insol.
„ sulphate	$BaSO_4$	233	insol.	insol.
Benzene (benzene	C_6H_6	78	insol.	insol.
Benzoquinone	$C_6H_4O_2$	108	s. sol.	s. sol.
Borax (see Sodium borate)				
Bromine	Br	80	28	—
Cadmium ammonium bromide	$2CdBr_2\ 2NH_4BrH_2O$	758	·73	v. sol.
„ ammonium iodide	$CdI_2\ 2NH_4I\ 2H_2O$	692	·58	—
„ bromide	$CdBr_2\ 4H_2O$	344	·94	v. sol.
„ chloride	$CdCl_2\ 2H_2O$	201	·71	·67
„ iodide	CdI	366	1·08	·75
Calcium bromide	$CaBr_2$	200	·7	·75
„ carbide	CaC_2	64	dec.	dec.

TABLE OF FORMULÆ AND SOLUBILITIES OF PHOTOGRAPHIC CHEMICALS—continued

Name	Chemical Formula	Molecular weight	No. of parts of cold water in which 1 part is soluble	No. of parts of hot water in which 1 part is soluble
Calcium carbonate (chalk)	$CaCO_3$	100	insol.	insol.
" chloride (cryst.)	$CaCl_2\,6H_2O$	219	·25	v. sol.
" chloride (fused)	$CaCl_2$	111	1·4	·65
" chromate	$CaCrO_4\,2H_2O$	192	sol.	sol.
" hydroxide	$Ca(OH)_2$	74	700	1·300
" hypochlorite	$Ca(OCl)_2$	153	400	—
" oxide (quicklime)	CaO	56	—	—
" sulphate	$CaSO_4\,2H_2O$	172	380	450
Calomel (see Mercurous chloride)				
Camphor	$C_{10}H_{16}O$	152	700	—
Carbon disulphide	CS_2	76	insol.	insol.
" tetrachloride	CCl_4	156	insol.	insol.
Chalk (see Calcium carbonate)				
Celloidin				
Cellulose	$C_{18}H_{10}O_5(NO_2)_4$	504	insol.	insol.
"	$(C_6H_{10}O_5)_n\,3COOH$	162n	sol.	sol.
Ceric sulphate	$Ce(SO_4)_2\,4H_2O$	404	insol.	insol.
Chinoline blue or cyanine	$C_{29}H_{35}N_2I$	544	sl. sol.	sl. sol.
Chloral hydrate	$C_2H_3Cl_3O_2\cdot NaCl$	389·5	sl. sol.	sl. sol.
Chloride of lime (see Calcium hypochlorite)	$CCl_3CH(OH)_2$	165·5	v. sol.	—
Chlorine	Cl	35·5	absorbed by 1 to 2·5 vols.	—
Chloroform	$CHCl_3$	119·5	—	—
Chrome alum (see Alum, chrome)				
Chrysoidine	$C_6H_5N_2C_6H_3(NH_2)_2$	211·7	—	—
Cobalt chloride	$CoCl_2\,6H_2O$	238	sol.	sol.
Copper acetate (verdigris)	$Cu(C_2H_3O_2)_2\,H_2O$	199·5	14	5
" bromide	$CuBr_2$	223·5	v. sol.	v. sol.
" chloride	$CuCl_2\,2H_2O$	170·5	·83	·5
" sulphate (blue vitriol)	$CuSO_4\,5H_2O$	249·5	2·5	·5
" sulphate and ammonia	$CuSO_4\,4NH_3\,H_2O$	245·5	sol.	v. sol.
Corrosive sublimate (see Mercury chloride)				
Cyanine (see Chinoline blue)				
Dextrine (see Cellulose)				
Dextrose	$C_6H_{12}O_6$	180	sol.	sol.
Diamidophenol (see Amidol)				
Diamidoresorcin	$C_6H_3OHOHNH_2HClNH_2HCl$	153	sol.	sol.
Dinitro-naphthol	$C_{10}H_5(NO_2)_2OH$	234	sol.	—
Diphenal	$C_6H_3OHCH_3C_6H_3NH_2$	200	almost insol.	v. sol.
Edinol	$C_6H_3OHCH_2OHNH_2$	139	25	—
Eikonogen	$C_{10}H_6(OH)NH_2SO_3ONa$	263	sol.	v. sol.
Eosine	$C_6H_4(COC_6HBr_2OK)_2O$	708	—	sol.
Erythrosine	$C_{20}H_6(COC_7HI_4ONa)_2O$	660	sol.	—
Ether	$C_4H_5\cdot OC_2H_5$	74	12	—
Ferric ammonio-citrate, brown	$4Fe_2O_3,3(NH_4)_3C_6H_5O_7,3Fe(OH)_3$	2030	4	—
" ammonio-citrate, green	$5Fe_2O_3,2(NH_4)_2C_6H_5O_7,2HO\cdot NH_4$	1956	sol.	—
" ammonio-oxalate	$Fe_2(C_2O_4)_3\,3(NH_4)_2C_2O_4\,8H_2O$	892	21	—
" ammonio-sulphate	$FeSO_4(NH_4)_2SO_4\,6H_2O$	328	5	—
" chloride (lump)	$FeCl_3\,6H_2O$	270·5	v. sol.	v. sol.
" ferrocyanide (Prussian blue)	$Fe_2Fe_3(C_6N_6)_3$	860	insol.	v. sol.
" oxalate	$Fe_2(C_2O_4)_3$	376	v. sol.	v. sol.
" potassium oxalate (See Potassium ferric oxalate)				
" sodium oxalate	$Fe(C_2O_4),\,3Na_2C_2O_4,\,11H_2O$	976	1·69	·55
" sulphate	$Fe_2(SO_4)_3\,9H_2O$	563	sol.	—
Ferrous acetate	$Fe(CH_3COO)_2$	174	sol.	—
" ammonium sulphate	$FeSO_4(NH_4)_2SO_4\,6H_2O$	392	3	v. sol.
" chloride (dry)	$FeCl_2$	127	2	v. sol.
" chloride (cryst.)	$FeCl_2\,4H_2O$	199	1·4	—
" nitrate	$Fe(NO_3)_2\,18H_2O$	536	6	—
" oxalate	$FeC_2O_4\,2H_2O$	180	v. sol.	v. sol.
" potassium oxalate	$K_4Fe(C_2O_4)_3\,3H_2O$	328	4500	3800
" sulphate	$FeSO_4\,7H_2O$	278	1·8	5
Fluorescein	$C_6H_4(COC_6H_4OH)_2O$	332	insol.	—
Formaline	40 % sol. of CH_2O		sl. sol.	—
Gelatine (glutin)				—
Glycerine	$C_3H_5(OH)_3$	92	sol.	—
Glycine	$C_6H_4OHNH(CH_2COOH)$	167	insol.	insol.
Gold chloride, brown	$AuCl_3HCl\,2H_2O$	340	sol.	sol.
" chloride, yellow	$AuCl_3HCl\,3H_2O$	412	v. sol.	insol.
" potassium chloride	$KAuCl_4\,2H_2O$	414	v. sol.	insol.
" sodium chloride	$NaAuCl_4\,2H_2O$	398	v. sol.	v. sol.
Gun-cotton (tetra-nitrate cellulose)	$C_{12}H_{14}O_6(NO_2)_4$	504	insol.	insol.
" (tri-nitrato cellulose)	$C_{12}H_{17}O_6(NO_2)_3$	579	insol.	insol.
Hydramine	$C_6H_4(OH)(NH_2)_2,C_6H_4$	218	500	20
Hydrazine	$NH_2\cdot NH_2$	32	sol.	sol.
Hydrogen	H	1	—	—
" peroxide	H_2O_2	34	sol.	—
" sulphide	H_2S	34	sol.	20
Hydroquinone	$C_6H_4(OH)_2$	110	16	9
Hydroxylamine hydrochloride	NH_2OHHCl	69·5	·6	e.s.
Iodine	I	127	5000	—
Iridium chloride	$IrCl_3$	299·5	—	—
" potassium tetrachloride	$IrCl_3\,2KCl$	484	—	—
" sodium tetrachloride	Na_2IrCl_6	452	—	—
" tetrachloride	$IrCl_4$	335	—	—

Name	Chemical Formula	Molecular weight	No. of parts of cold water in which 1 part is soluble	No. of parts of hot water in which 1 part is soluble
Kaolin...	$Al_2Si_2O_7 + 2H_2O$	258·8	insol.	insol.
Lead acetate (sugar of lead)	$Pb(CH_3COO)_2\ 3H_2O$	379	2·3	·5
" chromate	$PbCrO_4$	323	insol.	insol.
" nitrate	$Pb(NO_3)_2$	331	1·85	·70
" oxide	PbO	223	insol.	insol.
Lithia, caustic (see Lithium hydrate)				
Lithium bromide	$LiBr$	87	·6	·4
" carbonate	Li_2CO_3	74	75	138
" chloride	$LiCl$ (cryst. has $2H_2O$)	42·5	1·25	·8
" hydrate	$LiOH$	24	sol.	
" iodide	LiI	134	·61	·2
Magnesium bromide	$MgBr_2\ 6H_2O$	291	1	·75
" carbonate	$MgCO_3$	84	insol.	insol.
" chloride	$MgCl_2\ 6H_2O$	202	·6	1·5
" iodide	$MgI_2\ 8H_2O$	421	1·5	·75
" sulphate (Epsom salt)	$MgSO_4\ 7H_2O$	246	·15	·15
Manganese dioxide	MnO_2	87	insol.	insol.
" sulphate	$MnSO_4\ 4H_2O$	223	·8	1
Mercury	Hg	200	—	—
" chloride (mercuric)	$HgCl_2$	271	16	1·8
" chloride (mercurous)	Hg_2Cl_2	471	insol.	insol.
" iodide (mercuric)	HgI_2	454	insol.	insol.
" potassium iodide (sol.)	$HgI_2\ 2KI$	786	sl. sol.	sl. sol.
" sulphocyanide	$Hg(SCN)_2$	316	insol.	insol.
Metol (mono-methyl-para-amido-phenol)	$C_6H_3(OH)(NHCH_3)$	344	sol.	
Ortol...	$C_6H_3OHNHCH_3C_6H_4(OH)_2$	234	sol.	
Palladious chloride	$PdCl_2$	177·5	sol.	sol.
" potassium chloride	$PdCl_2\ 2KCl$	326·5	sol.	
Para-amido-phenol (see Para-amido-phenol hydrochloride)				
Para-amido-phenol hydrochloride	$C_6H_4(OHNH_2)$	109	sol.	sol.
Para-formaldehyde	$(COH)_3$	90	sl. sol	sl. sol
Para-rosaniline (tri-amido-phenyl carbinol)	$C_{19}H_{21}N_3O$	305	insol.	in sol.
Pentane	C_5H_{12}	72	6	
Phenol (see Acid, carbolic)				
Platino-potassium chloride or chloro-platinite	K_2PtCl_4	413·4	insol.	
Platinum bichloride	$PtCl_4$	264·4	1	1
" perchloride	$H_2PtCl_6\ 6H_2O$	516·4		
Potassa (see Potassium hydrate)				
Potassium aluminium sulphate (see Alum potash)				
" bicarbonate	$KHCO_3$	100	3	dec.
" bichromate	$K_2Cr_2O_7$	294	10	1
Potassium bitartrate	$(CHOH)_2COOHCOOK$	198	sol.	—
" bisulphite	$KHSO_3$	120	·75	—
" boro-tartrate	$C_4H_4(OH)_2(COO)_2BOK$	214	1·5	v. sol.
" bromide	KBr	119	1·5	·9
" carbonate (dry)	K_2CO_3	138	·9	·64
" chlorate	$KClO_3$	122·5	16·7	2
" chloride	KCl	74·5	3	1·75
" chloroplatinite	K_2PtCl_4	413·4	6	3
" chromate	K_2CrO_4	194	2	1·2
" chromic sulph. (see Alum, chrome)				
" citrate	$K_3C_6H_5O_7H_2O$	342	·6	v. sol.
" cyanide	KCN	65	2	v. sol.
" ferric oxalate	$Fe(C_2O_4)_3K_3\ 3H_2O$	491	16	·5
" ferricyanide	$K_3Fe(CN)_6$	329	2·5	·4
" ferrocyanide	$K_4Fe(CN)_6\ 3H_2O$	422	4	1·3
" ferrous oxalate	$Fe(C_2O_4)_2K_2\ 2H_2O$	328	insol.	2
" fluoride	$KF2H_2O$	92	sol.	v. sol.
" hydrate	KHO	56	·4	v. sol.
" iodide	KI	166	·75	·5
" metabisulphite	$K_2S_2O_5$	222	3	dec.
" nitrate	KNO_3	101	3·8	·4
" nitrite	KNO_2	85	1	v. sol.
" oxalate	$K_2C_2O_4$	184	3	v. sol.
" percarbonate	$K_2C_2O_6$	198	15	dec.
" permanganate	K_2MnO_4	138·5	65	5
" persulphate	$K_2S_2O_8$	316	16	
" phosphate	K_2HPO_4	270	50	dec.
" silicate	K_2SiO_3	174	sol.	
" sulphide and sodium tartrate	$KNaC_4H_4O_6\ 4H_2O$	154	3	v. sol.
" sulphide	K_2S_5	174	1·4	v. sol.
" sulphocyanide	$KCNS$	97	·46	
Pyrocatechin	$C_6H_4(OH)_2$	110	1·25	
Pyrogallol (see Acid, pyrogallic)				
Pyroxyline				
Quinone (see Benzoquinone)				
Quinomet sodium-sulphonate	$C_{18}H_{10}O_6(NO_3)_4 + C_{12}H_{10}O_7$	947	insol.	
Resorcin	$C_6H_4(OH)_2 + C_6H_4(OH)(NHCH_3)_2$	263	100	
Rochelle salt (see Potassium and sodium tartrate)				
Rodinal (see Para-amido-phenol hydrochloride)	$C_6H_4(OH)_3SO_3Na$	211		v. sol.
	$C_6H_4(OH)_3$	110	·6	v. sol.

Name	Chemical Formula	Molecular weight	No. of parts of cold water in which 1 part is soluble	No. of parts of hot water in which 1 part is soluble
Schlippe's salt (see Sodium sulphantimoniate)				
Silver acetate	$AgC_2H_3O_2$	167	100	sl. sol.
" ammonio-carbonate	$Ag_2CO_3,4NH_3$	229	sol.	sol.
" ammonio-nitrate	$AgNO_3+2NH_3$	204	v. sol.	v. sol.
" bromide	$AgBr$	188	insol.	insol.
" carbonate	Ag_2CO_3	276	insol.	insol.
" chlorate	$AgClO_3$	191·5	20	sol.
" chloride	$AgCl$	143·5	insol.	insol.
" chromate	Ag_2CrO_4	332	insol.	—
" citrate	$AgC_6H_5O_7$	297	insol.	insol.
" cyanide	$AgCN$	134	insol.	insol.
" fluoride	AgF,H_2O	199	v. sol.	v. sol.
" iodide	AgI	235	insol.	insol.
" lactate	$AgC_3H_5O_3,H_2O$	215	15	—
" nitrate	$AgNO_3$	170	1	1
" oxalate	$Ag_2C_2O_4$	154	300	sol.
" oxide	Ag_2O	304	sl. sol.	insol.
" phosphate	Ag_3PO_4	232	insol.	insol.
" sulphate	Ag_2SO_4	419	insol.	insol.
" sulphide	Ag_2S	312	insol.	insol.
" sulphocyanide	$AgCNS$	248	insol.	insol.
" tartrate	$Ag_2C_4H_4O_6$	364	v. sol.	v. sol.
Soda, caustic (see Sodium hydrate)				
Sodium acetate fused	$NaC_2H_3O_2,3H_2O$	136	sl. sol.	sl. sol.
" bihnrate (borax; see Sod. borate)	$NaC_2H_3O_2$	82	1	v. sol.
" bicarbonate	$NaHCO_3$	84	11·3	dec.
" bichromate	$Na_2Cr_2O_7,2H_2O$	298	3	·6
" bisulphite	$NaHSO_3$	104	3·5	·5
" borate	$Na_2B_4O_7,10H_2O$	382	17	·5
" bromide	$NaBr$	103	1·1	·9
" carbonato (dry)	Na_2CO_3	106	6	2·2
" carbonate (cryst.)	$Na_2CO_3,10H_2O$	286	1·6	v. sol.
" chloride	$NaCl$	58·5	2·7	2·5
" chloroplatinite	$PtCl_2,2NaCl\,6H_2O$	560·4	sol.	v. sol.
" citrate	$2Na_3C_6H_5O_7,11H_2O$	714	1·1	—
" fluoride	NaF	42	23	—
" formate	$NaCHO_2,H_2O$	86	—	—
" hydrate (caustic)	$NaOH$	40	1·62	v. sol.
" hyposulphite	$Na_2S_2O_3,5H_2O$	248	·65	v. sol.
" iodide	NaI	150	·5	·4
" nitrate	$NaNO_3$	85	1·1	·6
Sodium nitrite	$NaNO_2$	69	1·4	—
" nitroprusside	$Na_4Fe(CN)_5(NO)\,2H_2O$	298	2·5	—
" oxalate	$Na_2C_2O_4$	134	33	sol.
" persulphate	$Na_2S_2O_8$	238	sol.	1
" phosphate	$Na_2HPO_4,12H_2O$	358	6·7	v. sol.
" silicate	Na_2SiO_3	124	3	v. sol.
" sulphantimoniate	$Na_3SbS_4,9H_2O$	479	3	4
" sulphate (cryst.)	$Na_2SO_4,10H_2O$	322	3	v. sol.
" sulphide	$Na_2S,9H_2O$	240	v. sol.	v. sol.
" sulphite (dry)	Na_2SO_3	126	4	4
" sulphite (cryst.)	$Na_2SO_3,7H_2O$	252	2·2	—
" tartrate	$Na_2C_4H_4O_6,2H_2O$	230	sol.	1
" tribasic phosphate	$Na_3PO_4,12H_2O$	380	5·1	sol.
" tungstate	$Na_{10}W_{12}O_{41},28H_2O$		8 to 12	v. sol.
" vanadate	Na_3VO_4	184	sol.	sol.
Starch (see Cellulose)				
Strontium bromide (dry)	$SrBr_2$	247·5	sol.	sol.
" bromide (cryst.)	$SrBr_2,6H_2O$	355·5	1	·5
" chloride (dry)	$SrCl_2$	158·5	1·96	1
" chloride (cryst.)	$SrCl_2,6H_2O$	266·5	1·33	·6
" iodide	$SrI_2,6H_2O$	449	·56	·25
Sugar of lead (see Lead acetate)				
Tannin (see Acid, digallic)				
Thiocarbamide	$CS(NH_2)_2$	76	11	v. sol.
Thiosinamine	$CS(NH_2)NHC_3H_5$	116	17	—
Thymol	$CH_3C_3H_7OHC_6H_3$	150	330	—
Tin (stannous) chloride	$SnCl_2+2H_2O$	225	1·1	v. sol.
Uranin	$C_{20}H_{10}O_5Na_2$	376	sol.	sol.
Uranium acetate	$UO_2(C_2H_3O_2)_2,2H_2O$	426	v. sol.	v. sol.
" chloride	UO_2Cl_2,H_2O	361	v. sol.	v. sol.
" nitrate	$UO_2(NO_3)_2,6H_2O$	504	4	v. sol.
" sulphate	$UO_2SO_4+3H_2O$	422	·5	·25
Vanadium chloride	$2VO_2,4HCl\,3H_2O$	—	v. sol.	v. sol.
Verdigris (see Copper acetate)				
Vitriol, blue (see Copper sulphate)				
" green (see Ferrous sulphate)				
" white (see Zinc sulphate)				
Water	H_2O	18	—	—
Washing soda (see Sodium carbonate)				
Wood alcohol (see Alcohol methyl)				
Zinc bromide	$ZnBr_2$	225	·3	v. sol.
" chloride	$ZnCl_2$	136	·3	v. sol.
" iodide	ZnI_2	319	·3	dec.
" sulphate (white vitriol)	$ZnSO_4,7H_2O$	287	·62	v. sol.

water than is required for the working strength, and adding water at the time of use. Take any one solution "ready-for-use" formula. Assume that it includes 10 oz. of water. To prepare a concentrated solution, use only 5 oz. of water, when, of course, a bottle half the size can be utilised. When required for use dilute with an equal bulk of water.

SOLUTIONS, MAKING UP

The method of making up photographic solutions should not be a haphazard one. The salts, in making up a stock solution, for example, must not be all placed in a dry bottle and the water added, for this conduces to slow and often incomplete solution. Another important point is the quantity of water used. In the majority of the formulæ given in this work the quantity of solvent is, where possible, given so as to make a total bulk of either 10 or 20 oz., or 1,000 ccs. Take any formula, such, for instance, as a developer containing—

Pyro .	.	1 oz.	50 g.
Sodium sulphite	.	4 ,,	220 ,,
Citric acid .	.	1 ,,	55 ,,
Distilled water to .	.	20 ,,	1,000 ccs.

If the solids were weighed out and 20 oz. or 1,000 ccs. of water added, the total bulk would be more than 20 oz. or 1,000 ccs., and unless the total bulk were measured it would be impossible to determine the exact quantity of solution to use for a given weight of pyro. The correct method is to dissolve the solids in about three-fourths of the total bulk of water, and then add sufficient water to make the given quantity. Again, in making developers, it is advisable to dissolve the preservative, the sulphite or metabisulphite, first and then add the developing agent, except in the case of metol, which should always be dissolved first. When there are several salts given, it is usual in photographic formulæ to dissolve them in the order in which they are given, and it is preferable always to use warm or hot water and dissolve each salt separately. In nearly all cases there is considerable lowering of the temperature when salts are dissolved, hence the value of hot water, for most salts are more soluble in hot than in cold water. As all solutions are of greater specific gravity or heavier than the solvents, it is not a good plan to place the salts in a bottle, fill up with water, and allow to stand, as the bottom of the liquid becomes a saturated solution, whilst the top may be nearly pure water. An excellent method is to use linen or muslin bags containing the salts and suspend them from the top of the bottle or jug, when the solution of the salts rapidly sinks to the bottom, its place being taken by fresh water or weaker solution; this method has the advantage, too, of straining out any dirt or foreign matter from the solution. The precautions given under the heading "Water" should also be noted.

In a 10 per cent. solution, 10 parts by measure contain 1 part of the dissolved substance. The rough-and-ready method of mixing together 1 oz. of the salt and 9 oz. of water does not make a true 10 per cent. solution. Ten fluid ounces contain 4,800 fluid grs., and should therefore contain 480 grs. of the salt. Chemicals are always sold by avoirdupois weight, 1 oz. of

which contains 437½ grs., the apothecaries' ounce consisting of 480 grs. The former and lighter ounce therefore needs less water than the latter in order to make a true 10 per cent. solution; but, happily, the difference is not so much as to make a very great difference in the working powers of solutions. The correct way to make a 10 per cent. solution is to place the 1 oz. (avoirdupois, as bought) of chemical in a measure or bottle, and make up to a total bulk with water, of 9 oz. 55 mins. (9 oz. 1 drm. is near enough). Ten mins. of such a solution will contain 1 gr. of the dissolved chemical.

Solutions are not always made up in the 10 per cent. strength. When the proportion in a formula is given as a percentage, the number of grains of solid per ounce of liquid can be obtained by multiplying the percentage figure by 4 and adding to the result its tenth part. Thus 5 per cent. $= 5 \times 4 = 20$; $\frac{1}{10} \times 20 = 2$; $20 + 2 = 22$; that is, 5 per cent. $= 22$ grs. per ounce. (approx.). The following table, compiled by C. C. Sherrard, shows at a glance the exact composition of "per cent." and "part" solutions, made by simple multiplication :—

Strength of Solution	For each 1 oz. of water take of the salt	Strength of Solution	For each 1 oz. of water take of the salt
	Grs.		Grs.
1 per cent. . .	4·557	1 in 1,000 . .	·4557
2 per cent. . .	9·114	1 in 500 . .	·9114
3 per cent. . .	13·671	1 in 400 . .	1·139
4 per cent. . .	18·228	1 in 300 . .	1·519
5 per cent. . .	22·785	1 in 200 . .	2·2785
10 per cent. . .	45·57	1 in 100 . .	4·557
15 per cent. . .	68·355	1 in 50 . . .	9·114
20 per cent. . .	91·14	1 in 25 . . .	18·228
25 per cent. . .	113·925	1 in 10 . . .	45·570
40 per cent. . .	182·28	1 in 5 . . .	91·14

SOLUTIONS, SATURATED (*See* "Saturated Solution.")

SOLUTIONS, STOCK (*See* "Solutions, Making up.")

SOLUTIONS, SUPER-SATURATED (*See* "Super-saturated Solutions.")

SOLUTIONS, TEMPERATURE OF (*See* "Temperatures.")

SPANISH COMBINED BATH

A combined toning and fixing bath for gelatino-chloride paper, said to have been invented by a Spanish expert, but closely resembling other combined baths. It gives rich tones on prints from good negatives, and the formula, as generally published, is as follows :—

"Hypo" .	.	2½ oz.	300 g.
Am. sulphocyanide .	.	75 grs.	19 ,,
Sub. acetate of lead .	.	50 ,,	12·5 ,,
Lead nitrate	.	15 ,,	3·75 ,,
Citric acid	.	15 ,,	3·75 ,,
Alum	.	50 ,,	12·5 ,,
Water	.	9 oz.	1,000 ccs.

Dissolve in hot water, stand a few days, filter, and add :—

Gold chloride	.	. 5 grs.	1·25 g.
Water	.	. 1 oz.	110 ccs.

SPECIFIC GRAVITY (Fr., *Pesanteur spéci-fique, Densité;* Ger., *Spezifisches Gewicht*)

Synonym, density. The weight of a certain bulk of a solid or liquid compared with that of the same bulk of water; in the case of gases, hydrogen is the standard. Thus, a certain measure of water is found to have a weight of 3 lb.; the same measure of mercury is found to have a weight of 40·8 lb; then $\frac{40·8}{3}$ = 13·6, which is the specific gravity of mercury. Densities of solutions are commonly measured with the hydrometer (*which see*), there being, as a rule, a relation between specific gravities and hydrometer degrees.

SPECTACLE LENSES

Simple lenses consisting of only one piece of glass, and occasionally used in photography. Owing to their being non-achromatic, their chemical and visual foci do not coincide, and, after focusing, the distance between lens and plate is decreased by $\frac{1}{40}$ to $\frac{1}{50}$ of an inch when photographing normal objects; in portraiture, copying, etc., the correction needs to be greater.

SPECTACLES, MONOCHROMATIC

Spectacles or monocles, usually of blue glass, used for judging the appearance of the view to be photographed. Seen through blue glass, the colours in the view are toned down or obliterated, and one gets a better idea of how the picture will be represented in the monochrome print. A blue focusing (ground-glass) screen gives the same effect. (*See also* "Stereoscopic Spectacles.")

SPECTROGRAPHY (Fr., *Spectrophotographie;* Ger., *Spektrophotographie*)

Any spectroscope may be converted into a spectrograph or camera for photographing the spectrum by attaching to the telescope a camera instead of an eyepiece. The simplest form is that in which a direct-vision spectroscope is used, and it may be either an ordinary camera or merely an oblong box to the front of which the spectroscope is attached, whilst the back carries the dark-slide for the plate. The usual eye-piece lens must be removed, and care should be taken that no part of the mount cuts off the spectrum. No lens need be used, and the length of the spectrum is then solely dependent on the extension of the camera. If a lens is used, then the lines will be sharper. A shows the simple box form without lens; F is the box, D the direct-vision prism, B the slit, A the condenser, and E the milled head for focusing the collimator lens. B shows the form with lens D behind the prisms; H is an outer tube that prevents stray light having access to the camera, K is the groove for the dark-slide, and E a central screw, on which the back can be swung to any angle and then fixed by the screw F; b is a short length of bellows.

When using the direct-vision spectroscope, the line that passes straight through is generally the D line; therefore the spectroscope must be placed above the centre of the plate, otherwise the violet end will not be included. With the spectrograph without lens, the length and width of the spectrum are dependent solely on the extension of the camera.

In the ordinary single or two-prism spectroscope the telescope should be entirely replaced by a light camera, and it is advisable to cover over the prism table and the lenses so that no light has access to the plate but through the slit; otherwise general fogging of the plate will ensue.

It is convenient to take a series of negatives on one plate, and this can be done by small sliding shutters in front of the slit, but more conveniently by providing a slit, say, of one inch width, in the back of the camera and arranging for the dark-slide to be shifted in its grooves so that three or four contiguous spectra may be obtained by merely shifting the plate. With all prismatic spectrographs it is essential to arrange for the swinging of the plane of the plate; that is, for putting the violet end nearer the lens than the red. If the spectroscope is always to be used with the same prisms and lenses, then this can be done once for all; otherwise slots and screws must be provided as shown in diagram B.

One great disadvantage of the prismatic spectrograph is the uneven dispersion, the red being cramped together and the blue and violet more extended. On the other hand, this may be an advantage in photographing very faint absorptions or sensitising action in the red if mere qualitative and not quantitative results are desired. This unequal dispersion is well shown in C and D; the former represents the spectrum produced by a diffraction grating and the latter a spectrum of equal length and dispersion produced by a prism.

With all glass there is more or less absorption of the ultra-violet, and with heavy flint glasses with great dispersion this may even extend into the visible violet. Quartz, calcite, and fluorite are very transparent to this region, and must be used both for prisms and lenses if photography of the ultra-violet is to be attempted. Undoubtedly the concave grating which requires no lens is most useful for this region. Practically, ordinary glass may be considered not to transmit beyond λ 3,400 when a thickness of about ¾ in. is used. Another disadvantage with the prismatic spectrograph is that the lines are curved with the convex side towards the red, due to the fact that only those rays which pass through the centre of the slit can pass through a plane perpendicular to the refracting edge of the prism, which is usually called the principal plane.

Diffraction-grating spectrographs are far more satisfactory for all photographic work, especially now that the excellent celluloid replicas can be obtained so cheaply. The principle of the direct-vision spectroscope is described elsewhere, and the same arrangement may be used for the spectrograph. A section of such an instrument, designed by Tallent, is shown at E, in which s is the slit, c the collimator lens, r the grating cemented to a narrow angle prism which refracts the central white beam to w into a small

pocket of blackened wood; L is the camera lens, and P the dark-slide. The lenses are single landscape lenses, and their foci or that of the camera lens will depend upon the length of the spectrum desired. A lens of $14\frac{1}{2}$ in. will give a spectrum of about 4 in. in length between λ 3,500 and λ 8,000. The slit must be placed at the equivalent focus of the collimator lens, and all parts except just the grating aperture should be blocked out and the interior of the camera lined with black velvet or blackened to prevent reflections.

If it is not desired to use a prism grating, then obviously the plate must not be in a straight line with the grating, but at the angle of diffraction. This may be calculated as follows: The

$$1 \text{ inch} = \frac{1}{.03937043}$$

$$\therefore b = \frac{1}{.03937043 \times 14490} \text{ mm.}$$

$$\therefore b = .00175292$$

The correct position of the plate may also be found by supporting the collimator lens on a block of wood, or temporarily attaching it to a card and placing the slit at its equivalent focus close to a strong light; then, on inserting the grating close behind the lens, the first order spectrum will be seen on each side of the white image of the slit, and the distance from this will, of course, give the angle between the axial line and the grating. The grating may be placed at

A. Box-form Spectrograph Camera

B. Spectrograph, with Slot and Screw Attachments

In diagrams C and D, the letter references are as follow :—

b, brown; *r*, red; *o*, orange; *oy*, orange yellow; *y*, yellow; *yg*, yellow green; *g*, green; *bg*, blue green; *b*, blue; *bv*, blue violet; *v*, violet; *l*, lavender

F. Calculating Angle of Diffraction

E. Tallent's Diffraction-grating Spectrograph

C and D. Spectra produced by Diffraction Grating and Prism respectively

spectra formed by a diffraction grating lie on each side of the central white image, and to find the distance of the first wave-length or the angle of diffraction let F represent a spectroscope in which *b* is the grating space—that is, the width of one ruling and the adjacent space—and *e* the angle of deviation. What we wish to determine is either *e*, or the length of A B, then taking ·0003340 mm. as the first wave-length which it is desired to find the position of—

$$\text{A B} = \sin e = ·0003340 \div b$$

and assuming that $b = ·001752$, we have—

$$\sin e = ·0003340 \div ·001752 = ·1906 = 11°$$
practically.

The grating space, or *b*, is found very easily, thus: Assuming that we have a grating with 14,490 lines to the inch, then—

right angles to the collimator lens, or preferably so that its plane cuts the angle between the axes of the collimator and camera lens—that is, so that the angles of incidence and diffraction are equal.

For a plane metal or reflection grating the arrangement shown for this (*see* " Spectroscope ") may be adopted, replacing the telescope by a camera, and fixing the collimator and camera at an angle of 45°, the grating being mounted on a revolving table.

Excellent replicas, cemented to sections of convex lenses so as to form concave gratings, being now obtainable, it may be as well to give Eder's method for mounting concave gratings for spectrography. The idea is to keep the slit position constant, which is a great convenience when using a heliostat or fixed source of artificial light, H in G. The camera moves round a

point G; the slit S, which is joined to the tube T, always moves along S G; the plate P moves on the arc P″ P P‴, which is struck from the centre G; the slit S is joined by a rod S B C to C, which is the centre of the distance P G, G being the grating. It is obvious then that as the plate is moved round the arc P″ P P‴ the slit and the grating also move. The central point of the grating must be exactly over the point G, and the slit S must be exactly over the point S, at which the rod is joined to T. T is a collapsible tube, which can be shortened or lengthened as it approaches or recedes along S G.

When diffraction spectra are used, the spectra are not isolated, but overlap; and this overlapping follows the law $\lambda^1 = 2\lambda^2 = 3\lambda^3 = 4\lambda^4 = 5\lambda^5$, in which λ^1, λ^2, λ^3, etc., are the wave-lengths in the first, second, third, etc., orders. This overlap is shown in the following table, taking λ 6,000 in the first order :—

First order spectrum		6,000				
Second	,,	,,	3,000	6,000		
Third	,,	,,	1,500	4,000	6,000	
Fourth	,,	,,		3,000	4,500	6,000
Fifth	,,	,,		3,600	4,800	
Sixth	,,	,,		3,000	4,000	

G. Use of Heliostat in Spectrography

For visual work this overlap is of no moment when using the first order only, because the eye is not sensitive to the ultra-violet; but in spectrography this overlapping may be very troublesome, particularly when dealing with the extreme red, for if we take the limit set by the absorption of the glass as λ 3,400, as that which would act on the plate, this line would coincide with λ 6,800 in the first order, and therefore the farther we proceed with the red the more active will be the ultra-violet of the second order, and thus totally erroneous conclusions may be drawn from the results.

This superposition of the second order can always be seen in negatives when using daylight, the electric arc, or magnesium ribbon; so that it is as well to use some absorbent material between the light source and the plate. This may be either in front of the slit or, preferably, in front of the plate itself. In the former position there may be used a cell containing a solution of æsculin or filter yellow K, or a gelatine screen stained with the above. For a screen in contact with the plate it is advisable to coat a sheet of thin patent plate with a 5 per cent. solution of gelatine, and when dry to stain up about half of the plate; that is, up to about where the D lines fall, with filter yellow K or dianil orange G. The screen should then

be placed in contact with a plate and a long exposure given to the arc or magnesium ribbon to see that it does absorb the whole of the ultra-violet.

It may also be found convenient to fix permanently in the dark-slide a scale either of wave-

H. Interpolation Chart

lengths or one merely divided into known divisions, and excellent glass scales 10 mm. in length and divided into millimetres can be obtained commercially. With such a scale, which is impressed on the plate at each exposure, it is easy to calculate with approximate accuracy the wave-length of any line or the limits of an absorption band, etc. For instance, having determined that the distance between H_1 and C is exactly 90 mm., we have only to divide $d\lambda$ —that is, their difference in wave-length—by 90 to find the number of wave-lengths to a millimetre, thus—

$$C \lambda 6563 — H \lambda 3968 = 2595$$
$$\therefore 2595 \div 90 = 28\cdot8 \text{ wave-lengths per millimetre,}$$

so that if an unknown line was found 10·5 mm. from H, its approximate wave-length would be

$$3968 + (28\cdot8 \times 10\cdot5) = 4270\cdot4.$$

Obviously, this method is but approximate, but it is useful when studying absorption spectra or the sensitiveness of a plate.

To construct a wave-length scale, the easiest method is that suggested by A. J. Newton

I. Wave-length Scale.

(*Penrose's Pictorial Annual*, 1905–6, p. 81), but it requires an arc lamp, though the lines may be obtained by the method described under the heading "Wave-lengths." Narrow the slit down so that the D lines are divided; then, using

a panchromatic plate, photograph the lithium sodium, thallium, and blue strontium line. A sheet of plain glass should be placed in the dark-slide to represent the scale plate which will subsequently be fixed there. For the lithium lines use a deep red screen in front of the slit and give about two minutes' exposure ; then with a yellow or green screen obtain the thallium line, and finally the blue strontium line without a screen.

After development, measure accurately the distance between the lines and make an interpolation chart with the wave-lengths as abscissæ (see H) and the distance of the lines as ordinates, and draw the curve or straight line. It is advisable to increase the actual distances by some unit, say 10, all through. Then mark the wave-lengths in whole numbers, starting at λ 3,500 and going up to λ 7,500 or higher. The result will be as shown in H. From this draw an enlarged diagram, with the distances marked as at I, and then copy this in an ordinary camera down to the required size. From this negative make a positive by contact, and cement it into the dark-slide so that the D lines coincide exactly with those marked on the scale.

In photographing the spectrum for any purpose whatever, one must take into account the various factors incident to each region. For the ultra-violet, as has been pointed out, we must discard glass or use a concave grating. For the infra-red, glass is transparent enough probably for as far as the beginner is likely to want it. For the ultra-violet and the visible spectrum up to about λ 5,000 any ordinary plate may be used ; but it is in dealing with the other half of the spectrum up to about λ 7,000 that one has to use special colour-sensitive plates. For green and blue-green, acridine orange NO is the best sensitiser, though this region may be well recorded on any commercial erythrosine or isochromatic plate provided a long exposure be given or absorbing screen used. The erythrosine plate will also record to about λ 6,000, but beyond this one must use a panchromatic plate, sensitised with orthochrome T, pinaverdol, pinachrome, or homocol. For the extreme red—that is, from about λ 6,400 to λ 6,800 —pinacyanol is the best dye; whilst for λ 7,000 to λ 7,200 dicyanine is the most satisfactory. The method of preparing these plates is described elsewhere.

The plates must have a black backing. As regards the exposure but little help can be given, and in developing care should be taken not to prolong the duration too much, as otherwise fine faint lines may be easily buried.

SPECTROMETER (Fr., *Spectromètre ;* Ger., *Spektrometer*)

A spectroscope in which the prism or grating is mounted on a table, which is graduated into degrees and minutes so that the deviation of any line may be read.

SPECTRO-PHOTOGRAPHY (See " Spectrography.")

SPECTRO-PHOTOMETER (Fr., *Spectrophotomètre ;* Ger., *Spektrophotometer*)

An instrument by means of which the luminosity of various regions of two spectra can be directly compared. Various forms have been suggested.

There is, first, the double-slit photometer of Vierordt, in which the lights to be compared fall on the slit, the two halves of which can be opened or closed, and thence passed through a prism, to appear at the eyepiece as adjacent spectra ; they are compared by opening and closing the one slit which transmits the light to be measured, whilst that transmitting the standard light is kept constant. The eyepiece of the telescope is provided with sliding shutters which enable one to limit the field of view to the particular region under examination. The disadvantage of this method is that the two spectra are not of equal purity, and therefore not of the same colour, this being an inherent defect in the use of two slits of different widths.

Lummer and Brodhun introduced a photometer with two collimators at right angles to one another, the lights being brought into juxtaposition by means of a Lummer-Brodhun rhomb and thence dispersed. The reduction of one of the lights is produced by rotating sectors.

Polarising photometers have been devised by Glan, Crova, Hüfner, König, Glazebrook, etc. Their principle is that the lights are received through two contiguous slits, then pass through the dispersing medium, a Wollaston prism, and are brought into juxtaposition by a biprism, thence reaching the eyepiece, which is fitted with an analyser. This method also has its faults, and is really only strictly correct when monochromatic spectrum rays are used.

SPECTROSCOPE (Fr., *Spectroscope ;* Ger., *Spektroskop*)

An instrument designed for seeing a spectrum and consisting essentially of three parts—the slit, the dispersing medium, and the observing telescope. The latter is essential if it is desired to see the spectrum uncontaminated by white light, though it is possible to see a spectrum in any ordinary room with no more apparatus than an opaque card with a slit in it and the dispersing medium. If, for instance, a slit about 1 in. long and ¼ in. wide is cut in an opaque card about 12 in. long and 6 in. wide, and this card is placed

A. Spectroscope

on the cross-bar of a window, a fairly pure spectrum can be seen by going to the other side of the room and examining the slit through the dispersing medium held close to the eye. A complete spectroscope is shown at A, in which C is the collimator, consisting of a slit S at the focus of the lens I ; P is the prism, or dispersing medium ; and F the telescope which receives the refracted and dispersed beam. A third telescope is sometimes provided which throws a numbered scale on to the second face of the prism, whence it is reflected to the telescope and the eyepiece.

The slit is usually made of metal, and consists of two plates, one of which may be fixed and the other movable, the latter being actuated

by a micrometer screw so that its distance from the fixed jaw may be varied at will. In purchasing a slit, stipulation should be made that the jaws are of platinoid, a hard white alloy which does not readily tarnish. It is advisable also to have what is known as a symmetrical slit—that is, one in which both jaws are moved simultaneously by one screw. For very accurate wavelength determination this is important, as it is the centre of the line which is measured, and with a symmetrical slit this is constant, whereas with an unsymmetrical slit the spectral line widens on one side. On the other hand, it is quite possible to obtain wave-length readings, of sufficient accuracy for all ordinary work, with a slit having only one movable jaw if the edge of the spectrum line that coincides with the fixed jaw is taken for measurement. It is necessary that the jaws of the slit be bevelled with the bevel inside, and that the bevel be blackened, as this prevents reflection of the light. The jaws must be parallel and without any side slip, and parallelism of the jaws can be easily tested by opening the slit, then gradually closing it down till the aperture entirely disappears. This it should do throughout its entire length simultaneously. The edges of the jaws are easily damaged, and therefore the slit should never be screwed up roughly or too tightly. As the slit for normal work is extremely narrow, dust particles are very apt to lodge between them and give rise to dust lines, which are longitudinal black lines running throughout the length of the spectrum. These dust lines, whilst detracting from the appearance of the spectrum, are convenient in one way, as they prove whether the slit is parallel to the edge of the prism or the ruling of the grating, as if parallelism exists the lines are parallel to the edges of the spectrum. To clean a slit from dust particles a soft wood match stick should be cut to a fine bevel or chisel shape, and, the jaws being opened, the match should be inserted and the jaws closed till just gripping the wood, and then the match should be moved up and down and the jaws again opened and the match removed. When chemicals or solutions are burnt or volatilised by a spark close to the slit, it is apt to get splashed with particles of the salt; it is advisable then to use a condenser, which enables the spark to be worked some distance from the slit and focuses the image on the slit, or a thin microscopic cover glass may be temporarily placed in front of the slit.

Frequently a slit is provided with draw plates which cover parts of the slit, thus enabling two or more contiguous spectra to be photographed.

The dimensions of the slit depend upon the aperture of the collimator lens and the prism or grating, and it may be taken as a safe rule that the clear aperture of the slit should not be less than one-third the diameter of the lens. To some slits is also fitted a piece of metal with a wedge-shaped aperture cut in it; this is used to limit the size of the spectrum, and is an advantage for spectrography, as it enables one to narrow the width of the spectrum and thus prevents the diffusion of stray light. In most spectroscopes the aperture of the slit is narrowed by an internal diaphragm, which prevents scat-

tered light reaching the collimator lens. It is usual, too, for the slit to be mounted on a focusing tube, but for spectrography it is just as well to determine once for all the accurate distance of the slit from the collimator lens, and fix it so; and this does not at all interfere with the use of the instrument for visual work. The focal length of the collimator lens is merely a question of convenience, though naturally there are certain theoretical considerations that govern this. The rays from the slit are parallelised by the collimator lens, and we may calculate the breadth of the slit image as formed by the telescope or camera lens thus: let s = the height or length of the slit, f = the focus of the collimator lens, F = the focus of the telescope or camera lens, and S = the image formed by the latter, then—

$$S = s \times \frac{F}{f}$$

For instance, suppose the length of the slit = 12 mm., the collimator lens focus = 250 mm., and the camera lens focus = 500 mm., then—

$$S = 12 \times \frac{500}{250} = 24 \text{ mm.}$$

which will be the breadth of the slit image or spectrum.

It is essential that the collimator lens be achromatic, and that the slit be exactly at its equivalent focus. If these two points be not attended to, the aberrations of the lens come into play, and critical sharpness of the spectrum lines is impossible. The method of adjusting the slit and collimator for visual work is very simple. Assuming that the telescope eyepiece is fitted with cross wires or spider lines, these should be sharply focused and then the telescope focused for a very distant object, such as a church spire or tree. Then, without altering the telescope focus, swing it into line with the collimator lens, removing the dispersing medium, and obtain a sharp image of the slit by racking it nearer to or from the collimator lens. It is important, too, that the slit should be central with the axes of the collimator and telescope lenses. This can be determined by placing an opaque card with a small central hole over the slit and seeing whether the image of this hole falls in the centre of the collimator lens and the eyepiece.

The prism usually supplied with spectroscopes has a refracting angle of 60°, and it is important that it should be level and with the refracting edge parallel with the slit. Should the slit not be parallel with the refracting edge, it will be found that the Fraunhofer lines are not exactly at right angles to the length of the spectrum. As a rule, it will be found that the slit tube can be revolved so that this fault can be easily remedied. Should the spectrum not entirely fill the eyepiece—that is to say, if the height of the slit be reduced so that the spectrum is seen only as a narrow stripe across the field of view—the non-parallelism of the slit and prism edge can also be seen by the width of the spectrum decreasing or increasing as the slit is turned one way or the other.

The dimensions of the prisms should be such that they will entirely take up the beam of parallel light from the collimator. The height must therefore be equal to the diameter of the

collimator lens, but the length must be greater This can be shown mathematically to be :

$$l = \frac{h}{\sqrt{1 - \mu^2 \sin^2 \dfrac{A}{2}}}$$

calling l = the length, h = the height, and μ = the index of refraction, then for a 60° prism and

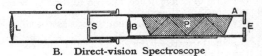

B. Direct-vision Spectroscope

an index of refraction of 1·5 and a height of 2 in. this becomes :

$$l = \frac{h}{\sqrt{1 - \dfrac{\mu_2}{4}}} = \frac{2}{\sqrt{1 - \dfrac{1\cdot5^2}{4}}} = 3\cdot02 \text{ in.}$$

The telescope should, like the collimator, have an achromatic lens, and should be of the same dimensions, and is generally of the same focus. The eyepiece is usually that known as a Ramsden, in which two plano-convex lenses are placed with their convex surfaces towards one another, the distance between them being about two-thirds of the focal length of one of them. This is frequently provided with cross wires or spider lines, which are used for measuring the position of a line. There are many different forms of eyepieces, some being provided with a bright metallic point, on to which the light is reflected from the outside by a small mirror. In others, such as the Gauss, a line of light is reflected by a piece of silvered glass. Micrometer eyepieces are also sometimes used, in which a micrometer screw moves a plate or wire across the spectrum, the amount of travel being read off on a divided drumhead or scale. These eyepieces are used for the measurement of wave-lengths, but visual measurement has been almost entirely superseded by the spectrographic method.

A very convenient accessory to the eyepiece is two sliding shutters, which can be pushed in from either side, thus enabling one to limit the field of view and cut out a brilliant line which might otherwise overpower a close, faint one. There are two other accessories often fitted, but which, except for rough visual measurement, are of little practical value. The first is the comparison prism, which is a small reflection prism that can be swung over half the slit, the advantage being that one can compare two light

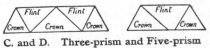

C. and D. Three-prism and Five-prism
Trains for Spectroscope

sources, for instance daylight, which may be admitted to the slit in a straight line, and a vacuum tube or cell filled with coloured fluid, which can be placed at right angles to the axis of the collimator. The other accessory is a scale of lines, which is projected from the last face of the prism into the eyepiece.

For rough visual work it is usual to employ direct-vision spectroscopes, and these are fitted

with three or five prisms placed base to apex, the glass being so chosen that whereas the deviation of the D line, for instance, by the one set of prisms is counteracted by the others, so that it emerges in a straight line, the other colours are spread out on either side of it. The usual form of the direct-vision spectroscope is shown at B, in which s is the slit, B the collimator lens, P the train of prisms. The distance between the slit and collimator lens is adjustable by sliding the whole tube A out. Frequently a lens is placed at the aperture E for an eyepiece. An extra fitting, C, carrying at one end a condensing lens, L, which can be focused on to the slit by sliding the tube, is a great advantage, as it limits the light received by the slit to that which it is desired to examine. Occasionally a comparison prism and photographed number scale are also fitted. C and D show respectively three-prism and five-prism trains.

For the critical examination of a spectrum it is advisable that the line or region under examination should pass through the prism at the angle of minimum deviation. Unless a special form, or, as it is usually called, an auto-collimating

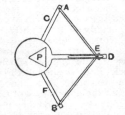

E. Auto-collimating Spectroscope

spectroscope, be used, it would be necessary to adjust the prism for this position for every line. Several such instruments can be obtained commercially, but a simple form, which is not difficult to fit to any spectroscope, is shown at E. To the prism table is fastened a slotted brass rod, D, a continuation of which just bisects the refracting angle of the prism P, when this is placed at the angle of minimum deviation for the D line. c is the collimator and F the telescope, and to their ends are fastened two thin brass rods, A E and B E, which, when the position of minimum deviation is found, are joined together by a pin, E. Then any movement of the telescope also moves the collimator and prism into the position of minimum deviation.

A spectroscope fitted with a diffraction grating is much to be preferred for most purposes, because the spectrum is normal ; that is to say, the distances apart of the rays of different colours are arranged according to their wavelength. On the other hand, as the prismatic spectrum is more brilliant, the prism is to be preferred for very faint spectra.

All the parts of the details given above for the prismatic spectroscope apply to that made with a diffraction grating or replica, and the same precautions have to be observed to ensure parallelism between the slit and the rulings of the grating, and the plan (see E) may be taken as the plan of a diffraction-grating spectroscope if the prism be removed and replaced by a transmission grating.

With a plain reflection grating it is obvious that we cannot see through the metal, but we see the spectrum reflected from its surface, so that, although we may use the same stand, the collimator and telescope are arranged as at F,

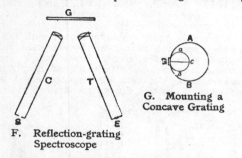

G. **Mounting a Concave Grating**

F. **Reflection-grating Spectroscope**

in which c is the collimator, s the slit, τ the telescope, E the eyepiece, and G the grating.

Direct-vision grating spectroscopes are also made, but in this case (as at H) the grating G is cemented to a prism P of narrow angle, throws the central white beam w out of the field of view. s is the slit, L the lens, and E the eyepiece. For all advanced work the concave grating is most generally used, and it has the great advantage that no lenses are required, for the metal, being cast and polished to a spherical form, acts like a concave mirror and forms an image without the aid of lenses. The particular method of mounting concave gratings is rather beyond the scope of this work, but the principles involved may be given. In diagram G, let A B be a circle struck from the centre c; G is the grating. It is obvious that G is an arc of the circle of which c G is the radius. Now it was proved by Rowland that if a light source—which is, of course, the slit—and the grating be placed on the circumference of a circle G a c β,

H. **Direct-vision Grating Spectroscope**

which has as diameter the radius of curvature of the grating, then the image of the slit would also be formed on this circumference. Therefore it would only be necessary to place an eyepiece at the point where the image is formed to see the spectrum.

SPECTRUM (Fr., *Spectre*; Ger., *Spektrum*)

A ribbon or band of colours formed when a narrow beam of heterogeneous light traverses a dispersing medium such as a prism or diffraction grating.

SPECTRUM ANALYSIS (Fr., *Analyse spectrale*; Ger., *Spektral-analyse*)

The analysis of a substance by burning or otherwise raising it to the point of incandescence, as, for instance, by the electric current, and then examining the light by a spectroscope. As all substances give characteristic spectra, with bright lines always of the same wave-length, it is possible to tell what substances are burning

or incandescent. Spectrum analysis is only qualitative and not quantitative; that is to say, the elements present can be named, but the quantities in which they exist in the substance under examination cannot be stated.

SPECTRUM CURVE (Fr., *Courbe spectrale*; Ger., *Spektrum-Krümmung*)

The curve obtained by photographing the spectrum on a sensitive surface, which, by the deposit of metallic silver or alteration of colour, indicates the colours to which the substance used is sensitive.

SPECTRUM HELIOGRAPH (See "Heliograph.")

SPECTRUM, LUMINOSITY OF

The first examination of a spectrum at once shows to the veriest tyro that the luminosity of the colours varies enormously. The following table gives the generally accepted distribution of the colours and the visual luminosity of the various regions of the solar spectrum.

Colour	Wave Length λ		Luminosity	Quantity of light, the total being = 1,000
	Of the colour μ μ	Of the limits of the colour		
Red	663		8	91
		625		
Orange	610		76	147
		600		
Yellow and Yellow-green	575		100	396
		550		
Green and Blue-green	526		64	303
		490		
Bright blue and Indigo	472		12	38
		450		
Blue-violet	440		7	13
		430		
Violet	420		4	12

Note that the above table applies only to the solar spectrum as regards the last two columns, and that the figures in these would differ for almost every light source.

SPECTRUM, PHOTOGRAPHING THE (See "Spectrography.")

SPECTRUM, SOLAR (Fr., *Spectre solaire*; Ger., *Sonnenspektrum*)

The spectrum given by direct or reflected sunlight. As has been pointed out (see "Fraunhofer Lines"), the solar spectrum is crossed by numerous dark lines of greater or less breadth and intensity, and the discovery of the actual cause of these lines is ascribed to Kirschoff in 1859. He enunciated three laws, which practically explain the formation of all spectra: he said (a) that a substance when excited by some means tends to emit definite rays, the length of the wave depending upon the substance and its temperature; (b) a substance also exerts a definite absorption, which is a maximum for the rays it emits; (c) the ratio between the emissive and absorptive power is constant for all

substances at the same temperature. The first two laws explain the occurrence of the Fraunhofer lines in the solar spectrum.

SPECTRUM, VIRTUAL (Fr., *Spectre virtuel;* Ger., *Virtuell Spektrum*)

A term applied to any spectrum seen through a prism or grating, and which is not formed by the aid of lenses.

SPEED INDICATOR (Fr. *Indicateur de vitesse;* Ger., *Geschwindigkeitsmesser*)

An appliance patented by the Thornton-Pickard Company for use with their roller-blind shutters. It consists of a dial marked with the different speeds, and having a pointer so geared as to move in accordance with the tension of the spring blind. The indicator shows at a glance the speed at which the shutter is set.

SPEEDS, PLATE (See "Sensitometry.")

SPERM CANDLE (See "Sensitometry," subheading "The Standard Light.")

SPHERICAL ABERRATION

The failure of a lens having a spherical surface to bring all the rays transmitted through it to a focus in one plane, so that when the margins of the image are in focus the centre is diffused. When the rays passing through the margin of the lens are brought to a focus nearer the lens than are the rays transmitted through the centre, the spherical aberration is said to be positive; when the contrary is the case, it is said to be negative. The flatter the surface of the lens which receives parallel rays from an object, the worse is the aberration. It is remedied by the use of a diaphragm or stop, but as this reduces the amount of light the lens manufacturer largely overcomes the trouble in another way; he combines two lenses, the one showing positive and the other negative aberration.

SPIKE OIL (Fr., *Essence d'aspic;* Ger., *Spiköl* or *Lavendelöl*)

Synonym, oil of spike lavender. It is a pale yellowish volatile oil with fragrant lavender odour obtained from the leaves and tops of *Lavendula spica*. It is used in some varnishes. *In process work,* this oil is given in several formulæ as an addition to bitumen solution. It prevents the film drying brittle.

SPILLER'S REDUCER (See "Copper Chloride.")

SPINTHARISCOPE

Sir William Crookes's instrument for demonstrating the action of radium upon a fluorescent screen.

SPIRIT OF HARTSHORN (See "Ammonia.")

SPIRIT LAMPS (Fr., *Lampes d'alcool;* Ger., *Spirituslampen*)

Spirit lamps of different kinds are used for various photographic purposes, as in heating burnishers and solutions, warming negatives prior to varnishing, etc. They all consist essentially of a reservoir for the spirit, having an earthenware or metal tube in which is placed a loose cotton wick. The flame given is hot and non-luminous.

SPIRIT LAMP, INCANDESCENT (Fr., *Lumière d'alcool à incandescence;* Ger., *Spiritus Glühlicht*)

A lamp in which a mantle coated with rare earths is rendered incandescent by vaporised and ignited methylated spirit. Such lamps are obtainable in various patterns for use in optical and enlarging lanterns. A typical model is shown at A. In this, the spirit, contained in the

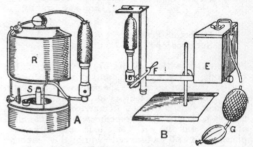

Two Types of Incandescent Spirit Lamp

chamber R, is volatilised by means of the small spirit flame S, placed below it, the height of which is adjusted to a nicety by rack and pinion, thus controlling the pressure of the combustible vapour. The lamp can be brought into full action in a few minutes, and yields a light of 300 candle-power for a couple of hours. In another type of lamp, B, the spirit flows from a reservoir, E, along a tube filled with asbestos. To start the lamp, an asbestos fork, F, is moistened with spirit and lighted, the heat vaporising the spirit in the tube and causing the vapour to flow up the bend and down the narrower tube at the side to the burner, where it ignites. Once started, the heat of the incandescent mantle keeps up the supply of vapour, while the pressure may be increased at will by means of the rubber bulb G. (See also "Sol Lamp.")

SPIRIT LEVEL (See "Camera Level.")

SPIRIT PHOTOGRAPHY (See "Psychic Photography.")

SPIRIT OF SALT (See "Hydrochloric Acid.")

SPIRIT OF WINE (See "Alcohol.")

SPIRITUS GLONOINI

Nitro-glycerine in a 1 per cent. alcoholic solution, and so named in the American Pharmacopœia. J. Vansant has recommended it as an accelerator for use with pyro.

SPIROSCOPE AND SPIROGRAPH

The former is the mechanical and optical apparatus used for viewing or projecting kinematograph pictures of microscopic size, the images of which are borne by a disc known by the second of the above terms. It is the invention of Theodore Brown and Charles Urban.

SPITZERTYPE

E. Spitzer's method of making process blocks. No details have been published, but the results seem to suggest that the basis of the process is the reticulation of the gelatine film on the lines of the Pretsch and Dallas processes.

SPLASHES AND DROPS, PHOTOGRAPHY OF

The photographs of splashes taken by A. M. Worthington, F.R.S., and R. S. Cole, M.A., and shown at the Royal Institution in 1894, were obtained by allowing a drop to fall in absolute darkness, and illuminating it at any desired stage by a Leyden jar discharge taking place between magnesium terminals. The following description is due to *Photography*. The spark was produced at the focus of a deep, silvered watch glass G (*see* diagram), subtending an angle of nearly 180°, and was brought very near to the place of impact. A single quartz spectacle

Arrangement for Photographing Splashes

lens, J, was substituted for the usual lens of the camera, H, and thus the absorption of photographic rays by glass was avoided. The diagram shows the arrangement of the apparatus. Simultaneously with the drop, a metal timing sphere, D, was allowed to fall between two other insulated spheres connected to the inner coats of two large oppositely charged Leyden jars, B B, standing on the same badly conducting table. C C indicate paraffin blocks. From the outer coats of the jars, wires E and F led into the dark-room, and there terminated in a spark-gap between magnesium terminals at the focus of a small concave mirror, consisting of a silvered watch glass. The Wimshurst machine, A, was turned till the lower ball of the rough electrometer shown was lifted up and struck a glass plate; then the sphere was liberated by tossing up by hand the remote end of the light, horizontal, pivoted rod which supported it. This broke the contact of crossed wires beneath the rod, cut off the current from the electro-magnet N in the dark-room, allowing an indiarubber catapult, M, to toss up one end of a similar horizontal lever, at whose other end the drop L had been supported, without adhesion, on a smoked watch glass. By this means sphere and drop were left in mid-air, free to fall at the same instant. The sphere, in its fall, discharged the inner coats of the two Leyden jars, and this produced a simultaneous discharge at the spark-gap, between the outer coatings, thus illuminat-

ing the plate K. The timing of the spark was effected by adjusting the height of fall of the timing sphere by sliding the liberating apparatus up or down the vertical supporting rod. (*See also* " Bullets in Flight, Photographing.")

SPONGE BRUSH

The Buckle brush, described under the heading " Brushes."

SPOT CUTTER

An appliance for cutting number labels or white spots for lantern slides. The numbers are supplied printed on paper strips, and when one is required a strip is paid into a slot in the cutter till the required number is under a circular aperture. On turning a handle at the bottom of the cutter the number is cut cleanly out in the form of a round disc. The advantage is that it is much easier to cut out the numbers in rotation as required than to hunt for them in a boxful of loose labels.

SPOT, FLARE (*See* " Flare Spot.")

SPOTS ON PRINTS (*See* " Black Spots," " Dust Spots," etc.)

SPOTTING MEDIUM

A term sometimes given to the medium applied to a negative to allow spotting, etc., to be done, and sometimes to the material with which the spotting is carried out. For the former, *see* " Retouching "; for the latter, *see* " Spotting Negatives " and " Spotting Prints."

SPOTTING NEGATIVES

For spotting, a negative should be placed on a retouching desk in front of a window, and a sheet of white paper used as a reflector. For small spots, finely pointed lead-pencils form the best means of removal. Those marked H H, H, and H B will be best, the hardest being used for the smallest spots. Precision of touch is necessary, and the use of a magnifying glass is very desirable. It is essential that a touch be given with the pencil accurately on the spot; there is a risk of pencilling on the film round the spot, and so aggravating the defect. It is better to leave the spot slightly visible as a grey rather than attempt to remove it too thoroughly. It may show as a strong white spot on the print if worked too much. When spots are large, the pencil will frequently fail to be effective. In that case water-colour, applied with a brush or a fine mapping pen, will be better. The most suitable colour is either lamp-black or ivory-black, used in a very thin solution, so that it is grey rather than black. In many cases spots may be difficult to remove without showing on the print. The only course to adopt is to obliterate them thoroughly, so that they show as white spots on the print, and then touch them out on the print as described under the heading " Spotting Prints."

SPOTTING PRINTS

Bromide prints, platinotypes and carbon prints should be spotted, when required, with water-colour applied with a finely pointed brush; or a lead-pencil, H B, may be used for matt bromide

prints if they are not toned. Lamp-black water-colour will be the most suitable for black platinotypes, carbons and untoned bromides; while sepia and vandyke brown mixed in various proportions will allow any tint of brown carbon, bromide or platinotype to be matched. For glossy or semi-glossy bromide or silver prints a little gum may be added to the colour for spotting, and neutral tint and crimson lake added to the stock of colours will provide material for matching the tones of silver prints. No medium is necessary as a general rule, but occasionally the surface of a gelatine print will repel the colour. In that case, a very little prepared oxgall should be added to the mixed colour; it may be obtained at an artists' colourman's. Spotting should be done after the prints are mounted.

SPRINKLER (Fr., *Aspersoir*; Ger., *Sprenkelnder*)

A rose spray used for washing negatives and prints, and attached either to the end of a rubber tube connected with the water tap, or to a swing arm on the tap itself. A form of sprinkler is also made containing a filter in addition, to screw on any ordinary tap. Another kind of sprinkler consists of a metal tube like an inverted T, the horizontal arm of which is closed at the ends and pierced with a row of holes, while the end of the upright portion is connected to a rubber tube leading to the water supply.

Also the name given to any appliance for sprinkling or spraying the floors of dark-rooms and other photographic workrooms, to lay the dust.

SQUEEGEE (Fr., *Râcleur*; Ger., *Gummiquetsche*)

An appliance used for pressing wet prints into close contact with plate glass or ferrotype sheets when glazing; for rubbing prints down when mounting; and for various other purposes which require the application of pressure or call for the expression of moisture. There are two forms.

A. Flat Squeegee B. Roller Squeegee

The flat squeegee, A, consists of a strip of thick flexible rubber mounted in a wooden handle, and is used by drawing it to and fro across the print. It is sometimes used to remove splashes of water and solution from the developing bench, etc. In the roller squeegee, B, a movable rubber roller is attached to a handle, the method of use being obvious. A pattern with two rollers is also made.

SQUEEGEE PAD

An accessory for glazing or matting prints. It consists of a sheet of celluloid, either glossy or matt, placed between two covers of india-rubber cloth, which are fastened to it by one edge only. The prints are spread on the celluloid, film side down, and the indiarubber cloth laid over them, a squeegee being then applied in the usual manner. Both sides of the celluloid can be used. The rubber covers are then turned back and the celluloid sheet with the prints is hung up by means of a hook or pin passed through the edges of the covers. When dry, the prints fall off with a glazed or matt surface.

SQUEEGEE PLATE

A name for the pulp slab (*which see*). It is also applied to ferrotype plates and enamelled metal plates resembling them, employed in glazing prints.

STAGE PHOTOGRAPHY (*See* "Theatrical and Kinematograph Photography.")

STAIN REMOVERS

Acid solutions (usually hydrochloric and citric, combined with alum and sometimes with other substances) are used for clearing away stains caused by developers, particularly the pyrogallic acid developer. To 4 oz. of a saturated solution of common alum may be added 1 drm. of hydrochloric acid; there are many other formulæ. Chapman Jones has stated that acid stain removers are founded on wrong principles; the alum hardens the film and retards the washing away of stains, and the acid acts by lightening the colour of the stain, which, however, is rendered insoluble and is consequently fixed in the film. More satisfactory methods will be found described under the heading "Stains, Removing."

STAINS, REMOVING

Stains on Hands.—Pyro and some other developers stain the fingers by prolonged use; care must be taken to avoid putting the fingers in solutions, excepting when absolutely necessary. Any tendency to staining may be entirely obviated by rinsing the fingers and immersing them for a few seconds in an acid fixing-bath immediately after putting them in the developer. Rinsing and drying must follow at once. An acid fixing-bath or a solution of potassium meta-bisulphite will also remove stains of permanganate and many other photographic substances. It is a good plan to bathe the hands in hot water and then, before drying, rub glycerine into them.

Stains in Intensification.—Stains should not arise if the negative is in good condition and if all the previous work has been carried out correctly. Yellow stains that may appear during mercurial intensification are due solely to imperfect fixing of the negative. Insufficient washing after fixing will also cause staining. There is no method of removing these stains. In intensifying by silver, Wellington's method, surface staining may occur if the operation is very prolonged, the cause being the same as in a long or forced development. These stains may be easily removed by methylated spirit applied as directed under the heading "Reducing Negatives by Mechanical Means," or they may be treated by thiocarbamide or the "hypo" and ferricyanide solution.

Stains on Negatives.—When negatives show staining after development and fixing, the character of the stain will always indicate the cause and the cure. Iridescent markings round the edges of a negative are almost always caused by using old plates, especially if the plates have been kept under bad conditions or forced in development. They may be removed by means of thiocarbamide or by methylated spirit applied with friction. Surface stains, semi-iridescent, with rainbow-coloured markings, are sometimes seen on negatives otherwise perfect. These are due to scum on the developer, caused either by using the same solution for several plates in succession, or by mixing the developer in a measure without rinsing after previous use. A weak thiocarbamide solution will remove these stains almost instantly. A weak " hypo " and ferricyanide reducer will also remove them in a few seconds.

Stains on Prints.—Silver prints show yellowish-brown stains, semi - iridescent, if the surfaces cling to the dish or to another print during the first few seconds of washing in plain water before toning. These stains are most frequently attributed to " hypo," but they are in reality silver stains. There is no method of removing them satisfactorily. Similar stains may develop during fixing, or in the first washing water after fixing, if the prints are allowed to cling together ; and they cannot be removed satisfactorily. Platinotype prints may develop yellow stains after washing and drying if the clearing has been imperfectly or carelessly performed. It is difficult to remove these stains without injuring the print ; the best treatment is a strong solution of hydrochloric acid, 1 part of pure acid to 10 or 12 of water. Two or three successive baths of acid may be used, the prints being afterwards washed well. Prints on bromide or gaslight papers may be stained from the same causes as given under the sub-heading above, " Stains on Negatives." The treatment is the same, excepting that solutions about one-fourth of the strength are used.

STALE PLATES

Stale plates are distinguished after development and fixing by an iridescent or fogged edging round them ; but there is no satisfactory method of telling whether a plate is stale previous to exposure and development. The deterioration of plates is caused more by an unsuitable atmosphere than by the mere lapse of time. When plates are known to be stale, a special restrainer, as follows, may be used with them :—

Potassium bromide.	.	2 grs.	·46 g.
Potassium bichromate	.	2 ,,	·46 ,,
Water .	. .	1 oz.	1,000 ccs.

Double the normal exposure will not harm very stale plates. When about to develop, take enough water to cover the plate and mix with it 30 drops of the special restrainer given above. Flow the mixture over the plate and rock for a minute or two ; in a measure have ready any ordinary developer (not containing ammonia), and pour off the restrainer into the developer and return the whole to the plate and develop in the usual way ; add more restrainer if fog appears. If the plates are exceptionally bad, a single drop of sulphuric acid may be added.

Development as above is very slow and the results hard, that is to say, very contrasty ; thus, stale plates are useful for certain kinds of copying. The older the plates, the longer should be the exposure and the greater the quantity of restrainer used, and, of course, the harder the result.

STAMP PHOTOGRAPHS (*See* " Postage Stamp Photographs.")

STAND, CAMERA (*See* " Camera Stand," " Step-ladder Stand," etc.)

STAND DEVELOPMENT (*See* " Development, Stand.")

STANNOTYPE

A modification (1881) of the Woodburytype process, also invented by W. B. Woodbury. Instead of forcing the gelatine into a block of soft type metal by great pressure to make the matrix, the relief, made of bichromated gelatine, is faced with tin-foil.

STANNOUS CHLORIDE (*See* " Tin Chloride.")

STARCH (Fr., *Amidon :* Ger., *Stärke*)

$C_6H_{10}O_5$. A substance prepared from wheat, rice, Indian corn, potatoes, etc., and met with in the form of lumps or powder. Its principal photographic use is as a mountant. A variety of starch is arrowroot, which gives an almost clear solution when boiled, in which form it is used as a size for photographic papers, ordinary starch being sometimes used for the same purpose. Starch, when heated to about 400° F. (204° C.), is converted into dextrine.

STARCH MOUNTANT (*See* " Mountants.")

STARS, PHOTOGRAPHING

The various methods of photographing stars are so numerous that the most important of them will be best treated under special headings, as noted below. In general the science of astrophotography may be divided into two main classes, depending on whether the photographic camera is stationary, or is moved either by hand or clockwork so that the apparent motion of the stars across the field is neutralised.

Astrophotography with Stationary Camera.—There are numerous subjects with which valuable results may be obtained with no extra apparatus beyond an ordinary camera. Suppose the photographer wishes to prepare for himself an accurate chart of a certain constellation of stars. All that is necessary is to direct the camera, either by means of the tripod sliding legs or by some form of tilting table, to the middle of the constellation. The plates employed should be of the most rapid variety obtainable, and preferably panchromatic or uniformly colour-sensitive. When all is quite rigid, give an exposure of, say, ten or fifteen minutes with the largest stop available. On developing the plate a series of arcs of circles having different densities will be seen. These are the " trails " of the stars which were projected on the plate, the movement being due to the earth's rotation past the star during the exposure. Obviously, then, the length of the lines will depend on the

length of exposure. If, now, the beginning or ending of every star trail is marked with a small dot of Indian ink, of the same diameter as its corresponding line trail, the resulting series of dots will show as a star map. If the accompanying lines are found to be confusing, it is quite simple to trace the dots on tracing paper or cloth, when a star map will be obtained which may be placed in front of a small box containing a lamp. This contrivance will be found of great help to anyone wishing to teach the forms of the constellations, as the illuminated stars may be easily seen by a number of people at the same time.

Numerous other methods of utilising photographs obtained by fixed cameras will doubtless occur to the worker. For example, at the times of the year when it is known that a shower of meteors is expected, the camera may be directed to the proper position and left open for some time in the hope of a meteor flashing across the field of the lens. Many interesting pictures of these remarkable celestial visitors have been thus recorded. (See also "Meteor Photography.")

Astrophotography with Moving Cameras.—When it is desired to obtain accurate charts of the sky, the camera must be so mounted that by means of suitable clockwork the stars may be kept exactly on the same portions of the photographic plate throughout the exposure. The motion of the stars from east to west across the sky is at such a rate that a complete circuit of the heavens is made once in 24 hours. If the direction of motion be carefully examined, it will be found that all the stars travel in circles parallel to the equator, so that to follow them we must employ what is called an equatorial mounting; this consists of an arrangement whereby the axis of rotation can be tilted with respect to the horizon, until at any given place it is exactly parallel to the earth's axis. When this is accurately adjusted and the clockwork rated properly, it will be possible to obtain star photographs with any desired length of exposure.

With the apparatus above described it becomes possible to employ very powerful cameras, both as to aperture and focal length, so as to record stars so faint that they have never been seen by the unaided eye. The telescopic star cameras used in this way are of two kinds, depending on whether a refracting or reflecting system is used to give the image. The largest refracting lens telescope existing is that made for the Paris Exhibition of 1900, with a lens of 50 in. aperture and 180 ft. focal length. This is not in use, however, owing to the great expense of working.

The largest lens in actual use is that at the Yerkes Observatory, near Chicago, which has an aperture of 40 in. and a focal length of about 60 ft. Numerous reflecting telescopes are in use. The two largest now being used for photography are 60 in. in diameter; one, made by the late Dr. A. A. Common, is now at Harvard College Observatory, U.S.A.; the other, made by G. W. Ritchey, is at the Solar Observatory, Pasadena, California. This last is probably the most powerful telescope the world has ever known, and the resulting photographs are of wonderful clearness and beauty. Many researches are being made with this 60 in. reflector which are quite beyond the scope of any other instrument, such as large scale photographs of the spectra of stars and planets, measurements of the velocities of stars in space, etc.

One of the greatest applications of the equatorially mounted star camera has been the "International Photographic Chart of the Sky," a co-operative scheme shared by all the nations of the world. This was inaugurated at Paris in 1887, when a congress of the world's astronomers resolved to prepare a photographic chart of the heavens, showing stars down to the fourteenth magnitude. This was to be supplemented by a second series of plates of short exposure, for a catalogue of stars down to the eleventh magnitude. The standard instrument was a twin refracting telescope—a photographic camera of 13 in. aperture and 11 ft. focal length, attached to a visual guiding telescope of 11 in. aperture. Each photographic plate covers about four square degrees of the sky. This magnificent work is now being brought to a successful conclusion, and the publication of the charts is well advanced.

A task of such magnitude is obviously not applicable to the detection of rapid changes in the positions or brightness of the stars. To provide information for this purpose Pickering, at Harvard College Observatory, has arranged for a complete photographic survey of the sky with a short focus camera. Copies of this work are obtainable, and it will be repeated at convenient intervals, so that a definite check will be possible on any changes in the positions or magnitudes of the stars.

For charting very condensed areas, such as the Milky Way, in which it is important to obtain a record of the general aggregation of the stars, the most successful method is that adopted by Barnard, who used at the Lick and Yerkes Observatories a small lantern lens of 2 in. aperture and 5 in. focal length. An apparatus of this type gives exquisite pictures of the star groupings when used with an efficient equatorial mounting.

Photography is now used for systematically recording the brilliancy of stars. This is done by obtaining photographs with the plate slightly displaced from the true focus for parallel rays, so that the image of each star shows as a small round disc instead of a very tiny point. A series of standard density squares from a standard light source are impressed on the plates before exposure to the sky; it is therefore possible by measuring these density squares and the star discs to obtain accurate values of the relative brightness of the stars.

Planet Photography.—This is so much beyond the reach of the ordinary photographer that it is only suitable here to give a short outline of the results obtained by the photographic astronomer provided with the very special equipment necessary for the purpose.

The first successful attempts to obtain pictures of the planets showing the details of their surface markings were made by Gould, at Cordoba, in 1879, on the planet Mars, and by Dr. Common in the same year on Jupiter. The earliest satisfactory photographs of the wonder-

ful planet Saturn, with his accompanying system of rings, were obtained by M. M. Henri, at the Paris Observatory, in 1885.

Mars has always proved a fascinating object on account of its being our nearest celestial neighbour after the moon, and, further, it is thought that the conditions of its surface are somewhat similar to our own—that is, there seems good reason for believing that land and water are present in separated masses as on our earth, and the presence of ice is also very probable. The photographs of Mars show very clearly that the surface of the planet is irregularly divided into dusky and light patches, and at the two diametrically opposite points corresponding to the axes of rotation, there are small oval patches of intensely white material, which are generally considered to be the snow caps at the extremities of the poles of the planet, corresponding to our Arctic and Antarctic regions of perpetual ice and snow. This view is rendered more feasible by the further fact that these white polar caps are found to vary regularly in extent, getting smaller and smaller as the summer season on the planet approaches, and gradually increasing again on the advent of the Martian winter.

Some of the most beautiful photographs of Mars have been taken by Professor Lowell with his telescope of 24 in. aperture, at Arizona, on an elevated plateau well up out of the lower strata of our atmosphere. He has also succeeded in photographing several of the peculiar thread-like markings called " canals," which have caused so much controversy among astronomers during the last twenty years.

Excellent photographs have also been taken by Barnard at the Yerkes Observatory, and by Hale at the Mount Wilson Observatory. The general equipment is the same, and consists of the largest and most perfect telescope that the observer can command ; to this is applied the highest power magnifier that the objective and atmospheric conditions will stand, and also photographic plates of special rapidity and colour sensitiveness. The atmospheric conditions vary so rapidly that for such objects as planets it is usual to arrange the plate holder as a repeating back, fitted to take a great number of pictures at short intervals on the same plate, so that the few times of best definition may perhaps be caught among a great number of mediocre ones.

Jupiter, although not productive of such great discussion, offers many features for which the application of photography is eminently suitable. This planet is apparently clothed in clouds, and these are arranged in broad belts parallel to the planet's equator, showing as bands of alternately light and dark material on the photographs. In one of them there is a remarkable feature called the " Great Red Spot," a large oval patch of ruddy colour which has been visible now for many years. It is hoped that large scale pictures of this phenomenon may definitely decide the relation of its drift among the surrounding cloud belts, and later, possibly, its true character.

Saturn is the furthermost of the planets of the solar system of which satisfactory photographs have been obtained. Numerous excellent pictures have recently been taken at the Lowell Observatory showing most minute detail on the cloud belts and the surface of the rings.

Uranus and Neptune, the two outermost planets, have been often photographed, but their images so far have only been small discs without definite surface detail.

The minor planets are a closely associated swarm of small bodies revolving round the sun in orbits between Mars and Jupiter. The majority of them are so small as usually to be unobservable even with the largest telescopes, and they have nearly all been discovered by means of their trails on photographic plates exposed for long periods to the sky. The early part of this work was done by moving the telescopic camera at the same rate as the earth's rotation, so that each photograph showed all the stars as minute bright points. If then an object was found showing an elongated image, and it was decided to be a real marking, it was assigned a provisional number as a new planet, and after full confirmation on subsequent photographs a name would be given to it. Lately an ingenious method has been devised to permit of the discovery of small planets being recorded which, if left to trail, would be too faint to give any perceptible image. Sufficient is now known of the general motions of this belt of small planets to allow of their probable velocity in any region of their orbit being fairly accurately calculated. The camera is then set to travel at this velocity, instead of at the earth's velocity as before. This means that the little planet will now be able to accumulate its light on the image on the plate, and it will thus show up as a small round point among the surrounding stars represented by short elongated trails. The plates used should be of the fastest emulsion available, consistent with a fine grain.

Nebulæ Photography.—This branch of photographic astronomy is almost beyond the reach of the camera alone. There are only one or two nebulæ which can be photographed with rapid exposures, and then only on a very small scale, scarcely repaying the trouble which may be taken. With a small expenditure, however, a very serviceable driving mechanism may be obtained or constructed by the observer, and then very interesting pictures of the chief nebulæ may be photographed without any greater difficulty than is experienced in taking high-power telephotographs. The focal length of lens to be selected depends to some extent on the object selected for experiment. Thus the nebulæ of Orion, Andromeda, the Magellanic Cloud, the Pleiades, and other objects of considerable extent give very beautiful pictures with cameras of quite moderate focal lengths, say from 12 to 30 in. Naturally on such objects the lens should be of the largest relative aperture possible, as then the exposure necessary will be the minimum, and the chances of disturbance during the operation reduced as far as possible. The range of gradation is so great that the utmost care should be taken with the development, a moderately dilute solution of any of the standard formulæ being suitable. All plates should be thickly backed, otherwise the star images distributed over the region will be so

expanded as to detract seriously from the value of the picture.

The famous Orion, or "Fish Mouth," nebula was first satisfactorily portrayed by photography by Draper, in 1880. Later magnificent pictures were obtained by Dr. Common in 1883, at Ealing, with a large silvered glass reflector, 36 in. in diameter, which he had himself entirely constructed. With further advances in the rapidity of photographic plates and perfection of apparatus it was possible to delineate greater and fainter extensions, and also by employing instruments of enormous length the fine detailed structure was for the first time brought to our knowledge. The greatest advances of recent years were made by Keeler, at the Lick Observatory, California, and Ritchey, at the Yerkes Observatory, near Chicago. The former made an extensive survey of the class of nebulæ whose structure is distinctly spiral, and published an atlas of beautiful reproductions of the most important. Ritchey has more specially aimed at obtaining specially large-scale pictures of the principal nebulæ, showing the wonderful relationships existing between the cloud-like wisps and the star aggregations with which they are apparently associated. The study of these pictures is of the greatest importance.

STATUARY, PHOTOGRAPHING

Statuary should always be photographed in a light as softly diffused as possible in order to secure roundness and softness; but in order to secure contrast it is necessary that the direction of the lighting should be from one side, and sufficiently pronounced to give shadows and relief. In most cases a point of view towards one side will be the most satisfactory, and this should be the opposite side to that from which the light is coming. Occasionally, however, a full front view must be taken. A dark background, which will show as a dark grey in the print, should be used when possible, though in many cases the photographer will have very little choice. In outdoor statuary, dark foliage at a distance from the group will form a good background, and direct sunshine must be avoided. When a suitable background cannot be obtained, double-printing should be adopted.

A good method of determining the exposure for groups of statuary is by means of a meter, the meter being held close to the statuary and facing the camera. Using lens aperture $f/16$ and a plate 200 H. and D., the exposure for a single figure or small group of white statuary, not more than 5 ft. or 6 ft. high, will be one-tenth of the time that the meter requires to match its standard tint if a Wynne meter is used, and one-twentieth for a Watkins. For bronze or dark figures, one-fifth of the Wynne meter time, and one-tenth of the Watkins, should be given. Large groups, 10 ft. or 12 ft. high, will require half these exposures.

STELLAR PHOTOGRAPHY (See "Stars, Photographing.")

STENOPAIC PHOTOGRAPHY

Synonymous with pinhole photography.

STEP-LADDER STAND

A type of camera stand, largely used in France for street views, etc., when it is desirable to have the camera in a position above the heads of the spectators or pedestrians The type most widely

Step-ladder Stand

used consists of a step ladder of a convenient height to the top of which is hinged a table upon which the camera is screwed, the table and camera being adjusted by means of strut B.

STEREOPTICON

The American name for the optical lantern.

STEREOPHOTODUPLICON

An arrangement for taking stereoscopic photographs, invented by Theodore Brown and described under "Stereoscopic Photography."

STEREOSCOPE (Fr., *Stéréoscope*; Ger., *Stereoskop*)

An optical instrument for uniting into one image two plane representations as seen by each eye separately, and giving to them the appearance of relief and solidity. The subject of binocular vision was studied by various optical writers who have flourished since the time of Galen. Baptista Porta, one of the most eminent of them, repeats, in his work "On Refraction," the propositions of Euclid on the vision of a sphere with one and both eyes.

Leonardo da Vinci referred to the dissimilarity of the pictures seen by each eye as the reason why "a painting can never show a

A. Diagram Illustrating Stereoscopic Relief

relievo equal to that of the natural objects, unless these be viewed at a distance and with a single eye," which he thus demonstrates. If an object, C (in diagram A), be viewed by a single eye at A, all objects in the space behind it—included, as it were, in a shadow E C F, cast by a candle at A—are invisible to that eye; but when the other eye at B is opened, part of these objects become visible to it, those only

being hid from both eyes that are included, as it were, in the double shadow C D cast by two lights at A and B, and terminated in D ; the angular space E D G, beyond D, is always visible to both eyes. The hidden space C D is so much shorter as the object C is smaller and nearer to the eyes.

Elliot was the first to construct a stereoscope ; but as it was devoid of lenses, the coalescing of the two pictures depended upon a somewhat

scope," the fundamental principle of which forms the basis of all modern instruments. He conceived the idea that if prisms or sections of complete lenses were used to divert the rays coming from two pictures placed side by side, so that their images were thrown to a common centre, the evils of reflection obtaining in all reflecting instruments would be altogether dismissed. Diagram D shows his instrument. A

| B. Elliot's Stereoscope | C. Wheatstone's Stereoscope | D. Brewster's Stereoscope | E. Brown's "Blocket" Stereoscope | F. Prism Stereoscope |

unnatural accommodation of the eyes. In a box, F (*see* diagram B), he made apertures, D and E, and at the opposite end a single aperture C. The pictures to be combined were placed at a distance behind the box, with the picture belonging to the left eye at B, and the picture belonging to the right eye at A. On placing the eyes at L R their axes crossed at C, and then, by a slight effort in focal accommodation to A B, the two pictures A and B were seen combined and presented the desired illusion. Only persons possessing the power to accommodate the focus of the eyes to a remote plane whilst

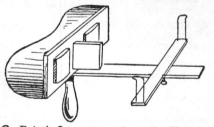

G. Bates's Improvement on the Holmes Stereoscope

their axes were converged to a nearer plane, could obtain the desired result. Wheatstone's " Reflecting Stereoscope " (C) proved to be the first practical stereoscope. Two plane mirrors M M, set at an angle of 45°, reflect the stereoscopic pictures A and B into the eyes at L and R, so that the combined result is seen somewhere in the direction of O. The mirrors are fixed, but the distance between A and B is made adjustable by a screw, threaded (left and right) at each end.

Sir David Brewster, who appears to have been investigating stereoscopic phenomena at the same time as Wheatstone, devised what is known as the " Refracting or Lenticular Stereo-

and B represent the pictures ; D and E are a pair of prisms fitted to a suitable framework and with their thinner edges turned towards each other. On placing the eyes at L R, the pictures A B are seen at a common point C, and stereoscopic solidity and relief results. Brewster soon found that the use of sections of convex lenses effected the necessary refraction, and at the same time provided magnifiers. The best-known form of Brewster's Lenticular Stereoscope is that of a tapering box, with the lenses at one end, and at the other a groove for the reception of the pictures. The box contains further a ground-glass panel at the back, so that when transparencies are under observation they are viewed by transmitted light ; while for opaque pictures, the box is fitted with a reflector hinged at the top.

Dr. Oliver Wendell Holmes, of America, in 1861, invented a form somewhat like that illustrated at G, but without the sliding viewholder, the latter improvement being added by Joseph L. Bates, of Boston, in 1864. The design shown at G has become universal. There are some persons, however, who experience considerable difficulty in seeing stereoscopic views properly with this class of instrument, the reason generally being that the pupillary centres of their eyes are not close enough together or far enough apart to suit the index of refraction and magnification of the lenses of the particular stereoscope in use. To obviate this difficulty, stereoscopes have been designed with means for varying the separation of the lenses, Baird's Lothian stereoscope being a good example of this type of instrument ; the proper distance for the pictures in relation to the lenses is arrived at by sliding the view-holder along parallel carrying tubes, the latter being detachable so that the instrument may be used for the examination of stereoscopic prints mounted in albums.

Theodore Brown's " Blocket " instrument (*see* E) is probably the smallest stereoscope. It is based on the laws of reflection, and acts as follows :—Let the pictures be represented as situated at A B, the eyes of the observer at L and R, and the optical part at E. The left eye L sees its picture by direct vision from L to A. Inside the small casing E two mirrors are fixed facing each other, but not quite parallel. The right eye R sees in the mirror C an image of the picture B by reflection from mirror D, and, by a suitable adjustment in the relative angles of these two mirrors, B is superimposed upon A, where stereoscopic fusion takes place. If a prism of the shape of the space between the mirrors C and D is substituted for the mirrors and the casing is dispensed with, a prism stereoscope (shown at F) is the result, and the light will be acted upon precisely in the same manner and with the same result.

STEREOSCOPIC CAMERA (*See* "Stereoscopic Photography.")

STEREOSCOPIC PHOTOGRAPHY

The invention of the stereoscope being prior to the discovery of photography, the first pictures for this instrument consisted of line drawings. With the advent of photography, the stereoscope became increasingly popular, as this discovery provided the means of reproducing the minutest details of a subject binocularly with absolute precision. To secure a photographic slide for the stereoscope, it is necessary that two distinct photographs of the subject be taken from standpoints corresponding to the positions of the two eyes, and that these photographs be mounted side by side. If the subject is still-life, the two pictures may be taken by successive exposures, moving the camera between them a distance of $2\frac{3}{4}$ in. to 3 in. To facilitate the operation, various contrivances have been devised, an example of which is shown at A, in which A is a slab of wood having attached to its upper surface two narrower strips B C linked together at D parallel-rule fashion. B is fixed to the base A, while C

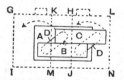

A. Arrangement for Stereoscopic Photography with Single Camera

is free to swing. The camera to be used is secured to C and rests lightly on B. With the camera in the position indicated at K L M N, the first exposure is made, which will give the picture belonging to the right eye. The strip C carrying the camera is now moved so that the camera occupies the position indicated at G H I J, when the second (left eye) picture is taken. Another method of stereo-photography with a single camera and by successive exposures is indicated in diagram B, in which E represents

in plan a camera turnable on its axis at J. If the dark-slide, holding a plate, is furnished with an opaque card just half the size of the plate itself and loose enough to be shaken from one end of the dark-slide to the other without opening the slide, the two photographs of one subject may be obtained on a single plate. The picture for the right eye is secured with the camera in the position indicated in full line, covering the field between A B, half the plate only at H being at first exposed. The dark-slide is then closed and withdrawn from the camera for the purpose of shaking the opaque card from G to H ; it is re-inserted in the camera and the shutter drawn out so that the portion of the plate at G may now be exposed. Before uncapping the lens, however, the camera is turned slightly from left to right, so that it covers the field between C D. A stereoscopic

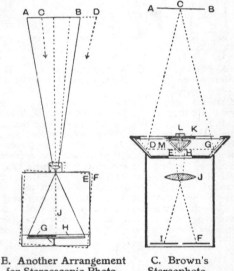

B. Another Arrangement for Stereoscopic Photography with Single Camera

C. Brown's Stereophotoduplicon

pair of images will thus be impressed upon one plate. Further, if the operation be carried out in the order indicated no transposition of the finished prints will be required. Stereo-photography by the successive exposures and displacement system, whilst being useful for still-life or fixed subjects, cannot be adopted with success in cases where movement of any part of the subject is likely to occur, or when the illumination of the subject is liable to alter. The most perfect results for the stereoscope can only be obtained when the two images are received upon the plate simultaneously. It is not, however, impossible to do this with a single-lens camera. For example, in Brown's stereophoto-duplicon (C) there is a chamber forming a supplementary extension of an ordinary camera. In the chamber are placed four mirrors as at D E H G. Let A B represent the subject to be photographed. Taking the centre ray, the light coming from C strikes the surface of the two outermost mirrors D G, is reflected to E H, thence through the lens

J to the plate I F at the back of the camera. Images from the binocular angle are thus secured simultaneously on one plate and at one exposure, and as the light crosses before reaching the plate the pictures are taken so that the negative yields a pair ready transposed for immediate inspection in the stereoscope.

A modification of the apparatus just described is that of the so-called stereoscopic transmitter, in which only two mirrors are employed, set at an angle to each other and placed at an angle of about 45° in relation to the axis of the lens of an ordinary camera. Transposition of the images takes place before the light reaches the sensitive plate. The mirrors are surface-silvered and of the kind used in reflex cameras.

The ideal apparatus for stereoscopic photography consists of a camera furnished with a pair of carefully matched achromatic and rectilinear lenses of 5 in. to 6 in. focal length duly corrected for spherical aberration. The distance between two such lenses should be adjustable, so that for near subjects their separation may be reduced to 2 in., or for remote subjects increased to 3 in. or 3½ in. The mechanism controlling the opening and closing of the two shutter apertures should be such as to ensure absolutely synchronous working. Lenses of a shorter focal length than 5 in. are unsuitable for stereoscopic work, as they appear to give an exaggerated perspective which is especially noticeable in architectural subjects. Again, too great a separation of the lenses on a stereoscopic camera induces abnormal relief in the stereoscope, besides making it difficult for the two pictures to be seen blended together at all planes in the composition.

The actual practice of stereoscopic photography, once the principle has been grasped, is simple. Exposure and development are as usual, taking great care, however, when the two images are on separate plates, to obtain results as uniform as possible. Hand-work on the negative is not desirable, and, indeed, will militate against success. It is only in the transposition of the prints that there is any difficulty. It has already been shown that by some methods of stereoscopic photography, transposition of the prints is not necessary. Again, it is possible to cut the negative and to transpose the halves in a special printing frame so that the print obtained is suitable for use without alteration; but in the case of photographs taken in two-lens cameras, and when the negative is not cut before printing, the following procedure will be necessary: Lay the print face downwards, and lightly mark the edges of the print so that the sequence of the images can be recognised at a later stage. Assume that, as the print lies face down, the image on the left is No. 1, and that on the right No. 2. Carefully trim, leaving on the right of the right-hand print ¼ in. more of the picture than appears on the left-hand print; in the same way leave on the left of the left-hand print ¼ in. more of the picture than appears on the right-hand print. Next sever the two images and mount the prints, being careful to place them about ¼ in. apart. Looking at the face side of the prints, No. 1 will be on the left and No. 2 on the right.

STEREOSCOPIC PROJECTION

The projection of a pair of stereoscopic pictures in such a manner that each eye of the observer shall see but one image, the one belonging to it. In 1841 Dove showed that if one of a pair of stereoscopic pictures is outlined in blue on a white ground, and the other element

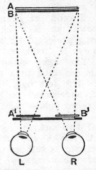

A. D'Almeida's System of Stereoscopic Projection

in red, the two being approximately superposed upon the same sheet, a spectator furnished with red and blue glasses will see the outlines as a single solid image. In demonstrating this fact Dove obviously foreshadowed the work of Ducos du Hauron. (*See* " Anaglyph.") De la Blanchère and Claudet, some years later, attempted to eliminate the use of the spectacles.

J. Ch. D'Almeida, in his communication (1858) to the French Academy of Sciences, described how he placed in the course of the luminous rays two coloured glasses (red and green); the observer views the projections through glasses of similar colours, the fusion being seen as a black and white combination in stereoscopic relief. D'Almeida's system is shown at A. A represents the green image on the lantern screen, and B the red·image; the

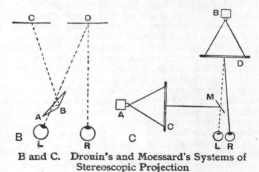

B and C. Drouin's and Moessard's Systems of Stereoscopic Projection

former is blotted out with the green spectacle glass B¹, so that the right eye R sees only the red image B. Likewise, the red image is blotted out by the red glass A¹, so that the left eye L sees only the green picture A. Many modern experimenters have modified the above system. It has been suggested that, instead of using two separate projections, similar results may be obtained by making a composite slide and projecting the same by a single lantern.

D'Almeida also invented the eclipse system in which a perforated shutter rotates in front of side-by-side lanterns. Another form of eclipse system, but of small practical value, consists in using a box apparatus similar to Elliot's stereoscope.

There are numerous ways in which stereoscopic elements when projected side by side upon a screen may be united so as to produce the desired results. Drouin, of France, suggested the system shown at B. The stereoscopic elements C D being projected by a lantern, D is seen by the right eye, R, direct, and C by reflection in the prism. The light emanating from C impinges at B, is deflected to A and thence to the left eye L. The left eye, therefore, sees the image of C, superposed on the image D, where unison takes place and stereoscopic effect results.

Moessard used two prisms, mounted opera-glass fashion. C shows an arrangement by which a single mirror M suffices to superpose a second image of the necessary pair upon its complement image D. Two lanterns A B are sed to project their respective elements upon lantern screens, C D. The observer, with his eyes situated at L R, sees one element, D, by

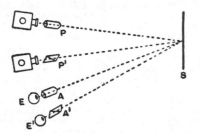

D. Anderson's System of Stereoscopic Projection

direct vision, and the companion element, C, by reflection in the mirror, stereoscopic relief resulting. There is a number of similar systems.

In 1890, Anderson, of Birmingham, invented stereoscopic lantern projection by means of polarised light. Two lanterns project the elements in superposition upon the screen S, in diagram D. Before each lantern is a polariser P P[1]. The picture received by the screen is thus formed of two polarised pictures; for instance, one in a vertical, and the other in a horizontal position. The observer looking at the composite picture through analysers A A[1], placed before his eyes, E E[1], will see with each eye its proper element, and fusion results. The fact that light is lost in polarisation and depolarisation somewhat discounted Anderson's method; but to rectify matters a flexible screen having a metallic reflecting surface was introduced, and this also had the merit of preventing depolarisation apart from the analysers. Anderson also constructed his polarisers and analysers of bundles of thin glass, like the microscopic cover glass, and set at about the polarising angle. The glasses in the bundles are not set quite parallel to each other; otherwise ill-defined images would result, owing to disturbing reflections. Many of the systems above described are obviously applicable to the kinematograph,

and, indeed, almost all have been tried with varying success.

Direct Stereoscopic Projection.—All the foregoing systems may be termed indirect methods of stereoscopic projection, inasmuch that in every case the final results are observed after looking through coloured glasses, prisms, mirrors, shutters or other devices; but as long as intermediate agencies are necessary, stereoscopic relief upon the lantern screen will remain commercially impracticable. The only systems of direct stereoscopic lantern and kinematograph projection have been evolved by Theodore Brown. One applies to ordinary lanterns and the other to the kinematograph. The former consists of a special carrier furnished with a plurality of glass slides or films carrying different sections of one subject in panoramic order and with varying speeds according to the supposed distance of each plane in the composition of the subject depicted. Remote mountains are depicted on one glass or rollable film; the middle distant objects (ships) on a second one; and foreground objects (trees, etc.) on a third. The mechanism of the carrier through which the three glasses are caused to slide horizontally is such that the first has hardly any movement, the second moderate movement, and the third quick movement. On the screen, and before the mechanism is set working, the composition appears as an ordinary picture; but on operating, and thus imparting the panoramic and varying movements, the observer at once perceives a depth of perspective, such as is apparent in any ordinary stereoscope. The fast-moving foreground appears decidedly at a near plane, the sea and ships at a distance beyond the foreground, and, finally, the remote mountains at a great distance away. With this impression comes the sense of actual space between foreground and background. In complicated subjects as many as six distinct layers of rollable films have been introduced.

In Brown's direct system as applied to kinematographs, there are four chief modes of procedure : (1) Placing the subject on a rotatable stand revolved synchronously with the working of the taking camera; (2) Causing the camera to circumscribe the subject, by making the former travel round the subject at a speed regulated by the working of the camera; (3) Using the camera on a special tripod head, designed to give an oscillation to the camera whilst in operation; and (4) Taking the subject in a continuous panoramic direction, at a speed of operating according to the movement of the vehicle carrying the camera.

STEREOSCOPIC SPECTACLES

Spectacles at one time largely used for viewing stereoscopic prints. They are even now used for viewing stereoscopic photographs in books and at times when the prints cannot be placed in a stereoscope. The earliest form of stereoscopic spectacles was made by Duboscq, of Paris, about 1852. Later he introduced spectacles which were actually skeleton box stereoscopes. John Parker, in the late 'fifties of the last century, made spectacles which were worn on the nose, but were encumbered with a division plate or blind on the bridge.

Stereoscopic spectacles of a different kind are used for inspecting anaglyphs. (*See* " Anaglyphoscope.")

STEREOSCOPIC VISION

A term used in reference to the power to see stereoscopic images coalesced without the aid of any instrument whatsoever. Briefly, it consists in directing the eyes' axes to a remote plane whilst accommodating their focus to a near plane. As this operation involves strain and considerable practice before it can be successfully accomplished, various suggestions have been made to assist the observer to train his eyes in the acquisition of this power. Probably the most successful method of acquiring the power to see stereographs stereoscopically without an optical instrument is the following :—

Diagram Illustrating Stereoscopic Vision

Referring to the diagram, cut a strip 1 in. wide out of both the right- and left-hand prints of a stereogram. The portions selected should show remote as well as near objects, and the foremost object should occupy the centre position in each strip. Obtain a piece of cardboard (preferably dead black) 1⅝ in. wide and about 6 in. high ; bend this at right angles in the centre, so that half may lie flat on a table, while the other half will stand erect. Place the two strips of view at A B, side by side, supported at the back, and at a distance of about 3 ft. from them place the cardboard E. Lower the eyes L R so that they are just above the level of the table top and at a distance from E of about 7 in., and in such a position that the left eye L sees only the strip A, and the right eye R sees only the strip B, each eye being prevented from seeing the other strip by the shutter card E.

As the two corresponding points in the views A and B have a separation only of 1 in. instead of 2¼ in. or 3 in. as in ordinary stereoscopic slides, the eyes are easily made to diverge their axes to this slight extent ; and the result is the two pictures combine and stereoscopic relief results. Having succeeded in coalescing A and B in this position, their separation may be gradually increased, until corresponding points reach 2¼ in. This done, ordinary full-sized views may be substituted for A B, and when by practice in this manner the observer has learnt the secret of muscular control of the axes of the eyes, he may dispense with the cardboard.

STERRY'S PROCESS

A process of obtaining soft bromide prints from very hard negatives, introduced by John Sterry. The exposed paper is immersed for about a minute in a ⅓ per cent. solution of potassium bichromate, washed and developed in the usual way, double the customary time being necessary. It will be found that the shadows retain much gradation. The colour of the image is not interfered with, and the process is also available for lantern plates.

STIGMATIC LENS

A lens free from astigmatism (fully described under its own heading). In addition, it is free from chromatic and spherical aberration.

STIGMATYPE

A process of producing pictures by setting up type characters consisting of dots, squares, etc., forming a sort of half-tone image ; introduced by Carl Fasol Pflege, in Vienna, in 1868.

STIPPLE (Fr., *Pointillage ;* Ger., *Punktierung*)

In retouching, working-up enlargements, etc., the covering of surfaces or filling-in of spots and imperfections with small points or dots, whether applied by pencil, brush, or crayon. The operation is known as stippling, and the dotted or grained work, however produced, as the stipple. (*See* " Retouching.")

In process work and lithography, " stipple " is a style of shading produced by making dots with a fine brush in a regular geometrical pattern, usually in small curves. By varying the size and spacing of the dots, great variety of light and shade is produced. Copper- and steel-plate engravers produce a similar stipple by means of a needle-point penetrating an etching ground. Process workers usually obtain their stipples ready made on copper plates, from which transfers are taken, or by means of shading mediums.

STIPPLETTE

A method of quickly and mechanically imitating the effect of sable brush stippling and hatching, introduced by T. S. Bruce, of Hampstead, in 1906.

STOCK SOLUTIONS (*See* "Solutions, Making up.")

STONE, PRINTING ON (*See* " Marble, Photographs on.")

STOPPERS, REMOVING FIXED

Prevention being better than cure, both necks and stoppers of glass bottles should be lubricated with tallow, vaseline, etc. The various methods of removing stoppers have been summarised as follows :—"(1) Press the stopper (longways) in one direction with the thumb (grasping the bottle with the fingers of the same hand) ; now with the other hand hold a chisel or file by the iron part and tap the opposite end of the stopper in the contrary direction to which you are pressing it. (2) Place the stopper in or under a clamp —as that of a carpenter's bench—first wrapping something soft round it, as a piece of leather or wool. Considerable leverage can thus be obtained, but it must not be used to too great an extent or the stopper will snap off. (3) A substitute for the wooden clamp is the use of a key whose handle is just large enough to go over the wrapped-up stopper. These three may be termed the mechanical methods. The use of heat is also very effective in expanding the neck of the bottle. For this purpose we may (4) invert the bottle and dip stopper and neck into a saucepan of hot water. A string should be tied round the stopper or it may drop out and the contents of the bottle be lost. (5) Rotate the neck of the bottle rapidly in the flame of a Bunsen burner.

This is a very effective method, but requires care. (6) Take one turn of a stout piece of string round the neck, and then by means of the two ends saw the string rapidly backwards and forwards. The heat produced by friction will cause the neck to expand."

Stoppers may become fixed owing to the evaporation of their contents, the solid matter crystallising between the neck and the stopper. The remedy is to pour some of the solvent used to make the solution round the stopper and renew as may be necessary, giving it time to work its way between stopper and neck.

STOPPING-DOWN

The use of a smaller stop to decrease the aperture of a lens with the object of improving the depth of focus or definition, of reducing spherical aberration to a negligible quantity, etc. (See "Diaphragms.") Stopping-down directly affects the duration of exposure, as explained under the heading "Exposure Tables."

STOPPING-OUT (See "Blocking-out.")

STOPPING-OUT VARNISH

A black or coloured shellac or asphalt varnish or lacquer used by process etchers for stopping-out the portions of plates which have been sufficiently etched, so that these parts are protected whilst the remaining portions can be re-etched.

STOPS (See "Diaphragms.")

STRESS MARKS

Synonymous with abrasion marks (which see).

STRIPPING FILMS (See "Film Stripping.")

STRONTIUM BROMIDE (Fr., Bromure de strontium ; Ger., Strontiumbromid)

Synonym, bromide of strontia. $SrBr_2 6H_2O$. Molecular weight, 355·5. Solubility, 1 in 1 water ; 1 in 30 alcohol. It is in the form of small colourless crystals, obtained by neutralising hydrobromic acid with strontium hydrate or carbonate. Occasionally it is used in collodion emulsions.

The anhydrous salt, $SrBr_2$, molecular weight 247·5, occurs as a white and very hygroscopic powder.

STRONTIUM CHLORIDE (Fr., Chlorure de strontium ; Ger., Strontiumchlorid)

Synonym, chloride of strontia. $SrCl_2 6H_2O$. Molecular weight, 266·5. Solubilities, 1 in 1·33 water ; slightly soluble in alcohol. It occurs as white needles, obtained in a similar manner to the bromide, and it is used for making chloride emulsions.

The anhydrous salt, $SrCl_2$, molecular weight 158·5, also occurs as a white powder ; solubilities, 1 in 1·96 water, slightly soluble in alcohol.

STRONTIUM IODIDE (Fr., Iodure de strontium ; Ger., Strontiumiodid).

Synonym, iodide of strontia. $SrI_2 6H_2O$. Molecular weight, 449. Solubilities, 1 in ·56, water ; soluble in alcohol and ether. It is a yellowish granular powder, prepared like the bromide. It is used the same as the bromide.

The anhydrous salt has the formula SrI_2. Molecular weight, 233·5.

STUDIO CAMERA (Fr., Chambre d'atelier ; Ger., Atelier Kamera)

The studio camera requires to be substantially made, rigidity and strength being here of primary importance, while portability is of secondary importance. It should have a swing back, a rising and falling front, and, if possible, a long bellows extension for use in copying. The illustration shows a typical studio camera and stand. It is furnished with a rack and pinion at both front and back, so that the camera can be racked backward or forward at either end. Each end has a draw-out extension in addition. Extending supports beneath the bellows prevent

Studio Camera

" sagging." The top of the stand has a tilting table worked by an Archimedean screw operating on an eccentric block, while for raising or lowering the camera a screw cog movement is provided. The dark-slide has a roller shutter, and is fitted with carriers for the smaller sizes of plates. Some workers prefer to have the focusing screen and dark-slide running side by side in grooved rails at the back of the camera, as then the ground glass may instantly be pushed out of the way after focusing and the slide simultaneously brought into position. Such an arrangement is often provided in connection with the repeating back.

STUDIO DESIGN AND CONSTRUCTION

The studio, or "glass-house," as it was originally called, or "gallery" or "operating room," as it is more generally termed in America, has, from the first days of photography, received a great amount of attention, and been the subject of much theory and experiment. The earliest illustration of the kind of place used for portraiture in the days of the daguerreotype process is to be found in a drawing by George Cruikshank, which appeared in the Omnibus of 1844, and which shows an apparently semicircular room,

with the sitter placed on a high platform at the central point of the diameter to bring him close to the completely glazed roof from which he received a flood of all-round top lighting. Modifications of this form of studio naturally came in with the advent of the wet collodion process, one of the earliest and most notable of these being the original " tunnel " studio, A, of Monkhoven, so called from the tunnel or unlighted portion in which the camera was placed. The idea of this was partly that the operator might be able to focus without the use of a cloth, and partly that the eye of the sitter, who was still illuminated by strong top front light, might have the pupil less contracted by the latter when he was looking into a dark space. It was also thought that a more " restful " expression would thereby be obtained, but the opposite effect was often produced ; and with other improvements, of which the first was the side lighting shown in the diagram, the original tunnel form fell into disuse and is now used for copying only.

One of the first studios constructed with side lighting was that of Col. Stuart Wortley (see B). The sloping front light was of clear glass, and that at the side of corrugated glass to 7 ft. from the ground, thence to the roof being of clear glass. It had two sets of blinds, one opaque and one transparent, and was thus the prototype of the modern system of lighting. The next step towards the more modern forms of studio may be said to be the celebrated one of Rejlander, who brought artistic knowledge to bear upon his photographic work, and designed his studio to get the effects he desired. As shown at C, the erection took more the ridge-roofed form, which later came entirely into use ; it had side, top, and front lights ; all the spaces indicated in the diagram were of clear glass, though those in the gable ends at least were usually covered with semi-transparent blinds, being used to give some amount of diffused lighting on to the shadow side of the sitter. A later studio was that of T. R. Williams (see D), and this, having had to be made simply by replacing a solid roof by a glazed one at his premises in Regent Street, London, had an unavoidable south aspect ; the difficulties of the direct sunlight illumination were got over partly by working diagonally across the apartment as shown, and partly by the use of no less than three sets of blinds, one over the other, the outer ones being of dark blue calico, the next of thick white calico, and the inner of thin jaconet muslin. In spite of all these difficulties of working, the finest photographic work as regards lighting and modelling, produced up to its date, was done in this studio by its clever user.

Another later and, indeed, almost modern, south-lit studio was that of Valentine Blanchard (E), in which the difficulties of direct sunlight were got over by the use of a movable trans-lucent screen, as shown on the plan and section, and the use of partly obscured glass in the portions indicated by shading in the diagram. Diagrams F to H show the three principal forms of studio now in use. These are drawn in section, and all to the same scale, to facilitate comparison, the glazed portions being shown by thin lines and the opaque portions of the walls and roof by thick ones. In the first place, all three studios have been drawn to an equal width of 15 ft., but in the " lean-to " and " single slant " types narrower and wider designs have been also respectively indicated to illustrate the greater suitability of the former to narrow studios, and of the latter to wide ones. In the lean-to diagram two roofs of varying pitch are also shown, one at an angle of 30°, and the other at that of 45°, in the latter of which cases it may be noted that the roof becomes rather long and somewhat costly, a defect which, however, might be reduced by making the upper portion a flat, which, in positions in which it is readily accessible, might be utilised for printing, etc. The roof is, of course, shorter in the case of the pitch of 30°, but it then has the disadvantage that snow would lie more easily upon it, and that the incidence of the light upon the sitter is made slightly more vertical than in the case of the steeper roof. This question of pitch also depends largely on the position of the studio and its surroundings, and in these diagrams it has been assumed that the glazed sides of the studios are facing due north, which is, theoretically, the ideal position, though in practice it is generally better to make a studio, if possible, face a little to the east of north, in order that the sun may be off it earlier in the day. The roof pitch is also governed by the fact that the maximum midday altitude of the sun in summer is a little more than 60° above the horizon, and that, therefore, unless the pitch of the roof approaches that angle in steepness, the sun will shine over the ridge into the apartment at that time. This is shown in the diagrams F, G and H by the dotted lines to the left. In the case of a lean-to studio, however, it may be assumed that that form would not be chosen unless there was already some structure in existence for it to be built against, and that it would, therefore, be probably protected from the south, in which case the roof might be kept flatter in pitch. The lean-to form of roof is best suited for studios of from 10 ft. to 15 ft. in width, which are protected by other buildings on the south side, and for which a pitch of 45° for the roof is, therefore, very suitable.

The ridge form has the advantages that it is easy of construction by the ordinary builder ; that almost any width can be covered by it ; that it gives plenty of headroom for the easy moving about of backgrounds (the square in each diagram represents an 8-ft. stretched background), and that its roof may be made almost of any patch desired. That in the diagram is at an angle of 45°, in which case, however, unless erected in a sheltered position, it would require a sun-screen on the ridge, at least, at midsummer. By making the slope of the roof 60°, and putting a flat on the top, this could be avoided, and the size of the roof be kept down, but in that case the " single slant " form, as shown in the last diagram, would be preferable. One of the defects of both the lean-to and the ridge forms of a roof is, that as ordinarily constructed, it is frequently necessary to make the wall plate at the eaves of such dimensions that it becomes a positive obstruction to the light, cutting it in two, and so producing a double high-light in the eye of the sitter which has to be either taken out by the use of the knife on the negative or by

that of the brush on the print. In those two forms of studio, also, there is the necessity of having two complete sets of blinds, which when both dark and light ones are used, as is most generally desirable, involves a great complication of cords, wires, and pulleys, to distract the attention of the operator. For these reasons and others, the single slant form of studio has of late

obtained. Of course, like most other things, the single slant studio is not absolutely perfect, it being sometimes not easy to get quite all the top light required, and, unless it is wide enough for one to work across it, it is not altogether a good studio for copying; yet for a fairly wide design, in which case there is also obviously more head room, it is a capital form for general portrait

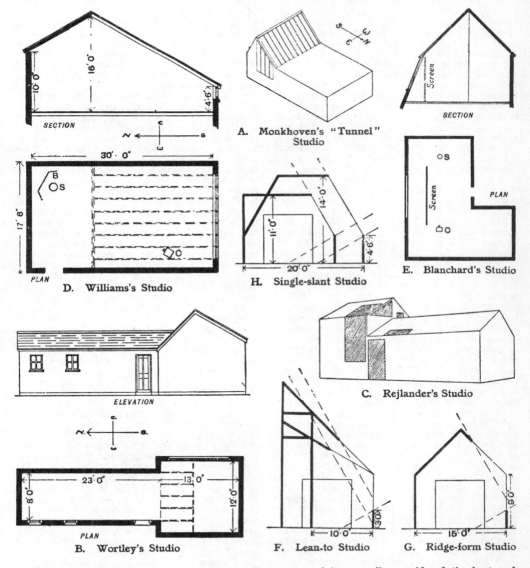

A. Monkhoven's "Tunnel" Studio

D. Williams's Studio

H. Single-slant Studio

E. Blanchard's Studio

C. Rejlander's Studio

B. Wortley's Studio

F. Lean-to Studio

G. Ridge-form Studio

years come more and more into favour, and with it, when roofed to an angle of 60°, the direct rays of the sun are excluded; there is no trouble with snow or leakage; the glass is easily cleaned both inside and out; and with opaque blinds pulling down from the top and up from the bottom, on spring rollers, and a series of transparent ones running on horizontal wires within, all varieties of lighting can be easily

work, and is generally considered the best and most modern form of construction.

With regard to the diagrams F, G and H, it may be noted that the dotted lines to the right enclose between themselves and the base or ground line, an angle which may be subtended by adjacent buildings without the latter obstructing much, if any, of the lighting of the studio itself. In neither of the forms of studio shown

BY (THE LATE) COL. J. GALE

SNOW AND HOAR FROST PHOTOGRAPHY

is it necessary to carry the side lighting down to within less than 3 ft. from the floor, and in most single slant designs 4 ft. 6 in. will be found quite sufficient. Neither in any studio, unless it be very short indeed, is it necessary to carry the side of top light right to the ends, from 3 ft. to 5 ft. at the extremities being preferably built solid to admit of the shading of backgrounds and the getting of a dark atmospheric space behind the sitter when required.

The length of the studio may be anything from 20 ft. to 35 ft., less being too short for the use of ordinary portrait lenses for full length figures, and a greater amount being of not much real practical use. A good amount of width is, however, always an advantage. A very fairly proportioned studio is one in which the width is rather more than half the length. As regards height it must be remembered that all tie rods and similar obstructions must be at least 9 ft. from the ground to allow of the movement of strained backgrounds beneath them; also that as the intensity of light decreases in the ratio of the square of the distance from the source, a very high studio may have a disadvantage in that respect.

The glazed portion of the studio should be executed in one of the many forms of patent glazing without putty which are now on the market. Clear glass is desirable in most positions, as transmitting most light, but if the situation is overlooked, or necessarily of such an aspect as to receive the direct rays of the sun, some kind of obscured glass may be used, the varieties known as rolled and fluted plate being those which stop the least amount of light.

In planning a studio, the entrance doors and those of the dressing-room and dark-room should, if possible, be kept in the unlighted side so as not to interfere with the use of both ends, which may with advantage be fitted up as permanent fixed backgrounds, with plain or papered walls, Lincrusta or other relief work, panelling, tapestry, or whatever form of artistic decoration, suitable for backgrounds, that the taste of the designer may suggest. In the matter of studio decoration generally, light and pleasant tints, such as warm and delicate greys and greens, may be recommended, but heavy and sombre colours should be avoided as absorbing light; strong reds and yellow are unsuitable on account of the non-actinic character of the light reflected from them.

A good smooth floor is, of course, a necessity to facilitate the easy movement of cameras, furniture and backgrounds, and if a stained and polished or parquet floor is not attainable, the best covering for an ordinary one is good inlaid linoleum, on which a few good rugs will produce a pleasing effect. D. B.

Studio Blinds.—The amount and direction of the light admitted to the studio is usually regulated by means of spring-roller blinds, of dark-blue or dark-green lining. It is advisable to have a double set for all the glazed portion of the studio, overlapping after the manner shown in the illustration. One set, A A, should draw from top to bottom in the ordinary way, while the other, B B, is arranged to pull up from bottom to top by cords passed over pulleys, P P, and carried down again, the free ends being then

fastened to brass hooks, H H. The number of blinds required will depend on the size of the glazed portion, which need not be of very large extent. They should not be too wide, or the lighting will be less under control; about 2 ft. is a convenient width. Where there is a good unobstructed light, white calico blinds are frequently fitted underneath the dark ones, to secure any desired degree of softening. Many workers prefer, instead of this, to have loose white muslin curtains running on wires behind or in front of the dark blinds; while another alternative is to paste white tissue paper on the glass, or to glaze the studio with ground glass. The last two methods have the disadvantage that they may obstruct too much light on dull days. When it is not desired to incur the expense of blinds, dark curtains made to run on wires or rods may be substituted.

Greenhouse as Studio.—Generally, a greenhouse is glazed on two, three, or four sides, and probably down to within 1 ft. or so of the ground, thus admitting light all around the figure. It

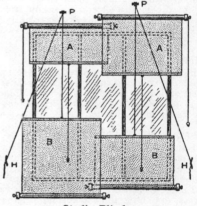

Studio Blinds.

is necessary to block out all unnecessary light by gluing Willesden waterproof paper, or similar material, on the inside of the glass. The choice of aspect depends on whether the studio is to be used most frequently in the morning or in the afternoon; if the former, choose a western aspect, and if the latter, an eastern aspect. If the studio is likely to be used at any time, heavy opaque blinds should be provided for each side; or one set of blinds may be made to do duty for either side as required by simply changing over the cord. The opaque blinds and the interior of the studio may be painted a light grey colour. Spring blinds are best for the roof, and two sets will be required, each blind being about 2 ft. across; one set should be of a dark blue (not a green-blue material), and one set of white calico. To regulate the light from the side, dark blue blinds on small brass rings, suspended from a wire, can be used.

STUDIO PORTRAITURE

The chief considerations in portraiture are dealt with under that main heading, but there remain a few special points in studio work that should be mentioned. The conditions of light

ing in a studio allow of numerous effects that are quite impossible in ordinary rooms. The large amount of available light should be controllable by blinds, and when the sitter enters the studio the top light should always be obscured. Otherwise the glare will be found to be too strong for most people, producing a screwing up of the eyes, thus giving a false expression ; whereas, by having a subdued light when the model enters, one is able to study features under more normal conditions, and to arrange the pose before letting in bright light. Having attained the desired position, the light is arranged by opening the blinds where required. In this way it is much easier to notice the different effects of light and shade than by having the full amount of light open and gradually cutting it off. The photographer must cultivate the art of making the sitter feel at ease in the studio, it being impossible to obtain a successful portrait if there is a feeling of constraint. Avoid the appearance of all unnecessary appliances ; make the studio appear as much like an ordinary room as possible, with interesting pictures, books, plants, etc., to divert the sitter's attention from any idea that he is in some strange place. Have everything ready and at hand that may be required.

STUMPING

The application of powdered colour to a photographic print or enlargement by means of a paper or leather stump, or with a finger-tip, the print being first prepared by rubbing with very fine pumice powder

SUBMARINE PHOTOGRAPHY

This is an application of photography which, probably on account of the very special apparatus, and the great difficulties encountered, has received but little attention. Attempts have been made from time to time, and with varying success, to photograph the bottom of large rock-pools and shallow lagoons, by connecting the camera with a tube of large diameter, pointed downwards through the water. A special raft having a well in its centre, to carry the downward-pointing photographic apparatus, has been used with success ; the shadow cast by the raft cuts off all sky reflections. By working at sunrise and an hour or so before sunset, a kind of oblique lighting was obtained which gave very pleasing results, the exposures varying from $\frac{1}{30}$th of a second to two seconds, according to the depth of water, lighting, etc. Green-sensitive orthochromatic plates were found to yield the best results, the greenish yellow tint, caused by the oblique rays of the sun passing through the sea-water, acting as a kind of natural compensating filter.

The actinic value of light decreases very rapidly with increasing depth of water, so that some means of artificial illumination soon becomes necessary. This at once presents many difficulties, as special apparatus to hold the illuminant becomes necessary, and is rather costly to construct, owing to the perfect fitting necessary to make every part water-tight. Heavy plate glass must be used for the window of the illuminant box, and the box itself must be well weighted to insure its sinking to the bottom on an even keel. The box must be fairly large, so

as to permit of a good sized window, and also a full charge of magnesium powder being used. The best results will be obtained by using two such illuminant boxes, sunk one on each side and slightly in advance of the camera, which also must be enclosed in a water-tight, glass-fronted, weighted box. Both the camera shutter release and the ignition of the magnesium flash can be worked by electrical switches. One trouble which may spoil many exposures is the condensation of moisture on the inner surface of the glass front of the box carrying the camera, due to warm moist air within the box. The glass should be very carefully cleaned, the box kept as cool as possible, and if there is great variation between the temperature of the air and the floor of the sea, a small quantity of calcium chloride may be placed in the box at the moment of closing it. This will be found to act as a preventive of condensation. F. M-D.

SUBSTITUTION PROCESS (See "Ceramic Process.")

SUBSTRATUM (Fr., *Substratum* ; Ger., *Unterguss*)

A solution, generally of gelatine and chrome alum, poured over a plate or other support to cause the sensitive film to adhere to its support. A dilute solution of sodium silicate (1 in 300) has also been used for this purpose, but it is by no means a safe remedy, as its alkaline nature is apt to act on the emulsion. Diluted albumen and a decoction of glasswort (Fr., *Percepierre* ; Ger., *Glaskraut*) have also been suggested. The chrome gelatine solution is prepared as follows :—

| Gelatine | . | . | . | 37 grs. | 4·25 g. |
| Distilled water to | . | . | 20 oz. | 1,000 ccs. |

Allow to soak for an hour, melt by the aid of a water bath, and add—

| Chrome alum (2% sol.) | . 185 mins. | 19 ccs. |

This should be applied freely to the plate, and the latter then set up to drain and dry.

SUGAR IN GELATINE

Ordinary sugar is occasionally added to gelatine solutions, particularly for the carbon process, to render it more soluble and to prevent spontaneous insolubilisation after sensitising. Its action is purely mechanical, as it dissolves out in water.

SUGAR OF LEAD (See "Lead Acetate.")

SUGAR OF MILK

Synonyms, lactose and milk sugar. $C_{12}H_{22}O_{11}$. It is prepared from milk by coagulating the proteid and evaporating the whey to a syrup, when crude sugar of milk will crystallise out ; it is then recrystallised, when it forms white rhombic crystals. It is used chiefly in the preparation of dry powder developers.

SULPHIDE TONING

Bromides.—Success depends on the use of a fresh developer for each print, full development, drying after fixing and before toning, and thorough bleaching to a light colour.

Two stock solutions should be prepared, each of which will keep indefinitely.

Bleaching Solution A

Potassium ferricyanide		1 oz.	110 g.
Potassium bromide	.	1½ ,,	165 ,,
Water to	. . .	9¼ ,,	925 ccs.

Bleaching Solution B

Mercuric chloride	.	120 grs.	28 g.
Potassium bromide	.	120 ,,	28 ,,
Water to	. .	10 oz.	1000 ccs.

The table shows the number of parts of these solutions and of water required to produce a variety of tones :—

	Rich brown	Colder brown	Deep brown	Brown-black	Pure black
Bleach. sol. A	1	1	¾	1	½
Bleach. sol. B	—	1	1	2	2
Water . .	11	10	10¼	13	9½

After bleaching thoroughly, the print must be washed ; in addition, an acid bath must be used whenever the working solution contains solution B. The acid bath is hydrochloric acid 30 mins., water about 6 oz. ; its object is to prevent the combination of the mercury with the gelatine. The print should be taken from the bleaching solution, washed in about three changes of water, and then immersed in the acid solution for two or three minutes. A second and third acid bath should be used, and then the print washed again for about twenty minutes in several changes of water. When the toner for pure black is used for bleaching, the print is intensified considerably, and allowance must be made in printing. There is also a slight strengthening when using the solutions for deep brown and brown-black.

When sufficiently washed after bleaching, the prints should be treated with the sulphide solution. Prepare a stock solution of 520 grs. of sodium sulphide in 10 oz. of boiling water, storing it in a screw-stoppered bottle. The working solution is 40 mins. of the stock solution in sufficient water to make 1 oz. This should be used once, and then thrown away.

Fine red and red-brown tones can be obtained by substituting a stock solution of 1 oz. of sodium sulphantimoniate (Schlippe's salt) and ¼ oz. of sodium carbonate in sufficient water to make 9¼ oz.

The prints are bleached in :—

| Bleaching solution A | . | . 1 part |
| Water | | . 11 parts |

Wash for half an hour, and immerse in one of the following mixtures :—

	Red chalk	Red-brown	Warm brown
Sod. sulphantimoniate sol.	1	2	2
Sodium sulphide sol. .	—	⅛	¼
Water . . .	11	24	24

The prints should be washed thoroughly for about half an hour, and then dried. Bleaching solution B—the mercuric solution—must not be used with sodium sulphantimoniate.

P.O.P.—Many attempts have been made to introduce a method of toning P.O.P. by the sulphide process, but they have not been sufficiently successful to render the process suitable for ordinary working.

SULPHIDING (*See* "Sulphide Toning.")

SULPHITE (Fr., *Sulfite ;* Ger., *Sulfit*)

A salt formed by the replacement of the hydrogen in sulphurous acid, H_2SO_3, by a metal, as, for example, in sodium sulphite, Na_2SO_3.

SULPHOCYANIDE POISONING

The question as to whether the sulphocyanides of ammonium and sodium are poisonous or not has been a matter of controversy. Dr. Heffter, of Leipzig, in 1896, took several doses of sulphocyanides without feeling any ill effects. On the other hand, it should be said there is the oft-quoted case of a Cambridge lady who, in 1894, was poisoned by taking less than 5 grs., the doctor stating that 3 grs. were sufficient to cause death. Dr. Leo Baekeland stated at the time that " it is a ridiculous mistake to think that the sulphocyanides are poisonous. There is certainly a confusion here with cyanide, which is really one of the most powerful poisons known." In any case, the admission of ammonium sulphocyanide, either by itself or in a gold toning bath, into cuts or sores upon the hand causes much trouble, and it is better in all cases to treat it as if it were a poison.

SULPHO-PYROGALLOL (*See* " Berkeley's Sulpho-pyrogallol.")

SULPHUR (Fr., *Soufre ;* Ger., *Schwefel*)

Synonym, brimstone. S. Atomic weight, 32. A non-metallic element, occurring native in many parts of the world. It is a brittle solid, lemon-yellow in colour, and tasteless. Solubilities, insoluble in water ; soluble in carbon disulphide, turpentine, benzol, and slightly in warm alcohol. The sublimed sulphur (flowers of sulphur) is the purest commercial form.

SULPHUR DIOXIDE (*See* " Sulphurous Acid.")

SULPHUR TONING

A method of toning in which free sulphur compounds are used. Bromide prints may be immersed in a hot solution of alum and " hypo," and silver prints, deeply printed, in an acid " hypo " bath. In the second case, the result is fugitive. It will be noted that these are combined toning and fixing methods.

Sulphur toning is frequently an accidental effect. In some forms of the combined toning and fixing baths, if the bath is overworked and the gold becomes exhausted, toning will still continue, the change in colour being due to the deposition of sulphur on the silver image. Sulphur prints are liable to discolour, deteriorate and fade.

SULPHURATED POTASH (*See* " Potassium Sulphide.")

SULPHURET OF AMMONIA (*See* " Ammonium Sulphide.")

SULPHURET OF CARBON (*See* "Carbon Disulphide.")

SULPHURETTED HYDROGEN (*See* "Hydrogen Sulphide.")

SULPHURIC ACID (Fr., *Acide sulfurique*; Ger., *Schwefel Säure*)

Synonym, oil of vitriol. H_2SO_4. A heavy, oily, colourless liquid; specific gravity, 1·84 (= 98 per cent. H_2SO_4 by weight). It is intensely corrosive and chars all organic matter it touches. It is used to acidify some developers, and occasionally with chrome alum as an addition to the "hypo" fixing bath. Great caution is necessary when mixing solutions with sulphuric acid, and the latter should be added slowly to the water, etc., not the water to the acid.

In process work, this acid is not much used, but it forms with potassium bichromate a good pickle for cleaning glass, and with chromic acid a cleaning bath for copper etching, the latter solution being also good for matting a copper plate. In electrotyping, sulphuric acid is largely used in making up the copper depositing bath.

SULPHURIC ETHER (*See* "Ether.")

SULPHUROUS ACID (Fr., *Acide sulfureux*; Ger., *Schweflige Säure*)

Synonyms, solution of sulphur dioxide or sulphurous anhydride, hydric sulphite. H_2SO_3, or more correctly, $SO_2 + H_2O$. Solubilities, miscible with water and alcohol. It is a colourless liquid smelling strongly of sulphur dioxide, and containing about 6 per cent. of SO_2. Molecular weight, 82. It is obtained by deoxidising sulphuric acid with copper or mercury, or by burning pyrites. It is used as a preservative and to acidify the fixing bath.

SULPHUROUS ANHYDRIDE (*See* "Sulphurous Acid.")

SUN, PHOTOGRAPHING THE

Very little interest attaches to photographs of the sun taken with cameras fitted with lenses of ordinary focal lengths, but good results may be obtained by means of medium or high-power telephoto equipments. If the equivalent focal length is sufficient to give an image about 1 in. or more in diameter, the photographs would probably be of value for scientific records of the phenomena taking place on the sun's surface. In the case of the photographer merely wishing to obtain a chance record, there is no necessity for providing any mounting, or, in fact, any accessories beyond some means of holding the camera steadily in the direction of the sun, and an exposure shutter giving the most rapid exposure it is possible to make. Use any good brand of slow plates, preferably of the fine-grain variety, and develop with a rather hard developer, as in most cases over-exposure will be experienced in spite of the rapid shutter.

If records of more perfect astronomical value are desired, the only difference will be an improvement of the mounting of the camera, to allow of repeated exposures without constant readjustment of the image, and for large-scale work an increase of the aperture and focal length of the lens system employed. In most cases an equatorial mounting will be found necessary, with clock-driven mechanism adjusted to the solar rate of movement. For the telephoto camera, however, either a positive or a negative secondary magnifier may be employed, the actual system chosen depending on the choice of the operator. Both methods are in constant use, and give practically equally good results, although, of course, the positive magnifier makes the apparatus more cumbersome. With such cameras the photographs will show simply the white round disc of the sun, with, at times, groups of dusky spots showing in belts across the middle regions. By means of a special spectroscopic attachment, called the spectroheliograph, it is now possible to screen off all light from the plate, except that of one particular colour, and on photographs thus taken it is found that certain patches of the surface are rendered much more prominent than on the ordinary pictures in integrated sunlight. Instruments of this type are now installed at all the chief observatories of the world.

(For notes on the phenomena to be photographed round the sun on special occasions, *see* under the headings "Corona Photography," and "Eclipses, Photographing.")

SUNNING-DOWN

Any part of a P.O.P. print that is white or too light and devoid of detail may be toned to a pale grey by sunning-down. A shield is cut and laid over the parts of the print that it is desired to protect, the print being put in a printing frame under a piece of plain glass.

SUNSET EFFECTS

Although the beauty of a sunset effect is so largely dependent on colour, the monochromatic rendering by photography is frequently charming and suggestive. The technical difficulties are, however, often very considerable. The light, although visually brilliant, is more or less non-actinic, and an exposure that is ample for the sky itself is far from sufficient for the rest of the subject. The discrepancy is not so great in the case of the sea as in the case, say, of a wooded landscape, or when there are dark foreground objects. Hence some of the most successful results are those showing the sun setting over the water. As the light at sunset is frequently rich in yellow and red, rather than blue, rays, the use of an orthochromatic plate, or, preferably, a panchromatic plate, is advisable. Under-exposure may produce greater contrasts in the sky, but it deprives the rest of the picture of that subdued luminosity which is one of the charms of sunset.

Sunrises are similar in character and effect to sunsets, but do not receive nearly the same amount of attention from photographers.

SUPER-SATURATED SOLUTIONS

Over-saturated solutions; those overcharged with the salt. A saturated solution of mercuric chloride in plain water may, for example, be made to take up more of the salt by adding hydrochloric acid. The use of such solutions is not recommended in photography.

SUPPLEMENTARY EXPOSURE (*See* "Auxiliary Exposure.")

SUPPLEMENTARY LENSES

Lenses employed to increase the usefulness of other lenses by altering the focal length. Derogy issued a portrait lens fitted with two supplementary lenses, one being positive and the other negative. J. Traill Taylor developed the idea by fitting a series of lenses upon a slide or wheel which was placed between the lenses of a rapid rectilinear. Later, supplementary lenses were used on many hand cameras to take the place of a focusing adjustment; the Kodak portrait attachment is an example. Achromatised supplementary lenses for portraiture, copying, distant and wide-angle work are sold under the name of "planiscopes." When a lens is set to its infinity focus and a supplementary lens is fitted close in front of it, an object placed at a distance equal to the focal length of the supplementary lens will be sharply defined upon the screen. Thus a spectacle lens of 40 in. focal length will enable an object at that distance to be photographed without focusing or additional camera extension.

SUPPLEMENTARY LIGHTING

Auxiliary exposures have been referred to as supplementary lighting, but the term more correctly refers to the system of casting additional light upon the subject by means of reflectors, mirrors, or magnesium light, in addition to daylight. Magnesium ribbon or powder is largely used for lighting up dark corners of interiors, etc. In interior work, such as crypts, the burning of a few inches of magnesium behind a pillar or other object helps exposure considerably. A mirror can be used in a similar way; it should be held in the path of the sun's rays, which are reflected by the mirror on to the darker parts of the view, the mirror being kept on the move and, of course, out of the field of view. Mirrors are of the greatest service for supplementary lighting when copying in picture galleries.

SWEATING OF THE SCREEN

In working the half-tone process with wet collodion or collodion emulsion, especially in winter time, considerable trouble is met with owing to the condensation of moisture on the screen—commonly known as "sweating." The remedy is to warm the screen, or to rub over it a trace of glycerine, or coat it with a thin film of gelatine ¼ oz., acetic acid ¼ oz., warm water 20 oz.

SWELLED GELATINE PROCESS

Before zinc and copper etching were fully developed this process was largely worked, but it was roundabout and uncertain. A thick glass plate was coated with a thick layer of bichromated gelatine, and after being dried was exposed under a line negative. The plate was then placed in a dish of clean cool water, when the swelling began immediately. The parts of the gelatine film not acted upon by light absorbed water and swelled up. The exposed parts remained at their original level. When the relief was thought to be sufficient, the plate was removed to a hardening bath of chrome alum, citric acid, and water. Whilst still moist, a plaster cast was taken from the gelatine relief, and when this was dry it formed a matrix for a wax mould for electrotyping. If a stereotype was required a second cast had to be made from the first, as the latter was in relief lines, which would have produced an intaglio result in the stereotype. The process is full of difficulty and uncertainty, and the operations take a long time.

SWING BACK (Fr., *Bascule* ; Ger., *Bewegliche Visirscheibe*)

An adjustment by means of which the camera back may be inclined towards or away from the lens. The simplest form of swing back is merely hinged at the bottom to the baseboard, but it is preferable to have it pivoted at the centre. The swing back is used when the camera has to be tilted to include the top of a high building. In such a case, the upright lines of the building would be shown converging towards the top, as

Use of the Swing Back

SUTTON, THOMAS

Died, 1875. An active photographic experimenter from 1856 to 1872. Founder and editor of *Photographic Notes*, and the inventor of a panoramic camera. In 1862 he invented a plan for giving paper a coating of indiarubber dissolved in benzole, before albumenising. In 1859 he invented a fluid lens.

SWANTYPE

A half-tone process devised by J. W. Swan, and differing from the ordinary half-tone process only in the manipulation of screens and stops.

if the building were falling over backwards. By bringing the swing back into operation, as at A, so that the focusing screen is parallel with the building, the lines are rendered vertical. The tilting of the lens with regard to the plate necessitates the use of a small stop, and it is better to avoid inclining the camera if the same result can be obtained by using the rising front. Another employment of the swing back is when objects at different distances are required to be equally sharp without stopping-down, as, for instance, the knees and hands as well as the head of a sitter in portraiture, or the foreground

and middle distance of a landscape. Near objects are always brought to a focus farther from the lens than distant ones, as shown at B, where the foreground of the picture is seen to be focused at F, beyond the position of the ground-glass screen s, when the distance D is sharp, while if the near foreground is in good definition the distance is thrown out of focus. By inclining the swing back outwards, as at C, both foreground and distance are in focus at once. This method of equalising the focus must be used cautiously, as it has the defect of introducing a slight distortion. Some cameras are provided also with a side-swing, the camera being then said to have a double swing back.

SWING FRONT (Fr., *Planchette à bascule ;* Ger., *Bewegliches Objektivbrett*)

An adjustment in which the camera front is hinged to the baseboard frame, or is pivoted at its own centre, so that the lens may be swung upward, or downward. The principal advantage is that high buildings may be included on the plate without having to tilt the camera. It is necessary to keep the back vertical, and some stopping-down of the lens is usually required, for which reason it is preferable whenever possible to employ the rising front movement instead, as this enables the lens to be used at a larger aperture. The use of the swing front has the same effect as that obtained by tilting the camera and using the swing back, but the lens is not so easily kept with its axis falling on the middle of the plate. Many field cameras have a swing adjustment to both back and front.

SYMBOLS (*See* " Element " and " Solubilities.")

SYMMETRICAL LENS

A lens in which the two combinations have similar curves and balance one another.

SYMPATHETIC PHOTOGRAPHS

A plain piece of paper is coated with a 10 per cent. solution of gelatine, dried, floated upon a 10 per cent. solution of potassium bichromate, and dried in the dark. The paper is exposed under a positive, say an unmounted lantern slide. The print, with the image showing very faintly, is then immersed in a 10 per cent. solution of cobalt chloride, when the parts not acted upon by light will absorb the solution. The print is then washed and dried. A faint image will be seen, and this will change colour according to the condition of the atmosphere. When the weather is fine and dry or heat is applied to the print, the picture will be of a pretty blue colour, but when damp the colour will change and the picture almost disappear. (*See also* " Barometer, Photographic.")

By the Stone method the image is composed, as above, of gelatine rendered insoluble upon unsized paper ; when the paper is dipped in water the image appears by reason of those portions of the picture having no gelatine upon them becoming comparatively transparent ; as the picture dries the image disappears. Stone's sensitive solution was : Water, 5 oz. ; gelatine, ¼ oz. ; potassium bichromate, 24 grs. Unsized paper was coated with this

(warm), dried in the dark, printed under a negative, and soaked in warm water.

SYNCHROMIE

A four-colour printing process in which all the colours are printed at one impression, invented by Vittorio Turati, of Milan. A mosaic of pigment colour was formed on the bed of the printing machine, and, the surface being damped, impressions were taken off on to paper.

SYNTHETIC GUM (*See* " Arabin Gumbichromate Process.")

SYNTHOL

A trade name for a developer in powder form, a hydrochloride of diamido-orcinol. $C_6H(CH_3)$ $(OH_2)(NH_2HCl)_{21}$. It is said to be obtained from various plants, the mother substance being orcin. It is very soluble in water and can be used in conjunction with sodium sulphite without an alkali, like amidol. A working formula is :—

Sodium sulphite .	.	300 grs.	68 g.
Potassium bromide	.	5 „	1·1 „
Synthol .	.	30 „	6·8 „
Water .	.	10 oz.	1,000 ccs.

SYPHON (Fr., *Siphon ;* Ger., *Heber, Siphon*)

An appliance for drawing off water or other liquid from a vessel without disturbing the latter. A simple syphon may be made with a bent lead pipe, one end of which is longer than the other. The short arm is corked and the tube filled with water, the long arm being then also corked. The short end of the pipe is introduced in the vessel and the cork removed ; then on taking out the other cork the syphon will commence to work, the liquid in the vessel rising up the tube and discharging. Another convenient device is a short length of rubber tubing with spring clips for the ends. Some syphons are provided with an additional tube joined near the end of the long arm ; by its means, the liquid is drawn over the bend by suction.

SZCZEPANIK'S PHOTO-WEAVING PROCESS

Jan Szczepanik invented an ingenious method of producing the cards for the Jacquard loom by photographic means. His method is based on the half-tone process, and consisted in the use of a series of special ruled screens and variously shaped diaphragms which produced a negative in square dots something like a design for crewel work. This negative was printed by means of sensitised fish-glue on to a zinc plate, the image being developed, so that the dots were isolated, with spaces of bare zinc around them, and in some parts there were no dots at all, as the light and shade of the picture demanded. The plate was then put into an electrical apparatus, so arranged that a tracer point passed in lines over the plate, the point alternately making and breaking contact as it passed from the enamel film dot to bare metal. Thus an electrical current was intermittently transmitted to a Jacquard punching machine, the keys of which were operated by the current.

T

TABLET CRUSHER

An appliance for pulverising "tabloid" and other compressed chemicals, and consisting of a round metal receptacle, in which fits a peculiar form of stopper which may be used as a pestle. The "tabloid" is placed in the receptacle and reduced to powder by working the stopper.

"TABLOIDS"

A proprietary name (registered in 1884) for compressed chemicals made by the successors of Brockendon, who, in 1842, originated compressed chemicals in the shape of bi-convex discs. They contain chemicals in correct and known quantities, and need simply to be dissolved in the required amount of water to make a working solution. There are many other forms and makes of compressed chemicals.

TACHYSCOPE (Fr., *Tachyscope* ; Ger., *Tachyskop*)

A form of zoëtrope invented by Ottomar Anschütz, of Lissa, and used to reconstruct the appearance of motion from animal photographs taken in series. It consisted of a shallow cylinder into which a bent strip of photographs was inserted. The strip was pierced with upright narrow slits between the photographs, the number of slits corresponding with that of the pictures. The advantage was that a variable number of photographs might be used to form a series, whereas with the zoëtrope the number must always correspond with the slits in the fixed side. Anschütz also invented an electrical tachyscope.

TALBOT, HENRY FOX

Born 1800, died September 17, 1877. Retired from public life in 1834 to devote his whole time to scientific work. While sketching at Lake Como with Wollaston's camera lucida in October, 1833, he was struck with the idea of fixing images produced by that instrument, and six years of steady work at the problem followed. He was to some extent successful, and on January 31, 1839, he read before the Royal Society a paper on the process, which he called " Photogenic Drawing "; this paper was afterwards published in the *Philosophical Magazine*. Prof. Faraday exhibited at the Royal Institution on January 25, 1839, a collection of Fox Talbot's "photogenic drawings," which were produced solely by the action of light, and at the same time described the process (*which see*, under the heading " Photogenic Drawing "). Daguerre was experimenting at the same time, and published his results in 1839, but the methods of the two men were different, that of Fox Talbot giving an image on paper, whereas that of Daguerre produced an image upon a polished silver surface. The calotype process, often called the talbotype process, was patented by Fox Talbot on February 8, 1841, and was the subject of the third British photographic patent. Fox Talbot in 1843 patented the use of a hot solution of sodium hyposulphite for making the pictures of his process whiter and more permanent ; Sir John Herschel had suggested it in 1819, and again advocated its use in 1843. In 1843 Fox Talbot took his process to Paris, and in the following year (1844) began to publish his famous work " The Pencil of Nature." After the introduction of the Archer collodion process in 1851, he devised a modification of it by which shorter exposures were possible. A year later he invented a process of engraving upon steel plates by means of photography, and in 1854 he introduced albumen to give a gloss to the surface of paper on which photographs were printed. The calotype (or talbotype) process of making negatives upon paper was largely used by amateurs of the period, it being less costly and troublesome than the daguerreotype process, which was preferred by the professional portraitists.

Talbot was the first to describe the use of line and network screens for the purpose of breaking up the image into dots, and for this purpose he made use of crêpe, silk gauze, muslin, and lines ruled on glass. He did not realise, however, the idea of optical formation of the dot in the negative as now practised.

TALBOTYPE (*See* " Calotype, or Talbotype, Process.")

TALC (*See* " Chalk, French.")

TANK DEVELOPMENT (*See* " Development, Stand.")

TANK, WASHING (*See* " Washing Tank.")

TANNIC ACID (*See* " Tannin.")

TANNIN (*Fr., Acide tannique ;* Ger., *Gerbsäure, Gerbstoff, Tannin*)

Synonym, tannic or digallic acid. $C_{14}H_{10}O_9$. Molecular weight, 322. Solubilities, 1 in 1 water, 1 in ·6 alcohol. A lustrous, faintly yellow amorphous powder extracted from gall nuts and all kinds of bark. It has been recommended as a hardening agent for prints, but it forms an insoluble compound with gelatine which darkens in light.

In process work, tannin is sometimes used as an ingredient in the etching solution for collotype plates, with the object of hardening the gelatine film. A strong solution is sometimes applied locally to make certain parts take the ink. It has also been used for writing titles and other lettering on collotype plates, the parts to which

the tannin ink was applied printing black. The addition of tannin to the chromated gelatine before coating the plate has been recommended for making the film more durable and lasting.

TANNIN PROCESS (Fr., *Procédé tannin, Procédé Russell ;* Ger., *Tannin Prozess*)

A dry collodion process invented by Major Russell, in which a preservative bath of tannin was used. The plate was coated with a substratum of gelatine and then with iodised collodion, after which it was sensitised for five minutes in a silver nitrate bath, and then well washed. The preservative was a filtered solution of 15 grs. of tannin to each ounce of distilled water. This was poured on and off the plate several times, throwing away the first portion, the plate being then stood up to dry in the dark-room. Plates prepared in this way were ready for use when dry, and would keep some time.

TANNING PRINTS

Tannin has been recommended for hardening gelatine negatives and prints, a typical formula being :—

Tannin	. . .	4½ grs.	1 g.
Sodium chloride	.	45 ,,	10 ,,
Alum (saturated sol.)	405 mins.	85 ccs.	
Water	. .	10 oz.	1,000 ,,

The tannin and sodium chloride (common salt) are first dissolved, and the saturated alum solution added, the mixture being filtered or decanted. The prints are immersed for a few minutes and well washed. It has been stated that prints hardened with tannin become yellow after a time ; whether this is so or not, the method has no advantage over the use of formaline or chrome alum. (*See also* " Hardeners " and " Fixing-hardening Baths.")

TARTAR, SALT OF (*See* " Potassium Carbonate.")

TARTARIC ACID (Fr., *Acide tartarique ;* Ger., *Weinsäure*)

$C_4H_6O_6$ or $(CH)_2(OH)_2(COOH)_2$. Molecular weight, 150. Solubilities, 1 in ·75 water, 1 in 3 alcohol, 1 in 250 ether. It is in the form of colourless transparent rhombic crystals obtained from argol or crude potassium bitartrate, deposited during the fermentation of wines. It is used as a preservative for sensitised papers and in printing-out emulsions.

TAUPENOT'S PROCESS

A collodio-albumen process invented in 1855 by Dr. J. M. Taupenot, a French scientist. It was largely used for the production of stereoscopic transparencies, and was a rival process to the albumen process used by Ferrier, the details of the latter being kept secret.

TAYLOR, J. TRAILL

Born 1827 ; died 1895. An authority on photographic optics and editor of the *British Journal of Photography* from 1864 to 1879 and 1886 until his death. He was a watchmaker by trade, but as a youth practised the daguerreotype process, and during his long residence in Edinburgh came into contact with Brewster, Fox Talbot, Ponton, and many other photographic and scientific celebrities. His first association with photographic journalism was in 1856. In 1860 he delivered a lecture before the Royal Scottish Society of Arts on " The Use of the Optical Lantern in Photography," on which occasion photographic lantern slides were publicly exhibited for the first time. Between 1880 and 1885 he edited an American photographic journal, the *Photographic Times*.

TEA PROCESS

In an obsolete process tea was used as a preservative or organifier for collodion plates. For other preservatives, *see* " Coffee Process."

TEA-TRAY LANDSCAPES

Landscapes built up in a miniature form upon a tea-tray, a branch of work with which the names of Newton Gibson and W. Perry Barringer are connected. Snowscapes and desert scenes are the easiest to produce, sugar, flour and sand being used to build up the scenes. Trees may be made out of small sprigs of foliage, asparagus, etc., and miniature china figures, animals, etc., included. Properly lighted and skilfully photographed, effective pictures may be produced in this way.

TELAUTOGRAPH (*See* " Photo-telegraphy.")

TELECTROGRAPH (*See* " Photo-telegraphy.")

TELECTROSCOPE

An early form of instrument for the electrical transmission of photographs ; invented by Szczepanik and Kleinberg, in 1898.

TELEGRAPH, PHOTOGRAPHS BY (*See* " Photo-telegraphy.")

TELEMETER (*See* " Distance Meter.")

TELEPHOTO LENS (Fr., *Lentille téléphotographique ;* Ger., *Teleobjektiv*)

A lens giving a high magnification compared with ordinary lenses used with the same extension of camera. The earliest commercial telephoto lens was made by Thomas R. Dallmeyer in 1891, and consisted of a single positive lens, somewhat like a telescope object glass, and a triple cemented negative lens of high power. In consequence of the low intensity and high magnification thus obtained, the telephoto lens was suitable only for a very limited class of subjects, and it was not until a moderate power combination with a maximum intensity of about $f/9$ was introduced that telephotography became general. Negative attachments for use with existing rectilinears and anastigmats were then issued, and finally the Adon lens, a complete telephoto lens of small size and weight, removed the last difficulties connected with this branch of work. Excellent telephoto lenses are now made by a number of makers. (*See also* " Telephotography " and " Bis-telar.")

TELEPHOTOGRAPHY (Fr., *Téléphotographie*)

The photography of distant objects by means of lenses giving high magnification compared

with ordinary lenses used with the same extension of the camera. A telephoto lens is, in fact, a long-focus lens requiring but a short camera extension; it has not a definite or fixed focal length like other lenses, and it may be so adjusted as to give a sharp image at any extension of the camera, provided that the extension is not less than the focus of the positive lens which forms part of the telephoto lens.

The combination of lenses which forms the telephoto system consists of an ordinary photographic lens, preferably a rapid anastigmat, called the positive element; and a negative lens, so arranged that its distance from the positive lens may be varied by means of a rack and pinion on the lens mount. The distance from the positive to the negative element and the distance from the negative lens to the sensitive plate are variable, the former being determined by the latter, and on these distances depends the degree of magnification; or, in other words, the proportionate size of the image compared with the size of the image yielded by the positive lens alone.

Unless the positive lens can work at $f/8$, focusing and the arrangement of the picture become very difficult. The value of the aperture of the positive lens is reduced by the negative element in direct proportion to the magnification; consequently, with a magnification of four times, $f/8$ becomes $f/32$.

For ordinary work, the focus of the negative lens should be about half that of the positive. If great magnification is required for special work, the focus of the negative lens should be still less. This short-focus negative lens has the disadvantage of reducing the covering power of the positive lens, and this is a serious but unavoidable objection to the telephoto lens system.

Although the focal length is lengthened, the area covered by the lens is reduced very considerably; but, with a given combination of lenses, the greater the magnification, the greater will be the covering power. It is very desirable that the focus of the negative element should be known, as it provides a definite basis for ascertaining the degree of magnification. Ernest Marriage gives the following simple rule for finding the magnification when the focus of the negative lens is known: After focusing, divide the distance from the negative lens to the focusing screen by the focus of the negative element, and add 1 to the result. *Example.*—A negative lens of 4 in. focal length is used, and, when the image is sharply focused, the negative lens is 8 in. distant from the focusing screen. What is the degree of magnification?

$$\frac{8}{4} = 2; \quad 2 + 1 = 3 \text{ times.}$$

Many telephoto lenses have a scale of magnifications engraved on the mount, so that, when the image is sharply focused, the degree of magnification can be read off from the position of the indicator on the scale.

The working value of the stop can be ascertained by multiplying the value of the aperture in the positive lens by the degree of magnification. Thus, with a magnification of three diameters, $f/8$ becomes $f/24$; and with a magnification of four times, $f/11\cdot3$ becomes about $f/45$.

The size of the image increases with the extension of the camera, so that it is a very simple matter to secure any size that may be desired. If the image when first focused is too small, the extension of the camera should be increased, and then the subject re-focused by the rack and pinion on the lens mount. If it is too large, decrease the camera extension and re-focus.

Attention has been directed to the fact that the covering capacity of the telephoto lens is very small; consequently, the use of the rising front becomes an impossibility, as the plate would show dark corners. Tilting the camera is necessary for all subjects which would require the rising front when using an ordinary lens; and when the tilting becomes excessive, as in photographing architectural details at a considerable height from the ground, it is not practicable to set the camera back vertical owing to the impossibility of securing good definition throughout when the plate is at such an angle to the axis of the lens.

An objection to many telephotographs is the very slight perspective effect obtained. It is the extreme opposite to the exaggerated effect sometimes produced by a wide-angle lens, but at times it is quite as pronounced and as unnatural.

Two difficulties that become serious when working with a telephoto lens for distant subjects are haziness in the atmosphere, which renders it impossible to secure clear detail, and wind, even a slight breeze introducing serious vibration with the long camera extension.

TELEPHOTOSCOPY OR TELE-ELECTROSCOPY (*See* "Photo-telegraphy.")

TELESCOPIC TRIPOD (*See* "Camera Stand.")

TEMPERATURES

Most of the solutions for ordinary photographic work should be used at a temperature of 65° F. (18° C.), or as near that as possible. Solutions for developing and fixing negatives and bromide prints, toning and fixing silver prints, toning bromide prints, and intensifying and reducing, should all be kept as nearly as possible to this standard temperature. In cold weather the dishes should be warmed before beginning any operation. The developing solution for cold-bath platinotype should not be used cooler than 65° F. or warmer than 90° F. (32° C.). The standard temperature for developing carbon prints is from 100° to 110° F. (38° to 43° C.).

The temperature of developers influences the time of development considerably. A normal Azol solution, for example, will, with a given plate and used at a temperature of 40°, develop a plate in 21 minutes, whereas if used at 90° development would be complete in 3½ minutes. The intermediate temperatures and times are:—45°, 17¼ min.; 50°, 14 min.; 55°, 12¼ min.; 60°, 10¼ min.; 65°, 8¾ min.; 70°, 7 min.; 75°, 6 min.; 80°, 5¼ min.; and 85°, 4¼ min.

Developer, fixer, and washing water should be of practically the same temperature, more particularly when bromide paper is used; otherwise blisters and other troubles may occur. If such is not possible, the change should be gradual.

TEMPORARY SUPPORT

This is used in carbon printing for the double transfer process; known also as a " flexible support." Its purpose is to hold the carbon film during development, etc., until ready for the second transfer to the final support. The flexible temporary support is a paper coated with a mixture of lac and gelatine that has been rendered quite insoluble; and, after coating, the paper is rolled under heavy pressure, so as to present a fine, smooth, and semi-glossy surface. The temporary support is prepared for use by rubbing over with a waxing solution (white wax dissolved in turpentine); after allowing two or three hours for the turpentine to evaporate, the support is ready for use in exactly the same manner as single transfer paper. After the flexible support has been soaked for a few minutes in water, the exposed print is squeegeed to the prepared surface: and after development, washing and drying, a piece of double transfer paper is squeegeed to the print. When thoroughly dry, the double transfer paper holding the film firmly may be pulled away from the temporary support, the surface of which is left quite clean. Before using again the flexible temporary support requires re-waxing. When using this support a longer immersion in the alum bath is necessary than for ordinary single transfer paper.

In addition to the flexible temporary support commonly used in the carbon process, a piece of matt-surfaced opal glass is sometimes used when it is desired to obtain prints with a matt surface instead of the semi-gloss imparted by the flexible paper support. This opal glass is prepared by waxing, and it is used in exactly the same manner as the flexible support.

TENT, DEVELOPING (*See* " Developing Tent.")

TEREBENTHENE

A rarely used synonym for turpentine.

TERTIARY COLOURS (Fr., *Couleurs tertiares ;* Ger., *Tertiäre Farben*)

A term usually applied to colours saddened or lowered in luminosity by the admixture of black or grey.

TERTIARY SPECTRUM (Fr., *Spectre tertiare ;* Ger., *Tertiäre Spektrum*)

The small residual colours of the spectrum left outstanding when the secondary spectrum is corrected in lenses. That is to say, an ordinary lens is corrected for two colours, and the outstanding spectrum is known as the secondary spectrum; if three colours are corrected, the outstanding spectrum is known as the tertiary spectrum.

TEST PAPER (Fr., *Papier réactif ;* Ger., *Reagens Papier*)

Bibulous paper immersed in various solutions and dried, used for testing the acidity or alkalinity, etc., of liquids. Various kinds, such as azolitmin, brazilin, congo red, dahlia, hæmatoxylin, etc., are used by chemists, but those principally used by photographers are litmus, methyl orange, phenol-phthalein, and cochineal.

The following table gives the resultant colours in the various solutions :—

	Acid	Alkaline	In the presence of carbon dioxide (carbonic acid)
Cochineal .	Yellow . .	Reddish violet	Not affected
Litmus . .	Bright red .	Blue . . .	Reddish purple
Methyl orange	Red . . .	Yellow-brown	Not affected
Phenol-phthalein . . .	Colourless .	Intense red .	Useless

TEXTILES, PHOTOGRAPHS ON (*See* " Fabrics, Printing on.")

TEXTURE (Fr., *Tissure ;* Ger., *Gefüge, Textur*)

The natural depiction of different surfaces or materials in a photograph, which is then said to have good textures, or textural rendering.

THAMES COLOUR PLATE

A screen-plate patented by C. L. Finlay, in 1906, and consisting of contiguous red and green circles with blue-violet interspaces, so small that there are 70,000 colour patches to the square inch. It is supplied either coated with an emulsion or for use with separate panchromatic plates. A compensating yellow filter of stained gelatine is inserted between the lens combinations, and the plate, loaded in darkness, is exposed glass side to the lens. It is developed in darkness for exactly five minutes in ordinary temperature, using hydroquinone with caustic potash. The plate is then washed for one minute and placed in the reversing solution: Potassium bichromate, 1 oz., or 80 ccs.; water, 10 oz., or 800 ccs., sulphuric acid, 1 drm., or 10 ccs. After a few seconds, the dish is taken into daylight and watched until a positive is seen on holding the plate up to the light. After well washing under the tap, the plate is re-developed till a little denser than required, washed for one minute, and fixed in " hypo," finally washing well, and when dry binding up with a cover-glass. If separate plates and screens are used, the plate is developed by itself, afterwards registering with the screen.

THEATRICAL AND KINEMATOGRAPH PHOTOGRAPHY

Theatrical Photography.—The usual plan of taking photographs in a theatre is to employ flashlight, elaborate arrangements and a large battery of lamps, combined with the usual stage lights, being necessary in most cases. The invention, in 1901, of the Grün fluid lens, working at an aperture of $f/2\cdot5$, enabled well-exposed negatives of stage scenes during a performance to be obtained in one-quarter of a second's exposure, and pictures of actresses, etc., in their dressing-rooms, with five seconds' exposure. Under very favourable circumstances even shorter exposures were given; at the London Alhambra, for example, excellently exposed negatives were taken from the stalls with an exposure of $\frac{1}{15}$ second without the knowledge of the performers. Rapid but not specially prepared plates were used in conjunction with the

Grün lens. Arthur Payne considers that no " ordinary " plate, however fast, can equal for such work, by artificial light, a plate specially bathed in the manner described below. The speed of these special plates varies from 500 to 550 H. and D. According to Arthur Payne's article in the *British Journal of Photography* (July 6, 1906), clean working plates of medium speed were bathed in the following :—A stock solution of orthochrom T dye is made by dissolving 1 g. in 1,000 ccs. of alcohol (90 per cent.), and 4 ccs. of this, together with 3 ccs. of liquor ammoniæ, are added to 200 ccs. of distilled water. This solution is filtered and used at a temperature of 60° to 65° F. (15·5° to 18° C.). It must be made up as required, as it can be used only once. The plates are immersed for three minutes, care being taken to rock the dish and avoid air-bells. The solution is then poured away and the plates washed in running water for three minutes and dried. The plates are now extremely sensitive to yellowish light, and therefore the bathing, washing, and drying must be carried out in darkness or in the safest of ruby lights. The plates should be used as soon as possible after they are dry. The development of these plates is as usual, except that it is best to use the developer at a temperature of about 75° F. (about 24° C.). Most of the organic developers probably give equally good results with these plates, but bromide or other restrainer must not be used, and they must be of maximum strength, so that when used a slight fog appears over the whole of the plate. Edinol is found to give one of the best kinds of negatives, fairly free from grain, which will bear enlarging up to five or six diameters.

The plates treated as described above were used with success by many workers, but Mr. Payne discovered later that a 1 in 50,000 solution of pinacyanol, used instead of orthochrom T, gave increased sensitiveness and made the plates more sensitive to red than to blue. The gain in speed by yellow light is considerable when pinacyanol is used ; indeed, when a stage is illuminated by yellow light, only focal plane shutter exposures of $\frac{1}{4}$ to $\frac{1}{10}$ second are possible with a lens working at $f/3$. In manipulating the plates, darkness is best, or a very weak green " safe " light.

In the majority of cases negatives of theatrical photographs will be found very thin, although possibly full of detail. Dr. Grün advocated intensification with uranium, but Arthur Payne advises printing upon gaslight paper, or the making of a contrasty transparency upon a photo-mechanical plate in the camera, enlarging the image about two diameters, and from this positive making an enlarged negative in the camera ; by obtaining as much contrast as possible in the enlarged negative and printing upon gaslight paper, the contrast in the final print will probably be all that is required.

Photographically, stage lighting may be divided into two classes : diffused lighting, when the whole of the stage is fairly equally flooded with light ; and focused arc lamps or lime lights when the light is concentrated upon one part of the stage or upon the principal actor in the scene. These effects are used independently and together, and the photographer should try to select a moment when the subject is illuminated by both focused and diffused lighting ; although the strong, bright lighting resulting from the use of focused arcs alone produces interesting effects, which photograph easily and well. Occasionally some pretty effects may be obtained from the wings on the stage, more especially when the figure is lit by focused arcs, but permission to use a camera in the wings during a performance is rarely given. Arthur Payne believes that the best position to work from, on the stage itself, is obtained by sitting upon a chair, this resulting in a low point of view, on the O.P. side of the stage—that is, on the right-hand side as the audience see it. The reason for selecting this side is to avoid obstructing the officials, who are generally on the " prompt " side in the execution of their duties. The stage appears to be brighter, by contrast with the darkened theatre, than is actually the case, but Mr. Payne says this difficulty may be overcome by observing the amount of light which is reflected from the stage into the auditorium ; in this manner fluctuations in the light may be followed with ease. It may be accepted as a general rule that the longest possible exposure should be given on all occasions, for it is unlikely that the photographer will ever meet with over-exposure, except under extreme conditions, as stage lighting usually gives heavy shadows.

Kinematograph Photography.—This involves similar lighting conditions to those necessary in ordinary photography. Excepting in the case of stage scenes and " make-ups," the operator of the kinematograph camera does not know many moments in advance what is going to happen next. A crowd of people may, perchance, unconsciously group themselves into a most desirable arrangement, but the chances are they will not. An elevated position should be chosen, so that possible obstructions, such as people passing close to the lens, and, therefore, out of focus, are avoided. The direction of the light, especially at noon, should be oblique and coming from the back of the operator, either from his right or left ; direct front lighting should be avoided. Ideal illumination occurs when the sky is thinly overcast, with plenty of light sifting through the clouds. Critical definition, a full range of tone values, and exact speed with even motion, are the three chief points to be aimed at. The first point relates to choice and management of the lens and the adjustment of the shutter aperture ; the second relates to the light and afterwards to proper development ; and the third to the correct operating of the mechanism. The handle must be turned at the rate of two revolutions per second, and its speed must be regular throughout the operation, irrespective of all else.

" Make-ups " and stage subjects afford opportunities of arrangements not possible with topical or street scenes. The questions of lighting and optical conditions remain the same. Stages on which motion-picture plots are executed are generally on the tops of houses, so that as the sun alters its position, there are no shadows of surrounding buildings cast upon the scene ; but the house-top studio is not to be preferred to a good open space on the ground level. The professional's stage is built on the revolving principle, so that the direction of the lighting can be kept

constant throughout the day. The amateur is not likely to want to take more than two or three subjects in one day, and these he can arrange for when the lighting is at its best.

When the camera has been set up on a rock-steady support, the field covered by the lens should be marked out on the floor of the stage by means of white tape or chalk lines, as an indication to the actors. The time limit for the actions in each section is arrived at by rehearsing the play, whilst the operator turns the handle of his machine at the recognised speed; the camera need not be loaded, providing it is fitted with a speed-indicator. It is the work of the stage manager to watch the acting and to decide upon the question of elimination. All superfluous action is cut out, not only to reduce expense, but to crystallise the plot. No action is introduced that can be assumed to happen, and only such natural motions are allowed as will render the subject intelligible to the average mind.

Trick and Make-up Subjects.—Motion-picture photography lends itself to trickery and make-believe more than any other branch of the picture-making art. In subjects where human beings are represented as passing through great peril, the stop-camera method is resorted to. Thus, an actual person acts the part up to the safe stage; the camera is then stopped, and a dummy substitute provided, made up to represent the original. In like manner, when inanimate objects are made to move without apparent human control—such, for instance, as a knife cutting by itself a loaf of bread; cups and saucers collecting themselves into a heap; and so on—the photographer takes one or two pictures, stops, the articles are moved to the second position in their progress of movement, the camera again operated for the space of one or two pictures and again stopped, the articles moved to their third position, and so on through the entire series of pictures. The process naturally takes a long time to accomplish, but the results are often well worth the trouble expended. Some cameras are fitted with means whereby the operator may ensure exposing only one picture space at a time, and an assistant generally carries out the work of altering the positions of the objects after each exposure. If a camera has its shutter aperture so adjusted that sufficient exposure is obtained whilst operating at less than the normal speed of sixteen exposures per second, a subject moving normally will appear to be moving swiftly when projected upon the screen; the opposite holds good when the camera is operated abnormally quick.

Stationary subjects, such as a man's face, may be represented as increasing in magnitude by causing the camera to travel towards the subject during operation. Likewise, diminution of objects may be produced by taking the camera away from the subject during operation. This diminishing and growing magnitude effect incidentally creates the illusion of an approaching or receding subject. Hence, a train represented on the screen as approaching, appears by its ever-increasing size, to rush almost off the sheet into the auditorium.

To give the effect of a balloon rising or falling, or a flying machine travelling in space, rollable backgrounds, on which are depicted distant land and clouds, are placed behind the scene and operated. The rollers on which such backgrounds are wound are fitted to supports capable of universal movement in one plane. If a balloon or any other object is to be represented as ascending, the background is wound from top roller to bottom, passing downwards, or in an opposite direction to that in which the balloon is supposed to be moving. If a flying machine is represented as travelling from left to right, the background is moved in panoramic order from right to left.

Many other effects are produced by what is known as composite printing, in which process masking is resorted to and the print made by exposure in contact with two, three or more separate negative films in succession, according to the complexity of the subject to be produced.

Dissolving effects are produced as described under the heading " Dissolving-views." Under the heading " Aerial Screen " is explained one method of producing " ghost effects " in kinematography.

THEATROGRAPH

A lantern projection apparatus for displaying a series of photographic pictures, invented by R. W. Paul, in 1896.

THERMO DEVELOPMENT (See " Development, Thermo.")

THERMOMETER

A temperature measurer; there are three thermometer systems in more or less common use, namely, Fahrenheit, Réaumur and Celsius, the latter being best known as Centigrade. The Fahrenheit system, invented in 1714, is the most widely used in England; the Centigrade system, invented in 1740, abroad; while the Réaumur system, invented 1731, was in use in Russia. It is a simple matter to convert one to another. To convert—

Centigrade into Fahrenheit, multiply by 9, divide by 5, and add 32;

Fahrenheit into Centigrade, subtract 32, multiply by 5, and divide by 9;

Centigrade into Réaumur, multiply by 4 and divide by 5;

Réaumur into Centigrade, multiply by 5 and divide by 4;

Fahrenheit into Réaumur, subtract 32, multiply by 4, and divide by 9;

Réaumur into Fahrenheit, multiply by 9, divide by 4, and add 32.

THERMO REGULATOR (See " Mercury Thermo Regulator.")

THINNING SOLUTION

A mixture of equal parts of ether and alcohol used for thinning collodion which has become thickened by evaporation, or which has been made up with too great a proportion of pyroxyline.

THIOCARBAMIDE (Fr., *Sulfo-urée, sulfocarbamide;* Ger., *Thiocarbamid, Sulfoharnstoff*)

Synonyms, sulphourea, thiourea. $CS(NH_2)_2$. Molecular weight, 76. Solubilities, 1 in 11 water, very soluble in alcohol and ether. White

lustrous crystals obtained by heating ammonium sulphocyanide for two hours at a temperature of 322° F. (161° C.), when the ammonium salt is converted without loss or gain into its isomeric molecular compound thiocarbamide. Water-house suggested it as an addition to the eikonogen developer to obtain reversal by direct exposure, and it is also used for toning with gold. The most satisfactory formula for this is the following, first suggested by Hélain :—

Gold chloride (1 %
 sol.) . . . 120 mins. 25 ccs.
Add—

Thiocarbamide (2 %
 sol.) . . . 65–71 mins. 13·5–15 ccs.
till the precipitate first formed is redissolved, then add—

Citric acid . . 24 grs. 5·5 g.
Distilled water to . 10 oz. 1,000 ccs.
And finally—

Salt . . . 48 grs. 11 g.
The prints should be rather deeply printed, and immersed in a 10 per cent. solution of salt prior to toning. This bath is economical, and free from any tendency to double tones. This carbamide is used also for clearing yellow stains.

THIOSINAMINE (Fr., *Sulfophenylurée ;* Ger., *Thiosinamin, Allylsulfoharnstoff*)

Synonyms, allyl sulphocarbamide, allyl sul-phourea, allyl thiourea, rhodalline. CS(NH$_2$) NHC$_3$H$_5$. Molecular weight, 1.6. Solubilities, slightly soluble in water, easily soluble in alcohol and ether. It is in the form of colourless crystals with faint garlic odour, ob-tained by the action of ammonia and alcohol on allyl sulphocyanate (mustard oil). It has been suggested as a fixing agent, but its solvent powers are very poor compared with " hypo," and its price is high.

THIOUREA (*See* " Thiocarbamide.")

THOUGHT PHOTOGRAPHY

Many of the " spirit " photographers have claimed to be able to photograph thought. In the *Review of Reviews* for April, 1893, W. T. Stead suggested that additional experiments should be tried to obtain psychic pictures without the agency of the camera, and in the following July an experiment was tried and recorded by Andrew Glendinning. A female medium and clairvoyante held between the palms of her hands an unexposed dry plate enclosed in a dark-slide. The plate was afterwards developed, when the picture of a child appeared upon it. Unfortunately, it is impossible to discover what was the subject of the lady's thoughts. It is recorded that Prof. Jordan, in 1896, placed seven men in front of his camera and asked each one to think of a cat ; they did so, and the resulting photograph was " a collec-tive psychical image which is none other than the astral cat in its real essence." Dr. Baraduc, of the Paris Société de Médecine, has stated that by concentrating his mind on a definite object so as to visualise distinctly a picture thereof, the image was impressed on a dry

plate. Several other experiments have been made in the direction indicated, but no properly authenticated result of any importance has been obtained. Many of the so-called thought pictures that have been exhibited require an immense amount of imagination to distinguish any image upon them.

THREE-COLOUR PHOTOGRAPHY

This particular branch of photography is, with the exception of the diffraction and Lipp-mann's processes, practically the basis of all colour photography. It is based on the theory that by the use of three colours only all the colours of nature can be simulated, either by the use of three lights—red, green, and blue-violet—when optical synthesis is used, or by the aid of three pigments—red, yellow and blue—when the subtractive process is employed on paper or glass.

The first idea of this process was enunciated by Clerk-Maxwell in a lecture before the Royal Institution, in 1861.

Henry Collen, the miniature painter to Queen Victoria, writing to the *British Journal of Photography* (1865, p. 547), threw out a sug-gestion, which, although theoretically incorrect, shows that he certainly conceived the idea, and apparently in ignorance of Clerk-Maxwell's sug-gestions.

Ducos du Hauron sent, in 1862, a letter to a M. Lelut, member of the Académie de Médecine et Sciences, in which he describes the principles of three-colour work, and though, like Collen's, they were erroneous, still they are of sufficient interest to warrant inclusion :—

" *Physical Solution of the Problem of Repro-ducing Colours by Photography.* — The method which I propose is based on the principle that the simple colours are reduced to three—red, yellow, and blue—the combinations of which in different proportions give us the infinite variety of shades which we see in nature. One may now say that analysis of the solar spectrum by means of a glass which only passes one colour has proved that red exists in all parts of the spectrum, and the like for yellow and blue, and that one is forced to admit that the solar spectrum is formed of three superposed spectra having their maxima of intensity at different points. Thus one might consider a picture which represents nature as composed of three pictures superimposed, the one red, the second yellow and the third blue. The result of this would be that if one could obtain separately these three images by photography and then reunite them in one, one would obtain an image of nature with all the tints that it contains."

Here also the theory of colour selection is erroneous, and founded on Brewster's theory, but the above note proves that Du Hauron had really conceived the idea of three-colour work independently of Clerk-Maxwell.

Du Hauron goes on to describe the use of three filters of deep red, deep yellow, and deep blue, and gives a sketch of a chromoscope by means of which the three positives could be seen visually, and even suggests a stereoscopic chromoscope. In November, 1868, Du Hauron took out a French patent for three-colour

work, and here he used red, green and violet filters, thus falling into line with modern practice. In 1865, Baron Rausonnet, of Vienna, attempted to produce three-colour photo-lithographs, but failed to obtain any result, and gave up the idea. In 1867, Charles Cros, a Frenchman, had quite independently been working on the same problem, and in 1869 published his ideas. Cros utilised the principle of monochromatic illumination of his subject, but he did not follow up the subject quite so energetically as Du Hauron, who was the first actually to produce a three-colour print. It was only after the discovery of the principle of orthochromatising that three-colour work made any advances. It is impossible to give a complete historical sketch of the subject, but the above includes reference to the first workers on the subject.

The commonly accepted theory of three-colour work is that the filters and plates must be so adjusted as to give a reproduction in black—that is, in metallic silver—of the three sensation curves according to Clerk-Maxwell, but the requirements of the printing inks, or the projection colours, necessitate modifications ; and the generally accepted practice now is that the three filters should have a slight overlap, as follows : The red filter should transmit from $\lambda 7,000$ to $\lambda 5,800$; the green from $\lambda 6,000$ to $\lambda 4,600$; and the blue from $\lambda 5,000$ to $\lambda 4,000$; and equal density should be obtained under each filter.

There is occasionally some little misunderstanding about the printing inks and the projection colours, but this can be cleared up by a very simple explanation. If a black-and-white drawing is photographed, it is obvious that the whites will give the density in the negative, whilst the black, which is the colour in which it is wished to print, gives the shadows, or bare glass, so that obviously we print in the colour that does not act. In projecting a transparency from the negative we should project by white light ; therefore we should project by the colour that did act on the negative. Dealing thus with a coloured subject, we use a red screen that cuts out the blue, and therefore print from this negative in the colour that does not act on the negative, namely, blue ; using a green screen we cut out the red, and therefore print in red ; and with a blue screen, which cuts out the yellow, we print in yellow. For projection, as stated above, we project by the light by which the negatives were taken and, therefore, project the transparency taken through the red screen by red light, that taken by the green screen by green light, and that taken by blue by blue light.

Theoretically, there should be, of course, correspondence between the light cut out by the screens and the light reflected by the inks, but here there is generally a departure from theory, as the theoretically correct inks are not sufficiently permanent to light.

Three-colour work may be divided into photomechanical printing ; the superposition of dyed films or pigments, as in the carbon process, in which the principle of subtractive colour mixture is made use of ; and the optical synthesis methods, such as the chromoscope, three-colour projection, and screen-plate processes. The production of filters for this work is treated of under the heading of " Colour Screen or Filter." It is far better to use a panchromatic plate for all three exposures, as the gradations are then more likely to be the same, which may not be the case when plates sensitised for each particular section of the spectrum are employed. In no case should the negatives be harsh, but rather tending towards softness. With correct filters adjusted to the plate with which they are to be used and correct exposure, hand work on the negatives—except for the retouching of pure mechanical defects—should be avoided, as no one can tell from looking at a subject exactly how much of any one of the three printing colours is contained in any colour of the original.

Pinatype is a three-colour process invented by Dr. König, in 1905. Three negatives are first obtained through red, green and blue filters, and from these transparencies are made. Special gelatinised plates, sensitised with potassium bichromate, are exposed under the positives and washed, being then soaked in blue, red and yellow dyes respectively, which are absorbed by the soft or image portions only. The three plates are pressed in turn in contact with moistened gelatinised paper, which takes up the dye ; a photograph, or strictly, print, in colours results.

THREE-COLOUR WORK

A term generally applied more particularly to process work and printing in three colours, as distinct from purely photographic methods, which come under the heading of three-colour photography.

THYMOL

An antiseptic obtained from certain volatile vegetable oils, and used as a preservative in mountants.

TIME DEVELOPMENT (See "Development Factorial," "Development, Thermo," and "Development, Time.")

TIME EXPOSURES

Exposures sufficiently long to be given by hand, the duration being determined by closing the lens at will, as distinguished from "instantaneous" exposures, or those that must be given automatically by a mechanical contrivance. A time exposure may be of any duration from a quarter or half of a second up to several hours. If very long, the lens cap will form the most convenient method of uncovering and covering the lens, but for exposures up to eight or ten seconds a mechanical shutter is preferable, as when this is employed the photographer can watch moving foliage or any subject that requires care in seizing the opportunity for making the exposure, and, without touching or looking at the camera, can release the shutter at the critical moment, thus ensuring exposure under the best conditions. If foliage should move or any other accidental necessity arise, he can at once close the shutter, if the exposure is nearly completed, and secure a negative that shows absence of movement. In long time exposures it may frequently become

necessary to give several short exposures to make up the total time. The photographer should acquire the art of capping and uncapping the lens without imparting a tremor to the camera.

For timing exposures, there is nothing better than a chronometer or a watch with a seconds hand. One exposure meter is fitted with a chain which swings to and fro in a given time and is approximately correct. Counting is fairly satisfactory if one has learnt to count always at the same speed, but a second is longer than the average worker imagines, and considerable practice is necessary before one can count without a watch with safety. A common plan is to count in a normal manner, as follows : " One little second," " two little seconds," " three little seconds," and so on, practising this until each sentence takes one second to repeat. For longer exposures, both for camera and dark-room work, a watch or a special dark-room clock is to be preferred.

TIN, BLACKENING (See " Blackening Apparatus.")

TIN CHLORIDE (Fr., *Chlorure d'étain ;* Ger., *Stannochlorid*)

Synonym, tin protochloride or dichloride, tin salt, stannous chloride. $SnCl_2 2H_2O$. Molecular weight, 225. Solubilities, 1 in 1·5 water, soluble in alcohol. It takes the form of white crystals, obtained by the action of hydrochloric acid on tin. It has been suggested for blackening negatives after bleaching with mercuric chloride, but it presents no particular advantage. Hélain's formula is :—

Tartaric acid .	.	. 96 grs.	22 g
Tin chloride .	.	. 96 ,,	22 ,,
Distilled water to .	.	. 10 oz.	1,000 ccs.

TINCAL, OR TINKAL (See " Sodium Borate.")

TINCTURE OF IODINE (See " Iodine.")

TINFOIL (Fr., *Étain en feuille, Feuille d'étain ;* Ger., *Blattzinn, Stanniol*)

An alloy of lead and tin rolled out into thin sheets. The thinnest variety is used for masking negatives, especially in collotype printing, so as to secure clean white margins. Woodbury used tinfoil in his Stannotype process.

A process of using tinfoil instead of paper as a base for photo-lithographic transfers was worked out by Captain Mantell, at the Royal Engineers' Military School, Chatham, its advantage being freedom from expansion when the transfer is damped.

TINT BLOCKS (Fr., *Clichés à teinte ;* Ger., *Ton-platten*)

A process block is sometimes printed on a tint ground imitating the effect of an India tint mount ; this ground is printed from a " tint block." Sometimes an etched block is used in half-tone work to give a preliminary printing in a lighter tint of ink than the main block. This block is termed a tint block.

TINT PLATES

Copper plates engraved with a mechanical stipple or line ruling for the purpose of pulling transfers therefrom. Lithographers and process workers use them for applying a tint to some part of an illustration that has to be shaded or darkened in colour. Tint plates have now been almost entirely superseded by shading mediums.

TINTED PRINTS

Printing papers with coloured supports are articles of commerce, as, for example, cream bromide papers and self-toning papers, and pink and mauve P.O.P. Other and much higher and pronounced colours are also supplied. It is a common practice to use white papers and to stain with dyes or tea and coffee.

TINTOMETER

An instrument for measuring and, as it were, analysing the colour in solids and liquids ; invented by J. W. Lovibond about 1887. The object is placed at one end of the instrument ; from a graded series of standards, made of coloured glasses, numbered according to their depth of colour, the colour of the object is matched. For investigation work, three colour scales are employed (red, yellow and blue), and the glass slips are graded in colour from plain glass to maximum intensity. The instrument itself consists of a double, parallel-sided tube, having at one end an eyepiece and at the other the viewing apertures.

TINTYPE (See " Ferrotype Process.")

TISSUE (See " Carbon Tissue.")

TISSUE NEGATIVES

In an early type of roll film, the sensitive emulsion was spread upon paper and stripped off after being developed and fixed.

TITHONOTYPE, OR TITHNOTYPE (Fr., *Tithonotype ;* Ger., *Tithonotypie*)

A process for obtaining metallic copies of daguerreotypes by electrotypy, discovered by J. W. Draper, of New York. The daguerreotype was gilded, and left exposed to the air for a few days. The back and edges were next varnished, and copper was electro-deposited upon the daguerretoype image, this taking from twelve to twenty hours. If the work had been done properly, the tithonotype was readily detached without injury to the original, of which it formed a perfect copy. Duplicates could be made from the tithonotype if required.

TITLING NEGATIVES AND PRINTS (See " Lettering Negatives and Prints.")

TOBACCO PRESERVATIVE

One of the many preservatives or organifiers introduced before the days of gelatine dry plates for keeping collodion plates in a good condition for a few days. The formula was : Water, 1 oz. ; gum arabic, 10 grs. ; tobacco, 20 grs. The mixture was boiled and filtered, then coated upon a sensitive plate.

TONE

A term that is applied in two distinct ways. It is used in the same sense as in painting, etching,

drawing and kindred arts, to signify the degree of depth of any mass of greys, such a mass being described as a "light" or "dark" tone, a "delicate" tone, etc. A picture is said to be "light" in tone when there are few dark masses, or it is "dark" in tone when the heavy or dark masses preponderate.

"Tone" also indicates the actual colour of a print, brown and red colours being termed "warm" tones, and purple and black colours, "cold" tones.

Light tones are called high, and dark ones low. The more a picture inclines to whites and light greys (or other colour) the higher it is in tone; the heavier and darker it is, the lower it is in tone. (*See also* "Key.")

"Half-tones" are the shades of colour between black and white, a half-tone image being an image in which the half-tones have been broken up into dots; in contrast with which an ordinary photograph is said to be of "continuous tone."

TONE BLOCKS

Half-tone blocks are often referred to as "tone blocks."

TONING (Fr., *Virage*; Ger., *Tonen, Schönen.*)

The operation of changing the colour of a photographic image by changing its composition or depositing another metal. Toning is almost exclusively employed for modifying the silver images on printing-out, bromide, and gaslight papers. It is sometimes adopted in lantern slide making. Details of the processes are given under other headings.

TONING BATHS FOR SILVER PRINTS

A toning bath suitable for almost every brand of gelatine and collodion printing-out paper is :—

Am. sulphocyanide	12 grs.	4·5 g.
Gold chloride .	1 gr.	·37 ,,
Water . .	. 5–6 oz.	830–1,000 ccs.

Full working details are given in the article on "Toning P.O.P."

The following toning baths work admirably with some brands of P.O.P. :—

Sodium phosphate .	20 grs.	7·5 g.
Gold chloride .	1 gr.	·37 ,,
Water . .	. 6 oz.	1,000 ccs.

Sodium formate .	15 grs.	5·6 g.
Gold chloride .	1 gr.	·37 ,,
Water . .	. 6 oz.	1,000 ccs.

The sodium phosphate and the following baths are all suitable for albumenised paper :—

Sodium acetate .	30 grs.	10 g.
Gold chloride .	1 gr.	·3 ,,
Water . .	. 7 oz.	1,000 ccs.

This bath should be mixed at least ten hours before required for use.

Sodium bicarbonate	4 grs.	1·2 g.
Gold chloride .	1 ,,	·3 ,,
Water . .	. 7 oz.	1,000 ccs.

Other formulæ are given under the headings "Borax Toning," "Chloride of Lime Toning Bath," "Bennett's Toning Bath for P.O.P.," etc.

TONING BROMIDE PRINTS

There are various methods of toning bromide prints; the most satisfactory being those that produce various shades of brown-black and cold and warm brown, although red tones are very suitable for flower studies and portraits of children, etc. Green and blue tones are the least desirable. In monochrome work it is rarely desirable to imitate the colour of the subject.

In all toning processes, the method of producing the print considerably influences the final colour and quality. A strong, rich print is essential for securing rich tones, and a strong print cannot be obtained from a weak, flat negative. From a good negative, a strong print can only be obtained by correct exposure and full development; over-exposure and short development yield a print that will never tone to a rich colour; the result is always weak and poor. Another source of imperfect results in toning is the very common practice of using one quantity of developer for several prints. Those developed last will invariably give weak and poor colours when toned. Fresh developer should be used for every print, excepting small prints, for which, relatively, a large quantity of solution is employed. For these, two prints may be developed in succession in one quantity of solution, but this should be the limit.

Thorough fixation is essential to success in toning bromide prints; thorough washing is often equally important. Bromide prints should always be dried after fixing and washing before toning; with some processes this affects the colour very materially.

Copper Toning.—Very delicate red tones, red-chalk, or rather sanguine, can be obtained by toning with copper. For the formulæ, see "Copper Toning."

Platinum Toning.—Good sepia tones may be obtained by this method, which is fully described under a separate heading.

Vanadium Toning.—A good green tone can be obtained by this process. (*See* "Vanadium Toning.")

Iron Toning.—Rich blue tones are obtained by iron toning; the bath should be prepared by adding each ingredient in the same order as in the formula :—

Ferric am.-citrate .	3 grs.	·62 g.
Pot. ferricyanide .	3 ,,	·62 ,,
Nitric acid .	6 mins	1·2 ccs.
Water . .	. 8 oz.	800 ,,

The print tones rapidly in this solution to a rich blue; it requires washing in various changes of water until the whites lose the stain acquired during toning, and become quite pure. It is better to prolong the washing a little beyond the visible clearing. The permanency of prints toned either by iron or vanadium is doubtful.

"Hypo"-alum Toning.—A method of sulphide toning by means of a solution of "hypo" and alum. The colour is a purple-brown, and the results are thoroughly permanent. Working details are given under the heading of "Alum-'hypo' Toning."

Sulphide Toning.—A process of toning by the use of a solution of sodium sulphide which is in every respect the most satisfactory method of toning bromide prints. Very rich, pure

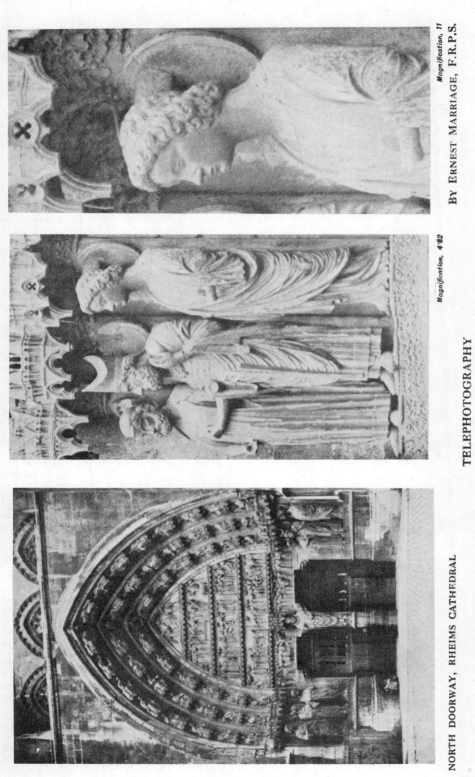

NORTH DOORWAY, RHEIMS CATHEDRAL

Magnification, 4·82

Magnification, 11

BY ERNEST MARRIAGE, F.R.P.S.

TELEPHOTOGRAPHY

The second and third photographs show the magnifications of the sculptured figures to the right of the doorway obtained by means of a telephoto lens, the camera remaining stationary.

19

brown colours are obtained, the process is simple and certain, and the prints after toning are quite permanent. The process, one of combined toning and intensification, is fully described under the heading " Sulphide Toning."

TONING, DOUBLE (See " Double Toning.")

TONING AFTER FIXING

A method that has been recommended on account of the occasional loss of tone in the fixing bath after toning. Success depends, as in all toning processes, upon the quality of the print. Prints intended for fixing before toning should be deeply printed, fixed, well washed, and then toned in the ordinary sulphocyanide and gold toner. With some papers, a more satisfactory system is to immerse the fixed and washed prints in a solution of 1 oz. of formaline in 9 oz. of water. The toning bath is then used just warm and kept warm while in use.

TONING AND FIXING COMBINED

A bath very frequently employed for toning and fixing silver prints at one operation. It is not merely the obvious saving of time and trouble that has rendered it a favourite method with many workers, but rather the great advantage that the tone or colour of the prints remains the same after finishing as when taken from the toning bath. In separate toning and fixing, the colour obtained by toning is frequently considerably modified by the subsequent fixing. A serious objection to the combined bath is that prints may be toned to the desired colour before they are properly fixed, and subsequent fading is the inevitable result. Or the bath may contain sulphur, and the tones may be due to this substance rather than to gold, and this also produces prints which will deteriorate quickly. These objections may be entirely obviated by adopting a suitable formula, preferably one that contains neither acid nor alum ; keeping stock solutions from which the bath may be prepared when required ; mixing sufficient solution for the prints that are to be toned, and throwing away the mixed solution after using it once. Using a combined bath many times in succession is one of the most frequent causes of want of permanence. A reliable formula and method of working will be found under the heading " Bennett's Toning Bath for P.O.P."

TONING LANTERN SLIDES

Lantern slides may be toned by any of the methods given for bromide prints. Some of the toning methods intensify as well as change the colour of the slide—the sulphide, for example—and somewhat destroy the transparency of the image. Copper toning produces attractive red tones, with transparency and delicate quality. (See " Toning Bromide Prints.") The most satisfactory warm and cool brown tones are those produced by development.

TONING PLATINOTYPE PRINTS (See " Platinotype Process.")

TONING P.O.P.

Of the two methods of toning and fixing prints on printing-out silver papers, one is to tone first

and afterwards fix, and the other is to tone and fix at one operation, the second method saving much time and trouble, while capable of producing quite as good results. It is described under the heading " Toning and Fixing Combined."

For separate toning and fixing, the prints require first to be washed for about twenty to thirty minutes in several changes of water ; the first two changes should be made as quickly as possible, care being exercised to prevent the prints from clinging together. To prepare the toning bath, two solutions are necessary :—

A. Am. sulphocyanide	.	.	520 grs.	120 g.
Water to	.	.	10 oz.	1,000 ccs.
B. Gold chloride	.	.	15 grs.	3·5 g.
Water to	.	.	3¾ oz.	375 ccs.

To prepare the toning bath, take 2 drms. of A, add 5 oz. of water, and then add slowly 2 drms. of B ; in ten minutes the bath will be ready for use. It will be sufficient for four whole-plate prints or sixteen quarter-plates. A proportionate quantity should be prepared for any other number of prints, allowing always ½ drm. each of A and B, and 1¼ oz. of water for each whole-plate print. The prints to be toned are placed in the solution and continuously turned over by lifting the lowest print and placing it on top until the desired colour is reached. They are then rinsed in two or three changes of water and fixed for fifteen minutes in the following :—

Sodium hyposulphite	.	1½ oz.	165 g.	
Liquor ammoniæ	.	5 mins.	1 cc.	
Water	.	.	10 oz.	1,000 ccs.

Take care to ensure free access of the solution to the surfaces of the prints, and to prevent them from clinging together. After fixing, wash the prints, in water frequently changed, for from one to two hours.

An additional method of toning P.O.P. is by means of platinum. The most satisfactory manner of working is by first toning with gold, preferably by the sulphocyanide bath, then, after a short washing, toning with platinum, washing again, and fixing.

An alternative plan is to use a self-toning paper, by which the operation of gold toning is avoided, and then the prints are washed, toned simply with platinum, washed and fixed. Or the prints may be toned first with platinum and then finished in a combined gold toning and fixing bath.

Formulæ for platinum toning baths are given under the heading " Platinum Toning " ; another is :—

Potassium chloroplatinite	1 gr.	·25 g.		
Sodium chloride	.	.	10 grs.	2·5 ,,
Citric acid	.	.	10 ,,	2·5 ,,
Water	.	.	.5–6 oz.	500–600 ccs.

Whatever method of toning is adopted, only sufficient of the working solution should be prepared for the prints to be toned ; it should be used once, and then thrown away.

TONING, SULPHIDE (See " Sulphide Toning.")

TONING, SYSTEMATIC

A process of toning by which the exact amount of gold, etc., is used, the solution being thrown

away after use. W. J. Wilson was (in 1894) one of the first to publish working details. The amount of gold chloride required to tone safely and thoroughly may be taken as from 1½ to 1¾ grs. for each sheet of paper 24½ in. by 17 in., dark or heavy prints requiring more gold than lightly printed ones. Taking 1¾ grs. as a fair average (equivalent to ·6 gr. per 1 sq. ft.), the following bath may be made up :—

Ammonium sulpho-			
cyanide	.	. 12 grs.	2·3 g.
Gold chloride .	.	1 ,,	·2 ,,
Water .	•	. 12 oz.	1,000 ccs.

Twenty-four minims of this bath will tone 1 sq. in. of P.O.P. print, or the bath may be used in the following proportions :—

	Inches		Sq. Ins.		Oz.	Drs.
One whole sheet	24½ × 17	=	416.5	requires	21	0
One piece . .	. 15 × 12	=	180	,,	9	0
,,	. . . 12 × 10	=	120	,,	6	0
,,	. . . 10 × 8	=	80	,,	4	0
,,	. . . 8½ × 6½	=	55.25	,,	2	6½
,,	. . . 6½ × 4¾	=	30.87	,,	1	4
,,	. . . 6 × 4½	=	26	,,	1	2½
,,	. . . 4¼ × 3¼	=	13.81	,,	0	6

The above bath is weaker than that originally advocated by W. J. Wilson.

TONING WITHOUT GOLD OR PLATINUM

One of the most popular of the "no gold" baths is the following, which gives rich tones from warm brown to purple. The results are fairly permanent, and the process is widely used for prints required as rough proofs or those which it is not desired to keep for any length of time :—

Sodium hyposulphite	. 2 oz.	220 g.
Lead acetate	. . ¼ ,,	28 ,,
Water (hot) .	. . 10 ,,	1,000 ccs.

The bath is ready for use when cold. A dense precipitate is formed and the solution needs to be decanted. The prints are printed more deeply than usual, and are not washed previous to immersion, but well washed afterwards.

TOUCH PAPER

Slow-burning paper strips used for firing a flash-light mixture, which is piled up on one end of the strip and the other ignited. The time taken for burning depends upon the length of the strip, 2 in. or 3 in. being usually enough. The paper is made by soaking blotting-paper in a solution of saltpetre in water, drying, and cutting into strips about ½ in. wide. Another recipe is as follows : Finely powder separately equal parts by weight of antimony sulphide and potassium chlorate, mix together, and add enough shellac, dissolved in alcohol (ordinary French polish answers well) to make a thick cream. Spread this evenly upon paper, allow to dry naturally, and cut up for use.

TRACING PAPER (Fr., *Papier à calquer;* Ger., *Papier zum Durchzeichnen*)

This paper has been recommended for use on the glass side of a negative for the purpose of working upon or for retarding printing. Some of the French tracing "papers" are actually *papier glacé*, which consists of isinglass. Ordinary thin paper may be made translucent by coating with thin dammar varnish and allowing to dry ; another substance is bleached beeswax dissolved in alcohol and ether. A translucent paper suitable for use with colours mixed with spirit is made by coating paper with bleached shellac 3 parts, mastic 1 part, strong alcohol 20 parts.

In lithography, several varieties of transfer tracing paper are used for making drawings in lithographic writing or drawing ink. These tracing papers have a gelatine surface to render it possible to transfer the ink when the paper is damped and pressed down to stone or metal.

TRACINGS, PRINTING FROM

Tracings made by engineers, architects, etc., are easily duplicated by photographic printing, the iron printing processes being widely used because of their simplicity and cheapness. *See* under the following headings : " Blue-print Process " (white lines on a blue ground), " Pellet Process " (blue lines on a white ground), " Ferrogallic Process " (black lines on a white ground), " Kallitype " (brown lines on a white ground), " Ordoverax " (black ink lines on a white ground), etc.

TRAGACANTH (*See* " Gums and Resins.")

TRANSFER PAPERS

Single transfer paper and final support for double transfer are used in the carbon process (*which see*).

In process work and lithography, numerous kinds of transfer papers are used, some for making original drawings upon and others for retransferring impressions from existing stones to plates bearing designs on them. Tracing transfer and writing transfer papers are for making original designs upon with pen or brush and lithographic ink. Scotch transfer, India transfer, and re-transfer papers are for retransferring designs. Grained transfer papers are for making drawings upon with lithographic crayons. Photo-litho transfer paper is for sensitising with potassium bichromate to print under a negative. Decalcomanie transfer paper is for transferring designs to porcelain for vitrifying.

TRANSFEROTYPE

A special kind of bromide paper, widely used many years ago. It was prepared on one side with soluble gelatine and with a specially hardened sensitive emulsion. The wet bromide print was squeegeed, face down, on the support where it was intended to remain. Hot water was poured on the back of the print, which melted the soluble gelatine and released the paper, leaving the image on the support.

The term is now used rather loosely to describe transferred pictures by other processes.

TRANSFERRED LIGHT ACTION ON DRY PLATES

It has often been stated that when an exposed and undeveloped plate is packed in contact with an unexposed plate, film to film, the light action will be transferred. Experiments made with English dry plates have proved that even after ten years' contact no appreciable light action has been transferred. There is a

difference of opinion on the subject, but the photographer can easily test the matter for himself.

TRANSFERRING FILMS FROM NEGATIVES (*See* "Cracked Negatives.")

TRANSIT BOXES

Boxes specially designed for sending negatives, lantern slides, etc., by post or rail. For negatives, wooden boxes lined with felt or rubber are best. Various kinds of transit boxes are described under the headings "Box, Lantern-slide," and "Packing Negatives for Post."

TRANSLUCENT PAPER (*See* "Paper Negatives" and "Tracing Paper.")

TRANSMISSION OF PHOTOGRAPHS ELECTRICALLY (*See* "Photo-telegraphy.")

TRANSMITTER, STEREOSCOPIC (*See* "Stereoscopic Photography.")

TRANSPARENCIES, CARBON

Transparent positives made by the carbon process. A special tissue for the purpose contains more colour than the tissues for paper prints, and requires from three to five times the exposure necessary for an ordinary print. The exposed tissue is squeegeed to, and developed on, a sheet of glass previously coated with a thin solution of bichromated gelatine, and the remaining work resembles that described for single transfer prints under the heading "Carbon Process."

Glass plates (old negatives cleaned) may be prepared by coating thinly with a solution of—

Gelatine	. . .	60 grs.	14 g.
Potassium bichromate	3 ,,		·7 ,,
Water	. .	10 oz.	1,000 ccs.

and, after drying, exposing to daylight to harden the coating. The gelatine must be soaked in cold water for an hour, and then dissolved by heat, the bichromate, dissolved separately in a little water, being added to the gelatine. Prepared glasses may be purchased when obtaining the transparency tissue.

TRANSPARENCY (Fr., *Transparence;* Ger., *Transparent, Durchsichtigkeit*)

A term commonly applied to lantern slides or other positives on glass. (*See also* "Window Transparencies.")

TREBLE PHOTOGRAPHS

Trick photographs in which a person is shown in three different positions in the same negative. They are produced in much the same way as doubles (*which see*), the best method being to use a black background and give three separate and equal exposures, taking care that the three images do not overlap.

TRIAMIDOPHENOL (Fr. and Ger., *Triamidophenol*)

$C_6H_2OH(NH_2)_3$ 3HCl. Molecular weight, 248·5. It is in the form of white needles, and has been recommended as a developer, but it is not much used.

TRICHROM EMULSION

A collodion emulsion sensitised with dyes for the purpose of making the selective negatives for three-colour printing. The emulsion is either panchromatised or issued with three different sensitisers, which can be added to the emulsion just before use, and which sensitise it respectively for red, green, and violet.

TRICHROMATIC PHOTOGRAPHY (*See* "Three-colour Photography.")

TRICK PHOTOGRAPHY

Photography lends itself to the production of a variety of "trick" effects, which may be classified as: (1) Those produced by dividing the exposure and making alterations in the subject during those times when the lens is covered (*see*, for example, "Doubles," "Treble Photographs," "Psychic Photography," "Theatrical and Kinematograph Photography," etc.); (2) those produced by manipulations in printing, as by the methods described under the heading, "Combination Printing"; (3) those produced by chemical manipulations (*see*, for example, "Magic Photographs").

TRICOLOUR PHOTOGRAPHY (*See* "Three-colour Photography.")

TRIHYDROXYBENZENE

Synonym, trihydric phenols. Three isomeric compounds, all possessing the same formula, $C_6H_3(OH)_3$, but differing in constitution. They are interesting because pyrogallol or pyro is one of them, and their graphic formulæ may be represented as follows :—

Pyrogallol	Phloroglucinol	Hydroxyhydroquinone
1-2-3 Trihydroxybenzene	1-3-5 Trihydroxybenzene	1-2-4 Trihydroxybenzene

It will be noted that the hydroxyl groups (OH_3) are in different positions in the benzene ring, their positions being shown by the numbers 1-2-3, etc., in the second line of the titles. In each case, one hydroxyl group has replaced one hydrogen atom.

TRIMETHYLAMINE (Fr., *Triméthylamine;* Ger., *Trimethylamin*)

$(CH_3)_3N$. Molecular weight, 59. A colourless gas obtained by the action of ammonia on methyl iodide. A 10 per cent. aqueous solution has been suggested as the accelerator for development, but its most unpleasant smell renders it of small practical use. It was employed in the Russian developer (*which see*).

TRIMMER (*See* "Print Trimmer.")

TRIMMING KNIFE (Fr., *Canif à decouper;* Ger., *Beschneidemesser*)

The knife used in trimming photographic prints and enlargements previous to mounting.

Many workers prefer a good penknife to the many patterns of knives made especially for the purpose. The average type of trimming knife is represented by A and B; C resembles a surgeon's scalpel, and is useful for many other purposes, such as mount-cutting, retouching, etc. D is a wheel trimmer, which, with due

Five Types of Trimming Knives

care, may be employed for trimming wet prints as well as dry; while E is a trimming nib, useful for cutting circular and oval prints, and intended for insertion into an ordinary penholder. Trimming knives should be sharpened at intervals by rubbing on a fine oil-stone. The trimming machine, or "print trimmer" (which see), is likely to supersede the knife.

TRIMMING PRINTS

Prints are trimmed, or cut down, partly to get rid of bare or rough edges, and partly to cut away those outside parts of the picture that are not required. A good method of deciding just how much of a print should be retained is to cut two L-shaped pieces of cardboard and adjust those on the print so that they form a rectangle including just the portion required. This is marked with pencil and the print trimmed accordingly.

The actual cutting may be accomplished with no more elaborate apparatus than a sharp knife, a steel straight-edge, and a sheet of glass or zinc to cut upon. In addition, a T-square or set-square must be used to secure accurate right angles. Although prints are generally trimmed dry, it is sometimes required to cut them while wet, and for this purpose a wheel trimmer must be used.

Trimming is greatly facilitated by employing one of the many machines made for the purpose. These usually take the form of a rectangular board with a guillotine blade working along one edge (see "Print Trimmer"). They are generally fitted with a scaled rule to assist in cutting to given dimensions. Rectangularity is of course secured automatically. Other apparatus is made for cutting circular prints of different diameters. Cutting shapes are also made, particularly for ovals.

Quite apart from the mechanical trimming of prints, much judgment and taste is demanded

in deciding just how much of a print shall be cut away to secure the best result. There should be no hesitation in sacrificing all that hinders, rather than helps, the proportion, composition, and concentration of the subject. However carefully arranged on the plate, few prints not gain by judicious subsequent pruning.

TRI-NITRO-PHENOL

Synonyms, carbazotic acid, picric acid. $C_6H_2(NO_2)_3OH$. Molecular weight, 229. It is obtained by dropping carbolic acid into nitric acid, and its salts are explosive. It is in the form of yellow crystals, which are very bitter to the taste. It is used principally as a dye.

TRIOXYMETHYLENE (See "Paraformaldehyde.")

TRIPLET LENS
A lens consisting of three separate combinations.

TRIPOD (See "Camera Stand.")

TRIPOD HOLDER OR SUPPORT
An arrangement to prevent the legs of the tripod slipping on polished floors, stone pavements, etc. Perhaps the simplest way of securing this end is to have a wooden triangle, as shown at A, with holes bored at the angles at which the points of the tripod legs may be inserted. This is often useful in architectural photography, or when it is desired to use a field

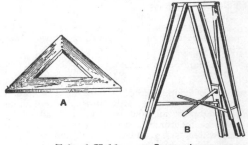

Tripod Holders or Supports

camera in an ordinary room for portraiture or copying. A more portable application of this idea consists of three wooden arms hinged together to fold up when not in use, and having holes at the ends. Slotted brass plates are also made which are hinged at one end to the legs of the tripod, as shown at B, a clamping screw being passed through the three slots and tightened up when the tripod is suitably adjusted.

TRIPOLI (Fr., *Tripoli*; Ger., *Tripolith*)
A siliceous pulverulent earth used for cleaning glass, generally mixed with alcohol and ammonia.

TRITURATION (Fr., *Trituration*; Ger., *Zerpulverung*)
The rubbing up of a powder or other substance in a mortar.

TROPICS, PHOTOGRAPHY IN THE
Light, flimsy cameras cannot withstand the effect of tropical heat for long, the shutters of

the dark-slides refusing to open and close and the woodwork generally going wrong. The camera should be well made of thoroughly seasoned mahogany, brass-bound for preference; waterproof glue should be used, or the bellows should be attached by means of brass strips. Cloth bellows are more immune from insect attacks than those of leather. Rustless metal fittings are better than those of wood. Plates should be packed in oiled paper, tinfoil, or in soldered tin-plate cases. Developers may be carried in concentrated form. The risk of melting the wet film during development must be guarded against, hardening with formaline being advisable. Plates should be dried out of the reach of insects. As regards the developer, the use of a more stable alkali than sodium carbonate is recommended by experienced travellers, and the diamidophenol and metol-hydroquinone developers are often advocated.

TROUGH, ETCHING

A shallow tray of earthenware or pitch-lined wood for the purpose of etching zinc and copper plates. The ends are usually covered over for a few inches to prevent the solution splashing over when the tray is rocked. The troughs are sometimes mounted on a machine for mechanically rocking them.

TUBE, CROOKES' (See "Crookes' Tube.")

TUBE, FOCUS (See "Crookes' Tube.")

TULOL

A developing compound introduced by Dr. Liesegang, of Düsseldorf, in 1899. It was a green pulpy mass put up in collapsible tubes. When required for use 1 part was dissolved in 50 parts of water.

TURMERIC (Fr., *Curcuma* ; Ger., *Kurkuma, Gelbwurzel*)

Synonyms, curcuma, Indian saffron. It is the rhizome of *Curcuma longa*, obtained from tropical climates. It has been used for making yellow screens and in orthochromatic collodion, but has fallen into disuse. An alcoholic tincture of turmeric is used to stain bibulous paper for a test paper, which turns a reddish brown colour with alkaline earths, a brown colour with boric acid, and a bright sulphur yellow with other acids.

TURNBULL'S BLUE (Fr., *Bleu de Turnbull* ; Ger., *Turnbullsches Blau*)

A bright blue ferrocyanide of iron, $Fe_3(CN)_{12}$, formed by the action of potassium ferricyanide on a ferrous salt and forming the image in the iron printing process when the print is developed with ferricyanide.

TURNTABLE (Fr., *Table tournante* ; Ger., *Drehscheibe*)

An arrangement permitting a field camera to be turned round in any direction on the tripod, to which it is directly attached. As illustrated, it consists of a brass ring let into the

camera baseboard, in which revolves a second ring having projecting eyes to fit the pegs on the tripod legs. A milled-head screw is provided to clamp the turntable in any position. The advantages of the turntable, in addition to the ease with which the camera may be pointed as desired, are that there is no loose tripod head to carry or screw to get mislaid, while the hole in the baseboard allows it to fold over the lens and shutter, so that a more portable construc-

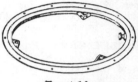

Turntable

tion of the camera becomes possible. Greater rigidity is said to be obtainable with a turntable than with the ordinary tripod head, though some workers dispute this.

In process work, a turntable is generally a feature on the camera stand used for copying, its object being to turn the camera sideways when the prism is used, and to turn it parallel to the length of the stand for direct work.

TURNTABLE TRIPOD TOP

A tripod head furnished with a revolving platform. It differs from the turntable proper in being attached to the stand itself instead of to the camera.

TURPENTINE (Fr., *Térébenthine* ; Ger., *Terpentin*)

A colourless volatile liquid obtained by distillation from an oily resinous substance extracted from various pine and fir trees. "Spirit" and "oil" of turpentine, and "turps," are identical. Rectified turpentine is a purer variety. Venice turpentine is an exudation from the larch, and occurs in the form of a honey-like product, very sticky and tenacious, and smelling of turpentine. Canada balsam is a similar product.

In process work, turpentine has numerous uses. Rectified turpentine is used for developing bitumen prints, and for thinning the transfer ink used for inking up albumen prints. Commercial turpentine is largely used for cleaning the ink off slabs, rollers, blocks, etc.

TWADDEL HYDROMETER (See "Hydrometer.")

TWIN-LENS CAMERA

A hand-camera with a full-size finder, having a lens of the same focal length as is used for taking the photograph. The image is reflected by a fixed mirror inclined at an angle of 45° to a horizontal screen, and may be focused right up to the moment of exposure. Though bulkier than the reflex, the twin-lens camera has the advantage that the image is always in view.

U

ULLMANINE

A white water-colour pigment much favoured by retouchers of photographs for reproduction. It works well with the aerograph, photographs white, and does not change colour.

ULTRA-VIOLET RAYS (Fr., *Rayons ultra-violets* ; Ger., *Ultraviolette Strahlen*)

A region of the spectrum lying beyond the visible violet, the commencement of which is sometimes known as the lavender rays. The research in this region of the spectrum has been much facilitated by the fact that the haloids of silver are extremely sensitive to it, and one has but to use a spectrograph fitted with quartz lenses and Iceland spar prisms to obtain a spectrogram of the same. Most of the work on the ultra-violet, however, is done with concave reflection gratings, which, forming a real image without the aid of lenses, introduce no absorptive medium. The farthest yet reached by photographic means is λ 1,181 by Victor Schumann using a quartz spectrograph with silver iodide deposited on glass with but very little gelatine as binding agent and with the plate and spectrograph exhausted of air, as he found that both gelatine and air were rather strong absorbents of the extreme ultra-violet. Ordinary glass does not transmit beyond about λ 3,400.

In the ultra-violet lies the region of the greatest photochemical action, and as has been pointed out in the description of the diffraction grating there is always an overlapping of the ultra-violet of the one order on the red of the preceding one, and therefore in spectrographic work this must be looked for and absorbed by the use of yellow filters. In ordinary photography, if anything like correct colour rendering is required also, the ultra-violet must be absorbed, for it is obvious that, as we do not see this region, any action on the plate would give a false rendering of the colour. Eder has given the following interesting table which shows the relative action of the ultra-violet rays in

	Effect of visible spectrum	Effect of ultra-violet
I.—Silver bromide with development—		
(a) The photographic effect of daylight (reflected from white paper) is composed of...	62 %	38 %
(b) Photographic effect of magnesium light (from white paper)	30 %	70 %
(c) Argand gas burner (from white paper)	80 %	20 %
II.—Silver chloride with development—		
The photographic effect of daylight (reflected from white paper) is composed of	1–2 %	98–99 %

When using artificial lights such as the electric arc, the mercury vapour lamp, and magnesium ribbon, it may be considered that the bulk of the photochemical action lies in the ultra-violet. The practical absorbents of the ultra-violet are æsculine and filter yellow K.

UNAL

Rodinal in powder form requiring to be mixed with water to make a developer ready for use.

UNDULATORY THEORY (*See* "Wavelengths.")

U.S. (UNIFORM STANDARD) STOPS (*See* "Diaphragms.")

UNIT OF LIGHT (Fr., *Étalon photométrique* ; Ger., *Lichteinheit*)

Different units have been adopted by various countries. The British standard is a spermaceti candle burning about 120 grs. per hour; the height of the flame from where the wick begins to char to the top of the flame should be 45 mm., and the top of the wick should turn over towards the edge of the flame. The candle should be lit at

COMPARISON OF LIGHT STANDARDS (SCHAUM).

	Hefner Lamp H.K.	Bougie decimale and British standard candles	German standard candle = D.V.K.	Carcel Lamp	10 c.-p. Pentane Lamp	Violle's unit
Hefner lamp . .	1	0·877	0·833	0·0936	0·0909	0·0439
Bougie decimale and British standard candle . }	1·14	1	0·950	0·106	0·104	0·05
German candle .	1·20	1·05	1	0·111	0·109	0·053
Carcel lamp . .	10·8	9·47	9·0	1	0·982	0·474
10 c.-p. pentane lamp . .	11·0	9·65	9·17	1·02	1	0·483
Violle's unit . .	22·8	20·0	19·0	2·11	2·07	1

least five minutes before use ; there should be a well formed cup of melted wax, and the flame should be well shielded from draughts.

The French standard is the Carcel lamp, burning 42 g. of colza oil per hour in a circular hollow wick lamp.

The German standard is the Hefner-Kerze, that is, the light emitted by the Hefner-Alteneck amyl-acetate ·lamp.

The German standard candle has a flame height of 50 mm.

The Vernon-Harcourt 10 c.-p. pentane lamp and the Harcourt-Simmance 1 c.-p. pentane lamp are also used, especially the former. These lamps burn a mixture of air and pentane vapour.

Violle's unit is the light emitted by the sq. cm. of glowing platinum, and is extremely difficult to reproduce.

The bougie decimale of the Geneva Congress (1896) is the Hefner lamp reduced to the one-twentieth of Violle's unit.

Other standards of less general use have been suggested by Werner-Siemens and Lummer-Kurlbaum. The table at the foot of page 550 shows the relation between the above units.

UNIVERSAL DEVELOPER

Any developer which will serve alike for dry plates, bromide and gaslight papers and lantern plates. The metol-hydroquinone developer is a popular universal developer, but the name "universal" was probably first used by the Ilford Company for a developer in 1891 :—

A. Hydroquinone	.	80 grs.	18 g.
Potass. bromide	.	15 ,,	3·5 ,,
Sodium sulphite	.	1 oz.	110 ,,
Water to	.	10 ,,	1,000 ccs.
B. Sodium hydrate	.	50 grs.	11·5 g.
Water	.	10 oz.	1,000 ccs.

For negatives use equal parts of A and B ; for bromide papers, one part A, one part B, and one part water ; for lantern plates equal parts of A and B.

UNIVERSAL LENS

A symmetrical anastigmat lens, highly corrected, and suitable for almost any kind of work.

UNOFOCAL LENS

A lens, invented by Rudolph Steinheil, of Munich, working at a large aperture. Astigmatism and other kinds of aberration are eliminated by employing unusually thin and

Unofocal Lens

transparent glasses of very slight curvature. The four elements (*see* illustration) are of the same refractive index and focal length, there being slight distances between them so as to prevent one combination neutralising the other. The lens has great rapidity, gives good definition, and has excellent covering power.

URANIC SALTS (Fr., *Sels uraniques* ; Ger., *Uranylsalzen*)

Uranium forms two classes of salts, the uranous and uranic. The latter are readily reduced to the uranous state by the action of light in the presence of organic matter, and this forms the basis of several printing processes.

URANIN (*See* "Eosine.")

URANIUM ACETATE (Fr., *Acétate d'urane* ; Ger., *Uranylacetat*)

Synonym, uranyl acetate. $UO_2(C_2H_3O_2)_2 2H_2O$. Molecular weight, 426. Solubilities, very easily soluble in water and alcohol. It is poisonous, the antidote being cobalt nitrate and emetics. It is in the form of small yellow crystals or crystalline powder, obtained by dissolving uranic oxide in acetic acid. It generally contains a little basic salt ; therefore a perfectly clear solution cannot be obtained without the addition of acetic acid. It has been suggested in place of the uranyl nitrate.

URANIUM CHLORIDE (Fr., *Chlorure d'urane* ; Ger., *Uranylchlorid*)

Synonyms, uranyl chloride or oxychloride. $UO_2Cl_2 H_2O$. Molecular weight, 361. Solubilities, soluble in water and alcohol. It is poisonous (*see* "Uranium Acetate"). It occurs as flat deliquescent greenish yellow plates, obtained by dissolving uranic oxide in hydrochloric acid. It can be used as a sensitive salt for printing out, and also confers hardness or increase of contrast when added to a chloride emulsion.

URANIUM COLLODION PROCESS (*See* "Wothly's Process.")

URANIUM FLUORIDE SCREENS

Fluorescent screens (*which see*) coated with uranium fluoride.

URANIUM INTENSIFIER

An intensifier which gives great additional printing power to thin negatives, the effect not being permanent. A simple formula is :—

Uranium nitrate	.	40 grs.	9 g.
Potass. ferricyanide	.	40 ,,	9 ,,
Acetic acid	.	27 mins.	6 ccs.
Water	. .	10 oz.	1,000 ,,

A well-washed negative assumes in this a reddish-brown colour. It is next briefly washed in water slightly acidified with acetic acid, and finally in plain water until the stain has gone. Any "hypo" left in the film will produce red stains, while any iron in the water, say rust from the waterpipes, will produce blue ones. The intensification may easily be removed by placing the negative in a weak solution of sodium carbonate or in ammonia, or by prolonged washing. The negative may be treated locally by intensifying the whole in the usual way and working over any parts that are too dense with a camel-hair brush dipped into a weak solution of ammonia and soda. Many other formulæ have been recommended, Dr. Lüppo Cramer's (used as above) being noteworthy. The originator claims that his formula, given on the next page, keeps well in the dark and gives a clear image.

Potass. ferricyanide (10 % sol.)	.	2 parts
Uranium nitrate (10 % sol.)	.	5 ,,
Potassium oxalate (10 % sol.)	.	5 ,,
Hydrochloric acid (10 % sol.)	.	1 ,,
Water	. . .	10 ,,

Washing is complete when the stain has disappeared from the shadow (clear) portions of the negative. When this stain is obstinate and there is a danger of the whole of the intensification being removed by prolonged washing, it is best to apply a 2 per cent. solution of ammonium sulphocyanide. This bath should not be used when the negative is to be worked upon locally with ammonia. Negatives intensified with uranium keep better if varnished, failing which store them in a dry place, not exposed to a strong light.

URANIUM NITRATE (Fr., *Azotate d'urane ;* Ger., *Uranylsalpetersäure*)

Synonyms, uranyl nitrate, uranium oxynitrate. $UO_2(NO_3)_2$ $6H_2O$. Molecular weight, 504. Solubilities, very soluble in water, alcohol and ether. It is poisonous (*see* " Uranium Acetate "). It is in the form of yellow efflorescent crystals with a greenish lustre by reflected light, obtained by dissolving uranic oxide in nitric acid. It is used for printing out, and in conjunction with potassium ferricyanide to tone bromide prints and intensify negatives, brown or reddish-brown uranyl ferrocyanide being formed on the image, which is partially soluble in water.

URANIUM PRINTING

The first uranium printing processes were worked out by J. C. Burnett (1857–8) and Niepce de Saint Victor, who took out an English patent in 1858. Paper was floated upon a 1 in 30 solution of uranium nitrate, dried in the dark, exposed under a negative to daylight until a faint image printed out, developed by floating on a bath of silver nitrate (40 grs. to the ounce) or upon a solution of gold chloride (9 grs. to the ounce), then washed and dried. In 1864 a process in which the uranium and silver were mixed with collodion and applied to paper was patented by Wothly. (*See* " Wothly's Process.")

One uranium process has points of similarity with platinotype. Paper is coated with ferrous oxalate in the proportion of 1 gr. to each square inch of paper, each ounce of the solution containing also 1 gr. of mercuric chloride. When dry the paper is exposed in contact with a negative and developed on the following bath :—

Gold chloride	.	.	3 grs.	·7 g.
Uranium nitrate	.	45 ,,	10·5 ,,	
Water	.	.	3 oz.	300 ccs.

It is washed, fixed in a weak solution of hydrochloric acid, washed again and dried. Other formulæ have been published.

Uranium for Gaslight Printing.—In Dr. J. Bartlett's process (1906), the paper is sized with gelatine containing potash alum and oxalic acid, and sensitised with—

Silver nitrate	.	.	275 grs.	63 g.
Uranium nitrate	.	4½ oz.	495 ,,	
Distilled water	.	.	8 ,,	800 ccs.

Float the paper on this bath for three minutes, dry in the dark, and keep free from moisture.

On account of the radiations from uranium it is necessary to prepare and use the sensitive solution in the dark-room. Exposure is made under a negative in the usual way ; with an average negative, from twenty to sixty seconds will be enough at 6 in. or 8 in. from a gas mantle ; one to five seconds to sunlight, and thirty seconds to dull daylight. The print is then developed in the following :—

Ferrous sulphate	.	1 oz.	110 g.	
Tartaric acid	.	.	½ ,,	55 ,,
Sulphuric acid	.	.	60 mins.	12·5 ccs.
Glycerine	.	.	60 ,,	12·5 ,,
Water to	.	.	10 oz.	1,000 ,,

The image develops rapidly and varies from brown to a warm black. Should the whites not be pure, due to over-exposure, add tartaric acid to the developer ; the tendency to discolour the whites is entirely prevented by adding a trace of nickel nitrate to the original coating solution, but this renders the paper less sensitive. A rinse in weak acid or plain water completes the process.

URANIUM TONING

Uranium toning is really a modified form of intensification, and is not therefore suitable for dense prints. It is not considered to yield lasting results. It resembles the process described under the heading " Uranium Intensifier." J. Weir Brown's one-solution formula is :—

Glacial acetic acid	.	1 drm.	12·5 ccs.	
Potass. ferricyanide	.	3 grs.	·7 g.	
Uranium nitrate	.	3 ,,	·7 ,,	
Water	.	.	6 oz.	600 ccs.

This acts slowly and less water may be used in order to make it work more quickly. Many modifications have been made in the formula, and the solutions which appear to find the most favour are :—

A. Uranium nitrate	.	45 grs.	10·5 g.
Distilled water	.	10 oz.	1,000 ccs.
B. Potass. ferricyanide	45 grs.	10·5 g.	
Glacial acetic acid	2 drms.	25 ccs.	
Distilled water	.	10 oz.	1,000 ,,

Uranium persulphate is said to act in precisely the same way as the nitrate above mentioned. The two solutions keep indefinitely as long as they are not mixed. For use, mix equal parts of A and B, and if this works too rapidly dilute with water. The prints should not have been developed with ferrous oxalate, as iron causes greenish spots to appear. Metol-hydroquinone developed prints tone excellently, especially if the toning is to be carried no farther than the sepias. Amidol developed prints tone to a full red. Prints if dried after washing should be immersed in water previous to toning so that the toner may work evenly. Toning begins as soon as the prints are immersed in the toner ; starting with a warm black the tones progress through the various shades of brown to red, and the image increases in density at the same time. A little before the desired tone has been reached the prints are transferred to a bath of weak acetic acid (about 100 drops to 10 oz. of water) ; after two or three minutes, they are washed by soaking in still water until the yellow stain has

disappeared. If washed in running water colour will be washed away, leaving a patchy result.

Dilute citric acid (10 grs. to the ounce), and oxalic acid (5 grs. to the ounce), are said to give clearer tones than when acetic acid is used.

Permanent yellow stains are caused by insufficiency of acid in the toner, the acid keeping the gelatine soft and facilitating the washing out of the stains. The last mentioned may be removed by dabbing them with cotton-wool soaked in a very weak solution of ammonium sulphocyanide. The toned image can be restored to its original state by soaking in a weak solution of ammonia or sodium carbonate and washing well.

Uranium may also be used for platinum prints :—

Uranium nitrate	.	5 grs.	1 g.
Potass. ferricyanide	.	5 ,,	1 ,,
Glacial acetic acid	.	5 mins.	1 cc.
Ammonium sulpho-cyanide.	. .	25 grs.	5 g.
Water	. . .	10 oz.	1,000 ccs.

Toning is carried out in the manner described for bromide prints above.

Uranium is also used in combination with gold for ordinary P.O.P. (gelatino-chloride) prints. The bath is—

Sodium bicarbonate	.	10 grs.	1 g.
Sodium chloride	.	30 ,,	3 ,,
Sodium acetate	.	60 ,,	6 ,,
Water	. .	15 oz.	750 ccs.

Dissolve and add—

Uranium nitrate	.	5 grs.	·25 g.
Gold chloride	.	4 ,,	·2 ,,
Water	. . .	20 oz.	1,000 ccs.

The toner gives brownish black or pure black tones according to the quality of the negative used for printing from. The bath must not be acid. After toning, the prints are fixed in an alkaline fixing bath and washed as usual.

URANIUM, RECOVERING

Uranium is recovered by adding to the old baths aqua regia, which destroys the ferricyanide, and then adding liquor ammoniæ in excess. Collect the precipitate, wash with hot water, and boil with slight excess of acetic acid ; then, on evaporating to dryness, uranium acetate will be left.

URANOTYPE

Prints made by the uranium mercuro-uranotype, and the platino-uranotype processes are known as uranotypes.

URANYL NITRATE (See "Uranium Nitrate.")

UVIOL

A term applied by Schott and Genossen, of Jena, to a variety of glass which is transparent to the ultra-violet rays. The name is derived from the words *ultra-violet*

VACUUM TUBES (See "Crookes' Tube" and "X-ray Photography.")

VANADIUM CHLORIDE (Fr., *Chlorure de vanade* ; Ger., *Chlorvanadium*)

Synonyms, hypovanadic hydrochloride, divanadyl tetrachloride. $2VO_2 4HCl 3H_2O$. Molecular weight, 366. Solubilities, very soluble in water and alcohol. It is a dark green syrupy deliquescent liquid obtained by dissolving vanadic anhydride in hydrochloric acid. It is used for toning bromide prints green, and also in the Donisthorpe process.

VANADIUM PRINTING

The brothers Lumière produced a vanadium printing paper in 1894. Paper with a gelatine coating is sensitised with a solution of vanadium chloride in alcohol and water, dried, and printed under a positive transparency. The joint positive image so produced needs to be treated with a solution of paramidophenol, washed, and any yellowness in the high lights removed in a weak bath of hydrochloric acid, afterwards washing free of acid.

M.M. Lumière found potassium vanadium tartrate the best salt to use, and they prepared it by dissolving vanadium pentoxide in potassium bitartrate.

VANADIUM TONING

Vanadium chloride was first used for toning bromide prints by Somerville in 1903. A formula is :—

Ferric chloride	.	10 grs.	2·3 g.
Oxalic acid (sat. sol.)	.	1¼ oz.	125 ccs.
Vanadium chloride	.	20 grs.	4·6 g.
Nitric acid	.	50 mins.	10 ccs.
Water to	. .	5 oz.	500 ,,

Then add, stirring the while, 10 grs. of potassium ferricyanide dissolved in 5 oz. water. Tone for one to two minutes, the longer the immersion the lighter being the green. Wash for ten minutes, and fix in a solution of 2 oz. of "hypo" and 200 grs. of boric acid in 10 oz. of water ; finally wash for ten minutes.

VANDYCK GRAVURE

An American imitation of Rembrandt photogravure.

VANDYKE PROCESS

A photo-lithographic process invented by F. Vandyke, of the Survey of India Office, Calcutta, and used largely for map printing in British and Colonial Government printing offices. Thin zinc plates are grained with sand, and coated with a fish-glue enamel printing solution, the

following being a suitable formula :—Fish-glue, 1 oz. ; ammonium bichromate (20 per cent. solution), 2 oz. ; water, 6 oz. ; chromic acid (10 per cent. solution), 5 mins. The copy, drawn or printed in black on white paper or a transparency on glass or celluloid, is placed in contact with the film side of the plate, and exposure made either to daylight or to an arc lamp. The plate is developed in plain water until the glue is removed from the lines, and it is then dyed with aniline dye, producing a negative image on the zinc. The following ink is next rolled over it :—Powdered bitumen, 4 oz. ; lithographic chalk printing ink, 1 oz. ; lithographic writing ink, 1 oz. ; Burgundy pitch, 1 oz. These ingredients are mixed together, with the aid of gentle heat, and sufficient turpentine added to dissolve the mass. After the plate has been inked it may be developed in water containing about 48 mins. of hydrochloric acid per pint of water, rubbing gently with cotton-wool. The result is that the image is reversed, yielding black lines on the plain ground. The plate is then treated in the usual way for lithographic printing.

VANSANT'S INTENSIFIER

A modification of the mercuric chloride intensifier. The bleached negative is washed and immersed in a freshly prepared bath of water 4 oz., gallic or tannic acid 60 grs., caustic potash 2 grs.; it is then washed and dried.

VAPOGRAPHY

A synonym for atmography.

VARNISH, REMOVAL OF

Varnishes may be removed by soaking the negative, etc., in the solvent used for making the varnish ; generally, this solvent is alcohol (methylated spirit). In the case of celluloid varnish, acetone, amyl acetate, etc., must be used. The negative is immersed in a bath of the solvent, allowed to remain for several minutes, with occasional rocking, and then while in the bath rubbed well with cotton-wool. Another solvent is a mixture of 10 parts of alcohol, 10 parts of water, and 1 part of caustic potash, after treatment with which wash the negative in water.

VARNISHES (Fr., *Vernises ;* Ger., *Firnisse, Lacke*)

Spirit varnishes are the most widely used for negatives upon glass, but for film negatives water varnishes are used, because of the action of the spirit upon the celluloid. Cold varnishes are more easily applied than warm ones, but take longer to dry. Some approved formulæ are :—

FOR HOT VARNISHING—

(1) Bleached shellac . 1 oz. 110 g.
 Alcohol . . 10 ,, 1,000 ccs.

Keep in a corked bottle in a warm place, and shake up at intervals until dissolved. Set aside to settle, and then decant the clear part for use.

(2) Orange shellac . 1¼ oz. 69 g.
 Turpentine . ¼ ,, 14 ,,
 Mastic . . ¼ ,, 14 ,,
 Castor oil . . 1 drm. 6·25 ccs.
 Sandarach . . 1¼ oz. 69 g.
 Methylated spirit 20 ,, 1,000 ccs.

Place all except the castor oil in the spirit, and shake at intervals till dissolved. Filter or allow to stand, pour off the clear portion, and add the castor oil, which gives elasticity to the film.

(3) Orange shellac . 1¼ oz. 138 g.
 Methylated spirit 10 ,, 1,000 ccs.

Mix as above, and when clear add 20 mins. or 4 ccs. of castor oil, or ¼ oz. or 25 ccs. of spike oil or turpentine. The addition of a teaspoonful of chalk or whiting assists to clear the varnish.

FOR COLD VARNISHING—

(1) Gold size . . 1 oz. 110 g.
 Benzole . . 1 ,, 100 ccs.

This was largely used in the early days. It dries rather slowly.

(2) *Celluloid Varnish* (see " Celluloid ").

Monckhoven's Water Varnish

(3) Shellac . . 1 oz. 110 g.
 Sodium carbonate
 (saturated sol.) 8 ,, 800 ccs.

Allow to stand for twenty-four hours, pour off the liquid and replace with clean water; boil till the shellac is dissolved, allow to stand, decant, and filter.

Borax Varnish

(4) Borax. . . 1 oz. 55 g.
 Shellac . . 5 ,, 275 ,,
 Water. . . 20 ,, 1,000 ccs.

Dissolve the borax in boiling water, add the shellac slowly, and keep hot till dissolved. When cool, pour off the clear part for use.

FILM VARNISHES—

Either a shellac or a celluloid varnish given above, as is suitable, and the films may be varnished wet or dry. For wet films use—

(1) Borax. . . 120 grs. 28 g.
 Sodium carbonate 30 ,, 7 ,,
 Hot water . 5½ ,, 550 ccs.

When dissolved, add 1 oz. or 110 g. of broken gum lac, and when this has dissolved add 20 mins. or 4 ccs. of glycerine, and more water to make 10 oz., or 1,000 ccs. in all. Allow to stand, or filter, and use the clear part. The film is immersed bodily for a minute or two and then pinned up to dry. For dry films use—

(2) Dammar . . 1 oz. 110 g.
 Benzole . 10 ,, 1,000 ccs.

The dried and slightly warmed film is immersed bodily and hung up to dry ; or it is pinned by its four corners to a board, varnish poured in a pool in the centre, and spread with a brush.

FOR WET COLLODION NEGATIVES—

(1) Gum arabic . . 1 oz. 110 g.
 Water . . 10 ,, 1,000 ccs.

(2) White of one egg
 Water . . 20 oz. 568 ccs.

PRINT VARNISHES—

Prints are sometimes varnished in order to remedy the dead or sunken-in effects so common with matt surface papers. Valenta's formula is

Benzole . . . 4 oz. 400 ccs.
Sandarach . . 1 ,, 110 g.
Acetone . . 4 ,, 400 ccs.
Absolute alcohol . 2 ,, 200 ,,

BLACK VARNISH—

Bleached shellac . . . 3 oz. . 330 g.
Methylated spirit . . . 10 ,, . 1,000 ccs.
Aniline black (sol. in
 spirit) . . . 60 grs. . 14 g.

VARNISHING NEGATIVES, ETC.

The object of varnishing is to protect the gelatine film from scratches, damp, etc., and to prevent silver staining due to the absorption of damp by both papers and negatives.

Hot Process.—The negative is warmed to drive out all moisture, and then allowed to cool. The negative need not be hot when the varnish is applied; it is much more important that the negative is dry. Hot negatives may crack when cold varnish touches them, and the varnish may dry with marks and streaks, while a damp film will cause the varnish to dry milky, fish-scale markings possibly appearing later. The negative is held film side upwards in the left hand, the bottle of varnish in the right, and a pool poured into the centre of the plate and allowed to spread almost to the edges; then the negative is tilted slightly until the varnish flows to the top right-hand corner, next to the left, then to the bottom left-hand corner, and finally to the bottom right-hand corner, from which corner the superfluous varnish is poured back into the bottle, holding the corner of the negative in the mouth of the bottle, and " see-sawing " the negative to prevent streaks. The negative is next heated before a fire or over a gas-burner until the coating is hard and dry, it being kept on the move to obviate the formation of streaks.

Cold Process.—In applying cold varnishes the chief consideration is absolute dryness. The varnish is applied in the manner described for the hot process, although with care it may be brushed on sparingly with a soft brush. The negatives are set aside to dry in a place where dust cannot form on them. Films may be immersed bodily in some varnishes.

Varnish Substitutes.—Various substitutes for varnishing are known. One method is to place a very thin celluloid film between the negative and the printing paper, but this is a protection only during printing. Another method is to harden the film with tannic acid and alum.

VELVET SURFACES

The semi-glossy surfaces of some bromide and gaslight papers; practically identical with " carbon surface," " semi-matt," etc.

VENEER, PHOTOGRAPHIC

A photographic veneer is a print fixed to transparent celluloid and applied to cabinet work.

VENICE TURPENTINE (*See* " Turpentine.")

VERANT (Fr. and Ger., *Verant*)

An optical instrument invented by Dr. Moritz von Rohr, in 1903, and used for viewing single photographs. It adopts a principle originally suggested by Prof. A. Gullstrand. It consists of an open holder for the print, and a viewing lens of such a focal length as to be practically equal to that of the objective with which the photograph was taken. The eye thus sees the print in the same manner as the camera lens viewed the original landscape or object. The result, with a properly lit, well-modelled photograph, is almost equivalent to stereoscopic effect. The single-lens Verant is for use with one eye only, but a double pattern for viewing two similar photographs is also made.

VERASCOPE

A two-lens camera taking twelve stereoscopic or twenty-four single pictures. It may be used as a viewing apparatus for the pictures taken with it.

VERDIGRIS

Impure copper acetate.

VERRE SOUPLE

An early name for celluloid or other flexible material used instead of glass for negative making.

VERTICAL CAMERA (*See* " Camera, Vertical" and " Copying Stand.")

VEST CAMERA (*See* " Buttonhole, or Vest, Camera.")

VICE, PLATE

A wooden clamp laid on the bench for holding plates whilst being cleaned.

VICTORIA

A commercial size of portrait mount measuring about 5 in. by 3¼ in.; the Victoria midget measures 2⅜ in. by 1½ in. These sizes are subject to slight variation.

VIEW ANGLES, TABLE OF

The following table gives the degree of angle subtended by any lens on the longer sides of various sizes of plates :—

Lens Focus.	Size of Plate in Inches.						
	4¼ × 3¼	5 × 4	6½ × 4¾	8½ × 6½	9 × 7	10 × 8	12 × 10
Ins.							
3	74	79	97				
4	58	64	78				
5	48	53	62	81	84		
6	41	45	53	70	73	79	
7	36	39	50	62	65	71	81
8	31	35	44	56	59	64	74
9	28	31	40	51	53	58	67
10	24	28	38	46	49	53	62
11	22	26	33	42	44	49	57
12	20	24	30	39	41	45	53
13	19	22	28	36	38	42	50
14		20	26	34	36	39	46
15		19	24	32	33	37	44
16			22	30	31	35	41
17			20	28	30	33	39
18			19	26	28	31	37
19			18	25	27	29	35
20				24	25	28	33

VIEW FINDER (Fr., *Viseur*; Ger., *Bildsucher, Sucher*)

An accessory showing the amount of subject included by the lens of a camera. The commonest form A resembles a miniature camera obscura. A small convex lens L throws upon a mirror M the rays proceeding from objects in front of the camera. M is inclined at an angle of 45°, and reflects an image upon a horizontal

ground-glass screen S. Usually a hood shields the ground glass from extraneous light. The frame, or mask, surrounding the ground glass should be of such a size that the image contains the same amount of subject as is shown by the camera lens on the focusing screen or plate. A new finder should be tested, and if it includes too much, pencil lines should be drawn round the margins of the ground glass to exclude the surplus subject, the outer space being then blocked out with black paint. If it shows too little, a mental allowance will have to be made when exposing. With this type of finder the image is dull, due to loss of light caused by the ground glass.

In the brilliant finder B the ground glass is replaced by a second convex lens, which receives the rays from the mirror, forming a very bright image. The first finder of this kind was constructed by A. L. Adams and H. Hill in 1894, and there have been many modifications. Some

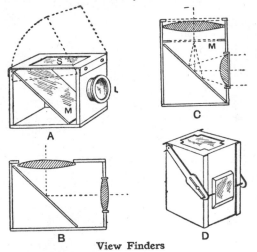

View Finders

patterns have a reflecting prism instead of a mirror, with one side ground to a curve to form a lens. An unfortunate peculiarity of the brilliant finder in its simplest form is that the amount of image included varies slightly according to the position of the observer's eye. This defect was overcome, in 1898, by Beck, who placed a rectangular opening or mask M between the two lenses at the focal distance of the first lens. (*See* diagram C.)

There is a growing tendency to use a finder in which the object is directly viewed. This may consist either of a small concave lens or an open wire frame with a sight. (*See* "Direct Finder.") A few cameras for special purposes are fitted with field-glass or telescopic finders.

Among more recent improvements in finders must be mentioned the Adams Identoscope (1905), illustrated at D, the front lens of which is made to move in unison with the camera lens, so that the exact effect of using the rising or falling front is immediately shown.

The reflex and twin-lens cameras have full-size finders of the camera obscura type, the camera lens itself, in the case of the reflex, serving also as the finder lens.

VIEW METER (Fr., *Chercheur, Iconomètre;* Ger., *Bildmesser*)

A device for showing the amount of subject which would be included on the plate if the camera were set up in a given position, thus enabling the operator to judge the best point of view without experimentally erecting the apparatus. One pattern is like a small telescope with

View Meter

a suitable mask or opening inserted to limit the view to the required proportions. Another form consists of a small rectangular frame sliding on a graduated rod, at the other end of which is a sight. (*See* the illustration.) The opening should be proportional to the size of plate to be used, while the distance from the sight to the opening should bear the same proportion to the focal length of the lens. Thus, for a quarter-plate camera with a lens of 6-in. focal length, the opening might be $2\frac{1}{8}$ in. by $1\frac{5}{8}$ in. and the distance of the sight 3 in. On applying the eye to the sight, the view seen through the opening is then exactly identical with that which would be included if the camera were set up with its lens in the position of the sight and pointing in the same direction. Such a view meter is readily made to fold up when not in use, and may be carried in the pocket.

By marking different distances on the rod, the finder may be made to show the view included by lenses of various focal lengths. Thus, in the foregoing example, if the frame is slid along the rod until it is 2 in. from the opening, it gives the same amount of view as a 4-in. focus lens, and so on. The open frame gives the clearest view; but, if preferred, a piece of blue glass may be fixed in or against the opening, when the subject is seen in monochrome and its photographic value is more easily judged.

VIEW POINTS

On the selection of the point of view depends the composition of the subject. A slight change in the point of view frequently results in a great change in the lines and arrangement of the subject. When the lighting is strong a still further alteration is made in the result by varying the position and direction. It should form a part of every photographer's practice to select a subject and carefully study the variations produced by examining it from every possible point of view; these should include the variations resulting from a different standpoint and those obtained by placing the camera above or below normal eye level. A striking example of wide differences in form is given by the appearance of a sailing vessel as seen broadside on, bows on, stern on, or "three-quarters." But differences almost as striking may be noted by studying

the different aspects of a cottage, or even of a landscape. In figure work, also, the many variations are obvious.

VIEWING DEVICES (*See* " Alethoscope," " Graphoscope," " Lanternoscope," " Neomonoscope," " Pantoscope," " Stereoscope," " Verant," etc.)

VIGNETTERS AND VIGNETTING

A vignetted picture softens off gradually until whiteness is met with at the edges. Vignetting is believed to have been introduced in photography by Latimer Clark in 1853, and while it is invariably condemned by artistic workers, it is still popularly considered a pleasing style of finish-

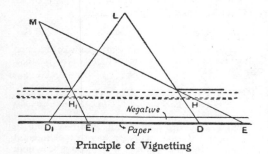

Principle of Vignetting

ing for portrait heads. It is produced by allowing the centre part to print while the edges are shielded in such a way that the light gradually decreases in actinic power as it reaches the edges. From the diagram it is seen that a vignetted contact print is produced by the diffusion of the light rays as they fall upon the negative with the sensitive paper beneath. Assuming the light rays to proceed from a source L, their full force acts upon the negative between D and D_1. The diffused rays from M, however, act upon the area $E E_1$, and consequently the part between D and E_1 is more strongly lighted than the other parts. Also, as the light rays become more oblique, an increased amount of light is lost by means of reflection. The greater the separation, up to a certain point, between the vignetter and the negative, the more gradual will be the merging of the print into a white border. If, for example, the vignetter were lowered or the negative raised to the dotted lines shown the result in the latter case would be that the parts between H_1 and H would be printed strongly and the image would not soften off to E as it would do with a greater separation. In practice, it is found that ¾ in. to 1 in. is enough for a carte de visite portrait, and from 1 in. to 1½ in. for a cabinet.

Clark, in the published account of his methods (1853), states that he used a hole cut in an opaque substance placed ½ in. above the negative; the whole arrangement was caused to revolve by means of a bottle-jack to assist the diffusion of the light at the edges.

In 1857, Forrest, of Liverpool, introduced the stained glass vignetter, which is a piece of flashed ruby or orange glass with a colourless centre; it is usually of the same size as the negative, and is often placed in the frame with

it, but it gives softer and better results if laid on the frame in such a way as to increase the space between it and the negative; being of the same size as the negative, the separation possible is not great. The extent of the clear glass portion is fixed, and in order to do good work the photographer must have a supply of such glasses with different shapes and sizes of openings.

The iris vignetter consists of a piece of vulcanised fibre or thin wood large enough to cover the printing frame, and having a central aperture, round the edge of which is a series of riveted plates, one slightly overlapping the other. The shape and size of the opening are altered by moving the plates.

An easily made vignetter utilises a piece of card or the lid or bottom of a plate box; it must be large enough to cover the whole frame, and a hole is cut in the centre. This card is laid over the frame during printing, the separation between card and negative being such as to diffuse the light at the edges. To assist in obtaining a soft edge to the image, the edge of the card may be serrated, and small holes made around the large hole, or one, two, three, or more thicknesses of tissue paper may be pasted around the edge of the hole. Of the many other kinds of vignetter only the sand vignetter need be mentioned. A lid of a plate box large enough to cover the frame is taken and the bottom of the lid cut away, leaving a narrow ledge, about ¼ in. wide, all round. A piece of plain glass is then dropped into the lid and rests upon the ledges, thus forming a glass-bottomed tray. This is laid on the printing-frame, and fine dry sand is poured into the shallow tray in such a way as to leave a clear glass centre.

Portrait heads make the most effective vignettes. Dark backgrounds should not be vignetted, neither should Rembrandt and other strongly lighted portraits. When printing vignettes, it is necessary to use diffused light and to select a spot where the light reaches the frame equally from all parts; the more slowly a vignette is printed the better and softer will be the grading, and any attempt to use strong light or direct sunlight would cause the outlines of the vignetter to show in the form of a well-defined line on the print. Should the light spread too much under the vignetting device, place loose cotton-wool between the negative and the vignetter; but this must be done with great skill, or the wool will form an outline on the print. The above remarks apply to the vignetting of prints made upon printing-out paper in diffused daylight.

The methods of vignetting given above do not give the best effects with bromide and gaslight paper, although some commercial vignettes allow of printing to be performed by artificial light almost as easily as by diffused daylight. For vignetting bromide prints or enlargements the vignetter must be moved while the exposure is being made, cut-out cards being used. A card is cut of the desired shape and size, the latter being sufficient to prevent the light creeping round the sides and causing fog in the case of enlargements. The card is held between the sensitive paper and the lens, and moved backwards and forwards in order to spread the light.

The nearer the lens the greater the diffusion, and the more of the image upon the paper. Contact bromide and gaslight prints are vignetted in the same way, except, of course, that the bromide paper is placed in a frame with the negative in the usual way and the vignetter held between the frame and the source of light. The hole in the card must be small in comparison with the size of the vignette desired, as the light spreads considerably ; it is also advisable to arrange the light so that the print or enlargement takes some little time to expose, in order to give more time for effective vignetting.

In process work, half-tones are vignetted by special means. Holt's vignetter is a triangular frame supporting at its apex a clockwork movement which gives an eccentric motion to a serrated white cardboard frame, placed some distance in front of the copy and illuminated by arc lamps on the side towards the lens. The frame is set in motion during the exposure, and the effect is a darkening of the negative towards the margins. Mole's vignetter acts by chamfering the edges of the half-tone plates from underneath. A revolving cutter projects slightly through a slot in the table, and the back of the plate is pressed over it at the parts where the cutting down has to be done. The edges of the plate are then beaten down with a fibre mallet, so that they are lower than the central part ; thus when the plate is mounted the edges are below the type height and print lighter.

VILLAIN'S DYE PROCESS (*See* "Phototincture.")

VIOLET TONES

These are invariably difficult to obtain. For toning black-and-white bromide prints to a violet colour, use :—

A. Copper chloride	. 25 grs.	5·75 g.	
Water	. 5 oz.	500 ccs.	
B. Ferric oxalate	. 2½ grs.	·575 g.	
Potass. ferricyanide	2½ "	·575 "	
Water .	. 10 oz.	1,000 ccs.	

To each solution add a saturated solution of ammonium carbonate until the first precipitate formed is dissolved. The bromide print is placed in B until it is a strong blue, and then in A until it appears a good violet ; finally it is washed.

VIRTUAL FOCUS

An imaginary focus, or focal length, as, for example, that of a concave lens, which does not form an image.

VIRTUAL IMAGE (Fr., *Image virtuelle ;* Ger., *Virtuelles Bild*)

An image formed in the air by negative lenses and used in contradistinction to the real image projected by a positive lens.

VISCOUS DEVELOPER

A developer made thick with glycerine or treacle ; said by some to give greater softness, finer grain, and prevent halation to a very large extent. Treacle is the most widely recommended, a solution of equal parts of treacle and water being used instead of plain water when preparing any developer for use.

VISION, PERSISTENCE OF (*See* "Kinematography.")

VISUAL FOCUS

The focus of those rays most visible to the eyes; that is, the green-yellow rays, as opposed to the focus of the blue-violet or chemical rays.

VISUAL RAYS

The luminous rays of the spectrum, by which an image is focused in the camera, as opposed to the less visible actinic or chemical rays.

VITRIOL (*See* "Sulphuric Acid.")

VITROTYPE

A process of producing burnt-in photographs on glass or ceramic ware and patented in 1857 by McCraw, of Edinburgh.

VOICE PHOTOGRAPHY (Fr., *La photographie de la voix ;* Ger., *Stimmenphotographie*)

The photography of sound vibrations due to the voice. Various workers have experimented in this direction, among them being Czermak (1862), Blake (1878), and Hermann. The first-named secured photographs of the vocal chords in action. Prof. Blake, of Brown University, U.S., used a small mirror caused to move by the vibration of a telephone diaphragm. A beam of light was thrown on the mirror, and the movements of the latter which resulted from the use of the telephone were recorded on a photographic plate kept in regular motion by clockwork. Prof. Hermann, at an International Congress of Physiology, at Liège, demonstrated the possibility of using a microphone in connection with a phonograph to record vowel sounds. The vowels were spoken or sung into a phonograph, and the cylinder containing the reproduction was afterwards revolved very slowly before a microphone furnished with a small mirror. A beam of electric light was thrown on the mirror, which vibrated in accordance with the sound given out by the phonograph, and reflected the beam through a slit upon a revolving cylinder covered with sensitised paper.

VOLATILE ALKALI

A synonym for ammonium carbonate.

VON BENTIVEGNI'S COLOUR PROCESS

A kind of crystoleum process. The glass, with the mounted and dried print attached, is soaked in a warm mixture of castor-oil, vaseline, etc., then in castor-oil alone, and is then rubbed dry and coloured.

VULCANITE (Fr., *Vulcanite ;* Ger., *Ebonit*)

India-rubber treated ("vulcanised") with sulphur in a closed furnace and obtainable in many different colours. Black vulcanite is commonly known as ebonite.

W

WARNERKE, LEON

Born in Hungary, 1837; died at Geneva, 1900. He settled in England about 1870, and was a civil engineer, but took to photographic experimenting, and contributed largely to photographic knowledge. He was well known to the photographic societies of many countries. In 1877 he was awarded a prize in Belgium for the best dry-plate process, and in 1881 the British R.P.S. Progress medal. His sensitometer numbers were used by plate makers for indicating speeds, his actinometer being introduced in 1880. As early as 1869 he experimented with other supports than glass for the sensitive film, and used Steinbach paper sized with starch, coated with collodio-bromide emulsion. At one time he used the sheets of sensitive material interleaved with orange paper in the form of a block resembling an artist's sketching block, and employed it in this form in the camera. The difficulties of using these early types of films led him, in 1875, to invent a roller dark-slide, in order that the film in a band could be wound from one roller at one end to a roller at the other. In 1885 he introduced and patented a negative paper coated on both of its sides. In 1881 he found that an exposed gelatine film developed with pyro-ammonia becomes insoluble in hot water in the parts affected by light, and that if soaked in warm water and attached to a glass plate, the paper can be stripped off and the soluble gelatine washed away, leaving a reversed negative attached to the glass.

WARNERKE'S SENSITOMETER

A sheet of glass bearing a series of numbered squares, ranging from 1 to 25, with varying quantities of opaque pigment, used for testing the sensitiveness of plates. With it was issued a plate of phosphorescent calcium sulphide or Balmain's luminous paint, which was excited with 1 in. of burning magnesium ribbon, and after the lapse of a given time (30 seconds) the plate to be tested was exposed to the luminous rays emitted by the tablet; after development the last number legible when the negative was laid against white paper was taken as the speed of the plate. It is now practically obsolete.

WARNERKE'S TISSUE

A gelatino-silver emulsion tissue used in an obsolete process of photo-engraving.

WARNER-POWRIE PROCESS

A method of producing screen-plates for colour photography based on the insolubilisation of bichromated fish-glue by the action of light, and subsequent mordanting and staining of the in soluble gelatine. The chief feature of the process is the extreme simplicity of its working, and the absence of overlap of or interspaces between the lines. Briefly, the details of the process are as follows: A sheet of glass is coated with bichromated fish-glue and exposed under a black-and-white line screen in which the black lines are twice the width of the transparent spaces. After exposure the plate is developed in warm water, which removes the gelatine not rendered insoluble by the action of light. The insolubilised gelatine lines are then mordanted with an acid aniline dye and stained with a basic dye, the result being an insoluble, transparent precipitate of dye. The coloured lines thus produced are hardened with tannin or other agent, and the whole plate coated with bichromated fish-glue again. After drying, the original black-and-white matrix is now arranged in contact with the screen plate so as to cover all the coloured lines thereon and a second exposure made. The result is a second series of lines of insoluble colloid which may or may not be in contact with the first series. This second series is now mordanted, stained, and hardened precisely as at first. Again the plate is coated with bichromated fish-glue, and, after drying, exposed without the intervention of any screen through the back of the plate. The previously coloured lines, which should be the red and green, act as the protection for those portions of the third coating of bichromated colloid immediately over them, whereas in the interspaces, where there is no protecting colour, the bichromated colloid is rendered insoluble, and again mordanted, stained and hardened.

A more recent modification of the process is the placing of the second set of lines at right angles to the first and the subsequent filling up of the third interspace by a similar process as above outlined. This gives a screen with one set of lines and the interspaces divided up into rectangles of the two other colours.

WASHERS (Fr., *Panier-laveur*; Ger., *Positivwässerung, Papierwässerung*)

Vessels or appliances for washing photographic prints, usually consisting of an enamelled metal

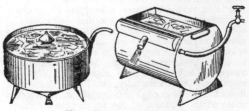

Two Forms of Washer

tank with or without a syphon outlet. They are frequently made of a circular form, or with curved sides, the water being introduced in

such a way that a rotary motion is given to the prints. The motion should not be overdone by using too violent a stream of water, or the prints may be damaged. Commonly a perforated plate is fitted near the bottom of the washer, to prevent the prints being carried away through the outlet, and to allow a more efficient separation of the "hypo." The illustrations show two typical patterns of print washer. For work on a large scale, flat dishes or tanks are usually preferred.

WASHING (Fr., *Lavage;* Ger., *Waschen, Reinigen*)

Negatives and prints that have been fixed in "hypo" must be freed of this substance by washing with water before they can be safely dried; otherwise the permanency of the result is impaired. "Hypo" being of greater specific gravity than water, it follows that as part of the washing water removes "hypo" from the gelatine and paper it becomes a solution which is denser than plain water, and therefore tends to sink to the bottom of the washing vessel. Agitation is necessary to cause the plain water and the "hypo" solution to mix thoroughly, although slight admixture must, of course, occur. It

Negative Holder for use in Washing

follows, then, that the worst method of washing is to place a negative or print film side upwards in still water, and that the quickest and best way is to support the film in such a way that the "hypo" may, as it were, fall out of the film to the bottom of the vessel. For washing a single negative quickly, it may be held in the hand, face downwards in a pail of water, where it will be freed from "hypo" much more quickly than if laid in a dish and water allowed to run upon it. A convenient accessory for holding a negative film side downwards is shown. To a piece of wood the same size as the negative are nailed strips of tin-plate, as shown, these being bent under so as to hold the negative. The last named is slid into place, film side outwards, and the whole floated in a vessel of water; in this way the suspending of a negative film side downwards in water becomes a very simple matter. Another method is to use a dish with sloping sides, which support the negative when this is placed horizontally. Most of the commercial washers hold the negatives in a vertical position, in which position they wash quickly and well if space is left below the negatives. When a negative is held vertically, the "hypo" solution flows to the lower edge and congregates in a dense mass at the bottom of the vessel; this demonstrates the necessity of having a space below the negative if still water is used. The propping up of a negative on a brick placed in a pail of still water is a simple method of washing when running water is not available, as by

frequent changes the "hypo" may be quickly got rid of.

The time taken to wash a negative or print depends upon the method employed and upon other considerations. Several experimenters, after exhaustive trials, have stated that a washing of twenty minutes is enough for negatives under favourable conditions. Complete removal of "hypo" from negatives occupies about twice the time the plates take to fix, in favourable circumstances. Negatives do not hold "hypo" as prints do, as in the latter there is the porous paper to consider. Lumière and Seyewetz concluded that the use of running water for washing was both wasteful and inefficient, and that the best way to wash negatives is to immerse each negative, vertically or upside down, in five successive baths for five minutes each (twenty-five minutes in all), allowing 17 oz. of water to each half-plate. Gaedicke discovered a number of useful facts, the most important of which is that when the water is changed every five minutes, three times as much "hypo" is extracted as when the water is changed every half-hour.

As regards the washing of prints, practically all the above remarks apply. Prints and celluloid films should be kept on the move and the water frequently changed or carried away from the bottom of the tank. If they are soaked in still water, this must be frequently changed, or the prints should be transferred from one dish to another. From data published by Messrs. Lumière, it seems that eight changes, using 3½ oz. of water for each 7-in. by 5-in. print, are sufficient; 90 per cent. of the "hypo" is soaked out by the first two baths. In the case of a print placed for twenty minutes under a tap passing about 14 pints per minute, and then allowing it to soak for five minutes in 3½ oz. of water, the latter was found to contain about the same quantity of "hypo" as the water after one-fifth the washing in the manner above described. The experimenters state, however, that these methods do not remove the last minute traces of "hypo," and that even twenty-four hours in running water will not do it. Haddon and Grundy stated in 1894 that they had proved that gelatino-chloride prints, washed for ten minutes in running water and under proper conditions, had lost the whole of the soluble salts, and that there was no necessity whatever to wash longer; further, they also found that six changes of water after five minutes' soaking were equally effective. Thus it is obvious that the amount of washing necessary for both negatives and prints depends entirely upon the conditions under which they are washed, no two experimenters agreeing.

For methods of testing washing water for "hypo," *see* "Sodium Hyposulphite, Testing for."

WASHING EMULSION (*See* "Emulsion.")

WASHING SODA (*See* "Sodium Carbonate.")

WASHING TANK (Fr., *Cuve à lavage, Cuve à rainures;* Ger., *Wässerungskasten*)

Tanks for washing negatives are generally of metal or porcelain, with grooves at the sides.

They should be furnished with syphons to empty off all the water from the bottom when it reaches a certain height ; otherwise the current from the tap will merely run over the top of the full tank, and the water in the latter will not get changed. A shows a porcelain washing trough of practical

A. Porcelain Trough B. Metal Tank

design. Metal tanks are frequently fitted with a removable rack, as shown at B, which serves for drying the negatives after they are washed. (For print washers, see " Washers.")

WASHINGS (See " Residues.")

WASH-OUT GELATINE PROCESS

A modification of the swelled-gelatine process for the production of photo reliefs. The unexposed parts of the image were washed away, instead of being swelled up, and a plaster cast was taken from the relief. Ultimately, either a stereotype or electrotype was made from the cast.

WASTES (See " Residues.")

WATCH CAMERA (Fr., *Chambre montre*; Ger., *Uhrkamera*)

Various cameras have been made in the form of a watch. In one, a series of telescopic metal tubes forming the body sprang out into position on pressing a spring. A more recent form of watch camera, the " Ticka " introduced in 1906, takes roll-films, twenty-five negatives the size of a postage stamp being obtained. Owing to its short focus, the depth of definition is great, and the small negatives will stand enlarging to 3¼ in. by 2¼ in., or even larger.

WATCH-DIAL PHOTOGRAPHS

A miniature of the portrait is taken by the collodion emulsion process, transferred to the dial, and varnished over. Similar results have been obtained by the carbon process. If the collodion film is toned with platinum, the image may be fired and burnt into the enamel.

WATER (Fr., *Eau*; Ger., *Wasser*)

Ordinary tap-water usually contains chlorides, sulphates and earthy salts, which, by causing precipitates, may give rise to trouble, particularly in the case of developers. All tap-water contains carbonic acid and oxygen, which tend to discolour the developing agent. Distilled water can be obtained very cheaply. In any case, ordinary water should be well boiled, allowed to cool, and filtered before use. For all solutions of the noble metals, platinum, gold and silver, distilled water is an absolute necessity. (*See also* " Distilled Water.")

36

WATER LENSES (*See* " Fluid Lens.")

WATER-DEVELOPED PLATES (*See* " Self-developing Plates.")

WATERFALLS, PHOTOGRAPHING

The strong contrast between the bright water and the dark foliage or rocks surrounding it make the photographing of waterfalls somewhat difficult. If the quality, the sparkle, and the movement of the water are to be retained, a very short exposure is necessary ; and such an exposure cannot be expected to secure detail and gradation in the surroundings at the same time. On the other hand, if an exposure is given to render the setting properly the water will lose its texture and become woolly or streaky. Sometimes, with a very fast plate and a large lens aperture a compromise may be arrived at, and the whole subject be properly rendered on one plate. The effect may be further improved by shielding the dark portions (light portions of the negative) with paper or matt varnish, and so allowing the denser water to print out more fully.

When this is not feasible, it is well to make two exposures, timing one for the moving water and the other for the surroundings. Each negative is then masked so that one prints only the water, the other the setting.

WATER-GLASS (*See* " Potassium Silicate " and " Sodium Silicate.")

WATERHOUSE STOPS (*See* "Diaphragms.")

WATERPROOF PAPER

Waterproof paper is used for mounting and wrapping up chemicals and sensitive material. A serviceable waterproof paper may be made by brushing a strong solution of Castile soap over some paper, and when nearly dry brushing over with a strong solution of chrome alum. This method of waterproofing answers well for fabrics generally.

WAVE-LENGTHS (Fr., *Longueurs des ondes*; Ger., *Wellenlängen*)

Light is considered to be an undulatory or wave-like motion in the ether, and the conventional figures used to illustrate this are the following :—

Wave-lengths

Assume that the light is travelling from left to right in each of the above figures, A, B, and C ; the ether particles vibrate to and fro, and

each excites its neighbour till the motion reaches the maximum of the crest of the wave at A, and then it vibrates in the contrary direction till it reaches the maximum of the trough at B, each ether particle merely moving to and fro between the planes bounding A and B. Now, a wave length is the distance from any two points in the same phase of movement, such as A and C, C and E, B and D, and D and F. These points have been taken on the axis of the direction of the propagation of light, but any two other points could be measured from, such as A′ and A″ or a′ and a″, or β and β″, or b′ and b″. If the distance A C is a wave length, A B or B C is exactly half a wave length, and so on ; further, the length of the wave A to C in A red light is double that of C, the violet A to C, whilst in B green light, the length is midway between them. The wave length of any pure spectrum is always constant, no matter what the source of light ; and it could be used as a definite standard of colour ; and it is by no means uncommon to see the expression that a colour is that of D $\frac{1}{2}$ E ; that is to say, a colour can be matched by the spectrum ray, which lies exactly midway between the solar Fraunhofer lines D and E.

There are several units of measurement or methods of writing the wave-length, which is usually abbreviated to λ. The unit most generally adopted is the tenth-metre $= 1 \times 10^{10}$ metre or the ten-millionth of a millimetre, which was the unit adopted by the great Swedish physicist Angström, one of the first to give a reliable map of the solar spectrum, and this is then abbreviated to A.U. (Angström's Unit) or t.m. It may also be expressed in millionths of a milli metre, called a milli-microne, and written $\mu\,\mu$, or in thousandths of a millimetre, called a micron, and written μ ; or it is also written as a ten-thousandth of a centimetre or 10^5 cm. So that we might describe the D_1 line as—

λ 5·89616 × 10^5 cm. = ·0000589616 cm.
or λ 0·589616 μ
or λ 589·616 $\mu\mu$,
or λ 5896·16 A.U. or t.m.

For all methods for measuring wave-lengths, except rough visual work, that of photographic coincidence is usually adopted.

WAX (*See* " Beeswax " and " Paraffin.")

WAX ENGRAVING

Synonym, cerography. A brass plate is cleaned, then blackened by flowing with a solution of silver nitrate 10 g., water 250 g., and nitric acid 2 drops. It is rinsed, dried, warmed, and covered with a mixture of paraffin-wax and white pigment such as zinc white. When cool, an outline tracing is set-off on to the surface with red chalk, and the lines of the design are scratched through the film. For map work, the names are pressed into the wax with heated metal type. Finally, the large whites are built up with wax run off a hot tool, and the surface is made conductive with blacklead. Then the plate is used as a mould for electro-deposition.

WAX PROCESS

A general term for reproduction processes in which wax is used ; in particular, wax engraving.

WAXED-PAPER PROCESS

A modification of the calotype process introduced, in 1855, by Le Gray. The wax was used in order to prevent the grain showing, and also to stop up the pores of the paper. The original process was, briefly, as follows : A suitable paper was placed on a heated silvered copper plate, and pure white wax rubbed well into it ; it was ironed between sheets of blotting-paper. For preparing the iodising solution, rice was soaked in distilled water. To a little less than a quart of the rice water 620 grs. of sugar of milk, 225 grs. of potassium iodide, 12 grs. of potassium cyanide, and 7 grs. of potassium fluoride were added, and the waxed paper was soaked therein for about an hour and dried. The paper was then sensitised by floating for four or five minutes on a bath made by dissolving 78 grs. of silver nitrate in 2,325 grs. of distilled water, and then adding 186 grs. of crystallised acetic acid ; for portrait work, however, Le Gray advised 155 grs. of silver nitrate. The paper was then dried in the dark and exposed in the camera, the exposure being from twenty seconds to fifteen minutes. It was developed by immersing in a solution of gallic acid (1$\frac{1}{2}$ grs. to the 1 oz.).

WAXING

Wax is applied to paper negatives in order to make them more translucent, and to facilitate printing.

WEATHER PICTURES (*See* " Barometer, Photographic.")

WEDGWOOD, THOMAS

Born 1771, died 1805. Third son of Josiah Wedgwood, the potter. He studied the action of light upon certain compounds of silver, and in 1795 obtained " sun pictures " by placing more or less opaque objects upon paper and white leather coated with a weak solution of silver nitrate.

WEIGHTS AND MEASURES

Recognised abbreviations are : Pounds, lb. ; ounces, oz. or ℥ ; drams, drs., drms., or ʒ ; scruples, sc. or ℈ ; grains, grs. ; pints, pt. ; minims, mins. ; pennyweights, dwt. The only metric abbreviations of interest are : gramme, g. ; cubic centimetres, ccs. ; millimetres, mm. ; centimetre, cm.

The grain has the same value in apothecaries', avoirdupois, and troy weight.

Apothecaries' Weight
(Formulæ are made up by this weight.)

lb.	oz.	drms.	sc.	grs.	(Metric.) grammes.
1	12	96	288	5,760	373·276
	1	8	24	480	31·106
		1	3	60	3·887
			1	20	1·296
				1	0·0648

Fluid Measure

Pt.	oz.	drms.	mins	(Metric.) ccs.
1 (American)	16	128	7,680	454·4
1 (English)	20	160	9,600	568
	1	8	480	28·4
		1	60	3·5
			1	0·058

The fluid pound = 12 oz. = 5,760 mins. = 340·8 ccs.
The fluid ounce of water weighs 437$\frac{1}{2}$ grs. = 28·4 g.

Avoirdupois Weight

(Most chemicals are sold by this weight.)

lb.	oz.	drms.	grs.	(METRIC.) grammes.
1	16	256	7,000	453·59
	1	16	437½	28·4
		1	27¹¹⁄₃₂	17·7

Troy Weight

(Gold, silver, etc., are sold by this weight.)

lb.	oz.	dwt.	grs.	(METRIC.) grammes.
1	12	240	5,760	373·2
	1	20	480	31·1
		1	24	1·55
			1	0·6

Grains to Grammes

Odd numbers may be found by simple addition.

grs.	g.	grs.	g.	grs.	g.
1 equals	0·065	12 equals	0·775	55 equals	3·564
2 ,,	0·13	15 ,,	0·972	60 ,,	3·888
3 ,,	0·194	18 ,,	1·166	65 ,,	4·212
4 ,,	0·259	20 ,,	1·296	70 ,,	4·536
5 ,,	0·324	25 ,,	1·620	75 ,,	4·860
6 ,,	0·389	30 ,,	1·944	80 ,,	5·184
7 ,,	0·454	35 ,,	2·268	85 ,,	5·508
8 ,,	0·518	40 ,,	2·592	90 ,,	5·832
9 ,,	0·584	45 ,,	2·916	95 ,,	6·156
10 ,,	0·648	50 ,,	3·240	100 ,,	6·480

Ounces (Apothecaries') to Grammes

oz.	g.	oz.	g.	oz.	g.
¼ equals	7·776	2 equals	62·212	6 equals	186·636
½ ,,	15·553	3 ,,	93·318	7 ,,	217·742
¾ ,,	23·329	4 ,,	124·424	8 ,,	248·848
1 ,,	31·106	5 ,,	155·530	9 ,,	279·954
				10 ,,	311·06

Fluid Measure to ccs.

mins.	ccs.	drms.	ccs.	oz.	ccs.
5 equals	0·3	1 equals	3·55	1 equals	28·41
10 ,,	0·6	2 ,,	7·10	2 ,,	56·8
15 ,,	0·9	3 ,,	10·65	3 ,,	85·2
20 ,,	1·2	4 ,,	14·20	5 ,,	142·0
25 ,,	1·4	5 ,,	17·75	10 ,,	284·0
30 ,,	1·78	6 ,,	21·30	16 ,,	454·5
60 ,,	3·55	7 ,,	24·86	17 ,,	483·0
		8 ,,	28·40	20 ,,	568·0

Inches to Millimetres

in.	mm.	in.	mm.	in.	mm.
1 equals	25·4	⅝ equals	15·9	9⁄32 equals	7·1
15⁄16 ,,	23·8	9⁄16 ,,	14·3	¼ ,,	6·4
10⁄16 ,,	23	½ ,,	12·7	7⁄32 ,,	5·6
⅞ ,,	22·2	7⁄16 ,,	11·1	3⁄16 ,,	4·8
13⁄16 ,,	20·16	⅜ ,,	9·5	⅛ ,,	3·2
¾ ,,	19·1	11⁄32 ,,	8·7	3⁄32 ,,	2·4
11⁄16 ,,	17·5	5⁄16 ,,	7·9	1⁄16 ,,	1·6
				1⁄32 ,,	0·8

Grammes to Grains

g.	grs.	g.	grs.	g.	grs.
1 equals	15·4	11 equals	169·4	20 equals	308
2 ,,	30·8	12 ,,	184·8	30 ,,	462
3 ,,	46·4	13 ,,	200·2	40 ,,	616
4 ,,	61·6	14 ,,	215·6	50 ,,	770
5 ,,	77	15 ,,	231	60 ,,	924
6 ,,	92·4	16 ,,	246·4	70 ,,	1,078
7 ,,	107·8	17 ,,	261·8	80 ,,	1,232
8 ,,	123·2	18 ,,	277·2	90 ,,	1,386
9 ,,	138·6	19 ,,	292·6	100 ,,	1,540
10 ,,	154				

Cubic Centimetres (ccs.) to Minims

ccs.	mins.	ccs.	mins.	ccs.	mins.
1 equals	17	8 equals	136	50 equals	850
2 ,,	34	9 ,,	153	60 ,,	1,020
3 ,,	51	10 ,,	170	70 ,,	1,190
4 ,,	68	20 ,,	340	80 ,,	1,360
5 ,,	85	30 ,,	510	90 ,,	1,530
6 ,,	102	40 ,,	680	100 ,,	1,700
7 ,,	119				

Millimetres to Inches

mm.	in.	mm.	in.	mm.	in.
1 equals	0·04	10 equals	0·39	19 equals	0·75
2 ,,	0·08	11 ,,	0·43	20 ,,	0·79
3 ,,	0·12	12 ,,	0·47	21 ,,	0·83
4 ,,	0·16	13 ,,	0·51	22 ,,	0·87
5 ,,	0·20	14 ,,	0·55	23 ,,	0·90
6 ,,	0·24	15 ,,	0·59	24 ,,	0·94
7 ,,	0·28	16 ,,	0·63	25 ,,	0·98
8 ,,	0·31	17 ,,	0·67	25·4 ,,	1·0
9 ,,	0·36	18 ,,	0·71		

Rules for Conversions

Inches to centimetres: multiply by 2·54; approx., multiply by 5 and divide by 2.

Centimetres to inches: divide by 2·54; approx., multiply by 2 and divide by 5.

Inches to millimetres: multiply by 25·4; approx., multiply by 100 and divide by 4.

Millimetres to inches; divide by 25·4; approx., multiply by 4 and divide by 100.

Ounces (fluid) to cubic centimetres: multiply by 28·3.

Cubic centimetres to ounces (fluid): divide by 28·3.

Litres to pints: multiply by 1·76; approx., multiply by 7 and divide by 4.

Pints to litres: divide by 1·76; approx., multiply by 4 and divide by 7.

Grains to grammes: divide by 15·43.

Grammes to grains: multiply by 15·43.

Ounces (avoir.) to grammes: multiply by 28·4.

Grammes to ounces (avoir.): divide by 28·4.

Ounces (apoth.) to grammes: multiply by 31·1.

Grammes to ounces (apoth.): divide by 31·1.

The standard method of presenting formulæ in the metric system is to make the quantity of water equal 1,000 ccs., as in the majority of cases throughout this work. The following (merely approximate) table makes such conversions easy. For example, "hypo," 1 oz.; water 9 oz. becomes "hypo" 122 g.; water, 1,000 ccs. By a simple proportion sum this table can be used for converting metric formulæ to British:—

If 1 oz. (fl.) becomes 1,000 ccs., 1 oz (apoth.) becomes 1,100 g.
,, 2 ,, ,, ,, ,, 1 ,, ,, 550 ,,
,, 3 ,, ,, ,, ,, 1 ,, ,, 367 ,,
,, 4 ,, ,, ,, ,, 1 ,, ,, 275 ,,
,, 5 ,, ,, ,, ,, 1 ,, ,, 220 ,,
,, 6 ,, ,, ,, ,, 1 ,, ,, 183 ,,
,, 7 ,, ,, ,, ,, 1 ,, ,, 157 ,,
,, 8 ,, ,, ,, ,, 1 ,, ,, 138 ,,
,, 9 ,, ,, ,, ,, 1 ,, ,, 122 ,,
,, 10 ,, ,, ,, ,, 1 ,, ,, 110 ,,
,, 15 ,, ,, ,, ,, 1 ,, ,, 73 ,,
,, 20 ,, ,, ,, ,, 1 ,, ,, 55 ,,

Metric System

Proportion	Length		Capacity		Weight	
Unit 1⁄1000 part	Metre Millimetre	39·37 in. 0·039 ,,	Litre Millilitre or cubic centimetre	35 oz. 94 mins. 17 ,,	Gramme Milligramme	15·43 grs. 0·01543 grs.
1⁄100 ,,	Centimetre	0·394 ,,	Centilitre	170 ,,	Centigramme	0·1543 grs.
1⁄10 ,,	Decimetre	3·94 ,,	Decilitre	3 oz. 250 ,,	Decigramme	1·543 grs.

"Deka" = 10 (dekametre = 10 m., etc.); "hecto" = 100 (hectolitre = 100 l., etc.); "kilo" = 1,000 (kilogramme = 1,000 g., etc.); and "myria" = 10,000 (myriametre = 10,000 m., etc.)

WELLINGTON'S SILVER INTENSIFIER

Wellington's original formula (1889) is given under the heading " Silver Intensifier." In July, 1911, Wellington published particulars of an improved process which does not stain or dissolve the film of some plates, as the original is said to do. The film is first hardened with formaline (1 part to 10 of water for five minutes), rinsed and immersed for one minute in the following : a solution of potassium bichromate, $\frac{1}{2}$ gr.; potassium bromide, 10 grs.; hydrochloric acid, 30 mins.; and water, 10 oz. Too long an immersion causes the image to bleach, and must be avoided. The intensifier is in the form of two stock solutions, both of which will keep good for years :—

A. Silver nitrate	.	. 400 grs.	92 g.
Water (distilled) to	.	10 oz.	1,000 ccs.
B. Potass. sulphocyanide	700 grs.	161 g.	
" Hypo "	.	. 700 ,,	161 ,,
Water to .	.	10 oz.	1,000 ccs.

Take $\frac{1}{2}$ oz. of B, and add $\frac{1}{2}$ oz. of A, stirring vigorously with a glass rod ; the result should be a clear solution. Add 60 mins. of a 10 per cent. solution of pyro preserved with sulphite, and 120 mins. of a 10 per cent. solution of ammonia.

The solution given above is poured over the negative. The deposition of silver begins to take place in a minute or two, and the image gains in strength. When dense enough, the negative is placed in an acid fixing bath until the slight pyro stain is removed, and is then well washed. The image can be reduced with the ferricyanide-" hypo " reducer.

WET NEGATIVES, PRINTING FROM (See " Quick Prints from Wet Negatives.")

WET COLLODION PROCESS (See " Collodion Process (Wet), or Wet-plate Process.")

WHEATSTONE, CHARLES

Born 1802, died 1875. Professor of experimental philosophy at King's College, London. He invented the stereoscope in 1838, his paper on binocular vision being read at the Royal Society on June 21, when the instrument was first exhibited.

WHEY PROCESS (Fr., *Procédé à petit-lait* ; Ger., *Molken Prozess*)

An early iodo-bromide enlarging process, used with the solar camera. Paper was floated on :—

Potassium iodide	. 88 grs.	20 g.
Potassium bromide	. 44 ,,	10 ,,
Milk whey (filtered)	. 10 oz.	1,000 ccs.

for from two to three minutes and hung up to dry. It was then sensitised with silver nitrate, exposed for from ten to sixty seconds and developed with pyro.

WHIRLER (Fr., *Tournette* ; Ger., *Schleuder-apparat*)

An appliance for rapidly drying glass or metal plates to which a sensitive coating has been applied, and for securing an evenly distributed film. It is principally used in photo-mechanical processes. The pneumatic whirler A has a rubber bulb, which is simply pressed against the plate to be coated, holding it firmly by suction. The whirler is then turned upward, and the sensitising mixture, as, for example, the fish-glue solution used in the enamel process of half-tone, is poured in the centre of the plate until the pool covers about three-fourths of the surface. The whirler is now reversed, so that the plate is face downward, and revolved at a moderate speed by turning the handle at the side, holding it meanwhile over a sink until the surplus solution ceases to be thrown off. The whirler is finally held over a gas burner, still face down, and the revolution continued till the plate is dry.

Another type of whirler, invented by Max Levy and employed in process work, is shown at B. This is supported by a bracket, which may be fastened to a wall. The adjustable jaws which hold the plate can be turned upward for coating ; then, when ready, a lever is pressed and the plate holder is turned down for whirling, a stove being placed beneath and a metal casing built round to receive the splashings. Or, if

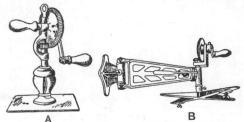

Two Types of Whirler

preferred, the whirler may be fixed over a tub and then swung from the latter over a gas burner for drying. For lithographic stones and thick heavy plates a fixed whirler with a circular turntable is used.

WHITE LAC (See " Gums and Resins.")

WHITE, PERMANENT (See " Barium Sulphate.")

WHITE WAX (See " Beeswax.")

WHITENED CAMERA

An old French idea for whitening the interior of the camera with the object of reflecting some light on to the plate to reduce harsh contrasts. It has somewhat the same effect as giving a preliminary exposure to white paper.

WHOLE-PLATE

A commercial size of camera, plate, paper, etc., measuring $8\frac{1}{2}$ by $6\frac{1}{2}$ in.; sometimes written " 1/1." (See also " Sizes of Plates and Papers.")

WIDE-ANGLE LENS

A lens of short focal length, including, even at close quarters, a wide angle of field or of view, and therefore frequently of great advantage in general photography. (See also " Angle of Field or of View.")

WILDE'S RESTRAINER

A solution of 19 grs. of iodine in 200 mins. of alcohol, afterwards adding 200 mins. of water.

From 2 to 4 drops is added to 1 oz. of ferrous oxalate developer.

WILLIS'S PROCESS (*See* "Aniline Process.")

WINDOW, BLOCKING UP

The best way of blocking up a window when the room is to be used for developing or similar work, is to make a light wooden frame to fit inside the beading of the window-frame, and over this to paste or glue two thicknesses of ruby fabric or paper. If artificial light is to be used for working, as is preferable owing to its uniformity, two thicknesses of stout brown paper will serve the purpose. The advantage of the wooden frame is that it can be instantly removed; otherwise the fabric is secured round the window itself.

WINDOW TRANSPARENCIES

In the production of transparencies upon glass or paper for window decoration, specially prepared plates are generally used, these being made and used exactly like lantern slides. If made upon glass in which the high lights are represented as clear glass, it is advisable to bind the transparency up in contact with a piece of finely ground glass or thin opal glass in order that the view outside the window may not be seen through the clear glass parts of the transparency. Coating the plain glass side with a matt varnish, tinted if required, has the same effect, and allows of obtaining good results in one or more colours. Certain plates ("matt ground" or "M.G.") have a matt surface and obviate the use of additional ground glass, but the film side should be protected with plain glass.

Window transparencies may be made from any paper prints, but the blue-prints and platinotype prints are considered the best. The print is made darker than usual, finished and finally made translucent by oiling or waxing. Platinotype prints on thin paper answer admirably without waxing, as do also blue-prints on tracing paper sensitised on one side only. Paper prints should be bound up between glass, with strips of paper or linen round the edges.

WINE, SPIRIT OF (*See* "Alcohol.")

WOLLASTON AND FRAUNHOFER LINES
(*See* "Fraunhofer Lines.")

WOOD, PHOTOGRAPHS ON

Photography on wood as a guide to the engraver was extensively practised when wood engraving was at its height of popularity. One of the simplest methods is to prepare the surface of the boxwood with a mixture of gum and zinc-white, then to coat it with albumen mixed with ammonium chloride; and after drying and waterproofing the sides of the block with wax to dip the surface into a silver nitrate bath. The surface is then dried and exposed under a negative until an image is obtained like the ordinary albumen silver print. Fixing with "hypo," rinsing, and drying complete the operation. Care has to be taken not to get the body of the wood block wet. An improvement on this is to coat the albumenised surface with iodised collodion, thinned down considerably; then to sensitise in a silver bath and print as before. After

developing and fixing, the block is dried off and is ready for engraving.

Various processes of toning with gold, etc., have been used for strengthening the image.

WOOD NAPHTHA, OR WOOD SPIRIT
(*See* "Alcohol.")

WOODBURY, WALTER BENTLEY

Born at Manchester, 1834; died at Margate, 1885. Inventor of the Woodburytype process, which he first demonstrated in London in 1865, and patented the following year. He went to the Australian gold fields in 1849, and four years later became a professional photographer there. In 1859 he went to Java, where he did much photographic work, returning to England and settling in Birmingham in 1863. Between 1864 and 1884 he took out twenty patents for improvements in photographic apparatus and for photo-mechanical processes.

WOODBURYTYPE

A photo-mechanical process invented by Mr. W. B. Woodbury in 1865, and patented by him on July 24, 1866. A relief image is obtained on bichromated gelatine, covered with lead, and the two forced together in a hydraulic press, which produces a reverse or mould in the lead. The mould is then inked with pigmented gelatine and printed from under pressure. A modification of the process was afterwards published under the name of "Stannotype," in which no hydraulic process was necessary. Woodburytype is quite unlike any other process in its working details, which, based on the inventor's own words, are as follow: The production of pictures, either on white paper, upon glass as transparencies, opal, etc., by this method of printing is based on the principle that layers of any semi-transparent material seen against a light ground produce different degrees of light and shade, according to their thickness, as the carbon process, for example. Therefore, by having a mould in intaglio produced by the action of light upon bichromated gelatine, and filling the intaglio so produced with a semi-transparent material, there is obtained a mould in which the parts that are the thickest give a dark colour; while the thinner the layer becomes it gradually merges into white. By pouring a mixture of coloured gelatine on to the intaglio mould, and placing a piece of white paper thereon, and squeezing the whole between two perfectly true planes, the superfluous colour is squeezed out, and the gelatine, having set, adheres to the paper and leaves the mould quite clean. When the picture leaves the mould it is in slight relief, but during drying the gelatine contracts and leaves hardly any perceptible relief. To make the gelatine relief, wet several pieces of talc, and affix them to a large sheet of glass; squeeze out the superfluous moisture, and polish the whole of the pieces. Next prepare the bichromatised gelatine as follows:—Soak 4 oz. of opaque gelatine in 28 oz. of water; dissolve by heat, clarify with white of egg, and filter. To 4 oz. of this solution add 60 grs. of ammonium bichromate dissolved in $\frac{1}{2}$ oz. of warm water and a small quantity of Prussian blue; the latter serves to give the finished relief

a colour by which to judge of its printing qualities, and does not interfere with the action of the light in penetrating the gelatine. When well mixed, the solution is filtered through muslin, and is then ready for coating upon the talc-covered glass, placed upon a levelling stand, and dried. When set, each piece of talc is cut round the edges with a sharp knife and stripped from the glass. Lay the sensitised talc upon blotting paper and clean the talc side; then place in contact with the negative, and having placed a piece of glass behind, fasten all together with rubber bands, and place in the light of a condenser of 6 in. to 9 in. in diameter, at a distance of about 2 ft.; after exposing for 1 or 2 hours lay in a dish, and pour hot water over it until no soluble gelatine is left; then allow to dry by gentle heat. Having obtained the relief, it is ready for taking the mould.

The above is Woodbury's original process. A later method of making the relief plate is to clean sheets of plate glass with French chalk and coat with collodion. When dry, the sensitive mixture, made as follows, is poured on, and laid on a level place to set:—Sheet gelatine, $1\frac{3}{4}$ oz.; glycerine, 50 drops; sugar, $\frac{1}{2}$ oz.; Indian ink, 1 gr.; carbolic acid, 1 drop; ammonium bichromate, 150 grs.; liquor ammoniæ, $\frac{1}{2}$ drm.; water, 6 oz. The gelatine is soaked in three-fourths of the water, melted by heat, and the glycerine, sugar, carbolic acid, and ammonia added. The Indian ink is dissolved in the remaining water, and added gradually, and the bichromate, well powdered, stirred in. Exposure and development are the same as for carbon printing, hot water at a temperature of 110° F. (43° C.) being used to begin with, afterwards raising it to 160° F. (71° C.). Development—that is, the dissolving away of the unacted-upon bichromated gelatine—may take two hours or longer, but the process must not be hurried. When the image is developed, it is immersed in a 4 per cent. solution of chrome alum for a few minutes, washed, soaked in methylated spirit for an hour, and then dried.

Several other formulæ for making the necessary relief from the negative have been recommended, but all except one are based on the above. The exception is the use of a modern dry plate. The plate should be of the thickly coated variety; it is printed from in contact with the original negative, a full exposure being given, and developed with the following solutions:—No. 1: Pyrogallic acid, 30 grs.; water, 5 oz. No. 2: Sodium sulphite, $\frac{1}{4}$ oz.; potass. hydrate, $\frac{1}{4}$ oz.; water, 2 oz. No. 3: Potassium bromide, 60 grs.; water, 1 oz. For use, take $1\frac{1}{2}$ oz. of No. 1 and $\frac{1}{4}$ oz. of No. 2; develop the plate until all details are out, then add about 20 drops of No. 3 and continue development until dense enough. Place in a 10 per cent. solution of chrome alum warmed to 95° F. (35° C.), and brush the surface while under the solution with a camel-hair brush, allow to remain until in good relief, then wash well, fix in "hypo," and again wash well. It is absolutely essential that the dry plate is very thickly coated, and should there be any tendency to frill, this may be avoided by coating the edges with india-rubber solution. The dry plate process is the least satisfactory.

The metal mould has now to be made from the relief. Woodbury in his early experiments used the electrotype process to obtain an intaglio from the gelatine relief, but found that for practical purposes it was impossible to obtain uniform results. Soft metal (a mixture of lead and type metal) was found by him to be better. A sheet of the soft metal is placed in contact with the gelatine relief, then both in between two perfectly true plates of steel; a pressure of 50 to 200 tons is applied, according to size, 4 tons to the sq. in. being about the pressure necessary. The gelatine film is not damaged as might be supposed, and the result is a perfectly sharp intaglio in about one minute, and the same relief will serve for several moulds. Before taking the mould, however, the film or talc containing the relief image must be stripped from the plate and used with the metal, as the enormous pressure would break the glass support, and for this reason the talc support, as advocated originally, will be found the most convenient, even if more difficult to prepare. The mould is placed in a press, and oiled slightly with a mixture of equal parts of olive and paraffin oils, and the mixture of gelatine and ink poured on. A suitable ink is made by dissolving 4 oz. of gelatine in about 25 oz. to 30 oz. of water, and then adding Indian ink, etc., the whole being kept at about 126° F. (52° C.). When the mould is covered with the ink, the paper to receive the picture is placed upon it, then a sheet of plate glass and pressure applied. The superfluous ink is forced out at the sides by the pressure, while that in the mould adheres to the paper and forms the image. After the gelatine has set, the glass plate and the paper are lifted off, and the image thereon placed in a weak solution of alum to harden.

The modified process needing no great pressure consists in making the gelatine relief in any of the ways named above; it is then, without stripping from the glass, covered with tinfoil and passed between rubber rollers. This presses the tinfoil into the interstices of the relief, producing a perfect counterpart. Copper is then electrically deposited on the tinfoil for the purpose of strengthening it.

WOOD'S DIFFRACTION GRATING PROCESS

This is practically a modification of the three-colour process in which diffraction gratings ruled with a varying number of lines to the inch are used instead of the three stained filters, and the principle of the process can be easily grasped from the following explanation. In the diagram

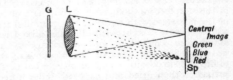

Use of Diffraction Grating

s is an intense source of light; between it and a lens l, is a diffraction grating g. There will be obtained not only the central white image, as indicated, but also on both sides a spectrum, and for the moment only consider the one spectrum, s p. Now, if we make an aperture in a

card at the point where red falls, and place the eye there, we shall see red only. If we replace the grating by one with finer rulings, then we shall find the green fall in the place of the red, and if we use a finer grating still, we should find there the blue. Now, if we put the two first gratings in front of the lens and overlapping one another, the red and green would fall on the aperture in the screen, and this would give us the sensation of yellow. If the third grating be added, then we should have red, green and blue light reaching the eye, and the result would be white.

The gratings used should have 2,000, 2,400 and 2,700 lines to the inch respectively for red, green and blue light to fall in the same spot. To produce a picture in colours, three negatives are taken in the usual manner through red, green and blue-violet screens as in ordinary three-colour work, and from these positives are made. A sheet of thin patent plate should be flowed over with the following :—

Gelatine	384 grs.	40 g.
Potassium bichromate		
(sat. sol.) .	154–226 mins.	16–24 ccs.
Distilled water to . . 20 oz.	1,000	,,

Filter whilst warm and allow the glass to drain for about 10 seconds, and then set on a level slab to dry. The sensitised glass is placed in contact with one of the three positives. The two plates should be held up in front of a lamp and register marks made on the glass surface of the sensitised plate, using minute ink dots and some prominent object that appears in all three pictures. Corresponding ink dots should now be made on the film side of the sensitised plate and the others rubbed off.

Then the grating with the coarsest ruling, which furnishes the red light, should be placed on the sensitised plate and on this the positive of the red light sensation. The lines of the grating should be vertical and the ink dots made to carefully register with the object in the positive. Expose the plates to sunlight for about 30 seconds, gripping them tightly in the fingers and holding them perpendicularly to the sun's rays. It is advisable to do this in a darkened room, using only a narrow beam of sunlight. The exposure will be about 30 seconds. Now remove the positive and grating, and substitute those for the green picture and repeat the operation, and finally, repeat the operation for the blue picture. Or preferably wash the plate in warm water after exposure through the red and green positives. The blue picture can then be made on a separate plate, placing the positive film out so as to reverse it, and after exposure, washing the plate, and then superimposing and building up.

The apparatus for viewing these pictures is a lens cut square like a reading glass mounted on a light frame, provided with a black screen perforated with an eyehole.

WOOL, COTTON- (*See* "Cotton-wool.")

WOOLLINESS

A loss of correct texture, and a substitution of a vague irregularity of definition and tone suggestive of masses of wool. It may appear,

for example, in renderings of trees and water when the focusing has been faulty or there has been movement during exposure. It sometimes results from misguided efforts at control by working on the back of the negative.

WORKING UP NEGATIVES

Methods of treating the glass side of negatives with thin tracing paper or with matt varnish are described under the heading "Control in Printing." In addition, pencil work may be applied to the tracing paper to give increased emphasis to small portions or details. (*See also* "Retouching.")

WORKING UP PRINTS

A term usually applied to working up photographs by means of crayon or water colour. The air-brush may be employed effectively for soft, shaded or clouded backgrounds, or for any mass of shading that is required to be evenly or delicately graded or perfectly flat.

The prints most suited for treatment are those on matt-surfaced bromide or gaslight papers ; the colour dries with a matt or smooth surface and becomes disagreeably evident on any paper with a semi-glossy surface, and still more prominent on a glossy print. The materials required are water colours and brushes of good quality, small saucers or china palettes for mixing the colours, and prepared ox-gall. A little of the last-named is mixed with the colour if the surface of the print is so repellent that the colour will not take readily. For black prints, the best pigments are lamp black, blue-black, ivory black, and zinc white or Chinese white. Ivory black is required only for warm black prints. For all excepting the deepest tones a little white should be mixed with the black to destroy its transparency and give body or solidity. All the pigments should be purchased in the moist form in tubes. For brown and purple-toned prints other pigments will be necessary, the most suitable being either Vandyke brown or burnt umber, which may be combined with ivory black for various shades of brown ; and neutral tint and either scarlet madder or alizarin crimson for mixing different shades of purple. Crimson lake and carmine should be avoided, as they are very fugitive.

The aim should be to strengthen or modify in depth, and to follow the character of existing work as closely as possible. The added work should improve the photograph *as a photograph*. For this reason, the outlining of details should not be attempted.

In working up photographs for process reproduction, the colours employed must be such that their photographic value is the same as their visual effect. For working in black, process white, blanc d'argent, and process black should be employed. Blanc d'argent is not permanent, but it possesses great body and mixes with black for producing greys. Chinese white reproduces as a distinct grey.

WORTLEY'S PROCESS

A dry collodion process introduced by Col. Stuart Wortley, in which a solution containing salicin, tannin, gallic acid, alcohol, sugar, and water was used as a preservative.

Col. Wortley, in 1873, discovered that a strongly alkaline developer had a more powerful action than the weaker one previously employed. Much shorter exposures were thus rendered possible. In 1879, he found that a gelatine emulsion might be ripened—that is, increased in sensitiveness—equally well by keeping it for a few hours at a fairly high temperature as by maintaining it for days at a lower one.

WOTHLY'S PROCESS, OR WOTHLYTYPE

A process of printing-out, patented by Wothly in 1864, in which the sensitive salts were a mixture of the nitrates of uranium and silver dissolved in collodion. The prints were washed after insolation with acetic or hydrochloric acid, and then toned with gold chloride. This process

was practically the immediate predecessor of collodio-chloride printing-out papers.

WRINKLING OF FILM

When a film wrinkles at the edges it is known as frilling (*which see*). When the whole of the film is wrinkled in wavy lines the defect is known as reticulation (*which see*).

WRITING INK, PRINTS IN (See "Ink Process.")

WYNNE'S EXPOSURE METER (See "Exposure Meter.")

WYNNE'S PLATE SPEEDS (See "Sensitometry.")

X

XANTHO-COLLODION

An iodised collodion to which is added a tincture of powdered turmeric giving to it a rich yellow colour. Positives are made with it on black glass, giving an effect like a gilded daguerreotype.

X-RAYS (Fr., *Rayons X ;* Ger., *X-Strahlen, Röntgen-Strahlen*)

Prof. Röntgen, in 1895, discovered certain rays, to which he gave the name of X-rays, and he investigated their action on the sensitive emulsion of the dry plate. X-rays are produced by the discharge of a high-potential current through a special form of vacuum tube, known as a Crookes' tube (*which see*). The positive terminal of an induction coil or Wimshurst machine is connected to the anode and the negative to the cathode of the tube. The anticathode is connected to the anode and is also positive. The vacuum of a tube is not perfect, and the current is conveyed through the tube by the infinitesimal quantity of air contained therein.

The "cathodal rays" which pass from the cathode to the anticathode consist of infinitesimal particles travelling at a high rate of speed ; when the progress of these minute bodies is arrested, X-rays are produced. The green fluorescence on the sides of the tube opposite the anticathode, though not caused by the X-rays, demonstrate their presence. The X-rays are ethereal vibrations travelling with much the same velocity as light. They travel in a straight line in all directions from the point of origin, and are almost incapable of reflection or refraction.

X-rays are invisible to the eye, but have the property of rendering fluorescent certain substances—for example, calcium tungstate and barium platino-cyanide. When a screen coated with these substances is placed near the X-ray tube in a darkened room, the tungstate or barium surface emits a fairly bright fluorescence. If an object such as the hand or a lead pencil is placed between the screen and the tube,

the denser parts (the bones or the graphite) appear as black shadows in a grey background.

X-rays penetrate all substances to a greater or less degree, although heavy metals, such as lead and mercury, are, for photographic or visual purposes, practically opaque to the rays.

The greater part of X-ray examination is conducted by photographic methods, as the image given by the rays on a dry plate or film show far more detail than can be seen by visual examination with the fluorescent screen.

X-RAY DERMATITIS

A painful and incurable disease, of a cancerous nature, to which radiographers are liable, caused by frequent and prolonged exposure to X-rays. Many of the pioneers of radiography have fallen victims to this complaint, but greater precautions are now taken to protect the operators from the X-rays. There is little danger of contracting this disease in X-ray photography, as the exposures are short and the operator need not stand directly in front of the tube. The chief risk is entailed by visual examination with the fluorescent screen. The disease first makes its appearance in the hands and gradually spreads to the arms and body. The skin at first appears as if it had been burned, hence the term " X-ray burning."

X-RAY PHOTOGRAPHY, OR RADIOGRAPHY (Fr., *Radiographie ;* Ger., *Röntgenphotographie*)

There being no method of bringing X-rays to a focus, the images produced on the photographic emulsion are merely shadows of the objects. The illustration shows the outfit for radiography, A being a metal-lined box containing the X-ray tube ; B, couch for patient ; C, plumb for centring the tube ; D, induction coil ; E, switchboard ; and F, ampère meter. X-ray photographs are produced by means of a high-voltage electrical apparatus and a Crookes' tube. The high pressure current necessary to produce fluorescence in the vacuum tube is obtained from a Wimshurst machine or

an induction coil. The Wimshurst machine is self-contained, the current being generated by revolving glass or vulcanite plates in opposite directions, but these machines have serious drawbacks, and the induction coil is now almost invariably used. The positive pole of the wires is connected to the anode, and the negative is connected to the cathode end of the tube. If the current flows in a reverse direction, the tube is quickly ruined. The half of the tube opposite the anticathode gives out a bright green fluorescence when the current is flowing from anode to cathode; but if the current is passing the reverse way, a flickering bluish-green fluorescence appears all over the tube.

A coil giving a 4-in. spark is sufficiently powerful for experimental radiography, but an 8-in. or 10-in. spark is the lowest that can be used for practical work.

The X-rays are not visible to the eye, and for the visual examination of objects a fluorescent screen of barium platino-cyanide must be used in a darkened room. Radiography, however, need not be conducted in a dark-room. The

Equipment for X-ray Photography

dry plates, packed in light-tight envelopes, are placed behind the object to be photographed, the film facing the tube. If only a 4-in. coil is used, the object must be as close as possible to the tube, but with a powerful coil the distance should be increased to about 30 in. to ensure a sharp image with but little distortion. In medical X-ray work, the patient is placed upon a couch consisting of a wooden frame covered with canvas. A box containing the tube moves on wheels and rails beneath the couch; it is lined with metal to shield the operator from the X-rays. The time of exposure depends upon the strength of current used, the power of the coil, and the condition of the tube. A "hard" tube—that is, a tube with an extremely high vacuum—requires less exposure than a "soft" or low-vacuum tube. The condition of the tube is ascertained by finding its "equivalent spark gap." While the coil and tube are working, the terminal points of the induction coil are slowly brought together. If a spark passes between the points while they are 6 in. or more apart, the vacuum is too high. If no sparking takes place between the terminals

till they are within 3 in. of each other, the tube is low. A good working spark gap distance is $4\frac{1}{2}$ in. A soft, or low-vacuum, tube gives better definition than a hard, or high-vacuum, tube, as the rays pass less easily through dense substances and show greater differentiation of tissue. A very high-vacuum tube may show but little difference between the bones and flesh, while a soft tube should give the minute structure of the bones. Tubes are now fitted with regulators for lowering the vacuum.

With a current of 5 ampères at 100 volts passing through the primary winding of a 10-in. coil, the exposure for a hand or foot would be from 3 to 15 seconds. The exposure for the thicker portions of the body would be from 20 seconds to 2 minutes. If an electrolytic break is used, about half the exposure would be required. Dry plates with extra thick sensitive films are specially prepared for radiography, the development and fixation being the same as in ordinary photography. The image is sometimes barely visible on the surface of the plate during development, but when fixed the negative may give good density and definition owing to the penetration into the film of the X-rays.

Several forms of "intensifying screens" have been introduced for the purpose of shortening exposure. The screens are coated with a substance giving a white or violet fluorescence. The coated side is placed in contact with the sensitive film of the dry plate which is exposed with the *glass* side facing the tube. Intensifying screens greatly reduce the exposure, but the quality of the negative is somewhat inferior owing to the grain of the screen being reproduced.

An energetic developer, such as metol-hydro-quinone, is most suitable for radiography, and development should not be hurried.

The comparative resistance to X-rays of the following list of substances will give some idea of the penetrating power of the rays. The figures are only approximate, as the results vary with the hardness of the tube, etc. :—

The unit is a sheet of cardboard, and the other substances are supposed to be of equal thicknesses. Cardboard, 1 ; wood, $\frac{1}{2}$; linen, 2 ; rubber, $\frac{3}{4}$; iron, 1,000 ; glass, 40 ; lead, 3,000.

Dry plates must not be stored in an X-ray room except in metal chests, as the paper boxes and envelopes give no protection to the sensitive film.

In X-ray work the operator often has to find the position and depth of some foreign object, such as a needle in the human body. This can be ascertained by visual examination with the fluorescent screen from both vertical and lateral points of view. The best method for finding the depth of a foreign body is to take two radiographs on the same plate, moving the tube to one side before the second exposure is given. Two images will appear on the plate, and the position of the foreign body is calculated from the separation of the two images and the distance of the tube from the plate.

J. I. P.

XYLO-AUTOGRAPHY

A half-tone block worked on by a wood-engraver to imitate the effects of wood engraving.

XYLOGRAPHS

Positive pictures by the wet collodion process, toned and transferred to a paper support, and thence to a wood block as a guide for the wood engraver.

XYLOGRAPHY, PHOTO (*See* "Wood, Photographs on.")

XYLOIDIN

A substance analogous to pyroxyline and pro-duced by acting on starch with a mixture of pyroxyline and acids. It dries from its solutions as a matt opaque film, which is very inflammable and explosive.

XYLONITE

A synonym for celluloid.

XYLO-PHOTOGRAPHS

Photographs made upon wood for engraving purposes.

Y

YELLOW GLASS

This is used in the production of the yellow light referred to in the next article.

YELLOW LIGHT

Used for dark-room illumination in the early days of photography, and before the introduction of fast dry plates. It may be used at the present time for bromide paper, lantern plates, and very slow dry plates, but not for dry plates of even the "ordinary" speed. Although a patent was taken out for a ruby light in 1844, yellow light was more widely used during the collodion period, say 1851 to 1880, as it was quite safe for the plates then in use.

YELLOW NEGATIVES

Yellowness in a negative must be regarded as a defect. The time required for printing is very long, and the result of intensifying or reducing must always be uncertain. The usual causes of yellowness are absence or insufficiency of sulphite in the developer, prolonged development with excess of alkali, and fixing in a stale or discoloured "hypo" solution. A good acid fixing bath, if not overworked, will largely correct the tendency to staining from the first two causes. Thiocarbamide is the most satisfactory reagent for removing the yellow stain.

When negatives gradually become yellow after finishing, or when they develop a yellow staining during the process of mercurial intensification, the cause is, almost invariably, imperfect fixing, that is, either too short an immersion in the fixing bath or the use of an exhausted fixing solution ; there is no remedy for such stains.

YELLOW PRINTS

Bromide prints may show a yellow discoloration from the same causes as those given for yellow negatives. If a print is allowed to float on the top of the fixing solution, face upwards, it is almost certain to become yellow stained. Prints should be fixed face downwards. A weak bath of thiocarbamide is the most effective method of removing yellow staining.

YELLOW PRUSSIATE OF POTASH (*See* "Potassium Ferrocyanide.")

YELLOW SCREENS (*See* "Isochromatic Screens.")

YELLOW STAINS

Yellow stains, in isolated patches, on negatives may arise from several causes. If too small a quantity of fixing solution is used, and parts of the negative become uncovered and exposed to the air during fixing, those parts will show a yellow discoloration. This cause can easily be identified, as the yellow stains are visible as soon as the plate is taken from the fixing bath. They are very difficult to remove, thiocarbamide being the most successful reagent.

Yellow stains that develop gradually after the plate is fixed, or those that arise in mercurial intensification, are due entirely to imperfect fixing. There is no method of removing them. (*See also* "Yellow Negatives" and "Yellow Prints.")

Z

ZANDER'S COMPLEMENTARY COLOUR PROCESS

A colour reproduction process invented and patented in 1905 by C. G. Zander, who called it the "Complementary Colour Process." The inventor assumed that it was necessary to use not three, but four, fundamental colours, namely, red, yellow, green and blue, by mixture of which, in suitable proportions, any colours in Nature could be matched. The hues of these four fundamental (or monochromatic) colours may, in popular terms, be described as magenta red, lemon yellow, emerald green, and ultramarine blue. The four colours were grouped into two pairs of complementary colours, namely, red and green and yellow and blue, so that when

the elements of either pair were mechanically mixed as pigments, by printing or staining, they produced black. The inventor claimed that practically the whole range of the spectrum colours could be produced by this process, besides extra spectral purples, dense pure black and homogeneous greys. Zander asserted that no pure black can be reproduced at all in three-colour printing, whilst by his process either of the two pairs would produce black or grey.

ZAPON VARNISH, OR ZAPONLAC

A varnish consisting of celluloid dissolved in amyl acetate. It gives a brilliant surface, impervious to heat or moisture, and may be used for negatives and positives, or as a lacquer for trays. "Zapon" is a proprietary and registered name.

ZENKER, DR. WILHELM

Born 1829; died 1899. A distinguished astronomer and physicist, of Berlin. He published, in 1868, *Lehrbuch der Photochromie*, treating of all the then known methods of colour photography, or approximations thereto. In it he suggested the theory of standing or stationary waves, on which Lippmann's process of interference heliochromy essentially depends.

ZENOTYPE

A process of toning introduced by E. J. Browne in 1894. A powder was supplied commercially which, when dissolved in water, was used as a developer to produce coloured prints.

ZINC, BLACKENING (See "Blackening Apparatus.")

ZINC BROMIDE (Fr., *Bromure de zinc*; Ger., *Zinkbromid*)

$ZnBr_2$. Molecular weight, 225. Solubilities, 1 in ·3 water; very soluble in alcohol and ether. It is a white hygroscopic crystalline powder, obtained by dissolving zinc carbonate in hydrobromic acid. It is occasionally used in collodion emulsion making.

ZINC CHLORIDE (Fr., *Chlorure de zinc*; Ger., *Zinkchlorid*)

$ZnCl_2$. Molecular weight, 136. Solubilities, 1 in ·3 water; soluble in alcohol and ether. It is poisonous, the antidotes being alkaline carbonates preceding water or milk, albumen, etc. It is a white powder which is very deliquescent, and is obtained by dissolving zinc or zinc carbonate in hydrochloric acid. It is used in collodion emulsion making.

ZINC ETCHING (Fr., *Zincographie*; Ger., *Zinkhochätzung*)

The process of reproducing line originals by transferring the image to zinc and etching into relief. Strictly speaking, the term applies to Gillot's original process, in which the image was put down on zinc by means of a lithographic transfer or by drawing on the zinc with lithographic ink or crayon as a preliminary to etching into relief with acid, but the term is also now applied to the "photo-zinco process." Zinc etchings are all kinds of etched zinc plates from line originals, or the equivalent of line

originals, such as coarse crayon grain, stipple, transfers from type or engraved copper and steel plates and woodcuts—anything, in fact, which has not to be reproduced by the half-tone screen.

ZINC HYPOCHLORITE (Fr., *Hypochlorite de zinc*; Ger., *Zinkhypochlorit*)

$ZnOCl_2$. Molecular weight, 152. It is a somewhat indefinite compound, obtained by mixing solutions of zinc sulphate and bleaching powder and filtering out the calcium sulphate. Formerly it was used to eliminate the last traces of "hypo," but it has now scarcely any practical application.

ZINC IODIDE (Fr., *Iodure de zinc*; Ger., *Zinkiodid*)

ZnI_2. Molecular weight, 319. Solubilities, 1 in ·3 water, soluble in alcohol and ether. It is a white deliquescent powder, obtained by dissolving zinc oxide in iodic acid or direct union of zinc and bromine, and it is used for making collodion emulsion.

ZINC OXIDE (See "Zinc White.")

ZINC PLATES

The zinc plates used in process work are of two kinds—thin, with grained surface for photo-lithography, and thick with polished surface for etching. A very pure zinc is requisite for process work, and the plates must be perfectly rolled, and free from surface blemishes. The thin zinc for lithography is chemically treated to free it from grease, and then grained in a trough filled with marbles and sand, which is then given a jogging motion. A fine matt is given to the surface. The thicker zinc, usually 16 B.W.G., or ·065 in. thick, is scraped and polished by buffing with abrading and polishing powders mixed with oil, until a high finish is obtained. Before use, the greasiness is removed by rubbing with pumice powder and water, and by passing through a bath of weak acid and alum.

ZINC SULPHATE (Fr., *Sulfate de zinc*; Ger., *Zinksulfat*)

Synonyms, white vitriol, zinc vitriol. $ZnSO_4 7H_2O$. Molecular weight, 287. Solubilities, 1 in ·62 water, insoluble in alcohol. It is in the form of colourless acicular crystals that effloresce in dry air. It is obtained by the direct action of sulphuric acid on zinc, and is used to form zinc hypochlorite.

ZINC, TRANSFERRING TO

Transfers may be put down on zinc in the same way as upon lithographic stones. The transfer, in lithographic ink on suitable transfer paper, is damped from the back, and laid down on a perfectly clean matted zinc plate; then the plate bearing the transfer is run through a lithographic press several times with increasing pressure. The back of the transfer paper is then damped and peeled off, leaving the ink image on the zinc. This is then treated with a solution of gum and nutgalls and rolled up with ink. The plate may then be printed from lithographically or etched into relief.

ZINC WHITE

Zinc oxide, ZnO. It enters into the composition of some of the white pigments used for retouching photographs for reproduction, and it has the advantage that it does not discolour so readily as the whites formed from lead pigments. It photographs darker than paper. (*See also* "Chinese White.")

ZINCOGRAPHY (Fr., *Zincographie ;* Ger., *Zinkographie*)

The process of lithography from zinc plates, first brought into regular use by Col. Sir Henry James, in 1859, at the Ordnance Survey Office, Southampton, for map printing. Originally the image was put down on the zinc by lithographic transfer, but this has been superseded by photo-zincography, which at first involved the making of a print on photo-lithographic transfer paper. This, in turn, has given way to methods of printing direct from the negative, or through the drawing, as in the Vandyke process.

ZIRCONIUM (Fr., *Zirconium ;* Ger., *Zirkon*)

One of the rarer metals from which is obtained zirconium oxide, which has been suggested as a substitute for the lime in the oxyhydrogen light, and is also used in making incandescent gas mantles.

ZOËTROPE, OR "WHEEL OF LIFE"

An open cylinder with vertical slits round its sides, and below them a series of motion pictures which were viewed through the slits as the cylinder revolved on its stand, the result being a kinematograph effect. It embodies in cylindrical form the principle of an earlier disc device—the phenakistoscope (*which see*), and was invented by Desvignes in 1860. In 1867, a patent for the same device was granted in the United States of America to William E. Lincoln, of Providence, who was the first to call it the

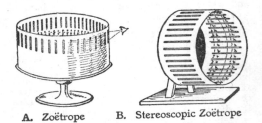

A. Zoëtrope B. Stereoscopic Zoëtrope

zoëtrope. But this type of slotted machine had its origin at a date far anterior to those quoted above ; in fact, only a little more than a twelvemonth elapsed between the invention of the phenakistoscope (1833) and the publication by W. G. Horner in *The Philosophical Magazine* of a description of a device strongly resembling the zoëtrope. The apparatus in its modern form is shown at A. A band of pictures having been placed inside the cylinder, the whole is rotated, when the figures are seen in motion.

A great variety of zoëtropic instruments have been devised, one of the most interesting being the stereoscopic zoëtrope shown at B. Anschütz used this form to produce the appearance of motion from a series of animal movements photographically recorded. The series of phases was taken in stereoscopic sets, and, as is shown, the cylinder was turned on its side, and the slits were long enough to permit of both eyes gaining a view of their respective series ; the blending of the two series was brought about by suitable prisms or other optical device.

ZÖLLNER'S PROCESS

An iodide of starch printing process, invented in 1863 by Dr. F. Zöllner, of Berlin, and used for reproducing plans, drawings, etc. Thin, smooth paper is sized with starch, and sensitised by floating for from thirty to sixty seconds on a solution of ferric chloride and ferric oxalate. The exposure varies from two or three minutes in the sun to fifteen or thirty minutes in diffused light, the image being at first invisible. The exposed prints should not be left longer than twelve hours before developing. The image appears of an intense blue colour on brushing on a solution of potassium iodide in dilute albumen. The developer should be washed off the print before it has time to dry, and the washed prints dried in the open air. To prepare the developing solution, the whites of two eggs of average size are well beaten and left for several hours, after which the liquid albumen is decanted from the bottom of the vessel and diluted with one-third its quantity of distilled water, 78 grs. of potassium iodide being then added and dissolved.

ZOOLOGICAL PHOTOGRAPHY

This includes not only the photography of animals and birds, but also of nests and eggs, insects, and their larvæ and pupæ, reptiles, fish, etc. Under separate headings will be found much information on these subjects, and in this place only general remarks will be given. The chief aim of all naturalistic photography is realism. Texture of all kinds should therefore be most truthfully indicated, and no pains be spared to secure the highest technical excellence ; not only should knowledge of the particular branch of natural history dealt with be acquired, but careful consideration should be devoted to accurate colour rendering, exposure, development, and printing methods. Within limits, some form of colour plate is of great value to the natural history photographer, especially for use as lantern slides ; and this value will increase with the inevitable advance in the speed and quality of the plates available. (*See also* "Animals, Photography of," "Birds, Photography of," "Fish, Photographing," "Insects, Photographing," "Reptiles, Photography of.")

ZOÖPRAXISCOPE

An instrument used to exhibit studies of animals in motion ; a forerunner of the kinematograph.